Gardner's

ART

THROUGH

THE AGES

Tenth Edition

I

ANCIENT, MEDIEVAL, AND NON-EUROPEAN ART

RICHARD G. TANSEY
FRED S. KLEINER

HARCOURT BRACE COLLEGE PUBLISHERS

Fort Worth Philadelphia San Diego New York Orlando Austin San Antonio
Toronto Montreal London Sydney Tokyo

PRESIDENT	*Carl N. Tyson*
PUBLISHER	*Ted Buchholz*
EDITOR IN CHIEF	*Christopher P. Klein*
ACQUISITIONS EDITOR	*Barbara J. C. Rosenberg*
DEVELOPMENTAL EDITOR	*Helen Triller*
SENIOR PROJECT EDITORS	*Margaret Allyson, Mark Hobbs*
SENIOR PRODUCTION MANAGER	*Kathleen Ferguson*
ART DIRECTOR	*Nick Welch*
PICTURE EDITORS	*Peggy Cooper, Carrie Ward*
SENIOR MARKETING MANAGER	*Patricia A. Murphree*
ELECTRONIC PAGE LAYOUT	*Bill Maize, Duo Design Group*
FILM PREPARATION, PRINTING, AND BINDING	*R. R. Donnelley & Sons, Willard, Ohio*
TIMELINE LAYOUTS	*Marco Ruiz*
MAP PREPARATION	*GeoSystems*

Cover Image: Young Woman with a Stylus (sometimes called Sappho), from Pompeii. 1st century A.D. Fresco, diameter 11³/₈″. Museo Nazionale Archeologico, Naples.

Address for Editorial Correspondence:
Harcourt Brace College Publishers, 301 Commerce Street, Suite 3700, Fort Worth, Texas 76102

Address for Orders:
Harcourt Brace & Company, 6277 Sea Harbor Drive, Orlando, Florida 32887
1-800-782-4479 or 1-800-433-0001 (in Florida).

Photograph credits and copyright acknowledgments precede the index and constitute a continuation of this copyright page.

Printed in the United States of America

ISBN:
0-15-501141-3 (hardbound)
0-15-501618-0 (paperbound, Vol. I)
0-15-501619-9 (paperbound, Vol. II)

Library of Congress Catalog Card Number:
95-76264 (hardbound)
95-76263 (paperbound, Vol. I)
95-76259 (paperbound, Vol. II)

5 6 7 8 9 0 1 2 3 4 048 9 8 7 6 5 4 3 2

PREFACE

Since its first edition, almost seventy years ago, Helen Gardner's *Art through the Ages* (1926), carried on by a succession of authors, has established a firm tradition of excellence in its presentation of art to three generations of beginning students. Helen Gardner lived long enough to see the third edition in preparation (1948). In 1958, Sumner Crosby and his colleagues in the History of Art Department at Yale University produced a fourth edition. The fifth through the ninth editions (1991) were prepared by Horst de la Croix and Richard G. Tansey of San Jose State University, the ninth with the collaboration of Diane Kirkpatrick of the University of Michigan. De la Croix's death in 1993 regrettably ended his long association with the Gardner project. His role as coauthor has been assumed by Fred S. Kleiner, Professor of Art History and Archaeology at Boston University and Editor-in-Chief of the *American Journal of Archaeology*. Herbert Cole, of the University of California, Santa Barbara, has been kind enough to contribute the chapter on the art of Africa.

The fundamental belief that guided Helen Gardner and her successors is that the history of art is essential to a liberal education. The study of art history, like its fellow humanistic studies, the history of literature and the history of music, has as its aim the opening of student perception and understanding to works of high esthetic quality and expressive significance—works that humankind has produced throughout history and around the world, and that—especially now—are cherished and conserved by the peoples of the world as representative of their cultural identities. The awareness, comprehension, and informed experience of these works are what a survey like this would encourage and hope to achieve. The art experience can only be informed, expanded, and made selective in its judgments if it is at the same time a historical experience. This means understanding works of art within the contexts of their times and places of origin and the temporal sequences of their production.

In sustaining this traditional view we are still convinced that art has its own history—within, of course, the general history of humankind—and that the discipline of art history has discernible boundaries and distinctive objects to which it attends and with which it operates. We are respectful of the fact that for a long time there has been a corpus of paintings, sculptures, buildings, and other works of art that have been considered most characteristic of the cultures that produced them, most worthy of conservation and study, and most definitive of the scope of art-historical interest. We do not reject the traditional list of "great" works or the very notion of a "canon." But we have also tried in our choice of monuments to reflect the increasingly wide range of interests of contemporary scholarship. We have included, for example, works produced for non-elite patrons alongside those of the emperors in the chapter on Roman art. The chapters on twentieth-century art cover the multitude of innovative art forms that reflect our contemporary world.

We have also taken into consideration present trends of art-historical criticism that would seem to dissolve the traditional art-historical boundaries, merging the humane studies in a kind of conglomerate that much resembles cultural anthropology. Works of art become value-free, cultural artifacts to be interpreted according to anthropological structures: sociopolitical, psychosocial, racial, ethnic, gender, and material, thought of as determined by the power and privilege enjoyed by dominant patronages. Postmodern "critical theory" would

redefine the history of art, its styles, periods, and canons, in terms of contemporary ideological agendas that, for a survey of the subject, cannot help but be tendentious. There is much to be learned from these new approaches to art history, and we have ourselves profited from them. But we feel that, although art is certainly illustrative of culture, and the construction of its cultural context is most valuable in the interpretation of it, art has in fact a cross-cultural independence that makes a history of art possible at all and renders its meanings intelligible and its peculiar values accessible to all interested minds. It is to the cultivation of this interest in art in general—art from all times and places—that a survey of the history of art is dedicated.

The first task, we believe, is to present characteristic works in historical order. To bring theory about the data in before the data are presented would be, its seems to us, premature and confusing. We prefer to fix the attention of beginning students on a wide range of art-historical data, familiarizing them with the stylistic features that identify the data visually, and that differentiate one work or group of works from others within the framework of historical time. Once the distinguishing features have been mastered, special theories about their causes can be debated, although perhaps more effectively in intermediate and advanced undergraduate courses in art history than in the introductory survey courses for which this book has been designed.

The text has been thoroughly revised and in large part rewritten. We have endeavored to update it in accordance with contemporary art-historical and archeological scholarship. Specialists have reviewed each chapter, and the text has benefited. Some previous chapters have been broken down into smaller chapters in response to reviewers' suggestions and to our own feeling that they require greater emphasis: there are now separate chapters for Etruscan and Roman; for Early Christian, Byzantine, and Islamic; and for African art. And the art of Korea is a new addition to our survey of Asian art. The sequence of the chapters dealing with the Renaissance in Italy and in Northern Europe has been altered according to new interpretations of the relationship of those areas in the Renaissance. To this end, Northern art of the fifteenth and sixteenth centuries has been placed in separate chapters. The material in Part V, The Modern World, has been entirely reorganized to chronicle the many styles that characterized the art of the nineteenth century and to trace the development in the twentieth century of Modernism and its sequel, Postmodernism.

Readers of earlier editions of Gardner's classic book will note other important changes. A great effort has been made to enhance the quality of the photographs in the volume by utilizing the latest technology and a finer grade of paper. New maps and timelines open each chapter, and more works in North American collections have been included to encourage the careful study of originals.

A comprehensive package of teaching and study aids also accompanies the tenth edition of *Art through the Ages*. The pronunciation guide to artists' names, included at the end of the book, has been expanded and refined. The Study Guide by Kathleen Cohen contains chapter-by-chapter drills on the identification of geographical locations, time periods, styles, terms, iconography, major art movements, and specific philosophical, religious, and historical movements as they relate to particular works of art examined in the textbook. Self-quizzes and discussion questions enable students to evaluate their grasp of the material. Lilla Sweatt and Timothy Adams are the authors of the Instructor's Manual, which includes sample lecture topics for each chapter, a testbank of questions in formats ranging from matching to essay, studio projects, and lists of resources. A computerized testbank, consisting of questions from the Instructor's Manual, has been created for textbook users.

A work as extensive as a history of world art could not be undertaken or completed without the counsel and active participation of experts in fields other than our own. In some cases, this took the form of preparation of portions of chapters; in others, of reviews of work in progress or already prepared. For such contributions to previous editions, we offer our sincere thanks to James Ackerman, Harvard University; Majorie P. Balge, Mount Holyoke College; Colleen Bercsi, California State University, Northridge; Jacques Bordaz, University of Pennsylvania; Louise Alpers Bordaz, Columbia University; James Cahill, University of California, Berkeley; Miles L. Chappell, College of William and Mary; George Corbin, Lehman College, City University of New York; Gerald Eknoian, DeAnza College; Mary S. Ellett, Randolph-Macon Woman's College; Roger K. Elliott, Central Virginia Community College; Mary F. Francey, University of Utah; Ian Fraser, Herron School of Art, Indiana University–Purdue University; Stockton Garver, Wichita State University; Judith Paetow George, Miami University; Oleg Grabar, Institute for Advanced Study, Princeton; Hamilton Hazlehurst, Vanderbilt University; Howard Hibbard, late of Columbia University; Philancy N. Holder, Austin Peay State University; John Howett, Emory University; Joseph M. Hutchinson, Texas A & M University; Joel Isaacson, University of Michigan; R. Steven Janke, State University of New York at Buffalo; M. Barry Katz, Virginia Commonwealth University; Herbert L. Kessler, Johns Hopkins University; Robert A. Koch, Princeton University; Avra Liakos, Northern Illinois University; Elizabeth Lipsmeyer, Old Dominion University; William L. MacDonald, formerly of Smith College; A. Dean McKenzie, University of Oregon; Mary Jo McNamara, Wayne State University; Kathleen Maxwell, Santa Clara University; Milan Mihal, Vanderbilt University; Diane Degasis Moran, Sweet Briar College; Harry Murutes, University of Akron; Kristi Nelson, University of Cincinnati; Jane S. Peters, University of Kentucky; Edith Porada, late of Columbia University; Bruce Radde, San Jose State University; Gervais Reed, University of Washington; Raphael X. Reichert, California State University at Fresno; Richard Rubenfeld, Eastern Michigan University; Grace Seiberling, University of Rochester; Peter Selz, University of California, Berkeley; David Simon, Colby College; Pamela H. Simpson, Washington and Lee University; David M. Sokol, University of Illinois at Chicago; Lilla Sweatt, San Diego State University; Marcia E. Vetrocq, University of New Orleans; Richard Vinograd, Stanford University; Joanna Williams, University of California, Berkeley; and the Art History Department, Herron School of Art, Indiana University–Purdue University at Indianapolis.

For contributions to the tenth edition in the form of extended critiques of work in progress or already prepared, we wish to thank Priscilla Scabury Albright; Barbara W. Blackmun, San Diego Mesa College; Jack W. Burnham, formerly of the University of Maryland, College Park; Janet Black, College of San Mateo; Martha B. Caldwell, James Madison University; Michael Camille, University of Chicago; David Cast, Bryn Mawr College; Mark Cheetham, University of Western Ontario; Madeline L. Cohen, Community College of Philadelphia; Michael A. Coronel, University of Northern Colorado; Patricia Crane Coronel, Colorado State University; Howard Crane, Ohio State University; Anne Glenn Crowe, Virginia Commonwealth University; Tracey Cullen, Archaeological Institute of America; Walter Denny, University of Massachusetts, Amherst; Lloyd C. Engelbrecht, University of Cincinnati; Benjamin R. Foster, Yale University; Karen Polinger Foster, Connecticut College; Mark D. Fullerton, Ohio State University; Sandra C. Haynes, Pasadena City College; M. F. Hearn, University of Pittsburgh; Robert C. Hobbs, Virginia Commonwealth University; Carol Ivory, Washington State University; Christopher M. S. Johns, University of Virginia; Sandra J. Jordan, University of

Montevallo; Kumja Paik Kim, Asian Art Museum of San Francisco; Martha Kingsbury, University of Washington; Eugene Kleinbauer, Indiana University, Bloomington; Karen Koehler, Skidmore College; Laetitia La Follette, University of Massachusetts, Amherst; Jody Lamb, Ohio University; Joanne Mannell, Montana State University; Virginia Hagelstein Marquardt, Marist College; Linda F. McGreevey, Old Dominion University; Laura Meixner, Cornell University; Mary Miller, Yale University; Robert Poor, University of Minnesota; Donald Preziosi, University of California, Los Angeles; Monica Rothschild-Boros, University of California, Irvine; Charles Sable, Marquette University; Ellen C. Schwartz, Eastern Michigan University; Laurie Taylor-Mitchell, Incarnate Word College; Robert Wojtowicz, Old Dominion University. Innumerable other instructors and students have also sent us helpful reactions, comments, and suggestions for ways to improve the book. We are grateful for their interest and their insights.

We should like to acknowledge the assistance given us in innumerable ways by art and slide librarian Luraine Collins Tansey, especially for bibliographical research and for her skillful management of communications and logistics. Dr. Joel Tansey was also of assistance in compiling the bibliography. In addition, we owe a debt of gratitude to Ivy Doak, who compiled the pronunciation guide.

Among those at Harcourt Brace who have contributed their efforts to the management of an enormously detailed manuscript and have done so with consummate skill, infinite patience, and good humor are our acquisitions editors, Janet Wilhite and Barbara Rosenberg; Barbara's editorial assistant, Diane Drexler; our developmental editor, Helen Triller; our project editors, Margaret Allyson and the late Mark Hobbs; our photo editors, Peggy Cooper and Carrie Ward; our designer, Nick Welch; and our production manager, Kathleen Ferguson. We are also grateful to the marketing staff, Pat Murphree, Toni Hawkins, Patti Holland, Laura Lashley, and Mark Hatley, for their dedication to making the book successful. Recognition and thanks are also due to copy editors Joan Harlan and J. R. Peacock; proofreaders Tom Torrans, Susan Petty, and Pete Gooch; consultant Jerry Edmonson; keyboarder Norman Haskell; compositor Bill Maize; and indexer Linda Webster.

We are especially grateful to the editors at Harcourt Brace for deciding in 1992 to reach out from coast to coast and from generation to generation to bring us together for this project. Our collaboration has already resulted in a lasting friendship and, we hope, a worthy successor to the inspired text that Helen Gardner penned so many years ago.

Richard G. Tansey
Fred S. Kleiner

This volume is one of two that constitute the paperbound version of Gardner's *Art through the Ages*, Tenth Edition. The two volumes exactly reproduce the text of the one-volume version, including its pagination. The first of these volumes contains Part I, The Ancient World; Part II, The Middle Ages; and Part III, The World Beyond Europe. The second volume contains Part IV, The Renaissance and the Baroque and Rococo; and Part V, The Modern and Postmodern World. The introduction, pronunciation guide to artists' names, glossary, bibliography, copyright acknowledgments, and index appear in both volumes. The two-volume printing is intended for those who have occasion to use only half of *Art through the Ages*. The differences between the one-volume and the two-volume versions of the book are differences in form only.

A NOTE TO READERS OF THIS BOOK

The objects pictured in the images in this book vary enormously in size. The authors urge you to take note of the scales provided on all plans and all dimensions provided in captions. This will help you to appreciate the relative sizes of the objects shown.

You will notice the names of modern nations on maps illustrating areas of the world as they were in earlier times. These modern names are used merely for your ease in locating sites.

CONTENTS

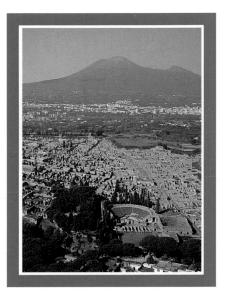

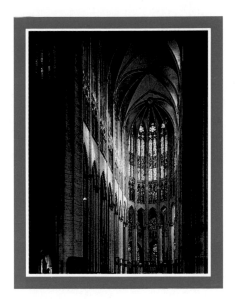

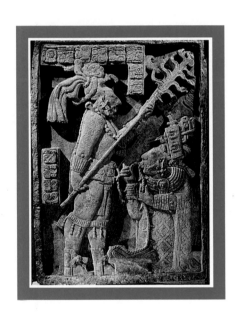

III THE WORLD BEYOND EUROPE 462

Gardner's

ART

THROUGH

THE AGES

Tenth Edition

I

ANCIENT,
MEDIEVAL, AND
NON-EUROPEAN
ART

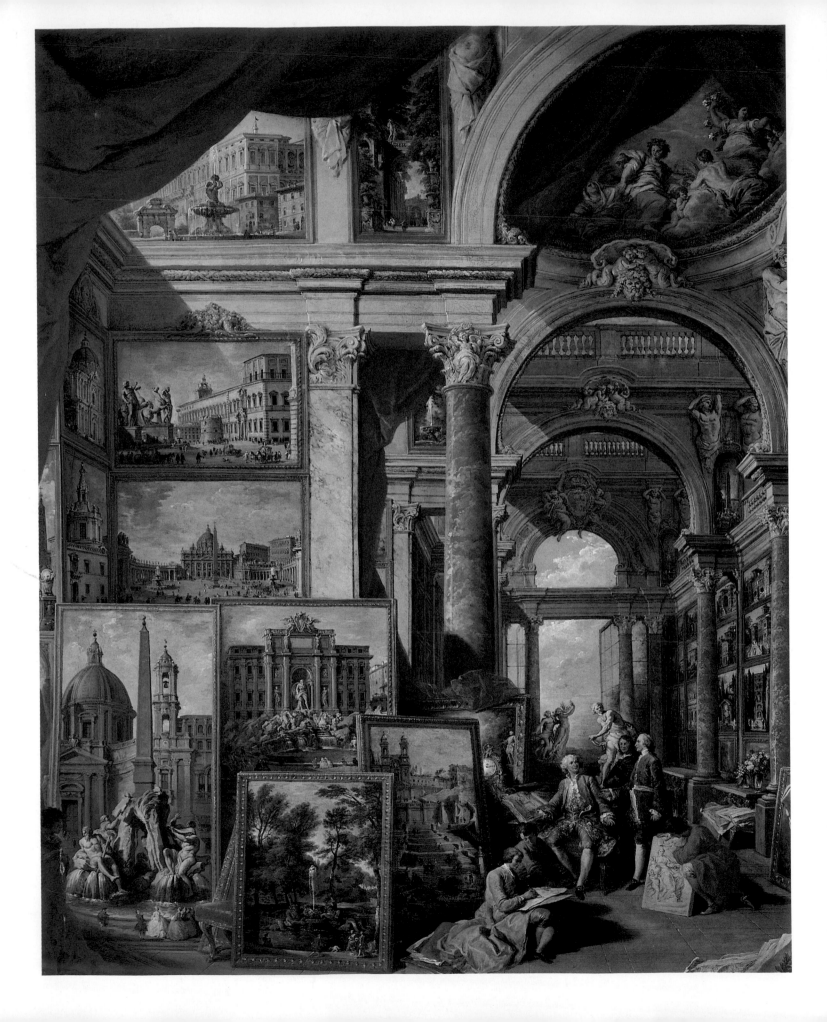

INTRODUCTION

OUTSIDE THE ACADEMIC WORLD, THE TERMS *ART* AND *HISTORY* ARE NOT OFTEN JUXTAPOSED. People tend to think of history as the record and interpretation of past human actions, particularly social and political actions. Most think of art, quite correctly, as something *present*— something that can be seen and touched—which, of course, the vanished human events that make up history are not. The fact is that a visible and tangible work of art is a kind of persisting event. It was made at a particular time and place by a particular person, even if we do not always know just when, where, and by whom. Although it is the creation of the past, art continues to exist in the present, long surviving its times; Charlemagne has been dead for a thousand years, but his chapel still stands at Aachen.

The persisting events that art history chronicles are visual and tangible objects made by human hands. These can be classified under architecture, sculpture, the pictorial arts (painting, drawing, printmaking, photography), and the craft arts, or arts of design, which produce objects of utility, like ceramic wares, metal wares, textiles, and similar accessories of ordinary living. Traditionally, machines and machine-produced objects fall outside the scope of art history, belonging rather to the history of technology (which, it is true, is currently moving into the art-historical domain, given the art-producing potential of the computer). By virtue of their function as temporal rather than spatial and static media, the performing arts—music, drama, and the dance—have their own separate histories. Today, the strict division of the arts, especially that which separates "fine" art from "craft" art and machine art from performance art, is being blurred in practice and often denied in theory.

AT LEFT: *GIOVANNI PAOLO PANNINI,* Picture Gallery with Views of Modern Rome, *1757. Oil on canvas, 67" × 96 1/4" (detail). Charles Potter Kling Fund, Courtesy of Museum of Fine Arts, Boston.*

In this book we shall deal primarily, but not exclusively, with architecture, sculpture, and painting and its related arts. Their monuments have long been the data with which art history has been principally concerned, in which art historians have mostly specialized, and which more immediately draw the attention of the interested public.

THE AIM OF ART HISTORY

Just as history in general seeks to understand the past through its documented events, so the history of art seeks to understand it through works of art. These works are not only "persisting events" but documents recording the times that produced them. Ultimately, art history seeks to arrive at not only as complete a picture as possible of art as it changes in time but also an explanation of those changes. Rather than attempt such an explanation, and risk premature theorizing, our survey intends only an introductory presentation of the material. It is sufficient at this point to define certain categories essential to art-historical procedure and to an understanding of its objects.

CLASSIFICATION CATEGORIES OF ART HISTORY

Art history makes use of several basic categories to identify, describe, and classify its objects, or works of art. For convenience we may call two of these categories *physical* and *esthetic.* The physical categories are the most elementary: the kind or type of object (building, statue, picture), the medium or material (brick, bronze, oil on canvas), the dimensions, the physical condition, and so forth. The esthetic categories name the visual and tactile features of the object (form, shape, line, color, mass, volume). We shall later discuss the esthetic categories in some detail (see pages 9–15).

Historical Categories

The historical categories that art history uses to arrange its objects in time sequences and time frames (*periods*) are date (*chronology*), place of origin (*provenance*), *style* and stylistic change, *iconography* and subject matter, *attribution* (assignment of a work to a maker or makers), and meaning, cause, and *context.* We shall consider them in order.

CHRONOLOGY Before we can construct a history, we must be sure that each monument is correctly dated. Thus, an indispensable tool of the historian is chronology, the measuring scale of historical time. Without chronology, there could be no history of style—only a confusion of unclassifiable monuments.

The table of contents of this book reflects what is essentially a series of periods and subperiods arranged in chronological order—the historical sequence that embraces the sequence of art styles. Until the later eighteenth century, the history of art was really a disconnected account of the lives and works of individual artists. Now, however, we regard art history as a record of the dynamic change of styles through time and the art of individual masters as substyles of the overall period styles. Although one speaks of "change" in the history of art, the objects themselves obviously do not change, but the fact that works of art from one period look different from those of other periods leads us to infer that *something* changes. This something can only be the ways of thinking, the thought patterns of the artists and their cultures with respect to the meaning of life and of art.

PROVENANCE Although our most fundamental way of classifying works of art is by the time of their making, classification by place of origin, or provenance, is also crucial. In many periods, a general style (Gothic, for example) will have a great many regional variations: French Gothic architecture is strikingly different from both English and Italian Gothic. Art history, then, is also concerned with the spread of a style from its place of origin. Supplementing time of origin with place of origin adds yet another dimension to our understanding of the overall stylistic development of art monuments.

STYLE AND STYLISTIC CHANGE The time in which a work of art was made has everything to do with the way it looks—with its style. In other words, the style of a work of art is a function of its historical period. The historiography of art sorts works into stylistic classes on the bases of their similarities and the times or periods in which they were produced. It is a fundamental hypothesis of art history that works of art produced at the same time and in the same place will generally have common stylistic traits. Of course, all historiography assumes that events derive their character from the time in which they happen (and perhaps from their most prominent personages, also products of their time). Thus, we can speak of the Periclean Age, the Age of Louis XIV, or even the Age of Roosevelt. We also must know the time of a work if we are to know its meaning—to know it for what it is. We can assume that artists in every age express in their works some sort of meaning that is intelligible to themselves and others. We can discover that meaning only by comparing a particular work to other works like it that were made about the same time. By grouping works in this way, we can infer a community of meaning as well as of form; a style will then be outlined. In a chronological series of works having common stylistic features, we may find also stylistic differences between the later and the earlier works. The art historian often has tended to think of this phenomenon as reflecting an evolution, a development, and not simply a random change.

It is important to stress, however, that "development" does not mean an orderly progression of styles toward some ideal type or formal perfection, such as absolute truth to natural appearances. Although at times in the development of Western art the "imitation of nature" has been an expressed goal of the artist, photographic realism (the mechanical reporting of what the eye perceives in the visual field) has been rarely either the purpose or the result of that development. Moreover, stylistic development does not lead to ever increasing esthetic value; later phases cannot be appraised as "better" than earlier ones simply because they are presumed closer to some imagined goal of competence and achievement. Instead, we should understand stylistic development as an irregular series of steps of varying duration in which the possibilities of a given style are worked out by artists, both independently and in collaboration with others, until those possibilities are fully realized and new stylistic traits and tendencies appear and are distinguishable as such. Thus, when we talk of stylistic development in art, we do not mean artistic progress—certainly not in the sense of scientific or technological progress, whereby our knowledge appears to increase in a sequence of necessary and interdependent steps toward ever greater scope and certainty.

But even in science and technology, where "later" may be "better" with respect to scientific truth or technological efficiency of function, there is not necessarily an increase in the *quality* of the work compared with past achievement. Though new models of aircraft, automobile, and ship outdate earlier models, many of the early ones can still be admired for their "classic" design. The tall sailing ship may not be a match in speed for the modern power-driven vessel, but its beauty of design and superb performance are still appreciated. The stylistic quality remains even though the style is obsolete.

ICONOGRAPHY AND SUBJECT MATTER Chronology, provenance, and style are supplemented by iconography in identifying, describing, and classifying works of art. *Iconography* means, literally, the "writing of" images, both the significance and the study of them. By extension it includes also the study of symbols. We experience countless images in our everyday environment as it is interpreted by the visual media, and symbols are just as familiar, not only in written, mathematical, and computer language, but in road signs, insignia, trademarks, and so forth. Symbols may be derived from images, as in the evolution of alphabets from pictographs; images may have symbolic significance, as, in Christian art, where the images of winged beasts symbolize the Gospels. The functions of image and symbol can merge, and it is the business of iconographical analysis to interpret them, whether merged or separate.

The analysis of subject matter or theme goes hand in hand with iconography. It is concerned with what the work of art is *about:* the story or narrative, the scene presented, the time and place of the action, the persons involved, the environment and its details. For different works of art some of these aspects are not present or are not relevant; but where they appear, they require identification if an understanding of the subject is to be complete. Pictorial subject matter traditionally has been broadly separated into religious, historical, mythological, genre (commonplace life), portrait, landscape, still life, and their numerous subdivisions. Even without considerations of style, and without knowledge of who the maker of a work might be, much can be determined about the period and provenance of it by iconographical and subject-matter analysis alone.

ATTRIBUTION: THE ARTIST Worldwide, there are great works of art whose artists remain unknown to us—the pyramids at Gizeh in Egypt, Angkor Wat in Cambodia, much of the medieval architecture of Europe, and the works of a number of "masters" still not identified. The analysis of works of art by chronology, provenance, style, iconography, and subject matter gives us an account of these works that makes the identity of the artist seem at first almost irrelevant for a history of art. Art history is essentially a history of art rather than of artists; yet we feel it incomplete and inexplicable without the factor of artistic personality.

A great many artists are identified by what we call *documentary evidence*. This consists of signatures and dates on works and the artist's own writings. Where documentary evidence is lacking, the art historian attempts to assign a work to an artist on the basis of *internal evidence*. This is what can be learned by stylistic and iconographical analysis, in comparison with other works, and by analysis of the physical properties of the medium itself. This complex procedure is known as *attribution,* the assignment of a particular work to a particular artist, or artists. It requires a keen, highly trained eye and long experience to become the expert we call a *connoisseur.* Attribution is bound to be subjective and ever open to doubt. At present, international debate rages over attributions and disattributions to the famous Dutch painter Rembrandt.

It is often the case—but not always!—that artists are influenced by their masters and then influence, or are influenced by, fellow artists working somewhat in the same style at the same time and place. We designate a group of such artists as a *school.* By "school," we do not mean an academy but a chronological and stylistic classification with a stipulation of place. We speak of the Dutch school of the seventeenth century and, within it, of subschools such as those of Haarlem, Utrecht, and Leyden.

It will strike today's readers as curious that the majority of the artists recorded by art history are male. The art-historical record often has tended to exclude the contributions of women to art. Evidence from many times and places (some

of it collected quite recently), however, indicates that women clearly have produced art and craftwork of extremely high quality. Women artists were known in classical antiquity and have been recognized in China, Japan, India, and many other cultures. In the Western Middle Ages, women were renowned as skilled illuminators of manuscripts and workers of textiles. With the Renaissance, women painters began to come into prominence, along with women printmakers and sculptors. The art-historical record demonstrates that artistic talent, skill, competence, inventiveness, and refinement clearly are not functions of gender.

MEANING, CAUSE, AND CONTEXT The meaning of a work of art is not completed by the categories of time, place, iconography, style, or attribution. All of these are the necessary materials of interpretation, but they are not sufficient for it. There remains the question of *cause:* Why does a particular work of art look the way it does and not some other way? What are the historical causes of its style? The answers to these specific questions enter into our explanation of works of art, the disclosure of their meaning, and the way they probably should be looked at. Of course, explanations can never be final, certain, or persuasive for all.

The iconography of a work should not be confused with its meaning. Iconography can show us what a work represents, *what* it is about, but its meaning depends upon the *way* the representation is made (its style) and the *cause* of that way of representation (the artist's purpose or intention). Works may have the same subject matter and imagery but differ markedly in style and purpose. For example, the Christian theme of the Crucifixion has been represented in different ways in different times and places (compare FIGS. 9-28, 13-35, 20-26, 23-3, and 24-38). Pious Christians will reverence these for what they represent. They are not likely to be concerned about stylistic peculiarities that might reveal levels of meaning not immediately given.

It would also seem at first that style is so bound up with meaning that it is impossible to separate them. But just as the iconography of what is represented does not exhaust the meaning of a work, so style alone does not disclose it. Nor are the procedures of attribution more than auxiliary in the elucidation of meaning. Identification of artists and the attribution to them of specific works of art constituted the history of art for centuries.

The history of art style began only in the eighteenth century. Today art history finds itself more and more engaged with *contextuality:* the causal relationships among artists, art work, and the society or culture that conditions them. The history of art has been successively a history of artists and their works, of styles and stylistic change, of images, and now contexts and cultures. Art history at its best makes use of all of these.

The cause of a particular work of art is, obviously, the artist. The purpose of the artist, the means used to fulfill that purpose, and the artist's success in doing so, should be revealed in the finished work, the effect of the artist as cause. But other factors contribute. The artist as a member of a society, as a participant in its culture, shares in a community of experience. Artists are conditioned by their culture's "styles" of seeing, perceiving and thinking, believing and knowing, speaking and acting, doing and making. This amounts to a social collaboration in the whole artistic enterprise.

Context changes in historical time just as do the art styles it conditions. Great historical changes of context cause great stylistic changes. The fall of Rome, the coming of Christianity, and the rise of Islam all had much to do with stylistic changes in architecture, sculpture, and painting in the early centuries of our era. The triumph of science and technology had everything to do with the great transformation of the Renaissance tradition that took place in what we call

"modern art"—the form of our own time. The work of art, the persisting event, is, after all, a historical document. What we have to do is learn to read it as such, so that we may more perceptively "read" it as also a work of art.*

To understand the relationship of historical context and the work of art we must confront the fundamental and perhaps insoluble problem of the relationship of *our* historical context to the historical context we are studying. How can we comprehend a culture that is unlike our own in many respects?

For centuries, travel, migrations, cultural interchanges, and historical curiosity have made us aware of the monuments of other cultures and those of our own. We have viewed them with interest, admiration, and awe. To make sense of them we apply the categories of art history to bring them into sharper focus. We try to reconstruct the cultural context in which they originated. In the reconstructive procedure we consult the evidence of religion, science, technology, language, philosophy, and the arts to discover the thought patterns common to artists and their audiences.† Whatever our reconstructive techniques may be, we are bound to be limited by our distance from the thought patterns of the culture we are studying and by the obstructions to understanding raised by our own thought patterns—the assumptions, presuppositions, and prejudices peculiar to our own culture. The picture of the past we are reconstructing may be distorted because of our own culture-bound blindness. At present, many art historians are insisting that this is indeed the case. For example, they claim that art history has, from the outset, been Eurocentric, viewing other cultures exclusively from a European perspective.

Many art historians, sympathetic to feminist aspirations and concerns, claim that the art of the West expresses the subordination and exploitation of women. Other art historians now emphasize the influence of power interests in determining thought and culture patterns. They see power as the prime mover and ultimate explanation of culture and art, whether political, social, economic, psychological, or psychosexual.

To verify these various claims, art historians who make them undertake to revise traditional and conventional art history by a method of analysis called *deconstruction*. Deconstruction proceeds by "re-reading" the received art-historical picture and showing where and how it is false to the realities of the cultures it attempts to explain and to the meanings of particular works of art.

Thus, in our postmodern world reconstruction and deconstruction of context and its meaning go on together as a kind of dialogue, the outcome of which is uncertain. It may be that the discipline of art history will widen into or merge

*It is important to pay attention to this dual aspect of the work of art in studying art history. As a historical document, the work of art might be regarded as simply one among many documentary artifacts that define a context and enter into the interpretation of it. The work of art would then be used to explain a context, whereas, in our view, the history of art should properly use the context in the explanation of the work of art. The emphasis upon building context pulls art history in the direction of anthropology and sociology. On the other hand, to neglect context would move the work of art away from cultural conditioning as part of its explanation. It would then be part of a historically independent history of art styles. Art historians are presently experiencing this conflict of emphasis and interest.

†These cultural "constructs," as they are called, are believed by many scholars today to encode the thought patterns of a culture, and require, like any code, deciphering. The terms *code* and *encode* are borrowed from the linguistic theory of *semiotics,* which is concerned with the nature of signs—the fundamental elements in communication. All constructs, it is believed, are reducible to signs that communicate significance or meaning. The sign (the signifier) can be anything that signifies, and what it signifies (the signified) is its meaning. The semiotic approach specifically reduces words, symbols, and images to signs and the interrelationships of signs. For reconstructing contexts it is useful both as an extension of the category of iconography and a simplification of it. Semiotic analysis proposes to recover substrata of meaning that conventional art-historical investigation cannot reach and, perhaps, to unify all the humanistic disciplines within one explanatory theory and practice.

with a new discipline that would take in all the humanities, on the model of cultural anthropology and with the methods of semiotics.

One thing seems certain: the intermingling of many cultures today in the phenomenon of multiculturalism can make it possible for us to overcome the limits of the culture-bound and to experience the finest features of all of them. Art made by human hands can be accessible to any human subject. Its esthetic properties, whether or not we fully grasp what they signify, can be discriminated and enjoyed by those who respond to art wherever in the world they may encounter it.

The Esthetic Categories and Terms of Art History

Certain categories and terms are indispensable for describing works of art from any time and place and will be used throughout this book. They make up the vocabulary of formal analysis. Esthetic definitions, like the ones we offer here, are by no means rigid; scholars sometimes use them in slightly different ways. For the purpose of our survey they will serve as keys to a somewhat specialized language. Dictionaries will help where the meaning may seem obscure.

Form, for the purposes of art history, refers to the shape of the "object" (work) of art; in the made object, form is the shape that the expression of content takes. To create forms, to make a work of art, artists shape materials with tools. Each of the materials, tools, and processes available has its own potentialities and limitations; it is part of all artists' creative activity to select the tools most suitable to their purpose. The technical processes that artists employ, as well as the distinctive, personal ways in which they handle them, we call their *technique*. If the material that artists use is the substance of their art, then their technique is their individual manner of giving that substance form. Form, technique, and material are interrelated, as we can readily see in a comparison of a marble statue called the *Kritios Boy* (FIG. 5-37) with a bronze statue of a charioteer (FIG. 5-39). The *Kritios Boy* is firmly modeled in broad, generalized planes, reflecting the ways of shaping stone that are more or less dictated by the character of that material and by the chisel. On the other hand, the charioteer's fineness of detail, seen in the crisp, sharp folds of the drapery, reflects the qualities inherent in cast metal (compare also Verrocchio's bronze *David* [FIG. 21-50] with Michelangelo's marble *David* [FIG. 22-19]). However, a given medium can lend itself to more than one kind of manipulation. The technique of Lehmbruck's bronze *Seated Youth* (FIG. **1**), for example, contrasts strikingly with Rodin's *The Thinker* (FIG. **2**), also in bronze. The surfaces of Lehmbruck's figure are smooth, flowing, quiet; those of Rodin's figure are rough, broken, and tortuous. Here, it is not so much the bronze that determines the form as it is the sculptor's difference of purpose and of personal technique.

Space, in our commonsense experience, is the bounded or boundless "container" of collections of objects. For the analysis of works of art, we regard space as bounded by and susceptible to esthetic and expressive organization. Architecture provides our most common experience of the actual manipulation of space; the art of painting frequently projects an image (or illusion) of our three-dimensional spatial world onto a two-dimensional surface.

Area and *plane* describe a limited, two-dimensional space and generally refer to surface. A plane is flat and two-dimensional. An area is often a plane or a flat surface that is enclosed or bounded.

Mass and *volume*, in contradistinction to plane and area, describe three-dimensional space. In both architecture and sculpture, mass is the bulk, density, and weight of matter in space. Yet the mass need not be solid; it can be the exterior form of enclosed space. For example, "mass" can apply to a pyramid (FIG. 3-8), which is essentially solid, or to the exterior of a church like Hagia Sophia (FIG. 9-1), which is essentially a shell enclosing vast spaces. Volume is

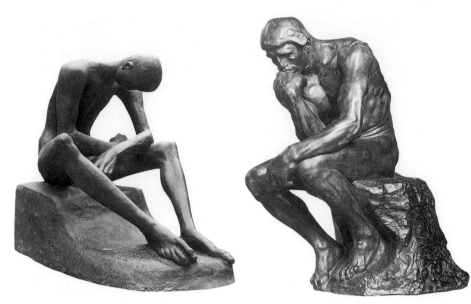

1 WILHELM LEHMBRUCK, *Seated Youth*, 1918.
Bronze. Wilhelm-Lehmbruck-Museum,
Duisburg.

2 AUGUSTE RODIN, *The Thinker,* 1880.
Bronze. Metropolitan Museum of Art, New
York (gift of Thomas F. Ryan, 1910).

the space that is organized, divided, or enclosed by mass. It may be the spaces of the interior of a building, the intervals between the masses of a building, or the amount of space occupied by three-dimensional objects like sculpture, ceramics, or furniture. Volume and mass describe the exterior as well as the interior forms of a work of art—the forms of the matter of which it is composed *and* the forms of the spaces that exist immediately around that matter and interact with it. For example, in the Lehmbruck statue (FIG. 1), the expressive volumes enclosed by the attenuated masses of the torso and legs play an important part in the open design of the piece. The absence of enclosed volumes in the Rodin figure (FIG. 2) is equally expressive, closing the design, making it compact, heavy, and confined. Yet both works convey a mood of brooding introversion. These closed and open forms demonstrate the intimate connection between mass and the space that surrounds and penetrates it.

Line is one of the most important, but most difficult, terms to comprehend fully. In both science and art, line can be understood as the path of a point moving in space. Because the directions of motions can be almost infinite, the quality of line can be incredibly various and subtle. It is well known that psychological responses are attached to the direction of a line: a vertical line is active; a horizontal line, passive; and so on. Hogarth regarded the *serpentine*, or S-curve, line as the "line of beauty." Our psychological response to line is also bound up with our esthetic sense of its quality. A line may be very thin, wire-like, and delicate, as in Klee's *Twittering Machine* (FIG. 27-68, compare FIG. 3-44). Or it may alternate quickly from thick to thin, the strokes jagged, the outline broken, as in a six-hundred-year-old Chinese painting (FIG. 15-23) in which the effect is of vigorous action and angry agitation. A gentle, undulating but firm line, like that in Picasso's *Bathers* (FIG. **3**), defines a *contour* that is restful and quietly sensuous. A contour continuously and subtly contains and suggests mass and volume. In the Picasso drawing, the line can be felt as a controlling presence in a hard edge, profile, or boundary created by a contrasting area, even when its tone differs only slightly from the tone of the area it bounds. A good example of this can be seen in the central figure of the goddess in Botticelli's *The Birth of Venus* (FIG. 21-57; see also FIGS. 12-39 and 14-24).

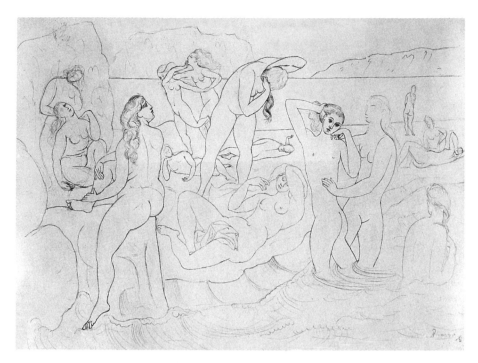

3 PABLO PICASSO, detail of *Bathers*, 1918. Pencil drawing. Fogg Art Museum, Harvard University, Cambridge, Massachusetts (bequest of Paul J. Sachs).

An *axis* is a line along which forms are organized. The axis line itself may not be evident; several axis lines may converge (usually with one dominant), as in the layout of a city. Although we are most familiar with directional axes in urban complexes, they occur in all the arts. A fine example of the use of axis in large-scale architecture is the plan of the Palace of Versailles and its magnificent gardens (FIG. 24-65). Axis, whether vertical, horizontal, or diagonal, is also an important compositional element in painting.

Perspective, like axis, is a method of organizing forms in space, but perspective is used primarily to create an illusion of depth or space on a two-dimensional surface. Because we are conditioned by exposure to Western, single-point perspective, an invention of the Italian Renaissance, we tend to see perspective as a systematic ordering of pictorial space in terms of a single point—a point at which lines converge to mark the diminishing size of forms as they recede into the distance (FIGS. 21-31, 22-15, 24-31). Renaissance and Baroque artists created masterpieces of perspective illusionism. For example, in Leonardo's *The Last Supper* (FIG. **4**), the lines of perspective (dashed lines) converge on Christ and, in the foreground, project the picture space into the room on the wall of which the painting appears, creating the illusion that the space of the picture and the space of the room are continuous. Yet we must remember that Renaissance perspective is only one of several systems for depicting depth. Other systems were used in ancient Greece and Rome (FIG. 7-21) and still others in the East (FIGS. 10-31 and 16-9). Some of these other systems, as well as the Italian Renaissance perspective, continue to be used. There is no final or absolutely correct projection of what we "in fact" see.

Proportion concerns the relationships (in terms of size) of the parts of a work. The experience of proportion is common to all of us. We seem to recognize at once when the features of the human face or body are "out of proportion." Formalized proportion is the mathematical relationship in size of one part of a work of art to the other parts within the work, as well as to the totality of the

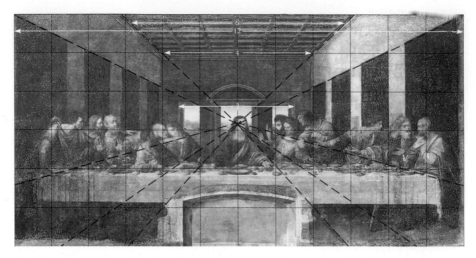

4 LEONARDO DA VINCI, *The Last Supper, c.* 1495-1498. Fresco. Santa Maria delle Grazie, Milan. (Perspective lines are dashed; lines indicating proportions are solid white or black.)

parts; it implies the use of a denominator that is common to the various parts. One researcher has shown that the major elements of Leonardo's *Last Supper* exhibit proportions found in harmonic ratios in music—12:6:4:3. These numbers (with the greatest width of a ceiling panel taken as one unit) are the horizontal widths, respectively, of the painting, the ceiling (at the front), the rear wall, and the three windows (taken together and including interstices); they apply to the vertical organization of the painting as well. Leonardo found proportion everywhere. The ancient Greeks, who considered beauty to be "correct" proportion, sought a *canon,* or rule, of proportion, not only in music, but also for the human figure. The famous Canon of Polykleitos (page 146) long served as an exemplar of correct proportion. But it should be noted that canons of proportion differ from time to time and culture to culture and that, occasionally, artists have used disproportion deliberately. Part of the task facing students of art history is to perceive and adjust to these differences in an effort to understand the wide universe of art forms.

Proportional relationships are often based on a *module,* a dimension of which the various parts of a building or other work are fractions or multiples. A module might be the diameter of a column, the height of a human body, or an abstract unit of measurement. For example, the famous "ideal" plan of the ninth-century monastery of St. Gall (FIG. 11-24) has a modular base of 2 1/2 feet, so that all parts of the structure are multiples or fractions of this dimension. In modern architecture, a module may be any repeatable unit that permits prefabrication (see FIGS. 28-65 and 28-66).

Scale also refers to the dimensional relationships of the parts of a work to its totality (or of a work to its setting), usually in terms of appropriateness to use or function. We do not think that a private home should be as high as an office building or that an elephant's house at the zoo should be the size of a hen coop. This sense of scale is necessary to the construction of form in all the arts. Most often, but not necessarily, it is the human figure that gives the scale to form.

Light in the world of nature is so pervasive that we often take its function for granted. Few of us realize the extraordinary variations wrought by light, either natural or artificial, on our most familiar surroundings. Daylight, for example, changes with the hour or season. The French artist Monet (pages 989–991), who realized the full extent to which light affects and reveals form, painted more than forty canvases of the facade of Rouen Cathedral revealing its changing appearance from dawn until twilight in different seasons (FIG. **5**). Light is as important for the perception of form as is the matter of which form is made.

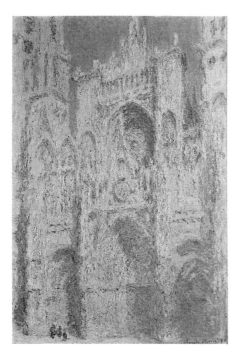
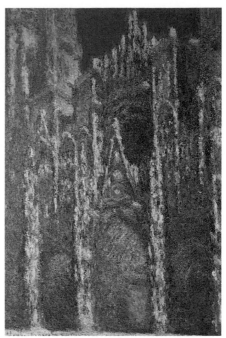

5 CLAUDE MONET, facade of Rouen Cathedral, early 1890s. (*Right*) Museum of Fine Arts, Boston (bequest of Hanna Marcy Edwards); (*left*) National Gallery of Art, Washington, D.C. (Chester Dale Collection).

Value is one function of light. In painting, and in the graphic arts generally, value refers to lightness, or the amount of light that is (or appears to be) reflected from a surface. Value is a subjective experience (see FIG. **6**). In absolute terms (if measured, for example, by a photoelectric device), the center bar in FIG. 6 is uniform in value. Yet, where the bar is adjacent to a dark area, it *looks* lighter, and where the bar is adjacent to a lighter area, it *looks* darker. Value is the basis of the quality called, in Italian, *chiaroscuro*, which refers to the gradations between light and dark that produce the effect of *modeling*, or of light reflected from three-dimensional surfaces, as exemplified in Leonardo's superb rendering of *The Virgin and Child with St. Anne and the Infant St. John* (FIG. 22-2; compare FIG. 7-26).

In the analysis of light, an important distinction must be made for the realm of art. Natural light, or sunlight, is whole or additive light, whereas the painter's light in art—the light reflected from pigments and objects—is subtractive light. Natural light is the sum of all the wavelengths composing the visible spectrum, which may be disassembled or fragmented into the individual colors of the spectral band. Although the esthetics of color is largely the province of the artist and can usually be genuinely experienced and understood only through

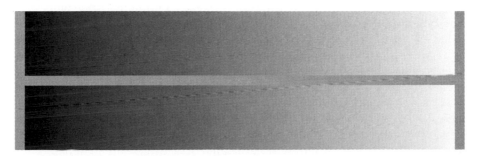

6 Effect of adjacent value on apparent value. Actual value of center bar is constant.

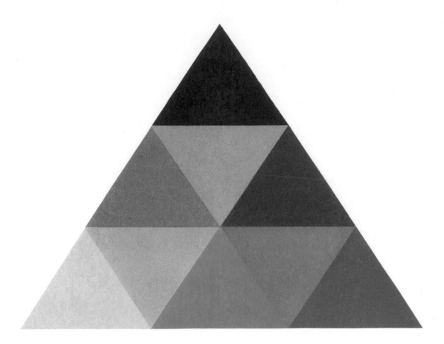

7 Color triangle. Developed by Josef Albers and Sewell Sillman, Yale University, New Haven, Connecticut.

practice and experimentation, some aspects can be analyzed and systematized. Paint pigments produce their individual colors by reflecting a segment of the spectrum while absorbing all the rest. "Green" pigment, for example, subtracts or absorbs all the light in the spectrum except that seen by us as green, which it reflects to the eye. (In the case of transmitted, rather than reflected, light, the coloring matter blocks or screens out all wavelengths of the spectrum except those of the color we see.) Thus, theoretically, a mixture of pigments that embraced all the colors of the spectrum would subtract all light—that is, it would be black; actually, such a mixture never produces more than a dark gray.

Hue is the property that gives a color its name—red, blue, yellow. Although the colors of the spectrum merge into each other, artists usually conceive of their hues as distinct from each other, giving rise to many different devices for representing color relationships. There are basically two variables in color—the apparent amount of light reflected and the apparent purity; a change in one must produce a change in the other. Some terms for these variables are *value* and *tonality* (for lightness) and *chroma, saturation,* and *intensity* (for purity).

One of the more noteworthy diagrams of the relationships of colors is the triangle (FIG. **7**) in which red, yellow, and blue (the *primary colors*) are the vertexes of the triangle, and orange, green, and purple (the *secondary colors,* which result from mixing pairs of primaries) lie between them. Colors that lie opposite each other, such as red and green, are called *complementary* colors, because they complement, or complete, one another, each absorbing those colors that the other reflects. The result is a neutral tone or gray (theoretically, black), which is produced when complementaries are mixed in the right proportions. The inner triangles are the products of such mixing. Color also has a psychological dimension: red and yellow connote warmth; blue and green, coolness. Generally, *warm colors* seem to advance and *cool colors* to recede.

Texture is the quality of a surface (rough, smooth, hard, soft, shiny, dull) as revealed by light. The many painting media and techniques permit the creation of a variety of textures. The artist may simulate the texture of the materials represented or may create arbitrary surface differences, even using materials other than canvas, as in Picasso's *Still Life with Chair-Caning* (FIG. 27-32).

Specialized Categories and Terms

The categories and terms we have been discussing are applicable to all the visual arts. Certain observations, however, are relevant to only one category of artistic endeavor—either to architecture, or to sculpture, or to painting.

IN ARCHITECTURE Works of architecture are so much a part of our environment that we accept them as fixed and scarcely notice them until our attention is summoned. The spatial aspect of the arts is most obvious in architecture. The architect makes groupings of enclosed spaces and enclosing masses, always keeping in mind the function of the structure, its construction and materials, and, of course, its design—the correlative of the other two. We experience architecture both visually and by moving through and around it so that we perceive architectural space and mass together. The articulation of space and mass in building is expressed graphically in several ways, including plans, sections, and elevations.

A *plan* is essentially a map of a floor, showing the placement of the masses of a structure and, therefore, the spaces they bound and enclose (FIGS. 13-6 and 27-4). A *section*, like a vertical plan, shows placement of the masses as if the building were cut through along a plane, often along a plane that is a major axis of the building (FIG. 13-7). An *elevation* is a head-on view of an external or internal wall, showing its features and often other elements that would be visible beyond or before the wall (FIG. 13-19).

The architect must have the sensibilities of a sculptor and of a painter and, in establishing the plan of a building, must be able to use the instruments of a mathematician. As architects resolve structural problems, they act as (or with) engineers who are cognizant of the principles underlying the basic structural devices used in architecture (FIG. **8**). Their major responsibilities, however, lie in the manner in which they interpret the *program* of the building. Any proposed building presents an architect with problems peculiar to it alone—problems related to the site and its surroundings, the requirements of the client, and the materials available, as well as the function of the building. A program, then, deals with more than function; it addresses all of the problems embodied in a specific building.

IN SCULPTURE Like architecture, sculpture exists in the three-dimensional space of our physical world. But sculpture as image is closer to painting than is

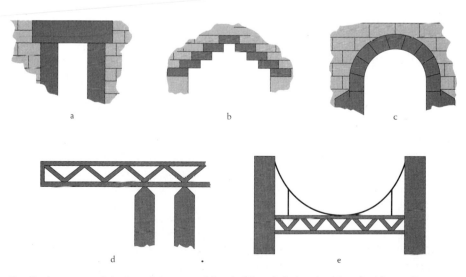

8 Basic structural devices: (a) post and lintel; (b) corbeled arch; (c) arch; (d) cantilever; (e) suspension.

architecture. Until recently, sculpture has been concerned primarily with the representation of human and natural forms in tangible materials, which exist in the same space as the forms they represent. However, sculpture also may embody visions and ideals and consistently has presented images of deities and people in their most heroic as well as their most human aspects (FIGS. 5-99, 5-100, 22-19). Today, sculpture often dispenses with the figure as image and even with the image itself, producing new forms in new materials and with new techniques (FIGS. 28-20 and 27-52).

Sculpture may be associated intimately with architecture, often to such a degree that it is impossible to dissociate the two (FIGS. 13-14, 14-33, 24-5). Sculpture is called *relief* sculpture when it is attached to a back slab or plate (FIGS. 3-43 and 23-22), *high relief,* if the figures or design project boldly (FIGS. 5-90, 21-1, 21-2), and *low relief,* or *bas-relief,* if the figures or design project slightly (FIGS. 5-54, 23-22).

Sculpture that exists in its own right, independent of any particular architectural frame or setting (FIGS. 5-42, 22-19, 22-45), is usually referred to as *freestanding* sculpture, or "sculpture in the round," although, in the art of Greece and of the Renaissance, freestanding sculpture was allied closely to architecture on many occasions. Indeed, sculpture is such a powerful agent in creating a spatial as well as an intellectual environment that its presence in city squares or in parks and gardens is usually the controlling factor in creating their "atmosphere" or general effect (FIG. 24-70).

Some statues are meant to be seen as a whole—to be walked around (FIGS. 5-98, 7-66, 22-45). Others have been created to be viewed only from a restricted angle. How a sculpture is meant to be seen must be taken into account by the sculptor and by those who exhibit the work. The effect of ignoring this is illustrated in FIG. **9.** The left figure has been photographed directly from the front, as the piece is now seen in a museum; the right figure has been

9 DONATELLO, *St. John the Evangelist,* 1412-1415. Marble. Museo del Duomo, Florence. (*Left*) as seen in museum; (*right*) as intended to be seen on facade of Florence Cathedral.

photographed from below, at approximately the same angle from which the statue was originally meant to be seen.

In sculpture, perhaps more than in any other medium, textures, or tactile values, are important. One's first impulse is almost always to handle a piece of sculpture. The sculptor plans for this, using surfaces that vary in texture from rugged coarseness to polished smoothness (FIGS. 2-5, 5-98, 21-48). Textures, of course, are often intrinsic to a material, and this influences the type of stone, wood, plastic, clay, or metal that the sculptor selects. Sculptural technique falls into two basic categories: *subtractive* and *additive*. Carving is a subtractive technique; the final form is a reduction of the original mass (FIG. **10**). Additive sculpture is built up, usually in clay around a framework, or armature; the piece is fired and used to make a mold in which the final work is cast in a material such as bronze (FIGS. 5-98 and 21-10). Casting is a popular technique today. Another common additive technique is the direct construction of forms accomplished by welding shaped metals together (FIG. 28-18).

Within the sculptural family, we must include ceramics and metalwork and numerous smaller, related arts, all of which employ highly specialized techniques described in distinct vocabularies. These will be considered as they arise in the text.

IN THE PICTORIAL ARTS The forms of architecture and sculpture exist in actual, three-dimensional space. The forms of painting (and of its relatives, drawing, engraving, and the like) exist almost wholly on a two-dimensional surface on which the artist creates an illusion, something that replicates what we see around us or something that is unique to the artist's imagination and corresponds only vaguely to anything we can see in the optical world. Human discovery of the power to project illusions of the three-dimensional world onto two-dimensional surfaces goes back thousands of years and marks an enormous

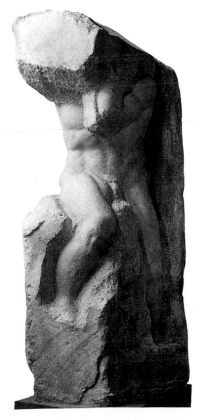

10 MICHELANGELO, *Unfinished Bound Slave*, 1519. Marble. Accademia, Florence.

step in the control and manipulation of the things we perceive. To achieve this illusion, the artist configures images or representations drawn from the world of common visual experience. Throughout the history of art, this world has been interpreted in an almost infinite variety of ways. Undoubtedly, there is much that all people *see* in common and can agree on: the moon at night, a flying bird, an obstacle in one's path. People differ, however, in their *interpretation* of the seen. Seeing and then representing what is seen are very different matters. The difference between seeing and representing determines the variability of artistic styles, both cultural and personal. What we actually see (the optical "fact") is not necessarily reported in what we represent. In other words, in art, there is little agreement between the *likeness* of a thing and the *representation* of it. This lack of agreement makes for a persisting problem in the history of art. How are we to interpret or "read" images or replicas of the seen? Is there a "correct" vision of the "real" world?

THE PROBLEM OF REPRESENTATION

The cartoon of a life-drawing class in ancient Egypt and the actual representation of an Egyptian queen (FIGS. **11** and **12**) raise many questions: Did Egyptian artists copy models exactly as they saw them? (Did Egyptians actually see each other in this way?) Or did they translate what they saw according to some formula dictated by conventions of representation peculiar to their culture? Beginning students usually ask questions like these when they perceive deviations in styles from the recent Western realism to which they are conditioned. They wonder whether the Egyptians, or other artists, were simply unskilled at matching eye and hand and could not draw from what they saw. But such a question presupposes that the objective of the artist has always been to match appearances with cameralike exactitude. This is not the case, nor is it the case that artists of one period "see" more "correctly" and render more "skillfully" than those of another. Rather, it seems that artists represent what they *conceive* to be real, not what they *perceive*. They understand the visible world in certain unconscious, culturally agreed-on ways and thus bring to the artistic process ideas and meanings out of a common stock. They record not so much what they

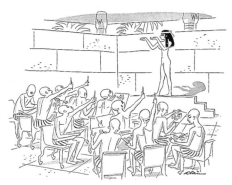

11 ALAIN, Drawing from *The New Yorker*.

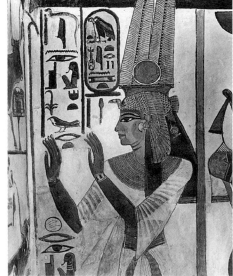

12 Queen Nofretari, from her tomb at Thebes, *c.* 1250 B.C. Detail of a painted bas-relief.

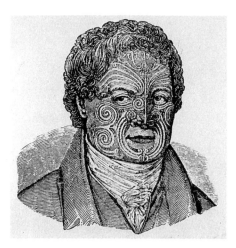 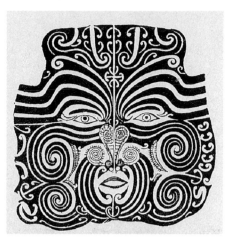

13 The Maori Chief Tupai Kupa, *c.* 1800. (*Left*) after a drawing by John Sylvester; (*right*) a self-portrait. From *The childhood of Man* by Leo Frobenius, 1909, J. B. Lippincott Company.

see as what they know or mean. Personal vision joins with the artistic conventions of time and place to decide the manner and effect of the representation. Yet, even at the same time and place (for example, nineteenth-century Paris), we can find sharp differences in representation when the opposing personal styles of Ingres and Delacroix record the same subject (FIGS. 26-8 and 26-15; compare also FIGS. 11-14 and 11-15, 19-15 and 19-16).

A final example will underscore the relativity of vision and representation that differences in human cultures produce. Although both portraits of a Maori chieftain from New Zealand (FIG. **13**)—one by a European, the other by the chieftain himself—reproduce his facial tattooing, the first portrait is a simple, commonplace likeness that underplays the tattooing. The self-portrait is a statement by the chieftain of the supreme importance of the design that symbolizes his rank among his people. It is the splendidly composed insignia that is his image of himself.

Students of the history of art, then, learn to distinguish works by scrutinizing them closely within the context of their time and provenance. But this is only the beginning. The causes of stylistic change over time are mysterious and innumerable, and neither this book nor any other can contain an outlay of facts that are incontestable. It is only through the continuing process of art-historical research that we can hope to make the picture even fragmentarily recognizable. Incomplete though the picture is and will remain, the panorama of art, changing in time, lies before students, and as their art-historical perspective gains depth and focus, they will come to perceive the continuity of the art of the past with that of the present. It will become clear that one cannot be understood without the other and that our understanding of the one will constantly change with changes in our understanding of the other. The great poet and critic T. S. Eliot has cogently expressed this truth for all art in a passage that suggests the philosophy and method of this book:

> What happens when a new work of art is created is something that happens simultaneously to all the works of art which preceded it. The existing monuments form an ideal order among themselves, which is modified by the introduction of the new (the really new) work of art among them. . . . Whoever has approved this idea of order . . . will not find it preposterous that the past should be altered by the present as much as the present is directed by the past.*

*T. S. Eliot, "Tradition and the Individual Talent," in *Selected Essays 1917–1932* (New York: Harcourt Brace, 1932), p. 5.

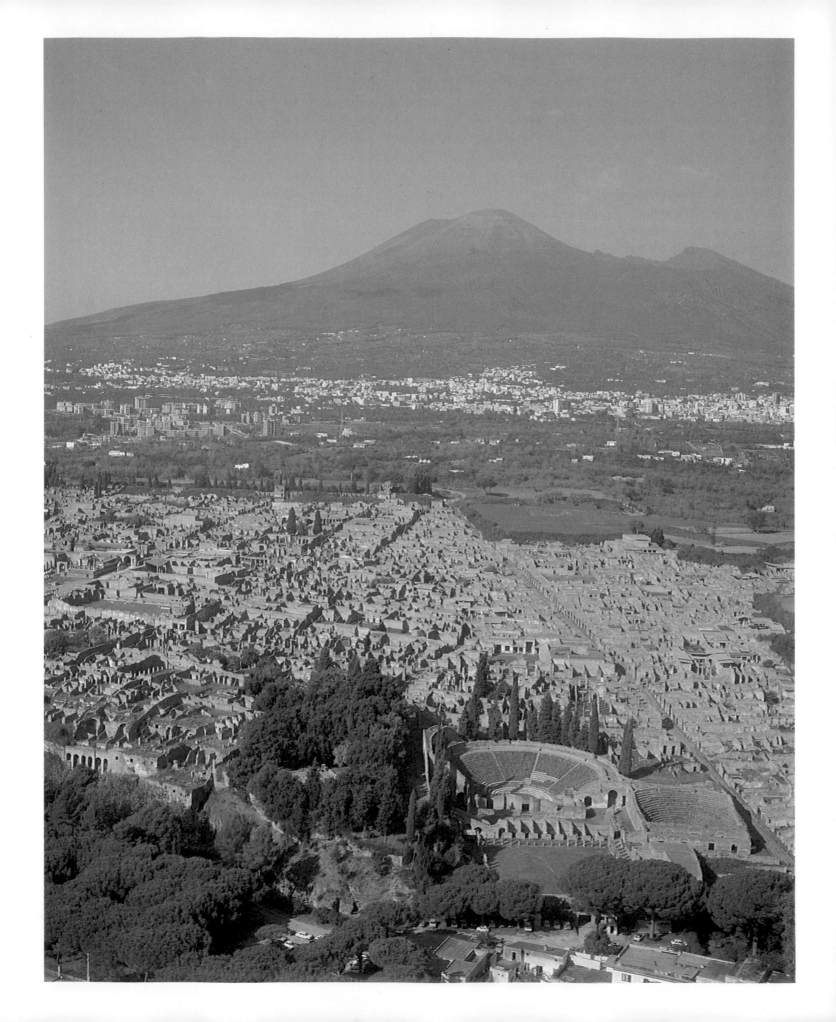

PART ONE

◆

THE ANCIENT WORLD

THE CHRISTIAN CIVILIZATIONS OF THE WESTERN WORLD EARLY DISTINGUISHED AN ANCIENT past from a new age—the times, respectively, before (B.C.) and after (A.D.) Christ. For these people, the ancient world of the Old Testament had the character of a preparation; it was related to the new era as promise is related to fulfillment. This slightly condescending view toward antiquity changed during the Renaissance, when scholars and artists deeply admired the Greco-Roman past and debated the question of which was superior, the "ancient" or the "modern." Interest in Classical antiquity later broadened to encompass the great civilizations that preceded it: the pre-Greek Mediterranean, the Egyptian, the Near Eastern, and the remote, prehistoric cultures of western Europe.

All these ancient civilizations, so unlike one another, still seem to most of us to be different in kind from our own modern world. Until we become familiar with the ancient world, it seems to us to be simply *that* (ancient, exceedingly old), and we imagine it in terms and images of faded inscriptions and dusty ruins. More properly, we should see *ourselves* as "ancient"—as living in a later era of a great epoch at the beginning of which some of our most fundamental beliefs, institutions, folkways, and art and science had their inception.

Following the development of agriculture and the widespread domestication of animals, the precarious, furtive life of the cave-dwelling hunter and the later nomadic herders was succeeded by the more sedentary and ordered life of the village farmer. This leap from food gathering to food production significantly transformed the human condition and made possible all that has followed. In

AT LEFT: *The city of Pompeii on the Bay of Naples in Italy, destroyed by the eruption of Mount Vesuvius (in the background) in A.D. 79, has been excavated since the eighteenth century and has provided invaluable evidence for the function and display of works of art in Roman cities.*

Mesopotamia, Anatolia, and Egypt, more complex forms of human community were created—cities, city-states, and kingdoms. Formal religion and codes of law were developed to regulate the relationships among human beings and between gods and human beings. Writing was invented, as well as numbers and the art of calculation. The course of the stars was plotted in order to predict the seasons and the times for planting and harvesting. Architecture, sculpture, and painting flourished in the service of kingly magnificence.

With the Greeks, there emerged what might be called the specifically "Western intelligence," with its respect for reason, scientific inquiry, the physical concept of nature, and the humanistic view of humankind. It was in ancient Greece—Athens in particular—that democracy first evolved in a limited form. About twenty-five hundred years ago, the government of Athens was largely run by a council of citizens, who were chosen by lot, and a kind of legislative assembly made up of all citizens—although citizenship did not extend to women or to the slaves who made up nearly half the population. The Greeks inaugurated the first authentic phase of European culture, the content and spirit of which are still largely with us in our patterns of life and thought today.

Rome, the cultural and political heir to the world of Alexander the Great and the Hellenistic kings, became the greatest empire of the ancient world. In about a thousand years, Rome progressed from a small village of huts to a city ruled by Etruscan kings to the zenith of its empire, which extended from what are now the borders of Scotland to North Africa. The dynamic and aggressive Roman spirit was reflected in and supported by an astonishing military machine and technology, although Roman control over diverse peoples was exercised as much by the encouragement of their participation in the empire as by the

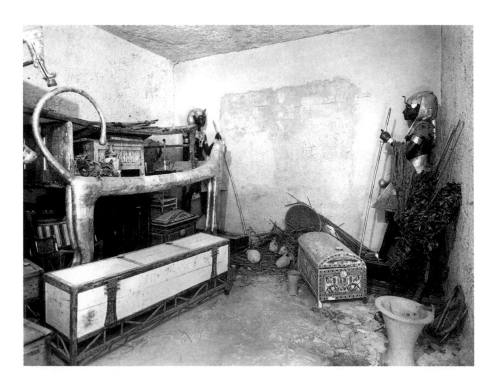

Howard Carter, a British archeologist, spent six years searching for the tomb of the Egyptian pharaoh Tutankhamen and another eight years removing, cataloguing, and restoring the more than two thousand objects found in the tomb. In one of the tomb's chambers two "sentinels" were found guarding the sealed entrance to the pharaoh's burial chamber.

naked assertion of Roman power. The Romanization of western Europe still has much to do with its character today, and the language of the Romans, Latin, is still the core of the so-called Romance (descended from the Roman) languages of modern Europe and much of the Americas.

One way, however, in which the ancient world *is* fundamentally different from our world is that ancient art is largely anonymous and undated. There simply is no equivalent in antiquity for the systematic signing and dating of works of art that is commonplace in the contemporary world. That is why the role of archeology in the study of ancient art is so important. Only the scientific excavation of ancient monuments can establish their *context*. An exquisitely painted Greek vase or sensitively modeled Roman portrait head that appears mysteriously on the art market as the result of clandestine excavation and looting of an ancient site may be appreciated as a masterpiece. But to understand the role the work of art played in ancient society—in many cases, even to determine the date and place of origin of the object—the art historian must know where the object was uncovered. Only when the context of a work of art is known can we go beyond an appreciation of its formal qualities and begin to analyze its place in the *history* of art—to trace the evolution of art through the ages.

Fortunately, there are instances where methodical excavation has recovered great tracts of forgotten history to fill out our picture of the distant past and to permit us to see the ways in which works of art functioned in their original contexts. At Roman Pompeii, for example, a town on the Bay of Naples tragically buried by the volcanic eruption of Mount Vesuvius in A.D. 79, we can study the different purposes of works of art created for different contexts—dignified formal portraits of leading citizens in the forum, copies of Greek statues of gods and heroes in gardens, erotic paintings on the walls of private houses—because they were found by archeologists in their original locations, where they were meant to be seen. So too, we can achieve an unparalleled understanding not only of the art but also of the beliefs of the ancient Egyptians from the discovery *in situ* of the furnishings of the magnificent tomb of Tutankhamen. We can determine, for example, that two of the statues served as eternal sentinels flanking the sealed entrance to the burial chamber in which the mummified Tutankhamen was laid to rest in a golden coffin. And, of course, the secure dating of all the objects found in Tutankhamen's tomb and, to a lesser extent, of everything found at Pompeii—which must antedate the city's destruction in 79—allows us by comparison to date other objects of uncertain provenance that might otherwise be undatable.

The study of ancient art is also complicated by a very low survival rate in general and by the nearly total loss of those works of art most admired by the ancients themselves. We have, for example, none of the the paintings on wooden panels of the Greek masters—all have vanished because of their perishable nature. And our history of Greek sculpture is based almost exclusively on copies fashioned in Roman times—often in a different material.

Yet despite the handicaps posed by looted archeological sites, undated and contextless objects, and lost masterpieces, art historians, acting as detectives aided by archeologists, have been able to reconstruct a remarkably complete picture of the origin and evolution of art and architecture in ancient times. The result is an exciting drama that begins in the caves of prehistoric Europe and takes the reader to the "fertile crescent" of the ancient Near East where the first true cities can be found, to the great pyramids in Egypt, to the dawn of the Classical age in Greece, to the imperial art of Rome at its apogee, and, finally, to the birth of Christian art, which forms a virtually unbroken link between the art of late antiquity and that of modern times.

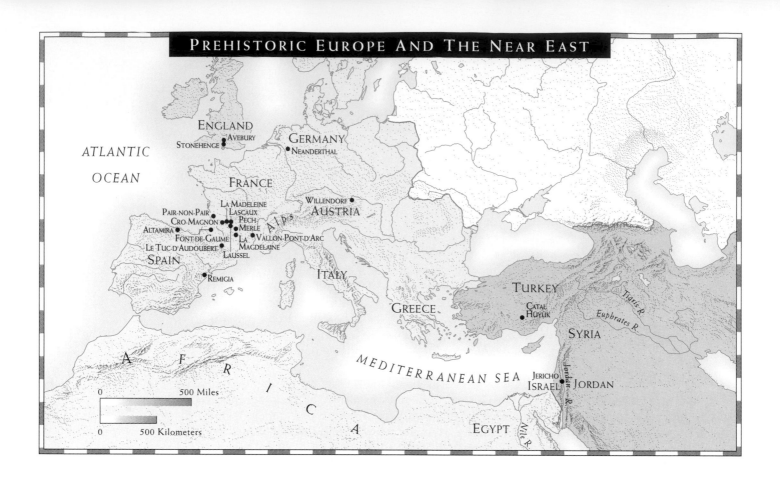

PREHISTORIC EUROPE AND THE NEAR EAST

ATLANTIC OCEAN

ENGLAND
Stonehenge • Avebury
GERMANY
• Neanderthal

FRANCE

Pair-non-Pair
La Madeleine
Lascaux
Cro-Magnon Pech-
Merle
Altamira
Font-de-Gaume La
Le Tuc-d'Audoubert Magdelaine
Laussel
SPAIN
Willendorf •
AUSTRIA
Alps
Vallon-Pont-d'Arc

Remigia •

ITALY

GREECE

TURKEY
Catal
Huyuk

Syria
Euphrates R.
Tigris R.

MEDITERRANEAN SEA

Jericho
ISRAEL Jordan R. JORDAN

EGYPT Nile R.

0 500 Miles
0 500 Kilometers

35,000 B.C.	32,000 B.C.	25,000 B.C.	20,000 B.C.	15,000 B.C.	9000 B.C.

PALEOLITHIC

Venus of Willendorf
c. 28,000–23,000 B.C.

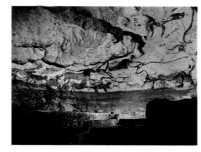

Hall of the Bulls, Lascaux
c. 15,000–13,000 B.C.

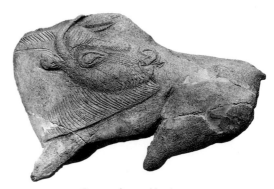

Bison with turned head
La Madeleine
c. 11,000–9000 B.C.

Neanderthal era at 35,000 B.C.

Emergence of Cro-Magnons at 32,000 B.C.

Final recession of ice and onset of temperate climate, c. 9000 B.C.

CHAPTER 1

THE BIRTH
OF ART

7000 B.C.		6000 B.C.	4000 B.C.	3500 B.C.	1500 B.C.
MESOLITHIC IN EUROPE			NEOLITHIC IN EUROPE		
MESOLITHIC IN NEAR EAST		NEOLITHIC IN NEAR EAST			

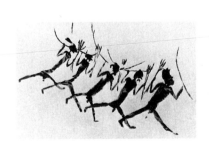

Marching warriors
Gasulla gorge, Remigia
c. 7000-4000 B.C.

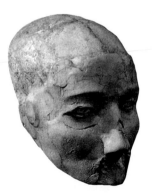

Human skull
Jericho
c. 7000-6000 B.C.

Çatal Hüyük
c. 6500-5700 B.C.

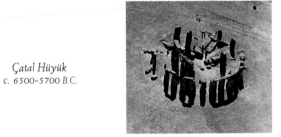

Stonehenge
c. 2000 B.C.

Earliest farming communities, c. 7000 B.C.

What Genesis is to the biblical account of the beginning of the human race, early cave art is to the history of human intelligence, imagination, and creative power. In the caves of southern France and northern Spain, the first of which were discovered only a little over a century ago, as well as in central Europe, Asia, and Africa, where humankind seems to have had its origin, we may witness the birth of that unique capability that has made us masters of our environment—the making of images and symbols. By this original and tremendous feat of abstraction, Paleolithic* cave dwellers were able to fix in place the world of their experience, rendering the continuous processes of life in discrete and unmoving shapes that had the identity and meaning of the living animals that were their prey.

In that remote time during the last advance and retreat of the great glaciers, Stone Age people made the critical breakthrough and became wholly human. Our intellectual and imaginative processes function through the recognition and construction of images and symbols. We see and understand the world around us much as we are taught to, according to representations of that world that are familiar to our particular time and place. The immense achievement of Stone Age people, the invention of *representation* (literally, the presenting again—in different and substitute form— of something observed), cannot be exaggerated.

PALEOLITHIC ART

Western Europe

The physical environment of the cave peoples over thousands of years would not appear to be favorable to the creation of an art of quality and sophistication; survival alone would seem to have required most of their energies. Tens of thousands of years ago a great sheet of ice advanced south from Scandinavia over the plains of north central Europe, and glaciers spread down from the Alps and other mountain ranges to produce a tundra and forest-tundra climate. Although for periods during this time parts of Europe were temperate, it was only about 9000 B.C. that the final recession of the ice came. In the cold periods, human hunters and food gatherers took refuge in caves. It was there that Cro-Magnon peoples, who first appeared about 30,000 B.C., replacing Neanderthals, took the remarkable steps that made them not simply fabricators of stone tools, but artists.

Prior to around 30,000 B.C. there is no evidence for anything that may properly be called art, but during the next several millennia there was a powerful outburst of artistic creativity, ranging from the manufacture of simple shell necklaces to the fashioning of human and animal forms in bone, clay, and stone. By 15,000 to 10,000 B.C. at the latest, it was common for Paleolithic artists to cover the walls of their caves with monumental paintings and relief sculptures.

CAVE PAINTING The first example of cave painting was discovered accidentally by an amateur archeologist in 1879 near Santander in northern Spain. The Marquis Marcelino de Sautuola, who was interested in the antiquity of the human race, was exploring the Altamira caves on his estate, in which he had already found specimens of flint and carved bone. His little daughter was with him. Because the ceiling of the debris-filled cavern was only a few inches above the father's head, it was the child who was first able to discern, from her lower vantage point, the shadowy forms of painted beasts on the cave roof (FIG. 1-1). De Sautuola was the first modern man to explore this cave,

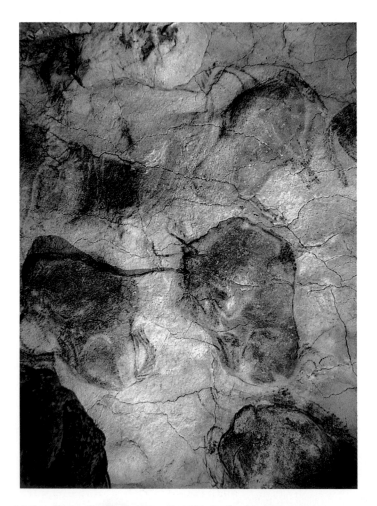

1-1 Bison, detail of a painted ceiling in the Altamira cave (Santander, Spain), *c.* 14,000–12,000 B.C. Each bison approx. 8′ long.

*The prehistoric periods Paleolithic, Mesolithic, and Neolithic refer to the stone (Greek: *lithos*) technology that prevailed through thousands of years of early human life; the prefixes *paleo-*, *meso-*, and *neo-* mean old (early), middle, and new (late), respectively. These terms were coined in the nineteenth century and no longer fit the facts as precisely as modern archeology now classifies them, but they are used habitually and are difficult to replace.

and he was certain that these paintings dated back to prehistoric times. Professional archeologists, however, were highly dubious of the authenticity of these works, and at the Lisbon Congress on Prehistoric Archeology in 1880, the Altamira paintings were officially dismissed as forgeries. But in 1896, at Pair-non-Pair in the Gironde district of France, paintings were discovered partially covered by calcareous deposits that would have taken thousands of years to accumulate. These paintings were the first to be recognized by experts as authentic. The conviction grew that these remarkable works were of an antiquity far greater than ever before dreamed. In 1901, Abbé Breuil discovered and verified the cave paintings of Font-de-Gaume in Dordogne, France. The skeptics were finally convinced.

The painted caverns of prehistoric Europe had served as subterranean water channels, a few hundred to several thousand feet long. They are often choked, sometimes almost impassably, by faults or by deposits, such as stalactites and stalagmites. Far inside these caverns, well removed from the cave mouths that they often chose for habitation, the hunter-artists engraved and painted pictures on the walls. For light, they used tiny stone lamps filled with marrow or fat, with a wick, perhaps, of moss. For drawing, they used chunks of red and yellow ocher; for painting, they ground these same ochers into powders that they blew onto the walls or mixed with some medium, such as animal fat, before applying. A large flat stone served as a palette; they could make brushes from reeds or bristles; they could use a blowpipe of reeds or hollow bones to trace outlines of figures and to put pigments on out-of-reach surfaces; and they had stone scrapers for smoothing the wall and sharp flint points for engraving. In some caves, recesses cut into the rock walls seven or more feet above the floor must have held joists for a scaffolding that could support a platform made of saplings lashed together. This permitted the painters access to the upper surfaces of the caves, where they could occupy themselves for hours if necessary; remains of meals indicate that they could take them without having to descend.

The group of bison from the Altamira cave (FIG. 1-1, a detail of a much larger group approximately 60 feet long) was painted on just such a ceiling some 15,000 years ago. The Altamira painter, like every artist in every age in every medium, had to answer two questions before beginning work: *What* shall be my subject? *How* shall I represent it? In the case of Paleolithic art, the almost universal answer to the first question was an animal—bison, mammoth, ibex, and horse were most common. In fact, humans were infrequently depicted and males almost never. In equally stark contrast to the world of today, in Paleolithic times there was also a consensus as to the best answer to the second question. Every one of the Altamira bison (and virtually every animal in every prehistoric cave painting) is presented in the same manner—in strict profile—whether alive and standing, or dead and collapsed on the ground (FIG. **1-2**), even if in the latter case the artist had to adopt

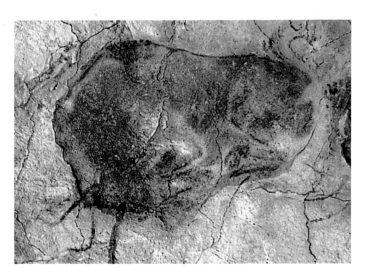

1-2 Dead bison, Altamira (detail of FIG. 1-1).

a viewpoint above the animal, looking down, rather than the view a person standing on the ground would have. We shall see that this profile view remains the norm for depictions of animals for thousands of years, because it is the only view of an animal wherein the head, body, tail, and all four legs can be seen. A frontal view would have concealed most of the body and a three-quarter view would not have shown either the front or side fully. Only the profile view is completely informative about the animal's shape and so it was always chosen by the prehistoric painter. It will be a very long time before artists will place any premium on "variety" or "originality," either in choice of subject or in manner of representation. These are quite modern notions in the history of art. The aim of the prehistoric painter was to create a convincing image of the subject, a kind of pictorial definition of the animal, capturing its very essence, and only the profile view met the artist's needs.

We have referred to the paintings on the ceiling of the Altamira cave as a *group* of bison, but that is very likely a misnomer. The several bison in our illustration (FIG. 1-1) do not stand on a common ground line nor do they share a common orientation. They seem almost to float above our heads, like clouds in the sky. And, as noted earlier, the dead bison is seen in an "aerial view," while the others are seen from a position on the ground. There is no setting, no background, no indication of place. The Paleolithic painter is not at all concerned with *where* the animals are or with how they relate to one another, if at all. What we have instead are several *separate* images of a bison, perhaps painted at different times, and each is as complete and informative as possible.

In the absence of any contemporary explanations—we deal with an era before writing, before (pre-) history—we can only speculate on the purpose and function of these paintings. Features common to all of them, however, provide some clues as to what they may have meant to their creators. It is interesting to note, for example, that the

Altamira bison were painted in a dark chamber some 85 feet from the entrance to the cave. This is true of Paleolithic painting in general, as may be seen in the plan of the caves at Lascaux (FIG. **1-3**), near Montignac, also in the Dordogne region of France. At Lascaux, the magnificent so-called Hall of the Bulls (FIG. **1-4**) is the first chamber that one encounters, although it was far removed from the daylight, and other paintings in the cave are hundreds of feet from the entrance. The remoteness and difficulty of access of many of the sites where cave paintings are found and the fact that they appear to have been used for centuries suggest that the prehistoric hunter attributed magical properties to them. Therefore, the paintings themselves could have had magical meaning for their creators. By confining them to the surface of their cave walls, the prehistoric hunters may have believed that they were bringing the animals under their control. Within this context, the artist's apparent aim of presenting as complete and convincing an image of the animal as possible may be explained by the belief that the painting's magical power was directly related to its lifelike

characteristics. It is noteworthy in this respect that today we can easily distinguish all the animals represented, even the extinct species.

This "naturalism" was achieved in different ways by different artists. In the Hall of the Bulls at Lascaux some of the animals—they are of several types and of varying size—are depicted using colored silhouettes, as at Altamira, while others—like the great bull at the right of our illustration (FIG. 1-4)—are created by outline alone. On the walls of this cave we already see the two basic approaches to drawing and painting that we will encounter again and again in the history of art (compare, for example, the Greek techniques of *black-figure* [silhouette] and *red-figure* [outline] painting a dozen millennia later, FIG. 5-24). This dichotomy of style and technique alone suggests that the animals in the Hall of the Bulls were painted at different times, and the sense that we get today of a rapidly moving herd of beasts was probably not the artists' intent. In any case, the "herd" consists of several different species and the animals move in different directions.

Another feature of the Lascaux paintings deserves our attention. The bulls there and elsewhere show a convention of representation of the horns that has been called *twisted perspective*, because we see the heads in profile but the horns from the front. Thus, the approach of the artist is not strictly or consistently *optical* (organized from the perspective of a fixed viewpoint). Rather, the approach is *descriptive* of the fact that cattle have two horns. Two horns would be part of the concept "bull." In strict optical-perspective profile, only one horn would be visible, but to paint the animal in that way would, as it were, amount to an incomplete definition of it.

Researchers have evidence that the hunters in the caves, perhaps in a frenzy stimulated by magical rites and dances, treated the painted animals as if they were alive. Not only was the quarry often painted as pierced by arrows, as in the "Chinese Horse" (named for its resemblance to horses in Chinese painting) in the Axial Gallery at Lascaux (FIG. **1-5**), but hunters actually may have thrown spears at the images, as sharp gouges in the sides of animals in some caves suggest. This practice, intended to predestinate and magically command the death of the animals, would be analogous to the kind of magic, still cultivated in parts of the world today, that is based on the belief that harm can be done to an enemy by abusing an image of the person.

The pictures of animals in the caves are often accompanied by signs consisting of checks, dots, squares, or other arrangements of lines. Several observers have seen a primitive form of writing in these representations of nonliving things, but they, too, may have had magical significance. The ones that look like traps or snares, for example, above the head of the Chinese Horse (FIG. 1-5), may have been drawn to insure success in hunting with these devices. In many places, as at Pech-Merle (FIG. **1-6**), representations of human hands, most of them "negative," appear where the artist placed one hand against the wall and then painted or

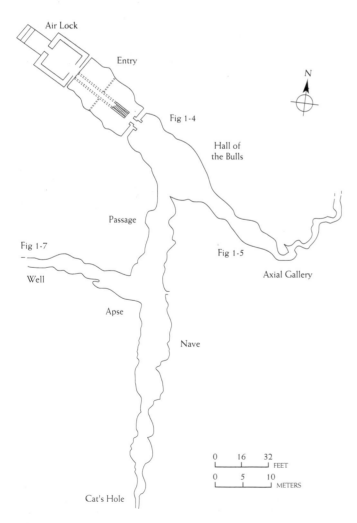

1-3 Diagram of the caves of Lascaux (Dordogne, France). (After Arlette Leroi-Gourhan.)

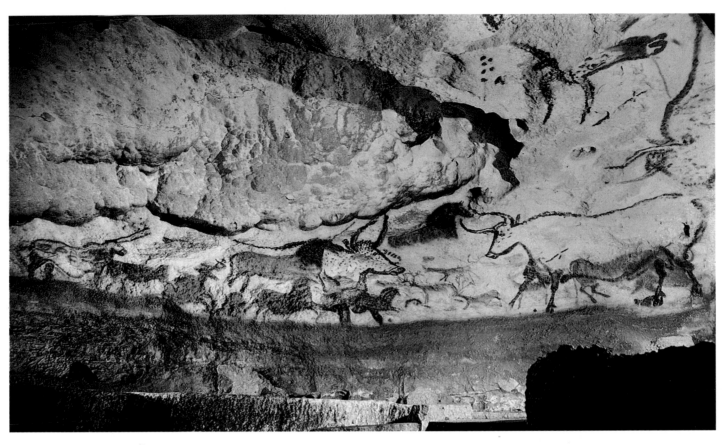

1-4 Hall of the Bulls (left wall), Lascaux, *c.* 15,000–13,000 B.C. Largest bull approx. 11′ 6″ long.

blew pigment around it. Occasionally, the artist would dip a hand in paint and then press it against the wall, leaving a "positive" imprint. These handprints, too, may have had magical significance or may have been "signatures" of members in a cult or community or, less likely, of individual artists. (Most of the negative handprints are of left hands, indicating that early humans were predominantly right-handed, as today, and used their right hands to apply the paint around the "stencils" of their left hands.)

The hunter-artists made frequent and skillful use of the naturally irregular surfaces of the walls, utilizing projections, recessions, fissures, and ridges to help give the illusion of real presence to their forms. An outward swelling of the wall could be used within the outline of a charging bison to suggest the bulging volume of the beast's body. One of the spotted horses at Pech-Merle (FIG. 1-6) may have been inspired by a rock formation that resembles a horse's head and neck (on the right of our illustration), although the artist's eventual version of the head is much smaller than the formation and is highly abstract. Natural forms, like those of foliage or clouds, the profile of a mountain, or the shapes of eroded earth and rock, can represent for any of us—sometimes quite startlingly—the features of people, animals, or objects. Thus, the first artistic representations may have followed some primal experience of resemblance between the chance configuration of a cave

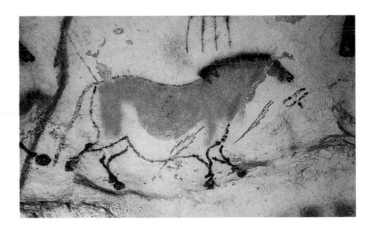

1-5 "Chinese Horse," detail of the right wall of the Axial Gallery, Lascaux, *c.* 15,000–13,000 B.C. Approx. 4′ 8″ long.

wall and the animal the artist had just been hunting. This resemblance might have had for the artist the effect of an awesome apparition of the very animal— a miraculous and magical reappearance of its vanished life. With the impulse to give the apparition even more presence, the artist could have "finished" the form by cutting an outline around the relief and continuing it until a more or less complete and familiar silhouette emerged. The addition of color would have enhanced the reality of the image.

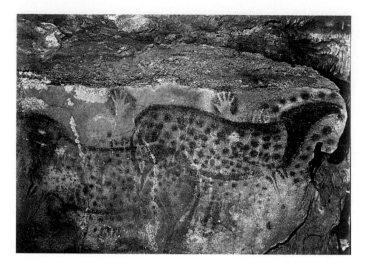

1-6 Spotted horses and negative hand imprints, wall painting in the cave at Pech-Merle (Lot, France), *c.* 14,000–12,000 B.C. Approx. 11′ 2″ long.

This art produced in caverns deep in the earth must have had some profound magical functions. Familiar in religious architecture, which had its beginning thousands of years after the era of the caves, are the cavelike spaces of the sanctuary where the most sacred and hidden mysteries are kept. It is significant that the miracle of *abstraction*—the creation of image and symbol—should take place in such secret and magical caverns. Abstraction is representation, a human device of fundamental power, by which not only art but ultimately science comes into existence. Both are methods for the control of human experience and the mastery of the environment. And that seems to have been the end purpose of the hunter-magicians— to control the world of the beasts they hunted. The making of the image was, by itself, a form of magic. By painting an animal, the hunter fixed and controlled its soul within the prison of its picture; from this initial magic, all the rest would follow. Rites before the paintings may have served to improve the hunter's luck. At the same time, prehistoric peoples must have been anxious to preserve their food supply, and the representations of pregnant animals (FIG. 1-5) suggest that these cavalcades of painted beasts also may have served magically to assure the survival of the actual herds.

But magic must not be considered the sole function of cave art; other purposes have also been suggested. Perhaps the paintings of animals on cave walls served as teaching tools, to instruct new hunters about the character of the various species they would encounter. In the end, we must admit that we do not know what the intent of these paintings was. In fact, a single explanation for all Paleolithic murals, even paintings that are similar in subject, style, and *composition* (the way in which the motifs are arranged upon the surface), is unlikely to be universally applicable. Anthropologists are still searching for the social context of

Paleolithic art and for those elements inherent in it that made it meaningful to the people who produced it.

For now, the paintings remain an enigma, but the extraordinary discovery in December 1994 of undisturbed painted caves at Vallon-Pont-d'Arc may hold the key to the meaning of all Paleolithic art. The caves are still being explored and interpreted, but already archeologists have found a chamber with bear footprints in which the skull of a bear was placed on a large rock against a backdrop of bear paintings. Is the rock a primitive altar, the focus of rituals involving the paintings themselves?

Perhaps the most perplexing painting in all the Paleolithic caves is that deep in the well shaft at Lascaux (FIG. **1-7**), where man makes one of his earliest appearances in prehistoric painting. At the left is a rhinoceros, rendered with all the skilled attention to animal detail to which we are accustomed in cave art. Beneath its tail are two rows of three dots of uncertain significance. At the right is a bison, more crudely painted, but the artist has quite successfully suggested the bristling rage of the animal, whose bowels are hanging from it in a heavy coil. Between the two beasts is a bird-faced (masked?) man with outstretched arms and hands with only four fingers; the gender is made explicit by the prominent penis. The man is depicted with far less care and detail than are the animals. Perhaps the cave painter did not have to strive for a realistic portrayal because there was no need to create humans for magical purposes. The position of the man is also ambiguous. Is he wounded or dead? Do the staff(?) with the bird on top and the spear belong to him? Is it he or the rhinoceros who has gravely wounded the bison—or neither? Which animal, if either, has knocked the man down, if indeed he is on the ground? Are these three images related at all? We can be sure of nothing, but if these figures have been placed beside each other in order to tell a story, then we have evidence for the creation of *narrative* compositions at a much earlier date than anyone had imagined only a few generations ago. Yet it is important to remember that even if a story is intended, very few would have been able to "read" it: the painting, in a deep shaft, is very difficult to reach and could be viewed only in the mysterious, flickering light of a primitive lamp.

SCULPTURE The great murals of the Paleolithic hunter-artists are their principal bequest to us, but they were not their first efforts at representing the world around them. Over ten thousand years before the walls of Altamira, Lascaux, and Vallon-Pont-d'Arc were covered with images of the animals that brought both life (food and clothing) and death (hunter as well as prey was killed in the search for food and clothing) to early humans, Paleolithic artists were making sculptures out of the stones and animal bones they found on the ground. Even the most ambitious of these sculptures are small, and the majority are only a few inches in height. Readily portable and of uncertain, although no doubt important, function, most of the fig-

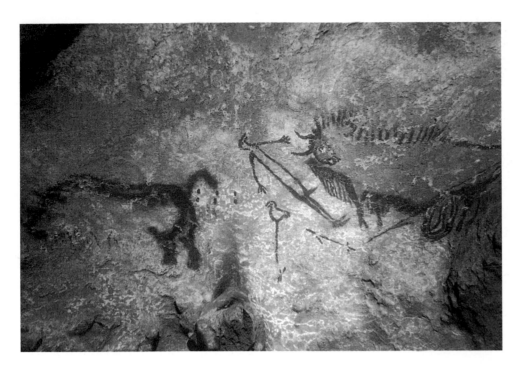

1-7 Rhinoceros, wounded man, and disemboweled bison, painting in the well, Lascaux, *c.* 15,000–13,000 B.C. Bison approx. 3' 8" long.

urines depict nude women and when first discovered were dubbed "Venuses," after the Greco-Roman goddess of beauty and love. Probably the most famous of these is the *Venus of Willendorf* (FIG. **1-8**), named for its find-spot in Austria, a tiny (only slightly more than 4 inches tall) limestone figurine of a woman composed of a cluster of almost ball-like shapes. The anatomical exaggeration suggests that this and similar statuettes served as fertility images; the needs for game and human offspring were equally important in the dangerous life of the hunter. In contrast to the much later cave paintings of animals—but more comparable to the schematic figure of the man in the well at Lascaux (FIG. 1-7)—the sculptor of the *Venus of Willendorf* did not aim for naturalism in shape and proportion. As is the case with most of these early figures, the facial features are not indicated. Here only a mass of curly hair is suggested, and in many examples the head is omitted entirely. The emphasis instead is upon female fecundity, which insures the survival of the species. The breasts are enormous, far larger than the diminutive forearms and hands that rest upon them, and the middle of the body bulges out even more than it does in actual pregnancies. And despite the lack of detail in the figure as a whole, the artist has taken pains to scratch into the stone the outline of the pubic triangle. Whatever the purpose of such statuettes was, it is clear that the artist's intent was not to represent a specific woman, but womanhood, or even just fertility as expressed by the form of a fecund woman.

Probably later in date than the *Venus of Willendorf* (although precision in dating is impossible in this era, and we can usually be no more specific than to assign a range of several thousand years to each artifact) is another

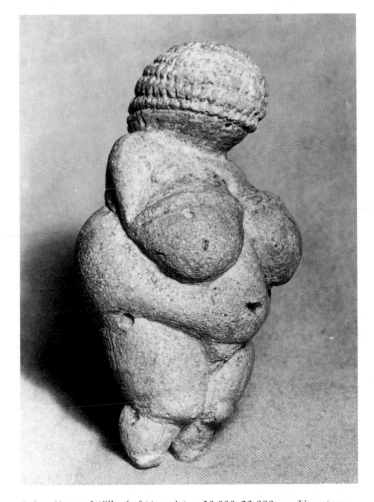

1-8 *Venus of Willendorf* (Austria), *c.* 28,000–23,000 B.C. Limestone, approx. 4¹/₄" high. Naturhistorisches Museum, Vienna.

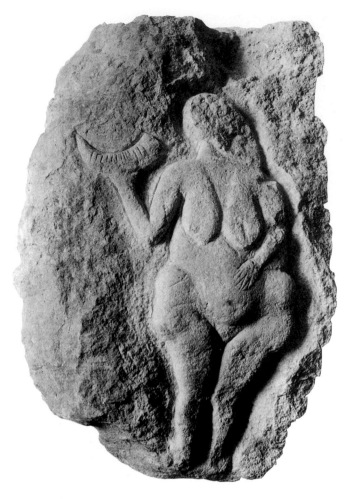

"Venus" figure from Laussel (FIG. **1-9**). One of the earliest *relief sculptures* known, it is much larger than the Willendorf statuette and was fashioned by chiseling into the surface of a conveniently flat slab of stone about a foot and a half tall. The resultant female form was then painted with red ocher (some color is also preserved on the *Venus of Willendorf*). The Laussel woman has the same bulbous forms as the earlier Willendorf figurine, with a similar exaggeration of the breasts, abdomen, and hips, and de-emphasis on the parts of the body below the pelvis. The head is once again featureless, but the arms have taken on greater importance: the left rests on the pregnant belly and draws attention to it, and in the raised right hand there is a bison horn, the meaning of which is debated.

Relief sculptures of nude women also adorned the walls of caves. Roughly contemporary to the great mural paintings of Altamira and Lascaux and about half life size are the rock-cut reliefs found in a cave at La Magdelaine in France, one of which we illustrate here (FIG. **1-10**). This sculpture is typical of many Paleolithic reliefs in that the artist has utilized the natural contours of the surface of the cave wall as the basis for the representation (compare the horse's head at Pech-Merle, FIG. 1-6). The sculptor then used a stone chisel to accentuate the outlines and add internal details to the figure. The La Magdelaine woman is shown in a reclining position with extended arms and the left leg crossed over the right one; she lacks a head, but her large breasts and pubic triangle are carefully delineated.

Other Paleolithic reliefs, however, do not owe their form to the recognition of fortuitous shapes in the natural rock. In the rotunda-like space that terminates a succession of chambers in the caves at Le Tuc d'Audoubert, a master sculptor modeled a pair of bison in clay against the rock

1-9 Woman holding a bison horn, from Laussel (Dordogne, France), *c.* 23,000–20,000 B.C. Painted limestone, approx. 18" high. Musee d'Aquitaine, Bordeaux.

1-10 Reclining woman, rock-cut relief, La Magdelaine cave (Tarn, France), *c.* 12,000 B.C. Approx. half life size.

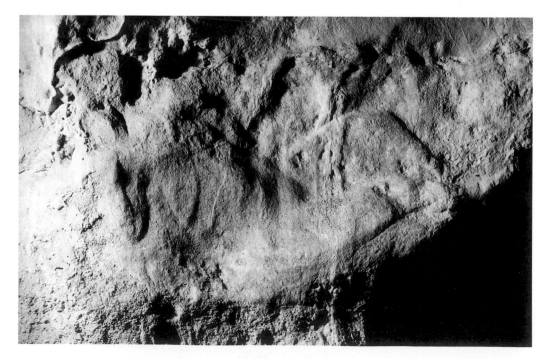

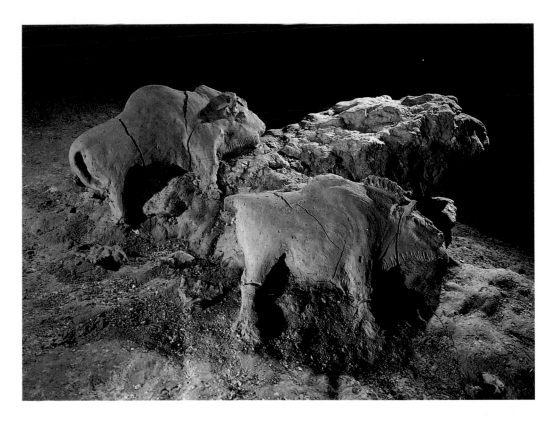

1-11 Two bison, clay relief in cave at Le Tuc d'Audoubert (Ariège, France), *c.* 12,000 B.C. Each approx. 2' long.

wall (FIG. **1-11**). The bison are closely related stylistically to their painted counterparts and are also represented in strict profile. Each is about 2 feet long. The bison of Le Tuc d'Audoubert are among the most monumental Paleolithic sculptures known today, but they are dwarfed by many of the painted bison in the caves of France and Spain. It must be remembered that it is far more difficult to build up a form out of clay than to make a comparably large image of the same subject with paint.

Bone was also used as a sculptural medium in Paleolithic times, even though it meant that the sculptor was forced to work on a very small scale. One of the finest bone sculptures of this date is a representation of a bison found at La Madeleine (FIG. **1-12**) that was fashioned from a reindeer horn; it is only 4 inches long. The sculptor has rendered the mane of the animal in the same way as did the artist responsible for the clay reliefs at Le Tuc d'Audoubert: by using a sharp point to *incise* lines into the surface of the bone. The horns, ears, eyes, and mouth of the La Madeleine bison have also been etched into the surface. (Incising the outlines of a figure before the tones were introduced was also the usual procedure for painting in the Paleolithic caves.) Especially interesting is the artist's decision to represent the bison with the head turned. The small size of the reindeer horn fragment may have been the motivation for this space-saving device, but whatever the reason, it is noteworthy that the neck has been turned a full 180 degrees—in order to maintain the strict profile that the Paleolithic artist insisted upon for the sake of clarity and completeness.

MESOLITHIC ART

Around 9000 B.C., the ice of the Paleolithic period melted as the climate grew warmer. The reindeer migrated north, the woolly mammoth and rhinoceros disappeared, and the hunters left their caves. The Ice Age gave way to a transitional period, the Mesolithic, during which Europe became climatically, geographically, and biologically much as it is today. In this period, a culture flourished and produced art

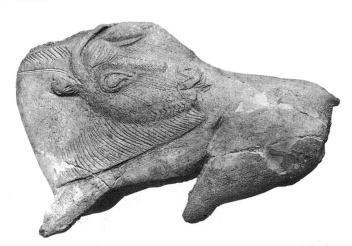

1-12 Bison with turned head, from La Madeleine (Dordogne, France), *c.* 12,000 B.C. Reindeer horn, approx. 4" long. Musée des Antiquités Nationales, St. Germain-en-Laye.

that complements—and, indeed, may have partially originated from—cave art. Since 1903, diminutive, extraordinarily lively paintings of animals and humans in scenes of the hunt, battle, ritual dance, and harvest have been discovered on the stone walls of shallow rock shelters among the barren hills along the east coast of Spain. The artists show the same masterful skill in depicting animal figures as that demonstrated by their predecessors in the caves, and it may be that we have here specimens of a lingering tradition or long-persisting habit of vision and representation of animals. But what is strikingly new is the regular appearance of the human figure—not only singly, but in large, coherent groups with a wide variety of poses, subjects, and settings. We have seen that humans are exceptional in cave painting and that pictorial narratives are almost never to be found; even the one we have examined (FIG 1-7) is doubtful. In the rock-shelter paintings, which seem to date between 7000 and 4000 B.C., however, the new emphases on human themes and concerns and on action in which humans dominate animals are central. The new inventory of forms may have migrated across the Mediterranean from North Africa, where paintings similar to those in eastern Spain have been found. (In Namibia, engravings of animals dating as early as 25,000 B.C. are known. Only the *Venus of Willendorf* (FIG. 1-8) can perhaps claim greater antiquity, and Africa may have produced the first art.)

Some characteristic features of the rock paintings appear in an energetic group of five warriors found at Remigia in the Gasulla gorge (FIG. **1-13**). The group—and there is no doubt that it is, indeed, a group—is only about 9 inches in width and shows a customary tense exaggeration of movement and a rhythmic repetition of basic shape. Even so, we can distinguish important descriptive details—for example, bows, arrows, and the feathered headdress of the leader. The widely splayed legs signify a leaping stride, perhaps a march to battle or a ritual dance. Although the bodies are treated summarily, the heads have clearly discernible noses, mouths, and chins. All the heads are shown in profile for the same reason that the profile view was the universal choice for representations of animals in Paleolithic art: only the side view of the human head shows all its shapes clearly. The torsos, however, seem to be seen from the front—again, the most informative viewpoint—while the profile view is preferred for the legs and arms. This *composite view* of the human body is quite artificial—the human body cannot make an abrupt 90-degree shift at the hips—but it is very descriptive and ideally suited to the prehistoric artist's primary purpose of communicating meaning. It is another manifestation of the twisted perspective of Paleolithic painting in which a frontal view of an animal's two horns was combined with a profile view of the head (FIGS. 1-4 and 1-7). We shall see that the composite view of the human body was overwhelmingly preferred by artists for millennia, until it was suddenly and definitively rejected by the Greeks at the dawn of the Classical age, around 500 B.C. (see Chapter 5).

Like the Paleolithic cave paintings, the Mesolithic rock paintings are probably of magical-religious significance, although some observers believe them to be no more than pictorial records of memorable events. The rock paintings are concentrated at particular sites that were used for long periods; nearby places, better suited for painting, were not used. This fact suggests that the sites were held sacred, not only by the Mesolithic painters, but also by artists working

1-13 Marching warriors (or a ritual dance?), rock painting at Cingle de la Mola, Remigia (Castellón, Spain), *c.* 7000–4000 B.C. Approx. 9″ wide.

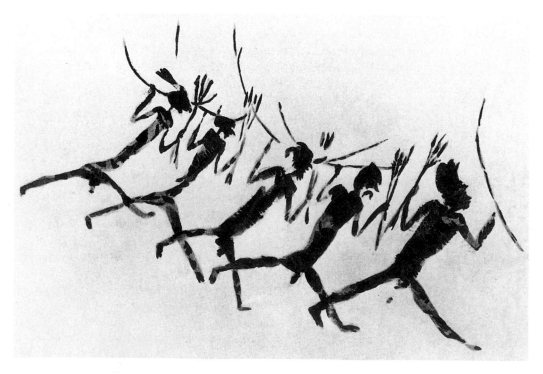

well into the historical period. Iberian and Latin inscriptions indicate that supernatural powers were ascribed to some of these holy places as late as the Roman era.

NEOLITHIC ART

In a supreme feat of intellection, Paleolithic peoples learned to abstract their world by making a picture of it. They sought to control the world by capturing and holding its image. In the Neolithic period, human beings took a giant stride toward the actual, concrete control of their environment by settling in fixed abodes and domesticating plants and animals. Their food supply assured, they changed from hunters to herders, to farmers, and finally to townspeople. The wandering hunter settled down to organized community living in villages surrounded by cultivated fields.

The conventional division of prehistory into the Paleolithic, Mesolithic, and Neolithic periods is based on the development of stone implements, but a different kind of distinction, based on subsistence strategy, may be made between an age of food gathering and an age of food production. In this scheme, the Paleolithic period corresponds roughly to the age of food gathering, and the Mesolithic period, the last phase of the age, is marked by intensified food gathering and the domestication of the dog. The proto-Neolithic period of incipient food production and greater domestication of animals precedes the Neolithic period, when agriculture and stock-raising became humankind's major food sources.

Ancient Near East

At one time, researchers proposed that the area we know today as the Near East (Egypt, Israel, Jordan, Lebanon, Syria, Iraq, Iran, and part of Turkey) dried out into desert and semidesert after the last retreat of the glaciers, compelling the inhabitants to move to the fertile alluvial valleys of the Nile in Egypt and the Tigris and Euphrates in Mesopotamia (parts of modern Syria and Iraq). This view is no longer tenable in light of archeological and paleoenvironmental findings. The oldest settled communities are found not in the river valleys but in the grassy uplands bordering them. These regions provided the necessary preconditions for the development of agriculture. Species of native plants, such as wild wheat and barley, were plentiful, as were herds of animals (goats, sheep, and pigs) that could be domesticated; sufficient rain was available for the raising of crops. It was only after village farming life was well developed that settlers, attracted by the greater fertility of the soil and perhaps also by the need to find more land for their rapidly growing populations, moved into the river valleys and deltas. There, in addition to systematic agriculture, civilized societies originated government, law, and formal religion, as well as writing, measurement and calculation, weaving, metal-craft, and pottery.

For a long time, it was thought that these developments occurred concurrently in Egypt and Mesopotamia. But again, archeology has forced a revision of our views. It is now clear that Mesopotamia was ahead of Egypt temporally and that innovations there spread to northern Syria and Anatolia (Turkey) at an early date. Village farming communities like Jarmo in Iraq and Çatal Hüyük in southern Anatolia date back to the mid-seventh millennium B.C., and the remarkable fortified town of Jericho, before whose walls the biblical Joshua appeared thousands of years later, is even older. Archeologists are expanding the corpus of Neolithic and proto-Neolithic material almost daily, and the discovery and exploration of new sites each year constantly compel us to revise our views about the emergence of civilization. Two sites that have been known for some time, however, can give us a reasonably representative picture of the rapid and exciting transformation of human society—and of art—that occurred during the Neolithic period.

JERICHO By 7000 B.C., agriculture was well established in at least three Near Eastern regions: Israel/Jordan, Iran, and Anatolia (Turkey). Although no remains of domestic cereals have been found that can be dated before 7000 B.C., the advanced state of agriculture at that time presupposes a long development; indeed, the very existence of a town like Jericho gives strong support to this assumption. The site of Jericho—a plateau in the Jordan River valley with an unfailing spring—was occupied by a small village as early as the ninth millennium B.C. This proto-Neolithic village underwent spectacular development around 8000 B.C., when a new Neolithic town covering about 10 acres was built with houses of mud brick on round or oval stone foundations with roofs of branches covered with earth. As the town's wealth grew and powerful neighbors established themselves, the need for protection resulted in the first known permanent stone fortifications. By approximately 7500 B.C., the town, estimated to have had a population of over two thousand people, was surrounded by a wide, rock-cut ditch and a 5-foot-thick wall. Into this wall, which has been preserved to a height of almost 13 feet, was built a great circular stone tower (FIG. **1-14**), 28 feet in height and almost 33 feet in diameter at the base, with an inner stairway leading to its summit. Not enough of the site has been excavated to determine whether this tower was solitary, like the keeps in medieval castles, or one of several similar towers that formed a complete defense system. In either case, a structure like this, built with only the most primitive kinds of stone tools, was certainly a tremendous technical achievement. It constitutes for us the beginning of the long history of monumental architecture, which will lead from this stone tower in Neolithic Jericho to today's hundred-story skyscrapers of steel, concrete, and glass.

Around 7000 B.C., the Jericho site was abandoned by its original inhabitants, but new settlers arrived in the early seventh millennium. They built rectangular mud-brick houses on stone foundations and carefully plastered and

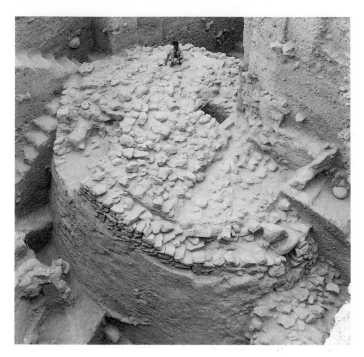

1-14 Great stone tower built into the settlement wall, Jericho, *c.* 8000–7000 B.C.

painted their floors and walls. Several of the excavated buildings seem to have served as shrines, and the settlers fashioned statuettes of women or goddesses and of animals associated with a fertility cult. Most striking is a group of human skulls on which the features have been "reconstructed" in plaster (FIG. **1-15**). Subtly modeled, with inlaid seashells for eyes and painted hair (including a painted mustache that has been preserved on one specimen), their appearance is strikingly lifelike. Because the skulls were detached from the bodies and buried separately, they may have been regarded as "spirit traps," implying a well-developed belief in survival after the death of the body. Whatever their purpose, by their size alone they are to be distinguished from Paleolithic figurines like the *Venus of Willendorf* (FIG. 1-8); the Jericho skulls mark the beginning of monumental sculpture in the ancient Near East and the advent of the concept of individual portraiture in the history of art.

ÇATAL HÜYÜK Remarkable discoveries have also been made in Anatolia. Excavations at Hacilar, Çatal Hüyük, and elsewhere have shown not only that the central Anatolian plateau was the site of a flourishing Neolithic culture between 7000 and 5000 B.C., but also that it may well have been culturally the most advanced region of its time. Twelve successive building levels excavated at Çatal Hüyük between 1961 and 1965 have been dated between 6500 and 5700 B.C. On a single 32-acre site (of which only one acre has been explored), it is possible to retrace, in an unbroken sequence, the evolution of a Neolithic culture over a period of eight hundred years.

The source of Çatal Hüyük's wealth was trade, especially in obsidian, a vitreous volcanic stone easily chipped into fine cutting edges and highly valued by Neolithic tool- and weapon-makers. Along with Jericho, Çatal Hüyük seems to have been one of the first experiments in urban living. The regularity of its plan suggests that the town was built according to some a priori scheme. A peculiar feature is the settlement's complete lack of streets; the houses adjoin each other and have no doors; access was provided through openings in the roofs (FIG. **1-16**). The openings also served as chimneys to ventilate the hearth in the combination living room/kitchen that formed the core of the house. Impractical as such an arrangement may appear today, it did offer some advantages. The buildings, being attached, were more stable than freestanding structures and, at the limits of the town site, formed a perimeter wall well suited to defense against human or natural forces. Thus, if an enemy managed to breach the exterior wall, he would find himself not inside the town, but inside a single room with the defenders waiting for him on the roof.

The houses, constructed of mud brick strengthened by sturdy timber frames, varied in size but were of a standard plan. Walls and floors were plastered and painted, and platforms along walls served for sleep, work, and eating. The dead were buried beneath the floors. A great number of shrines have been found intermingled with standard houses. Varying with the different levels, the average ratio in the excavated portion of the town is about one shrine to every three houses.

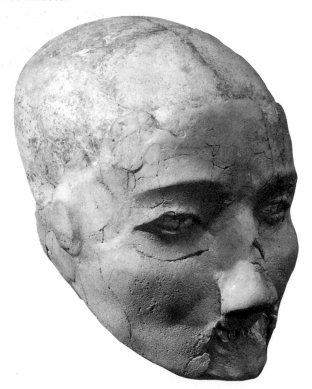

1-15 Human skull, Jericho, *c.* 7000–6000 B.C. Features molded in plaster, painted and inlaid with shell. Archeological Museum, Amman. Jericho Excavation Fund.

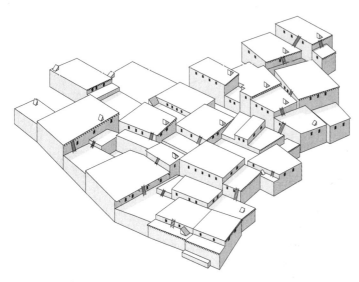

1-16 Schematic reconstruction of a section of level VI, Çatal Hüyük, *c.* 6000–5900 B.C. (After J. Mellaart.)

The shrines are distinguished from the house structures by the greater richness of their interior decoration, which consisted of wall paintings, plaster reliefs, animal heads, and bucrania (bovine skulls). Bulls' horns, symbols of masculine potency, adorn most shrines, sometimes in considerable numbers, and were set into stylized heads of bulls or into benches and pillars (FIG. **1-17**). Sometimes they are juxtaposed with plaster breasts, symbols of female fecundity, projecting from the walls.

Statuettes of stone or terracotta (baked clay) have also been found in considerable numbers at Çatal Hüyük. Most are quite small (2 to 8 inches high); only a few reach 12 inches. All the female figures, which predominate, seem to represent a mother goddess or personification of fertility— alone, giving birth, as mistress of wild animals, and in a variety of other aspects. The bulbous forms of the headless seated goddess illustrated here (FIG. **1-18**) remind us of the *Venus of Willendorf* (FIG. 1-8), and the two artists' approaches to the subject are quite comparable. Judging from other examples, however, it may be safely assumed that the lost head of the Çatal Hüyük goddess had fairly well-described

facial features. The figure is also painted with crosslike patterns, the significance of which is not certain, but they may endow the goddess with the specific function of an agrarian deity.

Fertility and agricultural symbolism dominate the art of the upper (later) levels of Çatal Hüyük, but hunting also played an important part in the early Neolithic economy; Paleolithic hunting rituals survived far into the Neolithic period. Numerous crude animal figurines, broken and damaged, have been found at Çatal Hüyük. They may have served as animal surrogates during hunting rites and then been buried in pits. The importance of hunting as a food source (until about 5700 B.C.) is reflected also in wall paintings, in which, in the older shrines, hunting scenes predominate. In style and concept, the deer hunt mural at Çatal Hüyük (FIG. **1-19**) recalls the rock-shelter paintings of eastern Spain. The composite view is again employed for almost all the human figures, but at Çatal Hüyük the figures are more full-bodied and are rendered with greater realism. The artist used a full range of pigments, primarily derived from minerals, which were applied with a brush to the white background of dry plaster. Once the apparently ritual function of these paintings had been fulfilled, they were covered with a layer of white plaster and later replaced with a new painting of a similar or different subject. The careful preparation of the wall surface is in striking contrast to the direct application of pigment to the rock face in earlier eras and is a significant step toward the

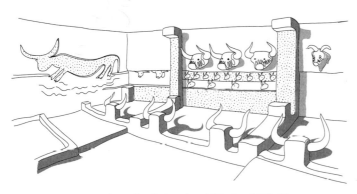

1-17 Reconstruction of a shrine, level VI, Çatal Hüyük, *c.* 5900 B.C. (After J. Mellaart.)

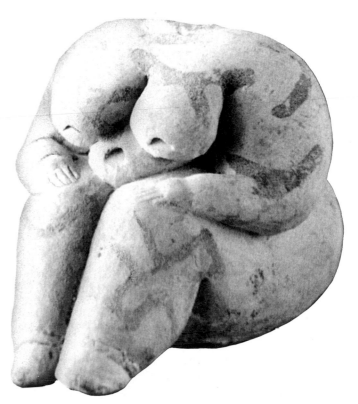

1-18 Seated goddess, Çatal Hüyük, *c.* 5900 B.C. Painted terracotta, approx. 2" high. Archeological Museum, Ankara.

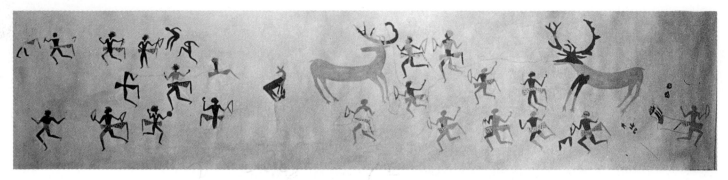

1-19 Deer hunt, detail of a copy of a wall painting from level III, Çatal Hüyük, *c.* 5750 B.C.

modern notion of an easel painting with a frame that defines its limits.

In one of the older shrines at Çatal Hüyük, a painting was uncovered that has generally been interpreted as a pure landscape (FIG. **1-20**). As such, it would be unique for thousands of years into the future. According to radiocarbon dating, the painting was executed around 6150 B.C. In the foreground is a town, with rectangular houses neatly laid out side by side, probably representing Çatal Hüyük itself. Behind the town appears a mountain with two peaks; dots and lines issuing from the higher of the two cones are thought to represent a volcanic eruption. The mountain has been identified as the 10,600-foot Hasan Dağ, which was located within view of Çatal Hüyük and was the only twin-peaked volcano in central Anatolia. Because the painting appears on the walls of a shrine, the conjectured volcanic eruption would have had some religious meaning; we should not necessarily think of it as a depiction of a specific historical event. Nonetheless, it does relate a story, even if a recurring one, and in this respect it is not a true landscape (a picture of a place in its own right, without any narrative content).

The rich finds at Çatal Hüyük give the impression of a prosperous and well-ordered society that practiced a great variety of arts and crafts. In addition to painting and sculpture, weaving and pottery were well established, and even the art of smelting copper and lead in small quantities was known before 6000 B.C. The society seems to have been conservative in its long retention of Paleolithic traditions and practices, but it also was progressive in its slow but relentless achievement of a complex, fully food-producing economy. At Çatal Hüyük, the conversion to a fully agrarian economy appears to have been completed by about 5700 B.C. Less than a century later, the site was abandoned.

Western Europe

In western Europe, where Paleolithic paintings and sculptures abound, there are no comparably developed towns of the time of Çatal Hüyük, but in succeeding millennia, perhaps as early as 4000 B.C., the local Neolithic populations in several areas developed a monumental architecture consisting of graves and of rows or circles of massive, rough-hewn stones. The very dimensions of the stones, some as high as 17 feet and weighing as much as 50 tons, have prompted historians to call them *megaliths* (great stones) and to designate the culture that produced them *megalithic.*

Several types of megalithic structures have been classified. The *dolmen* consists of several great stones set on end, with a large covering slab. Dolmens may be the remains of *passage graves* from which a covering earth mound has been washed away. The passage grave, the dominant megalithic tomb type (with literally thousands having been found in France and England), has a corridor lined with large stone slabs leading to a circular chamber in which each of numerous rings of stones projects inward beyond the underlying course, until the rings close at the top (a *corbeled* vault construction). These graves were frequently built into a hill slope or covered by mounds of earth. At Carnac in Brittany, great single stones, called *menhirs*, set on end, were arranged in parallel rows, some of which run for several miles and consist of thousands of stones. Their purpose was evidently religious and may have had to do with a cult of the dead or the worship of the sun.

STONEHENGE Sometimes these huge stones were arranged in a circle known as a *cromlech*. Among the most imposing cromlechs are those located at Avebury and at Stonehenge in England (FIG. **1-21**). The structure at Avebury is surrounded by a stone bank about four-fifths of a mile in diameter. The remains at Stonehenge are of a complex of rough-cut sarsen (a form of sandstone) stones and smaller "bluestones" (various igneous rocks). Outermost is a ring of large monoliths of sarsen stones capped by *lintels* (a stone "beam" used to span an opening). Next is a ring of bluestones, which, in turn, encircle a horseshoe (open end facing east) of *trilithons*—five lintel-topped pairs of the largest sarsens, each weighing 45 to 50 tons. Standing apart and to the east is the "heel-stone," which, for a person looking outward from the center of the complex, would have marked the point at which the sun rose at the midsummer solstice.

Stonehenge was probably built in several phases around 2000 B.C., according to radiocarbon dating. It seems to have

1-20 Landscape with volcanic eruption (?), detail of a copy of a wall painting from level VII, Çatal Hüyük, *c.* 6150 B.C.

been a kind of astronomical observatory. The mysterious structures—believed in the Middle Ages to have been the work of the magician Merlin, who spirited them from Ireland, or the work of a race of giants—have now come to be considered a remarkably accurate calendar—testimony to the rapidly developing intellectual powers of humans. Even in their ruined condition, the monoliths of Stonehenge, created by heroic physical and intellectual effort, possess a solemn majesty. At Avebury, the series of concentric circles with connecting curvilinear pathways or avenues conveys a feeling for order, symmetry, and rhythm that is characteristic also of Stonehenge and is evidence not only of well-developed and systematized ceremonial ritu-

als, but perhaps also of a maturing geometrical sense born of the observation of the apparent movements of the sun and moon.

Impressive as this *prehistoric* achievement is even today, by 2000 B.C. the peoples occupying the Mesopotamian plain between the Tigris and Euphrates rivers had been erecting multichambered temples on huge platforms for at least a millennium, and in the fertile valley of the Nile in Egypt the great stone pyramids of the pharaohs were already five hundred or more years old. It is to those civilizations, with their written records and *historical* personalities that we now must turn.

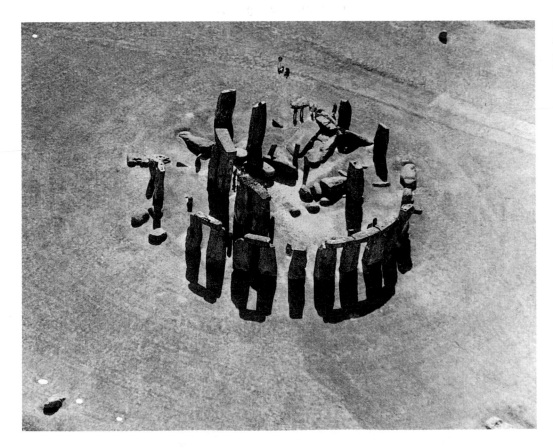

1-21 Stonehenge, aerial view, *c.* 2000 B.C. 97' diameter; trilithons approx. 24' high. Salisbury Plain, Wiltshire, England.

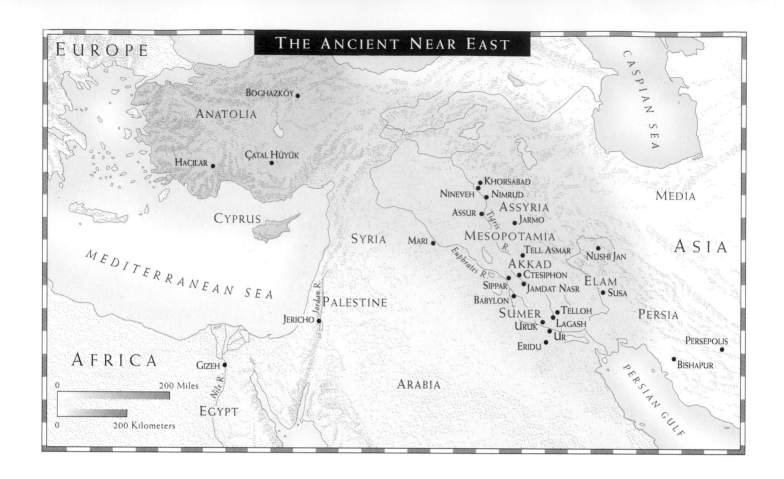

THE ANCIENT NEAR EAST

EUROPE

ANATOLIA

BOGHAZKÖY

HACILAR · ÇATAL HÜYÜK

CYPRUS

MEDITERRANEAN SEA

CASPIAN SEA

MEDIA

KHORSABAD
NINEVEH · NIMRUD
ASSUR · ASSYRIA · JARMO

SYRIA · MARI · MESOPOTAMIA

Tigris R.
Euphrates R.

TELL ASMAR · NUSHI JAN
AKKAD · CTESIPHON
SIPPAR · JAMDAT NASR · ELAM · SUSA
BABYLON · SUMER · TELLOH
URUK · LAGASH
ERIDU · UR

ASIA

PERSIA

PERSEPOLIS
BISHAPUR

PERSIAN GULF

PALESTINE
Jordan R.
JERICHO

AFRICA · GIZEH

Nile R.

ARABIA

EGYPT

0 ——— 200 Miles
0 ——— 200 Kilometers

3500 B.C.	3000 B.C.	2300 B.C.	2150 B.C.	2000 B.C.	1900 B.C.	1600 B.C.
PROTOLITERATE PERIOD	EARLY DYNASTIC PERIOD (SUMERIAN)	AKKADIAN DYNASTY	THIRD DYNASTY OF UR (NEO-SUMERIAN)		OLD BABYLONIAN PERIOD	KASSITES AND MITANNI (MESOPOTAMIA)
						HITTITES (ANATOLIA)
						MIDDLE ELAMITE PERIOD (IRAN)

Female head (Inanna?)
from Uruk
c. 3500–3000 B.C.

Standard of Ur
c. 2700 B.C.

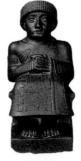

Head of an
Akkadian ruler from Nineveh
c. 2200 B.C.

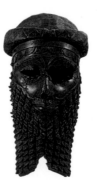

Seated Gudea from Telloh
c. 2100 B.C.

Stele of
Hammurabi
c. 1780 B.C.

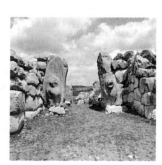

Lion Gate, Boghazköy, c. 1400 B.C.

Invention of the wheel

Development of writing and the
beginnings of recorded history

Hammurabi, c. 1790–1750 B.C.

Sack of Babylon by Hittites, c. 1595 B.C.

Flowering of independent city-states

Sargon of Akkad, c. 2300 B.C.

Guti invasions, c. 2150 B.C.

Gudea, c. 2100 B.C.

CHAPTER 2

ANCIENT NEAR EASTERN ART

1000 B.C. 900 B.C.		612 B.C.	538 B.C.	330 B.C.	224 A.D.	636
	ASSYRIAN EMPIRE	NEO-BABYLONIAN KINGDOM	ACHAEMENID PERSIAN EMPIRE	GRECO-ROMAN PERIOD	SASANIAN DYNASTY	

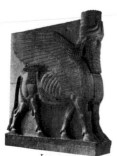

Lamassu
Khorsabad, c. 720 B.C.

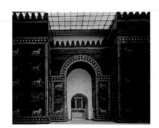

Ishtar Gate
Babylon, c. 575 B.C.

Palace at Persepolis
c. 520-460 B.C.

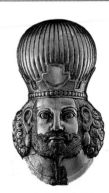

Head of Shapur II (?)
c. A.D. 350

Darius I, 520-486 B.C.

Xerxes, 485-465 B.C.

Ashurnasirpal II, 883-859 B.C.

Sargon II, 721-705 B.C.

Ashurbanipal, 668-627 B.C.

Battle of Issus, 331 B.C.

Death of Alexander the Great, 323 B.C.

Nebuchadnezzar II, 605-562 B.C.

Augustus, first emperor of Rome, 27 B.C.-A.D. 14

Defeat of Valerian by Shapur I, A.D. 260

Final defeat of Persians
by the Arabs, A.D. 642

Some time in the early fourth millennium B.C. a critical event—the settlement of the great river valleys—took place in Mesopotamia (a Greek word meaning "the land between the [Tigris and Euphrates] rivers"). Writing, monumental architecture, and new political forms appeared shortly thereafter, both in Mesopotamia and in Egypt. From this time forward, world history was to be the record of the birth, development, and disappearance of civilizations and the rise and decline within them of peoples, states, and nations. It is with the emergence of the two mighty, contrasting civilizations of Mesopotamia and Egypt that the drama of Western humanity truly begins.

One must not think, however, that these two distinct societies were geographically or culturally isolated from each other. Ancient Palestine and Syria connected them on the west. On the east, Mesopotamia adjoined the vast territory of Iran and the north Indian civilization of the Indus River valley, with its important city of Mohenjo-Daro (see Chapter 14). Thus, a continuous range of more or less contemporaneous city civilizations existed from Egypt to India, linked by trade, cultural diffusion, and conquest, and ringed by nomadic peoples or sedentary farmer villages in Arabia, North Africa, and northern Eurasia.

SUMERIAN ART

At the dawn of recorded history, the fertile lower valley of the Tigris and Euphrates was occupied by the Sumerians, an agricultural people who utilized both the wheel and the plow and learned to control floods and construct irrigation canals to divert the river channels and bring fertility to the lands not immediately adjacent to the two great waterways. In fact, the Sumerians transformed this vast, flat, and formerly sparsely inhabited land into a veritable oasis, often referred to as the "fertile crescent" of the ancient world. Within this crescent, thought to be the site of the biblical Garden of Eden, the Sumerians established the first great urban communities, among them Uruk (Erech in the Old Testament, modern Warka) and Lagash (Al-Hiba), and they developed the earliest known script, which in time became the system of wedge-shaped (*cuneiform*) signs that was regularly used for recording administrative acts and commercial transactions. The Sumerians also produced a significant literature, most notably the *Epic of Gilgamesh*, which antedates Homer's *Iliad* and *Odyssey* by some fifteen hundred years. The origin of the Sumerians is still uncertain and their language does not belong to any of the major linguistic groups of antiquity, but there is no doubt that the Sumerians were a major force in the spread of civilization. Their influence extended widely from southern Mesopotamia, eastward to the Iranian plateau, northward to Assur, and westward to Syria, where archeologists have

discovered archives, consisting of thousands of clay tablets, some in the Sumerian language, testifying to the far-flung network of Sumerian contacts made throughout the ancient Near East. Trade was essential for the Sumerians, because, despite the fertility of their land, it was poor in such vital natural resources as metal, stone, and wood.

From as early a time as the Paleolithic caves, we have evidence of people's efforts to control their environment by picture magic. With the appearance of the Sumerians and the beginning of recorded history, the older magic was replaced by a religion of gods and goddesses, benevolent or malevolent, who personified the forces of nature that often contended destructively with human hopes and designs. While the waters of the Tigris and Euphrates made possible the cultivation of the land and the formation of the first true urban centers in human history, the climate of ancient Mesopotamia also produced the fiery heat of summer and the catastrophic floods, droughts, blights, and locusts that might easily have persuaded people that powers above and beyond their control must somehow be placated and won over. Formal religion, a kind of system of transactions between gods and human beings, may have begun with the Sumerians; no matter how it has been systematized and diversified since then, religion has retained its original propitiatory devices—prayer, sacrifice, and ritual—as well as a view of humans as imperfect by nature and dependent on and obligated to some higher being. The religion of the Sumerians and those who followed them centered about nature gods, among them Anu, god of the sky and supreme deity in the Mesopotamian pantheon; En-lil, lord of the winds and of the earth; Abu, god of vegetation; Ea (or Enki), ruler of the waters; Nanna (Sin), the moon god; and Utu (Shamash), the sun god.

Ancient Sumer was not a unified nation but was made up of a dozen or so independent *city-states*, each of which was thought to be under the protection of one of the Mesopotamian nature gods. The Sumerian rulers were the god's representatives on earth and the stewards of the god's earthly treasure. The priests were the chief civic administrators, who directed all communal activities, such as the construction of canals and the collection and distribution of food to those who were not farmers themselves. This specialization of labor—made possible by the development of agriculture to the point where only a portion of the population had to be engaged in food production, freeing others to take up activities such as manufacturing, trade, and administration—is the hallmark of the first complex urban societies. It was in the city-states of ancient Sumer that activities that once had been left to the individual became regularized, with the community assuming functions such as defense against others and the caprices of nature. The city-state itself, with its permanent identity as a discrete community ruled by a single person and a god with specific names, was one of the great inventions of the Sumerians,

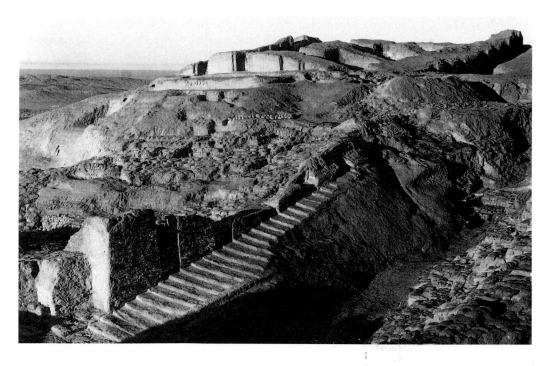

2-1 White Temple and ziggurat, Uruk (Warka), c. 3200–3000 B.C.

along with the art of writing and the system of gods and god-human relationships. Together these innovations provided the basis for a new order of human society.

Architecture

The plan of the Sumerian city reflected the central role of the god in city life, the god's temple being the city's monumental nucleus. The temple was not only the focus of local religious practice but also served as an administrative and economic center. It was indeed the domain of the god, who was regarded as a great and rich holder of lands and herds as well as the protector of the city. The vast temple complex, a kind of city within a city, had multiple functions. A temple staff of priests and scribes carried on city business, looking after the possessions of the god and of the ruler. It must have been in such a setting that writing developed into an instrument of precision; the very earliest examples have to do with the keeping of accounts. The priests recorded transactions and inventories by pressing a stylus into wet clay plaques; these hardened into breakable, yet nearly indestructible, tablets. Hundreds of thousands of these tablets have survived to this day and give us insights into the nature of life in these first cities, information that we will never have for the era before the invention of writing.

The outstanding preserved example of early Sumerian temple architecture is the so-called White Temple (FIG. **2-1**) at Uruk (the home of the legendary Gilgamesh), which dates to the late fourth millennium B.C. Usually only the foundations of early Mesopotamian temples can still be recognized; the White Temple is a rare exception. Sumerian

builders did not have access to stone quarries and instead utilized mud brick for the superstructures of their temples and other buildings, which have almost all eroded over the course of time. The fragile nature of the building materials did not, however, prevent the Sumerians from erecting towering structures like the Uruk temple several centuries before the stone pyramids of the Egyptians. This says a great deal about the desire on the part of the Sumerians to provide monumental settings for the worship of their deities.

Enough of the Uruk complex remains to permit a fairly reliable reconstruction (FIG. **2-2**). The temple (whose white-washed walls lend it its modern nickname) stands on top of a high stepped platform, or *ziggurat*, 40 feet above street level in the center of the city. The platform has sloping sides of paneled brickwork, and ascent was by means of a winding stairway (a ramp was also provided for the bringing up of sacrificial animals) that ended at the summit of the platform, although not in front of any of the doorways to the temple, necessitating one last angular change in direction

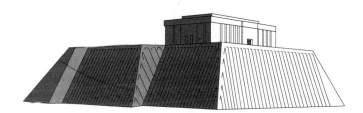

2-2 Reconstruction of the White Temple and ziggurat, Uruk. (After S. E. Piggott.)

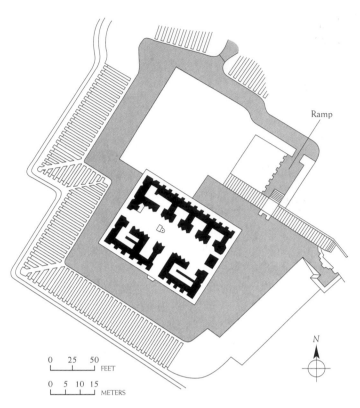

2-3 Plan of the White Temple and ziggurat, Uruk.
(After H. Frankfort.)

members of the community. The temple has several chambers. The central hall, or *cella*, was set aside for the divinity and housed a stepped altar; it is uncertain how or if the temple was roofed. The Sumerians referred to their temples as "waiting rooms," a reflection of their belief that the deity would descend from the heavens to appear before the priests in the cella. The idea that the gods reside above the world of humans is central to most of the world's religions: Moses ascended Mount Sinai to receive the Ten Commandments, and the Greeks placed the home of their gods and goddesses on Mount Olympus.

The ziggurat is undoubtedly the most characteristic structure found in Mesopotamia. Most of the ruined cities of Sumer—Ur, Nippur, Larsa, Eridu, as well as Uruk—are still dominated by their eroded ziggurats. The ziggurat at Ur (FIG. **2-4**), home of the biblical Abraham, is about a millennium later in date than that at Uruk and is much larger. It was constructed during the brief Neo-Sumerian period that followed the demise of the Akkadians (see Neo-Sumerian Art in this chapter). The base is a solid mass of mud brick 50 feet high; both the base and the only partially preserved stage above it were faced with baked brick laid in bitumen. Three ramplike stairways of a hundred steps converge on a tower-flanked gateway from which another flight of steps probably led to the temple proper, which does not survive, even in part. Only officiating priests were permitted access to the shrine level. The loftiness of the great ziggurats—especially the one at Babylon, which was about 270 feet high and intended by its pious builders to reach into heaven—made a profound impression on the ancient Hebrews, who memorialized the Babylon ziggurat as the Tower of Babel, a monument to the insolent pride of humans.

Sculpture

The Sumerians seem also to have been the first to set up monumental statues in their cities and sanctuaries. One of the earliest, and an extraordinary achievement, is the white

(FIG. **2-3**). This "bent-axis" approach was the standard arrangement for Sumerian temples, a striking contrast, as we shall see in Chapter 3, to the linear approach preferred by the Egyptians in their temples and great tombs.

Like other Sumerian temples, the corners of the White Temple are oriented to the cardinal points of the compass. The shrine, which was probably dedicated to the sky god, Anu, is of modest proportions (61 by 16 feet); it was designed not to accommodate large throngs of worshipers but only the select few, the priests and perhaps the leading

2-4 Ziggurat (northeastern facade with restored stairs), Ur, *c.* 2100 B.C.

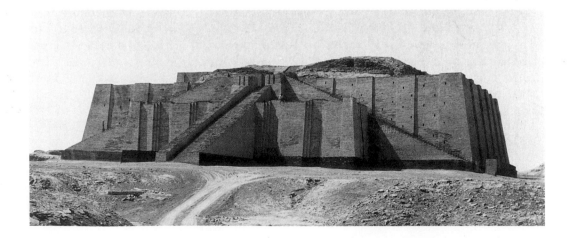

marble female head (FIG. **2-5**) found at Uruk in the sacred precinct of Inanna, the goddess associated with the planet Venus, daughter of the moon god. Unlike the life-size Neolithic plastered and painted skulls from Jericho (FIG. 1-15), the Uruk head is entirely manmade. The stone had to be imported and was too costly to be employed for the full statue. The marble face was probably attached to a wooden body. The deep groove at the top of the head anchored a wig, probably made of gold leaf; the hair fell in waves over the forehead and sides of the head. The deep recesses for the eyebrows were filled with colored shell or stone, as were the large eyes. The subject is unknown; many have suggested that this is an image of Inanna herself, but a mortal woman, perhaps a priestess, may be portrayed here. Our ignorance of her and of the history of the head does not diminish our appreciation of its exquisite refinement of feature and expression, despite the mutilations of time and accident. The soft modeling of the cheeks and sensitivity of the mouth, however, were likely overshadowed by the bright coloration of the eyes, brows, and

hair; the original appearance of the head would have been much more vibrant than the pure white fragment that has come down to us.

A group of statuettes (FIG. **2-6**), also from a religious context, ranging in size from well under a foot to about 30 inches in height, were found at Tell Asmar (ancient Eshnunna). Carved of gypsum, with shell and black limestone inlays, the Tell Asmar figures were once set up in a temple dedicated to Abu, the god of vegetation. The differing heights of the men and women represented may correspond to their relative importance in Eshnunna, but all represent mortals, rather than deities, with their hands folded in front of their chests in a gesture of prayer. Many also hold the small beakers the Sumerians used in religious rites; hundreds of such goblets have been found in the temple complex at Tell Asmar. Some of the statuettes are inscribed; these and similar figurines from other sites give such information as the name of the donor and the god or even offer specific prayers to the deity on behalf of the owner. With their heads tilted upward, they waited in the Sumerian "waiting room" for the apparition of the divinity.

The Tell Asmar statuettes are made up of simple forms, primarily cones and cylinders. They are not portraits in the strict sense of the word, but they do distinguish physical types. At least one child was portrayed; next to the tallest of the female figures are the remains of two small legs. Most striking is the disproportionate relationship between the oversized eyes (FIG. **2-7**) and the tiny hands. The exaggeration of the size of the eyes has been variously explained, but many scholars believe that the intention was to convey a sense of the awe with which humans confront the supernatural; the sight of the divine has mesmerized these substitute worshipers and they are depicted as if in a hypnotic trance. Since the purpose of these votive figures was to offer constant prayers to the gods on behalf of their donors, their open-eyed stares may also symbolize the eternal wakefulness necessary to fulfill their duty.

Royal Cemetery at Ur

The city-states of ancient Sumer were often at war with one another. A testimony to the bellicose aspect of Sumerian society—and also to the considerable wealth of its rulers—comes from the so-called Royal Cemetery at Ur. There, in sixteen vaulted chambers beneath the earth (out of well over a thousand modest burials), were interred the leading families of Ur. Scholars are still debating whether the deceased were true kings and queens or simply aristocrats and priests, but they were laid to rest in regal fashion. In the graves were found golden helmets and daggers with handles of lapis lazuli (an imported rich azure-blue stone favored by the Sumerians), golden beakers and bowls, jewelry of gold and lapis, musical instruments, chariots, and other luxurious items. The "kings and queens"

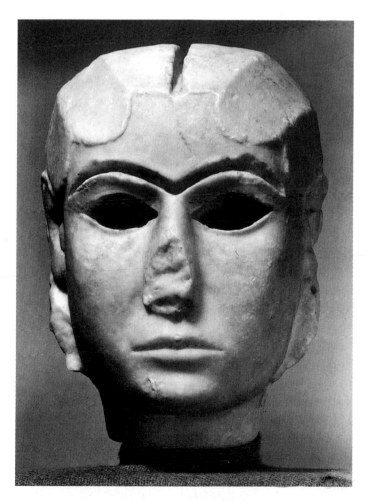

2-5 Female head (Inanna?), from Uruk, *c.* 3500–3000 B.C. Marble, approx. 8" high. Iraq Museum, Baghdad.

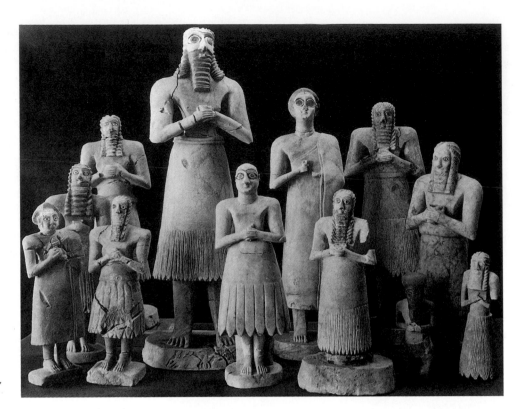

2-6 Statuettes from the Temple of Abu, Tell Asmar, *c.* 2700–2600 B.C. Gypsum with shell and black limestone inlay, tallest figure approx. 30″ high. Iraq Museum, Baghdad, and Oriental Institute, University of Chicago.

were also buried with a retinue of musicians, servants, charioteers, and soldiers, who gave their lives willingly to accompany their leaders to the afterlife.

Not the costliest object found in the "royal" graves, but probably the most significant from the point of view of the history of art, is the so-called *Standard of Ur* (FIG. **2-8**), a rectangular box of uncertain function with sloping sides inlaid with shell, lapis lazuli, and red limestone. The two long sides of the box are divided into three horizontal bands. The two sides have been conventionally designated as the "war side" and "peace side" of the *Standard of Ur*. On the war side the narrative reads from left to right and bottom to top: first we see four war chariots (the earliest such representations yet known) crushing enemies; then a file of foot soldiers gathers up and leads away captured foes; and in the uppermost register, naked and bound captives are presented to a kinglike figure, who has stepped out of his chariot and who is set apart from all the other figures not only by his central place in the composition but also by his greater stature. On the peace side the mosaic narrative is also read from the bottom up. In the lowest band, men are shown carrying what may be tribute to be given to their conquerors. Above, attendants bring animals and fish for the great banquet in the uppermost register, where seated dignitaries and a larger-than-life "king" (third from the left) feast, while a lyre player and singer (at the far right) entertain the group. The absence of an inscription prevents us from connecting the scenes with a specific event, but there can be little doubt that this is a historical narrative—not, however,

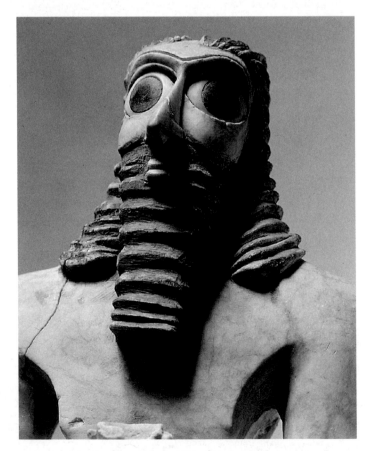

2-7 Detail of the head of the tallest figure in FIG. 2-6. Iraq Museum, Baghdad.

the first in the history of art, an honor that belongs (at the moment, at least) to an Egyptian relief over three centuries earlier in date (FIG. 3-2).

Each individual figure on the *Standard of Ur* is carefully spaced, with little overlapping. We may contrast this regularized, formal presentation (characteristic also of Egyptian art) with the casual, haphazard placement of the figures in Paleolithic and Mesolithic art. Poses are repeated, as in the line of foot soldiers, to suggest large numbers. The horses of the war chariots (with the lines of the legs repeated to suggest the other horses of the team and their alignment in space) change from a walk to a gallop as they attack.

The human figures are essentially in profile, but it is an almost universal convention in the pre-Classical world that the eyes are in front view, as are the torsos. As we have already observed in connection with the Mesolithic rock paintings from Remigia in Spain (FIG. 1-13), the artist has indicated the parts of the human body that enter into our concept of what the human form looks like and avoids positions, attitudes, or views that would conceal or obscure the characterizing parts. For example, if the figures were in strict profile, an arm and perhaps a leg would be concealed;

the body would appear to have only half its breadth; and the eye would not "read" as an eye at all, because it would not have its distinctive flat oval shape, and the pupil, so important in the Tell Asmar figures, would not appear. We could call this approach "conceptual" rather than "optical," because the artist records not the immediate, fleeting aspect of things but rather a concept of the distinguishing and abiding properties of the human body. It is the fundamental forms of things and the artist's knowledge of them, not their accidental appearance, that direct the artist's hand and that dictated the selection of the composite view as the best way of representing the human body.

From the grave of "Queen" Puabi (many scholars now prefer to designate her more conservatively and ambiguously as "Lady" Puabi) at Ur comes a splendid lyre (FIG. **2-9**) that, in its newly restored state, resembles the comparable instrument depicted in the feast scene on the *Standard of Ur*. The sound box of the instrument is capped by a magnificent bull's head fashioned of gold leaf over a wooden core with hair, beard, and details of lapis lazuli. The sound box itself (FIG. **2-10**) also features bearded, but in this case human-headed, bulls in the uppermost of its four inlaid

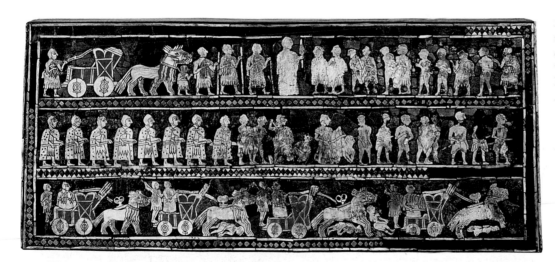

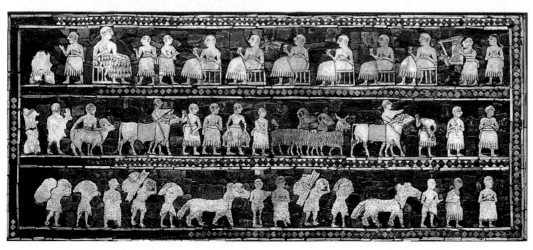

2-8 War side (above) and peace side (below) of the *Standard of Ur,* *c.* 2700 B.C. Wooden panel inlaid with shell, lapis lazuli, and red limestone, approx. 8″ × 19″. British Museum, London.

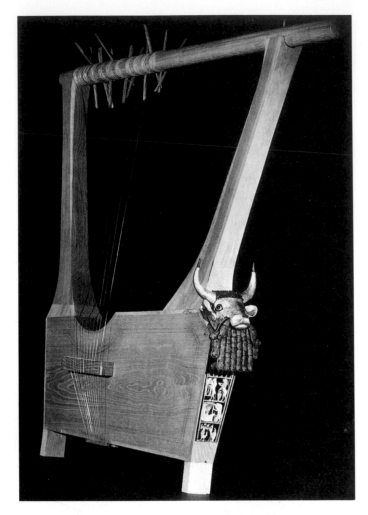

2-9 Bull-headed lyre from the tomb of Puabi, Royal Cemetery, Ur, *c.* 2600 B.C. Gold leaf and lapis lazuli over a wooden core, approx. 5' 5" high. University Museum, University of Pennsylvania, Philadelphia.

the artist of this panel to Aesop's fables in ancient Greece, to the medieval bestiaries, and to the zoological creations of Walt Disney.

A banquet is also the subject of a cylinder seal (FIG. **2-11**) found in Puabi's grave. The seal is typical of the period, consisting of a cylindrical piece of stone usually about an inch or so in height, pierced for the attachment of a cord. Made of various colored stones, both hard and soft, such as rock crystal, agate, carnelian, jasper, lapis lazuli, marble, and alabaster, seals were prized objects and were often worn as amulets. They were decorated with a design in *intaglio* (incised), so that a raised pattern was left when the seal was rolled over soft clay. With this device, the Sumerians sealed, signed, and identified their documents, storage jars, and other important possessions. Our illustra-

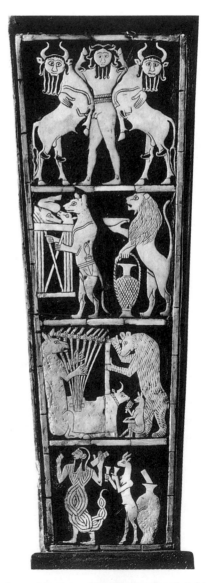

2-10 Soundbox of the lyre of Puabi. Wood with inlaid gold, lapis lazuli, and shell, approx. 12" high. University Museum, University of Pennsylvania, Philadelphia.

panels. Such imaginary composite creatures are commonplace in the art of the ancient Near East and Egypt; the man-headed lion that is the Great Sphinx of Gizeh (FIG. 3-11) is undoubtedly the most famous example. On the Ur lyre a great Gilgamesh-like hero wrestles the two man-bulls in a heraldically symmetrical composition. He and the scorpion-man in the lowest panel are shown in a composite view, whereas the animals are, equally characteristically, depicted in profile: the dog wearing a dagger and carrying a laden table, the lion bringing in the beverage service, the ass playing the lyre, the jackal playing the zither, the bear steadying the lyre (or perhaps dancing), and the gazelle bearing goblets. The banquet animals seem almost to be burlesquing the kind of regal feast reproduced on the peace side of the *Standard of Ur*. The meaning of all these scenes is unclear, but surely the sound box of Puabi's lyre is a very early specimen of the recurring theme in both literature and art in which animals act as people; thus, we pass from

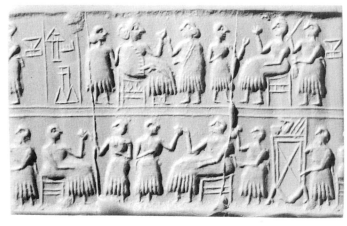

2-11 Cylinder seal and its impression, from the tomb of Puabi, Royal Cemetery, Ur, *c.* 2600 B.C. Lapis lazuli, approx. 2" high. British Museum, London.

tion shows both one side of the seal and the complete relief design made from it. In the upper zone, a seated woman and man attended by servants sit and drink from beakers; below, two more seated figures are also waited on by attendants. The seal is inscribed with Puabi's name.

AKKADIAN ART

About 2300 B.C., the loose group of cities known as Sumer, where the tremendous change from prehistory to civilization had begun, came under the domination of a great ruler, Sargon of Akkad. The Akkadians, although they were Semitic in origin and spoke a language entirely different from that of Sumer, had assimilated Sumerian culture. Under Sargon and his followers, they introduced a new concept of royal power; its basis was unswerving loyalty to the king rather than to the city-state. During the rule of Sargon's grandson, Naram-Sin, governors of cities were considered mere servants of the king, who, in turn, called himself "King of the Four Quarters"—in effect, ruler of the earth.

A magnificent bronze head of an Akkadian king found at Nineveh (FIG. **2-12**) embodies this new concept of absolute monarchy, and the damage it later suffered is a result of its status as a political work of art. The head is all that survives

of a statue that was overturned in antiquity, perhaps by an enemy of the Akkadians, but the damage to the portrait is not due solely to the statue's toppling. The eyes, once inlaid with precious or semiprecious stones, have been gouged out, the lower part of the beard has been broken off, and the ears have been mutilated. Nonetheless, the majestic serenity, dignity, and authority of the king are evident, as is the masterful way the sculptor has balanced naturalism and stylization. The distinctive Semitic features of the man—the profile of the nose, the long, curly beard—have been carefully observed and recorded, and the artist has brilliantly communicated the differing textures of flesh and hair, even the contrasting textures of the mustache, beard proper, and the plaited and braided hair on the top of the head. At the same time, the artist's sensitivity to formal pattern may be seen in the triangles, lozenges, and overlapping disks of hair that make up the coiffure, and the great arching eyebrows that give such character to the portrait. No

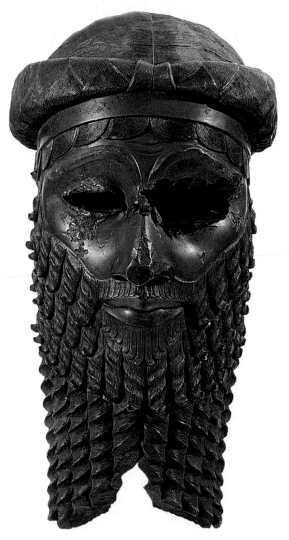

2-12 Head of an Akkadian ruler, from Nineveh, *c.* 2200 B.C. Bronze, approx. 12" high. Iraq Museum, Baghdad.

less remarkable is the fact that this is a life-size, hollow-cast bronze sculpture, one of the first ever attempted. The age of metals has come, and the head demonstrates the artisan's sophisticated skill in casting and polishing the bronze and in engraving the details. The portrait is the first great monumental work of bronze sculpture that has come down to us and is a superb achievement at any date.

The godlike sovereignty claimed by the kings of Akkad is also evident in another masterpiece of Akkadian art, the victory stele (FIG. **2-13**) set up by Naram-Sin at Sippar to commemorate his defeat of the Lullubi, a people of the Iranian mountains to the east. The stele is inscribed

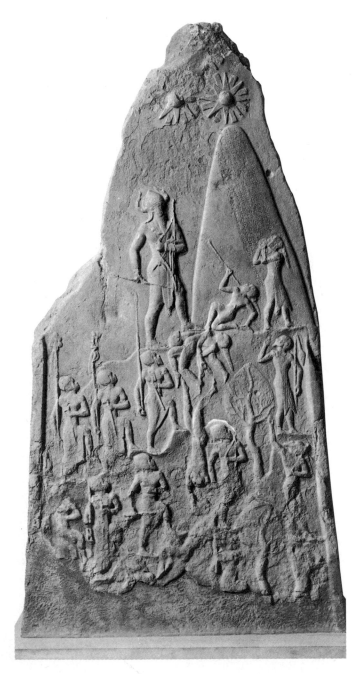

2-13 Victory stele of Naram-Sin, from Susa, *c.* 2200 B.C. Pink sandstone, approx. 6' 7" high. Louvre, Paris.

twice, once in honor of Naram-Sin, and once by a twelfth-century B.C. Elamite king who had captured Sippar and taken the stele as booty back to Susa, where it was found. On the stele, the grandson of Sargon is represented leading his victorious army up the slopes of a wooded mountain and through the routed enemy, who are crushed underfoot, fall, flee, die, or beg for mercy. The king stands alone, far taller than his men, treading on the bodies of two of the fallen enemy. He wears the horned helmet that signifies his deification, and at least three auspicious astral bodies (the stele is damaged at the top as well as broken at the bottom) shine on his triumph. In storming the mountain, Naram-Sin seems also to be scaling the ladder to the heavens, the same conceit that lies behind the great ziggurat towers of the ancient Near East. His troops march up the mountain behind him in orderly files, suggesting the discipline and organization of the king's forces. The enemy, by contrast, is in disarray and is depicted in a great variety of postures—one falls headlong down the mountainside. Although the sculptor has adhered to older conventions in many details, especially in portraying the king and his soldiers in composite views (note, too, the frontal placement of Naram-Sin's two-horned helmet on his profile head), in other respects this work shows daring innovation. Here the sculptor has created the first landscape in Near Eastern art since Çatal Hüyük (FIG. 1-20) and has set the figures on successive tiers within that landscape, rejecting the standard means of telling a story in a series of horizontal registers, which was the rule not only in earlier Mesopotamian art but also in Egyptian art.

NEO-SUMERIAN ART

The achievements of Akkad were brought to an end by an incursion of barbarous mountaineers, the Guti, who dominated life in central and lower Mesopotamia until the cities of Sumer, responding to the alien presence, reasserted themselves and established a Neo-Sumerian polity under the kings of Ur. This is the age that saw the construction of the great ziggurat at Ur (FIG. 2-4), but the most conspicuous sculptural monuments come from the city of Lagash, under its governor, Gudea.

There are about twenty preserved statues of Gudea, showing him seated or standing, hands tightly clasped, sometimes wearing a woolen brimmed hat and always dressed in a long garment that leaves one shoulder and arm exposed; the statue illustrated here (FIG. **2-14**) is typical. Gudea attributed his good fortune and that of his city to the favor of the gods, and he was a zealous overseer of the performance of rites in their honor. His statues were numerous so that he could take his symbolic place in the temples and there render perpetual service to the benevolent deities—as the cuneiform inscription on the lap of our statue explicitly states. Gudea's portraits thus revive the tradition of the votive statuettes from Tell Asmar (FIG. 2-6) and

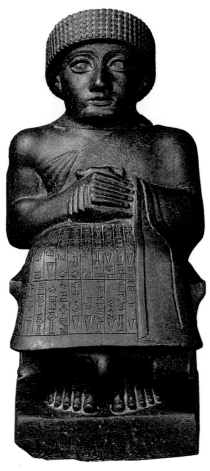

2-14 Seated statue of Gudea, from Telloh, *c.* 2100 B.C. Diorite, approx. 17¼" high. Metropolitan Museum of Art, New York. Harris Brisbane Dick Fund, 1959.

abandon the regal trappings of Sargon and his successors. The artist's focus upon the portrait head with its great arching eyebrows is evident in its disproportionate size, but the hands have also been enlarged to underscore Gudea's piety. Our example is less than a foot and a half tall, but, like the other known portraits of Gudea, it is carved of diorite, an extremely hard stone that had to be imported and was rare and costly. The pride that Gudea took in seeing his image replicated in such a fine—and difficult to carve—stone is proclaimed in the inscription on one of his other portraits: "This statue has not been made from silver nor from lapis lazuli, nor from copper nor from lead, nor yet from bronze; it is made of diorite."

BABYLONIAN ART

Lagash, which had retained its independence during the Guti invasion, became a dependency of Ur during that city's brief resurgence late in the third millennium B.C. For a little over a century, the Third Dynasty of Ur ruled a once-more united realm. Its last king fell before the attacks of

foreign invaders, and the following two centuries witnessed the re-emergence of the traditional Mesopotamian political pattern in which several independent city-states existed side by side. Until its most powerful king, Hammurabi, was able to re-establish a centralized government that ruled the whole country, Babylon was one of these city-states. Perhaps the most renowned king in Mesopotamian history, Hammurabi was famous for his law code, which prescribed penalties for everything from adultery and murder to the cutting down of a neighbor's trees.

The code, beautifully inscribed on a tall black basalt stele (FIG. **2-15**), which was carried off as booty to Susa in the twelfth century B.C., together with the Naram-Sin stele, is capped by a relief sculpture of Hammurabi receiving the inspiration for the laws from the flame-shouldered sun god, Shamash. The god holds the symbols of divine power, ring and staff, in a hand stretched toward Hammurabi, who is represented in a gesture of reverent attention, his hand raised in prayer. Shamash is depicted in the familiar convention of combined front and side views, but with two important exceptions. His great headdress with its four pairs of horns is shown in true profile, so that only four, not

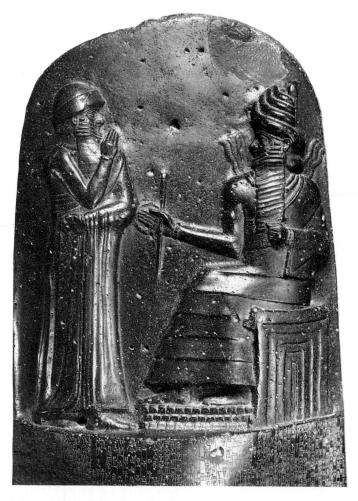

2-15 Stele with law code of Hammurabi (upper part), from Susa, *c.* 1780 B.C. Basalt, entire stele approx. 7′ 4″ high. Louvre, Paris.

all eight, of the horns are visible, and the artist seems to be tentatively exploring the notion of foreshortening by rendering the god's beard with a series of diagonal rather than horizontal lines, suggesting its recession from the picture plane. Experiments like this and the tiered landscape of the Naram-Sin stele (FIG. 2-13) testify to the creativity and brilliance of the artists of the ancient Near East; innovations such as these were, however, isolated phenomena, and the composite view for the human body and the setting out of a story in registers remained the rule for well over a millennium after the erection of Hammurabi's stele.

HITTITE ART

The Babylonian Empire was brought down by the Hittites, an Anatolian people who conquered and sacked Babylon around 1595 B.C. and then retired to their homeland, leaving Babylon in the hands of the Kassites. Remains of the strongly fortified capital city of the Hittites may still be seen near the modern Turkish village of Boghazköy. Constructed of large blocks of heavy stone—a striking contrast to the brick architecture of Mesopotamia—the walls and towers of the Hittites were designed to protect them from attack. The gateway to the Boghazköy citadel (FIG. **2-16**) was guarded not only by Hittite soldiers but by huge (7-foot-high) lions, whose forequarters project from massive blocks of stone to either side of the entrance. These great guardian animals will have many successors in the

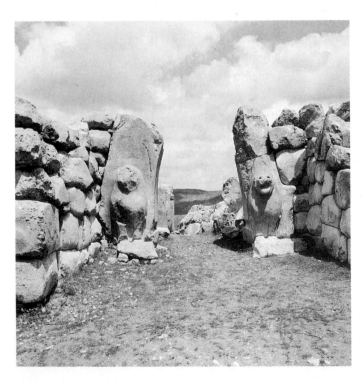

2-16 Lion Gate, Boghazköy, *c.* 1400 B.C. Limestone, lions approx. 7′ high.

ancient Near East, even at Babylon itself, and especially in the fortress cities of one of the greatest empires of the ancient world, that of Assyria.

ELAMITE ART

To the east of Sumer, Akkad, and Babylon, in the area corresponding roughly to the western Iranian province of Khuzistan, a civilization flourished that is known today by the biblical name Elam. During the second half of the second millennium B.C.—what scholars refer to as the Middle Elamite period—Elam reached the apogee of its political and military power. It was at this time that Elam was strong enough to plunder Babylonia and to carry off the stelae of Naram-Sin and Hammurabi (FIGS. 2-13 and 2-15) and re-erect them at their capital city, Susa. The empire of Elam was finally destroyed by the Assyrian king Ashurbanipal in 641 B.C.; he sacked Susa, although the city would rise again to great importance under the Achaemenid Persian Empire.

From the ruins of Susa comes the life-size bronze statue of Queen Napirasu (FIG. **2-17**), wife of one of the most powerful Middle Elamite kings. The statue weighs 3,760 pounds even in its fragmentary and mutilated state, because the sculptor, incredibly, cast the statue with a solid bronze core, rather than hollow, as did the artist responsible for the Akkadian royal portrait already examined (FIG. 2-12). The solid casting increased the cost of the statue enormously, but it was intended to be a permanent votive offering in the temple in which it was found, one unlikely to be carried away. In fact, the Elamite inscription on the queen's skirt explicitly entreats the gods to protect her statue:

> He who would seize my statue, who would smash it,
> who would destroy its inscription, who would erase my
> name, may he be smitten by the curse of [the gods],
> that his name shall become extinct, that his offspring be
> barren. . . . This is Napirasu's offering.

The statue thus falls within the votive tradition going back to the third millennium B.C. and the figurines from Tell Asmar (FIG. 2-6), and in the Elamite statue the Mesopotamian instinct for cylindrical volume is again evident. The tight silhouette, strict frontality, and firmly crossed hands held close to the body are all enduring characteristics common to both the Sumerian statuettes and the portrait of Napirasu. Yet within these rigid conventions of form and pose, the Elamite artist manages to create refinements that could only be the result of close observation: the feminine softness of arm and bust, the grace and elegance of the long-fingered hands, the supple and quiet bend of the wrist, the ring and bracelets, the brocaded gown and the wave pattern of its hem. The figure presents the ideal in queenly deportment, with just a touch of demureness to mitigate the severity of the conventional pose. The loss of the head is especially unfortunate.

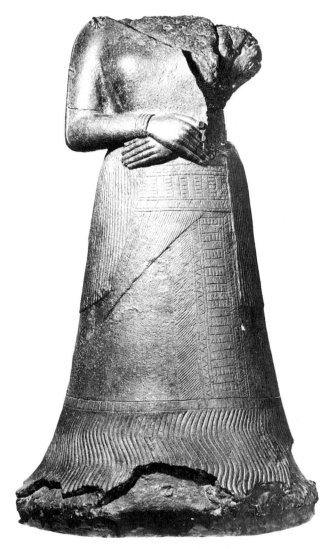

2-17 Statue of Queen Napirasu, from Susa, *c.* 1300 B.C. Bronze, approx. 51" high. Louvre, Paris.

ASSYRIAN ART

For most of the first half of the first millennium B.C., the Assyrians (who take their name from Assur, the city on the Tigris River in northeastern Syria named for the god Assur) were the dominant power in the Near Eastern world, having overcome all the warring peoples that succeeded the Babylonians and Hittites, among them the Kassites and the Mitanni. By about 900 B.C. the Assyrian Empire was firmly established. Assyria, with its center successively at Nimrud, Khorsabad (ancient Dur Sharrukin), and Nineveh, was a garrison state with an imperial structure that extended from the Tigris to the Nile and from the Persian Gulf to Asia Minor. Centuries of unremitting warfare against their neighbors and often rebellious subjects hardened the Assyrians into a cruel and merciless people whose atrocities in warfare were bitterly decried throughout the ancient world.

Architecture

The unfinished royal citadel of Sargon II of Assyria (FIG. **2-18**) built at Khorsabad reveals in its ambitious layout the confidence of the Assyrian kings in their all-conquering might—but, with its strong defensive walls, it also reflects a society ever fearful of attack during a period of almost incessant warfare. The palace covered some 25 acres and had over two hundred courtyards and rooms. The city itself, above which the citadel-palace stood on a mound 50 feet high, measures about a square mile in area. The palace may have been elevated solely to raise it above flood level, but its elevation served also to put the king's residence above those of his subjects and midway between his subjects and the gods. Although there is a basic symmetry in the layout of the palace complex, the plan is rambling, embracing an aggregation of rectangular rooms and halls grouped around square and rectangular courts. The shape of the long, narrow rooms and the massiveness of the side walls suggest that the rooms were covered by brick *barrel vaults* (in effect, a deep arch or an uninterrupted series of arches, one behind the other, over an oblong space, see FIG. 7-4), the most practical roofing method in a region that lacks both timber and good building stone. Behind the main courtyard, each side of which measures 300 feet in length, were the residential quarters of the king, who received foreign emissaries in the long, high, brilliantly painted throne room. All visitors entered from another large courtyard, passing through the central entrance between huge guardian demons, over 13 feet tall. The walls of the court were lined with giant figures of the king and his courtiers.

Sargon II regarded his city and palace as an expression of his grandeur, which he viewed as founded on the submission and enslavement of his enemies. He writes in an inscription: "I built a city with [the labors of] the peoples

2-18 Reconstruction drawing of the citadel of Sargon II, Khorsabad, *c.* 720 B.C. (After Charles Altman.)

subdued by my hand, whom Assur, Nabu, and Marduk had caused to lay themselves at my feet and bear my yoke at the foot of Mount Musri, above Nineveh." And in another text, he proclaims: "Sargon, King of the World, has built a city. Dur Sharrukin he has named it. A peerless palace he has built within it."

In addition to the complex of courtyards, throne room, state chambers, service quarters, and guard rooms that made up the palace, the citadel included the essential temple and ziggurat. The ziggurat at Khorsabad may have had as many as seven stages, of which four have been preserved, each 18 feet high and each painted a different color. The ascent was made by a continuous ramp that spiraled around the building from its base to its summit; in it we see

the legacy of the Sumerian bent-axis approach over two millennia after the erection of the White Temple on the ziggurat at Uruk (FIG. 2-3).

The palace facade consisted of a massive crenelated wall broken by huge rectangular towers flanking an arched doorway. Around the arch and on the towers were friezes of brilliantly colored glazed tiles. Dazzling brilliance also seems to have been part of the royal Assyrian plan to overwhelm the visitor.

Sculpture

The doorway to the Khorsabad palace was guarded by colossal genii called *lamassu* (FIG. **2-19**). These winged,

2-19 *Lamassu* (winged human-headed bull), from the citadel of Sargon II, Khorsabad, *c.* 720 B.C. Limestone, approx. 13' 10" high. Louvre, Paris.

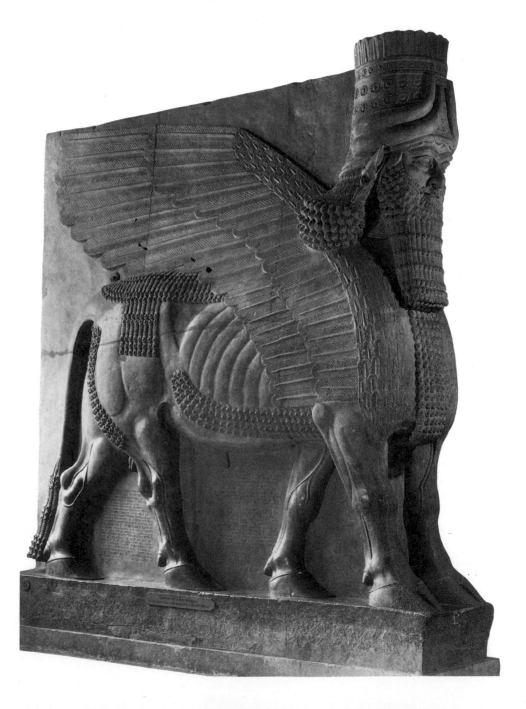

man-headed bulls, derived from age-old composite creatures of Mesopotamian art, served to ward off the king's enemies, visible and invisible. Carved partly in the round, these figures nonetheless are conceived as high reliefs on adjacent sides of a corner. They combine the front view of the guardian figure at rest with the side view in motion. Seeking to present a complete picture of the lamassu from both the front and the side, the sculptor gave the monster five legs (two seen from the front, four seen from the side). The three-quarter view chosen by the modern photographer is not one that would have been favored in antiquity. Once again, we see the effort made by early artists to provide a "conceptual" picture of an animal or person and of all its important parts, not an "optical" view of the lamassu as it actually stands in space.

The Assyrian kings expected their greatness to be recorded in unmistakably exact and concrete forms in their palaces, and in the official quarter of their citadels the lower parts of the thick mud-brick walls were revetted with limestone slabs (which were more readily available in northern than in southern Mesopotamia) and carved with relief sculptures exalting the king, his victories on the battlefield, and his triumphs over powerful beasts. Prowess in hunting was widely regarded as a manly virtue on a par with success in warfare. The history of Assyrian art is mainly the history of relief carving; very little sculpture in the round survives. Even the great lamassu, conceived as relief sculptures, are, as we have seen, locked into their stone slabs. The narrative reliefs of warfare and hunting that covered the walls of the Assyrian palaces are among the first monumental historical chronicles in stone that we possess. Not until the rise of the Roman Empire will we again see historical events regularly recorded for posterity in relief sculpture.

An important early example of historical narrative in relief comes from the palace of Ashurnasirpal II at Nimrud (FIG. **2-20**), where the king is shown leading one of his many military campaigns. He stands in his chariot drawing his bow and is accompanied by officers; in the sky above him, the winged god of Assyria, Assur, leads him on. The king's team, the reins tight, is passing an enemy chariot that is already breaking up; its driver has been thrown down and one horse has fallen. Assyrian foot soldiers cut the throats of the wounded enemies. At the upper center, an Assyrian soldier slays a foe while another enemy warrior tries to save his comrade. Behind them a soldier is lying dead; in the upper right, enemy bowmen desperately defend the towers of their city. The ease with which we read these incidents is quite remarkable, especially since they are not depicted in perspective or in logical sequence. The artist uses the space of the limestone block as a field to be divided as narrative convenience and a sense of both the factual and the dramatic dictate. The liveliness of individual poses and movements is exceptionally fine and convincing, and despite the formality in Mesopotamian art that exists side by side with naturalistic details, sophisticated spatial devices appear throughout. One is the overlapping of figures to suggest greater or lesser distance from the observer; the king overlapping his officers is a good example.

Two centuries later are the reliefs from the palace of Ashurbanipal at Nineveh depicting the king hunting lions. The hunt does not take place in the wild, but rather in a controlled environment assuring the safety and success of the king, who was the conqueror of Elamite Susa. In the

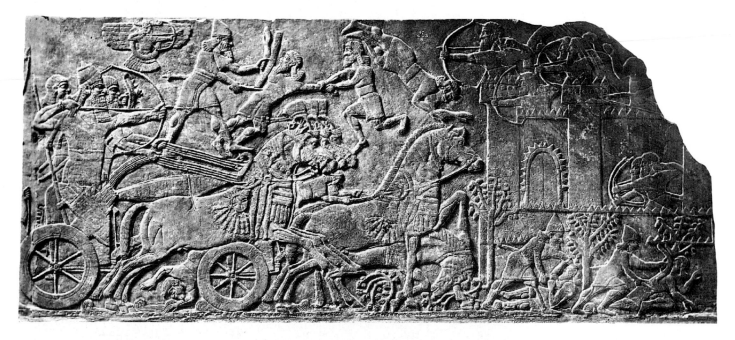

2-20 Ashurnasirpal II at war, relief from the palace of Ashurnasirpal II, Nimrud, *c.* 875 B.C. Limestone, approx. 39" high. British Museum, London.

relief illustrated here (FIG. **2-21**), lions released from cages in a large, enclosed arena charge the king, who, in his chariot and with his servants protecting his blind sides, shoots down the enraged animals. The king, menaced by the savage spring of a lion at his back, is saved by the quick action of two of his spearmen. Behind his chariot lies a pathetic trail of dead and dying animals, pierced by what would appear to be far more arrows than are needed to kill them.

A dying lioness (FIG. **2-22**), blood streaming from her wounds, drags her hindquarters, paralyzed by arrows that have pierced her spine. The artist gives a ruthless reading of the straining muscles, the swelling veins, the corrugations of the muzzle, and the flattened ears—hard realism under the control of the formality of a silhouette in low relief. Modern sympathies make this scene of carnage a kind of heroic tragedy, with the lions as protagonists, but it is

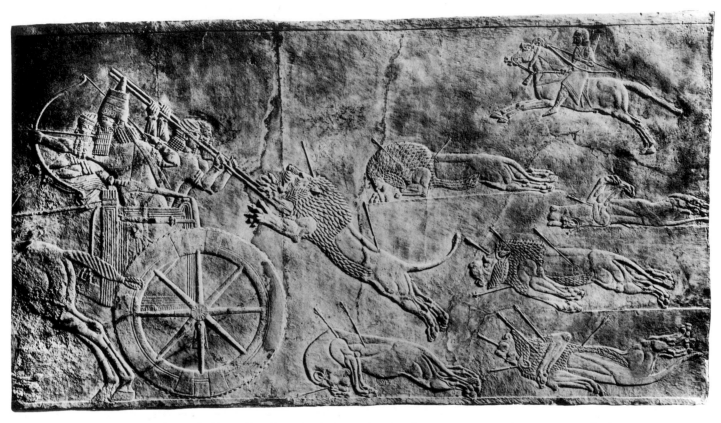

2-21 Ashurbanipal hunting lions, relief from the palace of Ashurbanipal, Nineveh, *c.* 650 B.C. Limestone, approx. 60" high. British Museum, London.

2-22 Dying lioness, detail of relief from the palace of Ashurbanipal, Nineveh, *c.* 650 B.C. Limestone, figure approx. 16" high. British Museum, London.

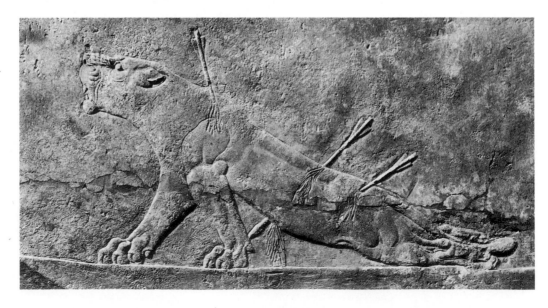

unlikely that the artists of the king had any intention other than to aggrandize his image by piling up his kills, by showing the king of men pitting himself against and conquering the king of beasts. Depicting Ashurbanipal's beastly foe as possessing not merely strength, but courage and nobility as well, served to make the king's accomplishment that much grander.

NEO-BABYLONIAN ART

The Assyrian Empire was never very secure, and most of its kings had to fight revolts in large sections of the Near East. Opposition to Assyrian rule increased steadily throughout the seventh century B.C., and during the last years of Ashurbanipal's reign, the empire began to disintegrate. Under his weak successors, it collapsed before the simultaneous onslaught of the Medes from the east and the resurgent Babylonians from the south. Babylon rose once again, and in a brief renewal (612–538 B.C.), the old southern Mesopotamian culture flourished. King Nebuchadnezzar, whose exploits are recounted in the biblical Book of Daniel, restored Babylon to the rank of one of the great cities of antiquity, and its famous "hanging gardens" were counted among the seven wonders of the ancient world. Only a little of the great ziggurat of Babylon's temple to Bel (the Hebrews' Tower of Babel) remains, but the fifth-century B.C. Greek historian Herodotus, in his chronicle of the war between the Greeks and the Persians, has left us the following description of the temple complex:

> In the one [division of the city] stood the palace of the kings, surrounded by a wall of great strength and size; in the other was the sacred precinct of Zeus-Bel, an enclosure a quarter of a mile square, with gates of solid brass, which was also remaining in my time. In the middle of the precinct, there was a tower of solid masonry, a furlong in length and breadth, on which was raised a second tower, and on that a third, and so on up to eight. The ascent to the top is on the outside, by a path which winds round all the towers. When one is about halfway up, one finds a resting place and seats, where persons are wont to sit some time on their way to the summit. On the topmost tower, there is a spacious temple, and inside the temple, stands a couch of unusual size, richly adorned, with a golden table by its side. . . . They also declare that the god comes down in person into this chamber, and sleeps on the couch, but I do not believe it.

A grand approach to the temple complex led down a walled processional way lined with sixty stately figures of lions molded in relief on brightly colored glazed bricks (FIG. **2-23**). These remarkable beasts, sacred to the goddess Ishtar, are glazed in yellow-brown and red against a ground of turquoise or dark blue. The Babylonian glazes are opaque and hard; possibly, each brick was molded and enameled separately. Since the animals have no narrative function, they are not individually characterized as were the lions in the Nineveh reliefs (FIGS. 2-21 and 2-22), but their vigor is suggested by snarling muzzles, long, nervous tails, and carefully depicted muscles.

The processional way passed through the monumental, brilliantly glazed Ishtar Gate (FIG. **2-24**), the design of which, with its flanking crenelated towers, conforms to the type of gate found in earlier Babylonian and Assyrian architecture. Glazed tiles had been used much earlier, but the

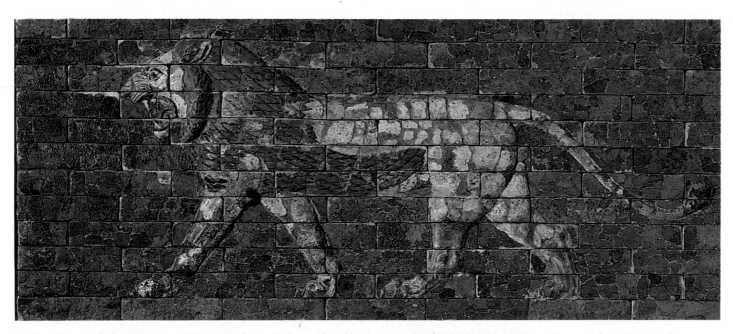

2-23 Lion, from the Processional Way, Babylon, *c.* 575 B.C. Glazed brick, approx. 38¼″ high. Metropolitan Museum of Art, New York. Fletcher Fund, 1931.

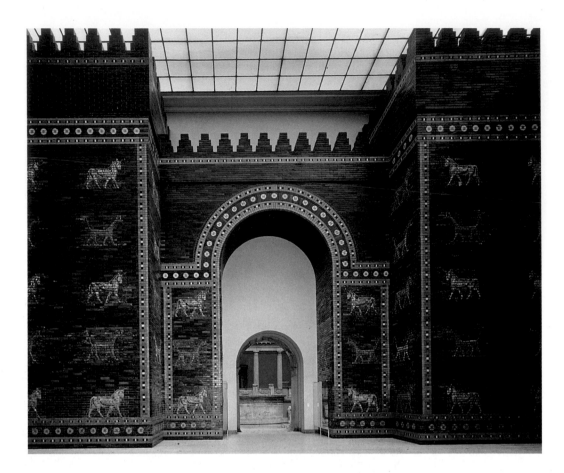

2-24 Ishtar Gate (restored), Babylon, *c.* 575 B.C. Glazed brick, Staatliche Museen, Berlin.

surface of the bricks, even of those on which figures appeared, was flat. On the surfaces of the Ishtar Gate, laboriously reassembled in Berlin, are superposed tiers of the alternating profile figures of the dragon of Marduk and the bull of Adad. This gate is characteristic Mesopotamian formality at its best. The figures compose a stately heraldry proclaiming the gods of the temples toward which the Sacred Way leads. The perfect adjustment of figure to wall found in the Ishtar animals rarely has been surpassed; certainly, in the history of architecture, few more colorful and durable surface ornaments are known.

ACHAEMENID PERSIAN ART

Although Nebuchadnezzar, Daniel's "King of Kings," had boasted that "I caused a mighty wall to circumscribe Babylon . . . so that the enemy who would do evil would not threaten . . . [and] of the city of Babylon [I] made a fortress," his city was taken in the sixth century B.C. by Cyrus of Persia (559–529 B.C.). Cyrus, who may have been descended from an Elamite line, was the founder of the Achaemenid dynasty and traced his ancestry back to a mythical King Achaemenes. The impetus of the Persians' expansion carried them far beyond Babylon. Egypt fell to them in 525 B.C., and by 480 B.C., the Persian Empire was

the largest the world had ever known, extending from the Indus to the Danube; only the successful resistance of the Greeks in the fifth century prevented it from embracing southeastern Europe as well. The Achaemenid line came to an end with the death of Darius III in 330 B.C., after his defeat in the Battle of Issus (see FIG. 5-79) and the fall of his empire to Alexander the Great.

Architecture

The most important source of our knowledge of Persian architecture is the palace at Persepolis (FIG. **2-25**), built between 520 and 460 B.C. by Darius I and Xerxes I, successors of Cyrus. Situated on a high plateau, the heavily fortified palace stood on a wide platform overlooking the plain. Although destroyed by Alexander the Great in a gesture symbolizing the destruction of Persian imperial power (and, some say, as an act of revenge for the Persian sack of the Athenian acropolis in the early fifth century B.C.), the still-impressive ruins of the palace complex permit a fairly complete reconstruction of its original appearance, ambitious scale, and spatial intricacy.

Unlike the Assyrian citadel-palace, with its tightly enclosed courts (FIG. 2-18), the Persepolis buildings, although axially aligned, were loosely grouped and separated from one another by streets and irregular open spaces

(FIG. **2-26**). The dominant structure was a vast columned hall, 60 feet high and over 200 feet square. Standing on its own rock-cut podium, about 10 feet high, this huge royal audience hall, or *apadana*, contained thirty-six columns, each 40 feet high. The fluted shafts of the columns culminated in capitals composed of the foreparts of bulls or lions, arranged to provide a firm cradle for the roof timbers. A well-preserved example from the somewhat later palace of Artaxerxes II at Susa, the former Elamite city, is shown in FIG. **2-27**. These unique capitals are an impressive and decorative Persian invention with no known antecedents or descendants. The square, many-columned hall so characteristic of the Persepolis palace may, however, have been derived from Median architecture; a similar seventh-century B.C. hall with twelve wooden columns supporting the roof has been excavated at the Median site of Nushi Jan. The Medes were the northern allies and later subjects of the Persians and are believed to have been the intermediaries through whom Persian art received a variety of Iranian

stylistic elements it incorporated as permanent constituents.

Sculpture

The approach to the apadana leads through a monumental gateway flanked by colossal man-headed bulls and then turns at right angles toward the elevated great hall. Broad, ceremonial stairways provide access to the royal audience hall. The walls of the terrace and staircases are decorated with reliefs representing processions of royal guards, Persian and Median nobles and dignitaries, and representatives from the subjected nations bringing tribute and gifts to the king (FIG. **2-28**).

Traces of color found on similar monuments at other Persian sites suggest that the Persepolis reliefs were colored, and the original effect must have been even more impressive than it is today. On the other hand, the present denuded state of the reliefs makes it easier for us to appreciate

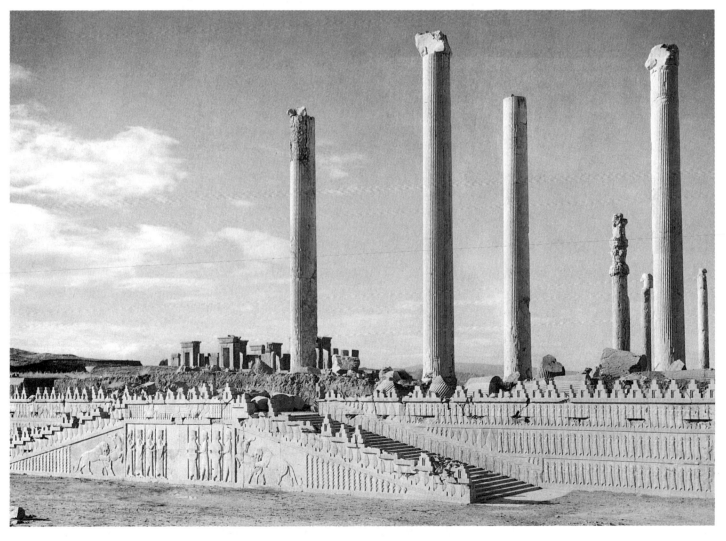

2-25 Royal audience hall (*apadana*) and stairway, palace of Darius I, Persepolis, *c.* 500 B.C.

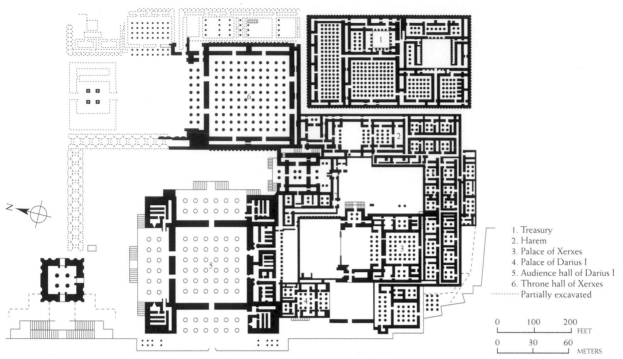

2-26 Plan of the palace complex at Persepolis.

1. Treasury
2. Harem
3. Palace of Xerxes
4. Palace of Darius I
5. Audience hall of Darius I
6. Throne hall of Xerxes
⋯⋯ Partially excavated

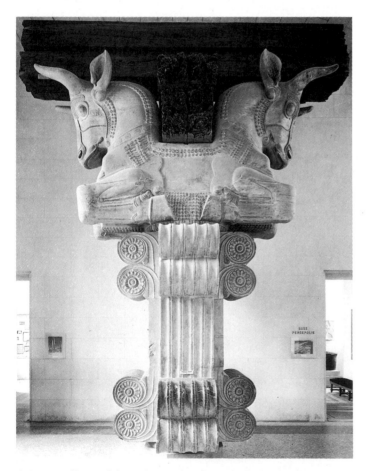

2-27 Bull capital from the royal audience hall of the palace of Artaxerxes II, Susa, *c.* 375 B.C. Gray marble, approx. 7′ 7″ high. Louvre, Paris.

their highly refined sculptural style. The cutting of the stone, both in the subtly modeled surfaces and the crisply chiseled details, is technically superb. Although they may have been inspired by the reliefs in the great palaces of the Assyrians, these Persian reliefs are strikingly different in style. The forms are more rounded, project more from the background, and seem organically more unified, as the torsos are now shown in natural side view and are thus more convincingly related to heads and legs. Some of the details, notably the treatment of drapery folds, echo forms characteristic of Archaic Greek sculpture, and Greek influence seems to be one of the ingredients of Achaemenid style. In the previous century, the impact of the art of Egypt and the Near East upon Greek art was so strong that, as we shall see in Chapter 5, art historians commonly apply the term "Orientalizing" to this period of Greek art. The detection of Greek elements in sixth- and fifth-century Persian art testifies to the active exchange of ideas among all the civilizations of the Classical and Near Eastern worlds at this date. A building inscription at Susa, for example, names Ionian Greeks, Medes, Egyptians, and Babylonians among the workmen who built and decorated the palace. Under the single-minded direction of its Persian masters, this mixed crowd, with a widely varied cultural and artistic background, created a new and coherent style that was perfectly suited to the expression of Persian imperial ambitions.

Persian conquests, of course, brought to Cyrus and his successors not merely new artistic ideas, but also great wealth. Numerous surviving items of fine tableware in precious metals attest to the excellence of the goldsmiths and silversmiths in the employ of the Persian nobility. One

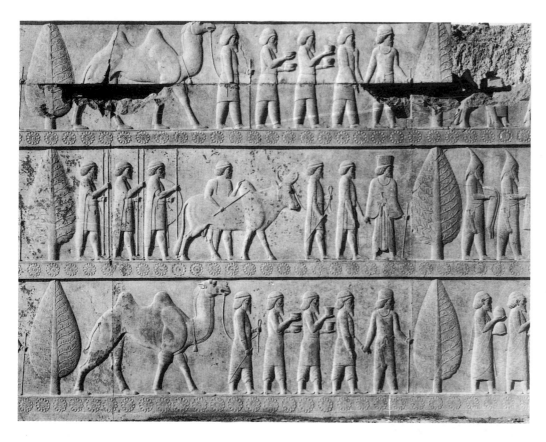

2-28 Subjects bringing gifts to the king, detail of the reliefs on the stairway to the royal audience hall, Persepolis, *c.* 500 B.C. Limestone.

of the finest is a gold *rhyton*, or drinking vessel ending in the forepart of an animal (FIG. **2-29**). Dating to the fifth century B.C., the rhyton culminates in a winged lion with a protruding tongue. Formed of seven pieces joined almost without a trace, the rhyton is technically flawless; the upper band of the cup, for example, is ornamented with no less than forty-four rows of gold wire only about one-fifth of a millimeter in diameter. Artistically, one notes in particular the highly refined decorative sensibility of the metalsmith, seen in the domino-like mane, the feather-like wings, and the tulip-like form of the muscles of the composite creature's forelegs. The rhyton deserves a place on the table of a "Great King, King of Kings, King of Persia," as the Achaemenids styled themselves.

SASANIAN ART

With the conquest of Persia by Alexander the Great in 330 B.C., the history of the ancient Near East becomes part of the history of Greece and Rome. In the third century A.D., however, a new power rose up in Persia to challenge the Romans and sought to force them out of Asia. The new dynasts called themselves Sasanians and traced their lineage to a legendary figure named Sasan, who was said to be a direct descendant of the Achaemenid kings. Their New Persian Empire was founded in A.D. 224, when the first

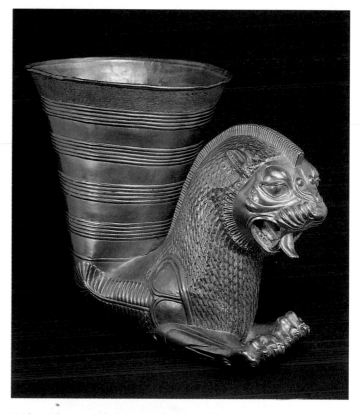

2-29 Rhyton with forepart of a winged lion, 5th century B.C. Gold, approx. 6³/₄″ high. Metropolitan Museum of Art, New York.

Sasanian king, Artaxerxes I (211–241), defeated the Parthians (another of Rome's eastern enemies) and established his capital at Ctesiphon, near modern Baghdad in Iraq. The son and successor of Artaxerxes, Shapur I (241–272), succeeded in further extending Sasanian territory and even captured the Roman emperor Valerian (near Edessa in modern Turkey) in 260.

Shapur's palace at Ctesiphon is today in a ruined state, but our photograph (FIG. **2-30**), taken before an 1880 earthquake caused the collapse of the right-hand portion of the facade, gives a good idea of its character. The central feature is the monumental brick audience hall covered by a barrel

vault that comes almost to a point. The facade to the left and right of the great arch is divided into a series of horizontal bands made up of *blind arcades* (arcades having no actual openings, applied as wall decoration) in syncopated rhythm. Both the pointed arch and the blind arcades will prove to be enduring features of Islamic architecture, both in the Near East and elsewhere.

The great victory of Shapur I over Valerian was commemorated in a series of rock-cut reliefs in the cliffs of Bishapur; we illustrate a detail of one of them in FIG. **2-31.** Shapur is shown larger than life riding in from the left and wearing the distinctive tall Sasanian crown, which breaks

2-30 Palace of Shapur I, Ctesiphon, *c.* A.D. 250.

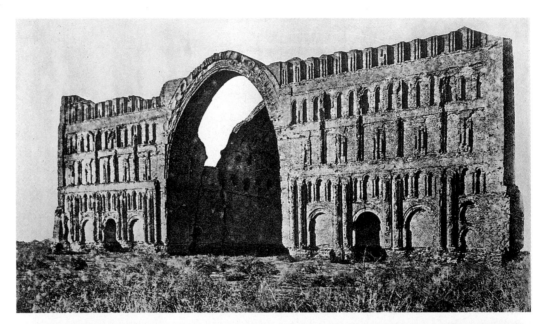

2-31 Triumph of Shapur I over Valerian, rock-cut relief, Bishapur, *c.* A.D. 260.

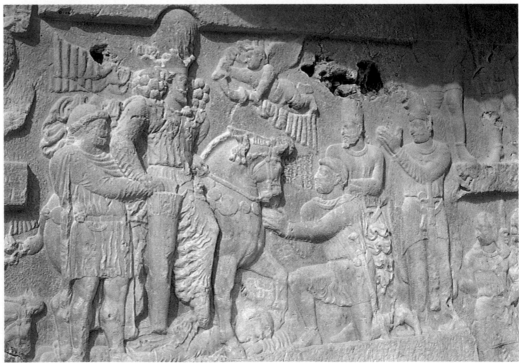

through the border of the relief and serves to draw the viewer's attention to the king. Below the legs of his steed is the crumpled body of a Roman soldier, probably meant to personify the entire Roman army. At the right, attendants of the king lead in Valerian himself, who kneels before Shapur and begs for mercy. Above, a *putto*-like (cherub or childlike) figure borrowed from the repertory of Greco-Roman art hovers above the king and brings him a fillet. Similar scenes of prostrating enemies before triumphant generals are commonplace in the art of imperial Rome—but at Bishapur the roles are reversed. This appropriation of Roman compositional patterns and motifs, in a relief celebrating the defeat of the Romans by the Sasanians, adds another, ironic, level of meaning to the political message in stone.

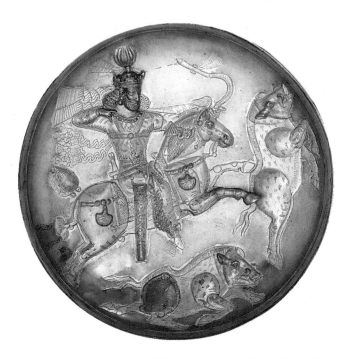

2-33 Shapur II hunting wild boar, *c.* A.D. 350. Silver plate with gilded relief, approx. 9^1/$_2$" diameter. Freer Gallery of Art, Washington, D.C. Arthur M. Sackler Gallery Archives.

A silver head, (FIG. **2-32**) thought by many to portray Shapur II (310–379), testifies to the wealth of the Sasanian dynasty in the fourth century A.D. and to the superb craftsmanship of the court artists. The head is slightly under life size and was hammered from a single sheet of silver. Details were then engraved into the metal surface to give form and texture to the coiffure and beard and to lend the eyes an almost hypnotic stare.

Equally luxurious, but surviving in far greater numbers, are the silver plates with gilded relief decoration that were fashioned for the Sasanian kings. On one especially fine example (FIG. **2-33**), Shapur II is shown on horseback hunting wild boar. A similar theme and composition, also within a circular frame, appears in a second-century A.D. relief depicting the emperor Hadrian that was re-used on the fourth-century A.D. Arch of Constantine in Rome (FIG. 7-86), once again underscoring the commonality of iconography between imperial Rome and Sasanian Persia. The theme of the hunt was a venerable one in the ancient Near East, and we have noted the important role of hunting scenes in the relief decoration of Assyrian palaces (FIGS. 2-21 and 2-22).

The successors of Shapur I and II were not their equals as generals (nor as patrons of the arts), and the Sasanians were eventually driven out of Mesopotamia by the Arabs in A.D. 636, just four years after the death of Muhammad. Thereafter the greatest artists and architects of Mesopotamia worked in the service of Islam; we shall consider their achievements in our survey of the art of the Middle Ages (Chapter 10).

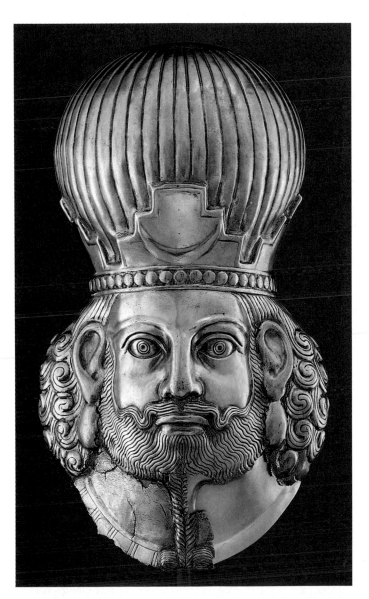

2-32 Head of a Sasanian king (Shapur II?), *c.* A.D. 350. Silver with mercury gilding, approx. 15^3/$_4$" high. Metropolitan Museum of Art, New York. Fletcher Fund.

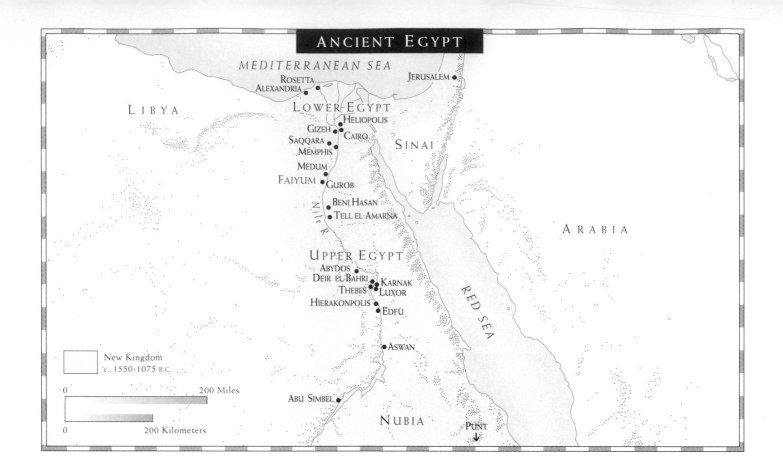

ANCIENT EGYPT

MEDITERRANEAN SEA

JERUSALEM

LIBYA

ROSETTA
ALEXANDRIA

LOWER EGYPT
HELIOPOLIS
GIZEH
SAQQARA CAIRO
MEMPHIS
MEDUM
FAIYUM GUROB
BENI HASAN
TELL EL-AMARNA

SINAI

ARABIA

UPPER EGYPT
ABYDOS
DEIR EL-BAHRI KARNAK
THEBES LUXOR
HIERAKONPOLIS
EDFU

RED SEA

ASWAN

New Kingdom
c. 1550-1075 B.C.

0 200 Miles

0 200 Kilometers

ABU SIMBEL

NUBIA PUNT

3500 B.C.		3000 B.C.	2700 B.C.		2150 B.C.
PREDYNASTIC PERIOD		EARLY DYNASTIC PERIOD (DYNASTIES I-II)	OLD KINGDOM (DYNASTIES III-VI)		FIRST INTERMEDIATE PERIOD (DYNASTIES VII-X)

*Tomb painting
Hierakonpolis*
c. 3500-3200 B.C.

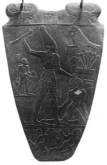

Palette of Narmer
c. 3100-3000 B.C.

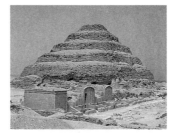

*Stepped Pyramid of Zoser
Saqqara*
c. 2675-2625 B.C.

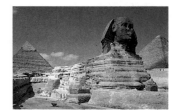

Great Sphinx, Gizeh
c. 2575- 2525 B.C.

Union of Upper and Lower Egypt
c. 3100-3000 B.C.

*Imhotep, fl. c. 2650 B.C.
first recorded name of an artist*

Civil wars

CHAPTER 3

EGYPTIAN ART

2050 B.C.	1750 B.C.	1550 B.C.	1075 B.C.	332 B.C.	30 B.C..
MIDDLE KINGDOM (DYNASTIES XI-XIII)	SECOND INTERMEDIATE PERIOD (DYNASTIES XIV-XVII)	NEW KINGDOM (DYNASTIES XVIII-XX)	LATE PERIOD (DYNASTIES XXI-XXXI)	GREEK (PTOLEMAIC) PERIOD	ROMAN PERIOD

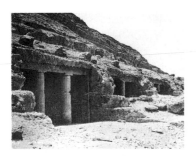

Rock-cut tombs
Beni Hasan
c. 2000-1900 B.C.

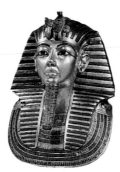

Death mask of
King Tutankhamen
c. 1325 B.C.

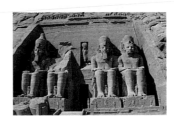

Temple of Ramses II
Abu Simbel
c. 1275-1225 B.C.

Temple of Horus
Edfu
c. 235 B.C.

Amarna period:
Akhenaton, c. 1355-1335 B.C.
Tutankhamen, c. 1335-1325 B.C.

Reunification of Egypt
under Mentuhotep II

Persia conquers Egypt, 525 B.C.

Alexander the Great conquers Persia and Egypt, 332 B.C.

Invasions of the Hyksos

Egypt becomes a Roman province, 30 B.C.

Ahmose I defeats the Hyksos, c. 1550 B.C.

Nearly twenty-five hundred years ago, the Greek historian Herodotus wrote: "Concerning Egypt itself I shall extend my remarks to a great length, because there is no country that possesses so many wonders, nor any that has such a number of works that defy description." A little later, he added: "They [the Egyptians] are religious to excess, far beyond any other race of men." People of discernment, aware of the profusion of monuments left to the world by the ancient Egyptians, have long been in agreement with these observations. Although the Egyptians built their dwellings of impermanent materials, they constructed their tombs (which they believed would preserve their bodies forever), their temples to the immortal gods, and the statues of their equally immortal god-king of imperishable stone. The stone cliffs of the Libyan and Arabian deserts, from which the building materials were hewn, and the Nile River flowing between them, could represent, respectively, the timelessness of the Egyptian world and the endless cycles of natural processes. Religion and permanence are the elements that characterize the solemn and ageless art of Egypt and express the unchanging order that, for the ancient Egyptians, was divinely ordained.

Even more than the Tigris and the Euphrates rivers, the Nile, by virtue of its presence, defined the cultures that developed along its banks. Originating deep in Africa, the world's longest river descended through many cataracts to sea level in Egypt, where, in annual flood, it deposited rich soil brought thousands of miles from the African hills. Hemmed in by the narrow valley, which reaches a width of only about 12 miles in its widest parts, the Nile flows through regions that may not have a single drop of rainfall in a decade. Yet crops grew luxuriantly from the fertilizing silt. Game also abounded then, and the great river that made life possible entered the consciousness of the Egyptians as a god and as a symbol of life.

In ancient times, the river held wider sway than it does today. Egypt was a land of marshes dotted with island ridges, and what is now arid desert valley was grassy parkland well suited for hunting and grazing cattle. Amphibious animals swarmed in the marshes and were hunted through tall forests of papyrus and rushes. The fertility of Egypt was proverbial, and at the end of its royal history, when Egypt had become a province of the Roman Empire, it was the granary of the Mediterranean world.

Before settled communities could be built along the Nile's banks, however, it was necessary to control the annual floods. The Egyptians built dams to divert floodwaters into fields instead of attempting to control the flow of the river; the communal effort put forth to construct these dams provided the basis for the growth of an Egyptian civilization, just as the irrigation projects in the Mesopotamian valley had furnished the civilizing impetus for that region a few centuries earlier.

In the Middle Ages, when the history of Egypt was thought of as part of the history of Islam, Egypt's reputation as an ancient land of wonders and mystery lived on in more-or-less fabulous report. Until the later eighteenth century, its undeciphered writing and exotic monuments were regarded as treasures of occult wisdom, locked away from any but those initiated in the mystic arts. Scholars knew something of the history of Egypt from references in the Old Testament, from the unreliable reports of ancient and modern travelers, and from preserved portions of a history of Egypt written in Greek in the third century B.C. by an Egyptian high priest named Manetho. Manetho described the succession of pharaohs, dividing them into the still-useful groups we call *dynasties,* but his chronology is inaccurate, and the absolute chronology of the pharaohs is still debated. The dates proposed by scholars for the earliest Egyptian dynasties can vary by as much as two centuries, although the reigns of the pharaohs of the second and first millennia B.C. have been established generally with a variance of ten to twenty years or less.

Scientific history—or, at least, scientific archeology—had its start at the end of the eighteenth century, when modern Europe rediscovered Egypt. Egypt became the first subject of archeological exploration, followed by the uncovering of the ancient civilizations of the Tigris and the Euphrates. In 1799, Napoleon Bonaparte, on a military expedition to Egypt, took with him a small troop of scholars, linguists, antiquarians, and artists. The chance discovery of the famed *Rosetta Stone,* now in the British Museum, gave the eager scholars a key to deciphering Egyptian hieroglyphic writing. The stone bears an inscription in three sections: one in Greek, which was easily read; one in *demotic* (Late Egyptian); and one in formal *hieroglyphic.* It was at once suspected that the text was the same in all three sections and that, using Greek as the key, the other two sections could be deciphered. More than two decades later, after many false starts, a young linguist, Jean-François Champollion, deduced that the hieroglyphs were not simply pictographs; he proposed that they were the signs of a once-spoken language, vestiges of which survived in Coptic, the later language of Christian Egypt. Champollion's feat established him as a giant in the new field of *Egyptology.* Those who followed Champollion—individuals such as Auguste Mariette and Gaston Maspero— sought to build classified collections and to protect Egyptian art from unscrupulous plundering. Archeologists like Flinders Petrie introduced new excavating techniques, laying the groundwork for the development of sounder methods for validating knowledge of Egyptian civilization.

THE PREDYNASTIC PERIOD

The Predynastic, or prehistoric, beginnings of Egyptian civilization are chronologically vague, as are those of Mesopotamia. Sometime around 3500 B.C., a people of native African stock may have been exposed to influences from Mesopotamia, or it is possible that, as in Sumer, the

sudden cultural development may have been due to an actual incursion of a new people. In any case, from the middle of the fourth millennium B.C. on, tantalizing remains attest to the existence of a sophisticated civilization on the banks of the Nile River.

A wall painting from the Late Predynastic period (FIG. **3-1**), found in a tomb at Hierakonpolis, represents what seems to be, at least in part, a funerary scene with people, animals, and boats distributed over the surface in a helter-skelter fashion. The boats, symbolic of the journey down the river of life and death, are painted white and carry a cargo of tombs and mourning women. Also depicted are a heraldic grouping of two animals flanking a human figure (at the lower center) and a man striking three prisoners with a mace (lower left). The heraldic group, a compositional type usually associated with Mesopotamian art (FIG. 2-10), suggests that influences from Mesopotamia not only had reached Egypt by this time but already had made the thousand-mile journey up the Nile. The second group, however, is characteristically Egyptian and will have a long history in Egyptian painting and sculpture alike. The stick figures and their apparently random arrangement remind us of Mesolithic art from Spain (FIG. 1-13) and North Africa,

the style of which flourished also in the central Sahara. Throughout its history, Egypt had continuous contact with Nubia to the south and Libya to the west, and the prehistoric rock art of black Africa may have been an important impetus to the development of Egyptian art.

In Predynastic times, Egypt was divided geographically and politically into Upper Egypt (the southern, upstream, part of the Nile Valley), which was dry, rocky, and culturally rustic, and Lower (northern) Egypt, which was opulent, urban, and populous. The ancient Egyptians began the history of their kingdom with the forced unification of the two lands. Until recently this was thought to have taken place during the rule of the First Dynasty pharaoh Menes, identified by many scholars with King Narmer, whose image and name appear on both sides of a ceremonial *palette*, or slate slab, found at Hierakonpolis. The *Palette of King Narmer* (FIG. **3-2**) is one of the earliest *historical* works of art preserved, and although it is no longer regarded as commemorating the foundation of the first of Egypt's thirty-one dynasties around 3000 B.C. (the last ended in 332 B.C.), it does record the unification of Upper and Lower Egypt into the "Kingdom of the Two Lands" at the very end of the Predynastic period.

3-1 People, boats, and animals, detail of a watercolor copy of a wall painting from a Predynastic tomb at Hierakonpolis, *c.* 3500–3200 B.C. Egyptian Museum, Cairo.

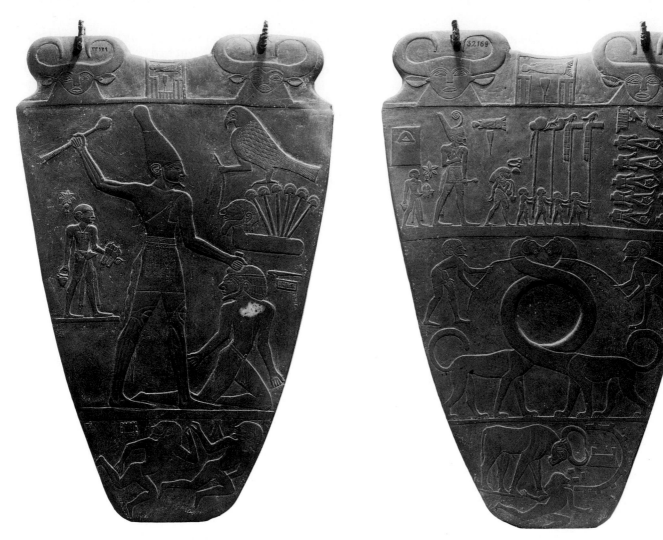

3-2 *Palette of King Narmer* (back and front), from Hierakonpolis, Late Predynastic, *c.* 3100–3000 B.C. Slate, approx. 25″ high. Egyptian Museum, Cairo.

The *Palette of King Narmer* is an elaborate, formalized version of a utilitarian object commonly used in the Predynastic period as a tablet on which eye makeup was prepared to protect the eyes against irritation and the glare of the sun. It is important, not only as a document marking the transition from the prehistoric to the historical period in ancient Egypt, but also as a kind of early blueprint of the formula of figure representation that was to rule Egyptian art for three thousand years.

On the back of the palette, the king, wearing the high, white, bowling-pin-shaped crown of Upper Egypt and accompanied by an official who carries his sandals, is about to slay an enemy as a sacrifice. The motif closely resembles that at the lower left of the Hierakonpolis mural (FIG. 3-1). A human-armed falcon, symbol of the sky god, Horus, and protector of the king, faces Narmer and takes captive a man-headed hieroglyph for land from which papyrus grows (a symbol for Lower Egypt). Below the king are two fallen enemies. Two heads of Hathor, a goddess favorably disposed to Narmer and shown in the form of a cow

with a woman's face, are depicted at the top. Between the Hathor heads is the hieroglyph giving Narmer's name within a frame representing the royal palace, making this palette the earliest labeled work of historical art extant.

The front of the palette shows Narmer wearing the red cobra crown of Lower Egypt and reviewing the beheaded bodies of the enemy. Each body is seen from above (like the dead bison on the ceiling of the Altamira Cave [FIG. 1-2]) with its severed head neatly placed between its legs. By virtue of his superior rank, the king, on both sides of the palette, performs his ritual task alone and towers over his own men and the enemy. The superhuman strength of the king is symbolized by the depiction of a great bull knocking down a rebellious city, the fortress walls of which also are seen in an "aerial view." Specific historical narrative is not of primary importance in this work. What is important is the concentration on the king as a deified figure, isolated from and larger than all ordinary men and solely responsible for his triumph. Here, at the very beginning of Egyptian history, we see evidence of the Egyptian convention of

thought, of art, and of state policy that establishes the kingship as divine and proclaims that its prestige is one with the prestige of the gods.

If what belongs to the gods and to nature is unchanging, and if the king is divine, then his attributes must be eternal. We have already seen in Mesopotamian art that natural shapes are formalized into simple poses, attitudes, and actions. The same thing happens in Egypt, even though the instinct for convention leads to a somewhat different style. In the figure of Narmer, we find the stereotype of kingly transcendence that, with several slight variations, will be repeated, with few exceptions, in subsequent representations of all Egyptian dynasts. The king is seen in a perspective that combines the profile views of head, legs, and arms with the front views of eye and torso, a composite view of the human figure that we have seen to be characteristic of Mesopotamian art and to have precedents even in Mesolithic painting. Although the proportions of the figure would change, the method of its representation became a standard for all later Egyptian art. Like a set of primordial commandments, the *Palette of King Narmer* sets forth the basic laws that would govern art along the Nile for thousands of years. In the Hierakonpolis painting (FIG. 3-1), figures are scattered across the wall more or less haphazardly; on the palette, the surface is subdivided into a number of bands, and the pictorial elements are inserted into their organized setting in a neat and orderly way. The horizontal lines that separate the registers also define the ground that supports the figures, a mode of representation that would persist in hundreds of acres of Egyptian wall paintings and reliefs and that also, as we have seen, was the preferred mode in the ancient Near East.

THE OLD KINGDOM

Narmer's palette is exceptional among surviving works of Egyptian art because it is commemorative rather than funerary in nature. Far more typical is the Predynastic mural from Hierakonpolis (FIG. 3-1), the earliest known representative of a multimillennia tradition of building and decorating the tombs of pharaohs and other important members of Egyptian society. In fact, Egyptian tombs provide the principal, if not the exclusive, evidence for the historical reconstruction of Egyptian civilization. In Herodotus's words, the Egyptians were "religious to excess," and their concern for immortality amounted to near obsession; the overall preoccupation in this life was to insure safety and happiness in the next life. The majority of monuments the Egyptians left behind them were dedicated to this preoccupation.

The sharp distinction between body and soul, long familiar to Christians and to adherents of other later religions, was not made by the Egyptians. Rather, they believed that, from birth, one was accompanied by a kind of other self, the *ka*, which, on the death of the fleshly body, could inhabit the corpse and live on. For the ka to live securely, however, the dead body had to remain as nearly intact as possible. To insure that it did, the Egyptians developed the technique of embalming to a high art; their success is evident in numerous well-preserved mummies of kings, princes, and others of noble birth, as well as those of some common persons.

Mummification was only the first requirement for immortality. Food and drink also had to be provided, as did clothing, utensils, and all the apparatus of living, so that nothing would be lacking that had been enjoyed on earth. Images of the deceased, sculpted in the round and placed in shallow recesses, guaranteed the permanence of one's identity by providing substitute dwelling places for the ka in case the mummy disintegrated. Wall paintings (for the use and delectation of the ka) recorded, with great animation and detail, the recurring round of human activities—a cycle of "works and days" that changed with the calendar and the seasons. The Egyptians hoped and expected that the images and inventory of life, collected and set up within the protective stone walls of the tomb, would insure immortality, but almost from the beginning of the elaborate interments, the thorough plundering of tombs became a profitable occupation. Only one royal burial place escaped nearly intact. At the time of its discovery in 1922, the tomb of the Eighteenth Dynasty (New Kingdom) ruler Tutankhamen revealed to a fascinated world for the first time the full splendor of a pharaoh's funerary assemblage.

Architecture

The standard tomb type during the Old Kingdom was the mastaba (FIG. **3-3**). The *mastaba* (Arabic for "bench") was a rectangular brick or stone structure with sloping sides erected over a subterranean tomb chamber that was connected with the outside by a shaft, which provided the ka with access to the tomb. The form probably was developed from mounds of earth or stone that had covered earlier tombs. Although mastabas originally housed single burials, during the latter part of the Old Kingdom they were used for multiple family burials and became increasingly complex. The central, underground chamber was surrounded by storage rooms and compartments, whose number and size increased with time, until the area covered far surpassed that of the tomb chamber proper. Built into the superstructure, or sometimes attached to the outside of its eastern face, was the funerary chapel, which contained a statue of the deceased in a small, concealed chamber called the *serdab*. The interior walls of the chapel and the ancillary rooms were decorated with colored relief carvings and paintings of scenes from daily life intended magically to provide the deceased with food and entertainment.

About 2650 B.C., the Stepped Pyramid (FIG. **3-4**) of King Zoser (or Djoser) of the Third Dynasty was raised at Saqqara, the ancient *necropolis* (Greek for "city of the dead") of Memphis, the capital city founded by Menes. It is one of

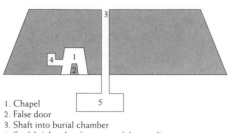

1. Chapel
2. False door
3. Shaft into burial chamber
4. Serdab (chamber for statue of deseased)
5. Burial chamber

3-3 Section (*left*), plan (*middle*), and restored view (*right*) of typical mastaba tombs.

the oldest stone structures in Egypt and the first monumental royal tomb. Begun as a large mastaba with each of its faces oriented toward one of the cardinal points of the compass, the structure was enlarged twice before taking on its final shape, which appears to be a sort of compromise between a mastaba and the later "true" pyramids at Gizeh. About 200 feet high, the stepped pyramid seems to be composed of a series of mastabas of diminishing size, piled one on top of another to form a structure that resembles the great ziggurats of Mesopotamia. Unlike the ziggurats, however, Zoser's pyramid is a tomb, not a temple platform, and its dual function was to protect the mummified king and his possessions and to symbolize, by its gigantic presence, his absolute and godlike power.

Befitting the majesty of the god-king, Zoser's pyramid stands near the center of a rectangular enclosure that measures about 1,800 feet by 900 feet and is surrounded by a monumental, 35-foot-high, niched wall of white limestone (FIG. **3-5**). The immense precinct with its protective walls and tightly regulated access stands in sharp contrast to the roughly contemporary Sumerian royal cemetery at Ur, in which there were no walls to keep people away from the burials. There were also no temples in the Ur cemetery for the celebration of the dead, but against the northern face of the pyramid at Saqqara stands the funerary temple where daily rituals for Zoser were performed. At Saqqara there are also numerous buildings in the temple complex arranged around several courts. With the exception of the funerary temple and a royal pavilion, all are dummy structures with stone walls enclosing fills of rubble, sand, or gravel. The buildings imitate in stone masonry various types of temporary structures made of plant stems and mats that were

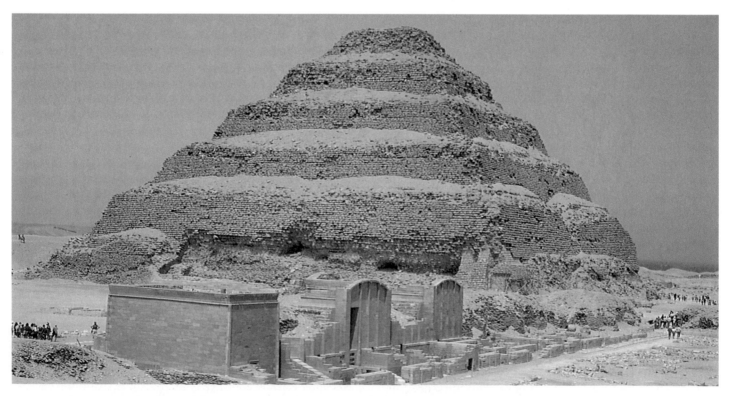

3-4 IMHOTEP, Stepped Pyramid and mortuary precinct of King Zoser, Saqqara, Dynasty III, *c.* 2675–2625 B.C.

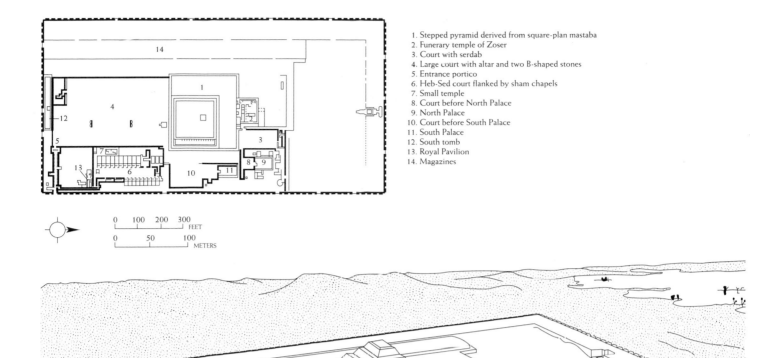

1. Stepped pyramid derived from square-plan mastaba
2. Funerary temple of Zoser
3. Court with serdab
4. Large court with altar and two B-shaped stones
5. Entrance portico
6. Heb-Sed court flanked by sham chapels
7. Small temple
8. Court before North Palace
9. North Palace
10. Court before South Palace
11. South Palace
12. South tomb
13. Royal Pavilion
14. Magazines

3-5 Restored plan (*top*) and view (*bottom*) of the mortuary precinct of Zoser, Saqqara.

erected in Upper and Lower Egypt for the celebration of the Jubilee Festival, the rituals of which perpetually renewed the affirmation of the royal existence in the hereafter.

The translation into stone of structural forms previously made out of plants may be seen in the long entrance corridor to Zoser's funerary precinct (FIG. **3-6**) where columns that resemble bundles of reeds project from short spur walls on either side of the once-roofed and dark passageway. A person walking through would have emerged suddenly into a large courtyard and the brilliant light of the Egyptian sun. There, to the right upon exiting the portico, one would have seen the gleaming focus of the entire complex, Zoser's pyramid.

The columns flanking the pathway into Zoser's precinct resemble later Greek columns, and there is little doubt today that the architecture of ancient Egypt had a profound impact on the designers of the first stone columnar temples of the Greeks (see Chapter 5). The upper parts of the columns of the Saqqara entrance portico are not preserved, but those of Zoser's North Palace (FIG. **3-7**) still stand. They end in capitals that take the form of the papyrus blossoms of Lower Egypt; the column shafts resemble papyrus stalks.

Greek columns will also terminate in capitals, although the Greek capitals will take a very different form. The shafts of Greek columns are also generally freestanding, but all the columns in the Saqqara complex are *engaged* (attached) to walls; the builders seem not to have realized the full structural potential of stone columns. Still, this is the first appearance of the stone column in the history of architecture and thus epochal for its subsequent development in later periods.

The architect of Zoser's mortuary complex is the first known artist of recorded history: IMHOTEP, the king's grandvizier and a man of legendary powers. Priest, scribe, physician, and architect, Imhotep later was revered as a god. As an architect, his greatest achievement was to translate the impermanent building types of both Upper and Lower Egypt into stone and combine them with two funerary traditions in a single compound, thereby consolidating and giving visual permanence to the idea of a unified Egyptian kingdom.

At Gizeh, near modern Cairo but on the west side of the Nile (the dead were always buried on the side where the sun sets), stand the three pyramids (FIG. **3-8**) of the Fourth

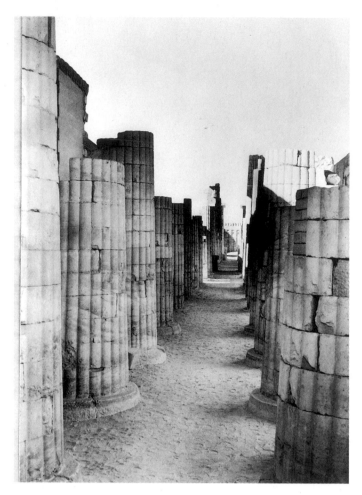

3-6 Columnar entrance corridor to the mortuary precinct of Zoser.

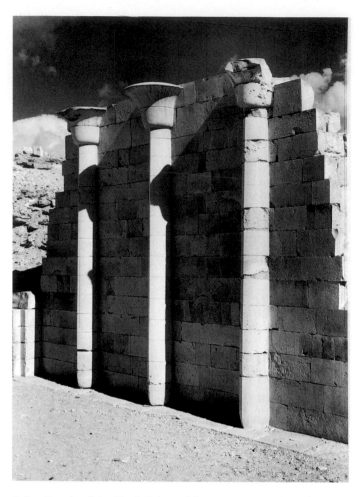

3-7 Facade of the North Palace of the mortuary precinct of Zoser.

Dynasty pharaohs Khufu (Cheops in Greek), Khafre (Chephren), and Menkaure (Mycerinus). Built over a period of about seventy-five years, the pyramids of Gizeh represent the culmination of an architectural evolution that began with the mastaba. The pyramid form did not evolve out of necessity; kings could have gone on indefinitely piling mastabas, one on top of another, to make their weighty tombs. Rather, it has been suggested that the kings of the Third Dynasty came under the influence of Heliopolis, not far from their royal residence at Memphis. This city was the seat of the powerful cult of Re, the sun god, whose fetish was a pyramidal stone, the *ben-ben*. By the Fourth Dynasty, the pharaohs considered themselves the sons of Re and his incarnation on earth. For the pharaohs, it would have been only a small step from their belief that the spirit and power of Re resided in the pyramidal ben-ben to the belief that their divine spirits and bodies would be similarly preserved within pyramidal tombs.

Is the pyramid form, then, an invention inspired by a religious demand, rather than the result of a formal evolution? We need not resolve this question here. Our concern is with the remarkable features of the Fourth Dynasty pyra-

mids. Of the three great pyramids at Gizeh, that of Khufu (FIG. **3-9**) is the oldest and largest. Except for the galleries and burial chamber, it is an almost solid mass of limestone masonry—a stone mountain built on the same principle as the Stepped Pyramid of King Zoser (FIG. 3-4), the interior spaces in plan and elevation being relatively tiny, as if crushed out of the scheme by the sheer weight of the stone.

The limestone was quarried in the eastern Nile cliffs and floated across the river during the seasonal floods. After the masons finished cutting the stones, they marked them with red ink to indicate the position of each stone in the structure. Then great gangs of laborers dragged them up temporary ramps and laid them course on course. Finally, the pyramid was surfaced with a casing of pearly white limestone, cut so precisely that the eye could scarcely detect the joints. A few casing stones can still be seen in the cap that covers the Pyramid of Khafre, all that remain after many centuries during which the pyramids were stripped to supply limestone for the Islamic builders of Cairo.

The immensity of the Pyramid of Khufu is indicated by some dimensions in round numbers: at the base, the length of one side is 775 feet and its area is some 13 acres; its pre-

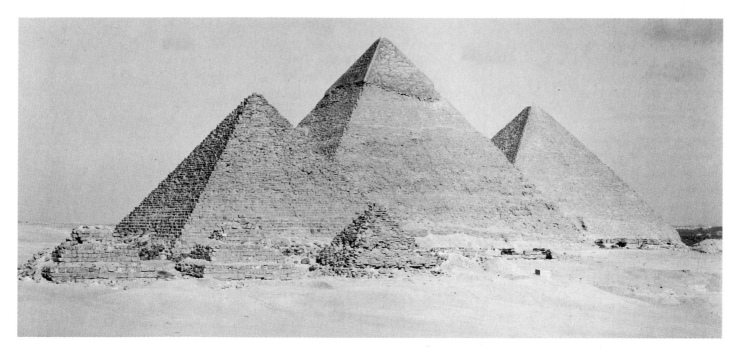

3-8 Great Pyramids (Dynasty IV) of Gizeh. *From left:* Menkaure, *c.* 2525–2475 B.C.; Khafre, *c.* 2575–2525 B.C.; Khufu, *c.* 2600–2550 B.C.

sent height is 450 feet (originally 480 feet). According to Flinders Petrie, the structure contains about 2.3 million blocks of stone, each weighing an average of $2\frac{1}{2}$ tons. Napoleon's scholars calculated that the blocks in the three pyramids were sufficient to build a wall 1 foot wide and 10 feet high around France. The art of this structure is inherent not only in its huge size and successful engineering but also in its formal design. The proportions and immense dignity are consistent with its funerary and religious functions and well adapted to its geographical setting. As was the case with Zoser's Stepped Pyramid, the four sides of each of the Gizeh pyramids are oriented to the cardinal points of the compass, and the simple mass of these monuments dominates the flat landscape to the horizon.

The ironic outcome of this stupendous effort may be read from the cross-section (shown in FIG. 3-9). The dotted lines at the base of the structure (at 2) indicate the path cut into the pyramid by ancient grave robbers. Unable to locate the carefully sealed and hidden entrance, they started some 40 feet above the base and tunneled into the structure until they intercepted the ascending corridor. Many royal tombs were plundered almost as soon as the funeral ceremonies had ended; the very conspicuousness of the pyramid was an invitation to despoilment. The successors of the Old Kingdom pyramid builders had learned this hard lesson; they built few pyramids, and those were relatively small and inconspicuous.

From the remains surrounding the Pyramid of Khafre at Gizeh, we can reconstruct an entire pyramid complex (FIG. **3-10**) consisting of the pyramid itself, within or below which was the burial chamber; the chapel, adjoining

the pyramid on the east side, where offerings were made, ceremonies were performed, and cloth, food, and ceremonial vessels were stored; the covered causeway leading down to the valley; and the valley temple, or vestibule, of the causeway.

Beside the causeway and dominating the temple of Khafre rises the Great Sphinx (FIG. **3-11**), carved from a spur of rock to commemorate the pharaoh and to serve as an immovable, eternal silent guardian of his tomb, much as the later lions and lamassu of Mesopotamia (FIGS. 2-16 and

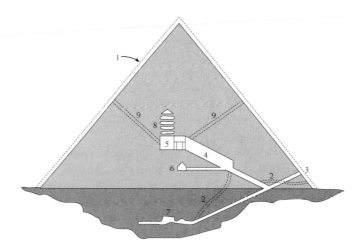

1. Silhouette with original facing stone
2. Thieves' tunnels
3. Entrance
4. Grand gallery
5. King's chamber
6. So-called queen's chamber
7. False tomb chamber
8. Relieving blocks
9. Airshafts?

3-9 Section of the Pyramid of Khufu, Gizeh.

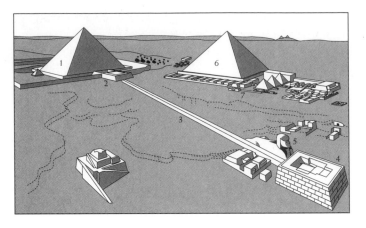

1. Pyramid of Khafre
2. Mortuary temple
3. Covered causeway
4. Valley temple
5. Great Sphinx
6. Pyramid of Khufu
7. Pyramids of the royal family and mastabas of nobles

3-10 Reconstruction of the pyramids of Khufu and Khafre, Gizeh.

2-19) stood watch at the entrances to the palaces of their kings. At Gizeh, the rock was cut so that the immense figure of the sphinx, adjacent to the valley temple's west front, gives visitors coming from the east the illusion that it rests on a great pedestal. The lion figure with human head, probably a portrait of Khafre, again shows the conjunction of a powerful beast with the attributes of absolute kingship, as we have seen in the falcon and the bull of the *Palette of King Narmer* (FIG. 3-2). For centuries, the huge head of the Great Sphinx stood up above the drifting tides of desert sand that covered the body, providing generations of ancient and modern travelers with an awe-inspiring and unforgettable image of mysterious power.

The valley temple of the Pyramid of Khafre (FIG. **3-12**) was built using the simple *post-and-lintel* system of Stonehenge (FIG. 1-21) and other ancient monuments, in which horizontal beams, or lintels, rest on upright supports, or posts. At Gizeh, both posts and lintels were huge, rectangular, red-granite monoliths, finely proportioned, skill-

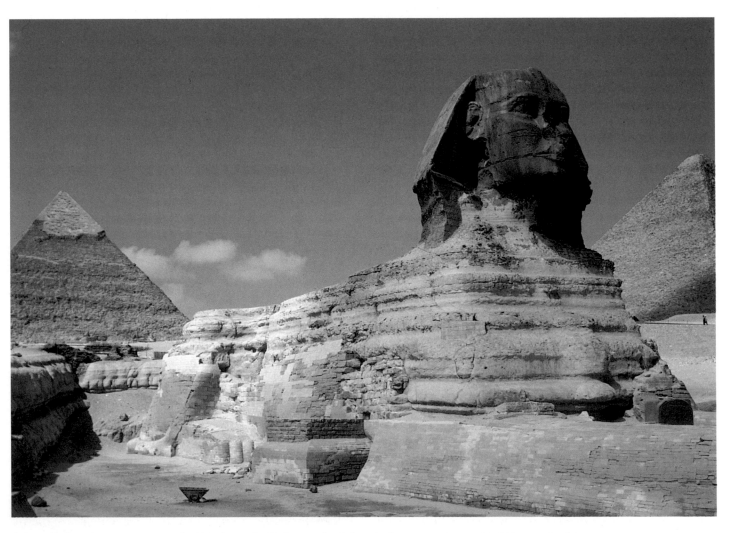

3-11 Great Sphinx (with Pyramid of Khafre in the background at left), Gizeh, Dynasty IV, *c.* 2575–2525 B.C. Sandstone, approx. 65' high, 240' long.

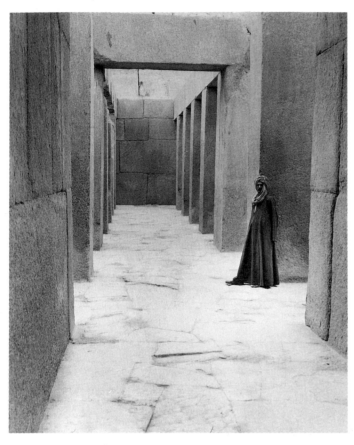

3-12 Middle aisle of the hall of pillars, valley temple of the Pyramid of Khafre, Gizeh, Dynasty IV, *c.* 2575–2525 B.C.

fully cut and polished, and devoid of decoration. Alabaster slabs covered the floor; seated statues, the only embellishment of the temple, were ranged along the wall. The interior was lighted by a few slanting rays filtering in from above. Although the Egyptians knew of the arch and the vault and had used them occasionally in Predynastic tombs, they rarely used them after the beginning of the Dynastic period. Egyptian architects preferred the static forms of the post-and-lintel system, which, if cast into the heavy, massive shapes of the Khafre temple, express, perhaps better than any other architectural style, the changeless and the eternal.

Statuary

In Egyptian tombs, we have already noted that sculpture in the round served the important function of creating an image of the deceased that could serve as an abode for the ka, should the mummy be destroyed. For this reason, an interest in portraiture developed early in Egypt. Thus, too, permanence of style and material was essential. Although wood, clay, and other materials were used, mostly for images of those not of the royal or noble classes, stone was the primary material. Limestone and sandstone were

brought from the Nile cliffs, granite from the cataracts of the upper Nile, and diorite from the desert.

The seated statue of Khafre (illustrated in two views in FIG. **3-13**) is one of a series of similar statues carved for Khafre's valley temple near the Great Sphinx. These statues, the only organic forms in the geometric severity of the temple structure, with its flat-planed posts and lintels, helps to create a striking atmosphere of solemn majesty. An intertwined lotus and papyrus, symbol of the united Egypt, is carved between the legs of Khafre's throne (seen in the side view). Sheltering Khafre's head are the protecting wings of the falcon of Horus, indicating the pharaoh's divine status. Khafre wears the simple kilt of the Old Kingdom and a linen headdress that covers his forehead and falls in pleated folds over his shoulders. (The head of Khafre's sphinx is similarly attired.) As befitting a divinity, Khafre is shown with a well-developed, flawless body and a perfect face. A *canon* of ideal proportions, designated as appropriate for the representation of imposing majesty, was accepted by Egyptian artists and applied quite independently of optical fact. This generalized anatomy persisted in Egyptian statuary even into the Ptolemaic period following Alexander the Great's conquest of Egypt, regardless of the actual age and physique of the pharaoh portrayed.

The seated representation of the king is permeated with an imperturbable calm, reflecting the enduring power of the pharaoh and of kingship in general. This effect, common to royal statues of the ka, is achieved in part by the great compactness and solidity of the figure, which has few projecting, breakable parts; the form manifests the purpose: to last for eternity. The body is attached to a back slab, the arms are held close to the torso and thighs, the legs are close together and attached to the throne by stone webs. The pose is frontal, rigid, and bilaterally symmetrical; all movement is suppressed—and with it the notion of time.

This repeatable scheme arranges the parts of the body so that they are presented in a totally frontal projection or entirely in profile. The sculptor produced the statue by first drawing the front, back, and two profile views of the pharaoh on the four vertical faces of the stone block; by chiseling away the excess stone on each side, working inward until the planes met at right angles; then rounding the corners. This *subtractive* method of creating the pharaoh's portrait accounts in large part for the blocklike look of the standard Egyptian statue. The solid appearance of the final image was enhanced by using the hardest stone, which also insured the permanence of the image (and Egypt, unlike Mesopotamia, was rich in stone). Even so, the difficulty of working granite and diorite with bronze tools made production too expensive for all but the wealthiest. Much of the finishing had to be done by abrasion.

The seated statue is one of only a very small number of basic formulaic types employed by the sculptors of the Old Kingdom for representations of the human figure. Another is the image of a person or deity standing, either alone or

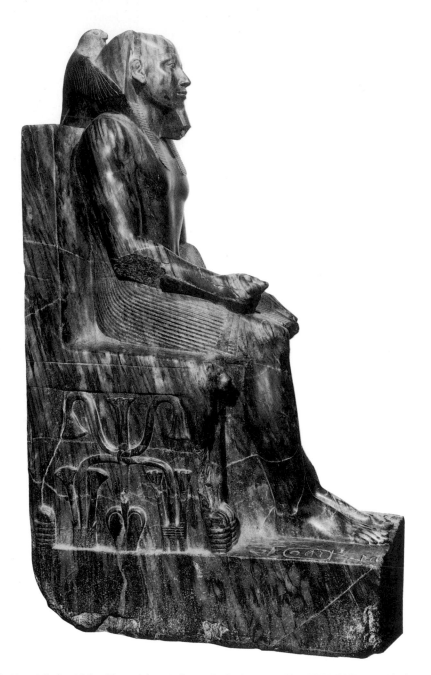
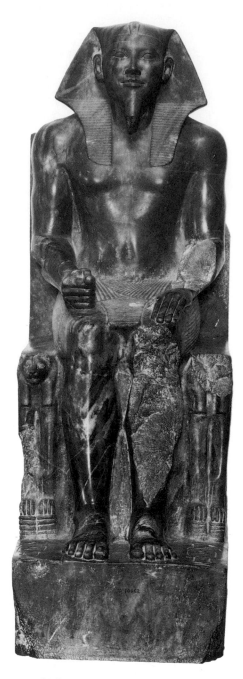

3-13 Khafre (right side and front), from Gizeh, Dynasty IV, *c.* 2575–2525 B.C. Diorite, approx. 5′ 6″ high. Egyptian Museum, Cairo.

in groups. Superb examples of the standing type are the joined portrait statues (FIG. **3-14**) of Menkaure (whose pyramid tomb rises next to Khafre's at Gizeh) and his queen, Khamerernebty. Here, too, the statues remain wedded to the block of stone from which they were carved, and conventional postures are used to suggest the timeless nature of these eternal substitute homes for the ka. Menkaure's pose is *canonical:* rigidly frontal with the arms hanging straight down and close to his well-built body, and the hands clenched into fists with the thumbs forward; the

left leg is slightly advanced, but there is no shift in the angle of the hips to correspond to the uneven distribution of weight. Khamerernebty stands in a similar position; her right arm, however, circles around her husband's waist and her left hand gently rests on his left arm. This is a frozen, stereotypical gesture that connotes their marital status; there is no other sign of affection or emotion, and husband and wife look not at each other but out into space.

The timeless quality of the portraits of Khafre, Menkaure, and Khamerernebty is enhanced by the absence

of any color but that of the dark natural stone selected for the statues. Many other Egyptian portrait statues, however, were painted, including the striking image (FIG. **3-15**) of a Fifth Dynasty seated scribe of unknown identity. Despite the stiff upright posture and the frontality of head and body, the color lends a lifelike quality to the statue that one might argue is detrimental to the portrait's success, inasmuch as the color detracts from the statue's role as a timeless image of the deceased. The head displays an extraordinary sensitivity. The personality, that of a sharply intelligent and alert individual, is read by the sculptor with a penetration and sympathy seldom achieved at such an early date. The scribe sits directly on the ground, not on a throne nor even on a chair, and is a much lower figure in

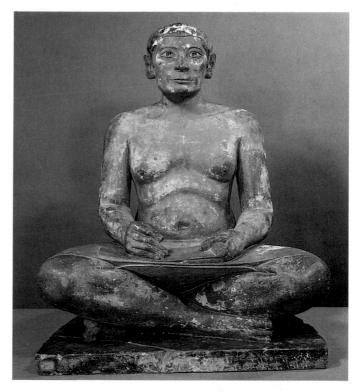

3-15 Seated scribe, from a mastaba tomb at Saqqara, Dynasty V, *c.* 2500–2400 B.C. Painted limestone, approx. 21" high. Louvre, Paris.

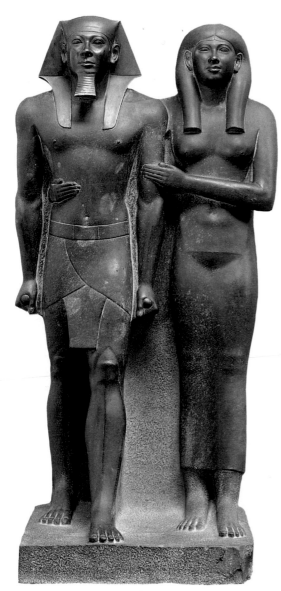

3-14 Menkaure and Khamerernebty, from Gizeh, Dynasty IV, *c.* 2525–2475 B.C. Slate, approx. 4' 6¹/₂" high. Courtesy, Museum of Fine Arts, Boston.

the hierarchy of Egyptian society than is the pharaoh, whose divinity makes him superhuman. In the history of art, especially portraiture, it is almost a rule that formality is relaxed and realism is increased when the subject is a person of lesser importance. It is telling that the scribe is shown with sagging chest muscles and a protruding belly; such signs of age would have been disrespectful and wholly inappropriate in a portrait of an Egyptian god-king.

A second case in point illustrating this rule of relaxed formality and increased realism is the Fifth Dynasty wooden statue (FIG. **3-16**) of Ka-Aper (nicknamed the Sheikh el Beled or "headman of the village"), which, like the statue of the seated scribe, comes from the deceased's simple brick mastaba tomb at Saqqara. As in the portrait of the scribe, the face is startlingly alive, an effect that is heightened in this work by eyes of rock crystal. The figure stands erect in the conventional frontal pose used for pharaonic portraits, with the left leg advanced. Ka-Aper's paunchy physique is in even greater contrast than the scribe's to the idealized proportions used to portray Khafre and Menkaure; he was, after all, only a minor official. The statue retains something of the shape of the tree trunk from which it was fashioned, and because there is no back slab, the figure seems to stand more freely than the stone images of Menkaure and Khamerernebty; the artist, however, had no more interest in portraying motion than had the sculptor of those royal images in stone. Actually, what we see here is a wood core

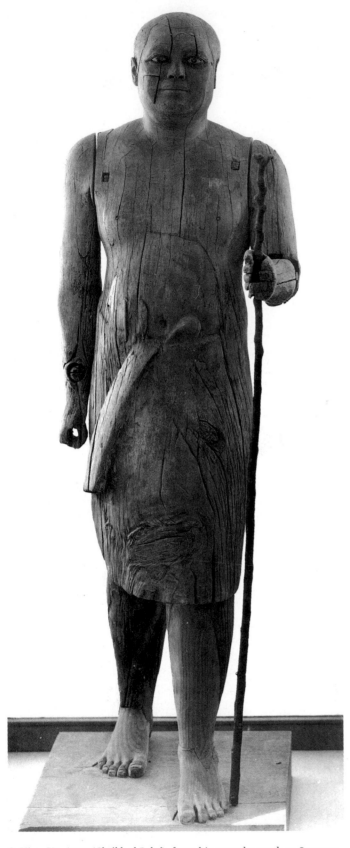

3-16 Ka-Aper (*Sheikh el Beled*), from his mastaba tomb at Saqqara, Dynasty V, *c.* 2500–2400 B.C. Wood, approx. 43″ high. Egyptian Museum, Cairo.

that originally was covered with painted plaster, a common procedure when soft or unattractive woods were used.

Relief Sculpture and Painting

In Egyptian tombs, the deceased were not represented exclusively in freestanding statuary, but many individuals were also portrayed in relief sculpture and in mural painting, sometimes alone, sometimes in a narrative context. One of the finest early relief portraits we have is of Hesire, a high official in the Third Dynasty court of Zoser. He is shown on a carved wooden panel (FIG. **3-17**) from his tomb in the necropolis at Saqqara, not far from the great precinct of his pharaoh. The basic conventions of Egyptian figure representation that were set up in the *Palette of King Narmer* (FIG. 3-2) are here refined and systematized. The figure's swelling forms have been modeled with greater subtlety, and its proportions have been modified, but the broad-shouldered, narrow-hipped ideal remains. As on the earlier palette, the artist uses the *conceptual* approach, rather than the *optical,* representing what is known to be true of the subject, instead of some random view of it, and showing its most characteristic parts at right angles to the line of vision. This conceptual approach expresses a feeling for the constant and changeless aspect of things and is well suited for Egyptian funerary art. It also lends itself to systematic methods of figure construction, and we know that Egyptian artists applied a strict canon of proportions to the human figure. A grid was first drawn on the wall or panel and the various parts of the human body placed at specific points on the network of squares. The height of a figure, for example, would be a fixed number of squares, and the head, shoulders, waist, knees, and other body parts would also have a predetermined size and place within the scheme. The use of such a canon reflects the same principles of permanence and regularity that we have observed in the design of Egyptian tombs and funerary statues.

The scenes in painted limestone relief (FIGS. **3-18** and **3-19**) that decorate the walls of another tomb at Saqqara, the mastaba of Ti, an official of the Fifth Dynasty, typify the subjects favored by Old Kingdom patrons for the adornment of the chambers of their final resting places. Most often the scenes are of agriculture and hunting, activities representing the fundamental human concern with nature and associated with the provisioning of the ka in the hereafter. On one wall (FIG. 3-18), Ti, his men, and his boats move slowly through the marshes, hunting hippopotami and birds in a dense growth of towering papyrus. The slender, reedy stems of the plants are delineated with repeated fine grooves that fan out gracefully at the top into a commotion of frightened birds and stalking beasts. The water beneath the boats, signified by a pattern of wavy lines, is crowded with hippopotami and other aquatic fauna. Ti's men seem frantically busy with their spears, while Ti himself, portrayed twice their size, stands impassive and aloof

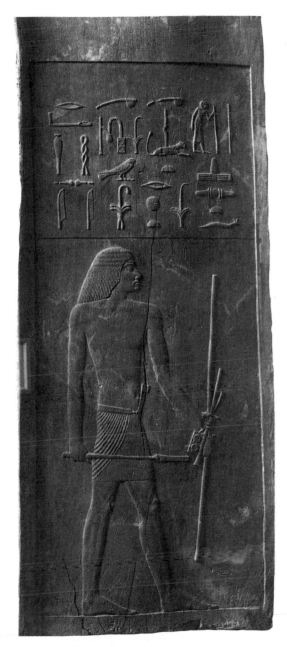

3-17 Hesire, panel from his mastaba tomb at Saqqara, Dynasty III, *c.* 2675–2625 B.C. Wood, approx. 45" high. Egyptian Museum, Cairo.

ipate in the narrative, which, despite the repeated use of similar poses for most of the human and animal figures, is full of anecdotal details. Especially charming is the group at the lower right of our illustration. A youth, portrayed in a complex posture, carries a calf on his back. The animal, not a little afraid, turns its head back a full 180 degrees (compare the Paleolithic bison in FIG. 1-12) to seek reassurance from its mother, who returns the calf's gaze. Scenes such as this demonstrate that the Egyptian artist could be a close observer of daily life and that the absence of the anecdotal (that is to say, of the time-bound) from portrayals of the deceased both in relief and in the round was a deliberate choice intended both to distinguish more important from less important figures and to suggest their eternal existence in the afterlife.

A rare and fine example of Old Kingdom painting is the frieze of geese (FIG. **3-20**) from the Tomb of Atet at Medum, a detail of a multiregister composition that also includes men and cattle, as in Ti's tomb. The *fresco secco* (dry-fresco)

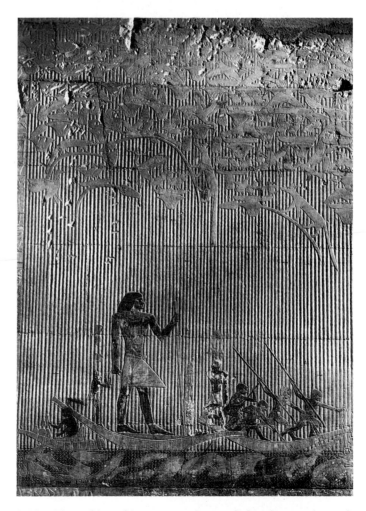

3-18 Ti watching a hippopotamus hunt, relief in the mastaba tomb of Ti, Saqqara, Dynasty V, *c.* 2500–2400 B.C. Painted limestone, approx. 48" high.

in the formal stance employed earlier for Narmer and Hesire. The outsize and ideal proportions bespeak Ti's rank, as does the conventional pose, which contrasts with the realistically rendered activity of his diminutive servants and with the precisely observed figures of the birds and animals among the papyrus buds. The immobility of the pose suggests that Ti is not an actor in the hunt. He does not *do* anything; he simply *is*, a figure apart from time, an impassive observer of life, like his ka.

On another wall of Ti's mastaba, goats treading in seed grain and cattle fording a canal are depicted in two registers (FIG. 3-19). Ti is absent and all the men and animals partic-

technique used, in which the artist lets the plaster dry before painting on it, lends itself to slow and meticulous work, encouraging the trained professional to take pains in rendering the image and in expressing an exact knowledge of the subject. The delicate, prehensile necks of the geese, the beaks, the supple bodies, and the animals' characteristic step and carriage are rendered with an exactitude and discernment that would elicit the admiration of an

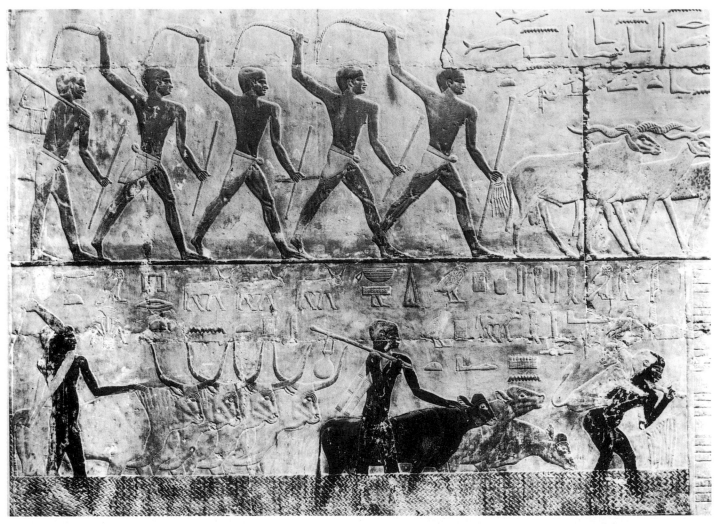

3-19 Goats treading seed and cattle fording a canal, painted limestone reliefs in the tomb of Ti, Saqqara.

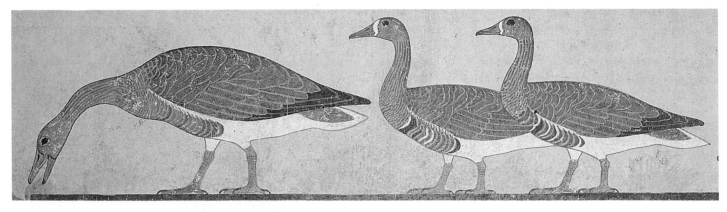

3-20 Geese, detail of a fresco in the mastaba tomb of Atet at Medum, Dynasty IV, *c.* 2600–2550 B.C. Tempera on plaster, approx. 18" × 68". Egyptian Museum, Cairo.

Audubon. The firm, strong execution of the figures is the work of an expert with a superbly trained eye and hand. It is probable, too, that religious motives mingled here with esthetic ones, for, after all, once a tomb was sealed, no mortal eyes were ever expected to see the paintings again. It must have been thought that, in the darkness and silence, the pictures worked their own spell, creating a force that would serve the ka eternally; some of the magical intent of the Stone Age cave paintings seems to persist here.

The art of the Old Kingdom is the classic art of Egypt in that its conventions, definitively established, remained the basis of subsequent styles of Egyptian art through three millennia.

THE MIDDLE KINGDOM

About 2150 B.C., the power of the pharaohs was challenged by ambitious feudal lords; for over a century, the land was in a state of civil unrest and near anarchy. Eventually, a Theban ruler, Mentuhotep II, managed to unite Egypt again under the rule of a single king. In the Eleventh, Twelfth, and Thirteenth Dynasties (the Middle Kingdom), art was revived and a rich and varied literature appeared.

Architecture

During the Middle Kingdom, the Egyptians continued to build pyramids but on a much smaller scale than in the Old Kingdom. Since it had become apparent that size was no

defense against tomb robbers, builders now attempted to thwart thieves with intricate and ingenious interior layouts. Entrances were not placed in the center of the north side, as was traditional, but were hidden and screened from the secret tomb chamber by various types of sliding doors and by a series of passages that turned and doubled back on themselves at various levels in labyrinthine fashion. Less massive than their Old Kingdom predecessors, Middle Kingdom pyramids were built either entirely of brick or as stone frameworks filled with brick or rubble. What the pyramids lost in size and mass during the Middle Kingdom, however, was partly recompensed by the increased size of the *sarcophagi* (literally "flesh-eaters") housing the mummified remains of the dead. These granite coffins became extremely large and heavy. Designed like small tomb chambers and weighing up to 150 tons, they were intended to foil potential robbers by their very bulk and mass.

Among the most characteristic remains of the Middle Kingdom are the rock-cut tombs at Beni Hasan (FIG. **3-21**), south of Memphis. One of the best preserved is the Twelfth Dynasty tomb of Khnumhotep, who boasted in an inscription of its elaborateness, saying that its doors were of cedar, 7 cubits (about 20 feet) high. Expressing the characteristic Egyptian attitude toward the last resting place, he added:

> My chief nobility was: I executed a cliff-tomb, for a man should imitate that which his father does. My father made for himself a house of the ka in the town of Menofret, of good stone of Ayan, in order to perpetuate his name forever and establish it eternally.

3-21 Rock-cut tombs, Beni Hasan, *c.* 2000–1900 B.C.

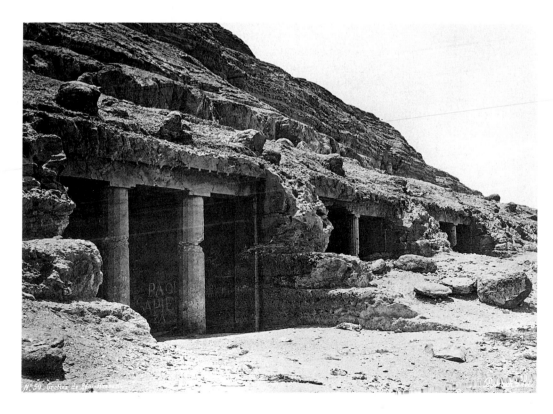

The rock-cut tombs of the Middle Kingdom largely replaced the Old Kingdom mastabas. Hollowed out of the living rock at remote sites, these tombs, fronted by a shallow, columned *portico*, or vestibule, contained the fundamental units of Egyptian architecture: a portico, a columned hall, and a sacred chamber (FIG. **3-22**). In the hall of the Twelfth Dynasty rock-cut tomb of Amenemhet (FIG. **3-23**), the *reserve* columns serve no supporting function, being, like the portico columns, continuous parts of the rock fabric. (Note the broken column in the rear, suspended from the ceiling like a stalactite.) The column shafts are *fluted* with vertical channels in a manner similar to that of later Greek columns. Fluted Egyptian columns are known as early as Imhotep and are believed to be derived from the dressing of softwood trunks with the rounded cutting edge of the adze. Once again we witness the translation of perishable natural forms into permanent stone architecture. Tomb walls were decorated with paintings and painted reliefs, as in former times, and the subjects were much the same.

Sculpture

A somewhat deepened perception of personality and mood can be noted in portrait sculpture of the Middle Kingdom,

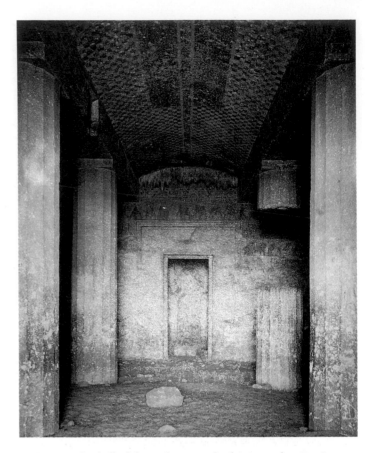

3-23 Interior hall of the rock-cut tomb of Amenemhet, Beni Hasan, Dynasty XII, *c.* 1950–1900 B.C. Photo courtesy Metropolitan Museum of Art, New York.

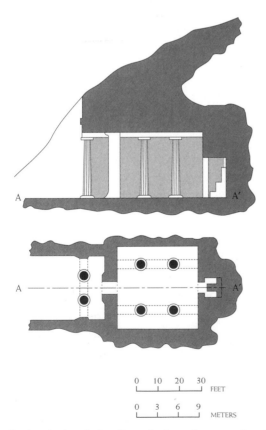

3-22 Section (*top*) and plan (*bottom*) of a rock-cut tomb at Beni Hasan, *c.* 2000–1900 B.C.

as shown in a fragmentary head of Sesostris III (FIG. **3-24**), one of the pharaohs of Egypt's Twelfth Dynasty. The head has a pessimistic expression that, interestingly, reflects the dominant mood of the literature of the Middle Kingdom. The strong mouth, the drooping lines about the nose and eyes, and the shadowy brows show a determined ruler, who had also shared in the cares of the world, sunk in brooding meditation. The portrait is different in kind from the typically impassive faces of the Old Kingdom; it is personal, almost intimate, in its revelation of the mark of anxiety that a troubled age might leave on the soul of a king.

THE NEW KINGDOM

This anxiety may have reflected premonitions of disaster. Like its predecessor, the Middle Kingdom disintegrated, and power passed to a line of migrant Semitic Asiatics from the Syrian and Mesopotamian uplands. The Hyksos, or shepherd kings, brought with them a new and influential culture and that practical animal, the horse. The invasion and domination of the Hyksos, traditionally thought to have

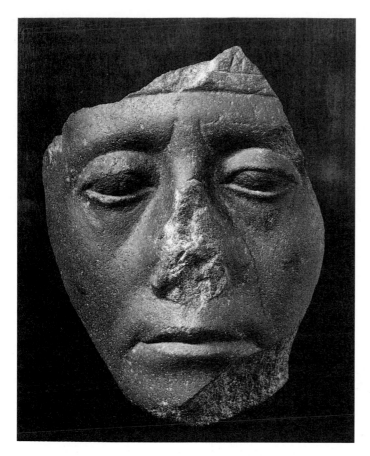

3-24 Fragmentary portrait head of Sesostris III, Dynasty XII, *c.* 1875–1825 B.C. Quartzite, approx. 6¹/₂″ high. Metropolitan Museum of Art, New York, Camarvon Collection, GIFT OF EDWARD S. HARKNESS, 1926.

heen disastrous, were later reassessed and judged seminal influences that kept Egypt in the mainstream of Bronze Age culture in the eastern Mediterranean. In any event, the innovations introduced by the Hyksos, especially in weaponry and the techniques of war, contributed to their own overthrow by native Egyptian kings of the Seventeenth Dynasty. Ahmose I, final conqueror of the Hyksos and first king of the Eighteenth Dynasty, ushered in the New Kingdom (the Empire)—the most brilliant period in Egypt's long history.

At this time, Egypt extended its borders by conquest from the Euphrates River in the east deep into Nubia (the Sudan) to the south. Wider foreign contact was afforded by visiting embassies and by new and profitable trade with Asia and the Aegean islands. The booty taken in wars and the tribute exacted from subjected peoples made possible the development of a new capital, Thebes, which became a great and luxurious metropolis with magnificent palaces, tombs, and temples along both banks of the Nile. Thutmose III, who died in the fifty-first year of his reign in the second half of the fifteenth century B.C., was the greatest pharaoh

of the New Kingdom, if not of all Egyptian history, and his successors continued the grand traditions he established. The optimistic mood of the new era is recorded in an inscription above the heads of revelers in a painting now in the British Museum:

> The Earth-god has implanted his beauty in every body.
> The Creator has done this with his two hands as balm to his heart.
> The channels are filled with waters anew
> And the land is flooded with his love.

Architecture

If the most impressive monuments of the Old Kingdom are its pyramids, those of the New Kingdom are its grandiose temples. Burial still demanded the elaborate care shown earlier, and, partly in keeping with the tradition of the Middle Kingdom, nobles and kings hollowed their burial chambers deep in the cliffs west of the Nile. In the Valley of the Kings, the rock-cut tombs are approached by long corridors that extend as far as 500 feet into the hillside. The entrances to these burial chambers were concealed carefully, and the mortuary temples were built along the banks of the Nile at some distance from the tombs. The temple, which provided the king with a place for worshiping his patron god and then served as a mortuary temple after his death, became elaborate and sumptuous, befitting both the king and the god.

The most majestic of these royal mortuary temples, at Deir el-Bahri (FIG. **3-25**), was that of Queen Hatshepsut, the stepmother of the conquering pharaoh Thutmose III. When Thutmose II, her brother, died and there were no legitimate male heirs old enough to rule, Hatshepsut came to power as regent for the twelve-year-old Thutmose III, son of Thutmose II by a minor wife (he and other Egyptian pharaohs had extensive harems). Hatshepsut is the first female monarch whose name is recorded, and she boasted of having made the "Two Lands to labor with bowed back for her." For two decades she ruled what was then the most powerful and prosperous empire in the world, and ample evidence indicates that she did not view herself as a mere stand-in until a man could be named king of Egypt. Several years after becoming regent for Thutmose III, Hatshepsut announced that were it not for the fact that she was a woman she would rightfully be king in her own right, and she proclaimed herself pharaoh. Many of Hatshepsut's portraits were destroyed after her death, probably at the order of the resentful Thutmose III, whose elevation to kingship was delayed well over a decade by his stepmother's decision to become pharaoh. It is interesting to note that in her surviving portraits the queen is uniformly dressed in the costume of the male pharaohs, with royal headdress and kilt, and in some cases even a false ceremonial beard, although

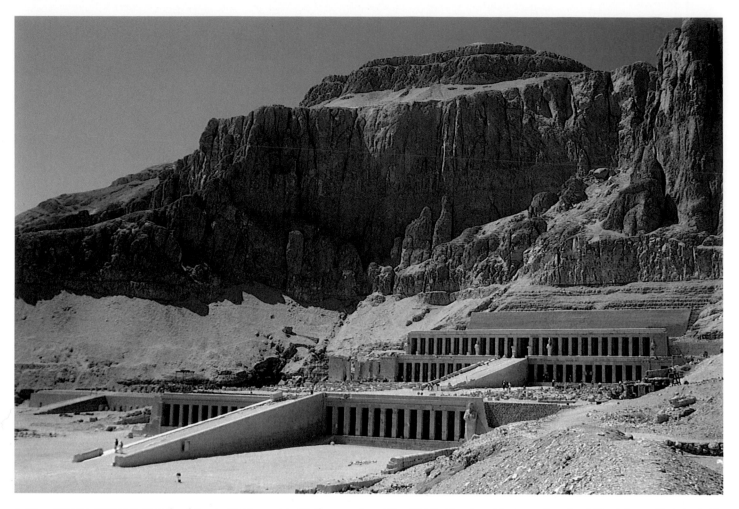

3-25 SENMUT, Mortuary Temple of Queen Hatshepsut (with the remains of the Middle Kingdom Mortuary Temple of Mentuhotep II at the left), Deir el-Bahri, Dynasty XVIII, *c.* 1490–1460 B.C.

there are examples where her delicate features, slender frame, and breasts leave no doubt that a woman is represented. Many inscriptions refer to Hatshepsut as "*His* Majesty!"

Built along the lines of the neighboring Middle Kingdom temple of Mentuhotep II by the queen's chancellor, architect-engineer, and possible lover, SENMUT, Hatshepsut's mortuary temple rises from the valley floor in three colonnaded terraces connected by ramps. It is remarkable how visually well suited the structure is to its natural setting. The long horizontals and verticals of the colonnades and their rhythm of light and dark repeat, in man-made symmetry, the pattern of the rocky cliffs above. The pillars of the colonnades, which are either simply rectangular or *chamfered* (beveled, or flattened at the edges) into sixteen sides, are esthetically proportioned and spaced. Statues in the round, perhaps as many as two hundred before they were removed or shattered by Thutmose III, were intimately associated with the temple architecture. The brightly painted low reliefs that covered the walls were also carefully integrated into the structure's design. The reliefs,

many of which are preserved despite later vandalism, represented Hatshepsut's divine birth (she was said to be the daughter of the god Amen), coronation, and great deeds, and constitute the first great pictorial tribute to the achievements of a woman in the history of art. In Hatshepsut's day, the terraces were not the barren places they are now but gardens with frankincense trees and rare plants brought by the queen from an expedition to the faraway "land of Punt" on the Red Sea, an event that figures prominently in the temple's relief decorations.

Hatshepsut's mortuary temple never fails to impress visitors by its sheer size, and this is no less true of the immense rock-cut temple of Ramses II, Egypt's last great warrior-pharaoh, who lived a little before the Exodus from Egypt under Moses. Built far up the Nile at Abu Simbel, the whole monument was moved in 1968 to save it from submersion in the Aswan High Dam reservoir. Ramses, proud of his many campaigns to restore the empire, augmented his greatness by placing four colossal images of himself in the temple facade (FIG. **3-26**). In later times, the glories of kings and emperors in periods of conquest and imperial grandeur

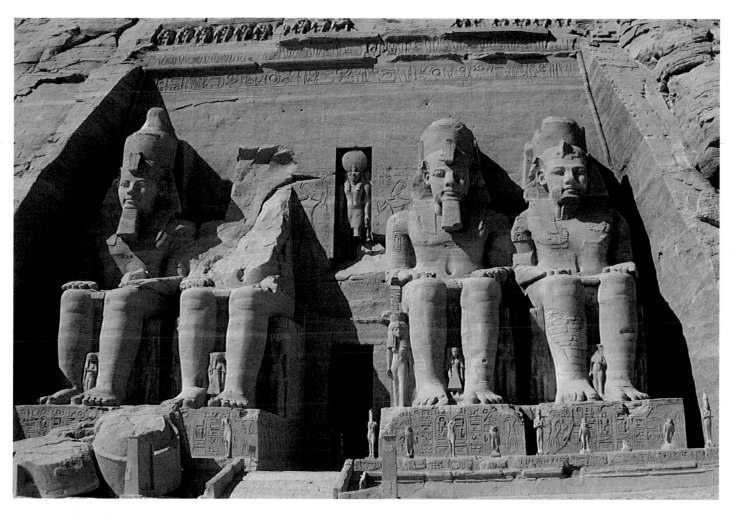

3-26 Temple of Ramses II, Abu Simbel (now relocated), Dynasty XIX, *c.* 1275–1225 B.C. Colossi approx. 65′ high.

were also celebrated in huge monuments; gigantism seems characteristic of much of the art of empires that have reached their peaks. At Abu Simbel, Ramses's artists used the principle of augmentation both by size and by repetition. The massive statues lack the refinement of earlier periods, because much is sacrificed to overwhelming size.

The grand scale is carried out in the interior also (FIG. **3-27**), where giant figures of the king, carved as one with the pillars, face each other across the narrow corridor; their exaggerated mass appears to appropriate the architectural space. The pillars, hewn from the living rock like the pharaoh's facade portraits, have no load-bearing function; in this respect, they resemble the columns in the tombs at Beni Hasan (FIG. 3-23). The statue-column, in its male (*atlantid*) or female (*caryatid*) variants, will reappear throughout the history of art, often, as here, with the human figure attached to a column or pier, at other times with the figure replacing the architectural member and forming the sole source of support.

Distinct from the mortuary temples built during the New Kingdom were the edifices built to honor one or more of the gods and often added to by successive kings until they reached gigantic size. These temples all had similar plans. A typical *pylon temple* plan (the name derives from the simple and massive gateway, or pylon, with sloping walls), like that of the temple of Amen-Re at Karnak (FIG. **3-28**), is bilaterally symmetrical along a single axis that runs from an approaching avenue through a colonnaded court and hall into a dimly lighted sanctuary. The Egyptian temple plan evolved from ritualistic requirements. Only the pharaoh and the priest could enter the sanctuary; a chosen few were admitted to the great columnar hall; the majority of the people were allowed only as far as the open court, and a high mud-brick wall shut off the site from the outside world. The conservative Egyptians did not deviate from this basic plan for hundreds of years. The *corridor axis*, which dominates the plan, makes the temple not so much a building as, in Oswald Spengler's phrase, "a path enclosed by mighty masonry." Like the Nile, the corridor may have symbolized the Egyptian concept of life. Spengler suggests that the Egyptians saw themselves moving down a narrow, predestined life path that ended before the judges of the

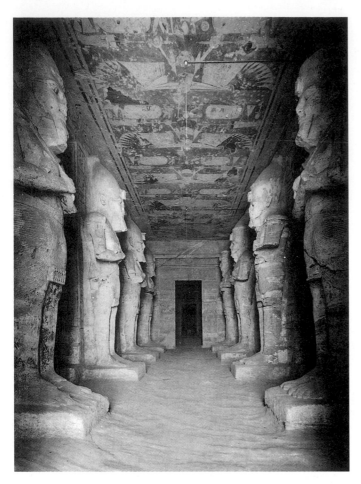

3-27 Interior of the Temple of Ramses II, Abu Simbel. Pillar statues approx. 32' high.

dead. Axial corridors also characterize the approaches to the great pyramids of Gizeh (FIG. 3-10) and to the burial chamber of Hatshepsut's mortuary temple at Deir el-Bahri (FIG. 3-25). The whole of Egyptian culture can be regarded as illustrating this theme.

The dominating feature of the statuary-lined approach to the New Kingdom temple is the monumental facade of the pylon. Inside is an open court with columns on two or more sides, followed by a hall between court and sanctuary, its long axis placed at right angles to that of the entire building complex. This *hypostyle* hall (one having a roof supported by columns) is crowded with massive columns and roofed by stone slabs carried on lintels that rest on *impost blocks* (stones with the shape of truncated, inverted pyramids) supported by the great capitals. In the hypostyle hall at Karnak (FIGS. **3-29** and **3-30**), the central columns are 66 feet high, and the capitals are 22 feet in diameter at the top, large enough to hold one hundred people. The Egyptians, who used no cement, depended on the weight of the huge stones to hold the columns in place. In the Amen-Re temple at Karnak and in many other Egyptian hypostyle halls, the central rows of columns were higher than those at the sides, raising the roof of the central section and creating a *clerestory*. Openings in the clerestory permitted light to filter into the interior. This method of construction appears in primitive form as early as the Old Kingdom in the valley temple of the Pyramid of Khafre. Evidently an Egyptian innovation, its significance can hardly be overstated; before the invention of the light bulb, illuminating the interior of a building was always a challenge for the architect. The clerestory played a key role, for example, in the design of

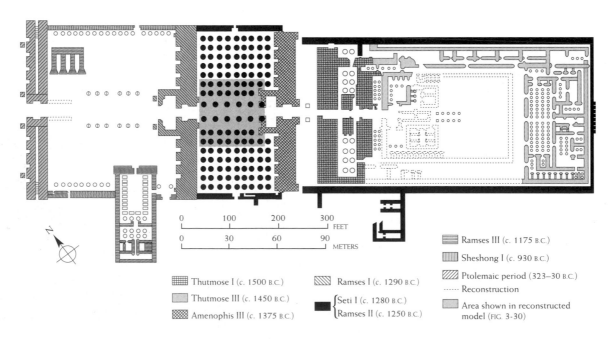

0 100 200 300
⊢━━━━━━━━━━━━━━━━━⊣ FEET

0 30 60 90
⊢━━━━━━━━━━━━━━━━━⊣ METERS

▦ Thutmose I (c. 1500 B.C.)	▧ Ramses I (c. 1290 B.C.)
▢ Thutmose III (c. 1450 B.C.)	{ Seti I (c. 1280 B.C.)
▨ Amenophis III (c. 1375 B.C.)	{ Ramses II (c. 1250 B.C.)

▤ Ramses III (c. 1175 B.C.)
▥ Sheshong I (c. 930 B.C.)
▨ Ptolemaic period (323–30 B.C.)
⋯ Reconstruction
▨ Area shown in reconstructed model (FIG. 3-30)

3-28 Plan of the Temple of Amen-Re, Karnak. (After Sir Bannister Fletcher.) Dates in parentheses indicate time of construction. The shaded area in the hypostyle hall corresponds to the model in FIG. 3-30.

sharply with most Egyptian practice as well as with later Greek architecture, in which the architects emphasized the vertical lines of the column and its structural function by freeing the surfaces of the shaft from all ornament.

The usual Egyptian columnar style is exhibited especially well in the courts and colonnades of the Temple of Amen-Mut-Khonsu at Luxor (FIG. **3-31**). The post-and-lintel structure of Egyptian temples appears to have had its origin in an early building technique that used firmly bound sheaves of reeds and swamp plants as roof supports in adobe structures. We have seen how Imhotep, over a millennium earlier, first translated such early and relatively impermanent building methods into stone at Saqqara (FIGS. 3-6 and 3-7). Evidence of their swamp-plant origin is still seen in these columns at Karnak and Luxor, which are carved to resemble lotus or papyrus, with bud-cluster or bell-shaped capitals. Painted decorations, traces of which still can be seen on the surfaces of the shafts and capitals, emphasized these natural details. In fact, the flora of the Nile Valley supplied the basic decorative motifs in all Egyptian art. The formalization of plant forms into the rigid profiles of architecture closely parallels the formalization of human bodies and action that the Egyptians achieved so skillfully in tomb painting and sculpture.

Egyptian traditions once formulated tended to have very long lives. A thousand years after Karnak and Luxor, the pylon temple of Horus at Edfu (FIG. **3-32**), built after the close of Egyptian dynastic history during the Ptolemaic period, still followed the basic scheme worked out by architects of the second millennium B.C. The great entrance pylon at Edfu is especially impressive. The broad surface of its massive facade, with its sloping walls, is broken only by the doorway with its overshadowing cornice, moldings at the top and sides, deep channels to hold great flagstaffs, and by sunken reliefs. It is a striking monument to the persistence of Egyptian architectural thought.

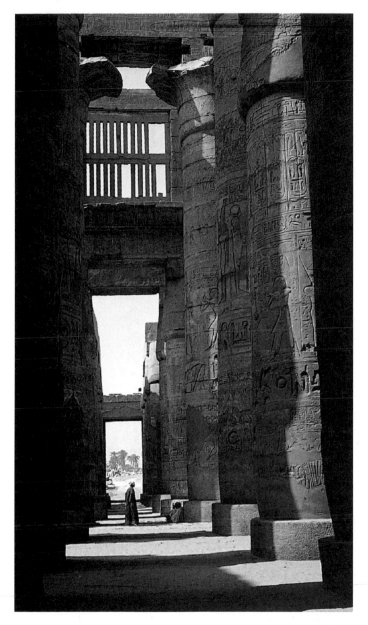

3-29 Hypostyle hall, Temple of Amen-Re, Karnak, Dynasty XIX, c. 1275–1225 B.C.

Roman basilicas and medieval churches and has remained an important architectural feature down to our own times.

In the hypostyle hall at Karnak, the columns all have smooth shafts, but there are two different types of capitals: bud shaped and bell shaped, or *campaniform*. Although the columns are structural members, unlike the reserve columns of the Middle Kingdom tombs at Beni Hasan (FIG. 3-23) and the figure-columns at Abu Simbel (FIG. 3-27), their function as carriers of vertical stress is almost hidden by horizontal bands of relief sculpture and painting, suggesting that the intention of the architects was not to emphasize the functional role of the columns so much as to utilize them as surfaces for decoration. This contrasts

3-30 Model of hypostyle hall, Karnak. Metropolitan Museum of Art, New York. Levi Hale Willard Bequest, 1890.

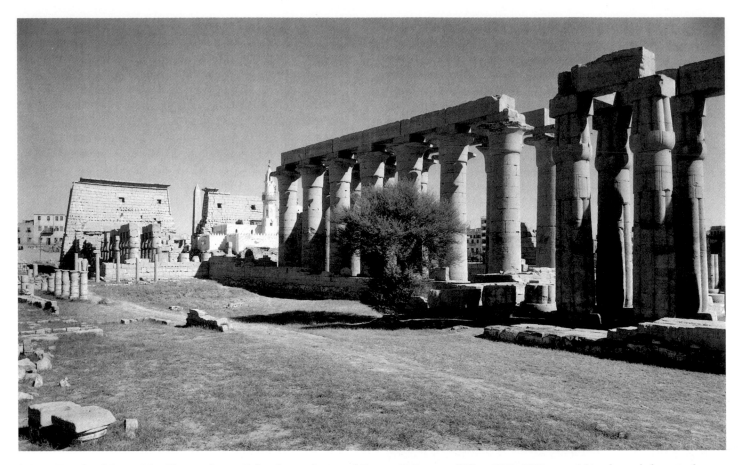

3-31 Temple of Amen-Mut-Khonsu, Luxor. *Left*: pylon and court of Ramses II, Dynasty XIX, *c.* 1275–1225 B.C.; *right*: colonnaded court of Amenhotep III, Dynasty XVIII, *c.* 1390–1350 B.C.

3-32 Pylon Temple of Horus, Edfu, begun *c.* 235 B.C.

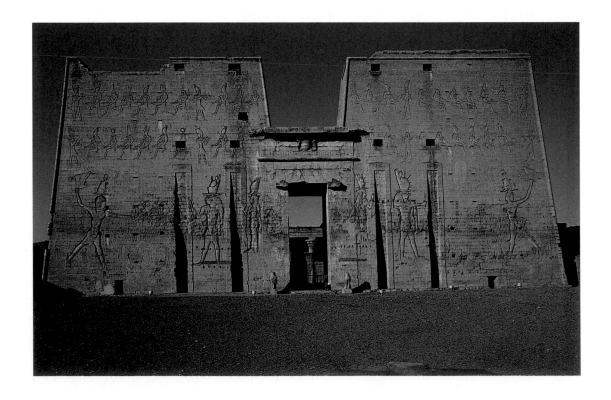

Sculpture and Painting

If architectural practices were long-lived in Egypt, sculptural habits were even more tenacious. The patterns set by the masters of the Old Kingdom continued to dominate the production of statuary in the Nile Valley even under the emperors of Rome. Extremely popular during the Middle and New Kingdoms were "block statue" portraits, in which the idea that the ka can find an eternal home in the cubic stone image of the deceased is expressed in an even more radical simplification of form than was true of Old Kingdom statuary. A fine example of this genre is the block statue of Hatshepsut's favorite, Senmut, holding the queen's daughter, Princess Nefrua, in his "lap" and enveloping the girl in his cloak (FIG. **3-33**). The streamlined design concentrates

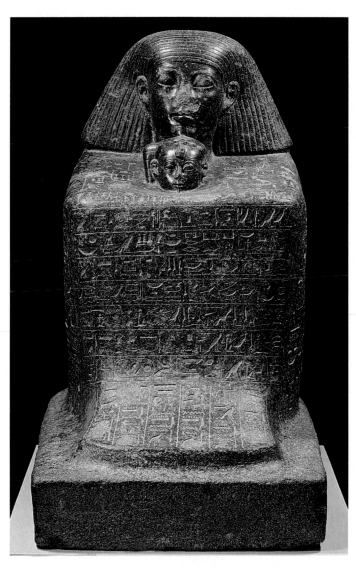

3-33 Senmut with Princess Nefrua, from Thebes, Dynasty XVIII, *c.* 1490–1460 B.C. Granite, approx. 36¹/₂" high. Ägyptisches Museum, Berlin.

attention on the portrait heads and treats the two bodies as a single cubic block, given over to inscriptions. The polished stone shape has its own simple beauty. With surfaces turning subtly about smoothly rounded corners, it is another expression of the Egyptian fondness for volume enclosed by flat, unambiguous planes that characterizes Egyptian statuary from the Old Kingdom forward. The work—one of many surviving statues depicting the queen's chancellor with her daughter—is also a reflection of the power of Egypt's first female ruler. The depiction over and over again of Senmut with Nefrua was meant to enhance his own stature through his association with the queen's daughter (he was her tutor), and by implication, with Hatshepsut herself. Toward the end of her reign, however, Hatshepsut came to believe that Senmut had become too powerful, and she had him removed.

The persistence of the formulas for projection of an image onto a flat surface can be seen in one of the wall paintings from a Theban tomb (FIG. **3-34**) dating from the Eighteenth Dynasty, probably the tomb of Nebamun. The deceased nobleman, whose official titles were "scribe and counter of grain," is standing in his boat, flushing the birds from a papyrus swamp. The hieroglyphic text beneath his left arm tells us that Nebamun is enjoying recreation in his eternal afterlife. In contrast to the static pose of Ti watching others hunt hippopotami (FIG. 3-18), Nebamun is shown striding forward and vigorously swinging his throwstick. In his right hand, he holds three birds he has caught; a wild cat, on a papyrus stem just in front of him, has caught two more in her claws and is holding the wings of a third in her teeth. Nebamun is accompanied on this hunt by his wife and daughter, who are holding the lotuses they have gathered. Their figures are scaled down in proportion to their rank. Save for the participation of the deceased and his family in the hunt, formally and conceptually this New Kingdom fowling scene differs little from the hippopotamus hunt in the Old Kingdom tomb of Ti. The water and the human figures are represented by the usual conventions, while cat, fish, and birds, like the Saqqara animals, show a naturalism based on visual perception similar to what we have already seen in the Old Kingdom painted frieze of geese from Medum (FIG. 3-20).

Another fresco fragment from Nebamun's tomb shows, however, that artists did not always adhere to the old standards for figural representation. Our detail (FIG. **3-35**) includes four noblewomen watching and apparently participating in a musicale and dance in which two nimble and almost nude dancing girls perform at a banquet, either in honor of the dead or provided by Nebamun for his friends in the afterlife. The overlapping of the dancers' figures, facing in opposite directions, and the rather complicated gyrations of the dance are carefully and accurately observed and executed, but the result is also a very pleasing intertwined motif. The profile view of the dancers is consistent with

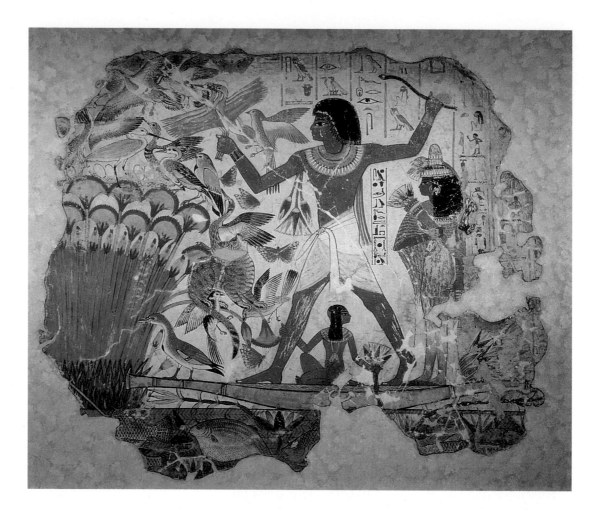

3-34 Fowling scene, wall painting from the tomb of Nebamun (?), Thebes, Dynasty XVIII, *c.* 1400–1350 B.C. Painting on dry plaster, approx. 32" high. British Museum, London.

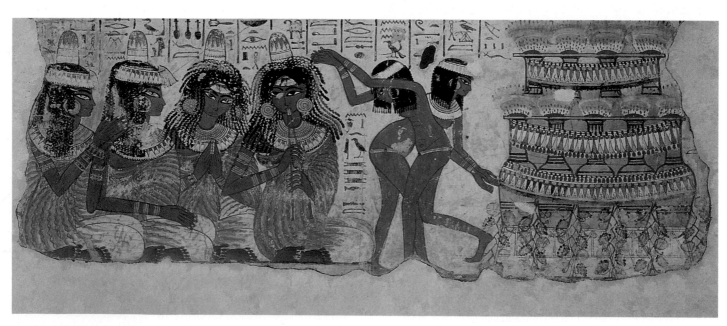

3-35 Musicians and dancers, detail of a wall painting from the tomb of Nebamun (?), Thebes. Fragment approx. 12" × 27". British Museum, London.

their lesser importance in the Egyptian hierarchy; the composite view is still reserved for Nebamun and his family. Of the four seated ladies, the two at the left are represented conventionally, but the other two face the observer in what is a most unusual and very rarely attempted frontal pose. They clap and beat time to the dance; one of them plays the reeds. The artist takes careful note of the soles of their feet as they sit cross-legged and suggests the movement of the women's heads by the loose arrangement of the strands of their hair. This informality constitutes a relaxation not only of the stiff rules of representation but also of the set themes once thought appropriate for tomb painting. In addition, we may have here the reflection of a more luxurious mode of life in the New Kingdom; at this point, the ka may have required not only necessities and comforts in the hereafter but formal entertainment as well.

Akhenaton and the Amarna Period

These small variations on age-old formulas heralded a short but violent upheaval in Egyptian art, the only major break in the continuity of its long tradition. In the fourteenth century B.C., the pharaoh Amenophis IV (Amenhotep IV), later known as Akhenaton (or Ikhnaton), proclaimed the religion of Aton, the universal and only god of the sun. He thus contested and abolished the native cult of Amen, sacred to Thebes and professed by the mighty priests of such temples as Karnak and Luxor, as well as by the people of Egypt. He blotted out the name of Amen from all inscriptions and even from his own name and that of his father, Amenophis III. He emptied the great temples, embittered the priests and people, and moved his capital downriver from Thebes to a site now called Tell el-Amarna, where he built his own city and shrines to the religion of Aton.

These actions by Amenophis IV—now called Akhenaton—although they might savor of the psychotic or of the fanaticism of sudden conversion, were portended by events in the formation and expansion of the power of the great Eighteenth Dynasty. Egyptian might had formed the first world empire. The conquering imperialist pharaohs—ruling over an empire that included Syria in the north and Nubia in the south—had gradually enlarged the powers of their old sun god, Amen, to make him not simply god of the Egyptians, but god of all men. Even before Egypt had become the main force in the Mediterranean world, Thutmose I, a founder of the fortunes of the dynasty, could say of the sun god that his kingdom extended as far as "the circuit of the sun." The military pharaoh, Thutmose III, said of this aggrandized god: "He seeth the whole earth hourly." Thus, Akhenaton was exploiting already-gathering forces when he raised the imperialized god of the sun to be the only god of all the earth and proscribed any rival as blasphemous. He appropriated to himself the new and universal god, making himself both the son and prophet, even the sole experient, of Aton. To him alone could the god make revelation. Akhenaton's hymn to Aton survives:

> Thou art in my heart.
> There is no other that knoweth thee
> Save thy son Ikhnaton.
> Thou hast made him wise
> In thy designs and might.
> The world is in thy hand,
> Even as thou hast made them . . .
> Thou didst establish the world,
> And raise them up for thy son,
> Who came forth from thy limbs,
> The king of Upper and Lower Egypt,
> Living in Truth, Lord of Two Lands.

One effect of the new religious philosophy seems to have been a temporary relaxation of the Egyptian preoccupation with death and the hereafter and a correspondingly greater concern with life on earth. In art, this change is reflected in a different attitude toward the representation of the human figure. Artists aimed for a new sense of life and movement, expressed in swelling, curvilinear forms; their long-fostered naturalistic tendencies, thus far confined largely to the representation of animals, were extended not only to the lowly human figure but, significantly, to royalty as well.

A colossal statue of Akhenaton from Karnak (FIG. **3-36**) retains the standard frontal pose, but the epicene body, with its curving contours, and the long, full-lipped face, heavy-lidded eyes, and dreaming expression, show that the artist has studied the subject with care and rendered him with all the physiognomical and physical irregularities that were part of the king's actual appearance, perhaps even to the point of caricature, something unthinkable under previous pharaohs. The predilection for curved lines stresses the softness of the slack, big-hipped body, a far cry indeed from the heroically proportioned figures of Akhenaton's predecessors. In a daring mixture of naturalism and stylization, the artist has given us an informal and uncompromising portrayal of the king, charged with both vitality and a psychological complexity that has been called expressionistic.

The famous painted limestone bust of Akhenaton's queen, Nefertiti (FIG. **3-37**), exhibits a similar expression of entranced musing and an almost mannered sensitivity and delicacy of curving contour. The piece was found in the workshop of the queen's official sculptor, THUTMOSE, and is a deliberately unfinished model very likely by the master's own hand. The left eye socket still lacks the inlaid eyeball, making the portrait a kind of before-and-after demonstration piece. In this supremely elegant bust Thutmose may have been alluding to a heavy flower on its slender stalk by exaggerating the weight of the crowned head and the length of the almost serpentine neck. One thinks of those modern descendants of Queen Nefertiti—models in fashion

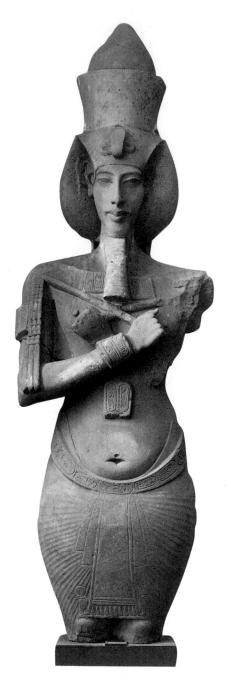

3-36 Akhenaton, pillar statue from the Temple of Amen-Re, Karnak, Dynasty XVIII, *c.* 1355–1335 B.C. Sandstone, approx. 13' high. Egyptian Museum, Cairo.

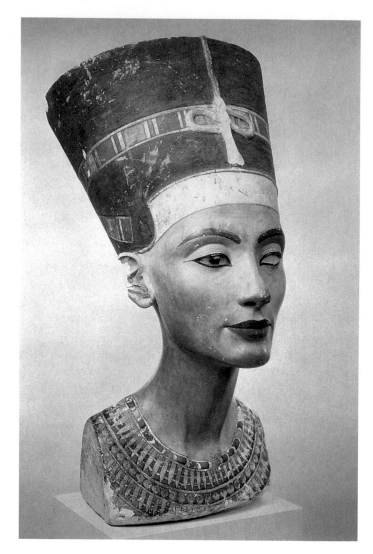

3-37 THUTMOSE, Queen Nefertiti, from Tell el-Amarna, Dynasty XVIII, *c.* 1355–1335 B.C. Painted limestone, approx. 20" high. Ägyptisches Museum, Berlin.

magazines, with their gaunt, swaying frames, masklike, pallid faces, and enormous, shadowed eyes. As modern mannerism shapes the living model to its dictates, so the sculptors of Tell el-Amarna may have held some standard of spiritual beauty to which they adjusted the actual likenesses of their subjects. Even so, one is made very much aware of the reality of the queen through her contrived mask of beauty, a masterpiece of cosmetic art. The Nefertiti bust is

one more example of that elegant blending of the real and the formal that we have noticed so often in the art of the ancient Near East.

A contemporary and very moving portrait of old age is preserved for us in the likeness of Queen Tiye (FIG. **3-38**), mother of Akhenaton. Tiye was the chief wife of Amenhotep III and a commoner by birth; the pharaoh seems to have married her for love rather than for political reasons. In the portrait illustrated here, fashioned during her son's reign and seemingly found in a royal residence at Gurob, the beautiful black queen (the Egyptians were a people of mixed race and frequently married other Africans) is shown as an older woman with lines and furrows, consistent with the new realism of the Amarna age. The under life-size head is carved in ebony, the eyes are inlaid in glass, the preserved earring is of gold and lapis

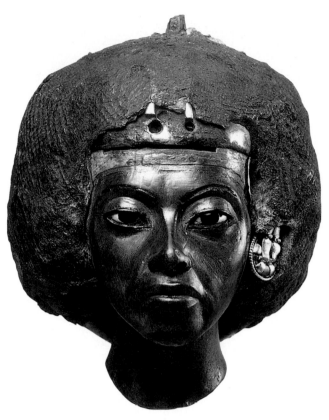

3-38 Queen Tiye, from Gurob, Dynasty XVIII, *c.* 1355–1335 B.C. Ebony, approx. 4″ high. Ägyptisches Museum, Berlin.

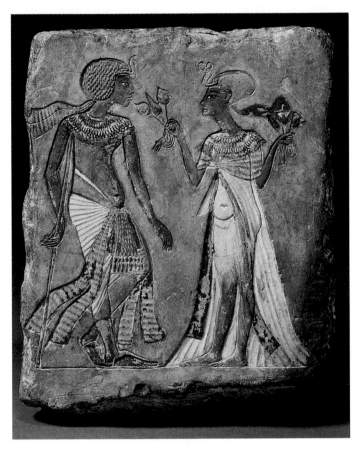

3-39 King Smenkhkare and Meritaten (?), from Tell el-Amarna, Dynasty XVIII, *c.* 1335 B.C. Painted limestone relief, approx. 9¹/₂″ high. Ägyptisches Museum, Berlin.

lazuli, and the headcloth is of plaster and linen with small blue beads. The luxurious materials are worthy of a beloved queen.

During the last three years of his reign, Akhenaton's co-regent was his half-brother, Smenkhkare. A relief from Tell el-Amarna (FIG. **3-39**) may show Smenkhkare and his wife Meritaten in an informal, even intimate, pose that contrasts strongly with the traditional formality in the representation of exalted persons. Once-rigid lines have become undulating curves, and the pose of Smenkhkare has no known precedent. The prince leans casually on his staff, one leg at ease, in an attitude that presumes knowledge on the sculptor's part of the flexible shift of body masses, a principle not fully grasped until the Classical period in Greece. This quite realistic detail accompanies others that are the result of a freer expression of what is observed: details of costume and the departures from the traditional formality, such as the elongated and bulging head of Meritaten and the prominent bellies that characterize figures of the Amarna school. The size of figures no longer depends on rank; the princess is depicted at the same scale as her husband on the basis of their natural proportions. In relief sculpture and painting as well as in statuary, the political and religious revolution under Akhenaton engendered an equally radical upheaval in the realm of art.

The Tomb of Tutankhamen and the Post-Amarna Period

The survival of the Amarna style is seen in the fabulously rich art and artifacts found in the largely unplundered tomb of the pharaoh Tutankhamen, who ruled for only nine years and died around 1325 B.C. at age eighteen. The treasures of his tomb, which include sculpture, furniture, jewelry, and accessories of all sorts, were uncovered in 1922. The adventure of their discovery gained world renown. Installed in the Egyptian Museum in Cairo, a selection of these treasures was made available to a larger public in the late 1970s, when they were sent on a tour of museums throughout the world. It has been estimated that the collection attracted the greatest number of visitors recorded for any single tour of works of art. It reawakened public interest in the legend of the boy king and undoubtedly stimulated appreciation of ancient Egyptian art.

The principal monument in the collection is, of course, the final home of the pharaoh himself. The royal mummy reposed in the innermost of three coffins, nested one within the other and shaped in the form of Osiris, god of death.

The innermost coffin (FIG. **3-40**) was the most sumptuous-ly wrought of the three. Made of beaten gold (about a quarter ton of it) and inlaid with such semiprecious stones as lapis lazuli, turquoise, and carnelian, it is a supreme monument to the sculptor's and goldsmith's craft. The stylized portrait mask (FIG. **3-41**), which covered the king's face, shows his features relaxed in a kind of musing serenity that betokens his confidence in eternal life. Despite a lingering

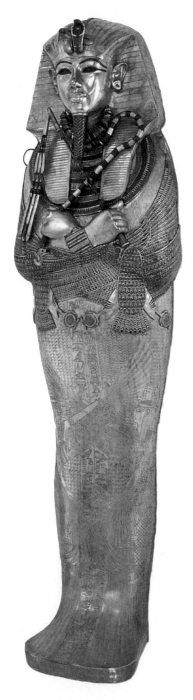

3-40 Innermost coffin of Tutankhamen, from his tomb at Thebes, Dynasty XVIII, *c.* 1325 B.C. Gold with inlay of enamel and semiprecious stones, approx. 6′ 1″ long. Egyptian Museum, Cairo.

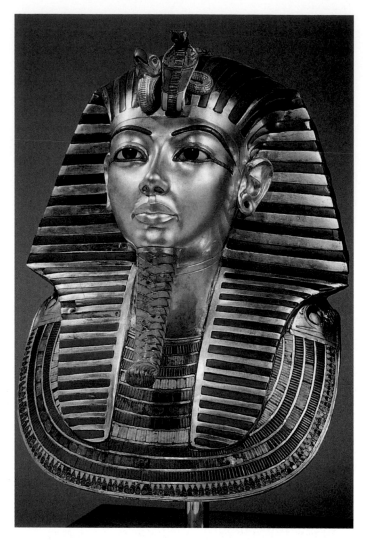

3-41 Death mask of Tutankhamen, from his innermost coffin. Gold with inlay of semiprecious stones. Egyptian Museum, Cairo.

Amarnan sensitivity, softness of contour, and subtlety in the reading of personality, the general effect is one of grandeur and richness expressive of Egyptian power, pride, and affluence at the time of the onset of the empire.

That the king must have defined his mission as imperial conqueror, and would have himself so represented, is shown in the panels of a painted chest from the treasures of the young pharaoh's tomb (FIG. **3-42**; also illustrated in situ in the tomb on page 22). The lid panel shows the king as a great hunter pursuing droves of fleeing animals in the desert, and the side panel shows him as a great warrior. Together, the two panels are a double advertisement of royal power already familiar to us from the later reliefs adorning Assyrian palaces. From a war chariot drawn by spirited, plumed horses, Tutankhamen, shown, as in pre-Amarna art, larger than all other figures on the chest, draws his bow against a cluster of bearded, Asian enemies, who fall in confusion before him. He slays the enemy, like

game, in great numbers. Above him, the sun disc shines on his victory and the vulture goddess, Nckh-bct, his special protectress, shelters him with her wings. Behind Tutankhamen are three tiers of war chariots in diminutive scale, which serve to magnify the figure of the king and to increase the count of his warriors. The themes are traditional, but the fluid, curvilinear forms, the dynamic compositions with their emphasis on movement and action, and the disposition of the hunted, overthrown animals and enemy—who, freed of conventional ground lines, race wildly across the panels—are features reminiscent of the Amarna style.

The pharaohs who followed Akhenaton re-established the cult and priesthood of Amen, restored the temples and the inscriptions, and returned to the old manner in art. Akhenaton's monuments were wiped out, his heresy anathematized, and his city abandoned. The conservative reaction can be seen in a relief of the pharaoh Seti I (FIG. **3-43**). The rigid, flattened shapes repeat the formula of the *Palette of King Narmer* (FIG. 3-2) and the static formality of Old Kingdom art.

Seti I and his successor, Ramses II, were builders both of the Egyptian Empire and the titanic colonnades of Karnak and Luxor, where their victories are celebrated in thousands of feet of relief sculpture and hieroglyphic inscription. Karnak and Luxor were monuments to the Theban god Amen, restored to favor after the heresy of Akhenaton. Sixteen miles northwest of Karnak at Abydos, Seti I also constructed a great temple to the death god Osiris, whose religion he expanded from a local to a national one. The gods of Thebes were official, belonging to the state religion; their temples were in the care of an elite, privileged

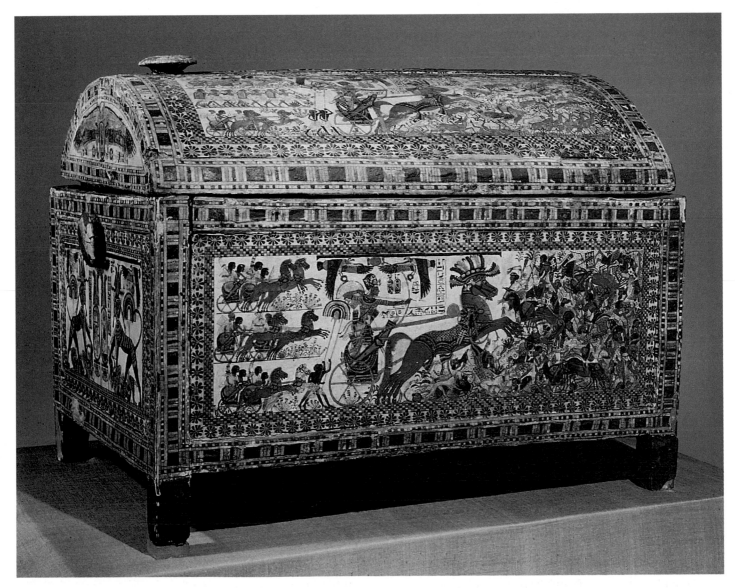

3-42 Painted chest, from the tomb of Tutankhamen, Thebes, *c.* 1325 B.C. Wood, approx. 20″ long. Egyptian Museum, Cairo.

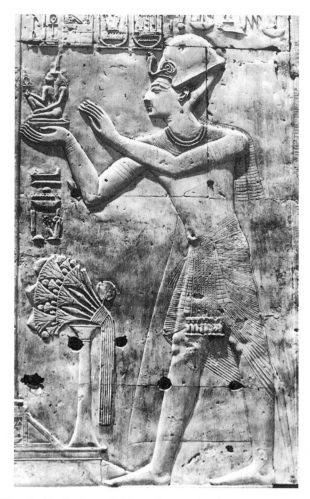

3-43 Seti I offering, relief from the Temple of Seti I, Abydos, Dynasty XIX, *c.* 1290–1280 B.C. Painted limestone. Louvre, Paris.

priesthood isolated from the people. But Osiris, god of the dead and king of the underworld as well as giver of eternal life, became the object of devotion for all Egyptians, including the humblest among them. According to the myth of Osiris, he is slain and dismembered but rises again and, by his resurrection, conquers death; thus, he becomes the source of immortality for all humanity.

The ritual of the cult of Osiris is recorded in collections of spells, prayers, formulas, and counsels that compose the so-called *Book of the Dead.* Illustrated papyrus scrolls, some as long as 70 feet, were the essential equipment of the tombs of well-to-do persons. The papyrus scroll of Hu-Nefer (FIG. **3-44**), the royal scribe and steward of Seti I, found in his tomb in the Theban necropolis, represents the final judgment of the deceased. At the left, Hu-Nefer is led into the hall of judgment by Anubis, the jackal-headed god of embalming. Anubis then adjusts the scales to weigh the heart of the dead man against the feather of the goddess Maat, protectress of truth and right. A hybrid monster, Ammit, half hippopotamus and half lion, the devourer of the sinful, awaits the decision of the scales; if it is unfavorable to the deceased, the monster will eat his heart on the spot. The ibis-headed god Thoth records the proceedings. Above, the gods of the Egyptian pantheon are arranged as witnesses; Hu-Nefer kneels in adoration before them. Having been justified by the scales, Hu-Nefer is brought by Osiris's son, the falcon-headed Horus, into the presence of the green-faced Osiris, the goddess Isis (wife of Osiris and mother of Horus), and the goddess Nephtys (the sister of Isis and Osiris) to receive the award of eternal life.

The figures have all the formality of stance, shape, and attitude—all the flat linearity—that we find in the art of the

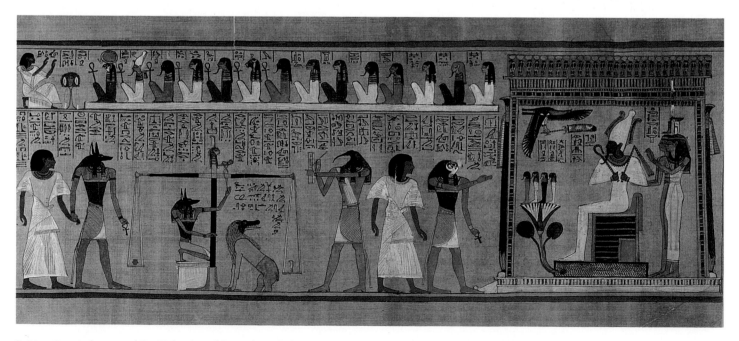

3-44 Last judgment of Hu-Nefer, from his tomb at Thebes, Dynasty XIX, *c.* 1290–1280 B.C. Painted papyrus scroll, approx. 18″ high. British Museum, London.

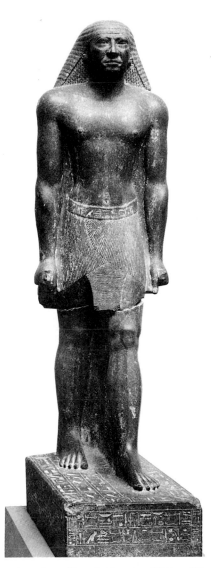

3-45 Mentemhet, from Karnak, Dynasty XXV, *c.* 650 B.C. Granite, approx. 4′ 5″ high. Egyptian Museum, Cairo.

Old Kingdom. Abstract figures and hieroglyphs alike are aligned rigidly along the same planar surface. There is nothing here of the flexible, curvilinear style suggestive of movement that is evident in the art of Amarna and Tutankhamen. The conservatism is complete, as it is in the Seti I relief (FIG. 3-43).

And so, in essence, it remained through the last centuries of Egyptian figural art. During this time, Egypt lost the commanding role it once had played in the ancient Near East. The empire dwindled away, and the land was invaded, occupied, and ruled by foreign powers—Assyria and Persia, and peoples from the west, Libya, and south, Nubia-Ethiopia. From the period of the last-mentioned reign in Egypt, a portrait statue of the governor Mentemhet (FIG. **3-45**) survives that easily could be mistaken for a work of the Old Kingdom (FIG. 3-14). Yet this statue dates from the Twenty-Fifth Dynasty in the seventh century B.C. The Old Kingdom formulas, conventions, and details of representation are all here in summary: the rigidity of the stance, frontality, spareness of silhouette, arms at the side and left leg advanced, the kilt, the headdress, even the material (granite) and the carving technique recall the Old Kingdom. Only the realism of the head, with its rough, almost brutal, characterization, differentiates the work from that of the earlier age.

The pharaohs of the late period deliberately referred back to the art of Egypt's classical phase to give authority to their royal image; religious and political motives only partly explain this deliberate archaism, however. As we noted at the beginning of this chapter, conservatism is a trait of the Egyptian character, perhaps the principal trait. The Egyptians' resistance to significant change over a period of almost three millennia may stem from a profound religiosity inspired by the steady sun, the eternal desert, the slow pulse of the Nilotic seasons, and the enduring conviction that life is not really interrupted by death.

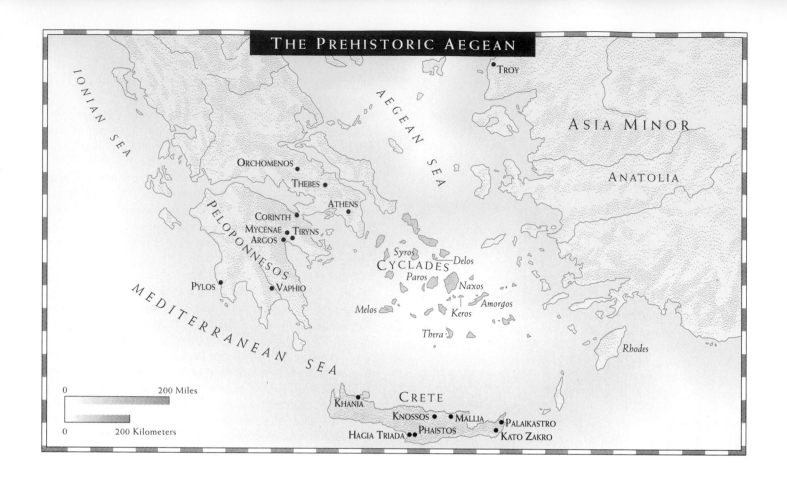

THE PREHISTORIC AEGEAN

TROY

IONIAN SEA

AEGEAN SEA

ASIA MINOR

ANATOLIA

ORCHOMENOS
THEBES
ATHENS
PELOPONNESOS
CORINTH
MYCENAE • TIRYNS
ARGOS
PYLOS • VAPHIO

MEDITERRANEAN SEA

Syros
CYCLADES • Delos
Paros
Naxos
Melos
Amorgos
Keros
Thera

Rhodes

0 ___ 200 Miles

0 ___ 200 Kilometers

CRETE
KHANIA
KNOSSOS • • MALLIA
PHAISTOS • PALAIKASTRO
HAGIA TRIADA • • KATO ZAKRO

		3000 B.C.	2000 B.C.	1700 B.C.
CYCLADES	NEOLITHIC	EARLY CYCLADIC	MIDDLE CYCLADIC	LATE CYCLADIC
CRETE	NEOLITHIC	EARLY MINOAN	MIDDLE MINOAN	LATE MINOAN
MAINLAND GREECE	NEOLITHIC	EARLY HELLADIC	MIDDLE HELLADIC	LATE HELLADIC (MYCENAEAN)

Cycladic figurine
Syros, c. 2500–2300 B.C.

Spring Fresco
Thera, c. 1650 B.C.

Kamares Ware jar
Phaistos, c. 1800–1700 B.C.

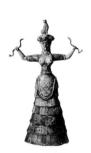

Snake Goddess
Knossos, c. 1600 B.C.

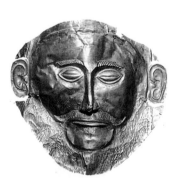

Gold funerary mask
Mycenae, c. 1600–1500 B.C.

Old Palace Period on Crete, c. 2000–1700 B.C.

Linear A script developed, c. 1700–1600 B.C.
New Palace Period on Crete, c. 1700–1400 B.C.

Theran eruption, c. 1628 B.C.

CHAPTER 4

AEGEAN
ART

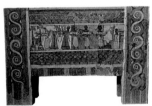

*Toreador Fresco
Knossos,
c. 1450-1400 B.C.*

*Hagia Triada sarcophagus
c. 1450-1400 B.C.*

*Citadel at Tiryns
c. 1400-1200 B.C.*

*Lion Gate, Mycenae
c. 1300-1250 B.C.*

*Warrior Vase
Mycenae, c. 1200 B.C.*

Post-Palatial Period on Crete, c. 1400-1200 B.C.

Destruction of Mycenaean palaces, c. 1200 B.C.

Mycenaeans at Knossos, c. 1450-1400 B.C.

Linear B script developed, c. 1400-1300 B.C.

In the *Iliad,* Homer wrote of the might and splendor of the Achaean host deployed for war against Troy:

So clan after clan poured out from the ships and huts onto the plain of Scamander, and . . . found their places in the flowery meadows by the river, innumerable as the leaves and blossoms in their season . . . the Locrians . . . the Athenians . . . the citizens of Argos and Tiryns of the Great Walls . . . troops from the great stronghold of Mycenae, from wealthy Corinth . . . from Lacedaemon . . . from Pylos . . . Knossos in Crete, Phaistos . . . and the other troops that had their homes in Crete of the Hundred Towns.

The list goes on and on, outlining the peoples and the geography of the Aegean world in intimate detail. Until about 1870, historians of ancient Greece, although they acknowledged Homer's genius as an epic poet, discounted him as a historian, attributing the profusion of names and places in his writings to the rich abundance of his imagination. The prehistory of Classical Greece remained shadowy and lost, historians believed, in an impenetrable world of myth.

That they had done less than justice to the truth of Homer's account, or for that matter, to ancient Greek literary sources in general, was proved by a German amateur archeologist. Between 1870 and his death twenty years later, Heinrich Schliemann uncovered some of the very cities of the Trojan and Achaean heroes celebrated by Homer: Troy, Mycenae, and Tiryns. In 1870, at Hissarlik in the northwest corner of Asia Minor, which a British archeologist, Frank Calvert, had postulated was the site of Homer's Troy, Schliemann dug into a vast *tell,* or mound, and found there a number of fortified cities built on the remains of one another, together with the evidence of the destruction of one of them by fire. Schliemann continued his excavations at Mycenae on the Greek mainland, from which, he believed, Agamemnon and the Greeks had sailed to avenge the capture of Helen, as recounted by Homer in the *Iliad.* Here his finds were even more startling; massive fortress-palaces, elaborate tombs, quantities of gold jewelry and ornaments, cups, and inlaid weapons revealed a magnificent pre-Classical civilization.

But further discoveries were to prove that Mycenae had not been the only center of this fabulous civilization. Nor had the lesson of Schliemann's success in pursuing hunches based on the careful reading of ancient literature been lost on his successors. Another important Greek legend told of Minos, king of Crete, who had exacted from Athens a tribute of youths and maidens to be fed to the Minotaur, a creature half bull and half man that was housed in a vast labyrinth. Might this legend, too, be based on historical fact? An Englishman, Arthur Evans, had long considered Crete a potentially fertile field for investigation, and Schliemann himself, shortly before his death, had wanted

to explore the site of Knossos. In 1900, Evans began work on Crete, and a short time later he uncovered extensive Minoan palaces that did indeed resemble mazes. His findings, primarily at Knossos, were augmented by additional excavations at Phaistos, Hagia Triada, and other sites.

More recently, important Minoan remains have been excavated at many other locations on Crete, and contemporary sites have been discovered on other islands in the Aegean, most notably on Santorini (ancient Thera). Art historians now have a rich corpus of buildings, paintings, and, to a lesser extent, sculptures, that attests to the wealth and sophistication of the peoples of the Aegean in that once obscure heroic age celebrated in later Greek mythology. We also now possess a great many documents from the Aegean Bronze Age written in scripts that scholars have dubbed Linear A and Linear B. The progress that has been made during the last several decades in the deciphering of these texts has provided a welcome corrective to the romanticism that characterized the work of Schliemann and Evans. Archeologists can now begin to reconstruct Aegean society by referring to contemporary documents recording mundane transactions and not just to the heroic account of Homer.

From recent discoveries we now also know that humans inhabited Greece as far back as the Lower Paleolithic period and that village life was firmly established in Greece in Neolithic times. The heyday of the ancient Aegean was not, however, until the second millennium B.C., well after the emergence of the river valley civilizations of Egypt and Mesopotamia. Although close contact existed at various times between the Aegean and the Near East and Egypt, each civilization manifested an originality of its own. The Aegean civilizations hold a special interest for students of the later history of art. They were the direct forerunners of the first truly European civilization, that of Greece, but, as we shall see, the art and architecture of the ancient Near East and Egypt also played a major role in the early development of Greek art. It is also well to remember that the Minoans and Mycenaeans were not Greeks, even though they inhabited a part of the Mediterranean that is today incorporated in the modern nation of Greece.

The sea-dominated geography of the Aegean contrasts sharply with that of the Near East, as does its temperate climate. The situation of Crete in particular, and the Aegean islands in general, at the commercial crossroads of the ancient Mediterranean had a major effect on their prosperity. The sea also provided a natural defense against the frequent and often disruptive invasions that checker the histories of land-bound civilizations like those of Mesopotamia.

Historians, art historians, and archeologists alike divide the Bronze Age Aegean into three geographical areas, and each has a distinctive artistic identity. *Cycladic* art is that of the Cycladic islands (those that circle around Delos) as well

as of the adjacent islands in the Aegean, excluding Crete; *Minoan* art, named for the legendary King Minos of Knossos, encompasses the art of Crete; and *Helladic* art is that of the Greek mainland (*Hellas* in Greek). Each area has been subdivided chronologically into early, middle, and late periods, with the art of the Late Helladic period being designated *Mycenaean* after the great citadel of Mycenae, home of Homer's king Agamemnon.

CYCLADIC ART

As in Anatolia and the Near East, the Neolithic period in the Aegean saw the production of large numbers of human figurines, mostly female, made of clay, limestone, and—rarely but notably—white marble. Marble was abundantly available in the superb quarries of the Aegean Islands, especially on Naxos and Paros. These same quarries later supplied the master sculptors of Classical Greece and Rome with fine marble blocks for monumental statues. The Aegean examples share many of the qualities we observed in Neolithic and even Paleolithic fertility figures such as the *Venus of Willendorf* (FIG. 1-8) and the goddess from Çatal Hüyük (FIG. 1-18). More unusual are their Bronze Age descendants (FIG. **4-1**) dating from the Early Cycladic period, which are much revered today because of their striking abstract forms that call to mind the simple and sleek shapes of some twentieth-century statues (FIG. 27-51). The popularity of Cycladic figurines has had unfortunate consequences. Treasure hunters, anxious to meet the insatiable demands of modern collectors, have plundered many sites; forgeries have also been produced in large numbers.

Most of the genuine Cycladic sculptures, like many of their Stone Age predecessors, represent nude females with their arms folded across their abdomens. They vary in height from a few inches to almost life size. Our example (FIG. 4-1) is about a foot and a half tall and comes from a grave on the island of Syros. The statuette typifies many of these figures. It is almost flat, and the human body is rendered in a highly schematized manner. Large simple triangles dominate the form; note the shape of the head and the body, which tapers from exceptionally broad shoulders to tiny feet, as well as, of course, the incised triangular pubis. The feet are too fragile to support the figurine; if these sculptures were primarily funerary offerings, as we believe they were, they must have been placed on their backs in the graves—lying down, like the deceased themselves. Whether they represent those buried with the statuettes or fertility figures or goddesses remains a subject of debate, but, as in all such images, the sculptor has taken pains to emphasize the breasts as well as the pubic area; in the Syros statuette a slight swelling of the belly suggests pregnancy. Traces of paint found on some of the Cycladic figurines indicate that at least parts of these sculptures were

4-1 Female figurine, from Syros, *c.* 2500–2300 B.C. Marble, approx. 18" high. National Archeological Museum, Athens.

colored. The now almost featureless faces would have had painted eyes and mouths in addition to the sculptured noses. Red and blue necklaces and bracelets as well as painted dots on the cheeks characterize a number of the surviving figurines.

Male figures also occur in the Cycladic repertoire. The most elaborate of these take the form of seated musicians, like the lyre player from Keros (FIG. **4-2**), who, wedged between the echoing shapes of chair and instrument, may be playing for the deceased in the afterlife, although, again, the meaning of these statuettes eludes us today. The harpist reflects the same preference for simple geometric shapes and large flat planes as the supine female figures; still, the artist shows a keen interest in recording the elegant shape

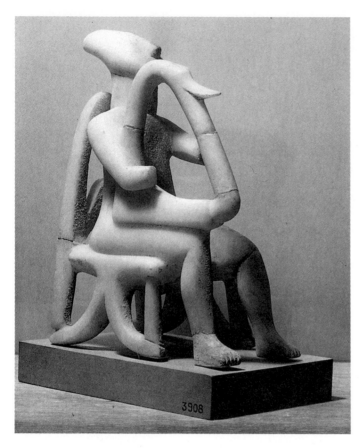

4-2 Male lyre player, from Keros, *c.* 2700–2500 B.C. Marble, approx. 9″ high. National Archeological Museum, Athens.

of what must have been a prized possession: the harp with its duck-bill or swan-head ornament at the apex of its soundbox. In one instance both a musician figure and a reclining woman figure were placed in a woman's grave. This would suggest that the lyre players are not images of dead men. However, it does not prove that the female figurines represent dead women; the man might be entertaining the deceased herself, not her image. The musicians could also portray a deity, a forerunner of the Greek god Apollo, whose instrument was the lyre and whose sacred animal was the swan. In the absence of written documents in Greece at this date, as in prehistoric western Europe and the Near East, we simply cannot be sure of the meaning of many works of art. Some Cycladic figurines have been found in settlements rather than cemeteries, and it is likely, in fact, that the same form took on different meanings in different contexts.

MINOAN ART

During the third millennium B.C., both on the islands of the Aegean and on the Greek mainland, hardly any large communities developed. Most settlements consisted only of simple buildings and only rarely were the dead buried with

costly offerings like the Cycladic statuettes we have just examined. The opening centuries of the second millennium (the Middle Minoan period on Crete) are marked, in contrast, by the foundation of palaces to house kings and their retinues and by royal towns, which grew up around them. This first or Old Palace period came to an abrupt end around 1700 B.C., when these grand structures were destroyed, perhaps by an earthquake. Rebuilding began sometime after 1700 B.C., and the ensuing New Palace (Late Minoan) period is the golden age of Crete, an era when the first great Western civilization emerged.

Architecture

The rebuilt palaces were large, comfortable, and handsome, with ample staircases and courtyards for pageants, ceremonies, and games. Archeologists have uncovered their ruins, along with rich treasures of art and artifacts that document the power and prosperity of Minoan civilization. The principal palace sites on Crete are at Knossos, Phaistos, Mallia, Kato Zakro, and Khania. All of these are laid out along similar lines.

The largest of the palaces (FIGS. **4-3** and **4-4**), that at Knossos, the legendary home of King Minos, is a rambling structure built against the upper slopes and across the top of a low hill that rises from a fertile plain. All around the palace proper were mansions and villas, presumably belonging to high officials in the service of the royal house. The great rectangular court (4), around which the units of the palace are grouped, had been leveled in the time of the old palace; the manner of the grouping of buildings suggests that the new palace was carefully planned, with the court as the major organizing element. A secondary organization of the palace plan is provided by two long corridors. On the west side of the court, a north-south corridor (6) separates official and ceremonial rooms from the magazines (8), where wine, grain, oil, and honey were stored in large jars. On the east side of the court, an east-west corridor (14) separates the royal residential quarters and reception rooms (to the south) from the workmen's and servant's quarters (on the north). At the northwest corner of the entire building complex is a theaterlike area (5) with steps on two sides that may have served as seats. This form is a possible forerunner of the later Greek theater (FIG. 5-80). Its purpose is unknown, but it is a feature that is paralleled in the Minoan palace at Phaistos. The central courtyard is a feature of many Cretan palaces, and despite the complexity of the plans—giving rise to the myth of the Minotaur in the labyrinth—the Minoan palaces seem to be a series of variations of a common layout. The buildings were well constructed, with thick walls composed of rough, unshaped fieldstones imbedded in clay. *Ashlar masonry*—carefully cut and regularly shaped blocks of stone—was used at building corners and around door and window openings. Thought was also given to such questions as drainage; a remarkably

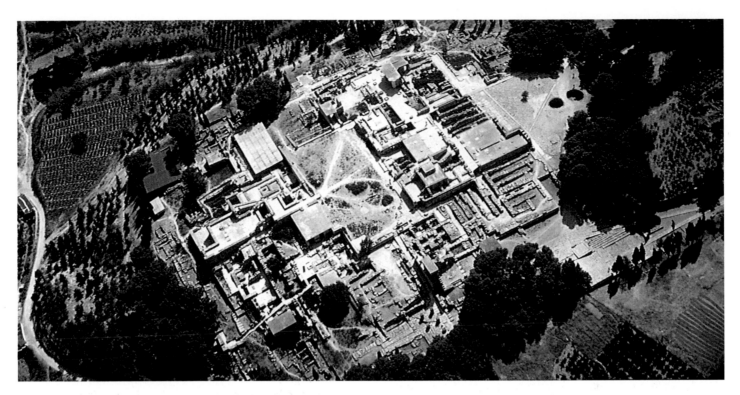

4-3 Aerial view of the palace at Knossos, *c.* 1700–1400 B.C.

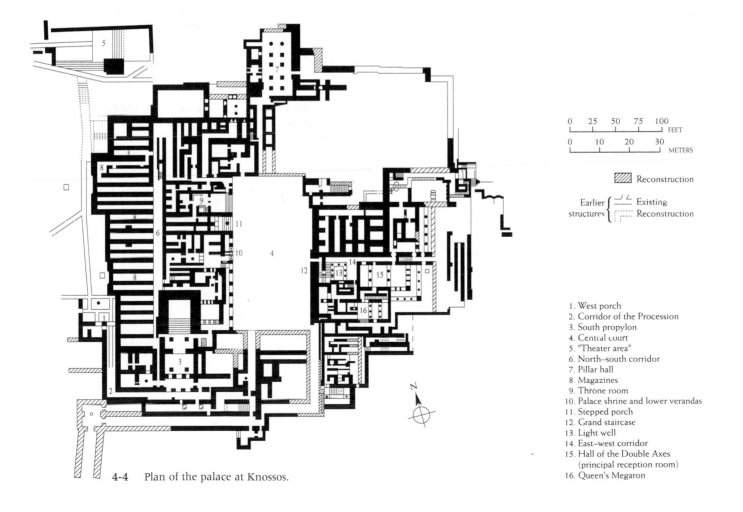

0 25 50 75 100
|___|___|___|___|___| FEET

0 10 20 30
|___|___|___|___| METERS

▨ Reconstruction

Earlier { ⌐⌐ Existing
structures { ⠃⠃⠃ Reconstruction

1. West porch
2. Corridor of the Procession
3. South propylon
4. Central court
5. "Theater area"
6. North–south corridor
7. Pillar hall
8. Magazines
9. Throne room
10. Palace shrine and lower verandas
11. Stepped porch
12. Grand staircase
13. Light well
14. East–west corridor
15. Hall of the Double Axes
 (principal reception room)
16. Queen's Megaron

4-4 Plan of the palace at Knossos.

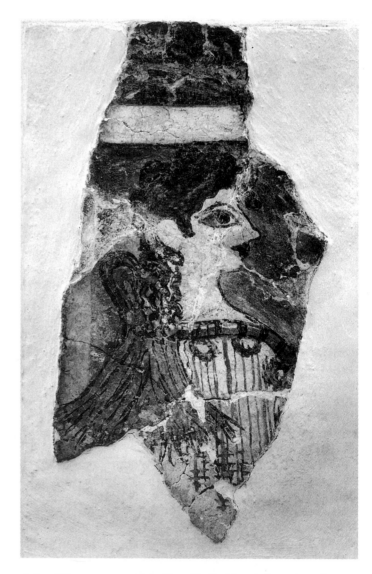

4-5 Stairwell in the residential quarter of the palace at Knossos.

efficent system of terracotta pipes underlies the palace. The bathrooms and toilets in the residential quarter were luxuries at the time.

The Knossos palace was complex not only in plan but also in elevation. It had as many as three stories around the central court and even more on the south and east sides where the terrain sloped off sharply. Interior staircases built around light and air wells (FIG. **4-5**) provided necessary illumination and ventilation. Painted Minoan columns, originally fashioned of wood but restored in stone, are characterized by their bulbous, cushionlike capitals, which resemble those of the later Greek Doric order (FIG. 5-15), and by their distinctive shape. The shafts taper from a wider top to a narrower base—the opposite of both Egyptian and later Greek columns.

Painting

KNOSSOS Mural paintings liberally adorn the palace at Knossos, one of its most striking aspects. The rough fabric of the rubble walls was often coated with a fine white lime plaster and painted with frescoes, which, together with the bright red shafts and black capitals of the wooden columns, must have provided an extraordinarily rich effect. The fres-

coes depict many aspects of Minoan life (bull-leaping, processions, and ceremonies) and of nature (birds, animals, flowers, and marine life).

From a ceremonial scene of uncertain significance comes the famous fragment (FIG. **4-6**) that was dubbed *La Parisienne* (*The Parisian Woman*) upon its discovery, because of the elegance, elaborate coiffure, and full rouged lips of the young woman (perhaps a priestess or even a goddess) depicted in the fresco. Although the representation is still convention-bound (note especially the oversized frontal eye in the profile head), the charm and freshness of the mural are undeniable. The painting method used is appropriate to the lively spirit of the Minoans. Unlike the Egyptians, who painted in fresco secco, the Minoans used a *true*, or *wet, fresco* method, which required rapid execution and skill in achieving quick, almost impressionistic effects.

4-6 Minoan woman or goddess (*La Parisienne*), from the palace at Knossos, *c.* 1450–1400 B.C. Fragment of a fresco, approx. 10″ high. Archeological Museum, Herakleion.

To catch an interesting but fugitive aspect of an object or a scene, the artist had to work quickly, even spontaneously, allowing for happy accidents. Thus, because the wet-fresco technique compelled the artist to work rapidly, the spirit of *La Parisienne* is also a product of the resultant verve of the artist's hand; the simple, light delicacy of the technique exactly matches the vivacity of the subject.

Vivacity and spontaneity also characterize the so-called *Toreador Fresco* (FIG. **4-7**) from the palace at Knossos. Although here, too, only fragments of the full composition have been recovered, they are extraordinary in their depiction of the vigorous movements of the young women (with fair skin) and the youth (with dark skin, according to the widely accepted ancient convention for distinguishing male and female) who take part in the uniquely Minoan ceremony of bull-leaping. These bull games took place in the central courtyards of the great palaces and, despite the modern nickname of the fresco, were unlike modern bull-fights: no weapons were used and the bull was left unharmed, unless it was sacrificed after the games were concluded. The young man in the fresco is shown in the air, having, it seems, grasped the bull's horns and somersaulted over its back in a dangerous and extremely difficult acrobatic maneuver. The powerful charge of the bull is brilliantly suggested by the elongation of the animal's shape and the sweeping lines that form a funnel of energy, beginning at the very narrow hindquarters of the bull and culminating in its large sharp horns and galloping forelegs. The human figures also have stylized shapes, with typically Minoan pinched waists, and are highly animated. Although the profile pose with the full-view eye was a familiar convention in Egypt and Mesopotamia, the elegance of the Cretan figures, with their long curly hair, proud and self-confident bearing, and smiling faces distinguishes them from all other early figure styles. The angularity of the figures seen in Egyptian wall paintings is modified in the curving Minoan line that suggests the elasticity of the living and moving being.

AKROTIRI The Minoan figure style also may be seen in the fresco of a young fisherman (FIG. **4-8**) who holds his abundant catch in both hands. The painting is remarkable as a very early monumental study of the nude male figure, a subject that will preoccupy later Greek artists for centuries. The fresco is not, however, from Knossos or even from Crete, but was uncovered much more recently in the excavations of Akrotiri on the volcanic island of Santorini (ancient Thera) in the Cyclades, some sixty miles north of Crete. In the Late Cycladic period, Thera was artistically, and possibly also politically, within the Minoan orbit, and the extremely well-preserved mural paintings from Akrotiri are invaluable additions to the fragmentary and frequently misrestored corpus of frescoes from Crete. The excellent preservation of the Theran paintings is due to an enormous seismic explosion on the island of Santorini that buried Akrotiri in ash, making it a kind of Pompeii of the prehistoric Aegean. Archeologists formerly dated the event around 1500 B.C. and speculated that it must have had disastrous effects on the palaces of Crete as well. But recent investigations have pushed the date back as far as 1628 B.C.—forcing a revision in the chronology of both Late Minoan and Late Cycladic art.

The Akrotiri frescoes decorated the walls of houses, not those of a great palace like that at Knossos, and the number of painted walls from the site is especially impressive. Another fresco from the same room of the same house as that of the fisherman is much smaller in size but filled with dozens of figures, ships, and buildings. This *Miniature Ships Fresco*, as it has been called, formed a frieze about 17 inches high at the top of at least three walls of the room. In our

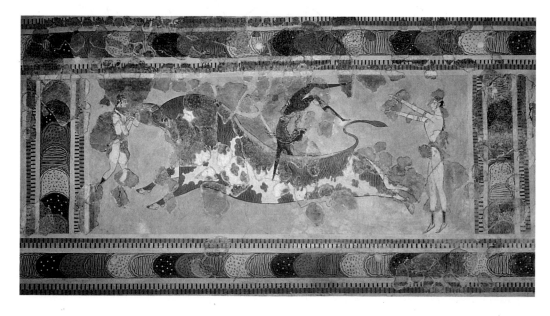

4-7 Bull-leaping (*Toreador Fresco*), from the palace at Knossos, *c.* 1450–1400 B.C. Approx. 32" high, including border. Archeological Museum, Herakleion.

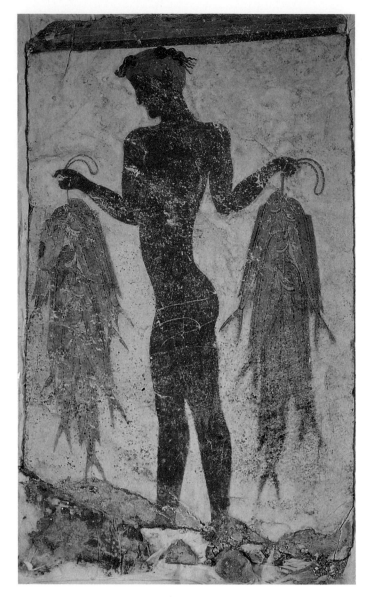

4-8 Young fisherman with his catch, detail of a fresco in Room 5, West House, Akrotiri, Thera, *c.* 1650 B.C. Approx. 53″ high. National Archeological Museum, Athens.

variation in the arrangement of figures and poses according to the role being played—steering, tending to the sail, rowing, or simply sitting and conversing. Dolphins frolic about the ships, and on the left shore a lion pursues fleeing deer. The ports—the one at the left encircled by a river represented as arching above it—show quays, houses, and streets occupied by a variety of people attentive to the coming and going of the ships. The whole composition has the openness and lightness of the seagirt lands of Crete and the Greek islands, suggesting the freedom of movement of a people born to the sea, and nature—with all its flora and fauna—is, in itself, delightful and worthy of representation.

We can feel the freshness and vitality of this Aegean vision of nature especially well in the almost perfectly preserved mural paintings (FIG. 4-10) of another room from Akrotiri that has been reconstructed in the National Archeological Museum in Athens. In this *Spring Fresco,* nature itself is the sole subject, although the aim of the artist is not to render the rocky island terrain realistically, but rather to capture the essence of the landscape and to express joy in one's surroundings. The irrationally undulating and vividly colored rocks, the graceful lilies swaying in the cool island breezes, and the darting swallows express vernal qualities—the vigor of growth, the delicacy of flowering, and the lightness of bird song and flight. In the lyrical language of curving line, the artist celebrates the rhythms of spring. Never before have we encountered a landscape in which humans are not present at all—nor will we find one again for many centuries. We have here the polar opposite of the first efforts at mural painting in the caves of Paleolithic Europe, where animals (and occasionally humans) appeared as isolated figures without any indication of setting. This and other Aegean landscapes were unknown to artists of later ages, but they have spiritual heirs in the pastoral scenes painted on walls and canvases from Greco-Roman times to the present day.

Pottery and Sarcophagi

The love of nature manifested itself in Crete on the surfaces of painted vases even before the period of the new palaces. During the Middle Minoan period, Cretan potters fashioned sophisticated shapes using newly introduced potters' wheels and decorated their vases in a distinctive and fully polychromatic style. These Kamares Ware vessels, named for the cave on the slope of Mount Ida in which they were first discovered, have been found in quantity at Phaistos and Knossos. On our example (fig. 4-11), as on other Kamares vases, we find a rich black ground with creamy white and reddish-brown decoration upon it. The central motif is a great leaping fish—a forerunner of the diving dolphins of Late Minoan and Late Cycladic murals—and perhaps a fish net surrounded by a host of curvilinear abstract patterns including waves and spirals. The swirling lines evoke life in the sea, and both the abstract and the natural forms

detail of the fresco (FIG. 4-9), a great fleet sails between two ports, perhaps taking part in a sea festival, perhaps engaged in a naval campaign that calls to mind Homer's much later catalogue of ships in the *Iliad.* We shall not see such a detailed representation of the movement of ships and men from port to port until the Column of the Roman emperor Trajan (FIG. 7-49) in the second century A.D.—almost two millennia later than the Theran fresco. The details of ship design and sailing are carefully observed in the fresco, as if by one who knew ships well. Just as closely studied are the placements and poses of steersmen, sailors, rowers, and passengers. Little of the conventional stereotyping and repetition that appears in such representations throughout the history of art is evident here; instead, we find significant

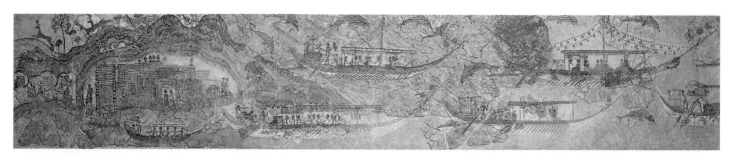
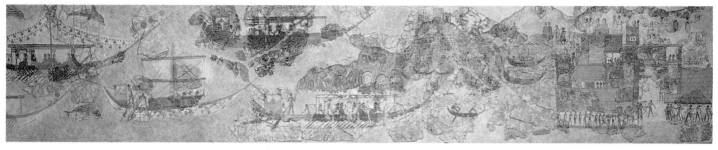

4-9 Flotilla, detail of *Miniature Ships Fresco*, from Room 5, West House, Thera, *c.* 1650 B.C. Approx. 17″ high. National Archeological Museum, Athens.

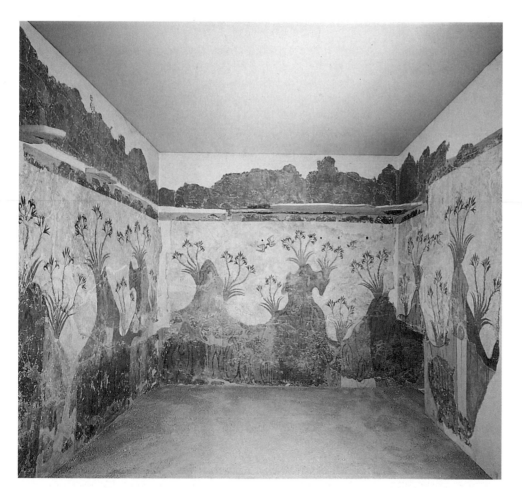

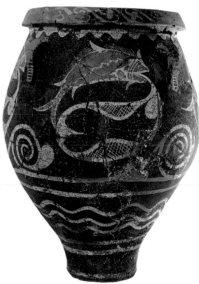

4-11 Kamares Ware jar, from Phaistos, *c.* 1800–1700 B.C. Approx. 20″ high. Archeological Museum, Herakleion.

4-10 Landscape with swallows (*Spring Fresco*), from Room Delta 2, Akrotiri, Thera, *c.* 1650 B.C. Fresco, approx. 7′ 6″ high. National Archeological Museum, Athens.

are beautifully adjusted to and integrated with the shape of the vessel.

The sea and the creatures that inhabit it also inspired the Late Minoan Marine Style octopus jar (FIG. **4-12**) from

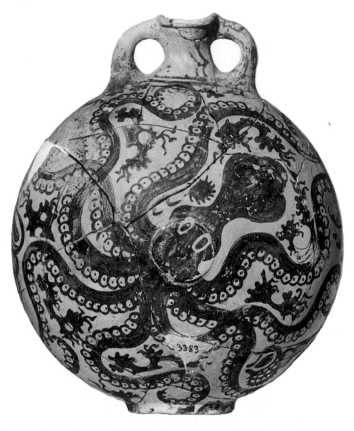

4-12 Marine Style octopus jar, from Palaikastro, *c.* 1500 B.C. Approx. 11″ high. Archeological Museum, Herakleion.

4-13 Sarcophagus, from Hagia Triada, *c.* 1450–1400 B.C. Painted limestone, approx. 54″ long. Archeological Museum, Herakleion.

Palaikastro, which is contemporary with the new palaces at Knossos and elsewhere. The tentacles of the octopus reach out over the curving surfaces of the vessel, embracing the piece and emphasizing its elastic volume. This is a masterful realization of the relationship between the decoration of the vessel and its shape, always a problem for the ceramicist. This later vase differs markedly from its Kamares Ware predecessor in the choice of colors. Not only is the octopus jar more muted in tone, but the Late Minoan artist also reverses the earlier scheme and places dark silhouettes on a light ground. This will remain the norm for about a millennium in Greece, until about 530 B.C. when, albeit in a very different form, light figures on a dark ground emerge once again as the preferred manner (FIG. 5-24).

Midway in size and complexity between these decorated clay vessels and the monumental frescoes of Crete and Thera are the paintings on a Late Minoan limestone sarcophagus (FIG. **4-13**) found at Hagia Triada near Phaistos on the southern coast of Crete. The paintings are closely related in technique, color scheme, and figure style to contemporary palace frescoes, but the subject is foreign to the monumental repertoire. Befitting the function of the sarcophagus as a burial container, the paintings illustrate the funerary rites in honor of the dead and provide welcome information about Minoan religion, which still remains obscure despite a century of excavation on Crete. At the right the dead man appears upright in front of his own tomb, like the New Testament raised Lazarus in medieval art, and watches as three men (note their dark flesh tone) bring offerings to him. At the left two light-skinned women carry vessels and pour a libation to the deceased while a male musician plays a lyre. The musician immediately brings to mind the Early Cycladic statuettes of lyre players

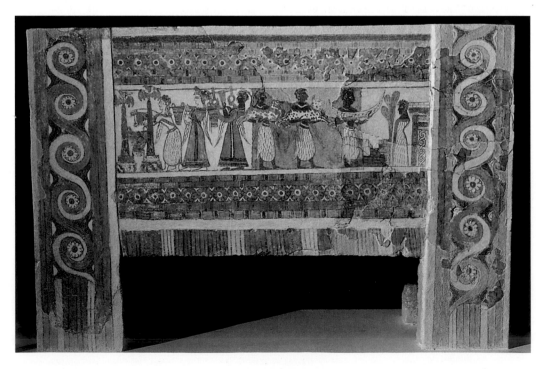

(FIG. 4-2) that were deposited in tombs, which may indicate some continuity in funerary customs and beliefs from the Early to the Late Bronze Age in the Aegean.

Sculpture

Also from Hagia Triada is the so-called *Harvesters Vase* (FIG. **4-14**), probably the finest surviving example of Minoan relief sculpture, there being nothing comparable to the great stone reliefs of the Assyrian palaces in Minoan Crete. Only the upper half of the egg-shaped body and neck of the vessel are preserved; missing are the lower parts of the harvesters (or, as some think, sowers) and the ground on which they stand. Formulaic scenes of sowing and harvesting were staples of Egyptian funerary art (FIG. 3-19), but the Minoan artist has shunned static repetition in favor of a composition that bursts with the energy of its individually characterized figures. The relief shows a riotous crowd singing and shouting as they go to or return from the fields. They are led by an older man wearing a great cloak patterned with scales and carrying a staff. The forward movement and lusty exuberance of the youths who follow him are vividly expressed. Although most of the figures conform to the age-old convention of combined profile and frontal views, one figure (FIG. **4-15**) is singled out from his companions. He shakes a rattle to beat time and is depicted in full profile with his lungs so inflated with air that his ribs show. This is one of the first instances in the history of art in which a sculptor shows a keen interest in the underlying muscular and skeletal structure of the human body. This is not a pictogram for man, but a painstaking study of human anatomy, a remarkable achievement, especially given the very small size of the *Harvesters Vase*. Equally noteworthy is the astonishing exactitude with which the facial expressions of the men have been rendered; degrees of hilarity and vocal effort are clearly visible, all marked in the tension or relaxation of facial muscles. This reading of the human face as a vehicle of emotional states is without precedent in ancient art before the Minoans.

No monumental statues of gods, kings, or monsters, such as we find in Mesopotamia and Egypt, have been

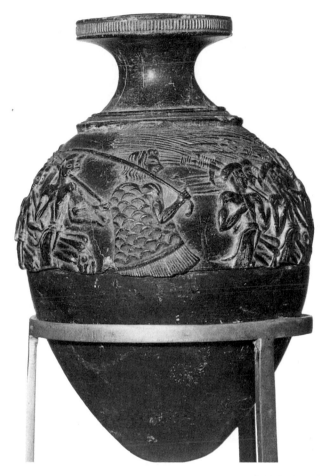

4-14 *Harvesters Vase*, from Hagia Triada, *c.* 1500 B.C. Steatite, greatest diameter approx. 5". Archeological Museum, Herakleion.

4-15 Detail of the *Harvesters Vase*.

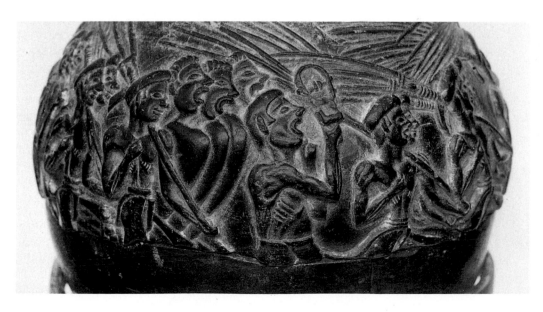

found on Minoan Crete, although large wooden images may once have existed. What remains of Minoan sculpture in the round is small in scale, like the so-called *Snake Goddess* (FIG. **4-16**) from the palace at Knossos, one of several similar figurines that some scholars believe may represent mortal attendants rather than a deity, although the prominently exposed breasts suggest that these *faïence* (glazed earthenware) figurines stand in the long line of prehistoric fertility images that are usually considered to be divinities. (The woman depicted in the Knossos statuette not only holds snakes in her hands but supports a leopard-like feline peacefully on her head; this implied power over the animal world also seems appropriate for a deity.) The frontality of the figure is reminiscent of Egyptian and Near Eastern statuary, but the costume is clearly Minoan. We find the open bodice and flounced skirt worn by Minoan women depicted many times over. If the statuette represents a goddess, as seems more likely, then it is yet another example of human beings fashioning their gods in their own images.

The circumstances under which the Minoan civilization came to an end are still disputed, although it is now wide-

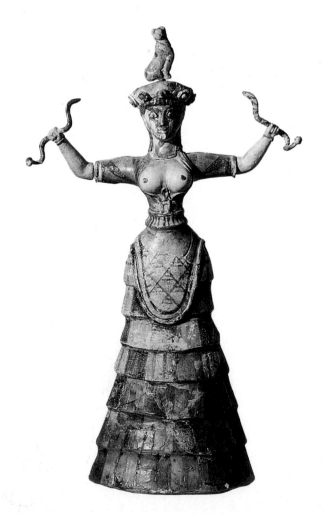

4-16 *Snake Goddess*, from the palace at Knossos, *c.* 1600 B.C. Faïence, approx. 13¹/₂″ high. Archeological Museum, Herakleion.

ly believed that Mycenaeans had already moved onto Crete and established themselves at Knossos at the end of the New Palace period. From the palace at Knossos, these intruders appear to have ruled the island for at least half a century, perhaps much longer. Parts of the palace continued to be occupied until its final destruction around 1200 B.C., but its importance as a cultural center faded soon after 1400 B.C., as the focus of Aegean civilization shifted to the Greek mainland.

MYCENAEAN (LATE HELLADIC) ART

The origins of the Mycenaean culture are still being debated. All that is certain is that there is evidence for the presence of these forerunners of the Greeks on the mainland about the time the old palaces were being built on Crete—that is, about the beginning of the second millennium B.C. Doubtless these people were influenced by Crete even then, and some believe that the mainland was a Minoan economic dependency for a long time. At any rate, Mycenaean power developed on the mainland in the days of the new palaces on Crete, and by 1500 B.C., a distinctive Mycenaean culture was flourishing in Greece—a culture to which, some seven hundred years later, Homer was to give the epithet "rich in gold." This is a characterization that the dramatic discoveries of Schliemann and his successors have proven to be fully justified, even if today's archeologists no longer view the Mycenaeans solely through the romantic eyes of Homer.

Architecture

The destruction of the Cretan palaces left the mainland culture supreme. Although this Late Helladic civilization has come to be called Mycenaean, Mycenae is but one of several large citadels explored by archeologists. Mycenaean remains have been uncovered at Tiryns, Orchomenos, Pylos, and elsewhere, and Mycenaean fortification walls have even been found on the Acropolis of Athens, home of the legendary King Theseus. The best-preserved and most impressive Mycenaean remains are those of the fortified palaces at Tiryns and Mycenae, both built about 1400 B.C. and burned (along with all the others) between 1250 and 1200 B.C., when the Mycenaeans seem to have been overrun by invaders from the north or to have fallen victim to internal warfare.

TIRYNS The citadel of Tiryns (FIG. **4-17**), located about ten miles from Mycenae, was known by Homer as Tiryns of the Great Walls and was the legendary birthplace of Herakles (Hercules), the greatest of the Greek heroes. In the second century A.D., when Pausanias, author of an invaluable guidebook to Greece, visited Tiryns, he marveled at the towering fortifications and considered the walls of Tiryns to be as spectacular as the pyramids of Egypt. Indeed, the

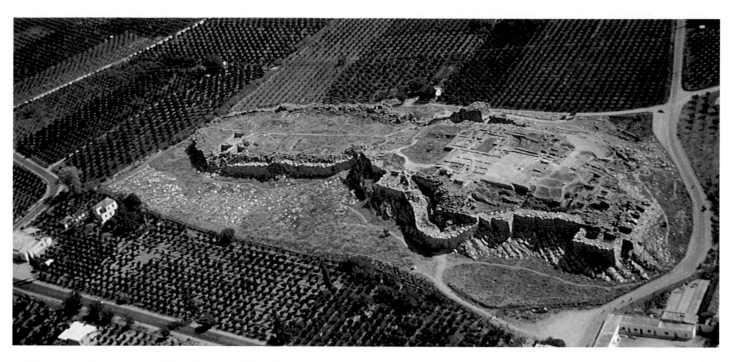

4-17 Aerial view of the citadel at Tiryns, *c.* 1400–1200 B.C.

Greeks of the historical age believed that mere humans could not have erected such edifices and instead attributed the construction of the great Mycenaean citadels to the mythical race of giants, the Cyclopes. We still refer to the huge unhewn and roughly cut blocks of stone used to form the massive fortification walls of Tiryns and other Mycenaean sites as *Cyclopean masonry.*

The heavy walls of Tiryns and other Mycenaean palaces contrast sharply with the open Cretan palaces and clearly reveal their defensive character. Those of Tiryns average about 20 feet in thickness and in one section house a long gallery covered by a corbeled vault (FIG. **4-18**). Here the large irregular Cyclopean blocks have been piled in horizontal courses and then cantilevered inward until the two walls meet in a pointed arch. No mortar was used and the vault is held in place only by the weight of the blocks themselves (often several tons each), the smaller stones used as wedges, and the clay that fills some of the empty spaces. This primitive but effective vaulting scheme possesses an earthy dynamism and is very impressive in its crude monumentality. It is easy to see how a later age came to believe that the uncouth Cyclopes were responsible for these massive but unsophisticated fortifications.

Would-be attackers at Tiryns were compelled to approach the palace within the walls by way of a long ramp (FIG. **4-19**) that forced the normally right-handed soldiers to expose their unshielded sides to the Mycenaean defenders above, and then—if they got that far—to pass through a series of narrow gates that could also be defended easily. Inside, at Tiryns as elsewhere, the most important element in the palace plan was the *megaron*, or reception hall, of the king, the main room of which had a throne placed against

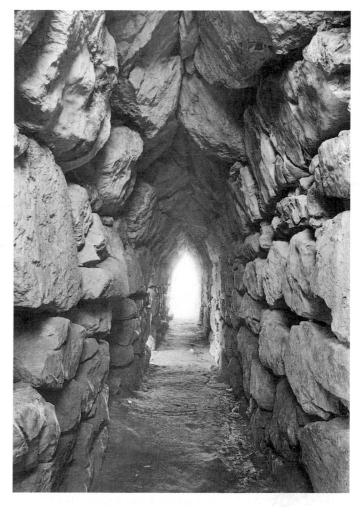

4-18 Corbeled gallery in the walls of the citadel, Tiryns.

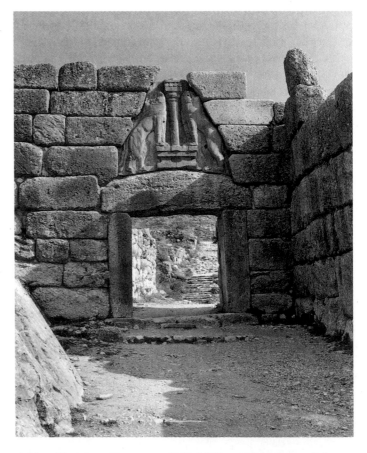

4-19 Plan of the palace and southern part of the citadel, Tiryns.

the right wall and a central hearth bordered by four Minoan-style wooden columns that served as supports for the roof. The throne room was preceded by a vestibule with a columnar facade. A variation of this plan later formed the core of some of the earliest Greek temple plans, a fact that suggests some architectural continuity during the so-called Dark Ages that followed the collapse of Mycenaean civilization.

MYCENAE The severity of these fortress-palaces was relieved by frescoes, as in the Cretan palaces, and, at Mycenae at least, by monumental architectural sculpture. The Lion Gate at Mycenae (FIG. 4-20) is the outer gateway of the stronghold. It is protected on the left by a wall built on a natural rock outcropping and on the right by a projecting man-made bastion, so that any approaching enemies would have to enter this 20-foot-wide channel and face Mycenaean defenders above them on both sides. The gate itself is formed of two great monoliths capped with a huge lintel. Above the lintel, the masonry courses form a corbeled arch, leaving an opening that serves to lighten the weight to be carried by the lintel itself. This *relieving triangle* is filled with a great limestone slab on which two lions (or perhaps sphinxes or griffins—the heads were fashioned

separately and are lost), carved in high relief, stand on either side of a column of Minoan type, and rest their forepaws on the two altars on which the column stands. The animals are carved with breadth and vigor, and the whole design admirably fills its triangular space, harmonizing in dignity, strength, and scale with the massive stones that form the walls and gate. We find similar groups in miniature on Cretan seals, but the idea of placing monstrous guardian figures at the entrances to palaces, tombs, and sacred places has its origin rather in Egypt and the Near East (compare, for example, the Great Sphinx of Gizeh, FIG. 3-11, and the later lion and lamassu gates of Assyria, FIGS. 2-16 and 2-19).

Within the Mycenaean Lion Gate and to the right lies Grave Circle A (FIG. 4-21), an enclosure roughly 30 yards in diameter bordered by two rings of tall stone blocks covered with slabs. Within the circle are six deep shafts that served as tombs for kings and their families during the sixteenth century B.C., a few hundred years before the erection of the final fortification walls of the citadel, which were extended to enclose Grave Circle A within their protective circuit. Several of the graves were marked by tombstones (*stelae*) akin to those employed in modern cemeteries. The dead were laid to rest on the floors of these shaft graves with

4-20 Lion Gate, Mycenae, *c.* 1300–1250 B.C. Limestone, relief panel approx. 9¹/₂' high.

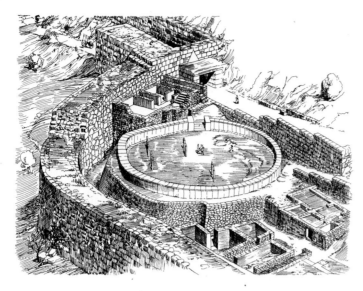

4-21 Reconstruction of Grave Circle A, Mycenae, *c.* 1600–1500 B.C., within the later citadel walls, *c.* 1300–1250 B.C.

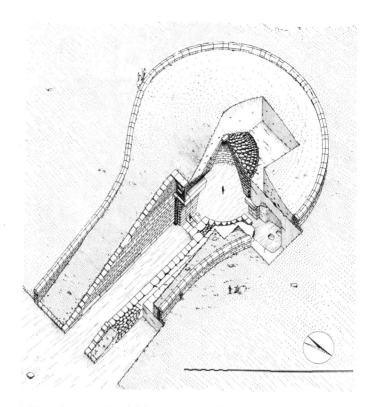

4-22 Cutaway view of the "Treasury of Atreus", Mycenae, *c.* 1300–1250 B.C.

masks covering their faces, recalling Egyptian funerary practice, with which the Mycenaeans were doubtless familiar. Women were buried with their jewelry and men with their weapons and golden cups. The finds from these graves, some of which are illustrated and discussed (FIGS. 4-25 and 4-26) were Schliemann's most spectacular discoveries.

By the time the Lion Gate was erected at Mycenae wealthy Mycenaeans were no longer buried in shaft graves but in beehive-shaped tombs (*tholoi,* singular *tholos*). These tombs were covered by enormous earthen mounds, of which the best preserved is the so-called Treasury of Atreus (FIG. **4-22**), which already in antiquity was mistakenly believed to be the repository of the treasure of Atreus, father of Agamemnon and Menelaus. Approached by a long passageway (*dromos*), the tomb chamber was entered through a doorway surmounted by a relieving triangle similar to that employed in the design of the roughly contemporary Lion Gate. The tholos is composed of a series of corbeled courses of stone laid on a circular base and ending in a lofty dome (FIG. **4-23**). The vault was probably constructed using rough-hewn blocks; after they were set in place, the stonemasons had to finish the surfaces with great precision to conform to both the horizontal and vertical curve of the wall. The principle involved is no different from that of the corbeled gallery of Tiryns (FIG. 4-18), but the problem of constructing a complete dome is much more complicated, and the execution of the vault in the Treasury of Atreus is much more sophisticated than that of the vaulted gallery at Tiryns. About 43 feet high, this was the largest vaulted space without interior supports in all antiquity until the Roman Pantheon (FIG. 7-57) was built almost fifteen hundred years later—utilizing a new technology (concrete construction) unknown to the Mycenaeans.

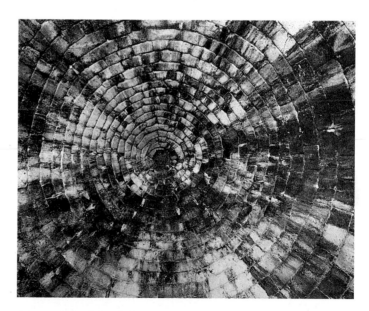

4-23 Vault of the tholos of the "Treasury of Atreus", seen from below.

Metalwork, Sculpture, and Painting

The Treasury of Atreus had been thoroughly looted long before its modern rediscovery, but, as already mentioned, rich finds were made in the shaft graves of Mycenae. Among the most spectacular is the beaten gold (*repoussé*)

mask (FIG. **4-24**) from Grave Circle A, one of several from the royal burial complex. It has often been compared with the fabulous gold mummy mask of Tutankhamen (FIG. 3-41). The treatment of the human face is, of course, more primitive in the Mycenaean mask, but it must be noted that this is one of the first attempts in Greece to render the human face at life size, whereas Tutankhamen's mask stands in a venerable line of monumental Egyptian sculptures going back more than a millennium. It is not known whether the Mycenaean masks were intended as portraits, but different physical types were recorded with care. There are youthful faces as well as mature ones; our example, with its full beard, must portray a mature man, perhaps a king, while others may have covered the faces of princes.

Also found in Grave Circle A were several magnificent bronze dagger blades inlaid with gold, silver, and black niello, again attesting to the wealth of the Mycenaean kings and their warlike nature. The largest and most elaborate of the group (FIG. **4-25**) is decorated with a hunting scene in which four hunters attack a lion that has struck down a fifth hunter, while two other lions flee. The slim-waisted, long-haired figures are Minoan in style, but the subject is borrowed from the repertoire of the ancient Near East. It is likely that the dagger was made by a Minoan craftsman for a Mycenaean patron, who admired Minoan art but had different tastes in subject matter than his Cretan counterparts.

Possibly of Minoan manufacture, but found on the mainland at Vaphio in a Mycenaean tholos, is a gold cup depicting the capture of a bull (FIG. **4-26**). It is one of a pair, and scholarly opinion is divided as to whether both are Minoan or both Mycenaean; many think, in fact, that one cup is a Minoan import and the other a Mycenaean imitation. Whatever the answer to the problem, the figure style is unmistakably Minoan (compare the similar youths on the *Harvesters Vase*, FIGS. 4-14 and 4-15) as is the subject matter, which is related to the bull-leaping games of the Cretan palaces. On one cup, bulls are being trapped and snared, with a cow used as a lure. Areas not filled by the animal and human figures contain landscape motifs of

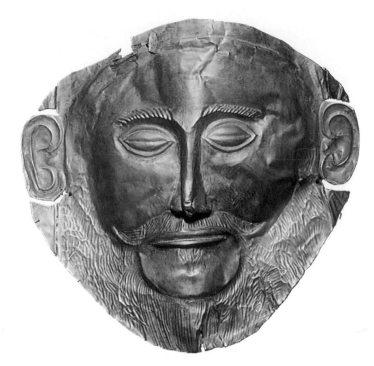

4-24 Funerary mask, from Grave Circle A, Mycenae, *c.* 1600–1500 B.C. Beaten gold, approx. 12″ high. National Archeological Museum, Athens.

trees, rocks, and clouds similar to those in contemporary Minoan paintings (compare the *Miniature Ships Fresco* from Akrotiri, FIG. 4-10). The two cups document once more the admiration of wealthy Mycenaean patrons for Minoan art. They also attest to the technical expertise of the Minoan or Mycenaean metalsmiths. Each vessel is made of two plates of gold. One plate was worked in repoussé for the outside of the cup, the other left plain to make a smooth surface for the inside. The plates were fastened together, the handles riveted on, and some of the details engraved.

Monumental figural art is very rare on the mainland, as on Crete, other than the Minoan-style paintings that once adorned the walls of Mycenaean palaces. The triangular relief of the Lion Gate at Mycenae is exceptional, as is the

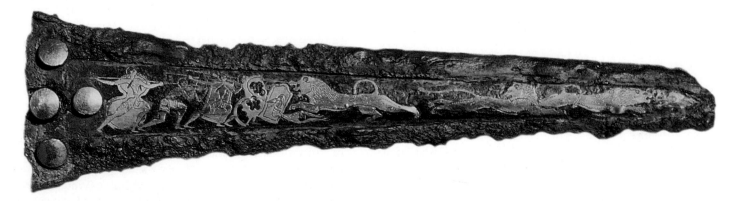

4-25 Inlaid dagger blade with lion hunt, from Grave Circle A, Mycenae. Bronze, inlaid with gold, silver, and niello, approx. 9″ long. National Archeological Museum, Athens.

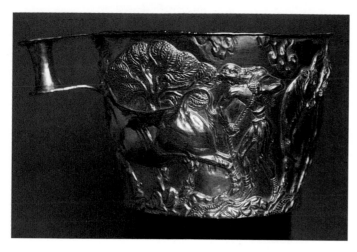

4-26 *Vaphio Cup* (one of a pair), from Vaphio, *c.* 1500 B.C. Gold with repoussé decoration, approx. 3¹/₂″ high. National Archeological Museum, Athens.

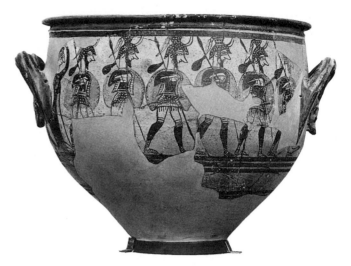

4-28 *Warrior Vase*, from Mycenae, *c.* 1200 B.C. Approx. 16″ high. National Archeological Museum, Athens.

almost life-size painted plaster head of a woman, goddess, or, perhaps, sphinx (FIG. **4-27**) found just outside the citadel of Mycenae. That the head is female is evident from the white flesh tone. The hair and eyes are painted dark blue, almost black, while the lips, ears, and headband are red. The cheeks and chin are decorated with red circles surrounded by a ring of red dots, recalling the facial paint or tattoos recorded on Early Cycladic figurines of women.

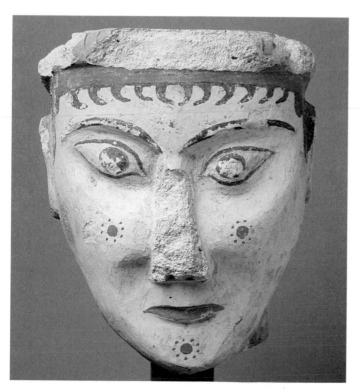

4-27 Head of a sphinx (?), from Mycenae, *c.* 1300–1250 B.C. Painted plaster, approx. 6¹/₂″ high. National Archeological Museum, Athens.

The large staring eyes give the face a menacing, if not terrifying, expression, appropriate for a guardian figure like a sphinx. Were it not for this head and one or two other exceptional pieces, we might conclude, wrongly, that the Mycenaeans had no monumental freestanding statuary—a reminder that it is always dangerous to generalize from the fragmentary remains of an ancient civilization. Nonetheless, life-size Aegean statuary must have been rare, and after the collapse of Mycenaean civilization any attempts at monumental statuary are not evident for several hundred years until, after the waning of the Dark Ages, Greek sculptors were exposed to the great sculptural tradition of Pharaonic Egypt.

One art that did continue throughout the period after the downfall of the Mycenaean palaces was the art of vase painting. One of the latest examples of Bronze Age painting is the *krater* (bowl for mixing wine and water) from Mycenae commonly called the *Warrior Vase* (FIG. **4-28**) after its prominent frieze of soldiers marching off to battle. At the left a woman bids farewell to the column of heavily armed warriors moving away from her. On this vase all indication of setting is gone and the landscape elements that characterized earlier Minoan and Mycenaean art are nowhere to be found. All the soldiers also repeat the same pattern, a far cry from the variety and anecdotal detail of the lively procession of the Minoan *Harvesters Vase* (FIGS. 4-15 and 4-16). This simplification of narrative is paralleled in other painted vases by the increasingly schematic and abstract treatment of marine life, where eventually the octopus, for example, becomes a stylized motif composed of concentric circles and spirals that are almost unrecognizable as a creature of the sea. By the time of Homer, as we have seen, the heyday of Aegean civilization was but a distant memory, and the men and women of Crete and Mycenae—Minos and Ariadne, Agamemnon and Helen— had assumed the stature of heroes of a lost golden age.

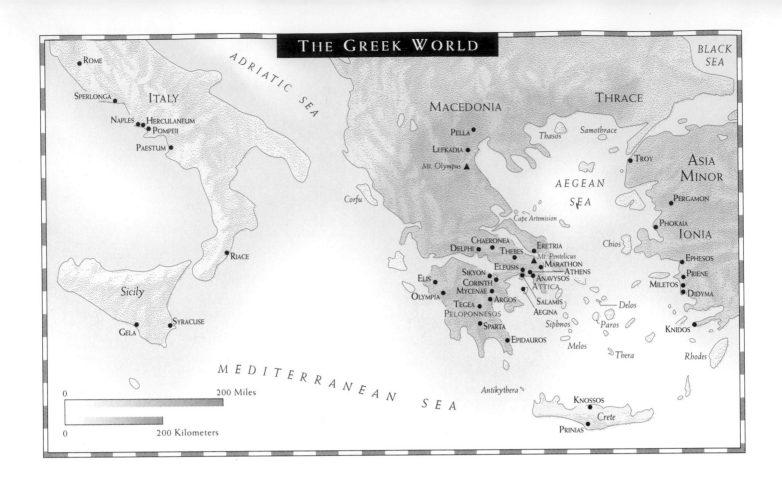

THE GREEK WORLD

BLACK SEA

ADRIATIC SEA

ROME

SPERLONGA

ITALY

NAPLES
HERCULANEUM
POMPEII

PAESTUM

MACEDONIA

THRACE

PELLA

Thasos

Samothrace

LEFKADIA

Mt. Olympus ▲

TROY

ASIA MINOR

AEGEAN SEA

Corfu

Cape Artemision

PERGAMON

PHOKAIA

Chios

IONIA

RIACE

Sicily

CHAERONEA
DELPHI
THEBES
Mt. Pentelicus
ELEUSIS
SIKYON
CORINTH
ELIS
MYCENAE
OLYMPIA
TEGEA
ARGOS
PELOPONNESOS
SPARTA
EPIDAUROS

ERETRIA
MARATHON
ATHENS
ANAVYSOS
ATTICA
SALAMIS
AEGINA

Delos

EPHESOS
PRIENE
MILETOS
DIDYMA

Siphnos
Paros
KNIDOS

GELA
SYRACUSE

Melos
Thera
Rhodes

MEDITERRANEAN SEA

Antikythera

KNOSSOS
Crete
PRINIAS

0 200 Miles

0 200 Kilometers

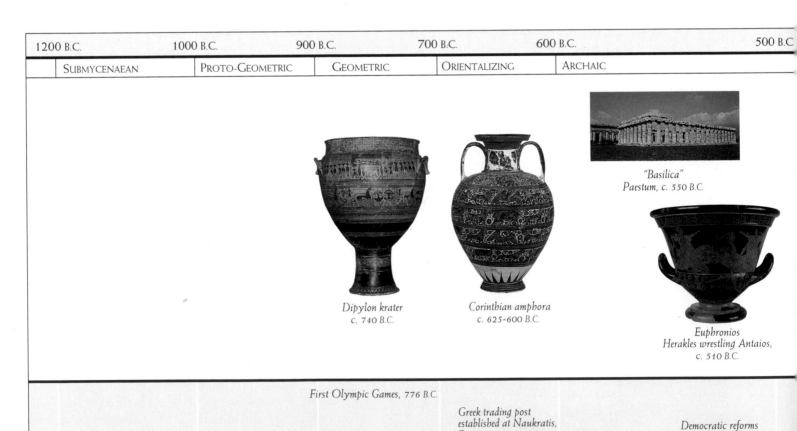

1200 B.C.	1000 B.C.	900 B.C.	700 B.C.	600 B.C.	500 B.C.
SUBMYCENAEAN	PROTO-GEOMETRIC	GEOMETRIC	ORIENTALIZING	ARCHAIC	

"Basilica"
Paestum, c. 550 B.C.

Dipylon krater
c. 740 B.C.

Corinthian amphora
c. 625-600 B.C.

Euphronios
Herakles wrestling Antaios,
c. 510 B.C.

First Olympic Games, 776 B.C.

Greek trading post
established at Naukratis,
Egypt, c. 650-630 B.C.

Democratic reforms
of Kleisthenes, 507 B.C.

Doric Invasions

Homer, fl. c. 750-700 B.C.

Sappho, fl. c. 600 B.C.

Aeschylus, 525-456 B.C.

CHAPTER 5

GREEK
ART

480 B.C.	450 B.C.	400 B.C.	323 B.C.	31 B.C.
EARLY CLASSICAL (Severe)	HIGH CLASSICAL	LATE CLASSICAL	HELLENISTIC	

Kritios Boy
c. 480 B.C.

Temple of Zeus
Olympia
c. 470-456 B.C.

Phidias
Athena Parthenos
c. 440 B.C.

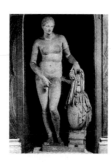

Praxiteles
Aphrodite of Knidos
c. 350-340 B.C.

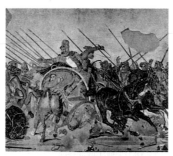

Philoxenos of Eretria
Battle of Issus
c. 310 B.C.

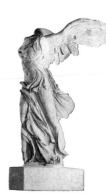

Nike of
Samothrace
c. 190 B.C.

Altar of Zeus
Pergamon
c. 175 B.C.

Delian League treasury transferred to Athens, 454 B.C.

Battle of Issus, 333 B.C.

Sack of Athens by Sulla, 86 B.C.

Persian Wars, 499-479 B.C. Peloponnesian War, 431-404 B.C.

Roman conquest of Greece, 146 B.C.

Sack of Athenian Acropolis
by Persians, 480 B.C.

Sophocles, 496-406 B.C.

Attalos III wills Pergamene kingdom to Rome, 133 B.C.

Euripides, 485-406 B.C.

Battle of Actium, 31 B.C.

Pericles, 490-429 B.C. Socrates, 469-399 B.C. Aristotle, 384-322 B.C.

Herodotus, c. 485-425 B.C. Plato, 429-347 B.C. Alexander the Great, r. 336-323 B.C.

For we are lovers of the beautiful, yet with simplicity, and we cultivate the mind without loss of manliness. . . . We are the school of Greece." In the fifth century B.C., the golden age of Athens, the historian Thucydides had Pericles, the leader of the Athenians, make this assertion in praise of his fellow citizens, comparing their open, democratic society with the closed, barracks-state of their rivals, the Spartans. But Pericles might have been speaking in general of Greek culture and of the ideal of humanistic education and life created by that culture. For the Greeks, man is what matters, and he is, in the words of the philosopher Protagoras, the "measure of all things."

This humanistic view of the world is what led the Greeks to create democracy (rule by the *demos*, the people) and to make seminal contributions in the fields of art, literature, and science. The Greek exaltation of humanity and honoring of the individual is so completely part of the modern Western habit of mind that we are scarcely aware of it and of its origin in the minds of the Greeks.

Even the gods of the Greeks, in marked contrast to the divinities of the Near East, assumed human forms whose grandeur and nobility were not free from human frailty; indeed, unlike the gods of Egypt and Mesopotamia, the Greek deities differed from human beings only in that they were immortal. It has been said that the Greeks made their gods into men and their men into gods. Man, becoming the measure of all things, in turn must represent, if all things in their perfection are beautiful, the unchanging standard of the best. To create the perfect individual became the Greek ideal, and to meet this challenge, one had first to comply with that typically Greek command, "Know thyself!"

The Greeks, or Hellenes, as they called themselves, appear to have been the product of an intermingling of Aegean peoples and Indo-European invaders. They never formed a single nation, but rather established independent city-states or *poleis* (sing., *polis*). The Dorians of the north, who many believe brought an end to Mycenaean civilization, settled in the Peloponnesos. Across the Aegean, the western coast of Asia Minor (modern Turkey) was settled by the Ionians, whose origin is disputed. Some say that they were forced out of Greece by the northern invaders and sailed from Athens to Asia Minor; others hold that the Ionians developed in Asia Minor itself between the eleventh and eighth centuries B.C. out of a mixed stock of settlers.

Whatever the origins of the various regional populations, political development differed from polis to polis, although a pattern emerged in which rule was first by kings, then by nobles, and then by tyrants who seized personal power. At last, in Athens, almost exactly twenty-five hundred years ago, the tyrants were overthrown and democracy established. (The anniversary was duly celebrated recently in Greece and marked in the United States by loan exhibitions of antiquities from Greek museums.)

In 776 B.C., the separate Greek-speaking states held their first ceremonial games in common at Olympia. It was from these first Olympic Games—the first Olympiad—that the later Greeks calculated their chronology. From then on, despite their differences and rivalries, they regarded themselves as Hellenes, distinct from the surrounding "barbarians" who did not speak Greek. The enterprising Hellenes, greatly aided by their indented coasts and island stepping-stones, became a trading and colonizing people who enlarged the geographic and cultural boundaries of Hellas. In fact, today the best preserved of all the grand temples erected by the Greeks are to be found not in Greece proper but in their western colonies in Italy.

Nonetheless, Athens, the capital of the modern nation of Greece, has justifiably come to be the symbol of ancient Greek culture. It is there that many of the finest products of Greek civilization were created. It is there that the great plays of Aeschylus, Sophocles, and Euripides were performed before the Athenian citizenry; and there, in the city's marketplace (*agora*), covered colonnades (*stoas*), and gymnasiums (*palestras*) Socrates engaged his fellow citizens in philosophical argument and Plato set down his prescription for the ideal form of government in the *Republic*.

The rich intellectual life of ancient Athens was complemented by a strong interest in physical exercise, which played a large role in education as well as in daily life. The Athenian aim of achieving a balance of intellectual and physical discipline, an ideal of humanisitic education, is expressed in the Latin phrase *mens sana in corpore sano* (a sound mind in a sound body).

The distinctiveness and originality of Greek contributions in art, science, and politics should not, however, obscure the enormous debt that Greek civilization owes to the earlier great cultures of Egypt and the Near East. This debt is increasingly recognized by scholars today and the ancient Greeks themselves readily acknowledged borrowing ideas, motifs, conventions, and skills from these older civilizations.

Nor should our high estimation of Greek art and culture blind us to the realities of Greek life and society. The eighteenth and nineteenth centuries' uncritical admiration of anything Greek has undergone sharp revision in our own time. Not only have many modern artists rejected Greek standards (the late nineteenth-century French painter, Paul Gauguin, called Greek art "a lie!"), but even Athenian "democracy" was a political reality for only one segment of the demos.

Slavery was regarded as natural, even beneficial, and was a universal institution among the Greeks. Aristotle declared at the beginning of his *Politics*: "It is clear that some are free by nature, and others are slaves." Greek women were secluded in their homes, emerging usually only for weddings, funerals, and religious festivals, and played little part in public or political life. And despite the fame of the poet Sappho, only a handful of female artists' names are

known, and none of their works has survived. The existence of slavery and the exclusion of women from public life are both reflected in Greek art, where on many occasions free-born men and women appear with their slaves in monumental sculpture and where the symposium (attended only by men and prostitutes) is a popular subject on painted vases.

Although the Greeks invented and passed on to us the concept and practice of democracy, most Greek states, even those constituted as democracies, were dominated by well-born white males, and the most admired virtues were not wisdom and justice, but statecraft and military valor. Greek men were educated in the values of the heroes of Homer and the athletic exercises of the palestra. War among the city-states was chronic and often atrocious. Fighting among themselves and incapable of unification, the Greeks eventually fell prey to the autocracy of Macedon and the imperialism of Rome.

THE GEOMETRIC AND ORIENTALIZING PERIODS (NINTH–SEVENTH CENTURIES B.C.)

The destruction of the Mycenaean palaces was accompanied by the disintegration of the Bronze Age social order. The disappearance of powerful kings and their retinue was followed by the loss of the knowledge of how to cut masonry and construct citadels and tombs, and of how to paint frescoes, fashion tableware in precious metals, and sculpt in stone. Even the art of reading and writing was forgotten. The succeeding centuries, the Dark Age of Greece, were characterized by depopulation, poverty, and an almost total loss of contact with the outside world.

Only in the eighth century B.C. did economic conditions improve and the population begin to grow again. This era was in its own way a heroic age, a time when the poleis of Classical Greece took shape; when the Greeks broke out of their isolation and once again began to trade with cities both in the east and the west; when the epic poems of Homer, formerly memorized and passed down from bard to bard, were recorded in written form; and when the Olympic Games were established.

Geometric Art

It is also during the eighth century that we see the return of the human figure to Greek art—not, of course, in monumental statuary, which was exceedingly rare even in Bronze Age Greece, but painted on the surfaces of ceramic pots, which continued to be manufactured after the fall of Mycenae and even throughout the Dark Age.

One of the earliest examples is to be found on the swelling "belly" between the handles of a huge *amphora* (a two-handled storage jar, FIG. **5-1**) that marked the grave of

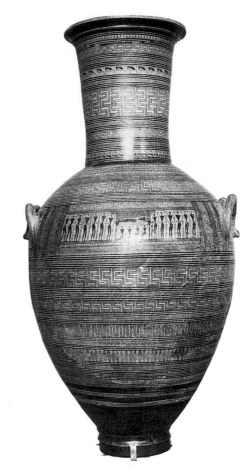

5-1 DIPYLON MASTER, *Dipylon Vase* (Attic Geometric amphora), from the Dipylon cemetery, Athens, *c.* 750 B.C. Approx. 61″ high. National Archeological Museum, Athens.

an Athenian buried around 750 B.C. in the city's Dipylon cemetery. Roughly the height of a man or woman in the eighth century B.C., the *Dipylon Vase* is a grand technical achievement and testifies both to the skill of the potter and to the wealth and position of the deceased's family in the community. The bottom of the great vessel is open, perhaps to permit visitors to the grave to pour libations in honor of the dead, perhaps simply to provide a drain for rainwater, or both. From top to bottom the surface is covered with precisely painted abstract angular motifs, especially the meander, or key, pattern, in horizontal bands of varying height. The nature of the ornament has led art historians to designate the formative period of Greek art represented by this amphora as Geometric.

On the *Dipylon Vase* a small panel was set aside at the widest part of the amphora for the introduction of human figures. Befitting the function of the vase as a grave marker, the scene is one of mourning for a dead Athenian (at this early date the gender of the deceased is not specified), who is laid out on a bier. The shroud, which has been raised by two attendants to reveal the corpse, is an abstract checkerboard-like backdrop and the funerary couch has

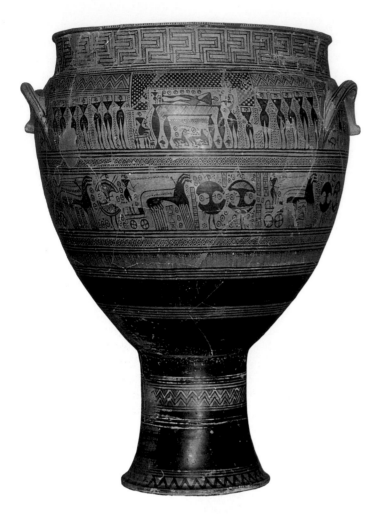

only two legs because the artist has no interest in suggesting depth or representing space; the human figures and the furniture are as two-dimensional as the geometric shapes elsewhere on the amphora. Every empty surface has been filled with asterisks and M-shaped ornament, further negating any sense that the mourners inhabit open space. The figures themselves are silhouettes constructed of triangular (frontal) torsos to which profile arms, legs, and heads have been attached, following the age-old convention. The mourners show their grief by tearing their hair; not only has the human figure been reintroduced into the Greek repertoire, but the art of storytelling has been resuscitated, albeit in a highly stylized and conventional manner. This is a significant turning point in the history of Greek art.

The interest in narrative is even more pronounced in a slightly later krater (FIG. **5-2**), also of monumental scale and used as a grave marker in the Dipylon cemetery. Here the geometric ornament becomes secondary, and two large figural bands dominate the surface. In the upper band, the mourning scene of the *Dipylon Vase* has been expanded to take up the full area between the handles. The silhouette figures are somewhat more detailed. The profile heads have been rendered in outline so that a single frontal eye can be placed on the face and the two sexes have been distinguished. The deceased is a man, with his penis shown as if it were growing out of one of his thighs; the mourning women's breasts are added beneath their armpits. In both cases the artist is concerned with specifying gender, not with anatomical accuracy. Below, a grand procession in honor of the deceased is represented. The chariots are

5-2 Attic Geometric krater (general view and detail), from the Dipylon cemetery, Athens, *c.* 740 B.C. Approx. 40¹⁄₂" high. Metropolitan Museum of Art, New York. Rogers Fund.

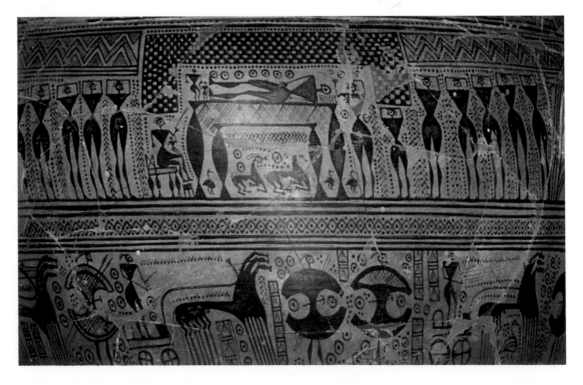

accompanied by warriors who are drawn as if they are walking shields and, in the old conceptual manner, both wheels of the chariots are shown. The horses have the correct number of heads and legs, but seem to share a common body, negating any sense of depth. Geometric ornament continues to fill empty spaces.

Similarly stylized figures also appear in the round at this date, but only at very small scale. One of the most impressive surviving Geometric sculptures is a small solid-cast bronze group (FIG. **5-3**) of a hero, probably Herakles, battling a centaur (a mythological beast that was part man, part horse), possibly Nessos, the centaur who had volunteered to carry the hero's bride across a river and then assaulted her. Whether or not the hero is Herakles and the centaur is Nessos, the mythological nature of the group is certain; the repertoire of the Geometric artist was not limited to scenes inspired by daily life (and death).

Composite monsters were, as we have seen, enormously popular in Egypt and the ancient Near East and renewed contact with foreign cultures may have inspired such figures in Geometric Greece. The centaur is, however, a purely Greek invention—and one that posed a problem for the artist, who had, of course, never seen such a creature. The Geometric centaur is conceived as a man in front and a

horse in back, a rather unhappy and unconvincing configuration that results in fore- and hindlegs belonging to different species. The figure of the hero and the human part of the centaur are rendered in a similar fashion; both are bearded and wear helmets, but (contradictory to nature) the man is larger than the horse, probably to suggest that he will be the victor. Like other Geometric male figures, both painted and sculptured, this hero is nude, in contrast to the Near Eastern statuettes that might have inspired such Greek works. Here, at the very beginning of Greek figural art, we can observe the Hellenic instinct for the natural beauty of the human figure, which is reflected in the fact that Greek athletes exercised without their clothes and even competed nude in the Olympic Games from very early times.

Orientalizing Art

A half century later Greek sculptors were producing bronze figurines that are more and more detailed, with much closer attention paid to human anatomy. A splendid example is the small bronze statuette, the so-called *Mantiklos Apollo* (FIG. **5-4**), dedicated to Apollo at Thebes by an otherwise unknown man named Mantiklos. With characteristic pride in the ability to write, the sculptor (or another) has scratched into the thighs of the figure a message from the dedicator to the deity: "Mantiklos dedicated me as a tithe to the far-shooting Lord of the Silver Bow; you, Phoibos [Apollo], might give some pleasing favor in return." Because the Greeks conceived their gods in human form we cannot be sure whether the figure is meant to represent the youthful Apollo or Mantiklos (or neither), but if the left hand at one time held the bow cited in the dedication, then we are dealing with an image of the deity. In either case, the purpose of the votive offering is clear. Equally apparent is the increased interest of the artist in reproducing details such as the youthful figure's long hair (resulting in an unnaturally elongated neck) and the pectoral and abdominal muscles, which give definition to the stylized triangular torso. The triangular face has eye sockets that were once inlaid, and there may have been a separately fashioned helmet on the head.

The *Mantiklos Apollo* is a product of the seventh century B.C., a time when the pace and scope of Greek trade and colonization accelerated and when Greek artists were exposed more than ever before to Eastern works of art, especially small portable objects like Syrian ivory carvings. The closer contact had a profound effect on the development of Greek art; indeed, so many motifs borrowed from or inspired by Egyptian and Near Eastern works of art entered the Greek pictorial vocabulary at this time that the seventh century has been dubbed the "Orientalizing" period.

The potters and painters of the mercantile city of Corinth were especially successful in selling their Orientalizing

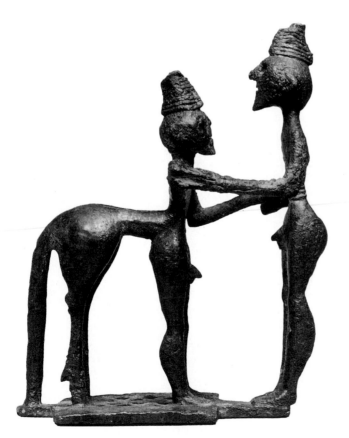

5-3 Hero and centaur (Herakles and Nessos?), c. 750–730 B.C. Bronze, approx. 4¹/₂" high. Metropolitan Museum of Art, New York, Gift of J. Pierpont.

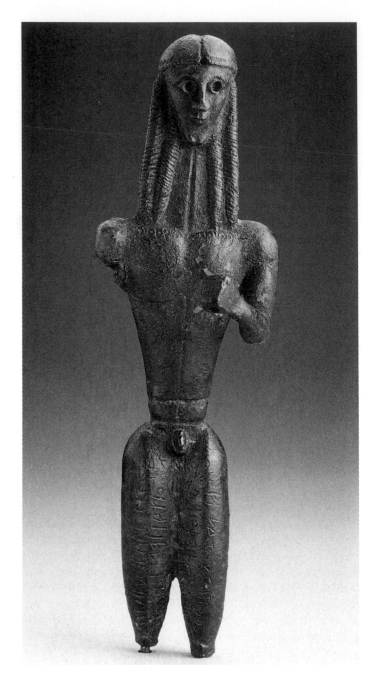

5-4 *Mantiklos Apollo*, statuette of a youth dedicated by Mantiklos to Apollo, from Thebes, *c.* 700–680 B.C. Bronze, approx. 8" high. Courtesy, Museum of Fine Arts, Boston.

bird, part woman) that is prominently displayed on the amphora's neck.

The appeal of such vases was not due solely to their Orientalizing animal friezes, but also to a new ceramic technique invented by the Corinthians, which we call *black-figure* painting. The black-figure painter first puts down black silhouettes on the clay surface, as in Geometric times, but then uses a sharp, pointed instrument to incise linear details within the forms, usually adding highlights in purplish-red or white over the black figures before firing the vessel. The combination of the weighty black silhouettes with the delicate detailing and the bright polychrome overlay proved to be irresistible and, as we shall see, Athenian painters soon copied the technique from the Corinthians.

Although the black areas are customarily referred to as "glazes," it should be pointed out that the black on these Greek pots is neither a pigment nor a glaze but *engobe,* a slip of finely sifted clay that originally is of the same color as the clay of the pot. In the three-phase firing process used by

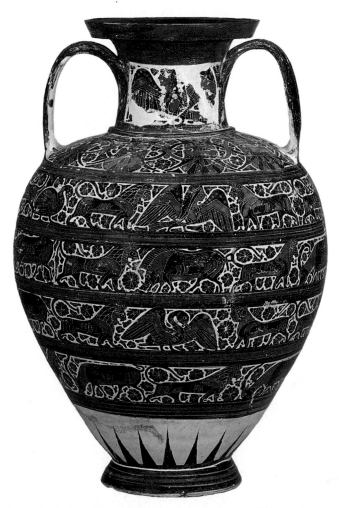

5-5 Corinthian black-figure amphora with animal friezes, from Rhodes, *c.* 625–600 B.C. Approx. 14" high. British Museum, London.

vases all over the ancient Mediterranean. The amphora illustrated here (FIG. **5-5**) was found on the island of Rhodes, at the opposite side of the Aegean from mainland Corinth, and is typical of its genre. In a series of bands that recalls the organization of Geometric painted vases, animals like the native boar appear beside exotic lions and panthers and composite creatures inspired by eastern monsters like the sphinx and lamassu—in this instance the siren (part

Greek potters, the first (oxidizing) phase turns both pot and slip red; during the second (reducing) phase, the oxygen supply into the kiln is shut off and both pot and slip turn black; in the final (reoxidizing) phase, the coarser material of the pot reabsorbs oxygen and becomes red again, while the smoother, silica-laden slip does not and remains black. After long experiment, Greek potters developed a velvety, jet-black "glaze" of this kind. The touches of purplish-red and white were used more sparingly, resulting in an even stronger contrast of figures against the reddish backgrounds.

The foundation of the Greek trading colony of Naukratis in Egypt before 630 B.C. brought the Greeks into direct contact with the monumental stone architecture of the Egyptians; not long after that the first stone buildings since the fall of the Mycenaean kingdoms began to be constructed in Greece. At Prinias on Crete, for example, a stone temple (FIG. **5-6**) was built around 625 B.C. to honor an unknown deity. Although the inspiration for the structure came from the East, the form resembles that of a typical Mycenaean megaron, like that at Tiryns (FIG. 4-19), with a hearth or sacrificial pit flanked by two columns in the cella. The facade consisted of three great piers; the roof was probably flat.

Above the doorway of the Prinias temple was a huge limestone lintel (FIG. **5-7**) surmounted by confronting statues of seated women, probably goddesses, wearing tall headdresses and capes. Two other similarly dressed, but standing, goddesses are carved on the underside of the

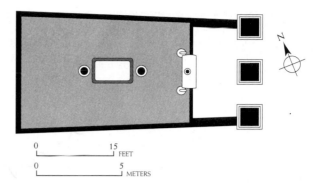

5-6 Plan of Temple A, Prinias, *c.* 625 B.C.

block, visible to those entering the temple. On the face of the lintel is a frieze of Orientalizing panthers with frontal heads—the same motif as that on the contemporary Corinthian black-figure amphora (FIG. 5-5). Temple A at Prinias is the earliest example we have of a Greek temple with sculptured decoration.

Somewhat earlier than the Prinias temple and probably also originally from Crete is a limestone statuette of a goddess or maiden (*kore*, pl. *korai*) popularly known as the *Lady of Auxerre* (FIG. **5-8**) after the French town that is her oldest recorded provenance. As with the figure dedicated by Mantiklos, it is uncertain whether the young woman is a mortal or a deity. She wears a long skirt and a cape, as do the Prinias women, but the Auxerre maiden has no headdress, and the right hand placed across the chest is probably

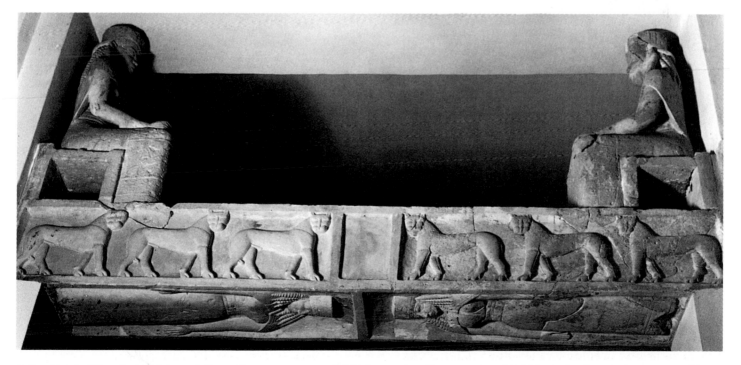

5-7 Lintel of Temple A, Prinias, *c.* 625 B.C. Limestone, approx. 33″ high; seated goddesses approx. 32″ high. Archeological Museum, Herakleion.

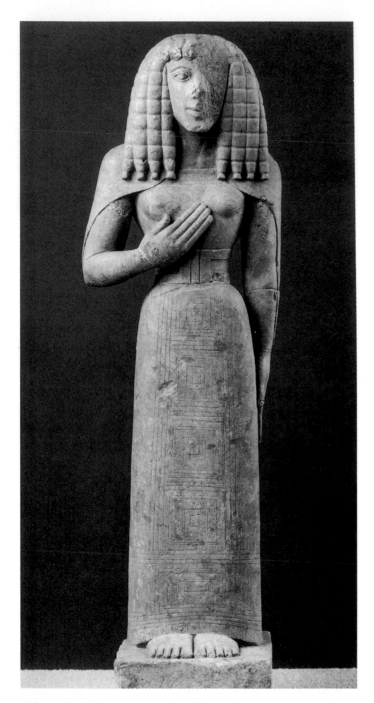

5-8 *Lady of Auxerre,* statue of a goddess or kore, *c.* 650–625 B.C. Limestone, approx. 25¹/₂" high. Louvre, Paris.

a gesture of prayer, indicating that this is a kore. Despite its monumental quality, the statue is only a little over 2 feet tall—smaller than the seated goddesses of the Prinias lintel but much larger than the bronze statuettes of the era.

The *Lady of Auxerre* is the masterpiece of a style that is usually referred to as *Daedalic,* after the legendary artist, Daedalus, whose name means "the skillful one." Characteristic of the style is the triangular flat-topped head framed by long strands of hair that form complementary

triangles to that of the face. Also typical are the small belted waist and a fondness for pattern: note the almost Geometric treatment of the long skirt with its incised concentric squares, once brightly painted.

THE ARCHAIC PERIOD (SIXTH CENTURY B.C.)

In addition to having been a great sculptor, Daedalus was said to have built the labyrinth in Crete to house the Minotaur and also to have designed a temple at Memphis in Egypt. The historical Greeks attributed to him almost all the great achievements in early sculpture and architecture before the names of artists and architects were recorded. The story that Daedalus worked in Egypt is a reflection of the enormous impact of Egyptian art and architecture upon the Greeks of the aptly named Orientalizing age, as well as on their offspring in the succeeding Archaic period.

Statuary

KOUROI According to one Greek writer, Daedalus used the same compositional patterns for his statues as the Egyptians used for their own, and the first truly monumental stone statues of the Greeks follow very closely the canonical Egyptian format. A life-size marble *kouros* (youth, pl. *kouroi*) in the Metropolitan Museum of Art (FIG. **5-9**) emulates the stance of Egyptian statues; compare, for example, the portrait of Mentemhet (FIG. 3-45) carved only a half century before the Greek statue. In both cases the figure is rigidly frontal with the left foot advanced slightly. The arms are held beside the body and the fists are clenched with the thumbs forward. The New York kouros even served a funerary purpose; it is said to have stood over a grave in Attica, the region of Greece centered on Athens. Such statues replaced the huge amphoras and kraters of Geometric times as the preferred form of grave marker in the sixth century B.C. They were also used as votive offerings in sanctuaries (at one time it was thought that all kouroi were images of Apollo) and the kouros type, because of its very ambiguity, could be employed in several different contexts.

Despite the adherence to Egyptian prototypes, the Greek kouros statue differs from its Oriental brethren in two important ways. First, it has been liberated from the stone block from which it was fashioned. The Egyptian obsession with permanence was alien to the Greeks, who, we shall see, will be preoccupied with finding ways to represent motion rather than stability in their sculptured figures. Second, the Greek statue is nude and, in the absence of attributes, the monumental marble kouros, like the tiny bronze dedicated by Mantiklos (FIG. 5-4), is formally indistinguishable from Greek statues of deities with their perfect bodies exposed for all to see.

The New York kouros shares many traits with Greek Orientalizing works like the *Mantiklos Apollo* and the *Lady of Auxerre*, especially the triangular shape of head and hair and the flatness of the face. Eyes, nose, and mouth all sit on the front of the head, ears are placed on the sides, and the long hair forms a flat backdrop behind the head. In every instance we see the result of the sculptor's having drawn these features on four independent sides of his marble

block, following the same workshop procedure as was used in Egypt for millennia. The New York kouros also has the slim waist of earlier Greek statues, and the same love of pattern may be discerned. The pointed arch of the rib cage, for example, echoes the V-shaped ridge of the hips, which suggests but does not accurately reproduce the rounded flesh and muscle of the human body.

A generation later than the New York kouros is the statue of a *moschophoros*, a calf-bearer (FIG. **5-10**), found on the Athenian Acropolis in fragments, but preserving its inscribed base stating that a man whose name has been

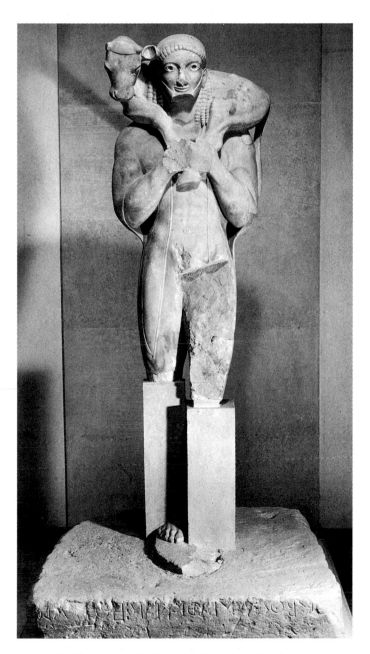

5-9 Kouros, from Attica, *c.* 600 B.C. Marble, approx. 6′ ¹/₂″ high. Metropolitan Museum of Art, New York.

5-10 Calf-bearer (*Moschophoros*), dedicated by Rhonbos on the Acropolis, Athens, *c.* 560 B.C. Marble, restored height approx. 5′ 5″. Acropolis Museum, Athens.

reconstructed as Rhonbos dedicated the statue. Rhonbos is almost certainly the calf-bearer himself bringing an offering to Athena in thanksgiving for his prosperity. He stands in the left-foot-forward manner of the kouroi, but he is bearded and therefore no longer a youth. He wears a thin cloak (which once was set off from the otherwise nude body by paint). No one dressed in such a manner in ancient Athens; the sculptor has adhered to the artistic convention of male nudity and attributed to the calf-bearer the noble perfection that such nudity suggests, and at the same time indicated that this mature gentleman is clothed, as any respectable citizen would be in such a context. The Archaic sculptor's love of pattern is paramount once again in the way he has tackled the difficult problem of representing man and animal together: the legs of the calf and the arms of the moschophoros form a bold X that unites the two bodies both physically and formally.

The calf-bearer's face differs markedly from those of earlier Greek statues (and those of Egypt and the Near East also) in one notable way: the man smiles—or seems to. From this time on, Archaic Greek statues will smile at us, even in the most inappropriate contexts (see, for example FIG. 5-31, where a dying warrior with an arrow in his chest grins broadly at the spectator!). This so-called Archaic smile has been variously interpreted, but it is not to be taken literally. Rather, the smile seems to be the Archaic sculptor's way of indicating that the subject of his statue is alive, and in adopting such a convention the Greek artist is signaling a very different intention from that of his counterpart in Egypt.

Sometime around 530 B.C. a young man named Kroisos died a hero's death in battle, and his grave at Anavysos, not far from Athens, was marked by a kouros statue (FIG. **5-11**) with an inscribed base inviting the visitor to "stay and mourn at the tomb of dead Kroisos, whom raging Ares [the Greek god of war] destroyed one day as he fought in the foremost ranks." The statue, with its distinctive Archaic smile, is no more a portrait of a specific youth than is the New York kouros. But two generations have passed and the Greek sculptor has greatly refined the type, and, without rejecting the Egyptian stance, has rendered the human body in a far more naturalistic manner. The head is no longer too large for the body, and the face is more rounded, with swelling cheeks replacing the flat planes of the earlier work. The long hair does not form a stiff backdrop to the head but falls naturally over the back; rounded hips replace the V-shaped ridges of the New York kouros.

The original paint survives in part on the Kroisos statue, enhancing the sense of life. All Greek stone statues were painted; the modern notion that Classical statuary was pure white is mistaken. The Greeks did not, however, color their statues garishly. The flesh was left in the natural color of the stone, which was waxed and polished, while eyes, lips, hair, and drapery were painted. The painting was done in the very durable technique of *encaustic*, in which pigment is mixed with wax and applied to the surface while

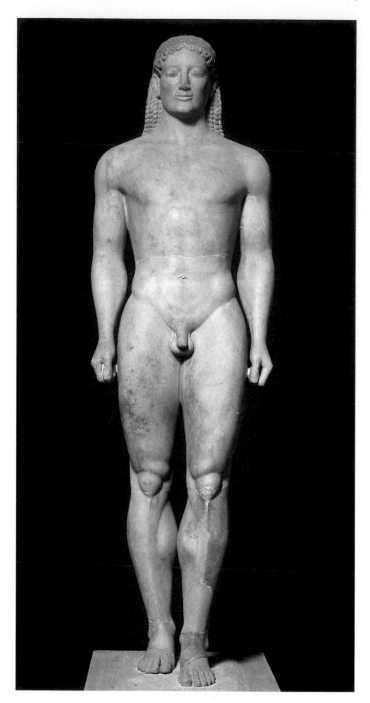

5-11 *Kroisos,* from Anavysos, *c.* 530 B.C. Marble, approx. 6' 4" high. National Archeological Museum, Athens.

hot. This method was widely used for paintings on wooden panels as well as in the embellishment of statues.

KORAI A stylistic "sister" to the Kroisos kouros is the statue of a kore wearing a *peplos* (FIG. **5-12**), a simple long woolen belted garment that gives the female figure a columnar appearance. Traces of paint are preserved here also (and for the same reason): the statue was covered by earth for nearly twenty-five hundred years, protecting the painted surface from the destructive effects of exposure to

the atmosphere and especially to bad weather. The *Peplos Kore*, as she is affectionately known, was, like the earlier statue of the calf-bearer (FIG. 5-10), thrown down by the Persians during their sack of the Acropolis in 480 B.C. (discussed later) and shortly thereafter buried by the Athenians themselves. Before that time, she stood as a votive offering in Athena's sanctuary. Her missing left arm was extended, a break from the frontal compression of the arms at the sides in Egyptian statues. She once held in her hand an attribute that would identify the figure as a maiden or, as has been suggested recently, a goddess, perhaps Athena herself. Whatever her identity, the contrast with the *Lady of Auxerre* (FIG. 5-8) is striking. Although in both cases the drapery conceals the entire body save for head, arms, and feet, the

later sculptor has given us a much more natural rendition of the soft female form, sharply differentiating it from the hard muscular body of the kouros.

The *Peplos Kore* is one of the latest dedications on the Acropolis to wear that garment. By the later sixth century, the light linen Ionian *chiton*, worn in conjunction with a heavier *himation* (mantle), was the garment of choice for fashionable women. Archaic sculptors delighted in rendering the intricate patterns created by the cascading folds of thin, soft material, as may be seen in another kore (FIG. **5-13**) buried on the Acropolis after the Persian destruction. The asymmetry of the folds greatly relieves the stiff frontality of the bodies and makes these figures appear much more lifelike than contemporary kouros statues. Added

5-12 *Peplos Kore*, from the Acropolis, Athens, *c.* 530 B.C. Marble, approx. 4′ high. Acropolis Museum, Athens.

5-13 Kore, from the Acropolis, Athens, *c.* 510 B.C. Marble, approx. 21¹/₂″ high. Acropolis Museum, Athens.

variety is achieved by showing the kore grasping part of her chiton in her left hand (unfortunately broken off in this statue) to lift it off the ground as she takes a step forward. This is the equivalent of the advanced left foot of the kouroi, and is standard for statues of korai; despite the variety in the surface treatment of their brightly colored garments, the postures of the korai are as fixed as those of their male counterparts.

Architecture and Architectural Sculpture

Already in the Orientalizing seventh century B.C., at Prinias, the Greeks had built a stone temple embellished with stone sculptures (FIGS. 5-6 and 5-7), but despite the contemporary Daedalic style of its statues and reliefs, the Cretan temple resembled the megaron of a Mycenaean palace more than anything Greek traders had seen in their travels overseas. In the Archaic age of the sixth century, with the model of Egyptian columnar halls like that at Karnak (FIG. 3-29) before them, Greek architects began to build the gable-roofed columnar stone temples that have been more influential on the later history of architecture in the Western world than any other building type ever devised.

Greek architecture and its Roman and Renaissance descendants and hybrids are almost as familiar to us as modern architecture. The so-called Greek revival instituted by European architects in the late eighteenth century brought about a wide diffusion of the Greek architectural style; official public buildings (courthouses, banks, city halls, legislative chambers), designed for impressive formality, especially imitated the architecture of Classicism, which was fundamentally Greek in inspiration. The ancient Greeks were industrious builders, even though their homes were unpretentious places, they had no monarchs to house royally until Hellenistic times, and they performed religious rites in the open. Their temples were not places within which the faithful gathered to worship a deity, as in most of the modern religions of the world. The altar lay outside the temple, at the east end, facing the rising sun, and the temple proper was a shrine for that grandest of all votive offerings to the deities, the cult statue. Both in its early and mature manifestations, the Greek temple was the house of the god or goddess, not of his or her followers.

Figural sculpture played a major role in the exterior program of the Greek temple from early times, partly to embellish the god's shrine, partly to tell something about the deity symbolized within, and partly as a votive offering. But the building itself, with its finely carved capitals and moldings, also was conceived as sculpture, abstract in form and possessing the power of sculpture to evoke human responses. The commanding importance of the sculptured temple, its inspiring function in public life, was emphasized in its elevated site, often on a hill above the city (the *acropolis* or "high city"). As Aristotle stipulated: "The site should be a spot seen far and wide, which gives due elevation to virtue and towers over the neighborhood."

Many of the earliest Greek temples do not survive because they were made of wood and mud brick. Pausanias, who wrote an invaluable guidebook to Greece in the second century A.D., noted that in the even-then ancient Temple of Hera at Olympia, one oak column was still in place; the others had been replaced by stone columns. Archaic and later Greek temples were, however, built of more permanent materials—limestone in many cases, and, where it was available, marble, which was more impressive (and more expensive). In Greece proper, if not in its colonies in the west, marble was readily at hand: bluish-white stone came from Hymettus, just east of Athens; glittering white stone particularly adapted for carving was brought from Pentelicus, northeast of the city; and from the islands of the Aegean, Paros in particular, marble of varying quantities and qualities was supplied.

In its canonical plan (FIG. **5-14**) the Greek temple still discloses a close affinity with the Mycenaean megaron (FIG. 4-19) and, even in its most elaborate form, it retains the latter structure's basic simplicity. The core of the temple was the *naos* or cella, a room with no windows that housed the cult statue of the deity. As in the megaron, it was preceded by a porch, or *pronaos,* usually with two columns between the extended walls (columns *in antis,* that is, between the *antae*). A smaller second room might be placed behind the cella, but in its classical form, the Greek temple had a porch at the rear also (*opisthodomos*), set against the blank back wall of the cella; the purpose was not functional but rather decorative, satisfying the Greek passion for balance and symmetry. A colonnade could be placed across the front of the temple (*prostyle*), across both front and back (*amphiprostyle,* FIG. 5-61), or, more commonly, all around the cella and its porch(es) to form a *peristyle.* Single (*peripteral*) colonnades are the norm, but double (*dipteral*) colonnades were features of especially elaborate temples (FIG. 5-84).

In all cases, what strikes the eye first in the Greek scheme is its remarkable order, compactness, and symmetry, reflecting the Greeks' sense of proportion and their effort to achieve ideal forms in terms of regular numerical relationships and the rules of geometry. Whether the plan is simple or more complex, there is no fundamental change in the nature of the units or of their grouping. Classical Greek

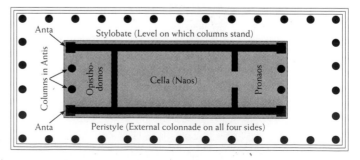

5-14 Ground plan of a typical Doric temple.

architecture, like classical music, has a simple core theme from which a series of complex, but always quite intelligible, variations is developed. And, to change the analogy, the development of the temple scheme is like that other great invention of the Greeks, geometry, in which theorems, propositions, and their corollaries are deduced from a simple original set of axioms. The Greeks' insistence on proportional order guided the experiments with the proportions of temple plans. The earliest temples tended to be long and narrow, with the proportion of the ends to the sides roughly expressible as 1:3. From the sixth century on, plans approached but rarely had a proportion of exactly 1:2, with Classical temples tending to be a little longer than twice their width. Proportion in architecture and sculpture, and harmony in music, were much the same to the Greek mind and reflected and embodied the cosmic order.

DORIC AND IONIC ORDERS The elevation of a Greek temple is described in terms of the platform, the colonnade, and the superstructure (*entablature*). In the Archaic period, two basic systems evolved for articulating the three units; these are the so-called orders of Greek architecture (FIG. **5-15**). The orders are differentiated both in the nature of the details and in the relative proportions of the parts. The orders take their names from the geographical regions of Greece in which they were most commonly employed. The *Doric* was formulated on the mainland and remained the preferred manner there and in the western colonies of the Greeks. The *Ionic* was the order of choice in the Aegean Islands and on the western coast of Asia Minor. The geographical distinctions are by no means absolute; the Ionic order is, for example, often used in Athens (where, according to some, the Athenians were considered to be Ionians who never migrated).

In both orders, the columns rest on the *stylobate*, the uppermost course of the platform. The blocks of stone in each horizontal course were held together by metal clamps, while those of different courses, one above the other, were joined vertically by metal dowels. The columns have two or three parts, depending on the order: the *shaft*, which is marked with vertical channels (*flutes*); the *capital*; and, in the Ionic order, the *base*. Greek column shafts, in contrast to their Minoan and Mycenaean forebears, taper gradually from bottom to top. They are usually composed of separate *drums* joined by metal dowels to prevent turning as well as shifting, although instances of the use of monolithic columns are known. In the Doric order, the top of the shaft is marked with one or several horizontal lines (*necking*) that furnish the transition to the capital. The capital has two elements, the lower of which (the *echinus*) varies with the order: in the Doric, it is convex and cushionlike, similar to the echinus of Minoan and Mycenaean capitals; in the Ionic, it is small and supports a bolster ending in scroll-like spirals (the *volutes*). The upper element, present in both orders, is a flat, square block (the *abacus*) that provides the immediate support for the entablature.

The entablature has three parts: the *architrave* or *epistyle*, the main weight-bearing and weight-distributing element; the *frieze*; and the *cornice*, a molded horizontal projection that together with two sloping (*raking*) cornices forms a triangle that enframes the *pediment*. In the Ionic order, the architrave is usually subdivided into three horizontal bands (*fasciae*). In the Doric order, the frieze is subdivided into *triglyphs* and *metopes*, while in the Ionic, the frieze is left open to provide a continuous field for relief sculpture.

Many of the parts of the Doric order seem to be translations into stone of an earlier timber architecture. The organization of the frieze into triglyphs and metopes, for

5-15 Doric and Ionic orders.

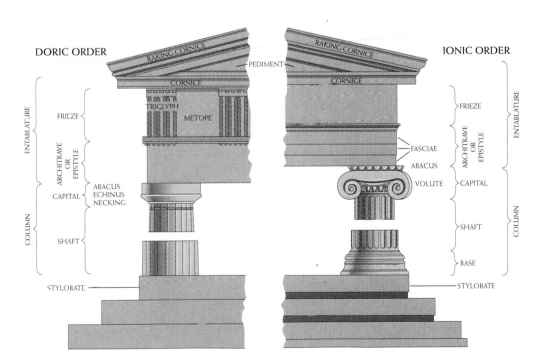

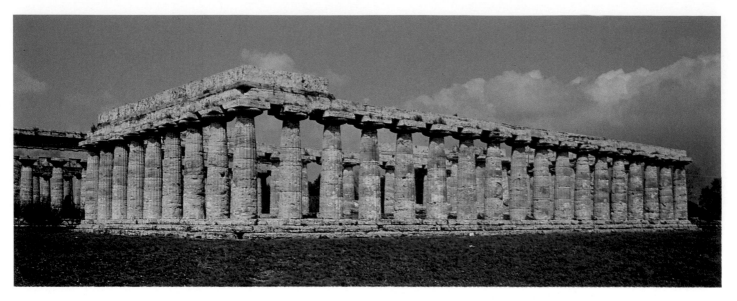

5-16 Temple of Hera I ("Basilica"), Paestum, *c.* 550 B.C.

example, can be explained best as a stone version of what was originally carpentry. The triglyphs most likely derived from the ends of crossbeams that rested on the main horizontal support, the architrave. The metopes would then correspond to the voids between the beam ends in the original wooden structure.

The Doric order is massive in appearance, its sturdy columns firmly planted on the stylobate. Compared with the weighty and severe Doric, the Ionic order seems light, airy, and much more decorative. Its columns are more slender and rise from molded bases. The Doric flutes meet in sharp ridges (*arrises*), but the Ionic ridges are flat (*fillets*). The most obvious differences betweeen the two orders are, of course, in the capitals: the Doric, severely plain; the Ionic, highly ornamental.

Sculptural ornament, which played an important part in the design of the Greek temple, was concentrated on the upper part of the building, in the frieze and pediments. Architectural sculpture, like freestanding statuary, was painted, and usually was placed only in those parts of the building that had no structural function. This is true particularly of the Doric order, in which decorative sculpture was applied only to the "voids" of the metopes and of the pediment. Ionic builders, less severe in this respect as well, were willing to decorate the entire frieze and sometimes even the lower drums of columns. Occasionally, they replaced their columns with female figures (*caryatids*; FIGS. 5-20 and 5-60). Using color, the designer could bring out more clearly the relationships of the structural parts, soften the glitter of the stone at specific points, and provide a background to set off the figures.

Although color was used for emphasis and to mitigate what might have seemed too bare a simplicity (in Doric as well as in Ionic buildings), the primary dependence in Greek architecture was on clarity and balance. To the

Greeks, it was unthinkable to use surfaces in the way the Egyptians used their gigantic columns: as fields for complicated ornamentation. The very building itself—its plan, elevation, and function-enhancing ornamentation—must have the clarity of a Euclidean demonstration. The history of Greek temple architecture is the history of Greek artists' unflagging efforts to express the form of the building in its most satisfactory (that is to say, what they believed to be perfect) proportions.

TEMPLES AND TREASURIES The prime example of early Greek efforts at Doric temple design is the unusually well-preserved Archaic temple (FIG. **5-16**) erected around 550 B.C. at Paestum (Greek Poseidonia), south of Naples in Italy. The entire peripteral colonnade of this huge (80 by 170 feet) building is still standing, but most of the entablature, including the frieze, pediment, and all of the roof, has vanished. Called the Basilica after the Roman columnar hall

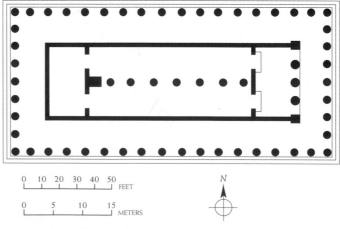

5-17 Plan of the Temple of Hera I, Paestum.

building type that early investigators felt it resembled, we now know that this structure was a temple dedicated to Hera. It is referred to as the Temple of Hera I in current literature, to distinguish it from the later Temple of Hera II, which stands nearby. The misnomer is partly due to the building's plan (FIG. **5-17**), which differs from that of most other Greek temples. The unusual feature, which is found only in early Archaic temples, is the central row of columns that divides the naos into two aisles. Placing columns underneath the ridgepole might seem to be the logical way to provide interior support for the roof structure, but it resulted in several disadvantages. Among these was the fact that this interior arrangement allowed no place for a central cult statue. Also, the peripteral colonnade, in order to correspond with the interior, had to have an odd number of columns (nine) across the building's facade. Three columns were also set in antis instead of the canonical two, which in turn ruled out a central doorway through which the cult statue could be viewed. There are, however, eighteen columns on each side of the Hera I temple, resulting in a simple 1:2 ratio of facade and flank columns.

The elevation of the temple is characterized by heavy, closely spaced columns with a pronounced swelling at the middle of the shafts (*entasis*), giving the columns a profile akin to that of a cigar. The shafts are topped by large, bulky, pancake-like Doric capitals, which seem to have been compressed by the overbearing weight of the entablature. If the temple's immense roof were preserved, these columns would seem even more compressed and squat beneath what must have been a high and massive entablature. The columns and capitals thus express in a vivid manner their weight-bearing function. One structural reason, perhaps, for the heaviness of the design and the narrowness of the spans between the columns might be that the Archaic builders were afraid that thinner and more widely spaced columns would result in the collapse of the superstructure. In later Doric structures, the columns are placed farther apart and the forms are gradually refined; the shafts become more slender, the entasis subtler, the capitals small-

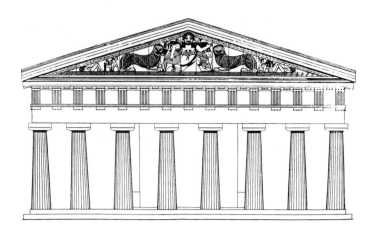

5-18 Reconstruction drawing of the facade of the Temple of Artemis at Corfu, *c.* 600–580 B.C.

er, and the entablature lighter. The Greek architects are seeking the ideal proportional relationship among the parts of their buildings. The sculptors of Archaic kouroi and korai were grappling with similar problems contemporaneously; architecture and sculpture developed in a parallel manner in the sixth century.

Architects and sculptors were also frequently called upon to work together, as at Corfu (ancient Corcyra), where a great Doric temple dedicated to Artemis (FIG. **5-18**) was constructed early in the sixth century B.C. Corfu is an island off the western coast of Greece and was an important stop on the trade route between the mainland and the Greek settlements in Italy. Prosperity made possible the erection of one of the earliest stone peripteral temples in Greece, one that was also lavishly embellished with sculpture. The metopes of the frieze were decorated with reliefs (unfortunately very fragmentary today), and both pediments were filled with huge sculptures (over 9 feet high at the center). The pediments on either end of the temple appear to have been decorated in an identical manner; the west pediment (FIG. **5-19**) is better preserved.

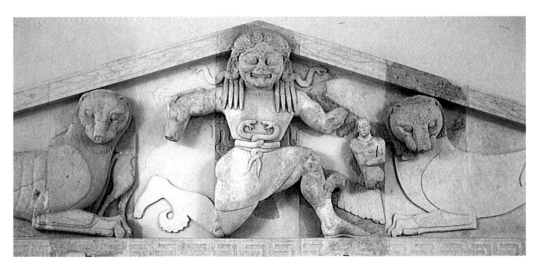

5-19 Central portion of the west pediment of the Temple of Artemis. Limestone, greatest height approx. 9' 4". Archeological Museum, Corfu.

Designing figural decoration for a pediment was never an easy task because of the awkward triangular space that had to be filled. Figures placed at the center needed to be of great size; by contrast, as the pediment tapered toward the corners, the available area became increasingly cramped. The central figure at Corfu is the gorgon Medusa, a demon with the body of a woman and the wings of a bird. Medusa also had a hideous face and snake hair, and anyone who gazed at her was turned into stone. She is shown in the conventional Archaic bent-leg, bent-arm, pinwheel-like posture that signifies running or, for a winged creature, flying. By her side are two great felines; together they serve as guardians of the temple, repulsing all enemies from the sanctuary of the goddess. Similar panthers stand sentinel on the lintel of the seventh-century temple at Prinias (FIG. 5-7). The Corfu felines are in the tradition of the guardian lions of the gate to the citadel at Mycenae (FIG. 4-20) and the sphinx and lamassu figures that stood guard at the entrances to tombs and palaces in Egypt (FIG. 3-11) and the ancient Near East (FIGS. 2-16 and 2-18). The triad of Medusa and the felines recalls as well the heraldic human-beast compositions of Mesopotamia (FIG. 2-10). They are, in short, still further examples of the Orientalizing manner in early Greek sculpture.

Between Medusa and the great beasts are two small figures: the human Chrysaor at her left and the winged horse Pegasus at her right. Chrysaor and Pegasus are Medusa's children; according to legend they sprang from her head when it was severed by the sword of the Greek hero Perseus. Their presence here on either side of the living Medusa is therefore a chronological impossibility, but the Archaic artist is not interested in telling a coherent story but in identifying the central figure by showing us her offspring. Narration is, however, the purpose of the much smaller groups situated in the corners of the pediment. To our right is Zeus, brandishing his thunderbolt and slaying a kneeling giant; in the extreme corner is a dead giant. The *gigantomachy* (battle of gods and giants) was a popular theme in Greek art from Archaic through Hellenistic times and was a metaphor for the triumph of reason and order over chaos. In the left corner of the pediment is one of the climactic events of the Trojan War: Neoptolemos kills the enthroned King Priam; another fallen figure to the left of this group may be a dead Trojan.

The master responsible for the Corfu pediments was a pioneer and the composition shows all the signs of being an experimental effort. The lack of narrative unity in the Corfu pediment and the extraordinary diversity of scale of the figures would eventually give way to pedimental designs in which the figures all act out a single event and appear to be of the same size. But the Corfu designer has already shown the way. He has realized, for example, that the area beneath the raking cornice can be filled with gods and heroes of similar size if a combination of standing, leaning, kneeling, seated, and prostrate figures is employed in the composition, and he has discovered that animals can be

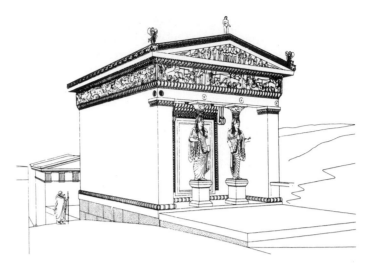

5-20 Reconstruction drawing of the Treasury of the Siphnians, Delphi, *c.* 530 B.C.

very useful space fillers because, unlike humans, they have one end that is taller than the other.

The sixth century B.C. also saw the erection of grandiose Ionic temples on the Aegean Islands and the western coast of Asia Minor. The gem of Archaic Ionic architecture and architectural sculpture is, however, not a temple but a treasury (FIG. **5-20**), erected by the citizens of Siphnos in the Sanctuary of Apollo at Delphi. Greek *treasuries* were small buildings set up for the safe storage of votive offerings, and at Delphi many poleis expressed their civic pride by erecting these temple-like, but nonperipteral, structures. Athens built one with Doric columns in the porch and sculptured metopes in the frieze. The Siphnians equally characteristically employed the Ionic order for their Delphic treasury. The building was made possible by the wealth of the island's gold and silver mines. In the porch, where one would expect to find fluted Ionic columns, far more expensive caryatids were employed instead. Caryatids are rare, even in Ionic architecture, but they are unknown in Doric architecture, where they would have been discordant elements in that much more severe order. The Siphnian statue-columns resemble contemporary korai dressed in Ionian chitons and himations (FIG. 5-13).

Another Ionic feature of the Siphnian Treasury is the use of a continuous sculptured frieze on all four sides of the building. The north frieze represents the popular theme of the gigantomachy, but it is a much more detailed rendition than that in the corner of the Corfu pediment. In the section reproduced here (FIG. **5-21**), Apollo and Artemis pursue a fleeing giant at the right, while behind them Themis, followed by Dionysos, drives a lion chariot; one of the lions has attacked a giant and has bitten into his midsection. The crowded composition was originally enlivened by paint (painted labels identified the various protagonists), and some figures had metal weapons; the effect must have been dazzling. On one of the shields the sculptor inscribed his

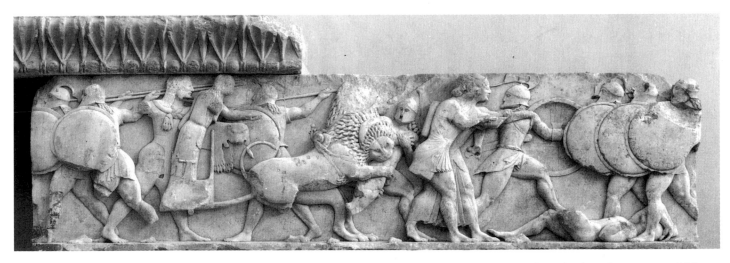

5-21 Detail of the gigantomachy from the north frieze of the Siphnian Treasury. Marble, approx. 25" high. Archeological Museum, Delphi.

name (unfortunately lost), a clear indication of pride in workmanship.

Vase Painting

BLACK-FIGURE Labeled figures and artists' signatures also appear on Archaic painted vases. The masterpiece of this stage of Greek vase painting is the *François Vase* (FIG. **5-22**), named for the excavator who uncovered it (in an enormous number of fragments) at Chiusi in Italy, where it had been imported from Athens to be placed in an Etruscan tomb. This is in itself a testimony to the esteem in which the potters and painters of Athens were held at this time. In fact, having learned the black-figure technique from the Corinthians, the Athenians had by now taken over the export market for fine painted ceramics.

The *François Vase* (a new kind of krater with volute-shaped handles probably inspired by costly metal prototypes) is signed by both its painter ("KLEITIAS painted me") and potter ("ERGOTIMOS made me"); in fact each signed twice! It is ornamented with over two hundred figures in six friezes. Labels abound, naming humans and animals alike, even some inanimate objects. Only one of the bands is given over to the Orientalizing repertoire of animals and sphinxes. The rest constitute a selective encyclopedia of Greek mythology, focusing on the exploits of Peleus and his son Achilles, the great hero of Homer's *Iliad*, and of Theseus, the legendary king of Athens.

In the detail shown here, Lapiths (a northern Greek tribe) and centaurs do battle (*centauromachy*) after a wedding celebration in which the man-beasts, who were invited guests, got drunk and attempted to abduct the Lapith maidens and young boys. Theseus, also on the guest list,

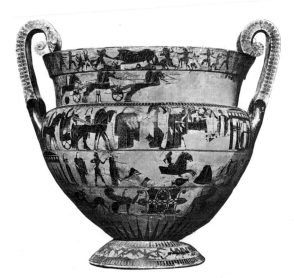

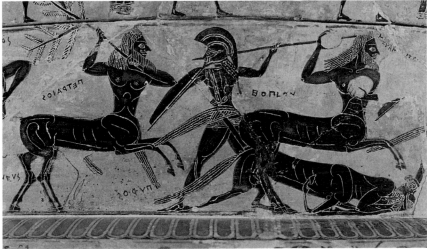

5-22 KLEITIAS and ERGOTIMOS, *François Vase* (Attic black-figure volute-krater), from Chiusi, *c.* 570 B.C. General view (left) and detail of centauromachy on other side of vase (right). Approx. 26" high. Museo Archeologico, Florence.

was prominent among the centaurs' Greek adversaries. Kleitias no longer fills the space between his figures with decorative ornament, but the figures themselves conform to the age-old composite type (profile heads with frontal eyes, frontal torsos, profile legs and arms). His centaurs, like those of his contemporaries, are much more believable than their Geometric predecessors (FIG. 5-3). The man-horse combination is top/bottom rather than front/back: the lower (horse) portion has four legs of uniform type, and the upper part of the monster is fully human. In characteristic fashion, the animal section of the centaur is shown in strict profile, while the man's head and torso is a composite of frontal and profile views. (Kleitias utilized a consistent profile for the more adventurous detail of the collapsed centaur at the right.)

The acknowledged master of the black-figure technique was an Athenian named EXEKIAS, whose vases were not only widely exported but, as we shall see, copied as well. Perhaps his greatest work is an amphora (FIG. **5-23**) in the Etruscan collection of the Vatican Museums—it, too, comes from an Etruscan tomb—and Exekias has signed the vessel as both painter and potter. No longer is the surface divided into a series of horizontal bands; instead, a single large framed panel is peopled by figures of monumental stature. At the left is Achilles, fully armed. He is playing a game of dice with his comrade Ajax. Out of the lips of Achilles comes the word *tesara* (four); Ajax calls out *tria* (three). Ajax has taken off his helmet but both men hold their spears; their shields are nearby and each man is ready for action at a moment's notice. It is a classic case of "the calm before the storm," and the moment that Exekias has chosen to depict is the antithesis of the Archaic penchant for dramatic action. There is a gravity and tension here that is absent in Archaic art—but that will characterize much Classical Greek art of the next century.

Exekias had no equal as a black-figure painter. That may be seen in such details as the extraordinarily intricate engraving of the patterns on the heroes' cloaks (highlighted with delicate touches of white) and in the brilliance of the composition. The arch formed by the backs of the two warriors echoes the shape of the rounded shoulders of the amphora; the vessel's shape is echoed again in the void between the heads and spears of Achilles and Ajax. The spears are used to lead our eyes toward the thrown dice, where the heroes' eyes are also fixed. Of course, those eyes do not really look down at the table, but stare out from the profile heads in the old manner. For all his brilliance, Exekias is still wedded to many of the old conventions. Real innovation in figure drawing would have to await the invention of a new ceramic painting technique of greater versatility than black-figure, with its dark silhouettes and incised details.

RED-FIGURE The birth of this new technique came around 530 B.C., and the person responsible is known to us as the ANDOKIDES PAINTER, that is, the anonymous painter who decorated the vases signed by the potter ANDOKIDES. The differences between the two techniques can best be studied on a series of experimental vases in which the same composition is painted on both sides, once in black-figure

5-23 EXEKIAS, Ajax and Achilles playing a game (detail from an Attic black-figure amphora), from Vulci, *c.* 540–530 B.C. Whole vessel approx. 24" high. Vatican Museums, Rome.

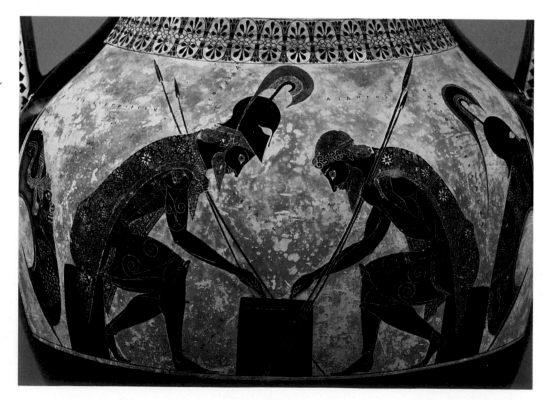

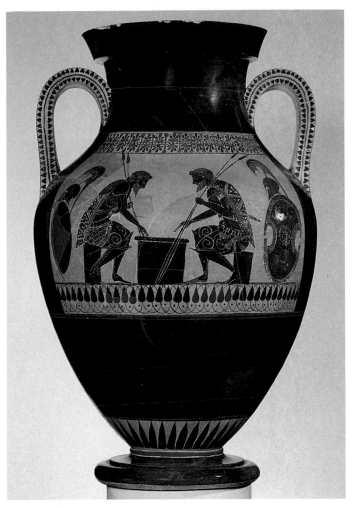 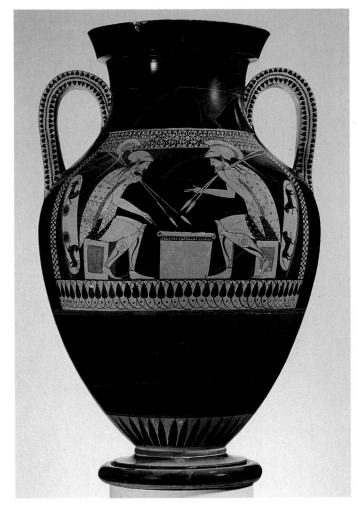

5-24 ANDOKIDES PAINTER, Ajax and Achilles playing a game (Attic bilingual amphora), from Orvieto, *c.* 525–520 B.C. Black-figure side (left) and red-figure side (right). Approx. 1′ 9″ high. Courtesy, Museum of Fine Arts, Boston.

and once in red-figure. Such vases, nicknamed "bilingual vases," were produced only for a short time. An especially interesting example is the amphora, now in Boston, by the Andokides Painter (FIG. **5-24**), which features copies of the Achilles and Ajax panel of the bilingual painter's teacher, Exekias.

Neither in black-figure nor red-figure does the Andokides Painter capture the intensity of his model, and the treatment of details is decidedly inferior. Yet the new red-figure technique has obvious advantages over the old black-figure, not the least of which is that the Caucasian Greeks are now depicted in a more natural flesh tone. *Red-figure* is the opposite of black-figure; what was previously black is now red, and vice versa. The artist still employs the same black glaze, but instead of using it to create the silhouettes of figures, he paints only the outlines of the figures and then colors the background black. The red clay is reserved for the figures themselves; interior details are now drawn with the soft brush in place of the stiff metal graver. And the artist can vary the thickness of the glaze,

building it up to give relief to curls of hair or diluting it to create shades of brown, thereby expanding the chromatic range of the Greek vase painter's craft. The Andokides Painter does not yet appreciate the full potential of his own invention, but he has created a technique that, in the hands of other, more skilled artists, will help revolutionize the art of drawing.

One of these younger and more adventurous painters was EUPHRONIOS, whose krater depicting the struggle between Herakles and Antaios (FIG. **5-25**) reveals the exciting possibilities of the new red-figure technique. Antaios was a Libyan giant, a son of Earth, and he derived his power from contact with the ground. To defeat him, Herakles had to lift him up into the air and strangle him while no part of his body touched the earth. The moment Euphronios chose to represent occurs while the two are wrestling on the ground and Antaios still possesses enormous strength. Nonetheless, Herakles has the upper hand. The giant's face is a mask of pain; his eyes roll and his teeth are bared; and his right arm is paralyzed, with the fingers

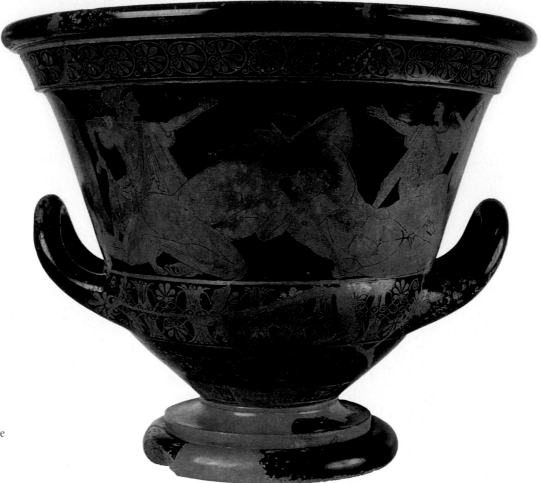

5-25 EUPHRONIOS, Herakles wrestling Antaios, (Attic red-figure calyx-krater), from Cerveteri, *c.* 510 B.C. Approx. 19″ high. Louvre, Paris.

limp. Euphronios has used diluted glaze to show Antaios's unkempt golden-brown hair—intentionally contrasted with the neat coiffure and carefully trimmed beard of the emotionless Greek hero.

The artist has also used thinned glaze to delineate the muscles of both figures. But Euphronios is interested not only in rendering human anatomy convincingly; he also wishes to show that his figures occupy space. The conventional composite posture for the human figure, which communicates so well what the various parts of the human body *are,* is deliberately rejected as Euphronios attempts to reproduce how a particular human body is *seen.* The right thigh of Antaios, for example, is shown from the front; the lower leg disappears behind the giant and we see only part of the right foot. We must make the connection between the upper leg and the foot in our minds. Euphronios has not given us a two-dimensional panel painted on the surface of a pot and filled with figures in stereotypical postures, as his Archaic and pre-Greek predecessors always did, but a window onto a mythological world in which the protagonists occupy three-dimensional space. This is a revolutionary new conception of what a picture is supposed to be.

A preoccupation with the art of drawing per se may be seen in an extraordinary amphora (FIG. **5-26**) painted by EUTHYMIDES, a contemporary and competitor of Euphronios. The subject is one appropriate for a wine storage jar—three tipsy revelers—but the theme is little more than an excuse for the artist to experiment with the representation of unusual positions of the human form. It is no coincidence that there is no overlapping of the bodies, for each is an independent figure study. Euthymides has rejected the frontal and profile conventions of the past and has given us torsos that are no longer two-dimensional surface patterns but are *foreshortened,* that is, drawn in a three-quarter view. Most remarkable is the central figure, who is shown from the rear with a twisting spinal column and buttocks in three-quarter view. This is neither an attractive nor a complete view of the human figure, and earlier artists had no interest in attempting such postures. But for Euthymides the challenge of drawing the figure from such an unusual viewpoint was a reward in itself. With understandable pride he proclaimed his achievement by adding to the formulaic signature "Euthymides painted me" the phrase "as never Euphronios [could do]!"

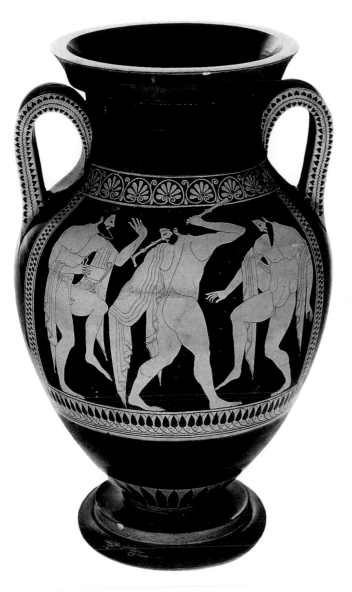

5-26 EUTHYMIDES, Three revelers (Attic red-figure amphora), from Vulci, *c.* 510 B.C. Approx. 24″ high. Staatliche Antikensammlungen, Munich.

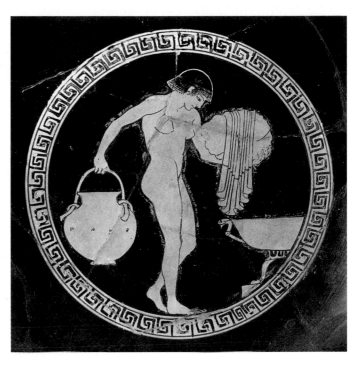

5-27 ONESIMOS, Girl going to wash (interior of an Attic red-figure *kylix*), from Chiusi, *c.* 490 B.C. Approx. 6″ in diameter. Musées Royaux, Brussels.

Aegina and the Transition to the Classical Period

The years just before and after 500 B.C. were also a time of dynamic transition in architecture and architectural sculpture. Some of the changes were evolutionary in nature, others revolutionary; both kinds are evident in the Temple of Aphaia at Aegina (FIG. **5-28**). The temple was constructed on a prominent ridge with dramatic views out to the sea on both sides. The colonnade is 45 by 95 feet and consists of six Doric columns on the facade and twelve on the flanks; this is a much more compact structure than the impressive but ungainly Archaic Paestum Basilica (FIG. 5-16), even though the ratio of width to length is similar. The Doric architect has learned a great deal in the half century that has elapsed, and the columns of the Temple of Aphaia are more widely spaced and more slender. The capitals create a smooth transition from the vertical shafts below to the horizontal architrave above; gone are the Archaic flattened echinuses and bulging shafts of the Paestum columns.

The plan and internal elevation of the temple (FIG. **5-29**) are also refined. In place of a single row of columns down the center of the cella, there is a double colonnade—and each row has two stories. This arrangement allows the center of the cella to accommodate a cult statue and also gives those gathered in front of the building an unobstructed view through the pair of columns in the pronaos.

Interest in the foreshortening of the human figure is soon extended to studies of nude women, as on the interior of a *kylix* (drinking cup) painted by ONESIMOS (FIG. **5-27**). The representation is remarkable not only for the successful foreshortening of the girl's torso and breasts, seen in three-quarter view, but also for its subject. This is neither mythology nor a scene of wealthy noblemen partying; this is a servant girl, not the lady of the house, who has removed her clothes in order to wash. Such a genre scene, not to mention female nudity, would never have been portrayed in monumental painting or sculpture of this time; only in the private sphere was such a subject acceptable.

Both pediments of the temple (FIG. **5-30**) were filled with life-size statuary, and the same subject and similar compositions were employed at both ends of the building. The theme was the battle of the Greeks and Trojans, with Athena at the center of the bloody combat. She is larger than all the other figures because she is superhuman, but the Greeks and Trojans are all carved at the same scale, regardless of their position in the pediment. Unlike the experimental design at Corfu (FIG. 5-18), the Aegina pediments feature unity of theme and consistency of size. The latter was achieved by utilizing the whole gamut of bodily postures from upright (Athena) to leaning, falling, kneeling, and lying (Greeks and Trojans).

The sculptures of the Aegina pediments were set in place when the temple was completed around 490 B.C., but the pedimental statues at the eastern end were damaged and

5-28 Temple of Aphaia, Aegina, *c.* 500–490 B.C.

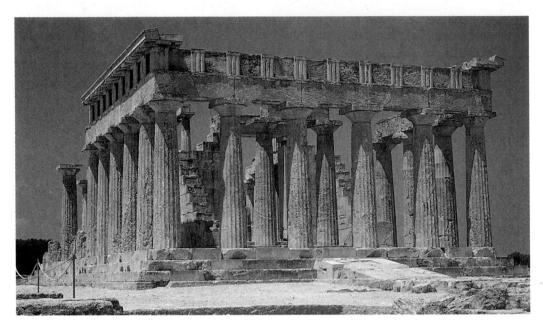

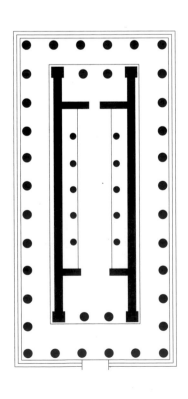

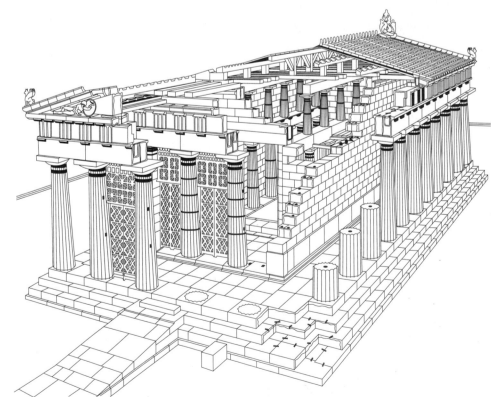

5-29 Plan *(left)* and restored cutaway view *(right)* of the Temple of Aphaia at Aegina.

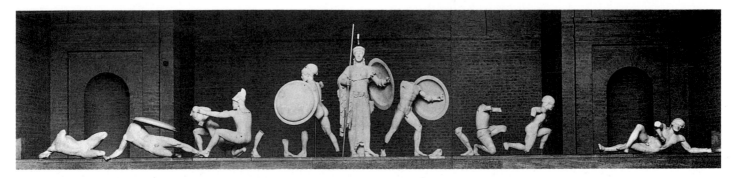

5-30 West pediment of the Temple of Aphaia at Aegina, c. 500–490 B.C. Marble, approx. 5' 8" high at center. Glyptothek, Munich.

replaced with a new group a decade or two later. It is very instructive to compare the earlier and later figures. The dying warrior of the west pediment (FIG. **5-31**) is still conceived in the Archaic mode. His torso is rigidly frontal and he looks out directly at the spectator—in fact, he smiles at us, in spite of the bronze arrow (now missing) that punctures his chest. He is like a mannequin in a store window whose arms and legs have been arranged by someone else for effective display; there is no sense whatsoever of a thinking and feeling human being. The comparable figure of the later east pediment (FIG. **5-32**) is radically different. Not only is his posture more natural and more complex,

with the torso placed at an angle to the viewer—he is on a par with the painted figures of Euphronios and Euthymides—but he reacts to his wound as would a flesh-and-blood human. He knows that death is inevitable, but he still struggles to rise once again. And he does not look out at the spectator. He is concerned with his pain, not with us. Only a decade, perhaps two, separates the two statues, but they belong to different eras. With the later warrior we have left the Archaic world, where statues had anatomical patterns (and smiles) imposed upon them from without, and entered the Classical world, where statues move as humans move and possess the self-consciousness of real

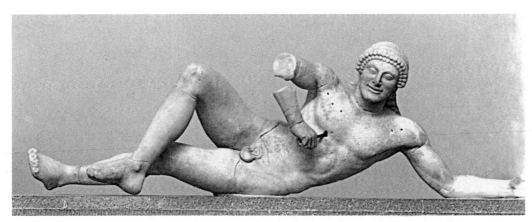

5-31 Dying warrior from the west pediment of the Temple of Aphaia at Aegina, *c.* 500–490 B.C. Marble, approx. 62¹/₂" long. Glyptothek, Munich.

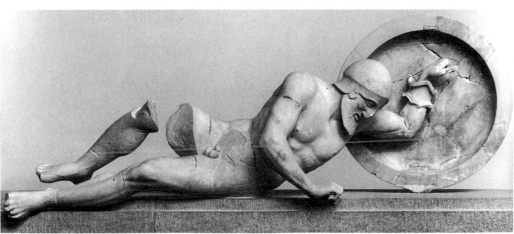

5-32 Dying warrior from the east pediment of the Temple of Aphaia at Aegina, *c.* 490–480 B.C. Marble, approx. 73" long. Glyptothek, Munich.

men and women. This is nothing less than a sea change in the conception of what a statue is meant to be. In sculpture, as in painting, the Classical revolution has occurred.

THE EARLY AND HIGH CLASSICAL PERIODS (FIFTH CENTURY B.C.)

The beginning of the Classical age is reckoned from a historical event, the defeat of the Persian invaders of Greece by the allied Hellenic city-states. Shortly after Athens was occupied and sacked in 480 B.C., the Greeks won a decisive naval victory over the Persians at Salamis. It had been a difficult war, and at times it had seemed as if Greece would be swallowed up by Asia and the Persian king Xerxes would rule over all. When Miletos was destroyed in 494 B.C., the Persians killed the male inhabitants of the Greek city and sold the women and children into slavery. The close escape of the Greeks from domination by Asian "barbarians" nurtured a sense of Hellenic identity so strong that thenceforth the history of European civilization would be distinct from the civilization of Asia, even though in interaction with it.

Typical of the time were the views of the great dramatist Aeschylus, who celebrated, in his *Oresteia*, the triumph of reason and law over barbarous crime, blood feud, and mad vengeance. Himself a veteran of the epic battle of Marathon, Aeschylus repudiated in majestic verse all the slavish and inhuman traits of nature that the Greeks at that time of crisis associated with the Persians.

The decades following the removal of the Persian threat are universally considered to be the apogee of Greek civilization. This is the era of the dramatists Sophocles and Euripides as well as Aeschylus, of the historian Herodotus, the statesman Pericles, the philosopher Socrates, and many of the most famous Greek architects, sculptors, and painters.

Architecture and Architectural Sculpture

TEMPLE OF ZEUS, OLYMPIA The first great monument of Classical art and architecture is the Temple of Zeus at Olympia, site of the quadrennial Olympic Games that legend held had been established by Herakles himself. The temple was begun about 470 B.C. and was probably completed by 457 B.C.; the architect was LIBON OF ELIS. Today the structure is in ruins, its picturesque tumbled column drums an eloquent reminder of the effect of the passage of time upon even the grandest monuments built by man. We can get a good idea of its original appearance, however, by looking at a slightly later Doric temple that was modeled closely upon the Olympian shrine of Zeus: the second Temple of Hera (or the Temple of Hera II) at Paestum (FIG. **5-33**). The plans and elevations of both temples follow the pattern used for the Temple of Aphaia at Aegina (FIG. 5-28): an even number of columns (six) on the short ends, two columns in antis, and two rows of columns in two stories inside the cella.

The Temple of Zeus, unlike the second Temple of Hera, was lavishly decorated with exterior sculpture. Statues filled both pediments, and the six metopes of the Doric frieze of the pronaos, as well as the matching six of the opisthodomos were decorated with reliefs.

The subject of the east pediment (FIG. **5-34**) was one of deep local significance: the chariot race between Pelops (from whom the Peloponnesos takes its name) and King

5-33 Temple of Hera II, Paestum, *c.* 460 B.C.

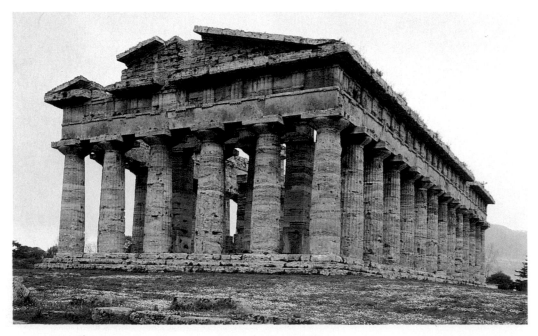

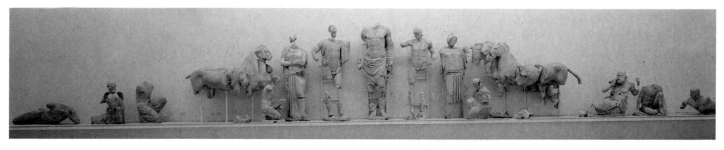

5-34 East pediment of the Temple of Zeus at Olympia, *c.* 470–456 B.C. Marble, approx. 87′ wide. Archeological Museum, Olympia.

Oinomaos. The story is a sinister one. Oinomaos had one daughter, Hippodameia, whom he did not want to marry because it was foretold that he would die if she did. Consequently, any suitor who wished to make her his bride was challenged by Oinomaos to a chariot race from Olympia to Corinth. If the suitor won, he also won the hand of the king's daughter; but if he lost, he was killed. The outcome was predetermined because Oinomaos possessed divine horses given to him by his father Ares. Many suitors had been killed, and to insure his victory Pelops resorted to bribing the king's groom Myrtilos to rig the royal chariot so that it would collapse during the race. Oinomaos was killed and Pelops won his bride, but he drowned Myrtilos rather than pay his debt. Before he died Myrtilos brought a curse upon Pelops and his descendants. It was this curse that led to the murder of Pelops's son Atreus and to events that figure prominently in some of

the great Greek tragedies of the day, the three plays known collectively as Aeschylus's *Oresteia:* the sacrifice by Atreus's son Agamemnon of his daughter Iphigeneia; the slaying of Agamemnon by Aegisthus, lover of Agamemnon's wife Clytaemnestra; and the murder of Aegisthus and Clytaemnestra by Orestes, the son of Agamemnon and Clytaemnestra.

The pedimental statues (which faced toward the starting point of all Olympic chariot races) are, in fact, posed like actors on a stage, Zeus in the center, Oinomaos and his wife, Pelops and Hippodameia, and their respective chariots to each side. All is quiet; the horrible events known to every spectator have yet to occur. Only one man reacts: a seer (FIG. **5-35**) who knows the future. His is a magnificent figure. Unlike the gods, heroes, and noble youths and maidens that are the almost exclusive subjects of Archaic and Classical Greek statuary, this seer is a rare depiction of

5-35 Seer, from the east pediment of the Temple of Zeus at Olympia. Marble, approx. 4′ 6″ high. Archeological Museum, Olympia.

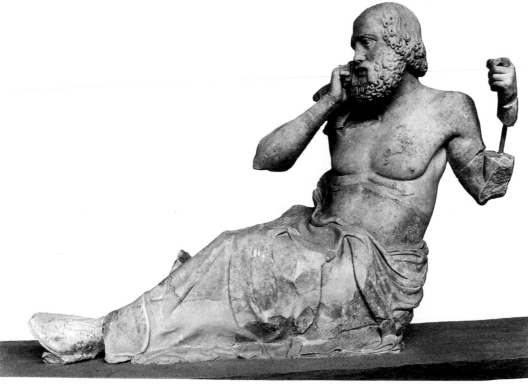

5-36 Athena, Herakles, and Atlas with the Apples of the Hesperides, metope from the Temple of Zeus at Olympia, *c.* 470–456 B.C. Marble, approx. 5′ 3″ high. Archeological Museum, Olympia.

old age. He has a balding, wrinkled head and sagging musculature—and a horrified expression on his face. This is a true show of emotion, unlike the stereotypical "Archaic smile," something without precedent in earlier Greek sculpture and an element that does not become a regular feature of Greek art until the Hellenistic age.

The metopes of the Zeus temple are also thematically connected with the site, for they depict the twelve labors of Herakles, the legendary founder of the Olympic Games. In the metope illustrated here (FIG. **5-36**), Herakles is shown holding up the sky (with the aid of the goddess Athena—and a cushion) in place of Atlas, who has undertaken the dangerous journey to fetch the golden apples of the Hesperides for the hero. The load will soon be transferred back to Atlas, but now each of the very high relief figures in the metope stands quietly with the same serene dignity as the statues in the Olympia pediment.

In both attitude and dress (simple Doric peplos for the women), all these figures display a severity that contrasts sharply with the smiling and elaborately clad figures of the late Archaic period, leading many scholars to call this Early Classical phase of Greek art the "Severe Style."

Statuary

The Early Classical is also characterized by a final break from the rigid and unnatural Egyptian-inspired pose of the

Archaic kouroi. This may be seen in the postures of the Olympia figures and in the somewhat earlier statue dedicated on the Athenian Acropolis around 480 B.C., known as the *Kritios Boy* (FIG. **5-37**) because it was once thought to have been carved by the sculptor Kritios. The statue is our earliest evidence of a sculptor whose concern is not simply with the representation of bodily parts but with the

5-37 *Kritios Boy*, from the Acropolis, Athens, *c.* 480 B.C. Marble, approx. 34″ high. Acropolis Museum, Athens.

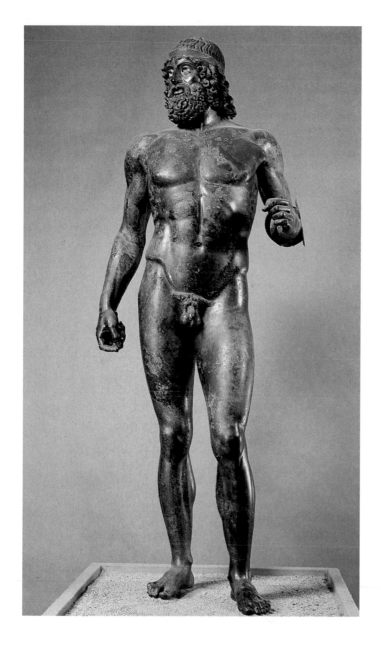

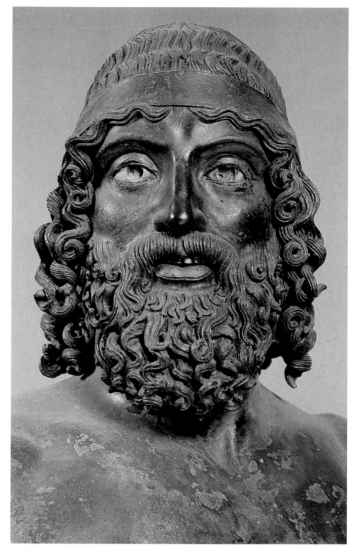

5-38 Warrior (front and detail of head), from the sea off Riace (Italy), *c.* 460–450 B.C. Bronze, approx. 6′ 6″ high. Archeological Museum, Reggio Calabria.

portrayal of how a real human being (as opposed to a stone image of a person) actually stands. Real people do not stand in the stiff-legged pose of the kouroi and korai or their Egyptian predecessors. Humans shift their weight and the position of the main parts of the body around the vertical, but flexible, axis of the spine. When we move, the elastic musculoskeletal structure of our bodies dictates a harmonious, smooth motion of all the elements of the body. The sculptor of the *Kritios Boy* was among the first to grasp this fact and to represent it in statuary. There is a slight dip to the right hip, indicating the shifting of weight onto the left leg. The right leg is bent, at ease. Even the head turns slightly to the right, breaking the unwritten rule of frontality that dictated the form of virtually all earlier statues. This weight shift, which art historians have come to describe as *contrapposto* (counterbalance), separates Classical from Archaic Greek statuary and, when we see it reappear after

a long absence in the sculpture of the later Middle Ages and the Renaissance, it will be an unmistakable sign of renewed interest in Classical art.

The innovations of the *Kritios Boy* are carried even further in the bronze statue of a warrior (FIG. **5-38**) found in the sea off the coast of Calabria near Riace at the toe of the Italian boot. It is one of a pair of statues that formed part of the cargo of a ship that went down in antiquity on its way from Greece probably to Rome, where Greek sculpture was much admired and, as we shall see, often copied. These statues, now known as the Riace bronzes, were discovered accidentally by a diver. Although they had to undergo several years of cleaning and restoration after nearly two millennia of submersion in salt water, they are nearly intact. The statue shown here lacks only its shield, spear, and wreath. It is hollow-cast by the *cire perdue* (lost-wax) method in which a figure is modeled in a thin layer of wax

over a clay core and then covered with clay; the whole is fired, melting away the wax and hardening the clay, which then becomes a mold for molten metal, in this case bronze. Weight, cost, and the tendency of large masses of bronze to distort when cooling make life-size castings in solid bronze impractical, if not impossible. Larger sculptures like the Riace bronzes were therefore hollow-cast in sections (head, arms, torso, etc.) and then assembled. Finally the eyes might be inlaid, as here, and other metals used to add color and variety to the statue: silver is used for the teeth and eyelashes of the Riace warrior, copper for the lips and nipples. The weight shift is more pronounced than in the *Kritios Boy*. The head turns more forcefully to the right, the shoulders tilt, the hips swing more markedly, and the arms are freed from the body. Archaic frontality and rigidity have given way to natural motion in space.

The high technical quality of the Riace warrior is equaled in another bronze statue (FIG. **5-39**) set up a decade or two earlier to commemorate the victory of the tyrant Polyzalos of Gela (Sicily) in a chariot race in the Pythian Games at Delphi. The statue is almost all that remains of an enormous group composed of Polyzalos's driver, the chariot, the team of horses, and a young groom. The charioteer stands in an almost Archaic pose, but the turn of the head and feet in opposite directions as well as a slight twist at the waist are in keeping with the Severe Style. The moment chosen for depiction is not during the frenetic race, but rather after, when the driver quietly and modestly holds his horses still in the winner's circle. He grasps the reins in his outstretched right hand (the lower left arm, cast separately, is missing) and he wears the standard charioteer's garment, girdled high and held in at the shoulders and the back to keep it from flapping. The folds emphasize both the verticality and calm of the figure and recall the flutes of a Greek column. A band inlaid with silver is tied around the head and confines the hair. The eyes are made of glass paste and shaded by delicate bronze lashes.

The male human form in motion is, by contrast, the subject of another Early Classical bronze statue (FIG. **5-40**), which, like the Riace warrior, was found in an ancient shipwreck, this time off the coast of Greece itself at Cape Artemision. The bearded god once hurled a weapon held in his right hand, probably a thunderbolt, in which case he is Zeus; a less likely suggestion is that this is Poseidon, lord of the sea, with his trident. The pose could be employed equally well for a youthful javelin-thrower. Both arms are boldly extended and the right heel is raised off the ground, underscoring the lightness and stability of hollow-cast monumental statues.

MYRON AND POLYKLEITOS A bronze statue of similar character was the renowned *Diskobolos* (discus-thrower) of MYRON (FIG. **5-41**), which is known to us only through marble copies made in Roman times. Even when the original was removed from Greece, as were the Riace warrior and

the Artemision Zeus, only one community or individual could own it. Demand so far exceeded the supply that a veritable industry was born to meet the call for Greek statuary to display in public places and private villas alike. The copies were usually made in less costly marble and the change in medium resulted not only in a different surface appearance, but also, in most cases, the copyist had to add

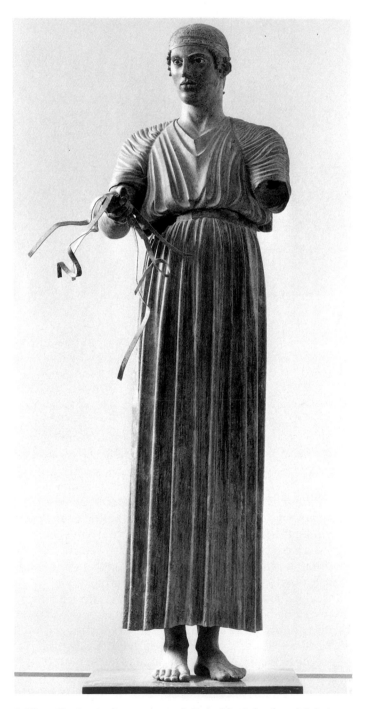

5-39 Charioteer, from a group dedicated by Polyzalos of Gela in the Sanctuary of Apollo at Delphi, *c.* 470 B.C. Bronze, approx. 5' 11" high. Archeological Museum, Delphi.

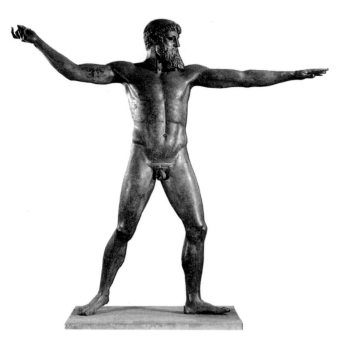

5-40 Zeus or Poseidon, from the sea off Cape Artemision, *c.* 460–450 B.C. Bronze, approx. 6′ 10″ high. National Archeological Museum, Athens.

an intrusive tree trunk (to support the great weight of the stone statue) and struts between arms and body to strengthen weak points. The copies rarely approach the quality of the originals, and the Roman sculptors sometimes took liberties with their models to conform to their own tastes and needs; occasionally, for example, a mirror image of the original was required for a specific setting. Nevertheless, the copies are indispensable today; without them it would be impossible to reconstruct the history of Greek sculpture after the Archaic period.

Myron's discus-thrower is a vigorous action statue, like the Artemision Zeus, but it is composed in an almost Archaic manner, with profile limbs and a nearly frontal chest, so that the artist can suggest the tension of a coiled spring. Like the arm of a pendulum clock, the right arm of the *Diskobolos* has reached the apex of its arc but has not yet begun to swing down again. Myron has frozen the action and so arranged the body and limbs that two intersecting arcs are formed, creating the impression of a tightly stretched bow a moment before the string is released. This tension is not, however, mirrored in the athlete's face, which remains expressionless. Once again, as in the later of the two warrior statues from the Aegina pediments (FIG. 5-32), the head is turned away from the spectator; in contrast to Archaic athlete statues, the Classical *Diskobolos* is not performing for us, he is concentrating on the task at hand.

One of the most frequently copied Greek statues was the *Doryphoros* (spear-bearer) of POLYKLEITOS, a work that epitomizes the intellectual rigor of Classical statuary design. Illustrated here are a full-length but prosaic marble copy

(FIG. **5-42**) that stood in a palestra at Pompeii, where it served as a model for Roman athletes exercising, and an abbreviated copy in bronze (FIG. **5-43**) from a villa at nearby Herculaneum, which gives a better sense of the original. So famous was this fifth-century statue that the bronze *herm* (a bust on a quadrangular pillar) is inscribed only with the name of the copyist; the owner of the Roman villa and his educated guests did not need a label to identify the head as that of Polykleitos's *Doryphoros.*

Polykleitos hailed from Argos in the Peloponnesos, but like his contemporaries in Athens and elsewhere, he believed that beauty resided in perfect proportions, in harmonious numerical ratios, and he set down his own prescription for the ideal statue of a nude male athlete or

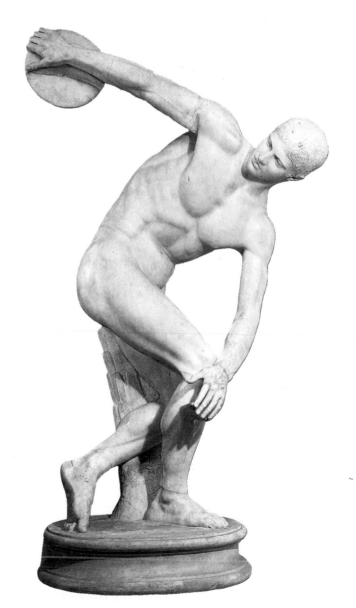

5-41 MYRON, *Diskobolos* (Discus-thrower). Roman marble copy after a bronze original of *c.* 450 B.C. 5′ 1″ high. Museo Nazionale Romano, Rome.

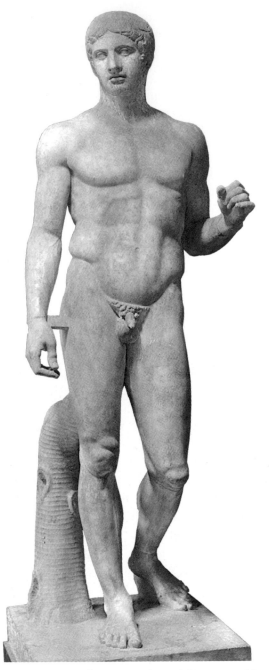

5-42 POLYKLEITOS, *Doryphoros* (Spear-bearer). Roman marble copy after a bronze original of *c.* 450–440 B.C. 6' 11" high. Museo Nazionale, Naples.

5-43 POLYKLEITOS, *Doryphoros.* Detail of Roman bronze herm copy signed by APOLLONIOS OF ATHENS. Herm 21¼" high. Museo Nazionale, Naples.

warrior in a treatise aptly entitled the *Canon*. The *Doryphoros* is the embodiment of those principles and was created to illustrate the treatise. In fact, "Spear-bearer" is but a descriptive title for the statue; the name assigned to it by Polykleitos was *Canon*.

Polykleitos's treatise is unfortunately not preserved, but a physician, Galen, who lived during the second century A.D., summarized the sculptor's principle of *symmetria* (commensurability of parts) as follows:

[Beauty consists] in the proportions, not of the elements, but of the parts, that is to say, of finger to finger, and of all the fingers to the palm and the wrist, and of these to the forearm, and of the forearm to the upper arm, and of all the other parts to each other, as they are set forth in the *Canon* of Polykleitos.

Pliny the Elder, writing in the first century A.D., maintained that Polykleitos, "alone of men, had rendered art itself [i.e., the theoretical basis of art] in a work of art."

The *Doryphoros* is the culmination of the evolution we have observed in Greek statuary from the kouros to the *Kritios Boy* to the Riace warrior. The contrapposto is more pronounced than ever before in a standing statue, but Polykleitos was not content with simply rendering a figure that stands naturally. His aim was to impose order upon human movement, to make it "beautiful," to "perfect" it. He achieved this through a system of chiastic, or cross, balance. What appears at first to be a casually natural pose is, in fact, the result of an extremely complex and subtle organization of the various parts of the figure. Note, for instance, how the function of the supporting leg is echoed by the straight-hanging arm to provide the right side of the figure with the columnar stability needed to anchor the

dynamically flexed limbs of the left side. If read anatomically, on the other hand, the tensed and relaxed limbs may be seen to oppose each other diagonally (that is, the right arm and the left leg are relaxed, and the tensed supporting leg is opposed by the flexed arm, which held a spear). In like manner, the head turns to the right while the hips twist slightly to the left, and although the *Doryphoros* takes a step forward, he does not move. This dynamic asymmetrical balance, this motion while at rest, and the resulting harmony of opposites, is the essence of the Polykleitan style.

The Athenian Acropolis

While Polykleitos was formulating his *Canon* in Argos, the Athenians, under the leadership of Pericles, were at work on one of the most ambitious building projects ever undertaken, the reconstruction of the Acropolis after the Persian sack of 480 B.C. Athens, despite the damage that it suffered at the hands of the army of Xerxes, emerged from the war with enormous power and prestige, for it was under the Athenian commander Themistocles that the Persian navy was decisively defeated at Salamis and forced to retreat to Asia.

In 478 B.C., in the aftermath of the expulsion of the Persians from the Aegean, the Greeks formed an alliance for mutual protection against any renewed threat from the Orient. The new confederacy came to be known as the Delian League, because its headquarters were on the sacred island of Delos. Although at the outset each member of the league had an equal vote, Athens was "first among equals," providing the commander of the allied fleet and determining which cities were to furnish ships and which were instead to pay an annual tribute to the treasury at Delos. Continued fighting against the Persians kept the alliance intact, but Athens gradually assumed a dominant role, and in 454 B.C. the Delian treasury was transferred to Athens, ostensibly for reasons of security. Pericles, who was only in his teens when the Persians laid waste to the Acropolis, was, by the middle of the century, the recognized leader of the Athenians, and he succeeded in converting the alliance into an Athenian empire. Tribute continued to be paid, but the surplus reserves were not expended for the common good of the allied Greek states; rather they were expropriated to pay the enormous cost of executing Pericles's grand plan to embellish the Acropolis of Athens.

The reaction of the allies—in reality the subjects of Athens—was predictable. Plutarch, who wrote a biography of Pericles in the early second century A.D., gives us an idea of the wrath felt by the Greek victims of Athenian tyranny by recording the protest voiced against Pericles's decision even in the Athenian assembly. Greece, Pericles's enemies said, had been dealt "a terrible, wanton insult" when Athens used the funds that had been contributed out of necessity for a common war effort to "gild and embellish itself, like some pretentious woman bedecked with precious stones." It is important to keep in mind when we examine those great and universally admired buildings erected on the Acropolis in accordance with Pericles's vision of his polis reborn from the ashes of the Persian sack, that they are *not*, as some would wish us to believe, the glorious fruits of Athenian democracy, but instead the by-products of tyranny and the abuse of power. Too often historians of art and architecture do not ask how a monument was paid for; the answer can be very revealing—and very embarrassing.

We are fortunate in possessing a number of Roman copies of a famous portrait of Pericles that was fashioned by KRESILAS, a contemporary of Polykleitos, who was born on Crete but who worked in Athens. The portrait took the form of a bronze statue set up on the Acropolis, probably immediately after the death of Pericles in 429 B.C. Our copies, in marble, only reproduce the head. The herm copy in the Vatican Museums (FIG. **5-44**), from a Roman villa at Tivoli, near Rome, is inscribed "Pericles, son of Xanthippos, the Athenian." It portrays Pericles wearing the helmet of a *strategos* (general), the position to which he was elected

5-44 KRESILAS, *Pericles.* Roman marble herm copy after a bronze original of *c.* 429 B.C. Approx. 72" high. Vatican Museums, Rome.

fifteen times. Pericles was said to have had an abnormally elongated skull, and Kresilas has recorded this feature (and concealed it at the same time) by giving us a glimpse through the helmet's eye slots of the hair at the top of Pericles's head. This, together with the unblemished features of the Classically aloof face—and, no doubt, the perfect physique of the body of the full-length portrait, which must have resembled that of the Riace warrior (FIG. 5-38)—led Pliny to assert that Kresilas had the ability to make noble men appear even more noble in their portraits. In fact, he refers to Kresilas's "portrait"—it is not a portrait at all in the modern sense of a likeness of an individual—of the Athenian statesman as "the Olympian Pericles," for in this image Pericles appears almost godlike.

PARTHENON The centerpiece of Pericles's great building program on the Acropolis (FIGS. **5-45** and **5-46**) was the Parthenon, erected in the remarkably short period between 447 and 438 B.C. (Work on the ambitious sculptural ornamentation of the great temple continued until 432 B.C.) As soon as that temple was completed, construction was commenced on a grand new gateway to the Acropolis from the west (the only accessible side of the natural plateau), the Propylaia; begun in 437 B.C., it was left unfinished in 431 B.C. at the outbreak of the Peloponnesian War between Athens and Sparta. Two later temples, the Erechtheion and the Temple of Athena Nike, built after Pericles's death, were probably also part of the original design. The construction and decoration of these four buildings were the focus of attention of the greatest Athenian architects and sculptors of the age. The Periclean Acropolis saw the concentration of more human creative genius than has been seen in any other place or time in the history of Western civilization.

That we have these buildings at all today is something of a miracle. The Parthenon, for example, was converted into a Byzantine and later a Catholic church in the Middle Ages and, after the Ottoman conquest of Greece, into an Islamic mosque. Each time the building was remodeled for use by a different religion, it was modified structurally. The cult statue was removed early on, and the church had a great apse, while the mosque had a minaret. In 1687, the Venetians besieged the Acropolis, which at that time was in Turkish hands. One of their rockets scored a direct hit on the ammunition depot that the Turks had installed in part of the Parthenon; the resultant explosion blew out the center of the building. To make matters worse, the Venetians subsequently tried to remove some of the statues from the pediments of the Parthenon; in more than one case statues were dropped and smashed on the ground. Today, a

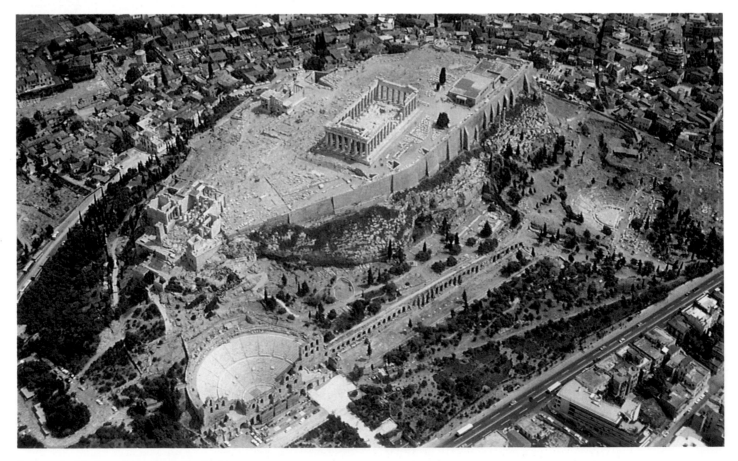

5-45 Aerial view of the Acropolis of Athens.

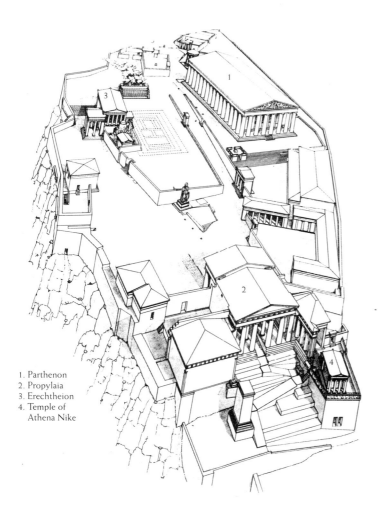

1. Parthenon
2. Propylaia
3. Erechtheion
4. Temple of
 Athena Nike

5-46 Restored view of the Acropolis, seen from the northwest
(G. P. Stevens).

uniquely modern blight threatens the Parthenon and the other buildings of the Periclean age. The corrosive emissions of automobile exhaust are decomposing the ancient marbles. A great campaign has been under way for some time to protect the columns and walls from further deterioration, and what little original sculpture remained *in situ* when modern restoration began was transferred to the climate-controlled rooms of the Acropolis Museum.

In spite of the ravages of time and man, most of the peripteral colonnade of the Parthenon (FIG. **5-47**) is still standing (or has been re-erected), and we know a great deal about the building and its sculptural program. The architects were IKTINOS and KALLIKRATES. The cult statue was the work of PHIDIAS, who was also the overseer of all the sculptural decoration of the temple. In fact, Plutarch claims that Phidias was in charge of the entire Periclean project for the Acropolis.

Just as the contemporary *Doryphoros* of Polykleitos may be seen as the culmination of nearly two centuries of searching for the ideal proportions of the various parts of human anatomy, so, too, the Pentelic marble Parthenon may be viewed as the ideal solution to the Greek architect's quest for perfect proportions in Doric temple design. Its well-spaced columns, with their slender shafts, and the capitals, with their straight-sided conical echinuses, are the ultimate refinement of the bulging and squat Doric columns and compressed capitals of the Archaic Hera temple at Paestum (FIG. 5-16).

The designers of the Parthenon and the *Doryphoros* also were kindred spirits in their belief that beautiful proportions were achieved through strict adherence to harmonious numerical ratios. In the Parthenon, the controlling ratio for the symmetria of the parts may be expressed

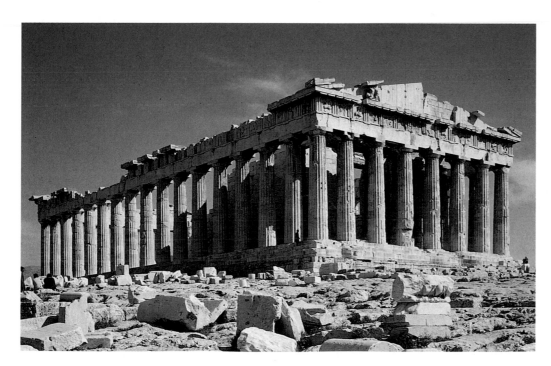

5-47 IKTINOS and KALLIKRATES, Parthenon (Temple of Athena Parthenos), Acropolis, Athens, 447–438 B.C. (view from the northwest).

5-48 Diagram in exaggerated proportion of the horizontal curvature of the Parthenon.

algebraically as $x = 2y + 1$, where x is the larger number and y is the smaller number. Thus, for example, there are eight columns on the short ends of the temple and seventeen on the long sides: $17 = (2 \times 8) + 1$. The ratio of the length of the stylobate to its width is 9:4, and this ratio also characterizes the proportion of the length of the cella to its width, the distance between the center of one column drum and the center of the next (the *interaxial*) to the diameter of the columns, etc. In such details we can detect the shared principles of design of works of Classical Greek art as seemingly different as a life-size statue of a nude man and a temple over 200 feet long.

The mathematical precision with which the size of the constituent elements of the Parthenon was determined tends to blind us to the fact that this temple, as actually constructed, was anything but regular in shape. Throughout the building there are pronounced deviations from the strictly horizontal and vertical lines that one assumes to be the basis of all Greek post-and-lintel structures. The stylobate, for example, curves upward at the center on both the sides and the facade, forming a kind of shallow dome, and this curvature is carried up into the entablature (FIG. **5-48**). Moreover, the columns of the peristyle lean inward slightly. Those at the corners have a diagonal inclination and are also about 2 inches thicker than the rest; if their lines were continued, they would meet about 1½ miles above the temple. These deviations from the norm meant that virtually every block and drum of the Parthenon had to be carved according to the special set of specifications dictated by its unique place in the structure.

This was obviously a daunting task and it would not have been undertaken without a reason. There have been a variety of explanations for these so-called refinements in the Parthenon. Some modern observers have noted, for example, how the curving of straight lines and the tilting of vertical ones create a dynamic balance in the building—a kind of architectural contrapposto—and give it a greater sense of life, but the oldest recorded thesis may well be the correct one. Vitruvius, a Roman architect of the late first century B.C. who claims to have had access to the treatise on the Parthenon written by Iktinos—again we note the kinship with the *Canon* of Polykleitos—maintains that these adjustments were made to compensate for optical illusions. He states, for example, that if a stylobate is laid out on a level surface, it will appear to sag at the center, and that the corner columns of a building should be thicker since they are surrounded by light and would otherwise appear thinner than their neighbors.

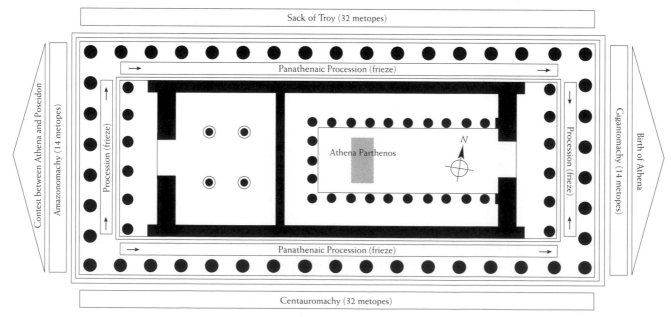

5-49 Plan of the Parthenon, with diagram of sculptural program. (After A. Stewart.)

The Parthenon is "irregular" in other ways as well. One of the ironies of this most famous of all Doric temples is that it is "contaminated" by Ionic elements. Although the cella had a two-story Doric colonnade around Phidias's cult statue, the back room (which housed Athena's treasury and the tribute collected from the Delian League) had four tall and slender Ionic columns as sole supports for the superstructure (FIG. **5-49**). And while the exterior of the temple had a canonical Doric frieze, the inner frieze that ran around the top of the cella wall was Ionic. Perhaps this fusion of Doric and Ionic reflects the Athenians' belief that the Ionians of the Cycladic Islands and Asia Minor were descended from Athenian settlers and were therefore their kin. Or it may be Pericles and Iktinos's way of suggesting that Athens was the leader of *all* the Greeks. In any case, we shall see that a mix of Doric and Ionic characterizes the fifth-century buildings of the Acropolis as a whole.

The costly decision to incorporate two sculptured friezes in the design of the Parthenon is symptomatic; this temple was more lavishly decorated than any Greek temple before it, Doric or Ionic (FIG. 5-49). Every one of the ninety-two Doric metopes was decorated with relief sculpture; so too was every inch of the 524-foot-long Ionic frieze. The pediments were filled with dozens of over-life-size statues.

Most of the reliefs and statues of the Parthenon are today exhibited in a special gallery in the British Museum in London, where they are known popularly as the "Elgin Marbles." Between 1801 and 1803, while Greece was still under Turkish rule, Lord Elgin, the British ambassador to the Ottoman court at Constantinople (modern Istanbul), was permitted to dismantle many of the Parthenon sculptures and to ship the best-preserved ones to England. He eventually sold them to the British government at a great financial loss to himself. Although he has often been accused of "stealing" the cultural heritage of Greece (the Greek government has long sought the return of the Elgin Marbles to Athens), Lord Elgin must be credited with saving the sculptures from almost certain ruin if they had been left at the site.

One statue that even Elgin could not recover was Phidias's image of Athena Parthenos, the Virgin, which had been destroyed long before the nineteenth century. We know a great deal about it, however, from descriptions by Greek and Latin authors and from Roman copies. A model in Toronto (FIG. **5-50**) gives a good idea of its appearance and setting. It was a *chryselephantine* statue, that is, fashioned of gold and ivory, the latter used for the exposed flesh of Athena. Phidias's statue stood 38 feet tall, and to a large extent the Parthenon was designed around it. To accommodate its huge size, the cella had to be wider than usual and this, in turn, dictated the width of the eight-column facade at a time when six columns were the norm, as at Aegina (FIGS. 5-28 and 5-29).

Athena was fully armed with shield, spear, and helmet, and held Nike (the winged female personification of Victory) in her extended right hand. There is no doubt as to

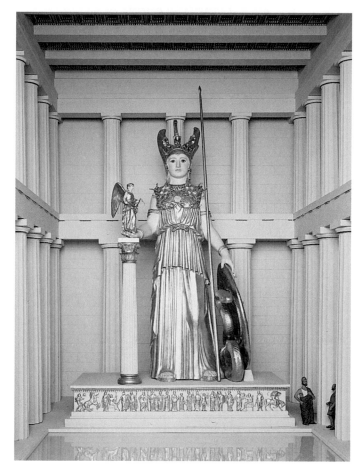

5-50 PHIDIAS, *Athena Parthenos, c.* 438 B.C. Model of the lost statue, which was approx. 38' tall. Royal Ontario Museum, Toronto.

which victory this Nike referred; the memory of the Persian sack of the Acropolis was still vivid, and the Athenians were intensely conscious that in driving back the Persians they were saving their civilization from being overrun by the Oriental "barbarians" who had committed atrocities at Miletos. In fact, there were multiple allusions to the Persian defeat in the cult statue of the Parthenon. On the thick soles of the sandals of Athena's feet was a representation of a centauromachy; the exterior of her shield was emblazoned with high reliefs depicting the battle of Greeks and Amazons (*Amazonomachy*) in which Theseus drove the Amazons out of Athens; and on the shield's interior was painted a gigantomachy. Each of these mythological contests was a metaphor for the triumph of order over chaos, of civilization over barbarism, and of Athens over Persia.

These same themes were taken up again in the Doric metopes of the Parthenon (see diagram of sculptural program in FIG. 5-49). The best-preserved metopes are those of the south side, which depicted the battle of Lapiths and centaurs, a combat in which Theseus of Athens played a major role. The quality varies; Phidias had to employ some less accomplished carvers in order to complete the decoration of the Parthenon on time. But the best of the metopes

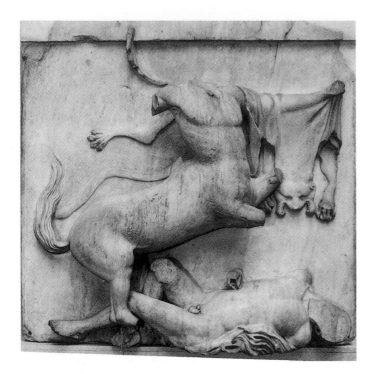

5-51 Lapith vs. centaur, metope from the south side of the Parthenon, c. 447–438 B.C. Marble, approx. 4′ 8″ high. British Museum, London.

but the Athenians. At the east the birth of Athena was depicted; at the west was the contest between Athena and Poseidon to determine which one would become the patron deity of the city; Athena won, hence the name of the polis and its citizens. It is significant that in the story and in the pediment the Athenians are the judges of the relative merits of the two gods; here we see the same arrogance that led to the use of Delian League funds to adorn the Acropolis.

The center of the east pediment was damaged when the apse was added to the Parthenon at the time of its conversion into a church. What remains are the spectators to the left and the right who witnessed Athena's birth on Mount Olympus. At the far left (FIG. **5-52**) were Helios (the Sun) and the horses of his chariot rising from the floor of the pediment. Next to them is a powerful male figure usually identified as Dionysos or possibly Herakles, who was awarded immortality and entered the realm of the gods upon completion of his twelve labors. At the right were three goddesses, probably Hestia, Dione, and Aphrodite (FIG. **5-53**), and either Selene (the Moon) or Nyx (Night) and more horses, this time sinking below the pediment's floor. Phidias, who designed the composition even if his assistants executed it, discovered an entirely new way to deal with the awkward triangular frame of the pediment: its bottom line is the horizon line and the heads of charioteers and horses move through it effortlessly. The individual figures, even the animals, are brilliantly characterized: the horses of the Sun, at the beginning of the day, are energetic; those of the Moon or Night, having labored until dawn, are weary.

The reclining figures fill the space beneath the raking cornice beautifully. Dionysos/Herakles and Aphrodite in the lap of her mother Dione are monumental Olympian presences yet totally relaxed organic forms. The sculptors fully understood not only the surface appearance of human anatomy, both male and female, but also the mechanics of how muscles and bones beneath the flesh and garments make the body move. The Phidian school has also mastered the rendition of clothed forms. In the Dione-Aphrodite

are truly magnificent. On one extraordinary slab (FIG. **5-51**) a triumphant centaur rises up on his hind legs, exulting over the crumpled body of the Greek whom he has defeated. The relief is so high that parts are fully in the round; some have broken off. The sculptor knows how to distinguish the vibrant, powerful form of the living beast from the lifeless corpse on the ground. In other metopes the Greeks have the upper hand, but the full set suggests that the battle was a difficult one against a dangerous enemy and that there were losses as well as victories. The same was true of the war against the Persians.

The subjects of the two pediments were especially appropriate for a temple that celebrated not only Athena

5-52 Helios and his horses, and Dionysos (Herakles?), from the east pediment of the Parthenon, c. 438–432 B.C. Marble, greatest height approx. 4′ 3″. British Museum, London.

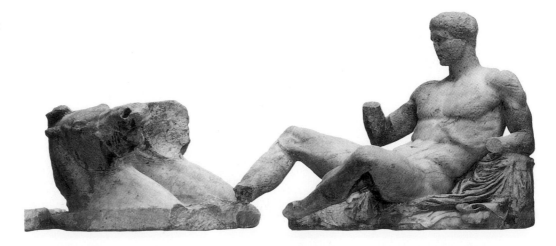

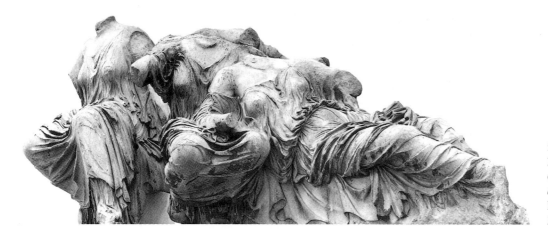

5-53 Three goddesses (Hestia, Dione, and Aphrodite?), from the east pediment of the Parthenon, *c.* 438–432 B.C. Marble, greatest height approx. 4′ 5″. British Museum, London.

group the thin and heavy folds of the garments alternately reveal and conceal the main and lesser masses of the bodies, and at the same time swirl in a compositional tide that subtly unifies the two figures. The articulation and integration of the bodies produce a wonderful variation of surface and play of light and shade. Not only are the bodies fluidly related to each other, but they are related to the draperies as well, although the latter, once painted, remain distinct from the bodies materially.

In many ways the most remarkable part of the sculptural program of the Parthenon is the inner Ionic frieze (FIGS. **5-54** to **5-56**). The subject of this frieze is still debated by scholars, but most agree that what is represented is the Panathenaic Festival procession that took place every four years in Athens. If this identification is correct, it is the first time a human event had been thought worthy of inclusion in the sculptural decoration of a Greek temple, and it is another example of the extraordinarily high opinion the Athenians had of their own worth.

The procession began in the marketplace and ended on the Acropolis, where a new peplos was placed on an ancient wooden statue of Athena. That statue (probably similar in general appearance to the *Lady of Auxerre*, FIG. 5-8) was housed in the Archaic temple razed by the Persians. The statue had been removed from the Acropolis before the Persian attack for security reasons, and eventually it was installed in the Erechtheion. On the Parthenon frieze the procession begins on the west, that is, on the rear of the temple, the side one first reached after emerging from the gateway to the Acropolis. It then proceeds in parallel lines down the long north and south sides of the building and ends at the center of the east frieze, over the doorway to the cella housing Phidias's statue. It is noteworthy that the upper part of the relief is higher than the lower part, so that the more distant and more shaded upper zone is as legible from the ground as the lower part of the frieze—another instance of taking optical effects into consideration in the design of the Parthenon.

The frieze vividly communicates the acceleration and deceleration of the procession. At the outset, on the west side, marshals gather and youths mount their horses. On the north (FIG. 5-54) and south, the momentum picks up as the cavalcade moves from the lower town to the Acropolis, accompanied by chariots, musicians, jar carriers, and animals destined for sacrifice. On the east, seated gods and goddesses (FIG. 5-55), the invited guests, watch the procession slow almost to a halt (FIG. 5-56) as it nears its goal at the shrine of Athena's ancient idol. Most remarkable of all

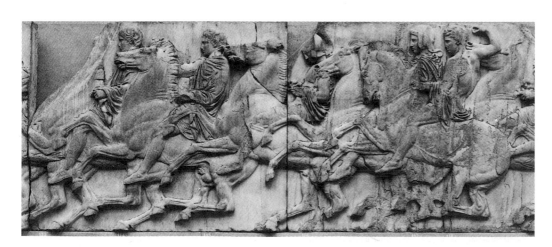

5-54 Horsemen, detail of the north frieze of the Parthenon, *c.* 447–438 B.C. Marble, approx. 3′ 6″ high. British Museum, London.

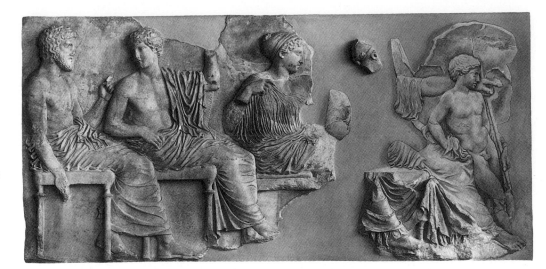

5-55 Seated gods and goddesses (Poseidon, Apollo, Artemis, Aphrodite, and Eros), detail of the east frieze of the Parthenon, *c.* 447–438 B.C. Marble, approx. 3′ 6″ high. Acropolis Museum, Athens.

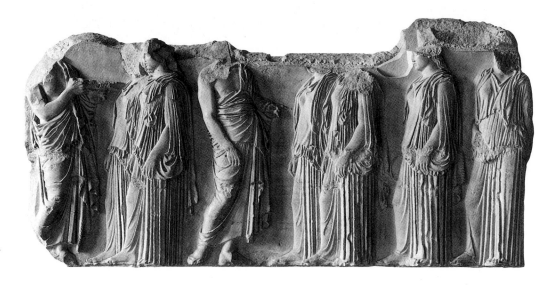

5-56 Procession of elders and maidens, detail of the east frieze of the Parthenon, *c.* 447–438 B.C. Marble, approx. 3′ 6″ high. Louvre, Paris.

is the role assigned to the Olympian deities. They do not take part in the festival or determine its outcome, but are merely spectators. Aphrodite, in fact, extends her left arm to draw the attention of her son Eros to the Athenians, much as a mother at a parade today would point out important people to her child. And the Athenian people *are* important—self-important one might say. They are the masters of an empire, and in Pericles's famous funeral oration he paints a picture of Athens that elevates its citizens almost to the stature of gods. The Parthenon celebrates the greatness of Athens and the Athenians as much as it honors Athena.

PROPYLAIA Even before all the sculpture was in place on the Parthenon, work was begun on a new monumental entrance to the Acropolis, the Propylaia (FIG. **5-57**). The architect entrusted with this important commission was MNESIKLES, and he apparently was given a liberal budget, because the gateway is constructed entirely of Pentelic marble. The site was a difficult one, on a steep slope, but

Mnesikles succeeded in disguising the change in ground level by splitting the building into eastern and western sections (FIG. 5-46), each one resembling the facade of a Doric temple. Practical considerations dictated that the space between the central pair of columns on each side be enlarged; this was the path taken by the chariots and animals of the Panathenaic Festival procession, and they required a wide ramped causeway. To either side of the central ramp there were stairs for pedestrian traffic. Inside, the split-level roof was supported by tall, slender Ionic columns. Once again we note the mixing of the two orders on the Acropolis, but as was the case with the Parthenon, the Doric order was used for the stately exterior and Ionic only for the interior; it would have been considered unseemly at this date to combine different kinds of columns on one facade. Hellenistic architects will not be as reticent.

Mnesikles's full plan for the Propylaia was never executed because of a change in the fortunes of Athens after the outbreak of the Peloponnesian War in 431 B.C. Of the side wings that were part of the original project, only that at the

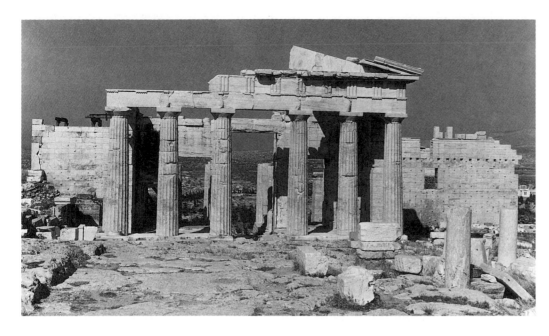

5-57 MNESIKLES, Propylaia, Acropolis, Athens, 437–432 B.C. (view from the east).

northwest was completed, but that wing is of special importance in the history of art. In Roman times it housed a *pinakotheke* (picture gallery), and in it were displayed paintings on wooden panels by some of the major artists of the fifth century B.C. It is uncertain whether or not this was the original function of this wing, but if it was, the pinakotheke of the Propylaia is the first recorded structure built for the specific purpose of displaying works of art and it is the forerunner of our modern museums.

ERECHTHEION In 421 B.C. work was finally begun on the temple that was to replace the Archaic Athena temple that had been razed by the Persians. The new structure, the

Erechtheion (FIG. **5-58**), built to the north of the remains of the old temple, was, however, to be a composite shrine. It honored Athena (and housed the ancient wooden image of the goddess that was the goal of the Panathenaic Festival procession), but also incorporated shrines to a host of other gods and demigods that loomed large in the legendary past of the city. Among these were Erechtheus, an early king of Athens, during whose reign the ancient wooden idol of Athena was said to have fallen from the heavens, and Kekrops, another king of Athens, who served as judge of the contest between Athena and Poseidon. In fact, the site chosen for the new temple was the very spot where that contest took place. Poseidon had staked his claim to

5-58 Erechtheion, Acropolis, Athens, *c.* 421–405 B.C. (view from the southeast).

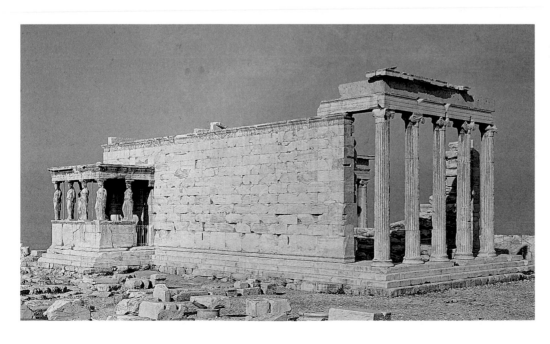

Athens by striking the Acropolis rock with his trident and producing a salt-water spring; the imprint of his trident remained for Athenians of the historical period to see. Nearby Athena had miraculously caused an olive tree to grow, and this tree still stood as a constant reminder of her victory over Poseidon.

The asymmetrical plan of the Ionic Erechtheion (FIG. **5-59**) is unique for a Greek temple and the antithesis of the simple and harmoniously balanced plan of the Doric Parthenon across the way. Its irregular form reflects the need to incorporate the tomb of Kekrops and other preexisting shrines, the trident mark, and the olive tree into a single complex. The nameless architect responsible for the building also had to struggle with the problem of irregular terrain. The uneven ground could not be made level by terracing because that would disturb the ancient sacred sites. As a result, the Erechtheion not only has four sides of very different character, but each side also rests on a different ground level.

Perhaps to compensate for the awkward character of the building as a whole, great care was taken with the decorative details of the Erechtheion. The frieze, for example, was given special treatment. The stone chosen was the dark blue limestone of Eleusis to contrast with the white Pentelic marble of the walls and columns. White relief figures were attached to this dark ground; fragments are now in the Acropolis Museum. The effect was much like that of modern Neoclassical Wedgwood pottery, which, through Roman intermediaries, is ultimately based on the Erechtheion frieze.

Other details of the Erechtheion's ornament were also much emulated, both in antiquity and in later times, but the most striking and famous feature of the temple is its south porch (FIG. **5-60**), where caryatids replace Ionic columns, as they did a century earlier on the Ionic treasury of the Siphnians at Delphi (FIG. 5-20). The Delphi caryatids resemble Archaic korai, and their Classical counterparts equally characteristically look like statues of the Phidian era. Although they exhibit the weight shift that is standard for the fifth century, the role of the caryatids as architectural supports for the unusual flat roof above is underscored by the vertical flute-like folds of the drapery concealing their stiff, weight-bearing legs. The Classical architect-sculptor has very successfully balanced the dual and contradictory function of these female statue-columns: the figures have enough rigidity to suggest the structural column and just the degree of flexibility needed to suggest the living body.

TEMPLE OF ATHENA NIKE Another Ionic building on the Athenian Acropolis is the beautiful little Temple of Athena Nike (FIG. **5-61**), designed by Kallikrates, who worked with Iktinos on the Parthenon (and perhaps was responsible for the Ionic elements of that Doric temple). The temple is amphiprostyle with four columns on both the east and west facades. It stands on what used to be a Mycenaean bastion near the Propylaia and greeted all visitors entering Athena's great sanctuary. As on the Parthenon, reference was made here to the victory over the Persians—and not just in the name of the temple. Part of its frieze was devot-

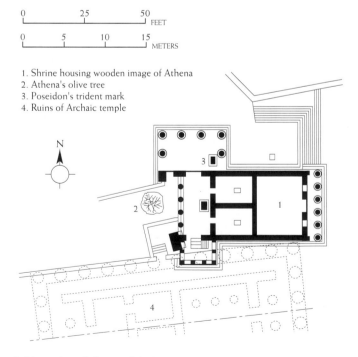

1. Shrine housing wooden image of Athena
2. Athena's olive tree
3. Poseidon's trident mark
4. Ruins of Archaic temple

5-59 Plan of the Erechtheion.

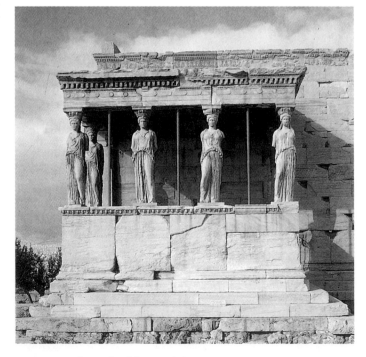

5-60 South porch of the Erechtheion.

than revealing the supple beauty of the young female body. The folds of the draperies form intricate linear patterns that are unrelated to the anatomical structure of the body and have a life of their own as abstract designs. Deep carving produces pockets of shade to contrast with the polished surface of the marble and enhances the ornamental beauty of what is admittedly a highly mannered design.

Relief Sculpture

Although the decoration of all the building projects on the Acropolis must have occupied most of the finest sculptors of Athens in the second half of the fifth century B.C., other commissions were available in the city, notably in the Dipylon cemetery. In Geometric times the graves of wealthy Athenians had been marked by huge amphoras

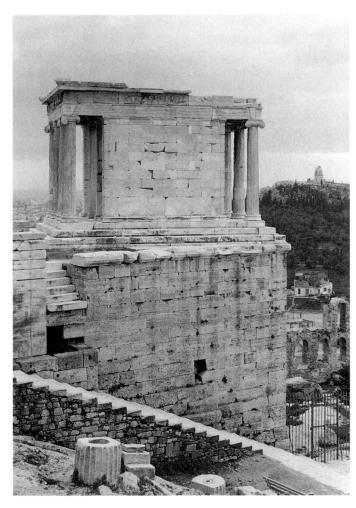

5-61 KALLIKRATES, Temple of Athena Nike, Acropolis, Athens, *c.* 427–424 B.C. (view from the northeast).

ed to a representation of the decisive battle at Marathon that turned the tide against the Persians. The frieze thus follows the precedent of the Panathenaic Festival procession frieze of the Parthenon in depicting a human event, but now a specific occasion is depicted, not a recurring event acted out by anonymous citizens.

Around the building, at the edge of the bastion, a parapet was built about 410 B.C. and decorated with exquisite reliefs. The theme of the balustrade matched that of the temple proper: Nike (Victory), whose image was repeated dozens of times, always in different attitudes, sometimes erecting trophies bedecked with Persian spoils, sometimes bringing forward sacrificial bulls to Athena. The most beautiful of the reliefs (FIG. **5-62**) shows a Nike adjusting her sandal—an awkward posture rendered elegant and graceful by a nameless master sculptor. The artist has carried the style of the Parthenon pediments (FIG. 5-53) even further and has given us a figure whose garments cling so tightly to the body that they seem almost transparent, as if drenched with water. The sculptor is, however, interested in much more

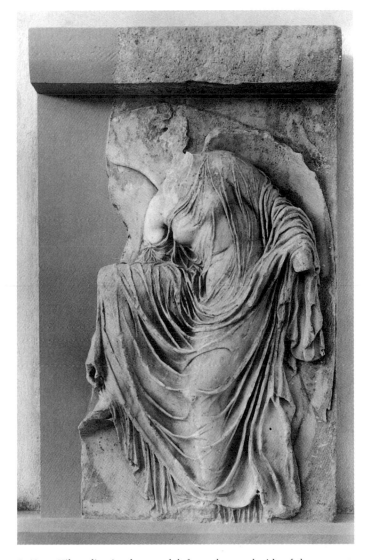

5-62 Nike adjusting her sandal, from the south side of the parapet of the Temple of Athena Nike, Acropolis, Athens, *c.* 410 B.C. Marble, approx. 3′ 6″ high. Acropolis Museum, Athens.

and kraters. In the Archaic period, kouroi and, to a lesser extent, korai were placed over Greek burials, as were grave stelae ornamented with depictions in relief of the deceased. A beautiful and touching grave stele (FIG. **5-63**) in the style of the parapet reliefs of the Temple of Athena Nike is in this tradition. It was set up at the end of the fifth century to commemorate the death of Hegeso, daughter of Proxenos, whose name is inscribed on the cornice of the pediment that crowns the stele; antae at left and right complete the architectural framework. The deceased is the well-dressed woman seated on an elegant chair (with footstool) who is examining a piece of jewelry (once painted, not now visible) that she has selected from a box brought to her by a servant girl, who wears a simple ungirt chiton. The garments of both women reveal the bodily forms beneath them. The faces are serene, without a trace of sadness; indeed, both mistress and maid are shown in a characteristic shared moment out of daily life. Only the greater stature of the free-born woman and the epitaph tell us that she is the one who has departed and that the stele was set up in her honor.

Painting

Scenes similar to that depicted on the Hegeso stele appear on the painted *lekythoi* (flasks containing perfumed oil) that were placed in Greek graves as offerings to the deceased. One of the finest of these vases (FIG. **5-64**) was painted by the so-called ACHILLES PAINTER and shows a youthful warrior taking leave of his wife. The red scarf, mirror, and jug hanging on the wall behind the woman indicate that the setting is the interior of their home. The motif of the seated woman is strikingly similar to that on the Hegeso stele (FIG. 5-63), but here she is the survivor. It is her husband,

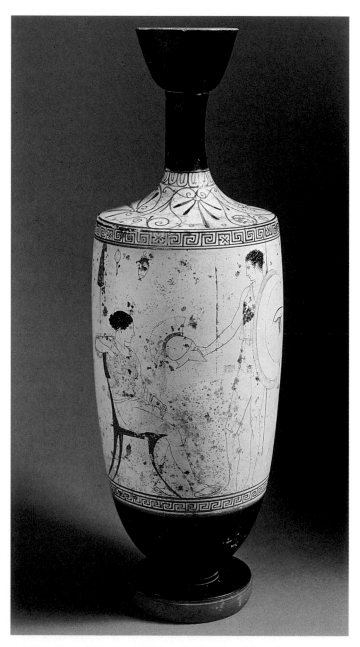

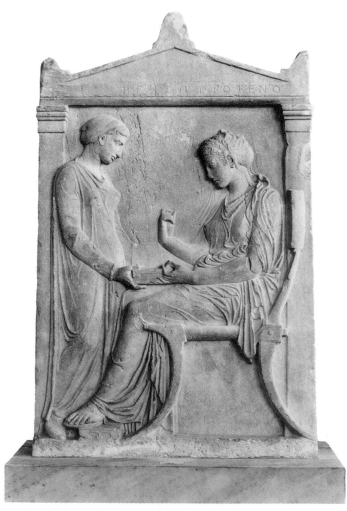

5-63 Grave stele of Hegeso, from the Dipylon cemetery, Athens, *c.* 410–400 B.C. Marble, 5′ 2″ high. National Archeological Museum, Athens.

5-64 ACHILLES PAINTER, Warrior taking leave of his wife (Attic white-ground lekythos), from Eretria, *c.* 440 B.C. Approx. 17″ high. National Archeological Museum, Athens.

preparing to go to war with helmet, shield, and spear, who will depart, never to return. On his shield is a huge painted eye, roughly life-size. Greek shields were often decorated with apotropaic devices intended to ward off evil spirits and frighten the enemy, like the horrific face of Medusa, and this eye is undoubtedly meant to recall this venerable tradition. In fact, it is little more than an excuse for the Achilles Painter to display his talents as a draftsman. Since the late sixth century B.C. Greek painters had abandoned the Archaic habit of placing frontal eyes on profile faces and attempted to render the eyes in profile. The Achilles Painter's mastery of this difficult problem in foreshortening is on display here.

The technique used to decorate the Achilles Painter's lekythos is called *white-ground*, after the chalky white slip that was used to provide a background for the painted figures. Experiments with the white-ground technique date back to the Andokides Painter, but the method became popular only toward the middle of the fifth century. The white-ground technique is essentially a variation of the red-figure technique; the pot was first covered with a slip of very fine white clay, over which black glaze was used to outline the figures, and diluted brown, purple, red, and white were used to color them. Other colors, for example, the yellow used for the garments of both husband and wife on our lekythos, could also be employed, but these had to be applied after firing because the Greeks did not know how to make them withstand the heat of the kiln. As attractive as this full polychrome painting was, the impermanence of the expanded range of colors discouraged the use of the white-ground technique for vessels destined for daily use, such as drinking cups and kraters. For funerary lekythoi, however, which were buried shortly after they were produced, this was not a drawback, and after the middle of the fifth century B.C., the full polychrome possibilities of white-ground painting were explored almost exclusively on these vessels designed for short-term use.

We know from ancient accounts that painting in Greece was not confined to the surfaces of vases and that in the Classical period some of the most renowned artists were the painters of monumental wooden panels displayed in public buildings, both secular and religious. Such works are, by nature, perishable, and unfortunately all of the great panels of the masters are lost. White-ground lekythoi can give us some idea of the polychrome nature of their work, but they differ from their monumental counterparts not only in size but also in theme and composition.

The leading painter of the first half of the fifth century B.C. was Polygnotos of Thasos, whose works adorned important buildings both in Athens and Delphi. One of these was the pinakotheke of Mnesikles's Propylaia, but the most famous was the stoa in the Athenian agora that came to be called the Stoa Poikile (Painted Stoa).* Descriptions of

Polygnotos's paintings make clear that he introduced a compositional style radically different from that used on all the Greek vases examined thus far, where all the figures are situated on a common groundline at the bottom of the picture plane, whether they appear in horizontal bands or single panels. Polygnotos placed his figures on different levels, staggered in tiers in the manner of Ashurbanipal's lion hunt relief (FIG. 2-21) of two centuries before. We are also told that he incorporated landscape elements into his paintings, making his pictures true "windows onto the world" and not simply surface designs peopled with foreshortened figures. The abandonment of a single groundline by Polygnotos and his followers was as momentous a break from the past as was the rejection of frontality in statuary by Greek sculptors of the Early Classical period.

We can get a good idea of what Polygnotos's compositions looked like from a red-figure krater (FIG. **5-65**) painted just before the middle of the fifth century B.C. by the NIOBID PAINTER. The painter, who did not sign his vases, gets his modern nickname from this krater, where one side is devoted to the massacre of the Niobids, the children of Niobe, by Apollo and Artemis. Niobe, who had at least a dozen children, had boasted that she was superior to the goddess Leto, who had only two offspring, Apollo and Artemis. To punish her *hubris* (arrogance) and teach the lesson that no mortal could be superior to a god or goddess, Leto sent her two children to slay all of Niobe's many sons and daughters. On the Niobid Painter's krater, the horrible slaughter takes place in a schematic landscape setting of rocks and trees. The figures are disposed on several levels and they actively interact with their setting. One slain son, for example, not only has fallen upon a rocky outcropping;

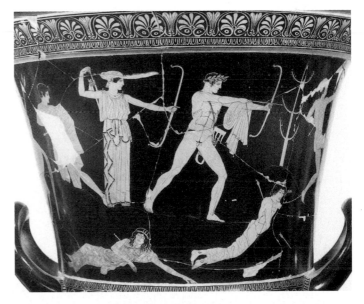

5-65 NIOBID PAINTER, Apollo and Artemis slaying the children of Niobe (detail from an Attic red-figure calyx-krater), from Orvieto, *c.* 455–450 B.C. Portion shown approx. 15" high, whole vessel approx. 21" high. Louvre, Paris.

*Because Zeno and his successors taught here, the building, in turn, lent its name to an important school of Greek philosophy, the Stoics.

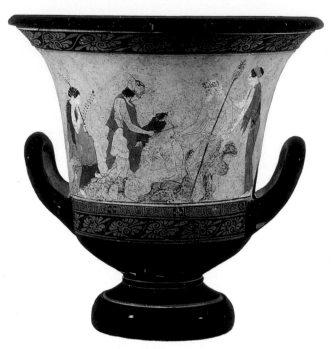

5-66 Phiale Painter, *Hermes bringing the infant Dionysos to Papposilenos* (Attic white-ground calyx-krater), from Vulci, *c.* 440–435 B.C. Approx. 14″ high. Vatican Museums, Rome.

he is partially hidden by it. His face is also drawn in a three-quarter view, something that had not been attempted even by Euphronios and Euthymides.

Further insight into the appearance of monumental panel painting of the fifth century B.C. comes from a white-ground krater (FIG. **5-66**) by the so-called Phiale Painter. This vessel, like the Niobid krater, was found at an Etruscan site in Italy. The subject is Hermes handing over his half brother, the infant Dionysos, to Papposilenos ("granddad-satyr"). The other figures represent the nymphs in the shady glens of Nysa, where Zeus had sent Dionysos, one of his numerous natural sons, to be raised, safe from the possible wrath of his wife, Hera. Unlike the decorators of funerary lekythoi, the Phiale Painter used for his krater only those colors that could survive the heat of the Greek kiln—reds, brown, purple, and a special snowy white reserved for the flesh of the nymphs and for such details as the hair, beard, and shaggy body of Papposilenos. The use of diluted brown wash to color and shade the rocks upon which the old satyr sits may reflect the coloration of Polygnotos's landscapes. This vase and the Niobid krater together provide us with a shadowy idea of the character and magnificence of Polygnotos's great paintings.

Although the panel paintings of the masters did not survive, there are some Greek mural paintings preserved today. A fine, early example is in the so-called Tomb of the Diver at Paestum in southern Italy (the site of the two well-preserved Doric temples of Hera, FIGS. 5-16 and 5-33, discussed earlier). The four walls of this small, coffin-like tomb are decorated with banquet scenes such as appear regularly on contemporary Greek vases. The ceiling block of the tomb (FIG. **5-67**) shows a youth diving from a stone platform into a body of water; it most likely symbolizes the plunge from this life into the next. Trees resembling those of the Niobid krater are also included within the decorative frame. The theme is not paralleled on extant Greek vases, but appears, as we shall see, on the wall of an Etruscan tomb of the late sixth century B.C. (FIG. 6-10). The Greek painter responsible for the murals of the Tomb of the Diver appears to have been as aware of developments in Etruscan painting as he was of the work of his contemporaries in mainland Greece.

5-67 Youth diving, painted ceiling of the Tomb of the Diver, Paestum, *c.* 480 B.C. Approx. 3′ 4″ high. Museo Archeologico Nazionale, Paestum.

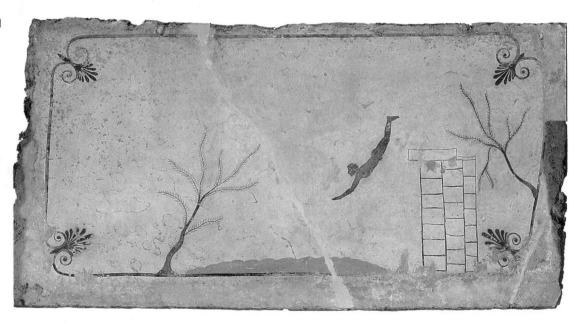

THE LATE CLASSICAL PERIOD (FOURTH CENTURY B.C.)

The Peloponnesian War, which began in 431 B.C., ended in 404 B.C. with the complete defeat of Athens and left Greece drained of its strength. Sparta and then Thebes took the leadership of Greece, both unsuccessfully. In the middle of the fourth century, a threat from without caused the rival Greek states to put aside their animosities and unite for their common defense, as they had earlier against the Persians. But at the battle of Chaeronea in 338 B.C., the Greek poleis suffered a devastating loss and had to relinquish their independence to Philip II, king of Macedon. Philip was assassinated in 336 B.C. and succeeded by his son, Alexander III, better known simply as Alexander the Great. In the decade before his death in 323 B.C. Alexander led a powerful army on an extraordinary campaign that overthrew the Persian Empire (the ultimate revenge for the Persian invasion of Greece in the early fifth century B.C.), wrested control of Egypt, and even reached India.

The fourth century B.C. was thus a time of political upheaval in Greece, and the chaos had a profound impact on the psyche of the Greeks and upon the art they produced. In the fifth century, there was a general belief that rational human beings could impose order upon their environment, create "perfect" statues like the *Canon* of Polykleitos, and discover the "correct" mathematical formulas with which to construct temples like the Parthenon. The frieze of the Parthenon celebrated the Athenians as a community of citizens with shared values. The Peloponnesian War and the unceasing strife of the fourth century brought an end to the serene idealism of the fifth century and a concomitant rise of disillusionment and alienation. Greek thought and Greek art began to focus more on the individual and on the real world of appearances rather than on the community and the ideal world of perfect beings and perfect buildings.

Sculpture

PRAXITELES AND HIS FOLLOWERS In the work of PRAXITELES, one of the great masters of the fourth century B.C., the new humanizing approach to art is immediately apparent. The themes favored by the sculptors of the High Classical period are not rejected, and the gods and goddesses of Mount Olympus retain their superhuman beauty, but they lose some of their solemn grandeur and take on a worldly sensuousness.

Nowhere is this new *ethos* plainer than in the statue of Aphrodite that Praxiteles made for the Knidians (FIG. **5-68**). The lost original, carved from Parian marble, is known only through copies made for the Romans, but it was considered by Pliny to be "superior to all the works, not only of Praxiteles, but indeed in the whole world." It made the island of Knidos famous, and many people sailed there just to see the statue in its round temple, where "it was possible to observe the image of the goddess from every side," and where some visitors were "overcome with love for the statue."

What caused such a sensation in its time was the fact that Praxiteles had taken the unprecedented step of representing the goddess of love completely nude. Female nudity was

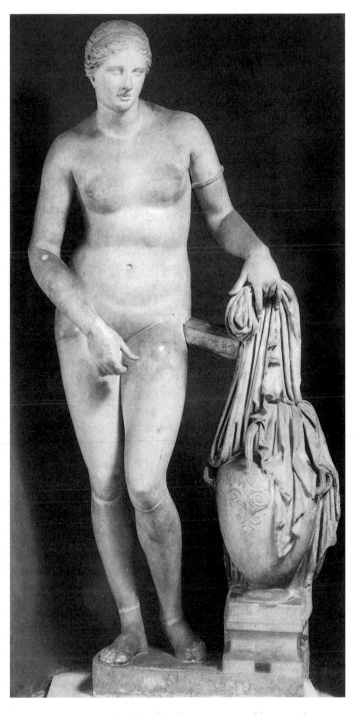

5-68 PRAXITELES, *Aphrodite of Knidos*. Roman marble copy after an original of *c.* 350–340 B.C. Approx. 6′ 8″ high. Vatican Museums, Rome.

exceedingly rare in earlier Greek art and had been confined almost exclusively to paintings on vases designed for household use, like the red-figure kylix of Onesimos (FIG. 5-27) discussed earlier. The women so depicted also tended to be courtesans and slave girls, not noblewomen or goddesses, and no one had dared fashion a monumental cult image of a goddess without her clothes. Moreover, the *Aphrodite of Knidos* is not a cold and remote image; rather the goddess is shown engaged in a trivial act out of everyday life. She has removed her garment, draped it over a large *hydria* (water pitcher), and is about to step into the bath; the motif is strikingly similar to that on Onesimos's kylix. Although shocking in its day, Praxiteles's Aphrodite is not openly erotic (the goddess modestly shields her pelvis with her right hand), but she is quite sensuous. Lucian (second century A.D.) notes she had a "welcoming look" and a "slight smile" and that Praxiteles was renowned for his ability to transform marble into soft and radiant flesh; he mentions, for example, the "dewy quality of Aphrodite's eyes."

Unfortunately, the rather mechanical Roman copies we possess do not capture the quality of Praxiteles's modeling of the stone, but we can get a good idea of the "look" of the *Aphrodite of Knidos* from original works by sculptors who emulated the master's manner. One of the finest of these is the head of a woman from Chios (FIG. **5-69**) that was once set into a draped statue. Here we can appreciate the way the chisel has been wielded to suggest the softness of the young girl's face and the "dewy" gaze of the eyes. The sharp outlining of precisely measured body parts that characterized the work of Polykleitos and his contemporaries has given way to a smooth flow of flesh from forehead to chin and to a very human sensuousness. In the statues of Praxiteles and his followers, the deities of Mount Olympus still possess a beauty that mortals can aspire to, although not achieve, but they are no longer awesome and remote. The Greek gods have stepped off their fifth-century pedestals and entered the fourth-century world of human experience.

The Praxitelean manner may also be seen in a statue once thought to be by the hand of the master himself, but now generally considered to be a copy of the very highest quality. The statue of Hermes and the infant Dionysos (FIG. **5-70**) found in the Temple of Hera at Olympia brings to the realm of monumental statuary the theme that the Phiale Painter had chosen for his white-ground krater (FIG. 5-66) a century earlier. Hermes has stopped to rest in a forest on his journey to Nysa to entrust the upbringing of Dionysos to Papposilenos and the nymphs. Hermes leans on a tree trunk (in this case it is an integral part of the composition and not an addition by the copyist), and his slender body forms a sinuous, shallow S-curve that is the hallmark of many of Praxiteles's statues. He looks off dreamily into space while he dangles a bunch of grapes (now missing) as a temptation for the infant who is to become the Greek god of the vine. This is the kind of tender and very human

5-69 Head of a woman, from Chios, *c.* 320–300 B.C. Marble, approx. 14" high. Courtesy, Museum of Fine Arts, Boston.

interaction between an adult and a child that one encounters frequently in real life but that had been absent from Greek statuary before the fourth century B.C.

The superb quality of the carving is faithful to the Praxitelean original. The modeling is deliberately smooth and subtle, producing soft shadows that follow the planes as they flow almost imperceptibly one into another. The delicacy of the features of the marble head stand in sharp contrast to the metallic precision of Polykleitos's *Doryphoros* (FIG. 5-43), where even the locks of hair are subjected to the fifth-century B.C. sculptor's laws of symmetry and do not violate the perfect curve of the skull. We need only compare these two statues to see how broad a change in artistic attitude and intent took place from the mid-fifth to the mid-fourth century. Majestic strength and rationalizing design are replaced by sensuous languor and an order of beauty that appeals more to the eye than to the mind.

Somewhat more remote but no less sensuous is the *Apollo Belvedere* (FIG. **5-71**), named for the spot in the Vatican where it has been displayed since the sixteenth century. The statue is a Roman marble version of a bronze original attributed by some scholars to Leochares, a contemporary of Praxiteles, but the attribution is tenuous. Admired in the Renaissance, in the eighteenth century

the statue was considered to be the crowning achievement of Greek sculpture. Although the work no longer elicits the extravagant praise that it once did, and contemporary taste finds the elaborate coiffure of the god less appealing, the original statue was nonetheless very impressive. The light-footed Apollo has just landed on the ground. His posture is not unlike that of the Niobid Painter's heartless Apollo systematically slaying the children of Niobe (FIG. 5-65), and the *Apollo Belvedere* is also shooting an arrow at some unseen opponent. This does not mean that the statue was once part of a group, but the spectator automatically completes the group in his mind. Through glance and gesture this Apollo reaches out into space; again the contrast with the self-contained *Doryphoros* of Polykleitos (FIG. 5-42) is instructive.

5-71 LEOCHARES *(?)*, *Apollo Belvedere*. Roman marble copy after a bronze original of *c.* 330 B.C. Approx. 7′ 4″ high. Vatican Museums, Rome.

5-70 PRAXITELES, Hermes and the infant Dionysos, from Olympia. Marble copy after an original of *c.* 340 B.C. Approx. 7′ 1″ high. Archeological Museum, Olympia.

SKOPAS, LYSIPPOS, AND OTHERS In the Archaic period and throughout most of the Early and High Classical periods, Greek sculptors generally shared common goals, but in the Late Classical period of the fourth century B.C., distinctive individual styles emerge. The dreamy, beautiful divinities of Praxiteles had enormous appeal and, as the head of the woman from Chios (FIG. 5-69) attests, the master had many followers. But other master sculptors pursued very different interests. One of these was SKOPAS OF PAROS, and although his work reflects the general trend toward the humanization of the gods and heroes of the Greeks, his style is marked by intense emotionalism. Skopas was an architect as well as a sculptor; he designed the Temple of Athena Alea at Tegea. Fragments of the pedimental statues from that temple are preserved, and they epitomize his approach to sculpture, even if they are not by his own hand. One of the heads (FIG. **5-72**) portrays a hero wearing a lion-skin headdress; it must be either Herakles or his son Telephos, whose battle with Achilles was the subject of the

5-72 Head of Herakles or Telephos, from the west pediment of the Temple of Athena Alea at Tegea, *c.* 340 B.C. Marble, approx. 12¹/₂″ high. National Archeological Museum, Athens.

west pediment. The head, like others from the Tegea pediments, is highly dramatic. There is an abrupt turn of the neck, and the expression on the face is one of great psychological tension. The eyes are large and set deeply into the head. The fleshy overhanging brows create deep shadows. The lips are slightly parted. The passionate visage reveals an anguished soul within. Skopas's work breaks with the Classical tradition of benign, serene features and prefigures later Hellenistic art in which the depiction of unbridled emotion became more common.

An unprecedented psychological intensity may also be seen in a grave stele (FIG. **5-73**) found near the Ilissos River in Athens that incorporates the innovations of Skopas. The stele was originally set into an architectural frame like that of the earlier Hegeso stele (FIG. 5-63), and the comparison between the two works is very telling. In the Ilissos stele the relief is much higher, with parts of the figures carved fully in the round, but the major difference is the pronounced change in mood. In the later work there is a clear distinction between the living and the dead, and overt mourning is depicted. The deceased is a young hunter whose features recall those of Skopas's Tegean heroes. At his feet is a small boy, either his servant or perhaps a younger brother, who sobs openly. The hunter's dog also droops its head in sorrow. Beside the youth is an old man,

undoubtedly his father, who leans on a walking stick and, in a gesture reminiscent of that of the seer at Olympia (FIG. 5-35), ponders the irony of fate that has taken the life of his powerful son and preserved him in his frail old age. Most remarkable of all, the hunter himself looks out at us, inviting our sympathy, creating an emotional bridge between the spectator and the work of art that is inconceivable in the art of the High Classical period.

The third great Late Classical sculptor was LYSIPPOS OF SIKYON, who was so renowned that he was selected by Alexander the Great to fashion his official portrait. (Alexander could afford to employ the best. The kingdom of Macedon enjoyed vast wealth; Philip had been able to hire the leading thinker of his age, Aristotle, as the young Alexander's tutor!)

Lysippos introduced a new canon of proportions in which the bodies were more slender than those of Polykleitos—whose own canon continued to exert enormous influence—and where the heads were roughly one-eighth the height of the body rather than one-seventh, as

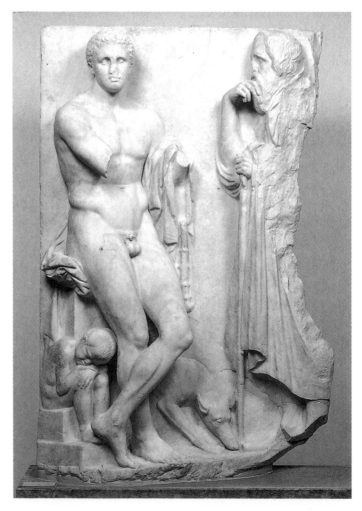

5-73 Grave stele of a young hunter, found near the Ilissos River, Athens, *c.* 340–330 B.C. Marble, approx. 5′ 6″ high. National Archeological Museum, Athens.

in the previous century. The new proportions may be seen in one of Lysippos's most famous works, a bronze statue of an *Apoxyomenos* (an athlete scraping oil from his body after exercising), known to us, as usual, only from Roman copies in marble (FIG. **5-74**). A comparison with Polykleitos's *Doryphoros* (FIG. 5-42) reveals more than a change in physique. A nervous energy runs through the *Apoxyomenos* that one seeks in vain in the balanced form of the *Doryphoros*. The *strigil* (scraper) is about to reach the end of the right arm and at any moment it will be switched to the other hand so that the left arm can be scraped; the weight will shift at the same time and the positions of the legs will be reversed. Lysippos has also begun to break down the dominance of the frontal view in statuary

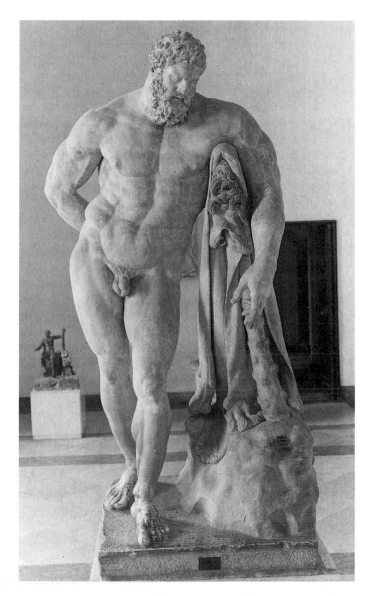

5-75 LYSIPPOS, Weary Herakles (*Farnese Herakles*). Roman marble copy, signed by GLYKON OF ATHENS, after a bronze original of *c*. 320 B.C. Approx. 10' 5" high. Museo Nazionale, Naples.

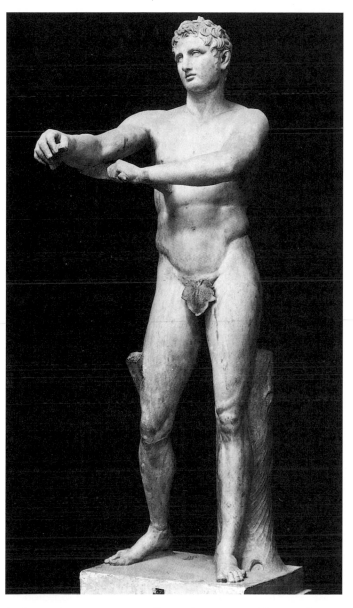

5-74 LYSIPPOS, *Apoxyomenos* (Scraper). Roman marble copy after a bronze original of *c*. 330 B.C. Approx. 6' 9" high. Vatican Museums, Rome.

and encourages the observer to look at his athlete from multiple angles. The *Apoxyomenos* breaks out of the shallow rectangular cube that defined the boundaries of earlier statues by boldly thrusting his right arm forward; to comprehend the action we must move to the side and view the work at a three-quarter angle or in full profile.

To grasp the full meaning of Lysippos's colossal statue of Herakles (FIG. **5-75**), the viewer must walk around it. Once again, the original is lost. The most famous of the marble copies that have come down to us is nearly twice life-size and is signed by one Glykon of Athens. It was exhibited in the Baths of the emperor Caracalla in Rome (FIG. 7-74), where, like the marble copy of Polykleitos's *Doryphoros* from the Roman palestra at Pompeii (FIG. 5-42), the muscle-bound Greek hero provided inspiration for Romans who

came there to exercise. In the hands of Lysippos, however, the exaggerated muscular development of Herakles is poignantly ironic, for the sculptor has depicted the strongman as so weary that he must lean on his club for support. Without that prop he would topple over; we note here, as in other fourth-century statues, the rejection of stability and balance as worthy goals for statuary. Behind his back—unseen unless one explores all sides of the statue—Herakles holds the golden apples of the Hesperides in his right hand. Lysippos's subject is thus the same as that of the artist responsible for the metope of the Early Classical Temple of Zeus at Olympia (FIG. 5-36), but the fourth-century Herakles is no longer serene. Instead of expressing joy, or at least satisfaction, at having completed one of the impossible Twelve Labors, he is almost dejected. Exhausted by his physical efforts, he can think only of his pain and weariness, not of the reward of immortality that awaits him. Lysippos's portrayal of Herakles in this statue is perhaps the most eloquent testimony we have to the interest of Late Classical sculptors in humanizing the great gods and heroes of the Greeks. In this respect, despite their divergent styles, Praxiteles, Skopas, and Lysippos follow a common path.

Alexander the Great and Macedonian Court Art

Alexander the Great's favorite book was the *Iliad*, and his own life was very much like an epic saga, full of heroic battles, exotic places, and unceasing drama. Alexander was a man of extraordinary character, an inspired leader with boundless energy and an almost foolhardy courage that regularly found him personally leading his army into battle on the back of Bucephalus, the wild and mighty steed that only he could tame and ride.

Ancient sources tell us that Alexander believed that only Lysippos had captured his essence in a portrait, and that is why only he was authorized to sculpt the king's image. Lysippos's most famous portrait of the Macedonian king was a full-length heroically nude bronze statue in which Alexander held a lance and turned his head upward toward the sky. On the base was inscribed an epigram stating that the statue depicted Alexander gazing at Zeus and proclaiming "I place the earth under my sway; you, O Zeus, keep Olympus." We read further that the portrait was characterized by "leonine" hair and a "melting glance."

The Lysippan original did not survive, and since Alexander was portrayed so many times for centuries after his death, it is very difficult to determine which of the many images we have is most faithful to the fourth-century B.C. portrait. A leading candidate is a second-century B.C. marble head (FIG. **5-76**) from Pella, the capital of Macedonia and the birthplace of Alexander. It has the sharp turn of the head and thick mane of hair that were key ingredients of Lysippos's portrait. Treatment of the features also is consistent with the style of the later fourth century: the deep-set eyes and parted lips recall the manner of

5-76 Head of Alexander the Great, from Pella, *c.* 200–150 B.C. Marble, approx. 12″ high. Archeological Museum, Pella.

Skopas, the delicate handling of the flesh brings to mind the faces of Praxitelean statues. Although not a copy, this head very likely approximates the official portrait of the young king and provides insight not only into Alexander's personality but also into the art of Lysippos.

MOSAIC AND PAINTING The palace of Alexander has not been excavated, but we can form an idea of the sumptuousness of life at the Macedonian court from the costly objects that have been found in Macedonian graves and from the abundance of mosaics that have been uncovered at Pella in the homes of the wealthy. As an art form, *mosaic* had a rather simple and utilitarian beginning and seems to have been invented primarily for the purpose of developing an inexpensive and durable flooring. Originally, small pebbles collected from beaches and riverbanks were set into a thick coat of cement. Artisans soon discovered, however, that the stones could be arranged in decorative patterns. At first, these patterns were quite simple and were confined to geometric shapes. Generally only black and white stones were used. Examples of this type, dating back to the eighth century B.C., have been found at Gordion in Asia Minor. Eventually, the stones were arranged to form more complex pictorial designs, and, by the fourth century B.C., the technique had developed to the point that elabo-

5-77 GNOSIS, *Stag hunt, c.* 300 B.C. Pebble mosaic, from Pella; figural panel 10′ 2″ high. In situ.

rate figural scenes could be represented utilizing a broader range of colors.

The finest pebble mosaic yet to come to light at Pella (FIG. **5-77**) has a stag hunt as its *emblema* (central, framed panel), bordered in turn by an intricate floral pattern and a stylized wave motif. The artist has signed his work in the same manner as did proud vase painters of the Archaic and Classical periods: "GNOSIS made it." This is the earliest mosaicist's signature known, and its prominence in the design undoubtedly attests to the artist's reputation: the owner of the house in which the mosaic was found would have wanted guests to know that Gnosis himself, and not an imitator, had laid the floor.

The design, with its light figures against a dark ground, has much in common with red-figure painting. In the pebble mosaic, however, most of the contour lines and some of the interior details are defined by thin strips of lead or terracotta, while the interior volumes are suggested by subtle gradations of yellow, brown, and red as well as black, white, and gray pebbles. The musculature of the hunters, and even their billowing cloaks and the bodies of the animals, are modeled by shading. Such use of light and dark to suggest volume is rarely seen on painted Greek vases, although examples do exist, but shading was commonly used by monumental painters. The Greek term for shading was *skiagraphia* (literally, shadow painting), and it was said to have been invented by an Athenian painter of the fifth century named Apollodoros. Gnosis's emblema, with its sparse landscape setting, probably reflects contemporary panel painting.

An even better idea of the character of monumental painting during Alexander's time may be gleaned from the painted walls of Macedonian tombs, especially a tomb at Lefkadia, which dates about 300 B.C. The elaborate facade of the tomb was articulated with engaged columns on either side of the entrance. Between pairs of columns were painted four large figures: at the far left, the deceased, dressed as a Macedonian soldier; then the god Hermes, whose job it was to guide souls to the Underworld; and finally, on the other side of the doorway, two of the judges of the dead, Aiakos, seated, and Rhadymanthos, leaning on his staff (FIG. **5-78**). The figure of Rhadymanthos resembles in many ways the mourning father on the Ilissos stele (FIG. 5-73), but his role is very different. He and Aiakos await the dead in the realm of Hades, god of the Underworld; the deceased is being led there by Hermes. What separates the judges from the judged and his guide is the door to the tomb, which is symbolically the entrance to the Underworld. The delicate gradations of color used by the unknown painter to suggest the volume of

5-78 *Rhadymanthos,* detail of the painted facade of a Macedonian tomb at Lefkadia, *c.* 300 B.C. Fresco, approx. 3′ 9 1/2″ high.

Rhadymanthos's face, body, and cloak are much more subtle than those employed by Gnosis, but one must remember how much easier it is to shade a figure with a brush and pigment than to do so with pebbles.

By the middle of the third century B.C., a new kind of mosaic had been invented that permitted the best mosaicists to create designs that more closely approximated true paintings. The new technique employed *tesserae* (tiny stones or pieces of glass) cut to the desired size and shape, which permitted more precise description of detail and ever more subtle gradations of color. One of the greatest tessera mosaics of antiquity (FIG. **5-79**) decorated the floor of a lavishly appointed Roman house at Pompeii. Its subject is a great battle between Alexander the Great and the Persian king Darius III, probably the *Battle of Issus*, in which Darius fled from the battlefield in his chariot in ignominious defeat. The mosaic dates to the late second or early first century B.C., but it is widely believed to be a reasonably faithful copy of a famous panel painting of *c.* 310 B.C. that PHILOXENOS OF ERETRIA made for King Cassander, one of Alexander's successors.

Philoxenos's painting is notable for its technical mastery of problems that had long fascinated Greek painters. The rearing horse in front of Darius's chariot, for example, is seen in a three-quarter rear view that even Euthymides would have marveled at, and the subtle modulation of the horse's rump through shading in browns and yellows is precisely what Gnosis was striving to imitate in his pebble mosaic. Other details are even more impressive. The Persian to the right of the rearing horse has fallen to the ground and raises, backwards, a dropped Macedonian shield to protect himself from being trampled. On the shield's polished surface we can see the reflection of the man's terrified face. And everywhere, men, animals, and weapons cast shadows upon the ground. The interest of Philoxenos and other Classical painters in the reflection of insubstantial light on a shiny surface, and in the absence of light (shadows), is radically different from the preoccupation of pre-Classical painters with the clear presentation of weighty figures on a blank background. The Greek painter has here truly given us a window onto a world filled not only with figures and trees and sky, but also with light. It is this Classical Greek notion of what a painting should be that characterizes most of the history of art in the Western world from the Renaissance on.

What impresses one most about the *Battle of Issus* is, however, not the virtuoso details, but the psychological intensity of the drama that is unfolding before our eyes. Alexander is leading his army into battle, recklessly one might say, without even a helmet to protect him. He drives his spear through one of Darius's trusted "Immortals," who were sworn to guard the king's life, while the Persian's horse

5-79 PHILOXENOS OF ERETRIA, *Battle of Issus*, *c.* 310 B.C. Roman mosaic copy of the late second or early first century B.C. from the House of the Faun, Pompeii. Approx. 8′ 10″ × 16′ 9″. Museo Nazionale, Naples.

5-80 POLYKLEITOS THE YOUNGER, Theater, Epidauros, *c.* 350 B.C.

collapses beneath him. The Macedonian king is only a few yards away from Darius now and his gaze is directed at the Persian king, not at the man impaled on his spear. Darius has called for retreat; in fact, his charioteer is already whipping the horses and speeding the king to safety. Before he escapes, Darius looks back at Alexander and in a pathetic gesture reaches out toward his brash foe—but the victory has slipped out of his hands. Pliny says that Philoxenos's painting of the battle between Alexander and Darius was "inferior to none" and it is easy to see how he reached that conclusion.

Architecture

The finest preserved theater in Greece, the theater at Epidauros (FIG. **5-80**), was probably constructed shortly after Alexander the Great was born. Its architect was POLYKLEITOS THE YOUNGER, possibly a nephew of the great Argive sculptor, and his theater is still used for performances of ancient Greek dramas, to the delight of tourists and natives alike. In antiquity, however, plays were not performed repeatedly over months or years as they are today, but only once, during sacred festivals. Greek drama was not pure entertainment, but was closely associated with religious rites. At Athens, for example, the great tragedies of Aeschylus, Sophocles, and Euripides were performed at the festival of Dionysos in his theater on the southern slope of the Acropolis (FIG. 5-46).

The precursor of the formal Greek theater was a place where ancient rites, songs, and dances were performed. This circular piece of earth with a hard and level surface later became the *orchestra* of the theater, a word that liter-

ally means "dancing place." This is where the actors and the chorus performed, and at Epidauros an altar to Dionysos was also placed at the center of the circle. The spectators sat on a slope overlooking the orchestra (the *theatron,* or place for seeing) and when the Greek theater took architectural shape, the auditorium (*cavea,* Latin for hollow place, cavity) was always situated on a hillside. The cavea at Epidauros, composed of wedge-shaped sections of stone benches separated by stairs, is somewhat greater than a semicircle in plan. The auditorium is 387 feet in diameter and its fifty-five rows of seats accommodated about twelve thousand spectators. They entered the theater by way of a passageway between the seating area and the scene building (*skene*), which housed dressing rooms for the actors and also formed a backdrop for the plays. The design is quite simple, but perfectly suited to its function, and even in antiquity Polykleitos the Younger's theater was renowned for the harmony of its proportions. Although spectators sitting in some of the seats in the Epidauros theater would have had a poor view of the skene, all had unobstructed views of the orchestra, and because of the excellent acoustics of the open-air cavea, everyone could hear the actors and chorus.

The theater at Epidauros is situated some 500 yards southeast of the sanctuary of Asklepios (the Greek god of healing, whose serpent-entwined staff is the emblem of modern medicine), and Polykleitos the Younger was employed there as well. He was the architect of the tholos, the circular shrine that probably housed the sacred snakes of Asklepios. That building lies in ruins today, its architectural fragments removed to the local museum, but one can get a reasonably good idea of its original appearance by

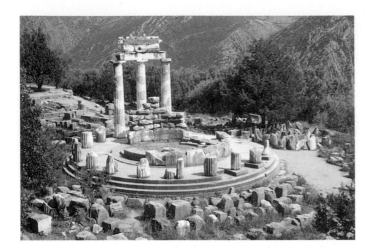

5-81 THEODOROS OF PHOKAIA, Tholos, Delphi, *c.* 375 B.C.

looking at the somewhat earlier and partially reconstructed tholos at Delphi (FIG. **5-81**), designed by THEODOROS OF PHOKAIA. Like the tholos at Epidauros, that at Delphi has an exterior colonnade of Doric columns. Within, however, both at Delphi and at Epidauros, the columns had Corinthian capitals (FIG. **5-82**).

The *Corinthian capital* is more ornate than either the Doric or Ionic; it consists of a double row of acanthus leaves from which tendrils and flowers grow, wrapped around a bell-shaped echinus. Although this capital is often cited as the distinguishing feature of the Corinthian order, there is, strictly speaking, no Corinthian order; the new capital type was simply substituted for the volute capital in the Ionic order. The Corinthian capital was invented during the second half of the fifth century B.C. by Kallimachos, who made the golden lamp that stood beside the ancient wooden statue of Athena in the Erechtheion. Many scholars believe that a Corinthian column supported the outstretched right hand of the Phidian Athena Parthenos (FIG. 5-50) because such a column is present in some of the Roman copies of the lost cult statue. In any case, the Corinthian capital proved to be enormously popular in later Greek and especially Roman times, not only because of its ornate character but also because it eliminated certain problems that were endemic in both the Doric and Ionic orders.

The Ionic capital, unlike the Doric, has two distinct profiles: the front and back (with the volutes) and the sides. The volutes always faced outward on a Greek temple, but architects met with a vexing problem at the corners of their buildings, where there were two adjacent "fronts." They solved the problem by placing volutes on both outer faces of the corner capitals (as on the Erechtheion, FIG. 5-58, and the Temple of Athena Nike, FIG. 5-61), but the solution was an awkward one. The rules of Doric design also presented problems for Greek architects at the corners of buildings. The Doric frieze was organized according to three supposedly inflexible rules: (1) a triglyph must be exactly over the center of each column; (2) a triglyph must be over the center of each intercolumniation; and (3) triglyphs at the corners of the frieze must meet, so that no space is left over. But the rules are contradictory; if the corner triglyphs must meet, then they cannot be placed over the center of the corner column (see, for example, the Doric temples at Aegina and Paestum and the Parthenon in Athens, FIGS. 5-28, 5-33, and 5-47).

The Corinthian capital eliminated both problems. Because all four sides of the capital have a similar appearance, corner Corinthian capitals do not have to be modified, as do corner Ionic capitals. And because the Ionic frieze is used for the Corinthian "order," there are no metopes or triglyphs with which to contend. Consistent with the extremely conservative nature of Greek temple design, the new capital type was not readily embraced by architects, and until the second century B.C., Corinthian capitals were employed only for the interiors of sacred buildings.

The earliest instance of a Corinthian capital on the exterior of a Greek building is the Choragic Monument of Lysikrates (FIG. **5-83**), which is not really a building at all. Lysikrates had sponsored a chorus in a theatrical contest in 334 B.C. and, after he won, he erected a monument to commemorate his victory. The monument consists of a cylindrical drum resembling a tholos on a rectangular base. Corinthian engaged columns adorn the drum of

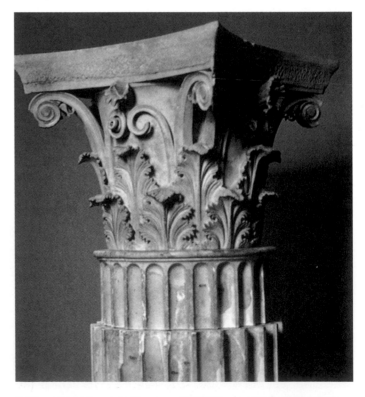

5-82 POLYKLEITOS THE YOUNGER, Corinthian capital from the tholos at Epidauros, *c.* 350 B.C. Archeological Museum, Epidauros.

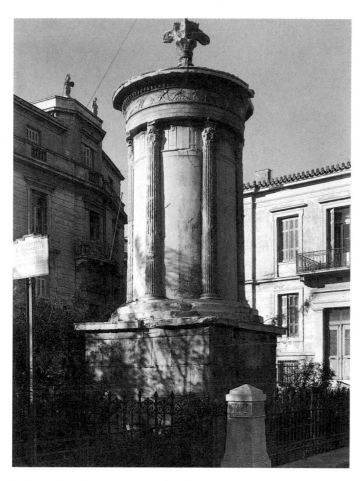

5-83 Choragic Monument of Lysikrates, Athens, 334 B.C.

Lysikrates's monument and a huge Corinthian capital sits on top of the roof; it once supported the bronze tripod that was the victor's prize.

THE HELLENISTIC PERIOD
(323–31 B.C.)

Alexander the Great's conquest of India, the Near East, and Egypt (where the Macedonian king was ultimately buried) ushered in a new cultural age that historians and art historians alike call Hellenistic. The Hellenistic period is traditionally reckoned from the death of Alexander in 323 B.C. and lasted nearly three centuries, until 31 B.C., when Mark Antony and Queen Cleopatra were decisively defeated at the battle of Actium by Augustus. A year later, Augustus made Egypt a province of the Roman Empire. It is said that when Alexander was on his deathbed, his generals, greedy for the lands their young leader had conquered, asked, "To which one of us do you leave your empire?" In the skeptical manner of the age, he supposedly answered, "To the strongest." Although probably apocryphal, this exchange points up the near inevitability of what followed—the divi-

sion of Alexander's far-flung empire among his Greek generals and their subsequent naturalization among those whom they held subject.

The centers of culture in the Hellenistic period were the court cities of the Greek kings—Antioch in Syria, Alexandria in Egypt, Pergamon in Asia Minor, and others. An international culture united the Hellenistic world, and its language was Greek. Hellenistic kings became enormously rich on the spoils of the East, priding themselves on their libraries, art collections, scientific enterprises, and skills as critics and connoisseurs as well as on the learned men they could assemble at their courts. The world of the small, austere, and heroic city-state passed away as had the power and prestige of its center, Athens; a world, or cosmopolitan (citizen of the world, in Greek), civilization, much like today's, replaced it.

Architecture

The greater variety, complexity, and sophistication of Hellenistic culture called for an architecture on an imperial scale and of wide diversity, something far beyond the requirements of the Classical polis, even beyond that of Athens at the height of its power in the fifth century B.C. Building activity shifted from the old centers on the Greek mainland to the opulent cities of the Hellenistic monarchs in Asia Minor—sites more central to the Hellenistic world.

Great scale, a theatrical element of surprise, and a willingness to break the rules of canonical temple design characterize one of the most ambitious temple projects of the Hellenistic period, the oracular Temple of Apollo at Didyma (FIGS. **5-84** and **5-85**), near Miletos, the old Ionian city on the west coast of Asia Minor. The Hellenistic temple was built to replace the Archaic temple at the site that had been burned down by the Persians in 494 B.C. Construction was begun in 313 B.C. according to the design of two architects who were natives of the area, PAIONIOS OF EPHESOS and DAPHNIS OF MILETOS. So vast was the undertaking, however, that work on the temple continued off and on for over five hundred years, and still the project was never completed.

The temple was dipteral in plan and had an unusually broad facade of ten huge Ionic columns almost 65 feet tall. There were twenty-one columns on the sides, consistent with the Classical formula for perfect proportions utilized in the Parthenon—(2 × 10) + 1—but nothing else about the design is Classical. One anomaly immediately apparent to anyone who approached the building was that it had no pediment and no roof—it was *hypaethral*, or open to the sky—and the grand doorway to what should be the cella of the temple was elevated nearly 5 feet off the ground so that it could not be entered. The explanation for these peculiarities is that the doorway served rather as a kind of stage from which the oracle of Apollo could be announced to those assembled in front of the temple, and the unroofed dipteral colonnade is really only an elaborate frame for a

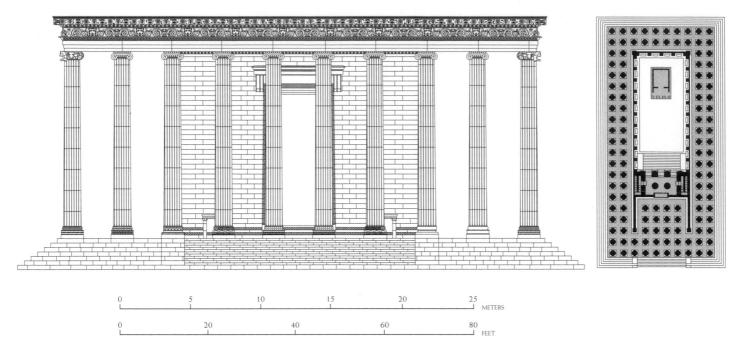

0 5 10 15 20 25 METERS

0 20 40 60 80 FEET

5-84 PAIONIOS OF EPHESOS and DAPHNIS OF MILETOS, Temple of Apollo, Didyma, begun 313 B.C. Restored view of facade (left) and plan (right).

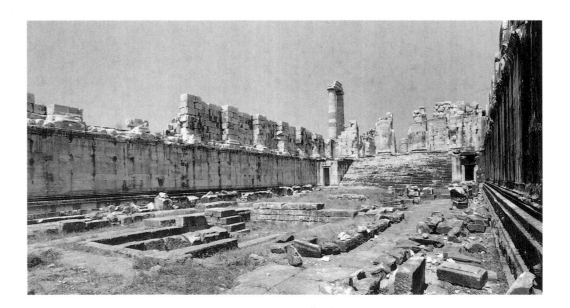

5-85 Interior of the Temple of Apollo at Didyma.

central courtyard that housed a small prostyle shrine that protected the cult statue of Apollo. (The foundations of the inner shrine may be seen in the foreground of FIG. 5-85.) Entrance to the interior court was through two smaller doorways to the left and right of the great portal and down two narrow vaulted tunnels that could accommodate only a single file of worshipers. From these dark and mysterious lateral passageways one emerged into the clear light of the courtyard, which contained a sacred spring and was planted with laurel trees in honor of Apollo. Opposite Apollo's inner temple, a stairway some 50 feet wide rose majestically toward three portals leading into the oracular room that also opened onto the front of the temple. This complex spa-

tial planning marks a sharp departure from Classical Greek architecture, which stressed the exterior of the building almost as a work of sculpture and left the interior relatively undeveloped.

CIVIC AND DOMESTIC ARCHITECTURE When, early in the fifth century B.C., Didyma's Archaic Apollo temple was razed by the Persians, so too was the neighboring city of Miletos. The city was reconstructed, probably after 466 B.C., according to a plan laid out by Hippodamos of Miletos, whom Aristotle singled out as the father of rational city planning. The scheme employed by Hippodamos was to impose a strict grid plan upon the site, regardless of the ter-

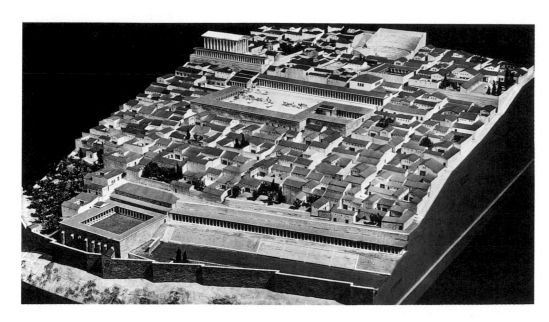

5-86 Model of the city of Priene, fourth century B.C. and later. Staatliche Museen, Berlin.

rain, so that all streets would meet at right angles. Such *orthogonal* planning actually predates Hippodamos, not only in Archaic Greece but also in the ancient Near East and Egypt, but Hippodamos was so famous that his name has ever since been synonymous with such urban plans. The so-called *Hippodamian plan* also called for separate quarters for public, private, and religious functions, so that a "Hippodamian city" was logically as well as regularly planned. This desire to impose order upon nature and to assign a proper place in the whole to each of the constituent parts of the city is very much in keeping with the philosophical tenets of the fifth century B.C. Hippodamos's formula for the ideal city is another manifestation of the same outlook that produced Polykleitos's *Canon* for the human body and Iktinos's treatise on the design of the Parthenon.

An excellent example of Hippodamian planning is the city of Priene (FIG. **5-86**), also in Asia Minor, which was laid out during the fourth century B.C. The city had fewer than five thousand inhabitants (Hippodamos thought ten thousand was the ideal number) and was situated on sloping ground, so that many of the narrow north-south streets were little more than long stairways. City blocks of uniform size were nonetheless imposed upon the irregular terrain, with the central agora being allotted six blocks; more than one unit was also reserved for major structures like the Temple of Athena and the theater.

As in any city, ancient or modern, most of the area within the walls of Priene is occupied by houses rather than by civic or religious buildings. Information about the homes of ordinary citizens is scanty, in part because archeologists have been more interested in uncovering grand edifices like temples and theaters, and in part because ancient authors usually describe only exceptional buildings, not common dwellings. The unpretentious houses of Priene (for example, FIG. **5-87**) are typical of later Greek times. They are rec-

tangular in plan and fit neatly into the Hippodamian grid, but internally they are not laid out symmetrically. A single entrance from the street leads to a modest central court, the largest room in the house, which was surrounded by several smaller roofed units. In the wealthiest homes the courtyard was framed by a peristyle and paved with a pebble mosaic; the house illustrated here has columns (of differing dimensions) on only two sides of the court. Exterior windows were rare, because most houses shared walls with their neighbors, and the court provided welcome light and air to the interior. These courtyards also served for the collection of rainwater, which could be stored in underground cisterns and used for drinking, cooking, and washing. In most houses a dining room (*andron*) opened onto the court (or onto an anteroom that in turn opened onto the court, as in our example) and was furnished with couches so that the man of the house and his male guests could recline

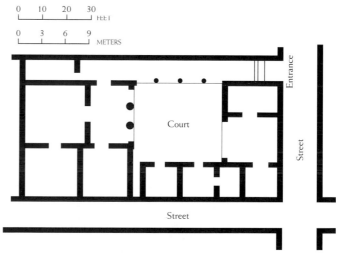

5-87 Plan of House XXXII, Priene, fourth century B.C.

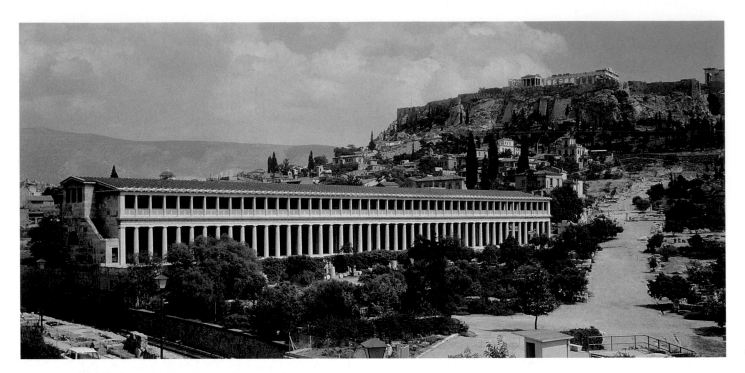

5-88 Stoa of Attalos II, Agora, Athens, *c.* 150 B.C.

while eating. A kitchen would not be far away. Bedrooms might also open onto the court, but when there was a second floor, they were normally located upstairs.

The heart of Priene was its agora, which was bordered by stoas. These covered colonnades, which often housed shops and civic offices, were ideal vehicles for shaping urban spaces, and they were staples of Hellenistic cities. Even the agora of Athens, an ancient city notable for its haphazard, unplanned development, was eventually framed to the east and south by stoas placed at right angles to one another. One of these was the Stoa of Attalos II (FIG. **5-88**), a gift to the city by a grateful alumnus, the king of Pergamon from 159 to 138 B.C., who had studied at Athens in his youth. The stoa has been meticulously reconstructed under the direction of the American School of Classical Studies at Athens and today has a second life as a museum housing over six decades of finds from the Athenian agora as well as the offices of the American excavation team. The stoa has two stories, each with twenty-one shops opening onto the colonnade. The columns of the facade are Doric on the lower story and Ionic on the upper. Such mixing of the two orders on a single facade had occurred even in the Late Classical period but became increasingly common in the Hellenistic period, when respect for the old rules of Greek architecture was greatly diminished and a desire for variety and decorative effects often prevailed. Practical considerations also governed the form of the Stoa of Attalos. The columns are far more widely spaced than in Greek temple architecture, to allow for easy access, and the lower third of every Doric column shaft is unfluted to guard against damage resulting from constant traffic.

Pergamon

The kingdom of Attalos II was one of those born in the early third century B.C. after the breakup of Alexander's empire. Founded by Philetairos, the Pergamene kingdom embraced almost all of western and southern Asia Minor. Upon the death in 133 B.C. of the last of its kings, Attalos III, the kingdom was bequeathed to Rome, which by then was the greatest power in the Mediterranean world. The Attalids enjoyed immense wealth, and much of it was expended on embellishing their capital city of Pergamon, especially its acropolis. Located there were the royal palace, an arsenal and barracks, a great library and theater, an agora, and the sacred precincts of Athena and Zeus.

ALTAR OF ZEUS The altar erected on the Pergamene acropolis in honor of Zeus about 175 B.C. is the most famous of all Hellenistic sculptural ensembles. The west front of the monument has been reconstructed in Berlin (FIG. **5-89**). The altar proper was on an elevated platform and framed by an Ionic stoa-like colonnade with projecting wings on either side of a broad central staircase. All around the platform was carved a frieze almost 400 feet long populated by some one hundred over-life-size figures (FIG. **5-90**). The subject is the battle of gods, led by Zeus, against the giants, and it is the most extensive representation of the gigantomachy ever attempted by Greek artists. It will be recalled that a similar subject appeared on the shield of Phidias's *Athena Parthenos* and on some of the metopes of the Parthenon, where the Athenians wished to draw a parallel between the defeat of the giants and the defeat of the

Persians. In the third century B.C., King Attalos I had successfully turned back an invasion of the Gauls in Asia Minor and the gigantomachy of the Altar of Zeus alludes to the Pergamene victory over those barbarians.

A deliberate connection is also made with Athens, whose earlier defeat of the Persians was by now legendary, and with the Parthenon, which was already recognized as a Classical monument—in both senses of the word. The figure of Athena, for example, who grabs the hair of the giant Alkyoneos as Nike flies in to crown her (FIG. 5-90), is a quotation of the Athena from the east pediment of the Parthenon, and Zeus himself (not illustrated) is based on

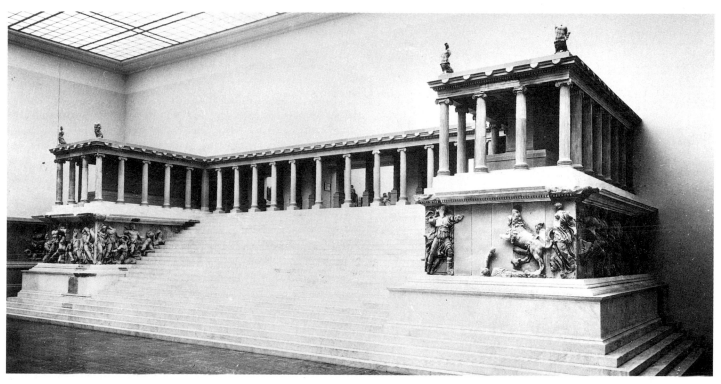

5-89 Altar of Zeus, Pergamon, *c.* 175 B.C. Staatliche Museen, Berlin. (West front reconstructed.)

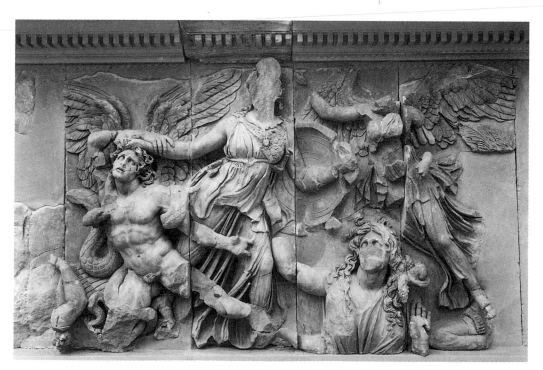

5-90 Athena battling Alkyoneos, detail of the gigantomachy frieze of the Altar of Zeus, Pergamon. Marble, approx. 7' 6" high. Staatliche Museen, Berlin.

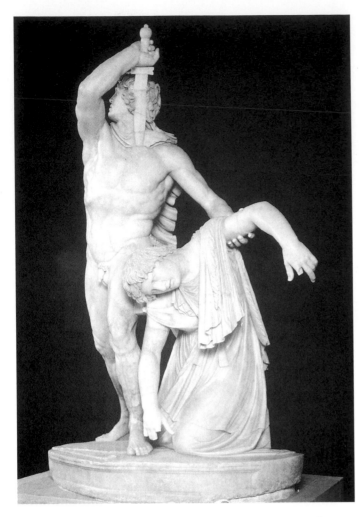

the Poseidon of the west pediment. But the Pergamene frieze is not a dry series of borrowed motifs. On the contrary, there is an emotional intensity to the tumultuous narrative that is without parallel on earlier monuments. The battle rages everywhere, even up and down the very steps that one must ascend to reach Zeus's altar. Violent movement, swirling draperies, and vivid depictions of death and suffering are the norm. Wounded figures writhe in pain and their faces reveal their anguish. When Zeus hurls his thunderbolt, one can almost hear the thunderclap. Deep carving creates dark shadows and the figures project from the background like bursts of light. These features have justly been termed "baroque" and reappear in the sculpture of seventeenth-century Europe (see Chapter 24). One can hardly imagine a greater contrast than between the Pergamene gigantomachy frieze and that of the Archaic Siphnian Treasury at Delphi (FIG. 5-20).

On the Altar of Zeus, the victory of Attalos I over the Gauls was presented in mythological disguise, but in an earlier statuary group set up on the acropolis of Pergamon the defeat of the barbarians was explicitly represented. Roman copies of some of these figures are preserved (FIGS. **5-91** and **5-92**). The sculptor has carefully studied and reproduced the distinctive features of the foreign Gauls, most notably their long bushy hair and mustaches and the torques (neck bands) they frequently wore. The Pergamene victors were apparently not included in the group; we see only their foes and their noble and moving response to defeat.

In what was probably the centerpiece of the Attalid group (FIG. 5-91), a heroic Gallic chieftain is defiantly driving a sword into his own chest just below the collarbone, preferring suicide to surrender. He has already taken the life of his wife, who, if captured, would have been sold as

5-91 EPIGONOS(?), Gallic chieftain killing himself and his wife. Roman marble copy after a bronze original from Pergamon of *c.* 230–220 B.C. Approx. 6' 11" high. Museo Nazionale Romano, Rome.

5-92 EPIGONOS(?), Dying Gaul. Roman marble copy after a bronze original from Pergamon of *c.* 230–220 B.C. Approx. 36¹/₂" high. Museo Capitolino, Rome.

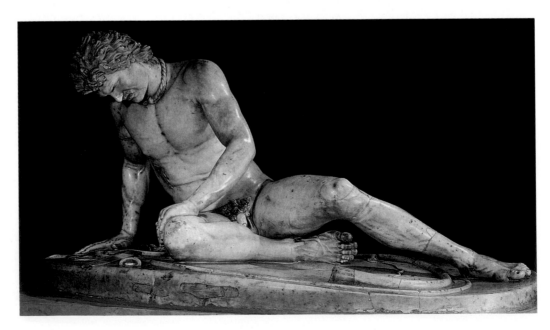

a slave. In the best Lysippan tradition, the group can be fully appreciated only by walking around it. From one side we see the intensely expressive face of the Gaul, from another his powerful body, from a third the limp and almost lifeless body of the woman. The twisting posture of the man, the almost theatrical gestures, and the emotional intensity of the suicidal act are hallmarks of the Pergamene "baroque" style and are closely paralleled in the later frieze of Zeus's altar.

The third Gaul from this group is a trumpeter who has collapsed upon his large oval shield as blood pours out of the gash in his chest (FIG. 5-92). He stares at the ground with a pained expression on his face and is reminiscent of the later dying warrior from the east pediment of the Temple of Aphaia at Aegina (FIG. 5-32), but the pathos and drama of the suffering Gaul are far more pronounced. As in the suicide group and the gigantomachy frieze, the male musculature is rendered in an exaggerated manner—note the tautness of the chest and the bulging veins of the left leg—implying that the unseen Attalid hero who has struck down this noble and savage foe must have been an extraordinary man. If this figure is the *tubicen* (trumpeter) mentioned by Pliny as the work of the Pergamene master EPIGONOS, then Epigonos may be the sculptor of the entire group and the creator of the dynamic Hellenistic baroque style.

Sculpture

One of the great masterpieces of the Hellenistic style was not created for the Attalid kings but was set up in the Sanctuary of the Great Gods on the island of Samothrace. The *Nike of Samothrace* (FIG. **5-93**) has just alighted on the prow of a Greek warship. Her missing right arm was once raised high in order to crown the naval victor, just as Nike places a wreath on Athena in the frieze of the Altar of Zeus (FIG. 5-90)—but the Pergamene relief figure seems calm by comparison. The Samothracian Nike's wings are still beating and her drapery is swept by the wind, her himation bunching in thick folds around her right leg, her chiton pulled tightly across her abdomen and left leg. The theatrical effect of the statue was amplified by its setting. The war galley was displayed in the upper basin of a two-tiered fountain; in the lower basin were placed large boulders. The flowing water of the fountain created the illusion of rushing waves dashing up against the ship, and the reflection of the statue in the shimmering water below accentuated the sense of lightness and movement. The sound of splashing water added an aural dimension to the visual drama. Art and nature are here combined in one of the most successful works of sculpture ever fashioned. In the *Nike of Samothrace* and other works in the Hellenistic baroque style, the Polykleitan conception of a statue as an ideally proportioned, self-contained entity on a bare pedestal has been resoundingly rejected in favor of statues

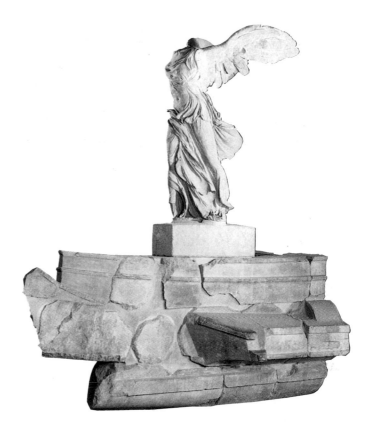

5-93 *Nike of Samothrace, c.* 190 B.C. Marble, figure approx. 8' 1" high. Louvre, Paris.

that interact with their environment and appear as living, breathing, intensely emotive human (or divine) presences.

Bold steps in this direction had already been taken in the fourth century B.C., in different ways, by Praxiteles, Skopas, and Lysippos, and the influence of their distinctive styles continued to be felt throughout the Hellenistic period. The undressing of Aphrodite by Praxiteles (FIG. 5-68), for example, became the norm, but Hellenistic sculptors went beyond the Late Classical master and openly explored the erotic aspects of the nude female form. In the famous *Venus de Milo* (FIG. **5-94**), an over-life-size marble statue of Aphrodite, found on Melos, together with its inscribed base (now lost) signed by the sculptor, ALEXANDROS OF ANTIOCH-ON-THE-MEANDER, the goddess of love is more modestly draped but more overtly sexual. Her left hand (separately preserved) held the apple she was awarded by Paris when he judged her to be the most beautiful goddess of all, and her right hand may have lightly grasped the edge of her drapery near the left hip in a halfhearted attempt to keep it from slipping farther down her body. The sculptor is intentionally teasing the spectator, and in so doing he has imbued his partially draped Aphrodite with a sexuality that is not present in Praxiteles's entirely nude image of the goddess.

The *Aphrodite of Knidos* is directly quoted in an even more playful and irreverent statue of the goddess found on

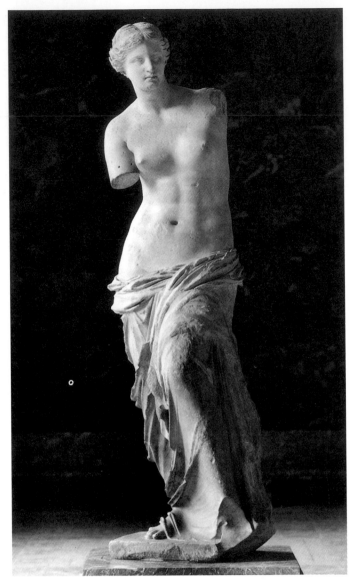

5-94 ALEXANDROS OF ANTIOCH-ON-THE-MEANDER, *Venus de Milo* (Aphrodite from Melos), *c.* 150–125 B.C. Marble, approx. 6′ 7″ high. Louvre, Paris.

In the Delian group and other Hellenistic sculptures Eros is shown as the pudgy infant Cupid known to us from innumerable later works of art, but in earlier Greek art he was depicted as an adolescent (FIG. 5-55). Another Hellenistic image of the baby Eros is a bronze statue (FIG. 5-96) in which the exhausted son of Aphrodite lies sleeping on a rock. In the history of art, babies are all too frequently rendered as miniature adults—often with adult personalities to match their mature bodies—but Hellenistic sculptors knew how to reproduce the soft forms of infants and how to portray the spirit of young children in memorable statues.

The portrayal of sleep greatly appealed to Hellenistic sculptors, probably because the suspension of consciousness and the entrance into the fantasy world of dreams were the antithesis of the Classical ideals of rationality and discipline. Eros enjoys the serene sleep of innocence, but restless, drunken sleep is the subject of the Hellenistic sculptor who carved the *Barberini Faun* (FIG. 5-97), a

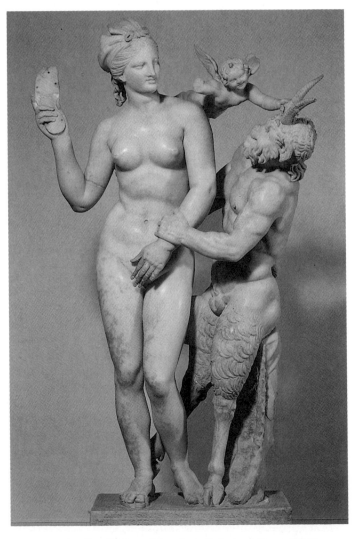

5-95 Aphrodite, Eros, and Pan, from Delos, *c.* 100 B.C. Marble, 4′ 4″ high. National Archeological Museum, Athens.

Delos (FIG. 5-95). Aphrodite is shown resisting the lecherous advances of the semihuman, semigoat Pan, the Greek god of the woods. She defends herself with one of her slippers while her loyal son Eros flies in to grab one of Pan's horns in an attempt to protect his mother from an unspeakable fate. One may wonder about the taste of Dionysios of Berytos (Beirut) who paid to have this statue erected in a businessmen's clubhouse—especially since both Aphrodite and Eros are portrayed as almost laughing—but such groups are commonplace in Hellenistic times. The combination of eroticism and parody of earlier masterpieces of Greek sculpture was apparently irresistible. These whimsical Hellenistic groups are a far cry from the solemn depictions of the deities of Mt. Olympus produced during Archaic and Classical times.

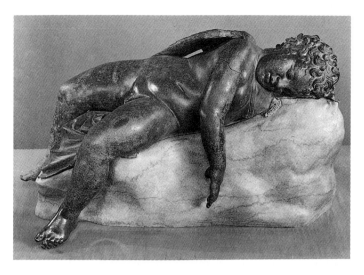

5-96 Sleeping Eros, from Rhodes, *c.* 150–100 B.C. Bronze, approx. 33½″ long. Metropolitan Museum of Art, New York.

statue of a satyr found in Rome in the seventeenth century and restored (not entirely accurately) by Gianlorenzo Bernini, the great Italian Baroque sculptor. The seventeenth-century master no doubt found this dynamic statue in the Pergamene manner to be the work of a kindred spirit. The satyr, a follower of Dionysos, has consumed too much wine and has thrown down his panther skin upon a convenient rock and then fallen into a disturbed, intoxicated sleep; his brows are furrowed and one can almost hear him snore. Eroticism also comes to the fore in this statue. Although men had been represented naked in Greek art for hundreds of years, Archaic kouroi and Classical athletes and gods do not exude sexuality. Sensuality surfaces in the works of Praxiteles in the fourth century B.C., but the dreamy and supremely beautiful Hermes playfully dangling grapes before the infant Dionysos (FIG. 5-68) has nothing of the blatant sexuality of the *Barberini Faun*, whose wantonly spread legs focus attention on his genitals.

5-97 Sleeping satyr (*Barberini Faun*), *c.* 230–200 B.C. Marble, approx. 7′ 1″ high. Glyptothek, Munich.

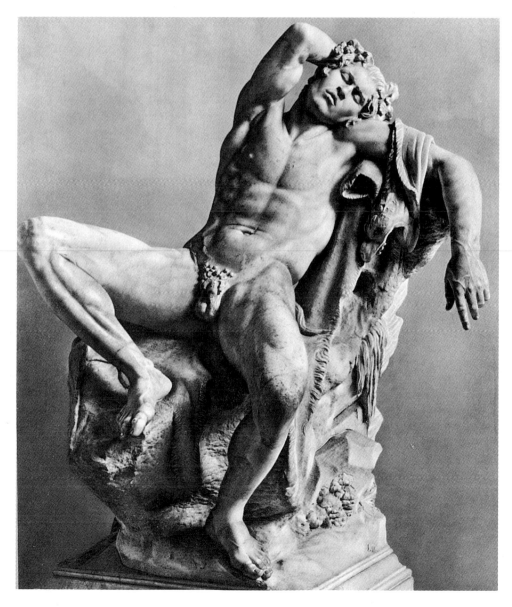

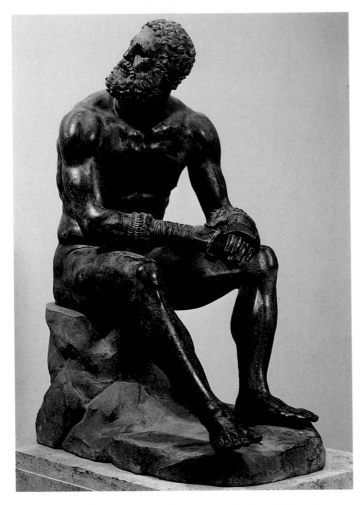

5-98 Seated boxer (general view and detail of head), from Rome, *c.* 100–50 B.C. Bronze, approx. 4′ 2¹/₂″ high. Museo Nazionale Romano, Rome.

Homosexuality was common in the man's world of ancient Greece (in Plato's *Symposium*, Alcibiades refers to Socrates's almost superhuman imperviousness to seduction), and it is not surprising that when the sexuality of the human body began to be explored by Hellenistic sculptors, they turned their attention to both men and women.

The expanded range of subjects treated by Hellenistic sculptors does not mean that they abandoned such traditional themes as the Greek athlete, but even the old subjects are rendered in novel ways. This is certainly true of the magnificent bronze statue of a seated boxer (FIG. **5-98**), a Hellenistic original found in Rome and perhaps at one time part of a group. The boxer is not a victorious young athlete with a perfect face and body, but a heavily battered, defeated veteran whose upward gaze may have been directed at the man who has just beaten him. Too many punches from powerful hands wrapped in leather thongs—Greek boxers did not use the cushioned gloves of the modern sport—have distorted the boxer's face. His nose is broken, as are his teeth, his cheeks and forehead are scarred, and he has smashed "cauliflower ears." How different is this rendition of a bearded head from that of the

noble warrior from Riace (FIG. 5-38) of the Early Classical period! The Hellenistic sculptor is appealing not to our intellect but to our emotions in striving to evoke compassion for the battered hulk of a once-mighty fighter.

The realistic bent of much of Hellenistic sculpture—the very opposite of the idealism of the Classical period—is evident above all in a series of statues of old men and women of the lower rungs of the social order—shepherdesses, fishermen, drunken beggars—the kinds of people who might be pictured earlier on red-figure vases but never before thought to be worthy of monumental statuary. One of the finest preserved statues of this type (FIG. **5-99**) depicts a haggard old woman bringing chickens and a basket of fruits and vegetables to sell in the market. Her face is wrinkled, her body is bent with age, and her spirit is broken by a lifetime of poverty. She carries on because she must, not because she derives any pleasure from life. We do not know the purpose of such statues, but they attest to an interest in social realism among Hellenistic sculptors that one looks for in vain in earlier Greek statuary.

Statues of the aged and the ugly are, of course, the polar opposites of the images of the young and the beautiful that

great achievements of Hellenistic artists was the redefinition of the art of portraiture. In the Classical period Kresilas was admired for having made the noble Pericles appear even nobler in his portrait (FIG. 5-44), but in Hellenistic times sculptors sought not only to record the actual appearance of their subjects in bronze and stone but also to capture the essence of their personalities in likenesses that were at once accurate and moving.

One of the earliest of these, perhaps the finest of the Hellenistic age, and frequently copied in Roman times, was a bronze portrait statue of Demosthenes (FIG. **5-100**) by POLYEUKTOS. The original was set up in the Athenian agora in 280 B.C., forty-two years after the great orator's death.

5-99 Old market woman, *c.* 150–100 B.C. Marble, approx. 49½" high. Metropolitan Museum of Art, New York.

dominated Greek art until the Hellenistic period, but they are consistent with the changed character of the age. The Hellenistic world was a cosmopolitan place and the highborn could not help but encounter the poor as well as a growing number of foreigners (non-Greek "barbarians") on a daily basis. Hellenistic art reflects this different social climate in the depiction of a much wider variety of physical types, including different ethnic types. We have already seen the sensitive portrayal of Gallic warriors with their shaggy hair, strange mustaches, and golden torques (FIGS. 5-91, 5-92), and it is also in Hellenistic art that Africans, Scythians, and others, formerly only the occasional subject of vase painters, enter the realm of monumental sculpture. These Hellenistic sculptures of foreigners and the urban poor, however realistic, are not portraits; rather they are sensitive studies of physical types. But the growing interest in the individual that we noted beginning in the Late Classical period led in the Hellenistic era to the production of true likenesses of specific persons. In fact, one of the

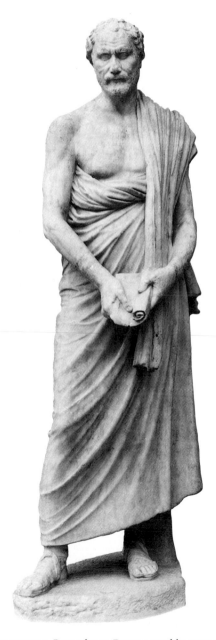

5-100 POLYEUKTOS, *Demosthenes*. Roman marble copy after a bronze original of *c.* 280 B.C. 6' 7½" high. Ny Carlsberg Glyptotek, Copenhagen.

Demosthenes was a frail man and in his youth even suffered from a speech impediment, but he had enormous courage and great moral conviction. A veteran of the disastrous battle against Philip II at Chaeronea, he repeatedly tried to rally opposition to Macedonian imperialism, both before and after Alexander's death. In the end, when it was clear that he would be captured by the Macedonians who were pursuing him, he took his own life by drinking poison.

Polyeuktos rejected Kresilas's and Lysippos's notions of the purpose of portraiture and did not attempt to portray a supremely confident leader with a magnificent physique. His Demosthenes has an old and slightly stooped body. The hands are nervously clasped in front of him as he looks downward, deep in thought. His face is lined, his hair is receding, and his expression is one of great sadness. Whatever physical discomfort Demosthenes felt is here joined by an inner pain, his deep sorrow over the tragic demise of democracy at the hands of the Macedonian conquerors.

Hellenistic Art under Roman Patronage

In the opening years of the second century B.C., the Roman general Flamininus defeated the Macedonian army and declared the old poleis of Classical Greece to be free once again. They never, however, regained their former glory. Athens, for example, sided with Mithridates in his war against Rome and was crushed by Sulla in 86 B.C. Thereafter it retained some of its earlier prestige as a center of culture and learning, but politically Athens was just another city that had been incorporated into the ever-expanding Roman Empire. Greek artists, however, continued to be in great demand, not only to furnish the Romans with an endless stream of copies of Classical and Hellenistic masterpieces, but also to create new statues à la grecque for Roman patrons.

One such work is the famous group of Laocoön and his sons (FIG. **5-101**), which was discovered in Rome in 1506 in the presence of Michelangelo and which Lessing referred to in his seminal 1766 essay *Laocoön* to distinguish between

5-101 ATHANADOROS, HAGESANDROS, and POLYDOROS OF RHODES, Laocoön and his sons, early first century A.D. Marble, approx. 7′ 10¹/₂″ high. Vatican Museums, Rome.

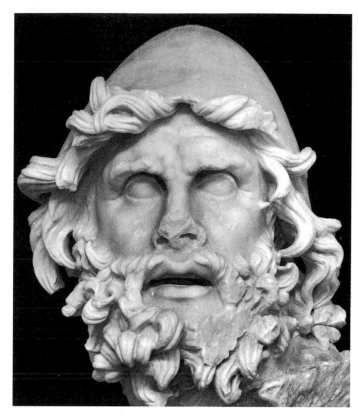

5-102 ATHANADOROS, HAGESANDROS, and POLYDOROS OF RHODES, Head of Odysseus, from Sperlonga, early first century A.D. Marble, approx. 25″ high. Museo Archeologico, Sperlonga.

poetry and the fine arts, giving birth to the branch of philosophy known as *esthetics*. The marble group, long believed to be an original of the second century B.C., was found in the remains of the palace of the emperor Titus, exactly where it had been seen by Pliny over fourteen centuries before.

Pliny attributed the statue to three Rhodian sculptors, ATHANADOROS, HAGESANDROS, and POLYDOROS, who are now generally thought to have worked in the early first century A.D. They probably based their group on a Hellenistic masterpiece depicting Laocoön and only one son. Their variation on the original adds the son at Laocoön's left (note the greater compositional integration of the two other figures) in order to conform with the account given in the *Aeneid* by Vergil, who vividly describes the strangling of the Trojan priest Laocoön and his *two* sons by sea serpents while sacrificing at an altar. The serpents had been sent by the gods who favored the Greeks in the war against Troy to punish

Laocoön, who had tried to warn his countrymen about the danger of bringing the Greeks' Wooden Horse within the walls of their city.

In Vergil's graphic account, Laocoön suffered in terrible agony, and the torment of the priest and his sons is communicated in a spectacular fashion in the marble group. The three Trojans writhe in pain as they struggle to free themselves from the death grip of the serpents, one of which is biting into Laocoön's left hip as the priest lets out a ferocious cry. The serpent-entwined figures recall the suffering giants of the great frieze of the Altar of Zeus at Pergamon, and Laocoön himself is strikingly similar to Alkyoneos (FIG. 5-90), the opponent of Athena. In fact, many scholars believe that a Pergamene statuary group of the second century B.C. was the inspiration for the three Rhodian sculptors.

That the work seen by Pliny and displayed in the Vatican Museums today was made for Romans rather than Greeks was confirmed in 1957 by the discovery of fragments of several Hellenistic-style groups illustrating scenes from the *Odyssey*. These fragments were found in a grotto that served as the picturesque summer banquet hall of the early first century A.D. seaside villa of the Roman emperor Tiberius at Sperlonga, some sixty miles south of Rome. One of these groups—that depicting Scylla attacking Odysseus's ship—is signed by the same three sculptors cited by Pliny as the authors of the Laocoön group. Another of the groups installed around a central pool in the grotto depicted the blinding of the Cyclops Polyphemos by Odysseus and his comrades, an incident that, in the Homeric epic, was also set in a cave. The head of Odysseus (FIG. **5-102**) from this theatrical group is one of the finest sculptures of antiquity. The hero's cap can barely contain the swirling locks of his hair; even Odysseus's beard seems to be swept up in the emotional intensity of the moment. The parted lips and the deep shadows produced by sharp undercutting add drama to the head, which must have been attached to an agitated body.

At Tiberius's villa at Sperlonga and in Titus's palace in Rome, the baroque school of Hellenistic sculpture lived on long after Greece ceased to be a political force in the Mediterranean. When Rome inherited the Pergamene kingdom from the last of the Attalids in 133 B.C., it also became heir to the artistic legacy of the Hellenistic world. What Rome adopted from Greece it passed on to the medieval and modern worlds. If Greece was peculiarly the inventor of the European spirit, Rome was its propagator and amplifier.

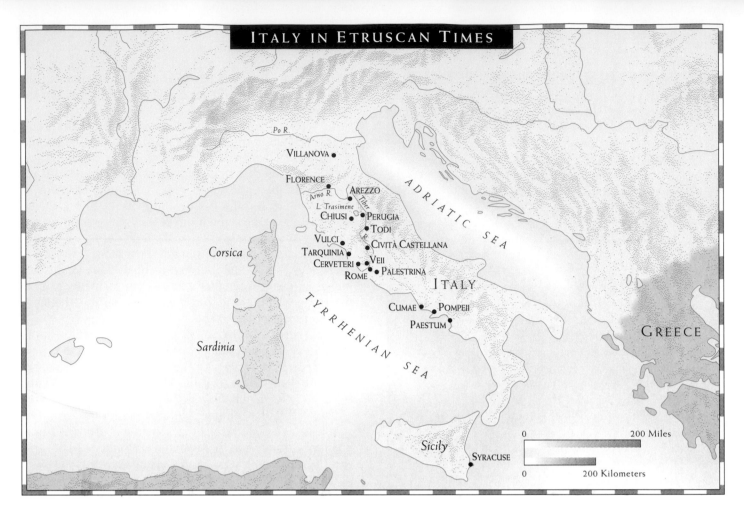

ITALY IN ETRUSCAN TIMES

Po R.

VILLANOVA

FLORENCE

AREZZO
Arno R.
L. Trasimene
CHIUSI • PERUGIA
Tiber
TODI
VULCI
CIVITÀ CASTELLANA
TARQUINIA
CERVETERI • VEII
ROME • PALESTRINA

ITALY

CUMAE • POMPEII
PAESTUM

GREECE

Corsica

Sardinia

TYRRHENIAN SEA

ADRIATIC SEA

Sicily
SYRACUSE

| 0 | 200 Miles |
| 0 | 200 Kilometers |

900 B.C.	700 B.C.	600 B.C.
VILLANOVAN	ORIENTALIZING	ARCHAIC

Regolini-Galassi fibula
Cerveteri
c. 650-640 B.C.

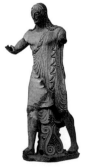

Apollo of Veii
c. 510-500 B.C.

Greek colonization of southern Italy and Sicily
begins, mid-eighth century B.C.

Expulsion of Etruscan kings from Rome, 509 B.C.

CHAPTER 6

ETRUSCAN ART

480 B.C. 323 B.C. 89 B.C.

| CLASSICAL | HELLENISTIC | |

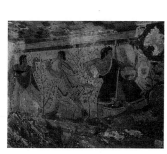

Tomb of the Leopards
Tarquinia, c. 480-470 B.C.

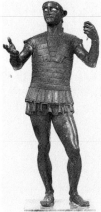

Mars, from Todi
early fourth century B.C.

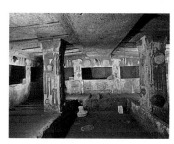

Tomb of the Reliefs
Cerveteri, third century B.C.

Porta Marzia
Perugia, second century B.C.

Aule Metele (Arringatore),
early first century B.C.

Social War and completion of Romanization of Italy, 89 B.C.

Etruscan naval defeat by the Greeks at Cumae, 474 B.C.

Destruction of Veii by the Romans, 396 B.C.

Peace between Rome and Tarquinia, 351 B.C.

Roman conquest of Cerveteri, 273 B.C.

The Etruscans, as everyone knows, were the people who occupied the middle of Italy in early Roman days, and whom the Romans, in their usual neighbourly fashion, wiped out entirely.

So opens D. H. Lawrence's witty and sensitive *Etruscan Places* (1929), one of the earliest modern essays in which Etruscan art is valued highly and treated as much more than a debased form of the art of the contemporary city-states of Greece and southern Italy. ("Most people despise everything B.C. that isn't Greek, for the good reason that it ought to be Greek if it isn't," Lawrence goes on to say!) Today it is no longer necessary to argue the importance and originality of Etruscan art. Deeply influenced by, yet different from, Greek art, Etruscan sculpture, painting, and architecture not only provided the models for the early art and architecture of the Romans but also had an impact upon the art of the Greek colonies in Italy.

The heartland of the Etruscans was the territory between the Arno and Tiber rivers of central Italy. The verdant hills still bear their name—Tuscany, the land of the people the Romans called *Tusci*, the region centered on Florence, birthplace of Renaissance art. So do the blue waters that splash up against the western coastline of the Italian peninsula, for the Greeks referred to the Etruscans as Tyrrhenians and gave their name to the sea off Tuscany. The origin of this people—the enduring "mystery of the Etruscans"—is, however, not clear at all. Their language, although written in a Greek-derived script and extant in inscriptions that are still in large part obscure, is unrelated to the Indo-European linguistic family. Ancient historians, as fascinated by the puzzle as are modern scholars, generally felt that the Etruscans emigrated from the east. Herodotus, the "father of history," specifically declared that they came from Lydia in Asia Minor and were led by King Tyrsenos, hence their Greek name. But Dionysius of Halicarnassus, a Greek author of the end of the first century B.C., maintained that the Tusci were autochthonous, that is, they were native Italians who did not migrate from anywhere. And some modern researchers have theorized that the Etruscans came into Italy from the north.

No doubt there is some truth in all these theories. The Etruscan people as we know them are very likely the result of a gradual fusion of native and immigrant populations between the end of the Bronze Age and the so-called Villanovan era in Italy (comparable to the Geometric period in Greece). The Etruscans emerged as a people with a culture related to but distinct from those of the other Italic peoples and the civilizations of Greece and the Orient.

During the eighth and seventh centuries B.C. the Etruscans, familiar with the urbanized colonies of the Greeks in southern Italy, established themselves in fortified hilltop cities and, as highly skilled seafarers, enriched themselves through trade abroad. By the sixth century B.C., they controlled most of northern and central Italy from such strongholds as Tarquinia (ancient Tarquinii), Cerveteri (Caere), Vulci, and Veii. But these cities never united to form a state, and so it is improper to speak of an Etruscan "nation" or "kingdom." The cities coexisted, flourishing or fading independently, and any semblance of unity among them was based primarily on common linguistic ties and religious beliefs and practices. This lack of political cohesion eventually made the Etruscans relatively easy prey for Lawrence's Roman aggressors.

EARLY ETRUSCAN ART

The great mineral wealth of Etruria—iron, tin, copper, and silver were all successfully mined in antiquity—brought about a transformation of Etruscan society during the seventh century B.C. The modest Villanovan villages and their agriculturally based economies gave way to prosperous cities engaged in international commerce. Cities like Cerveteri, blessed with rich mines, could acquire foreign goods, and Etruscan aristocrats quickly developed a taste for luxury items incorporating Eastern motifs. In order to satisfy the demand, local craftsmen, inspired by imported artifacts, produced magnificent items for both homes and tombs. As in Greece at the same time, we may speak of an Orientalizing period of Etruscan art followed by an Archaic period. And as in Greece, the local products cannot be mistaken for the foreign models.

Jewelry and Sculpture

Around the middle of the seventh century B.C., at the height of the Orientalizing period, the Regolini-Galassi Tomb at Cerveteri was stocked with bronze cauldrons and gold jewelry of Etruscan manufacture and Orientalizing style. The most spectacular of the many rich finds from the tomb is a golden fibula (FIG. **6-1**) of unique shape used to fasten a woman's gown at the shoulder. The giant clasp or safety pin is in the Italic tradition, but the lions, both in relief (above) and in the round (below, where they are winged), are borrowed from the Orient. The technique, also emulating Eastern imports, is masterful, combining hammered relief (repoussé) and granulation, and equals or exceeds in quality anything that might have served as a model. The jewelry from the Regolini-Galassi Tomb also includes a golden pectoral that covered the deceased woman's chest and two gold circlets that may be earrings, although they are large enough to be bracelets. Such a taste for ostentatious display is frequently the hallmark of newly acquired wealth, and this was certainly the case in seventh-century Etruria.

At the end of the century we encounter Etruscan monumental stone statuary for the first time. This parallels the

introduction of Egyptian-inspired large-scale statuary in Greece, but in Etruria the models seem to have been Greek rather than Oriental. The best of the Archaic examples is the statue of a centaur (FIG. **6-2**), a distinctly Greek monster, fashioned in local tufa and set up in the necropolis at Vulci, perhaps as a tomb guardian, conforming to very ancient practice. The statue adheres to the early Greek formula of attaching the rear part of a horse to the back of a man (FIG. 5-3), and the idea for the Etruscan statue may have come from representations of centaurs on small imported objects such as vases, since there are no known monumental stone statues of centaurs in Greece at this early date. Nonetheless, the artist's knowledge of contemporary Greek statuary is manifest in the adoption of the kouros posture for the human part of the man/horse. The flat, bearded head with large eyes and wiglike hair recalls Greek works of the so-called Daedalic style, and the position of the arms and the advanced left leg are characteristic of all Greek Archaic kouroi (FIGS. 5-9 and 5-11). In works such as this we see how eager the eclectic Etruscan artists were to adopt and adapt Greek as well as Oriental motifs.

6-2 Centaur, from Vulci, *c.* 590 B.C. Tufa, approx. 30½″ high. Museo Nazionale di Villa Giulia, Rome.

6-1 Fibula with Orientalizing lions, from the Regolini-Galassi Tomb, Cerveteri, *c.* 650–640 B.C. Gold, approx. 12½″ high. Vatican Museums, Rome.

Etruscan Temples

While it is difficult to isolate any peculiarly Etruscan stylistic traits in the Vulci centaur, the very notion of utilizing a centaur as a guardian figure in a cemetery is un-Greek, and the vast majority of Archaic Etruscan works of art depart markedly from their prototypes abroad, even in stylistic terms. This is especially true of religious architecture, where the design of Etruscan temples superficially owes much to Greece, but where the differences far outweigh the similarities. Because of the materials employed by Etruscan architects, usually only the foundations of Etruscan temples have survived. These are nonetheless sufficient to tell us about the plans of the edifices, and the archeological record is supplemented by the detailed account of Etruscan temple design contained in Vitruvius's treatise on classical architecture written near the end of the first century B.C.

The typical Archaic Etruscan temple (FIG. **6-3**) resembles the gable-roofed temples of the Greeks; however, it was constructed not of stone but of wood and sun-dried brick with terracotta decoration. Entrance was possible only via a narrow staircase at the center of the front of the temple, which sat on a high podium. Columns also were restricted to the front of the building, creating a deep porch that

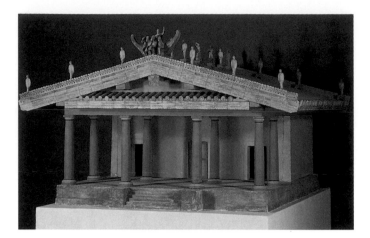

6-3 Model of a typical Etruscan temple of the sixth century B.C., as described by Vitruvius. Istituto di Etruscologia e di Antichità Italiche, Università di Roma, Rome.

occupied roughly half of the podium, setting off one side of the structure as the main side. This is contrary to Greek practice, where the front and rear of the temple are indistinguishable and where peripteral colonnades were accompanied by steps on all sides. (It is also, as we shall see, one of the important features of Etruscan temple design that will be retained by the Romans.) The Etruscan temple was not meant to be seen as a sculptural mass from the outside and from all directions, as the Greek temple was, but was instead intended to function primarily as an ornate home for the deity's cult image. It was a place of shelter, protected by the wide overhang of its roof.

There are other differences. Etruscan (or *Tuscan*) columns resemble Greek Doric columns, but they were made of wood, were unfluted, and had bases. Because of the lightness of the superstructure they had to support, Etruscan columns were, as a rule, much more widely spaced than Greek columns. Unlike their Greek counterparts, Etruscan temples frequently had three cellas—one for each of the Etruscan equivalents of the Romans' Jupiter, Juno, and Minerva (the Greeks' Zeus, Hera, and Athena). And pedimental statuary is exceedingly rare in Etruria. Normally narrative statuary (in terracotta instead of stone) was placed on the ridgepole of the roof of an Etruscan temple.

The finest of these rooftop statues to survive today is the life-size terracotta image of Apollo (FIG. **6-4**) from a temple in the Portonaccio sanctuary at Veii. This figure was but one of a group of at least four. Apollo was portrayed confronting Herakles for possession of the Ceryneian hind. The bright paint and the rippling folds of Apollo's garment call to mind the Ionian korai of the Acropolis (FIG. 5-13), but the extraordinary force, huge swelling contours, plunging motion, gesticulating arms, and animated face of this vital figure are distinctly Etruscan. The remarkable strength, energy, and excitement of Archaic Etruscan statuary are brilliantly on

display in the Apollo of Veii and allow us to visualize the style of VULCA OF VEII, the most famous Etruscan sculptor of the time. Some scholars have attributed the Apollo to Vulca, and the discovery of the statue in 1916 was instrumental in prompting a re-evaluation of the originality of Etruscan art.

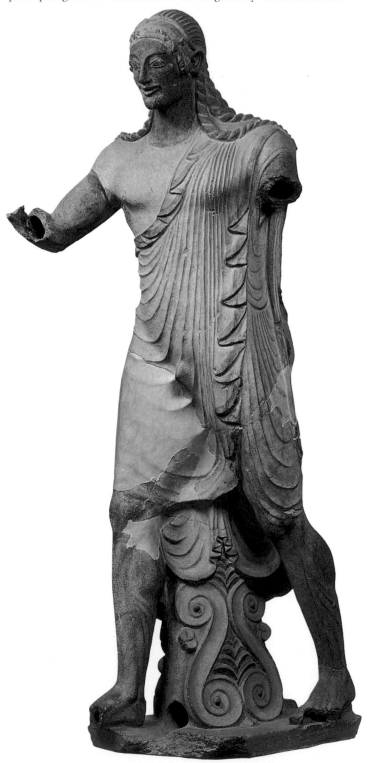

6-4 Apollo, from the roof of the Portonaccio Temple, Veii, c. 510–500 B.C. Painted terracotta, approx. 5' 11" high. Museo Nazionale di Villa Giulia, Rome.

Etruscan Cemeteries

CERVETERI Although life-size terracotta statuary is known in Greece, this medium was especially favored in Etruria. Another magnificent example of Archaic Etruscan terracotta sculpture is the sarcophagus in the form of a husband and wife reclining on a banqueting couch (FIG. **6-5**) that comes from a tomb in the Cerveteri necropolis. The work was cast in four sections and then joined; it has no parallel in Greece where, at this date, there were no monumental tombs to house such sarcophagi. Greek men and women were interred in simple graves marked by a stele or a statue. Moreover, although banquets are commonly depicted on Greek vases (which by the late sixth century B.C. were imported into Etruria in great quantities and regularly deposited in tombs), only men dined at Greek symposia. The image of a husband and wife sharing the same banqueting couch is uniquely Etruscan. Aristotle comments on the strange fact that Etruscan men ate with their wives, and the Greeks in general were shocked by the relative freedom that women enjoyed in Etruscan society. Etruscan inscriptions often give the names of both the father and mother of the person being commemorated, a practice unheard of in Greece (witness the grave stele of "Hegeso, daughter of Proxenos," FIG. **5-63**). Etruscan women regularly retained their own names and, it seems, could legally own property independent of their husbands.

The man and woman on the Cerveteri sarcophagus are as animated as the Apollo of Veii (FIG. 6-4), even though they are at rest, and they are the antithesis of the stiff and formal figures one encounters in Egyptian tomb sculptures. Also typically Etruscan, and in striking contrast to contemporary Greek statues with their emphasis on proportion and balance, is the way in which the upper and lower parts of the body are rendered by the Cerveteri sculptor. The legs are only summarily modeled, and the transition to the torso at the waist is unnatural. The Etruscan artist's interest is focused on the upper half of the figures, especially on the vibrant faces and gesticulating arms. Gestures are still an important ingredient of Italian conversation today, and the Cerveteri banqueters and the Veii Apollo speak to us in a way that the typical coeval Greek statue, with its closed contours and calm demeanor, never does.

The exact findspot of the Cerveteri sarcophagus is not known, but the kind of tomb from which it came is well documented. The typical tomb in the Banditaccia necropolis at Cerveteri and in other Etruscan cemeteries took the form of a *tumulus* (pl. *tumuli*; FIG. **6-6**), not unlike the Mycenaean Treasury of Atreus (FIG. 4-22). But whereas the Mycenaean tholos tomb was constructed of masonry blocks and then covered by an earthen mound, each Etruscan tumulus covered one or more subterranean multichambered tombs cut out of the local tufa. These burial mounds sometimes reached colossal size with diameters in excess of

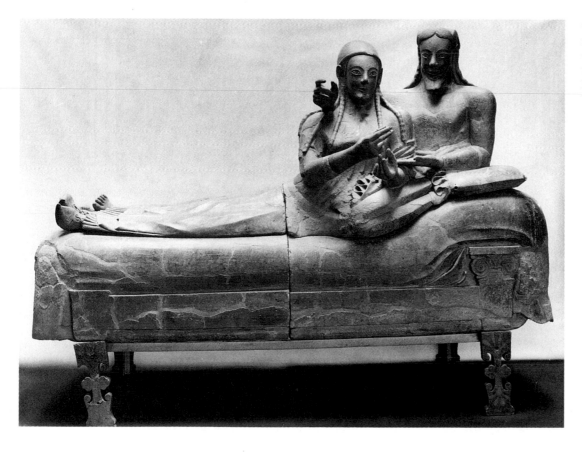

6-5 Sarcophagus with reclining couple, from Cerveteri, *c.* 520 B.C. Painted terracotta, approx. 45$\frac{1}{2}$" high. Museo Nazionale di Villa Giulia, Rome.

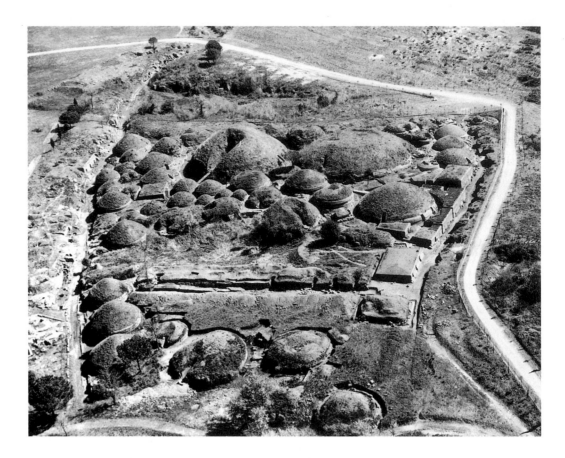

6-6 Banditaccia necropolis, Cerveteri, seventh to second centuries B.C.

130 feet. They were arranged in cemeteries in an orderly manner along a network of streets and produced the effect of veritable cities of the dead (which is the literal meaning of the Greek word *necropolis*), always located some distance from the cities of the living.

The underground tomb chambers cut into the rock resembled the houses of the living. In the plan of the sixth-century B.C. Tomb of the Shields and Chairs at Cerveteri (FIG. 6-7), for example, the central entrance and the way in which smaller chambers open onto a large central space is believed to mirror the axial sequence of rooms in actual Etruscan houses of the time. (The plan is also similar to that of early Roman houses, which, like Roman temples, show the deep influence of Etruscan design.) The effect of a domestic interior was enhanced by cutting out of the rock a series of beds and grand armchairs with curved backs and footstools (clearly visible on the plan), as well as ceiling beams, framed doorways, and even windows. The technique recalls that of the rock-cut Egyptian tombs at Beni Hasan (FIG. 3-23), and one cannot help but remark on the very different values of the Etruscans, whose temples no longer stand because they were constructed of wood and mud brick but whose grand subterranean tombs are as permanent as the bedrock itself, and the Greeks, who employed stone for the shrines of their gods but did not build monumental tombs for their dead at all.

The most elaborate of the Cerveteri underground tombs, in decoration if not in plan, is the so-called Tomb of the

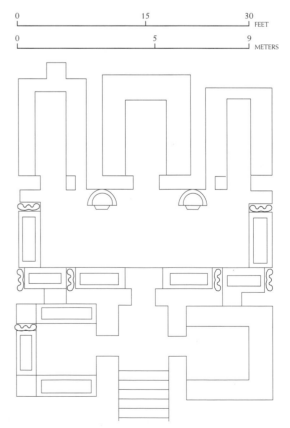

6-7 Plan of the Tomb of the Shields and Chairs, Cerveteri, second half of the sixth century B.C.

Reliefs (FIG. **6-8**). Like the much earlier Tomb of the Shields and Chairs, it was meant to accommodate several generations of a single family. The walls and piers of this tomb were, as usual, fashioned out of the tufa bedrock, but in this instance the stone was covered with stucco reliefs and then brightly painted. The stools, mirrors, drinking cups, pitchers, and knives effectively suggest a domestic context, underscoring the connection between Etruscan houses of the dead and those of the living.

TARQUINIA Large underground burial chambers hewn out of the natural rock were also the norm at Tarquinia, although there they were not covered with tumuli, and the interiors of the Tarquinian tombs were not carved to imitate the appearance of Etruscan houses. In some cases, however, the walls of the tomb chambers were decorated with paintings. Painted tombs are statistically rare, the privilege of only the wealthiest Etruscan families. Nevertheless, so many have been discovered at Tarquinia since archeologists began to use periscopes to explore the contents of tombs from the surface before considering time-consuming and

costly excavation, that we have an almost unbroken record of monumental painting in Etruria from Archaic to Hellenistic times.

A characteristic example dating to the early fifth century B.C. is the Tomb of the Leopards (FIG. **6-9**), named for the beasts that guard the interior from their perch within the pediment of the rear wall of the painted chamber. They are reminiscent of the panthers to either side of Medusa in the pediment of the Archaic Greek Temple of Artemis at Corfu (FIG. 5-19), but no mythological element can be found in the Tarquinian murals, either Greek or Etruscan. Instead we see a group of banqueting couples (the men with dark skin, the women with light skin in conformity with the age-old convention)—painted versions of the terracotta sarcophagus from Cerveteri (FIG. 6-5). They are being served by pitcher- and cup-bearers and entertained by musicians playing the double flute and the seven-stringed lyre. The banquet takes place in the open air, or perhaps in a tent set up for the occasion. In characteristic Etruscan fashion, the banqueters, servants, and entertainers all make exaggerated gestures with unnaturally enlarged hands. The man on the

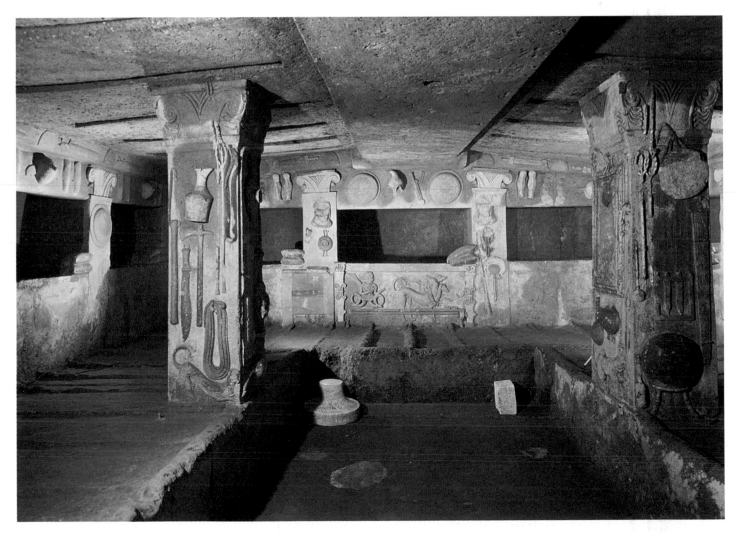

6-8 Interior of the Tomb of the Reliefs, Cerveteri, third century B.C.

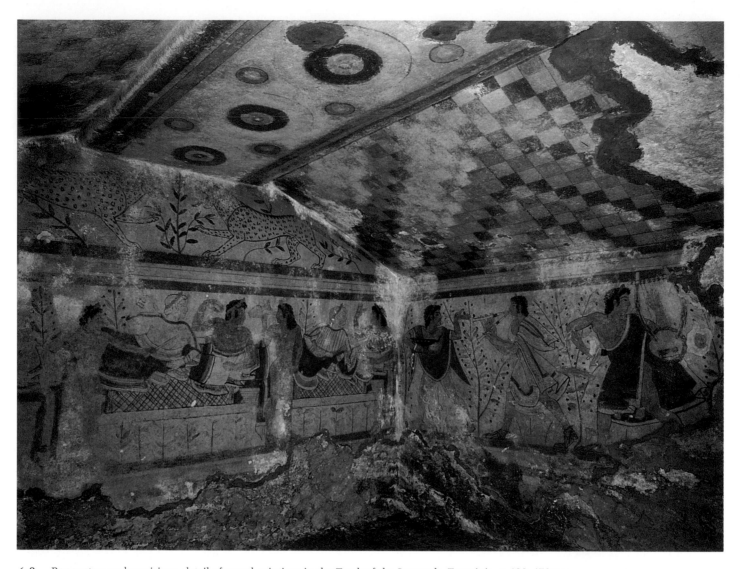

6-9 Banqueters and musicians, detail of mural paintings in the Tomb of the Leopards, Tarquinia, *c.* 480–470 B.C.

couch at the far right holds up an egg, the symbol of regeneration. The tone is joyful, a celebration of life, food, wine, music, and dance, rather than a somber contemplation of death.

In stylistic terms the Etruscan figures are comparable to those on sixth-century Greek vases before Late Archaic painters became preoccupied with the problem of foreshortening. Etruscan painters may be considered somewhat backward in this respect, but in other ways they seem to have outpaced their counterparts in Greece, especially in their interest in rendering nature. In the Tomb of the Leopards the landscape is but a few trees and shrubs placed between the entertainers (and leopards) and behind the banqueting couches, but elsewhere the natural environment is the chief interest of the Tarquinian painter.

All the walls of the main chamber of the aptly named Tomb of Hunting and Fishing at Tarquinia are decorated with scenes of Etruscans enjoying the pleasures of nature.

In our detail (FIG. **6-10**), a youth dives off a rocky promontory while others fish from a boat; elsewhere youthful hunters aim their slingshots at brightly painted birds. The scenes of hunting and fishing bring to mind the painted reliefs of the Old Kingdom Egyptian Tomb of Ti (FIG. 3-18) and the mural paintings of the New Kingdom Tomb of Nebamun (FIG. 3-34), and may indicate knowledge of this Egyptian funerary tradition. The multicolored rocks may also be compared to the seventeenth-century B.C. Aegean landscape frescoes of Thera (FIG. 4-10), but we know of nothing similar in contemporary Greek art save the Tomb of the Diver at Paestum (FIG. 5-67). The latter is, however, anomalous and from a Greek tomb in *Italy* about a half century *later* than the Tarquinian tomb. It is likely that the Paestum composition emulates older Etruscan designs and undermines the now outdated art historical judgment that Etruscan art was merely derivative and that Etruscan artists never set the standard for Greek artists.

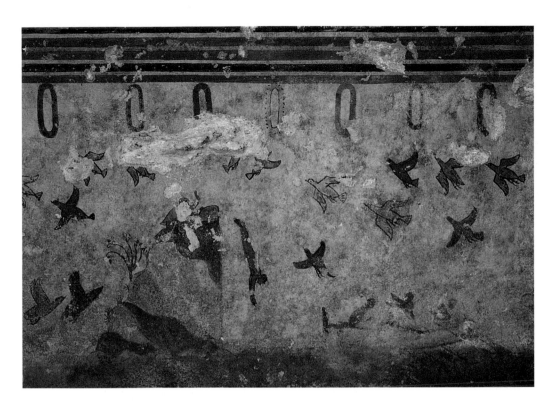

6-10 Diving and fishing, detail of mural paintings in the Tomb of Hunting and Fishing, Tarquinia, *c.* 530–520 B.C.

LATER ETRUSCAN ART

The fifth century B.C. was a golden age in Greece but not in Etruria. In 509 B.C., the Romans, who had been ruled by the Etruscans for some time, revolted and expelled the last of the Etruscan kings, Tarquinius Superbus, replacing the monarchy with a republican form of government. In 474 B.C., the Etruscan fleet was defeated off Cumae by an alliance of Cumaean Greeks and Hieron I of Syracuse, effectively destroying Etruscan dominance of the seas and with it Etruscan prosperity. In the fourth century B.C., Rome began to take over Etruscan territory. Veii fell to the Romans in 396 B.C., after a terrible ten-year siege. Peace was concluded with Tarquinia in 351 B.C., but by the beginning of the next century Tarquinia too was annexed by Rome, and Cerveteri was conquered in 273 B.C. There were important consequences in the world of art and architecture. The number of Etruscan tombs, for example, decreased sharply, and the quality of the furnishings declined markedly. No longer do we find tumuli full of golden jewelry and imported Greek vases or mural paintings of the first rank. But Etruscan art did not cease. Indeed, in the areas in which Etruscan artists excelled, especially the casting of statues in bronze and terracotta, impressive works continued to be produced, even if they were fewer in number.

Sculpture

The best-known of these later Etruscan statues—one of the most memorable portrayals of an animal in the history of world art—is the *Capitoline Wolf* (FIG. **6-11**), a somewhat over-life-size hollow-cast bronze statue of the she-wolf that, according to ancient legend, nursed the founding heroes of Rome, Romulus and Remus, after they were abandoned as infants. The statue seems to have been made for the new Roman Republic after the expulsion of Tarquinius Superbus and became the totem of the new state; the appropriately defiant image has remained the emblem of the city of Rome to this day. It is not, however, a work of Roman art, which had not yet developed a distinct identity, but the product

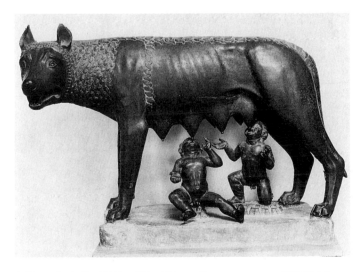

6-11 *Capitoline Wolf, c.* 500–480 B.C. Bronze, approx. 31¹/₂" high. Palazzo dei Conservatori, Rome.

of an Etruscan workshop. (The suckling infants are additions of Renaissance date and are probably the work of Antonio Pollaiuolo.) The vitality we have noted in the human figure in Etruscan art is here concentrated in the tense, watchful animal body of the she-wolf, with her spare flanks, gaunt ribs, and taut, powerful legs. The lowering of the neck and head, alert ears, glaring eyes, and ferocious muzzle capture the psychic intensity of the fierce and protective beast as danger approaches. Not even the great animal reliefs of Assyria (FIG. 2-22 can match, much less surpass, this profound rendering of animal temper.

Another masterpiece of Etruscan animal sculpture, greatly admired during the Renaissance, is the bronze *Chimera of Arezzo* (FIG. **6-12**), which is dated about a century later than the *Capitoline Wolf*. The chimera is a monster of Greek invention with the head and body of a lion and the tail of a serpent. A second head, that of a goat, grows out of the left side of the lion and bears the wound inflicted by the Greek hero Bellerophon, who hunted and slew the composite beast. As rendered by the Etruscan sculptor, the chimera, although injured and bleeding, is nowhere near defeated. As in the earlier statue of the she-wolf, the chimera's muscles are stretched tightly over its rib cage; it prepares to attack, and a ferocious cry emanates from its open jaws. Some scholars have postulated that the statue, found in 1553 and partially restored by Benvenuto Cellini, was part of a group that originally included Bellerophon, but the chimera could just as well have stood alone. The menacing gaze upward toward an unseen adversary need not have been answered; in this respect too the chimera is in the tradition of the guardian nurse of Romulus and Remus.

A certain nervous animation characterizes even those Etruscan statues that most closely emulate Classical Greek

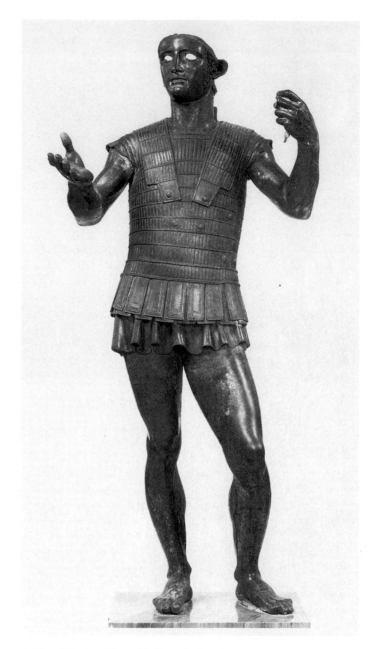

6-13　Warrior (*Mars of Todi*), early fourth century B.C. Bronze, approx. 4' 8" high. Vatican Museums, Rome.

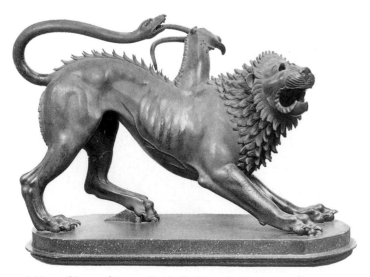

6-12　*Chimera of Arezzo*, first half of fourth century B.C. Bronze, approx. 31½" high. Museo Archeologico Nazionale, Florence.

prototypes. In the so-called *Mars of Todi* (FIG. **6-13**), an under-life-size bronze warrior (his helmet is missing as is the spear once held in his left hand) datable to the early fourth century B.C., we have an example of the Etruscan interpretation of the Polykleitan canon (FIG. 5-42). The figure, dressed in a cuirass, executes a restless movement of the whole body involving sideways and contrary directions of head, torso, arms, and legs without seeming to move from his position. The sculptor has rendered the contrapposto stance of Polykleitos with an agility quite unlike the Polykleitan balance of weight and poise. We find again, as

in the much earlier Apollo of Veii (FIG. 6-4), that an Etruscan rendition of the prevailing Greek style brings out the native quality of energy, whether in the blunt drive of the Apollo or in the almost sprightly stance of the *Mars*.

The baroque style of Hellenistic Greece was much more in keeping with the Etruscan temperament, and later Etruscan sculptors often were highly successful in mastering the Greek manner. The commonality of approach may be seen especially clearly in the fragmentary terracotta figure (FIG. **6-14**), perhaps the Etruscan equivalent of Apollo, from the Lo Scasato Temple at Città Castellana (ancient Falerii). The position of the statue in the decorative program of the temple is uncertain; it may be a rare instance of pedimental sculpture. The turn of the head and the rich mane of cascading locks of hair are in the tradition of Lysippos's portrait of Alexander the Great (FIG. 5-76), and the rotation of the torso is in the manner of such Hellenistic statues as the bronze boxer (FIG. 5-98). The preserved color (the golden hair contrasting with the reddish-brown flesh is particularly striking) adds a great deal to the statue's appeal

and heightens the impression that we are in the presence of a work of the highest caliber, perhaps the finest example of the Hellenistic style in Etruscan Italy.

Etruscan Art and the Rise of Rome

The growing power of Rome in central Italy is indicated indirectly by the engraved inscription on the *Ficoroni Cista* (FIG. **6-15**). Such cylindrical containers for a woman's toilet articles, made of sheet bronze with cast handles and feet and elaborately engraved bodies, were produced in large numbers from the fourth century B.C. forward. Together with engraved bronze mirrors, they were popular gifts for both the living and the dead. The center of the Etruscan bronze cista industry was Palestrina (ancient Praeneste), the findspot of the *Ficoroni Cista*. The inscription on the

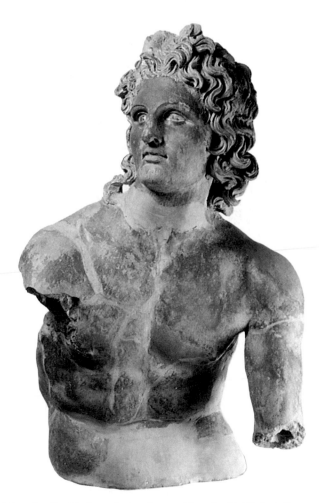

6-14 Apollo (?), from the Lo Scasato Temple, Città Castellana, late fourth or early third century B.C. Painted terracotta, approx. 22" high. Museo Nazionale di Villa Giulia, Rome.

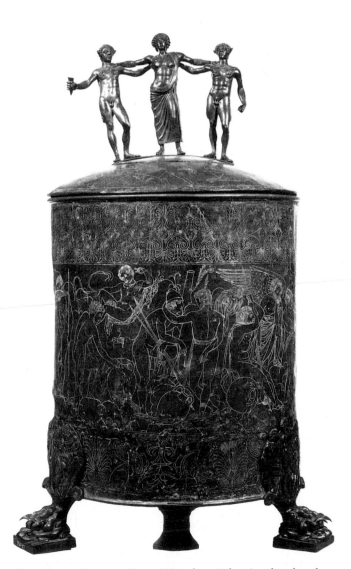

6-15 NOVIOS PLAUTIOS, *Ficoroni Cista*, from Palestrina, late fourth century B.C. Bronze, approx. 30" high. Museo Nazionale di Villa Giulia, Rome.

handle of the cista states that the bronze container was deposited by Dindia Macolnia, a local noblewoman, in her daughter's tomb and that the artist was one NOVIOS PLAUTIOS. His name is Italic but not Etruscan and, according to the inscription on the cista, his workshop

was not situated in Palestrina but in Rome, which by this date was becoming an important Italian cultural as well as political center.

The engraved frieze of the *Ficoroni Cista* depicts an episode from the Greek story of the expedition of the Argonauts in search of the Golden Fleece. Scholars are in general agreement that the composition is an adaptation of a lost Greek panel painting, perhaps one on display in Rome—another testimony to the burgeoning wealth and prestige of the city once ruled by Etruscan kings. The Greek source for Novios Plautios's engraving is evident in the figures seen entirely from behind or in three-quarter view and in the placement of the protagonists on several levels in the Polygnotan manner.

In the third century B.C., the Etruscan city of Perugia (ancient Perusia) formed an alliance with Rome and was spared the destruction suffered by Veii, Cerveteri, and other Etruscan cities. Portions of the ancient walls of the city are still standing, as are some of its gates. One of these, the so-called *Porta Marzia* (Gate of Mars), was dismantled by the Renaissance architect Antonio da Sangallo, but the upper part of the gate is preserved, imbedded in a later wall (FIG. **6-16**). The *arcuated* opening is formed by a series of trapezoidal stone *voussoirs* that are held in place by being pressed against each other (compare FIG. 8c in the Introduction). Such arches are known earlier in Greece as well as in Mesopotamia (FIG. 2-24), but it is in Italy, first under the Etruscans and later under the Romans, that arcu-

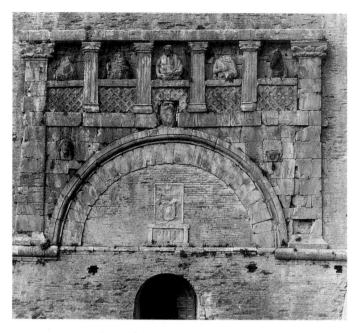

6-16 *Porta Marzia*, Perugia, second century B.C.

6-17 Sarcophagus of Lars Pulena, from Tarquinia. Tufa, approx. 6' 6" long. Tarquinia, Museo Archeologico Nazionale.

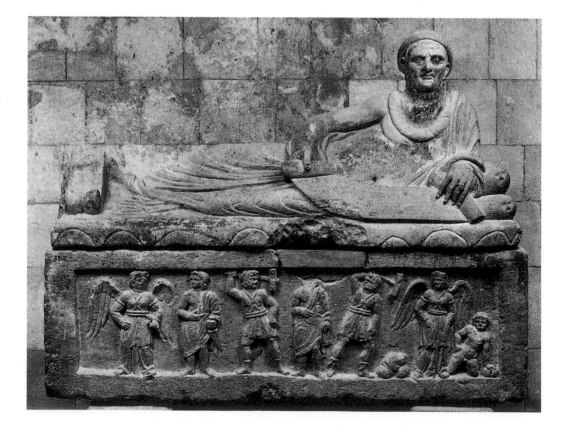

ated gateways and freestanding ("triumphal") arches become a major architectural type. The *Porta Marzia* typifies the Etruscan adaptation of Greek motifs in the use of Hellenic-inspired pilasters to frame the rounded opening. Arches bracketed by engaged columns or pilasters will have a long and distinguished history in Roman and later times. In the *Porta Marzia,* sculptured half-figures (Jupiter flanked by the Dioscuri and their steeds) are placed between the fluted pilasters. This may already reflect the new Roman practice of erecting triumphal arches crowned by gilded bronze statues, which we read about for the first time in the second century B.C.

In Hellenistic Etruria the descendants of the magnificent Archaic terracotta sarcophagus from Cerveteri (FIG. 6-5) were made of local stone and were carved rather than cast. The leading center of production was Tarquinia, and that is where the sarcophagus of Lars Pulena (FIG. **6-17**) was fashioned early in the second century B.C. and placed in his family's tomb. The deceased is shown in a reclining position, but he is not accompanied by his wife nor is he at a festive banquet. His expression is somber, a far cry from the smiling, confident visages of the Archaic era when Etruria enjoyed its greatest prosperity. Similar faces—realistic but generic types, not true portraits—may be found on all later Etruscan sarcophagi and in tomb paintings and are symptomatic of the economic and political decline of the once-mighty Etruscan city-states.

Also attesting to a gloomy assessment of the future is the choice of theme for the coffin proper. The deceased is shown in the underworld, attacked by two *Charuns* (Etruscan death demons) swinging lethal hammers. Above, on the lid, Lars Pulena exhibits a partially unfurled scroll inscribed with the record of his life's accomplishments. Lacking confidence in a happy afterlife, he dwells instead on the past.

In striking contrast, the portrait of Aule Metele (FIG. **6-18**) is a supremely self-confident image. He is portrayed as a magistrate raising his arm to address an assembly—hence his modern nickname *Arringatore* (*Orator*). The life-size bronze statue was discovered in 1566 near Lake Trasimene and is still another Etruscan masterpiece that was known to the sculptors of the Italian Renaissance. The statue of the orator proves that Etruscan artists continued to be experts at bronze casting long after the heyday of Etruscan prosperity.

The *Arringatore* was most likely produced at about the time that Roman hegemony over the Etruscans became total. The so-called Social War of the early first century B.C. ended in 89 B.C. with the conferring of Roman citizenship upon all the inhabitants of Italy. In fact, Aule Metele—his Etruscan name and the names of his father and mother are inscribed on the hem of his garment—wears the short toga and high laced boots of a Roman magistrate, and his head,

with its close-cropped hair and signs of age in the face, resembles portraits produced in Rome at the time. This orator is Etruscan in name only. If the origin of the Etruscans remains debatable, the question of their demise has a ready answer. Aule Metele and his compatriots became Romans, and Etruscan art became Roman art.

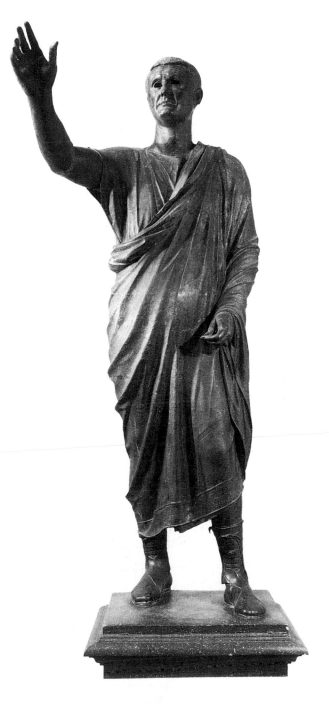

6-18　Aule Metele (*Arringatore, Orator*), from Sanguineto, near Lake Trasimene, early first century B.C. Bronze, approx. 5′ 7″ high. Museo Archeologico Nazionale, Florence.

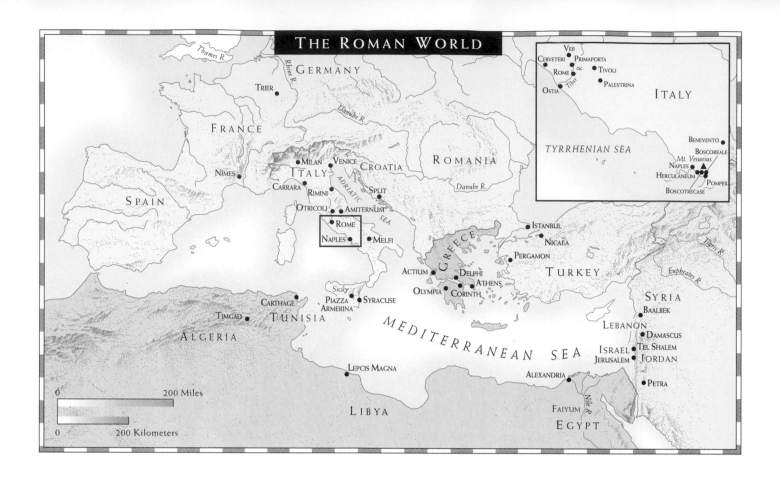

THE ROMAN WORLD

GERMANY

FRANCE

SPAIN

Thames R.

Rhine R.

Danube R.

TRIER

NÎMES

MILAN
ITALY
VENICE
CROATIA
CARRARA
RIMINI
OTRICOLI
AMITERNUM
ROME
NAPLES
MELFI

ADRIATIC SEA

SPLIT

ROMANIA

Danube R.

ISTANBUL

NICAEA

PERGAMON

GREECE
ACTIUM
DELPHI
ATHENS
OLYMPIA
CORINTH

TURKEY

Euphrates R.

Tigris R.

SYRIA

BAALBEK

LEBANON
DAMASCUS
TEL SHALEM
ISRAEL
JERUSALEM
JORDAN

CARTHAGE

Sicily
PIAZZA
ARMERINA
SYRACUSE

TIMGAD

ALGERIA

TUNISIA

MEDITERRANEAN SEA

LEPCIS MAGNA

ALEXANDRIA

PETRA

FAIYUM

Nile R.

LIBYA

EGYPT

VEII
CERVETERI
PRIMAPORTA
ROME
TIVOLI
Tiber R.
OSTIA
PALESTRINA

ITALY

TYRRHENIAN SEA

BENEVENTO
BOSCOREALE
Mt. Vesuvius
NAPLES
HERCULANEUM
POMPEII
BOSCOTRECASE

0 200 Miles

0 200 Kilometers

753 B.C.	509 B.C.	27 B.C.
LATIN AND ETRUSCAN KINGS	REPUBLIC	EARLY EMPIRE

Dionysiac mystery frieze
Villa of the Mysteries, Pompeii
c. 60-50 B.C.

Denarius with portrait
of Julius Caesar, 44 B.C

Portrait of Augustus
from Primaporta, c. 20 B.C

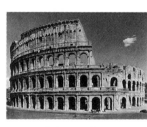

Colosseum, Rome
c. A.D. 70-80

Foundation of Rome by Romulus, 753 B.C.

Expulsion of Etruscan kings from Rome, 509 B.C.

Marcellus brings spoils of Syracuse to Rome, 211 B.C.

Roman conquest of Greece, 146 B.C.

Rome inherits kingdom of Pergamon, 133 B.C.

Foundation of Roman colony at Pompeii, 80 B.C.

Vergil, 70-19 B.C.

Assassination of Julius Caesar, 44 B.C.

Battle of Actium, 31 B.C.

Augustus, r. 27 B.C.- A.D. 14

Vitruvius, Ten Books on Architecture, c. 25 B.C.

Flavians, r. 69-96

Eruption of
Mt. Vesuvius, A.D. 79

Julio-Claudians, r. 14-68.

CHAPTER 7

ROMAN
ART

A.D. 98	192	400
HIGH EMPIRE	LATE EMPIRE	

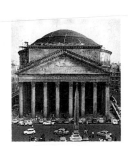

Pantheon, Rome
A.D. 118-125

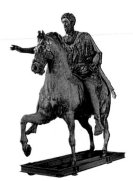

Equestrian statue
of Marcus Aurelius
c. A.D. 175

Painted portrait of
the Severan family
c. A.D. 200

Ludovisi battle
sarcophagus
c. A.D. 250-260

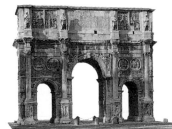

Arch of Constantine
Rome, A.D. 312-315

Soldier Emperors, r. 235-284

Diocletian, r. 284-305

Trajan, r. 98-117

Constantine, r.306-337

Hadrian, r. 117-138

Edict of Milan, 313

Antonines, r. 138-192

Dedication of Constantinople, 330

Severans, r. 193-235

With the rise and triumph of Rome, a single government ruled, for the first time in human history, from the Tigris and Euphrates to the Thames and beyond, from the Rhine and Danube to the Nile. In the Roman Empire lived people of innumerable races, creeds, tongues, traditions, and cultures: Britons and Gauls, Greeks and Egyptians, Africans and Syrians, Jews and Christians, to name only a very few. Of all the civilizations of the ancient world, only the Roman approximates our own in its cosmopolitan character. Indeed, the Roman world is the bridge—in politics, the arts, and religion—between the ancient and the medieval and modern worlds.

Roman monuments of art and architecture are distributed throughout the vast territory that the Romans governed and are the most conspicuous and numerous of all the remains of ancient civilization. An extraordinary number of these are part of the fabric of modern life and are not merely relics of the past that spark the curiosity of tourists, students, and scholars. In Rome, in western Europe, in Greece, the Middle East, and Africa today, Roman temples and basilicas have an afterlife as churches; the powerful concrete vaults of Roman theaters, baths, circuses, sanctuaries, and office buildings form the cores of modern houses, stores, restaurants, factories, and museums; bullfights, sports events, operas, and rock concerts take place in Roman arenas and bathing establishments; Roman aqueducts continue to supply water to some modern towns; ships dock in what were once Roman ports; and the highway system of western Europe still closely follows the paths of Roman roads. Even in North America, where there are no Roman remains save for the statues, paintings, mosaics, and other works of art imported by private collectors and museum curators, modern versions of famous Roman buildings like the Pantheon (FIG. 7-55) may be found in cities and on college campuses throughout the United States and Canada. And Roman civilization lives on in our concepts of law and government, in our languages, in our calendar—even in the coins we use daily. Indeed, Roman art speaks to us today in a language we can readily understand. In its diversity and eclecticism we can recognize a foreshadowing of the modern world. In the Roman use of art, especially portraits and historical relief sculptures, to manipulate public opinion we are reminded of the carefully crafted imagery of contemporary political campaigns. And in the Roman mastery of concrete construction, we sense the beginning of a revolution in architectural form that is still felt today.

The center of the far-flung Roman Empire was the city on the Tiber River that, according to legend, was founded by Romulus on April 21, 753 B.C.—just about the same time, or so the Greeks believed, that Herakles established the Olympic Games. Nine hundred years later, Rome was the capital of the greatest empire the world had ever known, an empire efficiently organized with 50,000 miles of sea routes and expertly engineered highways for travel and commerce. Within its boundaries stood marble and concrete temples, theaters, baths, basilicas, arches, and palaces. Roman walls and ceilings were adorned with paintings and stucco reliefs, the floors clad with marble slabs and mosaics, the niches and colonnades filled with statues. The imperial city of the second century A.D. awed foreign kings and even later Roman rulers. When the emperor Constantius visited Rome in A.D. 357 and was taken to the Forum of Trajan (FIG. 7-47), the contemporary historian Ammianus Marcellinus tells us that he "stopped in his tracks, astonished" and that he marveled at the opulence and size of the complex, "which cannot be described by words and could never again be attempted by mortal men."

THE REPUBLIC

Our story, however, begins long before Roman art and architecture embodied the imperial ideal of the Roman state, and at a time in which that "state" encompassed no territory beyond its famous seven hills. The Rome of Romulus in the eighth century B.C. was a modest Iron Age village of small huts made of wood, wattle, and daub, clustered together on the Palatine Hill, overlooking what was then uninhabited marshland. In the Archaic period, as we have seen, Rome was essentially an Etruscan city, both politically and culturally. Its greatest shrine, the temple erected in honor of Jupiter Optimus Maximus (Best and Greatest) on the Capitoline Hill, was constructed by an Etruscan king, designed by an Etruscan architect, built of wood and mud brick in the Etruscan manner (FIG. 6-3), and decorated with terracotta statuary fashioned by an Etruscan sculptor named Vulca of Veii. (Some scholars believe that the Apollo of Veii, FIG. 6-4, is a product of his workshop.) The earliest monumental art of Rome was thus, in all respects, Etruscan art.

In 509 B.C., Tarquinius Superbus (Tarquin the Arrogant), the last of the Etruscan kings of Rome, was thrown out of the city and constitutional government was established. Power in the new Roman Republic was vested mainly in a *senate* (literally a council of elders) and in two elected *consuls*, drawn originally only from among the wealthy landowners or *patricians* but later also from the *plebeian* class of small farmers, merchants, and freed slaves. Before long, Rome's neighbors—the Etruscans and the Gauls to the north, the Samnites and the Greek colonists to the south, and even the Carthaginians of North Africa (who, under the dynamic leadership of Hannibal, had annihilated some of Rome's armies and almost brought down the Republic) were, one by one, conquered by the descendants of Romulus.

From the point of view of the history of art, the year 211 B.C. was a turning point. It was then that an ambitious

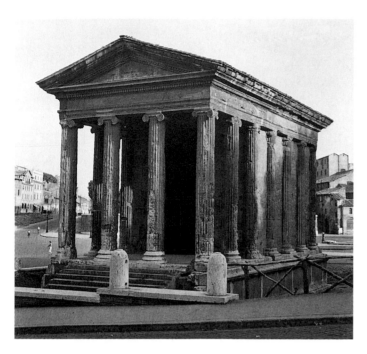

7-1 Temple of "Fortuna Virilis" (Temple of Portunus), Rome, late second or early first century B.C.

Roman general made a decision that would have a profound impact on the character of Rome itself. Breaking with precedent, Marcellus, conqueror of the fabulously wealthy Greek city of Syracuse, brought back to Rome not only the usual spoils of war—captured arms and armor, gold and silver coins, and the like—but also the artistic patrimony of the Sicilian city. Thus began, in the words of the historian Livy, "the craze for works of Greek art." According to the biographer Plutarch, the Romans, "who had hitherto been accustomed only to fighting or farming," now began "affecting urbane opinions about the arts and about artists, even to the point of wasting the better part of a day on such things." Ships weighed down with plundered Greek statues and paintings became a frequent sight in the harbor of Ostia at the mouth of the Tiber; as noted earlier in our survey of Greek art, when a desired original was unobtainable, a copy was commissioned.

Exposure to Greek sculpture and painting and to the splendid marble temples of the Greek gods increased as the Romans expanded their conquests beyond Italy to Greece itself, which became a Roman province in 146 B.C., and after 133 B.C., when the last Attalid king of Pergamon willed his kingdom to Rome. Nevertheless, although the Romans developed a virtually insatiable taste for Greek "antiques," the monuments they made for themselves were not slavish imitations of Greek masterpieces. The Etruscan basis of Roman art and architecture was never forgotten, and the statues and buildings of the Roman Republic are highly eclectic, drawing upon both Greek and Etruscan traditions. The resultant mix, however, is distinctly Roman.

Architecture

A superb example of this Republican eclecticism is the little temple on the banks of the Tiber popularly known as the Temple of "Fortuna Virilis" (FIG. **7-1**), actually the temple of the Roman god of harbors, Portunus. In plan it follows the Etruscan pattern. The high podium is accessible only at the front, where there is a wide flight of steps, and freestanding columns are confined to the deep porch. But the structure is built of tufa and travertine, overlaid originally with stucco, in imitation of the gleaming white marble temples of the Greeks, and the columns are not Tuscan but Ionic, complete with flutes and bases. Moreover, in an effort to approximate the appearance of a peripteral Greek temple—but without violating the planning principles of the Etruscans—the architect has added a series of engaged Ionic half-columns all around the sides and back of the cella. The result is what architectural historians call a *pseudoperipteral* temple and, although it is an amalgam of Etruscan and Greek elements, the design is uniquely Roman.

Roman admiration for the Greek temples they encountered in their conquests also led to the importation into Republican Italy of the round or tholos temple type, a form unknown in Etruscan architecture. At Tivoli (ancient Tibur), east of Rome, a Greek-inspired temple with circular plan—variously known as the Temple of "the Sibyl" or of "Vesta" (FIG. **7-2**)—was erected early in the first century B.C. on a dramatic site overlooking a deep gorge. The

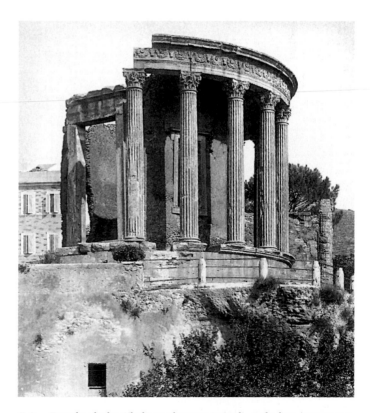

7-2 Temple of "the Sibyl" or of "Vesta," Tivoli, early first century B.C.

travertine columns are Corinthian and the frieze is carved (with garlands held up by the heads of oxen), also in emulation of Greek models, but the high podium can be reached only by means of a narrow stairway leading to the door to the cella. This arrangement introduces an axial alignment not found in Greek tholoi, where, as in Greek temples of rectangular plan, steps continue all around the structure.

Also in contrast with Greek practice, the cella wall is constructed not of masonry blocks, but with a kind of "artificial stone" of recent invention: concrete. Roman *concrete* was made from a changing recipe of lime mortar, volcanic sand, water, and small stones (*caementa*, from which the English word *cement* is derived). The mixture was placed in wooden frames and left to dry and bond with a facing of brick or stone in a procedure somewhat like the casting of statues in bronze or other metals. When the concrete was completely dry, the wooden molds were removed, leaving behind a solid mass of great strength, though rough in appearance, which was often covered afterward with stucco or even sheathed with marble revetment. Despite this, concrete walls were much less costly to construct than walls built of imported Greek marble or even local Italian

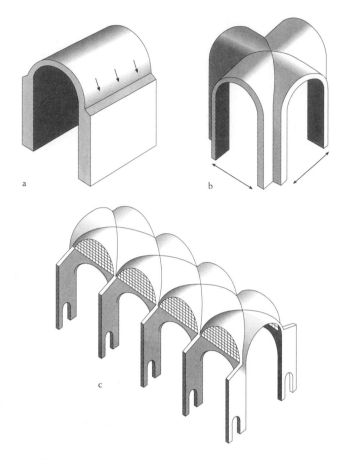

7-4 Roman vaulting systems: (**a**) barrel vault, (**b**) groin vault, (**c**) fenestrated sequence of groin vaults. (Arrows indicate direction of thrust.)

tufa and travertine. The advantages of concrete, however, go well beyond economy of construction, for it is possible to fashion shapes out of concrete that cannot be achieved by masonry construction, especially the huge vaulted and domed ceilings (without internal supports) that the Romans came to prefer over the post-and-lintel structures of the Greeks and Etruscans. The use of concrete enabled the Roman architect to think of architecture in terms radically different from those used by earlier builders. Roman architecture became an architecture of space rather than of sheer mass.

The most impressive and innovative use of concrete during the Republic is to be found in the Sanctuary of Fortuna Primigenia (FIG. **7-3**), constructed in the late second century B.C. on a hillside at Palestrina (ancient Praeneste, formerly an Etruscan city). The great size of the sanctuary, spread out over several terraces and culminating in a tholos at the peak of an ascending triangle, reflects the Republican taste for colossal Hellenistic designs, but the means of construction is uniquely Roman. Using concrete barrel vaults (FIG. **7-4**a) of enormous strength to support the mighty terraces and cover the great ramps leading to the grand central staircase as well as to give shape to the

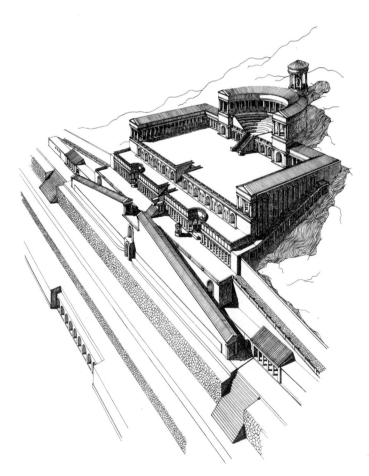

7-3 Reconstruction drawing of the Sanctuary of Fortuna Primigenia, Palestrina, late second century B.C.

shops that are disposed on two consecutive levels, the unknown architect was able to convert the entire hillside into a man-made design symbolic of Roman power and dominion. This assertive subjection of nature to man's will and rational order is the first full-blown manifestation of the Roman imperial spirit and contrasts with the more restrained Greek practice of crowning a hill with sacred buildings rather than transforming the hill itself into architecture.

Sculpture

The patrons of the great temples and sanctuaries of the Roman Republic were in almost all cases men from old and distinguished families, often victorious generals who used the spoils of war to finance their public works. These scions of aristocratic senatorial clans were fiercely proud of their lineage and, we are told, preserved likenesses (*imagines*) of their ancestors in wooden cupboards in their homes and paraded them at the funerals of prominent relatives. (Marius, a renowned Republican general, but one without a long and distinguished genealogy, was ridiculed by Roman patricians of his day as a man who had no ancestral imagines in his home.) The surviving sculptural portraits of prominent figures of the Roman Republic, which are uniformly literal reproductions of individual physiognomies, must be seen in this social context. Although undoubtedly indebted stylistically to some degree to Hellenistic and Etruscan, and perhaps even Ptolemaic Egyptian, portraits, Republican portraits are one of the means by which the patrician class celebrated its elevated status. It is interesting to note that the subjects of Republican portraits are also almost exclusively men (and, to a lesser extent, women) of advanced age, for it was generally these elders who held power in the state. The sculptors who were employed to make likenesses of these patricians were not asked to make them appear nobler than they were, as Kresilas did Pericles (FIG. 5-44), but to record their distinctive features for posterity, in the tradition of the treasured household imagines.

One of the most striking of these so-called *veristic* (super-realistic) portraits is the head of an unidentified patrician (FIG. **7-5**) found near Otricoli. The artist has painstakingly recorded each rise and fall, each bulge and fold, of the facial surface, as if the sculptor were proceeeding like a mapmaker, concerned not to miss the slightest detail of surface change. The result is a blunt record of the sitter's features and a statement about his personality: serious, experienced, determined—virtues much admired during the Republic.

The portrait from Otricoli is in bust form. The Romans believed that the head alone was sufficient to constitute a portrait; the Greeks, by contrast, characteristically insisted that head and body were inseparable parts of an integral whole and their portraits were always full length. In fact, in Republican portraiture veristic heads were commonly, although incongruently, placed on bodies to which they

7-5 Head of a Roman patrician, from Otricoli, *c.* 75–50 B.C. Marble, approx. 14" high. Museo Torlonia, Rome.

could not possibly belong. Such is the case with the portrait of a general (FIG. **7-6**) found at the Sanctuary of Hercules at Tivoli, in which a typically stern and lined Republican visage sits atop a powerful, youthful body. The portrait is modeled on the statues of heroically nude Greek youths so much admired by the Romans—although the modesty of this patron dictated that a mantle be provided to shield his genitals. By his side, and acting as a prop for the heavy marble statue, is a cuirass, emblem of his rank. This curious and discordant image can only be understood as the conveyer of a composite message: the portrait head preserves the appearance of the patron, consistent with old Republican values; the cuirass informs us that he is a military officer; and the Greek-inspired body type proclaims that he is a hero. As different as this statue is from the pseudoperipteral Temple of Fortuna Virilis (FIG. 7-1), the two exhibit the same combination of native and imported elements and underscore the eclectic nature of Republican art and architecture.

During the first half of the first century B.C., the desire to advertise distinguished ancestry also manifested itself in

7-6 Portrait of a Roman general, from the Sanctuary of Hercules, Tivoli, *c.* 75–50 B.C. Marble, approx. 6′ 2″ high. Museo Nazionale Romano, Rome.

mold public opinion in favor of the current ruler by announcing his achievements in war and peace, both real and fictional.

Historians and art historians alike tend to focus on the lives and monuments of famous personages like Caesar, but some of the most interesting remains of ancient Roman civilization are the modest reliefs that were set into the facades of the tombs of ordinary people. An especially fine example of the genre (FIG. **7-8**) portrays three members of the Gessius family. According to the inscription on the marble slab, the relief was paid for with funds provided in the will of one Publius Gessius, a freeborn Roman citizen shown wearing the same kind of cuirass as that used to support the statue of the Tivoli general and likewise portrayed in the standard Republican veristic fashion. He is accompanied by a younger woman and man, possibly sister and brother, possibly wife and husband, who are explicitly labeled as his freed slaves. As slaves this couple had no legal standing; they were the property of Publius Gessius. Upon manumission, however, in the eyes of the law the freedmen became people for the first time. These stern frontal portraits proclaim their new status as legal members of Roman society.

More rarely the monuments commissioned by freedmen and plebeians are narrative in character, as is the tomb relief from Amiternum (FIG. **7-9**) that depicts the funerary cortege in honor of the deceased, complete with musicians, professional female mourners who pull their hair from their heads in an overt display of feigned grief, and the deceased's wife and children. The deceased is laid out on a bier with a canopy as a backdrop, much like the figures on Greek Geometric vases (FIGS. 5-1 and 5-2), but here the dead man surprisingly props himself up as if still alive, sur-

the placement of portraits of illustrious forebears on Republican coins, supplanting the earlier Roman tradition (based on Greek convention) of using images of divinities as numismatic devices. No Roman, however, dared to place his own likeness on a coin until 44 B.C., when Julius Caesar, shortly before his assassination on the Ides of March, issued coins bearing his portrait and his newly acquired title, *dictator perpetuus* (dictator for life). The *denarius* (the standard Roman silver coin, from which the word *penny* ultimately derives) illustrated here (FIG. **7-7**) records the aging flesh and receding hairline of Caesar in conformity with the Republican veristic tradition, but the appearance of the likeness of a living person on Roman currency violated all the norms of Republican propriety. Henceforth, Roman coins, which circulated throughout the vast territories under Roman control, would be used as a means to

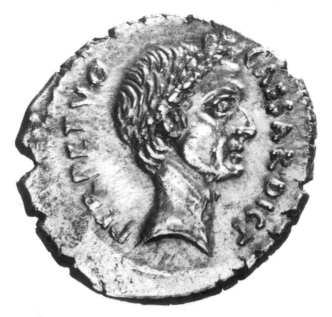

7-7 Denarius with portrait of Julius Caesar, 44 B.C. Silver, diameter approx. ³/₄″. American Numismatic Society, New York.

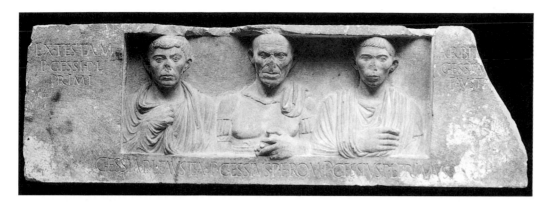

7-8 Funerary relief with portraits of the Gessius family, from Rome (?), *c.* 30 B.C. Marble, approx. 2′ 1¹/₂″ high. Courtesy, Museum of Fine Arts, Boston, Archibald Cary Coolidge Fund.

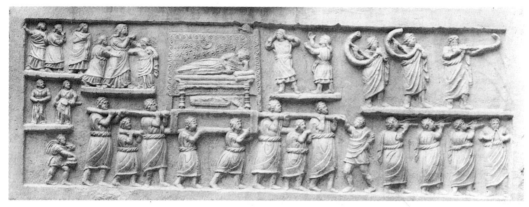

7-9 Relief with funerary procession, from Amiternum, second half of the first century B.C. Limestone, approx. 2′ 2″ high. Museo Nazionale d'Abruzzo, L'Aquila.

veying his own funeral. (This may be an effigy, like the reclining figures on the lids of Etruscan sarcophagi, rather than the deceased himself.) Compositionally, the relief is again not what one would expect. Mourners and musicians stand on floating ground lines, as if on "magic carpets." They are not, however, to be thought of as suspended in space, but rather as situated behind the front row of pall-bearers and musicians. This sculptor, in striking contrast to the (usually Greek) artists employed by the patrician aristocracy, has little regard for the rules of Classical art. Overlapping is studiously avoided and the figures are placed wherever they may fit on the stone slab, so long as they are clearly visible—an approach to making pictures characteristic of pre-Classical art, but one that had been out of favor for several centuries. One looks in vain for comparable compositions in the art commissioned by the likes of Julius Caesar and the generals and senators of the Roman Republic. In the cosmopolitan world of ancient Rome, as today, stylistic preferences were often tied to one's position in the political and social hierarchy.

POMPEII AND THE CITIES
OF VESUVIUS

On August 24, A.D. 79, Mount Vesuvius, a long dormant and supposedly extinct volcano whose fertile slopes were covered with vineyards during the Late Republic and Early

Empire, suddenly erupted and buried a host of prosperous towns around the Bay of Naples (the ancient Greek city of Neapolis), among them Pompeii. Pliny the Elder, whose *Natural History* in thirty-seven books is one of our most important sources for the history of Greek art, was one of those who observed the calamity; he was overcome by fumes from the eruption and died. What was a catastrophe for the inhabitants of the Vesuvian cities has proved to be a boon for archeologists and art historians. When the buried cities were rediscovered in the eighteenth century, they had been undisturbed for over sixteen centuries, and their remains, still being excavated today, permit us to reconstruct the art and life of a Roman town of the Late Republic and Early Empire with a completeness far beyond that achieved at any other archeological site.

Pompeii was first settled by the Oscans, one of the many Italic tribes that occupied Italy during the heyday of the Etruscans. It was taken over toward the end of the fifth century B.C. by the Samnites, who, under the influence of their Greek neighbors, greatly expanded the original town and gave monumental shape to the city center. Pompeii fought with other Italian cities on the losing side against Rome in the Social War, and in 80 B.C. the general Sulla founded a new Roman colony on the site and Latin became the official language. The population of the colony had expanded to between ten and twenty thousand people when, in February A.D. 62, an earthquake shook the city, causing extensive damage to many public and private

buildings. When Vesuvius erupted seventeen years later, repairs were still in progress throughout the town.

Walking through Pompeii today is an experience that cannot be approximated anywhere else. The streets with their heavy flagstone pavements and sidewalks are still there, as are the stepping stones that enabled pedestrians to cross from one side of a street to another without having to step in puddles. Ingeniously, the city planners placed these stones in such a way that they could be straddled by the wheels of vehicles so that supplies could be brought to the shops, taverns, and bakeries that lined the major thoroughfares. One can still visit the impressive concrete-vaulted rooms of Pompeii's public baths and sit in the seats of its open-air theater and indoor concert hall, even tour the tombs of the Pompeians interred outside the city's walls. And then there are the private residences with their mag-

nificently painted walls and pleasant gardens; some still have their kitchen utensils in place. There is good reason that Pompeii has been called the living city of the dead.

Architecture

The center of civic life in any Roman town was its *forum*, usually located at the geographical center of the city, at the intersection of the main north-south street, the *cardo*, and the main east-west avenue, the *decumanus*, although it was generally closed to all but pedestrian traffic. Pompeii's forum (FIGS. **7-10** and **7-11**) lies in the southwest corner of the expanded imperial city but at the heart of the original town. The long and narrow plaza took on monumental form in the second century B.C. under the Samnites, when two-story colonnades inspired by Hellenistic architecture

7-10 Forum, Pompeii, second century B.C. and later. (aerial view)

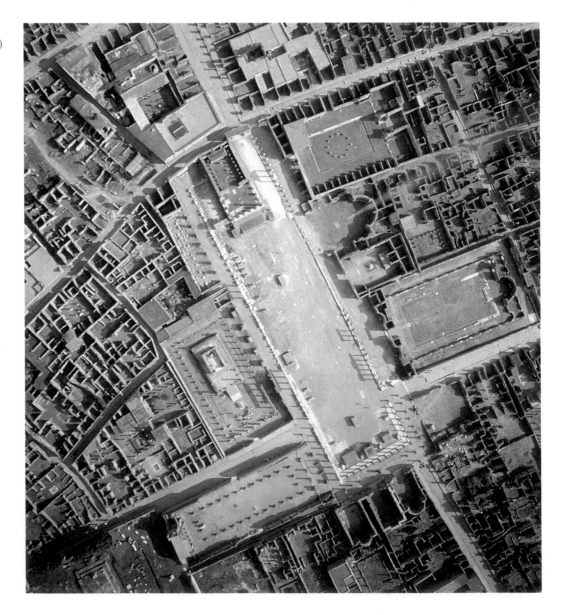

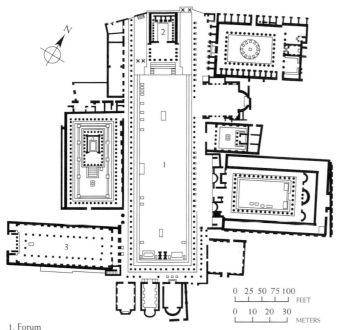

1. Forum
2. Temple of Jupiter (Capitolium)
3. Basilica

7-11 Plan of the forum of Pompeii.

were erected on three sides. At the narrow north end a Temple of Jupiter was constructed, which was converted into a triple shrine of Jupiter, Juno, and Minerva—a *Capitolium*—when Pompeii became a Roman colony in 80 B.C. The temple is of standard Republican type, constructed of tufa covered with fine white stucco and combines an Etruscan plan with Corinthian columns. It faces into the civic square, dominating the area. This is markedly different from the siting of Greek temples, which stood in isolation and could be approached and viewed from all sides, like colossal statues on giant stepped pedestals. The Roman forum, like the Etrusco-Roman temple, has a chief side, a focus of attention.

The area within the porticoes of the forum at Pompeii was left unencumbered, save for statues commemorating local dignitaries and later, Roman emperors; this is where daily commerce was conducted and festivities held. All around the square, however, behind the colonnades, were secular and religious structures, including the administrative offices of the town. Most noteworthy is the *basilica* at the southwest corner of the forum (FIG. **7-12**), the earliest well-preserved building of its kind. The basilica, constructed during the late second century B.C., housed the law court of Pompeii and was also used for other official purposes. In plan it resembles the forum itself: long and narrow, with two stories of internal columns dividing the space into a central *nave* and flanking *aisles*. This scheme will have a long afterlife in the history of architecture and will be

familiar to anyone who has ever entered a Christian church. For reasons that we shall discuss later, the models for Early Christian church builders were not pagan temples but Roman law courts and meeting halls.

The forum of Pompeii was an oasis in the heart of the city—an open, airy, strictly rectangular plaza. Throughout the rest of the city, as the aerial photographs (p. 20 and FIG. 7-10) make clear, every available square foot of land was developed. At the southeastern end of town, immediately after the foundation of the Roman colony in 80 B.C., a large amphitheater (FIG. **7-13**) was constructed. It is the earliest amphitheater known and was capable of seating some twenty thousand spectators—more than the entire population of the town a century and a half after it was built! The word *amphitheater* literally means double-theater, and the type closely resembles two Greek theaters put together, although the Greeks never built such structures. Greek theaters were situated on natural hillsides (FIGS. 5-45 and 5-80), but to support an amphitheater's continuous elliptical cavea it was necessary to build an artificial mountain—and only concrete technology, unknown to the Greeks, was capable of doing the job. In the Pompeii amphitheater a series of radially disposed concrete barrel vaults form a giant retaining wall that holds up the earthen mound and stone seats; barrel vaults also form the tunnels leading to the central *arena*, where bloody gladiatorial combats and other boisterous events took place—in contrast to the refined performances of comedies and tragedies that

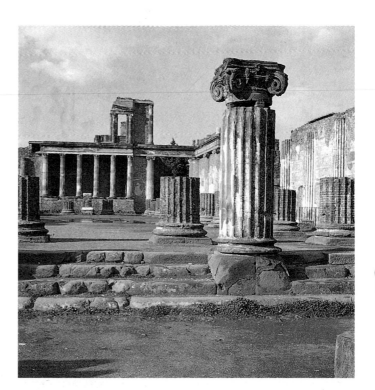

7-12 Basilica, Pompeii, late second century B.C.

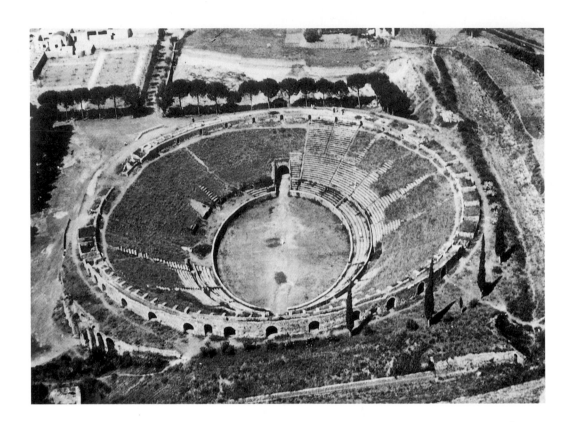

7-13 Amphitheater, Pompeii,
c. 80 B.C. (aerial view)

found a home in the theater. A painting on the wall of a
Pompeian house (FIG. **7-14**), now removed to the great
Archeological Museum in Naples, records an unfortunate
incident that occurred in the amphitheater in A.D. 59: a
brawl between the Pompeians and their neighbors, the
Nucerians, during a contest between the two towns that left
many seriously wounded and led to a decade-long prohibi-
tion against such events. The painting is also of value
because it shows the cloth awning (*velarium*) that could be
rolled down from the top of the cavea to shield spectators
from either sun or rain. It also features the distinctive exter-
nal double staircases (not visible in FIG. 7-13) that enabled
large numbers of people to enter and exit the cavea in an
orderly fashion.

At Pompeii, as in modern cities and towns, most of the
area was occupied by private homes. The evidence we have
from Pompeii regarding Roman domestic architecture is
unparalleled anywhere else and is the most precious by-
product of the catastrophic volcanic eruption of A.D. 79. The
typical Pompeian house (FIG. **7-15**) was entered through a
narrow foyer (*fauces*, literally the throat of the house),
which led to a large central reception area, the *atrium.*
The rooms flanking the fauces could open inward, as in our
diagram, or outward, in which case they were rented out as
shops. The roof over the atrium was partially open to the
sky, not only to admit light but also to channel rainwater
into a basin (*impluvium*) below; the water could be stored in
cisterns for household use. Opening onto the atrium was a
series of small bedrooms called *cubicula* (cubicles). At the

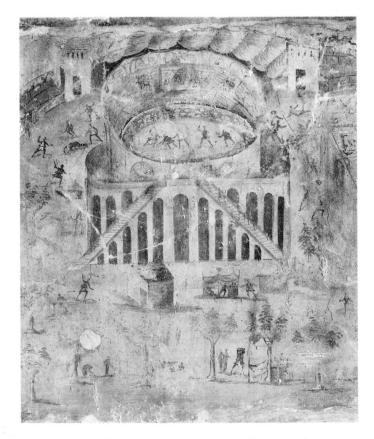

7-14 Brawl in the Pompeii amphitheater, wall painting from
House I,3,23, Pompeii, *c.* A.D. 60–79. Approx. 5′ 7″ × 6′ 1″.
Museo Nazionale, Naples.

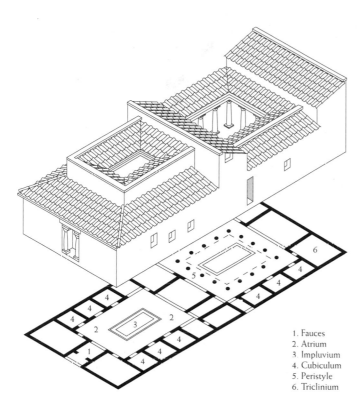

7-15 Reconstruction drawing and plan of a typical Pompeian house.

1. Fauces
2. Atrium
3. Impluvium
4. Cubiculum
5. Peristyle
6. Triclinium

back was a study, dining room (*triclinium*), kitchen, and sometimes a small garden. There are endless variations of the same basic scheme, dictated by personal taste, the nature of the plot of land, and so forth, but all Roman houses of this type are characterized by their inward-looking nature. The design shut off the noise and dust of the street, and all internal activity was focused on the brightly illuminated atrium at the physical center of the residence. This basic module (the front half of the typical house in FIG. 7-15) closely approximates the plan of the typical Etruscan house as reflected in such tombs as that of the Shields and Chairs at Cerveteri (FIG. 6-7), and there is little doubt that the early Roman house, like the early Roman temple, grew out of the Etruscan tradition.

During the course of the second century B.C., when Roman architects were beginning to build stone temples with Greek columns, the Pompeian house also took on Greek airs. The new element was the addition of a peristyle garden behind the Etruscan-style house, providing a second source of internal illumination as well as a pleasant and cool setting for meals served in a summer triclinium. The axial symmetry of the plan meant that upon entering the fauces of the house a visitor could be greeted by a vista through the atrium directly into the peristyle garden, which often boasted a fountain or pool, marble statuary, mural paintings, and mosaic floors. (The grand mosaic of Alexander the Great battling Darius of Persia, FIG. 5-79, a copy of a fourth-century B.C. Greek panel painting, came

from the floor of a room opening onto one of the two peristyles of a luxurious Pompeian mansion of the second century B.C., the so-called House of the Faun, named after the Hellenistic-style bronze statue that stood in the impluvium of one of its two atria.)

Such a vista may be seen in FIG. **7-16.** The photograph was taken in the fauces of the House of the Vettii, an old Pompeian house remodeled and repainted after the earthquake of A.D. 62. We see the impluvium in the center of the atrium, the opening in the roof above, and, in the background, the peristyle garden with its marble tables and splendid mural paintings dating to the last years of the Vesuvian city. The house was owned by two brothers, Aulus Vettius Restitutus and Aulus Vettius Conviva, probably freedmen who made their fortune as merchants. Their wealth enabled them to purchase and furnish the kind of fashionable town house that in an earlier era would have been the exclusive prerogative of the patrician class.

Painting

The houses of Pompeii have yielded a treasure trove of mural paintings, the most complete record of the changing fashions in interior decoration from any site in the Mediterranean—in fact, in the entire ancient world. The

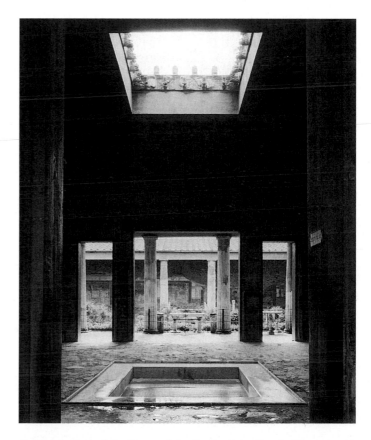

7-16 Atrium of the House of the Vettii, Pompeii, rebuilt A.D. 62–79.

mere quantity of wall paintings tells us a great deal about both the prosperity and the taste of the times. How many homes today, even of the very wealthy, have custom-painted frescoes in nearly every room?

In the early years of exploration at Pompeii, excavators were interested almost exclusively in the figural panels that formed part of the overall mural schemes, especially those that depicted Greek heroes and famous myths. These were systematically cut out of the walls and transferred to the Naples Archeological Museum, where they may be seen to this day. (The painting of the brawl in the amphitheater, FIG. 7-14, suffered this fate.) In time, more enlightened archeologists came onto the scene, and stopped the practice of cutting pieces out of the walls; serious attention was finally given to the mural designs as a whole. Toward the end of the nineteenth century, August Mau, a German art historian, divided the various mural painting schemes into four so-called Pompeian Styles. Mau's system of classification, although refined and modified in detail, still forms the basis for the modern art historical study of Roman painting.

FIRST STYLE The *First Style* has also been called the Masonry Style because the aim of the decorator was to imitate, using painted stucco relief, the appearance of costly marble panels. In the fauces (FIG. **7-17**) of the Samnite House at Herculaneum, a town also destroyed in the Vesuvian eruption of A.D. 79, the visitor is greeted at the doorway with the illusion of walls constructed with marble blocks or at least revetted with marble plaques imported from quarries all over the Mediterranean. This is an approach to wall decoration comparable to the modern practice, employed in private studies and corporate meeting rooms alike, of using man-made materials to approximate the look and shape of genuine wood paneling. The practice is not, however, uniquely Pompeian or Roman. First Style walls are well documented in the Greek East from the late fourth century B.C. on. The adoption of the First Style in Pompeian houses of the late second and early first centuries B.C. is yet another example of the Hellenization of Roman Republican architecture and of the craze for things Greek. First Style paintings, for example, adorn the walls of the room in the House of the Faun at Pompeii where the *Battle of Issus* mosaic (FIG. 5-79) was found.

The finest examples of First Style painting, like those in the Samnite House, are stunning in their illusion of actual marble veneers. Roman wall paintings were true frescoes, with the colors applied while the plaster was still damp, but the brilliance of the surfaces was achieved by painstaking preparation of the wall. The plaster, specially compounded with marble dust if the patron could afford it, was laid on in several layers with a smooth trowel. The surface was then polished to a marblelike finish.

SECOND STYLE The First Style never went completely out of fashion, but after 80 B.C. it was supplanted in popu-

larity by a new approach to mural design, which was in most respects the antithesis of the First Style, namely Mau's *Second Style*. Some scholars have argued that the Second Style also has precedents in Greece, but most believe that it is a Roman invention. Certainly it is in Italy that the Second Style evolved, until it in turn went out of favor with the introduction of the Third Style around 15 B.C. The aim of Second Style painters was not to create the appearance of an elegant marble wall, as First Style painters sought to do, but rather to dissolve the confining walls of a room and replace them with the illusion of a

7-17 First Style wall painting in the fauces of the Samnite House, Herculaneum, late second century B.C.

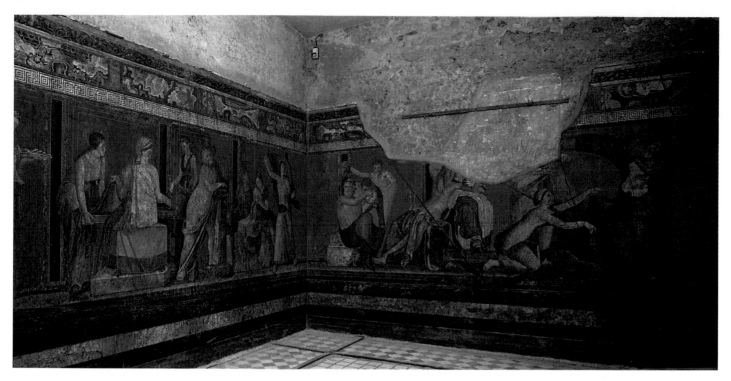

7-18 Dionysiac mystery frieze, Second Style wall paintings in Room 5 of the Villa of the Mysteries, Pompeii, *c.* 60–50 B.C. Frieze approx. 5′ 4″ high.

three-dimensional world constructed in the artist's imagination. This was done by purely pictorial means; the modeled stucco panels of the First Style gave way to flat wall surfaces in the Second Style.

An early example of the new style is the room that gives its name to the Villa of the Mysteries at Pompeii (FIG. **7-18**). In this chamber were probably celebrated, in private, the rites of the Greek god Dionysos, the focus of a popular but unofficial mystery religion in Italy at this time, whose adherents were all women. The precise nature of the Dionysiac rites is unknown, but the figural cycle in this room, in which mortals (all female save for one boy) interact with mythological figures, is generally thought to provide some evidence for the initiation rites of the cult, in which young women, emulating Ariadne, daughter of King Minos, were united in marriage with Dionysos. The backdrop for the nearly life-size figures is a series of painted panels that imitate marble revetment, just as in the First Style but without the modeling in relief. In front of this marble wall (but in actuality on the same two-dimensional surface) the painter has created the illusion of a shallow ledge on which the human and divine actors move around the room. Especially striking is the way some of the protagonists interact across the corners of the room—note, for example, the semi-nude winged woman at the far right of the rear wall who lashes out with her whip across the space of the room at a kneeling woman with a bare back (the initiate and bride-to-be of Dionysos) on the left end of the right wall. There is nothing comparable to this room in Hellenistic Greece; despite the presence of Dionysos, satyrs, and other figures from the Greek repertoire, this is a Roman design.

In the early Second Style Dionysiac mystery frieze of the Villa of the Mysteries, the spatial illusionism is confined to the painted platform that projects into the room, but in mature Second Style designs, the painter creates a three-dimensional setting that also extends beyond the wall. A prime example is a cubiculum (FIG. **7-19**) from the Villa of Publius Fannius Synistor at Boscoreale, near Pompeii, decorated between 50 and 40 B.C. The frescoes were removed from the site soon after its discovery, and today they are exhibited in a reconstructed Roman bedroom in the Metropolitan Museum of Art in New York. All around the room the Second Style painter has opened up the walls and given us vistas of Italian towns and sacred sanctuaries. Painted doors and gates invite us to walk through the wall and into the world the painter has created for us. Although he has applied it inconsistently, the painter demonstrates a knowledge of what is often incorrectly said to be an innovation of Italian Renaissance artists, namely *single vanishing-point perspective*, in which all the receding lines in a composition converge on a single point along the central axis of the painting. This kind of *linear perspective* painting, which ancient writers inform us was first used by Greek painters of the fifth century B.C. for the design of Athenian stage sets (hence its Greek name, *skenographia* or scene

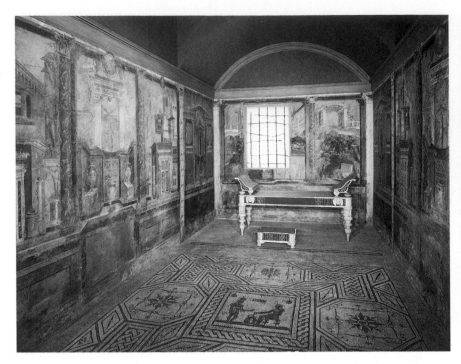
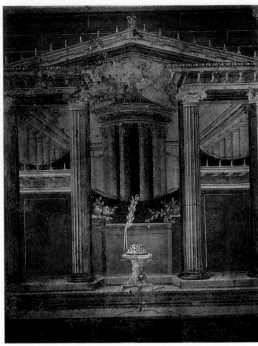

7-19 Second Style wall paintings (general view and detail of tholos) in Cubiculum M of the Villa of Publius Fannius Synistor, Boscoreale, *c.* 50–40 B.C. Approx. 8′ 9″ high. Metropolitan Museum of Art, New York.

painting), is most successfully employed in the far corners of the Boscoreale cubiculum where a low gate leads us into a peristyle framing a tholos temple. Single vanishing-point perspective is employed more consistently and on an even grander scale in the somewhat later Room of the Masks in what was probably the house of the emperor Augustus on the Palatine Hill in Rome and, less successfully, in numerous other Pompeian houses. It was a favored tool of Second Style painters seeking to transform the usually windowless walls of Roman houses into "picture-window" vistas that expanded the apparent space of the rooms.

From a house on the Esquiline Hill in Rome comes a series of landscape paintings in which the wanderings of Odysseus are depicted (FIG. **7-20**). The details of the narrative are on the whole faithful to Homer's great epic poem, the *Odyssey*, and many of the individual figures are labeled in Greek. This has led most scholars to conclude that the Roman frescoes we possess are copies or adaptations of Greek prototypes inserted into a contemporary Second Style context. While the supposed originals would have formed an unbroken narrative frieze, the Esquiline paintings occupied only the upper part of the wall of a Roman house and were divided into sections by painted piers. One might compare the Odyssey paintings to Roman copies of Greek statues displayed between the columns of a peristyle in a Pompeian house. In their new Roman setting, the Odyssey landscapes are consistent with other Second Style paintings in which the walls of a room are opened up to reveal a distant vista.

The ultimate example of a Second Style picture-window wall is found in the villa of the emperor Augustus's wife Livia at Primaporta, just north of Rome, where a vaulted, partially subterranean chamber is decorated on all sides with lush gardenscapes (FIG. **7-21**). Here the Roman painter has dispensed with the wall entirely, even as a framing element for the landscape. The only architectural element that remains is the flimsy fence that is part of the garden itself. To suggest recession, the painter has mastered another kind of perspective, *atmospheric perspective*, in which depth is indicated by the increasingly blurred appearance of objects in the distance. At Livia's Primaporta villa the fence, trees, and birds in the foreground are rendered with great precision, while the details of the dense foliage in the background are indistinct. Among the wall paintings we have examined, only the landscape fresco from Thera (FIG. 4-10) offers a comparable wraparound view of nature, but with its white sky and red, yellow, and blue rocky outcroppings, the Aegean fresco is not nearly so successful in creating the illusion of a world filled with air, light, and the sounds of birds, just a few steps away.

The love of country life and the idealizing of nature—what we may call the Arcadian spirit—prevails in the landscapes painted on Roman walls. The Arcadian spirit of the time speaks also in the formal, pastoral poetry of Vergil, a contemporary of Livia and Augustus. In one of his odes, Horace, another renowned Augustan poet, proclaims the satisfaction afforded the city dweller by a villa in the countryside, where life is beautiful, simple, and natural, in con-

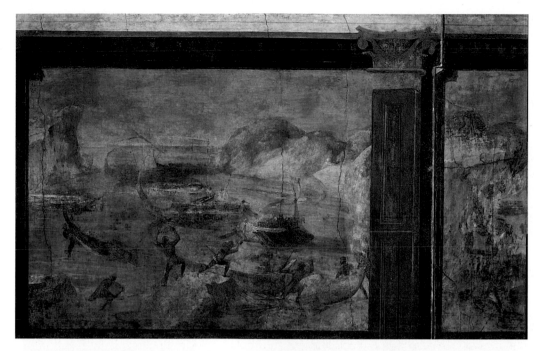

7-20 Odysseus in the Underworld, detail of a Second Style wall painting from a house on the Esquiline Hill, Rome, *c.* 50–40 B.C. Approx. 47″ high. Vatican Library, Rome.

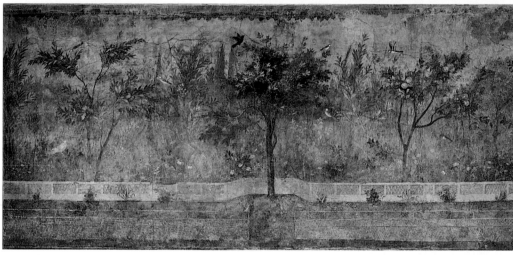

7-21 Gardenscape, Second Style wall painting from the Villa of Livia, Primaporta, *c.* 30–20 B.C. Approx. 6′ 7″ high. Museo Nazionale Romano, Rome.

trast with the urban greed for gold and power. We will encounter this Arcadianism again and again in the history of the West, in the Renaissance and in the nineteenth and twentieth centuries, as urban pressures begin to strain human nerves.

THIRD STYLE Livia's magnificent verdant gardenscape is the polar opposite of First Style designs in which the heavy presence of confining walls is reinforced, rather than denied, by modulated surfaces reproducing marble panels. But tastes changed rapidly in the Roman world, as in society today, and not long after the walls of the Primaporta villa were decorated with gardenscapes, Roman patrons began to favor mural designs in which the primacy of the wall surface was reasserted. In the *Third Style* of Pompeian painting, artists no longer attempted to replace the walls

with three-dimensional worlds of their own creation; nor did they seek to imitate the appearance of the marble walls of Hellenistic kings. Instead they decorated the walls of the homes of their Roman patrons with delicate linear fantasies sketched on predominantly monochrome backgrounds. One of the earliest examples of the new manner is a room in the Villa of Agrippa Postumus at Boscotrecase (FIG. **7-22**), probably painted just before 10 B.C. and also a property owned by the imperial family. Nowhere is the wall penetrated by illusionistic painting, and the artist makes a virtue of vacant space. The stately columns of the Second Style have been usurped by insubstantial and impossibly attenuated colonnettes supporting featherweight canopies barely reminiscent of pediments. In the center of this delicate and elegant architectural frame is a tiny floating landscape painted directly upon the jet-black ground; one

can scarcely imagine a sharper contrast with the panoramic gardenscape at Livia's Primaporta villa. On other Third Style walls, landscapes and mythological scenes are presented in frames, like modern paintings on canvas hung on walls; never can these framed panels be mistaken for windows opening onto a world beyond the room.

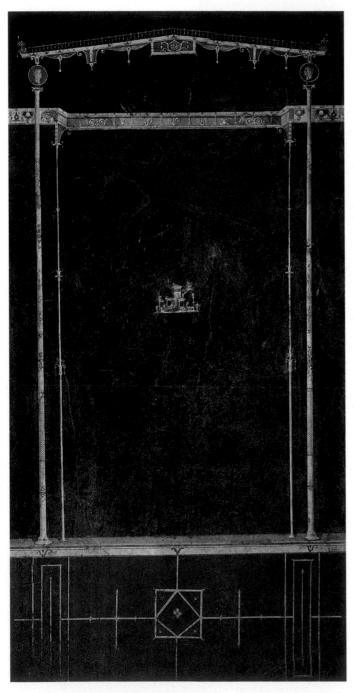

7-22 Detail of a Third Style wall painting from Cubiculum 15 of the Villa of Agrippa Postumus, Boscotrecase, *c.* 10 B.C. Approx. 7′ 8″ high. Metropolitan Museum of Art, New York.

FOURTH STYLE In the *Fourth Style*, however, a taste for architectural illusionism returns once again. This style became popular around the time of the Pompeian earthquake of A.D. 62 and it was the preferred manner of mural decoration when the town was buried in volcanic ash in A.D. 79. The earliest examples, like the room illustrated in FIG. **7-23** from the emperor Nero's fabulous pleasure palace in Rome, the Domus Aurea, or Golden House (see FIG. 7-38), reveal a kinship with the Third Style. All the walls are an austere creamy white, and in the upper zone, sea creatures are painted directly upon the monochrome background, much like the landscape in the black room of the Boscotrecase villa. Landscapes are present in the Neronian design too—as framed paintings placed in the center of each large white subdivision of the wall. But views through the wall are also part of the scheme, although the architectural vistas of the Fourth Style are irrational fantasies. Observers do not look out upon cityscapes or round temples set in peristyles but at fragments of buildings—columns supporting half-pediments, double stories of columns supporting nothing at all—painted on the same white ground as the rest of the wall. Architecture has become just another motif in the ornamental repertoire of the painter.

The latest Fourth Style walls conform to the same principles of design, but the painters often eschew the quiet elegance of the Third Style and early Fourth Style in favor of crowded and confused compositions and sometimes garish combinations of colors. The Ixion Room of the House of the Vettii at Pompeii (FIG. **7-24**) was decorated in this baroque manner just before the Vesuvian eruption. The room served as a triclinium in the house remodeled by the Vettius brothers after the earthquake and opened onto the peristyle seen in the background of FIG. 7-16. The scheme chosen for the dining room is a kind of résumé of all the previous styles, another instance of the eclecticism that we have noted as characteristic of Roman art in general. The lowest zone, for example, is one of the most successful imitations anywhere of fabulous, multicolored imported marbles, despite the fact that the illusion is created without recourse to relief, as in the First Style; and the large white panels in the corners of the room, with their delicate floral frames and floating central motifs, would fit naturally into the most elegant Third Style design. Unmistakably Fourth Style, however, are the fragmentary architectural vistas of the central and upper zones of the Vettii walls. They are unrelated to one another, do not constitute a unified cityscape beyond the wall, and are peopled with figures that would tumble into the room if they took a single step forward.

The Ixion Room takes its modern nickname from the mythological panel painting at the center of the rear wall. Ixion had attempted to seduce Hera, and Zeus punished him by binding him to a perpetually spinning wheel. The

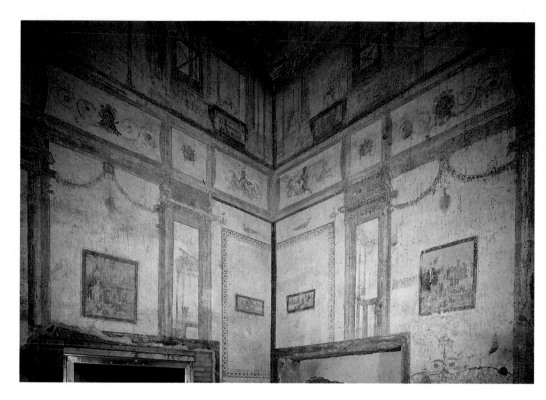

7-23 Fourth Style wall paintings in the Domus Aurea of Nero, Rome, A.D. 64–68.

panels on the two side walls of the triclinium also have Greek myths as subjects, and the Ixion Room may be likened to a small private art gallery in which paintings decorate the walls, as in many modern homes. Scholars have long believed that these and the many other mythological paintings that are common features of Third and Fourth Style walls are based upon lost Greek panels, although few if any can be described as true copies of "Old Masters." These paintings attest to the continuing admiration of works of Greek art three centuries after Marcellus brought the treasures of Syracuse to Rome.

Mythological figures were on occasion also the subject of Roman mosaics. The House of Neptune and Amphitrite at Herculaneum was named for the mosaic (FIG. **7-25**) in which statuesque images of the sea god Neptune and his wife Amphitrite are set into an elaborate niche (sea blue is the dominant color), appropriately presiding over the running water of the fountain in the courtyard in front of them. In the ancient world, mosaics are usually confined to floors (as was the *Battle of Issus*, FIG. 5-79, before it was transferred to a museum wall in Naples), where the tesserae formed a durable as well as decorative surface, but in Roman times they were also placed on walls and even on ceilings, foreshadowing the extensive use of wall and vault mosaics in the Middle Ages.

The subjects chosen for Roman wall paintings and mosaics were diverse; although mythological themes were immensely popular, a vast range of other subjects is also documented. We have already examined the ubiquitous

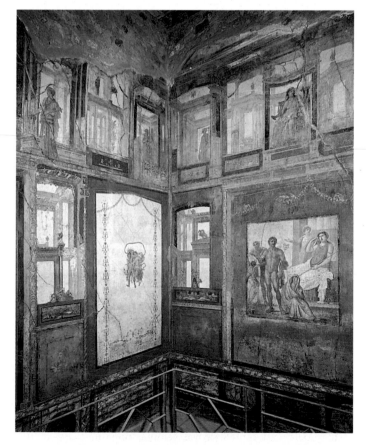

7-24 Fourth Style wall paintings in the Ixion Room (Triclinium P) of the House of the Vettii, Pompeii, *c.* A.D. 70–79.

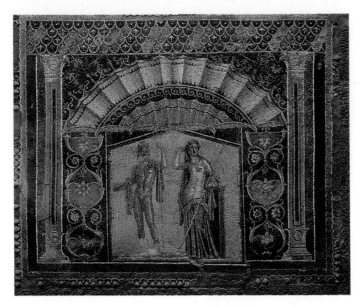

7-25 Neptune and Amphitrite, wall mosaic in the summer triclinium of the House of Neptune and Amphitrite, Herculaneum, *c.* A.D. 62–79.

landscape paintings on Second, Third, and Fourth Style walls, and in the category of history paintings and mosaics are to be counted both the *Battle of Issus* mosaic and the mural painting of the brawl betweeen the Pompeians and Nucerians in the amphitheater of Pompeii (FIG. 7-14).

Given the Roman tradition of preserving imagines of illustrious ancestors in atria, it is not at all surprising that painted portraits have been found on the walls of Pompeian houses, although they are relatively rare. Almost all were cut out of the walls upon discovery and brought to Naples, where they hang in the Archeological Museum as if they were independent panels in the tradition of Renaissance and later portraits on canvas. One must go to Naples to see the portrait of a husband and wife reproduced in FIG. **7-26**, but originally it formed part of a Fourth Style wall of an *exedra* (recessed area) opening onto the atrium of a Pompeian house. The man holds a scroll and the woman a stylus and a wax writing tablet, standard attributes in Roman marriage portraits intended to suggest the fine education of those depicted—even if, as was sometimes true, the sitters were uneducated or even illiterate. Portraits like these are thus the Roman equivalent of modern wedding photographs in which the bride and groom pose in rented formal garments never worn by them before or after. By contrast, the portraits proper are not standard types but sensitive studies of the physiognomies of the man and woman. We have here another instance of the placing of a realistic portrait on a conventional figure type, a recurring phenomenon in Roman portraiture that we first encountered in the statue of the Republican general found at Tivoli (FIG. 7-6).

The interest of Roman painters in the likenesses of individual people is paralleled by a concern for recording the appearance of everyday objects, hence the frequent inclusion of still-life paintings in the mural schemes of the Second, Third, and Fourth Styles. A still life with peaches and a carafe, a detail of a painted wall from Herculaneum now exhibited as a separate panel in Naples (FIG. **7-27**), demonstrates that the Roman painter sought illusionistic effects in depicting small objects as much as in depicting architectural forms and landscape spaces. Here, the method used involves light and shade, with scrupulous attention to contour shadows and to highlights; undoubtedly, the artist worked directly from an arrangement made specifically for this painting. The fruit, the stem and leaves, and the translucent glass jar were set out on shelves to give the illusion of the casual, almost accidental, relationship of objects in a cupboard. We find nothing like these Roman studies of food and inanimate objects until the Dutch still lifes of the seventeenth and eighteenth centuries (FIG. 24-54). The Roman murals are not, however, as exact in drawing, perspective, or the rendering of light and shade as the Dutch canvases. Still, the illusion the painter contrives here marks the point of furthest advancement made by the ancients in the technique of representation. The artist seems to understand that the look of things is a function of light. The goal is to paint light as one would strive to paint the touchable object that reflects and absorbs it.

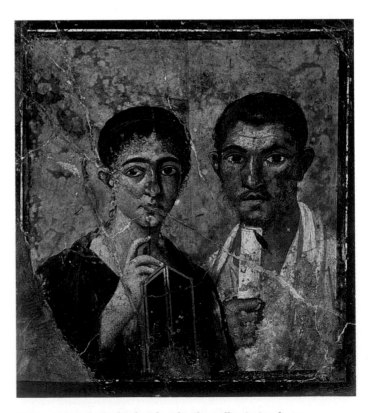

7-26 Portrait of a husband and wife, wall painting from House VII,2,6, Pompeii, *c.* A.D. 70–79. Approx. 23" × 20$\frac{1}{2}$". Museo Nazionale, Naples.

7-27 Still life with peaches, detail of a Fourth Style wall painting from Herculaneum, *c.* A.D. 62–79. Approx. 14″ × 13¹/₂″. Museo Nazionale, Naples.

THE EARLY EMPIRE

The murder of Julius Caesar on the Ides of March, 44 B.C., plunged the Roman world into a bloody civil war that lasted thirteen years and was resolved only when the grandnephew and adopted son of Caesar, Octavian—better known as Augustus—crushed the naval forces of Mark Antony and Queen Cleopatra of Egypt at Actium in northwestern Greece. Antony and Cleopatra subsequently committed suicide, and, in 30 B.C., Egypt, once the wealthiest and most powerful kingdom in the ancient world, became another province in the ever-expanding Roman Empire.

Historians reckon the passage from the old Roman Republic to the new Roman Empire from the day in 27 B.C. when the Senate conferred the majestic title of Augustus upon Octavian. The Empire was ostensibly a continuation of the Republic, with the same constitutional offices, but in fact Augustus, who was recognized as *princeps* (first citizen), occupied all the key positions, including that of consul and *imperator* (commander in chief, from which we derive the word *emperor*) and even, after 12 B.C., *pontifex maximus* (chief priest of the state religion), effectively giving him control of all aspects of Roman public life. With powerful armies keeping order on the frontiers of the empire and with no opposition at home, Augustus was able to bring peace and prosperity to a war-weary Mediterranean world. Known in his own day as the *Pax Augusta* (Augustan Peace), the peace that Augustus established prevailed for two centuries under a succession of, for the most part, able

emperors, and came to be called simply the *Pax Romana*. During this time a huge number of public works were commissioned in the capital and throughout the empire—roads, bridges, forums, temples, basilicas, theaters, amphitheaters, market halls, and bathing complexes, all on an unprecedented scale—and everywhere the populace was reminded of the source of this beneficence by the erection of portraits of the emperor and arches clad with reliefs recounting his great deeds. These portraits and reliefs often presented a picture of the emperor and his achievements that bore little resemblance to historical fact; their purpose, however, was not to provide an objective record but to mold public opinion. The Roman emperors and the artists in their employ had few equals in history in the effective use of art and architecture for propagandistic ends.

Augustus and the Julio-Claudians *(27 B.C.–A.D. 68)*

When Octavian inherited Caesar's fortune in 44 B.C., he was less than nineteen years old; when he routed Antony and Cleopatra at Actium in 31 B.C. and became undisputed master of the Mediterranean world, he had not yet celebrated his thirty-second birthday. The rule by elders that had characterized the Roman Republic for nearly half a millennium came to an abrupt end; suddenly Roman portraitists were called upon to produce images of a *youthful* head of state. But Augustus was more than merely young; after his death Caesar had been made a god and Augustus, while never claiming to be a god himself, widely advertised himself as the son of a god. His portraits—produced in great numbers by anonymous artists paid by the state—were designed to present the populace with the image of a godlike leader, a superior being who, miraculously, never aged. Although Augustus lived and ruled until A.D. 14, even the official portraits of him at age seventy-six continued to show the emperor as a handsome youth. Such a notion may seem a ridiculous conceit today, when television, magazines, and newspapers present the true appearance of world leaders, but in the ancient world few had ever actually seen the emperor, and his official image was all the people knew. It could therefore be manipulated at will.

The models for Augustus's idealized portraits cannot be found in the veristic likenesses of the Roman Republic; rather the sculptors employed by the emperor were inspired by the art of Classical Greece. The portrait statue of Augustus (FIG. **7-28**) found at Livia's villa at Primaporta depicting the emperor in his role as general (others portray him as pontifex maximus, and so forth) is based closely upon Polykleitos's *Doryphoros* (FIG. 5-42), except that the emperor is represented addressing his troops with his right arm extended in the manner of the orator Aule Metele (FIG. 6-18). Although the head (FIG. **7-29**) is that of an individual and not a nameless athlete, its overall shape, the sharp ridges of the brows, and the tight cap of layered hair all

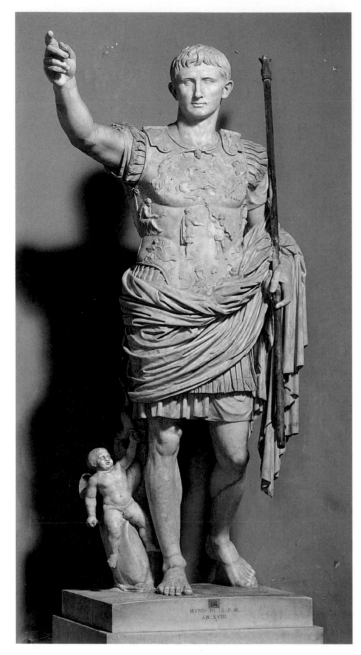

7-28 Portrait of Augustus as general, from Primaporta, copy of a bronze original of *c.* 20 B.C. Marble, 6' 8" high. Vatican Museums, Rome.

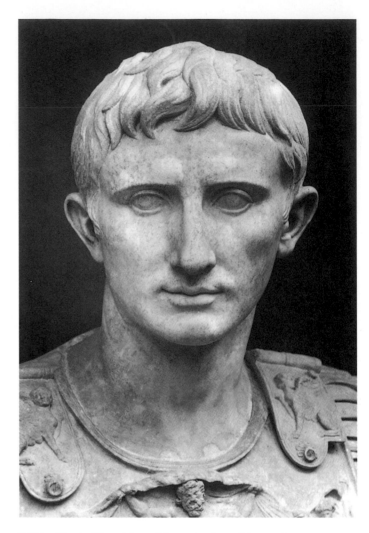

7-29 Head of the statue of Augustus from Primaporta.

emulate the Polykleitan style (FIG. 5-43). Reference to current events is made on Augustus's cuirass, where the return of captured Roman standards by the Parthians is depicted, but the Cupid at his feet serves a very different purpose. The family of Caesar, the Julians, traced their ancestry back to Venus, and the inclusion of Venus's son was an unsubtle reminder of Augustus's divine lineage. Every facet of the Primaporta statue was carefully crafted in light of its function as a vehicle of political propaganda.

A portrait bust of Livia (FIG. **7-30**), wife of Augustus and mother (with a former husband) of Rome's second emperor, Tiberius, shows that the imperial women of the Augustan age shared the emperor's eternal youthfulness. Although she sports the latest coiffure, with the hair rolled over the forehead and knotted at the nape of the neck, Livia's blemishless skin and sharply defined features are derived from images of Classical Greek goddesses. Livia outlived Augustus by fifteen years, dying at age eighty-seven. In her portraits the coiffure changes with each change of fashion, but her face remains ever young, as befitting her exalted position in the Roman state.

ARA PACIS AUGUSTAE On Livia's birthday in 9 B.C., Augustus dedicated the Ara Pacis Augustae (Altar of Augustan Peace), the monument celebrating his most important achievement, the establishment of peace. The altar (FIG. **7-31**) was reconstructed during the Fascist era in Italy in connection with the two thousandth anniversary

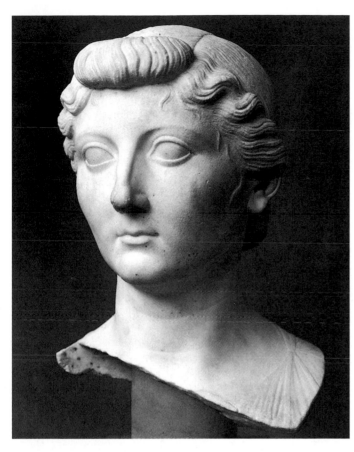

of Augustus's birth, when Mussolini was seeking to build a modern Roman Empire with himself at the head. The altar proper stands within an almost square precinct wall adorned with splendid acanthus tendrils in the lower zone and figural reliefs in the upper zone. Four panels on the east and west ends depict carefully selected mythological subjects, including (at the right in our photograph) a relief of Aeneas making a sacrifice. Aeneas was the son of Venus and therefore one of Augustus's forefathers. The connection between the emperor and Aeneas was a very important aspect of the political ideology of Augustus's new golden age. It is no coincidence that the *Aeneid* was written during the rule of Augustus; Vergil's epic poem glorifies the young emperor by celebrating the founder of the Julian line.

A second panel (FIG. **7-32**), on the opposite end of the altar precinct, depicts a seated matron with two animated babies on her lap. There has been much scholarly dispute about her identity. She is usually called Tellus (Mother Earth), although some have called her Pax (Peace), Ceres (goddess of grain), or even Venus. Whatever her name, she epitomizes the fruits of the Pax Augusta. All around her the bountiful earth is in bloom, and animals of different species live peacefully side by side. Personifications of refreshing breezes (note their wind-blown drapery) flank her; one rides a bird, the other a sea creature, so that earth, sky, and water are all incorporated into this picture of peace and fertility in the Augustan cosmos.

On the long north and south sides of the Ara Pacis are depicted processions of the imperial family and other

7-30 Portrait bust of Livia, from Faiyum, Egypt, early first century A.D. Marble, approx. 13¹/₂" high. Ny Carlsberg Glyptotek, Copenhagen.

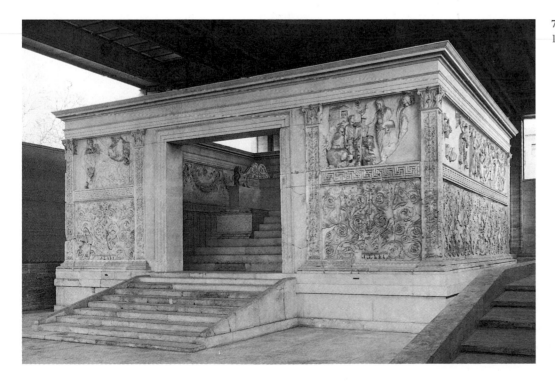

7-31 Ara Pacis Augustae, Rome, 13–9 B.C. (view from the southwest).

important dignitaries (FIG. **7-33**). That the parallel friezes of the Ara Pacis were inspired to some degree by the Panathenaic procession frieze of the Parthenon (FIG. 5-56) cannot be doubted and is another instance of the use of Classical Greek models by Augustan artists. Augustus sought to present his new order as a golden age comparable to the Periclean golden age of the middle of the fifth century B.C., and the emulation of Classical models made a political as well as an artistic statement. Nevertheless, despite the stylistic affinities, the Roman procession is markedly different in character from the Greek. On the Parthenon, anonymous figures act out an event that recurs every four years, and the frieze stands for *all* Panathenaic festival processions. On the Ara Pacis a specific event is depicted—probably the inaugural ceremony of 13 B.C. when work on the altar began—and recognizable historical personages are present. Among those portrayed are children, who restlessly tug on the garments of their elders and talk to one another when they should be quiet on a solemn occasion—in short, children who act like children, and not like miniature adults as they frequently do in the history of art. Their presence lends a great deal of charm to the procession, but that is not why children were included on the Ara Pacis when they had never had a place on any Greek or Roman state monument before. Augustus was concerned about a decline in the birthrate among the Roman nobility, and he enacted a series of laws designed to promote marriage, marital fidelity, and the raising of children.

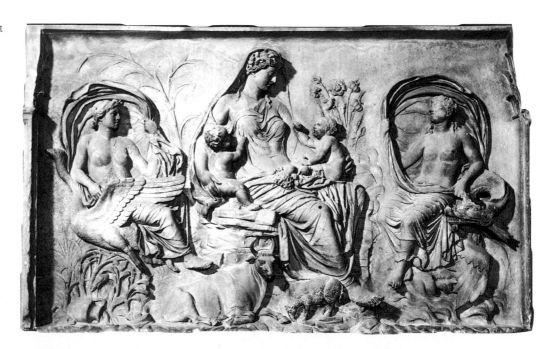

7-32 "Tellus," panel from the east facade of the Ara Pacis. Marble, approx. 5' 3" high.

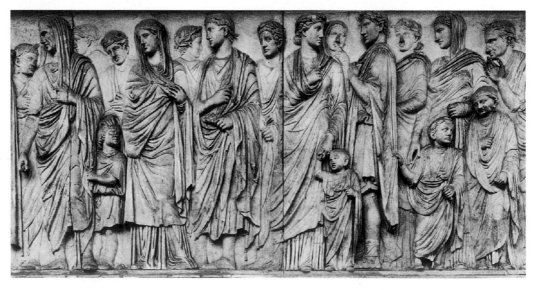

7-33 Procession of the imperial family, detail of the south frieze of the Ara Pacis. Marble, approx. 5' 3" high.

The portrayal of men with their families on the Altar of Peace was intended as a moral exemplar; once again, we see how in Augustan Rome art was employed to further the goals of the state—which are now synonymous with those of the emperor.

Augustus's most ambitious project in the capital was the construction of a new forum (FIG. 7-34). In plan the Forum of Augustus resembles that in Pompeii (FIG. 7-11), with a temple (dedicated to the Roman god of war, Mars) facing into a rectangular plaza flanked by porticoes. The temple and colonnades were constructed of white marble quarried at Carrara (ancient Luna), the same source used by the great sculptors of the Italian Renaissance. Prior to the opening of these quarries in the second half of the first century B.C., marble had to be imported at great cost from abroad, and it was used sparingly. The ready availability of Italian marble under Augustus made possible the emperor's famous boast that he had found Rome a city of brick and transformed it into a city of marble. The extensive use of Carrara marble for public monuments (including the Ara Pacis) must be seen as part of Augustus's larger program to make his city the equal of Periclean Athens. The Forum of Augustus contains several explicit references to Classical Athens and to the Acropolis in particular, most notably the copies of the caryatids of the Erechtheion (FIG. 5-60) in the upper story of the porticoes, one above each of the columns. More recent history was also evoked. The colonnades were lined with dozens of portrait statues, including images of all the major figures of the Julian family going back to Aeneas. Augustus's forum became a kind of public atrium filled with imagines, and his family history was made part of the official history of the Roman state. Although the Forum of Augustus and those of his successors served a practical function by providing alternative areas to the old and overcrowded Forum Romanum for the

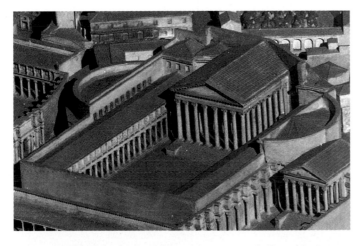

7-34 Model of the Forum of Augustus, Rome, dedicated in 2 B.C. Museo della Civiltà Romana, Rome.

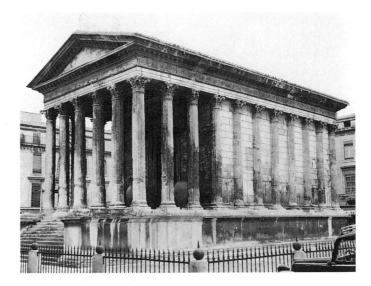

7-35 Maison Carrée, Nîmes, c. A.D. 1–10.

conduct of state business, they also gave the emperors the opportunity to present their own version of history to the Roman people.

The conservative Neo-Classical Augustan style in architecture may also be seen in the provinces, where, as in Rome, peace led to a burst of building activity. At Nîmes (ancient Nemausus) in southern France (ancient Gaul), the so-called Maison Carrée (FIG. 7-35) was constructed in the opening years of the first century A.D. Larger than the Temple of Fortuna Virilis in Rome (FIG. 7-1), this Corinthian pseudoperipteral temple was patterned on the Temple of Mars in the Forum of Augustus. In fact, many scholars now believe that some of the artisans responsible for the Roman temple moved on immediately to Nîmes to work on the Maison Carrée. The exceptionally well-preserved structure, now a museum, was much admired by Thomas Jefferson, who used it as the model for his design of the State Capitol in Richmond, Virginia. This Classicizing architectural manner was also preferred by Vitruvius, whose treatise, *The Ten Books of Architecture*, dedicated to Augustus, became the bible of Renaissance architects. Vitruvius was a competent architect-engineer, and the description of the technology of his day shows him to be fully aware of all contemporary developments. His treatise reveals, however, that he much preferred traditional Hellenic *trabeated* (post-and-lintel) construction to the newer Roman vaulted concrete idiom.

A somewhat earlier Augustan project at Nîmes was the construction of the great aqueduct-bridge known today as the Pont-du-Gard (FIG. 7-36). Throughout the far-flung territories administered by Rome, millions of individuals depended on the government for food distribution, water supply and sanitation, and the protection afforded by police and firefighters. Second only to the provision of food, an adequate water supply for the urban population was the

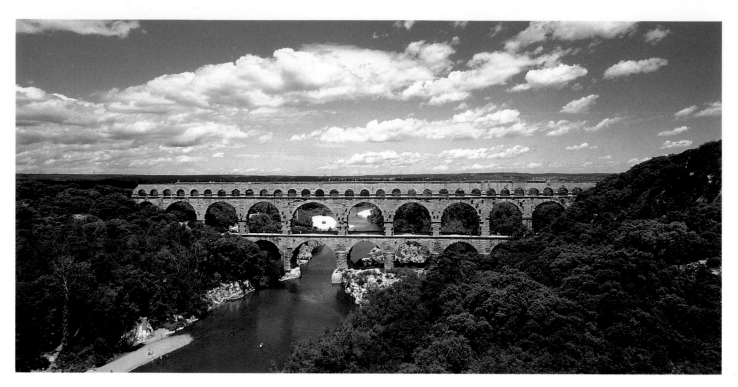

7-36 Pont-du-Gard, Nîmes, *c.* 16 B.C.

most imperative need. As early as the fourth century B.C., the Romans built aqueducts to carry water from mountain sources to the city on the Tiber, and as Rome's power spread through the Mediterranean world, aqueducts as well as roads and bridges were constructed to serve its colonies in Italy and the various provinces. The Pont-du-Gard is one of the most impressive witnesses to the skill of Roman hydraulic engineers. The Nîmes aqueduct was designed to provide about one hundred gallons of water a day for each inhabitant of the city from a source some 30 miles away. Water was carried over the considerable distance by gravity flow, which required the building of channels with a continuous gradual decline over the entire route from source to city. A great three-story bridge was constructed to maintain the height of the water channel when the water reached the Gard River. Each large arch spans some 82 feet and is constructed of uncemented blocks weighing up to two tons each. The uppermost level of the bridge consists of a row of smaller arches, three above each of the large openings below. They carry the water channel itself; their quickened rhythm and the harmonious proportional relationship between the larger and smaller arches demonstrate that the Roman engineer had a keen sense for the esthetic as well as the practical.

Many aqueducts were required to meet the demand for water in the capital. Under the emperor Claudius (A.D. 41–54), a grandiose gate was constructed at the point where two of Rome's water lines (and two intercity trunk roads) converged. The huge *attic* (uppermost story) of the

Porta Maggiore (FIG. **7-37**) bears a verbose dedicatory inscription and conceals the conduits of both aqueducts, one above the other, but the gate is most noteworthy as the outstanding preserved example of the Roman rusticated masonry style. Instead of employing the precisely shaped blocks favored by Hellenic and Augustan architects, the Claudian designer of the Porta Maggiore chose to combine smooth and rough (*rusticated*) surfaces to create an exciting, if eccentric, facade in which one finds crisply carved pedi-

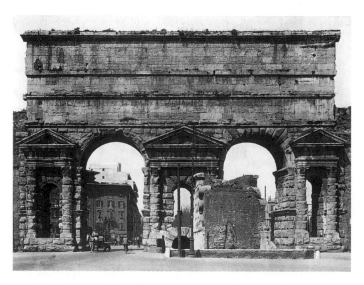

7-37 Porta Maggiore, Rome, *c.* A.D. 50.

ments resting on engaged columns composed of rusticated drums. The Porta Maggiore was closely studied by later architects and had a profound influence on the design of the facades of some Renaissance palaces.

Despite the Augustan preference for Classical forms and the Claudian fondness for rustication, Roman architects of the first century A.D. continued to explore the possibilities opened up by the use of concrete in lieu of traditional building materials. In A.D. 64, when Nero, stepson and successor of Claudius, was emperor of Rome (A.D. 54–68), a great fire destroyed large sections of the capital. The city was rebuilt in accordance with a new code that required greater fireproofing, resulting in the increased use of concrete, which was both cheap and fire-resistant. This increased use gave rise to an entirely new attitude toward the still relatively new material—an attitude that found one of its first full expressions when SEVERUS and CELER, two brilliant architect-engineers, were asked by Nero to build a grand imperial palace, the Domus Aurea (whose Fourth Style wall paintings, FIG. 7-23, we have already examined), on a huge expropriated plot of fire-ravaged land near the Forum Romanum.

As described by the Roman historians Tacitus and Suetonius, Nero's Golden House was a huge and luxurious country villa in the heart of Rome. Visitors were greeted by a colossal gilded bronze statue of the emperor, 120 feet high. There was a mile-long portico and an artificial lake surrounded by a landscaped park in which tilled fields and vineyards alternated with pastures and woods filled with great numbers of wild and domestic animals. The Domus Aurea proper was eventually buried beneath later imperial projects; its original plan cannot be reconstructed completely. The excavated portion of the palace contains a great number of rooms of uncertain purpose. Their walls and piers are of brick-faced concrete, most of them covered by vaults. The more important rooms seem to have been located on the southern side, where they faced the artificial lake. Traces of rich decorations, with marble paneling and painted and gilded stucco, have been found in them, but structurally they are unremarkable. One octagonal hall (FIG. 7-38), however, stands apart from the rest and testifies to Severus and Celer's entirely new approach to concrete architecture.

The octagonal room is covered by a dome that modulates from an eight-sided to a hemispherical form as it rises toward a round central opening, the *oculus* (eye). Radiating outward from the pavilion's five inner sides (the other three, directly or indirectly, face the outside) are smaller, rectangular rooms, covered by concrete vaults. These satellite rooms were enlivened by decorative recesses and the middle one by a cascade. Their lighting was ingeniously achieved by leaving a void between the vaulted ceilings of the radiating rooms and the exterior of the central dome. But most significant in the design of this group of rooms is the fact that here, for the first time, the architects appear to

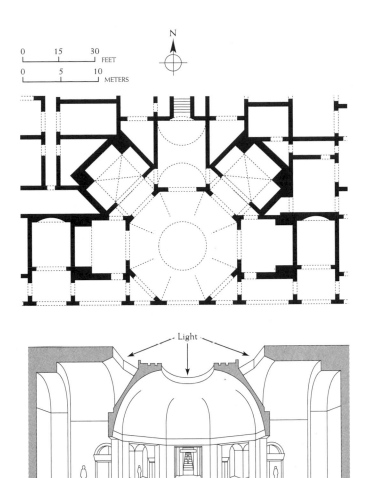

7-38 SEVERUS and CELER, plan *(above)* and section *(below)* of the Octagonal Hall of the Domus Aurea of Nero, Rome, A.D. 64–68.

have been thinking of the architectural solids—the walls and vaults—not as space-limiting but as space-molding agents.

Today, deprived of its marble and stucco incrustation, the concrete shell stands bare, but this serves to focus the visitor's attention upon the spatial complexity of the design, which only reveals itself fully to those who actually walk through the rooms. Then the central, domed octagon is found to be defined not by walls, but by eight angled piers—the wide, square openings between them so large that the rooms beyond appear to be mere extensions of the central pavilion. The grouping of spatial units of different sizes and proportions under a variety of vaults constitutes a dynamic, three-dimensional composition that is both complex and unified. This unique design establishes the Neronian architects as not only original and inventive but progressive in their recognition of the malleable nature of concrete, a material unbound by the rectilinear forms of traditional post-and-lintel construction.

The Flavians (A.D. 69–96)

When, because of his outrageous behavior, Nero was forced to commit suicide in A.D. 68, the Julio-Claudian dynasty came to an end, and a year of renewed civil strife followed. The man who emerged triumphant in this brief but bloody conflict was Vespasian, a general who had served under Claudius and Nero. Vespasian, whose family name was Flavius, had two sons, Titus and Domitian, who in turn succeeded him as emperor. The Flavian dynasty ruled Rome for over a quarter century.

COLOSSEUM The Flavians left their mark on the capital in many ways, not the least of which was the construction of the Colosseum (FIGS. **7-39** and **7-40**), the monument that, for most people, still represents Rome as does no other building. So closely was it identified in the past with the city and the Empire that an aphorism out of the early Middle Ages stated: "While the Colosseum stands, Rome stands; when the Colosseum falls, Rome falls; and when Rome, the world!"

The Flavian Amphitheater, as it was known in its own day, was one of Vespasian's first undertakings upon becoming emperor, and the decision to build it was very shrewd politically. The site chosen was the artificial lake of Nero's Domus Aurea park, which was drained for the purpose. In building the new amphitheater there, Vespasian was reclaiming for the public the land that Nero had confiscated for his private pleasure and, at the same time, providing the people of Rome with the largest arena for gladiatorial combats and other lavish spectacles that had ever been constructed. The Colosseum takes its name, however, not from its size—it could hold fifty thousand spectators—but from its location beside the Colossus of Nero at the entrance to his urban villa.

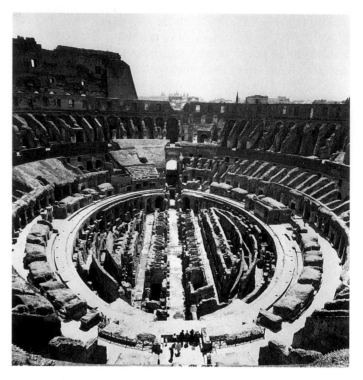

7-40 Colosseum (interior view).

Vespasian, who died in A.D. 79, did not live to see the Colosseum in use. The amphitheater was completed in A.D. 80 and formally dedicated by Titus. To mark the opening, games were held for one hundred days, at extravagant cost but to the delight of the people. The highlight was the flooding of the arena to make possible the staging of a complete naval battle with over three thousand participants. Later emperors would compete with each other to see who could produce the most elaborate spectacles, and over the years many thousands of lives were lost in the gladiatorial and animal combats staged within the Flavian Amphitheater. Many of those who died while entertaining the Romans were Christians, and the Colosseum has never quite outlived its infamy.

The Colosseum, like the much earlier amphitheater at Pompeii (FIG. 7-13), could not have been built without concrete technology. The enormous oval seating area is sustained by a complex system of radial and concentric corridors covered by concrete barrel vaults. This concrete "skeleton" reveals itself today to anyone who enters the amphitheater; in the centuries following the fall of Rome the Colosseum served as a convenient quarry for ready-made building materials, and almost all its marble seats were hauled away, exposing the network of vaults below. Hidden in antiquity but visible today are the substructures of the central arena. Here were housed the waiting rooms for the gladiators, animal cages, and machinery for raising and lowering stage settings as well as animal and human

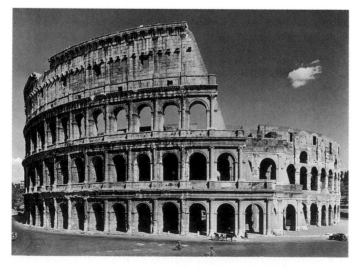

7-39 Colosseum, Rome, c. A.D. 70–80 (exterior view).

contestants. A great deal of technical ingenuity involving lifting tackle was employed to bring beasts from their dark dens into the violent light of the arena. Above the seats there was once a great velarium, as at Pompeii, to shield the spectators; it was held up by giant wooden poles affixed to the Colosseum's facade.

The exterior travertine shell is approximately 160 feet high, the height of a modern sixteen-story building. Seventy-six numbered entrances led to the seating area. The relationship of these openings to the tiers of seats within was very carefully thought out and, in essence, may be observed in the modern sports stadium. The articulation of the exterior, however, had nothing to do with function. The facade is divided into four horizontal bands, with large arched openings piercing the lower three. The arches are framed by ornamental Greek orders whose arrangement follows the standard Roman sequence for multistoried buildings: Doric-Ionic-Corinthian, from the ground up. This sequence is based on the inherent proportions of the orders, with the Doric, which appears to be the strongest, viewed as capable of supporting the heaviest load. The uppermost story is articulated with Corinthian pilasters (between which are the brackets for the poles that held up the velarium over the cavea).

The rectilinear framing of the arcuated openings in the Colosseum's facade by engaged columns and a lintel is a variation of the scheme used on the Etruscan Porta Marzia at Perugia (FIG. 6-16). The motif was commonly employed by the Romans from Late Republican times on. Like the Roman pseudoperipteral temple, which is an eclectic mix of Greek orders and Etruscan plan, this manner of articulating the facade of a building uses Greek orders to embellish an architectural form that is foreign to Greek post-and-lintel architecture, namely the arch. Revived in the Italian Renaissance, the motif has a long, illustrious history in Classical architecture. The Roman practice of framing an arch with an applied Greek order has no structural purpose but fulfills the esthetic function of introducing variety into a monotonous surface, while unifying a multistoried facade by casting a net of verticals and horizontals over it that ties everything together.

The Colosseum's patron, Vespasian, was an unpretentious career army officer who desired to distance himself from Nero's extravagant misrule, and his portraits (FIG. 7-41) reflect his much simpler tastes. They also make an important political statement. Breaking with the tradition established by Augustus of depicting the emperor of Rome as an eternally youthful god on earth, the sculptors employed by Vespasian resuscitated the veristic tradition of the Roman Republic, possibly at his specific direction. Although not as brutally descriptive as many Republican likenesses, Vespasian's portraits frankly record his receding hairline and aging leathery skin—and proclaim that his values are different from those of Nero.

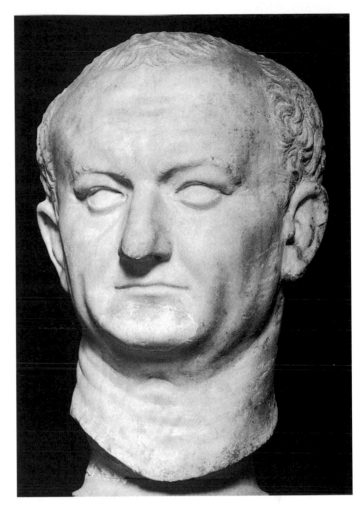

7-41 Portrait of Vespasian, from Ostia, *c.* A.D. 69–79. Marble, approx. 16″ high. Museo Nazionale Romano, Rome.

Flavian portraits of people of all ages are preserved, in contrast to Republican times, when only elders were deemed worthy of depiction. A portrait bust of a young woman (FIG. 7-42), probably a member of the Flavian dynasty, although her identity is uncertain, is a case in point. The portrait is notable for its elegance and delicacy and for the virtuoso way in which the sculptor has rendered the differing textures of hair and flesh. The elaborate Flavian coiffure, with its corkscrew curls punched out by the adroit use of a drill, creates a dense mass of light and shadow set off boldly from the softly modeled and highly polished skin of the woman's face and swanlike neck. The drill will play an increasingly large role in Roman sculpture in succeeding periods and will in time be used even for portraits of men, when male fashion called for much longer hair and full beards.

ARCH OF TITUS When Vespasian's older son Titus died in A.D. 81, only two years after becoming emperor, his

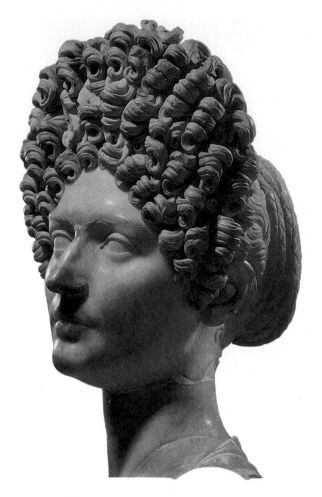

7-42 Portrait bust of a Flavian woman, *c.* A.D. 90. Marble, approx. 2′ 1″ high. Museo Capitolino, Rome.

younger brother Domitian succeeeded him and erected an arch (FIG. **7-43**) in Titus's honor on the Via Sacra (Sacred Way) leading into the Forum Romanum. The so-called triumphal arch has a long history in Roman art and architecture, beginning in the second century B.C. and continuing even into the era of Christian Roman emperors. The term is something of a misnomer, for such freestanding arches, usually crowned by gilded bronze statues, were set up to commemorate a wide variety of events, from victories abroad to the building of roads and bridges at home. The Arch of Titus is typical of the early form of Roman commemorative arch and consists of one passageway only. Engaged columns frame the arcuated opening, as on the Colosseum, but their capitals are of the *Composite* type, an ornate combination of Ionic and Corinthian that became popular at about the same time as the Fourth Style in Roman painting. The *spandrels* (the area between the arch proper and the framing columns and entablature) are filled with reliefs depicting personified Victories (winged women, as in Greek art). The attic is dominated by a dedicatory inscription informing us that the arch was set up to honor

the god Titus, son of the god Vespasian. (Roman emperors were normally proclaimed gods after they died, unless they ran afoul of the Senate, in which case they were damned. Those who suffered *damnatio memoriae* had their statues torn down and their names erased from public inscriptions; this was Nero's fate.)

Inside the passageway of the Arch of Titus are two great relief panels representing the triumphal parade of Titus down the Via Sacra upon his return from the conquest of Judaea at the end of the Jewish Wars in A.D. 70. One of the reliefs (FIG. **7-44**) depicts Roman soldiers carrying the spoils—including the sacred seven-branched candelabrum, the *menorah*—from the Temple in Jerusalem. Despite considerable damage to the relief, the illusion of movement is complete and convincing. The marching files press forward from the left background into the center foreground and disappear through the obliquely placed arch in the right background. The energy and swing of the column of soldiers suggest a rapid marching cadence. The Classicizing low relief of the Ara Pacis (FIG. 7-33) has been rejected in favor of extremely deep carving, which produces strong shadows. The heads of the forward figures have broken off because they stood vulnerably free from the block, emphasizing their different placement in space from the heads in

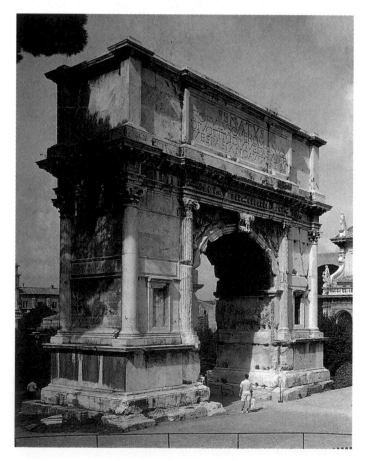

7-43 Arch of Titus, Rome, after A.D. 81.

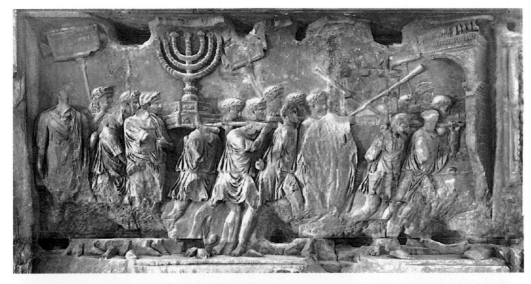

7-44 Spoils of Jerusalem, relief panel from the Arch of Titus. Marble, approx. 7' 10" high.

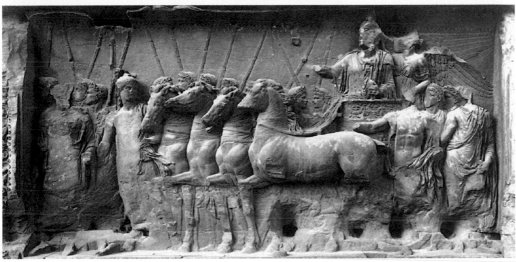

7-45 Triumph of Titus, relief panel from the Arch of Titus. Marble, approx. 7' 10" high.

low relief, which are intact. The play of light and shade across the protruding foreground and receding background figures quickens the sense of movement.

The accompanying panel on the opposite side of the passageway (FIG. 7-45) shows Titus in his triumphal chariot. The seeming historical accuracy of the spoils panel—there is a close correspondence between the relief and the contemporary description by the Jewish historian Josephus—gives way in the triumph panel to allegory. Riding with Titus in the four-horse chariot is Victory, the winged female who places a wreath on Titus's head. Below is a bare-chested youth who is probably a personification of Honor (*Honos*), and leading the team of horses is a female personification of Valor (*Virtus*). The addition of these allegorical figures transforms the relief from a documentation of Titus's success on the battlefield into a more general celebration of imperial virtues. We encountered such an intermingling of divine and human figures on the walls of the Villa of the Mysteries at Pompeii (FIG. 7-18), but this is the

first known instance of the insertion of divine beings into a Roman historical relief on a public monument. (On the Ara Pacis, Aeneas and Tellus appear in separate framed panels and are carefully segregated from the procession of living Romans.) It is well to remember, however, that the Arch of Titus was erected posthumously and that when its reliefs were carved, Titus was already a god. But the precedent had been set and soon this kind of interaction between mortals and immortals would become a staple of Roman narrative relief sculpture, even on monuments celebrating a living emperor.

THE HIGH EMPIRE

In the second century A.D., under Trajan, Hadrian, and the Antonines, the Roman Empire reached its greatest geographical extent and the summit of its power. Rome's might and influence were unchallenged in the Western

world, although pressure was constantly being applied by the Germanic peoples in the north, the Berbers in the south, and the Parthians and resurgent Persians in the east. Within the secure boundaries of the empire, the Pax Romana produced an unprecedented prosperity for all those who came under Roman rule.

Trajan (A.D. 98–117)

When Domitian, who resembled Nero in his extravagant life-style and who demanded that he be addressed as *dominus et deus* (lord and god), was assassinated in A.D. 96, the Senate chose the elderly Nerva, one of its own, as emperor. Nerva ruled for only sixteen months, but before he died he established a pattern of succession that was to last for almost a century by adopting as his son a capable and popular general to whom he was unrelated by blood. That man was Trajan, a Spaniard by birth, the first non-Italian to be granted imperial power. Under Trajan, Roman armies brought Roman rule to ever more distant areas, and the imperial government took on ever greater responsibility for the welfare of its people by instituting a number of far-sighted social programs. So popular was Trajan that he was granted the title *Optimus* (the Best), an epithet he shared with Jupiter (who was said to have instructed Nerva to choose Trajan as his successor) and that recalled the majestic title *Augustus* bestowed upon Octavian by a grateful Senate. In late antiquity Augustus and Trajan became the yardsticks for success, and the goal of new emperors was to be *felicior Augusto, melior Traiano* (happier than Augustus, better than Trajan).

In A.D. 100 Trajan founded a new colony for army veterans at Timgad (ancient Thamugadi, FIG. **7-46**) in North Africa, in what is today Algeria. Timgad was built along a major road one hundred miles from the sea, and, like other imperial foundations in the provinces, it became the physical embodiment of Roman authority and civilization for the local population and served as a key to the process of Romanization. The town was planned with great precision, its design resembling that of a Roman military encampment or *castrum*. (Scholars still debate the question of precedence; the castrum may have been based on the layout of Roman colonies.) Unlike the sprawling and irregular unplanned cities of Rome and Pompeii, Trajan's Timgad takes the form of a square divided into equal quarters by its two main arteries, the cardo and the decumanus, which cross at right angles and are bordered by colonnades. Monumental gates in the original walls of the colony mark the ends of the two avenues; the forum is located at the point where the streets intersect. The quarters are subdivided into square blocks, and the forum and public buildings, like the theater and baths, occupy areas that are multiples of these blocks. The whole plan was essentially a modification of the Hippodamian plan of Greek cities (FIG. 5-86) but more

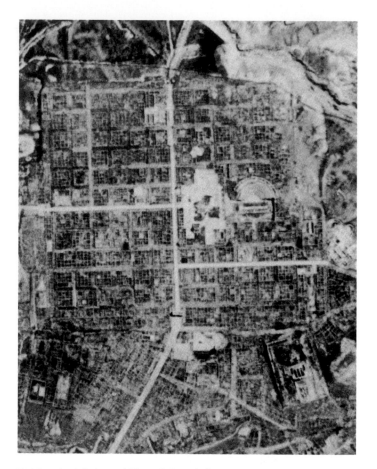

7-46 Aerial view of Timgad, founded A.D. 100.

rigidly ordered and systematized. The fact that most of these colonial settlements were laid out in the same manner, regardless of whether they were located in North Africa, Mesopotamia, or England, expresses more concretely than any building type or other construction project the unity and centralized power characteristic of the Roman Empire at its height. Nevertheless, even the Romans could not regulate human behavior completely, and as the population of Timgad expanded sevenfold and burst through the walls of the Trajanic settlement, rational planning was ignored as the city and its streets branched out haphazardly. The contrast between the Trajanic core of Timgad and the city of the later Empire is immediately apparent in our aerial view.

FORUM AND COLUMN OF TRAJAN Trajan's major building project in Rome was the construction of a huge new forum (FIG. **7-47**), roughly twice the size of the Forum of Augustus (FIG. 7-34), even if one excludes the enormous market complex that was an adjunct to the forum proper. The new forum glorified Trajan's victories in his two wars against the Dacians (who inhabited the area that now roughly corresponds to Romania) and was paid for with the

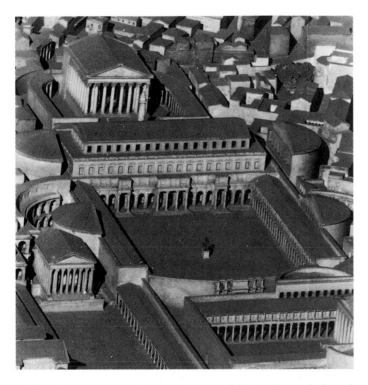

7-47 APOLLODORUS OF DAMASCUS, Forum of Trajan, Rome, dedicated A.D. 112 (model). Museo della Civiltà Romana, Rome.

spoils of those campaigns. The architect was APOLLODORUS OF DAMASCUS, who had served the emperor as military engineer during the Dacian wars and who had constructed a world-famous bridge across the Danube River. Apollodorus's plan incorporated the main features of Augustus's forum, but deviated from it in one important respect: a huge basilica, not a temple, dominated the colonnaded open square. The temple (completed after the emperor's death and dedicated to the newest god in the Roman pantheon, Trajan himself) was set instead behind the basilica, at the rear end of the forum in its own courtyard, where there were also two libraries flanking a giant commemorative column.

Entrance to the forum was gained through an impressive gateway that resembled a triumphal arch, complete with an attic statuary group in which Trajan drives a six-horse chariot while being crowned by Victory. Inside the forum the visitor was greeted by still more reminders of Trajan's military prowess. The center of the great court in front of the basilica was occupied by an over-life-size gilded-bronze equestrian statue of the emperor, and above the columns of the forum porticoes were statues of bound Dacians (modeled on the caryatids of Augustus's forum). The Basilica Ulpia (Trajan's family name was Ulpius) was a much larger version of the basilica in the forum of Pompeii. Its ruined state (FIG. **7-48**) gives hardly a hint of its former magnificence, but the preserved remains and ancient descriptions

permit a reasonably accurate reconstruction of the huge building, as shown in the model (FIG. 7-47). There were semicircular *apses,* or recesses, on each short end, a central longitudinal nave flanked by two aisles on each side, and—in contrast to the Pompeian basilica and later Christian churches—entrances on the long side facing the forum. The building was vast—some 400 feet long (without the apses) and 200 feet wide. Illumination for this great interior space was afforded by clerestory windows, provided by elevating the timber-roofed nave above the colonnaded aisles. In the Republican basilica at Pompeii, light reached the nave only indirectly through windows in the aisles; the clerestory (used millennia before at Karnak in Egypt, FIG. 3-29) was a much better solution, and this feature of the Basilica Ulpia was embraced by Early Christian architects for the design of the first churches.

The Column of Trajan, which stood between the Basilica Ulpia and the later Temple of the Deified Trajan, was probably also the brainchild of Apollodorus of Damascus. The idea of covering the shaft of a colossal freestanding column with a continuous spiral narrative frieze (FIG. **7-49**) seems to have been invented here, but it was often copied. As late as the nineteenth century, a column inspired by the Column of Trajan was erected in the Place Vendôme in Paris, in commemoration of the victories of Napoleon. Trajan's Column is 128 feet high. Coins tell us that it was once crowned by a heroically nude statue of the emperor (compare FIG. 7-6), which was lost in the Middle Ages and replaced by a statue of St. Peter in the sixteenth century. The square base served as Trajan's mausoleum, and his ashes and those of his wife Plotina were deposited there in golden urns. The 625-foot band that winds the height of the column, and which has been likened by many scholars to an ancient illustrated scroll of the type housed in the

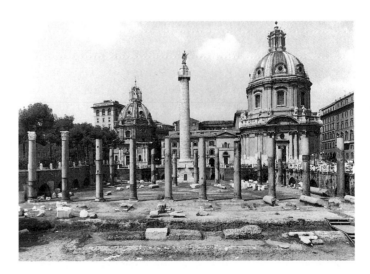

7-48 Column of Trajan and remains of the Basilica Ulpia in the Forum of Trajan.

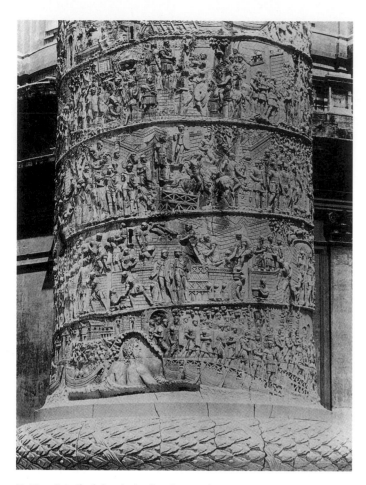

7-49 Detail of the shaft of Trajan's Column.

who appears again and again in the frieze, but the enemy is not belittled. On the Column of Trajan the Romans win because of their superior organizational skills and more powerful army, not because they are inherently superior beings.

On the Quirinal Hill overlooking the forum, Apollodorus built the Markets of Trajan (FIG. **7-50**) to house both shops and administrative offices. The transformation of a natural slope into a man-made multilevel complex was possible here, as earlier at Palestrina, only by employing concrete, and Trajan's architect shows himself a master of this modern medium as well as of the traditional stone-and-timber trabeated architecture of the forum below. The basic unit was the *taberna*, the single-room shop covered by a barrel vault. Each taberna had a wide doorway, usually surmounted by a window, which admitted light to a wooden inner attic used for storage. The individual shops were spread on several levels and opened either onto a hemispherical facade winding around one of the great exedras of Trajan's forum, onto a paved street farther up the hill, or onto the interior of a great indoor market hall resembling a modern shopping mall (FIG. **7-51**).

neighboring libraries (and held by Lars Pulena on his sarcophagus, FIG. 6-17), records Trajan's two successful campaigns against the Dacians. The story is told in over 150 separate episodes peopled by some twenty-five hundred figures. The band increases in width as it winds to the top of the column, for better visibility from the ground, but the height of the relief is uniformly very low, so as not to distort the contours of the shaft. Legibility would have been enhanced in antiquity by the addition of paint, but it still would have been very difficult for anyone to follow the narrative from beginning to end. In fact, much of the spiral frieze is given over to easily recognizable standard compositions of the type that regularly appear on coin reverses and on historical relief panels—Trajan addressing his troops, sacrificing to the state gods, and so on—and the narrative is not a reliable chronological account of the Dacian Wars, as was once thought. The general character of the campaigns is nonetheless accurately recorded. Notably, only about a quarter of the frieze is devoted to battle scenes. As is true of modern military operations, more time was spent by the Romans constructing forts, transporting men and matériel, and preparing for battle, than fighting. The focus of attention is always on the emperor,

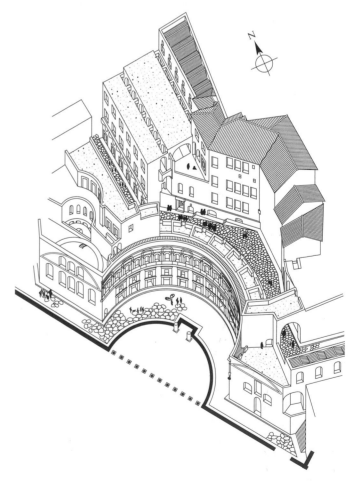

7-50 APOLLODORUS OF DAMASCUS, Markets of Trajan, Rome, *c.* A.D. 100–112. (Reconstruction drawing.)

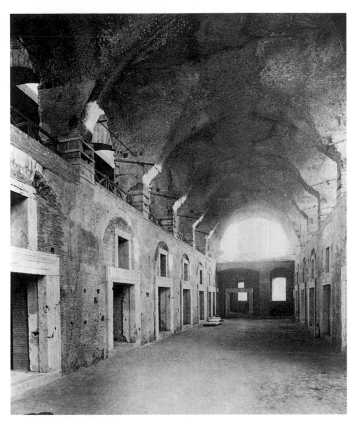

7-51 Interior of the great hall of Trajan's Markets.

in honor of Trajan (FIG. **7-52**) was built several years later at the point where the road entered Benevento (ancient Beneventum). Architecturally, the Arch of Trajan at Benevento is almost identical to Titus's arch on the Via Sacra in Rome (FIG. 7-43), but both facades of the Trajanic arch are covered with relief panels, giving it a billboard-like appearance. Every inch of the surface is now used to advertise the achievements of the emperor. In one panel he is seen entering Rome after a successful military campaign, in another he distributes largess to needy children, in still others he is portrayed as the founder of colonies for army veterans and as the builder of a new port at Ostia, Rome's harbor at the mouth of the Tiber. Trajan is the guarantor of peace and security in the empire, the benefactor of the poor, and the patron of soldiers and businessmen alike; in short, the emperor is "all things to all people." In several of the panels, Trajan freely intermingles with divinities and on the attic of the arch (which may have been completed after his death and deification) Jupiter proffers his thunderbolt to the emperor, awarding him dominion over the earth. Such scenes, in which the "first citizen" of Rome is depicted as a divinely sanctioned ruler in the company of the gods, will henceforth be the norm, not the exception, in the official pictorial propaganda of the Roman Empire.

One of Trajan's other benefactions to the Roman people was the restoration of the Circus Maximus, where the

The market hall housed two floors of shops, with the upper shops set back on each side and illuminated by skylights. Light was also provided from the same source to the ground-floor shops through arcuated openings beneath the great umbrella-like groin vaults covering the hall. *Groin vaults* are formed by the intersection at right angles of two barrel vaults of equal size (FIG. 7-4b). Besides being lighter in appearance than the barrel vault, the groin vault requires less *buttressing* (lateral support). In the barrel vault (FIG. 7-4a), the thrust is concentrated along the entire length of the supporting wall, which must be either thick enough to support the weight or reinforced by buttresses. In the groin vault, the thrust is concentrated along the groins, and buttressing is needed only at those points where the groins meet the vault's vertical supports, in this case the piers resting on the lower row of shops. The system leaves the covered area open and free of load-carrying members and permits light to enter the space beneath the groin vaults. When a continuous series of groin vaults covers an interior hall (FIG. 7-4c), as in Trajan's Markets, the open lateral arches of the vaults form the equivalent of a clerestory of a traditional timber-roofed structure, but they are relatively fireproof, always an important consideration given the fact that fires were common occurrences.

In A.D. 109 a new road, the Via Traiana, was opened in southern Italy, and to commemorate the event a great arch

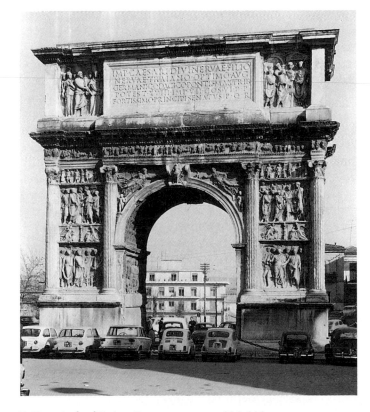

7-52 Arch of Trajan, Benevento, *c.* A.D. 114–118.

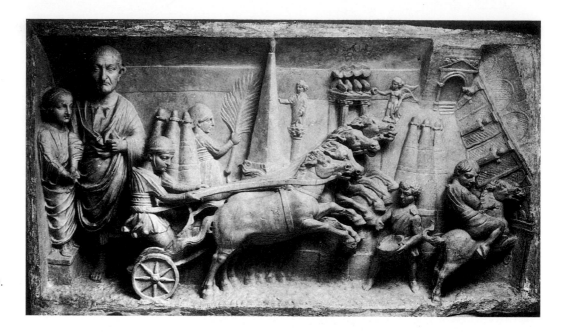

7-53 Funerary relief of a circus official, from Ostia, *c.* A.D. 110–130. Marble, approx. 20″ high. Vatican Museums, Rome.

world's best teams of horses competed in chariot races. We get a partial view (FIG. **7-53**) of the Circus Maximus as refurbished by Trajan on a relief that once decorated the tomb of a circus official. The relief is not a product of one of the emperor's official sculptural workshops and illustrates once again how different the art produced for freedmen and other members of Rome's huge working class was from that commissioned by the state and by wealthy citizens from old aristocratic families. Most of the relief is devoted to a chariot race in which the Circus Maximus is shown in distorted perspective. Only one team of horses races around the central island, but the charioteer is shown twice, once driving the horses, a second time holding the palm branch of victory after the race has been won. This is an example of *continuous narration*, that is, the same figure appearing more than one time in the same space at different stages in a story. This is not the first instance of continuous narration, but there are few earlier examples and it will only be much later that this manner of storytelling in pictures becomes common. (The appearance of the emperor in a series of different locales in the long spiral frieze of the Column of Trajan is not an example of continuous narration.) In fact, the charioteer may appear a third time within the same relief, for he may be the toga-clad official who appears, later in life, at the left end of the panel. There the recently deceased official is shown clasping hands with his wife—the handshake between man and woman is a traditional symbol of marriage in Roman art. She is of smaller stature (and of lesser importance than her husband in this context for it is *his* career in the circus that is being commemorated on *his* tomb), and she is shown standing on a base. The base indicates that the wife is not a living person but a statue. The handshake between man and statue is the plebeian artist's shorthand way of saying that the wife has

predeceased the husband, that their marriage bond was not broken by her death, and that, now that the husband has died, the two will be reunited in the afterlife. The rules of Classical design, which still guide the official artists of the Roman state, are ignored here, as in the funerary relief from Amiternum (FIG. 7-9), also made for a non-elite Roman patron. Before long, however, some of these non-Classical elements will appear in imperial art as well.

Hadrian (A.D. 117–138)

The most philhellenic of all the emperors of Rome was Hadrian, Trajan's chosen successor and fellow Spaniard. A connoisseur and lover of all the arts as well as an author and architect himself, Hadrian traveled widely as emperor, especially in the Greek East, and everywhere he went statues and arches were set up in his honor. More portraits of Hadrian are preserved today than of any other emperor except Augustus. Hadrian, who at the time of Trajan's death was 41 years old and who ruled for over two decades, is always depicted as a mature adult, but one who never ages in his portraits, as may be seen in the fragmentary bronze statue of the emperor wearing a cuirass (FIG. **7-54**) that was found in 1975 at Tel Shalem in Israel, several miles south of the ancient city of Scythopolis. The statue was probably erected toward the end of Hadrian's lifetime when a second Jewish revolt was put down and Judaea was reorganized as a new province called Syria Palaestina. Hadrian's portraits more closely resemble Kresilas's portrait of Pericles (FIG. 5-44) than those of any Roman emperor before him, and there is no doubt that his likenesses were inspired by Classical Greek statuary. The idealizing official portraits of Augustus were also inspired by fifth-century B.C. statues, but the prototypes for Augustus's portraits

were images of athletes; the models for Hadrian's artists were statues of mature Greek men. Hadrian himself wore a beard—a habit that, in its Roman context, must be viewed as a Greek affectation—and this would in turn become the norm for all subsequent Roman emperors for over a century and a half.

PANTHEON Immediately after Hadrian became emperor, work was begun on the Pantheon (FIGS. **7-55** to **7-57**), the temple of all the gods, one of the best preserved buildings of antiquity and one of the most influential designs in the history of architecture. In the Pantheon the full potential of concrete, both as a building material and as a means for the shaping of architectural space, is revealed. The temple was originally approached from a columnar courtyard and was situated at one narrow end of the enclosure, comparable to the siting of temples in Roman forums. Its facade with eight handsome Corinthian columns—almost all that could be seen from ground level in antiquity—is a bow to tradition,

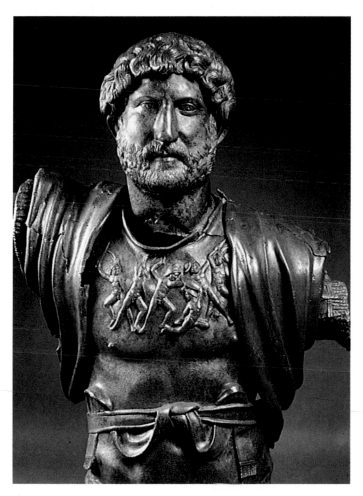

7-54 Portrait bust of Hadrian as general, from Tel Shalem, *c.* A.D. 130–138. Bronze, approx. 35" high. Israel Museum, Jerusalem.

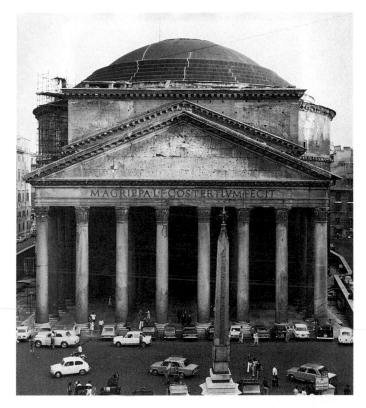

7-55 Pantheon, exterior view, Rome, A.D. 118–125.

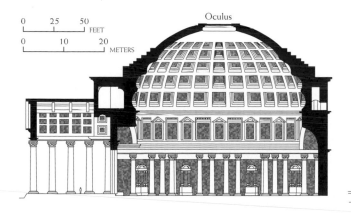

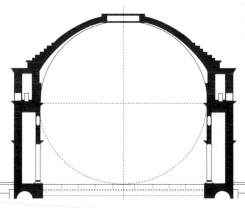

7-56 Longitudinal and lateral sections of the Pantheon.

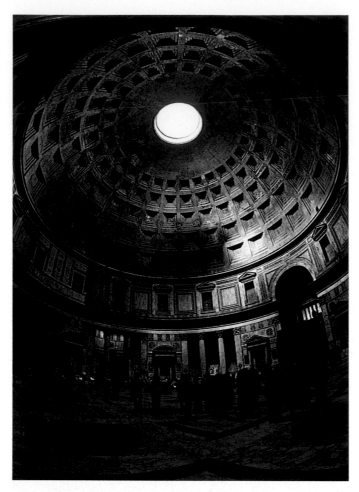

7-57 Interior of the Pantheon.

of squares within the vast circle. Renaissance drawings suggest that each coffer once had a glistening gilded-bronze rosette at its center, enhancing the symbolism of the dome as the starry heavens.

Below the dome much of the original marble veneer of the walls, niches, and floor has survived. In the Pantheon one can get a sense, as almost nowhere else, of how magnificent the interiors of Roman concrete buildings could be. But despite the luxurious skin of the Pantheon's interior, on first entering the structure one has a feeling not of the weight of the enclosing masses, but of the palpable presence of space itself. In pre-Roman architecture, the form of the enclosed space is determined by the placement of the solids, which do not so much shape as interrupt space. Roman architects were the first to conceive of architecture in terms of units of space that could be shaped by the enclosures. The interior of the Pantheon, in keeping with this interest, is a single, unified, self-sufficient whole, uninterrupted by supporting solids. It is a whole that encloses visitors without imprisoning them, a small cosmos that opens through the oculus to the drifting clouds, the blue sky, the sun, universal nature, and the gods. And it is a space in which light is used not just to illuminate the darkness but to create drama and underscore the symbolism of the interior shape. On a sunny day the light that passes through the oculus forms a circular beam on the coffered dome, a disk of light that moves across the dome in the course of the day as the sun moves across the sky itself. To escape from the noise and torrid heat of a Roman summer day into the sudden cool, calm, and mystical immensity of the Pantheon is an experience almost impossible to describe and one that should not be missed.

Although some have postulated that the architect of the Pantheon was none other than Hadrian himself, there is no basis for giving credit for the design to the amateur builder. Hadrian was, however, intimately involved with the construction of his own splendid private villa at Tivoli, where building activity seems never to have ceased until the emperor's death. One of the latest projects on the vast grounds of the suburban villa was the construction of a pool and an artificial grotto, called the *Canopus* and *Serapeum* (FIG. **7-58**) respectively, to commemorate the emperor's trip to Egypt, where he visited a famous temple of the god Serapis on a canal called the Canopus. Nonetheless, nothing about the design is inspired by Egyptian architecture. The grotto at the end of the pool is constructed of concrete and has an unusual pumpkin-shaped dome of a type that Hadrian is known to have designed himself. Yet in keeping with the persistent eclecticism of Roman art and architecture, the pool is lined with marble copies of famous Greek statues (as one might expect from a lover of Greek art), and at the curved end opposite the *Serapeum* is a Corinthian colonnade, but of a type unknown in Classical Greek architecture. Not only is there no superstructure, but the horizontal lintel of orthodox

but everything else about the Pantheon is revolutionary. Behind the columnar porch is an immense concrete cylinder covered by a huge hemispherical dome 142 feet in diameter. The summit of the dome is the same distance from the floor. The design is thus based on the intersection of two circles (one horizontal, the other vertical), so that the interior space may be imagined as the orb of the earth and the dome as the vault of the heavens.

If the design of the Pantheon is simplicity itself, executing that design took all the ingenuity of Hadrian's engineers. The cylindrical drum was built up level by level using concrete of varied composition; extremely hard and durable basalt was used in the mix in the foundations and the "recipe" was gradually modified until, at the summit, featherweight pumice was employed to lighten the load. The thickness of the dome also gradually decreases as it nears the central oculus, the circular opening 30 feet in diameter that is the only source of light for the interior. The weight of the dome was also lessened, without weakening its structure, by the use of *coffers* (sunken decorative panels), which further reduced the mass of the dome and also served the purpose of providing a handsome geometric foil

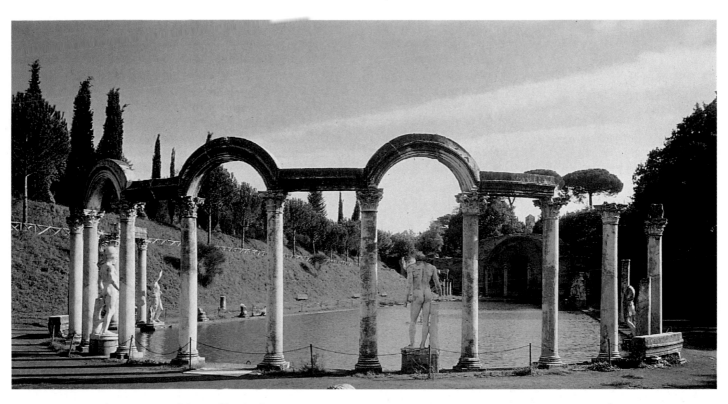

7-58 *Canopus* and *Serapeum*, Hadrian's Villa, Tivoli, *c.* A.D. 130–138.

designs has been arcuated between alternating pairs of columns. This kind of simultaneous respect for Greek architecture and willingness to break the rules of Greek design becomes increasingly characteristic of Roman architecture of the High and Late Empire.

An even more extreme example of what has been called Roman "baroque" architecture—the parallels with seventeenth-century Italian buildings are very striking—is to be found at Petra in modern Jordan where tomb facades were cut into the sheer rock faces of the local rose-colored mountains. One of the most elaborate of these is the second-century A.D. tomb nicknamed Al-Khazneh (the Treasury, FIG. **7-59**). As at Hadrian's villa, the elements of Classical architecture are employed here in a purely ornamental fashion and with a studied disregard for what had long been considered correct. The facade of the Treasury is over 130 feet high and consists of two stories. The lower story resembles a temple facade with six columns, but the columns are unevenly spaced and the pediment is only wide enough to cover the central four columns. On the upper level a temple-within-a-temple is set on top of the temple of the lower story. Here the facade columns and pediment have been split in half to make way for a central tholos-like cylinder, which contrasts sharply with the rectangles and triangles of the rest of the design. The rhythmic alternation of deep projection and indentation creates dynamic patterns of light and shade, an effect of restless oppositions of form. At Petra, as at Tivoli, the vocabulary of

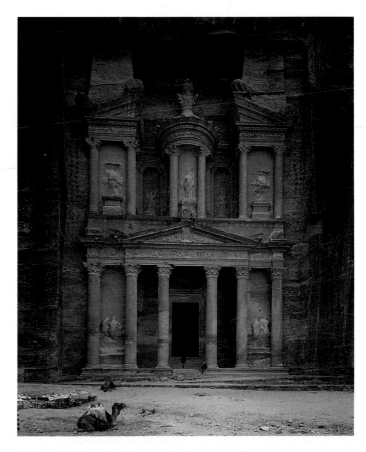

7-59 Al-Khazneh ("Treasury"), Petra, second century A.D.

7-60 Model of an insula, Ostia, second century A.D. Museo della Civiltà Romana, Rome.

Greek architecture is maintained, but the syntax is new and distinctively Roman. In fact, the design is reminiscent of some of the architectural fantasies painted on the walls of Roman houses—for example, the tholos seen through columns surmounted by a broken pediment in the Second Style cubiculum from Boscoreale (FIG. 7-19).

Ostia

The average Roman, of course, did not possess a luxurious country home and was not buried in a grand tomb with a columnar facade. In the capital, a population of close to one million had to be housed in multistory apartment blocks (*insulae*) built, after the great fire of A.D. 64, of brick-faced concrete. It is estimated that nearly ninety percent of those living in Rome were housed in such apartments. So too were most of the inhabitants of Ostia, Rome's harbor city, which, after the opening of its new port under Trajan, experienced a dramatic increase in prosperity—and population. A consequent burst of building activity began under Trajan and continued under Hadrian and throughout the second century A.D.

Many multistory second-century insulae have been preserved at Ostia (FIG. **7-60**). The ground floors were occupied by shops; above were up to four floors of apartments, accessible by individual staircases. Although many of the apartments were large, they had neither the space nor the light of the typical Pompeian private house (FIG. 7-15). In place of peristyles, the insulae of Ostia and Rome had only narrow lightwells or small courtyards. Consequently, instead of looking inward, large numbers of glass windows faced the noisy streets of the city. Only deluxe apartments had private toilets; others were served by community latrines on one or more floors. Still, the overall character of these insulae is similar to that of modern apartment houses, which also sometimes have shops on the ground floor that open onto the street. Brick facades, another strikingly modern feature of these multifamily residences, were not

concealed by stucco or marble veneers. When a Classical motif was desired, pilasters or engaged columns of brick could be added, but the brick was always left exposed. There are many examples at Ostia and Rome of apartment houses, warehouses, and tombs with intricate moldings and contrasting colors of bricks, and brick seems to have been appreciated as an esthetically attractive medium in its own right. An exposed-brick facade, with brick pilasters and brick pediments, was also chosen for the hemicycle of Trajan's Markets in Rome (FIG. 7-50).

The decoration of Ostian insulae tended to be more modest than that of the private houses of Pompeii, but the finer apartments had mosaic floors and mural and ceiling paintings. The painted groin vaults of Ostia are of special interest because few painted ceilings were preserved in the cities buried by the Vesuvian eruption, and they are rarely of the vaulted type. Room IV in the aptly named Insula of the Painted Vaults at Ostia (FIG. **7-61**) is typical of painted ceiling design of the second and third centuries A.D. The groin vault is treated as if it were a dome, with a central oculus-like red medallion surrounded by eight wedge-shaped segments resembling the spokes of a wheel. In each of the radiating segments is a white lunette with delicate paintings of birds and flowers, motifs also common earlier at Pompeii.

The most popular choice for elegant pavements at Ostia in both private and public edifices was the black-and-white mosaic. One of the largest and best preserved examples to come down to us is in the so-called Baths of Neptune. The bathing establishment takes its name from the grand mosaic floor in which the Roman god of the sea is pulled across the waves by four seahorses (FIG. **7-62**). Neptune needs no chariot to support him as he speeds along, his mantle billowing in the strong wind. All about the god are other denizens of the sea, variously positioned so that regardless of the direction from which one walks into the room some figures appear right side up. Roman black-and-white mosaics resemble Greek black-figure vase paintings

7-61 Ceiling and wall paintings in Room IV of the Insula of the Painted Vaults, Ostia, early third century A.D.

7-62 Neptune, floor mosaic in the Baths of Neptune, Ostia, c. A.D. 140.

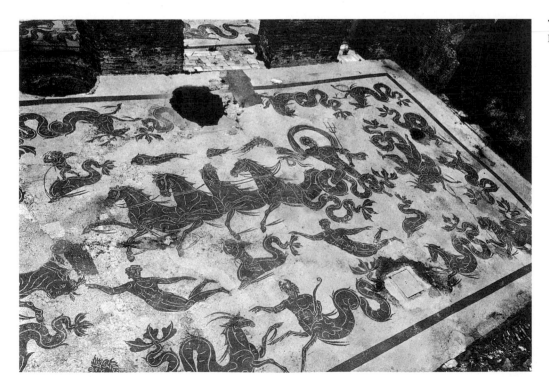

(although any connection between the two is unlikely) in their use of black silhouettes enlivened by interior lines of the same color as the background. Like Archaic paintings, the black-and-white mosaics are conceived as surface decorations and not as three-dimensional windows, and were especially appropriate for floors.

Ostian tombs of the second century A.D. were usually constructed of brick-faced concrete and the facades of these houses of the dead resembled those of the contemporary insulae of the living. These were generally communal tombs, not the final resting places of the very wealthy, and many of them were adorned with small painted terracotta plaques that immortalized the activities of the middle-class merchants and professional people who were interred within. Two of these plaques are illustrated here (FIG. **7-63**). One depicts a young man selling vegetables from behind a counter (which has been tilted forward so that we may see the produce clearly). The other shows a midwife delivering a baby. Because she looks out at the observer rather than at what she is doing, and because almost all these reliefs focus on the livelihoods of the deceased, it is likely that the relief commemorates the midwife rather than the mother. Scenes of working men and women such as these have counterparts in Roman funerary reliefs all over western Europe, and centuries later they may have provided the models for some medieval illustrations of the "labors of the months." They were as much, or more, a part of the legacy of classical antiquity to the later history of art as the monuments commissioned by Roman emperors, which until recently were the exclusive interest of art historians.

The Antonines (A.D. 138–192)

Early in A.D. 138, Hadrian adopted the 51-year-old Antoninus Pius as his son and simultaneously required that Antoninus adopt Marcus Aurelius and Lucius Verus, thereby assuring a peaceful succession for at least another generation. When Hadrian died later in the year, he was proclaimed a god, and Antoninus Pius became emperor; he ruled the Roman world with distinction for thirteen years. Upon the death and deification of Antoninus, Marcus Aurelius and Lucius Verus erected a memorial column in honor of their adoptive father. The pedestal of this column has a dedicatory inscription on one side, a relief illustrating the *apotheosis* (ascent to the heavens) of Antoninus and his wife Faustina on the opposite side (FIG. **7-64**), and two identical representations of the *decursio* (ritual circling of the imperial funerary pyre) on the adjacent sides (FIG. **7-65**).

The two figural compositions are of very different character. The apotheosis relief remains firmly in the Classical tradition with its elegant, well-proportioned figures, personifications, and single ground line corresponding to the lower edge of the panel. The Campus Martius (Field of Mars), personified as a youth holding the obelisk that stood in that area of Rome, reclines at the lower left corner of the

7-63 Funerary reliefs of a vegetable vendor *(above)* and a midwife *(below)*, from Ostia, second half of second century A.D. Painted terracotta, approx. 17" and 11" high respectively. Museo Ostiense, Ostia.

relief. Roma (Rome personified) leans on a shield emblazoned with the image of the she-wolf suckling Romulus and Remus and bids farewell to the couple being lifted into the realm of the gods on the wings of a personification of uncertain identity. All this is familiar from earlier scenes of apotheosis. New to the imperial repertoire, however, is the conflation of time that the joint apotheosis represents. Faustina had predeceased Antoninus Pius by twenty years. In depicting the two as ascending together, the imperial artist wished to suggest that Antoninus had been faithful to

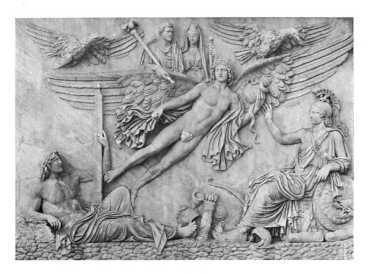

7-64 Apotheosis of Antoninus Pius and Faustina, pedestal of the Column of Antoninus Pius, Rome, *c.* A.D. 161. Marble, approx. 8' 1¹/₂" high. Vatican Museums, Rome.

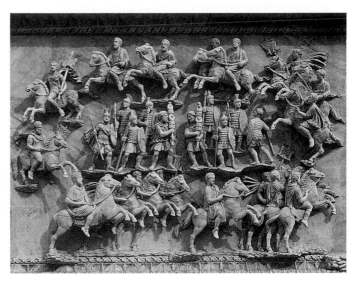

7-65 Decursio, pedestal of the Column of Antoninus Pius, Rome, *c.* A.D. 161. Marble, approx. 8' 1¹/₂" high. Vatican Museums, Rome.

his wife for two decades and that now they would be reunited in the afterlife. This is a conceit that had been employed before in the funerary reliefs commissioned by freedmen, for example that of the circus official discussed earlier (FIG. 7-53), but one that had never been used in an elite context.

The identical decursio reliefs break with Classical convention even more obviously. The figures are much stockier than those in the apotheosis composition and the panel is no longer conceived as a window onto the world. The ground is now the whole surface of the relief and marching soldiers and galloping horses alike are shown on floating patches of earth. This too is unparalleled in imperial art but has precursors in plebeian art, as on the first-century B.C. funerary relief from Amiternum (FIG. 7-9). After centuries of adhering to the rules of Classical design, the elite artists and patrons of Rome have finally become dissatisfied with the old manner—and in seeking a new direction they have adopted some of the non-Classical conventions of the art of Roman freedmen.

Another break with the past may be seen in the official portraits of Marcus Aurelius, although the pompous trappings of imperial iconography are retained. In the sixteenth century, Pope Paul III selected what many still consider to be the most magisterial portrait surviving from Roman antiquity—an over-life-size gilded-bronze equestrian statue of the emperor (FIG. **7-66**)—as the centerpiece for Michelangelo's new design for the Capitoline Hill in Rome (FIGS. 22-29 and 22-30). The statue would inspire many Renaissance sculptors to portray their patrons on horseback. Recently removed from its Renaissance site and painstakingly restored, the portrait owed its preservation throughout the Middle Ages (when most ancient bronze statues were melted down for their metal value, because they were regarded as impious images from the pagan,

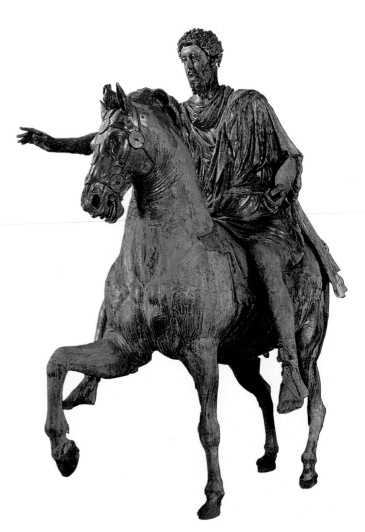

7-66 Equestrian statue of Marcus Aurelius, *c.* A.D. 175. Bronze, approx. 11' 6" high. Campidoglio, Rome.

demonic world of the Caesars) to the fact that it was mistakenly thought to portray Constantine, the first Christian emperor of Rome. Even today, after centuries of new finds, only a very few bronze equestrian statues are known. The type was, however, commonly used for imperial portraits—an equestrian statue of Trajan, for example, stood in the middle of his forum—and perhaps more than any other statuary type, the equestrian portrait expresses the majesty and authority of the Roman emperor.

In this portrait, Marcus possesses a superhuman grandeur and is much larger than any normal human would be in relation to his steed. He stretches out his right arm in a gesture much like a papal blessing. In the Roman context, it is both a greeting and an offer of clemency; some evidence suggests that, beneath the raised right foreleg of the horse, an enemy once cowered, appealing to the emperor for mercy. The statue conveys at once the awesome and universal significance of the godlike Roman emperor presiding over the whole world.

This message of supreme confidence is not, however, conveyed by the portrait head of Marcus Aurelius that sits atop the standard equestrian statuary type or by the late portraits of the emperor in marble, like the one illustrated in FIG. **7-67.** The latter is a detail of a panel from a lost arch that probably resembled Trajan's arch at Benevento (FIG. 7-52). The emperor is depicted riding in a triumphal

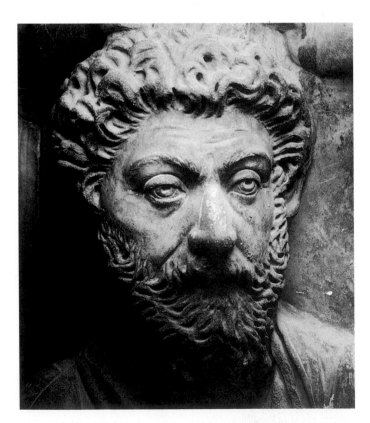

7-67 Portrait of Marcus Aurelius, detail of a relief from a lost arch, *c.* A.D. 175–180. Marble, approx. life size. Palazzo dei Conservatori, Rome.

chariot and, like Titus before him (FIG. 7-45), he is being crowned by Victory. The Antonine sculptor, in keeping with contemporary practice, has used a drill to render the long hair and beard of the emperor and even to accentuate the pupils of the eyes, creating bold patterns of light and shadow across the face. A chisel has been employed to record the lines in the forehead and the deep ridges that run from the nostrils to the corners of the mouth. Portraits of aged emperors are not a new phenomenon (compare the head of Vespasian, FIG. 7-41), but unprecedented is the portrayal of a Roman emperor—or any Western leader—as weary, saddened, and even worried. For the first time the strain of constant warfare on the frontiers and the burden of ruling a worldwide empire show in the face of the emperor. The Antonine sculptor has gone beyond mere Republican verism. The mind within the man, his character, his thoughts, his soul have now been exposed for all to see, as Marcus revealed them himself in his famous *Meditations*, a deeply moving philosophical treatise setting forth the emperor's personal world view. This is a major turning point in the history of ancient art and, coming as it does at the same time that the Classical style is being challenged in relief sculpture (FIG. 7-65), it marks the beginning of the end of the hegemony of Classical art in the Greco-Roman world.

Profound changes were also occurring in other aspects of Roman art and society at this time. Beginning under Trajan and Hadrian and especially during the rule of the Antonines, Romans began to favor inhumation over cremation, a reversal of burial practices that may reflect the influence of Christianity and other Eastern religions whose adherents believed in an afterlife for the human body. While Trajan, Hadrian, and the Antonine emperors themselves continued to be cremated in the traditional Roman manner, many private citizens opted for burial and required larger containers for their remains than the ash urns that were the norm until the second century A.D. This led in turn to a sudden demand for sarcophagi, which more closely resemble modern coffins than any other ancient type of burial container. One of the most popular subjects for the decoration of these sarcophagi was Greek mythology, and in many cases, especially in the late second and third centuries A.D., the Greek heroes and heroines were given the portrait features of the deceased Roman men and women laid to rest in the marble coffins, following the model of imperial portraiture, where emperors and empresses frequently masqueraded as gods and goddesses, heroes and heroines.

An early example of the type (although it lacks any portraits) is the sarcophagus illustrated in FIG. **7-68,** one of many decorated with the story of the tragic Greek hero Orestes. All the examples of this type utilize the same basic continuous-narrative composition in which Orestes appears several times: slaying his mother Clytaemnestra and her lover Aegisthus to revenge their murder of his father Agamemnon, taking refuge at Apollo's sanctuary at

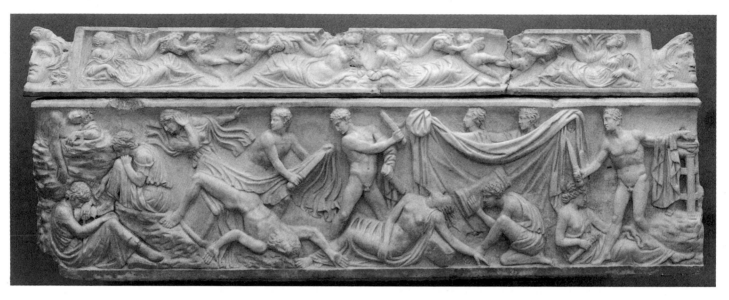

7-68 Sarcophagus with the myth of Orestes, *c.* A.D. 140–150. Marble, 2′ 7¹/₂″ high. Cleveland Museum of Art, Cleveland.

Delphi (symbolized by the god's tripod at the right), and so forth. The duplication of compositions indicates that the workshops that fashioned these sarcophagi had access to pattern books and, in fact, sarcophagus production was a veritable industry during the High and Late Empire. There were several important regional manufacturing centers. The sarcophagi produced in the Latin West, like the Cleveland Orestes sarcophagus, differ in format from those produced in the Greek-speaking East. Western sarcophagi are decorated on only the front and sides, because they were placed in floor-level niches inside Roman tombs.

Eastern sarcophagi are carved on all four sides and were set in the center of a burial chamber. This contrast exactly parallels the essential difference between the Etrusco-Roman temple and its Greek predecessor: the former was set against the wall of a forum or sanctuary and viewed primarily from the front, while the latter was accessible from every side.

An elaborate example of a sarcophagus of the Eastern type (FIG. **7-69**), with a portrait of a woman on the lid, was found at Melfi in southern Italy. It was manufactured, however, in Asia Minor and attests to the vibrant export market

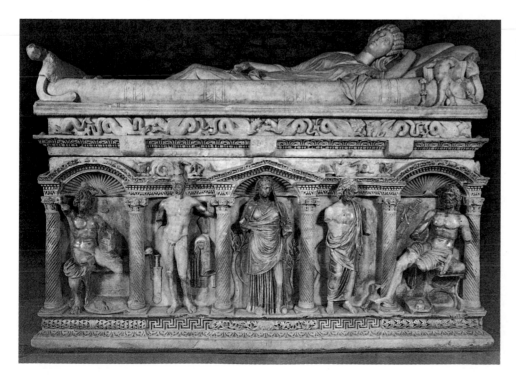

7-69 Asiatic sarcophagus, from Melfi, *c.* A.D. 165–170. Marble, approx. 5′ 7″ high. Cathedral, Melfi.

for such luxury items in Antonine times. The lid portrait, which carries on the tradition of Etruscan sarcophagi (FIGS. 6-5 and 6-17), is also a feature of the most expensive Western Roman coffins, but the decoration of all four sides of the marble box with statuesque images of Greek gods and heroes in architectural frames is distinctively Asiatic.

In Egypt, inhumation had been practiced for millennia and even after the Kingdom of the Nile was reduced to the status of a Roman province in 30 B.C., the tradition of burying the dead in mummy cases continued. In Roman times, however, the stylized portrait mask of Pharaonic Egypt was replaced by painted portraits of the deceased in encaustic or *tempera* (pigments in egg yolk) on wood. Hundreds of these painted mummy portraits have been preserved in the cemeteries of the Faiyum district of Egypt. One of these (FIG. **7-70**) portrays a man who, following the lead of Marcus Aurelius, has long curly hair and a full beard. These portraits, most of which date to the second and third centuries A.D., were probably painted while the subjects were still alive and permit us to study the evolution of portrait

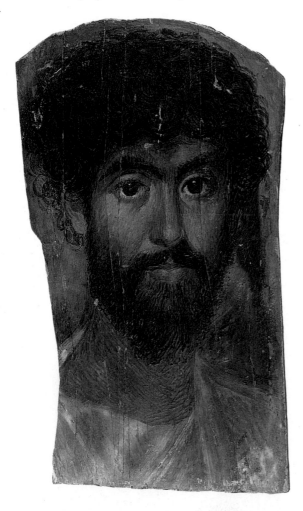

7-70　Mummy portrait of a man, from Faiyum, *c.* A.D. 160–170. Encaustic on wood, approx. 14″ high. Albright-Knox Art Gallery, Buffalo, Charles Clifton Fund.

painting after the eruption of Mount Vesuvius in A.D. 79 (compare FIG. 7-26). The Faiyum portrait shows the very highest level of craftsmanship: refined brushwork, soft and delicate modeling, and sensitive characterization of the calm demeanor of its thoughtful subject.

The Western and Eastern Roman sarcophagi and the mummy cases of Roman Egypt all served the same purpose, despite their differing shape and character. In an empire as vast as that of Rome, regional differences are to be expected. We shall see that geography also played a major role in the Middle Ages, where there is a sharp dichotomy between Western and Eastern Christian art.

THE LATE EMPIRE

By the time of Marcus Aurelius, two centuries after the establishment of the Pax Romana and the conferral by the Senate of the title Augustus on the victor at Actium, an erosion of Roman power was becoming increasingly evident. Order was more and more difficult to maintain on the frontiers, and imperial authority was even being questioned within the empire. Marcus's son Commodus, who succeeded his father in 180, was assassinated in 192, bringing the Antonine dynasty to an end. The economy was in decline, and the efficient imperial bureaucracy was gradually disintegrating. Even the official state religion was being challenged as Eastern cults, Christianity among them, began to enlist large numbers of converts. The story of the Late Empire is one of a civilization in transition, of a pivotal era in world history, when the pagan ancient world was gradually transformed into the Christian Middle Ages.

The Severans (A.D. 193–235)

Commodus's death was followed by civil conflict, with an African-born general named Septimius Severus emerging as master of the Roman world. The new emperor, anxious to establish his legitimacy, adopted himself into the Antonine dynasty, proclaiming himself as Marcus Aurelius's son. It is not too surprising, then, that the official portraits of Septimius Severus depict him with the full hair and beard of his Antonine "father"—whatever his actual appearance may have been. There are many surviving portraits in marble and bronze of the African emperor and of his wife, Julia Domna, the daughter of a Syrian priest, and their two sons, Caracalla and Geta, but there is only one painted portrait of the family. In fact, the portrait roundel (FIG. **7-71**), found in Egypt and painted in tempera on wood, as were many of the mummy portraits from Faiyum, is the only painted likeness we possess of any Roman emperor. Such portraits must, however, have been quite common in magistrates' offices all over the Roman empire; their perishable nature accounts for their almost total loss.

The Severan family portrait is of special interest for two reasons beyond its mere survival. The emperor's hair is tinged with gray, suggesting that his marble portraits—

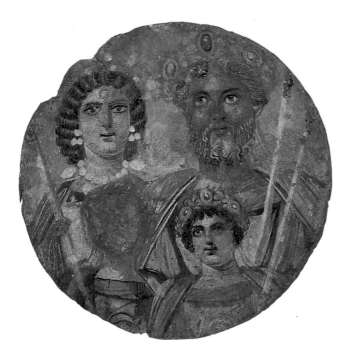

7-71 Painted portrait of Septimius Severus and his family, from Egypt, *c.* A.D. 200. Tempera on wood, approx. 14" diameter. Staatliche Museen, Berlin.

which, like all marble sculptures in antiquity, were painted—may also have revealed his advancing age. (The same was very likely true of the marble likenesses of the old and tired Marcus Aurelius.) The group portrait is also remarkable for the later erasure of the face of the emperor's younger son, Geta. When Caracalla succeeded his father as emperor, he had his brother murdered and his memory damned. The painted tondo from Egypt is an eloquent testimony to that *damnatio memoriae* and to the long arm of Roman authority.

The ruthless character of Caracalla (as emperor he also ordered the death of his wife; earlier he had convinced Septimius Severus to arrange the murder of his father-in-law) is captured in his portraits. Our marble head (FIG. **7-72**) is typical of all the emperor's official likenesses. The sculptor has suggested the texture of the short hair and close-cropped beard by incisions into the marble surface. Most remarkable, however, is the moving characterization of the emperor's suspicious psyche, a further development of the groundbreaking introspection of the portraits of Marcus Aurelius. Caracalla's brow is knotted and he abruptly turns his head over his left shoulder, as if he suspects that danger is approaching from behind. He had reason to be fearful: Caracalla was felled by an assassin's dagger in the sixth year of his rule. The manner of his death would soon become the norm for Roman emperors during the turbulent third century A.D.

The hometown of the Severans was Lepcis Magna, on the coast of what is now Libya, and in the late second and

early third centuries A.D. imperial funds were used to construct a modern harbor and to embellish the city with a new forum, basilica, arch, and other monuments. The arch, erected in 203, was located at the intersection of two major thoroughfares and had friezes on the attic on all four sides. One of these (FIG. **7-73**) shows the chariot procession of Septimius Severus and his two sons and invites comparison with the triumph panel from the Arch of Titus in Rome (FIG. 7-45). In the later relief there is no sense of rushing motion; rather there is a stately stillness. The chariot and the horsemen behind it are moving forward, but the emperor and his sons are detached from the procession and face us. Also different from the Arch of Titus panel is the way the figures in the second row have no connection with the ground and have been artificially elevated above the heads of those in the first row in order that they may be seen more clearly. Both the frontality and the floating figures are new to Roman state art in Antonine and Severan times, but both aspects of the composition have precedents in the private art of Roman freedmen (compare FIGS. 7-8

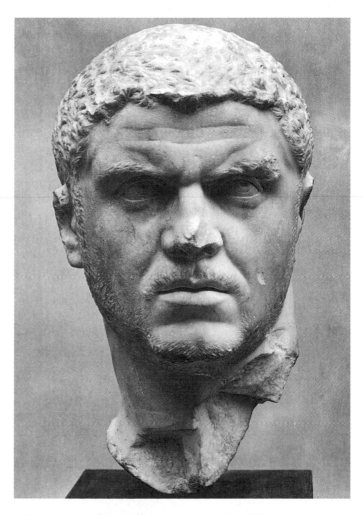

7-72 Portrait of Caracalla, *c.* A.D. 211–217. Marble, approx. 14" high. Metropolitan Museum of Art, New York.

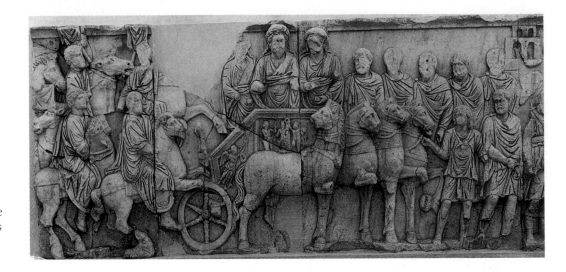

7-73 Chariot procession of Septimius Severus, relief from the Arch of Septimius Severus, Lepcis Magna, A.D. 203. Marble, approx. 5′ 6″ high. Museum, Tripoli.

and 7-9). Once embraced by sculptors in the employ of the emperor, these non-Classical elements had a long afterlife in the frontal iconic images of Christ and the saints in medieval art. As is often true in the history of art, periods of crisis, of social, political, and economic upheaval, are accompanied by the emergence of a new artistic esthetic.

BATHS OF CARACALLA The Severans were also active builders in the capital. The Baths of Caracalla in Rome (FIG. **7-74**) were the greatest in a long line of bathing and recreational complexes erected with imperial funds to win the favor of the public. Constructed in brick-faced concrete and covered by enormous barrel, groin, and domical vaults that sprang from thick walls up to 140 feet high, Caracalla's baths cover an area of almost 50 acres and dwarf in size the typical bathing establishment of cities and towns like Ostia and Pompeii and even Rome itself. The Baths of Caracalla

included landscaped gardens, lecture halls, libraries, palaestras, and a giant swimming pool (*natatio*), in addition to the baths proper. It is estimated that up to sixteen hundred bathers could be accommodated in this Roman equivalent of a modern health spa. Water was supplied by a branch of one of the city's major aqueducts, and central heating was provided by furnaces that circulated hot air through hollow floors and walls throughout the complex.

The design was symmetrical along a central axis facilitating the Roman custom of taking sequential plunges in cold-, warm-, and hot-water baths in, respectively, the *frigidarium*, *tepidarium*, and *caldarium*. In the Baths of Caracalla the caldarium was a circular chamber so large that today it easily seats hundreds of spectators at open-air performances of Italian operas; its dome was almost as large as that of the Pantheon (FIG. 7-57), and the concrete drum that supported it was much taller.

7-74 Plan of the central section of the Baths of Caracalla, Rome, A.D. 212–216. The bathing, swimming, and exercise areas were surrounded by landscaped gardens, lecture halls, and other rooms, all enclosed within a great concrete perimeter wall.

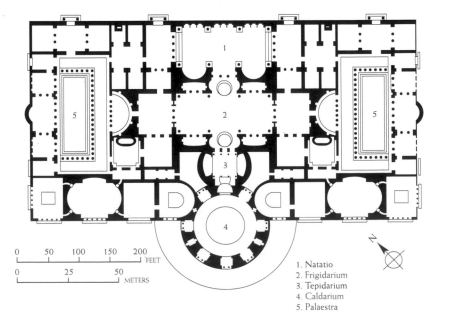

1. Natatio
2. Frigidarium
3. Tepidarium
4. Caldarium
5. Palaestra

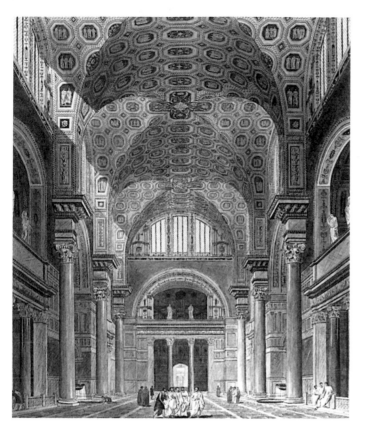

7-75 Reconstruction drawing of the central hall (frigidarium) of the Baths of Caracalla.

Our reconstruction of the great central hall (frigidarium) of the Baths of Caracalla (FIG. **7-75**) allows one to visualize not only the scale of the architecture and the way light entered the interior through fenestrated groin vaults, but also how lavishly decorated the rooms were. Stuccoed vaults, mosaic floors (both black-and-white and polychrome), marble-veneered walls, and colossal statuary were to be found throughout the complex. Although the vaults themselves collapsed long ago, many of the mosaics and statues are preserved, including the $10^{1}/_{2}$-foot-tall copy of Lysippos's Herakles (FIG. 5-75), whose muscular body may have inspired Romans of the third century A.D. to exercise vigorously.

The Soldier Emperors (A.D. 235–284)

The Severan dynasty came to an end when Severus Alexander was murdered in A.D. 235. The ensuing half century was a tumultuous one, with one general after another being declared emperor by his troops, only to be murdered by another general a few years or even a few months later. (In the year 238, two co-emperors chosen by the Senate were dragged from the imperial palace in Rome and summarily murdered in public after only three months in office.) In these unstable times, no emperor had the luxury of initiating ambitious architectural projects. In fact, the only significant building activity in Rome during the era of the "soldier emperors" took place under Aurelian (A.D. 270–275), who constructed a new defensive wall circuit for the capital—a military necessity and a poignant commentary on the decay of Roman power.

If architects went hungry in third-century Rome, there was much for sculptors and engravers to do. Coins were produced in great quantities (in debased metal) so that the troops could be paid with money stamped with the portrait of the current emperor and not with that of his predecessor or rival, and portrait statues and busts were set up everywhere to assert the authority of the new ruler.

The sculptured portraits of the third century A.D. are among the most moving ever produced—in antiquity or later. Following the lead of the sculptors of the portraits of Marcus Aurelius and Caracalla, the artists employed by the soldier emperors fashioned likenesses of their subjects that are as notable for their emotional content as they are for their technical virtuosity. Trajan Decius, for example, who ruled for only two years and is best known for his persecution of the Christians, is portrayed as an old man with bags under his eyes and a sad countenance (FIG. **7-76**). In his eyes, which glance away nervously rather than engage us

7-76 Portrait bust of Trajan Decius, A.D. 249–251. Marble, approx. 31″ high. Museo Capitolino, Rome.

directly, one can see the anxiety of a man who knows that he can do little if anything to restore order to an out-of-control world. The sculptor has modeled the marble as if it were pliant clay, compressing the sides of the head at the level of the eyes, etching the hair and beard into the stone, and chiseling the deep lines in the forehead and around the mouth. This is a portrait that reveals the anguished soul of the man—and of the times.

Decius's successor was Trebonianus Gallus, another short-lived emperor. We are fortunate in having an over-life-size bronze portrait of Trebonianus (FIG. **7-77**) in which he appears in heroic nudity, as had so many emperors and generals before him. His physique is not, however, that of

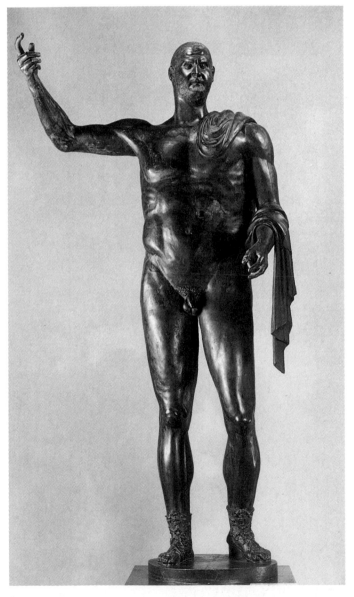

7-77 Heroic portrait of Trebonianus Gallus, from Rome, A.D. 251–253. Bronze, approx. 7′ 11″ high. Metropolitan Museum of Art, New York. Rogers Fund.

the strong but graceful Greek athletes who were so much admired by Augustus and his successors, but that of a wrestler with massive legs and a swollen trunk, whose head, with its nervous expression, is dwarfed by the heavy-set body. In this portrait, the Greek ideal of the keen mind in the harmoniously proportioned body has given way to an image of brute force, an image well suited to the era of the soldier emperors.

By the third century A.D. inhumation had become so widespread in the Roman world that even the imperial family was practicing burial in place of cremation, and sarcophagi were more popular than ever before. An unusually large sarcophagus discovered in Rome in 1621 (FIG. **7-78**) and purchased by Cardinal Ludovisi is decorated on the front with a chaotic scene of battle between Romans and one of their northern foes (probably the Goths), in which the writhing and highly emotive figures are spread evenly across the entire relief ground, with no illusion of space behind it. The piling up of figures on the *Ludovisi Battle Sarcophagus* constitutes an even more extreme rejection of Classical perspective than the use of floating ground lines for the circling figures of the decursio on the pedestal of the Column of Antoninus Pius (FIG. 7-65) and underscores the increasing dissatisfaction of Late Roman artists with the Classical style. From this dense mass of intertwined bodies, one figure stands out vividly. Several scholars have identified the central horseman as one of the sons of Trajan Decius. He is bareheaded and thrusts out his open right hand to demonstrate that he holds no weapon. In an age when the Roman army was far from invincible and Roman emperors were constantly being felled by other Romans, the young general on the sarcophagus is boasting (without foundation) that he is a fearless commander assured of victory. His self-assurance may stem from his having embraced one of the increasingly popular Oriental mystery religions: on the youth's forehead is carved the emblem of Mithras, the Persian god of light, truth, and victory over death, whose shrines are well attested at Rome and Ostia.

The insecurity of the times led many Romans to seek solace in philosophy, and on many third-century sarcophagi the deceased assumes the role of the learned intellectual, while others continued to masquerade as Greek heroes or Roman generals. One especially large example (FIG. **7-79**), once thought to portray the great philosopher Plotinus himself, depicts an enthroned Roman holding a scroll and flanked by two standing women (also with portrait features). In the background are other philosophers, students of the deceased teacher at the center of the relief. The philosopher sarcophagus would prove to be extremely popular for Christian burials, where the motif of the wise man is used not only to portray the deceased (FIG. 8-5) but also Christ flanked by his apostles (FIG. 8-6) and where frontal tripartite compositions like that on this sarcophagus and on the Severan arch at Lepcis Magna (FIG. 7-73) are quite common.

The decline in respect for the norms of Classical art also manifests itself in architecture. At Baalbek (ancient Heliopolis) in modern Lebanon, a Temple of Venus (FIG. **7-80**) erected in the third century A.D. ignores almost every tenet of orthodox design. Although constructed of stone, the building, with its circular domed cella set behind a gabled columnar facade, is in many ways a critique of the concrete Pantheon in Rome (FIG. 7-55), which had by now assumed the status of a "classic." The platform of the Baalbek temple is scalloped all around the cella. The columns—the only known instance of *five*-sided Corinthian capitals with corresponding pentagonal bases—also support a scalloped entablature (which served to buttress the shallow stone dome). These concave forms and those of the

7-78 Battle of Romans and barbarians (*Ludovisi Battle Sarcophagus*), from Rome, *c.* A.D. 250–260. Marble, approx. 5' high. Museo Nazionale Romano, Rome.

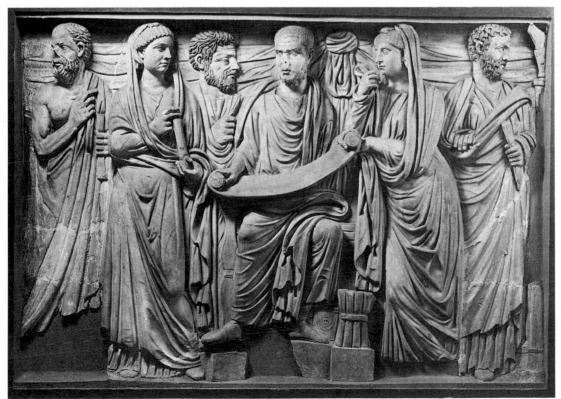

7-79 Sarcophagus of a philosopher, *c.* A.D. 270–280. Marble, approx. 4' 11" high. Vatican Museums, Rome.

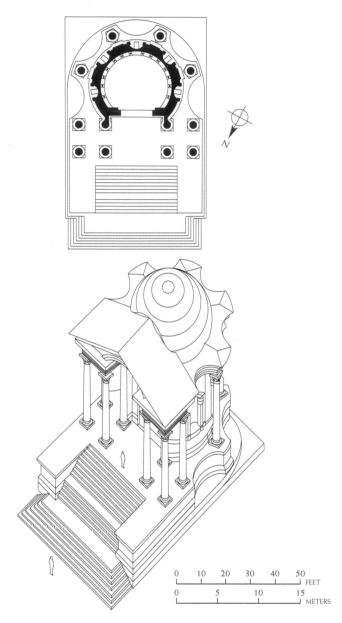

7-80 Plan and reconstruction drawing of the Temple of Venus at Baalbek, third century A.D.

and adopted the title of Augustus of the East. There was a corresponding Augustus of the West and two Caesars (whose allegiance to the two Augusti was cemented by marriage to their daughters). Together, the four emperors ruled without strife until Diocletian's retirement in 305. Without his dynamic leadership, the new tetrarchs soon began fighting among themselves and the tetrarchic form of government collapsed. The precedent for dividing the Roman Empire into eastern and western spheres survived, however, and established, a dichotomy that would persist throughout the Middle Ages and set the papacy of the Latin West apart from the Byzantine Empire of the East.

The four tetrarchs were often depicted together, both on coins and in the round, for the aim of the artists responsible for their official images was not to capture individual physiognomies and personalities but to represent the very nature of the tetrarchy itself—that is, to portray four equal partners in power. In the two pairs of porphyry (purple marble) portraits of the tetrarchs (FIG. **7-81**) that for centuries have been set into the corner of the facade of San

niches in the cella walls are played off against the convexity of the cella itself. Even the "traditional" facade of the Baalbek temple is treated eccentrically; the unknown architect has inserted an arch within the triangular pediment. Such baroque fantasies in stone will have an important afterlife in the architecture of seventeenth-century Italy.

Diocletian and the Tetrarchy
(A.D. 284–306)

In an attempt to restore order to the destabilized Roman Empire, Diocletian, who was proclaimed emperor by his troops in A.D. 284, decided to share power with his potential rivals. In 293, he established the *tetrarchy* (rule by four)

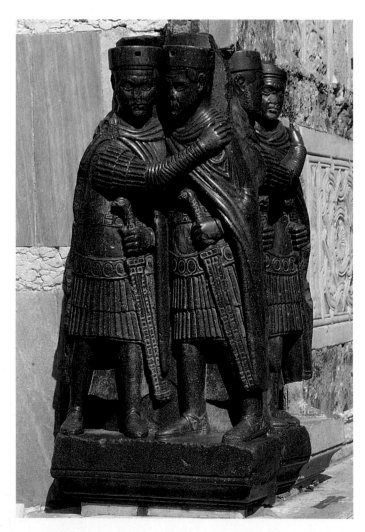

7-81 Portraits of the four tetrarchs, *c.* A.D. 305. Porphyry, approx. 4′ 3″ high. San Marco, Venice.

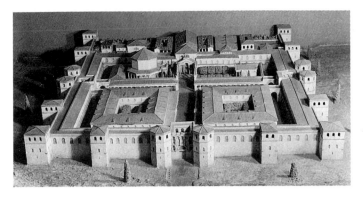

7-82 Model of the Palace of Diocletian, Split, *c.* A.D. 300–305. Museo della Civiltà Romana, Rome.

Marco in Venice, it is impossible to name the rulers. Each of the four emperors has lost all identity as an individual and has been subsumed into the larger entity that is the tetrarchy. All the tetrarchs are identically clad in cuirass and cloak; each grasps a sheathed sword in the left hand. With their right arms they embrace one another in an overt display of concord. The figures, like those on the decursio relief of the Column of Antoninus Pius (FIG. 7-65), have large cubical heads on squat bodies. The drapery is schematic and the bodies shapeless. The faces of the tetrarchs are emotionless masks, quadruplicate images as alike as freehand carving can achieve. In this group portrait, fashioned eight centuries after Greek sculptors first freed the human form from the formal rigidity of the Egyptian-inspired kouros stance, the human figure is once again conceived in iconic terms. Idealism and naturalism, individuality and personality, now belong to the past.

When Diocletian abdicated in 305, he returned to Dalmatia (roughly equivalent to the former Yugoslavia), where he was born, and to a palace (FIG. 7-82) he had built for himself on the Adriatic coast at Split near ancient Salona in Croatia. Just as Aurelian had felt it necessary to girdle Rome with fortress walls, Diocletian instructed his architects to provide him with a well-fortified suburban palace. The complex, which covers about 10 acres, was laid out like a Roman castrum, complete with watchtowers flanking the gates, and afforded the emperor a sense of security in the most insecure of times. Within the high walls, two main avenues (comparable to the cardo and decumanus in a provincial colony like Timgad, FIG. 7-46) intersected at the center of the palace. Where the forum of a city would have been situated, Diocletian's palace had a Temple of Jupiter, his mausoleum, and a peristyle court leading to the entrance to the imperial residence (FIG. 7-83). Like the Canopus (FIG. 7-58) of Hadrian's sprawling—and unfortified—villa at Tivoli, the colonnade supports an arcuated entablature, one of the many features of later Roman architecture that will be embraced by the architects of the Middle Ages. As in the Temple of Venus at Baalbek (FIG. 7-80), the columnar porch of the residential block has an arch within its pediment. The formal purpose of this motif was undoubtedly to emphasize the central axis of the design, but symbolically it became the "gable of glorification," under which Diocletian appeared before those who gathered in the peristyle court to pay homage to the emperor. To one side of the court and across from the temple of Jupiter stood Diocletian's mausoleum (left of center in FIG. 7-82), which towered above all other structures in the palace complex. The emperor's huge domed tomb was of a type that would prove to be very

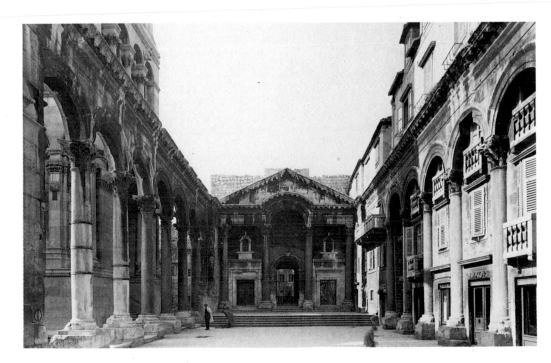

7-83 Peristyle court of the Palace of Diocletian.

popular in Early Christian times not only for mausolea but eventually also for churches, especially in the Byzantine East.

Those who, unlike the emperor, did not fear for their lives, could still live in unprotected residences, even in the early fourth century A.D. The luxurious villa at Piazza Armerina (FIG. **7-84**) in Sicily, which has yielded a treasure trove of mosaic pavements, was once thought to be the country seat of Maximian, Diocletian's Augustus of the West, but most scholars now believe its owner was a private wealthy landowner with ties to North Africa. The villa, whose rambling plan recalls that of Hadrian's villa at Tivoli, built in a more tranquil era, has no defensive walls and is the antithesis of Diocletian's fortress palace at Split with its rigid axiality and symmetry. The Sicilian villa displays, by contrast, an extraordinary array of round, elliptical, square, and rectangular forms in its horseshoe-shaped atrium, peristyle court, apsidal audience hall, tri-lobed triclinium, and poly-lobed bath complex, all arranged loosely along a variety of axes.

Like Hadrian's villa, which also had an adventurous architectural design, the Piazza Armerina villa was opulently decorated. Its 7,000 square feet of polychrome mosaics, probably the work of craftsmen from North Africa, provide a compendium of popular Roman themes: the hunt, chariot racing in the Circus Maximus, athletics, wild and domestic animals, Greek mythology, and so forth. Our illustration (FIG. **7-85**) reproduces the mosaic floor of the apse at the end of a long corridor between the peristyle and audience hall. The entire length of the corridor's floor was covered with scenes of the hunt, and the apse featured Africa personified, the source of the animals brought to

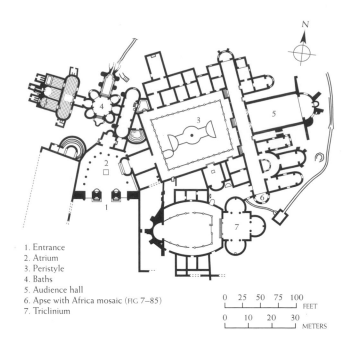

1. Entrance
2. Atrium
3. Peristyle
4. Baths
5. Audience hall
6. Apse with Africa mosaic (FIG 7–85)
7. Triclinium

7-84 Plan of the Roman villa at Piazza Armerina, early fourth century A.D.

Rome to entertain the populace in the Colosseum. Africa is a seated, semi-nude woman holding a huge elephant's tusk, flanked by a too-small elephant and a tiger, as well as by the mythical phoenix. Although the workmanship compares unfavorably with that of the Alexander mosaic from Pompeii (FIG. 5-79), the artist responsible for the villa floor is still working within the Classical tradition. The schematic landscape enhances the sense of depth, shading is used to

7-85 Africa, floor mosaic in the Roman villa at Piazza Armerina, early fourth century A.D.

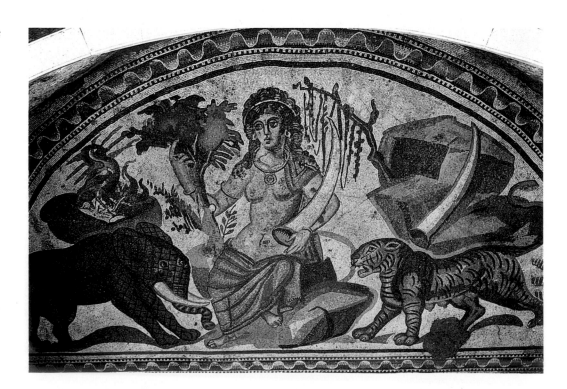

create volume, and shadows are included to remind us of the presence of light. The reaction against Classicism that we have noted in so much of the art of the late second, third, and early fourth centuries A.D. was not total, and for many artists—and patrons—Classical art was still the standard by which success was measured.

Constantine (A.D. 306–337)

The short-lived *concordia* among the tetrarchs that ceased with the abdication of Diocletian was followed by an all-too-familiar period of conflict that ended two decades later with the restoration of one-man rule. The eventual victor was Constantine the Great, son of Constantius Chlorus, Diocletian's Caesar of the West. After the death of his father, Constantine invaded Italy in A.D. 312 and defeated and killed his chief rival, Maxentius, at a battle at the Milvian Bridge at the gateway to Rome—a victory that Constantine attributed to the aid of the god of the Christians. In 313, he and Licinius, Constantine's co-emperor in the East, issued the Edict of Milan, ending the persecution of Christians. Constantine and Licinius eventually became foes, and in 324 Constantine defeated and executed Licinius near Byzantium (modern Istanbul, Turkey). Constantine was now unchallenged ruler of the whole Roman Empire, and shortly after the death of Licinius, Constantine founded a "New Rome" on the site of Byzantium and named it Constantinople (the city of Constantine). A year later, in 325, at the Council of Nicaea, Christianity became de facto the official Roman religion, and the decline of paganism began to accelerate. Constantinople was formally dedicated on May 11, 330, "by the commandment of God," and in succeeding decades Christian churches were constructed there in great numbers. Constantine himself was baptized on his deathbed in A.D. 337. For many scholars, the transfer of the seat of power from Rome to Constantinople and the establishment of Christianity as the official religion of the state mark the beginning of the Middle Ages.

Constantinian art is a mirror of this transition from the classical to the medieval world. In Rome, for example, Constantine was a builder in the grand tradition of the emperors of the first, second, and early third centuries A.D., erecting public baths, a basilica on the Sacred Way leading into the Roman Forum, and a great arch commemorating his success on the battlefield, but he was also the patron of the city's first churches, including St. Peter's (see Chapter 8).

ARCH OF CONSTANTINE Immediately after the Battle of the Milvian Bridge, Constantine erected a great triple-passageway arch (FIG. **7-86**) in the shadow of the Colosseum to commemorate his victory over Maxentius. The arch was the largest to be erected in the capital since

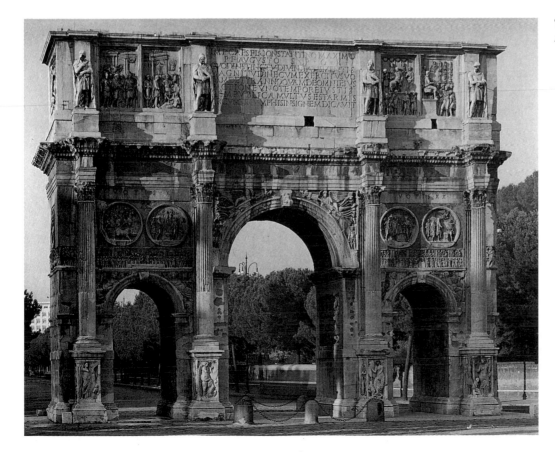

7-86 Arch of Constantine, Rome, A.D. 312–315.

7-87 Distribution of largess, detail of frieze of the Arch of Constantine, A.D. 312–315. Marble, approx. 3' 4" high.

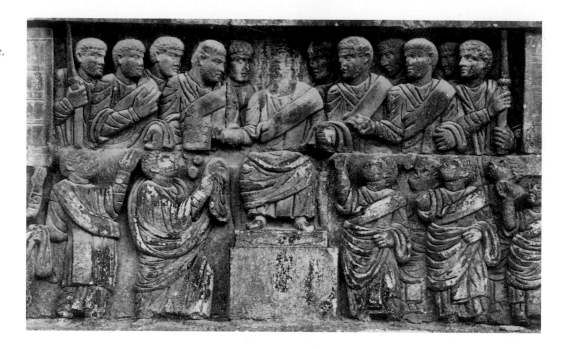

the end of the Severan dynasty nearly a century before, but the achievement is less impressive when it is revealed that much of the sculptural program of the arch was taken from earlier monuments of Trajan, Hadrian, and Marcus Aurelius, and that the columns and other architectural members also date to an earlier era. The second-century reliefs were, however, refashioned to honor Constantine by recutting the heads of the earlier emperors with the features of the new ruler and by adding labels to the old reliefs, such as *Fundator Quietus* (bringer of peace) and *Liberator Urbis* (liberator of the city), references to the beneficial consequences of the downfall of Maxentius. The reuse of second-century A.D. sculptures by the Constantinian artists has frequently been cited as evidence of a decline in creativity and technical skill in the waning years of the pagan Roman Empire. While such a judgment is in large part deserved, it ignores the fact that the reused sculptures were carefully selected in order to associate Constantine with the "good emperors" of the second century. That message is underscored in one of the Constantinian reliefs beneath the Hadrianic roundels situated above the lateral passageways of the arch, where Constantine is shown on the speaker's platform in the Roman Forum flanked by statues of Hadrian and Marcus Aurelius.

In one of the other Constantinian reliefs (FIG. **7-87**), the emperor is shown distributing largess to grateful citizens who approach him from right and left. Constantine is elevated above the recipients of his munificence, a frontal, enthroned, majestic presence. The figures are squat in proportion and reminiscent of the tetrarchs in Venice (FIG. 7-81). They do not move according to any Classical principle of naturalistic movement, but rather with the mechanical and repeated stances and gestures of puppets. The relief

is very shallow, the forms are no longer fully modeled, and the details are incised. The heads of those around the emperor are not distinguished from one another; the sculptor has given us a picture of a crowd, not a group of individuals. (Constantine's head, carved separately and set into the relief, is not preserved.) The presentation is not so much a historical narrative of action as the labeling of an event frozen into a tableau, so that the viewer can instantly distinguish the all-important imperial donor (at the center, on a throne) from his attendants (to the left and right above) and the recipients of the largess (below and of smaller stature). This approach to pictorial narrative was once characterized as a "decline of form," and when judged by the standards of Classical art, it undoubtedly is. But the rigid formality of the composition, determined by the hieratic roles of those portrayed, is consistent with a new set of values and would soon become the preferred mode, supplanting the Classical notion that a picture is a window onto a world of anecdotal action. One need only compare this Constantinian relief with a painted Byzantine icon of the sixth century A.D. (FIG. 9-15) to see that the new compositional principles are those of the Middle Ages and that they are different from but not necessarily "better" or "worse" than those of classical antiquity. The Arch of Constantine is the quintessential monument of its era, exhibiting a respect for the Classical past in the reuse of second-century sculptures while rejecting the norms of Classical design in its frieze, paving the way for the iconic art of the Middle Ages.

The official portraits of Constantine that postdate his victory over Maxentius break with tetrarchic tradition as well as with the style of the age of the soldier emperors and resuscitate the Augustan image of an eternally youthful head of state. The head illustrated in FIG. **7-88** is the most impressive by far of Constantine's preserved portraits. It is

$8^{1}/_{2}$ feet high, one of several marble fragments of a colossal 30-foot-tall enthroned statue of the emperor that was composed of a brick core, a wooden torso covered with bronze, and head and limbs of marble. The semi-nude seated portrait was modeled on Roman images of Jupiter. The emperor held an orb (possibly surmounted by the cross of Christ) in his extended left hand, the symbol of global power. The nervous glance of third-century portraits is absent, replaced by an uncompromisingly frontal mask with enormous eyes set into the broad and simple planes of the head. The personality of the emperor is lost in the immense image of eternal authority. It is his authority, not his personality or psychic state, that the sculptor displays. The colossal size, the likening of the emperor to Jupiter, the eyes directed at no person or thing of this world—all combine to produce the formula of overwhelming power appropriate to the exalted position of Constantine as absolute despot. To find an image of comparable grandeur and authority one must go back over fifteen hundred years to the colossal rock-cut portraits of the Egyptian pharaoh Ramses II (FIG. 3-26).

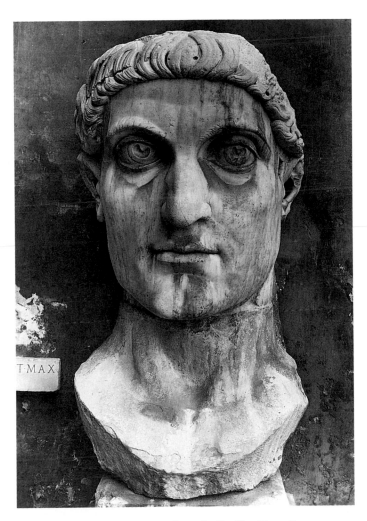

7-88 Portrait of Constantine, from the Basilica Nova, Rome, c. A.D. 315–330. Marble, approx. 8′ 6″ high. Palazzo dei Conservatori, Rome.

Constantine's colossal portrait was set up in the western apse of the Basilica Nova in Rome, the huge new basilica that Maxentius had begun on a site not far from the Arch of Titus and that Constantine completed after the death of his rival. From its position in the apse (FIG. 7-89) the iconic image of the emperor dominated the interior space of the basilica in much the same way that enthroned cult statues of Greco-Roman divinities looked down upon awestruck mortals who entered the cellas of pagan temples. Almost all that remains of the Basilica Nova are the three barrel-vaulted bays of the north aisle (FIG. 7-90), with brick-faced concrete walls 20 feet thick supporting the coffered vaults. The interior was richly marbled and stuccoed. The ruins, most impressive by virtue of their size and mass, represent only a small part of the original structure, which measured 300 feet long and 215 feet wide and had a groin-vaulted central nave 115 feet high. The groin vaults, which permitted light to enter the nave directly, were reinforced by buttresses where the groins join vertical supports. The buttresses channeled part of the pressure exerted by the weight of the vault across the aisles and into the outside walls. Remains of the springing of the central vault and of the buttresses can be seen in FIG. 7-90. The reconstruction (FIG. 7-89) is very effective in suggesting the immensity of the interior, in which not only those who came to the basilica to conduct business but even the colossal portrait of the emperor that presided over the nave are dwarfed by the great vaults. The drawing also shows the fenestration of the groin vaults, a lighting system akin to the clerestory of a traditional stone-and-timber basilica; the lessons learned in the design and construction of buildings like the great market hall of Trajan (FIG. 7-51) and the Baths of Caracalla (FIG. 7-75) have here been applied to the Roman basilica.

Although one could argue that the Basilica Nova represents the ideal solution to the problem of basilican design with its spacious, well-lit interior and economical, fire-resistant concrete frame, it proved to be the exception rather than the rule for basilica construction. The traditional basilican form exemplified by the basilica at Pompeii (FIG. 7-12) and Trajan's Basilica Ulpia in Rome (FIG. 7-48) remained the norm for centuries.

At Trier (ancient Augusta Treverorum) on the Moselle River in Germany, the imperial seat of Constantius Chlorus as Caesar of the West, Constantine built a new palace complex that included a basilica-like audience hall or Aula Palatina (FIGS. 7-91 and 7-92) of traditional form and materials. The Trier basilica measures about 190 feet long and 95 feet wide. The articulation of the building's austere brick exterior (FIG. 7-91), with boldly projecting vertical buttresses to create a pattern of alternating voids and solids, is characteristic of much later Roman—and Early Christian—architecture. The verticality of the building originally was lessened by horizontal timber galleries, which permitted the servicing of the windows. The brick wall was stuccoed in gray-white. The growing taste for large windows was due to the development and increasing use of lead-framed

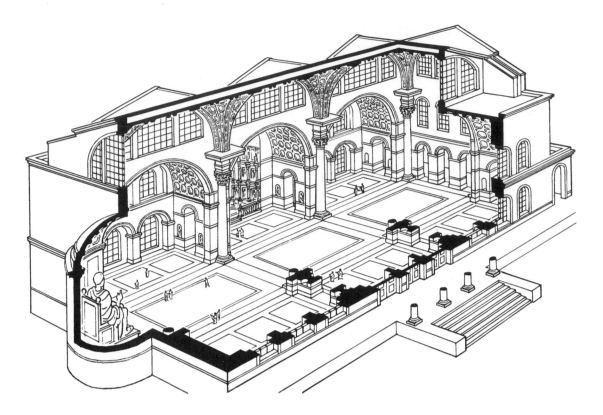

7-89 Reconstruction drawing of the Basilica Nova (Basilica of Constantine), Rome, *c.* A.D. 306–312.

panes of window glass, which offered late Roman builders the possibility of giving life and movement to blank exterior surfaces.

Inside (FIG. 7-92), the audience hall was also very simple. The flat, wooden, coffered ceiling is some 95 feet above the floor. There are no aisles, just a wide interior space with two stories of large windows that provided ample light. At the narrow north end, the main hall is divided from the semicircular apse (which also has a flat ceiling)

by a so-called triumphal arch. The interior of the Aula Palatina was quite severe, although the arch and apse originally were decorated with marble incrustation and mosaics to provide a magnificent environment for the enthroned emperor. The design of both the interior and exterior of the Constantinian audience hall at Trier is closely paralleled in many Early Christian basilicas (for example, FIG. 8-9), and the Aula Palatina itself was later converted into a Christian church.

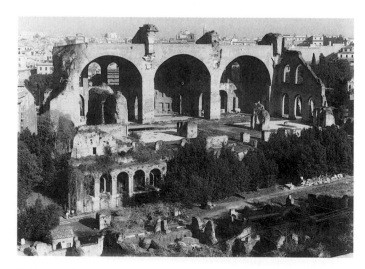

7-90 Basilica Nova, Rome.

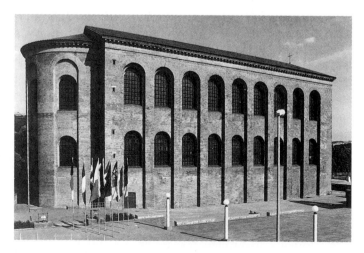

7-91 Aula Palatina (Basilica), Trier, early fourth century A.D. (exterior).

We close our survey of the art of ancient Rome with two portraits of Constantine stamped on Roman coins, two images that may serve to illuminate further both the essential character of Roman imperial portraiture and the special nature of Constantinian art. The first (FIG. **7-93,** left) was struck shortly after the death of Constantine's father, when Constantine was in his early twenties and his posi-

tion was still insecure. Here, in his official portrait, he appears considerably older, because he has adopted the imagery of the tetrarchs. Indeed, were it not for the accompanying label identifying this Caesar as Constantine, it would be impossible to know which of those struggling for power was represented.

Eight years later, after the defeat of Maxentius and the issuance of the Edict of Milan, Constantine's coin portrait (FIG. 7-93, right) has undergone a radical transformation. Clean shaven and looking his actual thirty years of age, the unchallenged Augustus of the West has rejected the mature tetrarchic "look" in favor of the image of eternal youth that would characterize all the emperor's portraits until his death over two decades later (compare FIG. 7-88). If the reader still harbors any doubts about the often fictive nature of imperial portraiture and the ability of Roman emperors to choose any official image that suits their needs, they should be dispelled by these two coins.

The later medallion is also an eloquent testimony to the dual nature of Constantinian rule. The emperor appears in his important role as imperator (general), dressed in armor, wearing an ornate helmet, and carrying a shield emblazoned with the enduring emblem of the Roman state—the she-wolf nursing the infants Romulus and Remus (compare FIG. 6-11). Yet he does not carry the scepter of the ruler of the pagan Roman Empire but rather a cross crowned by an orb, and at the crest of his helmet, at the front, just below the grand plume, is a disk containing the Christogram, the monogram made up of *chi* and *rho*, the initial letters of Christ's name in Greek (compare the shield held by one of the soldiers in FIG. 9-9). Constantine is at once Roman emperor and soldier in the army of the Lord. The coin, like Constantinian art in general, belongs both to the classical and to the medieval world.

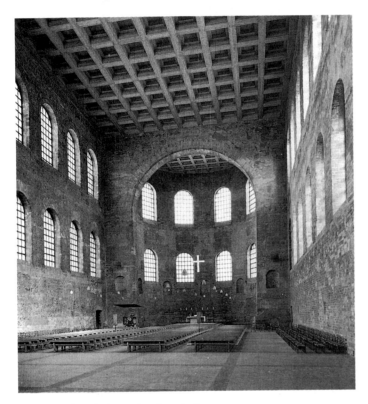

7-92 Aula Palatina, Trier (interior).

7-93 Coins with portraits of Constantine: nummus, A.D. 307. Billon, diameter, approx. 1". American Numismatic Society, New York (left); medallion, *c.* A.D. 315. Silver. Staatliche Münzsammlung, Munich (right).

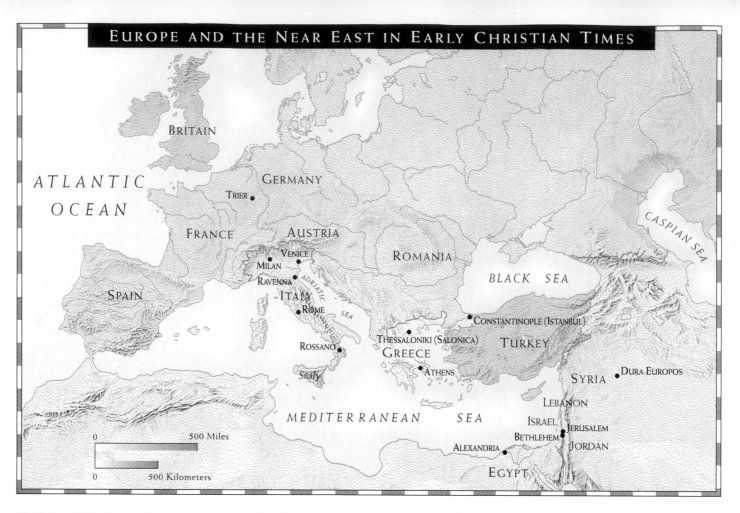

ATLANTIC OCEAN

BRITAIN

GERMANY

TRIER

FRANCE

AUSTRIA

VENICE

MILAN

RAVENNA

SPAIN

ITALY

ROME

ADRIATIC SEA

ROSSANO

Sicily

ROMANIA

BLACK SEA

CASPIAN SEA

CONSTANTINOPLE (ISTANBUL)

Thessaloniki (Salonica)

GREECE

TURKEY

ATHENS

SYRIA

DURA-EUROPOS

LEBANON

ISRAEL

JERUSALEM

BETHLEHEM

JORDAN

ALEXANDRIA

MEDITERRANEAN SEA

EGYPT

500 Miles

0

0 500 Kilometers

29	306
Pre-Constantinian	Constantinian

Santa Maria Antiqua
sarcophagus, c. 270

Catacomb of Sts. Peter
and Marcellinus, Rome
early 4th cent.

Crucifixion of Christ, 29

Persecution of the Christians under Trajan Decius, 249-251

Persecution of the Christians under Diocletian, 303-305

Constantine, r. 306-337

Edict of Milan, 313

Dedication of Constantinople, 330

CHAPTER 8

EARLY CHRISTIAN ART

POST-CONSTANTINIAN

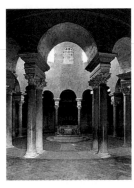

Santa Costanza
Rome, c. 337-351

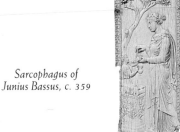

Sarcophagus of
Junius Bassus, c. 359

Panel from ivory diptych
of the Nicomachi and Symmachi
c. 380-400

Mausoleum of Galla Placidia
Ravenna, c. 425

Vienna Genesis, early 6th cent.

Theodosius I, r. 379-395
Christianity proclaimed state religion of Roman Empire, 380
Theodosius prohibits pagan worship, 391
Honorius, r. 395-423
Honorius moves capital to Ravenna, 404
Fall of Rome to Alaric, 410

Fall of Ravenna to Odoacer, 476
Theodoric at Ravenna, 493-526

The powerful religious crosscurrents of the world of late antiquity may be seen in microcosm in a distant outpost of the Roman Empire on a promontory overlooking the Euphrates River in Syria. Called Europos by the Greeks and Dura by the Romans, the town was probably founded shortly after the death of Alexander the Great by one of his successors. By the end of the second century B.C., Dura-Europos was in the hands of the Parthians. The city was captured by Trajan in 115* but reverted to Parthian control shortly thereafter. In 165, under Marcus Aurelius, the Romans retook Dura and placed a permanent garrison there. The siege and fall of Dura-Europos in 256 at the hands of Rome's new enemy in the East, the Sasanians, heirs to the Parthian Empire (see Chapter 2), is an important fixed point in the chronology of late antiquity because the population of the fortified town was evacuated and Dura's buildings were left largely intact. This "Pompeii of the desert" has revealed the remains of over a dozen different cult buildings, including many shrines of the polytheistic religions of the Classical and Near Eastern worlds, as well as places of worship for adherents of the monotheistic creeds of Judaism and Christianity— ... of which had the status of an approved religion in ... man state.

... synagogue at Dura-Europos (FIG. **8-1**) is remarkable ... ly for its very existence in a Roman garrison town ... lso for its extensive cycle of mural paintings depicting biblical themes. The building, originally a private house with a central courtyard, was converted into a synagogue during the latter part of the second century. The paintings seem to be in defiance of the Second Commandment prohibiting graven images and surprised scholars when they were first reported, but it is now apparent that while the Jews of the Roman Empire did not worship idols as did their pagan contemporaries, biblical stories not only were painted on the walls of synagogues like that at Dura-Europos but also were illustrated in painted manuscripts. God was never depicted in the synagogue paintings (or in the illustrated bibles), except as a hand emerging from the top of the framed panels. The style of the Dura murals is also instructive. Even when a narrative theme is illustrated, the compositions are devoid of action. The story is told through stylized gestures, and the figures, which have expressionless features and are lacking in both volume and shadow, tend to stand in frontal rows. These are traits that increasingly characterize the art of Rome during the third and fourth centuries; compare, for example, the friezes of the arches of Septimius Severus at Lepcis Magna (FIG. 7-73) and Constantine in Rome (FIG. 7-86). These features will dominate the art of the Byzantine Empire (Chapter 9).

The Christian community house at Dura-Europos (FIG. **8-2**) was also a remodeled private residence with a central courtyard. Its main hall (created by breaking down the partition between two rooms on the south side of the court) could accommodate no more than about seventy people at a time and had a raised platform at one end where the leader of the congregation sat or stood. Another room, on

*From this point on, all dates are A.D. unless otherwise indicated.

8-1 Interior of the synagogue at Dura-Europos with wall-paintings of biblical themes, 245–256. Tempera on plaster. National Museum, Damascus.

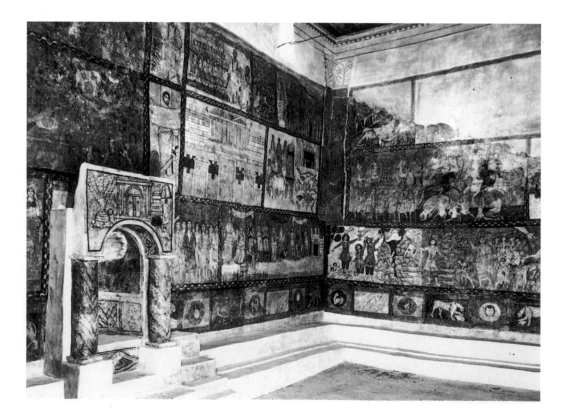

and that the death and resurrection of the god-man Christ made possible the salvation and redemption of all—but that they refused to pay even perfunctory homage to the official gods of the Roman state. As the appeal of Christianity grew, so too did the fear of destabilization of imperial authority. Persecution ended only when a Roman emperor, Constantine, after defeating Maxentius at the Milvian Bridge to Rome, came to believe that the Christian god was the source of his power rather than a threat to it. A year after that victory the Edict of Milan brought an end to the official mistreatment of Christians.

THE CATACOMBS AND FUNERARY ART

The most significant Christian monuments of the centuries preceding the Edict of Milan are the least conspicuous in Rome; they are entirely underground. The *catacombs* are vast subterranean networks of galleries and chambers in Rome and other cities that were designed as cemeteries for the burial of the Christian dead (and, to a much lesser extent, for the burial of Jews and others), many of them sainted martyrs. From the second through the fourth centuries, the catacombs were in constant use; as many as four million bodies may have been accommodated in the Roman catacombs alone. In times of persecution, the catacombs also could have served as places of concealment for fugitives; evidence of this function survives in blocked and cut-off staircases, secret *embrasures* (openings) and passages, and concealed entrances and exits. Undoubtedly, the Christian mysteries must have been enacted here, although the principal function of the catacombs was mortuary.

In Rome, the catacombs were tunneled out of a stratum of granular tufa, the convenient properties of which had been exploited earlier by the Etruscan necropolis builders (FIG. 6-6). After a plot of ground had been selected for the cemetery (Christians were not prevented by Roman law from owning property), a gallery, or passageway, 3 to 4 feet wide was dug around its perimeter at a convenient level below the surface. In the walls of these galleries, openings were cut to receive the bodies of the dead; these openings, called *loculi*, were placed one above another, like shelves, as in the Catacomb of Callixtus in Rome (FIG. **8-3**), which was hewn out of the Roman bedrock in the course of the second century. Often, small rooms, called cubicula (as in Roman houses of the living), were carved out of the rock to serve as mortuary chapels. Once the original perimeter galleries were full of loculi and cubicula, other galleries were cut at right angles to them; this process continued as long as lateral space permitted. Lower levels would then be dug and connected by staircases, some systems extending as deep as five levels. When adjacent burial areas belonged to members of the same Christian confraternity, or by gift or purchase fell into the same hands, communications were opened between the respective cemeteries so that

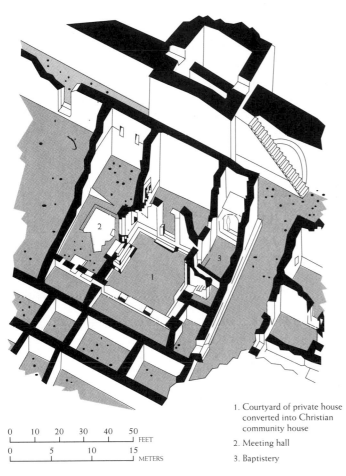

1. Courtyard of private house converted into Christian community house
2. Meeting hall
3. Baptistery

8-2 Reconstruction of the Christian community house at Dura-Europos, *c.* 240–256.

the opposite side of the courtyard, had a canopy-covered font installed for use in baptismal rites, the all-important ceremony in which a new convert was initiated into the Christian community. Upstairs there may have been a communal dining room for the celebration of the Eucharist, in which the faithful partook of the bread and wine that were symbolic of the body and blood of Christ.

Although there were mural paintings (poorly preserved) in the baptistery, the locus of Christian worship at Dura, as elsewhere in the Roman Empire, was thus an extraordinarily modest secondhand house, in striking contrast to the grand temples of Jupiter and the other Roman gods. Without the sanction of the state, Christian communities remained small in number and generally attracted the poorer classes of society, to whom the promise of an afterlife in which rich and poor were judged on equal terms was especially appealing. Nonetheless, Diocletian was so concerned by the growing popularity of Christianity in the ranks of the Roman army that he ordered a fresh round of persecutions in 303 to 305, a half century after the last great persecutions under Trajan Decius. What made the Christians so hateful to the Romans was not just their alien beliefs—that god had been incarnated in the body of a man

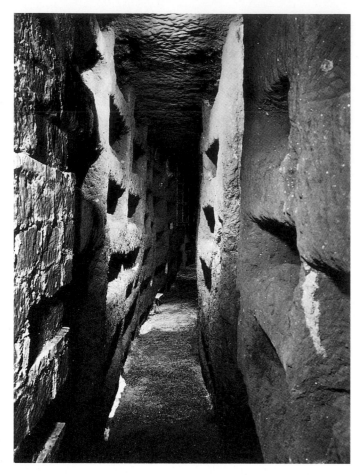

8-3 Gallery and loculi of the Catacomb of Callixtus, Rome, second century.

they spread laterally and gradually acquired a vast extent. After Christianity received official sanction, the catacombs fell into disuse except as holy places—monuments to the great martyrs—which were visited by the pious, who could worship in the churches that often were built directly above the catacombs.

Painting

Many cubicula were decorated with frescoes that were Roman in style but Christian in subject. The organization of the ceiling of a cubiculum in the Catacomb of Saints Peter and Marcellinus in Rome (FIG. **8-4**) is similar to the designs of vaulted ceilings in many Roman houses and tombs—for example, the century-earlier frescoed vault in the Insula of the Painted Vaults at Ostia (FIG. 7-61). In the catacomb, the polygonal frame of the Ostian spoked-wheel design has become a large circle, akin to the Dome of Heaven, within which has been inscribed the symbol of the Christian faith, the cross. The arms of the cross terminate in four lunettes, which also find parallels in the Ostian composition. Depicted in the lunettes are the key episodes from the Old Testament story of Jonah; he is thrown from his ship on the

left, emerges on the right from the "whale" (the Greek word is *ketos,* or sea-dragon, and the monstrous marine creature that swallows Jonah is represented as such), and, safe on land at the bottom, contemplates the miracle of his salvation and the mercy of God. Jonah, a popular figure in Early Christian painting and sculpture, especially in funerary contexts, was honored as a prefiguration of Christ, who rose from death as Jonah had been delivered from the belly of the ketos, also after three days. (Old Testament miracles prefiguring the resurrection of Christ abound in the catacombs and in Early Christian art in general.)

The compartments between the lunettes are occupied by a man, a woman, and at least one child, with their arms raised in the attitude of prayer, called *orans figures,* that together constitute a cross-section of the Christian family seeking a heavenly afterlife. The central medallion shows Christ as the Good Shepherd, whose powers of salvation are underscored by his juxtaposition with the story of Jonah. The motif can be traced back to Archaic Greek art (FIG. 5-10), but the pagan calf-bearer was shown offering his sheep in sacrifice to Athena. In Early Christian art, Christ is the youthful and loyal protector of the Christian flock, who said to his disciples, "I am the good shepherd; the good shepherd giveth his life for the sheep." Prior to Constantine, Christ was almost invariably represented either as the Good Shepherd or as a young teacher. Only after Christianity became the official state religion of the Roman Empire did Christ take on such imperial attributes as the halo, the purple robe, and the throne, which denoted rulership; eventually he would be depicted with the beard of a mature adult, which has been the canonical form for centuries, supplanting the youthful imagery of Early Christian art.

The style of the catacomb painters is most often a quick, sketchy impressionism that compares unfavorably with the best Roman frescoes. We must take into account that the catacombs were very unpromising places for the art of the mural decorator. The air was spoiled by decomposing corpses, the humidity was excessive, and the lighting (provided largely by oil lamps) was entirely unfit for elaborate compositions or painstaking execution. For designs on ceilings, arches, and lunettes, the painter was required to assume awkward and tiring poses, and it is therefore no wonder that the frescoes often were completed hastily and the results frequently were of mediocre quality.

Sculpture

All Christians rejected cremation, and the wealthier Christian faithful, like their pagan contemporaries, had their bodily remains deposited in impressive marble sarcophagi. A large number of these coffins have survived in the catacombs and elsewhere. As one would expect, the most common themes painted on the walls and vaults of the subterranean cemeteries of Rome are also the subjects favored on Early Christian sarcophagi. Often, the marble

coffins are decorated with a compendium of themes of Christian significance, just as on the painted ceiling in the Catacomb of Saints Peter and Marcellinus (FIG. 8-4). On the front of a sarcophagus (FIG. **8-5**) in the church of Santa Maria Antiqua in Rome, the left third is devoted to the story of Jonah. The center is given over to an orant and to a seated philosopher, the latter a motif borrowed directly from contemporary pagan sarcophagi (FIG. 7-79). The heads

of both the praying woman and the seated man reading from a scroll are unfinished. It was common for Roman workshops to produce sarcophagi before knowing who would purchase them; portraits were added only at the time of burial. The practice underscores the universal appeal of the themes chosen. At the right are two different representations of Christ—as the Good Shepherd and as receiving baptism in the Jordan River. The baptism scene was of

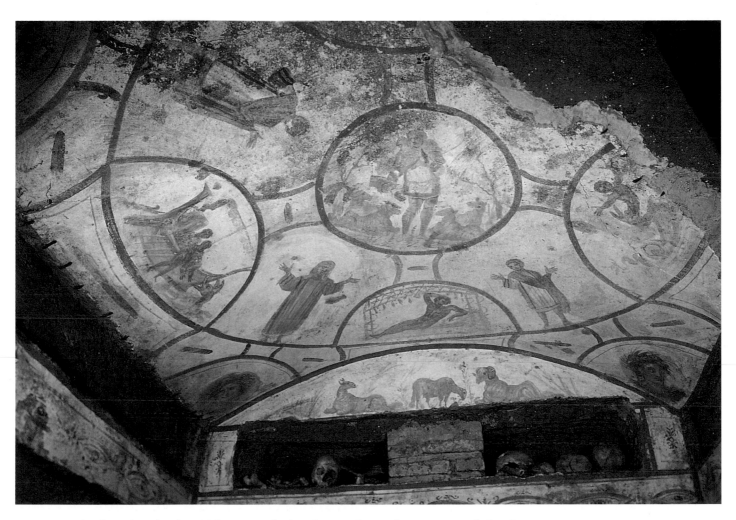

8-4 Painted ceiling of a cubiculum in the Catacomb of Sts. Peter and Marcellinus, Rome, early fourth century.

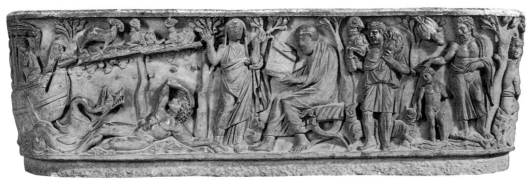

8-5 Sarcophagus with philosopher, orant, and Old and New Testament scenes, c. 270. Marble, 23^1/$_4$" × 86". Santa Maria Antiqua, Rome.

special significance in the early centuries of Christianity because so many adults were converted to the new faith in this manner.

One of those converts was the city prefect of Rome, Junius Bassus, who, according to the inscription on his sarcophagus (FIG. **8-6**), was baptized just before his death in 359. The sarcophagus, decorated only on the front in the western Roman manner, is divided into two registers of five compartments framed by columns, in the tradition of Asiatic sarcophagi (FIG. 7-69). In contrast to the Santa Maria Antiqua sarcophagus, the deceased here is not depicted on the body of the coffin; instead, the ten niches are devoted to stories from the Old and New Testaments. Pride of place is given to Christ himself, who is shown in the central compartment of each register: as a youthful teacher enthroned between Saints Peter and Paul (above), and triumphantly entering Jerusalem on a horselike donkey (below). Both compositions owe a great deal to Roman imperial iconography. In the upper zone, Christ, like an enthroned pagan emperor, sits above a personification of the sky god holding a billowing mantle over his head, indicating that Christ is ruler of the universe. The scene below closely follows the pattern of Roman emperors entering cities on horseback. Appropriately, the scene of Christ's heavenly triumph is situated above that of his earthly triumph.

The Old Testament scenes on the Junius Bassus sarcophagus were chosen for their significance in the early Church. Adam and Eve, for example, are in the second niche from the left on the lower level; it was their original

sin of eating the apple in the Garden of Eden that ultimately necessitated Christ's sacrifice for the salvation of humankind. At the upper left, Abraham is depicted about to sacrifice his son Isaac; the Christians believed that this Old Testament story prefigured the Lord's sacrifice of his own son, Jesus. The crucifixion itself is, however, rarely represented in Early Christian art, and no example is known prior to the fifth century. Christ's divinity and exemplary life as teacher and miracle worker, not his suffering and death at the hands of the Romans, were emphasized, although the latter are alluded to on this sarcophagus in the scene in the two compartments at the upper right depicting Christ being arrested and brought before Pontius Pilate for judgment and sentencing.

Apart from the reliefs on privately commissioned sarcophagi, monumental sculpture becomes increasingly rare in the fourth century and does not recover its place in the history of Western art until the twelfth century. As we shall see, Christian churches were not adorned with statues and reliefs, as were pagan temples. In his *Apologia*, Justin Martyr, a second-century ecclesiast mindful of the admonition of the Second Commandment to shun graven images, accused the pagans of worshiping statues as gods. The Christian tended to be suspicious of the freestanding statue, linking it with the false gods of the pagans, and there is no equivalent in Early Christian art of the pedimental statues and relief friezes of Greco-Roman temples.

The Greco-Roman experience, however, was still a living part of the Mediterranean mentality, and many Christians,

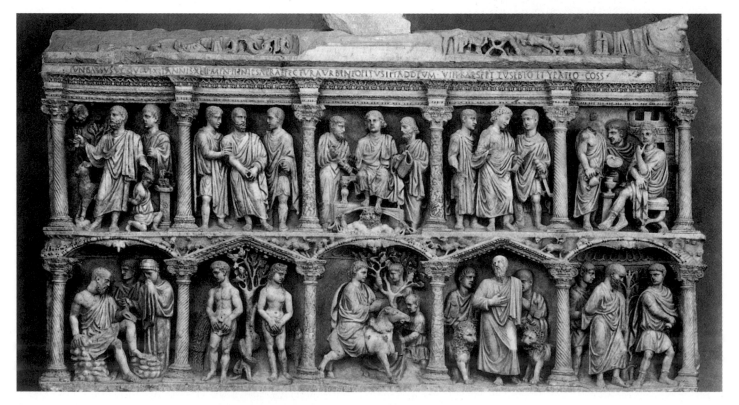

8-6 Sarcophagus of Junius Bassus, *c.* 359. Marble, 46¹/₂ × 96". Vatican Grottoes, Rome.

like Junius Bassus, were recent converts from paganism who retained some of their Classical values. This may account for those rare instances of Early Christian "idols," such as the marble statuette of Christ enthroned (FIG. **8-7**), contemporary with or somewhat later than, and a free-standing version of, the youthful Christ between Saints Peter and Paul on the Junius Bassus sarcophagus (FIG. 8-6). The piece is unique and, unfortunately, of unknown provenance, so we can only speculate about its original context and function. Several third- and fourth-century marble statuettes of Christ as the Good Shepherd and of Jonah also survive, but they are also exceptional. Although Constantine himself donated a set of life-size silver statues of Christ and his apostles to a church in Rome, in succeeding centuries the production of even small-scale marble statuettes ceased entirely.

8-7 Christ enthroned, *c.* 350–375. Marble, approx. 28¹/₂" high. Museo Nazionale Romano, Rome.

ARCHITECTURE AND MOSAICS

Although some Christian ceremonies were held in the catacombs, regular services took place in private community houses of the type we examined at Dura-Europos (FIG. 8-2). Once Christianity achieved imperial sanction under Constantine, an urgent need suddenly arose to set up buildings that would meet the requirements of the Christian liturgy and provide a suitably monumental setting for the celebration of the Christian faith, as well as accommodate the rapidly growing numbers of worshipers. Constantine was convinced that the God of the Christians had guided him to victory over Maxentius, and in life-long gratitude, he protected and advanced Christianity throughout the empire as well as in the obstinately pagan capital city of Rome. As emperor, he was, of course, obliged to safeguard the ancient Roman religion, traditions, and monuments, and, as we noted in Chapter 7, he was (for his time) a builder on a grand scale in the heart of the city. But eager to provide buildings to house the rituals of the Christians, their venerated burial places, and especially the memorials of their founding saints, Constantine discreetly drew upon his own imperial patrimony to endow an extraordinary architectural enterprise, constructing elaborate basilicas, memorials, and mausoleums not only in Rome but at other sites sacred to Christianity, most notably Bethlehem, the birthplace of Jesus, and Jerusalem, the site of his crucifixion.

Rome

Constantine's dual role as both Roman emperor and champion of the Christian faith is reflected in his decisions to locate the new churches of Rome on the outskirts of the city, so as to avoid any confrontation of Christian and pagan ideologies. The greatest of Constantine's churches in Rome was Old St. Peter's (FIG. **8-8**), probably begun as early as 319. The Constantinian structure was eventually replaced by the grand present-day church (FIG. 24-3) that is one of the masterpieces of Italian Renaissance and Baroque architecture. Old St. Peter's was built on the western side of the Tiber River in the center of what would become Vatican City and on the spot where it was believed that Peter, the first apostle, had been buried. Excavations beneath the later building have revealed the second-century memorial set up to honor the early Christian martyr at his reputed grave in a Roman cemetery. In the fourth century, Constantine and Pope Sylvester both were convinced that this was the veritable burial place of the Prince of the Apostles; thus, the great church, capable of housing three to four thousand worshipers at one time, was raised, at immense cost, upon a terrace over the ancient cemetery on the irregular slope of the Vatican Hill to enshrine one of the most hallowed sites in Christendom, second only to the Holy Sepulchre in Jerusalem, the site of Christ's resurrection. The project also fulfilled the figurative words of Christ himself, when he

1. Nave 4. Transept
2. Aisles 5. Narthex
3. Apse 6. Atrium

8-8 Restored view (*top*), plan
(*center*), and section (*bottom*) of Old
St. Peter's, Rome, begun *c.* 320.
(The restoration of the forecourt is
conjectural.)

said, "Thou art Peter, and upon this rock (in Greek, *petra*) I will build my church" (Matthew 16:18). Peter was the founder of the Christian community in Rome. As its first bishop, he was also the head of the long line of popes that extends to our own day.

The plan and elevation of Old St. Peter's resemble those of Roman basilicas and audience halls, such as the Basilica Ulpia in the Forum of Trajan (FIG. 7-47) and the Aula Palatina at Trier (FIGS. 7-91 and 7-92), rather than the design of any Greco-Roman temple. The Christians, understandably, did not want their houses of worship to mimic the form of pagan shrines, but practical considerations also contributed to their shunning the pagan temple type. The Greco-Roman temple was designed to house only the cult statue of the deity; the rituals were conducted outside at open-air altars. The Greco-Roman temple, therefore, could have been adapted only with great difficulty as a building destined to accommodate large numbers of people within it. The Roman basilica, on the other hand, was ideally suited as a place of congregation and was eagerly embraced by Early Christian architects. Like Roman basilicas, Old St. Peter's had a wide central nave (300 feet long), which was flanked by aisles and ended in an apse. It was preceded by an open colonnaded courtyard, very much like the forum proper in the Forum of Trajan, but called an atrium, like the central room in a private house. The basilica was entered through a *narthex*, or vestibule, and, upon emerging in the nave, worshipers had an unobstructed view of the altar in the apse, framed by the so-called triumphal arch dividing the nave from the area around the altar. A special feature of the Constantinian church was the transverse aisle, or *transept*, which housed the memoria of the saint

that the hordes of pilgrims came to see; this feature would become a standard element of church design in the West only much later, when it also took on the symbolism of the Christian cross.

Unlike pagan temples, but comparable to most Roman basilicas and audience halls, Old St. Peter's was not adorned with lavish exterior sculptures, and its brick walls were as austere as those of the Aula Palatina at Trier (FIG. 7-91). Inside, however, were frescoes and mosaics, marble columns (taken from pagan buildings, as was customary at the time), grandiose chandeliers, gold and silver vessels on jeweled altar cloths for use in the Mass, and a huge marble *baldacchino* (canopy) supported by spiral columns that marked the spot of St. Peter's tomb beneath the crossing of the nave and the transept. The Early Christian basilica may be likened to the ideal Christian, with a somber and plain exterior and a glowing and beautiful soul within.

Some idea of the character of the timber-roofed, five-aisled interior of Old St. Peter's may be gleaned by comparing the restored section (FIG. 8-8) with the photograph of the interior of Santa Sabina in Rome (FIG. **8-9**), a basilican church of much more modest proportions built a century later, but one that still retains its Early Christian character. The purloined Corinthian columns of Santa Sabina's nave produce a steady rhythm that focuses all attention upon the apse, which frames the altar and contains seats for the clergy. (In a pagan basilica, this is where the enthroned statue of the emperor was displayed, as in the Basilica Nova in Rome, FIG. 7-89. The seat of episcopal authority thus supplanted the secular throne in a pagan basilica. The word *cathedral* is derived from the Latin *cathedra*, the bishop's chair.) In Santa Sabina, as in Old St. Peter's, the nave is

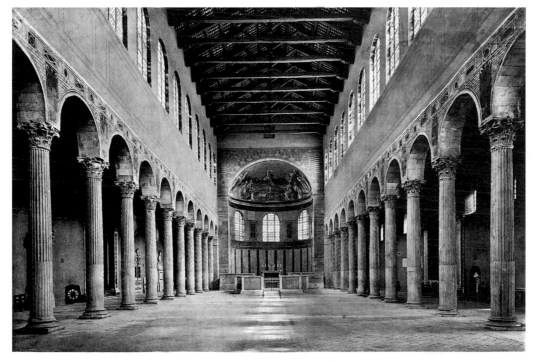

8-9 Interior of Santa Sabina, Rome, 422–432.

drenched with light from the clerestory windows piercing the thin upper wall beneath the timber roof, light that would have illuminated the frescoes and mosaics that commonly adorned the nave, triumphal arch, and apse of Early Christian churches. Outside, Santa Sabina's brick walls approximate quite closely the exterior of Trier's Aula Palatina (FIG. 7-91).

The rectangular, basilican church design was long the favorite of the Western Christian world, but Early Christian architects also adopted another Classical architectural type: the *central plan* building—a round or polygonal domed structure that later was favored in the East. Byzantine architects developed this form to monumental proportions and amplified its theme in numerous ingenious variations. In the West, the central-plan building was used generally for structures adjacent to the main basilicas, like mausoleums, baptisteries, and private chapels, rather than for actual churches, as in the East.

A highly refined example of the central-plan design is Santa Costanza in Rome (FIGS. **8-10** and **8-11**), built in the mid-fourth century as the mausoleum of Constantia, the emperor Constantine's daughter, whose monumental porphyry sarcophagus (now in the Vatican Museums) was exhibited inside it. The mausoleum, later converted into a

church, was built adjacent to the basilican church of St. Agnes, whose tomb was in a nearby catacomb. Santa Costanza has antecedents that can be traced back to the beehive tombs of the Mycenaeans (FIGS. 4-22 and 4-23), but its immediate predecessors are the domed structures of the Romans, like the Pantheon (FIG. 7-57), and especially imperial mausolea like that of Diocletian in his palace at Split (FIG. 7-82). At Santa Costanza, the interior design of the pagan Roman buildings has been modified to accommodate an *ambulatory,* a barrel-vaulted corridor that is separated from the central domed cylinder by a ring of a dozen pairs of columns. (Twelve is the number of Christ's apostles and twelve pairs of columns were also a feature of Constantine's centrally planned Church of the Holy Sepulchre in Jerusalem.) It is as if the nave of the Early Christian basilica with its clerestory wall has been bent around a circle, the ambulatory corresponding to the basilican aisles.

Like contemporary basilicas, Santa Costanza has a severe brick exterior and an interior adorned with mosaics. Most

8-10　Interior of Santa Costanza, Rome, *c.* 337–351.

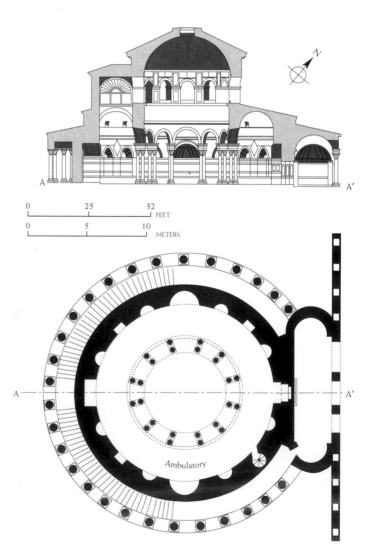

8-11　Section *(top)* and plan *(bottom)* of Santa Costanza.

of these are lost, but we know that Old and New Testament themes appeared side by side, as in the catacombs and on Early Christian sarcophagi. In Santa Costanza there was also an abundance of pagan imagery, appropriate for the tomb of an emperor's daughter. In our detail of the ambulatory vault (FIG. **8-12**), a portrait bust of Constantia is placed amid a rich vine scroll inhabited by putti and birds; scenes of putti harvesting grapes and producing wine, echoing the decoration of Constantia's sarcophagus, surround the portrait.

The surviving mosaics of Santa Costanza, despite their pagan themes, are a reminder of how important a role mosaic decoration played in the interiors of Early Christian buildings. When, under Constantine, Christianity suddenly became a public and official religion in Rome, not only were new buildings required to house the faithful, but wholesale programs of decoration for the churches also became necessary. To advertise the new faith in all its diverse aspects—its dogma, scriptural narrative, and symbolism—and to instruct and edify the believer, acres of walls in dozens of new churches had to be filled in the style and medium that would carry the message most effectively.

Brilliant ornamental mosaics, with sparkling tesserae of reflective glass, rather than the opaque, marble tesserae preferred by the Romans, almost immediately became the standard vehicle of expression. Mosaics were particularly suited to the flat, thin-walled surfaces of the new basilicas, becoming a durable, tangible part of the wall—a kind of architectural tapestry. The light flooding through the clerestories was caught in vibrant reflection by the mosaics, producing abrupt effects and contrasts and sharp concentrations of color that could focus attention on the central, most relevant features of a composition. Mosaic, worked in the Early Christian manner, is not intended for the subtle changes of tone that a naturalistic painter's approach would require, although (as we have seen in Roman examples) tonality is well within the mosaicist's reach. But in mosaic, color is *placed*, not blended; bright, hard, glittering texture, set within a rigorously simplified pattern, becomes the rule. For mosaics situated high on the wall, far above the observer's head, the painstaking use of tiny tesserae, seen in Roman floor mosaics, became meaningless. Early Christian mosaics, designed to be seen from a distance, employed larger stones; the surfaces were left uneven, so that the projecting edges of the tesserae could catch and reflect the light, and the designs were kept simple, for optimal legibility. For several centuries, mosaic, in the service of Christian theology, was the medium of some of the supreme masterpieces of medieval art.

Content and style find their medium; the content of Christian doctrine took centuries to fashion, and, for a long time, even the proper manner of representing the founder of Christianity was in question. Once Christianity became the official religion of the Roman state, Jesus' status changed. In early works, as already noted, he is shown as teacher and philosopher; in later works, he is imperialized as the ruler of heaven and earth. In the fourth and fifth

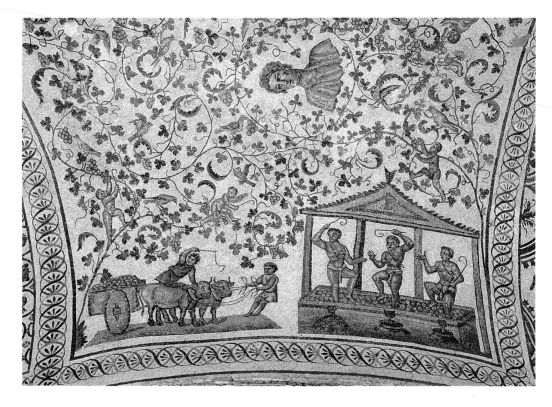

8-12 Detail of vault mosaic in the ambulatory of Santa Costanza.

centuries, artists were hesitant about how to represent Jesus, and variant types of images were produced. After some crucial theological questions on Jesus' nature were resolved, a more or less standard formula for his depiction emerged.

In the minds of simple Christians only recently converted, Jesus easily could have been identified with the familiar deities of the Mediterranean world, especially Sol Invictus (in Greek, Helios), the Invincible Sun. The late third-century vault mosaic (FIG. **8-13**) of a small Christian mausoleum, not far from St. Peter's tomb in the Roman cemetery beneath Old St. Peter's, shows Christ as Sol Invictus, with a rayed halo, driving the horses of the sun chariot through the heavens and holding an orb in his left hand—a conception far more grandiose than that of the Good Shepherd, which, interestingly, is the subject of another mosaic in the same tomb, as is the story of Jonah.

The style, or styles, of Christian art emerged as a transmutation of Greco-Roman art; for the mosaicists, the point of departure was Roman illusionism. We can see this readily in the apse mosaic of the church of Santa Pudenziana in

8-13 Christ as Sol Invictus, detail of a vault mosaic from the Mausoleum of the Julii, Rome, late third century.

Rome (FIG. **8-14**), securely datable to the early fifth century, which is the earliest surviving example in a succession of monumental apse mosaics that extend throughout the history of Christian art. Although the mosaic was drastically restored in the nineteenth century (almost the entire right half was damaged), enough remains to show the persistence of Roman forms and the assimilation of Roman imperial attributes to the image of Christ. On an emperor's throne, Christ, clad in imperial purple and gold and now bearded and haloed in contrast to fourth-century versions of the same motif (FIGS. 8-6 and 8-7), sits within the Heavenly Jerusalem and presides over the Church Triumphant. He is flanked on either side by his apostles, deployed like a Roman emperor's entourage of senators (compare FIG. 7-87). Behind them, on either side of the throne, stand two women, the personifications of the Church of the Gentiles (New Testament), on the left crowning Saint Paul, and the Church of the Synagogue (Old Testament), on the right crowning Saint Peter. Above and behind the head of Christ is a representation of the jeweled cross that Constantine raised on the site of Christ's crucifixion. Within the gold-streaked blue sky hover the four symbolic creatures of the visions of Ezekiel and the Book of Revelation, representing the Four Evangelists: the Angel of Matthew, the Lion of Mark, the Ox of Luke, and the Eagle of John. (This is an early appearance of these symbols, which we will find commonly represented throughout medieval art.) The background recalls the kind of perspective illusionism and naturalistic depiction of architectural forms found in Pompeian wall paintings, and the buildings may reflect, to some degree, those actually in Jerusalem at the time the mosaic was installed.

We also can note the union of the old naturalism and the new symbolism in the great mosaic cycle in Santa Maria Maggiore, a quarter century later in date than the Santa Pudenziana apse mosaic. The panel representing the parting of Lot and Abraham (FIG. **8-15**) tells its story (Genesis 13:5–13) succinctly. Agreeing to disagree, Lot leads his family and followers to the right, toward the city of Sodom, while Abraham moves toward a building (perhaps symbolizing the Church?) on the left. Lot's is the evil choice, and the instrumentalities of the evil (his two daughters) are depicted in front of him; the figure of the yet unborn Isaac, the instrument of good (and, as we have seen, a prefiguration of Christ), stands before his father, Abraham. The cleavage of the two groups is emphatic, and each group is represented by a shorthand device that could be called a "head cluster," which has precedents in antiquity and will have a long history in Christian art. The figures turn from each other in a kind of sharp dialogue of glance and gesture, and we recognize a moving away from the flexibility of naturalism toward the significant gesture and that primary method of medieval representation, *pantomime*, which simplifies all meaning into body attitude and gesture. The wide eyes, turned in their sockets; the broad gestures of enlarged hands; the opposed movements of the groups all remind us

of some silent, expressive chorus that comments only by gesture on the action of the drama. Thus, the complex action of Roman art stiffens into the art of simplified motion, which has great power to communicate without ambiguity and which, in the whole course of medieval art, will produce the richest kind of variety.

The fact that the figures of the panel have been moved to the foreground and that the artist takes no great pains to

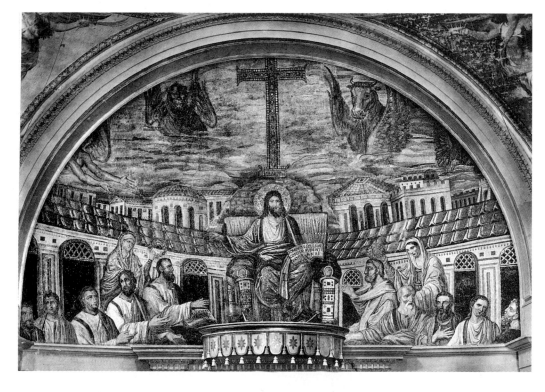

8-14 Christ enthroned and the apostles in the Heavenly Jerusalem, apse mosaic in Santa Pudenziana, Rome, 410–417.

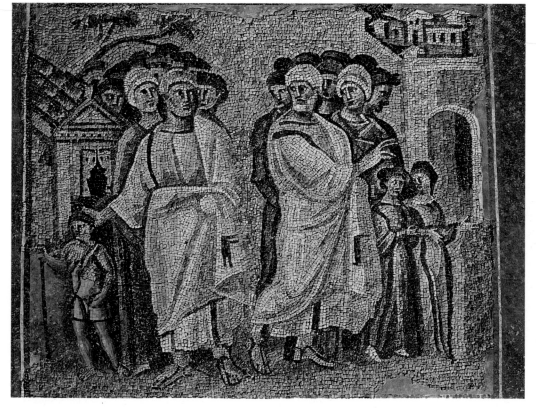

8-15 The parting of Lot and Abraham, mosaic in the nave of Santa Maria Maggiore, Rome, 432–440.

describe either space or landscape setting also foreshadows the character of later Christian art; the background town and building are symbolic, rather than descriptive. But within this relatively abstract setting, the figures themselves loom with massive solidity. They cast shadows and are modeled in dark and light to give them the three-dimensional appearance that testifies to the artist's heritage of Roman pictorial illusionism. Another century will be required before Christian artists in the West will be able to think of figures entirely as flat images, rather than as plastic bodies.

Ravenna

In the decades following the foundation of Constantinople in 330 and the death of Constantine in 337, the pace of Christianization of the Roman Empire quickened. In 380 the emperor Theodosius I issued an edict finally establishing Christianity as the state religion. In 391 he enacted a ban against pagan worship. In 394 the Olympic Games, the enduring symbol of the classical world and its values, were abolished. Theodosius died in 395 and imperial power passed to his two sons, Arcadius, who became Emperor of the East, and Honorius, Emperor of the West. The problems that plagued the last pagan emperors, most notably the threat of invasion from the north did not, however, disappear with the conversion to Christianity. In 404, when the Visigoths, under their king, Alaric, threatened to overrun Italy, Honorius moved the capital of his crumbling empire from Milan to Ravenna, an ancient Roman city (perhaps founded by the Etruscans) near Italy's Adriatic coast, some 80 miles south of Venice. There, in a city surrounded by swamps and thus easily defended, his imperial authority

survived the fall of Rome to Alaric in 410. Honorius died in 423, and the reins of government were taken by his half sister, Galla Placidia, who had been captured by the Visigoths in Rome in 410 and had married a Visigothic chieftain before returning to Ravenna and the Romans after the chieftain's death six years later. In 476 Ravenna fell to Odoacer, the first German king of Italy, who was overthrown in turn by Theodoric, king of the Goths, who established his Ostrogothic captial at Ravenna in 493. The subsequent history of the city belongs with that of the Byzantine Empire (see Chapter 9).

The so-called Mausoleum of Galla Placidia in Ravenna (FIGS. **8-16** and **8-17**) is a rather small, cruciform structure with a dome-covered crossing and barrel-vaulted arms. Built shortly after 425, almost a quarter century before Galla Placidia's death in 450, it was dedicated to Saint Lawrence and was also designed to house the sarcophagi of Honorius and Galla Placidia. It thus served the double function of imperial mausoleum and martyr's chapel and was originally attached to the narthex of the now greatly altered palace-church of Santa Croce (Holy Cross), which was also cruciform in plan. Although the mausoleum's plan is that of a Latin cross, the cross arms are very short and appear to be little more than apsidal extensions of a square. All emphasis is placed on the tall, dome-covered crossing,

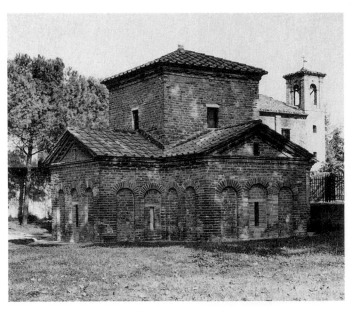

8-16 Mausoleum of Galla Placidia, Ravenna, *c.* 425.

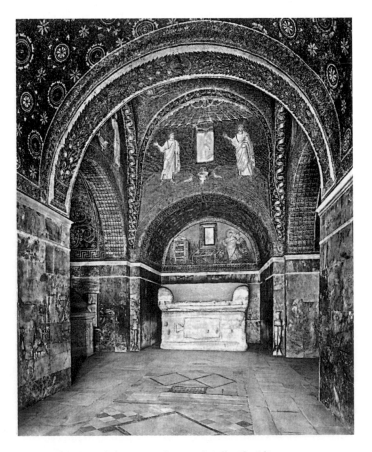

8-17 Interior of the Mausoleum of Galla Placidia.

and thus, the building becomes, in effect, a central-plan structure. On the other hand, this small, unassuming building also represents one of the earliest successful fusions of the two basic early church plans, the *longitudinal* (basilican) and the central, and it introduces us, on a small scale, to a building type that would have a long history in Christian architecture—the basilican plan with a domed crossing.

The mausoleum's plain, unadorned, brick shell encloses one of the richest mosaic ensembles in Early Christian art. Every square inch of the interior surfaces above the marble-faced walls is covered with mosaic decor: the barrel vaults of the nave and cross arms, with garlands and decorative medallions reminiscent of snowflakes on a dark blue ground; the dome, with a large, golden cross set against a star-studded sky; other surfaces, with representations of saints and apostles; and the lunette above the entrance, with a representation of Christ as the Good Shepherd (FIG. **8-18**). We have seen earlier versions of the Good Shepherd, but none so regal as this. Jesus no longer carries a lamb on his shoulders but is seated among his flock, haloed and robed in gold and purple. To his left and right, the sheep are distributed evenly in groups of three.

But their arrangement is rather loose and informal, and they have been placed in a carefully described landscape that extends from foreground to background and is covered by a blue sky. All forms are tonally rendered; they have three-dimensional bulk, cast shadows, and are disposed in depth. In short, the panel is replete with devices of Roman illusionism; its creator was still deeply rooted in the classical tradition. Some fifty years later, this artist's successors in Ravenna would work in a much more abstract and formal manner.

Around 504, soon after Theodoric settled in Ravenna, he ordered the construction of his own palace-church, a three-aisled basilica dedicated to the Savior. In the ninth century, the relics of Saint Apollinaris were transferred to this church, which was rededicated and has been known since that time as Sant'Apollinare Nuovo. The rich mosaic decorations of the interior nave walls (FIG. **8-19**) are arranged in three zones, of which the upper two date from the time of Theodoric. Old Testament patriarchs and prophets are represented between the clerestory windows; above them, scenes from the life of Christ alternate with decorative panels.

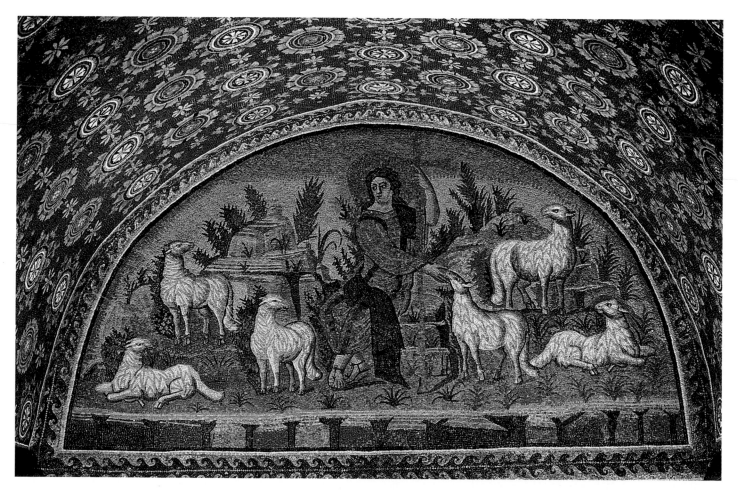

8-18 Christ as the Good Shepherd, mosaic from the entrance wall of the Mausoleum of Galla Placidia.

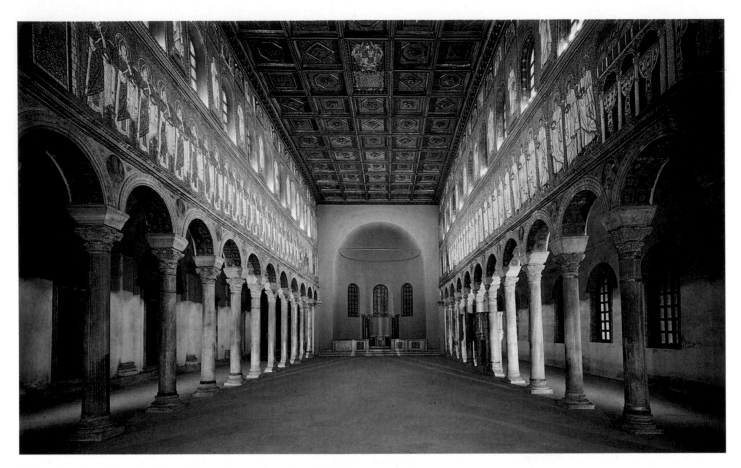

8-19 Interior of Sant'Apollinare Nuovo, Ravenna, dedicated 504.

Our example, showing the miracle of the loaves and fishes (FIG. **8-20**), illustrates well the stylistic change that has occurred since the decoration of the Mausoleum of Galla Placidia. Jesus, beardless and in the imperial dress of gold and purple, faces directly toward us as he directs his disciples to distribute the miraculously augmented supply of bread and fish to the great crowd to which he has preached. The artist has made no attempt to supply details of the event. The emphasis is instead on the sacramental character of it, the spiritual fact that Jesus, outstanding in the group, is performing a miracle by the power of God. The fact of the miracle takes it out of the world of time and of incident, for what is important in this scene is the presence of almighty power, which requires nothing but an unchanging presentation in terms of formal, unchanging aspect. The story is told with the least number of figures necessary to make its meaning explicit; these figures have been aligned laterally, moved close to the foreground, and placed in a shallow picture box that is cut off by a golden screen close behind the backs of the figures. The landscape setting, which was so explicitly described by the artist who worked for Galla Placidia, here is merely suggested by a few rocks and bushes that enclose the figure group like parentheses. That former reference to the physical world, the blue sky, is replaced by a neutral gold, which

would be the standard background color from this point on. Remnants of Roman illusionism are found only in the handling of the individual figures, which still cast shadows and retain some of their former volume. But the shadows of the drapery folds have already narrowed into bars and will soon disappear.

In the eastern Roman Empire the pace of stylistic change was even more rapid, and many of the features of the Sant'Apollinare Nuovo mosaic may be seen, in more advanced form, perhaps as much as a century earlier in the mosaics of the dome of the Church of St. George at Thessaloniki (Salonica) in northern Greece. The church, of the central-plan type, was originally built around 300 as the mausoleum of Galerius, tetrarchic Caesar of the East under Diocletian. Its conversion into a church sometime between 390 and 450 (the date is a matter of scholarly controversy) thus parallels the history of the mausoleum of Constantine's daughter, which became Santa Costanza (FIGS. 8-10 to 8-12).

Only part of the mosaic decoration of the Church of St. George is preserved. Originally the dome was clad with concentric rings of figures against a golden ground, climaxing at the summit of the dome in a central medallion with an apparition of Christ supported by flying angels. The detail that we illustrate here (FIG. **8-21**) comes from the

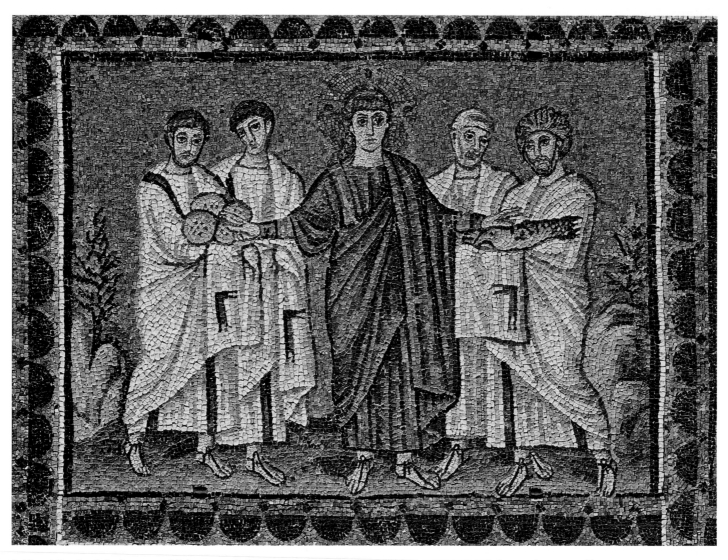

8-20 Miracle of the loaves and fishes, mosaic from top register of nave wall (above clerestory windows) of Sant'Apollinare Nuovo, *c.* 504.

lower band of mosaics, which had eight panels (seven are fairly well preserved) in which pairs of saints with their arms raised in prayer stand before two-story architectural fantasies reminiscent of Roman mural paintings (FIG. 7-20) and the facades of the rock-cut tombs of Petra (FIG. 7-59). In this respect, the Thessaloniki mosaics are more closely tied to the classical past than are those of Sant'Apollinare Nuovo. Yet figures and architecture alike have lost almost all corporeality, and it is increasingly difficult to imagine, for example, rounded torsos and limbs beneath the flat, curtainlike garments worn by Saints Onesiphorus and Porphyrius. The formality of the poses and the solemn, priestly demeanor of the figures will become unvarying features of the art of the Byzantine Empire throughout its centuries of life. The ethereal, golden splendor of the whole composition dissolves material form into spiritual phantasm. One could say that the dome mosaic of St. George completes the change from the images of the pagan floor mosaic, which are literally under the feet and of this world,

to the floating images of a celestial world high above the Christian's wondering gaze. Nonetheless, the classical tradition persists, something we have noted time and time again as a central feature of Early Christian art and architecture.

Despite the great changes that had taken place in art during the later third and fourth centuries, the classical tradition was by no means extinguished, even though many artists seemed to be turning away from Greco-Roman naturalism to something archaic, abstract, and bluntly expressive, as seen even in official imperial commissions like the portraits of the tetrarchs (FIG. 7-81) and the frieze of the Arch of Constantine (FIG. 7-87). The classical tradition lived on through the Middle Ages, if not with entirely discernible continuity, in intermittent revivals, renovations, and restorations, commingled with—or side by side and in contrast with—the opposing, nonclassicizing medieval styles. The end of the medieval world will be signalized by the rise of classical art to dominance in the Renaissance. As we follow the course of stylistic change throughout the history of

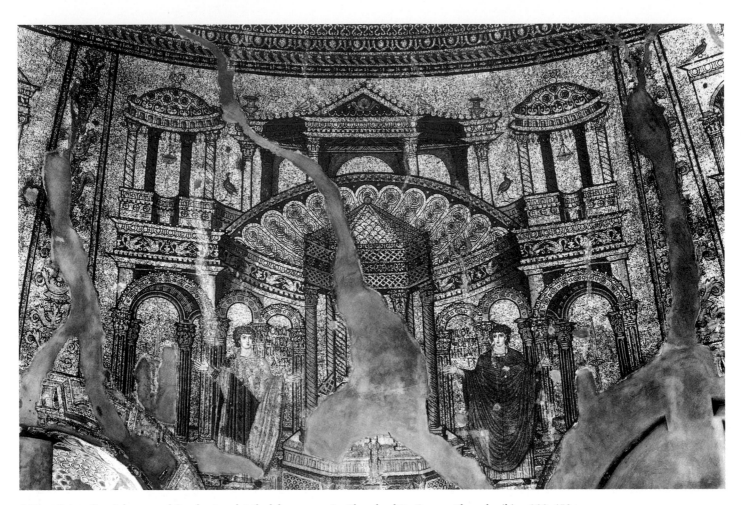

8-21 Saints Onesiphorus and Porphyrius, detail of dome mosaic, Church of St. George, Thessaloniki, *c.* 390–450.

Western art, especially in the Middle Ages, the strength of the classical tradition in its dialogue with competing strains and tendencies of style should always be kept in mind.

LUXURY ARTS

Ivory Carving

Although, after Constantine, all the most important architectural projects in Italy were Christian in character, not everyone converted to the new religion, even after Theodosius closed all temples and banned all pagan cults in 391. An ivory plaque (FIG. **8-22**), probably produced in Rome toward the end of the fourth century, strikingly exhibits the endurance of pagan themes and patrons and of the classical style. The ivory, one of a pair of leaves of a *diptych* (two carved, hinged panels), may commemorate the marriage of members of two powerful Roman families of the senatorial class, the Nicomachi and the Symmachi, although this has been questioned recently. Here, the families seem consciously to reaffirm their faith in the old

pagan gods; certainly, they favor the esthetic ideals of the classical past, much as we find these ideals realized in such works as the stately processional friezes of the Greek Parthenon (FIG. 5-56) and the Roman Ara Pacis (FIG. 7-33). The illustration represents a pagan priestess celebrating the rites of Bacchus and Jupiter; the other diptych panel, inscribed with the name of the Nicomachi, shows a priestess honoring Ceres and Cybele. The priestess on the Symmachi leaf prepares a libation at an altar. The precise yet fluent and graceful line, the easy, gliding pose, and the mood of spiritual serenity bespeak an artist practicing within a still-vital classical tradition to which idealized human beauty is central. That tradition probably was sustained deliberately by the great senatorial magnates of Rome, who resisted the empire-wide imposition of the Christian faith at the end of the fourth century.

An ivory panel (FIG. **8-23**) over a century later in date than the diptych of the Nicomachi and Symmachi, carved in the eastern empire, perhaps in Constantinople, offers still further evidence of the persistence of classical form, although subtle deviations from classical rules are apparent here. The panel, depicting Saint Michael the Archangel, is

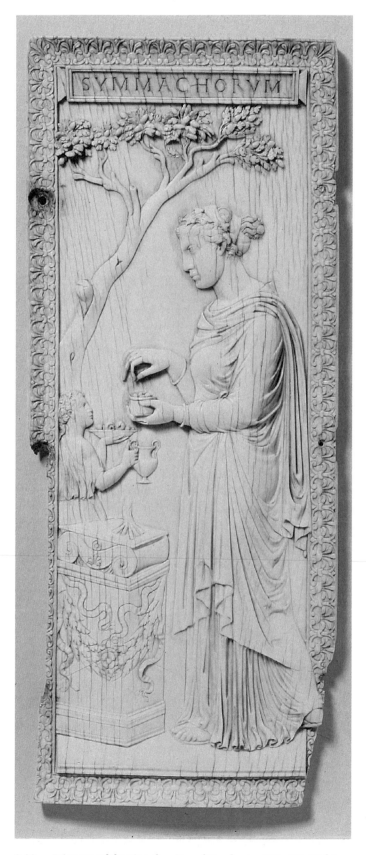

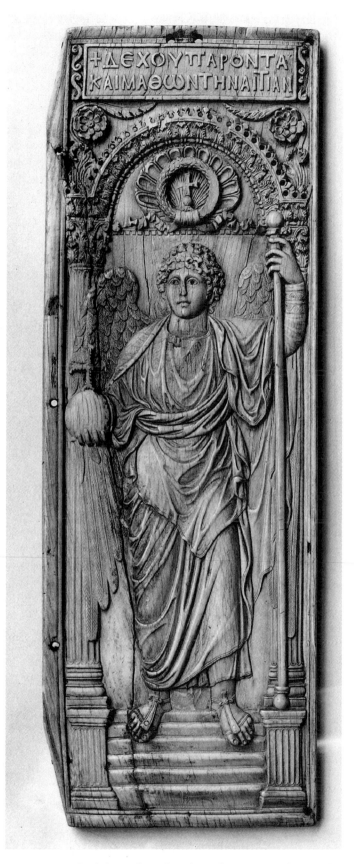

8-22 Priestess celebrating the rites of Bacchus, *c.* 380–400. Right leaf of the Diptych of the Nicomachi and the Symmachi. Ivory, 11³/₄″ × 5¹/₂″. Victoria and Albert Museum, London.

8-23 St. Michael the Archangel, early sixth century. Right leaf of a diptych. Ivory, approx. 17″ × 5¹/₂″. British Museum, London.

one leaf of an early sixth-century diptych. The prototype of Michael must have been a pagan winged Victory, although Victory was personified as a woman in classical art. Instead of carrying the palm branch of victory, Michael holds forth an orb surmounted by a cross, the symbol of the triumph of Christianity. The flowing classical drapery, the delicately incised wings, and the facial type and coiffure are, however, of the pre-Christian tradition. But even so, significant divergences—misinterpretations of or lack of concern for the rules of naturalistic representation—occur here. Subtle ambiguities in the relationship of the figure to its architectural setting appear in such details as the feet hovering above the steps without any real relationship to them and the placement of the upper body, wings, and arms in front

of the column shafts while the lower body is behind the column bases at the top of the receding staircase. These matters, of course, have little to do with the striking beauty of the form; they simply indicate the course of stylistic change, as the Greco-Roman world faded into history and the medieval era began.

We find that stylistic change almost complete in an ivory diptych (FIG. **8-24**) depicting (twice) the emperor Anastasius I, as consul, about to throw down the *mappa* (handkerchief), the signal for the start of the games shown in the arena below him. Although the diptych, dated 517, is almost contemporary with the Saint Michael ivory, the mutation of classical naturalism is much further advanced (a reminder that the process does not proceed evenly along

8-24 Diptych of Anastasius, 517. Ivory, each leaf 14″ × 5″. Bibliothèque Nationale, Paris.

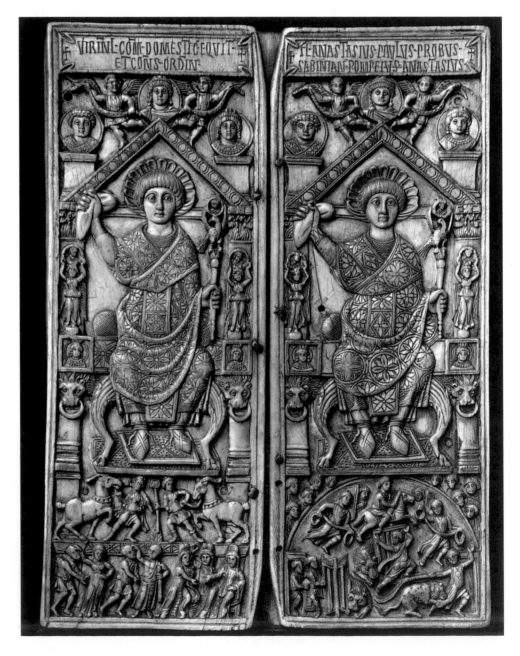

the same historical front or at the same tempo). The figure of the emperor in both panels is elevated above the lively scenes taking place in the arena. Like Constantine distributing largess on his arch (FIG. 7-87), Anastasius is enthroned in rigid formality, making a static, suspended gesture—entirely symbolic, the abstraction of his consular authority. His features are masklike, and his quasi-divine status is announced by a halo. The halo in the form of a shell is taken over from a model like that used for the Michael diptych, where the shell was originally an architectural feature, part of the pediment of a niche. It has here migrated to its place behind the emperor's head and is another example of the transformation of a classical prototype in the hands of an Early Christian artist. Other details of the architecture are confusing and have lost their original significance, and the spatial position of the emperor is even more ambiguous than that of Michael; Anastasius seems to float within the niche and above the games in the arena as the surface becomes increasingly flat and patterned, no longer a window onto a three-dimensional world rendered in consistent perspective. The work is entirely ornamental and symbolic; the living man is lost in the concept—in this case, the concept of supreme and suprahuman authority.

Illuminated Manuscripts

The survival rate of all works of ancient art is notoriously low, but nowhere is the lacuna greater than for the art of the book. The designers of the Old and New Testament narrative cycles in Santa Maria Maggiore (FIG. 8-15) and Sant'Apollinare Nuovo (FIG. 8-20) must have drawn on a long tradition of pictures in manuscripts that began in pharaonic Egypt (see FIG. 3-44) and was developed to a high degree by the Hellenistic Greeks of Alexandria. Thousands of texts, richly illustrated with Hebrew, Greek, and Christian themes, or with combinations of all three must have been available to the Early Christian mosaicists.

We know that Constantine summoned numerous savants and literati from Alexandria, an intellectual center for both Jews and pagans since Hellenistic times and one of the great episcopal sees of the Christian Church. He established a library where these authorities gave instruction. We know also that he was a generous donor of manuscripts to the Church. Hence, it is no wonder that Constantinople became a center of traditional and Christian learning, which was transmitted by the copying and recopying of manuscripts through the centuries.

The dissemination of manuscripts, as well as their preservation, was aided greatly by an important invention in the Early Imperial period. The long manuscript scroll (*rotulus*), used by Egyptians, Greeks, Etruscans, and Romans alike (which we have seen in the hands of the Etruscan magistrate Lars Pulena [FIG. 6-17] and philoso-

phers on Roman and Early Christian sarcophagi [FIGS. 7-79 and 8-5] as well as Christ himself in his role as teacher [FIGS. 8-6 and 8-7]) was superseded by the *codex*, which was made, much like the modern book, of separate pages enclosed within a cover and bound together at one side. Papyrus was replaced by the much more durable *vellum* (calfskin) and *parchment* (lambskin), which provided better surfaces for painting. These changes in the durability, reproduction, and format of texts greatly improved the possibility that the records of ancient civilizations could survive long centuries of neglect, even if not in great number.

The sacred texts were copied as faithfully as possible, as were the pictures in them. After the great fathers of the early Church recommended (despite the Second Commandment's prohibition of graven images) the use of pictures in churches and books to instruct the illiterate in the mysteries and stories of the faith, the illustrations became only slightly less significant than the text from which they drew their authority. We can see the transition from the scroll to the codex (from continuous narrative to a series of individual pictures) in two manuscripts of different dates (the later manuscript still reflects the scroll procedure).

The *Vatican Vergil* (FIG. **8-25**) dates from the early fifth century and is the oldest painted manuscript known. Its content is pagan, and our illustration represents a scene

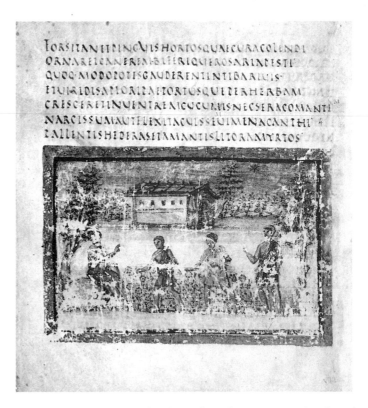

8-25 Farmer instructing his slaves, from the *Vatican Vergil*, early fifth century. Painted parchment, approx. 12½" × 12". Biblioteca Apostolica Vaticana, Rome.

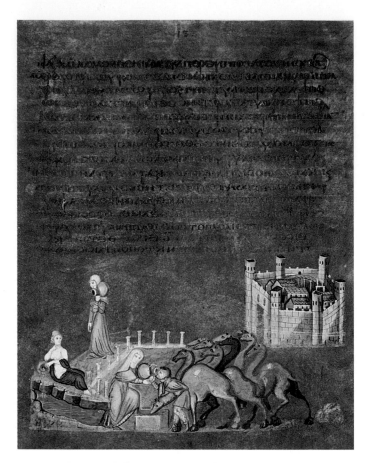

8-26 Rebecca and Eliezer at the well, from the *Vienna Genesis,*
early sixth century. Painted purple vellum, approx. 12¼″ × 9¼″.
Österreichische Nationalbibliothek, Vienna.

from Vergil's *Georgics,* in which a seated farmer (at the left)
instructs two of his slaves in the art of husbandry, while
Vergil (at the right) listens and records the instructions—we
are reminded of the Roman idealization of country life and
nature. The style is reminiscent of Pompeian landscapes.
The quick, impressionistic touches that suggest space and
atmosphere, the foreshortened villa in the background, and
the small, active figures in their wide, spacious setting are
all familiar features of Roman illusionistic painting. The
heavy, dark frame that isolates a single episode is also a fea-
ture of the late Pompeian styles.

The *Vatican Vergil* can be contrasted in form with the
Vienna Genesis (FIG. **8-26**), the earliest well-preserved paint-
ed manuscript we know of that contains biblical scenes. The
Vienna Genesis employs the continuity of a frieze in a scroll.
In a continuous narrative like this, two or more scenes of a
story are represented within a single frame; this will
become the common form of narrative in medieval art. In
this scene from the Book of Genesis (24:15–61), Rebecca
leaves the city of Nahor to fetch water from the well in the
first episode. In the second, she gives water to Eliezer and
his camels. Nahor is represented as a walled city seen from

above, in the manner of the cityscapes on the Column of
Trajan (FIG. 7-49) and the mosaics of Santa Maria Maggiore
(FIG. 8-15), which incorporate Roman pictorial conven-
tions. Rebecca walks to the well along the colonnaded
avenue of a Roman city; the source of the well water is
indicated by a seminude female personification of a
spring—a reminder of the persistence of classical motifs
and stylistic modes in Early Christian art. The action is pre-
sented with all possible simplicity in an expressive pan-
tomime that includes convincing touches; for example,
Rebecca braces herself with her raised left foot on the rim
of the well as she tips up her jug for Eliezer. The figures are
silhouetted against a landscape that is blank except for the
miniature city and the road to the well. Everything neces-
sary to bare narrative is present, and nothing else.
Although the figures have only narrative significance, the
page itself is sumptuous: a rich, purple ground of vellum is
lettered in silver. The luxuriousness of the ornament that
will become more and more typical of sacred books absorbs
the human figure or confines it exclusively to iconic or nar-
rative functions. The spiritual beauty of the text and the
material beauty of the vehicle that serves and intensifies it
will come to count above all else. The luster of holy objects
becomes the intent and the effect of Byzantine art.

Closely related to the *Vienna Genesis* is another manu-
script of about the same time, the early sixth century. The
Rossano Gospels is the earliest illuminated book we have that
contains illustrations of the New Testament (FIG. **8-27**). We
can infer from them that, by this time, a canon of New
Testament iconography had been fairly well established.
Like the *Vienna Genesis,* the text of the *Rossano Gospels* is
inscribed in silver on purple vellum. The Rossano artist,
however, has attempted with considerable success to har-
monize the colors with the purple ground. The subject of
our illustration, presented with vivid gestures, is the
appearance of Jesus before Pilate, who asks that the Jews
choose between Jesus and the thief Barabbas (Matthew
27:2–26). In the fashion of continuous narrative, separate
episodes of the story are combined in the same frame. The
figures are arranged on two levels separated by a simple
ground line. In the upper level, Pilate presides over the tri-
bunal (similar scenes are common in Roman art), at which
the people demand the death of Jesus as Judas returns the
thirty pieces of silver he had been paid for the capture of
Jesus—an inaccuracy in the time and place of the episode
as it occurs in the text. Jesus and the bound Barabbas
appear in the lower level. Christ, at the left, is now distin-
guished by the cross-inscribed *nimbus* (halo) that signifies
his divinity. The illuminator has assumed that the reader is
perfectly familiar with the text being illustrated and has
tried to make the composition as inclusive as possible.
Barabbas is explicitly labeled to avoid any possible confu-
sion; the artist wants the picture to be as readable as the
text. The nimbate Christ and Pilate on his elevated dais
need no further identification.

By the sixth century, the canon of Christian sacred texts, as well as the cycles of illustration appropriate to them, had been agreed on. The denaturing of classical form is well advanced, and a new art is originating. We are now a considerable distance in time from the painting of the Roman Imperial period, with its worldly themes, naturalism, perspective illusionism, modeling in light and shade, graded tonality, and proportionality. Very little regard will be given to the pagan ideals of beauty in the centuries to come.

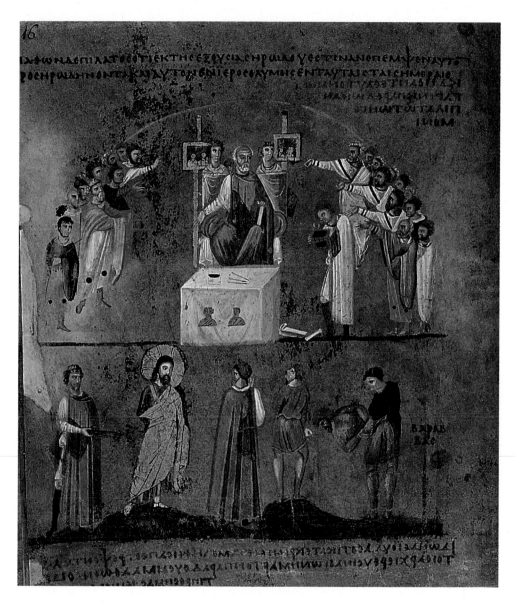

8-27 Christ before Pilate, from the *Rossano Gospels*, early sixth century. Painted purple vellum, approx. 11″ × 10¼″. Diocesan Museum, Archepiscopal Palace, Rossano.

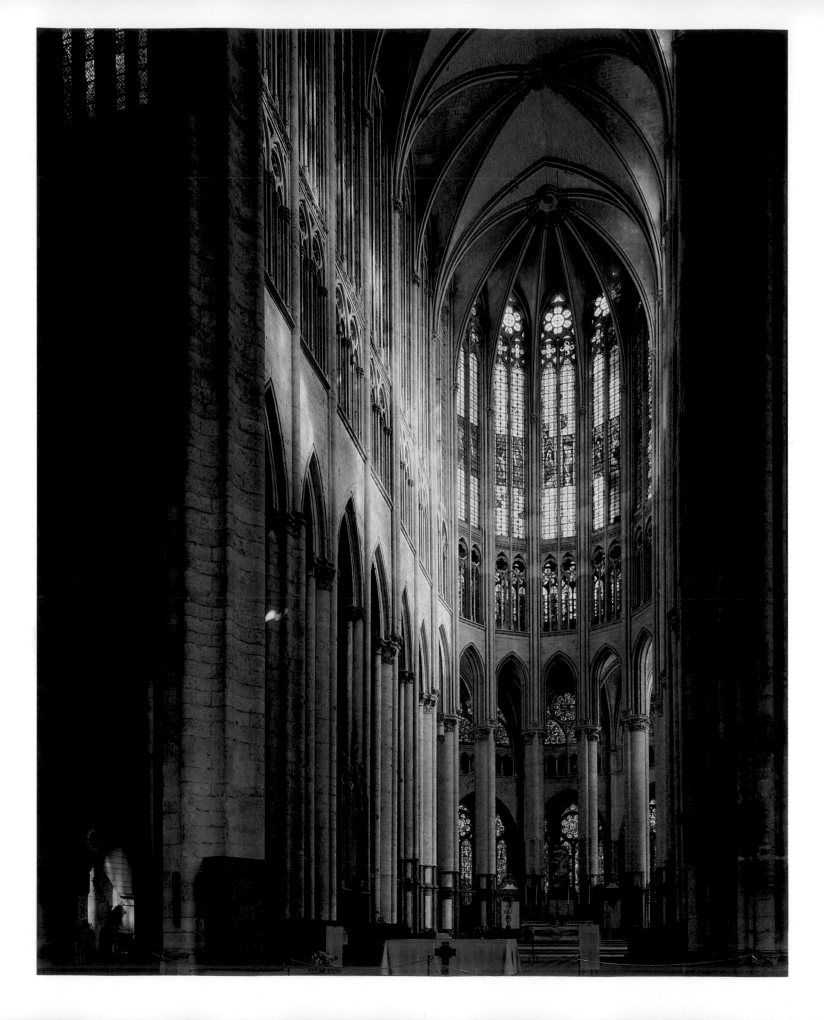

PART TWO

◆

THE MIDDLE
AGES

POETS OF THE AUGUSTAN AGE WERE SINGING THE GLORIES OF "ETERNAL ROME," WHILE
Jesus of Nazareth, obscure founder of the religion that was to transform the
City of Man into the City of God, was born and died. Within four centuries,
Christianity had become the official cult of the dying Empire and the faith of
new peoples who would inherit its cultural remains. We have reviewed the art
of these early Christian centuries, observing how Roman art was transformed
iconographically and stylistically. The process of transformation would contin-
ue through the ensuing centuries until the forms of art and architecture would
reveal a distinctively original spirit and world-view. Art would differ emphati-
cally from that of Greco-Roman antiquity, yet always reflect its remote but
lingering presence.

Historians once referred to the thousand years (roughly 400 to 1400), dur-
ing which the new art evolved and flourished, as the Middle Ages or the Dark
Ages. For centuries this long interval between Classical Antiquity and the mod-
ern world was thought to be rough and uncivilized, barbarous in manners and
superstitious in religion. This time was viewed as simply a blank between (in
the "middle" of) two great civilizations, the ancient and the modern, Even
today the word "medieval" (literally "middle age") is used disparagingly.

But since the late eighteenth century, historians have been revising this view
and, with it, the long-held belief that medieval art was crude and primitive. The
same romantic enthusiasm for past civilizations that motivated the archeologi-
cal revolution of Heinrich Schliemann's time, and the consequent recovery of
the ancient past, sent scholars in quest of the meaning of medieval culture—the

AT LEFT: *Choir of Beauvais Cathedral, 1272; vaults rebuilt after 1284.*

meaning of monuments that existed in great number and, in this case, that were aboveground and visible. Although we now see these centuries with different eyes, perceiving their innovation and greatness, the names "Middle Ages" and "medieval" continue to be used, simply for convenience.

Medieval civilization represents an interrelation of Christianity, Greco-Roman tradition, and the new, energetic spirit of the Celtic-Germanic peoples—the "barbarians," as the Greeks and Romans had called them. The Greco-Roman tradition survived, much transformed, in the empire of Byzantium. Greek learning deeply influenced the culture of Islam, the great monotheistic religion that, from the seventh century on, played a major role in the affairs of Christian Europe, in both the Celtic/Germanic west and the Byzantine east.

Byzantium, the eastern half of the Christianized Roman empire, became the New Rome, its capital, Constantinople, the most magnificent city of Christendom, replacing old Rome as the center of Christian civilization. From the time of the emperor Justinian the Great in the sixth century until the fall of Constantinople to the Muslim Turks in the fifteenth, the Byzantine empire played an important political and cultural role in Eastern Europe and in the Mediterranean. Byzantium maintained a continuous sovereignty and identity for centuries, defending itself against the power of the new religion and political entities of Islam. The old imperial provinces in the West disintegrated into warring kingdoms of Germanic invaders—Franks, Visigoths, Anglo-Saxons, Danes. The Latin church converted the Germanic peoples to Roman Christianity, Byzantium converted the Slavs to Orthodox Christianity. The division of those two Christian churches in the eleventh century has never been mended.

The religious and political expansion of Islam was the most dynamic and far-reaching movement of the Middle Ages. Originating in Arabia in the sixth century, it swept eastward through Persia (Iran), to India and Indonesia, and westward though North Africa to Spain and the Pyrenees. Arabic Islam repeatedly challenged the Christian world, and, when after centuries the West responded with the Crusades, the Islamic powers drove it back. Though confrontation and conflict were the rule, Islamic culture and learning, much of it derived from Arabic contact with the philosophic and scientific heritage of the ancient Greeks, decisively influenced the culture of the West.

The Celtic/Germanic peoples, migrating into, conquering, and settling Western Europe, merged with the Latins of the former Roman provinces and slowly developed political and social institutions that would continue into modern times. Through centuries of struggle a new order would replace the extinct Roman Empire and evolve into today's European nations.

During these "middle ages," the chieftains of the primitive Germanic war bands became the medieval barons, princes, and kings whose authority and tenure of land depended upon the interlocking loyalties of the feudal system. Power and privilege were based on birth, inheritance, and military might. War was incessant. Government for the most part was local, centering in the baron, his laws, lands, and people. Ambitious and fortunate barons, annexing by conquest or other means the lands of their neighbors, rose to be kings, able to form centralized governments that gradually overcame the conservative localism of the rural barons.

In the medieval struggle for authority, the Church was the major contestant with the barons and kings. Unlike Byzantium and Islam, where religion and government (church and state) were one and the same, the medieval West sharply separated the claims of religious and secular authority. The unified Catholic Christian Church, headed by the popes, was the most centralized and best organized government in Western Europe. By the thirteenth century the papacy could assert its divine right to temporal as well as spiritual authority over all Christendom. The breakup of the unity of Christendom, beginning in

the fourteenth century with the subversion of papal power, led eventually to the Christian civil war we know as the Protestant Reformation.

The political strength of the Church in the medieval West was a sign of the overwhelming power of religious faith in the lives of medieval people, whatever their rank. Historians have called the Middle Ages the Age of Faith. Faith was indeed the principal force behind medieval motivation and action, whether in Catholic Christianity, or the faith implicit in the feudal virtue of loyalty. Christianity, institutionalized in the Roman Church, civilized the still-wild Germanic tribes. Firmly established, it constituted a unifying force, even in the midst of anarchy and chronic warfare. Though itself often corrupted, it was just as often reformed. By the thirteenth century, when the Church was at the height of its power, western Europe had evolved into a great and original civilization, constantly stimulated by influences from the Greco-Roman past, Byzantium, and the world of Islam, but ever reworking those influences in novel ways. The Christian Church, with its monopoly on education, also preserved and handed on aspects of Roman culture not directly related to religion: the Latin language, Roman law, Roman administrative organization and practice—all elements used by the Church but, as the Renaissance would show, susceptible to entirely secular application.

The spirit of Christianity was oriented toward the world of the supernatural; its learning was centered in theology, which regarded questions about the nature of the physical world as both irrelevant to salvation and irreverent in intention. Nevertheless, by the thirteenth century, there was stirring—even within the Church—a new curiosity about the natural environment that could not be stifled entirely by the prevailing religious disposition. Within the medieval setting, notwithstanding its thoroughly religious view of nature, a different impulse was being felt—a secular and intellectual curiosity about the world.

Secular ways of thinking were greatly accelerated by the rise of towns. While medieval Europe remained almost ninety percent agricultural and its population to the same degree rural, its land-based economy was being challenged by the rise of a town-bred commercial and market economy that was destined to supersede it. The towns became the centers of organized industry, trade, finance, the accumulation of capital, and the exchange of new ideas. Within the town walls industry was carried on by free people organized in craft guilds. The Church's disapproval of slavery conferred a new dignity on manual labor and productive skills. The free craftsman and woman—not as in the ancient world the slave—constituted the firm foundation of the medieval urban economy.

Urbanization encouraged a critical spirit that questioned not only feudal authority, but also the hierarchical structure of the Church, the spiritual and temporal monarchy of the papacy, and even fundamental doctrines of Catholic Christianity. Though religious piety persisted and even increased in intensity, it only served to sharpen animosity to the status quo as maintained by the established church. By the fifteenth century the curtain was rising upon a scene of discontent and reformist sentiment, a scene that would introduce the modern epoch with the dissolution of the medieval order.

The critical spirit stimulated inquiry into the origins of the medieval order, the Christian scriptures and the literature of pagan Greece and Rome. An enthusiasm was kindled for the recovery of the world of Classical Antiquity as preserved in the Greek and Latin languages and in Roman art. Beginning in the late fourteenth century in the prosperous cities of Italy, this enthusiasm inspired the movement historians refer to as the Renaissance—that is, the rebirth of the humanistic outlook of the poets and philosophers of pagan antiquity. Along with the recovery of the classical past went the "discovery" of the great world beyond Europe and the beginning of that systematic investigation of physical nature that we call science.

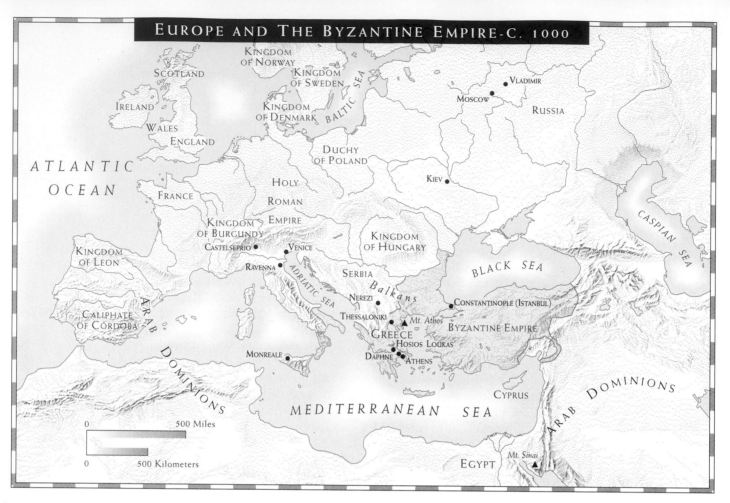

EUROPE AND THE BYZANTINE EMPIRE—C. 1000

ATLANTIC OCEAN

SCOTLAND

IRELAND

WALES

ENGLAND

KINGDOM OF NORWAY

KINGDOM OF SWEDEN

KINGDOM OF DENMARK

BALTIC SEA

FRANCE

HOLY ROMAN EMPIRE

KINGDOM OF BURGUNDY

CASTELSEPRIO

VENICE

RAVENNA

KINGDOM OF LEON

CALIPHATE OF CÓRDOBA

ARAB DOMINIONS

ADRIATIC SEA

DUCHY OF POLAND

KIEV

MOSCOW

VLADIMIR

RUSSIA

CASPIAN SEA

KINGDOM OF HUNGARY

SERBIA

Balkans

Nerezi

Thessaloniki

Mt. Athos

GREECE

Hosios Loukas

DAPHNE

ATHENS

MONREALE

BLACK SEA

Constantinople (Istanbul)

Byzantine Empire

CYPRUS

ARAB DOMINIONS

MEDITERRANEAN SEA

EGYPT

Mt. Sinai

ARAB DOMINIONS

500 Miles

0

0 500 Kilometers

500	600	700	800

EARLY BYZANTINE EMPIRE

TERRITORIAL LOSSES TO ISLAM - ARABS AND TURKS

AGE OF JUSTINIAN

PERIOD OF ICONOCLASM

MIDDLE BYZANTINE PERIOD

ISLAMIC ERA ▶

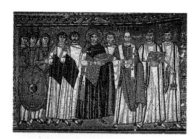

Justinian mosaic
San Vitale, c. 547

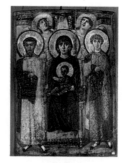

Mt. Sinai
Icon, 6th-7th cent.

Fall of Ravenna to Odoacer.
End of western Roman Empire, 476

Iconoclasm, 726

Restoration of images, 843

Justinian the Great r. 526-565
Empire briefly restored

Heraclius defeats Persians, 627

Revival of study of
Greek classics, c. 850

Islamic era begins when Muhammad flees Mecca, 622

Arabs besiege Constantinople, 717-18

CHAPTER 9

BYZANTINE ART

900	1000	1100	1200	1300	1400-53

(DYNASTIES) MACEDONIAN, COMNENIAN & ANGELI	PALAEOLOGI
	FRANKISH MONARCHS
	LATE BYZANTINE

Paris Psalter, c. 960

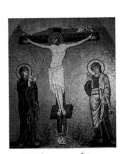

Daphni, crucifixion
mosaic, 1090-1100

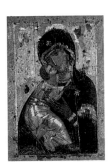

The Vladimir Madonna
12th century

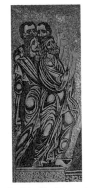

St. Mark's Anastasis
mosaic, c. 1280

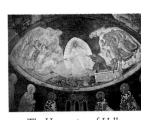

The Harrowing of Hell
c. 1310-1320

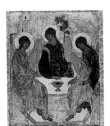

Andre Rublev
Trinity icon, c. 1410

Turks convert to Islam, 9th-10th century

Basil II, 980-1001, revival of Byzantine power

Schism between Byzantine and Roman churches, 1054

First Crusade, 1095-1099

Seljuk Turks capture Byzantine Asia Minor, 1073

The Palaeologan revival, 13-14th centuries

Michael VIII (Palaeologus) recaptures
Constantinople from the Franks, 1261

Ottoman Turks
capture Constantinople
End of Byzantine
Empire, 1453

Fourth Crusade and the Frankish conquest, 1202-1204

BYZANTIUM: THE EASTERN ROMAN CHRISTIAN EMPIRE

In the fifth century, as we have seen, the Roman Christian Empire fell apart: there was an emperor of the west at Ravenna, an emperor of the east at Constantinople. Though not recognized as official, and though briefly mended by Justinian in the sixth century, the division of the empire was to be permanent in fact. The western half disintegrated into a congeries of warring Barbarian states—the Germanic kingdoms—which, throughout the Middle Ages, formed the foundations of the modern nations of Western Europe. The eastern half of the empire, only loosely connected by religion to the west, and with only minor territorial holdings there, would have a long and complex history of its own. Centered at Constantinople, "New Rome," the eastern empire remained a cultural and political entity for a thousand years. Constantine I had founded the city in 330; Constantine XI, last of a long list of Eastern Roman emperors, died there in 1453, vainly defending it against the Ottoman Turks.

The ancient Greek city of Byzantium, the site upon which Constantinople was built, has given its name to the Eastern Roman Empire. We now call that empire "Byzantium," and *Byzantine* is the term by which we identify whatever pertains to Byzantium, its territory, its history, its culture. The Eastern Romans did not use these terms to define themselves. They called their empire "Rome" (*Romania*) and themselves "Romans" (*Romaioi*). The Turks, who for several centuries attacked and then conquered Byzantium, called it "Rúm." Though they spoke Greek and not Latin, the Eastern Roman emperors never relinquished their claim to be the legitimate successors to the ancient Roman emperors. Nevertheless, "Byzantium" and "Byzantine," though inexact terms, have become in modern times the accepted designations for the Eastern Roman empire, and we shall use them here.

Byzantium preserved its identity through alternating periods of good rule and misrule, stability and instability, expansion and contraction, victory and defeat. When its shrinking borders had reduced it to a mere fragment of the once mighty empire; when it had become only a small, medieval Greek kingdom, an enclave around the city of Constantinople; it was still stubbornly "Rome."* As such, it had resisted successive assaults of Sasanian Persians, Arabs, Avars, Bulgars, Russians, Serbs, Seljuk Turks, Normans, Franks, and Venetians, until it was finally overcome by the surging power of the Ottoman Turks. During the long course of its history, Byzantium was the Christian buffer against the expansion of Islam into central and northern Europe, and its cultural influence was felt repeatedly in Europe throughout the Middle Ages. Byzantium Christianized the Slavic peoples of the Balkans and of Russia, bequeathing them its orthodox religion and its alphabet, its literary culture, and its art and architecture. The collapse of Byzantium in 1453 brought the Ottoman Empire into Europe as far as the Danube; we still feel the clash of Byzantine and Turkish traditions in the politics of the Balkan nations. But the catastrophe of 1453 had a lasting and most important effect on Europe. The westward flight of Byzantine scholars after the fall of the capital introduced the study of classical Greek to Italy and helped inspire there the new consciousness of antiquity, which we call the Renaissance.

The Theocratic State

"One God, one empire, one religion" could be the motto of the Byzantine Empire.* In fact, it is a kind of abbreviation of an opening paragraph of the Justinian Code. Constantine had given recognition to Christianity at the beginning of the fourth century, Theodosius had established it as the official religion of the Roman Empire at the end of the fourth century, and Justinian, in the sixth century, proclaimed it to be the only *lawful* religion of the empire. By that time it was not simply the Christian religion, but the *orthodox* Christian doctrine that the emperor asserted to be the only permissible faith for his subjects. This orthodox Christianity was trinitarian: that is, its central article of faith was the trinity of Father, Son, and Holy Ghost (as stated in Roman Catholic, Protestant, and Eastern Orthodox creeds today). All other versions of Christianity were called heresies, especially the Arian, which denied the equality of the three persons of the Trinity, and the Monophysite, which denied the duality of the divine and human natures in Jesus Christ. The emperor considered it his first duty to extirpate all doctrines but the orthodox and to punish severely those who held them. By this time the old Roman pagan cults had mostly died out, but those that remained came under the same ban as the Christian heresies.

The Byzantine emperor was believed to be the earthly vicar of Jesus Christ, with whose will the imperial will must necessarily coincide. By heavenly delegation he alone received all temporal and spiritual authority. As sole executive for church and state, he shared power with neither senate nor ecclesiastical council; as theocrat he reigned supreme, combining the functions of both pope and caesar, which the Western Christian world would keep strictly separate. The emperor's exalted and godlike position made him quasi-divine. His church was simply an extension of

*Though, through the course of time, citizens of the polyglot, multicultured empire would identify themselves as "Christians," rather than "Romans"—*Orthodox* Christians, of course.

*So strong were Byzantine example and tradition among the Slavic peoples that as late as the nineteenth century Nicolas I, Czar of Russia (1825–1855), could still proclaim as motto for the Russian Empire: "one orthodoxy, one autocracy, one nation."

the imperial court, and the imperial court, with its hierarchies of lesser and greater functionaries converging upward to the throne, was an image of the kingdom of Heaven.

In this way, the deification of the pagan Roman emperors was continued under the Byzantines, with the difference, of course, that the latter were Christian, and the further difference that doctrinal uniformity was insisted upon for all imperial subjects, a matter of relative indifference to the cosmopolitan emperors of Old Rome.

In practice, the attempt of the Byzantine emperors to make real the ideal of absolute political and religious unity was a failure. They ruled over peoples of great ethnic, religious, cultural, and linguistic diversity, with varying histories and institutions—Armenians, Syrians, Egyptians, Palestinians, Jews, Arabs, Berbers, as well as Greeks, Italians, Germans, and Slavs. Many of these were heretical Christians, and Byzantine efforts to force orthodoxy upon them in the interest of political and doctrinal unity led to bitter resistance, especially in Monophysite Egypt and Syria. When Islam made its way into the Byzantine Empire in the seventh century, the disaffected peoples of these provinces gave it ready support. While religious intolerance lost the great Eastern provinces, the same rigid orthodoxy had by the twelfth century severed its last ties to the Latin Christianity of the West.

The unity of the empire at large, fragmented by invasions of hostile peoples and hostile creeds, was regularly disrupted by events at home. Byzantine history gives evidence enough of the structural weaknesses of the theocratic state and of the human failures of its absolute monarchs. We can read detailed accounts of the doings of bad and incompetent emperors, palace intrigues, conspiracies and betrayals, bureaucratic corruption, violent religious controversy, civil commotions, rebellions, usurpations, and assassinations.

Yet with characteristic resilience, Byzantium, in three great periods of revived energy, recovered from dismal defeats, disunity, and stagnation. In these periods the state was guided by rulers who were intelligent, able, and successful in war and peace. Under them Byzantium prospered and its culture flourished. And it was in these times that the unique stylistic features of Byzantine art and architecture were shaped and refined. It is convenient to set out the history of Byzantine art according to the outlines these three periods of greatest achievement provide us.

EARLY BYZANTINE ART

The Early Christian art we have examined is a preparatory stage of Early Byzantine art and is continuous with it in time. Early Christian art is late Roman pagan in form and Christian in content; it coincides chronologically and stylistically with the art of the late Roman Empire. In it we have

the preliminary collecting and assimilating of the diverse forms and meanings that are to be synthesized in Early Byzantine art.

Scholars still do not entirely agree on the correct location of Early Byzantine art in time: they debate whether to start the account of it in the age of Constantine, which would include Early Christian art with Early Byzantine, or in the age of Justinian, when, around 500, the power shift in the Empire from Rome to Constantinople begins the peculiarly Byzantine development of Christian art. We have already opted to consider as Early Christian the art of the earlier period, and as Early Byzantine the art of the Eastern Empire from about 500 to 730. This span includes the age of Justinian and his successors down to the terminating onset of *Iconoclasm* (the destruction of images used in religious worship). During these two centuries, Byzantine art emerges as a recognizably novel and distinctive style, leaving behind the uncertainties and hesitations of Early Christian artistic experiment. Though still revealing its sources in the art of the late Roman Empire, it definitively expresses, with a new independence and power of invention, the unique character of the Eastern Christian culture centered at Constantinople.

Constantinople

The reign of Justinian I (527–565), and his politically astute consort, the Empress Theodora, marks the end of the later Roman Empire and the beginning of the Byzantine. From the imperial capital at Constantinople, the power and the extent of the Roman Empire were briefly restored. Justinian's generals, Belisarius and Narses, drove the German Ostrogoths out of Italy, expelled the German Vandals from the African provinces, beat back the Bulgars on the northern frontier, and held the Sasanian Persians at bay on the eastern borders. At home, a dangerous rebellion of political/religious factions in the city was put down, and orthodoxy triumphed over the Monophysite heresy. Justinian supervised the codification of Roman law, which had wildly proliferated over the centuries. This great work, known as the *Corpus Juris Civilis* (Code of Civil Law), became the foundation of the law systems of most European nations today. A modern scholar briefly summarizes the achievements of this Early Byzantine state:

> It integrated Christianity within the Graeco-Roman tradition; it defined Christian dogma and set up the structures of Christian life; it created a Christian literature and a Christian art. There is barely an institution or idea in the entire Byzantine panoply that did not originate in the Early Period.*

*Cyril Mango, *Byzantium: The Empire of New Rome* (New York: Charles Scribner's Sons, 1980), 4.

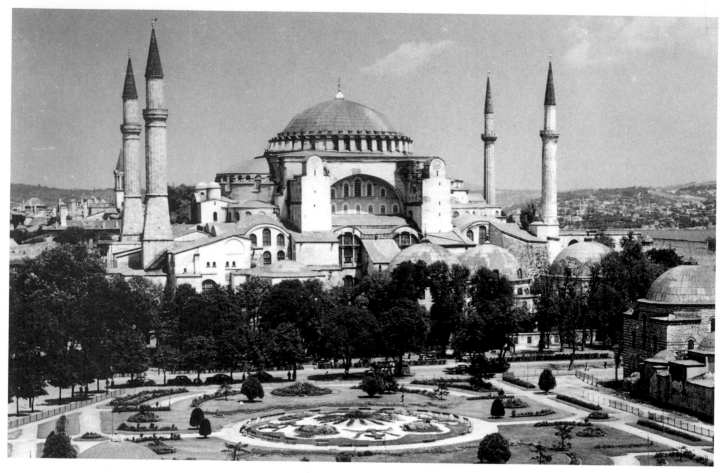

9-1 ANTHEMIUS OF TRALLES and ISIDORUS OF MILETUS, Hagia Sophia, Constantinople (Istanbul, Turkey), 532–537.

For the history of art, the most important contribution of Justinian's reign was the great church of Hagia Sophia (Holy Wisdom) in Constantinople. Justinian, like Constantine in Rome, was an enthusiastic builder of both civic and ecclesiastical structures. The historian of his reign, Procopius, declares that his building ambition was an obsession that cost his subjects dearly in taxation. However that may be, Hagia Sophia, the outstanding monument to the Justinianic age, is among the supreme accomplishments of world architecture.

Hagia Sophia (FIGS. **9-1** to **9-3**) was built for Justinian by the architects ANTHEMIUS OF TRALLES and ISIDORUS OF MILETUS between 532 and 537. Its dimensions are formidable for any structure not made of steel. In plan, it is about 270 feet long and 240 feet wide; the dome is 108 feet in diameter, and its crown rises some 180 feet above the pavement. In scale, Hagia Sophia rivals the great buildings we have seen in pagan and Christian Rome: the Pantheon, the Baths of Caracalla, or the Basilica of Constantine. In exterior view, the great dome dominates the structure, but the external aspects of the building are much changed from their original appearance. Huge buttresses were added to the original design, and four towering Turkish minarets were constructed after the Ottoman conquest of 1453, when Hagia Sophia

became an Islamic mosque. The building has been secularized in the twentieth century and is now a museum.

The characteristic Byzantine plainness and unpretentiousness of exterior (which, in this case, also disguise the great scale) scarcely prepare us for the interior of the building (FIG. 9-2). The huge narthex, with its many entrances, leads into the center of the structure, over which the soaring, canopylike dome rides on a halo of light provided by windows in the dome's base. The impression made on the people of the time, an impression not lost on us, is carried in the words of the poet Paulus, an usher at the court of Justinian:

About the center of the church, by the eastern and western half-circles, stand four mighty piers of stone, and from them spring great arches like the bow of Iris, four in all; and, as they rise slowly in the air, each separates from the other . . . and the spaces between them are filled with wondrous skill, for curved walls touch the arches on either side and spread over until they all unite above them. . . . The base of the dome is strongly fixed upon the great arches . . . while above, the dome covers the church like the radiant heavens. . . . Who shall describe the fields of marble gathered on the pavement and lofty walls of the

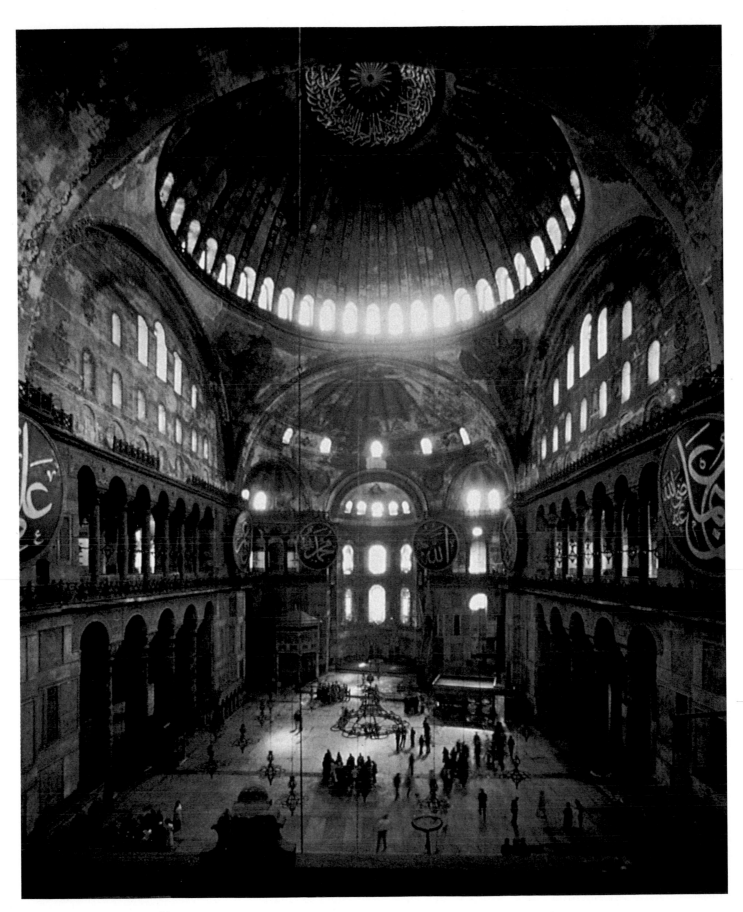

9-2 Interior of Hagia Sophia.

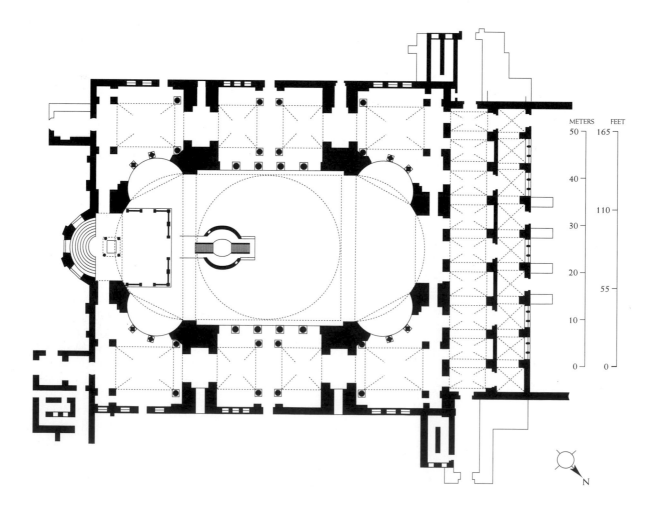

9-3 Section and plan of Hagia Sophia. (After drawings by Van Nice and Antoniades.)

church? Fresh green from Carystus, and many-colored Phrygian stone of rose and white, or deep red and silver; porphyry powdered with bright spots; emerald-green from Sparta, and Iassian marble with waving veins of blood-red and white; streaked red stone from Lydia, and crocus-colored marble from the hills of the Moors, and Celtic stone, like milk poured out on glittering black; the precious onyx like as if gold were shining through it, and the fresh green from the land of Atrax, in mingled contrast of shining surfaces.*

The dome rests on four *pendentives*. In pendentive construction (see FIG. 9-22), which apparently was developed after many years of experiment by builders in the Near East and constitutes *the* contribution of Byzantium to architectural engineering, a dome rests on what is, in effect, a second, larger dome. The top portion and four segments around the rim of the larger dome have been omitted, and the four segments form four arches, the planes of which bound a square. By transferring the weight to piers, rather than to the wall itself, pendentive construction makes possible a lofty, unobstructed interior space, as is particularly evident in Hagia Sophia. In our view of the interior (FIG. 9-2), the arches that bound two of the great pendentives supporting the central dome can be seen converging on their massive piers. The domes of earlier, central-plan buildings, like the Pantheon and Santa Costanza, spring from the circular bases of a continuous wall or arcade. The pendentive system is a dynamic solution to the problem of setting a round dome over a square or rectangular space, making possible a union of centralized and longitudinal or basilican structures. Hagia Sophia, in its successful fusion of these two architectural types, becomes a domed basilica—a uniquely successful conclusion to several centuries of experiment in Christian church architecture. However, the thrusts of the pendentive construction at Hagia Sophia make other elements necessary: huge wall piers to the north and south, and, to the east and west, half-domes, whose thrusts descend, in turn, into still smaller domes (FIG. 9-3), covering columned niches that give a curving flow to the design. And the wandering space, the diverse vistas, and the screenlike, ornamented surfaces all mask the lines of structure. The arcades of the nave and galleries have no real structural function; like the walls they pierce, they are only part of a fragile "fill" between the great piers. Structurally, although Hagia Sophia may seem Roman in its great scale and majesty, it does not have Roman organization of its masses. The very fact that what appears to be wall in Hagia Sophia is actually a concealed (and barely adequate) pier indicates that Roman monumentality was sought as an *effect* and not derived directly from Roman building principles.

The use of brick in place of concrete marks a further departure from Roman practice, and will characterize Byzantine architecture as a distinctive structural style. The eight great supporting piers are of ashlar masonry, but the screen walls are of brick, as are the vaults of the aisles and galleries, and of the domes and semi-circular half-domes known as *conches*. Stability factors are perilously ignored in order to achieve the intricate spatial variety and the apparent flow and mutation of surface, organic effects not achievable in the less plastic materials of concrete and stone. And these effects are enhanced by the skillful architectural management of light.

Visitors to Hagia Sophia have long been struck by the quality of light within the church and its effect on the human spirit. The forty windows at the base of the dome create the peculiar illusion that the dome is resting on the light that floods through them; an observer of the time thought that it looked as if the dome were suspended by a "gold chain from Heaven." The historian Procopius wrote: "One would declare that the place were not illuminated from the outside by the sun, but that the radiance originated from within, such is the abundance of light which is shed about this shrine." Paulus, the poet and court usher, observed: "The vaulting is covered over with many little squares of gold, from which the rays stream down and strike the eyes so that men can scarcely bear to look." Thus, we have a vastness of space shot through with light and a central dome that *appears* to be supported by the light it admits. Light is the mystic element—light that glitters in the mosaics, shines forth from the marbles, and pervades and defines spaces that, in themselves, seem to escape definition. Light becomes the agent that seems to dissolve material substance and transform it into an abstract, spiritual vision. Pseudo-Dionysius, perhaps the most influential mystic philosopher of the age, wrote in *The Divine Names*: "The name 'Good' shows forth all the processions of God. . . . Light comes from the Good and . . . light is the visual image of God."*

The ingenious design of Hagia Sophia provided the illumination and the setting for the solemn liturgy of the Orthodox faith. The large windows along the rim of the great dome poured down light upon its jeweled splendor, within which the sacred spectacle was staged. Sung by clerical choirs, the Orthodox equivalent of the Latin Mass celebrated the sacrament of the Eucharist at the altar in the apsidal sanctuary, in spiritual re-enactment of the sacrificial offering of Jesus. Processions of chanting priests, accompanying the Patriarch of Constantinople, moved slowly to and from the sanctuary and the vast nave, the gorgeous array of

*In W. R. Lethaby, "Santa Sophia, Constantinople," *Architectural Review* (April 1905): p. 12. See also, in somewhat differing translation, Cyril Mango, *The Art of the Byzantine Empire 312–1453: Sources and Documents* (Englewood Cliffs, NJ: Prentice-Hall 1972), 82 ff.

*Colm Luibheid, *Pseudo-Dionysius: The Complete Works* (New York: Mahwah, 1987), 68 ff.

their vestments rivaling its polychromed ensembles of marble, metal, and mosaic, all glowing in shafts of light from the dome.

The nave at Hagia Sophia, as with all Byzantine churches, was reserved for the clergy (unlike our modern understanding of it as intended for a congregation); the centralized plan would favor this. The laity, segregated by sex, were confined to the shadows of the aisles and galleries, restrained in most places by marble parapets. The complex spatial arrangement allowed only partial views of the brilliant ceremony. The emperor alone was privileged to enter the sanctuary. When he participated with the Patriarch in the liturgical drama his rule was again sanctified and his person exalted. Church and state were symbolically made one, as in fact they were. The church building was then the earthly image of the court of Heaven, its light the image of God and God's holy wisdom.

At Hagia Sophia, the intricate logic of Greek theology, the ambitious scale of Rome, the vaulting tradition of the Near East, and the mysticism of Eastern Christianity combine to create a monument that is at once a summation of antiquity and a positive assertion of the triumph of Christian faith.

Ravenna and Mount Sinai

In 493, the city of Ravenna, as we have seen, was chosen by Theodoric, the Goths' greatest king, to be the capital of his Ostrogothic kingdom, which encompassed much of the Balkans and all of Italy. During the short history of Theodoric's unfortunate successors, the importance of the city declined. But in 539, the Byzantine general Belisarius conquered Ravenna for his emperor, Justinian, and led the city into the third and most important stage of its history. Reunited with the Eastern empire, Ravenna remained the "sacred fortress" of Byzantium, a Byzantine foothold in Italy for two hundred years, until its conquest first by the Lombards and then by the Franks. Ravenna enjoyed its

9-4 Church of San Vitale, Ravenna, Italy, 526–547 (view from the southeast).

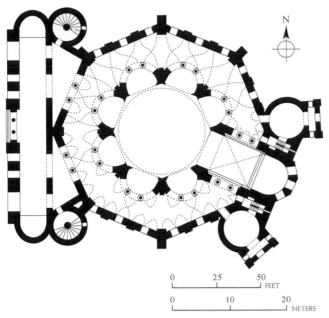

9-5 Plan of San Vitale.

integration between inner and outer spaces that, otherwise, would simply have existed side by side as independent units. A cross-vaulted sanctuary preceding the apse interrupts the ambulatory and provides the plan with some axial stability. This effect is weakened, however, by the unsymmetrical placement of the narthex, the odd angle of which never has been explained fully. (The atrium, which no longer exists, may have paralleled a street that ran in the same direction as the angle at which the narthex is placed; it also has been suggested that the angle of the narthex might have been intended to force visitors to reorient themselves as they entered the complex arrangement of the main space and, thereby, to experience the transition from the material world outside into the spiritual world inside the church.) The ambulatory (FIG. 9-6) has been provided with a second story, the gallery, which was reserved for women and is a typical element of Byzantine churches. Probably also of Byzantine origin are the so-called *impost blocks*, which have been inserted between the simply profiled, but richly patterned, column capitals and the springing of the arches (FIGS. 9-7 and 9-8). Resembling an inverted, truncated pyramid, these impost blocks appear in nearly all Ravenna churches and may be highly abstracted reflections of the entablature segments inserted between column and arch by Late Roman architects.

San Vitale's intricate plan and elevation combine to produce an effect of great complexity; in this respect, it relates on a much smaller scale to Hagia Sophia. Walking through the building, one is struck by the rich diversity of ever-changing perspectives. Arches looping over arches, curving

greatest cultural and economic prosperity during the reign of Justinian, at a time when the "eternal city" of Rome was threatened with complete extinction by repeated sieges, conquests, and sackings. As the seat of Byzantine dominion in Italy, ruled by Byzantine governors, or *exarchs,* Ravenna and its culture became an extension of Constantinople, and its art, more than that of the Byzantine capital (where relatively little outside of architecture has survived), clearly reveals the transition from the Early Christian to the Byzantine style.

The climactic points of Ravenna's history are linked closely with the personages of Galla Placidia, Theodoric, and Justinian. All left their stamp on the city in monuments that survive to our day (one might say miraculously, as the city was heavily bombed in World War II) and that make Ravenna one of the richest repositories of fifth- and sixth-century mosaics in Italy. The monuments of Ravenna, particularly the Justinianic ones, represent ideas that ultimately determined the forms of the culture, and certainly the art, of the Middle Ages.

Begun shortly after Theodoric's death and dedicated by Bishop Maximianus in 547, the church of San Vitale (FIGS. 9-4 to 9-8) features, like the other Ravenna churches, a plain exterior (somewhat marred by a Renaissance portal) and a polygonal apse. But beyond these elements, it is an entirely different building. The structure is centrally planned, like Justinian's churches in Constantinople, and consists of two concentric octagons (FIG. 9-5); the dome-covered inner octagon rises above the surrounding octagon to provide the interior with clerestory lighting. The central space is defined by eight large piers that alternate with curved, columned niches, pushing outward into the surrounding ambulatory and creating, on the plan, an intricate, *octafoliate* (eight-leafed) design. These niches effect a close

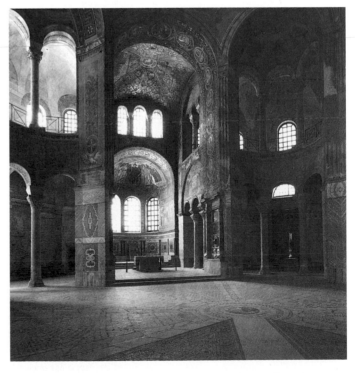

9-6 Interior of San Vitale (view facing forechoir and apse).

9-7 Sanctuary of San Vitale, Ravenna, Italy. Mosaics show in the forechoir (*left*): *Abraham and the Three Angels* and *The Sacrifice of Isaac;* and in the apse (*right*): *Justinian and Attendants.*

and flattened spaces, and shapes of wall and vault seem to change constantly with the viewer's position. Light filtered through alabaster-paned windows plays over the glittering mosaics and glowing marbles that cover the building's complex surfaces, producing an effect of sumptuousness that is not Western but Oriental. And, indeed, the inspiration for this design is to be found in Byzantium rather than Rome. In Constantinople, some ten years before the completion of San Vitale at Ravenna, a church dedicated to the saints Sergius and Bacchus appears to be a rough preparatory sketch for this later church, in which the suggestions of the earlier plan may be seen developed to their full potential.

The mosaics that decorate the sanctuary of San Vitale, like the building itself, must be regarded as one of the climactic achievements of Byzantine art. Completed less than a decade after the surrender of Ravenna by the Goths, the decorations of apse and forechoir proclaim the triumph of Justinian and of the Orthodox faith. The multiple panels of the sanctuary form a unified composition, a theme of which is the holy ratification of the emperor's right to the whole western empire, of which Ravenna was now the principal city. The apse mosaics are portrait groups representing Justinian on one wall (FIG. **9-9**) and his empress,

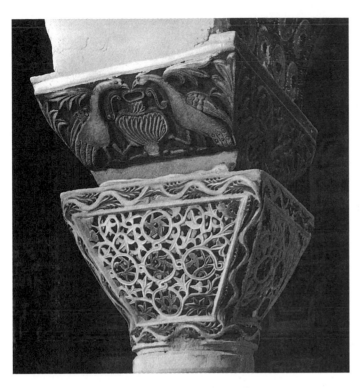

9-8 Capital with impost block from San Vitale.

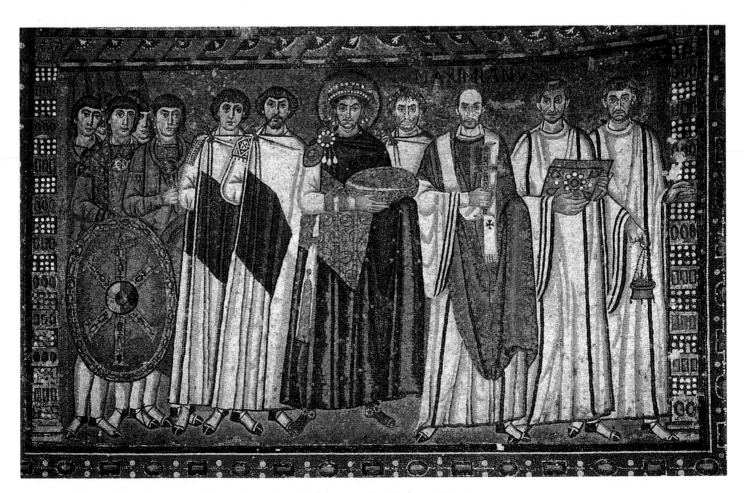

9-9 *Justinian and Attendants,* mosaic from the north wall of the apse, San Vitale, *c.* 547.

Theodora, on the other (FIG. **9-10**). The monarchs are accompanied by their retinues in a depiction of the offertory procession (the part of the liturgy in which the bread and wine of the Eucharist are brought forward and presented). Justinian, represented as a priest-king, carries a vessel containing the bread, and Theodora carries the golden cup with the wine. Images and symbols covering the entire sanctuary express the single idea of humanity's redemption by Christ and the re-enactment of it in the Eucharist. Moses, Melchizedek, Abraham, and Abel are represented as prefigurations of Christ and also as priestly leaders of the faithful, whose offerings to God were declared acceptable to Heaven.

In the apse vault, the Second Coming is represented (FIG. **9-11**). Christ, seated on the orb of the world, with the four rivers of Paradise beneath him and rainbow-hued clouds above, extends a golden wreath of victory to Vitalis, the patron saint of the church, who is introduced by an angel. At Christ's left, another angel introduces Bishop Ecclesius, in whose time the foundations of the church were laid and who carries a model of it. The arrangement recalls Christ's prophecy of the last days of the world: "And then shall they see the Son of Man coming in the clouds with great power and glory. And then shall he send his angels, and shall gather together his elect from the four winds, from the uttermost part of Heaven" (Mark 13:26–27).

It appears that Justinian's offering is acceptable, for the wreath extended to St. Vitalis also is extended to him in the dependent mosaic on the choir (chancel) wall just below and to the right of the vault mosaic (FIGS. 9-7 and 9-9). Thus, his rule is confirmed and sanctified by these rites, in which (as is so typical of such expressions of the Byzantine imperial ideal) the political and the religious, as we have noted, are one. The laws of the Church and the laws of the state, united in the laws of God, are manifest in the person of the emperor and in his God-given right. As we have seen, the pagan emperors had been deified; it could not have been difficult, given that tradition, to accept the deification of the Christian emperor. Justinian is distinguished from his dignitaries not only by his wearing of the imperial purple but also by his halo, a device emanating from ancient Persia and originally signifying the descent of the honored one from the sun and, hence, his godlike origin and status.

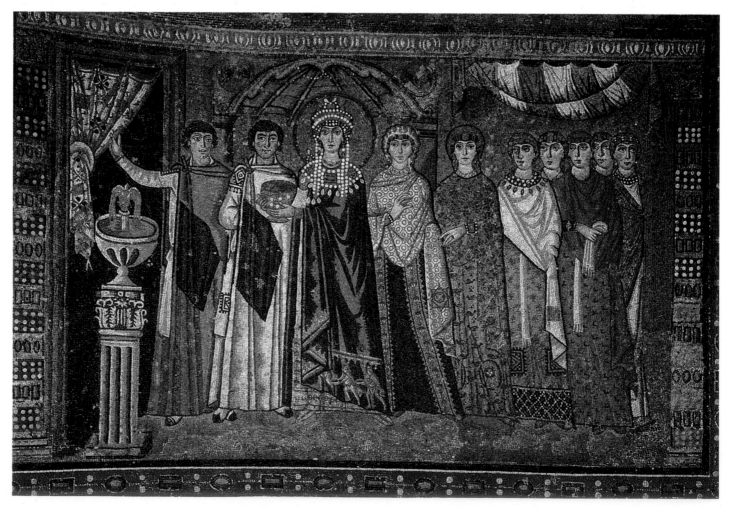

9-10 *Theodora and Attendants*, mosaic from the south wall of the apse, San Vitale.

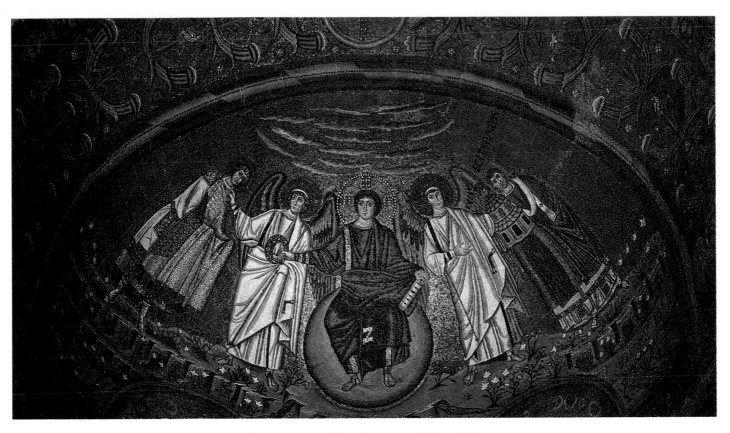

9-11 *Christ Between Angels and Saints* (*The Second Coming*), mosaic from the apse vault, San Vitale.

The etiquette and protocol of the imperial court fuse here with the ritual of the liturgy of the Church (see FIG. 9-9). The positions of the figures are all-important; they express the formula of precedence and the orders of rank. Justinian is exactly at the center. At his left is Bishop Maximianus, the architect of his ecclesiastical-political policy and the man responsible for the completion of San Vitale and its consecration in 547. The bishop's importance is stressed by the label bearing his name, the only identifying inscription in the composition. Between Justinian and Maximianus is Julius Argentarius(?), the principal benefactor of the church. The figures are in three groups: the emperor and his staff (standing for the imperial administration); the clergy; and the army, bearing a shield with the *chi-rho* monogram. Each group has a leader, one of whose feet precedes (by overlapping) the feet of those who follow. A curious ambiguity is observable in the positions of Justinian and Maximianus: although the emperor appears to be slightly behind the bishop, the sacred vessel he carries overlaps the bishop's arm. Thus, symbolized by place and gesture, the imperial and churchly powers are in balance. The paten (the plate holding the bread of the Eucharist) carried by Justinian, the cross carried by Maximianus, and the book and censer carried by his attendant clerics produce a slow, forward movement that strikingly modifies the rigid formality of the scene. No background is indicated; the observer is expected to understand the procession as taking place in this very sanctuary, where the emperor will appear forever as a participant in the sacred rites and as the proprietor of this royal church, the very symbol of his rule of the Western empire.

The portraits of the empress Theodora and her entourage (FIG. 9-10), on the other hand, are represented within a definite architecture, perhaps the narthex of San Vitale (the identification of the locale is still much disputed). The empress stands in state beneath an imperial canopy, waiting to follow the emperor's procession and to pass through the curtained doorway into which she is beckoned by an attendant. The fact that she is outside the sanctuary and only about to enter attests that, in the ceremonial protocol, her rank is not quite equal to that of her consort, even though the representation of the Three Magi on the border of her robe recalls their offerings to the infant Jesus and makes an allusive connection between Theodora and the Virgin Mary.

The figure style shows the maturing of conventions of representation that date back centuries. Tall, spare, angular, and elegant, the figures have lost the rather squat proportions characteristic of much Early Christian work. The gorgeous draperies fall straight, stiff, and thin from the narrow shoulders; the organic body has dematerialized, and, except for the heads, we see a procession of solemn spirits, gliding silently in the presence of the sacrament. Byzantine style will preserve this hieratic mood for centuries, no

matter how many individual variations occur within its conventions.

We can hardly talk of Byzantine art without using the term *hieratic*. Christianity, originating as a mystery cult, kept mystery at its center (one might say that the priest became a specialist in mystery). The priestly supernaturalism that disparages matter and material values prevails throughout the Christian Middle Ages, especially in Orthodox Byzantium. It is that hieratic supernaturalism that determines the look of Byzantine figurative art—an art without solid bodies or cast shadows, with blank, golden spaces, with the perspective of Paradise, which is nowhere and everywhere.

The portraits in San Vitale are individualized, despite the prevailing formality. However, this is true only of the principals; the lesser personages on the outskirts of the groups are treated more uniformly. In these portrait groups memorializing the dedicatory ceremony, the artists undoubtedly intended to create close likenesses of the central characters—the emperor and empress and the high officials of church and state. Since pagan times, the image of the deified emperor in public and sacred places had been tantamount to his actual presence, for the image and the reality were taken to be essentially one.

Thus, the symbol, the image, and what they represent are most often one and the same. Just as the image of Justinian or Theodora or a saint is venerated as if it were the person, so are a cross, relics, and mementos. Even vessels associated with holy rites came to be venerated as real presences of sacred powers that could cure not only spiritually but also physically. To the believer, this communion of reality between objects and what they represent is logical enough. Symbols, images, narratives, sacramental objects—the furniture and accessories of ritual—all can be venerable and spiritually potent in themselves.

In Ravenna, a powerful statecraft under the management of Justinian and Maximianus had been able to combine, in a group of monuments, the full force of Christian belief and political authority. In the process, a model of religious art, sacramental and magical in its power, was created that could work in the service of both the Church and the sanctified imperial state. This model, image, or ideal unity of the spiritual and temporal would influence the Middle Ages strongly in both the East and the West. The hieratic style of Byzantium, matured and exemplified in Ravenna, will remain both the standard and the point of departure for the content and form of the art of the Middle Ages.

The period of Justinianic Ravenna closes with the Church of Sant'Apollinare in Classe, a few miles from Ravenna, where, in the great apse mosaic, the Byzantine style reaches a standard of hieratic imagery. Here, until the ninth century (when it was transferred to Ravenna), rested the body of Saint Apollinaris, who suffered his martyrdom in Classe, Ravenna's port city. The building itself (FIG. **9-12**) is Early Christian in type, a three-aisled basilica with a plan

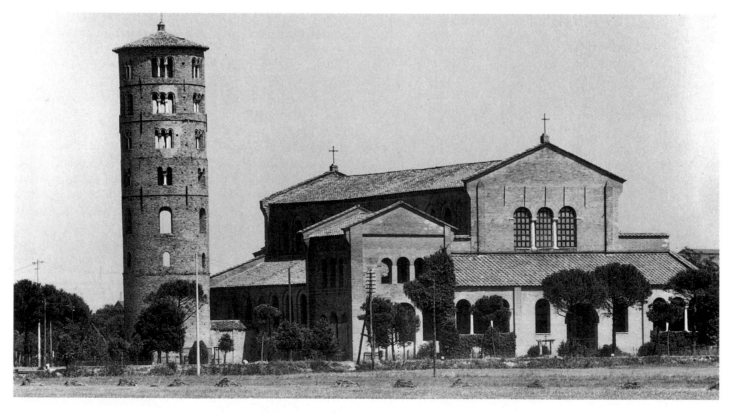

9-12 Sant'Apollinare in Classe, Ravenna, Italy, *c.* 533–549.

quite similar to that of Theodoric's palace-church in Ravenna (FIG. 8-19). The peculiar design of the apse, which combines a semicircular interior with a polygonal exterior, is typical of Ravenna churches and is probably of Byzantine origin. As usual for the period, the outside of the building is plain and unadorned (the cylindrical bell tower, or *campanile*, is of a later date).

The interior decoration in this case is confined to mosaics in the triumphal arch and the apse behind it. Of these, the mosaic decorating the semivault above the apse (FIG. **9-13**) was probably completed by 549, when the church was dedicated. It shows, against a gold ground, a large, blue medallion with a jeweled cross (symbol of the transfigured Christ); this may be another representation of the cross Constantine had erected on the hill of Calvary to commemorate the martyrdom of Jesus—the cross that we also saw represented at Santa Pudenziana in Rome (FIG. 8-14). Visible just above the cross is the hand of God. On either side of the medallion, in the clouds, appear the figures of Moses and Elijah, who appeared before Christ during his transfiguration. Below these two figures are three sheep, the three disciples who accompanied Christ to the foot of the Mount of the Transfiguration. Beneath, in the midst of green fields with trees, flowers, and birds, stands the patron saint of the church, Apollinaris. He is portrayed with uplifted arms, accompanied by twelve sheep, perhaps representing the Christian congregation under the protection of St. Apollinaris, and forming, as they march in regular file across the apse, a wonderfully decorative base. On the face of the triumphal arch above, the image of Christ in a medallion and the Signs of the Evangelists are represented in the rainbow-streaked heavens. The twelve lambs, issuing

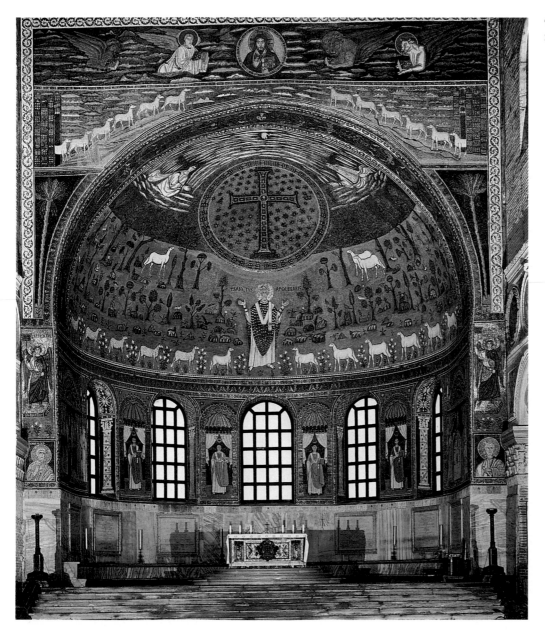

9-13 Apse mosaic from Sant'Apollinare in Classe, *c.* 549.

from the cities of Bethlehem and Jerusalem, are the twelve apostles. The iconographical program is completed by the two palms of Paradise in the narrow spandrels of the arch and by the two archangels below them.

Comparison with the Galla Placidia mosaic (FIG. 8-18) discussed in the previous chapter shows how the style and the artist's approach to the subject have changed during the course of a century. In both cases, we are looking at a human figure and some sheep in a landscape. But in Classe, in the mid-sixth century, the artist no longer tries to recreate a segment of the physical world, but tells the story instead in terms of flat symbols, lined up side by side. All overlapping is carefully avoided in what must have been an intentional effort to omit all reference to the three-dimensional space of the material world and physical reality. Shapes have lost their volume and become flat silhouettes into which details have been inscribed with lines. The effect is that of an extremely rich, flat, tapestry design that tells its story directly and explicitly without illusionistic devices. The Byzantine style has become the ideal vehicle for the conveyance of the extremely complex symbolism of the fully developed Christian dogma and its iconography.

Our apse mosaic, for example, has much more meaning than first meets the eye. The transfiguration of Christ—

here, into the image of the cross—symbolizes not only his own death, with its redeeming consequences, but also the death of his martyrs (in this case, St. Apollinaris). The lamb, also a symbol of martyrdom, is used appropriately to represent the martyred apostles. The whole scene expands above the altar, where the sacrament of the Eucharist—the miraculous recurrence of the supreme redemptive and transfigurative act—is celebrated. The very altars of Christian churches were, from early times, sanctified by the bones and relics of martyrs. Thus, the mystery and the martyrdom were joined in one concept: the death of the martyr, in imitation of Christ, is a triumph over death that leads to eternal life. The images above the altar present a kind of inspiring vision to the eyes of believers; the way of the martyr is open to them, and the reward of eternal life is within their reach. The organization of the symbolism and the images is hieratic, and the graphic message must have been delivered to the faithful with overwhelming force. Looming above their eyes is the apparition of a great mystery, ordered in such a way as to make perfectly simple and clear the "whole duty of man" seeking salvation. That the anonymous artists, working under the direction of the priests, expended every device of their craft to render the idea explicit is plain enough; the devout could read it as easily as an inscription. The martyr's glorification beneath

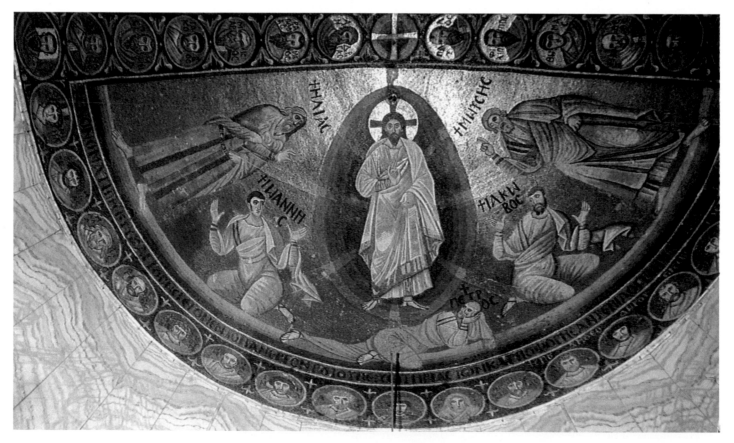

9-14 *The Transfiguration of Jesus,* apse mosaic from the church of the monastery of St. Catherine, Mount Sinai, Egypt, *c.* 560.

the cross, inscribed in the starry heavens, presented in one great tableau the eternal meaning of Christian life in terms of its deepest mystery.

Only slightly later than the Ravenna mosaics, the great apse mosaic in the church of the monastery of St. Catherine on Mount Sinai (on the Sinai peninsula, now under Egyptian control) shows striking divergences from the Ravenna style of San Vitale, though it is closer to the more abstract Sant'Apollinaire in Classe; both are likely to have emanated from Justinian's city, Constantinople. Justinian built the fortress monastery of St. Catherine between 548 and 565; it is unlikely that the apse mosaic could have been done much later than the year of the completion of the church building. In FIG. **9-14**, *The Transfiguration of Jesus* (Mark 9:2–8), Jesus appears in a deep blue *mandorla*, or "glory," flanked by Elijah and Moses, with the disciples John, Peter, and James at his feet; the whole scene is framed by portraits of saints in medallions. The artist has stressed the intense whiteness of Jesus' transfigured, spiritualized form, from which rays stream down on the disciples. The stately figures of Elijah and Moses and the static frontality of Jesus set off the frantic terror and astonishment of the gesticulating disciples in a contrast of the eternal composure of heavenly beings with the distraught responses of the earthbound. All traces of landscape or architectural setting have been swept away and replaced by a depthless field of gold, on which the figures and their labels are fixed in isolation from one another. The gold field is bounded at its base by a rainbow band of colors graduating from yellow to blue, a ground line to which the figures are ambiguously related: sometimes they are placed behind it; sometimes they overlap it. The bodies cast no shadows, even though supernatural light streams over them. We are in the world of mystical vision, where all substance that might suggest the passage of time or motion through physical space is subtracted, so that the eternal and motionless world of religious truth can be contemplated by the devout.

The formal, hieratic style of Ravenna, appropriate to a court church, and the cultic, visionary style of Mount Sinai, appropriate to a monastery church, although standing in obvious contrast, mark two main kinds of expression in Byzantine art and reflect their common source—Justinian's Constantinople.

Another work at Mount Sinai similarly reveals the stylistic traits of the art of Constantinople as it took form in the sixth century. It is an *icon* (image) painted in encaustic on a panel, representing the enthroned Virgin and Child with Saints Theodore and George (FIG. **9-15**). Behind them, two angels look upward to a shaft of light in which appears the hand of God. This format, with minimal variations, will remain typical of the compositional features of Byzantine icons for centuries: the foreground figures are strictly frontal and have the solemn mien of those at Ravenna; background details are few and suppressed; the forward plane of the picture dominates, and space is squeezed out. It is a perfect example of the hieratic style, the mode of

grave decorum that suits liturgical ritual. It is true that there remain traces of late Classical illusionism, in the rather personalized features of the Virgin and in her sideways glance, also in the posing of the heads of the angels, distant echoes of Hellenistic art. But the two guardian saints are quite in the new Byzantine manner, especially St. Theodore, whose piercing eyes are fixed upon the viewer as if summoning—commanding—all observers to witness and revere the miraculous apparition in which he is a participant.

From the sixth century on, the icon, portable or attached to the chancel screen (*iconostasis*) of a church, becomes enormously popular in Byzantine worship, both public and private. This aroused, as we shall see, the indignation and hostility of those Christians who would regard the devotion to icons as idolatry. Depiction of the sacred personages of Christianity was familiar enough in the earlier centuries of the faith. But now attention is focused more sharply on the icon as a portrait of a particular saint or saints, and as a personal, intimate, and indispensable medium for spiritual transaction with them. The icon becomes, even more, a potent sacramental, that is a bearer of curative grace for both body and soul. Icons are regarded as wonder-working, and miracles are ascribed to them. The icon, through its universal production and distribution throughout the Byzantine world, still testifies, above all other sacred objects, to the distinctive function of the holy image in Orthodox worship.

But in this early period of Byzantine art the icon and other figurative depictions of Christ, the Virgin Mary, the angels, prophets, and saints were, as we have noted, by no means universally accepted. From the very beginning many early Christians had been deeply suspicious of the practice of imaging the divine. They had in mind the Old Testament prohibition of images (Exodus 20:4, 5) as given by the Lord to Moses as the second of the Commandments: "Thou shalt not make unto thee any graven image or any likeness of anything that is in Heaven above, or that is in the earth beneath, or that is in the water under the earth. Thou shalt not bow down thyself to them, nor serve them."

When early in the fourth century, Constantia, sister of the emperor Constantine, requested an image of Christ from Eusebius, the first great historian of the Christian church, he rebuked her, referring to the Second Commandment:

> Can it be that you have forgotten that passage in which God lays down the law that no likeness should be made of what is in Heaven or in the earth beneath? Are not such things banished and excluded from churches all over the world, and is it not common knowledge that such practices are not lawful for us . . . lest we appear like idol worshipers to carry our god around in an image?*

*Cyril Mango, *op. cit.*, 16 ff.

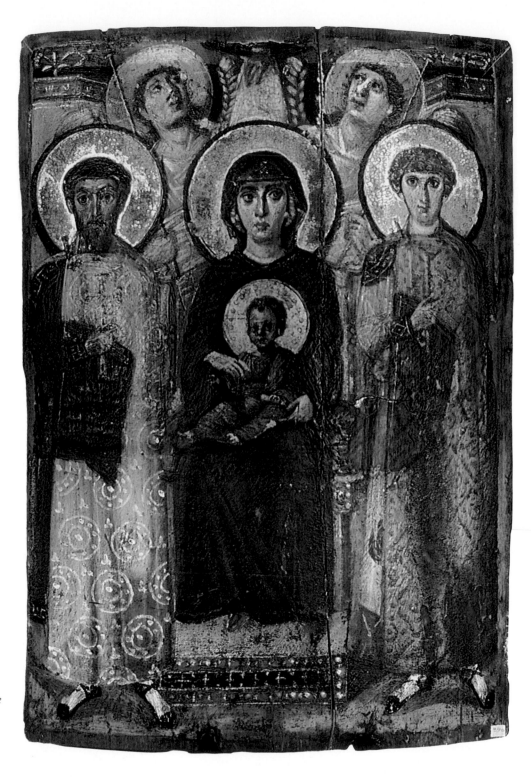

9-15 *Virgin and Child Between St. Theodore and St. George,* painted panel icon in the monastery of St. Catherine, Mount Sinai, Egypt, *c.* sixth to seventh centuries.

We have evidence enough from Early Christian art that images were widely used in churches. The immense popularity of the portable icon especially, beginning in the sixth century, led to abuses of worship that the enemies of religious imagery thought a relapse into pagan idolatry. Opposition to icon worship was especially prominent in the Monophysite provinces of Syria and Egypt. And it was there in the seventh century that a series of calamities

erupted, indirectly bringing about an imperial ban on images—the destruction of them we call "iconoclasm."

The Sasanid Persians, chronically at war with Rome, swept into the Eastern provinces early in the seventh century. Between 611 and 617 they captured the great cities of Antioch, Jerusalem, and Alexandria. Hardly had they been pressed back and defeated by the Byzantine emperor Heraclius, than a new and overwhelming power appeared

unexpectedly on the stage of history. The Arabs, under the banners of the new religion of Islam, conquered not only the Eastern provinces of Byzantium, but Persia itself, replacing Sasanian Persia in the age-old balance of power with the Christian West. In a few years the Arabs were launching attacks upon Constantinople, and Byzantium was fighting for its life.

These were catastrophic years for Byzantium, the New Rome. They terminated once and for all the old empire, the long story of imperial Rome, closed the period we have called Early Byzantine, and inaugurated the medieval era of Byzantine history. Almost two-thirds of the empire's territory was lost—its great cities and much of its population, wealth, and material resources. The shock of these events persuaded the emperors in the eighth century that God had punished the Christian empire for its idolatrous worship of icons by setting upon it the merciless armies of the infidel. The emperors Leo III and Constantine V proscribed the use of images, and for more than a century, the period of Iconoclasm, images were ruthlessly destroyed.

The *iconoclasts* (breakers of images) and the *iconophiles* (lovers of images) became bitter and irreconcilable enemies. The anguish of the latter can be read in a graphic description of the deeds of the iconoclasts, written in about 754:

> In every village and town one could witness the weeping and lamentation of the pious, whereas, on the part of the impious, one saw sacred things trodden upon, (liturgical) vessels turned to other use, churches scraped down and smeared with ashes because they contained holy images. And wherever there were venerable images of Christ or the Mother of God or the saints, these were consigned to the flames or were gouged out or smeared over. If, on the other hand, there were pictures of trees or birds or senseless beasts and, in particular horse-races, hunts, theatrical and hippodrome scenes, these were preserved with honor and given greater lustre.*

The iconophiles blamed the depredations of the iconoclasts on the influence of Islam. Indeed, the mostly Monophysite Christians of the conquered provinces were attracted to Islam, with its simple, *aniconic* (non-image) worship of one, rather than a trinitarian, God, and its sparse ritual and practice. Many of them were converted to the new religion and rendered the swift advance of the Arabs relatively easy.

Needless to say, little religious figurative art survives from the period of Iconoclasm (from 726 to 842). In place of images the iconoclasts used symbolic forms already familiar in Early Christian art: the cross (recall the one that crowns the great mosaic of the apse at Sant'Apollinare in Classe, FIG. 9-13), the vacant Throne of Heaven, the cabinet

with the scriptural scrolls, and so forth. Stylized floral, animal, and architectural motifs provided decorative fill. In this last respect, iconoclastic art much resembled that of Islam, which we shall consider presently.

MIDDLE BYZANTINE ART

In the ninth century, a powerful reaction against Iconoclasm set in; the destruction of images was condemned as a heresy, and restoration of the images began in 843. Shortly thereafter, under the auspices of a new line of emperors, the Macedonian Dynasty, art, literature, and learning spring to life once again. In this great renovation, as it has been called, Byzantine culture recovered something of its ancient Hellenistic sources and accommodated them to the forms inherited from the age of Justinian. Basil I, head of the new dynasty, thought of himself as the restorer of the Roman Empire. He denounced as usurpers the Frankish Carolingian monarchs of the West (see Chapter 11) who, since 800, had claimed the title Holy Roman Empire for their realm. Basil bluntly reminded their emissary that the only true emperor of Rome reigned in Constantinople: they were not emperors of Rome, they were merely "kings of the Germans."

Iconoclasm had forced many Byzantine artists westward, where doubtless they found employment at the courts of these kings of the Germans: their strong influence is felt in the art of the Carolingian period (FIG. 11-14). In North Italy, not far from Milan, wall paintings of great sophistication (FIG. **9-16**) in the church at Castelseprio are unquestionably the work of a Byzantine Greek. Recent scientific

9-16 *The Angel Appearing to Joseph,* detail of wall painting, Santa Maria de Castelseprio, Castelseprio, Italy, 800–850.

*Cited in Mango, *op. cit.*, 152.

tests of the beams and roof tiles of the church date the paintings between 800 and 850. Representing scenes from the life of the Virgin Mary, they are executed in a classicizing style by a deft and practiced hand. The fluent, sweeping, sketchy manner is a descendant of the enduring illusionistic Classicism born in Hellenistic times and destined to recur often in Middle Byzantine painting.

A fine example of the classicizing art of the period is a page from a book of the Psalms of David, the so-called *Paris Psalter* (FIG. **9-17**), which reasserts the artistic values of the Classical past with astonishing authority. The *Psalter* is believed to date from the early tenth century—a time of enthusiastic and careful study of the language and literature of ancient Greece as well as a time when the classics were regarded with humanistic reverence. It was only natural that, in art, inspiration should be drawn once again from the Hellenistic naturalism of the pre-Christian Mediterranean world. David, the psalmist, is seated with

his harp in a flowering, Arcadian landscape recalling those of Pompeian murals. He is accompanied by an allegorical figure of Melody and is surrounded by sheep, goats, and his faithful dog. Echo (or perhaps Spring) peers from behind a trophied column, and a reclining male figure points to an inscription that identifies him as representing the mountains of Bethlehem. These allegorical figures do not appear in the Bible; they are the stock population of Pompeian landscape. Apparently, the artist had seen a work from Late Antiquity or perhaps earlier and partly translated it into a Byzantine pictorial idiom. In the figure of Melody, we find some incongruity between the earlier and later styles. Her pose, head, and torso are quite Hellenistic, as is the light, impressionistic touch of the brush, but the drapery enwrapping the legs is a pattern of hard line. Byzantine illuminations like this repeatedly will exert their influence on Western painting in the Romanesque and Early Gothic periods.

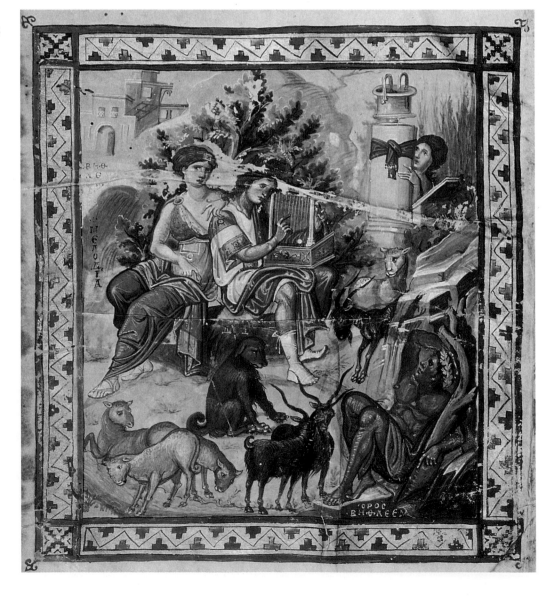

9-17 *David Composing the Psalms,* page from the so-called *Paris Psalter,* *c.* 960. Approx. 15″ × 11″. Bibliothèque Nationale, Paris.

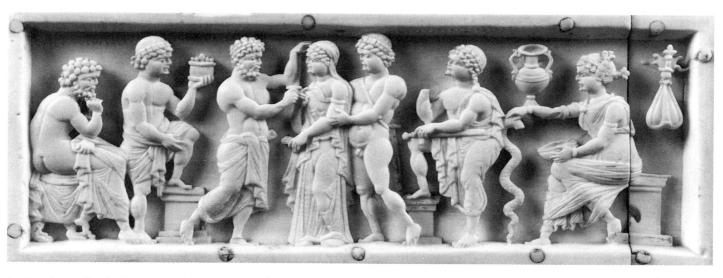

9-18 *The Sacrifice of Iphigenia,* panel from the Veroli Casket, tenth or eleventh century. Ivory, whole casket 4¹/₂″ high, 16″ long. Victoria and Albert Museum, London.

A panel from a small work in ivory, probably a jewel case, the so-called *Veroli Casket* (FIG. **9-18**), testifies to the persistence of Classical form and content in Byzantine art and to their strong revival in the tenth century. The panel depicts a scene at the end of Euripides's play, *Iphigenia in Aulis,* in which Iphigenia, at center, is about to be sacrificed. The characters are all identifiable, and the human types, poses, costumes, and accessories are all from classical anti-

quity, although the stunting of the proportions (perhaps partly a consequence of the diminutive space) and the bulbous modeling show the figures at a considerable distance in time and style from their prototypes in the Greco-Roman world.

From about the same time, the *Harbaville Triptych,* a portable shrine with hinged panels (FIG. **9-19**), manifests in its figures the hieratic formality and solemnity we have

9-19 *Christ Enthroned with Saints,* the *Harbaville Triptych, c.* 950. Ivory, central panel 9¹/₂″ × 5¹/₂″. Louvre, Paris.

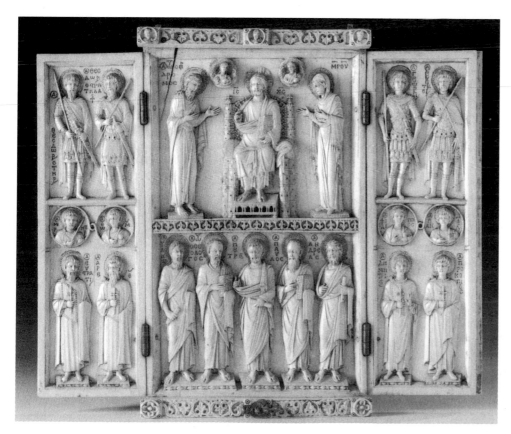

learned to associate with Byzantine art and have seen as standard in the mosaics of Ravenna. A softer, more fluent technique and the looser stance of the figures mitigate the hard austerity of the customary frontal pose. This softening may also result from the influential, classicizing spirit of the Middle Byzantine period. Originating in a workshop associated with the imperial palace in Constantinople, the triptych marshals Christ and the saints in such a way as to align the powers of church and state, of God and emperor. Christ is enthroned between St. John and the Virgin in the upper central zone. Beneath them are five apostles. In the wings are soldier-saints like George and Theodore and bishop-saints like Demetrius and Procopius. Between the levels are portraits of other saints. Here we have, in effect, a miniature, sculptured iconostasis, with the sacred personages placed in their celestial ranks of authority, like officials ranked in the imperial hierarchy.

Portable works like icons and ivories found their way to distant lands as royal gifts, as items of trade, or as plunder, so that the rich and potent religious art of Byzantium became known throughout Europe. Everywhere it had directing influence, nowhere more than in Russia, as we shall see. For the medieval West, the art of Byzantium was to inspire, through its steady influence, an approximating return to the principles of Classical humanism and naturalism long implicit in it.

Architecture

Basil I and his successors undertook the laborious and costly task of refurbishing the churches defaced and neglected by the Iconoclasts, Hagia Sophia first among them. For a while there was little new construction. But in the tenth century and through the twelfth, a number of monastic churches were built that are the flowers of Middle Byzantine architecture.

Monasticism was one of the most powerful institutions of Christianity, both Eastern and Western. Monks and the monasteries to which they were attached wielded great political as well as religious influence throughout the Middle Ages. In Byzantium they were defenders of orthodoxy, often against the government and the established church. Most monks were laymen and so had a certain freedom from the court-dominated patriarchy and the secular clergy. As defenders of images against both court and Patriarch in Iconoclastic times, they were harshly persecuted but became popular heroes. As spiritual guardians of the people, their exemplary works, austerities, charities, and miracles were recounted in numerous "lives of the saints" and treasured by the faithful. Many monks lived lives less than holy and were often a scandal; this did not lessen significantly the hold they had on the imagination, the devotional practice, and the confidence of the religious populace.

The monastic movement began in the third century in Egypt (we have already noted the sixth-century monastery church of St. Catherine at Mount Sinai) and spread rapidly to Palestine and Syria in the East, and as far as Ireland in the West (see Chapter 11). It began as a migration to the wilderness of those who sought a more spiritual way of life, far from the burdens, distractions, and temptations of town and city. In desert places these refuge seekers would live austerely as hermits, in contemplative isolation, cultivating perfection of the soul. So many thousands fled the cities that the authorities became alarmed—noting the effect on the tax base, military recruitment, and business in general. By the fifth century the numbers of these anchorites were so great that confusion and conflict called for regulation. Individuals were brought together to live according to a rule within a common enclosure, a community under the direction of an abbot. They came to be grouped typically in a walled monastery, an architectural complex that included the monks' residence (an alignment of single cells), a refectory (dining hall), kitchen, storage and service quarters, a guest house for pilgrims, and, of course, an oratory or monastery church.

The monastery church of Hosios Loukas in Greece is an outstanding example of church design during the Middle Byzantine period, when a brilliant series of variations on the domed central theme began to appear. From the exterior, the typical later Byzantine church building is a domed cube, with the dome rising above the square on a kind of cylinder or drum. (Less often, some other rectangular form, with something other than a square as its base, was used.) The churches are small, vertical, high-shouldered, and, unlike earlier Byzantine buildings, have exterior wall surfaces with ornament in relief. In the church of the Theotokos (FIGS. **9-20** and **9-21**), built in the tenth century at Hosios Loukas in Greece, one can see the form of a domed cross in square with four equal-length, vaulted cross

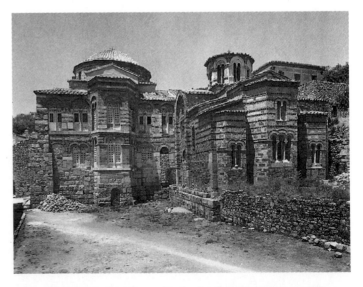

9-20 Monastery churches at Hosios Loukas, Phocis, Greece: The Katholikon, 1011–1022 (*left*), and the Church of the Theotokos, tenth century (*right*). (View from the east.)

arms (the Greek cross); the dome is on pendentives. Around this unit, and by the duplication of it, Byzantine architects developed bewilderingly involved spaces. In the adjacent, larger Katholikon (FIGS. 9-20 and 9-21), built in 1020/1022, a dome is placed over an octagon inscribed within a square; the octagon is formed by *squinches*—arches, corbeling, or lintels that bridge the corners of the square (FIG. **9-22**). This arrangement represents a subtle extension of the older designs, such as Santa Costanza's circular plan (FIG. 8-11), San Vitale's octagonal plan (FIG. 9-5), and Hagia Sophia's dome on pendentives rising from a square (FIG. 9-3). The complex core of the Katholikon lies within two rectangles, the outermost forming the exterior walls. Thus, in plan, from the center out, a circle-octagon-square-oblong series exhibits an intricate interrelationship that is at once complex and unified.

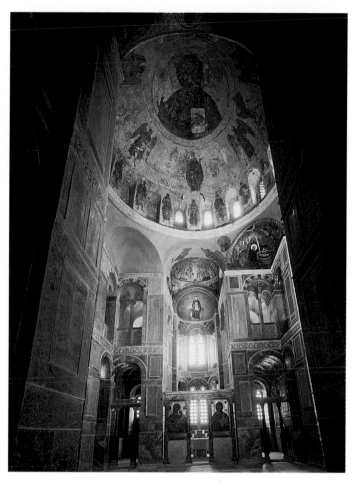

9-23　Interior of the Katholikon (view facing east).

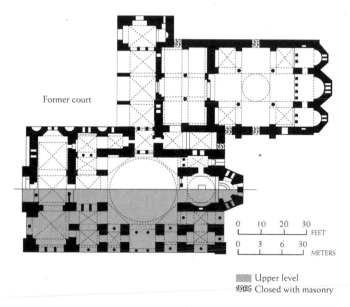

9-21　Plans of the Katholikon (*bottom*) and the Church of the Theotokos (*top*), Hosios Loukas.

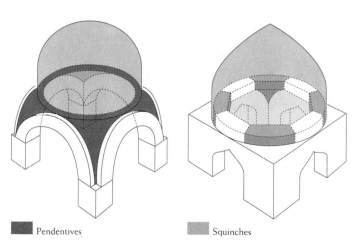

Pendentives　　　　Squinches

9-22　Domes on pendentives (*left*) and squinches (*right*).

The interior elevation of the Katholikon (FIG. **9-23**) reflects its involved plan. Like earlier Byzantine buildings, the church creates a mystery out of space, surface, light, and dark. High and narrow, it forces our gaze to rise and revolve: "The overall spatial effect is overwhelmingly beautiful in its complex interplay of higher and lower elements, of core and ancillary spaces, of clear, dim, and dark zones of lighting."* Thus, the aim of Middle and later Byzantine architecture seems to be the creation of complex interior spaces that issue into multiple domes in the upper levels; these, in exterior view, produce spectacular combinations of round forms that develop dramatically shifting perspectives.

The splendid church of the Holy Apostles, built in the time of Justinian, no longer exists. Fortunately, the great five-domed church of St. Mark's in Venice (FIGS. **9-24** to **9-26**) reflects many of its key elements. The original structure of St. Mark's, dating from the eleventh century, is disguised on its lower levels by Romanesque and Gothic

*Richard Krautheimer, *Early Christian and Byzantine Architecture* (Baltimore: Penguin, 1986), 340.

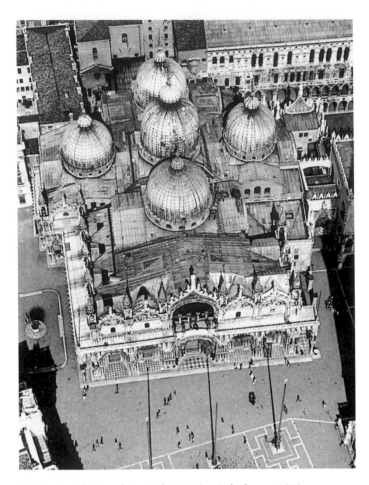

9-24 Aerial view of St. Mark's, Venice, Italy, begun 1063.

additions. But in plan, or from an aerial view, the domes, grouped along a cross of equal arms (the Greek cross again), make the Byzantine origins of St. Mark's evident at once. The inner masonry shells are covered with swelling, wooden, helmetlike forms sheathed in gilded copper; these forms protect the inner domes and contribute to the exuberant composition. Venice, like Ravenna, some 80 miles to the south, was under strong Byzantine influence, despite the independence it had won early in the Middle Ages and preserved for centuries. The interior of St. Mark's is, like its plan, Byzantine in effect, although the great Justinianic scale and intricate syncopation of domed bays here are modified slightly by Western Romanesque elements. The light effects and the rich cycles of mosaics, however, are entirely Byzantine.

Byzantine influence was wide-ranging not only in Italy, but also in the Slavic lands and in the regions of the east into which Islam had expanded. Byzantium exported its script, its religion, and much of its culture to Russia. Russian architecture, magnificently developed in the Middle Ages, is a brilliant, provincial variation on Byzantine themes.

The ecclesiastical architecture of medieval Russia was, at first, if not actually produced by Greeks, at least strongly under the influence of Constantinople. The church of St.

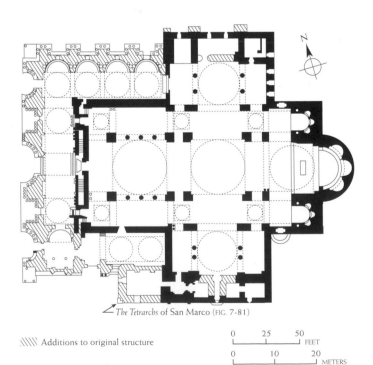

The Tetrarchs of San Marco (FIG. 7-81)

\\\\\ Additions to original structure

0 25 50
|——|——| FEET
0 10 20
|——|——| METERS

9-25 Plan of St. Mark's. (After Sir Banister Fletcher.)

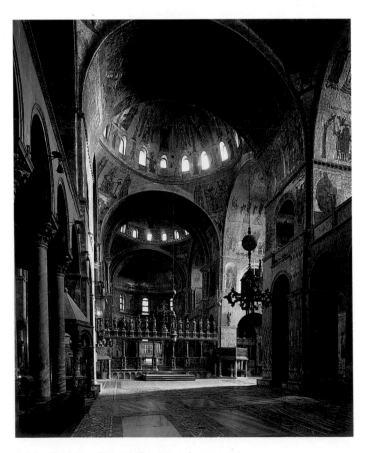

9-26 Interior of St. Mark's (view facing east).

century crucifixion scene, a mosaic on the wall of the monastery church at Daphne in Greece (FIG. **9-28**), shows the simplicity, dignity, and grace of Classicism fully assimilated by the Byzantine artist into a perfect synthesis with Byzantine piety and pathos. Christ is represented on the cross, flanked by the Virgin and St. John. A skull at the foot of the cross indicates Golgotha, the "place of skulls." Nothing is needed to complete the tableau. In quiet sorrow and resignation, the Virgin and St. John point to Christ as if to indicate the meaning of the cross. Symmetry and closed space combine to produce an effect of the motionless and unchanging aspect of the deepest mystery of the Christian religion; the timeless presence is, as it were, beheld in unbroken silence. The picture is not a narrative of the historical event of the Crucifixion, but a devotional object, a thing sacramental in itself, to be viewed by the monks in silent contemplation of the mystery of the Sacrifice. Although elongated, these figures from the Middle Period of Byzantine art (the tenth to the twelfth centuries) have regained their organic structure to a surprising degree, particularly compared to figures from the Justinianic period (compare FIGS. 9-9 and 9-10). The style is a masterful adaptation of Classical, statuesque qualities to the linear Byzantine style.

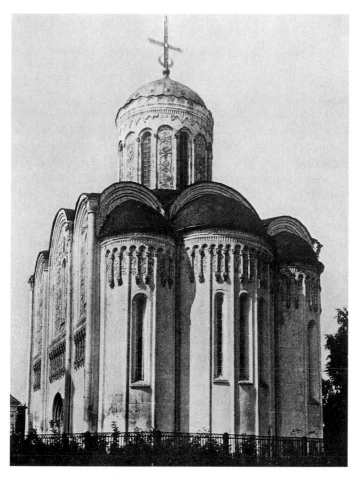

9-27 St. Dmitri at Vladimir, Russia, 1194–1197.

Dmitri at Vladimir (FIG. **9-27**) is built on the typical plan of a square enclosing a Greek cross and crowned with a single dome on a high drum. The church is of stone, a building material rare in Russia, where brick, stucco, and wood are more usual. Exterior wall spaces, which have few openings, are decorated here with moldings. Some of these, rising unbroken from the ground to the roof, divide the wall into panels; others, much shorter, form blind arcadings. The surface within the arcadings is elaborately carved in low reliefs that are peculiarly well adapted to stone and are close, in subject matter and form, to Sasanian and other western Asiatic carvings. The church of St. Dmitri is a masterpiece of simplicity and compactness, with a classic, monumental dignity. Later structures will develop a colorful complexity of plan and elevation.

Painting and Mosaic

When the ban against religious images was lifted and religious painting was again encouraged in Byzantium, a pictorial style emerged that was a subtle blend of the painterly, classicizing Hellenistic and the later, more abstract and formalistic Byzantine style. An eleventh-

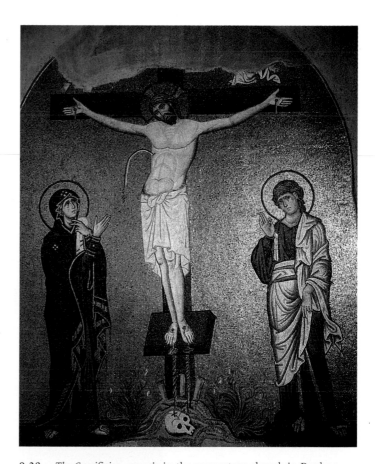

9-28 *The Crucifixion,* mosaic in the monastery church in Daphne, Greece, 1090–1100.

Variations of Byzantine style appeared widely in the twelfth century throughout the Balkan world (Bulgaria, Romania, and the former Yugoslavia) and in Venice, Southern Italy, and Sicily, where Mediterranean powers were eager to adopt Byzantine art and culture. At Nerezi in the former Yugoslavia (ancient and now modern Macedonia), paintings of amazing emotional power have been found that contrast dramatically with the almost stern formalism and hieraticism of the Daphne mosaic. The *Lamentation over the Dead Christ* (FIG. **9-29**), from the second half of the twelfth century, is a tableau of passionate grief. The friends of Christ are captured in attitudes, expressions, and gestures of quite human bereavement. The artist has striven above all to make this realization of the theme utterly convincing. The stirring staging of the subject points forward to the art of thirteenth-century (Gothic) Italy, when the reception of this mode of emotional realism would carry all before it into the Italian "Late Gothic" and the art of Giotto (compare FIG. 19-11).

In the art of the Middle Byzantine Period, particularly in its later phase, a kind of dialogue takes place between the formal, symbolic, hieratic style of the Daphne mosaic and the intense, emotional, active style of the Nerezi murals. The choice of one alternative over the other depended on the site and on ecclesiastical, political, and artistic intentions. An example of the hieratic style accommodated to a monumental site is found in the great cycle of mosaics at St. Mark's in Venice. Recent cleaning and restoration on a grand scale have returned the mosaics (FIGS. 9-26, 9-30) to their original splendor. It is now possible to experience, in all its iconographic complexity, the awe-inspiring decorative program of a major Byzantine church. One can appreciate to the fullest the radiance of mosaic (some 40,000 square feet of it!) as it covers, like a gold-brocaded and figured fabric, all architectural surfaces—walls, arches, vaults, and domes. This is the setting for the presentation of the divine personages—once banished by Iconoclasm—who preside in this church as they preside in the spiritual universe—though image and archetype are carefully distinguished by the post-Iconoclastic theology. The images receive, however, the reverence due them as would the saints in Heaven.

In the vast central dome, 80 feet above the floor and 42 feet in diameter, Christ reigns in the company of the Evangelists, the Virgin Mary, the Virtues, and the Beatitudes. The great arch, which partly interrupts our view of the dome, bears a narrative of the Crucifixion and Resurrection of Christ and of his liberation of the worthies of the Old Testament from death, the theme known as the Harrowing of Hell (see next paragraph). On these golden surfaces, the figures ("sages standing in God's holy fire"), levitating and insubstantial, are drawn with a flowing, calligraphic line; they project from their flat field no more than the letters of the elegant Latin script that captions them. Nothing here reflects on the world of matter, of solids, of light and shade, of perspective space; the trees are ornamental standards, the furniture of Paradise. We have before us the open book of the heavenly order, its image as solemn and hieratic as the sacred text that reveals it in words. Here, in hierarchical placement, the chief mysteries and narratives of the Christian Church are arrayed to present the supernatural and eternal world to which its dogma refers.

One of the most originally interpretive, powerfully expressive, and unforgettable scenes is the *Anastasis* (Greek: resurrection), or *Harrowing of Hell* (FIG. **9-30**). Between his death and resurrection, Christ, bearing his cross, descends into Limbo, where he tramples Satan and receives the supplication of the faithful at the left and the witness of St. John the Baptist and the prophets at the right. He has come to liberate those righteous who had died before his coming. The composition is boldly asymmetrical: the off-center,

9-29 *Lamentation over the Dead Christ,* wall painting, St. Pantaleimon, Nerezi, Macedonia (formerly Yugoslavia), 1164.

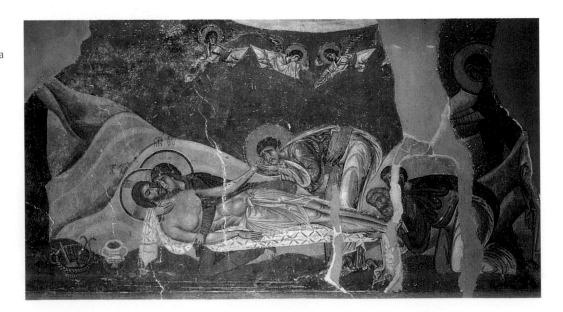

giant figure of Christ dominates it by the strength and span of his stride, the direction and intensity of his glance, and the imperious firmness with which he seizes the hand of Adam, the focus of the whole design. The hands of Eve and the other worthies of the Old Dispensation make of them-

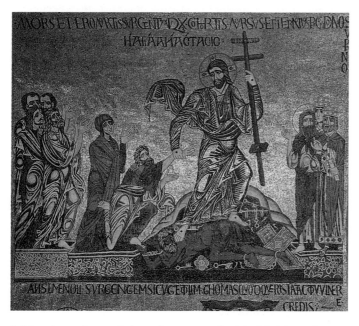

9-30 *Anastasis,* mosaic from the west vault of St. Mark's, Venice, *c.* 1180.

selves a pathetic chorus of begging gestures converging to the saving hand of Christ. Swirling draperies that leap and spin into waves and volumes compose a dramatic calligraphy. The jagged angularities of agitated pose and gesture are silhouetted with passionate eloquence against a featureless golden ground. This is a masterpiece of emotional, as well as hieratic, abstraction, merging the traits of both Daphne and Nerezi. The iconography is Byzantine; but the stage direction, the narrative, and psychic tension are believed to be the work not of a Byzantine Greek but of a Venetian master, an outstanding member of the great school of mosaicists that flourished at St. Mark's in the twelfth and thirteenth centuries.

The completion of the architectural fabric of St. Mark's with its magnificent Middle Byzantine mosaic decoration was a costly enterprise. Over the long run Venice could afford it—the Venetians, once sharing with Byzantium a monopoly of commerce in the eastern Mediterranean, seized full control in the twelfth and thirteenth centuries.

Venetian success was matched in the western Mediterranean by the Normans who, having driven the Arabs from Sicily, set up a powerful kingdom there, the resources of which were a match for those of Venice. Though they were the enemies of Byzantium, the Normans, like the Venetians, assimilated Byzantine culture. In their Sicilian kingdom, the mosaics of the great church of Monreale (FIG. **9-31**), not far from Palermo, are striking evidence of Byzantium's presence.

9-31 *The Pantocrator, with the Virgin, Angels, and Saints,* apse mosaic from the royal church of Monreale, Sicily, late twelfth century.

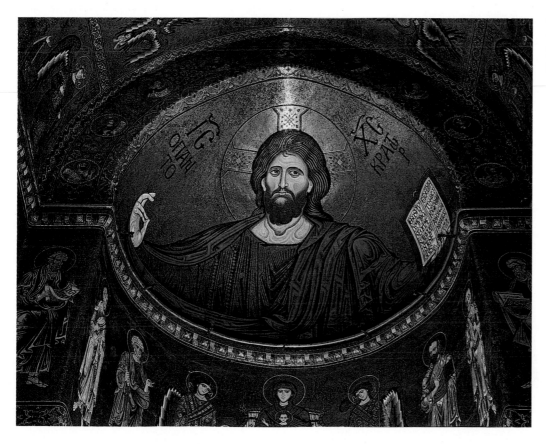

The apse mosaic in the hieratic style is part of a program of ecclesiastic-artistic aggrandizement conducted by Roger, the great Norman king of Sicily. Roger imported the splendor of Byzantium to justify his claim and glorify his reign, convinced that his own sovereign power was bestowed on him by divine authority. The image of Christ as Pantocrator, as ruler and judge of Heaven and earth, looms menacingly in the vault of the apse, a colossal allusion to kingly power, and a challenge to all who would dispute the royal right. In Byzantium proper, the Pantocrator's image usually appears in the main dome of centralized churches like Daphne, but these are monastic churches and not built for the glorification of monarchs. Monreale, moreover, is a basilica—longitudinally planned in the Western tradition; the semi-dome of the apse, as the architectural focus of the plan, would be the most conspicuous place for the vast image with its politically propagandistic overtones. Below the Pantocrator in rank and dignity, the Virgin and saints are symmetrically arranged, and the stern formalities of style characteristic of Byzantine hieraticism are conventionally observed.

In reviewing exemplary Middle Byzantine art on small scale (manuscript illumination and ivory carving) or on large scale (mural painting and mosaic) we must not neglect that especially Byzantine devotional object, the portable painted icon. After the restoration of images, the type was multiplied by the thousands to meet the requirements of public and private worship. One example, the renowned *Vladimir Madonna* (FIG. **9-32**), is a masterpiece of its kind and may be taken as a standard by which its myriad relatives might be judged. Descended from works like the Mount Sinai icon (FIG. 9-15), the *Vladimir Madonna* clearly reveals the stylized abstraction that centuries of working and reworking of the conventional image have wrought. Painted by an artist in Byzantium, the characteristic traits of the Byzantine icon of the Virgin and Child are all present: the sharp, sidewise inclination of the Virgin's head to meet the tightly embraced Christ Child; the long, straight nose and small mouth; the golden rays in the infant's drapery; the decorative sweep of the unbroken contour that encloses the two figures; the flat silhouette against the golden ground; the deep pathos of the Virgin's expression as she contemplates the future sacrifice of her son.

The icon of Vladimir, like most of its kind, has seen hard service. Placed before or above altars in churches or private chapels, it was blackened by incense and the smoke from candles that burned before or below it. It was frequently repainted, often by inferior artists; only the faces show the original surface. First painted in the later twelfth century, it was exported to Vladimir in Russia—hence its name—and then, as a wonder-working image, was taken in 1395 to Moscow to protect that city from the Mongols. As the especially sacred picture of Russia, it saved the city of Kazan from later Tartar invasions, and all of Russia from the Poles in the seventeenth century. Its form, destination, and reverent reception stand as historically symbolic of the religious and cultural mission of Byzantium to the Slavic world.

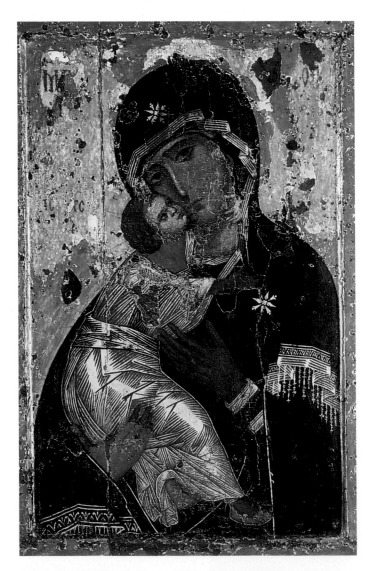

9-32 *The Vladimir Madonna*, twelfth century. Painted wood, original panel approx. 30¹/₂″ × 21″. State Historical Museum, Moscow.

LATE BYZANTINE ART

When rule passed from the Macedonian to the Comnenian Dynasty in the later eleventh and twelfth centuries, three events of fateful significance changed the fortunes of Byzantium for the worse: the Seljuk Turks conquered most of Anatolia, the Eastern half of the empire, the Byzantine Orthodox Church broke finally with the Church of Rome, and the Crusades brought the Latins (a generic term for the Germanic peoples of the West) into Byzantine lands on their way to fight for the Cross against the Saracens (Muslims) in the Holy Land. We have already noted the hostility of the Venetians and the Normans

toward Byzantium. This was now amplified by the religious animosity brought on by the division of the two churches (the Latins called the Greeks "heretics"), as well as by the political and economic ambitions of the Crusaders. For over a century, military expeditions had passed through Constantinople en route to "smite the infidel" and had marveled at its wealth and magnificence. Envy, greed, religious fanaticism, and even ethnic enmity motivated the Crusaders when, in 1203 and 1204, they were persuaded by the Venetians to divert their expedition against the Saracens in Palestine and to attack Constantinople instead.

The city was taken and atrociously sacked in a manner so horrible as to be remembered by Greek peoples to this day. Nicetas, a contemporary historian, expressed the feelings of the Byzantines toward the Crusaders: "The accursed Latins would plunder our wealth and wipe out our race. . . . Between us there can be only an unbridgeable gulf of hatred. . . . They bear the Cross of Christ on their shoulders, but even the Saracens are kinder."*

The Latins set up kingdoms within Byzantium, notably in Constantinople itself. What was left of Byzantium was split into three small states. One of these, the kingdom of Nicaea, was ruled by a member of the Palaeologan clan. In 1261, Michael VIII Palaeologus succeeded in recapturing Constantinople. But his empire was no more than a fragment, and even that disintegrated through the next two centuries. Isolated from the Christian West by Muslim conquests in the Balkans, and besieged by Muslim Turks to the east, Byzantium sought help from the West; it was not forthcoming. In 1453, the Ottoman Turks, now a formidable power, captured Constantinople and brought to an end the long history of Byzantium.

Despite the grim political condition of the state under the Palaeologan dynasty, the arts flourished well into the fourteenth century. And it was during this period that Byzantine art would stimulate even more the creative genius of the Balkans and of Russia.

Architecture

Late Byzantine architecture does not depart radically from the characteristic plans and elevations of Middle Byzantine architecture. But there is an increase in the number of domes and drums, which are arranged in dramatic groupings. Elevations are narrower and steeper, wall and drum arcades are more deeply cut back into overlapping arches. The eaves are rhythmically curved and the external walls ornamented with a variety of patterns in brick.

The church of St. Catherine in Thessaloniki (FIG. **9-33**), second city to Constantinople, shows all these Palaeologan variations on the grand stylistic theme of Middle Byzantine

*See Nina G. Garsoïan, "Later Byzantium," in John A. Garraty and Peter Gay, eds., *The Columbia History of the World.* (New York: Harper and Row, 1972), 453.

9-33 Church of St. Catherine, Thessaloniki, Greece, *c.* 1280.

architecture. The plan is an inscribed cross with a central dome and four additional domes at the corners. On the exterior these appear as *cupolas*, drums with shallow caps, the central drum rising a level above the others; there is thus a vertical gradation from a rectilinear base to the cylindrical volumes of the superstructure culminating in the dominant central unit. Wall and drum arcades are grouped rhythmically in alternating pairs and triads. Lively patternings face and punctuate the enframements of arches and niches and the scalloped eaves. The intricate harmonizing by alternation and repetition of walls and openings, and of verticals, half-circles and cylinders, produces a kind of architectural fugue. The complexity of surfaces and details characteristic of the interiors of earlier Byzantine buildings now breaks out to the exterior. The Late Byzantine architect aims for and achieves here a structural and ornamental unity of maximum visual effect—an effect that, in contrast with, say, San Vitale or Hosios Loukas, is conspicuously public and opulently picturesque.

This lively Late Byzantine grouping of the elementary architectural features—arch, arcade, drum, and dome—is greatly expanded in the late medieval churches of Russia, long the receptive province of Byzantine culture: we have noted the Byzantine features of the church of St. Dmitri at Vladimir (FIG. 9-27). Within the walls of the Kremlin at Moscow, the Cathedral of the Annunciation (FIG. **9-34**) shows a quite Russian interpretation of the received Byzantine scheme. All the elements are here in the superstructure, multiplied, attenuated, tightly clustered in complex harmonies of form, stepping upward and inward to a dramatic cadence in the central cupola (the musical analogy is inescapable!). Above the roof lines, complicated by cusped arches, the drums are now slender towers, their caps swelling out into the distinctive helmet and onion shapes that familiarly identify the old Russian skyline. The

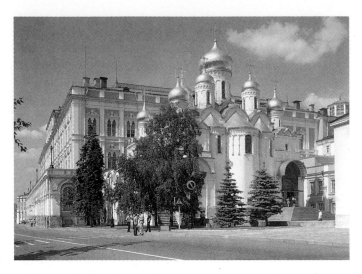

9-34 Cathedral of the Annunciation, the Kremlin, Moscow, 1482–1490.

bel arcades that punctuate the eaves of the apses and the towers. A cool simplicity takes the place of Byzantine complexity. This is a new style, imported from Lombard Italy at this the time of the early Renaissance. Lombard architects were everywhere at work in the Kremlin. Though the Cathedral of the Annunciation was built by Russian architects, it was a hybrid: Byzantine in plan, Russian in superstructure, North Italian in the lower elevation and in the ornamental program. At the very time of the fall of Constantinople, a powerful Classical influence was arriving from the West.

Painting

bright metal domes, peaked with crosses like miniature masts, reflect the moody Russian skies, proclaiming in architectural polyphony the glory of the Orthodox faith.

Below the intricate rhythms of the superstructure, the walls of apses, chapels, and narthex reveal features foreign to Byzantine style. The ornamental brickwork that textured St. Catherine's at Thessaloniki (FIG. 9-33) has been replaced by smooth stone surfaces paneled off by pilasters regularly and symmetrically placed. Ornament is limited to the cor-

Although carved ornament regularly appeared in Byzantine churches, monumental sculpture in stone, metal, or wood was never encouraged; this alone would set Byzantine artistic practice well apart from the Latin West. Life-size figures in the round were offensive to the East Christian sensitivity to the worship of images, pagan or Christian; the Iconoclastic experience had done little to change the prevailing attitude. As we have seen, the Byzantine sculptor was called on to carve small statues and reliefs, especially in ivory, to be used primarily for private devotional purposes, although secular themes often appeared (see FIG. 9-18). Ivory carvings were used to adorn books, caskets (jewel boxes), portable plaques, and venerable images in much the same manner as the painted icons (FIG. 9-19).

9-35 *The Harrowing of Hell,* fresco from the Mosque of the Káriye, Istanbul, Turkey, c. 1310–1320.

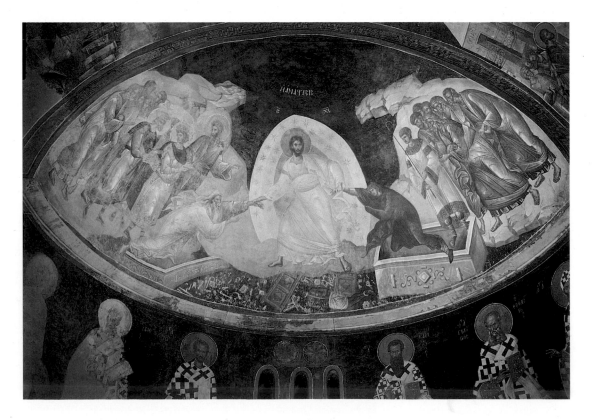

In Late Byzantine art, painting, like architecture, is enlivened by a new burst of creative energy; masterpieces of mural and icon painting are produced, rivaling those of the earlier periods.

A mural painting (FIG. **9-35**) in the apse of the *parekklesion* (side chapel) of the Mosque of the Káriye in Constantinople (formerly the Church of the Holy Saviour of the Chora) gives us another striking version of the theme of the Anastasis, represented earlier at St. Mark's in Venice (FIG. 9-30). In Byzantine tradition the resurrection of Christ (*Anastasis*) is identified with Christ's descent into Limbo (Harrowing of Hell), while the West sees the resurrection as the rising of Christ from the tomb (FIGS. 21-30, 23-4). In the Mosque of the Káriye, the Anastasis is central to a cycle of pictures portraying the theme of human mortality and redemption by Christ and the intercession of the Virgin.

As in the version in St. Mark's, Christ, trampling Satan and all the locks and keys of his prison house of Hell, raises Adam and Eve from their tombs in the presence of John the Baptist, King David, and King Solomon on the one hand, and the righteous of the Old Dispensation on the other (these are led by St. Stephen, first of the martyrs of the New Dispensation). Christ does not carry the cross, but is glorified instead by a luminous mandorla.

Comparison with the St. Mark's version reveals sharp differences in composition, expression, and style of figuration. Formal symmetry has returned with Christ at the center, his pose and gaze essentially frontal, his hands, free of the cross, reaching out equally to Adam and Eve. Instead of the rough, tormented angularities of the St. Mark's mosaic, the action is swift, smooth, even suave; all tension is erased, the motions are supple and executed with the grace of a ballet. The figures float and levitate in a spiritual atmosphere, spaceless, without material mass or shadow-casting volume. This same smoothness and lightness can be seen in the modeling of the figures and the subtly nuanced coloration. The jagged abstractions of drapery found in the St. Mark's figures have melted away, and there is a return to the fluent delineation of drapery characteristic of the long tradition of Classical illusionism.

It is useful here to compare the Anastasis of the Káriye not only with that of St. Mark's, but also with the *Transfiguration* mosaic of St. Catherine's at Mount Sinai (FIG. 9-14). This comparison sets side by side outstanding works from the three great periods of Byzantine art. Despite obvious differences of individual style and expression, we note an essential conservatism that determines the iconography, composition, figural and facial types, and bodily attitudes, and the rendering of space and volume, as well as the human form and its drapery. Throughout its history, Byzantine art looks back to its antecedents, Greco-Roman illusionism as transformed in the age of Justinian. Like Orthodox religion, it is suspicious of any real innovation, especially that imported from outside the Byzantine cultural sphere. Its images are drawn once and for all from a persisting and conventionalized vision of a spiritual world that is not susceptible to change. It is not concerned with the systematic observation of material nature as the source of its imaging of the eternal. That would be the concern of the art of the West.

Byzantine spirituality is most intensely felt in the art of the painted icon, which, from the fourteenth century on, will form the principal foundation of the art of Russia. One such work, a two-sided icon meant to be carried in religious processions, represents, on the one side, the Annunciation (FIG. **9-36**); the other side represents the Virgin as the savior of souls. On the Annunciation side, with a commanding gesture of heavenly authority, the angel Gabriel announces to the Virgin Mary that she is to be the mother of God. She responds with a simple gesture conveying both astonishment and acceptance. The gestures and attitudes of the figures are conventional; like the highly simplified architectural props, they have a long history in the iconographical vocabulary of Byzantium. The tall, elegant figure of the angel, the smooth rhythm of its

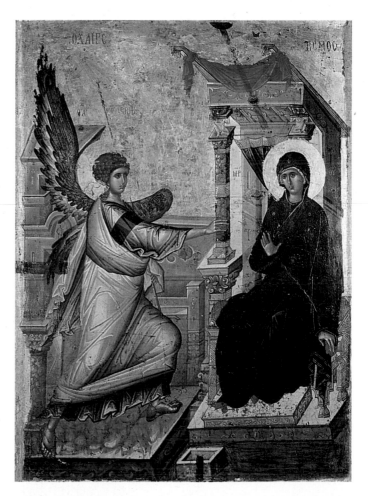

9-36 *Annunciation*, reverse of two-sided icon from the church of St. Clement, Skolpje, Macedonia (formerly Yugoslavia), *c.* 1340?–1370? Macedonian State Collections.

striding motion, and the delineation and modeling of the drapery reveal its close stylistic kinship to the Christ figure of the Káriye mural. Both are exemplary of the high artistic achievement of metropolitan Constantinople in the Palaeologan revival.

In Russia, icon painting flourished for centuries, extending the life of the style well beyond the collapse of the Byzantine Empire in 1453. The development of the *iconostasis*—the large, icon-bearing screen that shuts off the sanctuary from the rest of the church—into an elaborate structure with more than five tiers had an important effect on icon painting. The purpose of these paintings was to enable the worshiper to read pictorially. Clear, pictorial legibility in wavering candlelight and through clouds of incense required strong pattern, firm lines, and intense color. Hence, the relatively sober hues of the Early

Byzantine paintings gave way, more characteristically, to the intense, contrasting colors used in Russia. It was under a renewed Byzantine impulse, after the waning of the Mongol domination, and through the requirements of the iconostasis (just then reaching its highest development), that Russian painting reached a climax in the work of ANDREI RUBLĖV (*c.* 1370–1430). *The Old Testament Trinity Prefiguring the Incarnation* (FIG. **9-37**) is a work of great spiritual power, as well as an unsurpassed example of subtle line in union with intensely vivid color. The three angels who appeared to Abraham near the oaks of Mamre (Genesis 18:2–15) are seated about a table. (The angels are interpreted in Christian thought as a prefiguration of the Holy Trinity after the incarnation of Christ.) The figures, each framed with a halo and sweeping wings, are languorously poised within an implicit circle, each, in its way,

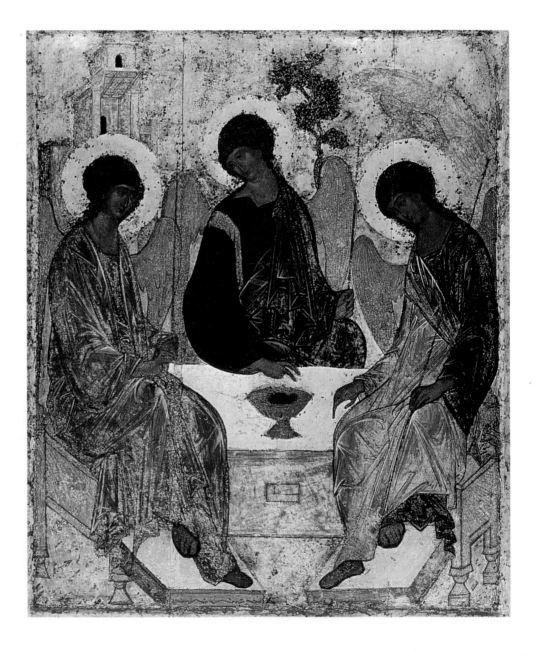

9-37 ANDREI RUBLĖV, *The Old Testament Trinity Prefiguring the Incarnation, c.* 1410. Painted wood, 56″ × 45″. Tretyakov Gallery, Moscow.

appearing rapt in meditation on the mystery of the Trinity. The tranquil demeanor of the figures is set off by the light, linear play of the draperies. Forms are defined by color, and areas frequently are intensified by the juxtaposition of a complementary hue—the intense blue and green folds of the cloak of the central figure, for example, stand out starkly against the deep red robe and the gilded orange of the wings. In the figure on the left, the highlights of the orange cloak are an opalescent blue-green. The color harmonies are Oriental in their unmodulated saturation, brilliance, and purity. In Russian painting, the Byzantine tradition was enlivened and enriched by a feeling and a touch that were not Byzantine or native but, rather, a fusion of the two; the same can be said of Russian architecture.

We should not forget, in considering the rich ecclesiastical art of Byzantium and Russia, the indispensable part played by other arts in the ensemble of a church interior: the carvings and rich metalwork of the iconostasis; the finely wrought, jeweled halos and other ornaments on the icons; the candlesticks and candelabra; the miters and ecclesiastical robes stiff with gold, embroidery, and jewels; the illuminated books bound in gold or ivory, inlaid with jewels and enamels; the crosses, croziers, sacred vessels, and processional banners. Each, with its great richness of texture and color, contributed to the total effect. In the life of Orthodox Byzantium, to produce this effect was to honor God and his vicar, the emperor.

With the passing of Byzantium, it was Russia that became the self-appointed heir and the defender of Christendom against the infidel. The court of the Tsar declared: "Because the Old Rome has fallen, and because the Second Rome, which is Constantinople, is now in the hands of the godless Turks, thy kingdom, O pious Tsar, is the Third Rome. . . . Two Romes have fallen, but the Third stands, and there shall be no more."*

This sense of inheritance and mission shaped the course of Russian and Turkish political relations well into the twentieth century. And despite the iconoclasm of the Bolshevik revolution and the Soviet regime, the Orthodox Christianity of "Holy" Russia has, apparently, lived on.

The mystic splendor of Byzantium has long since faded into the harsh light of modern day. But the icon, old or new, still presides in unchanging form at the devotions of the pious. And in our own times, when ethnic identity is a burning question, icons painted by anonymous artists (FIG. **9-38**) reappear, emblems by which a people proudly recognize themselves in terms of the glory of their past. Painted

*Nina Garsoïan, *op. cit.*, 460.

on rock faces in fugitive colors, only slightly more permanent than graffiti, these images are in the style of the high period of Byzantine art, the twelfth century (FIG. 9-32). The contemporary artists who create these images disdain to modernize their theme or their style. For them, their history and identity are given in these age-old images, and the act of painting them validates the painters' claims to be forever citizens of New Rome, of Byzantium.

9-38 Modern icon rock paintings *The Virgin* and *Music-Making Saints* or *David Playing the Harp for Saul (?)*, public park, The Plaka, Athens, Greece, late twentieth century.

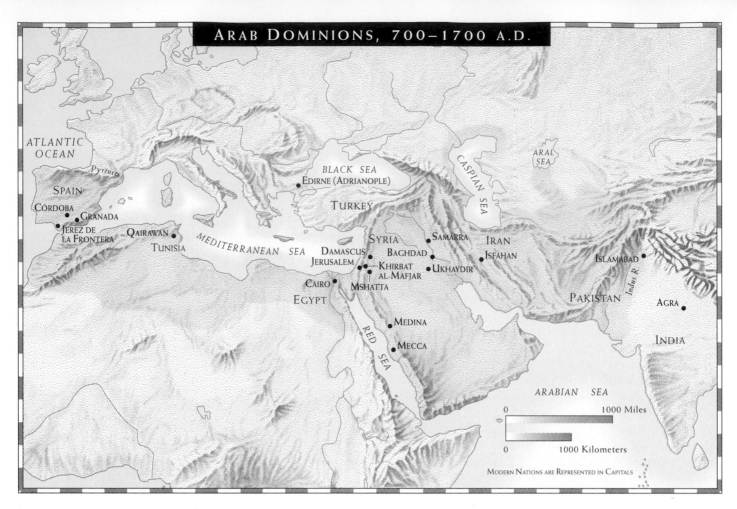

ARAB DOMINIONS, 700–1700 A.D.

ATLANTIC OCEAN

SPAIN
Pyrenees
CÓRDOBA
GRANADA
JEREZ DE LA FRONTERA
QAIRAWAN
TUNISIA

MEDITERRANEAN SEA

BLACK SEA
EDIRNE (ADRIANOPLE)
TURKEY

CASPIAN SEA

ARAL SEA

SYRIA
DAMASCUS
JERUSALEM
KHIRBAT AL-MAFJAR
MSHATTA
CAIRO
EGYPT

SAMARRA
BAGHDAD
UKHAYDIR

IRAN
ISFAHAN

ISLAMABAD
Indus R.

PAKISTAN

AGRA

INDIA

RED SEA

MEDINA
MECCA

ARABIAN SEA

0 1000 Miles

0 1000 Kilometers

MODERN NATIONS ARE REPRESENTED IN CAPITALS

500	600	700	800	900

FOUNDATION & EXPANSION OF ISLAM UMMAYAD CALIPHATE OF CÓRDOBA

UMMAYAD CALIPHATE OF BAGHDAD ABBASID CALIPHATE OF BAGHDAD

FATIMID CALIPHATE OF EGYPT

Dome of the Rock
Jerusalem, 691

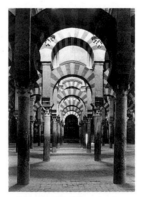

Mosque, Córdoba, 784–987

Birth of Muhammad, 570?

Hejira, 622

Arab conquests of Iraq, Syria, Egypt and Persia, 633–643

War with Byzantium, 791–809

al-Mamun (Mamun the Great), 813–833

al-Kwarizmi, mathematician, 835

Ibn Sina (Avicenna), 980–1037

CHAPTER 10

ISLAMIC
ART

1000	1100	1200	1300	1400	1500	1600

SAFAVID DYNASTY IN PERSIA ▶

MUGHAL EMPIRE IN INDIA ▶

THE SELJUK TURKS | OTTOMAN EMPIRE ▶

Ardebil Carpet, 1540

Madrasa and Mausoleum
of Sultan Hassan
Cairo, 1354-63

Leila and Majnun
in School, 1524-25

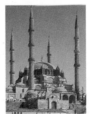

Sinan the Great.
The Selimiye Cami
Edirne, 1569-1575

Masjid-i Shah
Isfahan, 1630-31

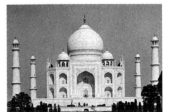

Taj Mahal, India, 1632-54

Firdawsi, Persian epic poet, d. 1020

Christians begin reconquest of Spain from Muslims, 1085

Crusaders capture Jerusalem, 1099 Sinan "The Great", 1491-1588

Omar Khayyam, d. 1123 Ottoman Turks capture Constantinople. End of Byzantine Empire, 1453

Mongol invasions, 1221-1260 Christians capture Granada. Muslims driven from Spain, 1492

Mamluk Sultanate in Egypt, 1250/60-1517

Islam, one of the world's great religions, arose among the peoples of the Arabian peninsula early in the seventh century; we have noted its impact on Christian Byzantium. The Arabs were a population of nomadic herdsmen and caravan merchants traversing, from ancient times, the wastes and oases of the vast Arabian desert and settling and controlling its coasts. At the time of the rise of Islam they were peripheral to the empires of Byzantium and Persia. Yet within little more than a century, the Mediterranean, once ringed and ruled by Byzantium, had become an Islamic lake; and the Middle East, long the seat of Persian dominance and influence, had been conquered by the armies of Islam and converted to its religion. The irresistible and far-ranging sweep of Islam from India to North Africa and Spain upset once and for all the balance of super-powers that had determined in large measure the political and cultural life of the ancient world.

The Expansion of Islam

The swiftness of the Islamic advance is among the wonders of world history. By 640, Syria, Palestine, and Iraq had been conquered by Muslim warriors in the name of Islam (the word *Muslim* means one who is a believer in Islam). In 642, the Byzantine army abandoned Alexandria, marking the Muslim conquest of Lower Egypt. In 651, Iran was conquered; by 710, all of North Africa had been overrun and a Muslim army crossed the Strait of Gibraltar into Spain. A victory at Jerez de la Frontera in 711 seemed to open all of western Europe to the Muslims. By 732, they had advanced north to Poitiers in France, where an army of Franks under Charles Martel, the grandfather of Charlemagne, opposed them successfully. Although they continued to conduct raids in France, they were unable to extend their control beyond the Pyrenees. But in Spain, the great caliphate of Córdoba flourished until 1031, and it was not until 1492, when Granada fell to Ferdinand and Isabella, that Islamic influence and power in the Iberian peninsula came to a close. Arab power prevailed in North Africa, the *Maghrib* or Arabic West. In the East, the Indus River had been reached by 751, and only in Anatolia was stubborn Byzantine resistance able to slow the Muslim advance. We have seen how relentless Muslim pressure against the shrinking Byzantine Empire eventually caused its collapse in 1453, when the Ottoman Turks conquered Constantinople.

The Religion of Islam

The fact that these initial conquests had effects that endured for centuries can be explained only by the nature of Islamic faith and its appeal to millions of converts. Muhammad, founder of Islam and revered as its greatest and final Prophet, was a native of Mecca on the west coast of Arabia. Critical of the polytheistic religion of his fellow Arabs, and being inspired to prophecy, he preached a religion of the one and only god, Allah. Opposition to his mes-

sage was strong enough to prompt Muhammad to flee from Mecca to Medinet-en-Nabi ("City of the Prophet," now Medina). From this flight in the year 622, known as the *Hejira*, Islam dates its beginnings.

The essential meaning of Islam is acceptance of and submission to the will of Allah. It broadly includes living according to simple rules laid down in the collected revelations communicated through Muhammad, the Qur'an (Koran), the sacred book of Islam, which was codified by the caliph Uthman (644–656), and remains unchanged to the present day. Believers in Islam, who yield their will to the will of Allah and have so professed are Muslims. This profession of faith is the first of five obligations binding upon all Muslims: in addition, the faithful must pray three or five times daily, bowed in the direction of Mecca; give alms to the poor; fast during the month of Ramadan; and once in a lifetime—if possible—make pilgrimage to Mecca. The reward of the faithful is Paradise, especially if one has died as a participant in a holy war (*jihad*).

Muslims are guided not only by the revelations of Muhammad as inscribed in the Qur'an, but by his example. The Sunna, collections of the Prophet's moral sayings and anecdotes of his exemplary deeds, are supplemental to the Qur'an, offering guidance to the faithful on ethical problems of everyday life. Thus, Muslims could be confident that an uncomplicated creed and a simple formula of worship would give them direct and equal access to Allah, truth, and right action. And this could be had without the intermediation of complex, possibly pagan, ritual, and a hierarchical, spiritually privileged priesthood.

Islam drew much upon Judaism and Christianity; it was by no means a radically new religion. Its adherents thought of it as a continuation, completion, and in some sense a reformation of these great Semitic monotheisms. In addition to the belief in one god, Islam accepted much of the revelation of the Old Testament, along with its sober ethical teaching. Adam, Abraham, Moses, and Jesus were acknowledged as the prophetic predecessors of Muhammad, who was the final and greatest of the prophets before the coming of Allah. Muhammad was not claimed to be divine, as was Jesus, but only the messenger of God, the purifier and perfector of the common faith of Jew, Christian, and Muslim in one God.

In its political structure, as Muhammad defined it, Islam was a theocracy more completely even than the Byzantine. Muhammad established a new social order, replacing the old, decentralized tribal one traditional with the Arabs. In this he was influenced no doubt by the example of the emperors and kings reigning in the lands his people would conquer. He took complete charge of the temporal as well as the spiritual affairs of his community. This practice of uniting religious and political leadership in the hands of a single ruler was continued after Muhammad's death by his successors, the caliphs, who based their claims to authority on their descent from the families of the Prophet or those of his early followers.

EARLY ISLAMIC ARCHITECTURE

During the early centuries of Islamic history, the political and cultural center of the Muslim world was the Fertile Crescent (a crescent-shaped area of cultivable land that extends from the eastern Mediterranean via the fertile steppe between the mountains of Asia Minor and the Arabian Desert to the Tigris and Euphrates rivers and the Persian Gulf)—that melting pot of East and West strewn with impressive ruins of earlier cultures that became one of the fountainheads of the development of Islamic art. The vast territories conquered by the Arabs were ruled by caliphs, originally sent out from Damascus or Baghdad, who eventually gained relative independence by setting up dynasties in various territories and provinces: the Umayyads in Syria (661–749) and in Spain (756–1031); the Abbasids in Iraq (749–1258; largely nominal after 945); the Fatimids in Tunisia and Egypt (909–1171); and so on. Despite the Qur'an's strictures against sumptuousness and license, the caliphs were not averse to surrounding themselves with luxuries commensurate with their enormous wealth and power. This duality is expressed by the two major architectural forms developed during the Early Islamic period: the mosque and the palace.

Umayyad Architecture in Palestine and Syria

But the first major building of the Umayyad dynasty that is still preserved is neither mosque nor palace. The Dome of the Rock in Jerusalem (FIG. **10-1**), completed in 691, is rather a monumental sanctuary, an architectural tribute to the triumph of Islam. It houses the rock from which, as Muslims believe, Muhammad ascended to Heaven. Erected on the traditional site of the Temple of Solomon on Mount Moriah, it rises from a huge, artificial platform to dominate the skyline of modern Jerusalem, the city sacred to both Christians and Jews, and to Islam. The magnificence of the Dome of the Rock rivals the monuments of the older faiths, which Islam had come to complete.

As Islam took over much of its teaching from Judaism and Christianity, so its architects and artists borrowed and transformed principles of design, construction, and ornamentation that had long been applied and were still current in Byzantium and the Middle East—Persia, Iraq, Syria, Palestine, Egypt. The plan of the Dome of the Rock is a domed octagon, resembling what we have seen at San Vitale (FIG. 9-5). In all likelihood, it was inspired by a neighboring Christian monument, the Martyrium rotunda

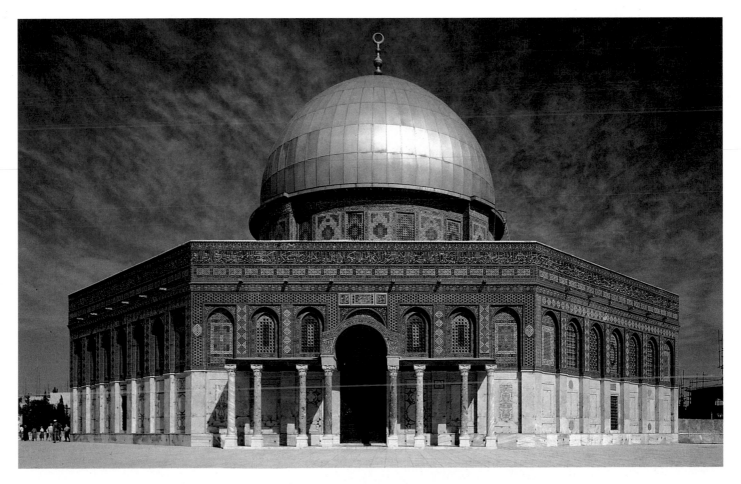

10-1　Dome of the Rock, Jerusalem, Israel, late seventh century.

of the church of the Holy Sepulchre, which had been begun by Constantine the Great in the fourth century. The double-shelled wooden dome, some 60 feet across and 75 feet in height, so dominates the elevation as to reduce the octagon to function merely as its base. This soaring, majestic unit creates a decidedly more commanding effect than that we have seen in the domical structures of Byzantium, where the silhouette of the dome is comparatively insignificant when seen from the outside. The dominance of the domed cupola will characterize the architecture of Islam, and, with the later minaret, identify it worldwide.

The exterior of the building has been much restored; tilework now replaces the original mosaic. Yet the vivid, colorful patterning that wraps the walls like a textile is typical of Islamic ornamentation; it contrasts markedly with Byzantine brickwork (FIG. 9-33) and the sculptured profiling and carved decoration of the Greco-Roman tradition. The rich mosaic ornament of the interior has been preserved; from it we can read something of what the exterior walls must have shown. Islamic practice will not distinguish significantly the décor of interior and exterior. The splendor of infinitely various surfaces is given to public gaze both within the building and outside it.

Muslim religious architecture is closely related to Muslim prayer, the performance of which is an obligation laid down in the Qur'an for all Muslims. Prayer as a private act requires neither liturgical ceremony nor a special locale; only the *qibla*—the direction (facing Mecca) toward which the prayer is addressed—is important. But prayer also became a communal act for which simple ritual was established by the first Muslim community. The community convened once a week, probably in the Prophet's house, the main feature of which was a large, square court with two *zullahs*, or shaded areas, along the north and south sides. These zullahs consisted of thatched roofs supported by rows of palm trunks; the southern zullah, wider and supported by a double row of trunks, indicated the qibla.

During these communal gatherings, the *imam*, or leader of collective worship, standing on a pulpit known as a *minbar* (FIG. 10-20, right) near the qibla wall, pronounced the *khutba*, which is both a sermon and an act of allegiance by the community to its leader. The minbar thus represents secular authority even as it serves its function in worship.

These features became standard in the Islamic mosque, as did the *mihrab*, a semi-circular niche usually set into the qibla wall (FIG. 10-22, left); often a dome over the bay in front of it signalized its position (FIGS. 10-9 and 10-10). The niche was a familiar architectural feature of the Greco-Roman world, generally enclosing a statue. But for Islamic architecture, its origin, purpose, and meaning are still matters of debate. Some historians feel that the mihrab originally may have honored the place where the Prophet stood in his house at Medina when he led the communal prayers; it would thus be a revered religious memorial. If the mihrab has this symbolic function, it is unusual, because one of the characteristics of early Islamic art is its concerted avoidance of symbols as a conscious rejection of Christian customs and practices.

The origin of the mosque (*mosque* from *masjid,* a place for bowing down) is still in dispute, although one prototype may well have been the Prophet's house in Medina. Once the Muslims had firmly established themselves in their conquered territories, they began to build on a large scale, impelled perhaps by a desire to create such visible evidence of their power as would surpass that of their non-Islamic predecessors in size and splendor.

The caliph al-Walid may have been thus motivated when he built the Great Mosque in the new Umayyad capital at Damascus in Syria (FIG. **10-2**) in 706. Like the Dome of the Rock, the Great Mosque owes much to the art and architecture of Greco-Roman and Early Christian Syria. Built on the precinct foundations of a Roman temple, the basic plan and fabric of the Great Mosque could stand as a

10-2 Courtyard of the Great Mosque, Damascus, Syria, *c.* 705–715.

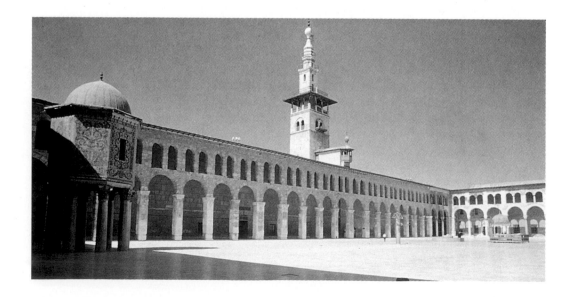

monumental symbol of Islamic conquest, not only of the territories of the older civilizations, but of their material forms and conceptual schemes as well.

The courtyard is bounded by pier arcades reminiscent of Roman aqueducts. It is constructed of masonry blocks, columns, and capitals salvaged from the Roman and Early Christian structures al-Walid had demolished to make way for his mosque. The pediment and the superposed arches of the entrance portal are respectively Classical and Byzantine (FIGS. 9-6 and 9-7). The square Roman tower at the corner of the enclosure has been converted into that distinctive feature of Islamic mosque architecture, the *minaret* (the cupola here is of much later date), from the elevated platform of which the *muezzin* (crier) calls the faithful to prayer. The columns and Corinthian capitals of the arcaded aisles, which are laid out in basilican style, are monolithic and gathered from the dismantled pre-Islamic structures. Yet the Great Mosque synthesizes all these received elements into a novel architectural unity, which includes the peculiarly Islamic elements in the design of all later mosques: mihrab, mihrab dome, minbar, and minaret.

The derivation of the cycles of mosaic that enrich the walls of the Great Mosque is, like its architecture, clearly Roman and Byzantine; we recall the Second Style of Pompeian wall painting (fig. 7-19, right) and the stage-set architectural motifs like those in the rotunda of St. George in Thessaloniki (fig. 8-21). Indeed, there is some evidence that mosaics of the Great Mosque are the work of Byzantine mosaicists imported for the purpose. Characteristically, temples, clusters of houses, trees, and rivers compose the pictorial fields, bounded by stylized vegetal design, familiar in Roman, Early Christian, and Byzantine ornament.

Though the pictorial spaces are filled with readily identified shapes, abstraction strangely dematerializes them; space is discontinuous, perspectives are contradictory. In our example (FIG. **10-3**), a conch shell niche "supports" an arcaded pavilion with flowering rooftop. Outside and inside views of the pavilion are given simultaneously. The houses that flank the pavilion are represented in Roman diagonal perspective, unrelated to that of the pavilion itself. To complete the abstraction, there are no zoomorphic forms, human or animal, either in the pictorial or ornamental spaces. This is true of all the mosaics in the Great Mosque, and is evidence, at this the very beginning of Islamic art, of the religious strictures of traditional Islam against the representation of fauna of any kind in sacred places.

The world shown in this mosaic, suspended mirage-like in a featureless field of gold, and empty of creature life, may be an image of Paradise. Many passages from the Qur'an describe gorgeous places of Paradise awaiting the occupancy of the faithful—gardens, groves of trees, flowing streams, and "lofty chambers." Indeed, the profusion of sumptuous images and ornament, floating free of all human reference, creates a vision of Paradise appealing to the spiritually oriented imagination, whatever its religion.

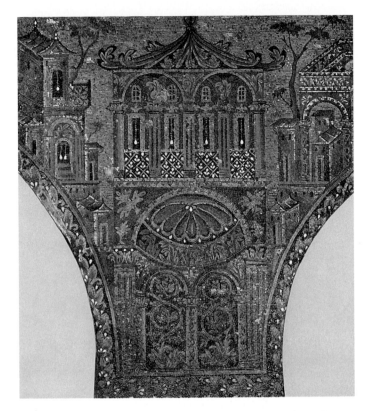

10-3 Detail of a mosaic, Great Mosque, Damascus, Syria, early eighth century.

While these early mosaics derive largely from Roman or Byzantine prototypes, we can discern a stylistic deviation from these sources that will lead in a very different direction, both for mosaic and carved ornament. The crowding of still partially illusionistic features will become much denser, and the illusionism will disappear (FIG. 10-14). The absence of zoomorphic forms, or their reduction to abstract shapes, will leave place for the compact, geometrical patterning that we associate with textile design. For Islam, this will be universal. The ornamentation of books and buildings, carpets and draperies, cups and costumes, utensils and accessories of all sorts will exhibit the peculiarly Islamic esthetic, an almost obsessive concern with and delight in woven patterns. The human figure, when it appears again in secular art, will be strictly subordinate to pattern. Distinctive as the source of one of the world's greatest arts is the "draped universe of Islam."

Abbasid Architecture in North Africa

In 750, after years of civil war in the Arab orient, the Abbasids, who claimed descent from Abbas, an uncle of Muhammad, drove out the Umayyed caliphs, and moved the capital from Damascus to a site in Iraq. There they built a new capital, Baghdad. For almost three hundred years Baghdad was the center of Arab power and of a brilliant Arab culture, strongly influenced by a surviving

Persian one. The influence of the Persian tradition can be felt in the design of the hypostyle mosque, a many-columned structure reminiscent of the apadana hall at Persepolis (FIG. 2-25).

The hypostyle mosque can be found throughout the wide expanse of the Arab empire, from the vast, now ruinous mosque of Samarra near Baghdad to the still functioning mosque at Qairawan in Tunisia. The simple, rather loosely composed plans of this type reflect more closely than the Great Mosque at Damascus the supposed origins of the mosque in the house of the Prophet at Medina. The Mosque at Qairawan (FIGS. **10-4** to **10-6**) has an enclosure in the form of a slightly askew parallelogram of huge scale, some 148 by 88 meters. Built of stone, its walls have sturdy buttresses, square in profile. The arcaded forecourt is entered through a massive minaret not quite in line with the two domes that fix the axis of the roofed sanctuary. The first dome is over the entrance bay, the second, more elaborate one, is over the bay that fronts the mihrab set into the qibla wall. The axis is defined by a raised nave flanked by eight columned aisles on either side, space for a large congregation. The nave that connects the entrance dome with the mihrab dome intersects with another nave at right angles to it, running the length of the qibla wall. The resultant T-shaped space provides an organization and focus of plan often missing from the rambling hypostyle scheme. Yet this very scheme had a flexibility that permitted enlargement and addition with minimum effort. Its main elements were the single supports of the square bay, either columns or piers, which could be multiplied at will and in any desired direction. A striking illustration of this flexibility is the mosque at Córdoba in Spain.

Umayyad Architecture in Spain

One Umayyad notable, Abd-al-Rahman, escaped the Abbasid massacre of his clan in Syria and fled to Spain. We have noted that the Arabs overthrew the Christian king-

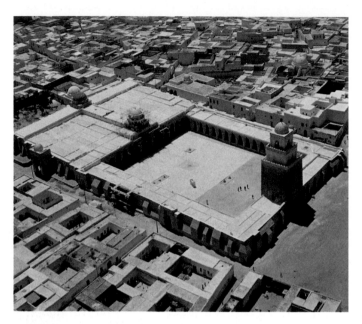

10-4 Great Mosque, Qairawan, Tunisia, 836–875.

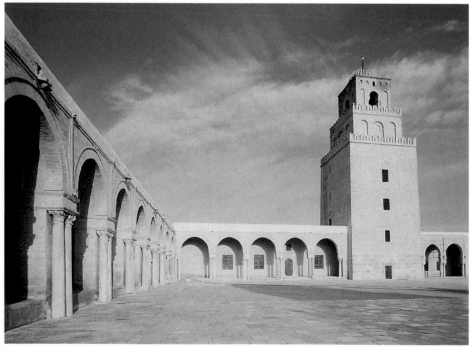

10-5 Courtyard of the Great Mosque, Qairawan, Tunisia.

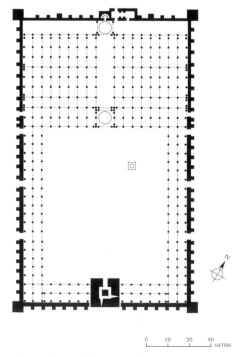

10-6 Plan of the Great Mosque, Qairawan.

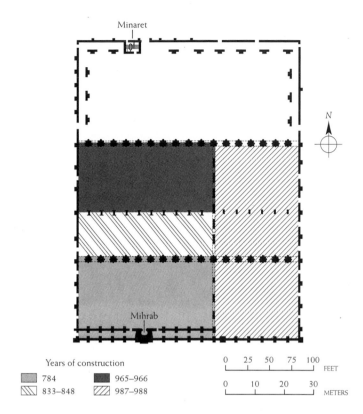

10-8 Plan of mosque at Córdoba.

Years of construction

■ 784
▨ 833–848
■ 965–966
▨ 987–988

visual effects. The same desire for decorative effect seems to have inspired the design of the dome that covers the area in front of the mihrab (FIG. 10-10), one of four domes built during the tenth century to emphasize the axis leading to the mihrab. Here, the large ribs that subdivide the hemispheric surface of the dome into a number of smaller sections are primarily ornamental. In the hands of Gothic builders, centuries later, ribs in combination with the pointed arch became fundamental structural elements of a new and revolutionary architectural system.

The mosaics of the domes and ribs, the last major wall mosaic decor of Muslim architecture, show the progressive reduction of illusionistic forms that began in the Great Mosque at Damascus (FIG. 10-3) into abstract shapes in flat, textile-like patterns. On the exterior of the building, the architectural theme is repeated along with the decorative theme. The intersecting, polychromed horseshoe arches of the interior are reproduced here, looping over an elegant blind arcade of leaf-shaped secondary arches, produced by the intersection of the main arches (FIG. 10-11). These secondary arches enclose panels of alternating geometrical and vestigially floral shapes: the maze, meander, fret and swastika, checkerboard and star appear, bounded by panels of palm leaf, rosettes, vine scrolls, and tendrils. The observer must inspect the composition closely and for some time to discern and appreciate the intricate system of decoration that everywhere identifies the art of Islam—the system

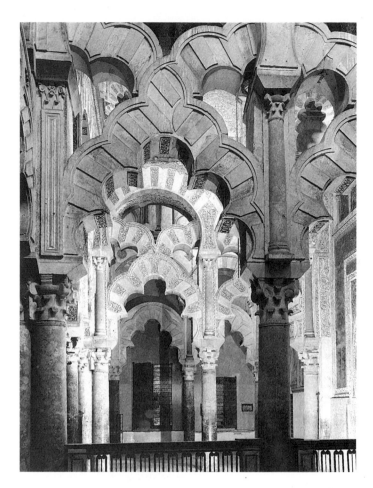

10-9 Mihrab of mosque at Córdoba.

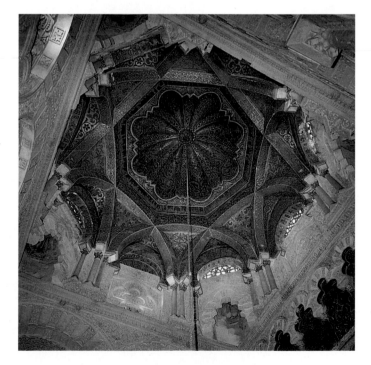

10-10 Dome before the mihrab of mosque at Córdoba.

dom of the Visigoths in Spain early in the eighth century. The Arab military governors of the peninsula accepted the fugitive as their overlord, and he became Abd-al-Rahman I, founder of the Spanish Umayyad dynasty, which was to last for two and a half centuries. The capital of the Spanish Umayyads was Córdoba, which was to become the center of a brilliant culture rivaling that of the Abbasids at Baghdad, and exerting major influence on the civilization of the Christian West.

The jewel of the capital at Córdoba was its great mosque (FIGS. **10-7** to **10-11**). The mosque was begun in 786 and enlarged several times during the ninth and tenth centuries. The additions followed the original style and arrangement of columns and arches, and the builders were able to maintain a striking stylistic unity for the entire building. The 36 piers and 514 columns are topped by a

unique system of double-tiered arches that carried a wooden roof, now replaced by vaults. The lower arches are horseshoe shaped, a form perhaps adapted from earlier Near Eastern architecture or of Visigothic origin and now closely associated with Muslim architecture. Visually, these arches seem to billow out like sails blown by the wind, and they contribute greatly to the light and airy effect of the mosque's interior.

In areas the builders wished to emphasize, such as that near the mihrab (FIG. 10-9), the arches become highly decorative, multilobed shapes. Other early Islamic experiments with arch forms led to the pointed arch, which, however, was not used to cover variable spaces, as in Gothic buildings. Early Islamic buildings had wooden roofs, and the experiments with arch forms were motivated less by structural necessity than by a desire to create rich and varied

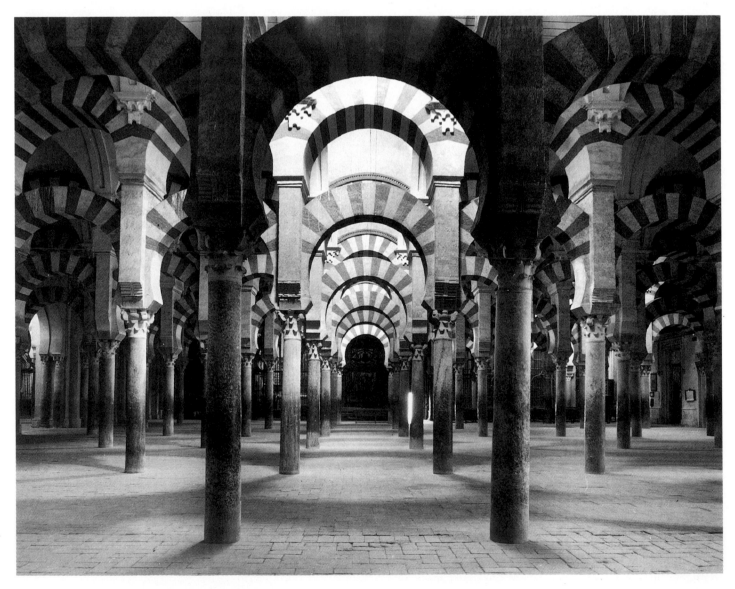

10-7 Interior of Mosque of Córdoba, Spain, eighth to tenth centuries.

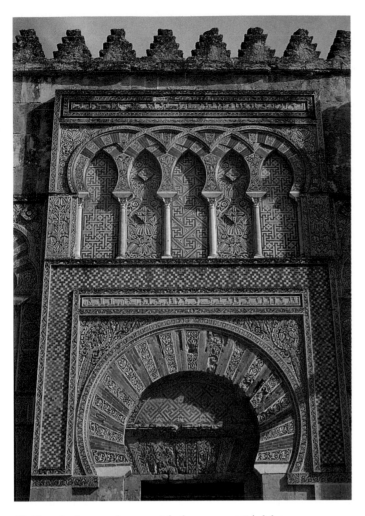

10-11 Arabesque above portal of mosque at Córdoba.

called *arabesque*. Renouncing the material world of shadow-casting objects, arabesque expresses the Islamic delight in the revelation and exploration of pure form, and the contemplation of it as the unity in the variety of the cosmos.

Given its profound importance, we shall presently examine the architectural ornament of Islamic art in more detail.

The Early Palaces

Of the early palaces, only scattered remains have survived, and they are of limited historical importance, serving primarily to illustrate the way of life of Muslim aristocrats and to provide us with some notion of the decorative styles of Early Islamic art.

Even the purpose of these early palaces is not quite certain. They were built both in cities and in the open country. The rural palaces, which have been better investigated, seem to have served a function similar to that of the Roman villas. That they reflect an Islamic taste for life in the desert seems too simple an explanation, although a desire to avoid plague-infested cities may well have been at least a partial motivation for their builders. But these rural palaces probably also served as nuclei for the agricultural development of conquered territories; in addition, they may have been symbols of authority over conquered and inherited lands, as well as expressions of the newly acquired wealth of their owners.

One of the better preserved of these early Muslim palaces is the Palace at Ukhaydir in Iraq (figs. **10-12** and **10-13**), built in the second half of the eighth century under the Abbasids. Somewhat larger than most, the palace is a

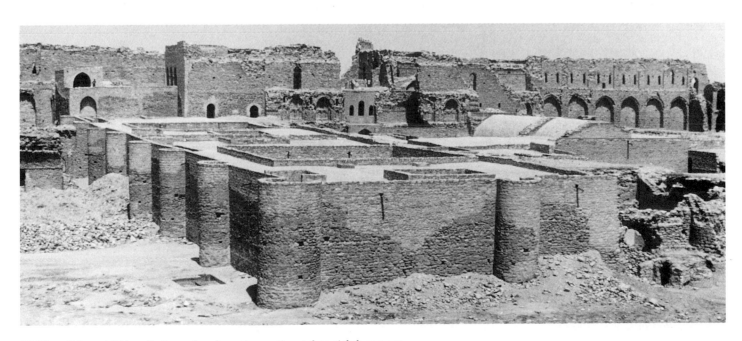

10-12 Palace at Ukhaydir, Iraq, view from the southeast, late eighth century.

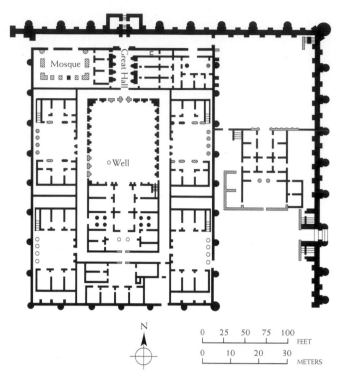

10-13 Plan of the palace at Ukhaydir.

Most palaces also were provided with fairly elaborate bathing facilities that displayed technical features, such as heating systems, adopted from the Roman tradition of baths. (The baths at Ukhaydir, only recently discovered near the mosque, are not shown on the plan.) Just as in classical antiquity, these baths probably served more than merely hygienic purposes. Large halls frequently attached to them seem to have been used as places of entertainment. Thus, a characteristic amenity of classical urban culture that died out in the Christian world survived in medieval Islamic culture.

The decoration of the Ukhaydir palace seems to have been rather sparse and was confined to simply molded stucco and occasional decorative brickwork. In this respect, finds made in the western palaces in Syria and Palestine (modern Jordan and Israel) have been much richer.

At Mshatta, an unfinished palace in the Jordanian desert, for instance, gate and facade are decorated by a wide, richly carved stone frieze (figs. **10-14** and **10-15**). Its design, arrangement, and relation to its carrier serve well to

separate entity within a fortified enclosure, with elements distinctively Sasanian in origin. The layout of this palace, like that of the mosque, illustrates a flexibility that is characteristic of Early Islamic monuments, as relatively minor changes could convert them from one purpose to another.

Differences between a mosque, a palace, or a *caravansary* (an inn where caravans could rest) rarely were evident from the exterior; the structures tended to share a rather grim, fortified look that belied their military inefficiency. The high walls may have offered safety from marauding nomadic tribes, but they also may have fulfilled abstract considerations more important to the builders, like the promise of seclusion for a mosque or—for a palace—privacy for the prince and the symbolic assertion of his power over newly conquered territories.

The plan of the palace at Ukhaydir (FIG. 10-13) expresses the structure's residential and official functions. An elaborate entrance complex, consisting of a monumentalized gate and a great hall between two small, domed rooms, leads onto the large central court, beyond which is a reception hall surrounded by satellite rooms. Flanking this ceremonial axis are four smaller courts, all with three rooms on each of two sides. These grouped rooms appear to be self-contained and probably served as family living units or guest houses. To the right of the entrance hall is a mosque, a standard feature of these early palaces, which here is incorporated into the main building complex, although sometimes it stood by itself.

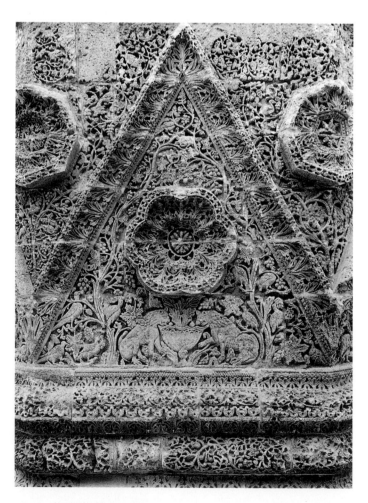

10-14 Portion of stone frieze, palace at Mshatta, Jordan, *c.* 743. Staatliche Museen, Berlin.

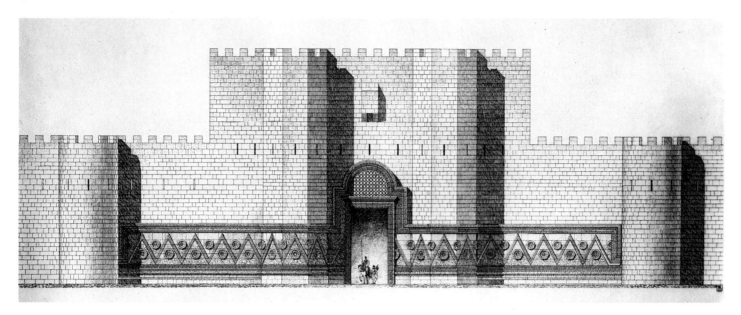

10-15 Reconstruction of facade of the palace at Mshatta. (After Schulz.)

illustrate the major characteristics of Early Islamic decoration current in the last years of Umayyad power.

A long band, almost 15 feet high, is decorated with a series of triangles of the same size framed by an elaborately carved molding. Each triangle contains a large rosette that projects from a field densely covered with curvilinear, vegetal designs; no two triangles are treated the same way, and animal figures appear in some of them (FIG. 10-14). The sources of the various design elements are easily identified as Late Classical, Early Byzantine, and Sasanian Persian, but their combination and arrangement are typically Islamic.

ISLAMIC ARCHITECTURAL ORNAMENT

As we have seen, most of the design elements of Islamic ornament are based on plant motifs, which are sometimes intermingled with symbolic geometric figures and with human and animal shapes. But the natural forms often become so stylized that they are lost in the purely decorative tracery of the tendrils, leaves, and stalks. These arabesques form a pattern that will cover an entire surface, be it that of a small utensil or the wall of a building (FIG. 10-11). (This *horror vacui* [crowded design, literally "fear of empty space."] is similar to tendencies in barbarian art (FIG. 11-2); although other aspects of Islamic design distinguish it from the abstract barbarian patterns.) The relationship of one form to another in Islamic art is more important than the totality of the design: the repetitive patterns serve to suggest divine infinity and indefinability. This system offers

a potential for unlimited growth, as it permits extension of the designs in any desired direction. Most characteristic, perhaps, is the design's independence of its carrier; neither its size (within limits) nor its forms are dictated by anything but the design itself. This arbitrariness imparts a certain quality of impermanence to Islamic design, a quality that may reflect the Muslim taste for readily movable furnishings, such as rugs and hangings.

FLOOR MOSAIC Stone carving was only one of several techniques used for architectural decoration. Floor mosaics and wall paintings continued a long Mediterranean tradition. In later periods, colored tile became increasingly important. A magnificent example of a floor mosaic was found in the bath of the Palace at Khirbat al-Mafjar (FIG. **10-16**) near Jericho. Set into square and rectangular fields covered with a rich variety of floral and geometric patterns are medallions with extremely intricate abstract designs, some of them creating the illusion of a downward projection of the dome or half-dome under which they are placed.

COLORED TILE The use of colored tile has a long history in the Middle East and Iran. After periods of neglect, the art was revived by the Abbasids in the ninth century at Samarra in Iraq, where tiles with a metallic sheen, called *luster ware,* were developed. From there, the fashion spread throughout the Muslim world, reaching the height of its development during the sixteenth and seventeenth centuries in Turkey and Iran. Used as veneer over a brick core, tiles could sheathe entire buildings, including domes and minarets. Our example, the Dome of Masjid-i Shah in

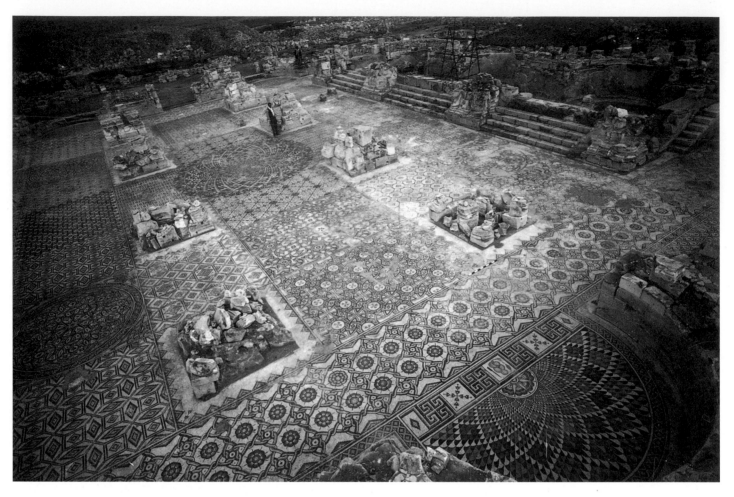

10-16 Floor mosaic, palace at Khirbat al-Mafjar, Jordan, mid-eighth century.

Isfahan (FIG. **10-17**), dates from the early seventeenth century and shows such tilework at its most brilliant. Beautifully adjusted to the shape of the dome, the design of the spiraling tendrils is at once rich and subtle, enveloping the dome without overpowering it. In contrast to the more general Islamic tendency to disguise structure, the design here enhances the dome's form without obscuring it. On parts of the dome and on the minarets, the tiles are curved to conform to the shape of the architecture.

The prayer hall within the building (FIG. **10-18**) shows glazed tilework so exquisitely refined as to counterfeit the woven textiles that adorned the tents of the Safavid monarchs of Persia (FIG. 10-27). The architectural forms resemble tentlike canopies, and the starlike spangling of minute floral motifs upon their surfaces evokes the constellations of the night sky. One could hardly find a more telling example of the aspiration of all Islamic art to the esthetic ideal of tapestry design.

STUCCO RELIEF Also particularly popular were *stucco reliefs*, a method of decoration that was known, and common, in pre-Islamic Iran and Iraq. Cheap, flexible, and

effective, the basic material (wet plaster) was particularly adaptable to the execution of the freely flowing line that distinguishes Islamic ornament, and stucco decoration became a favorite technique. Some of the very richest examples are found in the Alhambra palace in Granada, Spain, the last Muslim stronghold in western Europe in the Middle Ages. In the Court of the Lions (FIG. **10-19**) and the rooms around it, stucco decoration runs the gamut of the medium's possibilities and creates an exuberant atmosphere of elegant fantasy that seems to be the visible counterpart of the visions of the more ornate Muslim poets.

The court itself, proportioned according to the *Golden Mean*,* is framed by rhythmically spaced single, double, and triple columns with slender, reedlike shafts that carry richly decorated block-capitals and stilted arches of complex

*The *Golden Mean* (also known as the *Golden Rule* or *section*) is a system of measuring in which units used to construct designs are subdivided into two parts in such a way that the longer subdivision is related to the length of the whole unit in the same proportion as the shorter subdivision is related to the longer subdivision.

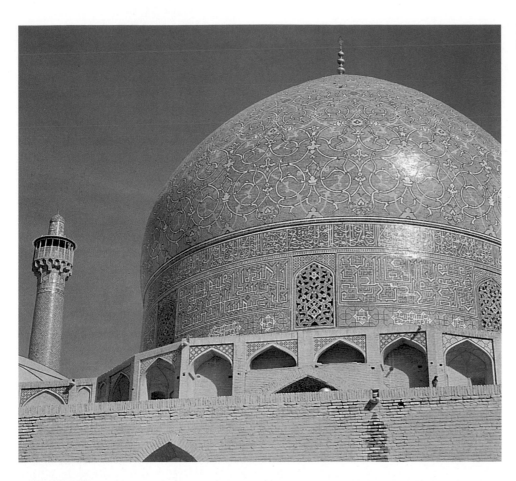

10-17 Dome of Masjid-i Shah, Isfahan, Iran, 1612–1637.

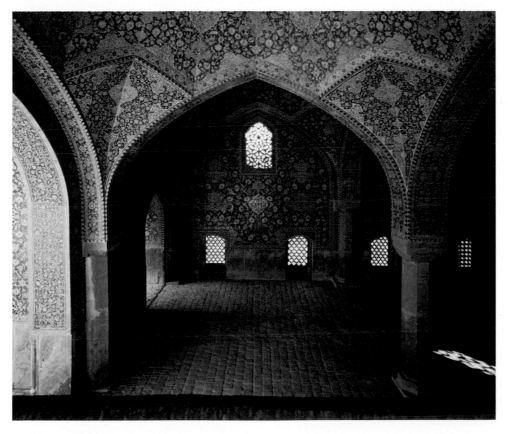

10-18 Prayer hall of Masjid-i Shah.

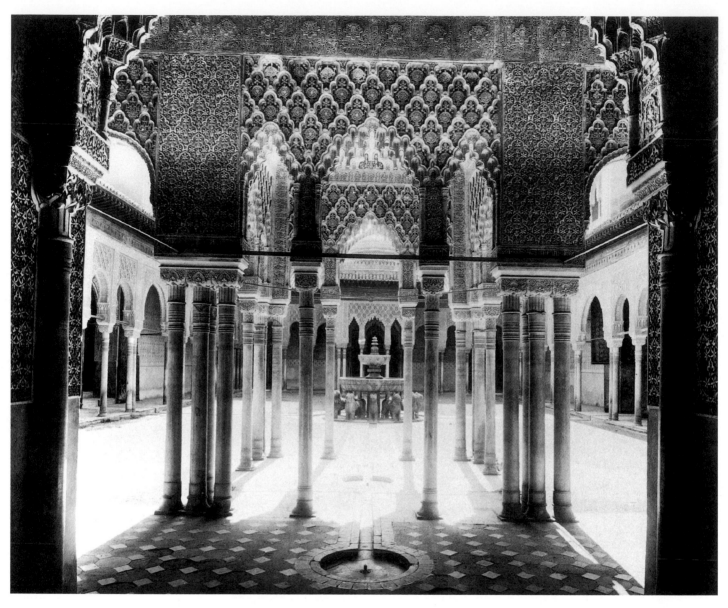

10-19 Court of the Lions, the Alhambra, Granada, Spain, 1354–1391.

shape. All surfaces above the columns are covered by colored stucco moldings that seem aimed at denying the solidity of the stone structure that supports them. The resulting, buoyant, airy, almost floating appearance of the building is enhanced by the "stalactite" (*muqarnas*) decorations that break up the structural appearance of the arches, transforming them into near-organic forms.

LATER ISLAMIC ARCHITECTURE:
MOSQUE, MADRASA, MAUSOLEUM

Much earlier than the Masjid-i Shah, and contemporary with the Court of the Lions, the madrasa and mausoleum of Sultan Hasan in Cairo (FIGS. **10-20** to **10-22**) express a very different architectural concept from those examined

thus far. The *madrasa* is a higher theological college adjoining and often containing a mosque. (The Madrasa of Sultan Hasan is actually four madrasas, one in each corner devoted to a major school of Islamic jurisprudence.) It was a building type developed in Fatimid Egypt in the late tenth century, and brought to Persia in the eleventh century by the advancing Seljuk Turks. It shares with the hypostyle mosque the open central court but replaces the early Islamic forests of columns with austere masses of brick and stone. The court is now surrounded by four vaulted halls, the one on the qibla side being larger than the other three. Crowded into the angles formed by these halls are the various apartments, offices, and schoolrooms of the Muslim educational institution. Decoration of the main building is confined to moldings around the wall openings and a frieze below the crenelated roofline, which serve

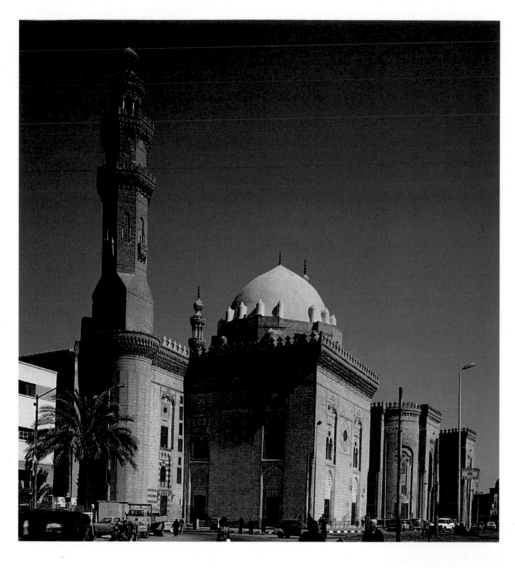

10-20 Madrasa and attached mausoleum of Sultan Hasan, Cairo, Egypt, 1356–1363 (view from the east).

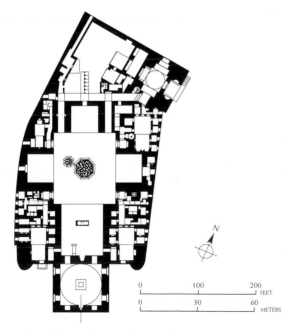

10-21 Plan of the madrasa and mausoleum of Sultan Hasan.

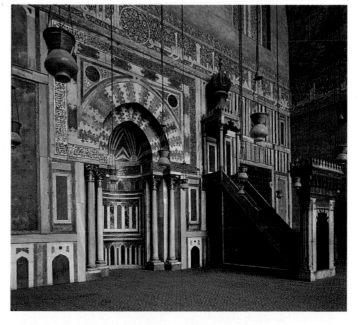

10-22 Mosque of Sultan Hasan, mihrab and minbar.

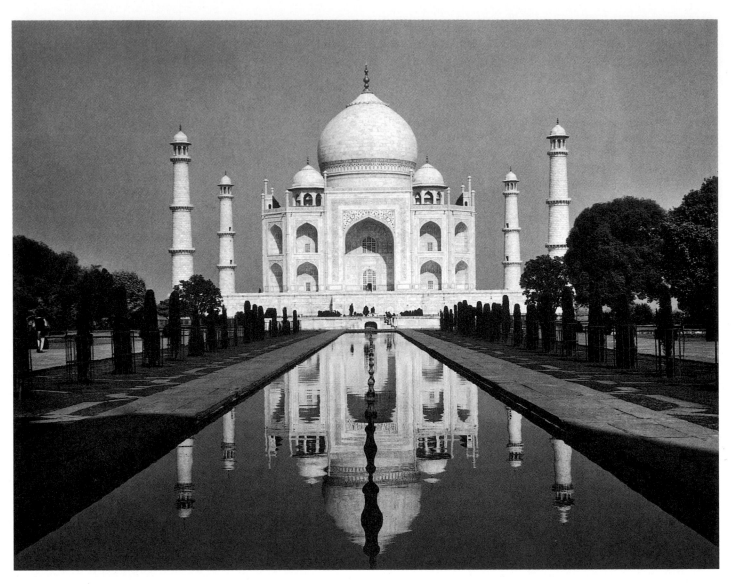

10-23 Taj Mahal, Agra, India, 1632–1654.

to accentuate, rather than to disguise, the geometric clarity of the massive structure, presenting a striking contrast to the filigreed elegance of the contemporary Alhambra.

Attached to the qibla side of the madrasa is the mausoleum, which is a simple cubical structure covered by a dome. *Mausoleums* (central-plan, domed structures) were adopted either from Iran or from the Antique vocabulary of the Mediterranean, as they had not been a part of the original inventory of Islamic architecture. They were built either as memorials to holy men or for the secular function of commemorating Islamic rulers. By the tenth century, the building type was well established in Iran, from which it spread both east and west; it became especially popular in Egypt, which, of course, had its own age-old tradition of large-scale funerary monuments.

The most famous of all Islamic mausoleums is the fabled Taj Mahal at Agra (FIG. **10-23**), which was built, as tradition relates, by one of the Muslim rulers in India, Shah Jahan, as a memorial to his wife, Mumtaz Mahal; it is now considered to be an architectural metaphor for Paradise and the Throne of God. The basic shape of the monument is that of the Cairo mausoleum, but modifications and refinements have converted the massive, cubical structure into an almost weightless vision of cream-colored marble that seems to float magically above the tree-lined reflecting pools. The Taj Mahal follows the plan of a Central Asian/Iranian garden pavilion, Timurid in origin, a Turkic innovation in India. The interplay of shadowy voids with gleaming marble walls that seem paper-thin creates an impression of translucency, and elimination of the Cairo structure's heavy, projecting cornice (which separated the blocky base of the earlier building from its dome) ties all the elements together. The result is a sweeping, upward movement toward the climactic, balloon-shaped dome. Carefully

related minarets and corner pavilions introduce, and at the same time stabilize, this soaring central theme. Although the entire monument recalls in its innumerable refinements of detail the fragile elegance of the Alhambra, in different ways they are both among the highest achievements of Muslim architecture.

Ottoman Architecture

A late regional style of Islamic architecture was developed by the Ottoman Turks. The Turkic people, of Central Asian origin, had been converted to Islam during the ninth and tenth centuries. They moved into Iran and the Near East in the eleventh century, and by 1055, the Seljuk Turks had built an imposing, although short-lived, empire that stretched from India to western Anatolia. By the end of the twelfth century this empire had broken up into regional states, and in the thirteenth century (1210–1220s) it came under the sway of the Mongols, led by Genghis Khan. After the empire's fall, a number of local dynasties established themselves in Anatolia, among them the Ottomans, founded by Osman I (1290–1326). Under his successors, the Ottoman state expanded over a period of two and a half centuries throughout vast areas of Asia, Europe, and North Africa to become, by the middle of the fifteenth century, one of the great world powers.

Ottoman art expressed itself primarily in terms of architecture. Ottoman builders developed a new type of mosque with a square prayer hall covered by a dome as its core. In fact, the dome-covered square, which had been a dominant form in Sasanian Iran, became the nucleus of all Ottoman architecture. The combination had an appealing geometric clarity. At first used singly, the domed units came to be used in multiples, a turning point in Ottoman architecture, because it drew in its wake the desire to create unity of space and form out of conglomerate aggregates. The resultant Ottoman style is geometric and formalistic, rather than ornamental.

When the Ottoman Turks conquered Constantinople (which they renamed Istanbul) in 1453, their architectural code was firmly established. Although impressed by Hagia Sophia (FIG. 9-1), which, in some respects, conformed to their own ideals, Ottoman builders were not overwhelmed by it. Direct influence of Hagia Sophia was not felt until about 1500, when a second half-dome, opposite the mihrab, was used for the first time.* But the processional way of Hagia Sophia's interior never satisfied Ottoman builders, and Anatolian development moved instead toward the centralized quatrefoil mosque.

*Ottoman builders had already adopted (from Byzantine architecture) the half-dome-covered apsidal projection for the mihrab, in addition to pendentive construction, although they preferred the Seljuk method of supporting domes with squinches or series of corbels (FIG. 9-22).

The first examples of the *quatrefoil* (cloverleaf) *mosque* plan, an ideal of Ottoman mosque design, were built in the 1520s, to be eclipsed only by the works of the most famous of Ottoman architects, SINAN THE GREAT (c. 1491–1588). A contemporary of Michelangelo and with equal aspirations to immortality, Sinan carried Ottoman architecture to the height of its classical period. By his time, the use of the basic domed unit was universal. It could be enlarged or contracted as needed, and almost any number of units could be used together. Thus, the typical Ottoman building of Sinan's time was an assembly of parts, usually erected with an extravagant margin of structural safety. Measures and forms had been standardized, and design and engineering methods tended to be conservative, with little room given to experimentation. But despite such strictures, which might have been stifling to a lesser architect, Sinan constantly searched for solutions to the problems of unifying the additive elements and of creating a monumental, centralized space with harmonious proportions.

In his early buildings, Sinan experimented with the cloverleaf plan, as well as with that of Hagia Sophia. In the mosque of Suleiman I in Istanbul, he flanked the central unit, in which the main dome is abutted by two half-domes, north and south, with dome-covered aisles. But where Hagia Sophia isolates the lateral aisles, Sinan, by reducing interior obstructions to a minimum, made every effort to combine them with the central area and to make central and flanking spaces flow into each other through wide and lofty arcades. Moreover, where the architects of Hagia Sophia (FIGS. 9-2 and 9-3) mask or obscure not only the aisles, but the four great piers that support the dome, Sinan, by contrast, looks not only for clarity of space, but emphasizes, rather than conceals, all the structural elements of the building.

THE SELIMIYE CAMI, EDIRNE Sinan's efforts to overcome the limitations of a segmented interior found their ultimate expression in the Selimiye Cami (FIGS. **10-24** to **10-26**) at Edirne (ancient Adrianople), where he created a structure in which the mihrab is visible from almost any spot in the building. The Selimiye Cami reputedly was built for Selim II at Edirne (which had been the capital of the Ottoman Empire from 1367–1472) to commemorate the Ottoman conquest of Cyprus, the spoils of which were used to embellish the building. (Even after the moving of the capital to Constantinople, Edirne remained the imperial residence). The structure's massive dome, effectively set off by four slender, pencil-shaped minarets (each more than 200 feet high), dominates the city's skyline. Various dependencies are placed around the mosque. (Most of the important mosques had numerous annexes, including libraries and schools, hospices, baths, soup kitchens for the poor, markets, and hospitals, as well as a cemetery containing the mausoleum of the sultan responsible for the building of the mosque. These utilitarian buildings were grouped

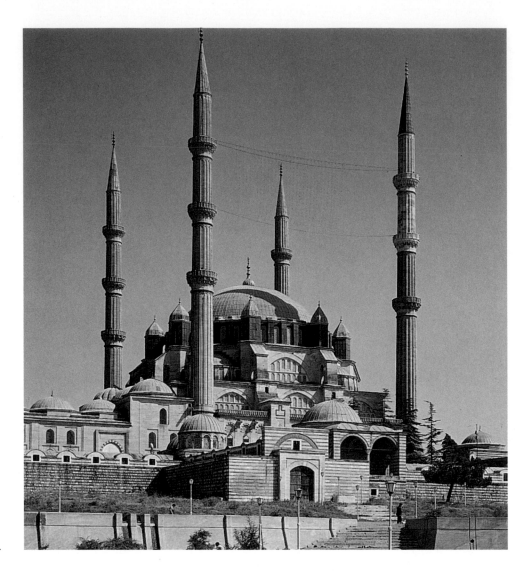

10-24 SINAN THE GREAT, the Selimiye Cami (mosque of Selim II), Edirne (ancient Adrianople), Turkey, 1569–1575.

around the mosque and axially aligned with it if possible; more generally, they were adjusted to their natural site and linked with the central building by plantings of shrubs and trees.)

The mosque is preceded by a rectangular court covering an area equal to that of the building. This *avlu* (a courtyard forming a summer extension of the mosque) is surrounded by porticoes formed by domed squares. Behind it, the building rises majestically to its climactic dome, which equals that of Hagia Sophia in width. But it is the organization of the interior space of this mosque that reveals the genius of its builder. The mihrab has been recessed into an apselike alcove deep enough to permit illumination from three sides, making the brilliantly colored tile panels of its lower walls sparkle as if with their own glowing light. The plan of the main hall is an ingenious fusion of an octagon with the dome-covered square. The octagon, formed by the eight massive dome supports, is pierced by the four half-dome-covered corners of the square. The result is a fluid interpenetration of several geometric volumes that repre-

sents the culminating solution to Sinan's lifelong search for a monumental, unified, interior space. The square gallery (visible in FIG. 10-26), a platform for the muezzins that at first may seem like a distracting piece of furniture, punctuates the central space. It restates the basic squareness of the prayer hall and provides an anchoring focus to a design that might seem diffuse without it. Placed under the center of the dome, it marks "the navel of the mosque."

Sinan's building elegantly resolves complicated laws of statics. The Islamic tendency to disguise the structural function of architectural elements is minimized and confined to a "honeycomb" treatment of the squinches and to "muqarnas" capitals, a form of decoration that was popular from the twelfth century onward. Sinan's forms are clear and legible, like mathematical equations; height, width, and masses are related to each other in a simple but effective ratio of 1:2. The building is generally regarded as the climax of Ottoman architecture. Sinan himself proudly proclaimed it his masterpiece, and, indeed, it encloses one of the most impressive domed spaces ever built.

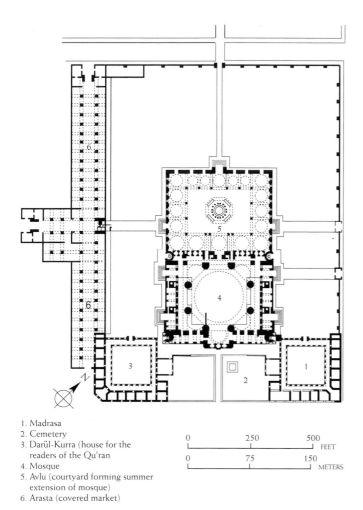

1. Madrasa
2. Cemetery
3. Darül-Kurra (house for the readers of the Qu'ran
4. Mosque
5. Avlu (courtyard forming summer extension of mosque)
6. Arasta (covered market)

```
0          250        500
|----------|----------| FEET
0          75         150
|----------|----------| METERS
```

10-25 Plan of the Selimiye Cami.

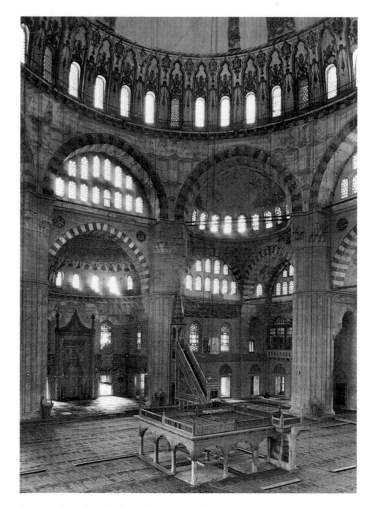

10-26 Interior of the Selimiye Cami.

OBJECT ART AND TEXTILES

The furnishings of the palaces, as well as of the mosques, reflected a love of rich and sumptuous effects. Metal, wood, glass, and ivory were artfully worked into a great variety of objects for use in mosque or home. Basins (often huge), ewers, jewel cases, writing boxes, and other decorative items were made of bronze or brass, chased and inlaid with silver (FIG. 10-30); enameled glass was used with striking effect in mosque lamps; richly decorated ceramics of high quality were produced in large numbers. Islamic potters, experimenting with different methods of polychrome painting, developed *luster painting*, a new and original technique that gives a metallic sheen to a surface. Their designs were based on the motifs found in architectural decoration. This ready adaptability of motifs to various scales as well as to various techniques again illustrates both the flexibility of Islamic design and its relative independence from its carrier.

Among the most prestigious and highly valued objects of all were textiles, which, in the Islamic world, served more than purely utilitarian or decorative purposes. Produced by imperial factories, they were used not only in homes, palaces, and mosques, but also served as gifts, rewards, and signs of political favor.

The Muslim weavers adopted and developed the textile traditions of Sasanian Iran and the Mediterranean region (the latter were best known through Coptic textiles from Egypt). The art spread across the Islamic world, and by the tenth century, Muslim textiles were famous and widely exported. The art of carpet-making was developed to a particularly high degree in Iran and Anatolia where the need for protection against the winter cold made carpets indispensable both in the shepherd's tent and in the prince's palace. In houses and palaces built of stone, brick, plaster, and glazed tile, carpets also provided a contrasting texture as floor and divan coverings and wall hangings (FIG. 10-31).

The carpet woven for the tomb-mosque of Shah Tahmasp at Ardebil (FIG. **10-27**) is a large example of the medallion type and bears a design of effectively massed large elements surrounded and enhanced by a wealth of subordinated details. The field of rich blue is covered with

10-27 Carpet from the tomb-mosque of Shah Tahmasp at Ardebil, Iran, 1540. Approx. 34$\frac{1}{2}$' × 17$\frac{1}{2}$'. Victoria and Albert Museum, London.

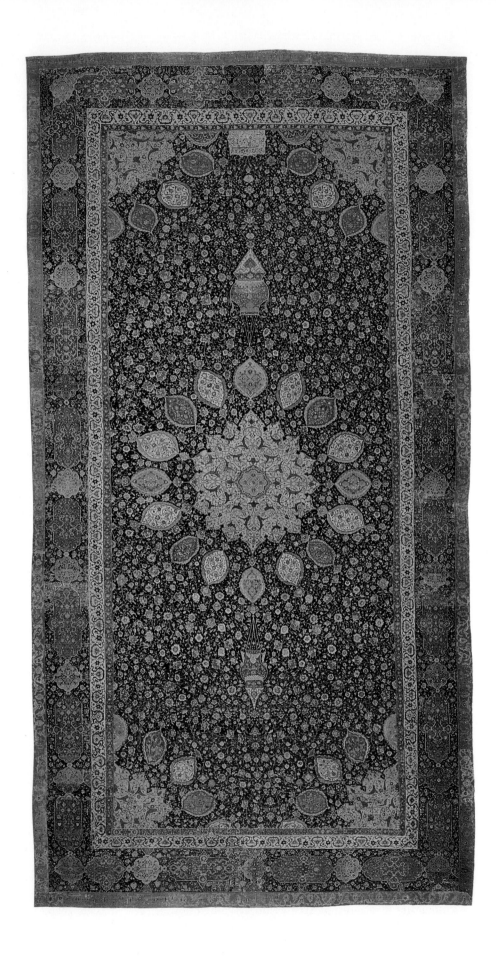

leaves and flowers (chiefly peonies, a Chinese influence) attached to a framework of delicate stems that weave a spiral design over the whole field. Great royal carpets like the one from Ardebil were products of the joint effort of a group of weavers, who probably were attached to the court. Pile weaving is a slow process at best, and because a carpet like the one from Ardebil often has more than three hundred knots to the square inch, a skilled weaver working alone would probably have needed more than twenty years to complete it.

Because the Ardebil carpet was made for a mosque, its decoration excludes human and animal figures, although other carpets from Iran show that the traditional strictures against the representation of human and animal figures were not taken so seriously in secular art. As we have seen, the ban against the worship of idols, however, had practically eliminated the image of humans from Islamic religious art, and, even in early secular art, it appeared only occasionally in secluded parts of palaces as royal imagery. For this reason also, large sculpture in the round and mural or panel painting, as developed in Europe and in the Far East, were rather rare in Early Islamic art. Contributing to this lack of interest in monumental plastic art may have been the predilections of the people who made up the Muslim world; many of them—Arabs, Turks, Persians, Mongols—were nomads, who traditionally preferred small, movable objects (the so-called nomad's gear) to large-scale works of art. And so, perhaps, it should not be surprising that, when painting did develop in later times, it was mainly on the small scale of book illumination.

THE ART OF CALLIGRAPHY

More revered even than the art of textiles in the Islamic world is the art of calligraphy, the art of ornamental writing. The sacred words of the Qur'an, its verses *(suras)*, must be reproduced in as beautiful a script as human hands can contrive and must appear on whatever material surfaces can carry it unsullied, from architecture to the fragile pages of books. The practice of calligraphy was itself a holy task, and one requiring long and arduous training. The scribe must be a person of exceptional spiritual refinement: an ancient Arabic proverb proclaims, "Purity of writing is purity of soul." Only in China do we find calligraphy holding so supreme a position among the arts.

As the language of the Qur'an established the form of classical Arabic, so the many scripts in which it was written fixed a standard of elegance for Arabic calligraphy and, later, Arabic print. Both can draw the admiration of those who know nothing whatever of the language or the figures of its alphabet.

The esthetic achievement of Arabic calligraphy lies not only in itself, but in its perfect union with that system of

Islamic ornamentation that, as we have seen, is known as arabesque (FIG. 10-11). A mihrab from Isfahan (FIG. **10-28**) exemplifies the strength and happiness of this union in architecture. The mihrab resembles a monument we have already seen, the dome of the Masjid-i Shah, another work of the architects of Isfahan (FIG. 10-17). The two monuments, though of greatly different date and scale, manifest the same principles of design.

The pointed arch that immediately enframes the mihrab niche bears an inscription from the Qur'an in *Kufic* (an early form of the Arabic alphabet), the stately vertical script from which derived the many supple, cursive styles that make up the repertoire of Islamic calligraphy. One of these styles, the so-called *Muhaqqaq,* fills the outer rectilinear frame of the mihrab. The ornament that occupies the curving surface of the niche, and the transom above the arch, is composed of tighter and looser networks of geometrical

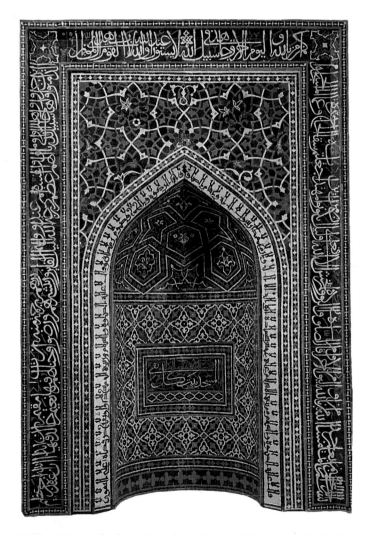

10-28 Mosaic tile decoration of a mihrab, *c.* 1354. Composite body, glazed, sawed to shape and assembled in mosaic. Height 11′ 3″. The Metropolitan Museum of Art, New York.

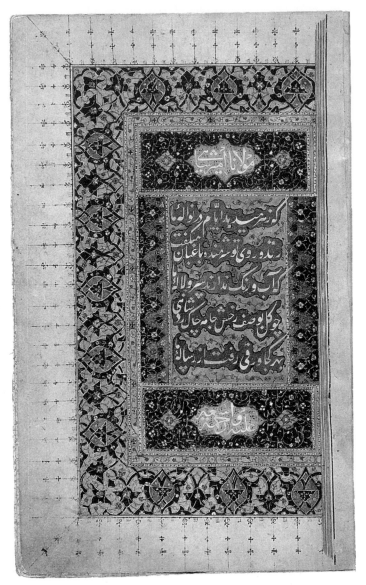

10-29 Calligraphic illumination of a page of poetry, Iran (?), sixteenth century, ink, colors, and gold on paper. 5³/₄″ × 8³/₄″. The Metropolitan Museum of Art, New York.

able. The fascination with calligraphy, moreover, was not confined to copies of the Qur'an, but extended to other works religious and secular.

A sumptuous example of the latter is a page of poetry ornamented with arabesqued compartments that center the script (FIG. **10-29**). A starlike sprinkling of minute motifs falls upon the immediate borders of the inscription, their profusion controlled by firm frames and strict symmetry. The broad outer margin holds an intricate interlacement of lobe and leaf shapes, the configuration of which can be read in a number of different ways. The script itself exhibits not only the skill of the calligrapher, but also those of the mosaicist and tile setter, all of whom practice the art of arabesque. For the letters are a work of *découpage;* that is, they are not painted or drawn directly upon the surface of the page, but have been previously cut out and then pasted to it, an astonishing technique of almost superhuman difficulty.

This love of the well-wrought surface engages the sense of touch as well as the sense of sight. As we have noted,

and abstract floral motifs. The framed inscription in the center of the niche—proclaiming that the mosque is the domicile of the pious believer—is smoothly integrated with the subtly varied patterns; and the outermost inscription—detailing the five pillars of Islamic faith—serves as a fringe-like extension as well as a boundary for the entire design. The harmonious consolidation of both calligraphic and geometrical elements makes so complete a unity that only the practiced eye can distinguish them. Architectural surface is transformed into textile surface, three-dimensional wall into two-dimensional hanging, with the calligraphy woven into it as another cluster of motifs within the total pattern.

The Qur'an, of course, is a book. Its copies must be books, and the pages of these books must be the ideal place for the written word, no matter the other surfaces avail-

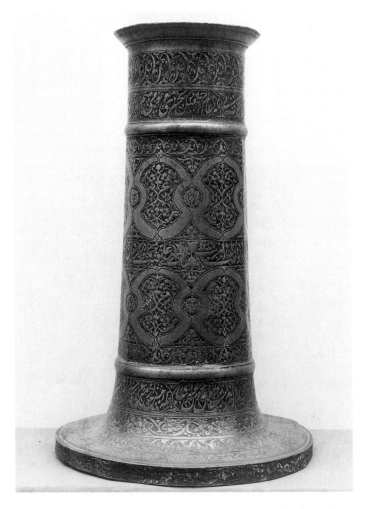

10-30 Candlestick engraved with a Persian poem, Safavid period, 1608, 11³/₈″. The Metropolitan Museum of Art, New York.

Islamic tradition, excluding that extension of tactile experience that accompanies large-scale figurative sculpture, confined carving and casting to the abstract ornamentation of architecture and to objects of use and display made of wood, ivory, metal, and other materials. Worked in a variety of techniques, the surfaces of these objects bear designs that, like the ones we have described, integrate arabesque and calligraphy in a unity of shape and figure. A brass candlestick from Iran (FIG. **10-30**) beautifully illustrates this unity, which flawless technique renders as a perfect evenness of texture. Bands of calligraphy at the neck, waist, and base of the piece compose a verse in Persian celebrating the radiance of a beloved's face. The optical and the tactile, the form and the function, and the literary and the decorative harmonize exquisitely in this small masterpiece of Islamic art.

THE ART OF BOOK ILLUSTRATION

The Arabs had no significant pictorial tradition of their own, and the Qur'an was not illustrated. It is possible that their interest in figurative illustration developed almost accidentally, as a by-product of their practice of translating and copying illustrated Greek scientific texts. In some of the earliest Islamic illuminated manuscripts (only a few dating earlier than 1200), the illustrations seem to have been drawn by the scribes who copied the texts. Whatever its origins (often Christian and Mediterranean, but also local Iranian and Buddhist), the art of book illustration had developed, mostly in Iraq and Syria, after 1200. It flourished in Egypt in the fourteenth century, in Iran from the fourteenth to the eighteenth century, in Muslim India from the late fifteenth to the early nineteenth century (FIG. 15-26), and in the Ottoman Empire from the late fifteenth to the late eighteenth century.

The Persian rulers were lovers of fine books and maintained at their courts not only skilled calligraphers but also some of the most famous artists of their day. The secular books of the Timurids and the Safavids in Persia (1502–1736) were illustrated by a whole galaxy of painters. Famous among them were Bihzad (c. 1440–1536), Aqa Mirak, and Sultan Muhammad, court painters of Tahmasp (1524–1576), a great patron of the arts. Although the rulers were Muslims, the orthodox Islamic restrictions regarding the depiction of the human figure were interpreted rather liberally by them and did not affect the secular arts. Within the framework of illustrating specific stories, the merry scenes of their life of pleasure—the hunt, the feast, music and romance—and battle scenes filled the pages of their books. In them we feel the luxury, the splendor, and the fleeting happiness of privileged living.

It is important to realize that Islamic painting was intended as illustration of a text, and was almost never designed for exhibition on a wall or in a gallery; that would be the tradition of the West. As we have seen, the art that held first place in the esteem of Islam was calligraphy; painted illustration, although providing a sort of portable museum for traveling rulers, was only an adjunct to writing and to arabesque. It is no wonder then that illustration would take over the design fundamentals of calligraphy and arabesque so as to harmonize with their two-dimensional patterning.

In *Laila and Majnun at School* (FIG. **10-31**), the painter AQA MIRAK (?) has illustrated one of Nizami's romantic poems. The scene represents a school, apparently in a mosque, and deals less with the pleasures than with some of the more earnest aspects of life. Seated on a rug is a

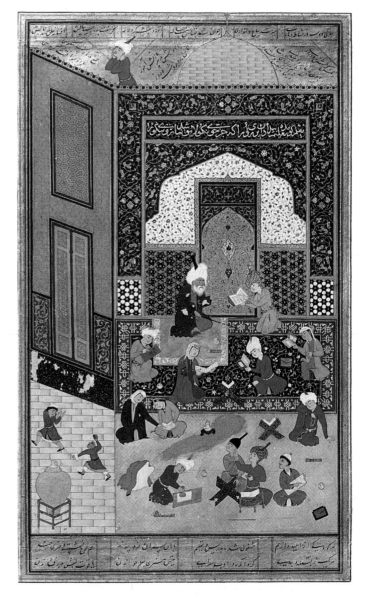

10-31 *Laila and Majnun at School,* miniature from a manuscript of the Khamsa of Nizami, 1524–1525. Ink, colors, and gold on paper. The Metropolitan Museum of Art, New York (gift of Alexander Smith Cochran, 1913).

turbaned *mullah*, or teacher, rod in hand, listening to a youth reading; around him are other youths studying, all seated on their knees and heels or with one knee raised, the customary sitting postures of the East. Here and there are cross-legged bookrests. In the foreground, one boy is pulling his companion's ear, and at the left, near the large water jar, two boys are playing ball. In the middle distance are the lovers Laila and Majnun, each obviously aware of the other's presence.

The figures of this lively scene, along with the whole setting, accommodate to the rules of arabesque design. They lie flat upon the surface like paper cutouts; they are without interior modeling; and they cast no shadows, because there is no source of illumination. As motifs, they are distributed only slightly more loosely than the tightly controlled motifs of the wall, the carpet, and the calligraphic inscription above the arch. The figuration is done in simple outline containing intensely colored shapes.

The space is as two-dimensional as the figures: the carpet and the tiled courtyard are seen in plan, that is, from above; the main wall is seen in front elevation; and the outside wall is seen in diagonal perspective, its lines parallel rather than convergent. The architectural features are thus like hanging textiles, their design and placement obedient to the fundamental command of the Islamic esthetic: design must begin with pattern—woven pattern!

The artist draws outlines both firm and delicate and fills them with fresh, bright, and clear color. With great economy of pictorial resources the narrative is set forth in delightfully descriptive and expressive detail.

We shall find numerous examples of this linear mode of representation in the art of the world; we have seen it already in ancient art, and shall see it again in the art of India, the Far East, and medieval Europe. Indeed, this fundamental mode, outline surrounding unshaded color, prevails above all other modes in world art.

Resembling products of the modern media is an illustration in the margins of a medical book produced in Egypt in the fourteenth century (FIG. **10-32**). It is as if this battle scene were lifted from an arabesque decorative context and simply silhouetted on the neutral white of the paper. The illustration represents a combat between two lance-bearing horsemen, one of whom is already stricken. The theme of battle is frequent in Muslim illustration, as it is in that of the medieval West (FIG. 12-36); both worlds knew war as a way of life, and victories and warlike prowess were celebrated in poetry and pictorial art. The symmetrically confronted, sharply profiled figures of the horsemen have the strong outlines and flat, strong colors of the linear mode. The minimal poses and gestures convey at once the action and its meaning; nothing more is needed to make the spare communication.

The traditions of Islamic art will live long—its media, its linear mode of representation, its thematic repertory. In the late twentieth century a fringed and figured textile produced in Muslim Pakistan (FIG. **10-33**) was offered for sale in an Islamabad bazaar. Its theme is the Soviet war in Afghanistan. Only a few figures, simplified in shape and pose, are placed on superposed levels and silhouetted against neutral grounds. The composition ironically contrasts with that of the lance-bearing horsemen in the previous illustration: now the horsemen carry machine guns, and helicopter gunships hover overhead. Times change, but the theme of war does not, nor do the stylistic means of representing it. They testify to a living tradition whose roots lie centuries in the past but whose branches still flourish today in the folk art of the Muslim world.

Islam created a culture and an art still worthy of universal admiration. Through the ages its relations with the Christian West have been marred by religious and political conflict. This unfortunate rivalry should not keep us from acknowledging Islamic achievement and the artistic debt the West owes to Islam.

As we now turn our attention to the medieval West, we should take note of the far-ranging influence of Islam in the awakening of the European intellect. Arabic translations of

10-32 Knights jousting, from a book on veterinary medicine, Egypt, fourteenth century, Museum of Islamic Art, Cairo.

10-33 *Horsemen and Helicopters,* from Islamabad, Pakistan, 1987. Fringed textile. (Courtesy of Mr. Todd Disotell.)

Aristotle and other Greek writers of antiquity, especially the scientists, were studied eagerly by Christian scholars of the twelfth and thirteenth centuries known as "Schoolmen"; indeed, it was mostly through the Arabs that the treasures of Greek thought and experimentation were made known to the West. Arab scholars laid the foundations of arithmetic and algebra as we still know them; and their contributions to astronomy, medicine, and the natural sciences have made a lasting impression. Arab philosophy shaped the thought of the Schoolmen. In literature, Arab love lyrics and poetic descriptions of nature inspired the early French troubadours. Arab art and architecture in Spain and the Spanish dominions make up an illustrious chapter in the history of art. It is one of the ironies of history that the West should have gained so much of lasting worth from a people and a power it deemed irremediably alien.

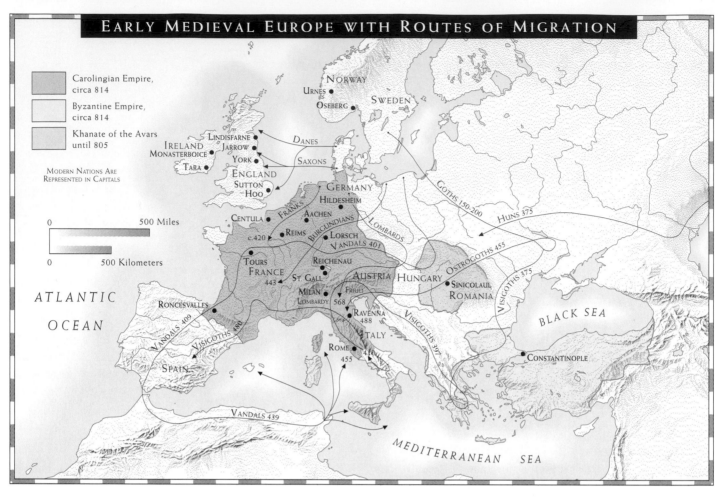

EARLY MEDIEVAL EUROPE WITH ROUTES OF MIGRATION

Carolingian Empire, circa 814

Byzantine Empire, circa 814

Khanate of the Avars until 805

MODERN NATIONS ARE REPRESENTED IN CAPITALS

0 500 Miles

0 500 Kilometers

NORWAY

SWEDEN

URNES

OSEBERG

IRELAND

MONASTERBOICE

TARA

LINDISFARNE

JARROW

YORK

ENGLAND

SUTTON HOO

DANES

SAXONS

GERMANY

HILDESHEIM

FRANKS

AACHEN

CENTULA

REIMS

c.420

BURGUNDIANS

LORSCH

VANDALS 401

LOMBARDS

GOTHS 150-200

HUNS 375

TOURS

443

FRANCE

ST. GALL

REICHENAU

MILAN

LOMBARDY

FRIULI

568

AUSTRIA

HUNGARY

OSTROGOTHS 455

VISIGOTHS 375

SINICOLAUL

ROMANIA

ATLANTIC OCEAN

RONCESVALLES

VANDALS 409

VISIGOTHS 480

RAVENNA

488

ITALY

ROME

455

410

VISIGOTHS 488

VISIGOTHS 397

BLACK SEA

CONSTANTINOPLE

SPAIN

VANDALS 439

MEDITERRANEAN SEA

375	400	500	600	700

MIGRATION PERIOD AND FORMATION OF GERMANIC KINGDOMS HIBERNO-SAXON ART

VIKING ART

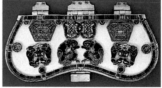

Sutton Hoo purse cover, 655

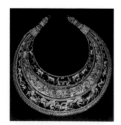

Scythian pectoral c. 4th century B.C.

Frankish ornament 6th-7th century

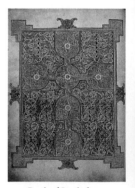

Book of Lindisfarne late 7th century

Invasion of western Roman Empire by the Huns, 376

Hiberno-Saxon (Irish/Anglo-Saxon) culture, 500-850

Franks in Gaul (Merovingian dynasty) 482-750

Anglo-Saxons take over Roman Britain, c.480 *Lombards in Italy, 568-774*

Ostrogoths take over Italy, 489-540

Visigoths in Spain, 412-715. Defeated by Muslim Arab invasion, 711-715.

Huns reach Gaul, 451 *St. Benedict establishes "Benedictine Rule" establishing western monasticism, 526*

CHAPTER 11

EARLY
MEDIEVAL ART
IN THE WEST

750	800	900	1002	1025
CAROLINGIAN PERIOD		OTTONIAN PERIOD		

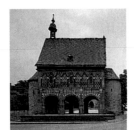

Lorsch Gatehouse, 800

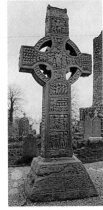

Animal head from
Oseberg ship, 825

High cross of
Muiredach, 923

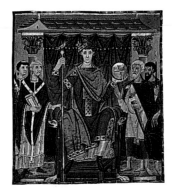

Otto III Enthroned, 997-1000

Pepin the Short r.741-768 Carolingian cultural
 revival c. 780-880

Pepin donates
Ravenna
to Pope, 754 Charlemagne r.768-814

 Coronation of Charlemagne in Rome,
 establishment of Holy Roman Empire, 800

Viking raids, 9th-11th centuries

 Otto I (the Great) r.936-973

 Partition of
 Carolingian empire, 843

Canute (Knut)II, briefly king of Norway,
Denmark and England, 1014-1035

Henry II, Holy Roman Emperor, r.1002-1024

 Edward the Confessor, Anglo-Saxon
 king of England, r. 1042-1066

 William I ("The Conqueror"), 1035-1066

For thousands of years, waves of migrating people moved slowly across the great Eurasian steppes and down into the Mediterranean world; we have met them as the Achaeans and Dorians of Mycenaean times, and again as the Gauls, who invaded Asia Minor and were defeated by Attalus I of Pergamon in the third century B.C.

In the second century A.D., many of the Germanic peoples of Europe were on the move. The Goths migrated southward from the Baltic region and settled on the north shore of the Black Sea, subjugating the Scythians and Sarmatians, who had inhabited the area for some eight centuries. On their march, the Goths had met and defeated the Vandals, pushing them toward central Europe where the Vandals sacked the city of Rome in 451. The displacement of the Vandals set in motion one of the longest and most infamous migratory treks in history—one that was to end only in the fifth century with the establishment of a Vandal kingdom in North Africa. The Goths themselves split into two groups in the early fourth century: the Ostrogoths (Eastern Goths), who remained in Sarmatia, and the Visigoths (Western Goths), who moved on into the Danube River basin.

For centuries, these migratory movements had been checked by Roman military might along the Rhine and Danube rivers. Despite constant friction with them since the first century B.C., the Romans had been able to contain the barbarians (as they were referred to by the Romans) along their northern frontiers. In the fourth century, however, the eruption of the Huns, an Asiatic people, pressed those tribes and nations against the Roman boundaries, which Rome found more and more difficult to defend. In 376, the Roman emperor Valens allowed the Visigoths, hard-pressed by the Huns, who had already conquered their Ostrogothic cousins, to settle west of the Danube. Maltreated by Roman officials, the Visigoths revolted two years later and, in a battle near Adrianople, killed the emperor and nearly two-thirds of his army. After this, Rome offered little resistance to the different barbarian nations who crossed into western Europe almost at will.

Early Medieval Society

The invasions of Roman territory by barbarian tribes were, in reality, migrations of ethnic groups seeking not to overthrow the Roman Empire, for which they often had great admiration, but to find a place where they could settle peacefully. They seldom were allowed to remain in any one location, however, as other tribes and nations would press in behind them and force them to move on. The Visigoths, for example, who moved in and out of Italy and formed a kingdom in southern France, were forced southward into Spain under pressure from the Franks, who had crossed the lower Rhine and established themselves firmly in northern France. The Huns themselves, the force that triggered this chain reaction of ethnic dislocations, reached France and

Italy in the mid-fifth century, and only the death of their great leader, Attila, in 453 prevented them from consolidating their vast conquests. As Hunnish power waned, the Ostrogoths shook off their yoke and moved first to Pannonia (at the junction of modern Hungary, Austria, and the former Yugoslavia) and then to Italy, where, under Theodoric, they established their kingdom, only to have it fall less than a century later to the Lombards, the last of the early Germanic invaders to occupy land within the limits of the old empire.

THE WARRIOR-LORDS The disintegration of the Roman Empire meant anarchy among the Germanic peoples and the Romanic peoples they displaced or dominated. Western Europe was reduced to a state of near savagery, from which, through slow, painful centuries, a new and distinctive world civilization would evolve. Power and land were taken and lost and taken again by pitiless hordes of warriors, whose depredations and atrocities were recorded by appalled chroniclers. As early as the latter fourth century, the Roman historian Ammianus Marcellinus wrote of the Alans, a Germanic people who were allies of the Huns and enemies of the Goths:

> The Halani [Alans] . . . delight in danger and warfare. . . . There is nothing in which they take more pride than in killing any man whatever; as trophies the heads of the slain are cut off and scalped; these they hang on their war horses as trappings [see FIG. 11-20]. . . . They do not know the meaning of slavery, since all are born of noble blood, and they choose as chiefs those men who are conspicuous for long experience as warriors.

We find in Ammianus's picture a rough outline of the rudimentary features of early medieval society. War is the dynamic that moves it. The warriors vest their power in a chieftain, a skillful and brave man experienced in war. They are noble, being born free; they do not comprehend slavery.

Documentary and archeological sources do much to fill out the picture of early medieval society as it comes into focus in the period of settlement following many of the migrations. Under the pressure of perpetual danger to their newly settled holdings, as well as the ever present need for personal protection, the migrant war bands evolved into settled associations of land-holding nobles tied together by mutual loyalty, interest, and obligation. The chieftain of the war band becomes the liege-lord, and the strongest liege-lord becomes a king. Lord and king assure protection, bestow privileges, and grant tenure of land to their vassals, the lesser lords. In return, the vassals swear allegiance to their liege and render military service. This relationship of liege-lord and vassal (who may in turn be the liege of a lesser vassal) is the bond that holds together the political, social, and economic system we call *feudalism*. Until the fourteenth century, feudalism and its associated institutions dominated the medieval world.

The feudal bond was taken very seriously by most who were bound by it. Personal identity derived from lineage, but status was determined by the power and prestige of one's liege-lord, who favored his retainers with a place in his hall and at his table and with gifts of gold. A vassal without a lord was an outcast—in our view, a man without a country, although the concepts of country, nation, state, class, and race were unknown in a society that recognized only nobles free by birth, others free by law, and the remaining majority, serfs and slaves.

An Anglo-Saxon poem of the early eighth century, *The Wanderer*, poignantly expresses the predicament of a vassal whose liege has been killed and his hall destroyed.

Only he who has experienced it can understand the loneliness of the lordless man. For him is the burden of exile, no twisted gold at the feast. . . . He remembers the hall-men and the treasure giving, how, in his youth, his lord entertained him at the banquet; joy now has failed! that he knows well who has been long without a king's protection. So sorrow and sleep come upon the miserable lonely man; it seems to him that he is clasping and kissing his lord and laying on his knees, hands, and head as once he did in days long ago.*

The mood of the time was one of stoic pessimism, the resigned fatalism common to the great sagas and epics of the migration and settlement—*Beowulf*, the Scandinavian *Eddas*, the *Song of the Nibelungs*. Christian optimism, with its promise of salvation through trust in God, does not touch these somber works. The warriors' hope is that Fate will send them a courageous death in the service of their lord.

The courage of the Germanic warriors, celebrated by Romans like Caesar and Tacitus, is shared by the Germanic women, who in the migration centuries often accompanied the men in battle, exhorting them with their cries, tending their wounds, and dying at their sides. By the time of the settlements, the roles of noble men and women were firmly distinguished and defined; the men did the fighting, the women managed the household—the "spear side" and the "distaff side," as they were known. Exceptional women like the audacious Frankish queens Fredegund and Brunhild might enter the complicated power struggles of the Merovingian families, but they did so at the same risk as men.

Women were influential mostly through their administrative skills and as exemplars of piety, especially as abbesses and prioresses of convents. As patronesses, they enriched churches with magnificent gifts of precious liturgical vessels, draperies, vestments, and books. Many woven and embroidered fabrics were of their making. Embroidery was considered their special art, and women embroiderers were renowned for most of the needlework masterpieces of medieval art (see FIG. 12-36).

* Translated from the Anglo-Saxon by George K. Anderson.

THE CHURCH AND THE CLERGY In all the destruction and disorder brought by the migrations and settlement, the Church was the only major institution to survive the Roman Empire in the West: Roman civil institutions, administrative apparatus, law, and pagan religion gradually faded away. What remained of distinctively Roman culture was merged with new Germanic elements, so as to be hardly recognizable. The Latin language by the sixth century was debased into a vernacular mixed with Germanic tongues.

Although they long acknowledged the Byzantine emperors at Constantinople as successors to the Caesars, the popes, the bishops of Rome, did feel that they had saved the West for Christianity, both by converting and by fending off the Germanic peoples, and that in thus preserving the authority of Christian Rome, they had the right to claim that they were its heirs. The papal claim to be the true heirs of Rome had apparent justification in the so-called *Donation of Constantine*. This document—later proved a forgery—purported to be a will made by the emperor Constantine, leaving the empire to the Church. By the territorial expansion and consolidation of the actual properties of the Church, the so-called Patrimony of St. Peter, the popes could function as temporal and not merely spiritual lords.

Beyond the confines of this papal estate the popes developed sufficient power and influence to claim supremacy later over all Christian monarchs. Ecclesiastical administration extended a network of control throughout the primitive German kingdoms. But the authority of the Church came to be questioned by the German kings. They regarded their lands as legally their property, tenanted, as we have seen, by vassal lords loyal to them. The kings wished to be masters in their own houses, the temporal lords of the properties, revenues, and privileges of both Church and state within their realms. A conflict of interest and jurisdiction between kings and popes arose that would divide medieval Europe and last into early modern times, and that would end only with the rejection of the papal claim to supremacy over all of Christendom.

On one point the papal and the royal parties were in agreement: the Church must remain orthodox in doctrine (as decided by the great ecumenical councils of the fourth and fifth centuries). Many of the German tribes had been early converts to Aryan Christianity, which denied the simultaneous divinity of Christ with the Father. The most important of them, however, the Franks under Clovis, were baptized in the Athanasian (Trinitarian) faith, and the others followed suit. We have noted the Byzantine emperors' insistence on orthodoxy; the German kings were just as zealous in their suppression of heresy. After all, heresy was as divisive politically as it was doctrinally.

Yet the interaction of the secular and the religious spheres inevitably led to periodic secularization of the Church, to the gross abuse of its regulations and the neglect of its spiritual mission. Worldliness and immorality often prevailed in ecclesiastical life and government. Venality

was rampant; church offices could be bought and sold, fees were charged for indulgences and exemptions from religious duties. There were relapses into paganism and old superstitions.

This corruption called for reform, which the best popes supported and sometimes initiated. But the movements for reform most often came from the spiritual initiative and fervor of monks, who throughout the Middle Ages created new monastic orders dedicated to the purification of the Church and of morals.

The most significant of these monks was Benedict of Nursia (Saint Benedict), who founded the Benedictine Order in 529. Monastic foundations had appeared in the West in Early Christian times, but the "Rule" given by Benedict (*Regula Sancti Benedicti*) had become standard by the ninth century for all Western monastic establishments.

Monks living according to the Rule, under their elected abbots, are known as *regular* (Latin: *regula*) clergy, while priests, living without a specific rule and subordinate to their bishops, are known as *secular* clergy. The regular clergy were directly responsible to the papacy. Their close alliance with Rome and the independence of the bishops counterbalanced the power of the latter, while greatly reinforcing the campaigns of reform.

Saint Benedict believed that the corruption of the clergy that accompanied the increasing worldliness of the Church was rooted in the lack of firm organization and regulation. Neglect of the commandments of God and of the Church was due, as he saw it, to idleness and venality, which in turn tempted the members of the clergy to loose living. The cure for this was communal association in a monastery under the absolute rule of an abbot elected by the monks, who would see to it that each hour of the day was spent in useful work and in sacred reading. The emphasis was on work and study and not upon meditation and austerity:

> "Idleness [stated Saint Benedict] is the enemy of the soul. . . . We blush with shame for the idle, the evil-living, and the negligent. Therefore the brethren at fixed times ought to be occupied in manual labor . . . they are truly monks if they live by the labor of their hands."

This is of great historical significance. Since antiquity, manual labor had been disgraceful, the business of the low-born or of slaves. Benedict raised it to the dignity of religion. The core idea of what we call today the "work ethic" finds early expression here as an essential feature of the spiritual life. In exalting thus the virtue of manual labor, Benedict not only rescues it from its age-old association with slavery, but he recognizes it as the way to self-sufficiency for the entire religious community:

> A monastery should if possible be so arranged that every-thing necessary—that is, water, a mill, a garden, a bak-ery—may be available, and different trades be carried on within the monastery; so that there shall be no need for

the monks to wander about outside. For that is not at all good for their souls.

In putting Saint Benedict's teachings into practice, Benedictine monks reached into their surroundings and helped reduce the vast areas of daunting wilderness that were the early medieval environment. They cleared dense forest teeming with wolves, bear, and wild boar; drained swamps; cultivated wastelands; built roads, bridges, and dams, as well, of course, as monastic churches and their associated living and service quarters (see FIG. 11-24).

The clergy, especially the regular clergy, who were scribes and scholars, had a monopoly on the skills of reading and writing in an age of almost universal illiteracy. The monastic libraries, where books were copied, illuminated, and bound with ornamented covers, became centers of study and learning, almost the sole repositories of what remained of the literary culture of the Greco-Roman world and early Christianity. The requirements of manual labor and sacred reading, stipulated by the Rule, were expanded to include writing and copying of books, the study of music for chanting the offices of the day, and—of great significance—teaching. The monasteries were the schools of the Early Middle Ages, as well as self-sufficient communities and centers of production.

THE COMMON PEOPLE According to writers of the time, early medieval society was divided into three groups—the warrior-nobility, the clergy, and the common people—or as it was said, those who fight, those who pray, and those who work. The commoners sustained all by their work. The peasant serf, but one step above the slave—who had neither social nor legal status except as property—was bound to the land and service of his master. He tilled the soil for the master's benefit, reserving for himself little more than a fraction of what he produced. In addition to his unending labor, he was under a variety of obligations to his lord—payment of rent and dues, care of the grounds, buildings, and implements of the lord's estate, and whatever other miscellaneous tasks of service might be demanded of him. Even if he could manage to acquire some holdings from his master, and some surplus above mere subsistence, he was rarely able to purchase his freedom from bondage. The Anglo-Saxon cleric Aelfric, writing in the tenth century, has a farmer/serf describe his lot:

> I go out at dawn, forcing my oxen to the field, and I yoke them to the plough; there is no winter so severe that I dare stay home for fear of my lord; but with yoked oxen, ploughshare, and colter, everyday I must cultivate a full acre or more. . . . Yes, it is a great labor, for I am not free.*

Manual labor, no matter the honor paid it by the Rule of Saint Benedict, was thought contemptible and the laboring

* Translated from the Anglo-Saxon by George K. Anderson.

serf vile. His lord owed him nothing but protection and basic sustenance, and was very likely to be careless and indifferent, indeed often abusive and destructive, in his relation with the serf.

Along with the farmers, cowherds, and shepherds, who are serfs, Aelfric also interviewed fishermen, falconers, cobblers, smiths, carpenters, and tailors, although this is by no means an exhaustive list of the trades and crafts of the age. Many of these individuals seem to be freemen (which is to say born free, as distinguished from *freedmen*, who have been freed from servitude), whose lot is considerably better than that of the serfs. Aelfric's smith and the carpenter argue about whose is the most useful occupation; ironically, a consensus appears that the farmer is the most indispensable, for the farmer produces the food needed by all. In the end, Aelfric advises all of them to go about their business with pleasure, to know their trade and know their place.

In addressing the three divisions of early medieval society, Aelfric implies that both their occupations and their rank and status are fixed. It is significant that he does not include the merchant, whom he has also interviewed. The merchant stands outside the tripartite society. He represents commerce and the life of towns; as such he is suspected and disliked, though patronized, by the three recognized social orders. His historical time is yet to come, when the rapid rise of towns toward the end of the tenth century will begin to transform the culture of early medieval society.

THE EARLY MEDIEVAL WORLD VIEW We date the Early Middle Ages from about 500 to 1000 A.D., a span of time equivalent to that which separates us from the age of Columbus. When we compare the two eras, the tempo of early medieval existence seems inconceivably slow. Events occur in slow motion, in ever-repeating patterns. There are no great discoveries, inventions, or breakthroughs in knowledge, no economic or industrial expansion, no fundamental transformations of society. It is an age whose pace is measured by the ox-cart. There is virtually nothing we could call progress.

In a world immobile and stagnant, the prevailing mood was one of rigid conservatism, a resistance to change, novelty, and whatever was strange and foreign. The peasant, the clergy, and the warrior-noble all shared this view. Naturally, this discouraged enterprise and experiment, whether scientific, technological, or social. A view of the world shaped by religion explained that all was as God had made it, and that it should remain so; it would be impious to try to improve upon it. Life in this world, unhappy as it might be, is only a preparation for life in the world to come.

As for one's status in this world, Aelfric's parting advice to his commoners was enough: "Be what you are and what you ought to be." Loyalty to one's superior is the early medieval virtue, disloyalty its vice; misfortune is to be without a liege-lord. For the members of early medieval society as Christians, faith is the virtue corresponding to loyalty, and faithlessness is the vice corresponding to disloyalty. For the Christian, misfortune is to be without baptism or to be excommunicated. To reject or fight against the faith, to be an infidel or a heretic, is criminal, and of all sins the most worthy of death.

So far as the value attached to the things of this world by early medieval people is concerned, their laws tell us a good deal about their society and their rural economy. Criminal offenses are matched to the rank of the victim, and the offender must compensate the victim or the victim's kinfolk with a payment in money or in kind, called *wergild* (literally, "man-money" or "man-gold"). If the offended family's honor and loss were satisfied with the compensatory payment, that ended the matter. In the law code of the Ripuarian Franks, a scale of money values and their equivalent in things serves as a kind of inventory of what the rural, warfare society valued and to what degree:

> If anyone begins to pay a wergild, let him give a horned ox, able to see and healthy, for two solidi [the *solidus* was a late Roman gold coin]. Let him give a horned cow, able to see and healthy, for one solidus. . . . Let him give a metal tunic in good condition for twelve solidi. Let him give a helmet in good condition for six solidi. . . . Let him give an untrained hawk for three solidi. Let him give a crane-seizing hawk for six solidi. Let him give a trained hawk for twelve solidi.*

The armored tunic and the trained hawk, the most valued items of the inventory, could aptly be the heraldic emblems of early medieval society.

Through the long, slow centuries of the Early Middle Ages, living conditions were harsh for the warrior, miserable for the peasant. For all orders of society, life itself was constantly threatened, not only by the violence of endemic war and lawlessness, but by epidemic famine and disease. The necessities of life were in short supply and unevenly distributed. Ignorance, bred and sustained by illiteracy, inhibited the application of intelligence to the problems of existence. And, as we have noted, a stubborn conservatism resisted all ideas of change. Small wonder that the early medieval view of the world was somber. The way things were could not, and should not, be changed. One could not evade the workings of Fate, which, for the Germanic mind, still ruled the universe; the Christians' God was Fate's deputy, and the two could be appealed to alternately.

Religious interpretation eventually merged Christian religion with Germanic magical lore, by which the people tried to manage as well as comprehend their rough world. The Germanic gods, such as Woden and Thor, were mortal, like humankind. Like humans, they were ruled by Fate and doomed to ruin. Their powers were supplemented and

*Edward James, *The Franks* (New York: Blackwell, 1988), 210.

summoned by spiritual forces that animated the natural world, pervading the entire scene of divine and human existence. Some of these spirits were good, some evil. By means of magic they could be communicated with and their powers brought into play.

Before the times when systematic reasoning and experimental science would seek explanation and control of natural events by identifying their natural causes, believers in myth and magic would see events and their causes as fundamentally supernatural. The supernatural powers could be controlled by occult practices: the casting of spells or lots, the reading of omens, soothsaying, wonder-working, incantation, conjuration. Among the Germanic peoples, as among many others, magic was practiced to achieve success in war, love, trade; or to bring about recovery from illness, a change in the weather or of fortune, the death of an enemy, the birth of an heir. Objects—charms, amulets, talismans, potions—could have magical power. The practitioners of magic were variously specialized as sorcerers, soothsayers, necromancers, wizards, witches; there were great numbers of these, and they were widely consulted.

The religious-magical traditions, practices, and mindset of the pagan Germans persisted after their conversion to Christianity. To avoid both confrontation and surrender, the Church gradually co-opted elements of the old traditions, transforming pagan supernaturalism by changing its meaning to fit Christian teachings.

The magical power of words, spoken or inscribed, struck awe into the Germanic mind. The very letters of the Germanic alphabet, the runes, were instruments of power; incised on a spearhead or a sword blade, they transmitted to those weapons a pitiless efficiency. Even the Lord's Prayer, as written in a West Saxon (England) manuscript of about the ninth century, the *Dialogues of Solomon and Saturn*, shows a remarkable fusion of Christian prayer with runic incantation magic.

The Early German mentality, credulous and suggestible, often failed to distinguish between the natural and the supernatural. Fantastic creatures of all sorts inhabited their world. The dark forests especially teemed with demons, fiends, gnomes, elves, werewolves; these were as menacing as the wild animals, which were real enough. But what gripped the Germanic imagination with particular dread was the lord of all phantasms, the dragon, which like

* We have given this rather lengthy account of early medieval society not only to suggest something of the struggle for survival that took place in primitive Western Europe, but also to stress those features that would live on through the Middle Ages, and, indeed, until the great modern revolutions: (a) the warrior-nobility competing for power among themselves and with (b) an established Church, with immense political and spiritual influence, which claimed to be the sole repository of religious truth; and (c) a subordinate, functionally disfranchised populace that supported their rulers while having nothing to say about how they themselves were ruled. This basic arrangement, fabricated in the turmoil of the five early centuries, will last politically, socially, and even psychologically in the history and thinking of Western Europe, beyond the French Revolution of 1789.

Siegfried's Fafnir and Beowulf's dragon-monster Grendel, was a devourer of epic heroes. The dragon figured luridly in epic and folklore and may also have been pictured in sculpture, painting, and textiles. In the world of wild beasts, real and fantastic, early medieval humanity thought itself subordinate and helpless, even with the resources of magic. It is not surprising that for their art they adopted motifs in harmony with this mindset. These originated in the Near East as early as Mesopotamian art, and made up what is called the "animal style."

The class structure of European society, originating in the Early Middle Ages, is steadily reflected in all the later European art surveyed in this volume.*

THE ANIMAL STYLE: SCYTHIAN ANTECEDENTS

Animal style is a generic term for the characteristic ornamentation of artifacts worn and carried by nomadic peoples who, for almost two millennia (B.C. into A.D.), moved restlessly to and fro across the vast, open grasslands that stretch from China into western Europe. Originating in prehistoric times, the decorative animal form appears in ancient Egypt and Mesopotamia. Transactions between the nomads and the settled civilizations of the Near East and the Mediterranean disseminated the style and produced numerous variants of its figures and patterns. The wide and steady propagation of the animal style was made possible by the fact that it was found on small, metal objects that were portable and easily exchanged. The great revolution in metallurgy that replaced the Bronze Age with the Iron Age after 1000 B.C. put the means of fashioning metallic artifacts in abundance into the hands of numerous skilled artisans, nomadic or sedentary, and guaranteed the broadest distribution of these items through gift, exchange, plunder, or migration.

Perhaps the principal agents of the transmission of the animal style from East to West were the Scythians, a Persian-speaking nomadic people who roamed the steppes north of the Black Sea. They were known to the ancient Assyrians, Persians, and Greeks with whom they were in alternately friendly and hostile contact. Though the period of Scythian predominance precedes the early medieval times we are describing, they (and their Sarmatian successors) are significant for passing on to the Germanic tribes, and to medieval art in general, the repertory of animal ornament familiar in the art of the ancient world.

The remains of the settlements of the Scythian-Sarmatians, and especially the tombs of their kings, are scattered throughout southern Russia and the Crimea, the Caucasus, and Anatolia. From them, modern archeology has recovered rich troves of metal treasure, the funeral ornaments and furnishings of elaborate royal burials. Whether of their own manufacture, or the work of Greek

craftsmen, Scythian gold ornaments attest to what an ancient Roman author calls the "Scythian lust for gold." At the same time, these objects exhibit to perfection the motifs of the animal style that will be transmitted to the early medieval West.

A superb crescent-shaped golden pectoral from about the fourth century B.C. (FIG. **11-1**), a product of Greek craftsmanship, sums up the animal vocabulary favored by Scythian ornamental taste. Some forty-eight figures, mostly of animals cast singly and soldered to the frame, are distributed friezelike on three concentric bands separated by cable moldings. The innermost band represents Scythians in an encampment accompanied by their domestic animals. Men make a shirt out of an animal skin, close an amphora, and milk sheep. Calves and foals are suckling, and a horse casually scratches itself with a hind hoof. Birds, a kid, and a goat also are depicted. The central band is Classical Greek in its ornament of rhythmical vine scrolls, acanthus, and rosettes. The figures on the outer band contrast sharply with the pastoral mood of the other two; heraldically symmetrical griffins attack horses, lions and panthers tear at a deer and a boar, hounds pursue hares, and even grasshoppers challenge each other. The animals, actual and fantastic, are rendered with crisp realism. Later, they will be transformed into abstract zoomorphic motifs as they are adapted to the ornamental vocabularies of the migrant Germanic peoples, the Goths and their successors.

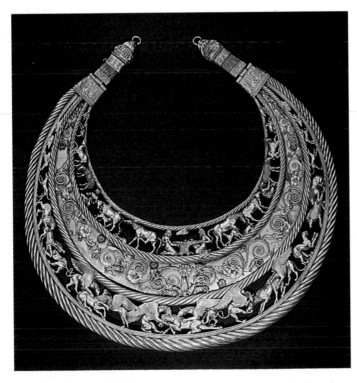

11-1 Pectoral with scenes from Scythian life (Greek craft done for the Scythians), *c.* fourth century B.C. Gold, diameter 12", weight 2½ lbs. Historical Museum, Kiev.

ART OF THE GERMANIC PEOPLES

The original art of the Germanic peoples was abstract, decorative, and geometric, and it ignored the world of organic nature. It was confined to the decoration of small, portable objects—weapons or items of personal adornment such as bracelets, pendants, and belt buckles. Most characteristic, perhaps, and produced in quantity by almost all tribes, was the *fibula* (FIG. **11-2**), a decorative pin usually used to fasten garments. Fibulae are made of bronze, silver, or gold and are decorated profusely, often with inlaid precious or semiprecious stones. The entire surface of these objects is covered with decorative patterns, reflecting the horror vacui so common in the art of many cultures. But we also note that the decorative patterns are adjusted carefully to the basic shape of the object they adorn and that they describe and amplify its form and structure, becoming an organic part of the object itself.

This highly disciplined, abstract, and functional type of decorative design was wedded to the animal style during the early centuries of the medieval era. The Scythians passed the animal style on to their Gothic overlords in the third century A.D. From that time on, the Goths became the main transmitters of this style, which was readily adopted by many of the other Germanic tribes. But its application was controlled severely by the native Germanic sense of order and design. Abstracted to the point of absolute integration with dominantly geometric patterns, the zoomorphic elements frequently became almost unrecognizable, and one often must examine a fibula carefully to discover that it contains a zoomorphic form (in the case of FIG. 11-2a, a fish).

The art of the Germanic peoples was expressed primarily in metalcraft. One of their preferred methods of decoration was *cloisonné*, a technique that may be of Byzantine and, ultimately, of Near Eastern origin, although recent archeology is pinpointing its source in Pannonia (roughly, modern Hungary), which in the late fifth century was central to the empire of the Huns. In this technique, used in the circular ornament shown in FIG. 11-2b, small metal strips (the *cloisons*), usually of gold, are soldered edge-up to a metal background. An enamel paste (subsequently to be fired) or semiprecious stones, such as garnets, or pieces of colored glass are placed in the compartments thus formed. The edges of the cloisons remain visible on the surface and are an important part of the design. This cloisonné personal gear was prized highly and handed down from generation to generation. Dispersion of some of the princely hoards at an early date would account for the discoveries of identical techniques and designs in widely divergent areas. Certainly, cloisonné ware must have been given to vassals as gifts and tokens of gratitude; everywhere in early medieval poetry, the name for the prince and lord is "treasure giver." Other collections or treasures must have been accumulated over time, which could explain the

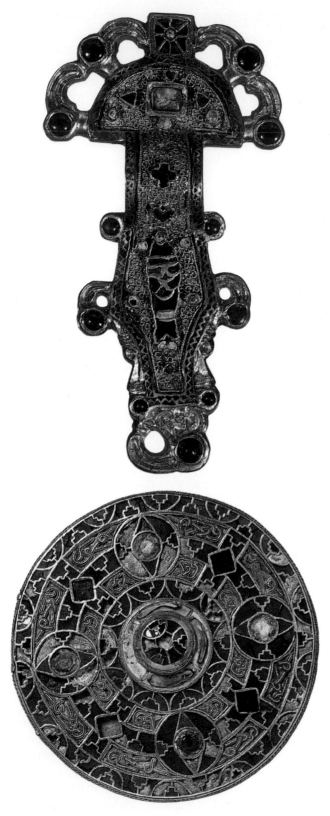

11-2 Frankish ornaments, sixth and seventh centuries: (a) looped fibula (4″ long), silver gilt worked in filigree, with inlays of garnets and other stones, Musée des Antiquités Nationales, Saint-Germain-en-Laye; (b) round fibula (diameter 3¹/₄″), gold, cloisonné technique, inlay of garnets and blue stones. City of Liverpool Museums.

different forms present in the magnificent discovery made at Sutton Hoo in Suffolk, England.

Excavated in 1939, the Sutton Hoo site now is associated with the ship burial of the East Anglian king Anna (or Redwald), who died in the seventh century. The purse lid shown in FIG. **11-3** is decorated with four symmetrically arranged groups of figures. The end groups consist of a man standing between two beasts; he faces front, they appear in profile. This heraldic type of grouping goes back to ancient Mesopotamia (FIG. 2-10), though of course with variation. The two center groups represent eagles attacking ducks, again a familiar predatory motif seen in both Mesopotamian and Egyptian art. The animal figures are adjusted to each other with the cunning we associate with the whole animal style through the centuries; for example, the convex beaks of eagles fit against the concave beaks of the ducks. The two figures fit together so snugly that they seem at first to be a single, dense, abstract design; this is true also of the man-animals motif. Above these figures are three geometric designs. The outer ones are clear and linear in style. In the central design, an interlace pattern, the interlacements turn into writhing animal figures. Interlacement was known outside the Germanic world but was seldom used in combination with animal figures. The Germanic peoples' fondness for the interlace pattern may have come from the quite familiar experience of interlacing leather thongs. In any event, the interlace, with its possibilities for great complexity, had natural attraction for the adroit jeweler.

Metalcraft and its vocabulary of interlace patterns and other motifs, beautifully integrated with the animal form, is, without doubt, *the* art of the Early Middle Ages in the West. Interest in it was so great that the colorful effects of jewelry designs were imitated in the painted decorations of manuscripts, in stone sculpture, in the masonry of the early churches, and in sculpture in wood, an especially important medium of Viking art (see FIGS. 11-11 through 11-13).

Representation of the human figure in scenes and narratives is rare in this period of the animal style. When it does appear, it places Christian and pagan German subjects side by side, as we find them in literary works of the age, like the *Solomon and Saturn*. The division of allegiance between pagan and Christian cultures is bluntly expressed in the figural carvings on a small box, the Franks Casket* (FIG. **11-4**), made in the early eighth century in Northumbria, the northernmost of the Anglo-Saxon kingdoms. On the box, biblical scenes alternate with illustrations from the adventures of Wayland the Smith, a character familiar in Germanic legend. A wonder-working craftsman, he is the personification of the cunning maker of magical implements. Hamstrung by the wicked king of Sweden, Wayland revenged himself by slaying the king's two sons, making

*The box takes its name from Sir A. W. Franks, who donated it to the British Museum.

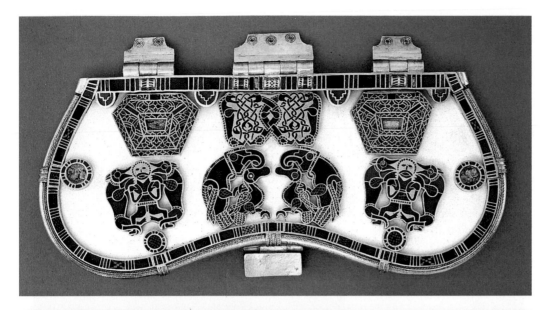

11-3 Purse cover from the Sutton Hoo ship burial, from Suffolk, England, *c.* 655. Gold and enamel, 7$^{1}/_{2}$" long. British Museum, London.

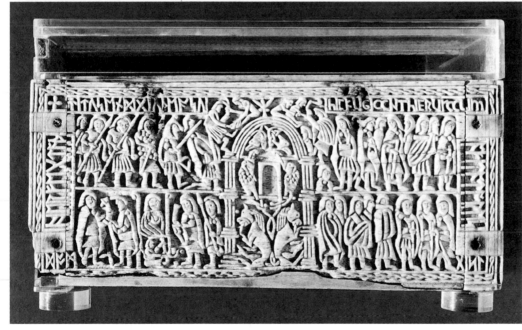

11-4 *The Franks Casket, c.* 700. Whalebone, British Museum, London.

their skulls into golden cups and presenting them to the unknowing father. After practicing other atrocities on the family, he flew away to Valhalla on wings of his own fabrication. In the front panel of the Franks Casket, not shown here, Wayland is depicted in his forge, making the cup from the skull of the dead boy shown at his feet. In the adjoining compartment is a representation of the Magi adoring the Christ child!

Our panel depicts the capture of Jerusalem in the year 70, the event celebrated in the reliefs from the Arch of Titus (FIGS. 7-44 and 7-45). Here the city is represented as an arched niche enclosing animal forms. The attacking army is at the left. Nude captives are dragged from the summit of the arch; others, at the right, flee from the city. At the lower

left the enthroned commander (Titus?) receives the spoils. The Roman military garb of the attackers is quite different from that of the Anglo-Saxon warriors shown on other panels—again the Germanic and the Latin opposition.

The carver of the casket is unfamiliar with illusionistic representation of the human figure; this is to be expected at a time when the highly abstracted zoomorphic form prevails in animal style design. The figures are stunted in proportion, impacted in closed spaces; the draperies are incised mistakenly. At the same time, the carver is at pains to indicate changes in the action, in pose, gesture, and facial angles. Taken as a whole, the panel has a unity of flattened, grouped, and repeated shapes and grooves, which produces an overall abstract pattern to which the figures are entirely

subordinate. The frame, inscribed with both Latin and Runic characters, fits the pattern while it encloses it. We have here the work of a Germanic artist, accustomed to the techniques of abstract pattern, encountering an illusionistic prototype of some sort—once or twice removed—and assimilating one to the other. The Mediterranean influence might be slight, yet it does appear in the symmetry of the composition, divided by the central architectural feature (with its quaintly misinterpreted details), the arrangement of the figures on two levels, and in suggested compartments (see FIG. 8-5). The figures themselves are distantly related to late Roman art (FIG. 7-87).

There is a vast difference in scale, in time, in cultural attitude, and in artistic practice between the Franks Casket and the reliefs of the Arch of Titus (FIGS. 7-44, 7-45) referenced earlier. But their differences are still instructive, in one respect particularly. The Titus reliefs come toward the *end* of a long tradition of Greco-Roman illusionism, when artists were concerned to make images of the natural world, more or less in accordance with its appearance as given. And, in the long history of Byzantine art, that illusionism lingered on through various transformations that often contradicted it, but could still be traced in the last productions of the school (FIG. 9-35).

The Franks Casket represents not the end of a tradition, not the persistence of a tradition that changes into something else; rather it represents, with other works of its time, a fresh, if hesitant, *beginning*. It is the primitive of an extended train of experiments in image-making from which a new, characteristically European illusionism will emerge, at some stage close to the Greco-Roman illusionism of the Arch of Titus relief.

In the Early Middle Ages images were rarely found outside a church building and often were sparse within. Religious images must have had awe-inspiring, magical, or miraculous power. Secular images could exert a power of their own. The animal heads that crowned the prows of ships (see FIG. 11-12) could direct such evil force upon an enemy that they had to be removed on the approach to a friendly port. The early medieval imagination, communally shared in dream, myth, and magic, must have swarmed with images not yet given shape by art. The shaping begins with works like the Franks Casket. One of them, a carved altar panel, was produced by a Lombard in northern Italy, about the same time.

The last and most ferocious of Germanic invasions of the late Empire was the Lombard descent into Italy, beginning in 568. The Lombards were far more destructive than the Ostrogoths who preceded them. Once Aryan Christians, the Lombards became Catholic Christians and fashioned a rambling kingdom in Italy, with the city of Pavia its North Italian capital. Their lords, known in Latin as "dukes," could become patrons of churches and of the art that ornamented them. Sculptured reliefs that were once the panels of an altar (FIG. **11-5**) were commissioned by a certain

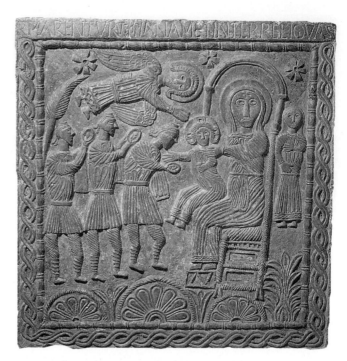

11-5 *Adoration of the Magi* from the altar of S. Martino in Cividale del Friuli, Italy, *c.* 745, Museo Cristiano, Friuli.

Duke Ratchis. In the panel shown, the sacred subject, the Adoration of the Magi, does not compete with any pagan image as do depictions on the Franks Casket. The prototype from which the work is copied is clearly Byzantine in iconography, composition, and detail. The three Magi who present gifts to the Christ child wear costumes and caps of the kind that in later Roman and Early Christian art represent Parthians or Persians. The ornamental motifs, shells and palmette, as well as the moldings of the frame, are all derived from Mediterranean sources.

The figure style is of course far removed from its Byzantine prototype. Like that of the Franks Casket, the style reveals the unfamiliarity of the Germanic artist with any illusionistic tradition of image-making. In contrast to the confident skill of the jewelers working in the abstract animal style, the carver here, confronted with images, is hesitant and inept, often confusing motifs and perspectives: the decorative lobes of the shell-form move into the drapery of the Magi; simultaneous frontal and side views confuse the perspective of the Virgin and Child, the throne and the canopy. Unaccustomed to making images of the human figure, the artist copies from another image. Yet there is a crude power in these naively conceived and rigid copies, a simplicity appropriate to the fashioning of an icon for a new and still strange religious faith. It is useful to compare the style of the Ratchis panel with another—though later—Byzantine work from Lombard Italy, the illusionistically sophisticated Castelseprio *Angel* (FIG. 9-16).

Both the Franks Casket and the Ratchis relief are emblematic of the collision and awkward compromise of

Germanic culture with that of the Mediterranean world. Crude as the artistic product of this encounter may be, it begins the process that will successfully fuse the two in the Romanesque style.

HIBERNO-SAXON ART

The artists of Celtic Ireland and Anglo-Saxon England mingled forms and motifs that, as we have seen, had long been elaborating into a recognizable regional style. The Christian culture of Celtic Ireland played a leading role in the civilizing of Europe. The Celts of Ireland, converted to Christianity in the fifth century, developed a form of monastic organization that preserved and cultivated literature, learning, philosophy, and the decorative and useful arts before the establishment of the Benedictine Rule. The Irish at first adopted Eastern rather than Western forms of monasticism and were not firmly connected to the Roman Church or the rule of the papacy. Their independence was strengthened by their historical good luck: they were not invaded by the Germanic migrants. From about 400 to 450 while most of Western Europe sank gradually into conflict, confusion, and ignorance, Ireland experienced a golden age. Irish monks, filled with missionary zeal, founded monastic establishments in the British islands at Iona, off the west coast of Scotland, and at Lindisfarne, on the Northumbrian (northeastern) coast of Anglo-Saxon England where, we recall, the Franks Casket (FIG. 11-4) was produced. From these foundations, which became great centers of learning for both Scotland and England, Irish monks, moved by a "wonderful spirit of missionary enterprise," journeyed through Europe, establishing great monasteries in Italy, Switzerland, Germany, and France, and making the names of *Scot* (the old term for *Irish*) and *Ireland* familiar in all Western Christendom as synonymous with education and learning. Until the eighth century, the influence of the Irish church rivaled that of Rome.

A style of decorative art we designate "Hiberno-Saxon," (or sometimes "Insular") to denote the Irish-English islands where it was produced, flourished under the auspices of the Irish church and within its institutions. Hiberno-Saxon art brings to synthesizing focus those design elements of nomadic and migration craft art that we have been describing. Traceable through centuries, from the Celtic Iron-Age art of Western Europe, and across the Eurasian continent, they appear all together and in definitive patterns on the surfaces of the so-called *Tara Brooch* (FIG. **11-6**), an article of Irish costume jewelry from the eighth century. The art of the migration period is summed up, as it were, in this single exquisite piece. In an age lacking artistic expression on a monumental scale, the human instinct for design concentrates powerfully, as here, in the small utensils of life—the clasps and fasteners of clothing, for example. The functional ring and pin of the brooch are embellished with panels of delicate filigree and are punctuated with studs of amber and amethyst-glass. The panels, chip-carved, engraved, and tooled, with inlays of copper, silver, and gold, enclose fields of ornamental motifs worked with threadlike refinement of detail. All the motifs of the decorative vocabulary of migration art appear here: interlaced birds, animals, and humanoids, strap work, scrolled bands and ribbons, whorls, knots, and bosses. The patterns balance, repeat, and reflect one another in cunningly intricate play. Despite the astonishing profusion, intricacy, and density of the ornamental elements, the overall geometry of ring and pin strictly controls their rich exuberance.

It would take pages of description and close work with a magnifying glass to do justice to the refinements of design and craftsmanship evident in the *Tara Brooch*. Though both elements are descended from long tradition and are not the consequence of unique invention, in the hands of an anonymous artisan of genius, they combine to make a world masterpiece of the jeweler's art.

11-6 *Tara Brooch*, Ireland, *c.* 700. Bronze with overlay of gold filigree, glass and amber settings. National Museum of Ireland, Dublin.

Manuscript Illumination

Remarkable as such works of secular art as the *Tara Brooch* may be, they are complemented by the illuminated manuscripts sponsored by the Church. With the Christianization of the peoples, liturgical books became an important vehicle of miniature art and a principal medium for the exchange of stylistic ideas between the northern and the Mediterranean worlds. The exchange is the result not only of restless migrations and incursions of peoples, but also of the missionary activities of the Church, Celtic or Roman, as it sought to stabilize the wandering groups and establish its authority. The encounter between Irish and Roman Christianity during the missionary enterprise is reflected in the commingling of ornamental elements on the illuminated pages of gospel books produced in Ireland and Anglo-Saxon England during the seventh and eighth centuries.

In an age of general illiteracy, books were scarce; for those who could read, books were jealously guarded treasures, most of them in the libraries and scriptoria of Benedictine monasteries or major churches. The illuminated books we now turn to are those that survived the depredations of the Danish/Viking invaders of the ninth century. They are the monuments of the brilliant culture that flourished in Ireland and Northumbria during the seventh and eighth centuries.

The Hiberno-Saxon illuminated manuscripts combine Irish and Anglo-Saxon motifs, sharing essentially, but by no means in all details, the same style. An ornamental "carpet" page (FIG. **11-7**), only one of several from the *Book of Lindisfarne*, is an exquisite example of Hiberno-Saxon art at its best. Here, the craft of intricate ornamental patterning, developed through centuries and seen in Viking art, is manifested in a tightly compacted design. Serpentine interlacements of fantastic animals devour each other, curling over and returning on their writhing, elastic shapes. The rhythm of expanding and contracting forms produces a most vivid effect of motion and change—a palpable rippling, as on the surface of a rapids. The inscribed cross, a variation on the stone Celtic crosses familiar in Ireland, regularizes the rhythms of the serpentines and, perhaps by contrast with its heavy immobility, seems to heighten the effect of motion. The motifs are placed in detailed symmetries, with inversions, reversals, and repetitions that must be studied closely to appreciate not so much their variety as their mazelike complexity. The zoomorphic forms are intermingled with clusters and knots of line, and the whole design pulses and vibrates like an electromagnetic energy field. The color is rich yet cool; the entire spectrum is embraced, but in hues of low intensity. Shape and color are so adroitly adjusted that a smooth and perfectly even surface is achieved, a balance between an overall, steady harmony of key (color) and maximum motion of figure and line. The discipline of touch is that of a master familiar with long-established conventions, yet neither the discipline nor the convention stiffens

the supple lines that tirelessly and endlessly thread and convolute their way through the design.

This joy at working on small, infinitely complex and painstaking projects—this goldsmith's, jeweler's, and weaver's craft—will endure in northern art throughout the Middle Ages in architectural detail, ivory carving, illumination, stained-glass work, and, ultimately, in panel painting. The instinct and taste for intricacy and precision, propagated in the art of the wandering Celts and Germans, will broaden beyond art into technology and the making of machines.

The Germanic origins of the craft remained, but the Hiberno-Saxon ornamental style, with its gorgeous essays in interlacements, was fated to be replaced by the Mediterranean styles that descended from Early Christian and Late Antique art. Political realities hastened its demise. Irish Christianity lost its influence in Anglo-Saxon England and on the continent; the adherents to the rule of Saint Benedict, who wholeheartedly followed the papacy and the Roman version of Christianity, gained the upper hand in power and influence, and although the Irish church held out for some time, eventually it accepted the Roman form.

Even while Hiberno-Saxon art prevailed in Ireland, Scotland, and Northumbria, other monastic foundations in England were copying Mediterranean prototypes. Naturally, the ascendancy of the Roman church would be expressed in manuscripts from the Mediterranean area, and wherever the Roman orthodoxy was accepted, an orthodox style of manuscript illumination had to follow. The contrast between the two very different styles is particularly striking in juxtaposition. *The Scribe Ezra Rewriting the Sacred Records* from the *Codex Amiatinus* (FIG. **11-8**) was copied from an Italian manuscript, the *Codex Grandior of Cassiodorus*, early in the eighth century by an illuminator with Italian training acquired in some Anglo-Saxon monastery. The same original must have been seen and "translated" a few years earlier by an artist trained in the abstract Hiberno-Saxon manner; his version appears as the *St. Matthew* figure in the *Book of Lindisfarne* (FIG. **11-9**). The *Ezra* and the architectural environment of the *Codex Amiatinus* are closely linked with the pictorial illusionism of Late Antiquity. The style is essentially that of the brush; the color, although applied here and there in flat planes, is blended smoothly to model the figure and to provide gradual transitions from light to dark. This procedure must have been continued in the Mediterranean world throughout the Early Middle Ages, despite the formalizing into line that we have seen taking place in mosaics (FIG. 9-15). But the Hiberno-Saxon artist of the Lindisfarne Matthew, trained in the use of hard, evenly stressed line, apparently knew nothing of the illusionistic, pictorial technique nor, for that matter, of the representation of the human figure; in this respect he is like his Northumbrian contemporary, the carver of the Franks Casket (FIG. 11-4). Although he carefully takes over the pose, he interprets the form in terms of line exclusively,

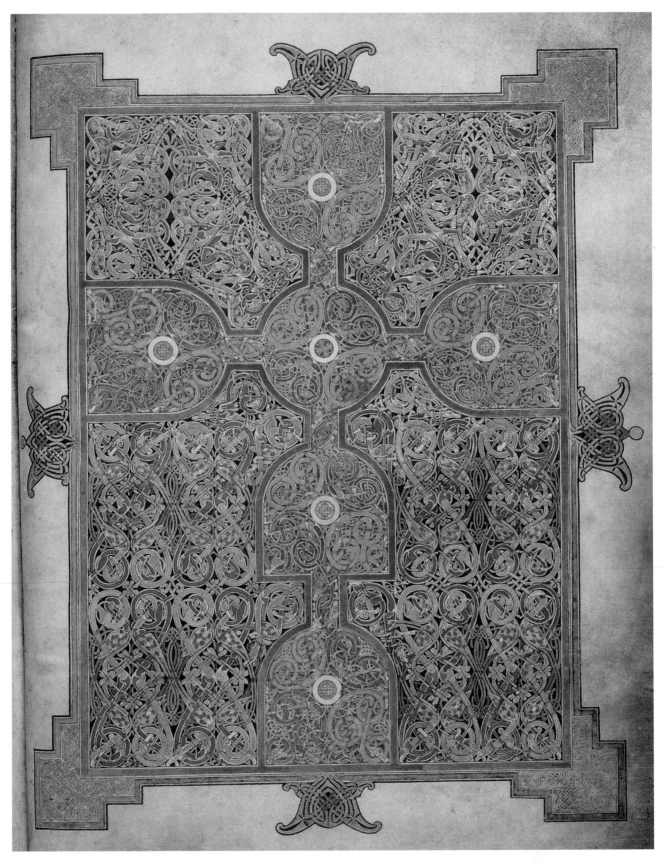

11-7 Ornamental page from the *Book of Lindisfarne*, from Northumberland, England, late seventh century. Illumination, approx. 13″ × 10″. British Museum, London.

11-8 *The Scribe Ezra Rewriting the Sacred Records*, from the *Codex Amiatinus*, Jarrow, early eighth century. Approx. 14″ × 10″. Biblioteca Medicea-Laurenziana, Florence.

11-9 *St. Matthew*, from the *Book of Lindisfarne*, from Northumberland, England, late seventh century. Approx. 11″ × 9″. British Library , London.

"abstracting" the unfamiliar tonal scheme of his model into a patterned figure not unlike what we see in the king, queen, and jack of a deck of cards. The soft folds of drapery in the *Ezra* become, in the *St. Matthew*, a series of sharp, regularly spaced, curving lines. No modeling is used; no variations occur in light and shade. The long training in the peculiar linear style of Germanic art made it necessary for the Lindisfarne artist to convert the strange Mediterranean forms into the linear idiom familiar to him; he finds before him a tonal *picture* and makes of it a linear *pattern.*

The medieval artist did not go to nature for models but to a prototype—another image, a statue, or a picture in a book. Each copy might be one in a long line of copies, and, in some cases, we can trace these copies back to a lost original, inferring its former existence. The medieval practice of copying pictures is closely related to the copying of books, especially sacred books like the scriptures and the books used in the liturgy. The medieval scribe or illuminator (before the thirteenth century, most often a monk) could have reasoned that just as the text of a holy book must be copied faithfully if the copy also is to be holy, so must the pictures be rendered faithfully. Of course, in the process of copying, mistakes are made, and while scholars seek to purge the book of these textual "corruptions," "mistakes" in the copying of pictures yield new pictorial styles, or represent the confluence of different styles, as in the relationship of the *Codex Amiatinus* and the *Book of Lindisfarne*. In any event, one should realize that the style of medieval images, whether in sculpture or in painting, was the result of copying from sources thought to have sacred authority, not from natural models. Thus, one learned what was true from authorities who declared the truth—the scriptures and the fathers of the Church—and one painted "true" images from authoritative images. To question authority on one's own, to investigate "nature" on one's own, would be to question God's truth as revealed and interpreted. Such actions would be blasphemy and heresy. It would be wrong, however, to leave the impression that dependence on authority in art is characteristic solely of the Middle Ages. In the Renaissance and since, and certainly today, new styles gain sudden

authority and win widespread reverence and imitation, even for reasons that differ from those operative in the Middle Ages.

Sculpture

The high crosses of Ireland, erected between the eighth and tenth centuries, are exceptional by their mass and scale within the art of the Early Middle Ages, which, as we have seen, is confined almost exclusively to works diminutive and portable. Indeed, the crosses are unique. These majestic monuments, some 17 feet in height or taller, preside over burial grounds adjoining the ruins of monasteries at sites widely distributed throughout the Irish countryside. Though several of these crosses are found in England, they are regarded as characteristically Irish in form and origin. The Celtic cross has become the very symbol of Christian Ireland in both religious and secular iconography. Freestanding and unattached to any architectural fabric, the high crosses have the imposing unity, weight, and presence of both building and statue, architecture and sculpture combined.

The *High Cross of Muiredach* at Monasterboice in County Louth (FIG. **11-10**), though a late representative of the type (dated by inscription 923), can serve as standard for the form. The cross element crowns a four-sided shaft of stone, which rises from a base with sloping sides. The concave, looping arms of the cross are joined by four arcs, which form a circle. The arms expand into squared terminals (see the carpet page of the *Lindisfarne Gospels*, FIG. 11-7). The circle-intersected cross is the characteristic figure that identifies the type as Celtic. The earlier high crosses bear abstract designs, especially the familiar interlace pattern. But the later ones have figured panels, with scenes from the life of Christ, or, occasionally, events from the life of some Celtic saint. In addition, fantastic animals and grotesque human figures sometimes are portrayed. Here, at the center of the transom of the cross, stands the risen Christ as judge of the world, the hope of the neighboring dead. The iconographic and stylistic sources of the figural carvings are far-flung: Early Christian art, the art of Coptic (Christian) Egypt, the animal motifs of the Near East and the migration period—all evidence of the cosmopolitanism of Irish culture in the period of its great flourishing. The high crosses are the monumental, consummate expression of the religious and esthetic values of Hiberno-Saxon creativity, which, by the twelfth century, was extinct.

VIKING ART

In 793 the pagan Scandinavian traders and pirates known as Vikings destroyed the church in Lindisfarne. From this time till about 1000, the Vikings would be the terror of

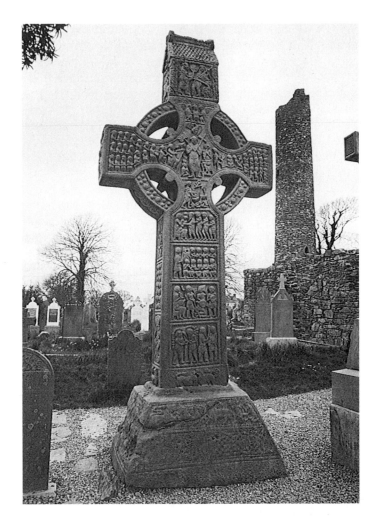

11-10 *High Cross of Muiredach,* Monasterboice, County Louth, Ireland, 923. Approx. 16' high.

Western Europe. The Scandinavian "Norsemen" were not converted to Christianity until the late tenth century, and then not completely; well into the eleventh century a deep substratum of paganism survived. The Vikings seasonally harried and plundered the coasts, harbors, and river settlements of the West. Their fast, seaworthy longboats took them on wide-ranging voyages, from Ireland to Russia, from their settlement at Dublin to their settlement at Kiev. They were not intent merely on a hit-and-run strategy of destruction but on colonizing the territory they occupied by conquest. Their exceptional talent for organization and administration as well as for war enabled them to take and govern large territories in Ireland, England, and France, as well as in the Baltic regions and Russia; for a while, in the early eleventh century, the whole of England was part of a Danish empire. The region of northern France surrounding the mouth of the Seine River became the powerful duchy of Normandy, whose duke William would conquer Anglo-Saxon England. Christianized and settling down, the

Vikings would become the Normans, one of the great peoples of medieval Europe. The art of the Viking sea-rovers is early associated with ships—with wood and the carving of it. Striking examples of Viking wood carving have been found in a royal ship buried near Oseberg, Norway. The Oseberg ship has yielded rich evidence of the quality of Early Viking art, which now has become established, along with Hiberno-Saxon art (with which it interacts), as an original and important artistic development of the Early Middle Ages. The ship has been reconstructed (FIG. **11-11**), but we can judge, from such surviving parts as the ornament of the prow, the skill of craftsmen familiar with a tradition of interlace design that was widely dispersed along the routes of the great migrations. The carved bands that follow the gracefully curving lines of the prow are embroidered with tightly interwoven animals, which writhe gripping and snapping, in serpentine and lacertine (lizardlike) interlacement. The convulsive movement is strictly controlled within the continuous margins of the composition.

An animal head that caps a post (FIG. **11-12**) expresses, like other animal forms in the ship, the fierce, untamed

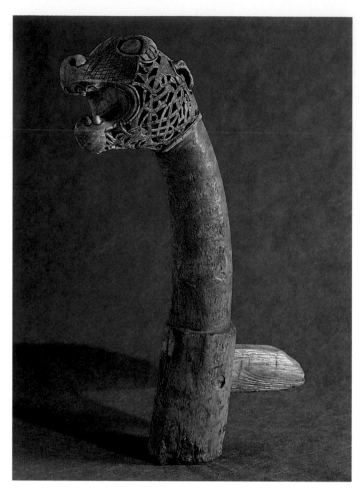

11-12 Animal-head post from the Oseberg ship burial, *c.* 825. Wood, approx. 5″ high. Vikingskipshuset Museum, Oslo.

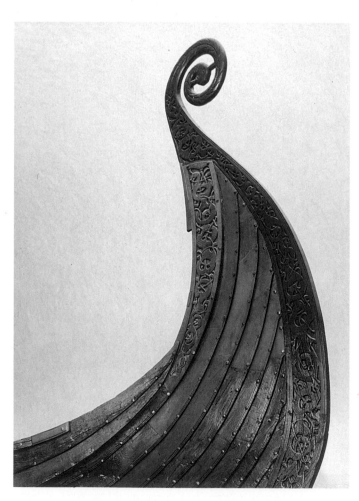

11-11 Prow of the Oseberg ship, early ninth century. Vikingskipshuset Museum, Oslo.

spirit and energy of the pagan sea rovers. This head brings together in one composition the image of a roaring beast—eyes protruding, nostrils flaring in predatory excitement—and the deftly carved, controlled, and contained interlace pattern. As in the carvings of the ship's prow, firm artistic limit contains wild vigor. The Oseberg animal head is, in miniature, a type of spell-casting monster for the figurehead of a Viking ship and a powerfully expressive example of the union of two fundamental motifs of the art of the Germanic peoples: the animal form and the interlace pattern.

The interpatterning of these motifs culminated in the eleventh century with such elegant designs as that on the porch of the "stave" church at Urnes in Norway (FIG. **11-13**). The church itself is constructed of wood (*staves* are wedge-shaped timbers placed vertically), which gives the woodcarver a special opportunity to show his craft in the embellishment of the architectural features of the building (in this case, the panels of the porch walls). Here, gracefully attenuated animal forms intertwine with flexible stalks and tendrils in spiraling rhythm; the effect of natural

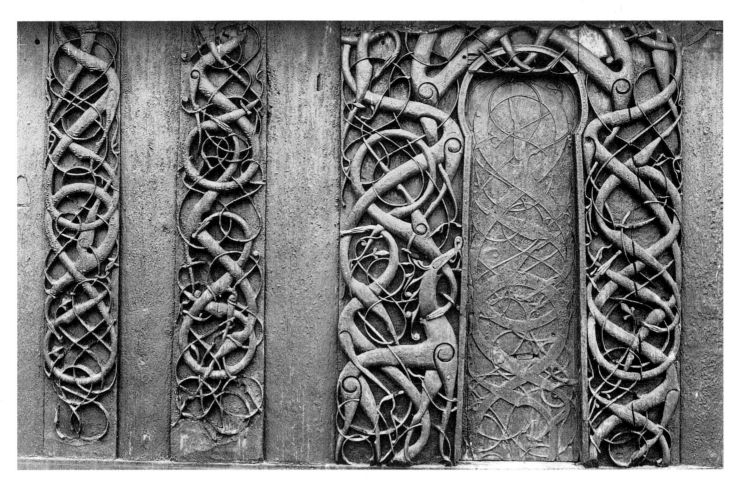

11-13 Wood-carved ornament (porch of stave church), Urnes, Norway, eleventh century.

growth is astonishing. At the same time, the elaboration of the forms is so intricate and refined that the animal-interlace art of design seems to have reached its limits of inventiveness. The Urnes style is the culmination of three centuries (the eighth to the eleventh) of Viking art, after which it merges with the Romanesque style. During the whole period that it flourished, the art of the Vikings interacted closely with Hiberno-Saxon art.

CAROLINGIAN ART

The remarkable historical phenomenon now called the Carolingian "renovation"—an energetic, brilliant emulation of the art, culture, and political ideals of Christian Rome—occurred during the late eighth and early ninth centuries. Out of the confusions attendant on the migrations and settlement of the Germanic peoples, Charlemagne's immediate forerunners built by force and political acumen a Frankish empire that contained or controlled a large part of Western Europe. Charlemagne, like Constantine, whom he often consciously imitated, wished to create a unified Christendom as a visible empire. He was

crowned by the pope in Rome in 800 as the head of the entity that became known as the Holy Roman Empire, which, waxing and waning over a thousand years and with many hiatuses, existed in central Europe until its destruction by Napoleon in 1806.

Charlemagne was a sincere admirer of learning and the arts. To make his empire as splendid as that of Rome, he invited to his court at Aachen (French: Aix-la-Chapelle) the best minds and the finest craftsmen of Western Europe and the Byzantine East. Although unlettered and scarcely able to write, he could speak Latin fluently and loved the discourses he frequently held with the learned men he gathered around him. Charlemagne also must have admired the splendid works created in the scriptorium of the school he established in his palace. One of his dearest projects had been the recovery of the true text of the Bible, which, through centuries of miscopying by ignorant scribes, had become almost hopelessly corrupt. Part of the great project, undertaken by the renowned scholar Alcuin of York at the new monastery at Tours, was the correction of actual script used, which, in the hands of the scribes, had become almost unreadable. The Carolingian rehabilitation of the inherited Latin script produced a clear, precise system

of letters; the letters on this page are descended from the alphabet renovated by the scribes of Tours.

Alcuin had been master of the cathedral school at York, center of Northumbrian learning. Charlemagne invited him to his palace at Aachen, where he became manager of the palace school, overseer of its educational program, and the teacher and friend of Charlemagne himself. Alcuin brought Anglo-Saxon scholarship into the Carolingian setting, a major stimulus of its cultural awakening.

Alcuin's revision of the biblical text was so important that the scribes of Tours were kept busy copying it for export to other monasteries. Though the monastery of St. Martin's and its library were destroyed by Vikings around 860, many of the exported Bibles survived in other locations; their illuminated pages are so stylistically similar that we can classify them as belonging to a Carolingian "school of Tours."

Painting and Illumination

Charlemagne, his successors, and the scholars under their patronage imported whole libraries, not only from Northumbria, but from Italy and Byzantium. The illustrations in these books must have astonished northern painters, some of whom had been trained in the Hiberno-Saxon manner of pattern making, while others were schooled in the weak and inept Frankish styles of the seventh and eighth centuries. Here, they were confronted suddenly with a sophisticated realism that somehow had survived from the Late Antique period amidst all the denaturing tendencies that followed.

The famous *Coronation Gospels* (the *Gospel Book of Charlemagne,* formerly in the Imperial Treasury in Vienna) may have been a favorite of Charlemagne himself; an old tradition records that it was found on the knees of the dead emperor when, in the year 1000, Otto III had the imperial tomb at Aachen opened. The picture of *St. Matthew* composing his gospel (FIG. **11-14**) descends from ancient depictions in sculpture and painting of an inspired philosopher or poet seated and writing (FIG. 7-79). Its technique is of the same antiquity—deft, illusionistic brushwork that easily and accurately defines the masses of the drapery as they wrap and enfold the body beneath. The curule chair, the lectern, and the saint's toga are familiar Roman accessories; the landscape background is classicizing, and the whole composition seems utterly out of place in the North in the ninth century. How were the native artists to receive this new influence, so alien to what they had known and so strong as to make their own practice suddenly obsolete?

The style evident in the *Coronation Gospels* was by no means the only one that appeared suddenly in the Carolingian world. A wide variety of styles from Antique prototypes were distributed through the court schools and

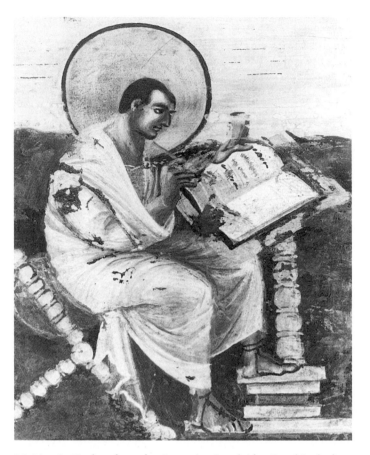

11-14 *St. Matthew,* from the *Coronation Gospels* (the *Gospel Book of Charlemagne*), *c.* 800–810. Approx. 9″ × 6³/4″. Kunsthistorisches Museum, Vienna.

the monasteries—a bewildering array, one can believe, for the natives, who attempted to appropriate them by copying them as accurately as possible. Thus, Carolingian painting is extremely diverse and uneven, and classification becomes a difficult matter of ascertaining prototypes and the descendants of prototypes, although, as we have seen, we can identify with some certainty a "school of Tours" and several others. If *St. Matthew* of the *Coronation Gospels* was painted by a Frank, rather than an Italian or a Byzantine, it is an amazing feat of approximation, since, except for the work of one copyist, nothing is known that could have prepared the way for it in the Hiberno-Saxon or Frankish West.

Another *St. Matthew* (FIG. **11-15**), in a gospel book made for Archbishop Ebbo of Reims, missionary to the Danes, may be an interpretation of a prototype very similar to the one used by the *Coronation Gospels* master, for it resembles it in pose and in brushwork technique, But there the resemblance stops. The Classical calm and solidity have been replaced by an energy that amounts to frenzy, and the frail saint almost leaps under its impulse. His hair stands on end, the folds of his drapery writhe and vibrate, the landscape behind him rears up alive. He appears in frantic haste, to

take down what his inspiration (the tiny angel in the upper-right corner) dictates. All fidelity to bodily proportions or structure is forsaken in the artist's effort to concentrate on the act of writing; the head, hands, ink-horn, pen, and book are the focus of the composition. This presentation contrasts strongly with the settled pose of the *St. Matthew* of the *Coronation Gospels* with its even stress, so that no part of the composition starts out at us to seize our attention. The native power of expression is unmistakable and will become one of the important distinguishing traits of late medieval art. Just as the painter of the *Lindisfarne Matthew* (FIG. 11-9) transformed the *Ezra* portrait in the *Codex Amiatinus* (FIG. 11-8) into something original and strong, translating its classicizing manner into his own Hiberno-Saxon idiom, so the *Ebbo Gospel's* artist translated his Classical prototype into a Carolingian vernacular that left little Classical substance. The four pictures should be studied carefully and compared.

Narrative illustration, so richly developed in Early Christian and Byzantine art, was revived by the Carolingians, and many fully illuminated books (some, large Bibles) were produced. One of the most extraordinary and enjoyable of all medieval manuscripts is the famous *Utrecht Psalter*, written at Hautvilliers, near Reims, France, about 830. The text, in three columns, reproduces the Psalms of David and is profusely illustrated by pen-and-ink drawings in the margins. The example shown in FIG. **11-16** depicts figures acting out Psalm 150, in which the psalmist exhorts us to praise the name of God in song and with timbrel, trumpet, and organ. The style shows a vivid animation of much the same kind as the *St. Matthew* of the *Ebbo Gospels* and may have been produced in the same "school of Reims." The bodies are tense, shoulders hunched, heads

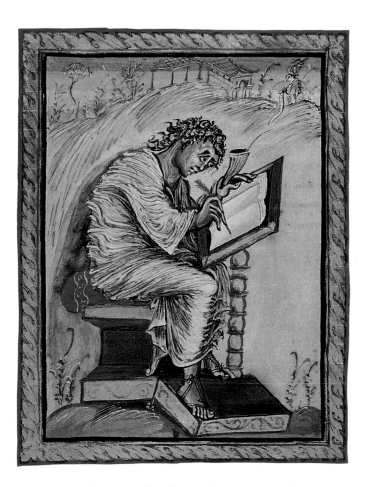

11-15 *St. Matthew,* from the *Ebbo Gospels* (the *Gospel Book of Archbishop Ebbo of Reims*), Hautvilliers (near Reims), France, c. 816–835. Approx. 10″ × 8″. Bibliothèque Nationale, Paris.

11-16 *Psalm 150,* from the *Utrecht Psalter,* from Hautvilliers, France, c. 830. $4^3/4$″ × $9^1/2$″. University Library, Utrecht, Netherlands.

LAUDENINOMENEIUSIN
CHORO·INTYMPANO
ETPSALTERIOPSALLANTEI
QUIABENEPLACITUMEST

EXSULTATIONESDEINGUT
TUREEORUM·ETGLADII
ANCIPITESINMANIB:EOR·
ADFACIENDAMUINDICIA

UTFACIANTINEISIUDICIU
CONSCRIPTUM·GLORIA
HAECESTOMNIBUSSCIS
EIUS

thrust forward. The spontaneity of their actions and the rapid, sketchy techniques with which they are rendered convey the same nervous vitality as the figure in the *Ebbo Gospels*. From details of the figures, their dress, and accessories, scholars feel certain that the artist was following one or more manuscripts compiled some four hundred years earlier. The interest in simple human emotions and actions, the pantomimic skill in the variety and descriptiveness of gesture, however, are essentially medieval characteristics, although they began in Early Christian art. Note, for example, how the two musicians playing the pipe organ shout at their helpers to pump air more strenuously. This candid observation of human behavior, often in unguarded moments, was to lend both truth and charm to the art of the Late Middle Ages.

Art in Metal and Ivory

To our knowledge, little or no monumental sculpture was produced in the Carolingian period. The traditional taste for sumptuously wrought and portable metal objects, which created the works we have seen, persisted under Charlemagne and his successors and was responsible for the production of numerous precious and beautiful works, like the book cover of the *Codex Aureus of St. Emmeram* (FIG. **11-17**). Dating from the second half of the ninth century, this book cover probably originated at either the St.-Denis or Reims court of Charles the Bald, a grandson of Charlemagne. Its golden surface is set with pearls and precious jewels. Within the inscribed, squared cross, Christ in Majesty appears in an attitude not far removed from that in the apse mosaic of San Vitale (FIG. 9-11)—an example of the persistence of types and attitudes from Early Christian art into subsequent periods. The Four Evangelists are seated around Christ, outside the cross, and four scenes from Christ's life are portrayed above and below the saints. In general, manuscript illumination provides the generative prototypes for ivory and metalwork. Here, the style of the figures echoes that of the *Ebbo Gospels* and the *Utrecht Psalter,* although it is modified by influences from other Carolingian schools. No trace of the intricate interlace patterns of Hiberno-Saxon art remains, although the complex and delicate floral filigree clustering about the border jewels and enamels recalls them and provides a foil for the classicizing figure style. At the core of the Carolingian renovation, the translated, classicizing style of Italy prevails, in keeping with the tastes and aspirations of the great Frankish emperor who fixed his admiring gaze on the culture of the south.

The ornamentation of book covers in metal was often complemented by ivory carving, the metalwork serving as frame for the figured plaque. The carving of small ivory objects, votive panels, diptychs, jewel caskets, furniture veneers, combs and the like, had a long history; we have seen Early Christian examples (FIGS. 8-22, 8-23, 8-24) and

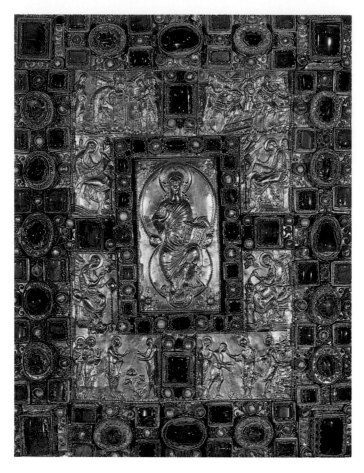

11-17 *Christ in Majesty, Four Evangelists, and Scenes from the Life of Christ,* cover of the *Codex Aureus of St. Emmeram, c.* 870. Gold set with pearls and precious stones, 17″ × 13″. Bayerische Staatsbibliothek, Munich.

Byzantine ones (FIGS. 9-18, 9-19), plus the Franks Casket (FIG. 11-4), which, though not strictly ivory, is of the type.

A sumptuous example of metal- and ivory-craft is the front cover of a psalter (FIG. **11-18**) belonging to Charles the Bald, patron of the royal abbey of St.-Denis near Paris, where the work was produced. The small ivory panel is set within a silver-gilt, filigreed frame inlaid with gems of cabochon cut. The panel illustrates verses from Psalm 57:1, 4, 6:

> Oh God, in the shadow of thy wings will I make my refuge. . . . My soul is among lions; and I lie even among them that are set on fire, even the sons of men, whose teeth are spears and arrows, and their tongues a sharp sword. . . . They have prepared a net for my steps; they have digged a pit before me, into the midst thereof they are fallen themselves.

The narrative closely follows the text. Beginning at the top, the panel shows the psalmist in the Lord's lap, flanked by lions; on the next level are men armed to the teeth, and at the bottom, men are digging the pit and falling into it.

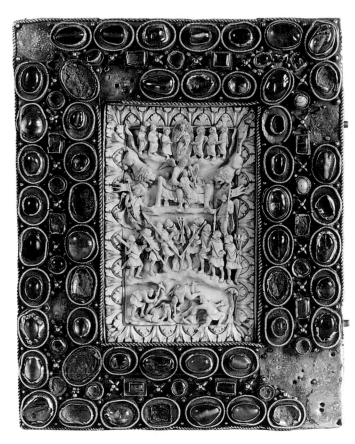

11-18 Cover of Psalter of Charles the Bald, *c.* 865. Ivory panel with scenes from Psalms 51 and 57 set in silver-gilt frame with filigree work and precious stones; panel 5¹/₂″ × 5¹/₄″, entire cover 9¹/₂″ × 7³/₄″. Bibliothèque Nationale, Paris.

The carver has the same literal respect for the text that a careful scholar would have had copying it.

The style of the carved figures, like that of the *Codex Aureus,* is derived from the illustrations of the *Utrecht Psalter,* which, in fact, it directly copies. The figures have the same quick, nervous movement and exaggerated gestures. It is the very model of a faithful reproduction of a prototype and exhibits significantly the dependence of much medieval sculpture, small or large scale, on pictorial sources.

Metal-craft was extended to produce works much larger than the book cover, while maintaining the same principles in terms of materials, methods of production, design, and figure style. An example is the magnificent golden altar, the *Paliotto,* of the church of Sant'Ambrogio in Milan (FIG. **11-19**). Shaped like a kind of large tomb, the altar was designed to contain the bones of Saint Ambrose, an early bishop of Milan and one of the fathers of the Latin Church. Its four sides are ornamented with the jeweler's workmanship and lavish detail that we find in the *Codex Aureus* cover. Like that work, the *Paliotto* is divided into framed compartments of geometric simplicity and formality. Its gold, silver, and precious and semiprecious stones are set forth in

exquisitely worked filigree to honor (in the central panels) the enthroned Christ, the Signs of the Evangelists, and the Twelve Apostles, all wrought in the classicizing figure style of the Carolingian renovation. Inscriptions on the back of the altar, where scenes from the life of St. Ambrose are found, tell us that the donor was Archbishop Angilbert II, who governed the church in Milan between 824 and 859, which gives us a date for the monument. St. Ambrose places a crown on the bishop's head; he also places a crown on the head of the designer of the altar and its principal artist, a certain "Master Wolvinius," whose name suggests his east Frankish origins and that he may have been trained in the main centers of Carolingian art. Whatever the questions as to its sources, this work of WOLVINIUS and his fellow craftsmen remains perhaps the supreme masterpiece of the Age of Charlemagne.

Beyond the western regions under Carolingian control, migrations of warlike peoples from the East kept eastern and central Europe in turmoil throughout the ninth century. Mounted nomads rode the great grasslands as the Vikings rode the western seas. Charlemagne managed to repulse the Avars, who had long dominated the Hungarian plain. Like the migrating peoples in general, the Avars were

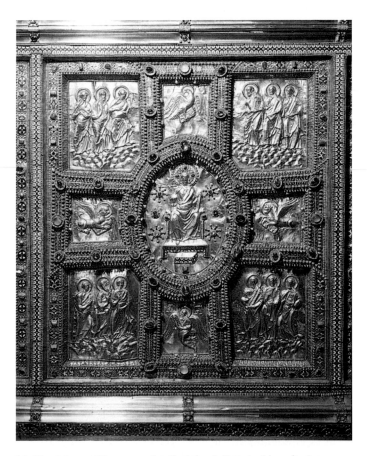

11-19 MASTER WOLVINIUS, detail of the *Paliotto* (golden altar), Sant'Ambrogio, Milan, early ninth century. Gold, silver, enamel, precious and semiprecious stones; entire altar 3′ high, 7′ long, 4′ deep.

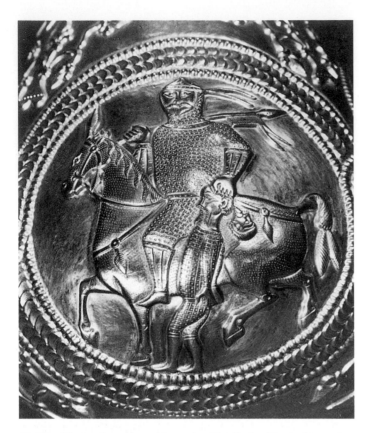

11-20 Mounted warrior with captive (detail of gold vessel; vessel 8³/₄″ high), from the Nagy-szent-miklós treasure hoard found at Sinicolaul, Romania, probably ninth century. Kunsthistorisches Museum, Vienna.

skilled metal-craftsmen. A detail of a vase from a hoard of golden vessels left by them (a buried treasure never reclaimed) is illustrated here (FIG. **11-20**). Made of beaten gold, it bears a medallion with the image of a mounted, armored warrior. Posed both frontally and in profile, an Archaic convention we have seen in ancient art, the warrior carries a spear over his right shoulder, and seizes a disarmed man with his left hand; the thrown-back head of another figure, which appears below the horseman's left wrist, may belong to a man he already has killed. The dominating bulk of the fierce victor is made larger by the puny stature of his victims, another Archaic convention we have seen in the art of Mesopotamia (FIG. 2-13) and Egypt (FIG. 3-42). Here is the very image of the times, when, as we have recounted, armed, pagan horsemen swept all before them in endless war and depredation. Yet the art of the Avars was influenced by the art of the settled and more civilized nations they came in contact with; the bead and fish-scale molding of the medallion frame and the floral motifs of the shoulder and base of the vessel are derived from Byzantine and Sasanian art. Whether inspired by the Christian God, or the god of war, the craft art of the Early Middle Ages achieved a rare distinction. The priest and the warrior were the patrons of the craftsman.

Architecture

In his eagerness to re-establish the imperial past, Charlemagne also encouraged the revival of Roman building techniques; in architecture, as in sculpture and painting, innovations made in the reinterpretation of earlier Roman-Christian sources became fundamental to medieval designs. Perhaps *importation* is a more appropriate term here than *revival,* as the Mediterranean tradition of stone-masonry could never have been more than an admirable curiosity to northern builders.

Charlemagne's adoption of southern building principles for the construction of his palaces and churches was epoch-making for the subsequent development of the architecture of northern Europe. For his models, he went to Rome and Ravenna—one, the former heart of the Roman Empire, which he wanted to revive, the other, the long-term western outpost of Byzantine might and splendor, which he wanted to emulate in his own capital at Aachen. Ravenna fell to the Lombards in 751 but was wrested from them only a few years later by the Frankish king Pepin the Short, founder of the Carolingian dynasty and father of Charlemagne. Pepin donated the former Byzantine exarchate to the pope and thus founded the papacy's temporal power, which was to last until the late nineteenth century.

Charlemagne often visited Ravenna, and historians have long thought that he chose one of its churches as the model for the Palatine Chapel of his own palace at Aachen. The plan of this structure (FIG. **11-21**) shows a resemblance to that of San Vitale (FIG. 9-5), and there is very likely a direct relationship between the two. Nevertheless, a comparison of the two buildings is instructive. The Aachen plan is simpler; the apselike extensions reaching from the central octa-

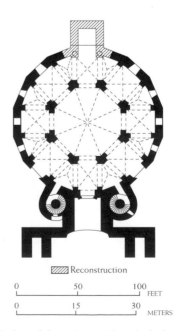

▨ Reconstruction

0 50 100
 FEET
0 15 30
 METERS

11-21 Restored plan of the Palatine Chapel of Charlemagne, Aachen, Germany, 792–805.

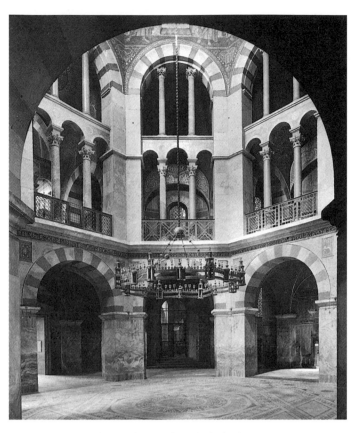

11-22 Interior of the Palatine Chapel of Charlemagne.

gon into the ambulatory have been omitted, so that the two main units stand in greater independence of one another. This solution may lack the subtle sophistication of the Byzantine building, but the Palatine Chapel gains geometric clarity. A view of the interior of the Palatine Chapel (FIG. **11-22**) shows that the "floating" quality of San Vitale has been converted into blunt massiveness and stiffened into solid geometric form; the Palatine Chapel is the first vaulted structure of the Western Middle Ages. The conversion of a complex and subtle Byzantine prototype into a building that expresses robust strength and clear structural articulation foreshadows the architecture of the eleventh and twelfth centuries and the style we call Romanesque.

Charlemagne's dependence on Roman models is illustrated by a fascinating survival from his time, the *Torhalle* (gatehouse, FIG. **11-23**) of the Lorsch Monastery, which dates from about 780. Originally built as a freestanding structure in the atrium of the now-lost monastic church, this decorative little entrance gate is a distant relative of the Arch of Constantine (FIG. 7-86) by way of its reinterpretation in Christian terms of the entrance to the atrium of Old St. Peter's in Rome (if, in fact, the entrance to that structure resembled the reconstruction shown in FIG. 8-8a). To Charlemagne, both the arch and the atrium entrance could have been symbols of Christian triumph over paganism. The triple-arched gateway on the lower level closely follows the design of Roman city gates, with its flanking

11-23 Torhalle (gatehouse), Lorsch, Germany, *c.* 800.

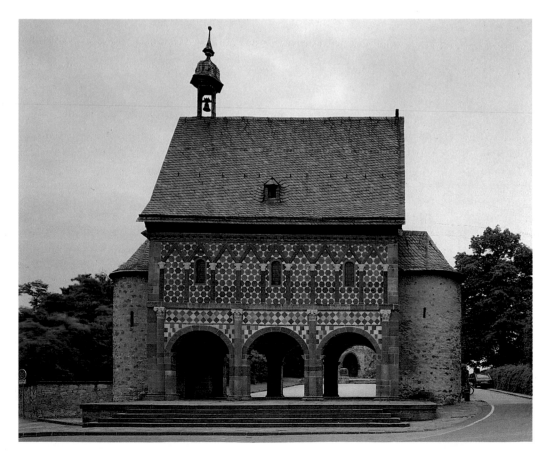

towers column-arch combination, the fairly close copies of Late Roman capitals, and the decorative treatment of the flat wall surfaces with colored inlays of cream and pink stone in imitation of Roman *opus reticulatum* (a method of facing concrete walls with lozenge-shaped bricks on stones to achieve a netlike ornamental surface pattern). However, the columns support a decorative *stringcourse* (raised horizontal *molding*, or band) instead of a full entablature, and what happens above it on the second level no longer has anything to do with triumphal arches. Instead of bearing the traditional dedicatory inscription, the second level is articulated with pseudo-Ionic pilasters that carry a zigzag of ornamental moldings, and the opus reticulatum has been converted into a decorative pattern of hexagons and triangles that form star shapes. Finally, the steeply pitched, timber roof that shelters a chapel dedicated to St. Michael unmistakably stamps this gatehouse as a northern building. Still, the source of inspiration is clear, and if the final product no longer closely resembles the original, it is due to the fact that it is not a copy but a free and fanciful interpretation of its model.

The models that carried the greatest authority for Charlemagne and his builders were those from the Christian phase of the late Roman Empire, and it was the adoption of the Early Christian basilica, rather than the domed, central plan of Byzantine churches, that was crucial to the subsequent development of Western church architecture in general and to the Romanesque style in particular. Several churches of the basilican type were built in northern Europe during the reign of Charlemagne, but none has survived. Nevertheless, it is possible to reconstruct the appearance of some of them with fair accuracy. A number of these structures appear to have followed their Early Christian models quite closely; the abbey church of Fulda (begun in 802) derives directly from Old St. Peter's and other Roman basilicas with transepts. But in other instances, Carolingian builders subjected the basilica plan to some very significant modifications, converting it into a much more complex form.

The study of a fascinating Carolingian document, the ideal plan for a monastery, preserved in the library of St. Gall, Switzerland (FIG. **11-24**), may provide some insight into the motivations of the Carolingian planner. As we have observed, the monasteries were of central importance in the revival of learning. About 819, a schematic plan for a Benedictine community was copied from a lost original, probably designed by the abbot of Reichenau, and sent to the abbot of St. Gall for use as a guide in his planned rebuilding of that monastery. Near the center, dominating everything, was the abbey church, with the cloister (not unlike the early colonnaded atrium) at one side. Around the cloister were grouped the most essential buildings: dormitory, refectory, kitchen, and storage rooms. Other buildings, including an infirmary, school, guest house, bakery, brewery, and workshops, were grouped around this central core of church and cloister. That the scheme may have been meant to be more than an ideal and actually to have been built is suggested by Walter Horn's discovery that the original plan must have been laid out on a module base of two-and-a-half feet and by the fact that parts or multiples of this module have been used consistently throughout the plan. Therefore, the width of the nave, indicated on the plan as 40 feet, would be equal to sixteen modules, the length of each monk's bed to two-and-a-half modules, and the width of paths in the vegetable garden to one-and-a-quarter modules.

Although the church is essentially a three-aisled basilica, it has features not found in any Early Christian churches. Perhaps most obvious is the addition of a second apse on the west end of the building. The origin and purpose of this feature have never been explained satisfactorily, but it remained a characteristic regional element of German churches until the eleventh century. Not quite as evident but much more important to the subsequent development of church architecture in the north is the fact that the transept is as wide as the nave. Early Christian builders had not been concerned with proportional relationships; they assembled the various portions of their buildings only in accordance with the dictates of liturgical needs. On the St. Gall plan, however, the various parts of the building have been related to each other by a geometric scheme that ties them together into a tight and cohesive unit. Equalizing the widths of nave and transept automatically makes the area in which they cross (the *crossing*) a square. This feature is shared by most Carolingian churches. But the St. Gall planner also took the subsequent steps that became fundamental to the development of Romanesque architecture: he used the crossing square as the unit of measurement for the remainder of the church plan. The arms of the transept are equal to one crossing square, the distance between transept and apse is one crossing square, and the nave is four-and-a-half crossing squares long. The fact that the aisles are half as wide as the nave integrates all parts of the church in a plan that is clear, rational, lucid, and extremely orderly.

The St. Gall plan reflects a medieval way of thinking that is important for Romanesque art and architecture. As a guide for the builder of an abbey, it expresses the authority of the Benedictine Rule and serves as a kind of prototype. In the interest of clarity and orderliness, the rule is worked out with systematic care. All units are balanced as the site is divided and subdivided. (This parallels the Carolingian invention of that most convenient device, the division of books into chapters and subchapters.) The neat "squaring" that characterizes the St. Gall plan and the principle of the balance of clearly defined, simple units will dominate Romanesque architectural design. The eagerness of the medieval mind to explain the Christian faith in terms of an orderly, rationalistic philosophy built on carefully distinguished propositions and well-planned arguments is visually anticipated in the plan of St. Gall.

Although the rebuilding project for St. Gall was not consummated, the Church of St.-Riquier at Centula in northeastern France (FIG. **11-25**) gives us some idea of what the St. Gall church would have looked like. A monastery church like that of St. Gall, the now-destroyed St.-Riquier was built toward the very end of the eighth century and therefore predates the St. Gall plan by approximately twenty years. Our illustration, taken from a seventeenth-century copy of a much older drawing, shows a feature not indicated on the plan of St. Gall but most likely common to all Carolingian churches—multiple, integrated towers. The St. Gall plan shows only two towers on the west side of the church, but they stand apart from it in the manner of Italian campaniles. If we assume a tower above the crossing, the silhouette of St. Gall would have shown three towers rising above the nave. St.-Riquier had six towers (not all are shown in the illustration) built directly onto or rising from the building proper. As large, vertical, cubic, and cylindrical masses, these towers rose above the horizontal roofline, balancing each other in two groups of three at each end of the basilican nave. Round stair towers on the west end provided access to the upper stories of the so-called *westwork* (entrance structure) and to the big, spired tower that balanced the spired tower above the eastern crossing. Such a grouping of three towers at the west, quite characteristic of churches built in the regions dominated by the Carolingians and their successors in German lands, probably foreshadows, in rudimentary form, the two-tower facades that were to become an almost universal standard in Late Romanesque and Gothic architecture. The St.-Riquier design, particularly the silhouette with its multiple integrated towers, was highly influential, especially in Germany. On the second floor, the towered westwork contained a complete chapel flanked by aisles—a small upper church that could be used for parish services. The main floor of the building was reserved for the use of the clergy.

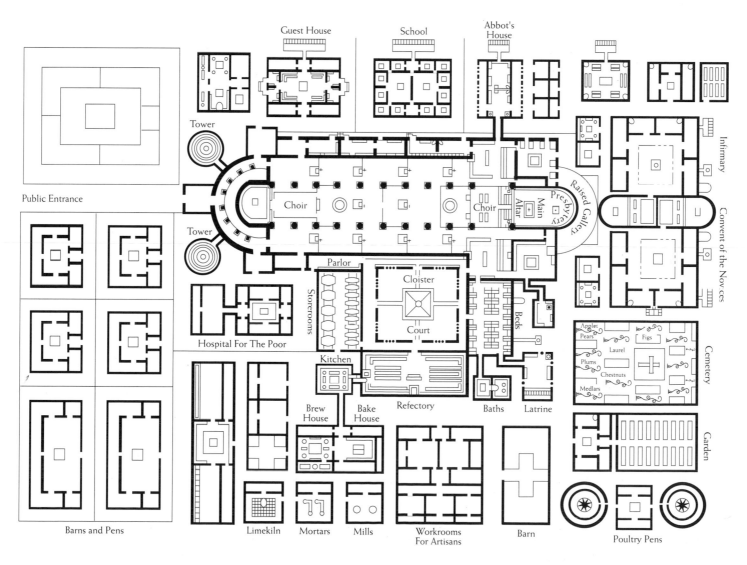

11-24 Schematic plan for a monastery at St. Gall, Switzerland, *c.* 819. (Redrawn after a ninth-century manuscript.)

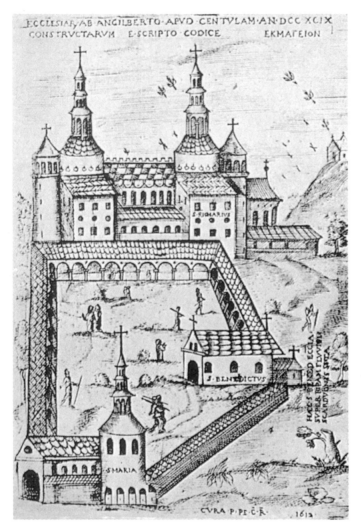

11-25 Monastery church of St.-Riquier, Centula, France, *c.* 800. (Engraving made in 1612 after a now-destroyed, eleventh-century miniature.)

(Remember that this was a monastery church.) A gallery opened onto the main nave, and from it, on occasion, the emperor and his entourage could watch and participate in the service below.

OTTONIAN ART

Charlemagne's empire survived him by less than thirty years. Under his three grandsons, Charles the Bald, Lothair, and Louis the German, the Carolingian Empire was partitioned (by 853) into western, central, and eastern areas, very roughly foreshadowing the later sections of France, Lorraine, and Germany. Intensified incursions by the Vikings in the west helped bring about the collapse of the Carolingians and the suspension of their great cultural effort. The breakup of the empire into weak kingdoms, ineffectual against the invasions, brought a time of dark-

ness and confusion that was perhaps even deeper than in the sixth and seventh centuries. The scourge of the Vikings in the west was complemented by the invasions of the Magyars in the east and by the plundering and piracy of the Saracen (Muslim) corsairs in the Mediterranean. Only in the mid-tenth century did the eastern part of the former empire consolidate under the rule of a new Saxon line of German emperors called, after the names of the three most illustrious members of the family, the "Ottonians." The three Ottos made headway against the invaders from the east, remained free from Viking depredations, and were able to found an empire that, nominally at least, became the successor to Charlemagne's Holy Roman Empire. The culture and tradition of the Carolingian period not only were preserved but were advanced and enriched. The Church, which had become corrupt and disorganized, recovered in the tenth century under the influence of a great monastic reform encouraged and sanctioned by the Ottonians, who also cemented ties with Italy and the papacy. When the last of the Ottonian line, Henry II, died in the early eleventh century, the pagan marauders had become Christianized and settled, the monastic reforms had been highly successful, and several signs pointed to a cultural renewal that was destined soon to produce greater monuments than had been known since ancient Rome.

Architecture

Ottonian architects followed the direction of their Carolingian predecessors. St. Michael's, the abbey church at Hildesheim (FIG. **11-26**), built between 1001 and 1031 by Bishop Bernward, retains the tower groupings and the westwork of St.-Riquier, as well as its massive, blank walls. But the addition of a second transept and apse results in a better balancing of east and west units. The plan and section of St. Michael's (FIG. **11-27**) clearly show the east and west centers of gravity, the nave being merely a hall that connects them. Lateral entrances leading into the aisles from the north and south are additional factors making for an almost complete loss of the traditional basilican orientation toward the east. The crossing squares have been used as a module for the dimensions of the nave, which is three crossing squares long and one square wide. This fact is emphasized visually by the placement of heavy piers at the corners of each square. These piers alternate with pairs of columns as wall supports, and the resultant "alternate-support system" will become a standard element of many Romanesque churches in northern Europe. Contrary to one view, the alternate-support system is not related to the development of Romanesque systems of vaulting. It made its first appearance in timber-roofed structures of the tenth century (such as St. Cyriakus at Gernrode, begun in 961, not shown) and appears to be the logical outcome of the Carolingian suggestion that the length of a building could be a multiple of the crossing square. Thus, the suitability of

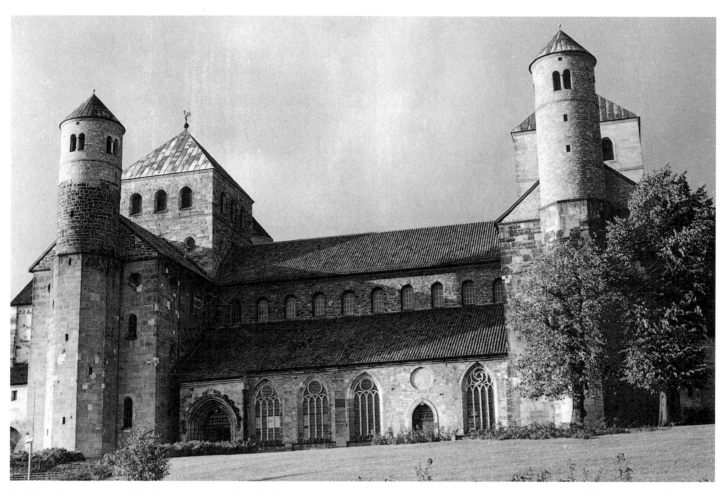

11-26　Abbey church of St. Michael (restored), Hildesheim, Germany, c. 1001–1031.

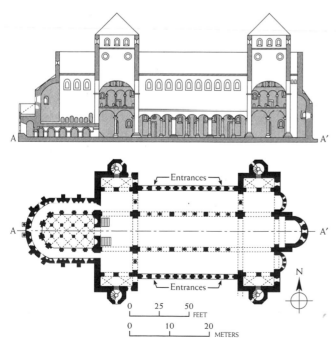

11-27　Section (*top*) and plan (*bottom*) of St. Michael's.

the alternate-support system to some Romanesque vaulting systems is only incidental; it seems to have been adopted not as a structural but as an esthetic device that furnishes visual proof of the geometric organization of the building's plan. It has been suggested that the alternate-support system is an importation from the Eastern empire, perhaps from Thessalonica. If so, it seems to have been adopted enthusiastically by northern architects, who, it has been proposed lately, may have seen it as an ideal means of converting unbroken basilican interiors into the modular units to which they were accustomed in their native timber architecture.

A view of the interior of St. Michael's (FIG. **11-28**) shows the rhythm of the alternating light and heavy wall supports. It shows as well that this rhythm is not reflected yet in the upper nave walls—that, in fact, it has not yet been carried further than the actual supports. Although its proportions have changed (it has become much taller in relation to its width than a Roman basilica), the nave retains the continuous and unbroken appearance of its Early Christian predecessors. We will see a fully developed Romanesque interior only when the geometric

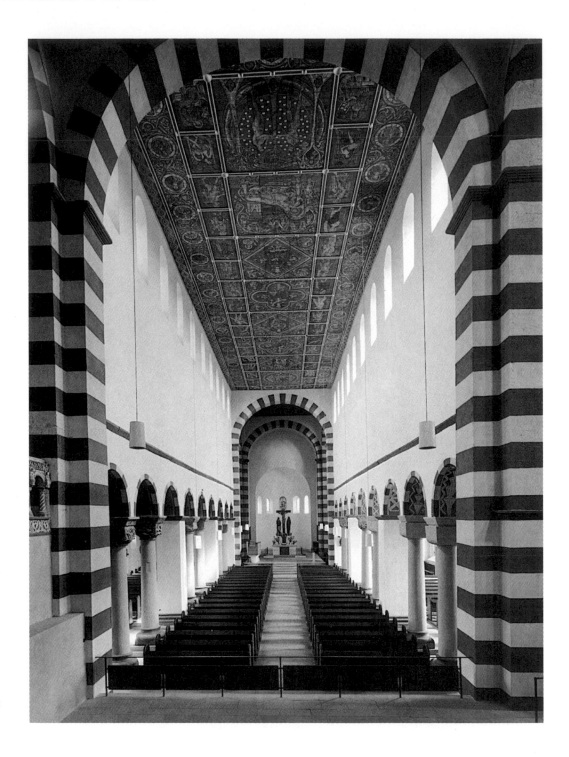

11-28 The nave of St. Michael's (restored).

organization of the church plan is fully reflected in the elevation of the nave walls and the interior space takes on the appearance of being composed of several vertical segments.

Sculpture

St. Michael's is an important and highly refined transitional monument that fills a gap between the Carolingian and Romanesque styles. Its patron, Bishop Bernward, who made Hildesheim a center of learning, was not only skilled

in affairs of state, but also was an eager scholar, a lover of the arts, and, according to his biographer, an expert craftsman and bronze caster. In 1001, he visited Rome as a guest of the emperor, Otto III, his friend and former pupil. This stay must have acquainted him with monuments like the Column of Trajan (FIG. 7-48), which may have influenced the great, columnlike paschal candlestick he set up in St. Michael's.

The wooden doors of an Early Christian church, Santa Sabina, may have inspired the remarkable bronze doors the

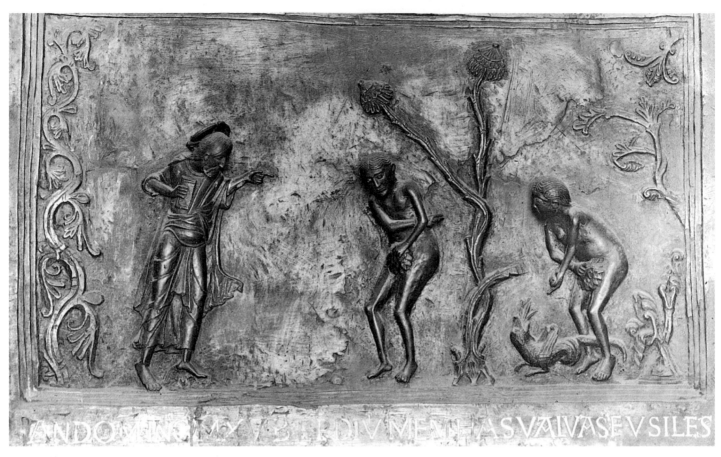

11-29 *Adam and Eve Reproached by the Lord,* from the bronze doors commissioned by Bishop Bernward for St. Michael's, 1015. Approx. 23″ × 43″.

bishop had cast for his splendid church. The doors were cast in a single piece with figural sculpture, an important innovation. Carolingian sculpture, like most sculpture since late antiquity, consisted primarily of small art executed in ivory and metal; the St. Michael's doors anticipated the coming reinstatement of large-scale sculpture in the Romanesque period. The style of the figures on the doors (FIG. **11-29**) derives from Carolingian manuscript illumination but has an expressive strength of its own—once again, a case of the form derived from a prototype becoming something new and firmly itself. God is accusing Adam and Eve after their fall from grace. As he lays on them the curse of mortality, the primal condemnation, he jabs his finger at them with the force of his whole body. The force is concentrated in the gesture, which becomes the psychic focus of the whole composition. The frightened pair crouch, not only to hide their shame but to escape the lightning bolt of the divine wrath. Each passes the blame—Adam pointing backward to Eve, Eve pointing downward to the deceitful serpent. The starkly flat setting throws the gestures and attitudes of rage, accusation, guilt, and fear into relief; once again, the story is presented with all the simplicity and impact of skilled pantomime.

We have seen how the instinct for pantomimic pose and gesture guides the representations and narratives of medieval art from the very beginning. Such pantomime, emphasized by telling exaggeration, appears in an ivory carving (FIG. **11-30**) that surely is among the masterpieces of the art of the Middle Ages. This small panel, only 9 inches high and 4 inches wide, carries a composition of two intertwined figures, beautifully adjusted to the space. The theme is the persuasion of Doubting Thomas. After the Resurrection, when Christ appears for the second time to his sorrowing disciples (John 20:24), all believe that he is truly Christ and truly risen except the skeptical Thomas, who demands to feel the bodily wounds of the master he has seen crucified. In the panel, Thomas explores the wound in Christ's side in a kind of climbing, aggressive curiosity. Christ, his right arm raised to reveal his side, bends over Thomas in an attitude that wonderfully combines gentleness, benign affection, protectiveness, and sorrow. The figures are represented entirely within the context of emotion; the concentration on the single act of Christ's revelation to the doubter, the emotional vibrations that accompany the doubt, and the ensuing conversion of Thomas determine every line of the rendering. The panel,

11-30 ECHTERNACHT MASTER, *Doubting Thomas*, c. 1000. Ivory, approx. 9″ × 4″. Staatliche Museen, Berlin.

made by the artist known as the Echternacht Master, is half of a diptych. Together the two subjects (the other is *Moses Receiving the Law*) depict faith by law and by revelation jointly. Although the swirling composition shows a ninth-century Byzantine influence, we are not aware here of the influence of a prototype; we seem to have before us an original work of great power.

Painting and Illumination

We must assume that, by Ottonian times, artists had become familiar enough with the Carolingian figurative modes to work with considerable independence, developing a functional, vernacular style of their own. A supreme example of this is an illumination in the *Lectionary of Henry II* (FIG. **11-31**), called *The Annunciation to the Shepherds,* in which an angel announces the birth of Christ to the shepherds. The angel has just alighted on a hill, his wings still beating, and the wind of his landing agitates his draperies. He looms immense above the startled and terrified shepherds, filling the sky, and bends on them a fierce and menacing glance as he extends his hand in the gesture of authority and instruction. Emphasized more than the message itself are the power and majesty of God's authority. The electric force of God's violent pointing in the Hildesheim doors is felt again here with the same pantomimic impact. Although the figure style may stem ultimately from the Carolingian school at Tours, the painters of the scriptorium of Reichenau, or of Lorsch or Trier, who produced the *Lectionary of Henry II,* have made of their received ideas something fresh and powerful; a new sureness in the touch is epitomized by the way in which the draperies are rendered in a hard, firm line and the planes are partitioned in sharp, often heavily modeled shapes.

We saw these features in Middle and Late Byzantine art, and indeed a close connection existed between the Ottonian and Byzantine spheres. Yet, for the most part, the Ottonian artists went their own way; Ottonian painting was produced for the court and for the great monasteries—for learned princes, abbots, abbesses, and bishops—and thus appealed to an aristocratic audience that could appreciate independent and sophisticated variations on inherited themes. Although an illumination like *The Annunciation to the Shepherds* could by no means be called Classical, it does display a certain sculpturesque clarity—a strong, relieflike projection and silhouette that suggests not a hesitating approximation of misunderstood prototypes from antiquity but a confident, if unconscious, capturing of the Antique spirit.

At the same time, the powerful means of expression of *The Annunciation to the Shepherds* miniature imply an intensification of Christian spirituality that is related to the broad monastic reforms of the tenth and eleventh centuries. With that force of expression goes a significantly new manner of fashioning the human figure in art, a manner that is not

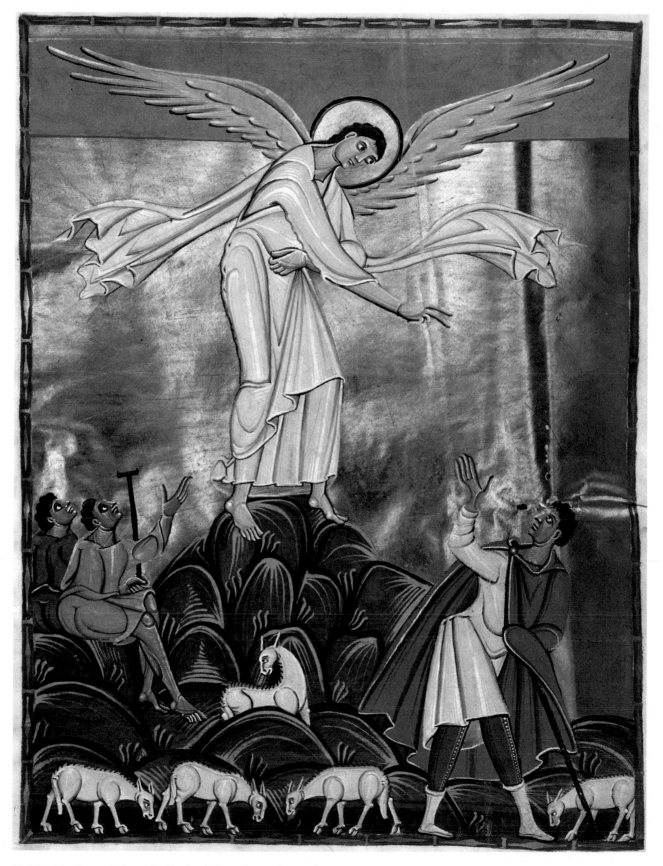

11-31 *The Annunciation to the Shepherds,* from the *Lectionary of Henry II,* 1002–1014. Approx. 17″ × 13″. Bayerische Staatsbibliothek, Munich.

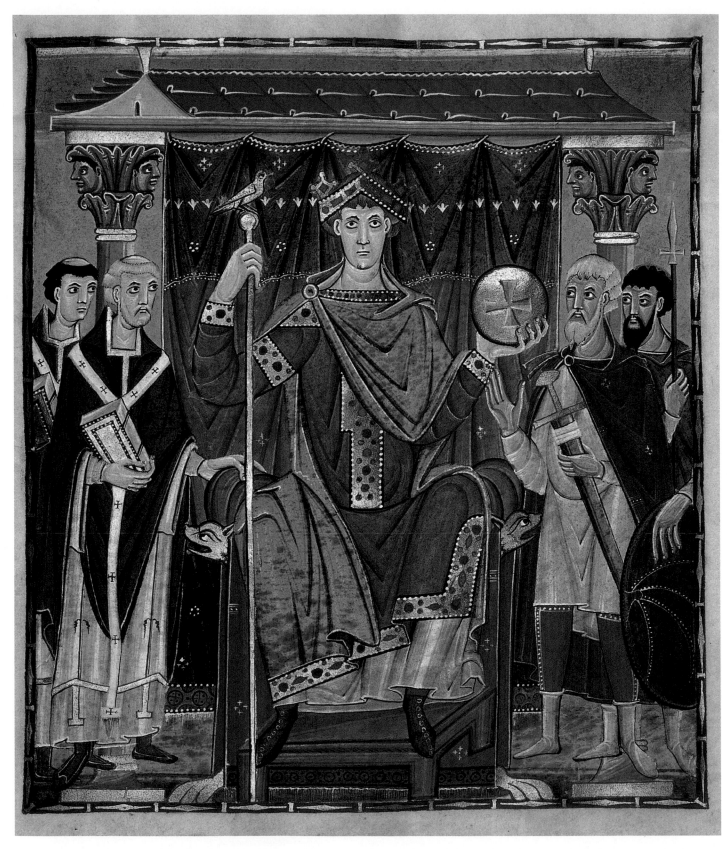

11-32 *Otto III Enthroned Receiving the Homage of Four Parts of the Empire* (with nobility and clergy), from the *Gospel Book of Otto III*, 997–1000. Approx. 14″ × 10″. Bayerische Staatsbibliothek, Munich.

slavishly dependent on prototypes even when prototypes are exchanged and studied. Ottonian figurative art reveals a translation of prototypical material into a kind of ready idiom of forms and a native way of drawing. Although exceptions are known, for the most part, Ottonian figures have lost the old realism of the *Coronation Gospels* (FIG. 11-14), inherited from the Antique style, and move with an abrupt, hinged, jerky movement that is not "according to nature" but nevertheless possesses a sharp and descriptive expressiveness. This new manner would be passed on to the figurative artists of the Romanesque period. As the spoken and written languages of Western Europe emerged from the polyglot Latin-Germanic of the early centuries into the vernacular tongues we recognize today, so figurative art gradually developed out of the same kind of mixture of Latin, Germanic, and Celtic elements into a new, strong, and self-sufficient vernacular of representation.

A picture from the *Gospel Book of Otto III*, representing the emperor himself (FIG. **11-32**), sums up much of what went before and points to what is coming. Of the three Ottos, it was Otto III (983–1002) for whom the dream of a revived Christian Roman Empire was most precious; indeed, it was his life's obsession. His mother was a Byzantine princess; he was keenly aware of his descent from both Eastern and Western imperial lines. He moved his court, with its Byzantine ceremonial, to Rome, and there set up theatrically the symbols and trappings of Roman imperialism, even issuing medals proclaiming the "renovation of the Roman Empire." Otto's romantic dream of imperial unity for Europe would never materialize. He died prematurely, at 22, and, at his own request, was buried beside Charlemagne at Aachen.

The emperor is represented enthroned, holding the scepter and cross-inscribed orb that represent his universal authority. He is flanked by the clergy and the barons (the Church and the state), both aligned in his support. Stylistically remote, the picture still has a clear political resemblance to the Justinianic mosaic in San Vitale (FIG. 9-9). It was the vestigial, imperial ideal—awakened in the Frankish Charlemagne and preserved for a while by his Ottonian successors—that gave partial unity to Western Europe while the Germanic peoples were settling down. This imperial ideal, salvaged from ancient Rome and bolstered by the experience of Byzantium, would survive long enough to give an example of order and law to the people; to this extent, ancient Rome lived on to the millennium, culminating in the frustrated ambition of Otto III. But native princes in England, France, Spain, Italy, and Eastern Europe would aspire to a sovereignty outside the imperial Carolingian and Ottonian hegemony; staking their claims, they make the history of the medieval power contests that led to the formation of the states of Europe as we know them. In the illumination (FIG. 11-32), Otto, sitting between the rivalrous representatives of church and state, typifies the very model of the medieval predicament that will divide Europe for centuries. The controversy of the Holy Roman Emperors with the popes will bring the German successors of the Ottonians to bitter defeat in the thirteenth century, and with that defeat, the authority of ancient Rome will come to an end. The Romanesque period that is to follow will, in fact, deny the imperial spirit that had prevailed for centuries. A new age is about to begin, one in which Rome—an august memory—will cease to be the deciding influence.

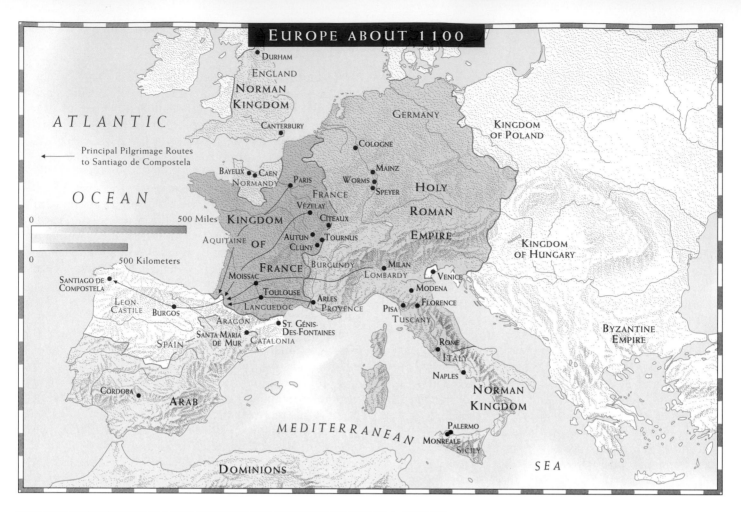

EUROPE ABOUT 1100

ATLANTIC

DURHAM
ENGLAND
NORMAN
KINGDOM
CANTERBURY

GERMANY

KINGDOM
OF POLAND

Principal Pilgrimage Routes
to Santiago de Compostela

OCEAN

BAYEUX • CAEN
NORMANDY
PARIS
FRANCE
VÉZELAY
CITEAUX
AUTUN • TOURNUS
CLUNY
BURGUNDY

COLOGNE

MAINZ
WORMS
SPEYER

HOLY

ROMAN

EMPIRE

KINGDOM
OF HUNGARY

500 Miles

KINGDOM OF

AQUITAINE

0

500 Kilometers

SANTIAGO DE
COMPOSTELA
LEÓN
CASTILE BURGOS
ARAGON
SANTA MARIA
de MUR CATALONIA
SPAIN

FRANCE
MOISSAC
TOULOUSE
LANGUEDOC
ST. GÉNIS-
DES-FONTAINES

MILAN
LOMBARDY
VENICE
MODENA
FLORENCE
PISA
TUSCANY

ARLES
PROVENCE

BYZANTINE
EMPIRE

CÓRDOBA

ARAB

ROME
ITALY
NAPLES

NORMAN
KINGDOM

MEDITERRANEAN

DOMINIONS

PALERMO
MONREALE
SICILY

SEA

900	950	1000	1050

FIRST ROMANESQUE	ROMANESQUE

Baptistery of San Giovanni
Florence, 11th century

Bayeux tapestry, 1070-1080

Cluniac Order founded, 910

Germany under Salian and Franconian Emperors, 1024-1138

Germany under Ottonian Emperors, 936-1024

Norman conquest of England (Battle of Hastings)1066

Viking raids, 9th-11th centuries

Norman conquest of Southern Italy and Sicily, 1060-1101

Final separation of Latin (Roman) Church from the
Byzantine (Greek Orthodox) Church, 1051-1054

First Crusade, 1095

Cistercian Order founded, 1098

Pope Gregory VII (1073-1085) asserts spiritual supremacy of Papacy over kings and emperors, 1077

Chapter 12

Romanesque Art

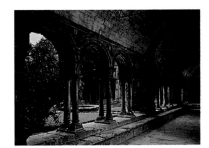

Pisa Cathedral
1053-1272

Moralia in Job
early 12th century

Portal of narthex of La Madeleine
Vézelay, 1120-1132

The scribe Eadwine, 1150

Cloister, St.-Trophime
Arles, late 12th century

Germany under Hohenstaufen Emperors, 1138-(1268)

St. Anselm of Canterbury, 1033-1109

Matilda, Countess of Tuscany, 1046-1115

Peter Abelard, 1079-1142

St. Bernard of Clairvaux, 1090-1153

St. Hildegard of Bingen, c.1099-1179

Second Crusade, 1146

The mid-eleventh century marked a turning point in European history. Western Europe, ringed by the Byzantine East and by Islam, began to emerge as a distinctive culture, its geographical and political spheres already taking rough shape. The great invasions that had disrupted life for five hundred years had come to an end. The last of the invaders had been Christianized, and the twelfth century would see the conversion of the peoples of the eastern frontiers to the Latin form of Christianity.

To put the rich resources of the physical environment to use, gradually expanding populations, in frontier-like settings, undertook the clearing of the vast forests and marshlands that covered much of the terrain, occupying and cultivating it as it was reclaimed. This "inward expansion" widely increased the area available for the raising of crops and breeding of stock, adding to the productive territory of the feudal barons, and in general providing an increase in the standard of living.

Western Europe during the Eleventh and Twelfth Centuries

THE TOWNS AND THE BARONS Though Western Europe in the period of the Romanesque* remained ninety percent agricultural, the accelerated founding and re-founding of towns, accompanied by a sharp increase in trade and in the accumulation of wealth, made for a commercial revolution that would eventually replace the land-based economy with a market-based economy. Many towns of ancient Roman foundation, such as Cologne, Paris, London, and most of the cities of Italy, were restored to busy urban life after centuries of relative stagnation. Located on navigable rivers, once the avenues of invasion, the towns were naturally the nuclei of networks of maritime and overland commerce. Populated by merchants, tradesmen, moneylenders, artisans, free peasants, and escaped serfs, the towns were also centers of ecclesiastical influence, often founded or reconstituted by bishops and archbishops, who built the towers, gates, and walls of the towns as well as the churches.

The independence so proudly cherished by the towns depended on their charters and on their own strength and skill at defending themselves. Charters were public documents granted by feudal lords, enumerating the rights, privileges, immunities, and exemptions that the communities might possess beyond the feudal obligations they owed the lords. Independence could be won often by outright purchase of a charter, or by the town's declaring itself by oath a free corporation or commune, willing and able to defend itself. The oath sworn by townspeople differed significantly from the oath of fealty sworn by the lords and their vassals. Of the oath sworn by the townspeople, a modern historian writes:

> What was revolutionary about the origins of the urban movement . . . was that the oath which linked the members of the primitive urban society was an egalitarian oath, in contrast to the contract of vassalage, which bound the inferior to a superior. It substituted a society organized on horizontal lines for (and in opposition to) the vertical feudal hierarchy.*

This new system threatened the world of the feudal elite, both lay and ecclesiastical. For the lay elite, "commune" was "a detestable name," principally because the towns, or communes, were centers of economic activity that the feudal warrior-lords† detested. The Church, for its part, censured the townspeople for cultivating the vice of avarice. It is indicative of the profound economic changes brought by increasing urbanism that the avarice of the merchant, and his presumed practice of usury, became for churchmen the supreme sin, superseding pride, the sin of the warrior-lord, the baron. Yet the economic and political interests of the towns were tied up with the feudal countryside, and towns were also feudal landholders, as exploitative of their peasantry as were the lords. The towns were cursed widely as "the root of all evil."

Thus, to the earlier three-fold ordering of medieval society—the warrior-lord (the baron), priest, and peasant—was added a fourth order, that of the merchant, trader, artisan, townsman, or burgher (*bourgeois* is the universally adopted French term). The relations among these orders were most often stormy. The resultant chronic instability of civil life was both a challenge and an opportunity for the lay barons and the princes of the Church—a chance to expand their own holdings and their control of their neighbors'. The lords became kings, and the popes became monarchs of the Church. Their conflicting claims of supremacy in Christendom brought them into fateful collision.

BARONS AND KINGS The feudal lord (the generic term is *baron*), despite the competition of a new institution like the town, was still at the center of Romanesque society. His Christian religion, his feudal oath, his mostly country locale, his land or *fief,* his vassals together constituted the

*The term *Romanesque* was first applied by critics in the early nineteenth century to describe the architecture of the later eleventh and the twelfth centuries, because certain architectural elements, principally the round arch, resembled those of ancient Roman architecture. Thus, the word served to distinguish Romanesque from Gothic buildings. By extension from art-historical usage, "Romanesque" is often used to designate the history and culture of Western Europe between about 1050 and 1200, overlapping twelfth-century Early Gothic developments in northern France.

*Le Goff, *Medieval Civilization,* p. 292. Jacques Le Goff, English edition, translated by Julia Barrow, published by Basil Blackwell, Oxford, 1988.

†The terms "warrior-lord," "lord," and "baron" are equivalent in meaning and are used interchangeably.

fundamental unit of the Romanesque social structure. His stone castle, the *chateau fort,* surrounded by thick walls and moats, was the seat and symbol of his authority and of the fact that it had been won most often by war and by war maintained; the baron's sole and proper profession, as he believed, was war. The moldering ruins of these castles recall to the modern visitor an age when government was always local, visible, singular, personal, and absolute.

This obstructive localism of the barons made unity and consistency of government difficult, in some cases impossible. The period of the Romanesque witnessed both the success and the failure of centralizing forces. Powerful barons could become kings in various ways: fortunate feudal connections, inheritance, election, marriage, conquest—singly or in combination. Sometimes they had the help of the towns, sometimes their hindrance. In general, the towns saw the advantages regulatory power could bring, peace and civil order most of all. The Church could oppose or encourage centralization of feudal government, depending upon its own interests.

The career of Henry II, king of England (1154–1189), illustrates dramatically the success of a feudal monarch pushing for a unified royal state. By inheritance he gained Normandy and other territories in northern France adjacent to the realm of Louis VII, the French king. By his fortunate marriage to Eleanor of Aquitaine, one of the most remarkable women of the Middle Ages, he came to control most of southwestern France. This made him far more powerful than Louis VII, even though by the complexity of feudal relationships he was at the same time Louis's vassal.

Where Henry II succeeded, his great contemporary Frederick I, "Barbarossa" (Redbeard), failed. Barbarossa was king of the Germans and Holy Roman Emperor of Germany and Italy. His ambition was to restore the empire of Charlemagne and of the Ottonians. Against what he thought was a challenge from the popes to make the emperor subordinate to the papacy, he declared in a manifesto that he "held the throne through the election of the princes of Germany from God alone." His claim to be head of both Church and empire—like the theocratic emperors of Byzantium—including the papacy itself at Rome, is expressed in the title "Holy Roman Empire," which he was the first to use.* The Roman Empire would be restored, but now it would be Christian and holy, rather than pagan and profane.

Intending to establish imperial control throughout the whole empire, not just in the Germanys, Barbarossa repeatedly invaded Italy. On all sides he met fierce opposition, especially from the cities. The cities of northern Italy, grown powerful in their own right, joined in the Lombard League and decisively defeated Barbarossa. Rebellions of the great barons in the Germanys added to his frustration; he gained peace only by parceling out the land to feudal magnates who became hereditary, and virtually independent, princes. His dream of empire vanished, as did all possibility of unity for either Germany or Italy until the nineteenth century.

KINGS, POPES, AND MONKS Henry II of England and Barbarossa were men representative of the twelfth century, when the struggle to overcome feudal constraints on the development of centralized government succeeded in some instances and failed in others. The Papacy, the most successfully centralized of all governments, played a decisive role in that great struggle.

The immense spiritual power of the popes expanded widely into the realm of temporal and political power in the age of the Romanesque. Since, as it was believed, there was no salvation outside the Church, and since the popes were heads of the Church, they claimed to be the sole, ultimate judges of those who would be saved and those who would be damned.

The Papacy based its claim for this supreme authority on the Petrine theory, which asserted that since Christ had bestowed upon Peter the "keys of the kingdom," that is, the power to punish or absolve from sin (Matthew 16:18, 19), the popes as the successors of Peter were "keepers of the keys," having Peter's power to "bind or to loose." The popes had long used this spiritual authority to interfere in the personal affairs, like marriages and divorces, of kings. Their weapon was the threat or the act of excommunication. Excommunication was much more than just a sign of papal disapproval; it could bring about the subversion of royal power. Not only could a king—or baron or prelate—be thrust outside the community of the faithful; he could be deposed from office, and his subjects released from all oaths of allegiance to him. Moreover, by a writ of interdiction, his subjects could be refused all religious services, removing from them the instruments of grace and the possibility of salvation.

With this powerful armament, the Papacy became a political as well as spiritual force, inciting or discouraging rebellion. Kings could and did fight back, by setting up antipopes and driving the legitimate ones from Rome. All this did little for the peace of Western Europe. On the other hand, papal political power could do much for kings submissive to it. To have the support of the pope greatly bolstered a king's authority at home and abroad. In politics, the Church had "entered the world, and the world had entered the Church." The papacy proclaimed a supremacy both spiritual and temporal, a universal authority to which all other authorities were subordinate.

In the preceding chapter, we outlined the conflict of interest that inevitably brought on the competition for power between the kings and the popes. That competition led to the first great confrontation, that of the German

*The Holy Roman Empire was for centuries the honorific name for a congeries of more than three hundred more or less independent German states and cities, whose only unity consisted in its name. Voltaire remarked that it was neither holy, Roman, nor an empire, and in 1807 Napoleon officially dissolved it.

emperor Henry IV (1056–1106) with Pope Gregory VII, who occupied the papal chair from 1073 to 1085.

Gregory strongly supported the movement for Church reform that had begun at Cluny in Burgundy, where in 910 a Benedictine community was founded free from all feudal dependency and directly responsible only to the pope. Cluny was dedicated to the correction of the evils that, during the centuries since Saint Benedict and the Carolingians, had sapped the moral foundations of the Church. Gregory adopted the Cluniac agenda of reforms, especially those that attacked simony (selling of Church offices) and lay investiture, by which secular lords—barons and kings—appointed clergy to Church offices, making them their feudal vassals and expropriating the revenues of Church lands. Henry IV insisted on his right as emperor to investiture of bishops and archbishops; Gregory excommunicated him, and Henry, fearful of the subversion of his realm, was forced to make a humiliating—if temporary—submission to the pope.

The most successful propagandist for papal authority and the Gregorian reforms was Saint Bernard of Clairvaux (1090?–1153). A Cistercian monk and abbot of the monastery of Clairvaux in northern Burgundy, he embodied not only the reforming spirit of the Cistercian order, but also the new religious fervor awakening in the West.

The Cistercians (so called from the Latin name for Cîteaux, their place of origin) were a Benedictine order that split from the older Benedictine monasticism of Cluny, which had become rich and worldly. They returned to the strict observance of the Rule of Saint Benedict, changing the color of their habits from Cluniac Benedictine black to unbleached white, and were known as the White Monks. Their emphasis upon productive manual labor and their systematic farming techniques stimulated the agricultural transformation of Europe. Under the leadership of Saint Bernard, and advertised by his fame, they expanded rapidly; by the end of the twelfth century there were some 530 Cistercian abbeys. Their practical as well as spiritual labors were a great force in the civilizing of medieval Europe.

Saint Bernard's impassioned eloquence made him a European celebrity, and drew him—reluctantly—into Europe's stormy politics. He intervened in high ecclesiastical and secular matters, defended and sheltered embattled popes, counseled kings and prelates, denounced heretics, and preached crusades against the infidel—all in defense of papal Christianity and spiritual values. He exhausted his energies in polemical business, always yearning to return to his real calling as the devoted leader of a purified and austere monastic community.

COUNTESSES, QUEENS, AND NUNS Though the Romanesque was still a man's world, women could and did have power and influence. Countess Matilda of Tuscany (1046–1115), sole heiress of vast holdings in northern Italy, joined the popes in the investiture struggle against the German emperors. With unflagging resolution she defended the Gregorian reforms and at her death willed most of her lands to the papacy. Her influence was not only political but intellectual, and she was long remembered as a wise counselor as well as the principal benefactor of the Holy See.

Perhaps the most famous woman of the twelfth century was Eleanor of Aquitaine (1122–1204), wife of Henry II of England. She married Henry after her marriage to Louis VII, king of France, was annulled. She was queen of France for fifteen years, and queen of England for thirty-five years, during which time she bore three daughters and five sons; among the latter were two future kings, Richard I (Lionheart) and John. She prompted her sons to rebel against their father, for which action Henry imprisoned her. Released at Henry's death, she lived on as dowager queen, managing the government of England and King John's holdings in France.

Of quite different stamp was her contemporary Saint Hildegard of Bingen (1099–1179), the visionary and mystic prioress of a convent of nuns. As we have seen, an upsurge of general religious fervor and personal piety accompanied the great reform movement sponsored by the papacy and the Cistercians. We noted the union of the reforming and devotional spirit in Saint Bernard, who was one of many correspondents of Hildegard, and in a way her male counterpart. As report of Saint Hildegard's visions spread abroad, her counsel came to be sought after by kings and popes, barons and prelates, all of whom were attracted by her spiritual insight into the truth of the mysteries of the Christian faith. Saint Hildegard of Bingen was the most prominent among the saintly women of the Romanesque.

Another well-known figure of the time, Héloïse, though not remembered for sanctity, will be forever famous as the pupil lover of Peter Abelard, the leading philosopher of the age. His career ended abruptly when their love affair was discovered by Fulbert, canon of Notre-Dame and uncle of Héloïse, who had Abelard castrated. Abelard entered a monastery and Héloïse became a nun. Their tragic love affair was recorded in Abelard's own *History of My Misfortunes*, and in the touchingly passionate and pathetic letters of Héloïse. Ever faithful to Abelard, she survived him by some twenty years, and when she died she was buried with him in the same tomb.

PILGRIMAGE AND CRUSADE For centuries Christians had traveled to sacred shrines where the relics of saints, believed to have the power to heal body and soul, were kept. Pilgrimage was the most conspicuous feature of public devotion, proclaiming the pilgrim's faith in the veneration of saints and hope for their special favor. The shrines drew pilgrims from all over Europe who braved for salvation's sake bad roads and hostile wildernesses infested with brigands. Pilgrimage was often enjoined as a penitential act of contrition or as a last resort in the search for a cure for some physical disability. Hardship and austerity were means for increasing the pilgrim's chances for the remission of sin or of disease; the distance and peril of the

pilgrimage were measures of the pilgrim's sincerity of repentance or of the reward being sought. In France, St.-Martin's at Tours, Ste.-Foi at Conques, and St.-Sernin at Toulouse, great shrines in themselves, were important waystations to the most venerated shrine in the West, Santiago de Compostella in northwestern Spain. Pilgrim traffic, greatly increasing in the Romanesque, established the routes that would later become avenues of commerce and communication.

The Crusades ("taking of the Cross") were mass, armed pilgrimages, the initial purpose of which was to rescue the Christian shrines of the Holy Land recently taken over by the Muslim Turks. In effect, the Crusades—the first three major ones from 1096 to 1192—were military expeditions launched in response to Muslim pressure in the Mediterranean, the Byzantine lands, and in general, the Middle East. Crusaders and pilgrims were bound by similar vows and hoped not only to expiate sins and win salvation, but to glorify God and extend the power of the Church. The joint action of the papacy and the barons—mostly French—in this type of holy war strengthened papal authority over the long run and created an image of Christian solidarity.

The joining of religious and secular forces in the Crusades was symbolically embodied in the Christian warrior, the fighting priest, or the priestly fighter. From the old Germanic warrior evolved the Christian knight, who fought for the honor of God rather than in defense of his tribal chieftain. The first and most typical of the Christian knights were the Knights Templars, who, after the Christian conquest of Jerusalem, stationed themselves near the site of Solomon's Temple to protect pilgrims visiting the recovered Christian shrines. Founded in 1118, the order was blessed by Saint Bernard, who gave them a rule of organization based on that of his own Cistercians. Saint Bernard justified their militancy in declaring that "the knight of Christ" is "glorified in slaying the infidel . . . because thereby Christ is glorified," and the Christian knight then wins salvation. Saint Bernard saw the Crusades as part of the general reform of the Church and as the defense of the supremacy of Christendom; he himself preached the Second Crusade in 1147.

The merger of the monastic and the military in the crusading orders greatly influenced the development of the institution of knighthood and its code of chivalry. For the medieval nobility, knighthood and chivalry became an ethical ideal, though not necessarily a guide to practical life. The new values of piety, courtesy, regard for the poor and the weak, the chaste love of and respect for women, were fused with the older values of military valor and feudal loyalty. They were instilled early in young nobles and were confirmed, after years of discipline, in the religious ceremony of the accolade, which made a man a knight and sanctified his sword.

The rough reality of the Crusades belied any idealism of Christian warriors, however. The atrocities wrought by the Christian conquerors of Jerusalem resembled the excesses of the early Germanic peoples. Quite worldly motives played a large part in enlisting the enthusiastic participation of the barons in the Crusades: adventure, the rewards of plunder, the opportunity to perform memorable feats of arms. The glory of battle was celebrated in song and story and re-enacted in the pageantry of tournaments.

The Crusades achieved little. A few unstable kingdoms and princely states were established in Syria and the Holy Land, later to be overthrown and assimilated by the Saracens (Muslims). In western Europe, the Crusaders' effect was to increase the power and prestige of the towns, many of which purchased their charters from the barons by way of financing the crusading campaigns. Italian maritime towns thrived on the commercial opportunities attendant upon the transportation of Crusaders overseas. Though barren in overall result, the Crusades widened the cultural perspectives of the provincial and still half-barbarous West, bringing into view more civilized peoples and more exotic and opulent ways of life than anything the West had yet known.

THE SCHOLARS AND THE LAWYERS While the Crusaders were warring against Islam, Western thinkers were deriving immense benefit from Islamic literary and philosophical culture as they found it locally in Muslim Spain. Islamic influence was especially felt by the theologians and philosophers. Through the greatest of the Arabic thinkers, Averroës (Arabic: ibn-Rushd), the logical and metaphysical works of Aristotle were made known, and these radically transformed Christian thought. Aristotle's rationalism was now applied to the interpretation of religious belief and to the systematizing of revealed truth by means of logical reasoning. Hitherto, truth had been considered the exclusive property of divine revelation as given in the scriptures; now the authority of Aristotle was invoked to demonstrate that there were truths arrived at by reason alone. The problem became to reconcile the apparently conflicting truths of revelation and of reason. It was hoped that the conflict was *only* apparent.

Even before the arrival of Aristotelian rationalism, Saint Anselm, archbishop of Canterbury (1033–1109) had offered a *logical* proof for the existence of God, without an appeal to the authority of scripture. This move to make the fundamental doctrines of religion reasonable greatly accelerated with the assimilation of the thought of Aristotle. Schools at Paris and neighboring cities in northern France taught the new, rationalizing philosophy, and its proponents became known as Schoolmen, and the philosophy they developed as Scholastic. We have already met the greatest of the early Schoolmen, Abelard, as lover of Héloïse. Abelard's way of thinking seemed to many traditional theologians to be leading to disbelief. Saint Bernard, the mystical thinker, bitterly denounced him: "Peter Abelard is trying to make void the merit of Christian faith, when he deems himself able by human reason to

comprehend God altogether." But though Saint Bernard secured the condemnation of Abelard, the philosophy of the Schoolmen developed systematically until it became the dominant philosophy of the Western Middle Ages.

Schools first appeared within the precincts of monasteries and then became associated with the great churches of the towns, where students, gathering to hear the lectures of influential teachers like Abelard, organized into corporations. The teachers followed suit; and the loosely linked corporations of students and teachers became the predecessors of the institutions we know as universities. A new profession was being born, uniting in itself the religious and the secular, analogously to the merger of the two in the crusading orders of knights. The universities produced the professional scholar, the "master" and "doctor" of arts, who supervised and advanced the whole enterprise of medieval learning.

As important as the recovery of the works of Aristotle was the rediscovery of the great corpus of Roman civil law, *Corpus Juris Civilis*, one of the outstanding achievements of the reign of Justinian. The analytical study of this great work at the beginning of the twelfth century opened a whole new avenue of intellectual and practical experience. Jurisprudence, the theory of law, became the rival in importance of theology, philosophy, and the liberal arts in the universities of Western Europe.

The revival of Roman civil law centered at the university of Bologna, where a whole school of commentators studied and taught the subject. From Bologna the new discipline spread to Montpellier, Orléans, Paris, and Oxford, whence trained jurists or "legists" could enter the administrative bureaucracies of the developing royal states. The complex political affairs of the period made for a surge of litigation that required the services of men skilled in the principles of law and the intricacies of legal deliberations. Hitherto, the Church had monopolized procedures requiring written documentation; now, a mostly secular profession of educated and specialized laymen was becoming competent to manage legal business, especially that of the monarchs in their dealings with one another and with the barons and the Church.

Against this alarming growth of secular, civil law, the Church was systematizing its own *canon law*. The Church was a state in its own right—indeed the best organized in Western Europe—and with the pope at its head was in effect the papal monarchy. The altercations among churchmen, kings, and barons, as well as questions of law arising within the Church itself, required the codification of centuries of decrees, decisions, precedents, and procedures into a coherent legal system. The organization of a unified canon law began also at Bologna and continued at Paris; inevitably canon law came into conflict with the civil law at many points.

The civil code widely displaced the old Germanic codes of the earlier Middle Ages (the exception was in England, where the "common law" prevails still). As a single, coher-

ent system the civil code both reflected and was an instrument of the consolidating tendencies of twelfth-century royal government. It served well the ambitions of monarchs and frustrated the conservative, localizing instincts of the barons. For the towns and cities the civil law was especially attractive. It provided a rationale of urban independence, expressed in charters, contracts, treaties, and all documents defining the rights, privileges, and obligations of citizens. The legal foundation for political and social relations made the myriad of legal problems arising from them the business of specialists in law, a new profession of lawyers and judges that would balance, and ultimately replace, ecclesiastical with civilian influence in the administration of governments and of justice.

THE MASTER MASONS The sharpening and focusing of intelligence, to the end of systematizing knowledge and regulating action, was not confined to the emerging professions of scholar/teacher and jurist. Something like their method of inquiry and analysis can be found in other occupations, not the least among them that of the master masons (not yet called "architects"), who built the churches of the Romanesque. The scholars and the jurists, making use of the logic of Greek philosophy and of Roman law, had developed a technique of thinking and a habit of mind that would characterize the age of the Romanesque and after. The master masons, at first depending on the authority of ancient Roman, Byzantine, and Carolingian/Ottonian building, would develop their own logic of architectural composition.

We know little about the master masons; until the thirteenth century they are anonymous. The patron who commissioned and subsidized a building project (not the actual designer and constructor) was called its builder. Thus, Abbot Suger was the "builder" of the new church of St.-Denis at Paris. Gervase, a monk of Canterbury, *does* mention with approval "a certain William of Sens, a man active and ready, and as a workman most skillful both in wood and stone." A Frenchman, William was among many "English and French artificers" summoned by the monks of Canterbury to rebuild their church, destroyed by fire in 1174. Gervase gives a detailed account of the rebuilding project as managed by William. After a revealing account of William's psychological adroitness in persuading the monks that the rebuilding must start from scratch, Gervase continues:

> And now he addressed himself to the procuring of stone from beyond the sea. He constructed ingenious machines for loading and unloading ships and for drawing cement and stone. He delivered molds for shaping stones to the sculptors who were assembled, and diligently prepared other things of the same kind.*

*Quoted in Elizabeth G. Holt, *A Documentary History of Art* (New York: Doubleday Anchor Books, 1957), vol. 1, pp. 55–56.

The master of the works was also the designer. He prepared a linear diagram and a scale of dimensions for the master masons, who in turn supervised the foremen of the work gangs. The coordination of effort required by a major project called for trained experts with broad intellectual grasp and managerial talents, men with the versatility and ingenuity of William of Sens. Masons and masters could be summoned from great distances, traveling in companies to take on jobs when and where they opened up. This mobility made for the diffusion and exchange of architectural ideas and the solutions to architectural problems. As more elaborate building projects were undertaken, challenging ever more specialized knowledge, the occupation of stone mason was transformed into the discipline and profession of architecture.

ARCHITECTURE

Between 1050 and 1150, after numerous trials and experiments, a distinctively Romanesque style of architecture emerges. It makes a clean break from the old basilican church scheme of continuous, hall-like space and flat walls (FIGS. 8-8. 11-27, 11-28). The Romanesque interior is divided into compartments, clearly defined modular units regularly repeated (FIGS. 12-4, 12-5). The module is the vaulted bay with its four supporting corner piers. The exterior wall surfaces are marked off by buttresses or colonettes placed so as to correspond to the compartments of the interior (FIG. 12-6). Thus a simple logic of design interrelates the structural parts that support the masses and enclose the spaces of the building. In addition to the vaulted bays, the conspicuous features of Romanesque are the round arch, wall arcade or buttress, cylindrical apse and chapels, and square, round, or polygonal towers (FIG. 12-3).

This, of course, is only a schematic model of Romanesque architecture. The multitude of Romanesque buildings that survive show a bewildering variety of arrangement of the basic features. Regional differences abound. What all the buildings manifest, no matter their differences, is a new, widely shared method of architectural thinking, a new logic of design and construction.

The immense building enterprise that raised thousands of churches in the Romanesque was part of the general expansion of populations, territories, and resources we have already sketched. This building impulse has continued into our own time and has become worldwide; in the age of the Romanesque and the century following, it was almost an obsession. Raoul Glaber, an eleventh-century monk, noted the beginning of it:

> There occurred, throughout the world, especially in
> Italy and Gaul, a rebuilding of church basilicas.
> Notwithstanding, the greater number were already well
> established and not in the least in need, nevertheless each
> Christian people strove against the others to erect nobler
> ones. It was as if the whole earth, having cast off the

old . . . were clothing itself everywhere in the white robe of the church.*

Great building efforts were provoked not only by the pilgrimages, the Crusades, and the needs of growing cities, but also by the fact that hundreds of churches (notably in Italy and France) had been destroyed during the depredations of the Norsemen and the Magyars. Architects of the time seemed to see their fundamental problem in terms of providing a building that would have space for the circulation of its congregations and visitors and that would be solid, fireproof, well lighted, and acoustically suitable. These requirements, of course, are the necessities of any great civic or religious architecture, as we saw in ancient Rome, but in this case, fireproofing must have been foremost in the builders' minds, for the wooden roofs of the pre-Romanesque churches of Italy, France, and elsewhere had burned fiercely and totally when set aflame by the marauders from north, east, and south in the ninth and tenth centuries. The memory was fresh in the victims' minds; the new churches would have to be covered with cut stone, and the structural problems that arose from this need for a solid masonry were to help determine the "look" of Romanesque architecture.

Languedoc-Burgundy

A fascinating building of the so-called First Romanesque period, in which a variety of experimental solutions to the vaulting problem are illustrated, is the church of St.-Philibert at Tournus on the Saône River in Burgundy (FIGS. 12-1 and 12-2). The long and complex building history of this church explains, in part, the curious assembly of various vaulting systems found in it. Of the original building, which was begun around 950, only the crypt survived a disastrous fire in 1008. The rebuilt church was consecrated in 1019, although the nave was not vaulted until 1066, and the crossing and choir were not completed until 1120. The new choir was built according to the plan of the crypt below it, but the original westwork was replaced with a two-story narthex.

The unusual variety of vaults resulted when each successive generation of builders addressed the problem of vaulting anew and produced fresh and ingenious solutions. In the crypt, the builders used small groin vaults over square areas defined by slender, supporting columns; the corridor surrounding the central area was covered by a curving barrel vault. The vaulting of the narthex, which probably was completed by 1019, is more complex. The groin-vaulted square bays of the ground floor's central passage are flanked by aisles slightly less than half as wide as the nave; they had to be covered with shallow barrel vaults, as true groin vaults can be erected only over square areas. Above this entrance hall, on the second level, stands a

*In Holt, *A Documentary History of Art*, p. 18

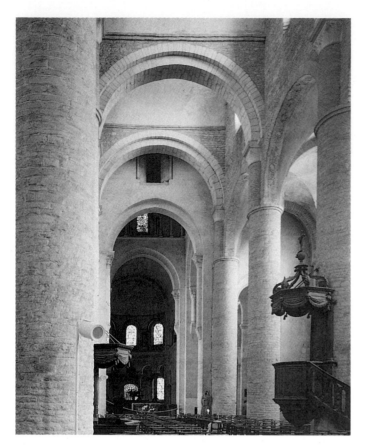

12-1 Interior of St.-Philibert, Tournus, France, *c.* 950–1020 and later.

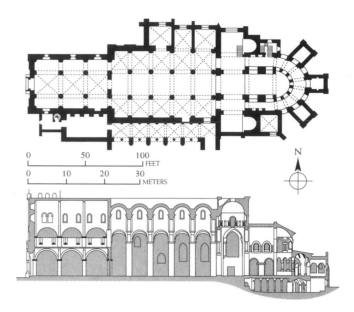

12-2 Plan and section of St.-Philibert.

three-aisled chapel dedicated to Saint Michael. Here, the central nave is covered by a longitudinal barrel vault that is buttressed by *quadrant vaults* (half-barrel vaults) over the flanking aisles. Most remarkable is the main church, where groin-vaulted aisles flank a nave that rises to a series of five parallel, transverse barrel vaults that buttress each other and obviate the massive side walls that a single, longitudinal vault would have required. This solution also allowed the builders to cut generous clerestory windows into the end walls of the barrels, which serve no major supporting function. As a result, the interior is adequately illuminated and light can play with marvelous effect over the simple, curved surfaces of the ceiling and the sturdy, cylindrical columns.

Just about all known vaulting methods, except the dome, were explored in this single building—a ready-to-choose-from collection of solutions for later builders. (As we will soon see, Burgundian masons opted for the longitudinal barrel vault.) But possibly an even more important and influential feature of this unique building is revealed by the plan of the choir (FIG. 12-2), which, if it does not repeat that of the one destroyed by the fire of 1008, does duplicate that of the crypt of 950. The monks' choir is surrounded by an ambulatory from which a series of chapels (and a stairwell) radiate outward. The ambulatory afforded

easy circulation for the pilgrims who came to venerate the relics of St.-Philibert, without interrupting the monks' obligations. This arrangement, in which subordinate chapels and ambulatories are ingeniously integrated, was to become, with due modifications, a standard feature of later pilgrimage churches.

St.-Sernin at Toulouse (FIG. 12-3) was one of the churches constructed in the Cluniac-Burgundian style that may have profited from the experiments made at Tournus; it met the requirement of a stone ceiling by using a semicircular barrel vault below a timber-roofed loft. Such churches dominated much of southern France and were related closely to those built along the pilgrimage road to Santiago de Compostella. The plan of St.-Sernin (FIG. 12-4) is one of extreme regularity and geometric precision. The crossing square, flanked by massive piers and marked off by heavy arches, has been used as the module for the entire body of the church. In this *square schematism,* each nave bay measures exactly one-half and each square in the aisles exactly one-quarter of a crossing square, and so on throughout the building. The first suggestion of such a planning scheme was seen almost three centuries earlier in the St. Gall plan (FIG. 11-24). Although St.-Sernin is neither the earliest nor the only (perhaps not even the ideal) solution, it does represent a crisply rational and highly refined realization of the germ of an idea first seen in Carolingian designs.

A view of the interior (FIG. 12-5) shows that this geometric floor plan is fully reflected in the nave walls, which are articulated by half-columns that rise from the corners of each bay to the *springing* (the lowest stone of an arch) of the vault and are continued across the nave as transverse arches. Ever since Early Christian times, as we have noted, basilican interiors had been framed by long, flat walls between arcades and clerestories that enclosed a single,

horizontal, unbroken volume of space. Now the aspect of the nave is changed radically, so that it seems to be composed of numerous, identical, vertical volumes of space that have been placed one behind the other, marching down the length of the building in orderly procession. This segmentation of St.-Sernin's interior space corresponds with and renders visual the geometric organization of the building's plan and also is reflected in the articulation of the building's exterior walls. The result is a structure in which all parts have been integrated to a degree unknown in earlier Christian architecture.

The grand scale of St.-Sernin at Toulouse is frequent in Romanesque churches. As we have seen, the popularity of

pilgrimages and of the cult of relics brought great crowds even to relatively isolated places, and large congregations were common at the shrines along the great pilgrimage routes and in the reawakening cities. Additional space was provided by increasing the length of the nave; by doubling the side aisles; and by building, over the inner aisle, upper galleries, or *tribunes*, to accommodate overflow crowds on special occasions. Circulation was complicated, though, as the monks' choir often occupied a good portion of the nave. As seen in St.-Philibert at Tournus, an extension of the aisles around the eastern end to make an ambulatory facilitated circulation, and the opening of the ambulatory (and often of the transepts) into separate chapels (as at St.-Sernin) provided more space for worshipers and for liturgical processions. Not all Romanesque churches were as large as St.-Sernin, however, nor did every one have an ambulatory with radiating chapels, but such chapels are typical Romanesque features, especially when treated as separate units projecting from the mass of the building.

The continuous, cut-stone barrel (or *tunnel*) vaults at St.-Sernin (FIG. 12-5) put constant pressure along the entire length of the supporting masonry. If, as in most instances, including St.-Sernin, the nave was flanked by side aisles, then the main vaults rested on arcades and the main thrust was transferred to the thick outer walls by the vaults over the aisles. In larger churches, the tribune galleries and their vaults (in cross-section, often a quadrant, embracing a ninety-degree arc) were an integral part of the structure, buttressing the high vaults over the nave. The wall-vault

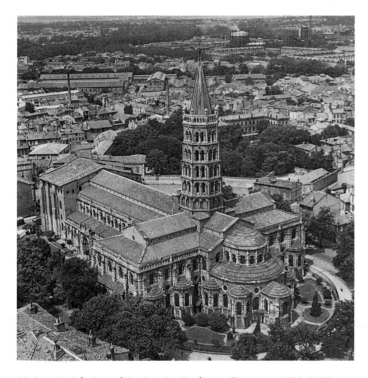

12-3 Aerial view of St.-Sernin, Toulouse, France, *c.* 1080–1120 (view from the southeast).

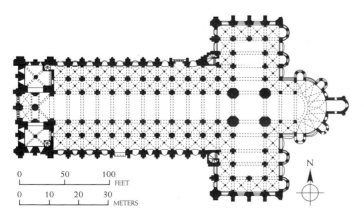

0 50 100
FEET

0 10 20 30
METERS

12-4 Plan of St.-Sernin. (After Kenneth John Conant.)

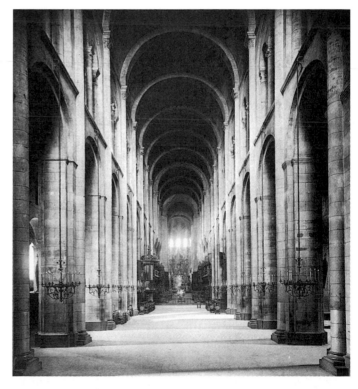

12-5 The nave of St.-Sernin.

system at St.-Sernin is successful in its supporting function; its great scale provides ample space, and its squaring-off into cleanly marked bays, as well as the relief of wall and pier, are thoroughly Romanesque. But the system fails in one critical requirement—that of lighting. Due to the great thrust exerted by the barrel vault, a clerestory was difficult to construct, and windows cut into the haunch of the vault would make it unstable. A more complex and efficient type of vaulting was needed. One might say that, structurally, the central problem of Romanesque architecture was the development of a masonry vault system that admitted light.

In working toward this end, Romanesque architectural ingenuity produced numerous experimental consequences that appear as a rich variety of substyles. We already have mentioned that one of the apparently confusing features of Romanesque architecture is the great variety of regional and local building styles—a variety that still makes classification, coordination, and interpretation very difficult for scholars. Ten or more types may be identified in France alone, each with its distinctive system of vaulting and its varying solutions to the problems of lighting the interior.

Among the numerous experimental solutions, the groin vault turned out to be the most efficient and flexible. The groin vault had been used widely by Roman builders, who

saw that its concentration of thrusts at four supporting points would allow clerestory fenestration (see FIGS. 7-4 and 7-75). The great Roman vaults were made possible by an intricate system of brick-and-tile relieving arches, as well as by the use of concrete, which could be poured into forms, where it solidified into a homogeneous mass. The technique of mixing concrete did not survive into the Middle Ages, however, and the technical problems of building groin vaults of cut stone and heavy rubble, which had very little cohesive quality, limited their use to the covering of small areas. But during the eleventh century, Romanesque masons, using cut stone joined by mortar, developed a groin vault of monumental dimensions. Although it still employed heavy buttressing walls, this vault eventually evolved into a self-sufficient, skeletal support system.

Germany-Lombardy

The progress of vaulting craft can be seen best in two regions: Germany-Lombardy and Normandy-England. Speyer Cathedral in the German Rhineland (FIGS. **12-6** to **12-9**) was begun in 1030 as a timber-roofed structure. When it was rebuilt by the emperor Henry IV, between

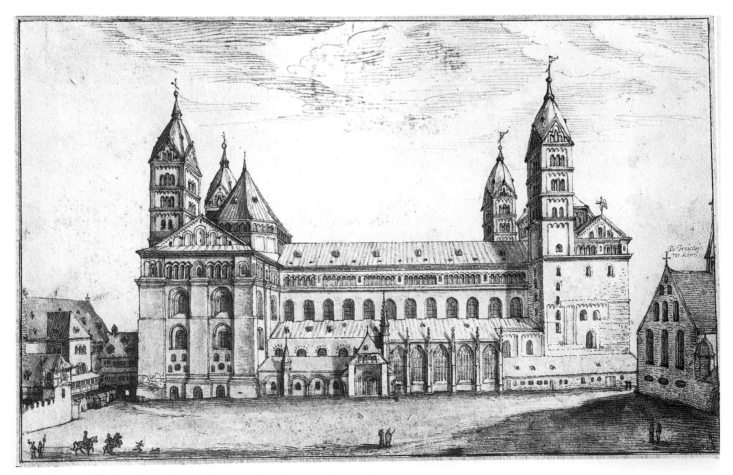

12-6 Speyer Cathedral, West Germany, begun 1030. (Pen-and-ink drawing by Wenzel Hollar, *c.* 1620.) Graphische Sammlung Albertina, Vienna.

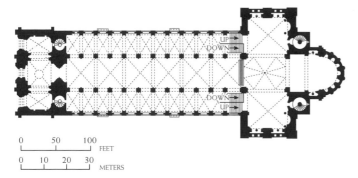

12-7 Plan of Speyer Cathedral.

scale had been used by Lombard builders throughout the early Middle Ages. The large groin vaults covering the nave (FIG. 12-8), however—probably the achievement of German masons—represent one of the most daring and successful vaulting enterprises of the time (the nave is 45 feet wide, and the crowns of the vaults are 107 feet high).

The plan of the cathedral (FIG. 12-7) shows that the west apse and the lateral Ottonian entrances have been eliminated and that the entrance has been moved back to the west end, re-establishing the processional axis leading to the sanctuary. The marked-off crossing, covered by an octagonal dome, has been used as the module for the arrangement of the building's east end. Because the nave bays are not square, the use of the crossing as a unit of measurement is not as obvious. In fact, the length of the nave is almost four times the crossing square, and every third wall support marks off an area in the nave the size of the crossing; the aisles are half the width of the nave.

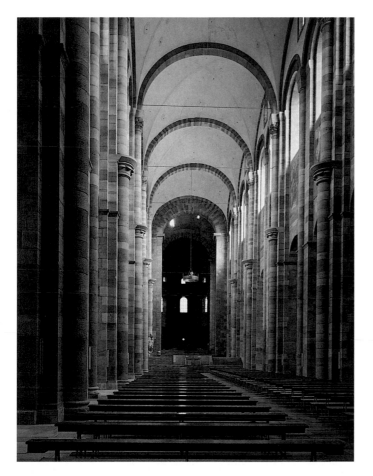

12-8 Interior of Speyer Cathedral.

1082 and 1106, it was covered with groin vaults. Thus, it may be one of the earliest, fully vaulted Romanesque churches in Europe. Its exterior preserves the Ottonian tradition of balanced groups of towers east and west but adds to it a rich articulation of wall surfaces. A great many of the decorative features, such as the arcades under the eaves, the stepped arcade gallery under the gable, and the moldings marking the stages of the towers, may be of Lombard origin. The inspiration for the groin vaults covering the aisles also may be Lombardic; groin-vaulting on a small

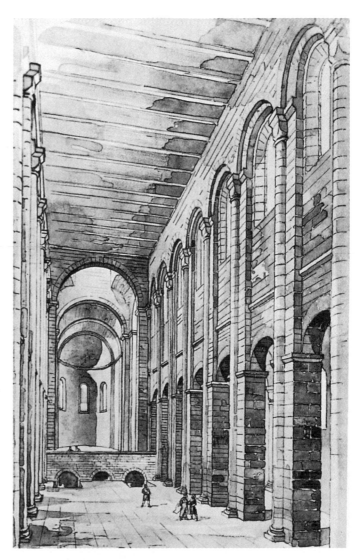

12-9 Reconstruction of the original nave of Speyer Cathedral, *c.* 1030–1060.

Although the plan has some irregularities and has not been worked out as neatly and precisely as the plan of St.-Sernin, the builders' intention to apply the square schematism is quite clear. Curiously, the alternative-support system, which now is carried all the way up into the vaults (FIG. 12-8), does not seem to reflect the square schematism of the building's plan. This discrepancy may be explained by the fact that the original building of 1030 was a timber-roofed structure and the walls were articulated by a series of identical shafts that rose to enframe the clerestory windows (FIG. 12-9). The alternate-support system was introduced in the 1080s (when the building was vaulted), perhaps partially to strengthen the piers at the corners of the large vaults and to provide bases for the springing of the transverse arches across the nave. The builders may have chosen to use every other support to anchor a nave vault simply because the walls were not as stable as the massive piers that carry the crossing dome, so that it would be safer to reduce each area to be vaulted by one-third. The resultant bay arrangement, in which a large unit in the nave is flanked by two small units in each aisle, becomes almost standard in northern Romanesque architecture. Speyer's interior shows the same striving for height and the same compartmentalized effect shown in St.-Sernin. By virtue of the use of the alternate-support system, the rhythm of the

Speyer nave is a little more complex—a little richer, perhaps—and because each compartment is individually vaulted, the effect of a sequence of vertical blocks of space is even more convincing.

From Carolingian times, as we have seen, Rhineland Germany and Lombardy had been in close political and cultural contact, and it generally is agreed that the two areas cross-fertilized each other artistically. But no such agreement exists as to which source of artistic influence was dominant: the northern or the southern. The question, no doubt, will remain the subject of controversy until the construction date of the Church of Sant'Ambrogio in Milan, the central monument of Lombard architecture, can be established unequivocally. Dates ranging from the tenth to the early twelfth century have been advanced for the present building, which was preceded by an earlier church that dated back to the fourth century; the late eleventh and early twelfth centuries apparently are most popular with architectural historians today.

Whether or not it is a prototype, Sant'Ambrogio remains a remarkable building. As shown in FIG. **12-10,** it has an atrium (one of the last to be built), a two-story narthex pierced by arches on both levels, two towers joined to the building, and, over the east end of the nave, an octagonal tower that recalls the crossing towers of German churches.

12-10 Sant'Ambrogio, Milan, Italy, late eleventh to early twelfth century (view from the northwest).

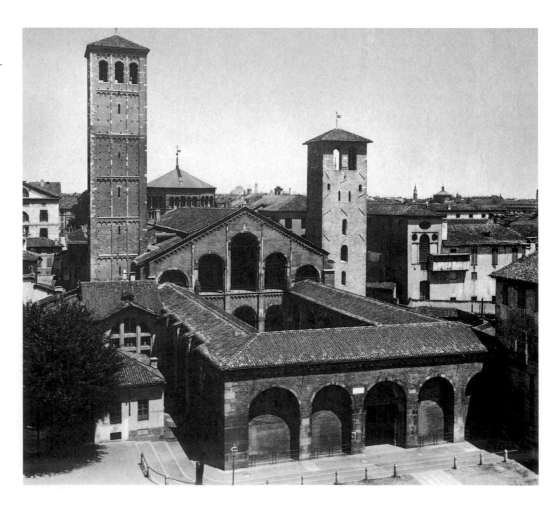

Of the facade towers, the shorter one dates back to the tenth century, while the taller north tower was built during the twelfth century. The latter is a sophisticated and typical example of Lombard tower design; it is articulated by pilasters and shafting and divided, by means of *corbel tables* (horizontal projections resting on corbels), into a number of levels, of which only the topmost (the bell chamber) has been opened by arches.

In plan (FIG. **12-11**), Sant'Ambrogio is three-aisled and without a transept. The square schematism has been applied with greater consistency and precision than at Speyer, each bay consisting of a full square in the nave

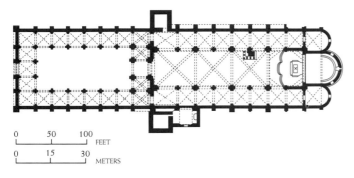

0 50 100
FEET
0 15 30
METERS

12-11 Plan of Sant'Ambrogio.

flanked by two small squares in each aisle, all covered with groin vaults. The main vaults are slightly domical, rising higher than the transverse arches, and the last bay is covered by an octagonal dome that provides the major light source (the building lacks a clerestory) for the otherwise rather dark interior (FIG. **12-12**). The geometric regularity of the plan is reflected perfectly in the emphatic alternate-support system, in which the light supports are interrupted at the gallery level and the heavy ones rise to support the main vaults. These ponderous vaults, which have supporting arches along their groins, are occasionally claimed to be the first examples of rib-vaulting; however, in fact, these vaults are solidly constructed groin vaults that have been strengthened by diagonal ribs.

The dating of the Sant'Ambrogio vaults remains controversial. Most scholars seem to feel that they were not built until after 1117, when a severe earthquake damaged the existing building. If 1117 is the correct date, the Speyer vaults would be earlier than the vaults of Sant'Ambrogio, and the inspiration and technical knowledge for the construction of groin vaults of this size would seem to have come from the north. But such possible influence did not affect the proportioning of the Milanese building, which does not aspire to the soaring height of the northern churches. Sant'Ambrogio's proportions are low and squat and remain close to those of Early Christian basilicas. As we

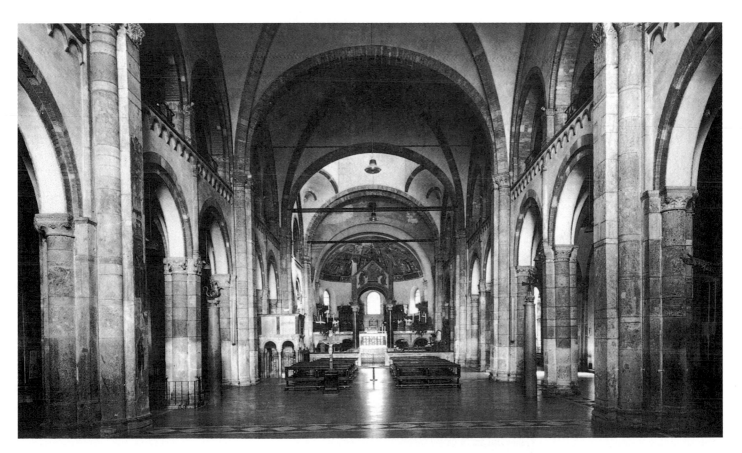

12-12 Interior of Sant'Ambrogio.

will see, Italian architects never accepted the verticality found in northern architecture, not even during the height of the Gothic period.

The fame of German architecture rests on its achievements in the eleventh and early twelfth centuries. After the mid-twelfth century, the Germans made no major contribution to architectural design. The architectural statements at Speyer were repeated at Worms and Mainz and in other, later churches. German builders were content with refining their successful formula; beyond that, they tended to follow the more adventurous, progressive Franks and Normans.

Normandy-England

The Vikings settled in northwestern France after their conversion to Christianity in the tenth century and, almost at once, proved themselves skilled administrators and builders; we have met them as the aggressive Normans, active in the Mediterranean as well as in northern Europe. With astounding rapidity, they absorbed the lessons to be learned from Ottonian architecture and went on to develop the most progressive of the many Romanesque styles and the one that was to become the major source in the evolution of Gothic architecture.

The church of St.-Étienne at Caen in Normandy is generally considered to be the master model of Norman Romanesque architecture. It was begun by William of Normandy (William the Conqueror) in 1067 and must have advanced rapidly, as he was buried there in 1087. The west facade (FIG. **12-13**) is a striking design that looks forward to the two-tower facades of later Gothic churches. Four large buttresses divide it into three bays that correspond to the nave and aisles in the interior. Above their buttresses, the towers also display a triple division and a progressively greater piercing of their walls from lower to upper stages. The spires are a later (Gothic) feature. The tripartite division is employed throughout the facade, both vertically and horizontally, organizing it into a close-knit, well-integrated design that reflects the careful and methodical planning of the entire structure. Like Speyer Cathedral, St.-Étienne originally was planned to have a wooden roof, but, from the beginning, the walls were articulated in an alternating rhythm (simple half-columns alternating with shafts attached to pilasters) that mirrors the precise square schematism of the building's plan (FIGS. **12-14** and **12-15**). This alternate-support system was utilized effectively some time after 1110 (significantly later than it was used at Speyer), when it was decided to cover the nave with vaults. Its original installation, however, must have been motivated by esthetic rather than structural concerns. In any event, the alternating compound *piers* (vertical supports) soar all the way to the springing of the vaults, and their branching ribs divide the large, square-vault compartments into six sections, making a *sexpartite vault*. These vaults, their crowns slightly depressed to avoid the "domed-up" effect of those at Sant'Ambrogio, rise high enough to make an effi-

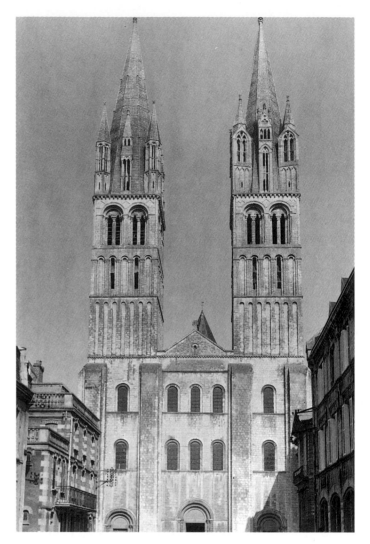

12-13 West facade of St.-Étienne, Caen, France, begun 1067.

cient clerestory; they also are viewed as some of the earliest true *rib vaults*, in which the diagonal and transverse ribs compose a structural skeleton that partially supports the still fairly massive paneling between them. Rib-vaulting was to become universal practice during the Gothic period, and its development by Norman builders must be rated as one of the major structural innovations of the Middle Ages.

Other elements in St.-Étienne also point to the future. The complex piers, their nuclei almost concealed by attached pilasters and engaged columns, forecast the Gothic "cluster pier," and the reduction in interior wall surfaces that resulted from use of very large, arched openings anticipates the bright curtain walls of Gothic architecture. In short, St.-Étienne at Caen is not only a carefully designed structure but also a highly progressive one in which the Romanesque style begins to merge into Early Gothic.

The conquest of Anglo-Saxon England in 1066 by William of Normandy began a new epoch in English history; in English architecture, it signaled the importation of Norman building and design methods. Durham Cathedral

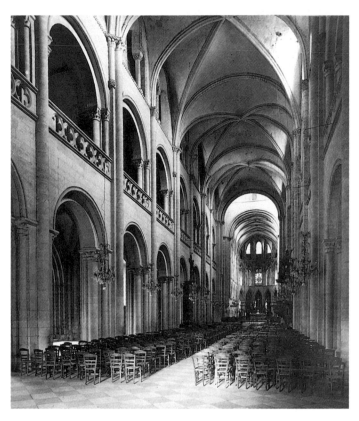

12-14 Interior of St.-Étienne, vaulted *c.* 1115–1120.

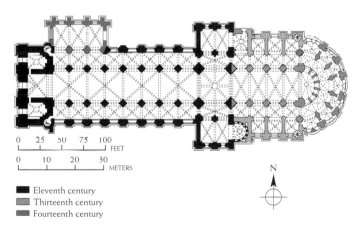

Eleventh century
Thirteenth century
Fourteenth century

12-15 Plan of St.-Étienne.

in northern England, begun around 1093, apparently was designed for vaulting at the outset. Like most Romanesque churches in England, it was subjected to many later alterations that, in this case, fortunately were confined largely to the exterior; the interior (fig. **12-16**) retains its original severe Romanesque appearance. Ambitious in scale—comparable to both St.-Sernin at Toulouse and St.-Étienne at Caen—its 400-foot length compares favorably with that of the great imperial cathedral of Speyer. With the latter, it also shares a reliance on mass for stability. But unlike Speyer, this building was con-

ceived from the very beginning as a completely integrated skeleton in which the vaults stand in intimate and continuous relation to the vertical elements of the compound piers that support them. At Durham, the alternate-support system is interpreted with blunt power and more emphasis, perhaps, than in any other Romanesque church. Large, simple pillars ornamented with abstract designs (diamond, chevron, and cable patterns descended from the metal-craft ornamentation of the migrations) alternate with compound piers that carry the transverse arches of the vaults. The pier-vault relationship scarcely could be more visible or the structural rationale of the building better expressed.

The plan (FIG. **12-17**), typically English with its long, slender proportions and strongly projecting transept, does not develop the square schematism with the same care and logic we see at Caen. But the rib vaults of the choir are the earliest in Europe (1104), and, when they were combined with slightly pointed arches in the western parts of the nave (before 1130), the two key elements that would determine the structural evolution of Gothic architecture were brought together for the first time. Only the rather massive construction and the irregular division into seven panels prevent these vaults from qualifying as Early Gothic structures.

Among the numerous regional Romanesque styles of architecture, it was the northern—more specifically, the

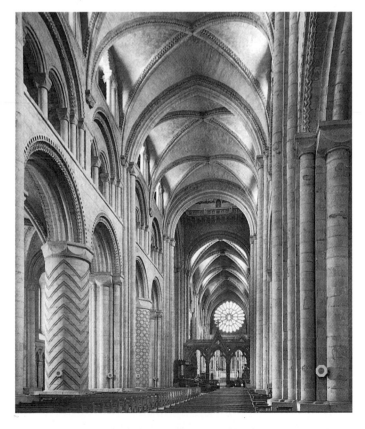

12-16 The nave of Durham Cathedral, England, begun *c.* 1093 (view facing east).

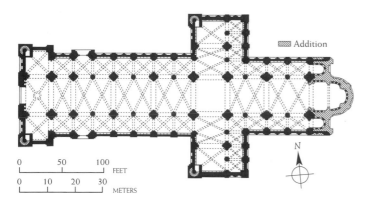

12-17 Plan of Durham Cathedral. (After Kenneth John Conant.)

Norman—style that indirectly would influence the development of Gothic architecture; no other style had as great a potential for evolution.

Tuscany

South of the Lombard region, Italy retained its ancient traditions and, for the most part, produced Romanesque architecture that was structurally less experimental than that of Lombardy. The buildings of Tuscany seem to adhere more closely than those of any other region to the traditions of the Early Christian basilica. The cathedral group of Pisa (FIG. **12-18**) manifests, in addition to these conservative qualities, those of the great Classical "renaissance" of the late eleventh and twelfth centuries, when architects, craftsmen, poets, and philosophers again confronted Classical-Christian prototypes and interpreted them in an original yet familiar way. The cathedral is large, five-aisled, and one of the most impressive and majestic of all Romanesque churches. At first glance, it resembles an Early Christian basilica, but the broadly projecting transept, the crossing dome, the rich marble *incrustation* (decoration in which wall is divided into bright, polychrome panels of solid colors), and the multiple arcade galleries of the facade soon distinguish it as Romanesque.

The interior (FIG. **12-19**) also at first suggests the basilica, with its timber roof rather than vault (originally the rafters were exposed, as in Early Christian basilicas), nave arcades, and Classical (imported) columns flanking the nave in unbroken procession. Above these columns is a continuous, horizontal molding, on which rest the gallery arcades. The gallery, of course, is not a basilican feature but is of

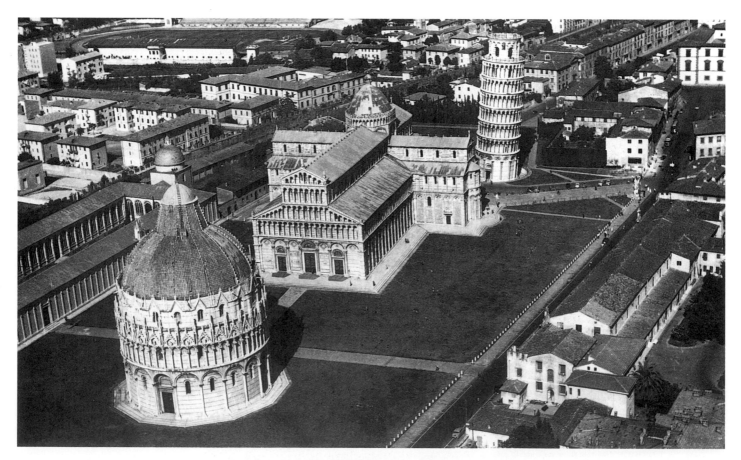

12-18 Aerial view of the cathedral group (baptistery, cathedral, and campanile) of Pisa, Italy, 1053–1272 (view from the southwest).

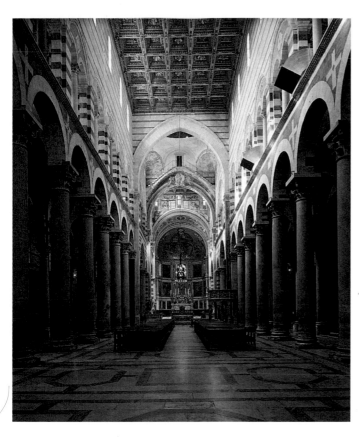

12-19 The nave of the cathedral of Pisa (view facing east).

Byzantine origin. Other divergences from the basilica form include the relatively great verticality of the interior and, at the crossing, the markedly un-Classical pointed arch, which probably was inspired by Islamic architecture. The striped incrustation, produced by alternating dark green and cream-colored marble, provides a luxurious polychromy that will become a hallmark of Tuscan Romanesque and Gothic buildings. The leaning campanile, the result of a settling foundation, tilted from the vertical even while it was being built and now inclines some 21 perilous feet out of plumb at the top. Round, like the Ravenna campaniles, it is much more elaborate; its stages are marked by graceful, arcaded galleries that repeat the motif of the cathedral's facade and effectively relate the tower to its mother building. Although the *baptistery* (building next to the church, used for baptism), with its partly remodeled Gothic exterior, may strike a slightly discordant note, the whole composition of the three buildings, with the adjacent Campo Santo (cemetery), makes one of the handsomest ensembles in the history of architecture. This grouping dramatically expresses the new building age that the prosperity enjoyed by the busy maritime cities of the Mediterranean made possible.

The gem of Tuscan Romanesque architecture is San Giovanni, the Baptistery of Florence (FIG. **12-20**), centrally situated in the city across from the great cathedral, and central in the history and culture of Florence. This structure

12-20 Baptistery of San Giovanni, Florence, Italy, eleventh century.

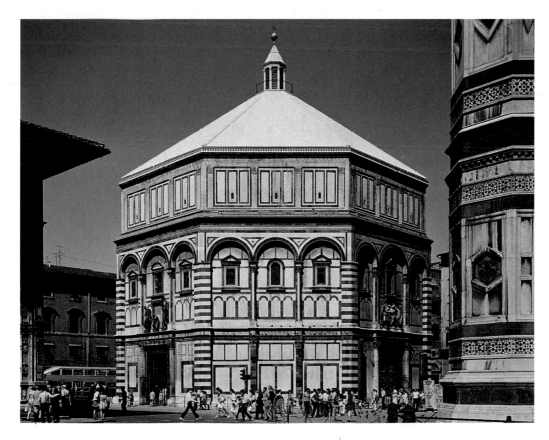

has been regarded with loyalty and affection by all Florentines, both before and long after Dante celebrated it in a phrase, "my beautiful San Giovanni" (*Inferno,* XIX:17).

The simple and serene classicism of its design long persuaded scholars that it must have been in direct line of descent from ancient Roman architecture, from the Pantheon to Santa Costanza and other centralizing structures of antiquity, pagan or Christian; they assigned it to the fifth or sixth century. It is now thought to date from the late eleventh century, from the time of Countess Matilda and her generous patronage of the city. The Baptistery established a Florentine style, Classical at the core, that would guide the thinking of the architects of Florence well into the Renaissance.

Like San Vitale and the Palatine Chapel at Aachen, the Baptistery evokes the image of the great rotunda of Constantine's church of the Holy Sepulcher in Jerusalem (not shown), as well as it repeats the centralizing schemes of Early Christian baptisteries. In plan it is a domed octagon, enwrapped on the exterior by a graceful arcade, three arches to a bay. It has three entrances, one each on the north, south, and east sides; on the west side an oblong sanctuary replaces the original semicircular apse. The domical vault is some 90 feet in diameter, its construction a feat remarkable for its time and an inspiration for the great architect Brunelleschi, who later would devise the immense dome of the cathedral of Florence.

A distinctive Florentine decorative feature is the marble incrustation that patterns the walls. These simple oblong and arcuated shapes not only outline the paneled surfaces, but assert the structural lines of the building and the levels of its elevation. The corner piers accentuating the apexes of the octagon are boldly striped in the Pisan fashion (FIG. 12-19).

Contemporaneous with the Baptistery and stylistically affiliated with it is another Florentine building, the church of San Miniato al Monte (FIGS. **12-21** and **12-22**). The main fabric here was completed by 1090, the facade during the twelfth and early thirteenth centuries. The structure recalls the Early Christian basilica in plan and elevation, although its elaborate geometric incrustation makes for a rich ornamental effect foreign to the earlier buildings. Though at first glance the lower level much resembles the patterning of the neighboring Baptistery, the arcades and panels do not reflect the building's structure. The upper levels of the facade, of much later date than the lower, are filled capriciously with geometrical shapes that have a purely ornamental function.

Retrospective as it may appear externally, San Miniato has a quite Romanesque interior. An elevated *chancel* (the area reserved for the priest and choir) makes a two-leveled structure that screens the apse. Although the church is timber-roofed, as are most Tuscan Romanesque churches, the nave is divided into three equal compartments by *diaphragm arches* that rise from compound piers.

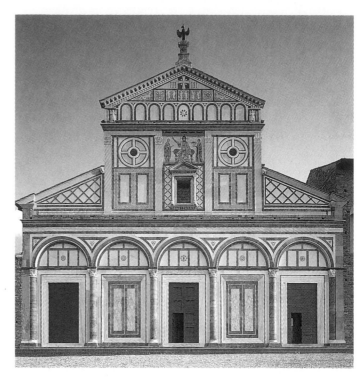

12-21 West facade of San Miniato al Monte, Florence, Italy, 1062 and twelfth century.

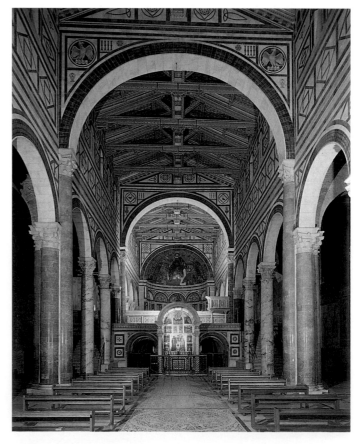

12-22 Interior of San Miniato al Monte (view facing east).

The piers alternate with pairs of simple columns in a rhythm that recalls St. Michael's in Hildesheim (FIG. 11-28). The diaphragm arches, which appear here for the first time (before 1060), have multiple functional and esthetic purposes. They brace the rather high, thin walls; provide firebreaks within the wooden roof structure; and compartmentalize the basilican interior in the manner so popular with most Romanesque builders. Antique, or neo-Antique, motifs appear in the capitals as well as in the incrustation, expressing again the persistence of the Classical tradition in Tuscany.

SCULPTURE

For medieval art, the first definite relation of architecture and sculpture appears in the Romanesque style. Figurative sculpture, confined for centuries to small art, flowers again in the new Romanesque churches of the mid-eleventh century. The rich profusion of sculpture and something of its nature may be guessed from Saint Bernard's famous tirade against it, written in 1127:

> [Men's] eyes are feasted with relics cased in gold, and their purse-strings are loosed. They are shown a most comely image of some saint, whom they think all the more saintly that he is the more gaudily painted. . . . O vanity of vanities, yet no more vain than insane! The church is resplendent in her walls, beggarly in her poor; she clothes her stones in gold and leaves her sons naked . . . in the cloister, under the eyes of the Brethren who read there, what profit is there in those ridiculous monsters, in that marvelous and deformed comeliness, that comely deformity? To what purpose are those unclean apes, those fierce lions, those monstrous centaurs, those half-men, those striped tigers, those fighting knights, those hunters winding their horns? Many bodies are there seen under one head, or again, many heads to a single body. . . . For God's sake, if men are not ashamed of these follies, why at least do they not shrink from the expense?*

Stone sculpture had almost disappeared from the art of Western Europe during the eighth and ninth centuries. The revival of the technique is one of the most important Romanesque achievements. As stone buildings began to rise again, so did the impulse to decorate parts of the structure with relief carving in stone. One might expect that the artists should turn for inspiration to surviving Roman sculpture and to sculptural forms such as ivory carving or metalwork; it is obvious that they also relied on painted figures in manuscripts. But these Romanesque artists developed their own attitude toward ornamental design and its relation to architecture. At first, this concept was somewhat

random and haphazard; the artists put the sculpture wherever there seemed to be a convenient place. A little later, the portals of the church seemed the appropriate setting, both for religious reasons and for the practical matter of display. As Romanesque sculpture turns into Gothic, the portal statuary becomes integrated with the design of the whole facade, following the lines of the architecture.

An example of the earlier, looser arrangement, in which sculpture is not yet an intrinsic part of the architecture, is the figure of *Christ in Majesty*, the centerpiece of a group of seven marble slabs affixed to the wall of the ambulatory of the church of St.-Sernin at Toulouse (FIG. **12-23**). The sculptured figures represent angels introducing saints to Christ. An inscription on a marble altar, part of the group, indicates that these figures were all part of an ensemble, a shrine dedicated to Saint Saturninus (Saint Sernin), and that the artist was a certain BERNARDUS GELDUINUS. These works of Gelduinus from the year 1096 are the first indisputably datable specimens of monumental Romanesque sculpture in France. The sources of Gelduinus's style are

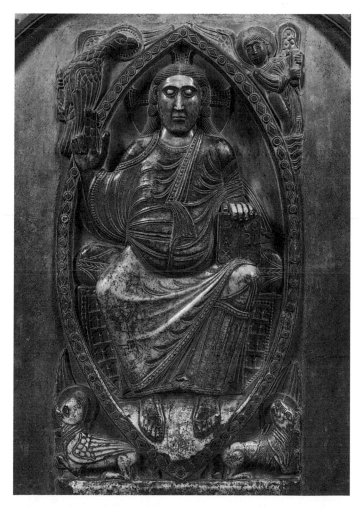

12-23 BERNARDUS GELDUINUS, *Christ in Majesty,* from the ambulatory of St.-Sernin, Toulouse, France, 1096.

*In Holt, *A Documentary History of Art,* pp. 18–21

debated; certainly, a principal one must be a Carolingian or Ottonian work in metal or ivory, perhaps a book cover. The polished marble has the gloss of both materials. Christ is seated in a mandorla, his right hand raised in blessing, his left hand resting on an open book inscribed with the words *Pax vobis* (peace be unto you). The Signs of the Evangelists occupy the corners of the slab: above, the Eagle of Saint John and the Angel of Saint Matthew, below, the Ox of Saint Luke and the Lion of Saint Mark.

Though at this time sculpture is not structurally integrated with the architectural elements, the discrete slabs are arranged so as to make an iconographically readable group. We shall see presently that in the later mode of sculptural composition the architectural limits of the parts of a portal, or the shapes of a pier or capital, were respected as an integrating framework for sculpture. Typically, the Romanesque portal reveals this integration of sculpture in architecture. At Vézelay (FIG. 12-32) and at St.-Trophîme, Arles (FIG. 12-34), the standard elements are revealed: *jambs* (side posts of a doorway), lintel, semicircular *tympanum* (area beneath the arches or *archivolts* [band of moldings that round the lower curve of an arch]), *voussoirs* (wedge-shaped blocks used in construction of a true arch), and the *trumeau* (the center post supporting the lintel) in the middle of the doorway (FIG. **12-24**).

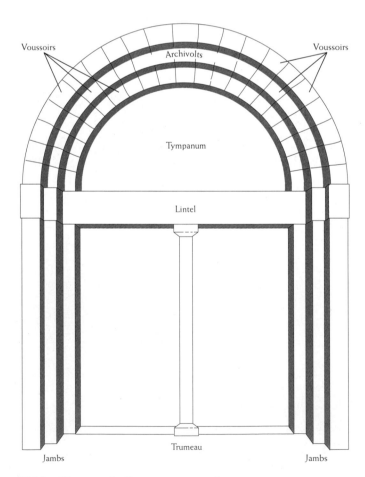

Voussoirs

Archivolts

Voussoirs

Tympanum

Lintel

Trumeau

Jambs Jambs

12-24 Diagram of a Romanesque portal.

Before the elements of the Romanesque portal were assembled in a unified design, they were placed in isolation inside or outside the church building, without any apparent scheme of organization. The St.-Sernin figure, as we have seen, is set into the ambulatory wall. At St.-Génis-des-Fontaines, in the extreme south of France, sculpture appears in the lintel over a doorway (FIG. **12-25**). Dated 1020 by inscription, the quite primitive style is more or less characteristic of "First Romanesque." It is representative of developments in sculptural art common to northeastern Spain, southern France, and northern Italy, an artistically integrated region that can be considered as originative of Romanesque art. On the lintel at St.-Génis-des-Fontaines, Christ is enthroned in a lobed mandorla supported by angels and is flanked by apostles in an arcade. The latter motif goes back centuries to late Antiquity. Some Late Antique or Early Christian sarcophagus, or perhaps some later Carolingian or Ottonian derivative therefrom, may have been the sculptor's prototype. Whatever his source, he has translated its images into his own rudimentary idiom and similarly has adapted the original's ornament in the foliate motifs of the frame.

Almost a century later, the full Romanesque style emerges in the sculptured frieze of the facade of the cathedral of Modena in northern Italy (FIG. **12-26**). The sculpture, which extends on two levels across three bays of the facade, represents scenes from Genesis. The segment shown illustrates the *Creation and Temptation of Adam and Eve* (Genesis 2, 3:1–8) and, at the far left, Christ in a mandorla held by angels—the theme of the central section of the lintel at St. Génis-des-Fontaines. But here the style and execution are far more mature in representational sophistication. The frieze is the work of a master craftsman, whose name, WILIGELMUS, is given in an inscription on another relief on the facade. The name is German, and the sculptor is believed to have been a German goldsmith. If so, the close relationship of Germany and Lombardy is indicated here in sculpture as well as in architecture. The figures have broken through the constriction of the arcade to make for a more continuous narrative. They are no longer in flat pattern but are cut in deep relief, some parts almost entirely in the round. The origins of the authoritative style of Wiligelmus are obscure. His prototypes may have been fragments of Late Antique sarcophagi, Carolingian ivories, or the panels of doors like those at Hildesheim (FIG. 11-29). The rectilinear shape and the arrangement of the frieze suggest that it may have been inspired by sculptured altar frontals, as yet the shape and arrangement are not logically related to the architecture of the facade, as the sculpture of the great Romanesque portals will be. Yet the Modena sculpture of Wiligelmus, whose work the inscription rightfully honors, is an outstanding and abrupt introduction to a new artistic style—"High Romanesque."

The stirring of the peoples in Romanesque Europe, the Crusades, the pilgrimages, and the commercial journeyings brought a slow realization that Europeans were of the same

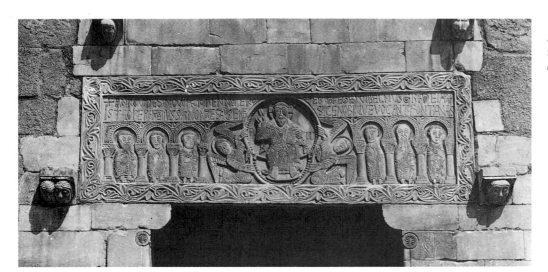

12-25 *Christ in Majesty with Apostles*, lintel over doorway, St.-Génis-des-Fontaines, France, *c.* 1019–1020. Marble, 24″ high.

religion, even if of different ethnic stock. The reception of hitherto unknown documents of Greek thought and learning strongly influenced theology, bringing to it, along with new and deep challenges, a kind of order and concentration. Theologians undoubtedly dictated the subjects of the Romanesque portals; church authorities felt it was just as important to have the right subjects carved in the right places as to have the right arguments rightly arranged in a theological treatise. The apocalyptic vision of the Last Judgment, appalling to the imagination of twelfth-century believers, was represented conspicuously at the western entrance portal as an inescapable reminder to all who entered.

At Modena, the great frieze recounted the beginning of the human race; in a portal at Moissac, some twenty-five years later, its end was announced. With new architectural and iconographic organization giving coherence to sculptural design on a grand scale, the vast tympanum that crowns the portal of St.-Pierre at Moissac (FIG. **12-27**) depicts the Second Coming of Christ as King and Judge of the world in its last days. As befits his majesty, Christ is centrally enthroned, reflecting a rule of composition that we

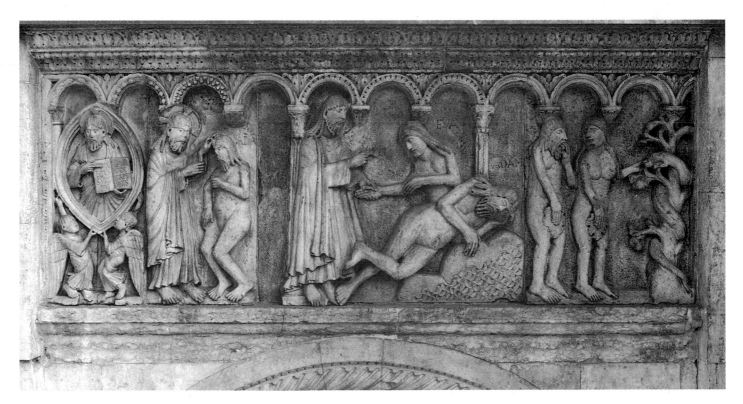

12-26 WILIGELMUS, *Creation and Temptation of Adam and Eve*, frieze on the west facade, Cathedral of Moderna, Italy, *c.* 1110. Approx. 36″ high.

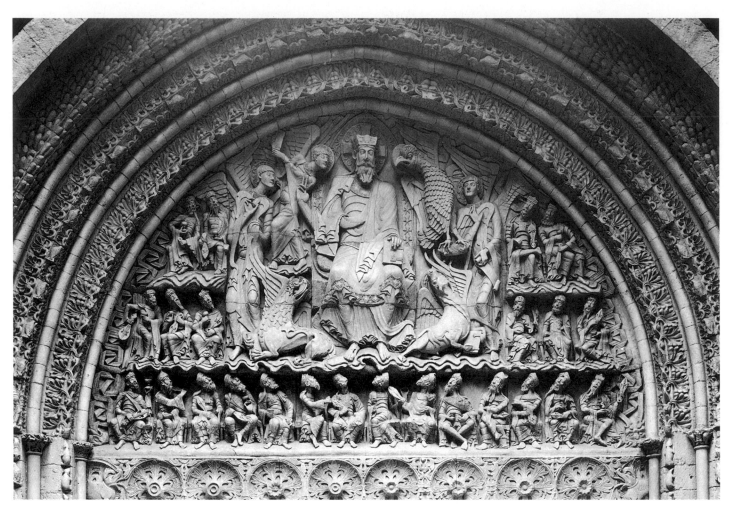

12-27 Tympanum of the south portal of St.-Pierre, Moissac, France, *c.* 1115–1135. Diameter 16′6″.

have seen followed since Early Christian times. The Signs of the Evangelists flank him: on his right side, the Angel of Saint Matthew and the Lion of Saint Mark, and on his left, the Eagle of Saint John and the Ox of Saint Luke. To one side of each pair of signs is an attendant angel holding scrolls on which to record the deeds of mankind for judgment. The figures of crowned musicians, which complete the design, are the twenty-four music-making Elders who accompany Christ as the kings of all this world and make music in his praise. Each turns to face him, much as would the courtiers of a Romanesque monarch in attendance on their lord. The central group, reminiscent of the heraldic groupings of ancient Mesopotamian art, is set among the elders, who are separated into three tiers by two courses of wavy lines that symbolize the clouds of Heaven.

As many variations exist within the general style of Romanesque sculpture as within Romanesque architecture, and the figures of the Moissac tympanum are no exception. Yet elements familiar in painting and sculpture throughout Western Europe in the eleventh and twelfth centuries also are found here. The extremely elongated figures of

the recording angels, the curious, cross-legged, dancing pose of the Angel of St. Matthew, and the jerky, hinged movement are characteristic in general of the emerging vernacular style of representing the human figure. Earlier Carolingian, Ottonian, and Anglo-Saxon manners diffused and interfused to produce the now sure and unhesitating style-languages of the Romanesque. The zigzag and dovetail lines of the draperies (the linear modes of manuscript painting are everywhere apparent), the bandlike folds of the torsos, the bending back of the hands against the body, and the wide cheekbones are also common features of this new, cosmopolitan style.

A triumph of the style is the splendid figure of *The Prophet Jeremiah* (identified by some as Isaiah) carved in the trumeau of the Moissac portal (FIG. **12-28**). His position below the apparition of Christ as the apocalyptic judge is explained by his prophecy (recalled here by his scroll) of the end of the world, when "ruin spreads from nation to nation." He is compressed in the mass of the trumeau behind roaring, interlaced lions of the kind familiar not only in early Germanic art but also in the art of ancient

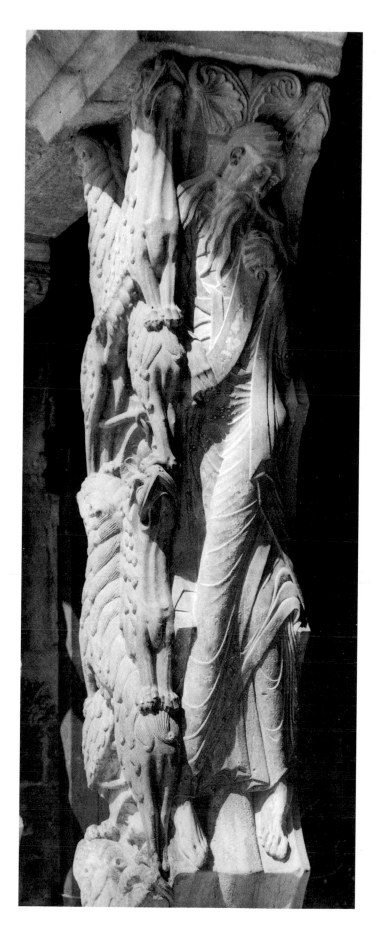

12-28 *The Prophet Jeremiah* (*Isaiah?*) from the trumeau of the south portal of St.-Pierre. Life size. *Above:* detail.

Mesopotamia and Persia and in Islamic Spain. The totemistic animal was never far from the instinct and imagination of the medieval artist and was certainly not far from the medieval mind in general. Kings and barons often were named by association with animals thought to be the most fiercely courageous—for example, Richard the Lionheart, Henry the Lion, Henry the Bear, and Richard III of England, whose heraldic animal was the wild boar. It is not unthinkable that the medieval artist, with millennia of animal lore and ornament to draw on, associated animal strength with architecture—the animal body being thought of as providing support and symbolizing the forces locked in the architectural fabric. The sphinxes and winged monsters at the palace gates in the ancient world are the ancestors of the interlaced lions at Moissac (FIGS. 2-16, 2-19, 2-23).

The figure of the prophet is very tall and thin, in the manner of the angels of the tympanum, and, like the Angel of St. Matthew, he executes a cross-legged step that repeats the crisscrossing of the lions, although no representation of movement is yet apparent in terms of the actual structure of the body or its natural proportions. At this time, the beginning of a new epoch in the history of sculpture, movement is a kind of grotesque, mechanical dance. The placing

of the parts of the body depends on the architectural setting, on the sculptor's interpretation of whatever carved or painted model is being used, or on the vocabulary of the prevailing vernacular styles; the artist's originality also might play a large part, as in this case. The folds of the drapery are incised in flowing, calligraphic lines that ultimately derive from manuscript illumination and here play gracefully around the elegant figure.

A detail of the head and shoulders (FIG. 12-28) reveals the artist's striking characterization of the subject. The long, serpentine locks of hair and beard (familiar in the vocabulary of French Romanesque details) frame an arresting image of the dreaming mystic. The prophet seems entranced by his vision of what is to come, the light of ordinary day unseen by his wide eyes. His expression is slightly melancholy—at once pensive and wistful. For the Middle Ages, two alternative callings were available: one calling was to *vita activa* (the active life); the other was to *vita contemplativa* (the religious life of contemplation), the pursuit of the beatific vision of God. The sculptor of the Moissac prophet has given us the very image of the vita contemplativa. It has been said of Greek sculpture that the body becomes "alive" before the head (as in the dying warrior from Aegina, FIG. 5-32); in the epoch that begins in the eleventh century, the head becomes humanly expressive well before the body is rendered as truly corporeal. The Moissac prophet is a remarkable instance of this.

Romanesque sculpture at Moissac is not confined to the portals; it also appears in delightful variety in the carved capitals within the church and in the cloister walk. It was sculpture such as this that Saint Bernard complained distracted the monks from their devotions. We are distracted, too—by the work's ingenuity and decorative beauty. The capitals of the Moissac cloister (FIG. **12-29**)—some of which are *historiated* (ornamented with representations that form a narrative), some purely decorative—are excellent examples. The capital in the foreground of the view at the top has an intricate leaf-and-vine pattern with volutes, an echo of the Corinthian capital. The abacus carries rosettes, and its upper edge exhibits the fish-scale motif. The capital in the background has figures seated at a table, probably a representation of the Marriage Feast at Cana. The two other capitals shown reveal the richness and color of the Romanesque sculptor's imagination. Monsters of all sorts—basilisks, griffins, lizards, gargoyles—cluster and interlace and pass grinning before us. We have the medieval bestiary in stone.

Yet for all its distinctive stylistic characteristics and exotic appearance, Romanesque art reveals its debt to ancient Roman, Early Christian, and Byzantine art and to their Classical heritage. For example, the beautifully carved rosettes on the lintel beneath the tympanum at Moissac (FIG. 12-27) derive from ancient Roman types. Some very late, still classicizing work, perhaps of the seventh century, probably served as a model for the rosettes. Other rosettes closely resembling those of the Moissac lintel survive. At

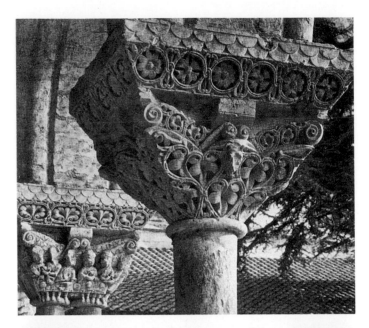

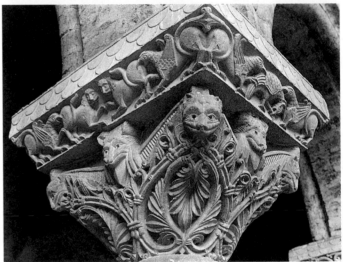

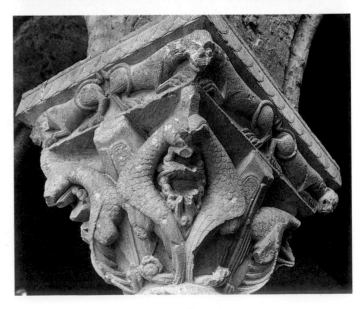

12-29 Capitals from the cloister of St.-Pierre.

the same time, Islamic influence is unmistakable in other decorative motifs of the portal.

The relatives of the monsters of the Moissac capitals appear as the demons of Hell in the awesome tympanum of the church of St.-Lazare at Autun in Burgundy (FIGS. **12-30** and **12-31**). At Moissac, we saw the apparition of the Divine Judge before he has summoned man; at Autun, the Judgment is in progress. The detail (FIG. 12-31) shows the weighing of souls (the reader may remember this theme from the Egyptian scroll in FIG. 3-44), while below, in the lintel, the dead are rising, one being plucked from the earth by giant hands. Humanity's pitiful weakness and littleness are distilled in these terror-stricken, weeping dolls, whom an angel with a trumpet summons to Judgment. Angels and devils contest at the scales where souls are being weighed, each trying to manipulate the beam for or against a soul. Hideous demons guffaw and roar. Their gaunt, lined bodies, with legs ending in sharp claws, writhe and bend like long, loathsome insects. A devil, leaning from the dragonmouth of Hell, drags souls in, while, above him, a howling demon crams souls headfirst

into a furnace. The resources of the Romanesque imagination, heated by a fearful faith, provide an appalling scene. We can appreciate the terror that the Autun tympanum must have inspired in the believers who passed beneath it as they entered the cathedral.

An inscription on the tympanum names MASTER GISLEBERTUS as the artist. This master stonecarver, whose work appears elsewhere at St.-Lazare, as well as on its portal, is like Wolvinius, who made the *Paliotto* in Sant'Ambrogio at Milan (FIG. 11-19), Gelduinus, who carved the St.-Sernin sculptures (FIG. 12-23), and Wiligelmus, sculptor of the Modena frieze (FIG. 12-26). He wants to make sure his work is remembered in association with his name. In the twelfth century, more and more craftsmen-artists, illuminators as well as sculptors, would begin to identify themselves (we have yet to encounter Master Hugo [FIG. 12-40] and Eadwine the Scribe [FIG. 12-42]). Although many medieval artists remain anonymous, the trend is now set that will culminate in the self-concerned "fine" artist of the Renaissance, who is attentive to reputation and fame.

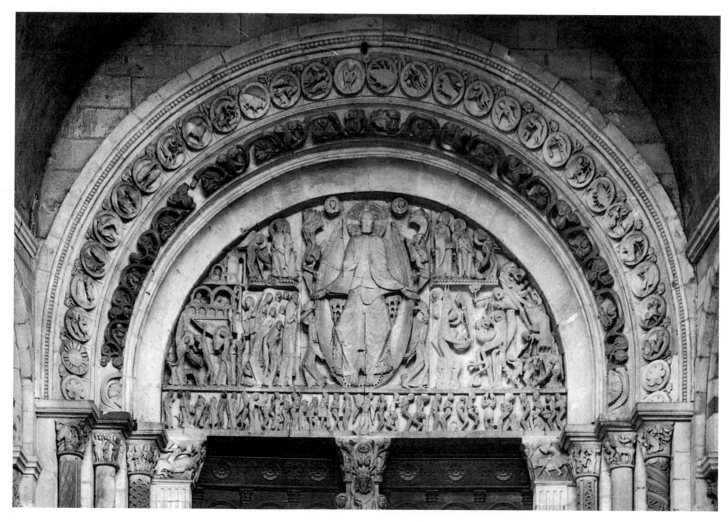

12-30 GISLEBERTUS, west tympanum of St.-Lazare, Autun, France, *c.* 1130. 11'4" high, 21' wide at base.

Another great tympanum, this one at the church of La Madeleine at Vézelay, not far from Autun, varies the theme of the apocalyptic Last Judgment, representing *The Ascension of Christ and the Pentecost Mission of the Apostles* (FIGS. **12-32** and **12-33**). As related in scripture (Acts 1:4–9), Christ foretold that the apostles would receive the power of the Holy Ghost and become the witnesses of the truth of the Gospels throughout the world. The rays of light emanating from Christ's hands at the Pentecost represent the promise of the coming of the Holy Ghost (Acts 2:1–42). The apostles, holding the Gospel books, receive their spiritual assignment. Christ assigns three specific tasks to the

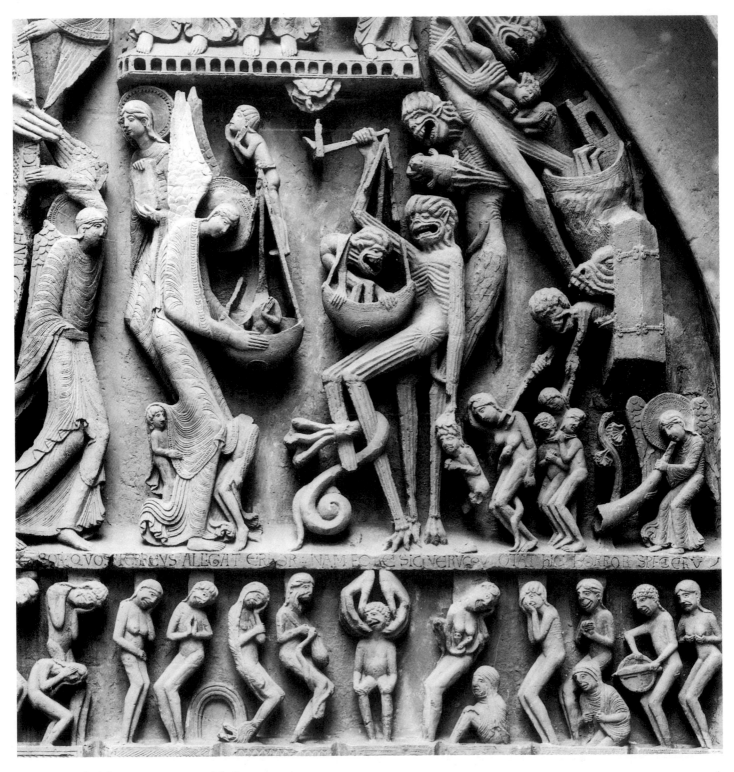

12-31 Detail of the west tympanum of St.-Lazare.

apostles and gives them the power to perform them: to save or to condemn; to preach the Gospel to all nations; to heal the sick and drive out devils. The task of saving or condemning is indicated in the central scene and in the lower four compartments adjacent to it. The task of preaching the Gospel to all nations (some at the very edge of the world)

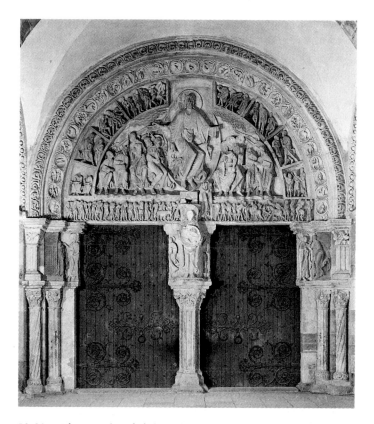

12-32 *The Ascension of Christ and the Pentecost Mission of the Apostles,* center portal of the narthex of La Madeleine, Vézelay, France, 1120–1132.

is represented on the lintel. The task of healing the sick and driving out devils is indicated in the upper four compartments. The outer archivolt has a repeated ornamental device; the inner archivolt has medallions with the signs of the zodiac, the seasons, and the labors characteristic of each month of a calendar year.

The Vézelay tympanum reflects, like a vast mirror, religious and secular writings and the influence of antiquity and the Byzantine East. It is a complete and encyclopedic work, in which the mission of the apostles and their power to perform it are merged in a single subject, the apparition of the risen Christ at Pentecost. The theme has its sources in the Acts and in the Gospels, in the prophecies of Isaiah, and in writings of antiquity and of the Middle Ages. The crowding, agitated figures reveal wild deformities. We find people with the heads of dogs, enormous ears, fiery hair, snoutlike noses; the lexicon of human defects and ailments includes hunchbacks, mutes, blind men, and lame men. Humanity, still suffering, awaits the salvation to come. The whole world is electrified by the promise of the ascended Christ, whose great figure, seeming to whirl in a vortex of spiritual energy, looms above human misery and deformity. Again, as in the Autun tympanum, we are made emphatically aware of the greatness of God and the littleness of human beings.

Vézelay is more closely associated with the Crusades than any other church in Europe. Pope Urban II had intended to preach the First Crusade at Vézelay in 1095, about thirty years before the tympanum was carved. In 1146, some fifteen years after the tympanum was in place, Saint Bernard preached the Second Crusade, and King Louis VII of France took up the cross. In 1190, it was from Vézelay that King Richard the Lionheart of England and King Philip Augustus of France set out on the Third Crusade. The spirit of the Crusades undoubtedly determined the iconography of the Vézelay tympanum, for it

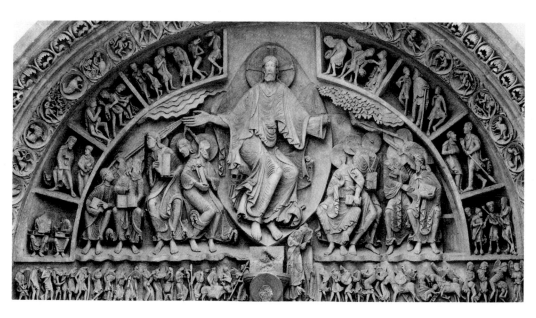

12-33 Detail of the center portal of the narthex of La Madeleine

was believed that the Crusades were a kind of "second mission of the apostles" to convert the infidel.

Stylistically, the figures of the Vézelay tympanum display characteristics similar to those of the Moissac and Autun tympanums: abrupt and jerky movement (strongly exaggerated at Vézelay), rapid play of line, wind-blown drapery hems, elongation, angularity, and agitated poses, gestures, and silhouettes. The figure of the Vézelay Christ (FIG. 12-33) is a splendid essay in calligraphic theme and variation and is almost a summary of the Romanesque skill with decorative line. The lines of the drapery shoot out in rays, break into quick, zigzag rhythms, and spin into whorls, wonderfully conveying the spiritual light and energy that flow from Christ over and into the animated apostles. The technical experience of centuries of working with small art—with manuscripts, ivories, and metal craft—is easily read from this monumental translation of such work into stone (compare the spiral whorls in FIG. 12-42 with those here).

In Provence, rich in the remains of Roman art and architecture, the vivid linear style of Languedoc (Moissac) and Burgundy (Autun and Vézelay) is considerably modified later in the twelfth century by the influence of the art of antiquity. The quieting influence of this art is seen at once in the figures on the facade of St.-Trophîme at Arles and in the design of the portal (FIG. 12-34), which reflects the artist's interpretation of a Roman triumphal arch. The tympanum shows Christ surrounded by the Signs of the Evangelists. On the lintel, directly below him, the Twelve Apostles appear at the center of a continuous frieze that depicts the Last Judgment; the outermost parts of the frieze depict the saved (on Christ's right) and the damned in the flames of Hell (on his left). Below this, in the jambs and the front bays of the portals, stand grave figures of saints draped in Classical garb, their quiet stance contrasting with the spinning, twisting dancing figures seen at Autun and Vézelay. The stiff regularity of the figures in the frieze also contrasts with the animation of the great Burgundian tympanums and reminds us of the "lining-up" seen in later Roman sculpture (FIG. 7-87). The draperies of these frieze figures at Arles, like those of the large statues below, are also less agitated and show nothing of the dexterous linear play familiar at Moissac, Autun, and Vézelay. Here, the rigid lines of the architecture of the facade as a whole (rather than just an enframing element, such as a tympanum) now are determining the placement and look of the

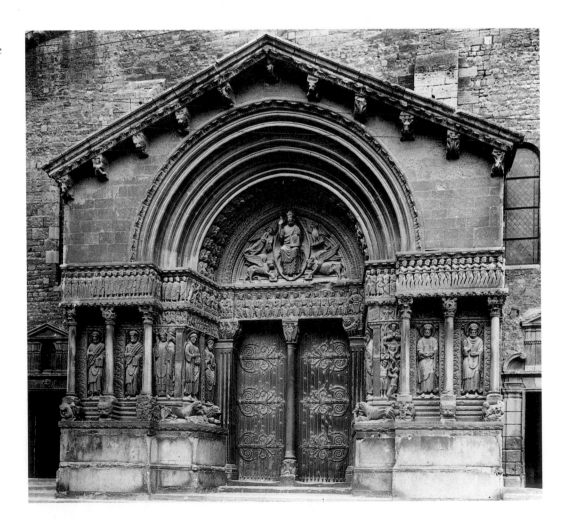

12-34 Portal on the west facade of St.-Trophîme, Arles, France, late twelfth century.

sculpture, and the freedom of execution appropriate to small art has been sacrificed to a simpler and more monumental adjustment to the architecture.

In the north of France, near Paris, a new system of portal sculpture developed some thirty years earlier than that at St.-Trophîme. In the Royal Portal of the cathedral of Chartres (FIG. 13-14), we shall see the expansion of the whole portal design into a magnificent frontispiece, in which the architectural and sculptural elements are balanced, the sculptural style being firmly determined by the lines of the building.

The cloister of St.-Trophîme (FIG. **12-35**), one of the best preserved in France, may be taken as exemplary of that indispensable feature of monastic architecture. A vaulted walkway surrounds the cloister *garth* (garden) on four sides. From the cloister walk one looks into the garden through rows of paired columns alternating with piers. At the four corners are heavy piers that aid in supporting the massive quadrant vaults that roof the corridor.

The sculpture of the column capitals is variously historiated, as at Moissac (FIG. 12-29), or ornamental, sometimes in late Roman Corinthian style; often the historiated and Corinthian styles are placed side by side, an interesting juxtaposition of Roman and Romanesque. The carved figures of the corner piers are mostly derived from Roman sculpture, even though markedly Romanesque in formal details.

Cloister, from the Latin word *claustrum,* an enclosed place, connotes being shut away from the world. Architecturally,

the cloister expresses the seclusion of the spiritual life, the vita contemplativa. It is the place where the monks walk in contemplation, reading their devotions, praying and meditating in an atmosphere of calm serenity, each withdrawn into the private world where the soul communes only with God. The physical silence of the cloister is one with the silence enjoined upon its members by the more austere monastic communities. The monastery cloisters of the twelfth century are monuments to the vitality, popularity, and influence of monasticism at its peak in the Romanesque, and their example is faithfully followed by architects who build for religious orders today.

PAINTING

We can begin an account of Romanesque painting with a work that is *not* a painting. Nor is the famous and unique *Bayeux Tapestry* (FIG. **12-36**) a woven tapestry. It is rather an embroidered (needle-worked) fabric made of wool sewn on linen. Some 20 inches high and about 230 feet long, this work is a continuous, friezelike, pictorial narrative of a crucial moment in the history of England and of the events that led up to it. The Norman defeat of the Anglo-Saxons at Hastings in 1066 brought Saxon England under the control of the Normans, uniting all of England and much of France under one rule; the dukes of Normandy (descendants of the Viking Norsemen) became the kings of England.

12-35 Cloister of St.-Trophîme.

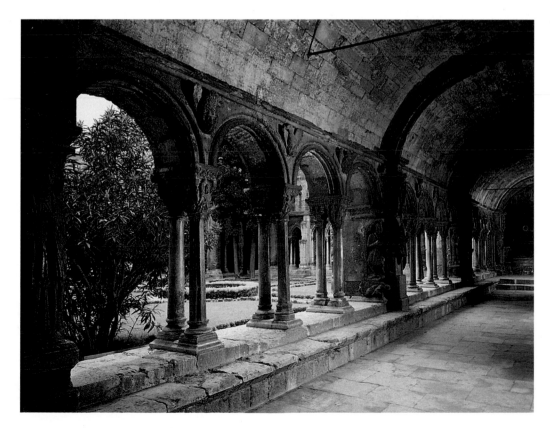

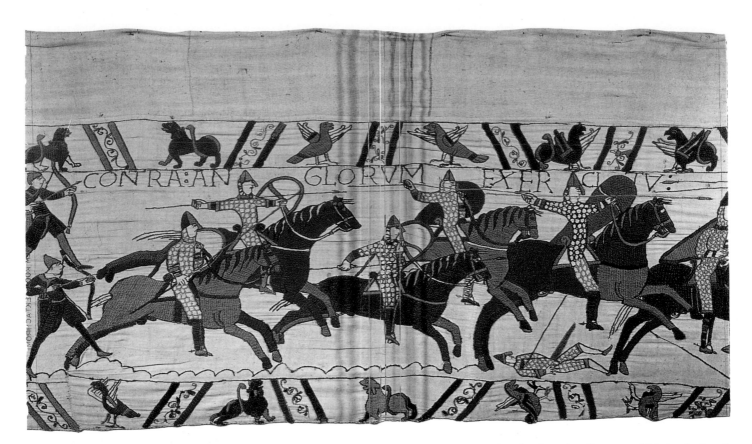

12-36 *Norman Cavalry Charging in the Battle of Hastings,* from the *Bayeux Tapestry,* 1070–1080. Embroidered wool on linen, 20" high (entire length of fabric 229'8"). Musée de Peinture, Bayeux.

Commissioned by Bishop Odo, the half brother of the conquering Duke William (under whose reign in Normandy St.-Étienne at Caen had been begun), the "tapestry" may have been sewn by ladies at the Norman court, although some believe it was the work of English needlewomen in Kent, where Odo had been given lands and influence by Duke William.

The *Bayeux Tapestry* is unique in Romanesque art in that it depicts a contemporary event in full detail at a time shortly after it took place—a kind of distant anticipation of modern pictorial reportage. Inscriptions accompanying the pictures comment on the action. A section of the embroidered frieze shows a charge of Norman cavalry; the upper and lower margins show various fanciful beasts and birds in heraldic arrangement. Despite the schematic simplification of form, the Archaic flatness without cast shadows, and an entirely neutral background, the tapestry conveys a surprisingly exact description of arms and armor, as well as a convincing representation of action, pose, and gesture. The work is of great importance, not only as art, but also as a valuable historical document. The stylistic unity and consistency found throughout the whole length of the tapestry suggest that it is the product of a single designer or a small "school" of needleworkers thoroughly trained in a distinctive idiom of representation.

Like monumental sculpture, monumental mural painting comes into its own once again in the eleventh century. Although we have several examples of it from Carolingian and Ottonian times and although an unbroken tradition of such painting existed in Italy, it blossoms in the Romanesque period. As with architecture and sculpture, mural painting exhibits many regional styles and many degrees of sophistication.

A number of small churches in Catalonia (northeastern Spain) are decorated with murals that show a vigorous regional Romanesque style. A fresco detached from the apse of the monastery church of Santa Maria de Mur, not far from Lerida, derives at some distance from Byzantine art, as does much of the Romanesque (FIG. **12-37**). The formality, symmetry, and placement of the figures is Byzantine (FIGS. 9-8, 9-14, 9-30), though the iconographic scheme in the upper shell of the apse is similar to what we have seen at Moissac and St.-Trophîme at Arles (FIGS. 12-27, 12-34).

Christ in a star-strewn mandorla is flanked by the Signs of the Evangelists and the Seven Lamps—the Apocalypse theme that so fascinated the Romanesque imagination. The Seven Lamps, or candlesticks, symbolized the seven Christian communities to which Saint John addressed his revelation (the Apocalypse) at the beginning of his book

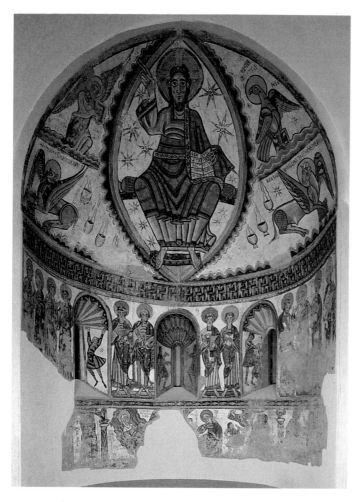 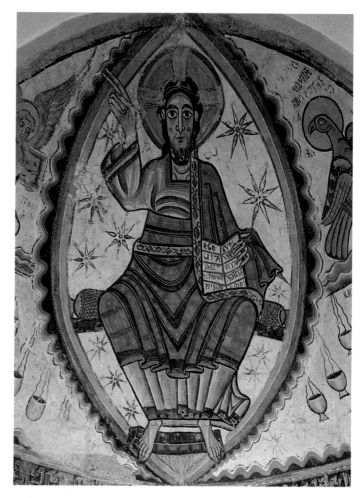

12-37 *Christ in Majesty,* detached apse fresco from Santa Maria de Mur, Catalonia, Spain, early twelfth century. 22' × 24'. Detail. Maria Antoinette Evans Fund. Courtesy Museum of Fine Arts, Boston.

(Revelation 1:4, 12, 20). The lamps surround the apparition of Christ—"like unto the Son of Man." A *meander* (ornamental bands consisting of interlocking geometric motifs) frieze in perspective separates the upper and lower registers, where the apostles are paired off in formal frontality, much as they are in the corner piers at St.-Trophîme. The small figures in the arched window niches depict Atlas supporting the Heavens, and the story of Cain and Abel.

The principal figures are rendered—as is customary in Romanesque art (see FIG. 12-27)—with partitioning of the drapery into volumes, here and there made tubular by local shading. The more fluent lines of the prototype used by the artist stiffen into irregular shapes and patterns made from repetition of angular and cylindrical areas. This hardening of originally illusionistic detail into geometric pattern goes back a long way (FIG. 11-9), and we find in this Catalan fresco the persistence of a long-practiced, even instinctive, method for decorative transformation of the prototype. The effect overall is one of simple, strong, even blunt directness of statement, reinforced by harsh, bright color, appropriate to a powerful icon.

ILLUMINATION

The vernacular Romanesque style can be seen almost in exaggeration in a manuscript illumination from northern France illustrating the life of Saint Audomarus (Omer) (FIG. 12-38). Here the figures are cut into patterns by hard lines, and the action is remote from even an approximation of organic motion. Saint Audomarus (bound and pulled by the beard) and his captors seem to be performing some bouncing ritual ballet. The frame creates no sense of containment, as it did in Anglo-Saxon and Carolingian manuscripts, and bodies and feet move arbitrarily in, out of, and across it. Although locally different from the Santa Maria de Mur mural, the St. Audomarus illumination shares its fundamental vocabulary.

That same vocabulary, richly applied and gracefully modulated, appears in what surely must be one of the masterpieces of medieval art—a manuscript illuminated in Saint Bernard's great abbey of Cîteaux. Cîteaux, and its sister abbey, Clairvaux, where Saint Bernard was abbot, produced magnificent illuminated manuscripts throughout the

12-38 *The Life and Miracles of St. Audomarus* (*Omer*), eleventh century. Illuminated manuscript, Bibliothèque Municipale, Saint-Omer.

twelfth century. One of the most remarkable was Gregory's *Moralia in Job,* painted before 1111. A splendid example of Cistercian illumination, the historiated initial from this manuscript (FIG. **12-39**) represents Saint George, his squire, and the roaring dragons intricately composed to make the letter *R.* Saint George, a slender, regal figure, raises his shield and sword against the dragons—distinguished representations of the age-old animal style so often encountered—while the squire, crouching beneath Saint George, runs a lance through one of the monsters. (An image of status, the greater and the lesser dragons correspond to the lord and his man.) The ornamented initial goes back to the Hiberno-Saxon eighth century; the inclusion of a narrative within the initial is a practice that would have an important future in Gothic illumination. The banding of the torso, the fold partitions (especially evident in the skirts of the servant), and the dovetail folds—all part of the Romanesque

manner—are done here with the skill of a master who deftly avoids the stiffness and angularity that result from less skillful management of the vocabulary. Instead, this artist makes a virtue of stylistic necessity; the partitioning accentuates the verticality and elegance of the figure of Saint George and the thrusting action of his servant. The flowing sleeves add a spirited flourish to Saint George's gesture. The knight, handsomely garbed, cavalierly wears no armor and aims a single stroke with proud disdain. This miniature may be a reliable picture of the costume of a medieval baron and of the air of nonchalant gallantry he cultivated.

We have noted the institution of knighthood as associated with the crusading barons; knighthood was a kind of consecration of the profession of arms in the service of Christendom. The baron, leaving his lands to journey to far places to campaign against the infidel, becomes the knight errant, roving in search of adventure as well as for

the sake of the cross. The knight errant sought also to protect the weak and the oppressed; inevitably he served as the defender and lover of a lady in distress, whose champion he became.

The image and the legend of Saint George, patron saint of soldiers, is that of the Christian knight, who not only rescues the beautiful maiden menaced by the dragon, but also appears to the Crusaders at the walls of Jerusalem and delivers the city into their hands. His figure here in this

Cistercian manuscript, produced in Saint Bernard's milieu, is telling historical evidence of the value set upon knighthood in the age of the Romanesque.

An illumination of exceedingly refined execution, exemplifying the sumptuous illustration common to the large Bibles produced in the wealthy Romanesque abbeys, is the frontispiece to the Book of Deuteronomy from the Bury Bible (FIG. **12-40**). Produced at the abbey of Bury St. Edmunds in England by MASTER HUGO in the early twelfth

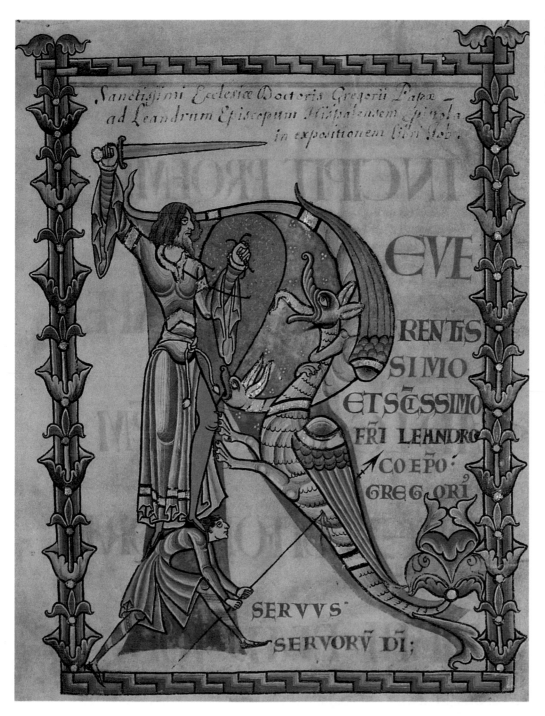

12-39 Initial *R* with *St. George and the Dragon*, from the *Moralia in Job*, Cîteaux, France, early twelfth century. Illuminated manuscript, $13^3/4'' \times 9^1/4''$. Bibliothèque Municipale, Dijon.

century, this work shows two scenes from Deuteronomy enframed by symmetrical leaf motifs in softly glowing, harmonized colors. The upper register shows Moses and Aaron proclaiming the law to the Israelites; the lower portrays Moses pointing out the clean and unclean beasts. The gestures are slow and gentle, and have quiet dignity. The figures of Moses and Aaron seem to glide. This presentation is quite different from the abrupt emphasis and spastic movement seen in earlier Romanesque painting; here, as the patterning softens, the movements of the figure become more integrated and smooth. Yet the patterning does remain in the multiple divisions of the draped limbs, the

lightly shaded volumes being connected with sinuous lines and ladderlike folds; the drapery and body are still thought of as somehow the same. The frame now has a quite definite limiting function, and the figures are carefully fitted within it.

The apocalyptic vision of the Second Coming of Christ, recorded in the Book of Revelation and carved on the great tympanum at Moissac (FIG. 12-27), is represented in the illumination of the *Apocalypse of St.-Sever* (FIG. **12-41**), a book of commentaries on the Apocalypse written by Beatus of Liébana, an eighth-century theologian. The theme of the Second Coming was of such interest that numerous manuscripts of Beatus's commentary were copied and illustrated; with the exception of this book, all were produced in Spain. The *Apocalypse of St.-Sever,* made in the French monastery of that name, is significant not only as a masterpiece of the illuminator's art but also as a pictorial relative of the Moissac tympanum, for which it, or another book like it, may have served as a prototype. The characters in the drama are essentially the same; only the composition is different. In both cases, the artist has strictly followed the biblical account of the vision of Saint John (Revelation 4:6–8, 5:8–9). Christ, enthroned in a sapphire aura, is surrounded by the Signs of the Evangelists, whose bodies are full of eyes and who are borne aloft by numerous wings. The twenty-four crowned and music-making Elders offer their golden cups of incense and their stringed rebecks (viols). Flights of angels frame the great circle of the apparition. Color, intense and vivid, is harmonized with great sophistication. The agile figures are fluently drawn. The seated Elders are shown in a kind of bird's-eye perspective, in which their figures overlap, and some of them are seen from behind. Within a context of visionary abstraction, these deft touches of realism still are contained by the characteristic patternings of Romanesque figural art.

The transition from the Romanesque vernacular style to something new seems to reach a midpoint in a work of great expressive power, the portrait of *The Scribe Eadwine* (FIG. **12-42**) in the *Canterbury Psalter,* by EADWINE THE SCRIBE. This portrait was made in Canterbury about the same time as the Bury Bible. Particularly noteworthy is the fact that the portrait represents a living man, a priestly scribe—not some sacred person or King David, who usually dominated the Psalter. Although it is true that Carolingian and Ottonian manuscripts included portraits of living men, those portraits were of reigning emperors, whose right to appear in sacred books was God-given, like the right of Justinian and Theodora and their court to be depicted in the sanctuary of San Vitale (FIGS. 9-9, 9-10). Here, the inclusion of his own portrait sanctified the scribe's work, marking a change in attitude that points to the future emergence of scribe as artist as a person and a name. Eadwine greatly has aggrandized his importance by likening his image to that of an Evangelist writing his gospel

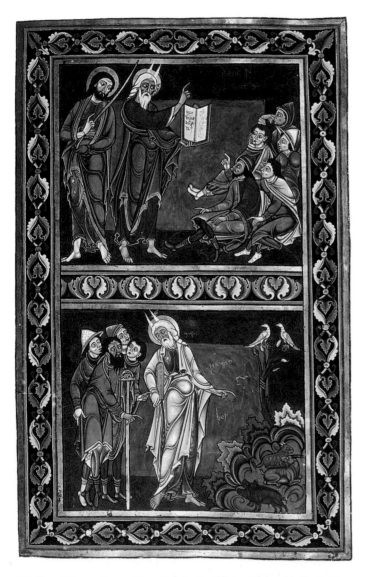

12-40 MASTER HUGO, *Moses Expounding the Law,* from the Book of Deuteronomy, Bury Bible, the abbey of Bury St. Edmunds, England, early twelfth century. Illuminated manuscript, approx. 20″ × 14″. Reproduced by permission of the Master and Fellows of Corpus Christi College, Cambridge, England.

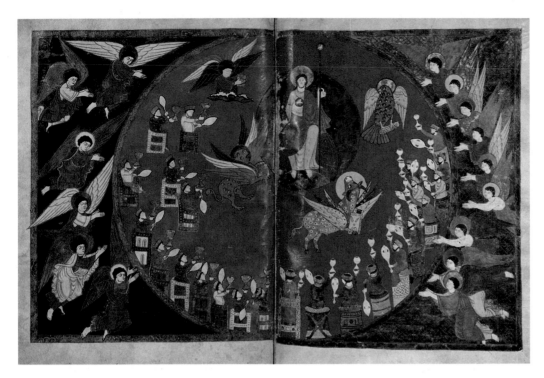

12-41 *The Revelation to St. John: Enthroned Christ with Signs of the Evangelists and the Twenty-four Elders,* from the *Apocalypse of St.-Sever,* painted in the abbey of St.-Sever, France, *c.* 1050. Bibliothèque Nationale, Paris.

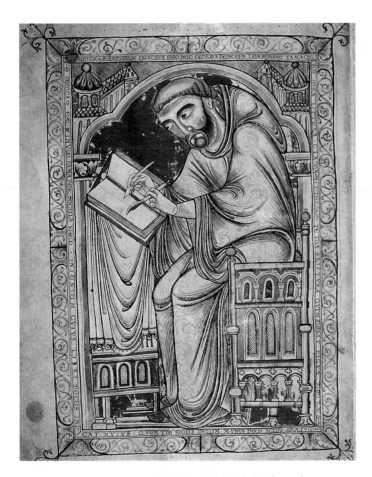

12-42 EADWINE THE SCRIBE (?), *The Scribe Eadwine,* from the *Canterbury Psalter, c.* 1150, Trinity College, Cambridge, England.

(FIGS. 11-8, 11-9, 11-14, 11-15) and by including an inscription within the inner frame that identifies him and proclaims that he is a prince among writers. He declares that, due to the excellence of his work, his fame will endure forever and that he can offer his book as an acceptable gift to God. The medieval artist, concerned as he might be for his fame, is not yet aware of the concepts of fine art and fine artist; these will emerge in the Renaissance. As yet, his work exists not for its own sake but for God's.

The style of the Eadwine portrait is related to that of the Bury Bible, but, although the patterning is still firm (notably in the cowl and the thigh), the drapery has begun to fall softly, to wrap about the frame, to overlap parts of it, and to follow the movements beneath. Here, the arbitrariness of the Romanesque vernacular style yields slightly, but clearly, to the requirements of a more naturalistic representation. The artist's instinct for decorative elaboration of the surface remains, as is apparent in the whorls and spirals of the gown, but significantly, these are painted in very lightly and do not conflict with the functional lines that contain them.

With the distinction of body and drapery finally achieved in the Gothic art of the thirteenth century, an epoch of increasing naturalism will begin. The Eadwine figure marks a turning point—in this case, in the history of medieval representation. The Late Romanesque and Early Gothic "feel" of body and drapery as surfaces that interact forcefully implies not only a sense of their materiality but also a sense of depth. That sense will sharpen and deepen into the representational art of the Renaissance.

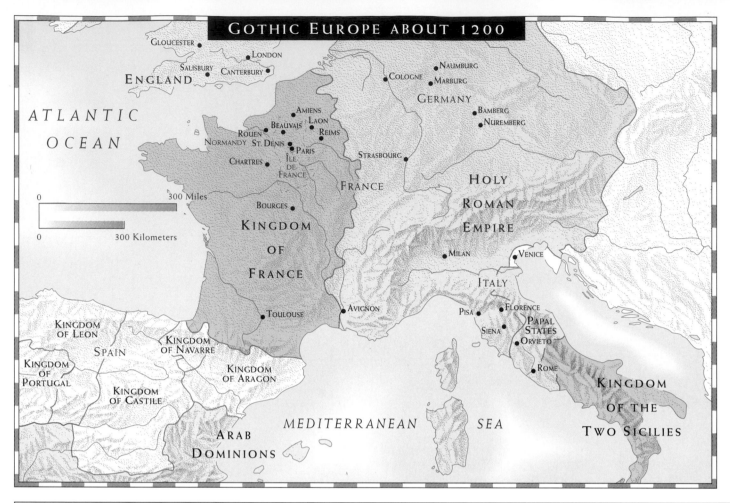

GOTHIC EUROPE ABOUT 1200

ATLANTIC OCEAN

ENGLAND
GLOUCESTER
LONDON
SALISBURY
CANTERBURY

0 ____ 300 Miles
0 ____ 300 Kilometers

NORMANDY
ROUEN
BEAUVAIS
ST. DENIS
CHARTRES
PARIS
ÎLE-DE-FRANCE
AMIENS
LAON
REIMS

FRANCE

KINGDOM OF FRANCE

BOURGES

TOULOUSE

AVIGNON

KINGDOM OF LEON
SPAIN
KINGDOM OF NAVARRE
KINGDOM OF PORTUGAL
KINGDOM OF CASTILE
KINGDOM OF ARAGON

ARAB DOMINIONS

NAUMBURG
COLOGNE
MARBURG
GERMANY
BAMBERG
NUREMBERG

STRASBOURG

HOLY ROMAN EMPIRE

MILAN
VENICE
ITALY
PISA
FLORENCE
SIENA
PAPAL STATES
ORVIETO
ROME

MEDITERRANEAN SEA

KINGDOM OF THE TWO SICILIES

1140	1194	1250
EARLY GOTHIC	HIGH GOTHIC	

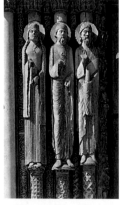

Chartres, Royal Portal
(detail), 1145–1170

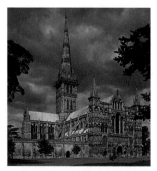

Salisbury Cathedral, 1220

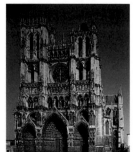

Amiens Cathedral, 1220–1230

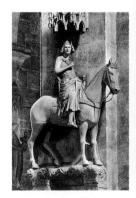

Bamberg Rider
late 13th century

John of Salisbury, c. 1110–1180
Louis VII of France, r. 1137–1180
Frederick Barbarossa, Holy Roman Emperor, r. 1152–1190
Henry II of England, r. 1154–1189
Marie de France, writer, 1160–90
Rise of Universities – Paris, Oxford, Cambridge, c. 1160–1215
Third Crusade, 1189–1192

Eleanor of Aquitaine
Richard the Lion-heart, r. 1189–1199

Fourth Crusade, 1204
Franciscan Order founded, c. 1210
St. Francis of Assisi, 1182–1226
Pope Innocent III, papacy at height of influence, 1198–1216

St. Thomas Aquinas c. 1225–1274
Albigensian Crusade, 1208–1214

Frederick II, r. 1220–1250

Magna Carta, 1215

King Louis IX of France (St. Louis), 1226–1270

Marco Polo in China, 1271–1292

Joinville, c. 1224–1318

Hapsburg dynasty established, 1273

CHAPTER 13

GOTHIC

ART

1300	1350	1400

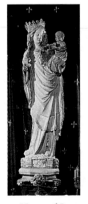

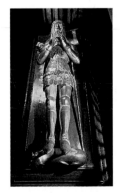

Virgin of Paris
early 14th century

Pucelle
David and Saul, 1325

Tomb of the Black Prince
1377-1380

"Babylonian captivity" of papacy at Avignon, 1309-1378

The Black Death, c. 1340-1400

Geoffrey Chaucer, c. 1343-1400 *Papacy returns to Rome, 1378*

The Great Schism, 1378-1417

Hundred Years War between France and England, 1338-(1453)

The word *Gothic* was first used as a term of derision by critics during the Renaissance, who condemned the lack of conformity of Gothic art to the standards of Classical Greece and Rome. "May he who invented it be cursed," wrote one of them. The style, the critics mistakenly thought, had originated with the Goths, who thus were responsible for the destruction of the good and true Classical style. People of the thirteenth and fourteenth centuries, however, referred to the Gothic cathedrals as *opus modernum* (modern work) or *opus francigtenum* (Frankish work). They recognized in these structures that towered over their towns a style of building and of decoration that was original. It was with confidence in their own faith that they regarded their cathedrals as the real image of the City of God, the Heavenly Jerusalem, which they were privileged to build on earth.

The Gothic West

The Gothic period overlaps the second half of the Romanesque; that is, it gets underway around 1140 in northern France as a distinctive innovating force within the mature Romanesque. By the thirteenth century, Gothic prevails in France and spreads throughout western and central Europe. It lasts through the fourteenth century and well into the fifteenth, principally in the westernmost countries. The decline of Gothic is hastened by great new developments in Italy, developments we know as the Renaissance. It is important to remember that Gothic originates in France and is essentially a French phenomenon.

By the years 1200 to 1215 the fundamental medieval institutions and social structures, which we have seen evolving since the eleventh century and earlier, were all in place: the papal government of the Church based in Rome; centralized governments in northern France and in England; the feudal barons, the towns with their diverse populations of citified barons, merchants, bankers, trade and craft guilds; the universities, with their new professions of scholars and jurists; the migrant bands of builders, masons, and masters, who now come to be associated with the major building sites; the secular bishops and clergy of the cities, who now begin to replace the great monasteries in power, influence, and patronage of learning and the arts. In all of this, though the culture of Western Europe was still profoundly religious, the lay and worldly spirit was ever more strongly in evidence.

CRUSADE AND COLONIZATION The inner development of Western European institutions was accompanied by outward expansion. The Crusades were only the most dramatic feature of a larger eastward movement of western populations, which exactly reversed the direction of the old Germanic migrations. Pressures of population, land hunger, escape from feudal constraints, and opportunities for trade stimulated the migration eastward of thousands of Flemish and German peasants, intent upon the colonization of the rich lands of central Europe and of as yet unsettled eastern Germany. This would become a policy of "Germanization" of the Slavic peoples displaced or subdued. For the Teutonic Knights, a crusading order whose military power backed up the German incursions, "Germanization" was a large part of their crusading mission to convert the still pagan Prussians and the peoples of the Baltic lands. The "re-conquest" of Muslim Spain by the Christian kingdoms of Castile/Leon and Aragon was, like all the Crusades, a series of military expeditions justified by religion, but intended also to satisfy the territorial ambitions of Christian monarchs. The Normans, for the same reasons, expelled the Muslims from Sicily, South Italy, and the western Mediterranean. And in their clashes with Christian Byzantium, the Normans could argue that they were dealing with schismatics who, though Christian, refused to accept the supremacy of the Roman Church.

As holy wars, the aggressions of the Crusades against the Muslim infidel had the sanction of the Church. But they could also on occasion be directed against Christian populations who were schismatic—those of Byzantium, as noted above—or heretical, that is, in disagreement with points of official Church doctrine. When the interest of spiritual domination coincided with that of territorial expansion, the religious and the secular powers could collaborate in destructive campaigns designed to achieve their shared aims.

We have given an account of one of these campaigns in Chapter 9, the ill-directed attack of the French Crusaders (the Franks) on Byzantium, and the barbarous sack of Constantinople in 1204. Though Pope Innocent III decried the excesses of the Crusaders, he and his predecessors had long desired papal hegemony over the Greek Orthodox Church and the establishment in Byzantium of a Latin power.

Closer to home, in the still independent south of France (principally Romanesque Languedoc), anti-Christian and reformist Christian heresies had taken hold. The pope, fearful of dissenting sects, wanted the extirpation of the heresies, and the king was not averse to annexing the region of Languedoc to the French crown. The Albigensian heresy (and Crusade to wipe it out) takes its name from the city of Albi, a center of the sect. The heresy was extinguished by fire and sword over a period of nearly twenty years (1208–1226), and with it the rich, proud culture of Languedoc. The whole operation was driven by religious intolerance and by the brutal cynicism of the French barons who led it.

The Albigensian Crusade had two consequences of lasting significance: the establishment by the papacy of the Inquisition, an agency for the investigation and rooting out of heresy, and the extension of the kingdom of France to

the Mediterranean. The first consequence greatly augmented papal power by the institution of thought control as an instrument of the papal governance of Christendom; the second helped establish the authority of the centralized state on the model of royal France.

THE PAPACY SUPREME

The power of Rome was absolute in the thirteenth century; never again would it have such widespread and recognized authority. Just as the popes brooked no rival religious authority, whether infidel, heretical, or schismatic, so they aimed to control the secular world of kings and emperors, playing one off against the other with shrewd diplomacy. The greatest of the medieval popes, Innocent III (1198–1215), following in the footsteps of Gregory VII, evoked the Petrine theory in asserting: "Single rulers have single provinces, and single kings have single kingdoms; but Peter [the papacy] . . . is preeminent over all, since he is the Vicar of Him whose is the earth and the fulness thereof, the whole wide world and all that dwell therein." Accordingly, Innocent claimed the right to decide the election of the German emperors; he forced King Philip II (Philip Augustus) of France to take back his estranged queen; he took England away from King John, returning it to him as a papal fief and making John his vassal. His ambassadors, the papal legates, busily advanced papal interests everywhere in Europe, at royal and princely courts as well as at ecclesiastical chapters and assemblies. The pope appointed to all Church offices, and, for support of the Holy See, taxed not only Church lands but royal and baronial domains. Innocent zealously pursued the reform of the Church that had begun under Gregory VII in the late eleventh century. The Fourth Lateran Council (1215) was summoned and managed by Innocent, who used it to tighten Church organization into an ever more extended and efficient bureaucracy, and to define once and for all the articles of Catholic faith and the rules of clerical practice. The cities, with their growing populations of articulate laymen, were increasingly the source of rising opposition to the power, wealth, and worldliness of the Church, as well as heresy-leaning criticism of some of its doctrines. To offset this with an urban campaign to foster orthodox piety among the people, Innocent III and his immediate successors approved the founding of the two great mendicant (begging) orders, the Dominican and the Franciscan. Responsible only to the papacy, independent of the great monasteries and of the city bishops and clergy, these new orders depended for their support on alms, rather than on the revenues of land. They preached and taught in the cities the ideals and practices of the spiritual life, endeavoring to touch the hearts of all believers, educated and uneducated, rich and poor. At the same time they served the recently established Inquisition as investigators and inquisitors in the searching out and punishing of heretical opinion.

THE PREEMINENCE OF FRANCE

The secular power of France paralleled and counterbalanced the ecclesiastical power of Rome throughout the thirteenth century. Between 1180 and 1270 the French monarchs Philip Augustus and Louis IX (Saint Louis) brought their vassal barons under control; expanded and consolidated the royal domain; developed a government staffed with paid professionals, many of whom were jurists skilled in Roman law; refined legal procedure and the administration of justice; systematized taxation; and did much else to secure the foundations of the centralized state recognizable as the kingdom of France.

Philip and Louis made clever use of feudal ties and obligations to draw power to the throne while they neutralized the barons. They overcame, for a time, the jealous and pugnacious attitudes encouraged by feudal localism and rivalry, replacing them with a sense of national solidarity and loyalty to the crown. This they accomplished while the barons and princes of Germany still insisted on their overriding feudal privileges and territorial sovereignty against any centralizing ambitions of the Holy Roman emperors and while the barons of England forced King John's submission to their demands as written down in the Magna Carta (Great Charter) in 1215. As for Italy, neither pope nor emperor could bring unity out of perpetual conflict. The Italian cities, some of which were republics (communes), and some governed by despots, were hopelessly divided by the politics of the struggle between Empire and Papacy. The great Hohenstaufen emperor, Frederick II, grandson of Barbarossa and ruler of Sicily, was unable to unify either Germany or Italy; his successors were overthrown by the Papacy and the line of Hohenstaufen emperors extinguished. Such was the prestige of France, that the pope offered the crown of Sicily to Charles of Anjou, brother of Louis IX. Ironically, within a generation a French king and a Roman pontiff would be the bitterest of enemies. France had replaced the empire in the ongoing power struggle with the papacy.

PARIS: THE INTELLECTUAL CENTER OF GOTHIC EUROPE

In the thirteenth century the city of Paris became a microcosm of the culture of Western Christendom, as Constantinople had long been the microcosm of the culture of Eastern Christendom. As capital of royal France it was the scene of a remarkable collaboration of a strong monarchy, a loyal Church, an even more loyal citizenry, and a great university, foremost among all the centers of European learning. Even before the crucial reign of Philip Augustus, great churchmen had come into the service of the crown: Suger, abbot of St.-Denis, had served both Louis VI and Louis VII as prime minister and regent; the bishop of Paris, Maurice de Sully, had begun the vast church of Notre-Dame, the very symbol of the sanctification of royal power and of the right of the house of Capet

to wield it. Philip Augustus renowned as "the maker of Paris," gave the city its walls, paved its streets, and built the palace of the Louvre to certify the royal proprietorship of the city. A prosperous population of bankers, merchants, and trade and industrial guildsmen lived in relative social harmony, their associations blessed by religious affiliation and ceremony. These laymen had the political confidence of the king, who on occasion appointed burgesses (leading citizens) as regents in his absence, or even as guards of the royal person against threats by the barons or by foreign powers.

There was thus a unity of interest and of purpose that concentrated the energies of the community and created a unique culture that radiated its influence abroad. While Rome was the religious and executive center of medieval Christendom, Paris was its intellectual center; one might say that the two cities formed an axis upon which medieval culture turned. The University of Paris had the attractive power to draw from all parts of Europe the best minds of the age; virtually every thinker of note in the Gothic world had at some point studied or taught at Paris. The scholarly community of the university, a cosmopolitan, self-conscious elite of the learned, was an independent corporation, a guild of master scholars that had early separated from the supervision of the chancellor of the bishop of Paris, who was in control of the numerous Church schools of the city. During the thirteenth century the Guild of Masters developed a characteristic organization, which would come to be the model for the universities of Europe.

The most renowned of the "faculties" of the University of Paris was that of theology. We have earlier seen that, since the time of Abelard and the reception of the logical and metaphysical writings of Aristotle, the "schools" of Paris were the site of the great debates among the Schoolmen concerning faith in relation to reason. The method and matter of these debates were formularized in the philosophy of "scholasticism."

The *method*—inaugurated by Abelard—was to arrive at proofs of the *matter*, that is, the central dogmas of the Christian faith, by argument, or *disputatio*. In accordance with the method, a possibility was stated, one authoritative view was cited in objection, the solution (a reconciliation of positions) was given, and finally a reply was given to each of the original arguments, all now rejected.

The greatest exponent of this systematic procedure—applied not only in theology but in the study of law—was Saint Thomas Aquinas, a Dominican monk. Aquinas, who was born in Italy, was a pupil of the German Schoolman Albertus Magnus and was an influential teacher at the University of Paris (note the cosmopolitan aspects of his career). Illustrative of the scholastic method is his treatise, the *Summa Theologica*, which was laid out into books, the books into questions, the questions into articles, each article into objections with contradictions and responses, and, as we have noted, final answers to the objections. Within

this framework the shrewdest and subtlest theological and philosophical arguments of the Middle Ages were advanced by scholars of all countries, by secular clergy, Dominicans, Franciscans, and laymen. The habit of mind created lasted for centuries, and scholasticism is still accepted as the philosophy of the Catholic Church.

NOTRE-DAME AND THE CULT OF THE LADY Paris was not just the center of systematic thought; the art of music was cultivated there, and the musical school of Notre-Dame led Europe in the development of polyphonic sacred song. It was fitting that music celebrating Our Lady should be composed and performed in the great church dedicated to her and situated in the Île de la Cité where royal France was born. Secular music, sung by the *trouvères* (minstrels), complimented the sacred love of Our Lady by praising the worldly love of woman and the pursuit of that love as the worthy occupation of the chivalrous knight.

Romanesque society had been dominated by men. In Gothic society, women assumed a more important role. The trouvères, the northern counterpart to the troubadours of the south, ceased singing the deeds of heroes in war and made their subjects love, beauty, and the yearnings of springtime. Eleanor of Aquitaine introduced the minstrelsy of her native south to the courts of her royal husbands. She was among the first to rule over a "court of love," in which courteous respect for women was prerequisite. The code of chivalry that so decided social relationships in the later Middle Ages was to emanate from courts such as this.

The monastic prejudice against women no longer determined their representation in art. In the twelfth century, *luxuria,* sensual pleasure, is represented at Moissac as a woman with serpents at her breasts; in the thirteenth century, *luxuria* is a pretty girl looking into a mirror. The Gothic upper classes turn almost with relief from the *chansons de geste* (epic song) to the new amorous songs and romances, in which such immortal lovers as Tristan and Isolde are celebrated. Marie de France, herself a noblewoman, introduced this tale, along with many other new Arthurian legends, to northern French feudal society. The poetry of the times nicely illustrates the contrast between Romanesque and Gothic taste and mood: in the Romanesque *Song of Roland,* the dying hero waxes rhapsodic over his sword, but the German minnesinger of the Gothic period, dreaming in a swooning ecstasy of his lady, is "woven round with delight."

The love of woman, celebrated in art and formalized in life, received spiritual sanction in the cult of the Virgin Mary, who, as the Mother of Heaven and of Christ and in the form of Mother Church, loved all her children. It was Mary who stood compassionately between the Judgment seat and the horrors of Hell, interceding for all her faithful. Worshipers in the later twelfth and thirteenth centuries sang hymns to her, put her image everywhere, and dedicated great cathedrals to her. Her image was carried into

battle on banners, and her name sounded in the battle cry of the king of France: "Ste. Marie . . . St. Denis . . . Mont-joie!" Mary became the spiritual lady of chivalry, and the Christian knight dedicated his life to her. The severity of Romanesque themes stressing the Last Judgment yields to the gentleness of the Gothic, in which Mary is represented crowned by Christ in Heaven.

SAINT FRANCIS OF ASSISI AND SAINT LOUIS OF FRANCE
It was not only the new position of women, the lyrical and spiritual exaltation of love, or the cult of the Virgin that softened barbarous manners. In concert with the new mood was the influence of a remarkable man, Saint Francis of Assisi, who saw Christ not as the remote and terrible judge but as the loving Savior who had walked among men and himself had been one of the "rejected of men." The series of reform movements that made up the history of medieval monasticism culminated in Saint Francis's founding of the religious order that bears his name—the Franciscans. Saint Francis felt that the members of his order should shun the cloistered life and walk the streets of the busy cities as mendicants, preaching the original message of Christ—the love of oneself and one's neighbor. Shortly after Francis's death and against his wish that his followers never settle in monasteries, the Franciscans commenced the great basilica built in his name at Assisi. The historical importance of the Franciscan movement lies in its strengthening of religious faith, its stimulating of the religious emotion among people in cities, and its weakening of the power and influence of the old, Romanesque, country abbeys. Saint Francis could be said to have brought a kind of democracy to religion in Europe at the expense of the feudal establishment.

The moral influence of Saint Francis was matched by that of Saint Louis—Louis IX, king of France (1226–1270). The saintly monk and the saintly king together personified the ideal union of the spiritual and the temporal worlds that inspired the cultural achievements of the thirteenth century. In his own time, before his death and subsequent canonization (1297), Louis was revered for his piety, justice, truthfulness, love of his people, and protection and support of the poor. As a crusading knight he was a model of the chivalric virtues of courage, loyalty, and self-sacrifice. These, added to the virtues of the good king, were extolled by his vassal and firm friend, Jean de Joinville, in his chronicle of Saint Louis:

> In the name of God Almighty, I, Jean, lord of Joinville
> seneschal of Champagne, dictate the life of our holy King
> Louis; that which I saw and heard in the space of six years
> that I was in his company on pilgrimage overseas, and
> that which I saw and heard after our return. And before I
> tell you of his great deeds, and of his prowess, I will tell
> you what I saw and heard of his good teachings and of his
> holy words. . . .

Thus the virtues of the chivalrous knight and those of the holy man meet in the person of the good king, a union long theorized and hoped for in the preceding centuries of conflict between the spiritual and the temporal powers. Saint Louis becomes the model of medieval Christian kingship.

Louis's accomplishments were many. He subdued the unruly French barons, so that between 1243 and 1314 there was no real challenge to the crown. He brought Languedoc into royal France without further violence. He made peace with the traditional enemy, England. He was a man of peace, and such was his reputation for integrity and just dealing that he was appealed to as arbiter in at least a dozen international disputes. So successful was he as peace-keeper that despite civil wars through most of the thirteenth century, international peace prevailed. France was at its most prosperous, and its identity and prestige were largely due to the almost universal respect for its king.

At home, Louis was loved by his people for his scrupulous administration of justice and for his endless generosity in support of the poor. His alms-giving and his donations to religious foundations and houses were extravagant. He especially favored the mendicants, the Dominicans, Franciscans, and the numerous orders branching from them. He admired their poverty, piety, and self-sacrificing disregard of material things.

The thought, energy, and wealth lavished so generously by Saint Louis in the interest of religion expressed the new spiritual vitality that was reforming the Church. It was part of the vast expenditure of human resources that was building the world of Gothic art, the glory of thirteenth-century France. Indeed, in a valedictory passage, Joinville compares the glory wrought by the charitable endowments of the crown to a work of art:

> A piteous thing, and worthy of tears, is the death of this
> saintly prince, who kept and guarded his realm with such
> sanctity and loyalty, and gave alms there so largely, and
> set therein so many fair foundations. And like as the scribe
> who, writing his book, illuminates it with gold and azure,
> so did the said king illuminate his realm with the fair
> abbeys that he built, and the great number of almshouses,
> and the houses for Preachers [Dominicans] and
> Franciscans, and the other religious orders we have
> named.

The thirteenth century represents the summit of achievement for unified Christendom: the triumph of the papacy; a successful and inspiring synthesis of religion, philosophy, and art; and the first firm formation of the states that will make modern history, foremost among them, the France of Saint Louis. The scene of this great but brief equilibrium of forces favoring religion is the Gothic city; within the city, the soaring cathedral, "flinging its passion against the sky," asserts the nature of the Gothic spirit.

EARLY GOTHIC

Architecture

On June 11, 1144, Louis VII of France, Eleanor of Aquitaine (his queen), members of the royal court, and a host of distinguished prelates, including five archbishops, as well as a vast crowd, converged on the royal abbey of St.-Denis, just a few miles north of Paris, for the dedication of the new choir. This choir, with its crown of chapels radiant with stained-glass windows, set a precedent that the builders in the region surrounding Paris, the Île-de-France, were to follow for the next half century.

Two eminent persons were particularly influential in the formation of the Gothic style: Saint Bernard of Clairvaux and Suger, abbot of St.-Denis. Saint Bernard held the belief that faith was mystical and intuitive rather than rational. In his battles with Abelard, he upheld this position with all the persuasiveness of his powerful personality and elo-

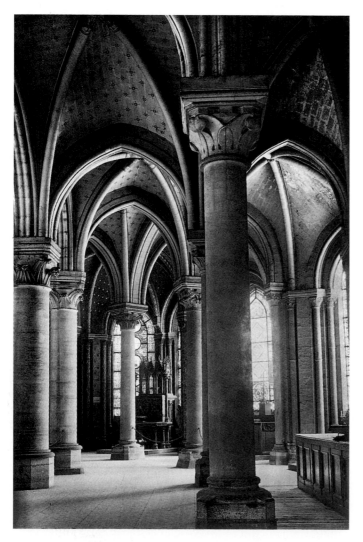

13-1 Ambulatory and radiating chapels of the abbey church of St.-Denis (near Paris), 1140–1144.

quence and by the example of his own holiness. The Cistercian churches that were being built under Saint Bernard's influence reflected his theology, stressing purity of outline, simplicity, and a form and lighting peculiarly conducive to meditation.

Although Saint Bernard denounced lavish decoration and elaborate architecture, the Gothic style was initiated by a fellow abbot who, accepting Bernard's admonitions to reform his monastery, built his new church in a style that surpassed the Romanesque in splendor. The fellow churchman was the Abbot Suger, who had risen from humble parentage to become the right-hand man of both Louis VI and Louis VII, and, during the latter's absence in the Second Crusade, served as regent of France. From his youth, Suger wrote, he had dreamed of the possibility of embellishing the church that had nurtured him, the Royal Church of France, within the precincts of which its kings had been buried since the ninth century. It was in fact his intention to confer authority on the claims of the kings of royal France to the territory we recognize as France today, for, in Suger's time, the power of the French king, except for scattered holdings, was confined to an area not much larger than the Île-de-France. Thus, Suger's political role and his building role were one: he sought to construct a kingdom and an architectural expression of it. In 1122, he was elected abbot of St.-Denis and, within fifteen years, was at work rebuilding the old monastery, which had been in use for almost three centuries. As he made his plans for the new building, he must have recalled many of the churches seen during his travels, and the workmen and artists who labored to raise the church were summoned from many regions. St.-Denis, one of the last great abbey churches to be built, became the monastic inspiration for the city cathedrals and is known as the cradle of Gothic art.

Suger described his new choir at St.-Denis (FIG. **13-1**) as follows:

> [I]t was cunningly provided that—through the upper columns and central arches which were to be placed upon the lower ones built in the crypt—the central nave of the new addition should be made the same width, by means of geometrical and arithmetical instruments, as the central nave of the old [Carolingian] church; and, likewise, that the dimensions of the new side-aisles should be the same as the dimensions of the old side-aisles, except for that elegant and praiseworthy extension . . . a circular string of chapels, by virtue of which the whole [church] would shine with the wonderful and uninterrupted light of most luminous windows, pervading the interior beauty.*

The abbot's description is a key to the understanding of Early Gothic architecture. As he says, the major dimensions

*Erwin Panofsky, trans., *Abbot Suger on the Abbey Church of St.-Denis and Its Art Treasures* (Princeton, NJ: Princeton University Press, 1951), 101.

The ancestors of the Gothic rib vault were found at Caen and Durham. A rib vault is identified easily by the presence of crossed, or diagonal, arches under the groins of a vault. These arches form the armature, which serves as the framework for Gothic skeletal construction. The Gothic vault may be distinguished from other rib or arched vaults by its use of the pointed, or broken, arch as an integral part of the skeletal armature, by the presence of thinly vaulted webs, or *severies*, between the arches, and by the fact that usually, regardless of the space to be vaulted, the crowns of all the arches are at approximately the same level—something the Romanesque architects could not achieve with their semi-circular arches (FIG. **13-4**). Thus, a major advantage of the Gothic vault is its flexibility, which permits the vaulting of compartments of varying shapes, as may be seen readily in the plan of the choir of St.-Denis and in many other Gothic choir plans. Moreover, although it does not support the webs entirely, the Gothic armature allows the builder to

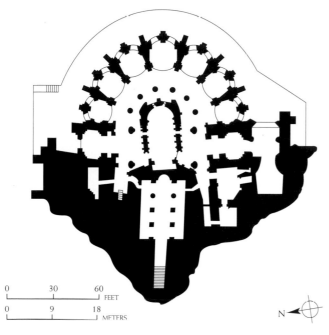

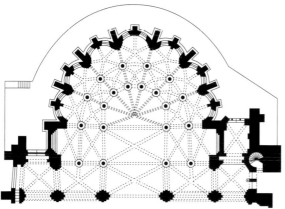

13-2 Plans of the crypt (*top*) and choir (*bottom*) of St.-Denis. (After Sumner Crosby.)

of the structure were dictated by an older church, but it was the "elegant and praiseworthy extension"—the "string of chapels" with "luminous windows"—that proclaimed the new style.

Although the *crypt* (a vaulted space underneath a building) at St.-Denis served as a foundation for the choir above it, a comparison of their respective plans and structures (FIG. **13-2**) reveals the major differences between Romanesque and Gothic building. The thick walls of the crypt create a series of separate volumes (a careful Romanesque "partitioning" into units), whereas the absence of walls in the choir above produces a unified space. The crypt is essentially a wall construction, and it is covered with groin vaults; the choir, on the other hand, is a skeleton construction, and its vaults are Gothic rib vaults (FIG. **13-3**).

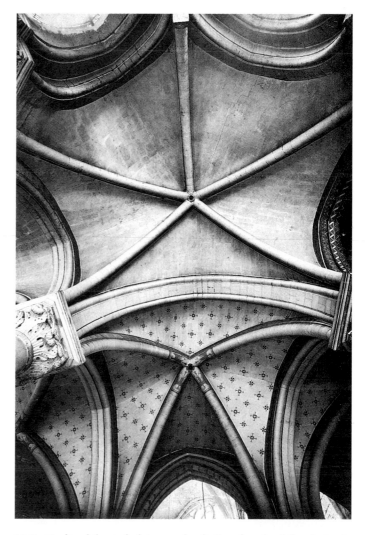

13-3 Vaults of the ambulatory and radiating chapels of the choir of St.-Denis.

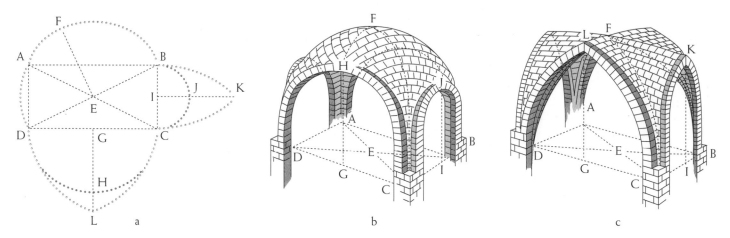

13-4 The Gothic rib vault and the domical vault differ in ways that derive from the fact that they are based on the pointed arch and the semi-circular arch, respectively. Diagram **a** illustrates this: *ABCD* is an oblong bay to be vaulted; *AC* and *BD* are the diagonal ribs; *AB* and *DC,* the transverse arches; and *AD* and *BC,* the wall arches. If semicircular arches (the dotted arcs) are used, their radii, and therefore their heights (*EF, GH,* and *IJ*), will be different. The result will be a domical vault (diagram **b**), irregular in shape and difficult to light. If pointed arches are used, the points (and hence the ribs) can have the same heights (*IK* and *GL*). The result will be a Gothic rib vault (diagram **c**), a lighter, more flexible system than the domical vault, affording ample space for large clerestory windows.

predetermine the alignment and concentration of thrusts to be buttressed (FIG. **13-5**).

Despite the fact that the medieval mason unquestionably derived great satisfaction from his mastery of these technical problems and at times must have been preoccupied with them, he did not permit them to be an end in themselves. The ambulatories and chapels at St.-Denis are proof that the whole church "would shine with . . . wonderful and uninterrupted light." This concept was, in medieval terms, the *scientia,* or the theory, and it was *ars,* or technical knowledge and practical skill, that made it possible. The difference between the two was akin to the difference between modern physics and engineering; when a medieval architect spoke of the "art of geometry," he meant not the abstract nature of geometric forms, but the practical uses to which mathematical formulations might be put in designing a piece of sculpture or in erecting a building. An understanding of Gothic architecture will not be reached, however, by trying to decide whether Gothic architects predominantly were concerned with ars or with scientia, but rather by realizing that the cathedrals were the result of both. And it is in the stones themselves—in the extraordinary sensitivity of the Gothic mason for stone as a building material—that the spirit of Gothic architecture is to be discovered. What still stands of Gothic is a monument to the supreme skill, persistence, and vision of its architects.

SYSTEM IN ARCHITECTURE AND PHILOSOPHY The ingenious planning and construction of Abbot Suger's new choir, the work of the anonymous "Master of St.-Denis," is contemporary with and analogous to the achievement of Peter Abelard; the first Early Gothic building parallels the first stage of Scholastic philosophy. Both originated in the same

milieu, Paris and its environs, at the time when the Capetian kings of France began their effective rule. Like that rule, Gothic building and Scholastic thought began their widespread influence.

Not that the two great disciplines were aware of each other. There is no evidence that the builders frequented the schools, or that the scholars consorted with the builders. What links them recognizably is a novel and shared instinct for systematic design and procedure.* In both architectural and philosophical thinking, a more-or-less flexible system is invented by which knowledge can be organized and applied to the solution of the special problems of each discipline. These solutions, whether made out of stone or out of sentences, are intended to be stable, coherent, consistent, and structurally intelligible. A flexible system, open to experiment, sets its own parameters, or defining limits, within which a characteristic style of design and method of execution can be widely elaborated and adopted.

The prelates who attended the dedication of the new choir at St.-Denis in 1144 must have found the event and the monument equally memorable. The event bonded them to their royal patron and protector, Louis VII, who like themselves had been anointed to holy office—in his case the monarchy—and in whose person was represented the identity, unity, and authority of the realm of France, small as it then was. The monument, dedicated to St. Denis,

*The appearance of this new passion for systematization can be compared in its scope and influence with what happens in the seventeenth century, when a mature mathematics was applied to physical experimentation and produced the universal science of physics; or, in the twentieth century, when electronic physics, information theory, and the computer transform the way we think about the world, even the way we live in it.

the spiritual patron of France, was his shrine as well as that of the monarchy. Its new design must necessarily have been associated with the royal cult of St.-Denis and a religious as well as political allegiance to the throne. That such association must have been perceived and remembered by the bishops and archbishops who were present at the dedication is attested by the fact that they and their successors rebuilt old churches or built new ones in no other style than that of the choir of St.-Denis.

In the inauguration of a church-building program, the bishops and their cathedral chapters would be in consulta-

tion with master masons (whom we now for convenience may call "architects"); we have noted Gervais's account of the conferences of the monks of Canterbury with William of Sens. In these conferences the specifications would be spelled out—the particular liturgical requirements for the allocation of space, distribution of light, the particulars of the elevations, and so forth. The architects would take over from there. They would, of course, be aware of the new work at St.-Denis, and, in any case, the prelates would have commissioned them to build in the St.-Denis fashion. The architects could be sure that as intercommunicating

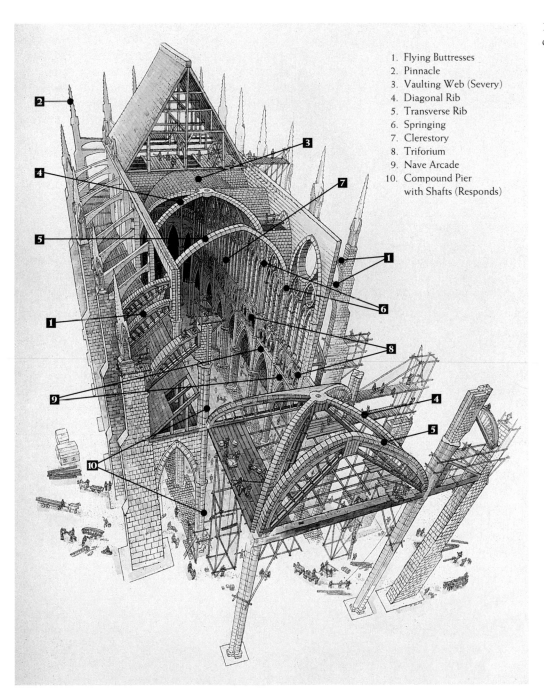

1. Flying Buttresses
2. Pinnacle
3. Vaulting Web (Severy)
4. Diagonal Rib
5. Transverse Rib
6. Springing
7. Clerestory
8. Triforium
9. Nave Arcade
10. Compound Pier with Shafts (Responds)

13-5 Construction of a Gothic cathedral.

professionals, they would be working in the same direction, experimenting with the same elements, and arriving at similar results. As we have generalized the process—they would be working within a system of plans and structures that had manifold possibilities. In what follows we shall describe in some detail the features of this system as they emerge from the experimentation of the builders.

This experimentation is a continuing adjustment of scale, proportion, buttressing, vault arrangement, and wall and facade design. Only the choir and narthex of St.-Denis were completed in the twelfth century; for a fairly complete view of the Early Gothic style of the second half of the century, one must turn to Laon Cathedral (figs. **13-6** to **13-9**). Begun about 1160 and completed shortly after 1200, this building retains many Romanesque features but combines them with the new Gothic structural devices of the rib vault and the pointed arch. Shortly after the building's completion, the choir was enlarged, and the present plan, relatively long and narrow with a square east end, has a decidedly English flavor.

Among the plan's easily discernible Romanesque features are the strongly marked-off crossing square and the bay system, composed of a large unit in the nave flanked by two small squares in each aisle (FIG. 13-6). The nave bays are defined by sexpartite rib vaults and an alternate-support system that, in combination, continue the Romanesque tradition of subdividing the interior into a

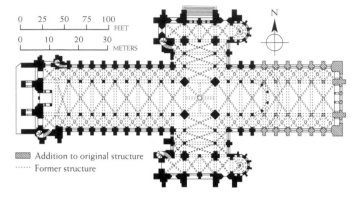

Addition to original structure
Former structure

13-6 Plan of Laon Cathedral, France, *c.* 1160–1205. Choir extended after 1210. (After E. Gall.)

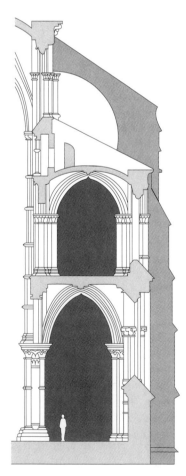

13-7 Section through the aisle, gallery, triforium, and clerestory of Laon Cathedral. (After E. Gall.)

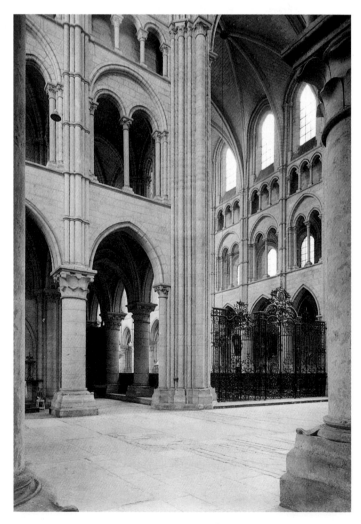

13-8 Laon Cathedral (view into the choir from the north transept).

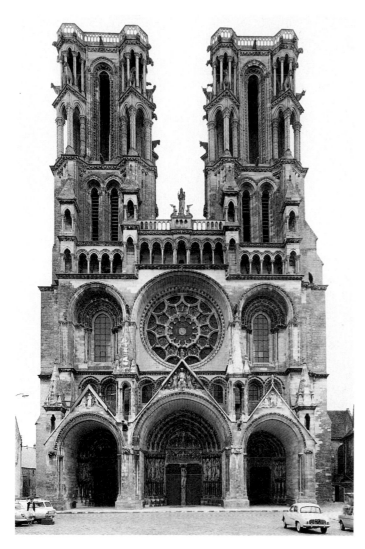

13-9 West facade of Laon Cathedral, begun *c.* 1190.

the main wall supports (FIG. 13-8). It appears that the Laon architect no longer is completely happy with the compartmentalized effect of Romanesque interiors, which tends to make visitors pause as they advance from unit to unit. Gothic builders aim, as yet rather timidly at Laon, to create an integrated, unified interior space that sweeps uninterruptedly from west to east. The alternate-support system, hugging the ground in Ottonian times and rising to dominate nave walls in northern Romanesque, has lost its footing at Laon and, like the solid masonry of Romanesque walls, is about to evaporate.

Important changes in the design of the church exterior were also part of the Early Gothic experience. At Laon, the doorways (under protective porches) and the towers have been treated as integral parts of the mass of the building (FIG. 13-9). The interior stories are reflected in the levels into which the facade was to be regulated in later designs. Typically Gothic are the deep embrasures of the doorways and windows and the open structure of the towers. A comparison of the facades of Laon and St.-Étienne at Caen (FIG. 12-13) reveals how deep the penetration of the mass of the wall has become. Here, as in Gothic architecture generally, the operating principle is one of the reduction of sheer mass by its replacement with intricately framed voids.

Laon has a pair of towers flanking each arm of the transept (only two were actually completed) and a lantern tower over the crossing, which, with the two western towers, gives a total of seven, the perfect mystic number (composed of three and four, it represents the Trinity and the four Evangelists or the Gospels). This complement of towers was the Early Gothic ideal and continued the German Romanesque tradition of multiple integrated towers. Rarely, however, did building funds suffice for the completion of all towers. Even the facade towers of French cathedrals seldom were finished; most, including those of Laon, lacked the crowning spires planned for them. Eventually, the massed towers of the east end were omitted from building plans, and the Norman two-tower facade became the French High Gothic standard.

Transept towers were not part of the plan for the cathedral of Paris, the renowned Notre-Dame (FIG. **13-10**). Thus, this essentially Early Gothic building has a High Gothic silhouette in which only the slender crossing spire interrupts the long horizontal roof line that extends eastward behind the massive facade towers (FIG. 13-11). Notre-Dame of Paris, begun in 1163, only a few years after Laon, embodies a fascinating mixture of conservative and progressive ideas. Choir and transept were completed by 1182; the nave, by 1225; and the facade by 1250. The plan (FIG. **13-12**) shows an ambitiously scaled, five-aisled structure in which a Romanesque bay system is combined with Early Gothic sexpartite nave vaulting. The original transept was short and did not project beyond the outer aisles. The original nave wall elevation had four parts, in the Early Gothic manner, with a triforium in the form of a series of rosettes.

number of separate compartments. Both features, as well as the gallery above the aisles, have been derived from Norman Romanesque architecture, which enjoyed great prestige in northern France throughout the twelfth century (FIGS. 12-14 and 12-15). A new feature of the interior, however, is the *triforium,* the band of arcades below the clerestory that occupies the space corresponding to the exterior strip of wall covered by the sloping timber roof above the galleries. The triforium expresses a growing desire to break up and eliminate all continuous wall surfaces. Its insertion produces the characteristic Early Gothic nave-wall elevation of four parts: nave arcade, gallery, triforium, and clerestory (FIGS. 13-7 and 13-8).

At Laon, the alternate-support system is treated less emphatically than in other Early Gothic churches (Sens or Noyon, for example). It is not reflected in the nave arcade (although colonnettes [small columns] were added to a few of the columns as an afterthought), as alternating bundles of three and five shafts have their origin above the level of

The building was extensively modified shortly after it was completed. Between 1225 and 1250, chapels were built into the spaces between buttresses, and in 1250 the transept arms were lengthened. At the same time—possibly as the result of a fire (according to Viollet-le-Duc, the cathedral's nineteenth-century restorer), but in greater likelihood, to admit more light into the nave—changes were made in the nave wall (the bays adjacent to the crossing were redone by Viollet-le-Duc). By this time, the nave of Chartres Cathedral (FIG. 13-18) had been completed and had rendered Early Gothic galleries and four-level wall elevations obsolete. As the galleries of Notre-Dame had already been built, the "modernization" of the nave there had to be a compromise. The clerestory windows were lowered to the top of the gallery by suppressing the rosettes of the triforium. This alteration, in turn, required that the gallery roof be lowered and redesigned. The solution was a pitched roof with one slope inclined toward the nave wall, creating a difficult drainage problem that was solved only in the nineteenth century, when Viollet-le-Duc designed a single-slope roof to throw the water outward.

Like the interior, the facade of Notre-Dame (FIG. 13-10) seems to waver between the old and the new. Begun after the Laon facade had been completed, it appears to be much more conservative and, in the preservation of its "mural presence," more closely related to Romanesque than to High Gothic facades. From the modern observer's point of view, this may be one of its great assets. Less perforated and more orderly than that of Laon, Notre-Dame's facade projects a sense of strength and permanence that is lacking in many contemporary and later designs. Careful balancing of

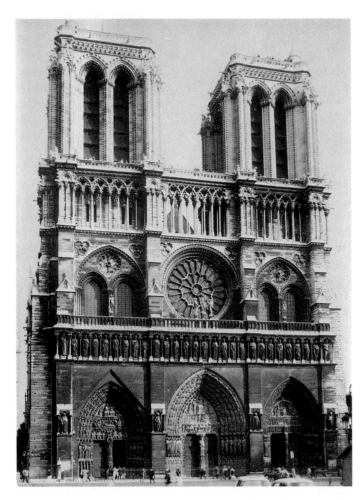

13-10 West facade of Notre-Dame, Paris, begun *c.* 1215.

13-11 South flank of Notre-Dame, Paris.

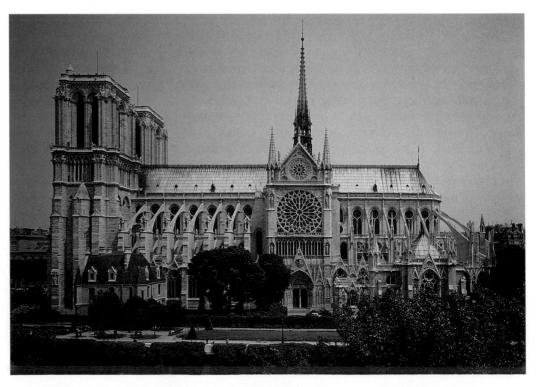

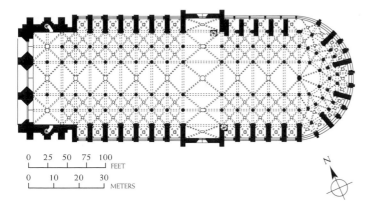

13-12 Plan of Notre-Dame, Paris. (After Frankl.)

The three west portals of Chartres, treated as a unit, proclaim the majesty and omnipotence of Christ. His Birth, the Presentation at the Temple, and Christ in Majesty with the Virgin Mother are shown on the right portal; Christ's Ascension into Heaven is shown on the left portal. Scenes from his life and from the Passion are carved vividly on the capitals, which continue as a frieze from one portal to the next. The Second Coming is depicted on the central portal. Christ is surrounded by the Signs of the Four Evangelists, and the Twelve Apostles are shown below, seated as representing the corporate body of the Christian Church. The Second Coming—in essence, the Last Judgment theme—remains centrally important, as in the Romanesque works we have seen, which are only twenty years older than the west portals of Chartres. Here, however, this theme has

vertical against horizontal elements has achieved a quality of restful stability that makes this facade one of the most satisfying and memorable in Gothic architecture.

While the new Gothic style was developing in northern France, the regional Romanesque style prevailed in the south of France and in most of Europe. We have seen the Romanesque Church of St.-Trophîme at Arles (FIG. 12-34), which, like its neighbor St.-Gilles-du-Gard, reflects ancient Roman architectural motifs, such as the gabled portico and triumphal arch. This region of the lower Rhône valley is crowded with remnants of Roman monuments, some of which, such as the Pont du Gard near Nîmes (FIG. 7-36), the Maison Carrée at Nîmes (FIG. 7-35), and the triumphal arch at Orange (not discussed in this text) are very well preserved. The classicizing Romanesque style in Italy (FIG. 12-21) almost can be regarded as an anticipation of the classicizing Renaissance style to come.

Sculpture

Gothic sculpture makes its first appearance in the Île-de-France and its environs with the same dramatic suddenness as Gothic architecture and, it is likely, in the very same place—the abbey church of St.-Denis. Almost nothing of the sculpture of the west facade of St.-Denis survived the French Revolution, but it was there that sculpture emerged completely from the interior of the church to dominate the western entrances, which were regarded as the "gateways to Heavenly Jerusalem" and the "Royal Portal."

The Royal Portal, so named because of the statues of kings and queens on the embrasures flanking the doorways, is typified by the west portals of Chartres Cathedral (FIGS. **13-13** to **13-15**), carved between 1145 and 1170. The lower parts of the massive west towers at Chartres and the portals between them are all that survived of an Early Gothic cathedral that was destroyed in a disastrous fire in 1194 before it had been completed. The cathedral was reconstructed immediately, but in the High Gothic style. The portals, however, constitute the most complete and impressive corpus of Early Gothic sculpture.

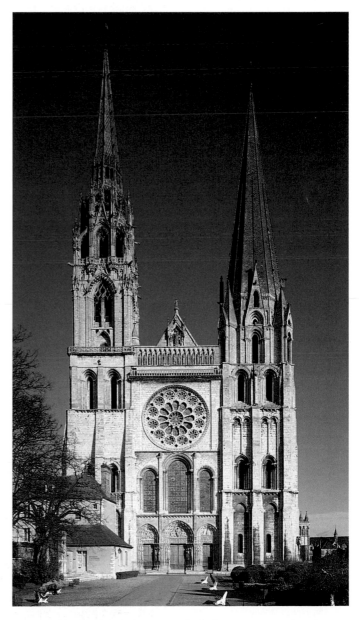

13-13 West facade of Chartres Cathedral, France, c. 1145–1170.

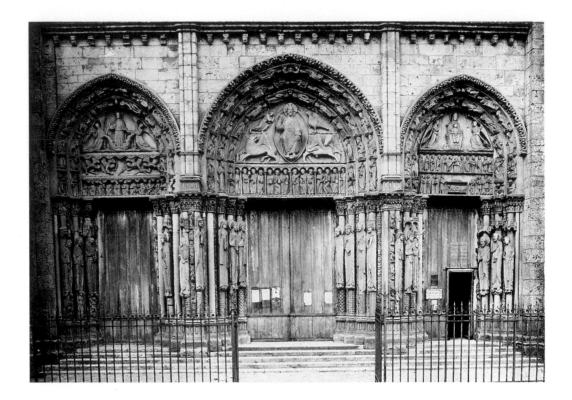

13-14 Royal (west) Portal of Chartres Cathedral.

become a symbol of salvation rather than damnation. It is, moreover, combined with other scenes and symbolic figures as part of a larger theme rather than a symbol of the dogma itself. In the archivolts of the right portal the seven liberal arts are shown. These represent the core of medieval learning and therefore are symbolic of man's knowledge, which will lead him to the true faith. The signs of the zodiac and scenes representing the various labors of the months of the year are carved into the left-portal archivolts as symbols of the cosmic and terrestrial worlds. Around the central tympanum appear the twenty-four elders of the Apocalypse, accompanying the Second Coming. Decorating the multiple jambs flanking each doorway are the most striking figures: the great statues of the kings and queens of the Old Testament, the royal ancestors of Christ. The medieval observer undoubtedly also regarded them as the figures of the kings and queens of France, symbols of secular as well as of biblical authority. The unity of the triple portal in its message and composition complements the unity of the cathedral itself, which, in its fluent, uninterrupted, vast, and soaring space, compounds earth and Heaven in a symbol of the spiritually perfected universe to come.

The jamb statues are among the few original forms of architectural sculpture to have appeared in any age. At first glance, in their disregard of normal proportions and their rigid adherence to an architectural frame, they seem to follow many of the precepts of Romanesque architectural sculpture. Yet the differences are striking and important. The statues stand out from the plane of the wall; they are not cut back into it. They are conceived and treated as three-dimensional volumes. They move into the space of the observer and participate in it with him. Most significant of all is the first trace of a new naturalism: drapery folds are no longer calligraphic exercises translated into stone; they now either fall vertically or radiate naturally from their

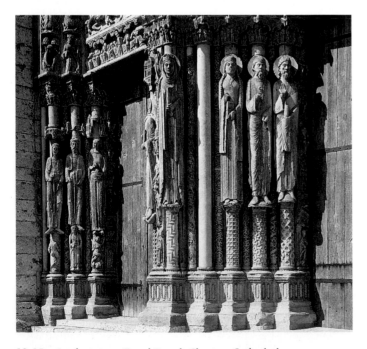

13-15 Jamb statues, Royal Portal, Chartres Cathedral.

points of suspension. Although carefully arranged in regular patterns, these folds suggest that the artist is no longer copying painted images but that actual models have been used here.

This observation is true particularly of the figures flanking the central doorway (some appear in the right foreground of FIG. 13-15), which are the work of the anonymous "Headmaster," the artist in charge of the overall design and decoration of the portals. The advanced nature of his style becomes noticeable especially when his figures are compared with those on the outside jamb of the lateral portal (left background in FIG. 13-15), which evidently were carved by a different, perhaps older, and certainly more conservative artist. The latter's approach still is rooted deeply in the Romanesque tradition. His figures seem more agitated; their silhouettes are curvilinear and broken. The drapery folds are treated decoratively and, here and there, continue to rotate in abstract swirls. Only the windblown lower garment edges, characteristic of much Romanesque sculpture, have come to rest—reluctantly, it seems, and perhaps at the Headmaster's insistence. Even so, the figures fail to adjust themselves as neatly to their architectural setting as do the Headmaster's statues, which—although they have stepped out of the wall and have become corporeal—are severely disciplined and have been rigorously subordinated to their architectural background. Seen from a distance, they appear to be little more than vertical, decorative accents within the larger designs of portals and facade (FIG. 13-14). And yet, within and despite this architectural straitjacket, the incipient naturalism has softened the appearance of the figures. This softening is noticeable particularly in their faces, in which the masklike features of the Romanesque can be seen being converted into human likenesses. A personalizing naturalism has begun that will become transformed first into idealized portraits of the perfect Christian and finally into the portraiture of specific individuals.

During the early twelfth century, great changes were taking place in Western humanity's view of itself, especially with respect to the relation of body and soul. Previously, the old Augustinian view had prevailed. The essence of the soul was completely unlike that of the body: the soul was spiritual and immortal; the body was material and subject to corruption. With the rediscovery of the main works of Aristotle, people gradually came to believe that the soul and the body are closely interrelated; they believed that the body is the *form* of the soul, and that, therefore, the body no longer is to be despised as merely the corruptible prison of the soul from which it is released only when the body dies. One scholastic philosopher saw the soul and the body as meeting and that union as responsible for the personality of the individual. Another saw the soul as ruling the body but also cherishing its prison. These views, in which the body is seen as coming into its own, reflected a universally changing outlook. John of Salisbury (*c.* 1110–1180),

the great English scholastic, and pupil of Abelard, took the perhaps radical view that the soul is stimulated and acted on by sensations from the world, rather than inspired and moved by entirely spiritual principles. He even declared that some of the principal problems of scholastic philosophy could be solved by psychological examination of the way people think. The West was now speaking with a new voice: souls must be manifested through bodies—the individual bodies of men and women. Thus, the new, individualized heads of Chartres herald an era of artistic concern with the realization of personality and individuality that may only now, in our times, be terminating. The figures of the Royal Portals of Chartres hold a place analogous to the works of Greek artists in the late sixth century B.C.; they turn the corner into a historical avenue of tremendous possibility.

HIGH GOTHIC
Architecture

The new Chartres Cathedral, as rebuilt after the fire of 1194 and largely completed by 1220, is usually considered to be the first of the High Gothic buildings—the first to have been planned from the beginning for the use of flying buttresses.

The flying buttress, that exceedingly useful and characteristic Gothic structural device, seems to have been employed as early as 1150 in a few smaller churches and by about 1180 for the bracing of the nave of Notre-Dame in Paris and, shortly thereafter, at Laon. A section through Laon Cathedral (FIG. 13-7) shows how the flying buttress (lightly shaded at top right) reaches across the lower vaults of aisle and gallery and abuts the nave walls at the points at which the vaults exert their major thrusts. Similar methods for strengthening the walls of vaulted naves already had been used in Romanesque architecture, but there the buttresses were concealed under the aisle roofing. Now, they are left exposed in a manner that has been both condemned as "architectural crudity" and praised as "structural honesty."

An aerial view of Chartres Cathedral (FIG. **13-16**) shows that a series of these highly dramatic devices has been placed around the *chevet* (the east, or apsidal, end of the church), thus supporting the vaults with permanent arms, like scaffolding left in place. With the mastery of this structural form, the technical vocabulary of Gothic architecture became complete. The buttress eliminates the need for Romanesque walls and permits the construction of a self-consistent and self-supporting skeletal structure (FIG. 13-5). The Chartres architect was the first to arrive at this conclusion and to design his building accordingly.

At Chartres, after the great fire, the overall dimensions of the new structure were determined by the facade left standing to the west and by the masonry of the crypt to the east. For reasons of piety and economy, the crypt—the

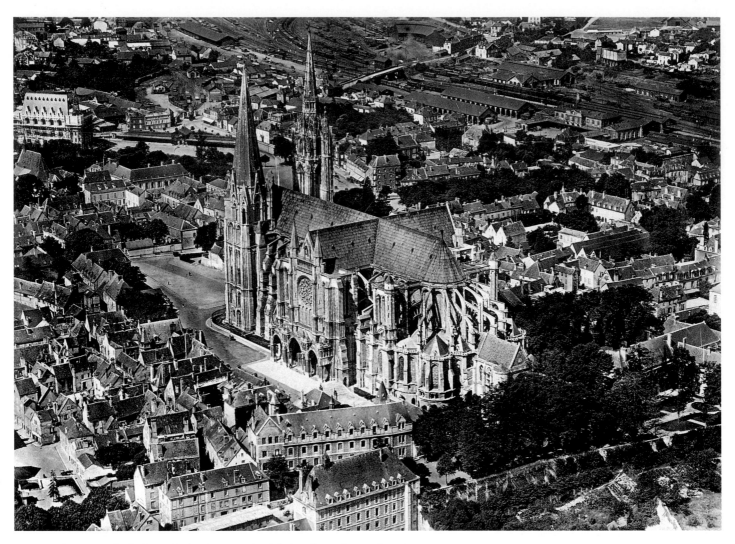

13-16 Chartres Cathedral, as rebuilt after 1194 (aerial view from the southeast).

repository of the most precious relic of Chartres, the mantle of the Virgin—was used as the foundation for the new structure. The earlier forms did not limit the plan (FIG. **13-17**), however; it shows an unusual equilibrium between chevet, transept, and nave, which are almost equal in dimension. More importantly, perhaps, the plan reveals a new kind of organization. The last remnants of square schematism, still present in Early Gothic churches, have been replaced by a "rectangular-bay system" that will become the High Gothic norm. Now a rectangular unit in the nave, defined by its own vault, is flanked by a single square in each aisle. This new bay arrangement was accompanied by a change in vault design. The new High Gothic vault, which covers a relatively smaller area and therefore is braced more easily than its Early Gothic predecessor, has only four panels. The visual effect of these changes is to decompartmentalize the interior (FIG. **13-18**); identical units have been aligned so that they are seen in too rapid a sequence to be discriminated as individual volumes of space. The alternate-support system, of course, is gone, and

the nave, although richly articulated, has become a vast, continuous hall, bounded not by opaque walls, but by stone-bonded screens of glass.

The organic, "flowing" quality of the High Gothic interior was enhanced by a new nave-wall elevation, which admits more light to the nave through greatly enlarged clerestory windows. The use of flying buttresses made it possible to eliminate the tribune gallery above the aisle, which had partially braced Romanesque and Early Gothic naves. The new, High Gothic, tripartite nave elevation, consisting of arcade, triforium, and clerestory, emphasizes the large clerestory windows; those at Chartres are almost as high as the main arcade. A comparison of the elevations of Laon and Chartres (FIG. **13-19**) illustrates the radical changes that could be achieved by logical application of the flying buttress, which had been used only tentatively at Laon.

Despite the vastly increased size of the clerestory windows, some High Gothic interiors remain relatively dark, largely due to the light-muffling effects of their colored

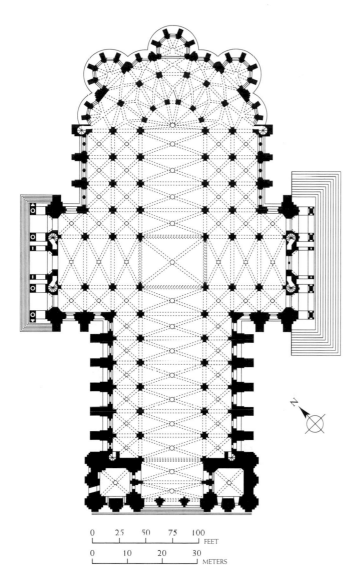

0 25 50 75 100
└────┴────┴────┴────┘ FEET
0 10 20 30
└──────┴──────┴──────┘ METERS

13-17 Plan of Chartres Cathedral. (After Frankl.)

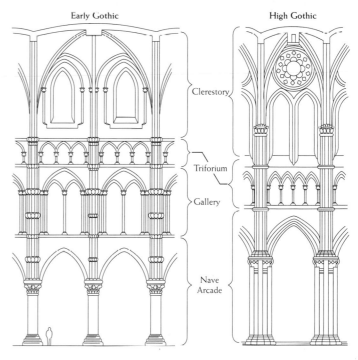

13-18 Nave of Chartres Cathedral (view facing east).

glass. Chartres has retained almost the full complement of its original stained glass, which, although it dims the interior, sheds a color-shot light of great beauty that has helped to make Chartres the favorite church of lovers of Gothic architecture.

Whatever the glory of Chartres, it had a contemporary rival in Bourges Cathedral (FIG. **13-20**), which, although it may lack the esthetic power of Chartres, may have been, to a degree, its superior in structural ingenuity, stability, and economy of means. The two buildings, begun at about the same time, were completely different yet satisfactory solutions to the problems of Gothic architectural design. As such, they offered architects two alternative models. The design of Chartres later was perfected at Amiens and Reims, and at Beauvais the first master architect conceived a kind of synthesis of Chartres and Bourges.

The plan of Bourges Cathedral (FIG. **13-21**) is strikingly different from that of Chartres Cathedral, resembling more

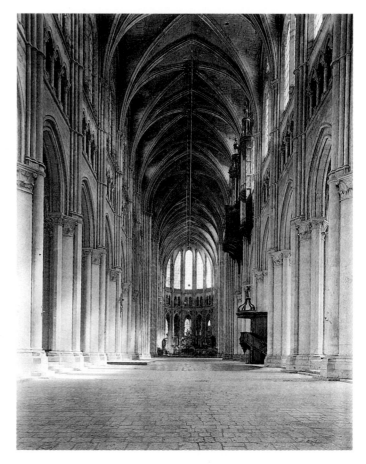

13-19 Elevations of the nave walls of the cathedrals of Laon (*left*) and Chartres (*right*), which is drawn to a smaller scale than the Laon elevation. (Umschau-Verlag, Frankfurt/Main.)

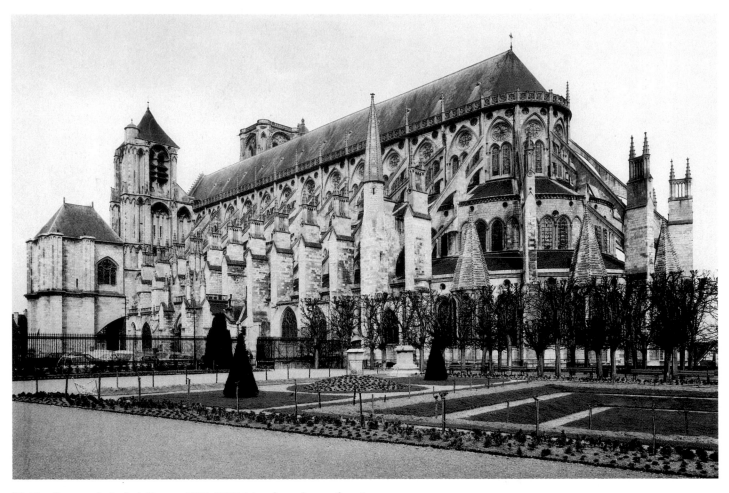

13-20 Bourges Cathedral, France, 1195–1255 (view from the southeast).

the plan of Notre-Dame in Paris (FIG. 13-12). At Chartres, the chevet, transept, and nave are of almost equal dimensions. At Bourges, the plan is continuous, eliminating the transept entirely, so that the double side aisles continue without interruption from the western facade around the choir to the east. The unity and sweeping continuity of the plan is furthered by the unusual elevation (FIG. **13-22**). Instead of one aisle on each side of the nave, Bourges has two; the inner one is higher and boasts its own clerestory, triforium, and arcade, all of which are visible through the nave arcade. The stepping upward of the heights of the side aisles to climax in the nave vaults and the restatement in the inner aisle (albeit on a smaller scale) of the three-part nave-wall elevation provide a rhythmic, vertical repetition of the distinctive High Gothic arrangement. At the same time, windows at three levels enhance the fluent opening of the space of the nave into the aisles by saturating the interior with a form-dissolving permeation of light—the goal of Gothic architecture.

The retention of older, Romanesque features at Bourges, like the sexpartite vaults, the alternate-support system (seen in the slight differentiation in the membering of alternate piers), and the small clerestory, does not reflect structural uncertainty. Modern engineering analysis of wind and dead-load stresses (necessary for the high-rise structures of today) show that the lighter and more open buttresses of Bourges transfer structural forces to the foundations more efficiently than the massive ones at Chartres; a pier buttress at Chartres is estimated to weigh one thousand tons, versus four hundred tons at Bourges, yet the stress levels for high winds have been shown to be equivalent. Nevertheless, the Chartres design, with its balanced, additive, and logical arrangements of plan and elevation, became the more influential of the two. At Bourges, the relationships of the parts were perhaps too elusive and individual to be grasped readily and applied widely as a standard.

The Cathedral of Amiens (FIGS. **13-23** to **13-26**) continued in the Chartrian manner and gracefully refined it. Amiens was begun in 1220, according to the designs of Robert de Luzarches. The nave was finished in 1236, and the radiating chapels were completed by 1247, but work on the choir continued until almost 1270. The facade (FIG. 13-23), slightly marred by uneven towers (the shorter

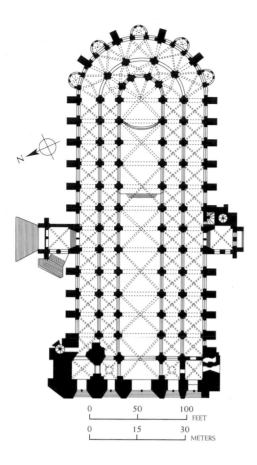

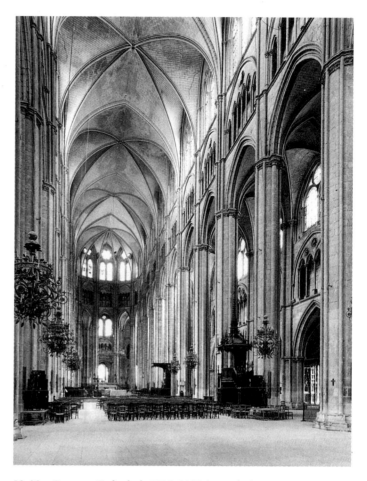

13-22 Bourges Cathedral, 1225–1250 (nave facing east).

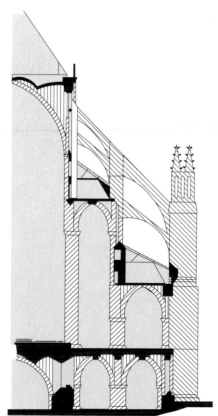

13-21 Plan (*top*) and section (*bottom*) of Bourges Cathedral.

dates from the fourteenth century, the taller from the fifteenth century), was begun at the same time as the nave (1220). Its lower parts seem to reflect the influence of the Laon facade in the spacing of its funnel-like and gable-covered portals. However, unlike Laon's, the Amiens portals do not project from the facade but are recessed behind the building's buttress-defined frontal plane. The upper parts of the facade, on the other hand, seem to be related to Notre-Dame in Paris, the rose window (with fifteenth-century tracery) being placed above the "king's gallery" and between double-arched openings in the towers. But the Amiens facade goes well beyond its apparent models in the richness and intricacy of its surface decoration. The deep piercing of walls and towers seems to have left few continuous surfaces to be decorated, but the ones that remain have been covered with a network of articulating colonnettes, arches, pinnacles, rosettes, and other decorative stonework that visually screens and nearly dissolves the structure's solid core. Despite its decorative intricacy, the facade retains its monumental grandeur and is one of the first to achieve full integration with the building behind it. The cavernous portals correspond in width and placement to the nave and aisles, and, in slightly different

proportions, the facade's three-part elevation reflects that of the nave, the rose window corresponding to the clerestory.

The plan of Amiens (FIG. 13-24), like the facade, is exemplary of the grand High Gothic style. Derived from Chartres and perhaps even more elegant in its proportions, it reflects the builder's unhesitating and confident use of the complete Gothic structural vocabulary: the rectangular-bay system, the four-paneled rib vault, and a buttressing system that permits almost complete dissolution of the heavy masses and thick weight-bearing walls of the Romanesque style. The concept of a self-sustaining, skeletal architecture

has reached full maturity; what remains of the walls has been stretched like a skin between the piers and seems to serve no purpose other than to provide a weather screen for the interior (FIG. 13-25). From a height of 144 feet, the tense, strong lines of the vault ribs converge to the colonnettes and speed down the shell-like walls to the compound piers; almost every part of the superstructure has its corresponding element below, the only exception being the *wall rib* (the rib at the junction of the vault and the wall). The overall effect is one of an effortless strength, of a buoyant lightness one would never associate with the obdurate materiality of stone. Viewed directly from below, the vaults

13-23 West facade of Amiens Cathedral, France, *c.* 1220–1236 (area above the rose window, early sixteenth century).

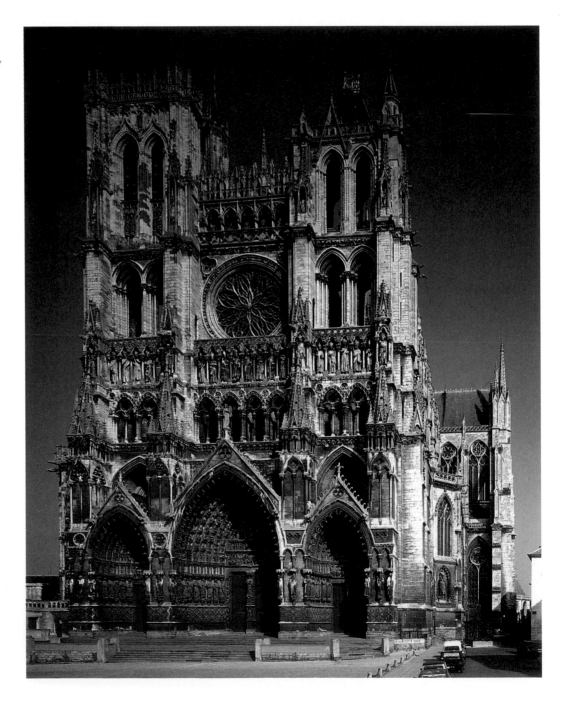

of the choir (FIG. 13-26) seem like a canopy, tentlike and suspended from bundled masts. The light flooding in from the clerestory imparts even more "lift" and, at the same time, blurs structural outlines. The effect is visionary, and we are reminded of another great building, one utterly dif-

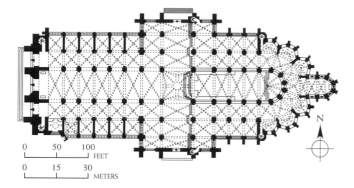

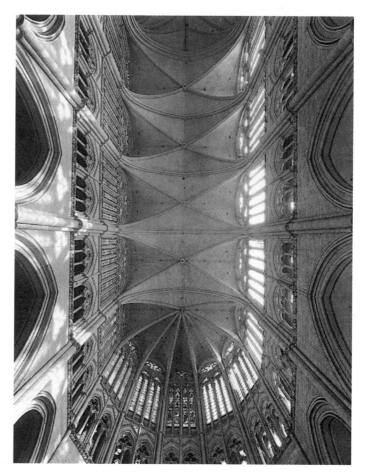

13-26 Choir vault of Amiens Cathedral.

13-24 ROBERT DE LUZARCHES, plan of Amiens Cathedral. (After Frankl.)

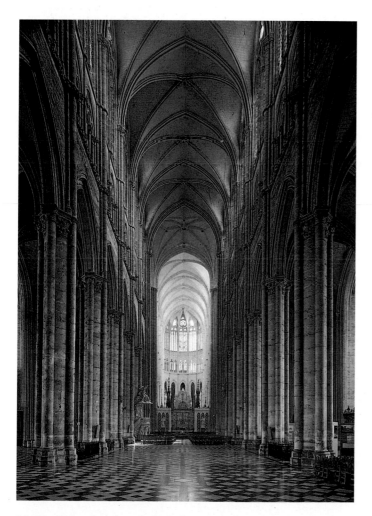

13-25 Nave of Amiens Cathedral (view facing east).

ferent from Amiens, in which light plays an analogous role—Hagia Sophia in Constantinople (FIG. 9-2). Not only is the physical mass of the building reduced by structural ingenuity and daring, but what remains visually is dematerialized further by light. As with Scholastic philosophy, the logic of the structure here is in the service of mystery. Although philosophy might prove the existence of God with reason, the experience of the beatific vision gave the believer a mystical proof, like Dante's experience in Paradise as he gazed, rapt, into the "heart of Light, the heart of Silence."

THE RAYONNANT STYLE From the grand style of the first half of the thirteenth century came a period of great refinement, the so-called *rayonnant* (radiant) style, which dominated the second half of the century and was associated with the royal Paris court of Saint Louis. Royal France, growing increasingly wealthy, powerful, and prestigious, radiated its art and culture throughout Europe. As we have seen, the king was lavish in embellishing the realm, especially with religious architecture.

Preeminent examples of rayonnant design, and of the bar tracery that is a fundamental feature of rayonnant, are

the two great rose windows in the north and south transept facades of Notre-Dame in Paris (FIGS. 13-11 and **13-27**). The tremendous north rose window, the work of the master builder JEAN DE CHELLES (his name is known from a contemporary inscription at the base of the south transept facade), is a masterpiece of architectural ingenuity. Almost the entire mass of wall opens up into stained glass, which is held in place by an intricate armature of bar tracery that practically has the tensile strength of steel. Here, the Gothic passion for light leads to a most daring and successful attempt to subtract all superfluous material bulk just short of destabilizing the structure and to transform hard substance into insubstantial, luminous color. The fact that this vast, complex fabric of stone-set glass has maintained its structural integrity and equilibrium against the disintegrative forces of nature and time for seven hundred years attests to the master builder's engineering genius.

The "multifoliate rose" of light, ever-changing in hue and intensity with the hours of the day, seems to turn solid architecture into a floating vision of the celestial heavens—a constellation of radiant, jewel-like stars. Expressive of the Gothic adoration of the Virgin Mary, the concentric circles exalt her as Mother of Christ; she appears at the very center of the design. Around her are figures of the prophets who foretold the Incarnation; in the second circle, are thirty-two Old Testament kings, the ancestors of Christ; in the outermost circle, are thirty-two high priests and patriarchs, who also testify to the royal lineage and divinity of Christ. The light of the north rose window is predominantly blue, the color of the northern sky, of the heavens, and of the mantle of the Virgin, which she throws protectively around all those devoted to her as the Queen of Heaven.

The Gothic architect uses light as a medium, as does the Byzantine, but he uses it in opposite ways. In Gothic architecture, light is *transmitted through* a kind of diffracting screen of stone-set glass; in Byzantine architecture, light is *reflected from* myriad glass tessarae set into the hard bed of the wall (FIGS. 8-20 and 9-11). With light, both stained glass and mosaic create an opalescent splendor that transforms

13-27 JEAN DE CHELLES, rose window of the north transept, Notre-Dame, Paris, 1240–1250. Stained glass, iron and lead stone-bar tracery, diameter 43′.

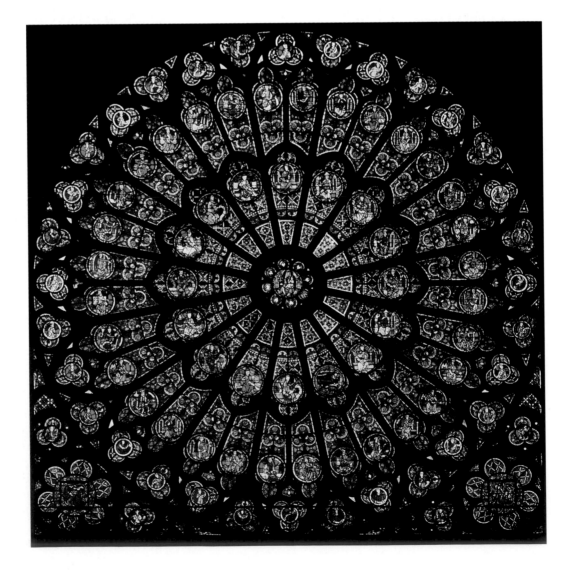

structure is composed of stained glass. The supporting elements have been so reduced that they are hardly more than large *mullions,* or vertical bars, separating the enormous windows, which are approximately 49 feet high and 15 feet wide and are the largest designed up to their time. Although the chapel was heavily restored during the nineteenth century (after being damaged in the French Revolution), it has retained most of its original thirteenth-century glass, which filters the light and fills the interior with an unearthly rose-violet atmosphere. Amid richly colored stone surfaces and shimmering strips of decorative mosaic stand statues of the apostles. Multicolored also, they stand on pedestals almost independent of the architecture, and their related poses, with multiple axes, foreshadow the graceful rhythms of later thirteenth- and fourteenth-century sculpture. The technical and esthetic

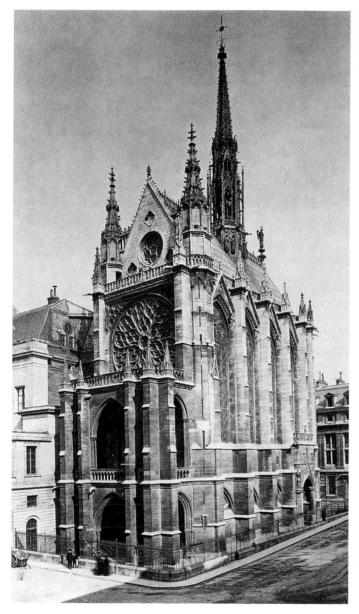

13-28 Ste.-Chapelle, Paris, 1243–1248 (view toward the tribune). The rose window was installed after 1485.

solid substance into insubstantial vision—the material world into the spiritual.

If the rose windows of the transepts of Notre-Dame demonstrate the wall-dissolving architecture of rayonnant design, the Sainte-Chapelle in Paris shows the principle of the style applied to a whole building (FIGS. **13-28** and **13-29**). The building, joined to the royal palace, was intended to be a repository for relics of the Passion of Christ brought back by Saint Louis after the ill-fated Sixth Crusade, so that its resemblance to an intricately carved reliquary is intentional. Here, the dissolution of the wall and the reduction of the bulk of the supports has been carried to the point that more than three-quarters of the

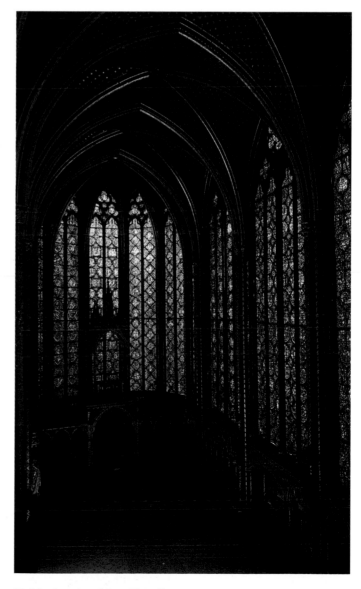

13-29 Interior of Ste.-Chapelle.

refinements here would have upset the solemn harmonies and monumentality of the art of the earlier part of the century. The emphasis on the extreme slenderness of the architectural forms and on linearity in general, with exquisite color and precise carving of details, does recall the richly ornamented reliquaries of the time.

Beauvais Cathedral (FIG. **13-30** and page 280) was begun in 1247, after plans that had been drawn in the 1230s. As was customary, the builders began construction at the east end, so that the apse and choir would be finished and ready for use while the remainder of the building was being completed. In contrast to monastic churches, which usually were assured of funding before construction began and which were completed in fairly short order, the building histories of urban cathedrals often extended over decades, and sometimes over centuries. Their financing depended largely on collections and public contributions (not always voluntary), and building programs were often interrupted by a lack of funds. Unforeseen events, such as wars, famines, or plagues, could stop construction, which might not be resumed for years. The rebuilding of Chartres Cathedral took a relatively short twenty-seven years; the building history of Cologne Cathedral (see FIG. 13-57) extended over six centuries, and Beauvais Cathedral never was completed.

The wisdom of starting at the east end and working westward was proven at Beauvais, where construction stopped around 1500 after a "flamboyant" Late Gothic

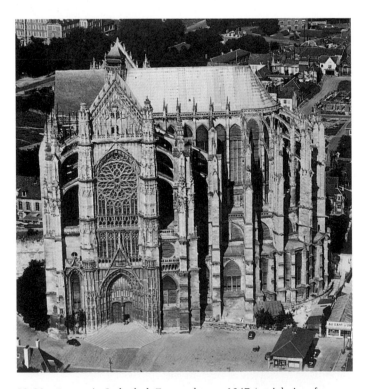

13-30 Beauvais Cathedral, France, begun 1247 (aerial view from the south).

transept had been added to the choir. Although the building is unfinished, the completed and serviceable part stands to this day as one of the most impressive examples of the Gothic "rush into the skies." That skyward impulse, seen first in the height of the nave of Notre-Dame at Paris, became an obsession with French Gothic builders. With their new skeletal frames of stone, they attempted goals almost beyond limit, pushing with ever-slenderer supports to new heights, aiming always at effects of insubstantial visions floating far beyond human reach. The nave vaults at Laon had risen to a height of about 80 feet; at Paris, to 107 feet; at Chartres, to 118 feet; and at Amiens, to 144 feet. In 1272, the builders of the choir of Beauvais planned a height of 157 feet.

In 1284, the vaults collapsed; the cause of the failure is still a matter of scholarly debate. The original design of the first master architect had been brilliant, audacious, and stable; the parts of the choir hemicycle completed by him remained standing. Modern engineering analysis, of the kind we have mentioned in the discussion of Chartres and Bourges, indicates that succeeding builders miscalculated wind and dead-load stresses, particularly those on the external intermediate piers. The choir, rebuilt with a broad margin of safety, has additional piers and old-fashioned, sexpartite vaults, not unlike those at Bourges. Unfortunately, the rebuilt vaults and piers disfigure the original design, for it was exactly those former features of wide-spread piers and slender buttresses that the rayonnant architects had sought in their effort to make an architecture seemingly out of nothing but line and light. Henceforth, the great structural innovations of the High Gothic style and the vast scale in which they were worked out would be things of the past. Late Gothic architecture, born of the linear rayonnant design, would be confined to buildings of quite modest size, conservative in structure and ornamented with restless designs of intricately meshed, pointed motifs.

SECULAR ARCHITECTURE So far we have considered only church architecture; of course secular structures were also designed and built. In an age of local and chronic warfare these were, conspicuously, often the fortified castles of the barons, located in places not easily accessible to enemies. Towns were enclosed by defensive walls, which in time they outgrew and expanded. With the historical changes that made purely defensive war obsolete, notably the invention of artillery, improvements in siege-craft, and tactical mobility, the era of the fortress gradually passed, and once impregnable citadels fell into ruin.

One of the most famous of these, Carcassonne (FIG. **13-31**), in the Languedoc, was restored in the nineteenth century. A heavily fortified town, it was the center of Albigensian resistance to the forces of royal France. Built on a hill bounded by the river Aude, Carcassonne had been fortified since Roman times. It had Visigothic walls dating

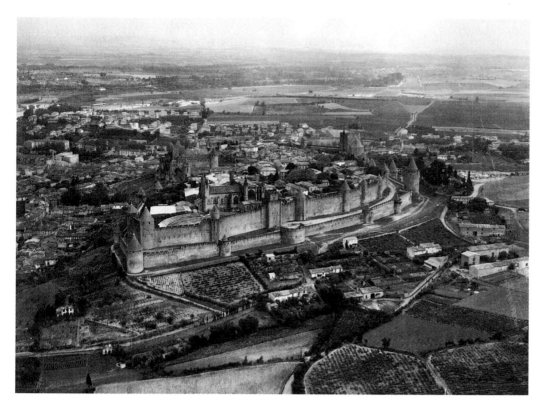

13-31 The fortified town of Carcassonne (aerial view).

from the sixth century; in the twelfth these were reinforced with bastions and towers. Its double ring of battlemented walls and the powerfully fortified castle were formidable obstacles to any attacking force; it might be surrendered, but could not easily be taken by storm.

Within the double walls of Carcassonne, in addition to the castle, were the Cathedral of St.-Nazaire and a cluster of buildings making up a small town. Today an aerial view spectacularly reveals this architectural expression of the conditions of medieval existence—a tightly contained ensemble of castle, cathedral, town, and towered walls, the limits of material and spiritual security.

Sculpture

Sculpture, as it had been since the Romanesque period, was subservient to architecture during the High Gothic period, but rapid changes were taking place. The unity of idea that controls the design of the Royal Portal of Chartres (FIG. 13-14) expanded to embrace the whole cathedral (see the facade of Amiens Cathedral, FIG. 13-23). The sculptural program came to include not only the huge portals but the upper levels of the building as well. The summit of Gothic art—the cathedral-building and cathedral-adorning age—lasted from about 1210 to 1260. The range of the iconography of the sculpture is as vast and complex as the buildings themselves. Most of the carved figures are symbolic, but many, particularly the grotesque gargoyles (used as rainspouts) and other details of the upper portions, are purely decorative and show the vivacity and charm of the medieval spirit at this moment, when it was confident in its faith. The iconographic program, no longer confined almost entirely to the letter of the dogma (as in Romanesque art), is extensive enough to embrace all the categories of medieval thought. Many iconographic schemes were based on the *Speculum Majus* (Great Mirror) of Vincent of Beauvais, a scholar at the court of (Saint) Louis IX. This was a comprehensive summary of medieval knowledge in which accounts of natural phenomena, scriptural themes, and moral philosophy serve a didactic religious purpose.

Nature begins to come forward as important, and in art the human figure comes forward with it. Three figures from the Porch of the Confessors in the south transept of Chartres Cathedral illustrate how much the incipient realism of the Royal Portal has advanced. The figures, representing St. Martin, St. Jerome, and St. Gregory (FIG. **13-32**), date from 1220 to 1230. Although attached to the architectural matrix, their poses are not determined by it as much as they would have been earlier. The setting now allows the figures to communicate quietly with one another, like waiting dignitaries; they turn slightly toward and away from each other, breaking the rigid vertical lines that, on the Royal Portal, fix the figures immovably. Their draperies no longer are described by the stiff and reedy lines of the figures of the Royal Portal; the fabric falls and laps over the bodies in soft, if still regular, folds.

The faces are most remarkable. They show, for the first time since the ancient world, the features of specifically

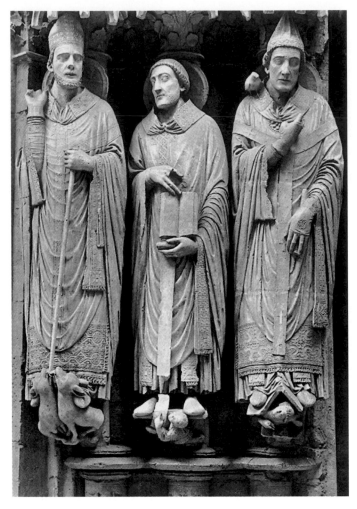

13-32 *St. Martin, St. Jerome, and St. Gregory, c.* 1220–1230, from the Porch of the Confessors, Chartres Cathedral, France.

Western men, with no admixture whatever of the denatured mask passed down over a thousand years. Moreover, they seem to have been taken from particular persons, and we have no difficulty characterizing them. St. Martin is tall and ascetic, an intense priest with gaunt features (compare the spiritually moved but not particularized face of the Moissac Jeremiah or Isaiah in FIG. 12-28). The subject may have been a saintly canon of Chartres who reluctantly became a bishop; in any event, in another realistic touch, his vestments are the liturgical costume of the time. One of his companions, St. Jerome, who appears as a humorous, kindly, practical administrator-scholar, holds his Vulgate translation of the Scriptures. Standing beside St. Jerome, the introspective St. Gregory seems lost in thought as he listens to the dove of the Holy Ghost on his shoulder. Thus, the three men are not simply contrasted in terms of their poses, gestures, and attributes but, most particularly and emphatically, as *persons,* so that personality, revealed in human faces, makes the real difference—a rarity even in Classical art. In another century or so, the identifiable portrait will emerge.

The fully ripened Gothic style can be seen in the west portals of Reims Cathedral (FIG. **13-33**), built in the mid-thirteenth century. At first glance, the jamb statues appear to be completely detached from their architectural background. The columns to which they are attached have shrunk into insignificance and in no way impede the free and easy movements of the full-bodied figures. (On the Royal Portal of Chartres, the background columns occupy a volume equal to that of the figures; see FIG. 13-15.) However, two architectural devices limit the statues' spheres of activity and tie them to the larger design of the portal and the architectural matrix—the pedestals on which

13-33 Central portal of the west facade of Reims Cathedral, France, *c.* 1225–1290.

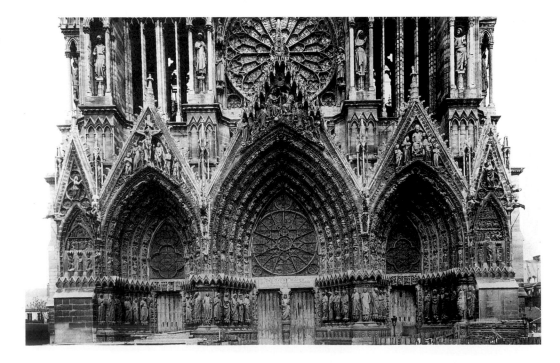

they stand and the canopies above their heads. Less sub-missive than their predecessors from the Royal Portal of Chartres, these Reims figures create an electric tension within the portal design; they were designed for this portal, however, and would look incongruous in any other setting. Gothic portal statues placed in museums to protect them from weathering look, without exception, forlorn and out of place.

On the right jamb of the central portal, two figures por-tray *The Visitation* (FIG. **13-34**). The master of the *Visitation* group, quite original in his manner, manifests a classicizing bent startlingly unlike anything seen since Roman times. The group illustrates the impact on its master carver of either actual Classical statuary he had seen or of manu-scripts or ivories from Late Antiquity or Byzantium. Whatever the artist's source, the facial types, costumes, and drapery treatment are astonishing approximations of the naturalistic style traits of ancient figure sculpture. The sculptor even has tried to present the Classical contrappos-to stance, although the only partially successful result betrays his ignorance of human anatomy.

The influence of these great cathedral statues must have been felt widely by those who contemplated them. Certainly, the statues' influence on artists must have been great, as in the case of the painter of the *Psalter of St. Louis* (see FIG. 13-38). Although the degree and the progress of that influence had not yet been worked out in complete detail, it is certain that, by the fourteenth century, Gothic sculpture was widely naturalized in Italy and elsewhere outside of France. In Italy, by the beginning of the fifteenth century, the native Gothic sense for realism had fused with a new classicizing impulse—generated partly from Byzantine art and partly from the discovery of the art of ancient Rome—to form the first distinctive styles of the Renaissance.

Stained Glass and Illumination

Gothic accomplishments in architecture and sculpture are matched by the magnificent stained glass of the time, which we already have seen at Notre-Dame and Sainte Chapelle in Paris. This medium is almost synonymous with the Gothic style; no other age has managed it with such craft and beauty. The mysticism of light that induced Abbot Suger to design an architecture that would allow for great windows is widespread in Gothic theology. "Stained-glass windows," wrote Hugh of St.-Victor, "are the Holy Scriptures . . . and since their brilliance lets the splendor of the True Light pass into the church, they enlighten those inside." The Gothic mood seems to take its inspiration from John (1:4–5): "In him was life; and the life was the light of men. And the light shineth in darkness."

The difference between these words and the sonorous verses of Revelation, which provide the program of the Romanesque "Last Judgments," reflects the difference between the shining walls of colored light, which change

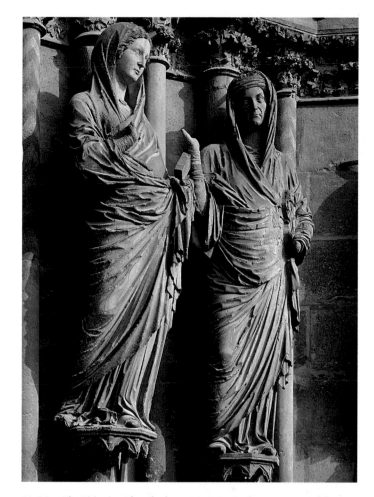

13-34 *The Visitation* (detail of FIG. 13-33). Jamb statues over life size.

with every passing hour or cloud, and the painted walls of Romanesque churches or the shimmering Byzantine mosaics.

Colored glass was used as early as the fourth century to decorate the windows of churches. Perfection of the tech-nique must have been gradual, with the greatest advance-ments made during the tenth and eleventh centuries. The first accurately dated windows, those of the choir of St.-Denis (1144), show a high degree of skill; according to Suger, they were "painted by the exquisite hands of many masters from different regions," proving that the art was known widely at that time. Yet the stained-glass window may be said to be the hallmark of the Gothic style, particu-larly in northern Europe, where the almost total dissolution of walls left few surfaces that were suitable for decoration with frescoes.

Imperfections or unexpected results in making colored glass were frequent; yet this was not an art left entirely to chance. The different properties of colors were well under-stood and carefully controlled. The glass was blown and either "spun" into a "crown" plate of varying thickness or shaped into a cylindrical "muff," which was cut and rolled out into square pieces. These pieces were broken or cut into

smaller fragments and assembled on a flat table on which a design had been marked with chalk dust. Many of the pieces actually were "painted" with a dark pigment, so that details, such as those of faces or clothing, could be rendered. The fragments then were "leaded," or joined by strips of lead that were used to separate colors or to heighten the effect of the design as a whole (FIGS. **13-35** and **13-36**). The completed window was strengthened with an armature of iron bands, which, in the twelfth century, took the form of a grid over the whole design (FIG. 13-35); in the thirteenth century, these bands were shaped to follow the outlines of the medallions and of the surrounding areas (FIG. 13-36).

The technical difficulties of assembling a large stained-glass window and fixing it firmly within its frame were matched by compositional problems. Illuminated manuscripts, the painter's chief vehicle during the earlier Middle Ages, had little instructional value for artists who not only had to work on an unprecedented scale but who also had to adjust their designs to the larger whole of the church

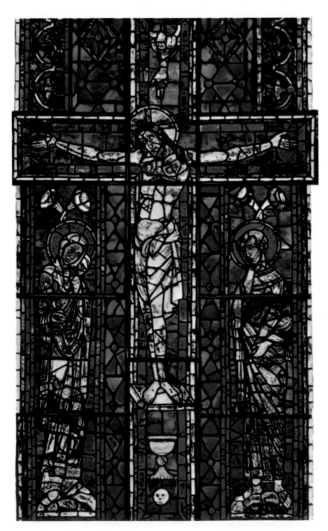

13-35 *Crucifixion*, detail of a window from St.-Remi, Reims, France, *c.* 1190. Stained glass, approx. 12' high.

building and its architecture. Sculptors, of course, already had solved these problems, and it is not surprising to learn that painters turned to them for instruction. Certainly, the saints flanking the cross in the St.-Remi window (FIG. 13-35) seem vaguely familiar (see FIG. 9-28). Their erect poses, the straight, almost unbroken silhouettes, and the rather precarious manner in which they perch on their hilltop pedestals stamp them as not too distant relatives of the jamb statues from the Royal Portals at Chartres. Here, the Romanesque process has been reversed, and the sculptors—the former students who found their inspiration in paintings—now have become the teachers.

Like the architects and sculptors with whom they worked in close collaboration, the stained-glass artists relied heavily on the *Ars de geometria* for their designs, layouts, and assemblies. The sketchbook compiled by VILLARD DE HONNECOURT, an early thirteenth-century draughtsman, is a curious mix of various subject matters, the purpose of which is not entirely clear.

In addition to details of buildings, plans of choirs with radiating chapels, and church towers, he also presents information on lifting devices, a sawmill, and stained-glass windows. Sprinkled liberally throughout the pages are drawings of figures, religious and worldly, and animals—some surprisingly realistic, others purely fantastic. In our illustration (FIG. **13-37**), Villard evidently is informing us of the usefulness of the *Ars de geometria* in designing human heads and animals. In some instances, he claimed to have drawn his animals from nature, but even these appear to have been composed around a skeleton not of bones but of abstract geometric figures. The designers of stained-glass windows proceeded in a similar manner. No matter how their designs and layouts were arrived at, the effect of these glowing, translucent paintings (FIG. 13-27), which often seem to be suspended in space, is as spellbinding today as it must have been to the medieval churchgoer. For the first time in centuries, the art of painting was accessible to the common man—painting in a form so compelling that the desire to have more and more of it, from pavement to vault, well may have influenced the development of Gothic architecture. By about the mid-thirteenth century, architectural techniques had advanced to the point that the space of cathedrals seems to be defined by the burning intensity of the stained-glass windows, rather than by the stone structure.

The radiance of stained glass must have inspired the glowing color of illuminated manuscripts; in some cases, glass and book must have been produced by masters in the same shop, or perhaps by one master who was expert in both arts. The *Psalter of St. Louis* (FIG. **13-38**) is believed to have been one of a number of books produced in Paris in the late thirteenth century for Saint Louis by craftsmen associated with those who made the stained glass for Sainte Chapelle (FIGS. 13-28 and 13-29). Certainly, the figures in the illuminated *Psalter* express the same aristocratic elegance as the "court" style of architecture (the rayonnant)

13-36 Detail of the *Good Samaritan* window, Chartres Cathedral, France, early thirteenth century. Stained glass.

favored by royal Paris. The painted architectural setting in the *Psalter* reflects the pierced, screenlike lightness and transparency of royal buildings like Sainte Chapelle and the new work at St.-Denis. The intense colors, especially the blues, emulate glass; the borders resemble glass partitioned by leading; and the gables, pierced by rose windows, are almost portraits of rayonnant architectural features.

The subject of the page from the *Psalter of St. Louis* shown here (FIG. 13-38) is *Abraham and the Three Angels*. (See Andrei Rublëv's version of essentially the same theme in FIG. 9-37.) Two episodes are included, separated by the Tree of Mamrc. In one, Abraham greets the three angels; in the other, he entertains them while Sarah peers at them from the tent. Compared with the figures in Romanesque illumination (FIG. 12-38), these are quieter in pose and attitude and have a firmness of stance and a sense of weight suggestive of sculpture. Moreover, here the busyness of the drapery lines is subdued, making us less mindful of the flat areas that encourage decorative line-play and more aware of the modeling tones that suggest plastic form and contour.

Although these figures owe much of their color to stained-glass works, the influence of sculpture also is evident. If we look at the general arrangement of the portal at Reims (FIG. 13-33), we see that the *Psalter* illuminator thinks of the sacred personages in the *Abraham* episodes as framed, canopied, and backed by the architecture and their placement as determined by it—like the actual sculptures of the portal.

The artist's response to the monumental, over-life-size sculptures of the cathedral portals may have led to a new

13-37 VILLARD DE HONNECOURT, page from a notebook, *c.* 1240. Bibliothèque Nationale, Paris.

13-38 *Abraham and the Three Angels,* illuminated page from the *Psalter of St. Louis,* 1253–1270. Bibliothèque Nationale, Paris.

sense of the possibilities of representation—the function of light and shade, for example, and of volume, contour, and silhouette. These imposing figures could have had a new, awesome authority that was not conveyed by the traditional prototypes (ivory carvings, say, or painted pages). The impulse toward naturalism and pictorial illusionism, endemic in the Greco-Roman world, and by no means lost in Early Christian and Byzantine art, could be receiving here a new and powerful impulse from monumental sculpture. The illusionistic effect of sculpture may have caught and held the Gothic artist's attention.

Byzantine artists would go in a different direction—working within received conventions, disdaining sculpture and the pictorial form built on it, respecting the flat surface, and showing little regard for the more or less systematic pursuit of three-dimensional illusionism widely favored in the West from this time till the twentieth century. We read of a Byzantine priest in the sixteenth century rejecting some paintings by Titian, the great Venetian master of the Renaissance (FIGS. 22-62 and 22-63), because "the figures stand quite out from the canvas" and therefore look "as bad as a group of statues."* The Byzantine artist did not find

*Edward Gibbon, *The Decline and Fall of the Roman Empire.* Quoted with citation in Ernst Kitzinger, *Byzantine Art in the Making* (Cambridge, MA: Harvard University Press, 1977), 107.

monumental sculpture like that of the Gothic portals in his environment. Would Byzantine painting and mosaic have been different if he had? The Gothic painter could not help but be struck by these majestic figures of great scale. The attention paid them is clearly evident in the figures of the *Psalter of St. Louis.*

LATE GOTHIC

Fourteenth-century Europe was exposed to a series of shocks that brought down the fragile equilibrium of the thirteenth century. The disruptive forces began with the great Mongol invasions of Central Asia, the Middle East, and Russia in the later thirteenth century. The Crusader kingdoms were lost to Saracens and Byzantines. In England and Germany the feudal barons fought for their privileges with new vigor. Philip IV of France, grandson of Saint Louis, and anything but saintly, brutally asserted royal power against the famous crusading order of the Templars, whom he plundered and destroyed, and against Pope Boniface VIII, whom he replaced with a line of French popes, moving the Holy See from Rome to Avignon in 1309. The later conflict of the Avignon popes with those once again established in Rome led to an ominous three-way split of the papacy called The Great Schism (1378–1417), a divisive scandal to Western Christendom.

The lapse of the West into what seemed interminable war and depredation encouraged violent social protest, revolts by peasants in the countryside and by working classes in the cities. Add to all this the plague called the "Black Death," which wiped out a third of the population of Europe, and it makes a sum of commotion and misery about equal to that of the period of the invasions (400–1000 A.D.). Yet, as we shall see, from the calamities of the fourteenth century, new systems and institutions would arise that historians describe as "early modern," and as the "Renaissance."

As for the arts in this Late Gothic age, the collapse of the vaults of Beauvais Cathedral would seem to have brought the great thirteenth-century architectural debate to an unarguable conclusion. Analogously, the followers of Saint Thomas Aquinas came to believe that his accommodations of faith and reason were impossible and that both must go their separate ways. This conviction was the beginning of the dissolution of the medieval synthesis, which would lead to the eventual destruction of the unity of Christendom. The resolution of opposites could not be achieved; the conflict that would reshape Western Europe was about to begin.

The search for an ideal solution for a building and the codification of artistic, as well as philosophical, procedures were essentially academic in spirit—conscious evaluations of a style that already had reached and passed its complete definition. For a long time, artistic practice and Scholastic method would retrace ground already covered, dealing with elaborations of surface forms but no longer attempting grandiose innovations in structure.

The Flowering of Ornament

By the early fourteenth century, the monumental and solemn sculpture of the High Gothic portals had been replaced by the "court" style, a quite rarefied example of which may be seen in the statue of *The Virgin of Paris* within Notre-Dame (FIG. **13-39**). The curving sway of the figure, emphasized by the bladelike sweeps of drapery that converge to the child, has a mannered elegance that will mark Late Gothic sculpture in general. This famed Late Gothic S-curve will be encountered again and again during the fourteenth and fifteenth centuries. Superficially, it somewhat resembles the shallow S-curve adopted by

13-39 *The Virgin of Paris,* Notre-Dame, Paris, early fourteenth century.

13-40 JEAN PUCELLE, *David before Saul,* page from the *Belleville Breviary, c.* 1325. Illumination, approx. 9¹/₂″ × 6³/₄″. Bibliothèque Nationale, Paris.

Praxiteles in the fourth century B.C. (FIG. 5-70), but unlike its Classical predecessor, the Late Gothic S is not organic (deriving from within the figure), nor is it the result of a rational, if pleasing, organization of the figure's anatomical parts. Rather, it is an artificial form imposed on the figure— a decorative device that may produce the desired effect of elegance but that has nothing to do with the figure's structure. In fact, in our example, the body is quite lost behind the heavy drapery, which, deeply cut and hollowed, would almost deny the figure a solid existence. The ornamental line created by the flexible fabric is analogous to the complex, restless tracery of the "flamboyant" style in architecture, which dominated northern Europe in the fourteenth and fifteenth centuries. The emphasis on ornament for its own sake is in harmony with the artificial prettiness the artist has contrived in the Virgin's doll-like face, with its large eyes and tiny mouth under a heavy, gem-encrusted crown.

The feeling for ornament, so characteristic of Late Gothic art and architecture, is expressed in the profusion of motifs that flower upon a page from the *Belleville Breviary* (FIG. **13-40**). Derived from the conventional vocabulary, spiky tendrils, cusped leaves, and ivy sprout along the margins and over them in great, calligraphic flourishes; these are interspersed with butterflies, dragonflies, birds, insects, a snail, and an ape. Musicians—a bagpiper with gargoyle, a flutist, and a lute player—perch effortlessly in or upon the tracery. The sharp cusps of the tracery scrolls contrast with the soft contours and modeling of the figures. A gratuitous decorative enhancement of the text, the ornament moves into and around it, threatening to take it over. The pictures at the top and at the bottom of the columns of text are independent of both text and of ornament; this is an innovation, since typically they are included within the outlines of an initial. There are small but sure touches of realism, especially in the rendering of the animal kingdom and of the perspective of the chapel occupied by Saul and David. These look forward to the next century, when figurative illustration will have taken over the text, and the playful riot of ornament will quiet down, subdued by a dominant pictorialism.

The name of JEAN PUCELLE, illuminator of the breviary, appears with the names of some of his assistants at the end of the book, in a memorandum recording the payment they have received for the work. Inscriptions in other illuminated books of the time regularly stipulate the costs of the production: the price paid for materials, particularly gold and ultramarine, and for the execution of initials, figures, floriated script, and other embellishments. By this time illuminators, women as well as men, were recognized as professionals and as guild members, whose work was of guaranteed quality. Though the cost of materials was still the determining factor in pricing, individual skill and reputation increasingly decided the value of the illuminator's services. Significantly, the artists now are lay people for the most part; only rarely does a cleric perform as scribe or illuminator. The centuries-old monopoly of the Church in the making of books is at an end.

The change from rayonnant architecture to the Late Gothic, or *flamboyant* style (named for the flamelike appearance of its pointed tracery), took place in the fourteenth century. The style reached its florid maturity nearly a century later. This period was a difficult one for royal France. Long wars against England and Burgundy sapped its economic and cultural strength, and building projects in the royal domain either were halted or not begun. The new style found its most enthusiastic acceptance in regions outside the Île-de-France. Normandy is particularly rich in flamboyant architecture, and its close ties with England suggest that the Anglo-Norman school of "decorated" architecture may have had much to do with the development of the flamboyant style.

The parish church of St.-Maclou (FIG. **13-41**), in Rouen, the capital of Normandy, presents a facade that differs

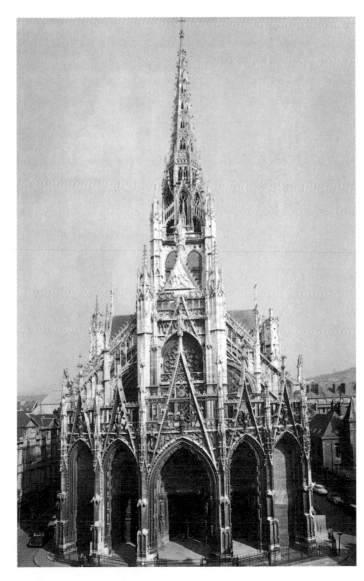

13-41 West facade of St.-Maclou, Rouen, France, *c.* 1500–1514.

widely from the thirteenth-century style. St.-Maclou, some 75 feet high and 180 feet long, is almost diminutive compared with the great cathedrals. The five portals, two of them blind, bend outward in an arc and are crowned by five gables, pierced through and filled with sinuous, wiry, flamboyant tracery. Spidery arcades climb steeply to the center bay, marching along behind the transparent gables. The overlapping of all features, pierced as they are, confuses the structural lines and produces a bewildering complexity of views. It is almost as if the Celtic-Germanic instinct for intricate line, expressed in works like the *Book of Lindisfarne* (FIG. 11-7), is manifesting itself once again against the form and logic newly abstracted from the traditions of the Mediterranean. Yet the Renaissance is not far off, and, within a generation or two, France will adopt a new Classical style from Italy.

GOTHIC OUTSIDE OF FRANCE

Around 1269, the prior of a German monastery "hired a skilled architect who had just come from the city of Paris"

to rebuild his monastery church. The architect reconstructed the church *opere francigeno* (in the Frankish manner)— that is, in the Gothic style of the Île-de-France. In 1268, Pope Clement IV, stipulating the conditions for the building of a new cathedral at Narbonne, wrote that the building was "to imitate the noble and magnificently worked churches, . . . which are built in the kingdom of France." The diffusion of the French Gothic style had begun even earlier, but it was in the second half of the thirteenth century that the new style became dominant and European architecture turned Gothic in many different ways. Because the old Romanesque traditions lingered on in many places, each area, marrying its local Romanesque design to the new style, developed its own brand of Gothic architecture.

England

The characteristics of English Gothic architecture are embodied admirably in Salisbury Cathedral (FIGS. **13-42** to **13-45**), built, for the most part, between 1220 and 1260 (the tower and flying buttresses were erected in the fourteenth century). The screenlike facade (FIG. 13-42) reaches

13-42 Salisbury Cathedral, England, begun *c.* 1220 (view from the northwest).

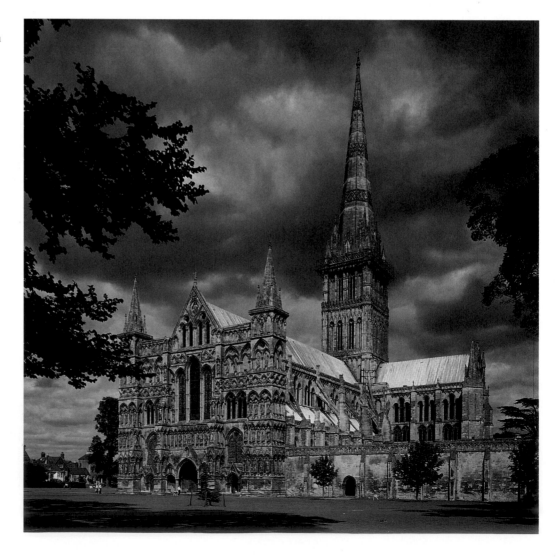

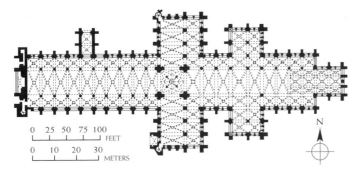

13-43 Plan of Salisbury Cathedral.

as height in the English building is not a decisive factor, the flying buttress is used sparingly and as a rigid prop rather than as an integral part of the armature of arches. The exterior of the building at Salisbury, were it not for its pointed features, would look more like an "additive" Romanesque than a Gothic building.

Equally distinctive is the long rectilinear plan (FIG. 13-43), with its double transept and flat eastern end. The latter feature was characteristic of Cistercian churches and had been favored in England since Romanesque times. The interior (FIG. 13-44), although Gothic in its three-story elevation, pointed arches, rib vaults, and compound piers (actually a combination of columnar piers with detached monolithic shafts or colonnettes), shows conspicuous differences from the French Gothic style. The pier colonnettes do not ride up the wall to connect with the vault ribs; instead, the vault ribs rise from corbels in the triforium, producing a strong horizontal emphasis. The rich detail in the moldings of the arches and the tracery of the triforium, enhanced by the contrast of colored stone, gives a peculiarly crisp and vivid sparkle to the interior. The structural craft of the English stonemason is at its best in the Lady Chapel

beyond and does not correspond to the interior. With its dwarf towers, horizontal tiers of niches, and small entrance portals, the Salisbury facade differs emphatically from the facades of either Notre-Dame of Paris (FIG. 13-10) or Amiens Cathedral (FIG. 13-23). Also different is the emphasis on the great crossing tower (*c.* 1320), which dominates the silhouette. The height of Salisbury is modest compared with that of the almost contemporary Cathedral of Amiens;

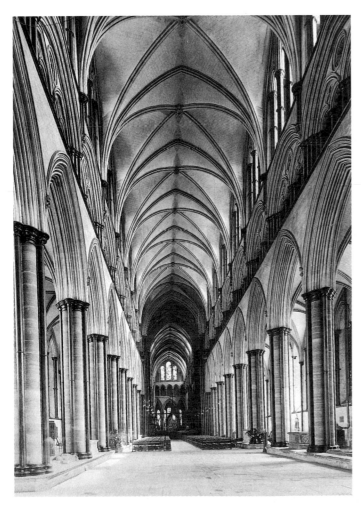

13-44 Nave of Salisbury Cathedral (view facing east).

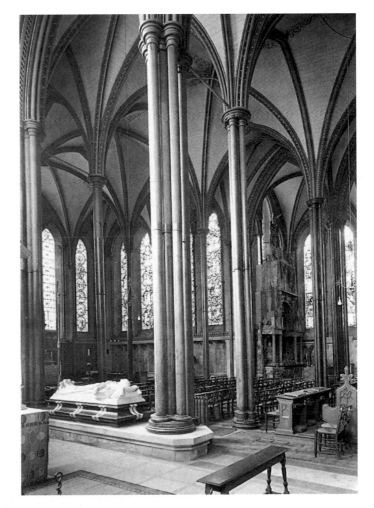

13-45 Retrochoir and Lady Chapel of Salisbury Cathedral, *c.* 1225.

(dedicated to the Virgin Mary) of Salisbury Cathedral (FIG. 13-45). There, incredibly slender piers composed of unattached shafts of Purbeck marble seem to tether the billowing vaults to the ground rather than to support them. The linearity and slender forms of this daring construction are analogous to the rayonnant style found on the continent.

Early on, English architecture finds its native language in the elaboration of architectural pattern for its own sake; structural logic, expressed in the building fabric, is secondary. The pier, wall, and vault elements became increasingly complex and decorative in the fourteenth century, and English Gothic architecture of that period has been described as "decorated." The choir of Gloucester Cathedral (FIG. **13-46**), built about a century after Salisbury, illustrates the transition from the decorated to the last English Gothic style, the *perpendicular* or "Tudor," which was named after the line of English kings that began with Henry VII in 1485.

The characteristically flat east end of Gloucester Cathedral opens into a single, enormous window divided into horizontal tiers of "transom" windows of like shape and proportion, reminiscent of the screen facade of Salisbury. In the nave wall, however, the strong, horizontal accents of Salisbury have been erased, as the vertical wall

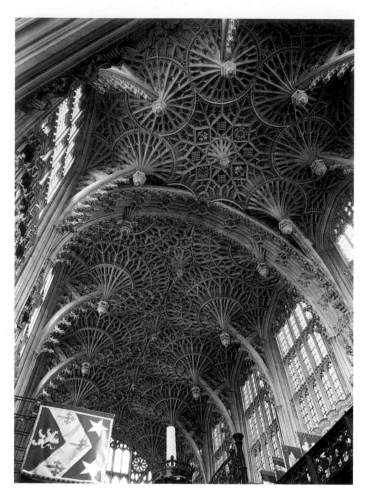

13-47 Detail of the vault of the Chapel of Henry VII, 1503–1519, Westminster Abbey, London.

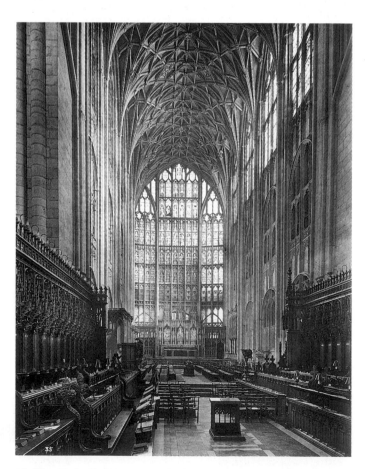

13-46 Choir of Gloucester Cathedral, England, 1332–1357 (view facing east).

elements (the *responds*) lift directly from the floor to the vaulting, pulling the whole elevation into a fluent unity. The vault ribs, which had begun to multiply soon after Salisbury, now have become a dense thicket of entirely ornamental strands that serve no structural purpose. This vault, in fact, is no longer a rib vault, but a continuous barrel vault with applied decorations.

We can see the culmination of the English perpendicular style and the flowering of the Tudor style (one of the late phases of the perpendicular) in the vault of the Chapel of Henry VII (FIG. **13-47**), which adjoins Westminster Abbey and was built in the first two decades of the sixteenth century. Here, the linear play of ribs has become a kind of architectural embroidery, pulled into "fan vault" shapes with pendant keystones resembling stalactites. The vault looks like something organic that has been petrified in the process of melting. The chapel represents the dissolution of structural Gothic into decorative fancy; its original lines, released from function, multiply, variegate, and flower into uninhibited architectural virtuosity and theatrics. The perpendicular style in this Tudor structure expresses peculiarly well the precious, affected, even dainty style of

life codified in the dying etiquette of chivalry at the end of the Middle Ages. Life was, of course, as violent as ever—indeed, we are at the threshold of the boisterous English Renaissance—but the description and expression of it in art comes in forms that are delicate rather than robust.

A type of monument familiar in the churches of Late Gothic England—indeed, of Late Gothic Europe—is the freestanding tomb bearing a recumbent effigy of the deceased. The Chapel of Henry VII at Westminster Abbey contains just such a tomb, upon which repose the effigies of Henry and his queen, Elizabeth of York. Though not strictly a part of the architectural fabric like the wall tomb, it establishes itself as a permanent and immovable unit of church furniture, serving to preserve both the remains and the memory of the person entombed.

Services for the dead were a vital part of the Christian liturgy. The Christian hope for salvation in the hereafter prompted the dying faithful to request masses to be sung, sometimes in perpetuity, for the eternal repose of their souls. Toward that end, the high-born and wealthy might endow whole chapels for the chanting of masses (chantries), as well as make rich bequests of treasure and property to the Church.

They might also require that a tomb be constructed for their bodies, and that it be placed as near as possible to the sanctuary or to some other venerable location in the church, if not in a chapel especially designed and endowed to house it, like the Chapel of Henry VII. The freestanding tomb, accessible to visitors to the church building, had a moral as well as a sepulchral and memorial purpose. The silent effigy, cold and still, was a solemn reminder of human mortality, all the more solemn and admonitory as the image of someone who had once actually lived, whose remains were here entombed, and whose soul beseeched the prayers of the living. Thus the tomb was exemplary of a central doctrine of the Church and played an important part in the instruction of the faithful.

A tomb that housed the remains of an illustrious person could bring distinction, pilgrims, and patronage to the church where it was placed. The cathedral of Canterbury became one of the most revered shrines in Europe because the martyred saint Thomas à Becket was buried in its crypt. In the same great cathedral was set up the tomb of Edward, prince of Wales, known as the "Black Prince" (1330–1376), famous for his military feats at the outset of the Hundred Years War between England and France.

The effigy on Edward's tomb (FIG. **13-48**) is that of a knight in full armor in an attitude of prayer, the gauntleted hands held up before the lower face, the fingertips touching. The figure, rigidly frontal, might be thought of as standing in the niche of a wall tomb; recumbent, as here, there is no change of stance. The armor and the great sword at his side identify his career as a soldier, and the tunic emblazoned with both the lions of England and the lilies of France, proclaims his right to both thrones. The partly covered face is not a portrait, but an idealized mask. How

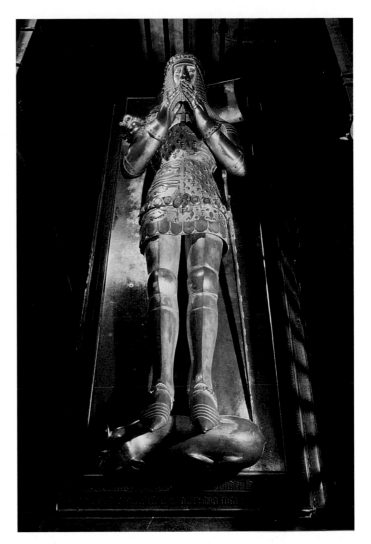

13-48 Tomb of Edward the Black Prince, attributed to John Orchard, 1377–1380. Gilded bronze. Canterbury Cathedral.

he *looked* was unimportant, *who* he was, his rank and quality, all important; *that* can be read from his royal accoutrements.

As a Late Gothic monument the tomb of the Black Prince is a summation of the virtues most revered by a warlike aristocracy: faith in the God of the Christians, hope of salvation through Christ and the Church, loyalty to the claims of lineage, and valor on the field of battle.

Germany

The architecture of Germany remained conservatively Romanesque well into the thirteenth century. The plan and massing of German churches included the familiar Rhenish double-apse system, with towers flanking both apses. In many of these, the only Gothic feature is the rib vault, which is buttressed solely by the heavy masonry of the walls. By mid-century, though, French influences had increased, and the 150-foot-high choir of Cologne

A different type of design, probably of French origin, that met with great favor and was developed broadly in Germany is that of the *hallenkirche*, or hall church. The term applies to those buildings in which the aisles rise to the same height as the nave section. An early and successful example of this type is the Church of St. Elizabeth at Marburg (FIGS. **13-50** to **13-52**), built between 1233 and 1283. Because the aisles provide much of the bracing for the central vault, the exterior of St. Elizabeth is without the dramatic parade of flying buttresses that circles French Gothic chevets and appears rather prosaic. But the interior, lighted by double rows of tall windows, is more unified and free flowing, less narrow and divided, than the interiors of other Gothic churches. A form widely used by later Gothic architects, the hallenkirche heralds the age of the Protestant Reformation in Germany, when the old ritual, which focuses on the altar, will be modified by a new emphasis on preaching, which will center attention on the pulpit.

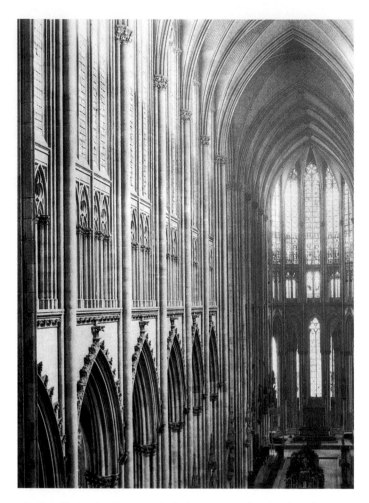

13-49 Choir of Cologne Cathedral, Germany, thirteenth and fourteenth centuries.

Cathedral (FIG. **13-49**) is a skillful and energetic interpretation of Amiens (FIG. 13-25). Cologne Cathedral (FIG. 13-57) has one of the longest building histories on record. Begun in 1248, it stood without a nave and with only its chevet, transept, and lower parts of the facade towers completed for some five centuries. Only in the early nineteenth century, when the original designs for the building were found, was the decision made that the structure should be completed.

The choir of Cologne Cathedral (FIG. 13-49) expresses the Gothic "rush into the skies" even more emphatically than the taller (but wider) choir of Beauvais Cathedral (page 280). Despite the cathedral's seeming lack of substance, the structure's stability was proven effectively during World War II, when the city of Cologne was subjected to extremely heavy aerial bombardments. The church survived the war by virtue of its Gothic, skeletal design. Once the first few bomb blasts had blown out all of its windows, the structure offered no further resistance to the effects of subsequent blasts, and the skeleton remained intact and structurally sound.

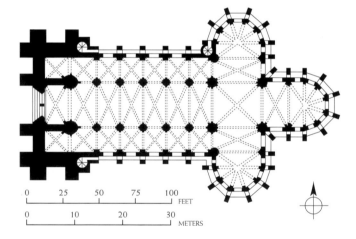

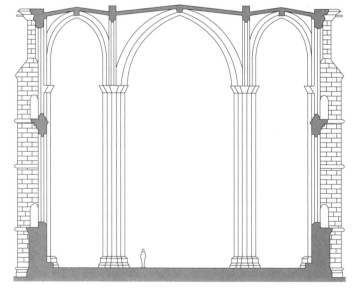

13-50 Plan and section of St. Elizabeth, Marburg, Germany.

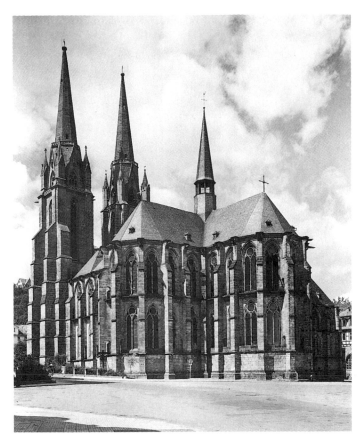

13-51 St. Elizabeth, 1233–1283 (view from the southeast).

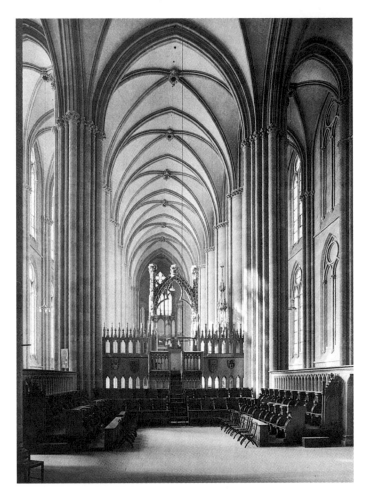

13-52 Interior of St. Elizabeth (view facing west)

Like French Gothic architecture, French sculpture also had its effect abroad. In Germany, the commingled influences of the statuary of the transept portals at Chartres (FIG. 13-32) and the west facade at Reims (FIG. 13-34) directed the sculptors of the south transept portal at Strasbourg Cathedral (FIG. **13-53**). The sculptured tympanum represents the death of the *Virgin Mary.* She is surrounded by the Twelve Apostles; at their center Christ receives her soul (the doll-like figure on his left arm). Mary Magdelene, wringing her hands in grief, crouches beside the deathbed. The sorrowing figures express emotion in varying degrees of intensity, from serene resignation to gesturing agitation. The group is organized not only by dramatic unification and by pose and gesture but also by the rippling flow of deeply incised drapery that passes among them like a rhythmic, electric pulse. The sculptor's objective is not to produce a timeless tableau presenting some mystery of the faith, but to depict a human event in a particular space and time—an event designed to stir an emotional response in the observer as if he or she were present. In the Gothic world, art is increasingly being humanized and made natural; in the art of the German lands, we will find an increasing and characteristic emphasis on passionate drama.

The Strasbourg style, with its feverish emotionalism, is balanced and complemented by two stately and reposeful statues from the west choir of Naumburg Cathedral (FIG. **13-54**) that depict the quiet, regal deportment of the French statuary of the High Gothic portals, but with a stronger tincture of realism. *Ekkehard and Uta* represent persons of the nobility who, in former times, had been patrons of the Church; the particularity of costume and visage almost makes these figures portrait statues, although the subjects lived well before the sculptor's time. Ekkehard, blunt and Teutonic, contrasts with the charming Uta, who, with a wonderfully graceful gesture, draws the collar of her gown partly across her face while she gathers up a soft fold of drapery with a jeweled, delicate hand. The drapery and the body it enfolds now are understood as distinct entities. The shape of the arm that draws the collar is subtly and accurately revealed beneath the drapery, as is the full curve of the bosom. The drapery folds are rendered with an accuracy that indicates the artist's use of a model. We have before us an arresting image of medieval people—a feudal baron and his handsome wife—as they may well have appeared in life. By mid-thirteenth century, images not only of sacred but also of secular personages had found their way into the cathedral.

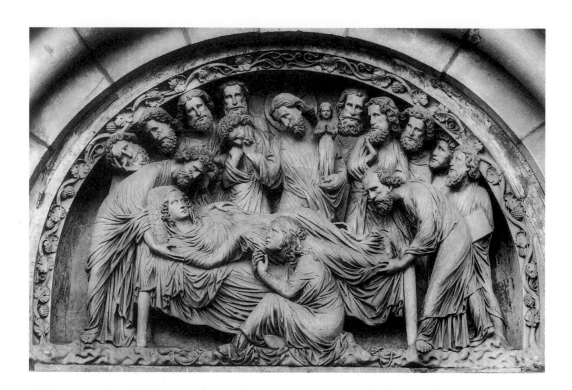

13-53 *Death of the Virgin,*
tympanum, south transept portal,
Strasbourg Cathedral, France,
c. 1230.

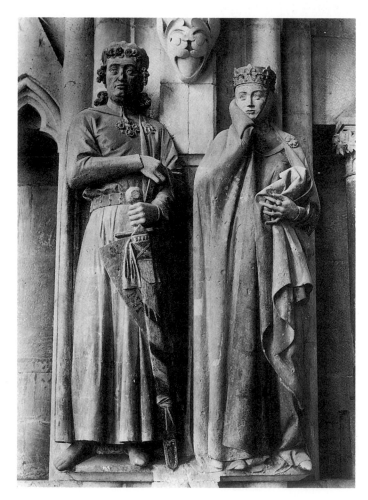

13-54 *Ekkehard and Uta, c.* 1250–1260, west choir, Naumburg
Cathedral, Germany.

The equestrian figure of a Gothic nobleman mounted
against a pier in the Cathedral of Bamberg (FIG. **13-55**) is
familiarly known as the *Bamberg Rider.* Like *Ekkehard and
Uta,* this statue has the quality of portraiture; some believe
it represents the German emperor Conrad III. The artist has
carefully described the costume of the rider, the high sad-
dle, and the trappings of the horse. The proportions of
horse and rider are real, although the anatomy of the ani-
mal is not quite comprehended and its shape is rather stiffly
schematic. An ever-present pedestal and canopy firmly
establish dependence on the architectural setting and man-
age to hold the horse in strict profile. The rider, however,
turns easily toward the observer, as if presiding at a review
of troops, and is beginning to break away from the pull of
the wall. The stirring and turning of this figure seem to
reflect the same impatience with subordination to architec-
ture that is found in the portal statues at Reims (FIG. 13-34).

The gradual growth of naturalism during the thirteenth
century was modified during the fourteenth century by an
impulse toward charmingly ornamental effects and courtly
convention, as seen in *The Virgin of Paris* (FIG. 13-39). A new
intensity of expression, anticipated in the *Death of the Virgin*
at Strasbourg (FIG. 13-53), also was developing at this time.

A markedly tragic tone characterizes this new emphasis.
The widespread troubles of the fourteenth century—war,
plague, famine, social strife—brought on an ever more
acute awareness of suffering; this found its way readily into
religious art. The Dance of Death, Christ as the Man of
Sorrow, and the Seven Sorrows of the Virgin Mary became
favorite themes. A fevered and fearful piety sought comfort
and reassurance in the reflection that Christ and the Virgin
Mother shared the woe of humankind. To represent this

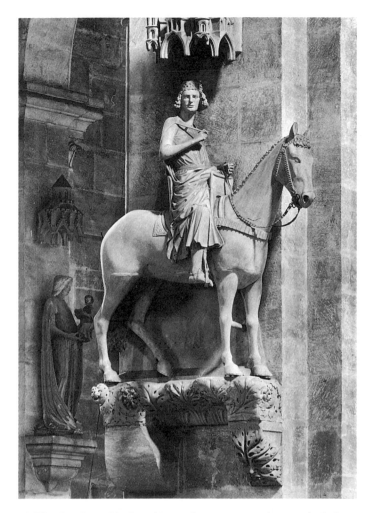

13-55 *Bamberg Rider,* late thirteenth century, Bamberg Cathedral, Germany. Sandstone, 90¹/₂" high.

teenth century art is addressing the private person (often in a private place) in a direct appeal to his or her emotions. The expression of *emotions* goes along with the representation of the *motion* of the human body. As the figures of the church portals move on their columns, then within their niches, and then become freestanding, their details become more outwardly related to the human audience as expressions of recognizable human feelings. In this little pietà group the mysteries of the Incarnation (the birth of Christ) and the Atonement (the sacrifice of Christ) are taught not by some impersonal symbol or some lofty image, but are brought down by empathy into the world of bitter human experience.

We shall see the pietà theme again in another version, different in time, place of origin, medium, scale, and conception (FIG. 22-18). Readers will agree that both works are alike unforgettable.

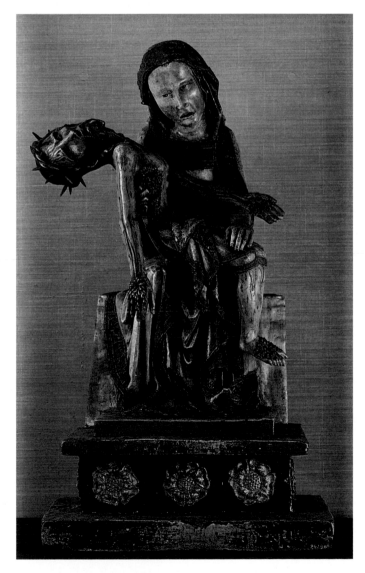

the artist emphasized in powerful, expressive exaggeration the traits of human suffering. In a carved and painted group (here in wood) called a *pietà,* (FIG. **13-56**), Christ is a stunted, distorted human wreck, stiff in rigor mortis, covered with gouts and streams of blood. The Virgin Mother, who cradles him like a child in her lap, is the very image of maternal anguish, her face twisted in an uncouth grimace of grief.

There is nothing here of the serenity we find in the thirteenth-century depiction of the great Christian saints as figures aloof and remote from earthly humanity. Here the devout are forcibly confronted with an appalling icon of agony, death, and sorrow that humanizes, to the point of heresy, the sacred personages. Divinity is completely submerged in damaged human being. The work calls out to the horrified believer: "what is your suffering compared to this!" It is the passionate voice of the new religious revivalism preached by the friars in the churches and in the streets.

The humanizing of religious themes and religious images accelerates steadily from the twelfth century. By the four-

13-56 *Pietà (Virgin with the Dead Christ),* c. 1325. Painted wood, 34" high. Rheinisches Landemuseum, Bonn.

Italy

Few Italian architects accepted the northern Gothic style, and the question has been raised as to whether it is proper to speak of buildings like Florence Cathedral (FIGS. **13-58** to **13-60**) as Gothic structures. Begun in 1296 by Arnolfo di Cambio and so large that it seemed to the fifteenth-century architect Leon Battista Alberti to cover "all of Tuscany with its shade," the cathedral scarcely looks Gothic. Most of the familiar Gothic features are missing; the building has neither flying buttresses nor stately clerestory windows, and its walls are pierced only by a few, relatively small openings. Like the facade of San Miniato al Monte (FIG. 12-21), the building's surfaces are ornamented, in the old Tuscan fashion, with marble-incrusted geometric designs to match it to the eleventh-century Romanesque Baptistery of San Giovanni nearby (FIG. 12-20). Beyond an occasional *ogival* (pointed arch) window and the fact that the nave is covered by rib vaults, very little identifies this building as Gothic. The vast gulf that separates this Italian church from its northern European cousins is strikingly evident when the former is compared with a full-blown German representative of the High Gothic style, such as the cathedral of Cologne (FIG. **13-57**).

In Cologne Cathedral, an emphatic stress on the vertical produces an awe-inspiring upward rush of almost unmatched vigor and intensity. The building has the character of an organic growth shooting heavenward, its toothed upper portions engaging the sky. The pierced, translucent stone tracery of the spires merges with the atmosphere.

Florence Cathedral clings to the ground and has no aspirations to flight. All emphasis is on the horizontal elements of the design, and the building rests firmly and massively

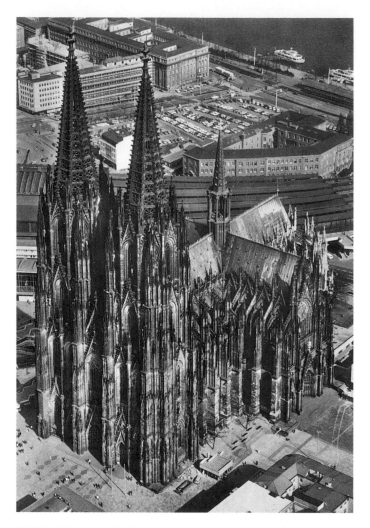

13-57 Cologne Cathedral, Germany, 1248; nave, facade, and towers, nineteenth century (view from the south).

13-58 Florence Cathedral, Italy, 1296–1436 (view from the south).

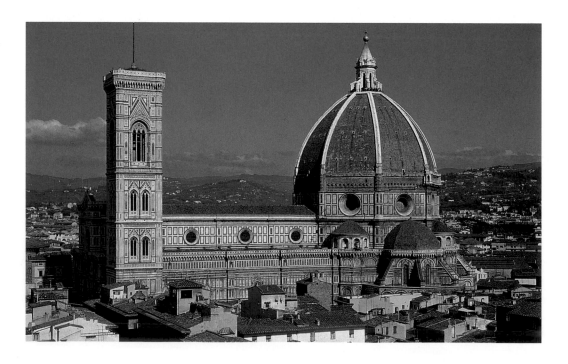

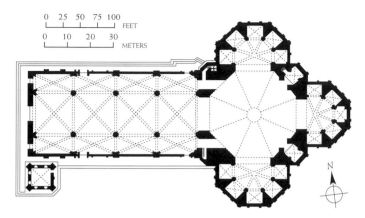

13-59 Plan of Florence Cathedral. (After Sir Banister Fletcher.)

(it was built by Filippo Brunelleschi between 1420 and 1436), a comparison of the campanile with the Cologne towers may be somewhat more appropriate.

Designed by the painter Giotto di Bondone in 1334 (and completed with some minor modifications after his death), the Florence campanile (FIG. 13-58) stands apart from the cathedral in the Italian tradition. In fact, it could stand anywhere else in Florence without looking out of place; it is essentially self-sufficient. The same can hardly be said of the Cologne towers (FIG. 13-57); they are essential elements of the building behind them, and it would be unthinkable to detach one of them and place it somewhere else. Heinrich Wölfflin compared buildings of this kind to a flame from which no single tongue can be separated.* This comparison holds true for every part of the Cologne structure, down to its smallest details. No individual element seems to be capable of an independent existence; one form merges into the next, in an unending series of rising movements that pull the eye upward and never permit it to rest until it reaches the sky. This structure's beauty is

on the ground. Simple, geometric volumes are defined clearly and show no tendency to merge either into each other or into the sky. The dome, though it may seem to be rising because of its ogival section, has a crisp, closed silhouette that sets it off emphatically against the sky behind it. But because this dome is the monument with which architectural historians usually introduce the Renaissance

*Heinrich Wölfflin, *Classic Art,* 2d ed. (London: Phaidon, 1953).

13-60 Nave of Florence Cathedral (view facing east).

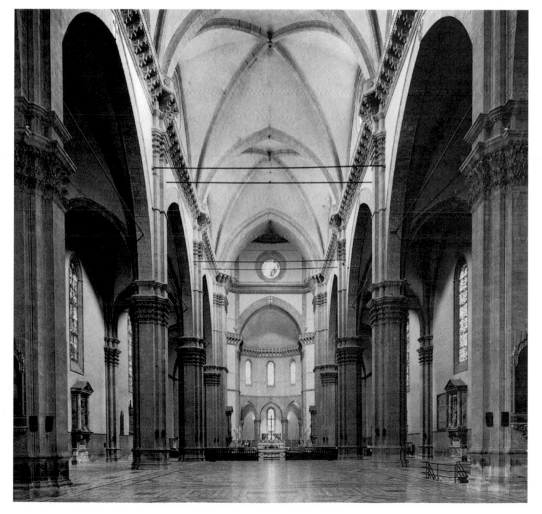

amorphous rather than formal; it is a beauty that speaks to the heart rather than to the intellect.

The Italian tower is entirely different. Neatly subdivided into cubic stages, Giotto's tower is the sum of its clearly distinguished parts. Not only could this tower be removed from the building without adverse effects, but each of the component parts—cleanly separated from one another by continuous, unbroken moldings—seems capable of existing independently as an object of considerable esthetic appeal. This compartmentalization is reminiscent of Romanesque, but it also forecasts the ideals of Renaissance architecture: to express structure in the clear, logical relationships of its component parts and to produce self-sufficient works that could exist in complete independence. Compared to the north towers of Cologne, Giotto's campanile has a cool and

rational quality that appeals more to the intellect than to the emotions.

In the plan of Florence Cathedral (FIG. 13-59), the nave almost appears to have been added to the crossing complex as an afterthought; in fact, the nave was built first, pretty much according to Arnolfo's original plans (except for the vaulting), and the crossing was redesigned midway through the fourteenth century to increase the cathedral's interior space. In its present form, the area beneath the dome is the focal point of the design, and the nave leads to it, as Paul Frankl says, "like an introduction of slow chords, to a goal of self-contained finality." To the visitor from the north, the nave seems as strange as the plan; neither has a northern European counterpart. The Florence nave bays (FIG. 13-60) are twice as deep as those of Amiens (FIG. 13-25), and the

13-61 West facade of Orvieto Cathedral, Italy, begun *c.* 1310.

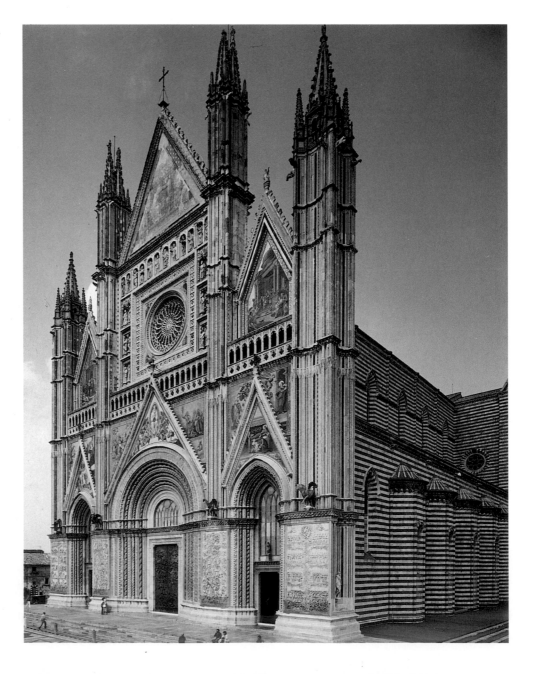

wide arcades permit the shallow aisles to become part of the central nave. The result is an interior of unmatched spaciousness. The accent here, as on the exterior, is on the horizontal elements. The substantial capitals of the piers prevent them from soaring into the vaults and emphasize their function as supports. This interior lacks the mystery of northern naves, and Nikolaus Pevsner has observed that its serene calm and clarity tell the visitor that the Tuscan architects never entirely rejected or forgot their Classical heritage and that it is indeed only here, in central Italy, that the Renaissance could have been born.

The facade of Florence Cathedral was not completed until the nineteenth century and then in a form much altered from its beginnings. In fact, Italian builders exhibited little concern for the facades of their churches, and dozens remain unfinished to this day. One reason for this may be that the facades were not conceived as integral parts of the structures, but rather as screens that could be added to the fabric at any time.

The facade of Orvieto Cathedral (FIG. **13-61**) is a typical and handsome example. Begun in the early fourteenth century, it pays the graceful compliment of imitation to some parts of the French Gothic repertoire of ornament, especially in the four large pinnacles that divide the facade into three bays. But these pinnacles—the outer ones serving as miniature substitutes for the big, northern, west-front towers—grow up, as it were, from an old Tuscan facade (FIG. 12-21) and, ultimately, from the Early Christian. The rectilinearity and triangularity of the old Tuscan marble incrustation (here enframing and pointing to the precisely wrought rose window) are seen clearly behind the transparent Gothic overlay. The whole effect of the Orvieto facade is that of a great altar screen, its single plane covered with carefully placed carved and painted ornament. In principle, Orvieto belongs with San Miniato al Monte or the cathedral of Pisa, rather than with Amiens or Notre-Dame of Paris.

Since Romanesque times, northern European influences had been felt more strongly in Lombardy than in central Italy. When the citizens of Milan decided to build their own cathedral (FIG. **13-62**) in 1386, they invited and consulted experts not only from Italy but also from France, Germany,

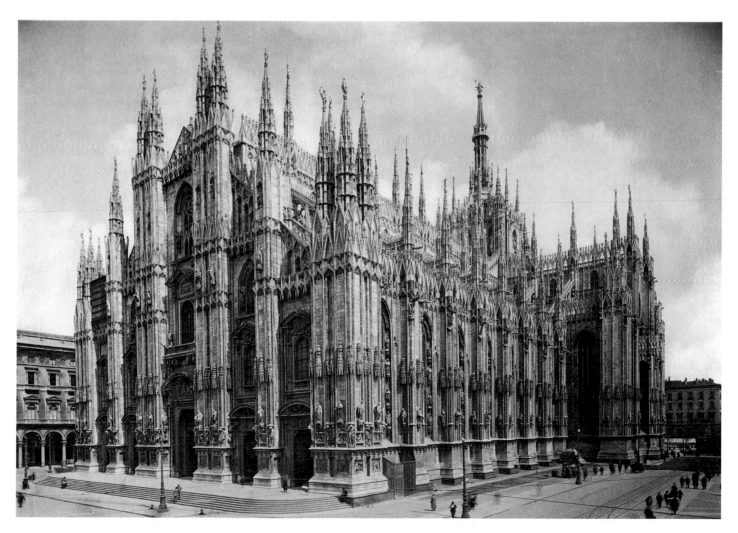

13-62 Milan Cathedral, Italy, begun 1386 (view from the southwest).

and England. These experts must have carried on a rough disputation about the strength of the foundations and the composition and adequacy of the piers and the vaults—the application of the true geometric *scientia* in working out plan and elevation. The result was a compromise; the proportions of the building, particularly those of the nave, became Italian (that is, wide in relation to height), and the surface decorations and details remained Gothic. But even before the cathedral was half finished, the new Classical style of the Renaissance had been well launched and the Milan design had become anachronistic. The elaborate facade represents a confused mixture of Late Gothic and Classical elements and stands as a symbol of the waning of the Gothic style.

The city churches of the Gothic world were just as much monuments of civic pride as they were temples or symbols of the spiritual and natural world. To undertake the construction of a great cathedral, a city had to be rich with thriving commerce. The profusion of large churches during the period attests to the affluence of those who built and maintained them, as well as to the general revival of the economy of Europe in the thirteenth century.

The secular center of the community, the town hall, was almost as much the object of civic pride as the cathedral. A building like the Palazzo Pubblico of Siena (FIG. **13-63**), the proud commercial and political rival of Florence, must have earned the admiration of Siena's citizens as well as of visiting strangers, inspiring in them respect for the city's power and success. More symmetrical in its design than most buildings of its type and period, it is flanked by a lofty tower, which (along with Giotto's campanile in Florence) is one of the finest in Italy. This tall structure served as look-

13-63 Palazzo Pubblico. Siena, Italy, 1288–1309.

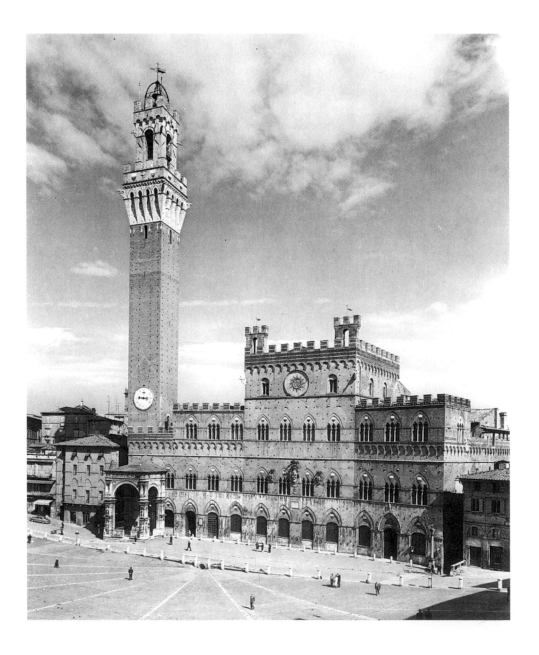

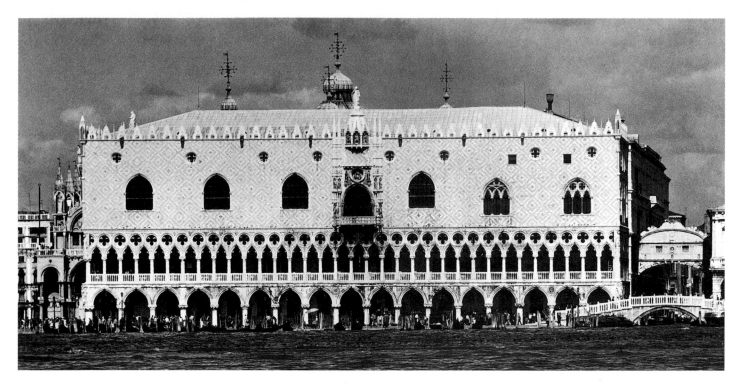

13-64 The Doge's Palace, Venice, Italy, *c.* 1345–1438.

out over the city and the countryside around it and as a bell tower from which signals of all sorts could be rung to the populace. The medieval city, a self-contained political unit, had to defend itself against neighboring cities and often against kings and emperors; in addition, it had to be secure against internal upheavals, which were common in the history of the Italian city-republics. Feuds between rich and powerful families, class struggle, even uprisings of the whole populace against the city fathers were constant threats to a city's internal security. The heavy walls and battlements of the Italian town hall eloquently express the frequent need of city governors to defend themselves against their own citizens. The high tower, out of reach of most missiles, is further protected by *machicolated* galleries, built out on corbels around the top of the structures to provide openings for a vertical (downward) defense of the tower's base.

The secular architecture of the Italian mainland tends to have this fortified look. But Venice, some miles out in the Venetian lagoon, was secure from land attack and could rely on a powerful navy for protection against attacks from the sea. Internally, Venice was a tight corporation of ruling families that, for centuries, provided an unshakable and efficient establishment, free from disruptive tumults within. Such a stable internal structure made possible the development of an unfortified, "open" architecture, exem-

plified in the Doge's Palace (FIG. **13-64**), the seat of government of the Venetian republic. This, the most splendid public building of medieval Italy, seems to invite passersby to enter rather than to ward them off. In a stately march, the short and heavy columns of the first level support low-pointed arches and look strong enough to carry the weight of the upper structure. Their rhythm is doubled in the upper arcades, where more slender columns carry ogival arches, which terminate in flamelike tips between medallions pierced with quatrefoils. Each story is taller than the one beneath it, the topmost being as high as the two lower arcades combined. Yet the building does not look top-heavy—a fact due in part to the complete absence of articulation in the top story and in part to the delicate patterning of the walls, in cream and rose-colored marbles, which somehow makes them appear paper-thin. The Doge's Palace is the monumental representative of a delightful and charming variant of Late Gothic architecture. Its slightly exotic style reminds us of Venice's strategic position at the crossroads of the West and the Orient, where it could synthesize artistic stimuli received from either direction. Colorful, decorative, light and airy in appearance, and never overloaded, the Venetian Gothic is ideally suited to the lagoon city of Venice, which floats between water and air.

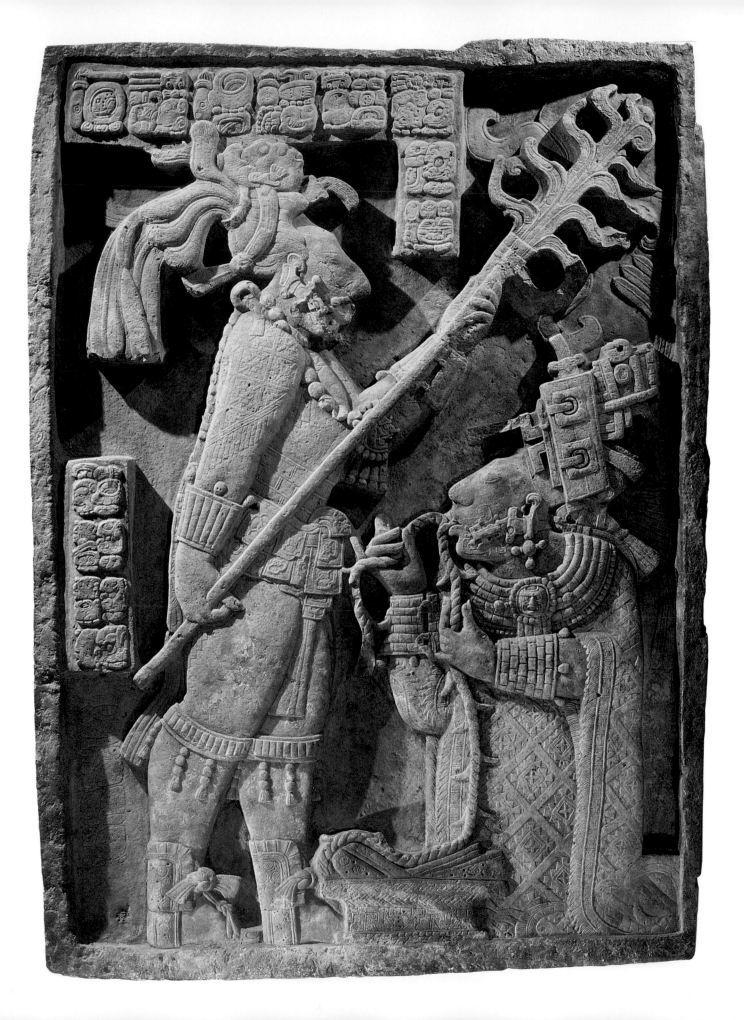

PART THREE

THE WORLD BEYOND EUROPE

A GLANCE AT A GLOBE WILL SHOW EUROPE TO BE A DIMINUTIVE PENINSULA OF ASIA, AND a mere geographical fragment compared with the vast land masses of Africa, the Americas, Australia, and the farflung archipelagos of the Pacific. During the Middle Ages, Christian Europe was enclosed by the Islamic crescent that curved from Ummayad Spain to Abbassid Baghdad in Iraq and penetrated India and central Asia to the borders of China. In Central America cultures like those of Teotihuacán and the Maya had produced cities of great scale and magnificence. In the ninth century Charlemagne's royal town of Aix-la-Chapelle (Aachen) was dwarfed in size and population by the immense city of Tang China, Chang'an, some seven by six miles in dimension, with perhaps a million inhabitants. The Latin Christian civilization of the West could not rival in grandeur, wealth, or refinement that of Tang China, of Muslim or Hindu India, or the successive Hindu-Buddhist kingdoms of Burma, Siam (Thailand), Cambodia, or Java. In West Africa the Sudanic empires of Ghana and Mali supplied both the Muslim and Christian worlds with gold. Byzantine Constantinople and Muslim Baghdad by far outshone in splendor and population the sadly decayed and deserted city of Rome, capital of the Latin Christian West.

In antiquity there had been extensive contacts, commercial and exploratory, among European, Asian, and African civilizations. The Phoenicians are said to have circumnavigated Africa as early as 600 B.C. Alexander the Great, bent on exploration as much as conquest, took his armies into Egypt and beyond the Indus river into India. The empires of Rome and of Han China, though not connected by formal diplomatic relations, included the coasts of East Africa, Arabia,

AT LEFT: *Shield Jaguar, Yaxchilán's ruler, hoists a torch while his principal wife, lady Xoc, pulls a length of thorn-lined rope through her pierced tongue in a gruesome rite of bloodletting. From a palace at Yaxchilan, Chiapas, Mexico. Classic Maya, c. 750.*

and India, in steady and extensive commercial traffic. Hoards of Roman gold have been found in India. The great silk route was a major artery linking China with the West as caravans traversed the steppes of Central Asia. The spices, textiles, and precious gems of the East found their way westward via shipping lanes through the Red Sea to the Mediterranean. These long and complex trade networks made the ancient world more cosmopolitan than it would be until modern times. The great medieval invasions and migrations of tribal peoples through both Asia and Europe from the fourth through the eighth centuries interrupted the commercial intercourse that connected Europe with Asia and Africa. It was in the thirteenth century that Europe rejoined this cosmopolitan world. The enterprising Venetian Marco Polo, in search of new trade routes to the East, reached the fabulous Chinese city of Beijing. The journey, and Marco's account of it, signaled the advent of a new era in world history.

The civilizations of the great continents beyond Europe are introduced here because, despite their vast differences in "look," they share with medieval Europe one overriding historical circumstance. Since the sixteenth century they all have been gradually affected, and to a lesser or greater degree transformed, by forces originating in post-medieval Europe, forces that by the twentieth century produced the foundations of a global civilization. European colonialism and imperialism, European theoretical/experimental science, technology, industry, market economics, and political theory and practice, whether for good or ill or both, have modified (and sometimes extinguished) the characteristic structures of the great civilizations elsewhere around the globe. At the same time, European culture has been transformed and revitalized by the enormous diversity of values, philosophies, concepts, and arts that have been introduced from the world beyond Europe. In the process, the identifiable features of European civilization *per se* have been significantly changed, and in our Postmodern world their very outlines seem to be fading.

There are characteristic features that medieval Europe shares with the other civilizations of the world that make it appropriate to correlate them at this point in our narrative. Though civilizations like those of China, Indian Asia, Africa, and the Americas have their beginnings as early as ancient Europe (the Aegean and Greece); and though they continue well beyond the chronological lines of medieval Europe (Romanesque/Gothic); they all share a worldview that might be classified—in broadest historical perspective—as pre-scientific. We mean here science in the modern sense, the systematic experimental procedures that identify, and to a degree control, the physical causes by which nature operates.

The modern scientific view of nature as physical has developed only over the last three centuries, a very small span of time in the thousands of years of world history. With the exception of certain philosophers of ancient Greece and of China, pre-scientific humankind held the religious view that nature is moved by mysterious, spiritual forces, of which the perceived world is only the deceptive shadow.

Not that the world civilizations and cultures neglected the study and the manipulation of physical nature. Their sciences were what we would call primarily "applied," rather than theoretical. The objects of their study varied in type, and the manipulation of them in degree, according to the different sectors of the world in which they were carried out. Taken altogether, pre-scientific humanity produced acute and accurate observations, as well as solutions to problems, in branches of science familiar today: astronomy, physics, rudimentary chemistry (mostly in the form of alchemy), mineralogy, animal and plant biology, physiology and medicine. They were skilled engineers—builders of great road networks, waterways, irrigation and drainage systems, as well as lasting monuments of architecture. Trade and transportation were facilitated by knowledge of magnetism, the magnetic compass, geography and navigation.

Intricate mechanisms were invented, like the clockwork and gear systems of China—a nation that also saw the invention of gunpowder, paper, and printing. Before the modern exploitation of steam power, petroleum combustion, and electricity, humankind knew well the use of man and horse power, and the driving forces of wind and water.

The abstract science of mathematics was widely cultivated, especially arithmetic and algebra; though, curiously, except for the ancient Greeks, there was no theoretical, axiomatic geometry, despite the existence of techniques for precise measurement and surveying. Of mathematics as the demonstrative language by which the causal laws of physical nature—the general laws that govern particular events—were to be known, there was no conception. There was no conception of a purely physical order behind the appearances of things that could be deduced through the engagement of experimental investigation and mathematical demonstration. Nor was there a theory of numbers that could lead from the computational techniques of the abacus to those of the computer.

For the great religions of the world—almost all of them originating outside the geographical limits of Europe, and still believed in by the vast majority of the human population—the actual causes and meaning of Nature cannot be found by scientific analysis and generalization of physical events. Though the religions of ancient Egypt, Mesopotamia, Greece, and Rome are extinct, monotheistic Judaism, Christianity, and Islam are still very much alive. But, like the religious civilizations of Asia, Africa, pre-Columbian America, and the Pacific, they have experienced what has been called the "crisis of modernization," that is, the secularizing of society by the challenges of modern science and technology.

Though the world religions vary immensely in type, complexity, and origin, and flourish at great distances from one another; they have in common the belief that mysterious power or powers beyond human comprehension rule both the cosmos and human life, and that these powers, whether immanent in the world or transcending it, are *personal* and are concerned with human beings. Their existence, firmly believed in, contradicts any scientific picture of the world as, after all, only an *impersonal* and indifferent "dance of atoms."*

These personal higher powers, often represented in art as superhuman persons, are in transaction with human beings through numerous modes of spiritual communication and of physical influence, The powers—god(s), spirits angelic, demonic, ancestral, genii—must be honored by humankind, for they can dispense good or withhold it. protect from evil, permit it, or inflict it. The acknowledgment of higher powers and the willing submission to them requires worship in many forms: prayer, ritual, sacrifice, self-denial, meditation and like performances, depending on the type, practice, and tradition of the given religion. The rewards of honoring the powers are grace, enlightenment, salvation, and immortality. To live in conformity with higher law ("the will of God") as it is revealed in sacred books, to live in harmony and rhythm with the organic being that is Nature, to live in conformity with the moral rules made sacred by tradition—these are variously the objectives of the great religions we have been considering and those we encounter at this stage of our narrative.

*Many religions *personify* the powers of nature; this was true, as we have seen, of the ancient religions. Animistic and polytheistic, they envision nature as alive with powerful beings inhabiting earth, sky and sea, mountains, valleys and streams, caves, rocks, and trees. These could become holy places, the residences of propitious deities, or could be shunned as dangerous. The holy places, sites of sacred groves, shrines and temples, would be seen by the scientist, *as* scientist, as merely more or less interesting geological features of the physical environment. Similarly, the religious believer sees the world as the spontaneous creation of a personal Higher Power, the scientist sees it as the work of an age-old process of evolution.

The Grand Temple Compound at Bhuvanesvara in northeast India was built between the eighth and thirteenth centuries. The buildings' majesty and mystery inspired Heinrich Zimmer to write in The Art of Indian Asia, *"[These temples] are visions that have become manifest on the human plane from a superior sphere; they are precipitations from the godly world of the divine chariot* [vimāna ratha] *which in these stone forms has found an earthly reproduction."*

The modification of world religions, the modernization of the societies that professed them, begins in the late Middle Ages. From the fifteenth to the twentieth centuries Christianity was modified by the Humanism of the Renaissance and fractured into sects by the Reformation. Its intellectual authority was reduced by the scientific revolution of the seventeenth century and by the free-thinking Enlightenment that accompanied it. Christianity, as an institution, was threatened by the political revolutions that brought democracy; the American constitution forbade any governmental establishment of religion.

Accompanying these secularizing trends was the expansion of Europe overseas, the colonialization of the Americas, Africa, Indian Asia, and Australia, and the Pacific islands. Inevitably, these societies, if not their religions, suffered crucial change. Some groups, like the indigenous inhabitants of the Americas and Australia, were all but exterminated and their lands expropriated. Africans were enslaved by the millions and exported to the colonial Americas. For centuries the disgraceful slave trade was carried on not only by Europeans, but by Arabs, and by West-African states like the Ashanti, Dahomey, Yoruba, and Benin kingdoms. The subcontinent of India became a "jewel in the crown" of the British empire, while the French ruled Indo-China (Vietnam, Laos, Cambodia), and the Dutch what is now Indonesia. In the nineteenth century the jealously guarded gates of China, Korea, and Japan were forced to open to European and American commerce. The twentieth century, as we have noted, has witnessed the worldwide adoption of the modernizing revolutions that began in post-medieval Europe—scientific, technological, industrial, political, cultural. The good and bad consequences of these great changes are everywhere manifested today, and their import for humankind is endlessly debated.

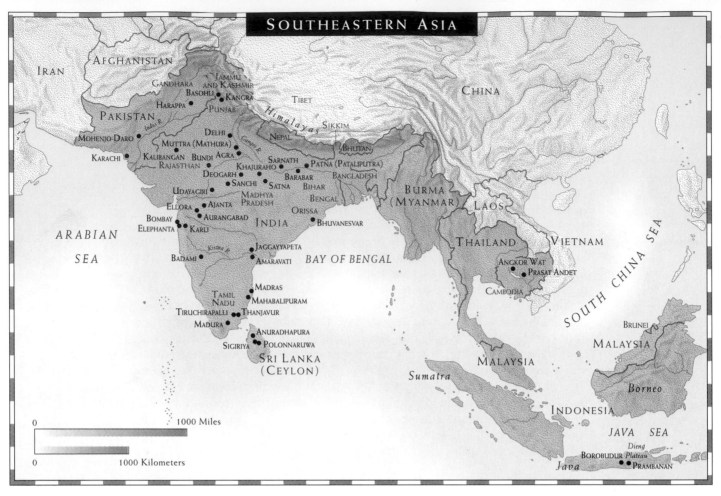

SOUTHEASTERN ASIA

IRAN

AFGHANISTAN

CHINA

GANDHARA
JAMMU AND KASHMIR
BASOHLI
KANGRA
HARAPPA
PUNJAB

Tibet

Himalayas
SIKKIM

PAKISTAN

Indus R.

MOHENJO-DARO
DELHI
Ganges R.
NEPAL
BHUTAN
MUTTRA (MATHURA)
KARACHI
KALIBANGAN
BUNDI AGRA
SARNATH
PATNA (PATALIPUTRA)
RAJASTHAN
KHAJURAHO
DEOGARH
BARABAR
BANGLADESH
UDAYAGIRI
SANCHI SATNA
BIHAR
ELLORA
AJANTA
MADHYA PRADESH
BENGAL
BOMBAY
AURANGABAD
INDIA
ORISSA
ELEPHANTA
KARLI
BHUVANESVAR

BURMA (MYANMAR)
LAOS

THAILAND
VIETNAM

ARABIAN
SEA

Kistna R.
JAGGAYYAPETA
BADAMI
AMARAVATI
BAY OF BENGAL

ANGKOR WAT
PRASAT ANDET

CAMBODIA

SOUTH CHINA SEA

MADRAS
TAMIL NADU
MAHABALIPURAM
TIRUCHIRAPALLI
THANJAVUR
MADURA
ANURADHAPURA
SIGIRIYA
POLONNARUWA
SRI LANKA (CEYLON)

BRUNEI

MALAYSIA

Sumatra

Borneo

MALAYSIA

INDONESIA

JAVA SEA

Dieng Plateau
BOROBUDUR
Java
PRAMBANAN

0 1000 Miles

0 1000 Kilometers

3000 B.C.	c.1800	1700	1500	500	322	184	70 B.C.	A.D.30

| INDUS VALLEY CIVILIZATION / ARYAN INVASIONS | | | | | MAURYA (ASOKA) | SUNGA | ANDHRA | |
| | | | | | | | KUSHAN | |

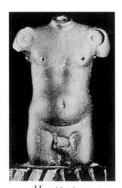

Harappa torso
3000–2000 B.C.

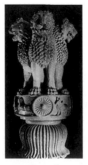

Capital
Palace of Asoka
272–232 B.C.

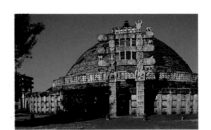

Great Stupa, Sanchi
completed 1st century

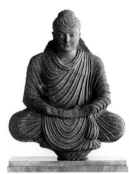

Seated Buddha, Gandhara
late 3rd century

Vedic religion introduced by Aryans, c. 1800 B.C.

Upanishads evolve, 800–600 B.C.

Birth of Sakyamuni Buddha, c. 563 B.C.

Gandhara conquered by Alexander the Great, 327 B.C.

Fall of Mauryan dynasty, political fragmentation of India, c. 184 B.C.

Bhagavad-Gita, c. 1st–2nd century B.C.

CHAPTER 14

THE ART OF INDIAN ASIA

320		C. 600	C. 750	846	1000	1173	1336		1736

GUPTA (NORTH INDIA)			LATER HINDU DYNASTIES	MUSLIM DYNASTIES		
CHALUKYA (CENTRAL INDIA)						
PALLAVA (SOUTH INDIA)			CHOLA KINGDOM		VIJAYANAGAR/NAYAK (HINDU) DYNASTIES	

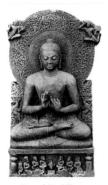

Seated Buddha
Sarnath, 5th century

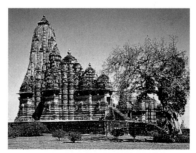

Visvanatha Temple
Khajuraho, c. 1000

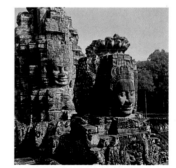

Bayon, Angkor Thom
12th–13th century

Indian emigrations to Burma, Cambodia,
Java, Thailand, Sumatra, 5th century

Muslim invasions begin, 1000

The subcontinent of India, contiguous with the Asian mainland on its northern boundaries, has three distinct geographical areas: the northeast, where the massive Himalayas, the traditional home of the gods, rise as a barrier; the fertile, densely populated area to the northwest and to the south of the Himalayas, where lie the valleys of the Indus and the Ganges rivers; and peninsular India, composed of tropical tablelands separated from the northern rivers by mountains and forests. Climatic extremes range from tropical heat to perpetual snow and glaciers, from desert conditions to some of the heaviest rainfall in the world.

The ethnic characteristics and religions of the people vary as much as the geography. The most common language of north central India is Hindi, a Sanskrit derivative. Urdu, closely related, is spoken by most of the Moslem population. Several Dravidian languages, unrelated to Sanskrit, are spoken in the south. Hinduism is the main religion of India, as Islam is of Pakistan; Jainism and Christianity have many adherents, Buddhism and Judaism, a few.

Early Indian Culture

The first major culture of India centered around the upper reaches of the Indus River valley during the late third and early second millennia B.C. Mohenjo-Daro and Harappa in Pakistan were the chief sites. Recently, other important centers of this culture have been found farther south at Kalibangan in Rajasthan, India, and near Karachi, Pakistan.

The architectural remains of Mohenjo-Daro suggest a modern commercial center, with major avenues along a north–south orientation, streets as wide as 40 feet, multi-storied houses of fired brick and wood, and elaborate drainage systems.

Some sculptures from this Indus civilization reflect Mesopotamian influences; others indicate the presence of a thoroughly developed Indian tradition. The latter is exemplified by a miniature torso from Harappa (FIG. **14-1**), which, at first glance, appears to be carved according to the precepts of Greek naturalism. (Some historians question the dating of this piece.) The emphasis given (by polishing) to the surface of the stone and to the swelling curves of the abdomen, however, reveals an interest, not in the logical anatomical structure of Greek sculpture, but in the fluid movement of a living body. This sense of pulsating vigor and the emphasis on sensuous surfaces were chief characteristics of Indian sculpture for four thousand years.

We have seen in Chapter 2 that the ancient civilizations of Egypt and Mesopotamia were connected on the west by Palestine and Syria. On the east, Mesopotamia adjoined the territory of Iran and the north Indian civilization of the Indus River valley with the important cities of Mohenjo-Daro and Harappa. Thus, a continuous range of more or less contemporaneous city civilizations stretched from Egypt to India, linked by trade, cultural diffusion, and conquest. This vast area was ringed about by nomadic peoples or sedentary farmer villages in Arabia, northern Africa, and northern Eurasia.

Great numbers of intaglio steatite seals found at Mohenjo-Daro exhibit a blend of Indian and Near Eastern elements (FIG. **14-2**). Indeed, it was the finding of a Mohenjo-Daro seal at a datable Mesopotamian site that enabled scholars to assign dates to the Indus valley cultures. The script on the seals has not been deciphered. Varied devices worked into the stone, such as trees (sometimes with animals and humanoid figures), are represented as objects of worship. The most common beasts are various kinds of bulls (including the humped variety), the water buffalo, the rhinoceros, and the elephant. Fantastic animals and anthropomorphic deities also are represented.

On one seal, a seated, three-headed figure appears in what is later known as a "yoga position." The heads carry a trident-shaped device that two thousand years later was used to symbolize the Buddhist community and the Hindu deity Siva. Around the deity are various animals, including the bull and the tiger, which also became symbols of Siva. Given its date, this seal probably represented a prototype of that god. Such continuity of iconography indicates the deep roots of religious tradition in India.

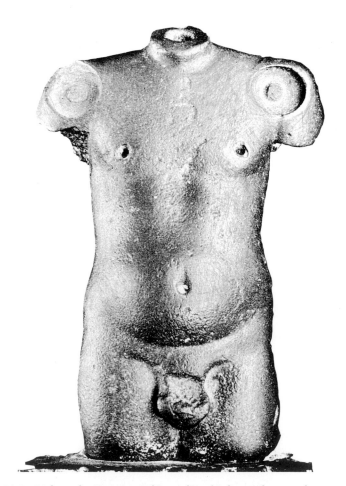

14-1 Male nude, Harappa, Pakistan, late third to early second millennium B.C. Red sandstone, 3¹/₂″ high. National Museum, New Delhi.

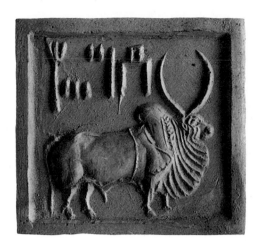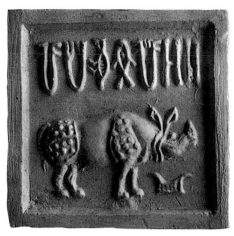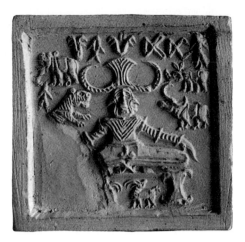

14-2 Seals, from Mohenjo-Daro, Pakistan, third millennium B.C. Steatite. National Museum, New Delhi.

The Aryan Invasions and the Vedic Religion

Style, too, shows a continuous tradition. The animals on the Indus valley seals have the flowing contours and sensuous surfaces (also seen in the Harappa figure) that characterize sculpture throughout most of Indian history. This artistic continuity is remarkable, not only because of the time spanned, but also because of the fact that virtually no remains of the visual arts have been found for the period between the disappearance of the Indus civilization (about 1700 B.C.) and the rise of the Maurya Empire (third century B.C.). The Aryan invasions, which began about 1800 B.C., may account for the break in the sequence of Indian art. The persistence of so many indigenous traits is even more amazing in view of the Aryans' profound effect on Indian culture. Destruction by the invaders, as well as the perishability of the materials used, undoubtedly accounted for the disappearance of many of the objects by which Indian traditions were passed on during the two thousand years following the collapse of the Indus civilization.

The Aryans brought the Vedic religion with them to India. The term derives from the Vedas, or hymns, which have survived to this day and are considered the most ancient and sacred literature of the Hindus. These hymns are addressed to the gods, who are personified aspects of nature. The warrior god Indra is thunder; Surya, the sun; and Varuna, the sky. These are but three of many. All were worshiped by means of hymns and sacrificial offerings in conformance with strict laws of ritual. Fire altars, built according to prescribed formulas, served as the focus of devotion. So important was the act of ritual that, in time, Agni (the sacrificial fire) and Soma (the sacrificial brew) became personified as gods in their own right.

The rather simple form of religion and propitiation so beautifully expressed in the Vedic hymns was elaborated greatly in the Upanishads (800–600 B.C.), a series of treatises on the nature of man and the universe that introduced a number of concepts alien to the simple nature worship of the northern invaders. Chief among the new ideas were those of samsara and karma. *Samsara* means the transformation of the soul into some other form of life on the death of the body. The type of existence into which the reborn soul enters depends on *karma*, the consequence of actions in all previous lifetimes. Bad karma means a dark future—rebirth in a hell or in this world as a lower animal (a reptile, for example, or an insect). Good karma means that the soul might go into the body of a king, a priest, or even a god, for gods also are subject to eventual death and to the endless cycle of rebirth. The goal of religion therefore became the submersion of individual life in a world soul, which is attainable only after an individual's karma has been perfected through countless rebirths. Penance, meditation, and asceticism were believed to speed the process.

Buddhist Dominance

During the sixth century B.C., two major religions developed in India. One, Buddhism, exerted a profound influence on the culture and art of India from the third century B.C. to the sixth or seventh century A.D. (In some parts, like Bengal and Bihar, it was influential to the eleventh century and, in the south, to an even later date.) Although Jainism, the other major religion, never achieved Buddhism's dominance, it continues to the present day as a small but distinct religion in India, while Buddhism is practically extinct there.

The arts of many Asian countries derive from Indian Buddhism, which began with the birth of the Buddha Sakyamuni about 563 B.C. The son of a king who ruled a small area on the border of Nepal and India, the child, according to legend, was miraculously conceived and sprang from his mother's side. Named Siddhartha, and also known as Gautama, the child displayed prodigious abilities. A sage predicted that he would become a Buddha, an "enlightened" holy man destined to achieve nirvana or

liberation. After a series of confrontations with old age, sickness, religious asceticism, and death, called the Four Encounters, Siddhartha renounced courtly luxury and the secular life. While meditating under a pipal tree in the city of Bodh Gaya, he obtained illumination—the complete understanding of the universe that is Buddhahood. His teachings are summed up in the Four Noble Truths: all existence implies suffering; the cause of suffering is attachment to selfish craving; selfish craving can be eliminated; it can be eliminated by following the Eightfold Path. This path prescribes the practices of right understanding, right purpose, right speech, right conduct, right vocation, right effort, right alertness, and right concentration. This initial formulation of Buddhism, in which salvation was achieved by individual efforts, was later known as Hinayana Buddhism. The religion of Buddhism, so conceived, was not opposed to basic Hindu thought, but was rather a minor heresy deriving from speculations in the Upanishads. What Buddhism did was offer a specific method for solving the ancient Indian problem of how to break the chain of existence so the individual could find ultimate peace.

EARLY ARCHITECTURE The earliest known examples of art in the service of Buddhism (from the middle of the third century B.C.) are both monumental and sophisticated. Emperor Asoka (272–232 B.C.), the grandson of Chandragupta, founder of the Maurya dynasty (c. 322–184 B.C.), was converted to Buddhism after witnessing the horrors of the brutal military campaigns by which he himself forcibly had unified most of northern India. His palace at Patna in Bihar (ancient Pataliputra) was designed after the Achaemenid palace at Persepolis (FIGS. 2-25 and 2-26).

Megasthenes, a Greek ambassador at the court of Asoka, has left a glowing report of Pataliputra. Only parts of columns, the foundations of buildings, and remnants of a wooden palisade now remain, but we may draw some idea of the architectural details from a series of commemorative and sacred columns that Asoka raised throughout much of northern India. These monolithic pillars were of polished sandstone, some as high as 60 or 70 feet. The capital of one (FIG. **14-3**) typifies the style of the period. It consists of a *lotiform* capital (a capital in the form of a lotus petal), on which rests a horizontal disk sculptured with a frieze of four animals alternating with four wheels. Seated on the disk are four *addorsed* (back-to-back) lions that originally were surmounted by another huge wheel. All of the forms are symbolic. The lotus, traditional symbol of divinity, also connoted humanity's salvation in Buddhism. The wheel represented the cycle of life, death, and rebirth. This "wheel of life" often had other levels of meaning. In this instance, it was the teaching of Buddha—the "turning of the wheel of the law." The wheel itself (probably developed from ancient sun symbols) and the four animals (the four quarters of the compass) with which it is associated here imply a cosmological meaning in which the pillar as a whole symbolizes the world axis. The lions also had manifold mean-

ings, but here they were specifically equated with Sakyamuni Buddha, known as the lion of the Sakya clan.

The pillars are noteworthy not only for their symbolism, but also because they exemplify continuity of style. Although the stiff, heraldic lions are typical of Persepolis, the low-relief animals around the disk are treated in the much earlier, fluid style of Mohenjo-Daro. So, too, are the colossal figures of *yakshas* and *yakshis*, sculptured during Asoka's time or somewhat later. These male and female divinities, originally worshiped as local nature spirits, gods of trees and rocks, now were incorporated into the Buddhist and Hindu pantheons.

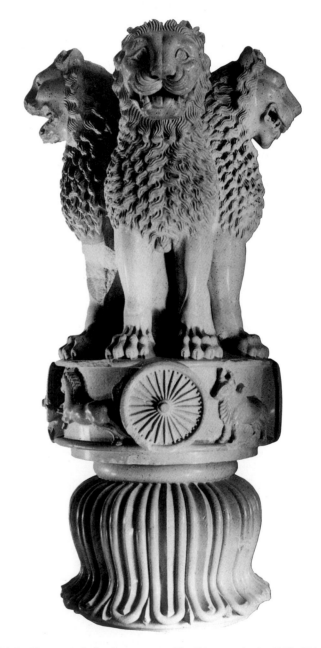

14-3 Lion capital of column erected by Emperor Asoka (272–232 B.C.) from Patna, (ancient Pataliputra), India. Polished sandstone, 7' high. Archeological Museum, Sarnath.

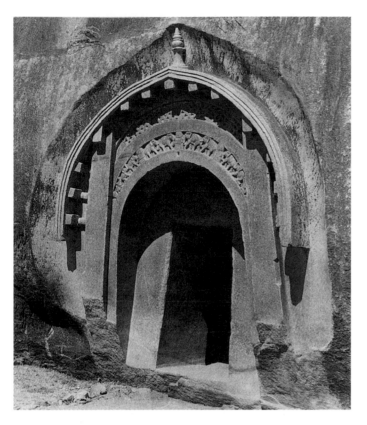

14-4 Entrance to the Lomas Rishi cave, Barabar Hills, India, third century B.C.

The Mauryan period also witnessed the beginnings of a unique architectural form—sanctuaries cut into the living rock of cliffs. Parts of the exteriors (and later the interiors) of these caves were carved to imitate in accurate detail the wooden constructions of the time. The Lomas Rishi cave, hollowed out during Asoka's reign, exhibits an entrance type (FIG. **14-4**) that will be perpetuated for a thousand years. This faithful replica of a wooden facade has a doorway with a curving eave that mimics a flexible wooden roof bent over rectangular beams. A decorative frieze of elephants over the doorway carries on the indigenous sculptural traditions.

The fall of the Mauryan dynasty, around the beginning of the second century B.C., led to the political fragmentation of India. Under the Sungas and the Andhras, who were the chief successors of the Mauryas, numerous *chaitya* (Buddhist assembly halls) and *viharas* (monasteries) were cut into the hills that run across central India from east to west. At the same time, the *stupa*, which originally was a small burial or reliquary mound of earth, evolved as an important architectural program. Asoka is supposed to have built thousands of stupas throughout India. By the end of the second century B.C., huge stupas were being constructed. Sculptured fragments from early stupas have been found at Muttra (ancient Mathura), near Satna (ancient Bharhut), and elsewhere in India, but the grandeur of this type of structure can be seen best at Sanchi in the state of Madhya Pradesh. There, on a hill overlooking a wide plain, several stupas containing sacred relics were built over a period of centuries. The Great Stupa (FIG. **14-5**), the tallest and finest, was originally dedicated by Asoka. Enlarged and finally completed about the middle of the first century,* it now stands as the culminating monument of an era.

A double stairway at the south side leads from the base to a drum about 20 feet high and permits access to a narrow, railed walk around the solid dome, which rises 50 feet

*As a reminder, all dates not designated by the epoch time designation B.C. refer to the period A.D. Unless required for clarification, especially in Chapters 14–18, where large ranges of time from B.C. to A.D. are being covered, A.D. will no longer be used throughout the text.

14-5 The Great Stupa, Sanchi, India, completed first century.

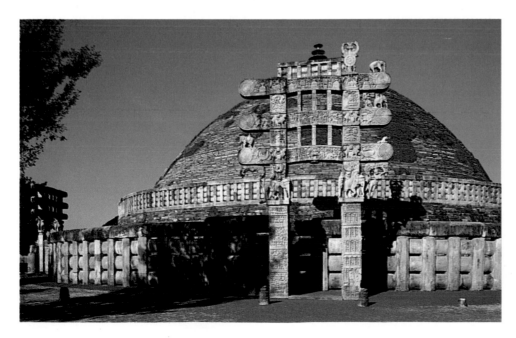

above the ground. Surmounting the dome is the *harmika*, a square enclosure from the center of which arises the *yasti*, or mast. The yasti is itself adorned with a series of *chatras* (umbrellas). Around the whole structure is a circular stone railing with ornamented *toranas*, or gateways to the stupa (FIG. **14-6**) on the north, east, south, and west sides.

The stupa, like most Indian structures, has more than just one function. As a receptacle for relics, it is an object of adoration, a symbol of the death of the Buddha, or a token of Buddhism in general. Devotion is given the stupa by the believer, who circumambulates its dome. But, in another sense, the stupa is a cosmic diagram, the world mountain with the cardinal points emphasized by the toranas. The harmika symbolizes the heaven of the thirty-three gods; the yasti, as the axis of the universe, rises from the mountain-dome and through the harmika, thus uniting this world with the paradises above.

The railings and domes of some stupas were decorated with relief sculpture. The toranas at Sanchi are covered with Buddhist symbols, deities, and narrative scenes, but the figure of the Buddha never appears. Instead, he is symbolized by such devices as an empty throne, the tree under which he meditated, the wheel of the law, or his footprints.

The awe expressed in this iconographic restraint, echoed by the quiet mass of the dome itself, is contradicted strik-

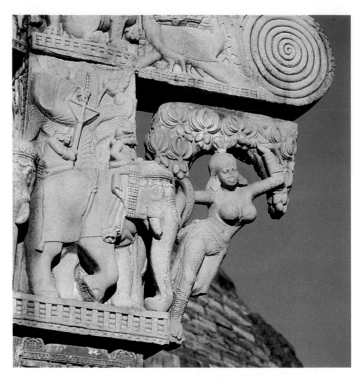

14-7 Yakshi, detail of eastern gateway in FIG. 14-6.

ingly and paradoxically by the sculptural luxuriance that crowds the toranas. Lush foliage mingles with the flowing forms of human bodies, and warm vitality pervades both animal and human forms. Sensuous yakshis hang like ripe fruit from tree brackets (FIG. **14-7**). This almost hedonistic expression is alien to the Buddhist renunciation of life. It is an assertion, rather, of a basic Indian attitude that at all times unites and dominates almost all of Buddhist, Hindu, and Jain art.

Sanchi is the greatest constructed monument of early Buddhism, much as the chaitya at Karli is the finest of the sculptured cave temples. During the second and first centuries B.C., the cave sanctuaries had developed complexities far beyond their simple beginnings in the Lomas Rishi cave. Splendid facades reproducing wooden architecture in exact detail were given permanence in stone. Around the year 100, at Karli, in the Western Ghats near Bombay, a cliff was hollowed out and carved into an apsidal temple nearly 45 feet high and 125 feet long. The nave of the hall leads to a monolithic stupa in the apse (FIG. **14-8**), and on either side of the nave is an aisle formed by a series of massive columns crowned with male and female riders on elephants. These great columns follow the curve of the apse, thus providing an ambulatory behind the stupa (FIG. **14-9**). The inner wall of the narthex, despite some later additions, is almost intact, and today it functions as a magnificent facade. On each side of the entrance, massive elephants, like atlantids, support a multistoried building, while male and female pairs (related to yakshas and yakshis) flank the central doorway, enhancing the rich surfaces with heroic

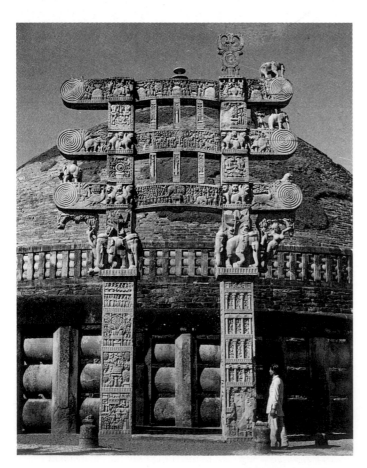

14-6 Eastern gateway, the Great Stupa, completed first century.

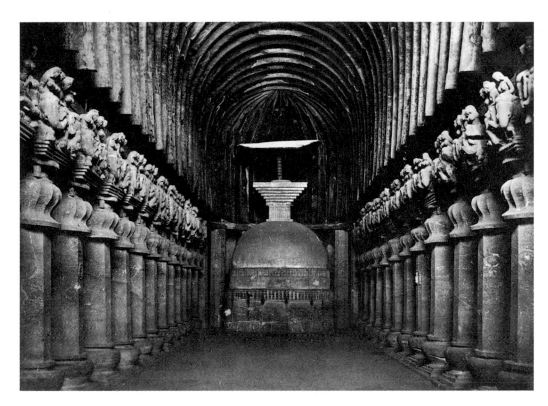

14-8 Interior of the chaitya hall at Karli, India, *c.* 100.

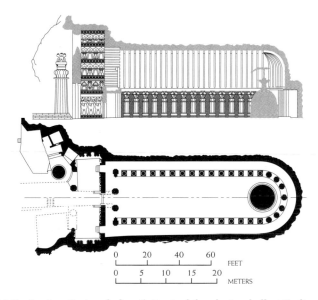

14-9 Section (*top*) and plan (*bottom*) of the chaitya hall at Karli.

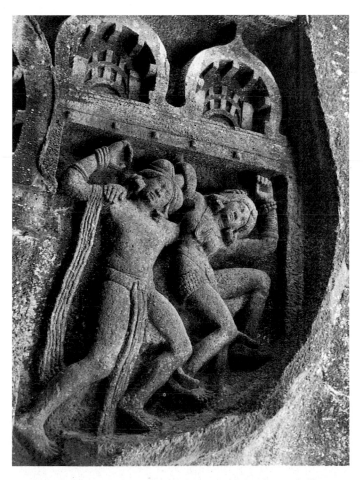

14-10 Amorous couple, from the entrance of the chaitya hall at Karli.

and voluptuous forms. These undulant figures (FIG. **14-10**) contrast with the immobile severity of the stupa within and, like the yakshis of Sanchi, speak of life, not death.

THE BUDDHA IMAGE For some four hundred years before the second century, the Buddha was represented only in symbols. At the end of the first century, in both Gandhara and Mathura, he suddenly was depicted in anthropomorphic form. The explanation is to be found partly in the development of the Buddhist movement,

which, during the first century, was divided by two conflicting philosophies. The more traditional believers regarded the Buddha as a great teacher who had taught a method by which the believer ultimately might attain nirvana. The newer thought, called *Mahayana* (the Great Vehicle) as opposed to the older *Hinayana* (the Lesser Vehicle), deified the Buddha and provided him with a host of divinities (*Bodhisattvas*) to aid him in saving humanity. According to the older belief, Sakyamuni was the last of seven Buddhas to exist on earth. The Mahayanists peopled the universe with thousands of Buddhas, of whom Amitabha, Lord of the Western Paradise, and Maitreya, a messiah who was to appear on this earth, soon rivaled Sakyamuni in popular favor. Symbols of the Buddha were too cold and abstract to appeal to great masses of people and were not suited to the pageantry of the new faith. In addition, Buddhism had borrowed from a reviving Hinduism the practice of *bhakti* (the adoration of a personalized deity as a means of achieving unity with it), which demanded the human figure as its focus. Thus Buddhism, out of emulation of its rival, produced its most distinct symbol, the Buddha image.

Gandhara, where one of the two versions of the anthropomorphic Buddha first appeared, may be taken loosely to include much of Afghanistan and the westernmost section of northern India, now part of modern Pakistan. In 327 B.C., Gandhara was conquered by the armies of Alexander the Great. Although the Greek occupation lasted only a short time, it led to continued contact with the Classical West. It is not surprising, then, that the Buddha image that developed at Gandhara (FIG. **14-11**) had Hellenistic and especially Roman sculpture as its model. Indeed, the features of the Buddha often suggest those of a marble Apollo, and many details, such as drapery patterns and coiffures, recall successive styles in contemporaneous Roman carving. Although the iconography was Indian, even the distinguishing marks of the Buddha (*lakshanas*) sometimes were translated into a Western idiom. Thus, the *ushnisha*, a knot of hair on the head, took on the appearance of a Classical chignon. At times, even the robe of the Indian monk was replaced by the Roman toga, and minor divinities were transformed into Western water gods, nymphs, or atlantids.

While this intrusion of Western style was dominating the northwest, the purely Indian version of the anthropomorphic Buddha was evolving one hundred miles south of Delhi in the holy city of Mathura. This image (FIG. **14-12**) is carved in stele form, which is common to most seated

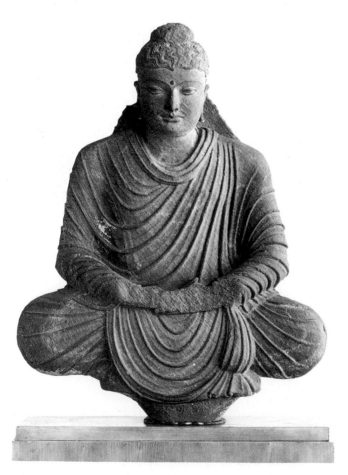

14-11 Seated Buddha, from Gandhara, Pakistan, late third century. Stone (black schist), 28³/₄″ high. Yale University Art Gallery.

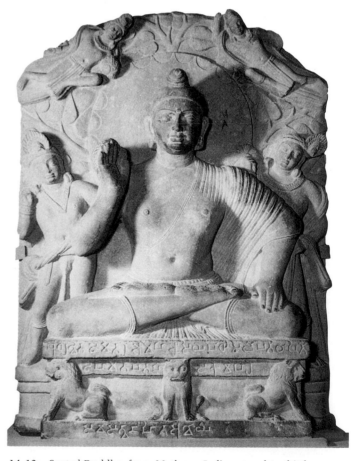

14-12 Seated Buddha, from Mathura, India, second to third centuries. Red sandstone, 27¹/₄″ high. Archeological Museum, Muttra.

Buddha images in India. Sitting on a throne, with heraldic lions at its base, and flanked by two turbaned men, the Buddha is surrounded by the leaves and branches of the Tree of Enlightenment. The image derives directly from the yaksha of popular art and, like the yaksha, is draped in a mantle so thin and clinging that, at first glance, the figure seems to be nude. The Mathura Buddha also has broad shoulders, a narrow waist, and a supple grace. Only such iconographic details as the ushnisha, the *urna* (a whorl of hair between the brows, represented as a dot), the long-lobed ears, and the *mudra* (a symbolic hand gesture) distinguish the Buddha from the earlier yaksha.

By the third century, the two anthropomorphic Buddha types began to coalesce into a form that served as a model for the earliest Chinese versions. But it is the Buddha at Sarnath (FIG. **14-13**), from the end of the fifth century, that conveys both the abstract idealism of the religion and the sensuousness of Indian art. The first element is evident in the simplified planes of the face; the second is found in the clinging drapery, which reveals the human form.

Hindu Resurgence

While Buddhism was at its height, Hinduism slowly was gathering the momentum that eventually was to crush its heretical offspring. Buddhism owed its original victory to the clearness of its formula for achieving salvation. About the first or second century B.C., Hinduism's answer appeared in the Bhagavad Gita, a poetic gospel that has been fundamental to Hindu doctrine ever since. According to the Bhagavad Gita, meditation and reason can lead to ultimate absorption in the godhead; so, too, can the selfless fulfillment of everyday duties. Because the Bhagavad Gita also stressed bhakti, which answered a fundamental emotional need, the Bhagavad Gita swept Hinduism to final supremacy in the sixth and seventh centuries A.D.

ARCHITECTURE AND SCULPTURE Sporadic examples of Hindu art dating from the last centuries B.C. have been found, but we know of no great monuments before the fourth century A.D. At that time, the Hindus began to emulate Buddhist cave temples, first by carving out monumental icons in shallow niches. One such temple is the Boar avatar of Vishnu (FIG. **14-14**)* at Udayagiri near Sanchi. Here, a 12-foot figure of Varaha, a manlike creature with a boar's head, is shown raising the earth goddess from the ocean—an act symbolic of the rescuing of the earth from destruction. The powerful form of Varaha, first formulated by the Kushans, served as a model for innumer-

*An *avatar* is a manifestation of a deity incarnated in some visible form in which the deity performs a sacred function on earth; the number of avatars a deity has varies, with Vishnu usually having ten, or sometimes twenty-nine.

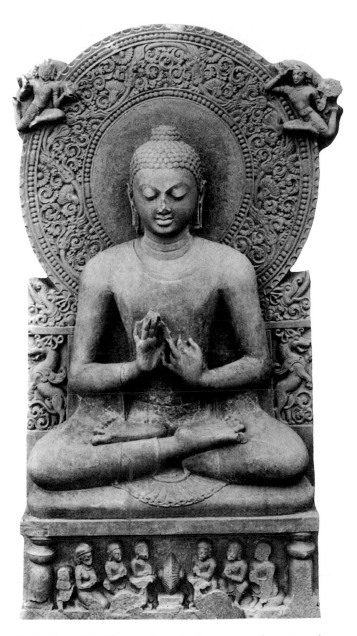

14-13 Seated Buddha preaching the first sermon, from Sarnath, India, fifth century. Stele, sandstone, 63″ high. Archeological Museum, Sarnath.

able later sculptures of this popular theme. Within a few decades, more developed caves at the same site acquired sculptural doorways, interior columns, and central icons.

During the sixth century, in the rock hillsides at Badami to the south, the Chalukyans carved out rectangular temples that had pillars, walls, and ceilings ornamented with figures of their favorite deities. Porches and interiors were defined by the embellished columns, which were so ordered as to focus attention on the shrine in the center of the rear wall. In a temple dedicated to Siva (with Vishnu, two of the chief divinities of the Hindu pantheon), the god is shown in his cosmic dance, with numerous arms spread

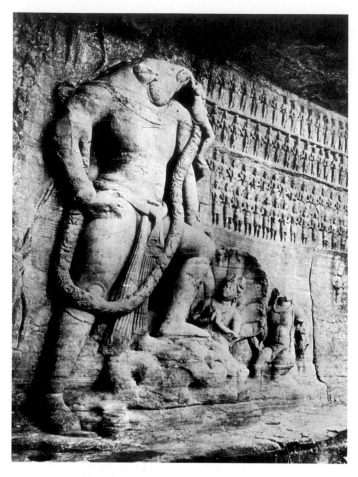

14-14 Boar avatar of Vishnu, Cave V at Udayagiri, India, *c.* 400. Vishnu is 12'8" high.

of the shapeless darkness of the background. Each of the three faces expresses a different aspect of the eternal. The center one, neither harsh nor compassionate, looks beyond humanity in the supreme indifference of eternal meditation. The other two faces—one soft and gentle, one angry and fearsome—speak of the sequence of birth and destruction that can be ended only by union with the godhead. The assurance of the period is manifest in the guardians of the shrine, who stand tall and relaxed. On the surrounding walls, deeply cut panels illustrating the legends of Siva carry on the robust and sensuous traditions of Harappa (FIG. 14-1) and Karli (FIG. 14-10).

During the fourth, fifth, and sixth centuries, Buddhism, in turn, borrowed heavily from Hindu doctrine. Elaborate rituals and incantations, inspired by similar Hindu practices, replaced the simple activities the Buddha had prescribed. Esoteric sects sprouted, and the popular Hindu worship of Sakti, the female power of the deity, was adapted for Buddhist usage. With little to distinguish it from Hinduism, Buddhism and its art gradually withered and, within a few centuries, virtually disappeared.

In the same burst of creativity that produced cave temples, other innovative Hindu architects were building the first structural temples with stone. One of the earliest that remains is the Vishnu temple built in the early sixth centu-

fanlike around his body (FIG. **14-15**). Some of the god's hands hold objects; others are represented in prescribed mudras. Each object and each mudra signifies a specific power of the deity. The arrangement of the limbs is so skillful and logical that it is hard to realize that the sculptor conceived of the figure as a symbol and not as an image of a many-armed being.

Perhaps the supreme achievement of Hindu art is at Elephanta, where, in the sixth century, craftsmen excavated a hilltop and carved out a pillared hall almost 100 feet square. On entering this sanctuary, the visitor peers through rows of heavy columns. As one's eyes adjust to the dark, the gigantic forms of three heads (FIG. **14-16**) begin to emerge from the end wall. The heads represent Siva as Mahadeva, Lord of Lords and incarnation of the forces of creation, preservation, and destruction. The concept of power is immediately transmitted by the sheer size of the heads, which rise nearly 17 feet from the floor, dwarfing the onlooker.

The trinity of colossal faces is placed so as to receive light from all of the different entrances of the cave, creating the awe-inspiring illusion that the forms rise mysteriously out

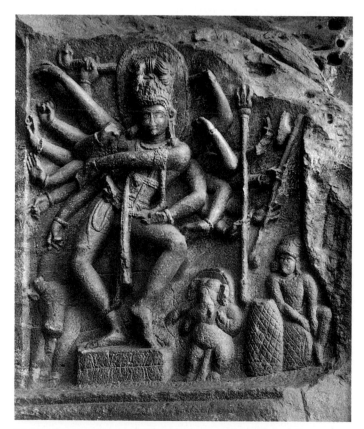

14-15 Dancing Siva, relief from cave temple, Badami, India, sixth century.

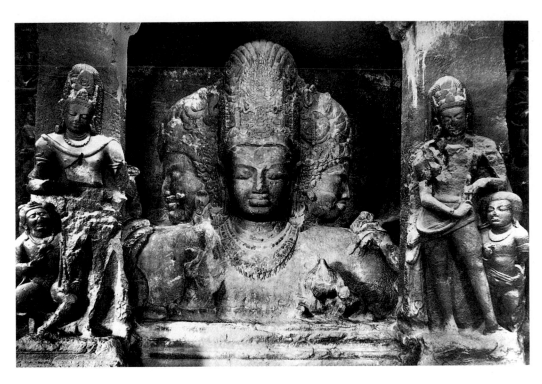

14-16 Siva as Mahadeva in rock-cut temple, Elephanta, India, sixth century. Siva is 17' high.

ry during the Gupta period (320–*c.* 600) at Deogarh in north central India (FIG. **14-17**). All later developments of the Hindu temple were in many ways elaborations on the principles embodied in the temple at Deogarh.

The Hindu temple is not a hall for congregational worship; it is the residence of the god. The basic requirement is a cubic cella for the cult image or symbol. This most holy of places, called the *garbha griha,* or womb chamber, has thick walls and a heavy ceiling to protect the deity. A doorway through which the devotee may enter is the only other architectural necessity. Like the stupa, the temple has other meanings, for it is also the symbol of the *purusha,* or primordial human being. In addition, in its plan, it is a *mandala,* or magic diagram of the cosmos, and its proportions are based on modules that have magical reference. Thus, the temple itself is a symbol to be observed from the exterior. Contemporary Western theories of architecture, defining it as the art or science that deals with the space-enclosing forms within which people carry on their activities, do not apply to the Hindu temple, which is to be appreciated as sculpture rather than as architecture.

In early temples, such as Deogarh, decoration is limited and restrained, and the form is a simple cube that originally was surmounted by a *sikhara* (tower). All of the walls except the entrance wall are solid but include sculptured panels, some like false doorways, framed in the walls. On these panels, in scenes from Hindu mythology, relaxed and supple figures carry on the Indian tradition of ease and poise.

In striking contrast to the robust plasticity of northern sculpture are the carvings on the Buddhist monuments

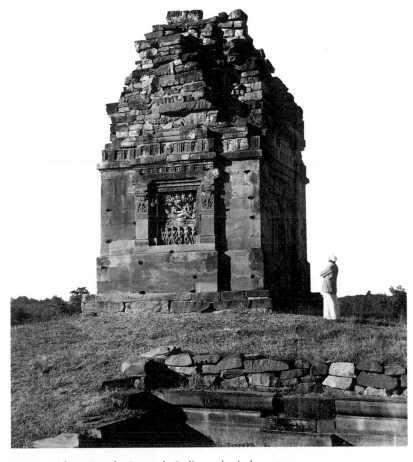

14-17 Vishnu Temple, Deogarh, India, early sixth century (side view).

situated at the mouth of the Kistna River on the Bay of Bengal. The major sites, in chronological order (dating roughly from the second century B.C. to the third century A.D.), are Jaggayyapeta, Amaravati, and Nagarjunakonda. Little remains from the first, but many reliefs from the other two sites are extant. These are ornamented elaborately and filled with hosts of figures that, particularly in later Amaravati scenes, are slender and graceful, rendered almost as if by brush.

The record of Indian art farther to the south begins with a cave temple at Mandagadippattu (early seventh century) that was commissioned by the first great ruler of the Pallavas, Mahendravarman I, and dedicated to the Hindu trinity. Mahendravarman soon was surpassed by his immediate successors at Mahabalipuram, on the coast not far from the city of Madras. Here, near a miscellany of monuments that includes cave shrines, carved cliffsides, and a masonry temple, a unique group of five, small, free-standing temples, known as *rathas* (FIG. **14-18**), were sculptured, perhaps as architectural models, from some of the huge boulders that litter the area. One of the temples is apsidal; another has a long, vaulted shape with a barrel roof, the ends of which reproduce the bentwood curves of the ancient chaitya. The smallest is a square shrine with a pyramidal roof that mimics in stone the thatch of primitive shrines as they appear in reliefs on the rails of early stupas. The Dharmaraja, largest of the rathas, has a simple cubic cella, as at Deogarh, but the *vimana* (composed of the garbha griha and the sikhara) ascends, in typical southern style, in pronounced tiers of cornices decorated with miniature

shrines (foreground, FIG. 14-18). Niches spaced along the walls contain figures of the major deities; these niches will become a regular feature of the southern temple.

In the following few centuries, a different architectural order evolved in northern India, characterized by a smoother integration of halls and porches with the main shrine and tower and by an increased vertical emphasis in all parts. The problem of creating a unified exterior was solved in separate stages. The first step, adding height to the horizontal *mandapa* (assembly hall) to mitigate the disparity between it and the vertical vimana, is illustrated in the immense Kailasa Temple (*c.* 750), an extraordinary rock-cut monument at Ellora. A second step is exemplified by the Temple at Bhuvanesvar, Orissa (FIG. **14-19**), where a high, pyramidal superstructure over the mandapa brought disproportionately horizontal elements into complete harmony with the tall sikhara. This evolution culminated during the tenth and eleventh centuries at Khajuraho (FIG. **14-20**) in north central India. There, the temples, numbering over twenty, became larger, more elaborate, and, by virtue of their high *plinths* (the square slab at the base of a column), even more prominent. Two and sometimes three mandapa were put before the cella. The greatest esthetic advance was made in the roofs of the mandapa and their pyramidal eaves, which unite with the sikhara to create a rapid and torrential sequence of cascading forms. The lower sections of the building, bound by a series of horizontal registers, are laden with sculptured deities, legends, and erotic scenes (FIG. **14-21**). Elongated figures often are set in complex, twisting poses that emphasize the sinuously curved

14-18 Rock-cut temples (Dharmaraja in foreground), Mahabalipuram, India, seventh century.

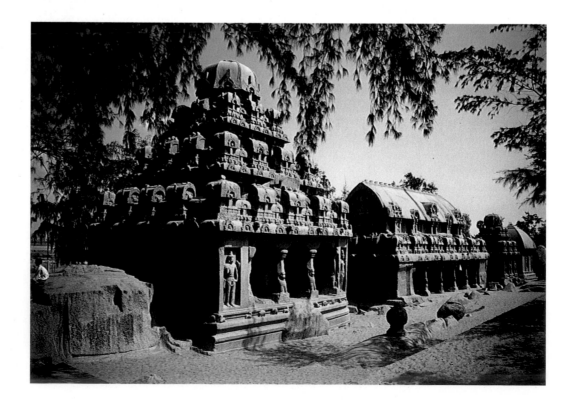

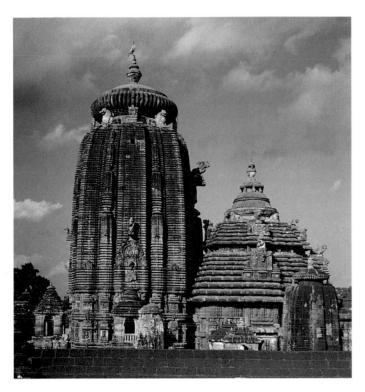

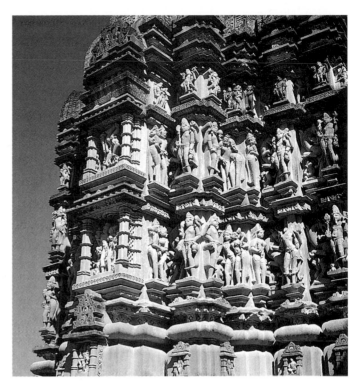

14-19 Lingaraja Temple, Bhuvanesvar, India, *c.* 950.

14-21 Sculptures from the Galleries of the Devi Jagadambi Temple, Khajuraho, *c.* 1000.

14-20 Visvanatha Temple, Khajuraho, India, *c.* 1000.

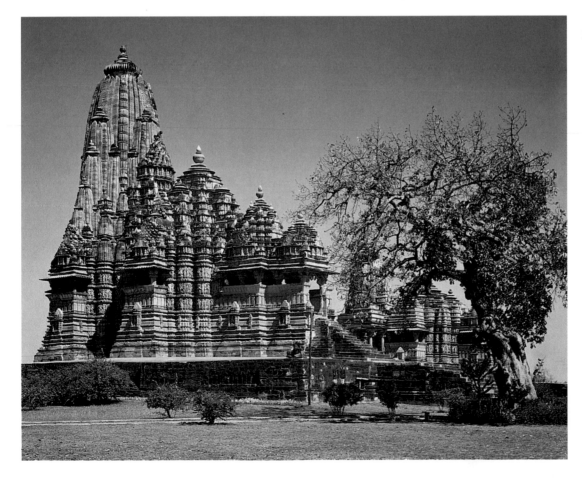

lines of the body. Although the rendering of living forms has become less natural and at times even disturbingly contorted, the sculptures function superbly in leading the eye around the shifting planes of the sides of the temple.

In the year 1000, the first of a series of Moslem invasions sounded the knell of Hindu architecture in northern India. But in the south—first under the Chola kingdom (846–1173) and later under the Hoysala (1022–1342), the Vijayanagar (1336–1565), and the Nayak (1420–1736) dynasties—sculpture and architecture continued to flourish.

Of particular beauty are the small, early Chola temples scattered throughout Tamil Nadu. Many are incomparable in their architectonic order, sensitive detail, and sculpture. A trend toward larger buildings, reflecting the imperial grandeur of the Chola kingdom, led to the great Brihadesvara Temple (c. 1000) of Thanjavur, which is 160 feet high and replete with architectural elements and figures. Many deities are represented on its walls, although fewer than at Khajuraho, and most appear in niches spaced with restraint at ordered intervals.

Bronze images were made to grace the shrines and to be carried in processions during important ceremonies. Some of the world's superb bronzes were produced in the Chola

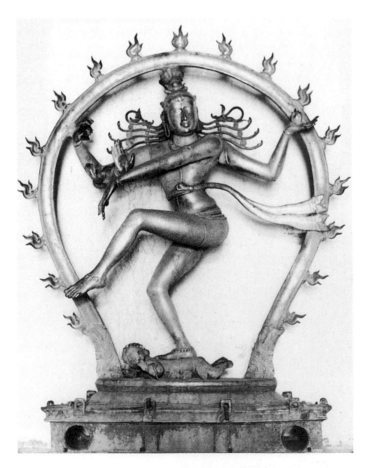

14-22 Siva as Nataraja (Lord of the Dance), bronze in the Naltunai Isvaram Temple, Punjai, India, c. 1000.

kingdom, where the figures of Siva as Nataraja, Lord of the Dance, reached a high point of quality in the tenth century. The Nataraja (c. 1000) at the Naltunai Isvaram Temple at Punjai, Tamil Nadu (FIG. **14-22**), shows the god, represented in an ideal human form, dancing vigorously within a flaming nimbus, one foot on the Demon of Ignorance. His flying locks terminate in rearing cobra heads and, on one side, support a tiny figure of the river goddess, Ganga. One of Siva's four hands sounds a drum, while, from another, a flame flashes. Dancing thus, the god periodically destroys the universe so that it may be reborn again. Exquisitely balanced, yet full of movement, this bronze is a triumph of three-dimensional sculpture and the art of bronze casting.

Enormous temple compounds were built around the nucleus of earlier temples. The Minakshi Temple at Madura and the Srirangam Temple at Tiruchirapalli eventually covered acres of ground. "Thousand-pillared" halls, built almost one beside the other, have the aspect of a continuous structure, interrupted only by courtyards and sacred water tanks for ritual bathing. Elaborate monolithic columns, carved with high- and low-relief figures, evoke a solemn mood, the stone sculpture having the effect of iron castings. The original walled enclosure came to be surrounded by other walls as the temple expanded, and the *gopuram*, or gateways to the temple compound, at each of the four cardinal points grew progressively higher with each additional wall. The fully developed gopuram is multistoried and crowded with sculpture. Many gopurams are over 150 feet high, and for this reason they dominate the landscape of southern India.

The spread of Moslem domination gradually weakened the Indian tradition, even in the south. By the seventeenth century, the harmonious proportions of earlier figures had been lost, and even the metal castings had become inferior.

PAINTING In India, the art of painting was probably as great as the art of sculpture but, unfortunately, less of it survives. The earliest traces are a few fragments in Cave X at Ajanta that date from approximately the first century B.C. Like the ornamentation on the toranas at Sanchi (FIG. 14-6), to which they are related in style, these fragments illustrate scenes from the past lives of the Buddha.

In Caves I and XVII at Ajanta, we find the next and most magnificent examples of Indian painting. These murals, dating from the fifth, sixth, and seventh centuries, embody all the clarity, dignity, and serenity of Gupta art and must be ranked among the great paintings of the world. The *Beautiful Bodhisattva Padmapani* in Cave I (FIG. **14-23**) moves with the subtle grace of the Deogarh sculptures, while the glow of color imparts an even more spiritual presence. The Ajanta paintings, however, are more than the manifestations of Buddhist devotion. Their genrelike scenes and worldly figures, although illustrating Buddhist texts, reflect a sophisticated and courtly art.

The Ajanta painting tradition, in all its colorful vitality, was continued under the Chola rule, as witnessed by the

paintings in the Brihadesvara Temple at Thanjavur. The dancing figures in these paintings, although drawn in the vivacious postures familiar in the Chola bronzes, retain some of the modeling and the soft tonality of the Gupta style.

The Moslem conquests inhibited the evolution of Hindu sculpture and architecture in northern India after the thirteenth century but revitalized the art of painting. In the sixteenth century, especially under the reign of Akbar, who was sympathetic to Hinduism and Christianity as well as Islam, traditional Indian painters were exposed to the delicate and conventionalized miniatures of the great Persian artists. During the seventeenth and eighteenth centuries, painting responded vigorously to the interplay between foreign modes at the imperial capital and autochthonous idioms at isolated feudal courts. Many delightful hybrids

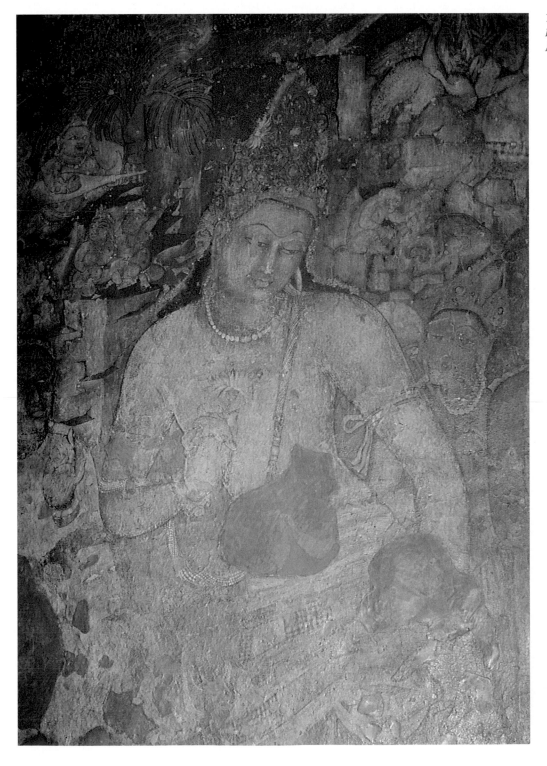

14-23 *Beautiful Bodhisattva Padmapani*, fresco from Cave I, Ajanta, India, *c.* 450–500.

and innovations resulted—some delicate and lyrical, as at Bundi and Kishangarh (modern Rajasthan); some stark and bold, as at Basohli in the Himalayan foothills. Among others, the hill schools in Guler and Kangra developed their own idioms, emphasizing such subjects as elegant figures in serene landscapes, portraits of rulers, interpretations of musical modes (*ragamalas*), and religious themes. The joy-

ous exuberance of these new styles was particularly well suited to newer Hindu cults, which were dedicated to the worship of Krishna, an avatar of Vishnu, whose praises were sung in the erotic poetry of the *Gita-Govinda*. The love of the lush and the sensuous, which the earliest Indian sculptures had expressed, thus found an entirely new medium in exquisitely colored, often tender paintings like

14-24 *Krishna and Radha in a Pavilion,* from Punjab, *c.* 1760. Opaque watercolor on paper $11^1/8'' \times 7^3/4''$. National Museum, New Delhi.

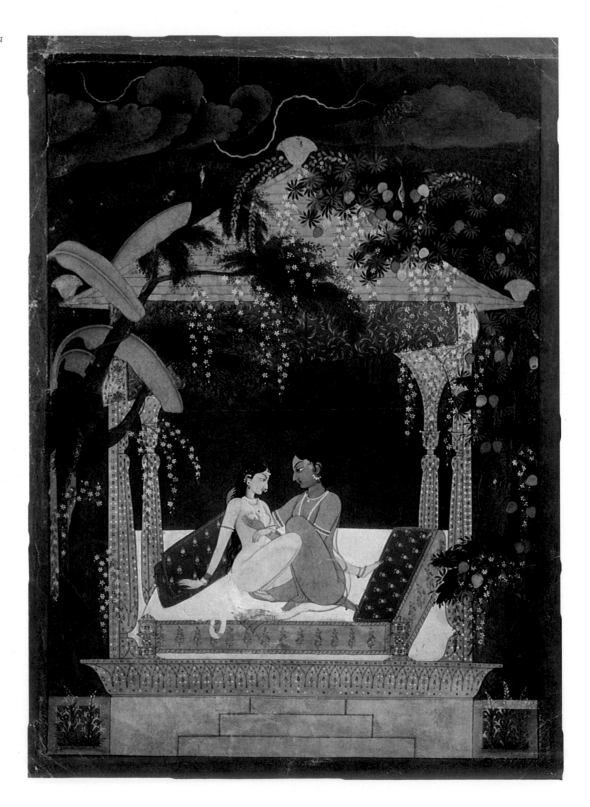

the miniature *Krishna and Radha in a Pavilion* (FIG. **14-24**). Krishna, the "Blue God," gently caresses his favorite shepherdess, Radha. They are seated within a golden pavilion hung with a rich scarlet textile and wreathed with flowering vines and succulent mangoes. Above the pavilion a lightning bolt crackles in the dark heavens, symbolizing the physical and spiritual energy that unites the pair. The firm yet gentle delineation describes a myriad of colored shapes with perfect fidelity and evenness, integrating the luxuriant variety of all elements of the design into coherent unity. Yet, such is the cunning of the designer that the figures of the narrative are adroitly centered and not absorbed into the pattern (compare FIG. 14-24 with FIG. 10-31). In this masterful depiction, the erotic theme is rarified into a suprasensual ideal of the mutual and enduring affection between man and woman. At the same time, the gorgeously colored accessories and the sinuously curved and supple bodies of the young lovers pay homage to the substances and rhythms of material nature as the source of love and pleasure. The last native masterpieces of Indian art, flourishing in the courts of the art-loving magnates of the Punjab, are among the world's supreme exemplars of amorous vision, rendered with delicacy and subtlety, sweetness and grace.

THE SPREAD OF INDIAN ART

The vigorous culture that generated the great achievements of art in India overflowed its borders. The great tide of Buddhism in the early centuries of the Christian era carried Mahayana beliefs and Gandhara-Mathura art through Afghanistan, across the desert trade routes of Xinjiang (formerly, Turkestan) into China, and eventually into Japan.

Sri Lanka

The path of Hinayana Buddhism, which was opened in the third century B.C. by the son of the emperor Asoka, led in another direction—south from Amaravati across the straits to Sri Lanka (formerly Ceylon). From that time on, Sri Lanka became a "Little India"; its arts were influenced first by Amaravati and then, successively, by the Guptas, the Pallavas, and the Cholas. The largest concentrations of art were at two royal centers: Anuradhapura (virtually an extension of Amaravati), where most of what remains is from the second and third centuries, and Polonnaruwa, best known for the colossal 46-foot-long sculpture of the expiring Buddha found there (FIG. **14-25**), which dates from the eleventh and twelfth centuries. Sri Lanka also is the site

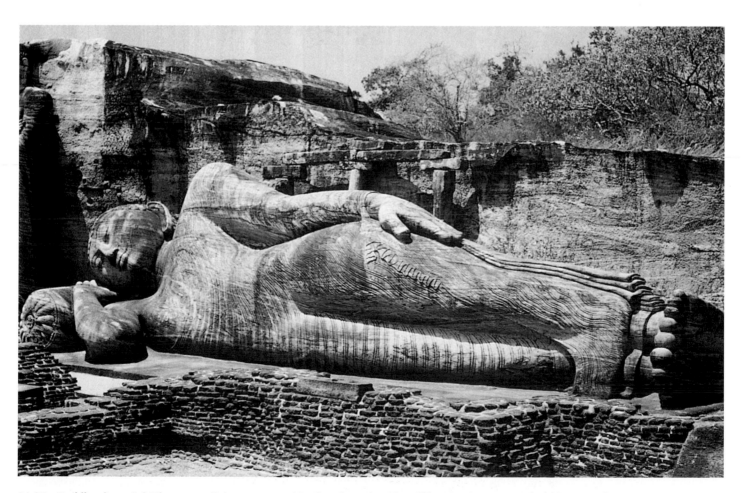

14-25 Buddha, from Gal Vihara, near Polonnaruwa, Sri Lanka, eleventh and twelfth centuries. Stone, whole figure 46' long.

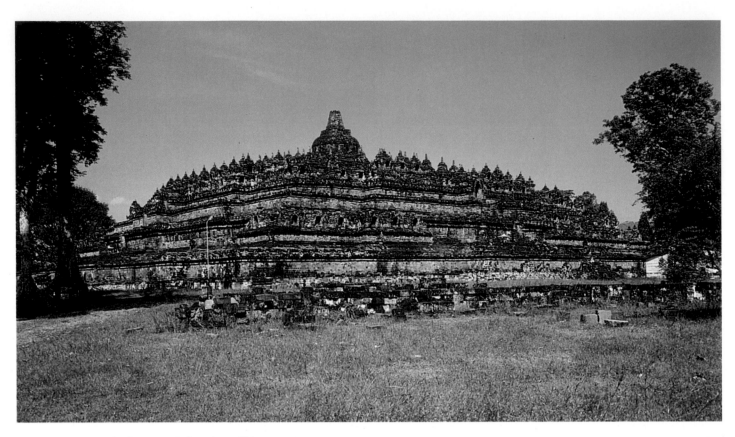

14-26 Stupa, Borobudur, Java, Indonesia, *c.* 800.

of many famous stupas that basically adhere to the Amaravati tradition but are simpler. Innovative carvings of guardian figures on stelae are placed at stupa entrances. Although some paintings have been discovered at Polonnaruwa, the earliest (fifth century) and most exquisite are the heavenly maidens on the escarpment of the fortress at Sigiriya.

Java

By the fifth century, a series of emigrations from India began the spread of Indian culture to Burma (Myanmar), Thailand, Cambodia, Sumatra, and Java. There, Buddhism and Hinduism continued their struggle for supremacy, with each introducing and fostering its arts. While Buddhism was under siege in India, one of its greatest monuments was rising at Borobudur in Java. There, around 800, a huge stupa (FIG. **14-26**), basically square and measuring over 400 feet across the base, was built of stone in nine terraced levels, with a central stairway in each of the four sides. The base and the first four tiers are rectilinear and signify the terrestrial world of sensation; the upper four tiers are circular and symbolize the heavens.

On the base, mostly covered by earth, 160 reliefs depict people trapped in the karmic cycle of life, death, and rebirth. Abundantly decorating the walls along the corri-

dors of the next four tiers are over one thousand cautionary scenes from the *jatakas* and different *sutras* (both are scriptural accounts of the Buddha). But above, on the circular terraces, no narratives intrude. Here, ringing the pathways in solitary dignity, are latticed stupas, near each of which is a seated Buddha of gentle beauty (originally, seventy-two of these small stupas were constructed to crown the upper tiers). The *dhyani* Buddhas (Buddhas of meditation) who accompany the stupas (FIG. **14-27**), are seated in yoga poses, expressing the tranquillity of pure and perfect transcendence of the world, rapt in eternal meditation. A larger stupa, rising at the pinnacle, may have enclosed a single Buddha, symbol of the Ultimate.

This architectural orchestration of sculptures is a mandala, a cosmic diagram perhaps representing the three spheres of Buddhist cosmology: the Human Sphere of Desire (didactic narratives crowded with figures and foliage); the Bodhisattva Sphere of Form; and the Buddha Sphere of Formlessness, where the simplicity and isolation of the individual stupas effect a serene release. The entire stupa has 505 Buddha figures. It is an eloquent statement of the esoteric Buddhism that developed from Mahayana in Java.

The Buddhists in Java also erected *chandis* (temples). Two near the stupa of Borobudur that date to the same time period are Chandi Mendut and Chandi Pawon. Their dark

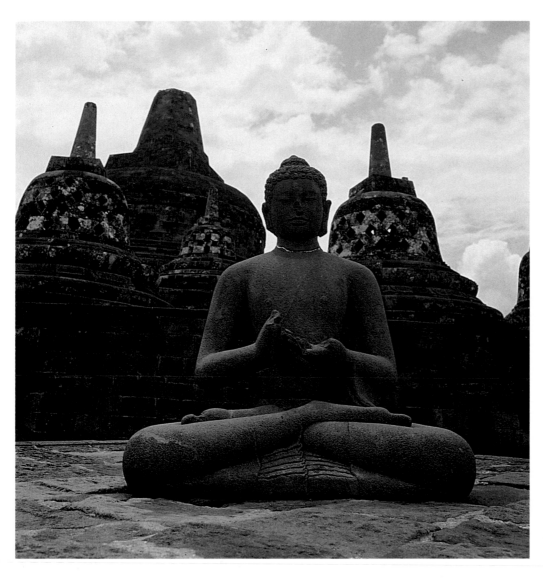

14-27 Dhyani Buddha, upper terrace, Great Stupa, Borobudur, *c.* 850.

sanctuaries, containing colossal Buddhist images, have the same awesome impact on the visitor as the shrines of the Buddhist cave temples in northwest India. Indeed, those caves, as well as other sacred sites throughout India, were well known to Indonesian pilgrims, whose exposure to Indian monuments and texts influenced their island culture.

The Hindus also were active in Java. On the Dieng Plateau, they erected single-celled Siva temples based on southern Indian Pallava models. At Prambanan in central Java, where structures and motifs were rapidly Javanized, the tall and narrow Siva temple of Lara Jonggrang (ninth and tenth centuries), is characteristically a studied aggregate of piled-up stones, terraced peaks, and sanctuaries— a symbol of Mahameru, axis of the universe and mountain home of the gods. Reliefs on the temple balustrade illustrate the great Hindu epic *Ramayana*. Naturalistic yet decorative, these dramatic narratives are a harmony of Indian forms and Javanese physical types.

Cambodia

The Indochinese mainland, in contact with India by the third century, also reacted to the stimuli of Indian culture. In Thailand, the softly modeled figures of bronze and stucco that were produced during the Dvaravati period (*c.* 500–900) were inspired by the Gupta style. During the pre-Angkor or Early Khmer period (*c.* 400–800), the Cambodians, too, borrowed the flowing planes and sensitive surfaces of Gupta. Around the seventh century, they also worked in the manner of the southern Indian Pallavas, as we can see in the figure of Harihara (a combined form of Siva and Vishnu) from Prasat Andet (FIG. **14-28**). The elegance of the Pallava prototypes at Mahabalipuram has been modified only slightly in this stone representation by the addition of a taut, almost springlike tension. Tall, broad shouldered, full-bodied, and slender legged, this is an idealized figure, more godly than human. We shall see later how the classical configuration of the pre-Angkor gods

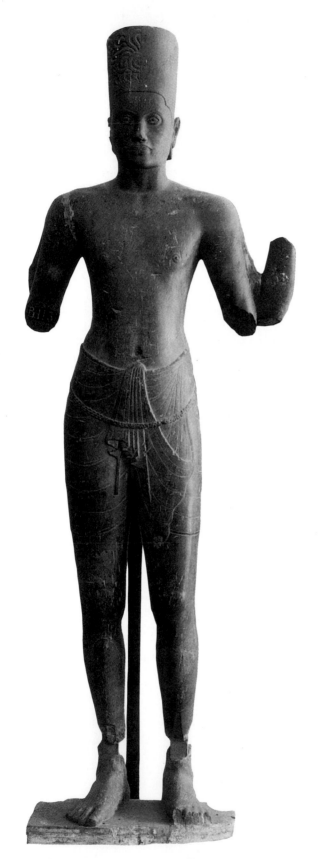

14-28 Harihara, from Prasat Andet, Cambodia, seventh century. Stone, 6'3" high. Musée Albert Sarraut, Phnom Penh.

gradually was transformed into a distinctly more Cambodian type, with a broad face composed of full lips (doubly outlined), continuous eyebrows, and flat nose (FIG. 14-33).

ANGKOR WAT AND ANGKOR THOM The temple in Cambodia was directly related to the Angkorian concept of kingship. Whereas in India the ideal king was the Universal Lord (*chakravartin*) who ruled through goodness, in Cambodia he was the god-king (*devaraja*) in life and after death. The temple the king built was dedicated to himself as the god. As the kings grew more powerful and ambitious, their temples were enlarged and the architectural and decorative elements multiplied.

At Angkor (meaning "the city" or "the capital" in the Khmer language), in the midst of a fertile plain, a dozen Khmer kings built their successive capitals between the ninth and the thirteenth centuries. Eventually, this agglomeration of capital cities spread across some seventy-five square miles and comprised many major brick and stone monuments amid a vast and intricate irrigation system (FIG. **14-29**). Only the temples were of stone or brick (materials reserved for the gods); other buildings, including the royal palaces, were constructed of wood and perished long ago. Laid out orthogonally, the network of canals, supported from large reservoirs (*barays*), served as a means of transportation as well as of irrigation for the fertile rice fields that fed an estimated population of one million. The canals also interconnected and fed the moats around many of the major temples, including the two largest, Angkor Wat and Angkor Thom.

Angkor Wat (a *wat* is a Buddhist monastery; FIG. **14-30**) was originally a Hindu temple built between 1113 and 1150. Dedicated to Vishnu by its builder, King Suryavarman II, it is a physical representation of Hindu cosmology. The five central towers represent the peaks of Mount Meru, the Olympus of the Hindu gods and the center of the universe. The outer wall symbolizes the mountains at the edge of the world; the moat represents the oceans beyond. Recent study suggests that the layout also had astronomical significance and that the sections of the design were aligned to form a kind of solar calendar by which the summer and winter solstices and the spring and fall equinoxes could be fixed. Sight lines from vantage points within the temple complex can be constructed to show that the varying positions of the sun and moon throughout the year could be observed, predicted, and marked systematically. The dimensions of the complex (which still stands, though badly eroded and riddled by gunfire in the Khmer Rouge wars) are enormous. The moat is 2¹/₂ miles long, and the circumference of the outer gallery measures half a mile and contains reliefs with literally thousands of figures representing the myths of Vishnu, Krishna, and Rama. The temples comprising this

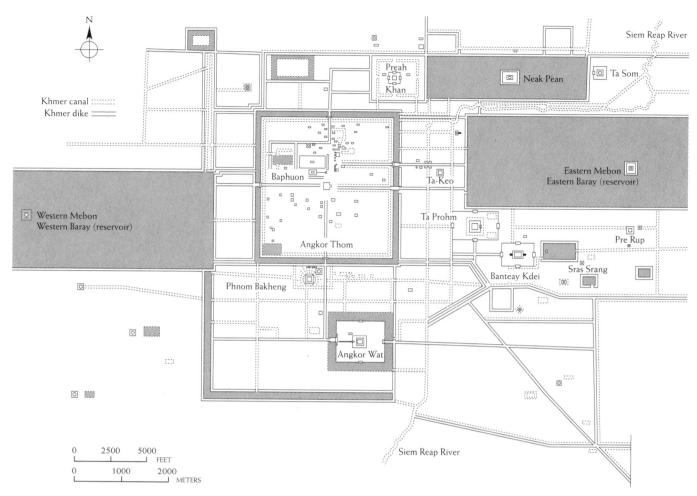

N

Khmer canal ·········
Khmer dike ━━━━━

Siem Reap River

Preah
Khan

Neak Pean

Ta Som

Western Mebon
Western Baray (reservoir)

Baphuon

Ta-Keo

Eastern Mebon
Eastern Baray (reservoir)

Angkor Thom

Ta Prohm

Pre Rup

Phnom Bakheng

Banteay Kdei

Sras Srang

Angkor Wat

Siem Reap River

0 2500 5000
┣━━━┻━━━┫ FEET
0 1000 2000
┣━━━┻━━━┫ METERS

14-29 Overall plan of Angkor site, Cambodia, during the twelfth and thirteenth centuries.

14-30 Aerial view of Angkor Wat, Cambodia.

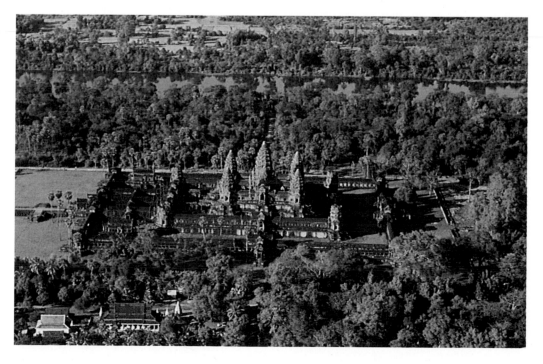

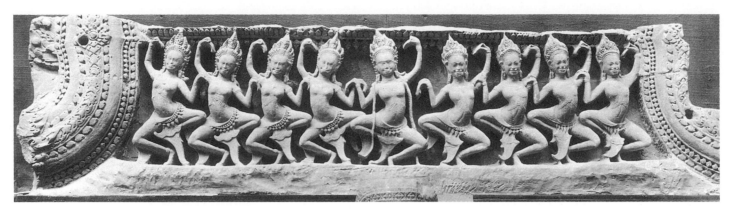

14-31 Dance relief, from Angkor Wat, twelfth century. Musée Guimet, Paris.

great complex are set at the corners of two concentric walls that gird the central shrine. Each of the temple towers repeats the form of the main spire, which rises in the center from a raised platform like the apex of a pyramid. The towers themselves resemble, in outline, the sikhara of northern Indian temples.

The relief carvings (FIG. **14-31**) express the Cambodian predilection for rhythmic design, the juxtaposition of two, three, or more identical figures, and the repetition of undulating contours. These graceful but stylized forms, thus locked together, move in a harmonious rhythm like their counterparts in Cambodian dance.

The Bayon at Angkor Thom (FIG. **14-32**), dating from the twelfth and thirteenth centuries, is, in many ways, the culmination of the Indian temple, particularly in its complete integration of sculpture and architecture. It also illustrates the syncretic relationship of Hinduism and Buddhism. The long, impressive approach to the Bayon, a Buddhist temple, is lined in places with giant gods and demons holding onto the body of the serpent Vasuki in an enactment of a Hindu legend, the Churning of the Sea of Milk. But the uniqueness of the bayon lies in the size and disposition of the colossal heads (FIG. **14-33**), one on each side of the square towers. These faces, their Cambodian features now fully

14-32 Bayon, Angkor Thom, Cambodia, twelfth and thirteenth centuries.

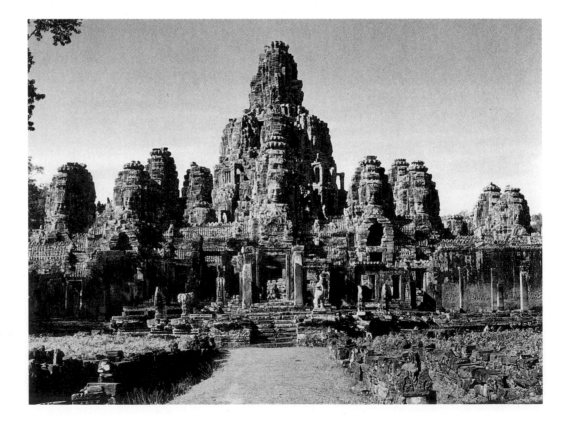

stylized, smile enigmatically from a lofty height. They are the faces of the Bodhisattva Lokesvara, a god form of the reigning king and symbol of the inexhaustible powers of the Devaraja-Bodhisattva, which extend to all points of the compass. The bayon was conceived as the world mountain.

On it and around it, a luxuriance of decorative and narrative carvings intensifies its magic. The creative force that had been India left its last great record abroad in these compassionate faces of Lokesvara, surveying from eternity the legendary history carved on the walls below.

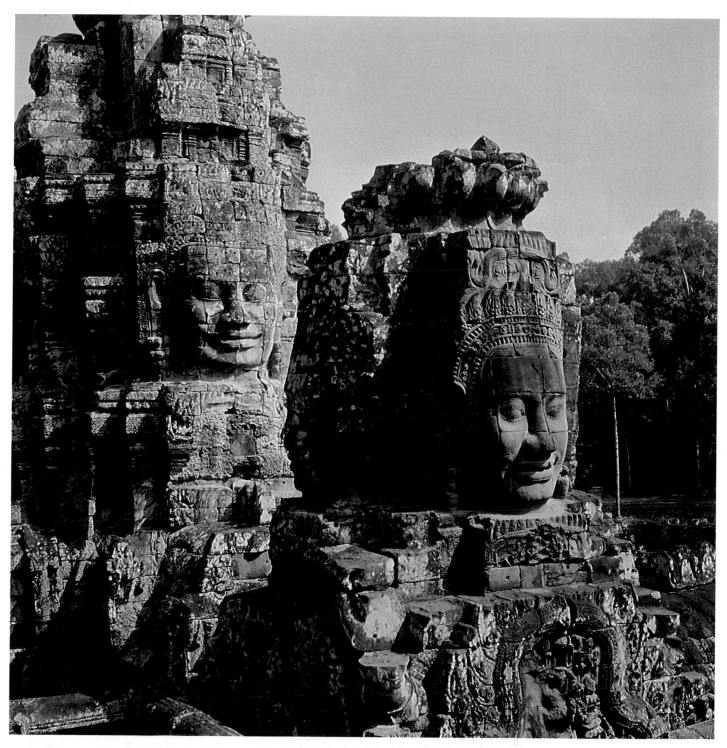

14-33 Tower of Bayon, Angkor Thom.

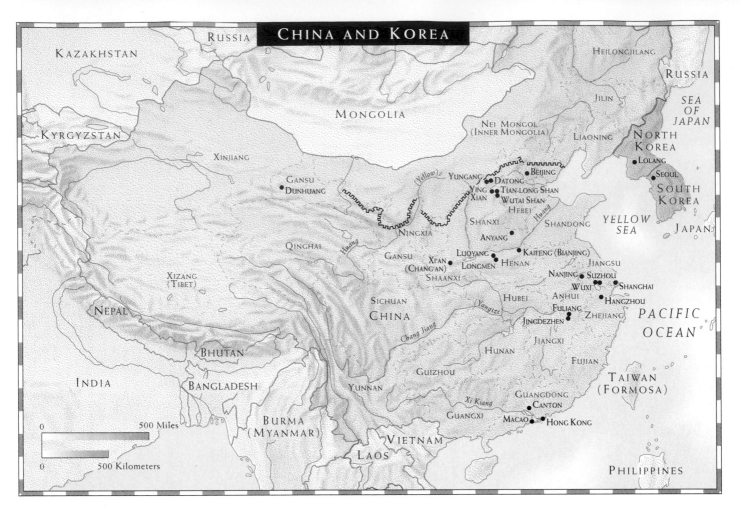

CHINA AND KOREA

c.1523 B.C.	1027	256	221	206	B.C. A.D.	A.D. 220	581
SHANG	ZHOU		QIN	HAN		NORTHERN AND SOUTHERN DYNASTIES	SUI

Guang
12th century B.C.

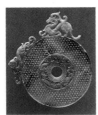

Pi
6th-3rd centuries B.C.

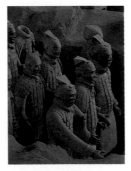

*Tomb of Emperor
Shi Huangdi*
221-206 B.C.

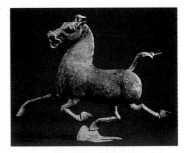

*Flying horse
2nd century*

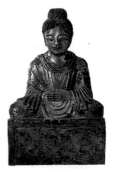

Sakyamuni Buddha
338

Shang dynasty overthrown by the Zhou, c. 1027 B.C.

Birth of Confucius , 550 B.C.

Shi Huangdi, r. 221-210 B.C.

Great Wall begun

Introduction of Buddhism, 1st century A.D.

Wei Tatars move court to Luoyang, 494

Xie He "Six Principles", late 5th century

Paradise Sects reach peak

CHAPTER 15

THE ART OF
CHINA AND KOREA

618	c.906	960	1127	1279	1368	1644	1912	1949
TANG	FIVE DYNASTIES	N. SONG	S. SONG	YUAN	MING	QING	REPUBLIC	PEOPLE'S REPUBLIC

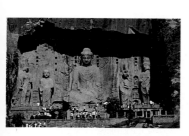

Colossal Buddha
Longmen Caves, 600-650

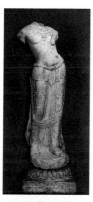

Bodhisattva
7th and 8th centuries

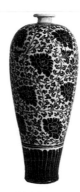

Meiping vase
13th century

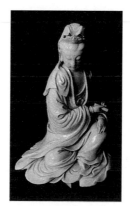

Guanyin
17th and 18th centuries

Xuan Zhuang intruduces doctrines of Esoteric Sects, 7th century

Confucian persecutions, 845

Song Huizong, r. 1101-1125

Capital of China moved south, 1127

S. Song dynasty falls to Kublai Khan

Mongols driven from power, 1368

Manchus overrun China, 1644

Mao Tse-tung establishes
People's Republic, 1949

CHINA

China is a vast and topographically varied country slightly larger in size than the United States. In ancient times it occupied a much smaller area. Over the centuries, areas inhabited by people originally non-Chinese have come under Chinese control including areas inhabited by Tibetans, Turkic peoples of Xinjiang (formerly Chinese Turkestan), the Mongols (of Inner Mongolia), the Manzhus (Manchuria), and the Koreans (north of the Yalu River). The country includes great stretches of sandy plains, mighty rivers, towering mountains, and fertile farmlands. Northern China, centered around Beijing,* has a dry and moderate-to-cold climate, whereas southern China is moist and tropical.

Although the spoken language of China varies so much as to be unrecognizable in different areas, the written language has remained uniform and intelligible in all parts of the country, permitting literary, philosophic, and religious traditions to be shared by people thousands of miles apart. Distinct regional styles of art did appear, especially in the early eras and during times of political fragmentation, but a broad cultural unity also permitted an easy flow of artistic ideas and influences throughout China.

Neolithic China

China, the only continuing—though not the earliest—civilization originating in the ancient world, had its beginnings in the basin of the Huang He, the Yellow River. In this respect it is like the great river civilizations we have seen watered by the Nile, the Tigris and Euphrates, the Indus, and the Ganges. Neolithic settlements dating back as far as 5000 B.C. are scattered along the erratic course of the big river, which again and again leaps its banks to flood catastrophically; the Chinese regard it as China's glory and as China's sorrow. Yet the archeological record is rich and in recent years has been enormously expanded; over six thousand neolithic and later sites have been discovered and hundreds excavated. Archeological investigation reveals a complex aggregation of cultures that, despite a limited technology, and even before the invention of the potter's wheel, produced ceramic wares in great variety and of high quality. At a time when writing was little more than crude, oracular figuration incised upon bone, when metal was not yet known, and when the domestication of animals was in a rudimentary stage, the mastery of potter's clay was at a point of astonishing sophistication.

The *Yangshao* culture, among many situated along the middle and upper reaches of the Yellow River, was especially prolific in fine pottery, as a *Hu* vase (FIG. **15-1**) illus-

trates. The piece manifests in form and technique a beauty and skill we might associate with the greatest periods of the Chinese potter's art. The shape of the vessel suggests an inverted cup fitted smoothly upon a lower one, the shoulders of the uppermost sweeping gracefully up to the mushroom-like mouth. The turning of the organic volume, the simplicity of surface, the flow of uninterrupted line, the purity of finish—all are qualities appealing to the modern taste as a perfect union of form and function.

Yangshao pottery of a very different type turns up in the western border province of Gansu, and is identified as "Yangshao of Gansu," or, more particularly, as of the *Majiayao* culture (FIG. **15-2**). Gansu was to become the terminal of the great silk trade route with Central Asia and the West, and, indeed, this pottery has certain affinities with that produced in regions bordering the Caspian Sea. These pots, robust and equipped with handles, are wide in the body and at the mouth and colorfully ornamented primarily in red and black with geometrical motifs: stripes, spirals, zigzags, networks. Their multiplicity here, and their obvious variety of function, attest to the many diversified needs of an industrious human community.

*In the romanization system of transliterating Chinese called *Hanyu Pinyin*, which this text uses, Peking presently is known as Beijing. A conversion table from the older system, Wade-Giles, to Pinyin, appears on page 527 and may be useful in working with less current research materials.

15-1 *Hu* vase, from Banpo, Xi'an, Shaanxi, Yangshao culture, *c.* 5000 B.C.

15-2 Neolithic vases, from Gansu Province, Majiayao culture, 5000–4000 B.C.

Shang Dynasty

According to traditional Chinese history, the fourth millennium would have been the period of the Xia, whose kings the tradition listed by name. Although the Xia state is still a matter of legend, the remains of a considerable kingdom, discovered within the last seventy years, have confirmed the existence of the Shang dynasty. As late as 1928, many scholars doubted the existence of the Shang dynasty, but excavations at Anyang in northern China in that year brought to light not only one of the last capitals of the Shang but also evidence of the dynasty's earlier development. Large numbers of inscribed bones, once used for divination, were among the astounding discoveries. The inscriptions tell us much about the Shang people. Their script was basically pictographic but sufficiently developed to express abstract ideas. These fragmentary records, together with other finds from the excavations, reveal an advanced, if undeveloped, civilization. They indicate that the king was a feudal ruler and that some of his wives were also his vassals, living in different cities. Warfare with neighboring states was frequent, and all cities were surrounded by walls of pounded earth for protection. Royal tombs were extensive, and the beheaded bodies of servants

or captives accompanied deceased rulers to their graves. Chariots, trappings of horses buried alive, weapons, and ritual objects found in these graves help us to describe the art of this period.

Although sculpture in marble and small carvings in bone and jade exist, the great art of the Shang dynasty consisted of ritual bronze vessels. These bronzes were made in piece molds. They show a casting technique as advanced as any ever used in the East or West, indicating that this art must have been practiced for some centuries before the period of Anyang. The bronze vessels were intended to hold wine, water, grain, and meat for use in sacrificial rites. The major elements of decoration are zoomorphic, but usually the background and sometimes the animals themselves are covered with round or squared spirals. Conventions, which obviously evolved over a long period, rigidly governed the stylistic representation of animals, so that images or symbols often are involved and difficult to decipher. A major zoomorphic motif is that of an animal divided in half lengthwise, with the two halves spread out on the vessel body in a bilaterally symmetrical design. The two head parts, meeting in the center, often also can be read as a complete frontal animal mask with vestigial bodies at both sides. Such ambiguity of design occurs frequently on Shang vessels, with fragmentary parts of bodies taking on a life of their own.

The covered libation vessel, or *guang*, shown here (FIG. **15-3**) is decorated with just such an animal. In this complex

15-3 *Guang*, Shang dynasty, twelfth century B.C. Bronze, 6¹/₂″ high. Asian Art Museum of San Francisco, The Avery Brundage Collection.

design, the representation (on the vessel's side) may be of the eyes of a tiger and the horns of a ram. (On other such Shang vessels, the eyes may be those of a sheep and the horns those of a bull, water buffalo, or deer.) The front of the lid is formed of a horned animal; the rear depicts a horned head with a bird's beak in its mouth. Another horned head is on the handle. Fish, birds, elephants, rabbits, and more abstract, composite creatures swarm over the surface against a background of spirals. Specific combinations of such animal motifs may have defined certain concepts; for example, an animal or bird in the mouth of another animal may signify generation. The multiple designs and their enigmatic fields of spirals are integrated so closely with the form of the vessel that they are not merely an external embellishment but an integral part of the sculptural whole. The tense outline of the bronze compactly encloses the forces symbolized on its surface. These vessels were not only ritual containers but also, in their very form and decoration, a kind of sculptural icon or visualization of the early Chinese attitude toward the powers of nature.

Zhou Dynasty

About 1027 B.C., the Shang dynasty was overthrown by the Zhou, whose dynasty endured until 256 B.C. Although the Zhou were a more primitive people from the west, their culture apparently resembled that of the Shang.

The very earliest Zhou bronzes are indistinguishable from those of the Shang. Indeed, they probably were made by the same craftsmen. But within a generation, the new and bolder spirit of the conquerors was imprinted unmistakably on the ritual vessels. Where the Shang silhouette had been suave and compact, the Zhou (FIG. **15-4**) was explosive and dynamic. Gradually, this vitality diminished, and, in a hundred years, the shapes became more utilitarian and the zoomorphic designs more ornamental. The animal forms were distorted and twisted into interlaces until, by the beginning of the Late Zhou period (600–256 B.C.), almost all evidence of the awesome original motifs was lost in an exuberance of playful rhythms over the surface of the bronzes. What once had expressed the power of magic and religion was transformed into a secular display of technical skill and fantasy.

During the sixth century B.C., the Zhou Empire began to dissolve into a number of warring feudal states. As old values were forgotten, Confucius and other philosophers strove to analyze the troubles of their day. While Confucius urged intelligent and moral action on his followers, his famous contemporary, Laozi (Lao-tzu), favored meditation, inaction, and withdrawal from society. Their philosophies have profoundly influenced Chinese life and thought till the present day.

The art of the Late Zhou, whether in bronze, jade (FIG. **15-5**), or lacquer, was produced to satisfy the elaborate

15-4 *Yu*, Early Zhou dynasty, late eleventh-early tenth century B.C. Bronze, approx. 20" high. Freer Gallery of Art, Smithsonian Institution, Washington, D.C.

demands of ostentatious feudal courts that vied with each other in lavish display. Bronzes inlaid with gold and silver were popular at this time as were mirrors highly polished on one side and decorated with current motifs on the other. About the fourth century B.C., ritual bronzes were embellished with an entirely new system of narrative designs. Scenes of hunting, religious rites, and magic practices, although small, nevertheless reveal subjects and compositions that probably are reflective of paintings lost but mentioned in the literature of the period.

In the Late Zhou period, carvings of jade, a stone regarded with special reverence by the Chinese and often found in Neolithic tombs, reached a peak of technical perfection in the jewelry and ritual objects entombed with the dead (FIG. 15-5). At this time, Confucius extolled the virtues of jade, in which, he said, superior men in ancient times "found the likeness of all excellent qualities. It was soft, smooth, and glossy (when polished), like benevolence; fine, compact, and strong, like intelligence; angular, but not sharp and cutting, like righteousness; and (when struck),

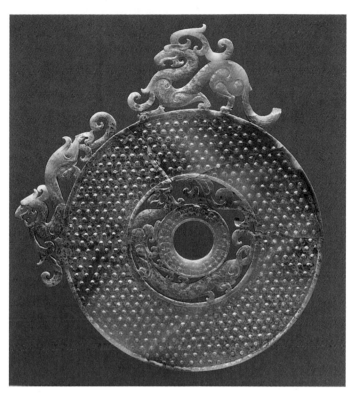

15-5 *Pi* (disc), Late Zhou dynasty, fourth to third centuries B.C. Jade, 6¹/₂" in diameter. Nelson Gallery-Atkins Museum, Kansas City, Missouri (Nelson Fund).

by the building of the Great Wall and by his attempt to eradicate old traditions by destroying all historical books and burying alive thousands of Confucian scholars.

In 1974, the immense tomb mound of Shi Huangdi was discovered in Shaanxi, and excavations in its vicinity, which are still proceeding, have revealed an astonishing collection of monuments, making this tomb mound one of the great archeological discoveries of modern times. More than six thousand life-size clay figures of soldiers and horses—and, more recently, bronze horses and chariots—have been found. Replicating the invincible hosts of the emperor, they serve as the immortal imperial bodyguard (FIG. **15-6**) deployed outside a vast, underground funerary palace designed to match the fabulous palace occupied by the emperor in life. Both palaces were described by the ancient historian Sima Qian (136–85 B.C.), whose account was not taken seriously until these recent discoveries validated it. The statues, originally in vivid color, were arranged in long ranks and files, as if lined up for battle: infantry, cavalry, horses and chariots, archers, lancers, and hand-to-hand fighters. The style of the Qin warriors blends archaic formalism—simplicity of volume and contour, rigidity, and frontality—with sharp realism of detail. Set poses are repeated with little or no variation, as if from a single mold, but subtle differences in details of facial features, coiffures, and equipment are delineated.

like music. Like loyalty, its flaws did not conceal its beauty nor its beauty its flaws, and, like virtue, it was conspicuous in the symbols of rank."*

The culture that had produced the great bronzes and jades of the Shang and Zhou periods was being transformed. The political turbulence of the Late Zhou period, at times called the "period of the Warring States," was accompanied by an intellectual and artistic upheaval that coincided with the rise of conflicting schools of philosophy, and, in art, a new iconography and style combined with vestigial elements from the Shang and Early Zhou periods. During the next four hundred years, a radically different art was to develop.

Qin and Han Dynasties

The political chaos of the last few hundred years of the Zhou dynasty was halted temporarily by Shi Huangdi, ruler of the state of Qin, whose powerful armies conquered all rival states. Shi Huangdi became the First Emperor of China, establishing totalitarian control over most of the country between 221 and 210 B.C. His reign was signalized

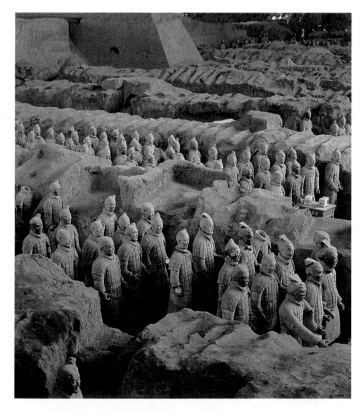

15-6 Soldiers of the Imperial Bodyguard, tomb of emperor Shi Huangdi, Shaanxi, 221–206 B.C. Painted ceramic, life size.

*From the *Liji* attributed to Confucius, trans. James Legge, in *The Sacred Books of the East* (New York: Clarendon, 1966), 28: 464.

On the death of Shi Huangdi, the people of Qin revolted, and a new dynasty, the Han, was founded in 206 B.C. A powerful, centralized government extended the southern and western boundaries of China. Chinese armies penetrated far into Xinjiang, and indirect trade was maintained with distant Rome. Confucianists struggled with Daoists (followers of the mystic philosophy of Laozi) for control of governmental power. The Confucianists eventually won, although the formalized Confucianism that triumphed was far removed from the teachings of the master. The Confucian legends of filial piety and the folklore of Daoism together provided most of the subject matter of Han art.

The Han pictorial style is known from a few extant paintings and many stone reliefs as well as stamped pottery tiles. In some paintings, the outlines of figures are rendered in the characteristic Chinese line, with calligraphic elasticity that conveys not only outline but depth and mass as well. Overlapping of arms and drapery further emphasizes the third dimension, while flat colors, applied within contours, accent the rhythmic relationship between figures. Background and environment are not represented.

Numerous stone reliefs from the Wu family shrines in Shandong (c. A.D. 150) also reflect modes of Han pictorial representation. On the slabs, scenes from history and folklore depict mythological beings associated with Daoism as well as exemplars of Confucian piety. The story on each relief unfolds in images of flat polished stone against an equally flat, though roughly striated, ground (FIG. **15-7**). The rounded figures are related by the linear rhythms of their contours. In addition, buildings and trees now indicate a milieu. Space, however, is conceptual, as in Egyptian painting, and distance is suggested by the superposition of figures, although, curiously enough, chariot wheels overlap. Individuals of importance are shown hierarchically, in larger size than their subordinates. Most interesting are the trees, which are highly stylized as masses of intertwined branches bearing isolated, overlarge leaves. Yet within this schematic form, some accidental variation in a twisted branch or broken bough shows how the designer's generalization derived from the observation of specific trees and how a detail of the particular can individualize the general. It is this subtle relationship between the specific and the abstract that will become one of the most important esthetic attributes of later Chinese painting.

A superb example of Han bronze craft, in the tradition of the Chinese mastery of that metal prevalent since Shang times, is a figure of a horse (FIG. **15-8**) from a tomb in Gansu discovered in 1969. Although its action is certainly that of a quick trot, the animal seems to be flying, one hoof lightly poised on a swallow, its single point of attachment to its pedestal. The horse, because it was revered for its power and majesty, has a prominence in Chinese art tantamount to that of the lion or bull in the art of the Near East.

Three Kingdoms and Sui Dynasty

Buddhism (pages 471-472), whose spirit differed profoundly from the ancient and native philosophies of China,

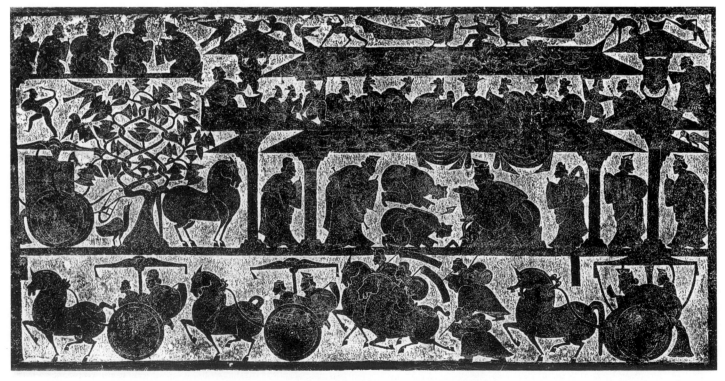

15-7　Mythological scenes, Wu family shrine, Shandong, Late Han dynasty, 147–168. Rubbing of stone relief approx. 60″ long.

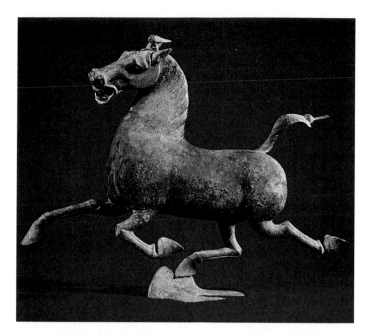

15-8 Flying horse poised on one leg on a swallow, from a tomb at Wuwei, Gansu, Late Han dynasty, second century. Bronze, 13¹/₂″ high, 17³/₄″ long. The Exhibition of Archeological Finds of the People's Republic of China.

was introduced by the first century of the Christian era. During the last century of Han rule and the succeeding Three Kingdoms period, China, splintered by strife, grasped eagerly at a new ideal by which to live. The Confucian system of ethics had proved itself incapable of adapting to the anarchy of the times, and Daoism, having degenerated into magic and superstition, no longer appealed to the philosophic mind. Buddhism offered the Chinese masses the promise of hope beyond the troubles of this world. In addition, the fully developed Buddhist system of logic, refined to the point of surpassing any previous Chinese system of thought, attracted the intellectuals. Buddhist missionaries from India, working at first with the ruling families, spread their gospel so successfully that their teachings ran like wildfire through China.

The arts flourished in the service of the imported religion. Following the brief Three Kingdoms period in the third century, China entered an era of political confusion known as the period of the Northern and Southern dynasties, which fostered many short-lived states. Native Chinese dynasties, centered at Nanjing, ruled in the south. Most of the Buddhist art that survives from this period, however, originated in the northern states, which were ruled by barbarian peoples who rapidly adopted Chinese ways and culture. A new esthetic developed in imitation of Indian or central Asian models that harmonized with the prescribed formalism of Buddhist doctrine. The earliest important Buddhist image, a gilded bronze statuette of Sakyamuni Buddha (FIG. **15-9**), dated by inscription to the year 338, is related clearly in both style and iconography to the proto-

type conceived and developed at Gandhara (FIG. 14-11).* The heavy concentric folds of the robe, the ushnisha on the head, and the cross-legged position all derived ultimately from the Indian prototype, examples of which were brought to China by pilgrims and priests who had made the hazardous trip along the desert trade routes of central Asia.

The Chinese artist transformed the basic Indian pattern during the following century or so. These changes are evident in a series of great cave temples that were carved into the hillsides after the fashion of the early Buddhists in India. At Dunhuang, westernmost gateway to China, over three hundred sanctuaries were cut into the loess cliffs, the walls decorated with paintings, and the chambers adorned with

*So new were the icon and its meaning that the Chinese craftsman, although endeavoring to make an image faithful to prescription, nevertheless erred in representing the canonical *mudra* of meditation: the Buddha's hands are clasped across his stomach; they should be turned palms upward, with thumbs barely touching (FIG. 14-13).

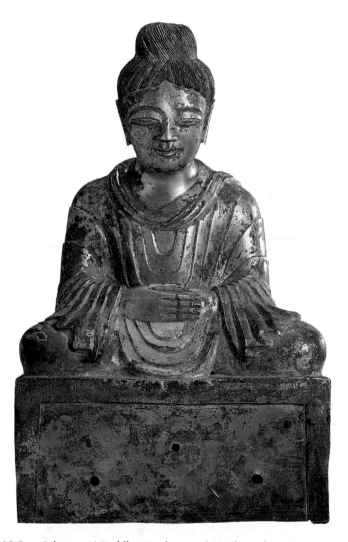

15-9 Sakyamuni Buddha, Northern and Southern dynasties, 338. Gilded bronze, 15¹/₂″ high, 9⁵/₈″ wide. Asian Art Museum of San Francisco, The Avery Brundage Collection.

15-10 Colossal Buddha, from Longmen Caves, Luoyang, Wei-Tang dynasties, *c.* 600–650. Natural rock, 50' high.

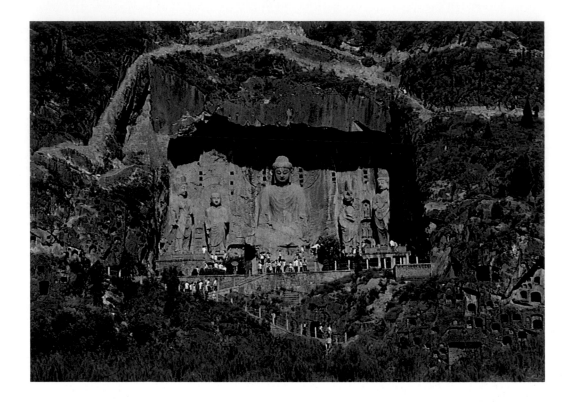

images of painted, unfired clay and stucco. This site was dedicated in 366, but the earliest extant caves date from the late fifth century. About the same time, in 460, sculptors at Yungang, near Datong in northern China, were carving temples in cliffs of sandstone.

In 494, the Wei Tatars, staunch Buddhists who had supported the colossal program at Yungang, moved their court southward to Luoyang in Henan. Near there, in the limestone cliffs of Longmen, another series of caves was started. The first phase of work here continued until the early part of the sixth century and then was resumed and brought to a monumental climax in the late seventh century, the first century of the Tang dynasty.

The huge stage cut out of a cliff in the great Longmen cave complex is occupied by a colossal figure of Vairocana Buddha (FIG. **15-10**). Vairocana was not the saving Buddha, but the personification of the cosmos as given in the Buddhist ontology, or theory of being. As such, he presides over an infinite number of worlds, each with its Buddha, symbolized in the lotus petals of his throne. In serene majesty, flanked by Buddhas and Bodhisattvas, he dominates overwhelmingly all of life, of which he is the supreme principle. The volume of the massive figure is emphasized by an almost geometric regularity of contour and smoothness of planes; the fall of the drapery is formalized into a few concentric arcs; surface detail is severely suppressed, in the interest of monumental simplicity, dignity, and sense of scale. The detailed and deeply channeled drapery of the Bodhisattvas at the extreme left and right make a telling contrast with the carving of Vairocana.

The figures occupying the right wing of the stage represent the Celestial King, who holds up a pagoda in his right hand, and the demon-masked Guardian of the Buddha (FIG. **15-11**). These, in their vigorous torsion of pose, elaborate draperies, and accessories, are as much the restless foils to the imperturbable central figure of the ruler of the universe as they are far below him in the hierarchy of being.

We get some notion of the intensity of Buddha worship from the almost frenetic multiplication of his images in the

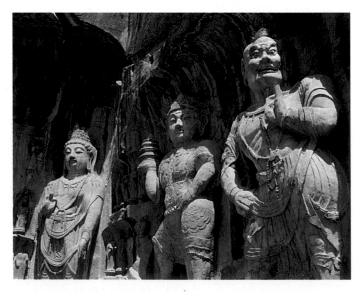

15-11 Celestial King and Guardian Demon, Longmen Caves, Luoyang.

Great Buddhist cave complexes. At Longmen there are 1,352 caves, over 97,000 statues, 3,600 inscriptions, and 785 niches. The worship of Vairocana Buddha, at the time only recently introduced into China, must have provoked the kind of passionate spiritual commitment that built the great cathedrals of medieval Europe.

While the Longmen caves were being worked on, the popular imagination was captured by a new form of Buddhism (promoted by various Paradise Sects) that promised rebirth in a Buddhist paradise rich in the material pleasures denied to most in this world. As an idyllic existence in this paradise could be gained merely by faith in the word of the Buddha, many who might have failed to appre-

ciate the goal of nirvana and the ultimate extinction of personality were won over to Buddhism by the more tangible and attractive goal offered by the Paradise Sects. Glories beyond those even of the imperial court thus were offered to every person who placed trust in the Buddha. The pleasant aspirations of these Buddhists were reflected in the greater naturalism of their arts, particularly the humanization of the deity. It is no wonder, therefore, that by the time the Paradise Sects reached their peak in the Sui dynasty (581–618), the Buddha gradually had been transformed from an archaic image of divine perfection into a gentle and human savior. The transition is manifest in a gilt-bronze shrine (FIG. **15-12**), which also reflects the attenuated

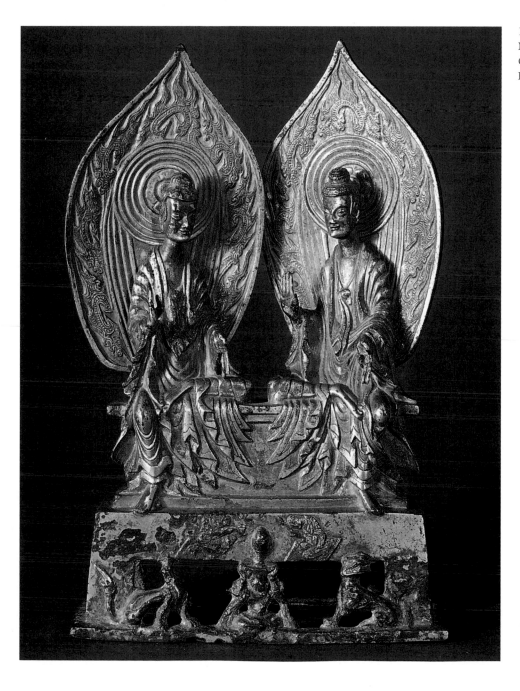

15-12 Prabhutaratna and Sakyamuni, Northern and Southern dynasties, *c.* 518. Gilded bronze, 10¹/₂″ high. Musée Guimet, Paris.

Longmen style. Prabhutaratna (Buddha of the remote past) listens to the sermon by Sakyamuni, the most recent Buddha. Seated within flamelike aureoles, the graceful, slender figures are almost absorbed into the rhythmic fall and flow of linear drapery that is beginning to acquire the character of cloth. The humanization is manifest in the gentle, suave beauty of attitude and gesture, although the faces retain the characteristics of archaic formulas.

Painting flourished at the courts of the Southern dynasties during the Sui period. Daoist nature cults and a new appreciation of landscape themes in poetry provided the stimulus for the early development of landscape painting. No scrolls from the hands of individual masters have survived from this early era, but descriptive texts indicate that the almost magical potential of landscape painting to re-create and organize the experience of nature or to transport the viewer to an imaginary realm already was well appreciated. When the painter Zong Bing (373–443), for example, became too old to continue his mountain wanderings, he re-created favorite landscapes on the walls of his studio so that he could take imaginary journeys. Of the representational power of painting, Zong wrote:

> Nowadays, when I spread out my silk to catch the distant scene, even the form of the Kunlun [Mountain] may be captured within a square inch of space; a vertical stroke of three inches equals a height of several thousand feet. . . . By such means as this, the beauty of the Song and Hua Mountains and the very soul of the *Xuanpin* [Dark Spirit of the Universe] may all be embraced within a single picture.*

Another fifth-century painter, Wang Wei, elaborated on the re-creative potential of landscape painting:

> I unroll a picture and examine it, and reveal mountains and seas unfamiliar to me. The wind scatters in the verdant forests, the torrent overflows in bubbling foam. Ah, how could this be achieved merely by the skillful use of hands and fingers? The spirit must also exercise control over it. For this is the essence of painting.†

The painter and essayist GU KAIZHI (c. 344–406) is one of the few individual artists from this period to whom extant paintings seriously have been attributed. In an essay on landscape painting couched in Daoist terms, he describes "crags, fanglike and tapering," and "rocks, split with fissures as though torn by lightning." But for Gu Kaizhi and others of his time, the crucial aspect of painting was not mere imitation of appearance but transmission of "spiritual quality."

*For this and other excerpts from essays on painting quoted subsequently, see Michael Sullivan, *The Birth of Landscape Painting in China* (Berkeley: University of California Press, 1962).

†ibid.

Indeed, in the late fifth century, the critic Xie He named, as the first of the "Six Principles" of painting, "spirit-consonance engendering movement"—a sense of animation through transmission of the vital spirit that pervades both artist and object—which was to remain the cardinal principle for artists and critics in China until modern times.

At this point we might pause to generalize some of the differences between the Chinese approach to painting and that of the West before Modern Art. Many of the fundamental differences between the Chinese and the Western approaches are based on differences between the philosophies of nature and of human nature held by the two cultures. For the Chinese, human beings are not dominant in nature; they are part of it, responding, like all human creatures, to its rhythms. To be happy is to live in accord with the natural rhythms in which all things move. To be a painter is to be the instrument through which nature reveals itself. The painter's work is an expression of personal immersion in the flow of life and attunement to all that changes and grows. In so being, the work is also the expression of a personal character refined by the contemplation of nature. Because nature is not measured and classified according to space and time, Chinese painters do not frame it off in perspective boxes with colors scaled in light and shade. Western perspective requires that one take a fixed standpoint *outside* of nature, in order to command it visually. Chinese artists do not attempt to fix natural appearances by matching them to what is being rendered. The asymmetry of growing things, the ceaseless and random movements of nature, the infinity of cosmic events—these forbid all enframements, rigid regularities, beginnings and endings. Appearance is transformed by the artist's passage through it. Each artist becomes part of the total expression of the art being produced, just as the art is the total expression of one's experience of nature.

This philosophical attitude of the Chinese toward painting can be seen even in the artists' almost ritualistic preparation of their medium, their materials. The best ink, for instance, was derived from soot or lampblack mixed with animal glue and pulverized clay, oyster shells or powdered jade, and various fragrances. From these ingredients, each of which had symbolic as well as physical properties, an ink stick (often carved) was formed that was treasured by the artist.

Something of the vital spirit, which Xie He named as first of his six principles of painting, appears in a horizontal scroll attributed to Gu Kaizhi called *Admonitions of the Instructress to the Court Ladies*, perhaps an early copy of a painting of Gu's era. Scrolls in this format were meant to be viewed slowly and in sections; in this case, scenes are illustrated between passages of explanatory text. One of the sections (FIG. **15-13**) depicts a well-known act of heroism in which the Lady Feng saved the life of her emperor by placing herself between him and an attacking bear. Although no background is shown and only a minimal

15-13 Attributed to GU KAIZHI, *Lady Feng and the Bear,* section of the *Admonitions of the Instructress to the Court Ladies.* Horizontal scroll, ink and colors on silk, 7⁵/₈" high. British Museum, London.

setting for the scene is provided, fluid poses and fluttering ribbons of drapery, in concert with individualized facial expressions, convey the quality of animation called for in texts of the period.

Tang Dynasty

The short-lived Sui dynasty was followed by the Tang dynasty (618–906), under which China entered a period of unequaled magnificence. Chinese armies marched across central Asia, opening a path for the flow of wealth, ideas, and foreign peoples. Arab traders, Nestorian Christians, and other travelers journeyed to the cosmopolitan capital of the Tang, and the Chinese, in turn, ventured westward. During the middle of the seventh century, Xuan Zhuang, a Chinese monk, visited India, as had some earlier devotees. He returned from the mother country of Buddhism with revolutionizing doctrines of the recently developed Esoteric Sects. These years were a critical time for Buddhism in China; Buddhist religious beliefs were being brought into disrepute by a lax court and a corrupt clergy. Under the notorious Empress Wu, who had usurped the throne, religion was used as an instrument for political power and as a cloak for personal excess. The material rewards promised in Heaven by the Paradise Sects offered no effective antidote to the troubles of the time. But the elaborate and mysterious rituals of the new Esoteric Sects attracted worshipers by giving them in their daily life many of the sensory pleasures that the Paradise Sects had promised in Heaven. As the new cult spread, Chinese craftsmen again looked to India, where they found appropriate models in Gupta sculpture.

The fluid style of art developed during the Gupta period in India (FIGS. 14-14 and 14-15) already had affected Chinese sculpture during the late sixth century, and, by the end of the seventh, Buddhist sculpture in China had lost much of its own character due to its borrowing from the sensuous carvings of India. Fleshiness increased even more, and drapery was made to cling, as if wet, against the body. The new wave of influence from India brought not only stylistic changes but also the iconography of the Esoteric Sects, which we see in figures with multiple arms and heads, symbolizing various aspects of the deities as described in the new gospels.

The Early Tang style, heavily influenced by Indian prototypes, is exemplified admirably by the Bodhisattva (FIG. **15-14**). The sinuous beauty of this figure has been accented by the hip-shot pose and revealing drapery, as in Gupta sculpture. Executed at almost the same time as the Bodhisattva (around 700) were carvings in the caves of Tianlong Shan, which anticipated the later Tang style. These cave figures might seem gross were it not for the graceful postures and the soft drapery that falls in rhythmic patterns over the plump bodies.

Esoteric Buddhism, with its emphasis on detailed and complicated ritual, placed the deity in a formal relationship to the worshiper. The followers of Amitabha Buddha—one of the most important Buddhas of the Paradise Sects—in stressing salvation by faith, visualized a warm and human deity, but, by the ninth century, the arduous discipline of the Esoteric Sects had inspired an austere, heavyset, almost repellent icon. At times, fleshiness was exaggerated almost to the point of obesity, and yet sufficient restraint lent the figures a somber dignity.*

* Few sculptures survived the terrible persecutions of Buddhism during a revival of Confucianism in 845. Many wooden temples were destroyed by fire, and their bronze images were melted down. Fortunately, we are able to reconstruct the style of the period from Buddhist art in Japan, which was then under direct Chinese influence (see FIGS. 16-4 to 16-6).

The westward expansion of the Tang Empire increased the importance of Dunhuang. Here, the desert routes converged and the cave temples profited from the growing prosperity of the people. By the eighth century, wealthy

15-14 Bodhisattva, Early Tang dynasty, seventh and eighth centuries. Marble. Private collection of Charles Uht, New York.

donors to Buddha were demanding larger and more elaborately decorated caves. The comparatively simple Buddha group in paintings of the previous century was enlarged to include crowds of attendant figures, lavish architectural settings, and minor deities who worshiped the resplendent Buddha with music and dance. The opulence of the Tang style is reflected in the detailed richness of the brilliantly colored *Paradise Paintings* (shown is *Paradise of Amitabha*, FIG. **15-15**). Vignettes flanking the Buddha group illustrate incidents from specific sutras. These little scenes, like the jataka tales in earlier caves, usually are set in landscapes painted in an altogether different style from that of the hieratic groups. Mountains, for example, are stacked one behind the other and painted in graded washes to give the impression of distance. (Although each mountain is related to the adjacent peak through this device of atmospheric perspective, no continuous perspective yet gives a sense of recession into the distance.)

The Confucian persecutions of 845 did not affect Dunhuang, which was then under Tibetan rule. Numerous paintings (murals and scrolls) were produced in this region, but because the area was isolated from the mainstream of Chinese culture, the paintings remained stylistically static from the middle of the ninth century to the beginning of the eleventh century. Meanwhile, during the seventh and eighth centuries at the Tang court in Chang'an (modern Xi'an)—perhaps the greatest city in the world during this period—a brilliant tradition of figure painting developed that, in its variety and balance, reflected the worldliness and self-assurance of the Tang Empire. Indeed, Chinese historians regard the Early Tang dynasty as their golden age of figure painting. Glowing accounts by poets and critics and a few remaining examples of the paintings themselves permit us to understand this enthusiasm.

In perfect accord with descriptions of the robust Tang style are the unrestored portions of *Portraits of the Emperors* or *The Thirteen Emperors* (FIG. **15-16**), masterfully drawn in line and in colored washes by YAN LIBEN (d. 673), a celebrated painter and statesman of the seventh century. Each emperor is represented as standing in undefined space, his eminence clearly indicated by his great size relative to that of his attendants. Yan Liben also made designs for a series of monumental and spirited stone horses that once flanked the approach to the tomb of the Tang emperor Tai Zong.

Wall paintings from the tomb of the Tang princess Yongtai (built in 706 near Chang'an) allow us to view court painting styles unobscured by problems of authenticity and reconstruction. The figures of palace ladies (FIG. **15-17**) are arranged as if on a shallow stage; although no indications of background or setting are given, intervals between the two rows and the grouping of the figures in an oval suggest a consistent ground plane. The women are shown full-face and in three-quarter views from the front and the back. The device of paired figures facing into and out of the space of

15-15 *Paradise of Amitabha*, Cave 139A, Dunhuang, Gansu, Tang dynasty, ninth century. Wall painting.

15-16 YAN LIBEN, *The Thirteen Emperors*, detail, Tang dynasty, *c.* 650. Handscroll, ink and colors on silk, 20$\frac{1}{4}$" × 17$\frac{1}{2}$". Museum of Fine Arts, Boston.

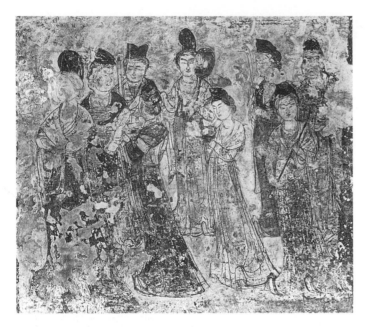

15-17 Palace ladies, from the tomb of Princess Yongtai, near Chang'an (Xi'an), Shaanxi, Tang dynasty, 706. Wall painting.

the picture in a near mirror image—an effective means of creating depth—appears often in paintings attributed to this period. Thick, even contour lines describe full-volumed faces and suggest solid forms beneath the drapery, all with the utmost economy. This simplicity of form and drawing, along with the measured cadence of the poses, results in an air of monumental dignity, as befits a daughter of the ruling house of the Tang.

Two of the most famous artists of the Tang period were Wang Wei (699–759; not to be confused with Wang Wei of the fifth century) and Wu Daozi (active *c.* 725–750), both of whom have become almost legendary figures, although none of their paintings has survived. Wang was not only a painter, but like many other Chinese artists, he was also a poet. His poems are mellow and lyrical, as his paintings are said to have been. Numerous imitations of his painting style have the peaceful lyricism of his poems. Many of these copies are of snow scenes, a favorite subject of Chinese artists, probably due to its adaptability to monochrome painting, an art of infinite variation and contrast in black and white. Wu's work, according to reports of his time, was very different. He painted with such speed and "ferocious energy" and over such large surfaces that people are said to have watched with awe as astonishingly real images rapidly appeared. His bold brushwork and expansive forms frequently were copied, and rubbings were made from engraved replicas. Later artists looked to Wu's virtuoso brushwork and to Wang's subtle harmonies for their models.

The Tang rulers embellished their empire with extravagant wooden structures, all of which have disappeared.

Judging from records, however, they were colorfully painted and of colossal size. Bronze mirrors with decorations in strong relief added to Tang luxury and to the furnishings of a court already enriched by elaborate gold and silver ornaments.

The potter met the demand for display by covering his wares with colorful lead glazes and by inventing robust shapes with clearly articulated parts—base, body, and neck. Earlier potters had imitated bronze models, but Tang craftsmen derived their forms directly from the character of the clay. Ceramic figures of people, domesticated animals, and fantastic creatures also were made by the thousands for burial in tombs. The extraordinarily delicate grace and flowing rhythms of these figures have a charm and vivacity seldom equaled in ceramic design. Their subject matter, which included such diverse figures as Greek acrobats and Semitic traders, is proof of the cosmopolitanism of Tang China.

Very frequently represented was the spirited, handsomely caparisoned horse (FIG. **15-18**), lord of the animal figurines in the Tang tombs. The horse in Chinese art reflected the importance the emperors placed on the quality of their stables; over seven hundred thousand studs in the Tang kingdom attested to their significance in the military success and the glory of the dynasty. Even Han emperors had sent missions westward to Bactria in north central Asia for blooded stock. The breed represented in this example is powerful in build, particularly hindquarters and neck, which, beautifully arched, terminates in a small, elegant head. The horse is richly harnessed and saddled, testimony

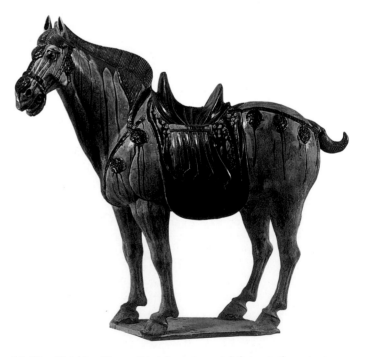

15-18 Neighing Horse, Tang dynasty, *c.* eighth to ninth centuries. Glazed earthenware, 20" high. Victoria and Albert Museum.

of the nobility of its rider. During the period of Tang power, represcntation of the horse in painting and ceramics was a special genre, on equal footing with figure composition and landscape.

Five Dynasties and Northern Song Dynasty

The last century of Tang rule witnessed the gradual disintegration of the empire. When the dynasty finally fell in 906, China once more was left to the ravages of civil war. Conflicting claims between rival states were not resolved until the country was consolidated under the Song, whose court was at Bianjing (modern Kaifeng in Henan). During the interim of internal strife known as the Five Dynasties (906–960), a marked development took place in the styles and techniques of landscape painting. An analogy with events of the period of the Northern and Southern dynasties may be justified here; that earlier period of political and social turmoil also witnessed a turning away from portrayals of society toward an involvement with nature and an accompanying development of landscape art though figure painting continues, often as copies of Tang work.

Jing Hao (c. 900–967) left an essay in which he listed his criteria for judging paintings. Under the classification of "divine," he grouped the greatest paintings. In these, he wrote, "there appears no trace of human effort; hands spontaneously reproduce natural forms." In the lowest category, he placed the "skillful" artist who "cuts out and pieces together fragments of beauty and welds them into the pretense of a masterpiece." "This," he added, "is owing to the poverty of inner reality and to the excess of outward form." Although these ideas were not original with Jing Hao, his restatement of them showed the continuity of thought underlying Chinese painting regardless of changing styles. The artist who painted the truth beneath surface appearances had to be imbued with *qi*, the "divine spirit" of the universe. Any artist who achieved this did so only through years of self-cultivation. Jing Hao and his equally famous contemporary Li Cheng (active c. 940–967), through the inherent power of their personalities, departed from Tang landscape formulas, breathing life into every twig and rock they painted. Succeeding generations went to their works for inspiration—great artists, to catch the spirit; lesser painters, to copy tricks for drawing trees and hills.

We know enough about the art of this period to distinguish the styles of some individual masters, such as Dong Yuan and Ju Ran, of the mid-tenth century, and FAN KUAN and Guo Xi, active early and late in the eleventh century, respectively. Paintings by the latter two artists, which exemplify the maturity of landscape painting styles in the Northern Song period (960–1127), express very different personalities and yet exhibit a common feeling for monumentality. A characteristic painting in this style presents a vertical landscape of massive mountains rising from the distance (FIG. **15-19**). Human figures, reduced to minute proportions, are dwarfed by overwhelming forms in nature. Paths and bridges in the middle region vanish, only to reappear in such a way as to lead the spectator on a journey

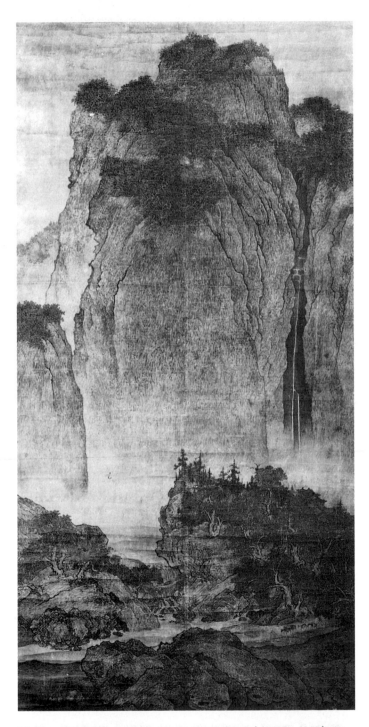

15-19 FAN KUAN, *Travelers Among Mountains and Streams*, Northern Song dynasty, early eleventh century. Hanging scroll, ink and colors on silk, 6'9" × 2'5". Collection of the National Palace Museum, Taipei, Taiwan.

through the landscape—a journey facilitated by shifting perspective points. No single vanishing point organizes the entire perspective, as in many Western paintings; as a result, the observer's eye moves with freedom. But to appreciate these paintings fully, one must focus on intricate details and on the character of each line.

The full development of the horizontal handscroll occurred during this period. The scroll, which might measure as long as 50 feet or more, had to be unrolled from right to left; only a small section could be seen at a time and then, properly, by only two or three persons. The organization of these paintings has been compared to the composition of a symphony because of the way in which motifs are repeated and moods are varied in the different sections. The temporal sequence of the scroll involved memory as well as vision; it was an art of contemplation and leisure.

Among the versatile figures clustered around the court at Bianjing was Su Dongpo (1036–1101), one of China's greatest poets, a celebrated painter and statesman. Another, Li Gonglin (1040–1106), was famous for his original Buddhist compositions and for his outline drawings of horses. These, along with the antiquarian and landscape artist Mi Fu (1051–1107), were the leading figures in a group of scholar-gentleman painters who created an alternative to the emphasis on the skillful representation of nature then prevalent among professional and academy artists. These amateurs of the "literary" school, by contrast, saw painting as primarily expressive of the moods and personality of the artist. Representational accuracy was de-emphasized, or even derided, in favor of learned allusions to antique styles, sometimes couched in deliberately awkward or naive forms. Many paintings in this style concentrate on qualities inherent in the medium of brush and ink. In this, they are close to the expressiveness of calligraphy, which depends, for its effects, on the controlled vitality of individual brush strokes and on the dynamic relationships of strokes within a character and among the characters themselves. Training in calligraphy was a fundamental part of the education and self-cultivation of Chinese scholars and officials; with Su Dongpo and Mi Fu ranked among the greatest of Northern Song calligraphers, calligraphic qualities and effects became part of the repertoire of many painters as well. We have noted in the art of Islam the supreme importance of calligraphy (FIG. 10-29).

The emperor SONG HUIZONG (1082–1135, ruled 1100–1125), an avid collector and patron of art, was himself an important painter. Though he was known particularly for his meticulous pictures of birds, in which almost every feather is carefully drawn in sharp lines, he was also adept at figure painting (FIG. 15-20). His graceful composition *Ladies Preparing Newly Woven Silk* is an adaptation of the Tang manner. Placed against a flat ground, with no spatial

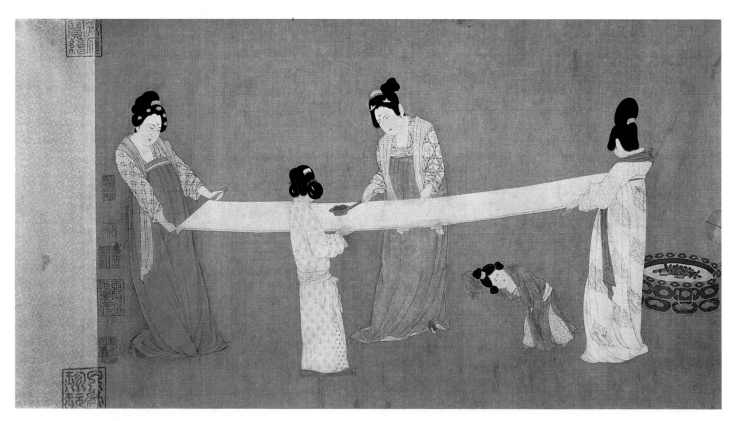

15-20 SONG HUIZONG (emperor 1082–1135), *Ladies Preparing Newly Woven Silk*, detail, Song dynasty, *c.* 1125. Handscroll, ink and colors on silk, 14¹/₂″ × 57¹/₄″. Courtesy Museum of Fine Arts, Boston.

cues except overlapping, the figures of the women, delicately silhouetted, provide all the essential details by which we can "read" their action, their dress and its patterns, even their age and rank. A masterpiece of delineation, this work shows the sparsest economy of representational means. As such, it could stand as a classical example of the Chinese approach to figurative art. It was painting like this that would inspire European artists at the end of the nineteenth century—the absence of modeling, cast shadows, perspective; the purity of line, simplicity of description, technical control. Lesser artists attached to the imperial court functioned as a sort of academy and, in general, followed the detailed and colorful style of the emperor. Illustrating some lines of poetry in painting often served as an examination for court office. Fans painted by master artists were treasured in albums. But while the court spent its energy on esthetic refinements, less cultured neighbors were assaulting the frontiers of China.

Southern Song Dynasty

In 1127, as a result of increasing pressure from the Tatars and Mongols in the west and north, the capital of China was moved to the south. From then until 1279, the Southern Song court lived out its days amid the tranquil beauty of Hangzhou. Neo-Confucianism, a blend of traditional Chinese thought and some Buddhist concepts, became the leading philosophy. Accordingly, orthodox Buddhism declined. Buddhist art continued to develop in the north, where a Tatar tribe had established itself as the Jin dynasty (1115–1234), but it stagnated in the south. Buddhist sculpture in the Southern Song period merely added grace and elegance to the Tang style. Secular paintings and those associated with Chan (a meditative school of Buddhism), however, reflected a new and more intimate relationship between the human being and nature.

This new relationship is expressed in a painting by ZHOU JICHANG, representing Arhats giving alms to beggars (FIG. **15-21**). *Arhats* (Bodhisattvas) are Buddhist holy persons who have achieved enlightenment and nirvana by suppression of all desire for earthly things. In contrast with Huizong's ladies, the figures are placed in a carefully delineated landscape, foreground, middleground, and background arranged vertically, so that their positions relative to one another and to the beggars are readily seen. The Arhats move with slow dignity in a plane above the ragged wretches who scramble miserably for the largesse thrown them by their serene benefactors. The extreme difference in deportment between the two groups distinguishes their status, as does the unsparing realism with which the beggars are depicted. The vivid colors, flowing draperies, and quiet gestures of the Arhats set them off from the dirt-colored and jagged shapes of the creatures physically and spiritually beneath them. The landscape itself sharply distinguishes the two spheres of being.

Landscape can take over the composition entirely, diminishing or eliminating figures altogether; we have seen this already in Northern Song painting (FIG. 15-19). In many Southern Song paintings the landscape has its own being, is

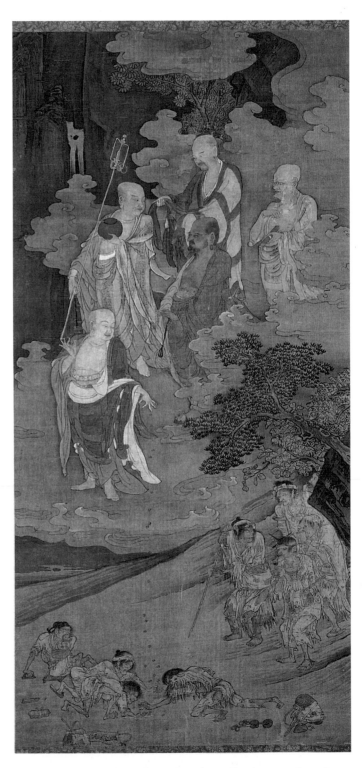

15-21 ZHOU JICHANG, Arhats giving alms to beggars, Southern Song dynasty, 1184. Ink and colors on silk, 44" × 21". Courtesy Museum of Fine Arts, Boston.

its own subject; and there is a more or less conventional system for arranging its elements. A typical Southern Song landscape is basically asymmetrical. It is composed on a diagonal and consists of three parts: foreground, middle distance, and far distance. These parts are separated from each other by a field of mist. The first part is marked by a rock, which, by its position, emphasizes the distance of the other parts. The middle distance may be marked by a flat cliff or given over entirely to mist or water. In the far distance, mountain peaks, which are usually tinted in pale blue, suggest the infinity of space. The whole composition illustrates the manner in which the Song artists used great voids to hold solid masses in equilibrium. The technique is one of China's unique contributions to the art of painting. To this basic composition, of which many variations were employed, the artist frequently added the figure of a scholar meditating under a gnarled pine tree, accompanied by an attendant. Such paintings were expressions of the artist's ideal of peace and pantheistic unity.

The chief painters in the Southern Song style were MA YUAN (c. 1160–1225) and Xia Gui (active c. 1195–1224). Ma was a master of suggestion, as demonstrated by a small, fan-shaped album leaf (FIG. 15-22), a picture of tranquillity stated in a few sensitively balanced and half-seen shapes. Xia Gui's misty landscapes were often so like those of Ma Yuan—though sometimes more delicate and sometimes bolder—that the Chinese refer to these artists and their followers as the Ma-Xia school. But the Ma-Xia tradition, despite its gentle beauty, could not be maintained. It per-

petuated an ephemeral, classic moment, but the serenity of its beliefs soon was threatened by political realities.

As orthodox Buddhism lost ground under the Song, the new school of Buddhism (called Chan in China, but better known by its Japanese name, Zen) gradually gained importance, until it was second only to Neo-Confucianism. The Zen sect traced its semi-legendary origins to Bodhidharma, an Indian missionary of the sixth century. By the time of the Sixth Chan Patriarch, who lived during the Early Tang period, the pattern of the school already was established, and Zen remains an important religion in Japan today.

The followers of Zen repudiate texts, ritual, and charms as instruments of enlightenment. They believe, instead, that the means of salvation lie within the individual, that meditation is useful, and that direct personal experience with some ultimate reality is the necessary step to enlight-

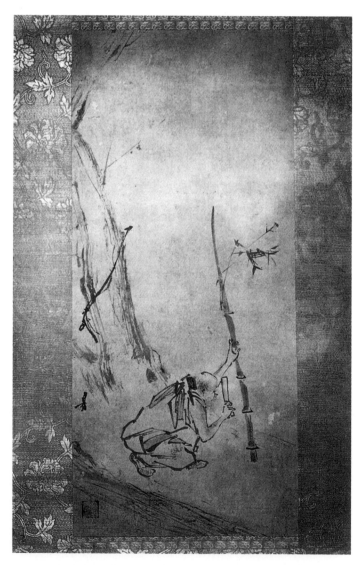

15-22 MA YUAN, *Bare Willows and Distant Mountains*, Southern Song dynasty, thirteenth century. Album leaf, ink and colors on silk, $9^1/_2$″ × $9^1/_2$″. Courtesy Museum of Fine Arts, Boston.

15-23 LIANG KAI, *The Sixth Chan Patriarch Chopping Bamboo*, Southern Song dynasty, thirteenth century. Hanging scroll, ink on paper, $29^1/_4$″ high. Tokyo National Museum.

enment. Zen enlightenment is conceived of as a sudden, almost spontaneous act. These beliefs shaped a new art.

The Zen painter LIANG KAI (c. 1140–1210) has left us two portraits of Huineng, the Sixth Chan Patriarch. In one (FIG. **15-23**), the patriarch is a crouching figure chopping bamboo; in the other, he is tearing up a Buddhist sutra. Both are informal sketches that look as though they were caricatures of the revered figure. The brush strokes are staccato and splintery, like the spontaneous process of Zen enlightenment. Each sketch probably was painted in a few minutes, but, like enlightenment, their execution required years of training. Their impact can be a shock, much like the shock of Zen understanding.

Southern Song artists also produced superb ceramics with monochrome glazes. The most famous of the single-glaze wares are known as *celadon* (a mat gray-green), *yingqing* (a subtle pale blue), and *ding* (a fine, white proto-porcelain). One type of the heavier *jun* ware employed a blue glaze, splashed with red and purple flowing over a stoneware body. A quite different kind of pottery, loosely classed as *Cizhou,* is a northern Chinese ceramic type. The subtle techniques of underglaze painting and incision of the design through a colored slip were developed for this pottery during the Song period. The intricate black-white design of the *meiping* vase shown here (FIG. **15-24**) was produced by cutting through a black slip to a white slip. The tightly twining vine and petal motifs closely embrace the high-shouldered vessel in a perfect accommodation of surface design to vase shape—a common characteristic of Chinese pottery in its great periods. These shapes were generally more suave than those of the Tang period; some, however, reflecting the prevailing interest in archeology, imitated the powerful forms of the Shang and Zhou bronzes. Other crafts, particularly jade carving, also were subjected to the influence of archeological or antiquarian interests.

Yuan Dynasty

The artistic vitality of Southern Song was not a reflection of the political conditions of the times. In 1279, the Song dynasty crumbled beneath the continued onslaughts of Kublai Khan. Yuan, the dynasty of the Mongol invaders, dominated China only until 1368, yet it profoundly affected the culture of the country and particularly the art of painting. Many scholar-painters chose exile in the provinces to avoid service under the barbarian usurpers in Beijing. Forced by their exile to reappraise their place in the world, these artists no longer looked at a landscape as an idyllic retreat; it had become part of a formidable environment. This new austerity is evident in a painting (FIG. **15-25**) by one of the great masters of Yuan, HUANG GONGWANG (1269–1354). Here, the misty atmosphere of the Southern Song landscapes has been replaced by massive, textureful forms. The inner structure and momentum of the landscape is rendered by a rhythmic play of brush and ink.

Another leader of the Yuan scholar-artist movement was Zhao Mengfu (1254–1322), whose paintings contain knowing allusions to old styles. The landscapes of his grandson, Wang Meng (d. 1385), reached a high level of dynamic, expressive intensity. Most of these painters rejected the mellow harmonies of Southern Song as no longer valid; for their sources, they went back to the more monumental works of the tenth century. The degree to which styles could become personalized in this period is shown in the spare, almost brittle landscapes and bamboo-and-rock paintings of Ni Zan (1301–1374), which reveal an aloof and fastidious personality. These works contrast markedly with the paintings of WU ZHEN (1280–1354), which are done in

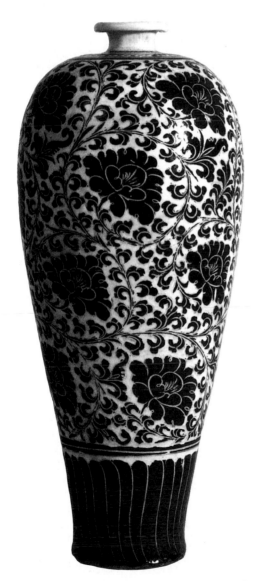

15-24 Meiping vase, Song dynasty. Cizhou stoneware, carved black slip over white slip, 19¹/₂" high, 7³/₄" wide. Asian Art Museum of San Francisco, The Avery Brundage Collection.

a softer and more relaxed manner. Paintings of bamboo (FIG. **15-26**), for which Wu Zhen is famous, were particularly favored at this time, for that plant is a symbol of the ideal Chinese gentleman, who, in adversity, bends but does not break. Moreover, the pattern of leaves, like that of calligraphic script, provided an excellent opportunity for the display of brushwork.

The Mongol regime apparently did little to disturb the Chinese potters' increasing mastery of porcelain. A Late

Yuan or Early Ming vase of white porcelain (FIG. **15-27**) exhibits brilliance in the use of the underglaze decoration that was so successful in the Song period.

Ming and Qing Dynasties

In 1368, a popular uprising drove out the hated Mongol overlords, and, from that time until 1644, China was ruled by the native Ming dynasty. Many of the fifteenth-century

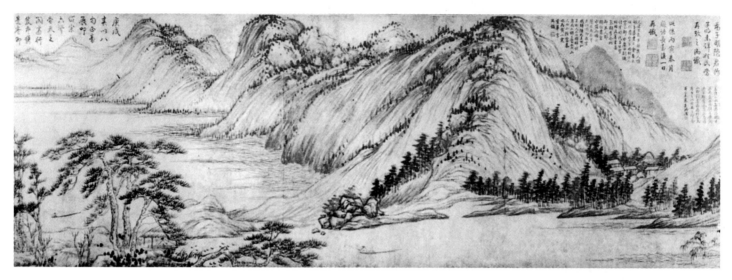

15-25 HUANG GONGWANG, *Dwelling in the Fuchun Mountains*, Yuan dynasty, 1347–1350. Section of a horizontal scroll, ink on paper, 13″ high. National Palace Museum, Taipei, Taiwan.

15-26 WU ZHEN, *Bamboo*, Yuan dynasty, 1350. Album leaf, ink on paper, 16″ × 21″. Collection of the National Palace Museum, Taipei, Taiwan.

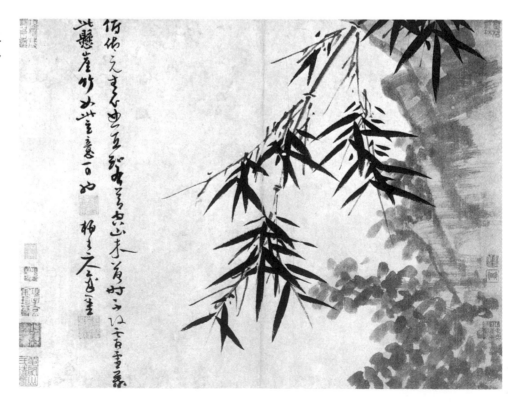

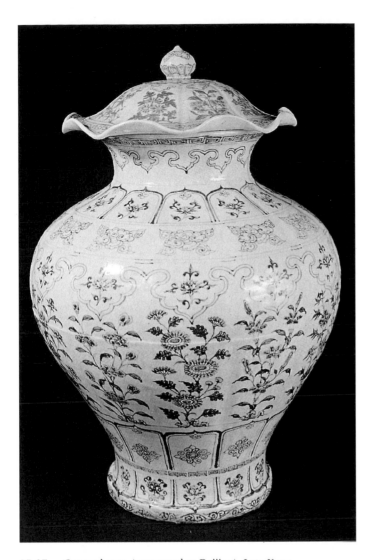

15-27 Covered vase (excavated at Beijing), Late Yuan or Early Ming dynasty, late fourteenth century. White porcelain with underglaze decoration, 26¹/₂" high. The Exhibition of Archeological Finds of the People's Republic of China.

Ming masters, such as DAI JIN (1388–1452), reverted to Song models. The court, where Dai Jin worked, was one center of patronage and activity; local schools of painting, such as those centered in Nanjing and in Suzhou, also became important. The Suzhou school, under the leadership of Shen Zhou (1427–1509) and Wen Zhengming (1470–1559), included many highly educated amateur painters who concentrated on refined recreations of the styles of the masters of the preceding Yuan dynasty. Professional artists, active in Suzhou and elsewhere, executed works that displayed great skill and spontaneity.

The distinction between scholar-amateur and academic-professional traditions was codified, rather artificially, in the writings of the influential critic, statesman, and artist DONG QICHANG (1555–1636), at the end of the Ming period. Dong's glorification of the amateur or literary school reflected his own voracious study and collecting of old paintings. His theories promoted the creation of an orthodoxy in later art that could be stifling, but his own works were true to his ideal of the transformation of old styles, rather than the sterile imitation of them. In Dong's landscapes, his attempts to reveal the inner structure and momentum of nature often result in a radical reorganization of forms (FIG. 15-28). Ground planes are allowed to tilt or shift; this—and the bold arrangement of rocks and trees to emphasize repeated abstract shapes and textures, without regard for natural scale and surface qualities—may seem arbitrarily distorted, or even crude. What is lost in harmony of surface or representational accuracy, however, is more than made up in qualities of monumentality and power. Paintings by Dong and other masters during the period of social and intellectual readjustment at the end of the Ming dynasty created an atmosphere of artistic freedom. The artists who lived into the next dynasty were its beneficiaries.

The internal decay of Ming bureaucracy permitted another group of invaders, the Manzhous, to overrun the country in the seventeenth century. Established as the Qing

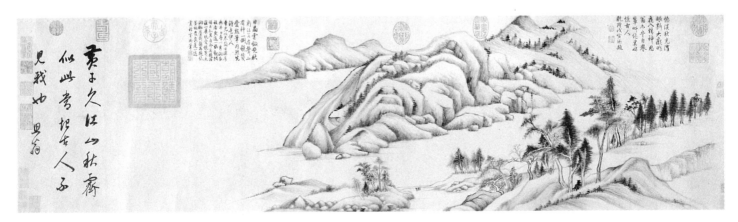

15-28 DONG QICHANG, *Autumn Mountains*, Ming dynasty, early seventeenth century. Horizontal scroll, ink on paper, 15¹/₈" × 53⁷/₈". Cleveland Museum of Art (purchase from the J. H. Wade Fund).

dynasty (1644–1912), these northerners quickly adapted themselves to Chinese life. The early Qing emperors cultivated a knowledge of China's arts, but their influence merely seems to have encouraged academic work. While the Yuan style continued to be fashionable among the conservatives, other painters experimented with extreme effects of massed ink or individualized patterns of brushwork. Bold and freely manipulated compositions that had a new, expressive force began to appear.

Two artists with intensely personal styles stand out against a mass of lesser painters during this period. The sketchy brush and wet-ink technique of Zhu Da (1625– c. 1705) derived from sixteenth-century precursors, but his subjects—whimsical animals or petulant birds that are tensely balanced on an album page—demonstrated his discontent with conventional themes. The theoretical writings of Zhu Da's great contemporary DAO JI (1641–c. 1717) called for a return to wellsprings of creativity through use of the "single brush stroke" or "primordial line" that was the root of all phenomena and representation. The figure in a hut in one of Dao Ji's album leaves (FIG. **15-29**) is surrounded by the surging energy of free-floating colored dots and multiple, sinuous, contour lines that suggest the vital arteries of an organism. What is depicted is not so much the appearance of the landscape as the animating, molding forces that run through it—the prime focus of Chinese landscape art from the earliest times.

Some twentieth-century artists, such as Qi Baishi, have found the free brush expressive and have maintained the calligraphic tradition with vitality. Xu Beihong (1895–1953), known for his boldly brushed pictures of horses, has imbued his work with social content, in keeping with China's political developments. The coming decades will reveal whether a popular art can assimilate the traditions of aristocratic painting that have dominated Chinese art for over a thousand years.

In ceramics, the technical ingenuity of the Ming and Qing potters exceeded the skill of even the Song potters. In general, porcelain was favored over stoneware and earthenware, with the exception of Ming stonewares, which were decorated broadly in "three-color" enamels. More delicate designs were painted on "five-color" wares, fine clay forms decorated with enamels and underglaze painting. The celebrated blue-and-white porcelains (FIG. **15-30**) owe their quality as much to the distinction of their painted decoration as to the purity of their imported cobalt pigments. Craftsmen also devised a "secret," barely visible decoration that was carved into paper-thin porcelain.

When the Manzhous came to power in 1644, they continued to support the great kilns at Fuliang (ancient

15-29 DAO JI, Landscape, Qing dynasty, late seventeenth century. Album leaf, ink and colors on paper, 9$^{1}/_{2}$″ × 11″. C. C. Wang Collection, New York.

During this long period, from the mid-seventeenth to the late eighteenth century, sculpture consisted primarily of charming but inconsequential porcelain bibelots and jade and ivory carvings of an almost unbelievable technical perfection. An example of this work is the white porcelain *Guanyin* (FIG. **15-31**), goddess of compassion, from the Early Qing dynasty, which completes that long process of the humanization of the sacred Buddhist images that began even before the Tang period (see FIG. 15-12). This lovely statuette, reflecting the culmination of the technical achievement of Chinese ceramists, embodies the Bodhisattva's quality of mercy in its softness of form. An easy play of line betrays the influence of painting on ceramics. This "white china ware" (*blanc-de-Chine*) was exported widely to Europe in the eighteenth century, and, in the

15-30 Vase, Ming dynasty, fifteenth century. Porcelain with blue underglaze decoration. Musée Guimet, Paris.

Jingdezhen), where enormous quantities of excellent porcelains were made until the destruction of the kilns during warfare in the mid-nineteenth century. During the Kangxi period (1662–1722), delicate glazes known as *clair de lune* (a pale, silvery blue) and *peachbloom* (pink dappled with green) vied with the polychrome wares. Experiments with glazes led to the invention of the superb imperial yellow and oxblood monochromes. A brief revival of Song simplicity occurred during the reign of Yong Zheng (1723–1735), but under Qianlong (1736–1795), a reaction against Song simplicity led to a style that was sometimes more elaborate than artistic.

Fine embroidered and woven textiles, created for lavish court ceremonies, followed the general style of the age, becoming more intricate and, at the same time, more delicate.

15-31 *Guanyin*, Early Qing dynasty, seventeenth and eighteenth centuries. Fujian ware, white porcelain, 8⁷/₈″ high, 6¹/₄″ wide. Trustees of the Barlow Collection, University of Sussex, England.

West to this day, fine ceramic wares, especially porcelain, are called "china."

As the eighteenth century waned, huge workshops, much like our own production-line factories, continued to provide masses of materials for imperial use. Specialists, instead of designer-craftsmen, worked on each stage of manufacture. By the middle of the nineteenth century, this system had drained all vitality from the crafts.

The establishment of the People's Republic of China in 1949 produced a social realism in art that is familiar to the world of the twentieth century and that breaks drastically with traditional Chinese art. Some Chinese artists carry on creative work based on the old traditions, but for most, the purpose of art now is, as the People's Republic would claim, to serve the people in the struggle to liberate and elevate the masses. In the work shown (FIG. **15-32**), a life-size tableau, the old times are depicted grimly in a scene common enough before the revolution. Peasants, worn and bent by toil, are bringing their taxes (in the form of produce) to the courtyard of their merciless, plundering landlord. The message is clear: this kind of thing must not happen again. Significantly, the artists who depict the event are an anonymous team. The "name" artist disappeared between 1955 and 1980; only collective action, said its theoreticians, could bring about the transformations sought by the People's Republic. Today, however, individual artists sign their work. Ironically, "collective action" by students protesting in Tiananmen Square in early June, 1989, produced not an image of an oppressed peasant or a militant worker, but an allegorical statue of "Liberty" based on the colossal one in New York harbor. This was not at all the kind of art the leaders of the People's Republic wanted to see.

Chinese Architecture

We have said little about Chinese architecture, partly because few early buildings exist and partly because Chinese architecture has not displayed distinctive changes in style over the centuries. The modern Chinese building closely resembles its prototype of a thousand years ago. Indeed, the dominant silhouette of the roof, which gives Chinese architecture much of its specific character, may go back to Zhou or Shang times. Even the simple buildings depicted on Han stone carvings reveal a style and a method of construction still basic to China. The essentials consist of a rectangular hall, dominated by a pitched roof with projecting eaves supported by a bracketing system and wooden columns. The walls serve no bearing function but act only as screening elements.

TEMPLE AND PAGODA CONSTRUCTION　　Our schematic cross-section and perspective of a Chinese building illustrate the column-beam-bracketing construction, one of the most ingenious and flexible support systems in world architecture (FIGS. **15-33** to **15-35**). Crosswise, beams were laid between the columns, their length decreasing as the structure rose. Vertically, the beams were separated by struts, which supported the purlins running the length of the building and carrying the rafters. Unlike the rigid elements of the triangular, trussed timber roof common in the West, the varying lengths of the cross beams and the variously placed purlins could produce roof lines of different shapes. The interlocking clusters of brackets could cantilever the roof to allow for broad overhang of the eaves. Multiplication of the bays formed by column-beam-bracket could extend the length of the building to any dimension

15-32　Anonymous team of sculptors, *The Rent Collection Courtyard* (detail of a larger tableau), Ta-yi, Sichuan, 1965. Clay-plaster, life size.

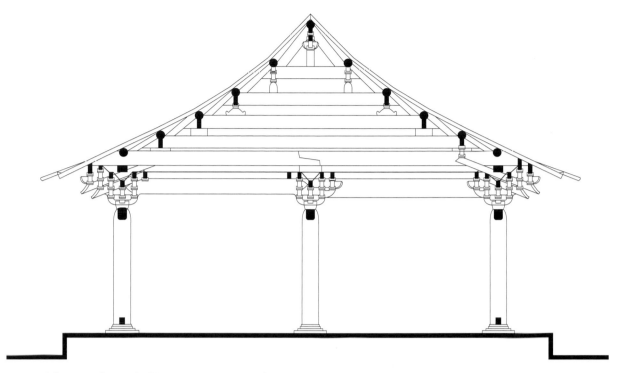

15-33 Structural diagram of typical Chinese construction. (After Watson.)

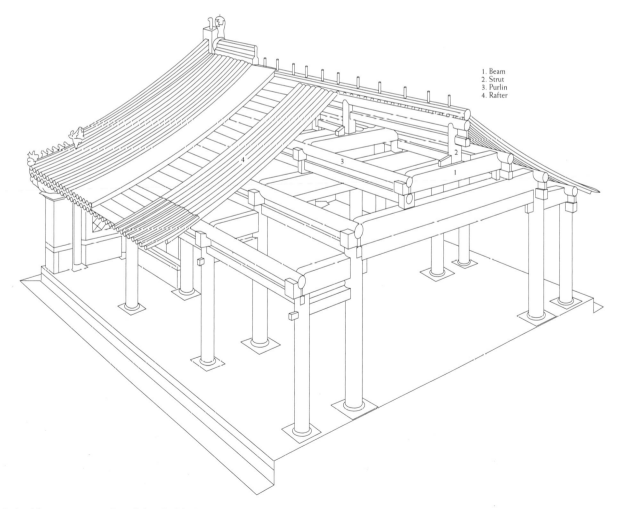

1. Beam
2. Strut
3. Purlin
4. Rafter

15-34 Raised beam construction. (after L. Liu.)

desired. The proportions of the structural elements could be fixed into modules, which allowed for standardization of parts. This made possible the construction of a building without prior complexities of the design procedure. The whole structure, as well as the building process, is a fitting together of modular units made of wood, somewhat akin to

cabinet making or the assembling of the parts of a "Chinese puzzle." The parts are fitted together, not bound by any adhesive substance like mortar or glue. Delicately joined as the parts might be, they were capable of carrying easily the heavy tiled roofs of the great Chinese temples and halls.

The classical support system is shown in cutaway cross-section and perspective drawings (FIG. **15-36**) of one of the oldest surviving temples, the Foguang Si, near Mount Wutai in northern China. The overhang of the eaves, some fourteen feet out from the faces of the columns, as well as the timbered and tiled roof, are supported by a complex grid of beams and purlins, and a thicket of interlocking brackets. The timber technology of China reaches early maturity in this masterpiece of Tang dynasty architecture.

A building type most often associated with China is the *pagoda*, the main feature of a temple complex, though we find similar structures in Burma (modern Myanmar) and India; it resembles the sikhara of Indian temples (FIGS.

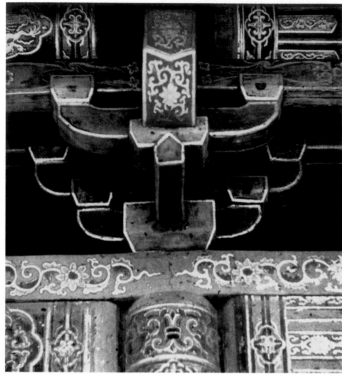

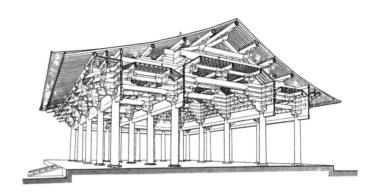

15-35 Console bracket cluster supporting eaves of a bell tower, Xi'an, Shaanxi.

15-36 Schematic cross-section and perspective drawing of Chinese beam-bracketing construction at Foguang Si temple, Wutai Shan, northern China, Tang dynasty, *c.* 857. (after L. Liu.)

15-37 Foguang Si Pagoda (Great Wooden Tower), Yingxian, Shaanxi, Liao dynasty, 1056.

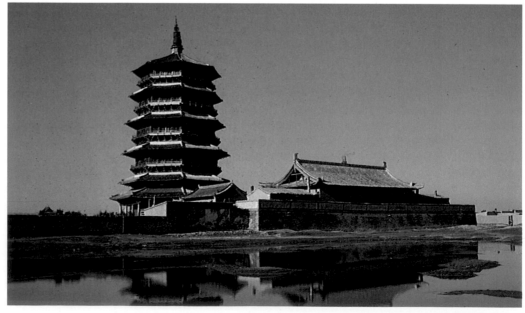

15-38 Plan and section drawing of Foguang Si Pagoda.
(after L. Liu.)

14-20, 14-21), and has a distant ancestor in the Indian stupa (FIG. 14-5). The pagoda of Foguang Si is octagonal in plan, 216 feet in height, and constructed entirely of wood (FIGS. **15-37** and **15-38**). Its five main storeys have broadly projecting eaves, which, with the floor beams, are carried on sixty giant, four-tiered, bracket clusters. The main storeys alternate with windowless mezzanines, making an elevation of nine storeys altogether. Balconies are cantilevered out at the mezzanine levels; these, along with the open veranda on the ground level, and the soaring pinnacle, serve visually to lighten the mass of the building. The cross-section shows the symmetrical placement of statues of the Buddha, the colossal scale of the ground floor statue, and the bewildering intricacy of the beam and bracket system at its most ingenious.

The plan of the typical Chinese temple precinct is instructive. The choice of site was for the Chinese an art to be cultivated. The north–south and east–west axes were carefully calculated in situating a building, as was the landscape environment; this was for both practical and spiritual reasons. The southern and southeastern orientations were favored as the source of climatic softness and the generation of vegetation, the life-giving sun against the deadly northern chill. In conformity with the Chinese belief in *fengshui* ("wind and water"), the breath of life, which is scattered by wind, must be stopped by water; thus the forces of wind and water must be adjusted in the orientation of buildings. In the layout of building complexes, the conservation of breath is expressed in the seclusion of the units and spaces of the enclosure. The plans are uniformly symmetrical, the buildings facing each other on either side of a central axis, which functions as a path and visual perspective through gateways, towers, halls, and courtyards in a sequence of primarily rectilinear units. The unchanging qualities of symmetry, regularity, uniformity, and secludedness in the layout, not only of halls and temple complexes but of whole cities, express powerfully the Chinese respect for tradition and order, and the enduring influence of the philosophy of Confucius.

The technical expertise of the Chinese architect is evident in a small temple occupying an almost impossible site (FIG. **15-39**). The Xuankong Si (Hanging Temple) seems to hover in the air in front of a huge cliff that is about to overwhelm it. The light, fragile fabric of the building is in startling contrast with the brutal mass of stone it seems to defy. Though later masonry foundations lend it support at the base, originally the structure was literally built from the top down: that is, the separate parts were fashioned beforehand, taken to the top of the cliff, and lowered along with the workmen, who then assembled them. The column-beam-bracket system, braced against the rock face, utilized the resistance of the cliff to stabilize the stresses. This remarkable structure, though often restored in centuries subsequent to its initial northern Wei dynasty construction, has withstood numerous earthquakes.

15-39 Xuankong Si (The Hanging Temple), Hunyuan, Shaanxi, Northern Wei dynasty, 386–534. Reconstructed during the Ming period.

In addition to its native structural finesse, Chinese architecture can be characterized by its color. The Chinese timber building was customarily designed to be polychromatic throughout, save for certain parts left in natural color, like white marble balustrades or roof crests. Surfaces were painted or lacquered to protect the timber from rot and wood parasites, as well as to have an arresting esthetic, even spiritual, effect. The predominant colors were red, black, yellow, and white, the screen walls and the columns usually red. Other members, beams, brackets, eaves, rafters, and ceilings could receive color in dazzling combinations (FIG. 15-35). The decorative function of color became more conspicuous in later centuries, as did the ornamental exaggeration of the turned-up eaves, which, by the time of the Ming dynasty, when the Hanging Temple was once again restored, took on the dramatically horned or winged silhouette that distinguishes the Chinese roofline.

HOUSE AND GARDEN The Chinese house and the Chinese garden are designed from two different philosophies, the house from the Confucian, the garden from the Daoist. The two philosophies, as we have seen, have equal influence in Chinese culture, representing two notions of harmony, not necessarily opposed; the Confucian, the harmony of the moral and social order, the Daoist, the harmony of man within, and resonant with, the forces of nature. We have seen the Confucian notion expressed in the axial, symmetrical design of temples and cities, and we have noted the Daoist influence in landscape painting. Confucianism stresses the qualities of regularity, symmetry, balance, and finiteness, Daoism stresses irregularity, asymmetry, and the instability and incompleteness of eternal change. Confucianism stresses control and definition,

Daoism, yielding to the undefined, the infinite forces of nature, which envelop and move humankind as everything else, animate or inanimate.

The Chinese house, like the Chinese temple and city, is an axial grouping of halls and courtyards within an enclosure. The plan of the house expresses the Confucian ideal of a patriarchal society based upon the patriarchal family, in which resident persons are subordinate to the commanding role and position of the elders; this is sanctified by the religion of ancestor worship and its traditional observances. The arrangements of halls and courtyards and living quarters are strictly determined by rule, although they may differ in minor detail. The *fengshui* conventions of orientation may decide the placement of the entrances and exits of the house with respect to the influence of favorable or unfavorable spiritual forces.

The facade of the house, the mask of its private interior, is most often modest, fronting upon an already narrow masonry street (FIG. **15-40**). Its entrance might bear a magical inscription insuring happiness and warding off the

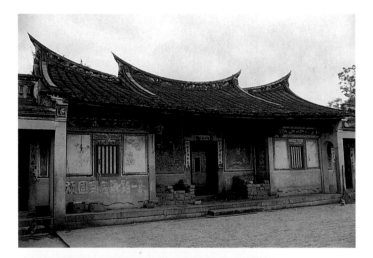

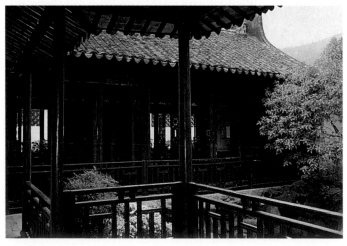

15-40 Courtyard house exterior in Wuxi, Jiangsu, and courtyard house interior in Fujian.

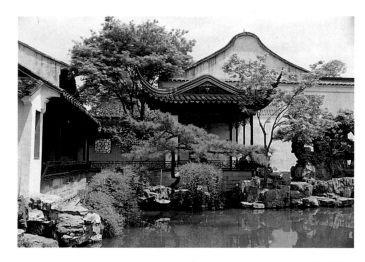

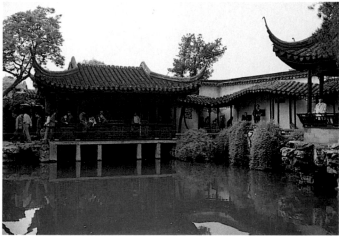

15-41 Wangshi Yuan, veranda and pavilion, and Wangshi Yuan, pavilion and pool, Suzhou, Jiangsu.

threat of demonic powers. The private precincts, set off by walls within, could open out into verandas from which the family and visitors could look out upon another enclosure, the garden, an artfully designed fragment of nature, an esthetic, intellectual, and spiritual resource prized in China as perhaps nowhere else.

There is a Chinese ideogram that in itself gives us a definition of a garden: "a place enclosed by walls, within which are buildings, waterways, rocks, trees, and flowering plants" (FIG. **15-41**). The purpose of the garden is to replicate in miniature the fullness of nature in all its variety, so as to produce an environment in which the soul can immerse itself and find tranquillity and peace. Chinese poets never cease to sing of the restorative effect of the garden upon mind and spirit. Garden design is a great art, akin to the composition of a poem or of a landscape painting. It is not a matter of cultivating plants in rows, or laying out terraces, parterres, avenues in geometrical fashion; but in cunningly contriving scenic arrangement of natural and artificial elements intended to reproduce the irregularities

of uncultivated nature. Verandas are built over ponds. Pavilions on stilts rise above the water; a principal feature of the garden, the pavilion controls a variety of views. Stone bridges, paths, and causeways encourage wandering through ever-changing vistas of trees, flowers, rocks and their reflections in the ponds—a sequence of carefully contrived visual surprises as the visitor moves. Primitive nature is represented in a favorite garden element, fantastic rockwork, which, ideally, should be "grotesque, sparc, and porous" (FIG. **15-42**). The Chinese garden is a sanctuary where nature is worshiped and communed with in all its representative forms and as an ever-changing and boundless presence.

The conservatism of Confucian China as expressed in its architecture can be seen in the Taihe Dian or Hall of Supreme Harmony (fig. **15-43**), one of the principal monuments of the Ming and Qing dynasties. The Taihe Dian is the largest building and the centerpiece of the grand, typically axial design of the "Forbidden City," the former Imperial Palace compound, which itself is centered on the main north–south axis of the capital city of Beijing. The great hall functioned as the throne room and audience hall of the Chinese emperor. Built in 1627, rebuilt in 1697, and restored in 1765, it is a late and monumental example of the persistence of the standard Chinese architectural style. Of great scale, some 200 feet long and 100 feet deep, it has a weighty, majestic formality appropriate for the staging of the quasi-sacred imperial ceremonies. Raised high on a terraced, white marble podium, the massive red and gold structure, with its overhanging eaves and upturned roof

15-42 Liu Yuan, Guanyun Peak, Suzhou, Jiangsu.

15-43 Taihe Dian, Imperial Palace, Forbidden City, Peking, seventeenth century and later.

lines, dominates a number of smaller halls that flank it symmetrically and are grouped behind it. Repeating the design of the major building, these halls with their hipped roofs and upswept eave lines are aligned with the north–south axis that runs through the rectangular, moat-surrounded imperial compound. The auxiliary halls with their courtyards provided the private quarters of the imperial family, service quarters, harems, places for study, gardens, and spaces enclosed for the innumerable activities of elaborate court life. The whole immense composition is faithfully laid out in accordance with rules for design and structure set down and followed for over a millennium.

It is a curious paradox that the architecture of China, the oldest continuing civilization in the world, should be represented by few surviving buildings older than the ninth century. The conservatism of China would seem to have made preservation of its ancient monuments one of its first cares. Yet the very flexibility of its methods of construction made conservation of the individual structure irrelevant; it could easily be dismantled, moved to another site, or simply replaced. What counted was the survival of the rule, the pattern, the tradition of building rather than the survival of the building itself—just as the eternal laws of right living as set forth in the philosophy of Confucius survive all changes of state and the particular fates of millions of human beings.

KOREA

A glance at the map will show Korea as a small peninsula of the Chinese-Manchurian mainland facing the archipelago of Japan. Caught between two great powers, one on

the west and one on the east, Korea was fated to be susceptible to attacks from both directions; time and again throughout its long history these attacks would politically destabilize it. On the other hand, Korea's exposed position made it both recipient and transmitter of cultural influences, principally from China eastward to Japan. Even so, Korea was not a mere way station dependent upon the east–west traffic of influence; it developed a distinctive civilization of its own.

Ethnically, the Koreans are related to the peoples of eastern Siberia and Mongolia, as well as to the Japanese. Their language has structural features resembling both Chinese and Japanese, but most scholars classify it with the Ural-Altaic languages of northern Asia. In the early centuries, Korean was written in Chinese characters but later in its own phonetic alphabet. Korean art, though unmistakably Chinese in origin, is not merely derivative, but has, like Korean civilization, a discernible native identity.

The Chinese are believed to have colonized a part of Korea as early as the twelfth century B.C. Much later, about 100 B.C., during the Han dynasty, the Chinese established a colony in Korea, Lolang, that was for centuries an important commercial center. Native kingdoms, Koguryo, Paekche, and Silla were established in different regions of the peninsula; the centuries of their contemporaneous reigns are known as the period of the Three Kingdoms (c. 57 B.C.–688 A.D.). It was in the kingdom of Paekche in A.D. 372 that Buddhism was introduced to Korea from China, an event of mighty consequence.

Silla, the oldest and, as it turned out, the strongest of the three kingdoms, aided by the emperor of China, conquered the other two and unified Korea as Great Silla. The era of Great Silla (638–935 A.D.), contemporary with the brilliant

culture of the Tang dynasty in China, enjoyed a prosperity that encouraged high achievement in the arts and is known as the golden age of Korea. The Tang Chinese, it is said, admired the Korea of Great Silla times and called it "Little China," an apparent compliment in which the Koreans took pride.

The Silla dynasty was replaced without conflict by the Koryo (an accepted abbreviation of "Koguryo") in 935, and the period of its ascendancy is roughly contemporary with that of the Song dynasty in China. Though Buddhism was the established religion of Korea, Confucianism, introduced from China during the Silla era, became increasingly formative of social and political conventions. In 1231 the Mongols, who had invaded China, used it as a base for the invasion of Korea. A war lasting thirty years ended with the submission of the Koryo and their alliance with the Mongols.

The last of the native Korean dynasties began with the Yi, whose founder took over the Koryo state in 1392. Buddhism had become corrupt and was replaced by a strict neo-Confucianism. In the last decade of the sixteenth century a Japanese invasion devastated the country for seven years and was only finally repulsed with the aid of China. But almost immediately, the Manzhus of China, who had overthrown the Ming emperor, occupied Korea and made it a province of Qing China.

Except for the enforced connection with China, Korea shut off all other foreign contacts until the nineteenth century, when its doors were forced open by Japan and other nations including the United States. Japan annexed Korea in 1910, and it remained a political part of Japan until 1945, when it was taken by the western Allies and the Soviet Union at the end of World War II. The Korea of 1950 to 1953, which engaged the major powers of the world politically and militarily, was a disastrous and ironic last chapter in Korea's long history of foreign intrusion.

Buddhist Art: Silla and Koryo

The introduction of Buddhism from China in the fourth century A.D. was a welcome and beneficial intrusion. Traveling like a slow wave from India through China, Buddhism was a civilizing influence in Korea, replacing the native, shamanistic religion of the northeastern Asiatic tribes to which the Koreans belonged. In Korea these primitive religions did not offer the resistance Buddhism found in the more developed and sophisticated Hinduism of India or Confucianism and Daoism of China. Thus, Korean art in the periods of its finest production was thoroughly Buddhist, and the fashioning of the Buddhist image was its first concern. Indeed, as we shall see, it was a Korean image of the Buddha, introduced along with the Buddhist scriptures to Japan in the sixth century, that stimulated the great artistic creativity of the Asuka period and set Japanese art and civilization on an entirely new course (see pages 532-534).

In devoutly Buddhist Korea the Buddha image was widely reproduced, especially in the periods of Silla and Koryo rule. A gilded bronze standing Buddha from the eighth century is typical (FIG. 15-44). A small-scale cousin to the thousands of images found in the great Chinese caves, and in Korea's own Sokkul-am grotto, the Buddha, standing upon the lotus pedestal, wears the ushnisha crown and makes the symbolic mudra of warding off evil and giving charity. The face is classically round, representing the moon, the ears

15-44 Standing Buddha, Unified Silla dynasty, eighth century. Gilded bronze, 18⁵/₈" × 12¹⁵/₁₆". Asian Art Museum of San Francisco, The Avery Brundage Collection.

15-45 *Buddha Amitabha and Eight Great Bodhisattvas*, Koryo dynasty, fourteenth century. Hanging scroll, ink, colors, and gold on silk, 59¹/₂″ × 34¹⁵/₁₆″. Asian Art Museum of San Francisco, The Avery Brundage Collection.

Bodhisattvas, who, like him, wear the haloes of sanctity and enlightenment. Amitabha, whose facial traits much resemble those of the small bronze, sits in the cross-legged lotus pose much favored by yoga for the exercise of meditation. His hands make the *mudra* symbolizing the wheel of causation, the wheel of life and death, whose endless turning can only be transcended by meditation and suppression of the self, the ways to enlightenment and eternal peace. A comparison with the Sarnath Buddha (FIG. 14-13), almost a thousand years earlier, will show how remote in time and place the Korean image is from its source in India, yet how faithful it is to that distant iconographic prototype.

Celadon Ware

The Amitabha scroll was painted during the Koryo period, at a time when not only were the pictorial arts in full flower, but when the famous Korean celadon wares were produced, which have long been known and admired

long, representing wisdom, the expression one of dreaming serenity that comes with enlightenment. The figure is archaic in its shortened proportions and rigid frontality, its drapery a schematic version of the more fluent type found in Tang sculpture in China (FIG. 15-14).

A scroll painting on silk, of much later date (FIG. **15-45**), evidences the long-lived vitality of the Buddhist tradition in Korea and the development of its iconography. The enthroned Buddha Amitabha is flanked by eight

15-46 Vase (*maebyŏng* type), Koryo dynasty, twelfth century. Celadon with inlaid ornament of cranes and bamboo, 12¹/₂″ high. Courtesy Museum of Fine Arts, Boston.

15-47 Ewer, Koryo dynasty, early twelfth century. Stoneware with celadon glaze, 9⁵/₈″ × 6¹/₂″. Asian Art Museum of San Francisco, The Avery Brundage Collection.

worldwide. An invention of Korean potters sometime in the twelfth century, the celadon wares developed out of experiments with stoneware technology. They are distinguished by their incised or engraved designs and their gray-green and bluish green glazes, which have a deep, mysterious tonality; the Chinese declared it to be among the ten wonders of the world.

A beautiful example of the art is a celadon vase of *maebyŏng* type (FIG. 15-46), which, by its simplicity compared with the elaborateness of later celadon design, may be dated early in the Koryo period. Delicate motifs, cranes and bamboo, were incised in the surface of the clay and then filled with white, green, and black slip. Next, the incised areas were covered with the celadon green glaze. The cranes rival in their effortless grace and truth to life the finest Chinese and Japanese nature painting; and the precise adjustment of the bamboo's curve to that of the vase bespeaks the potter's sure sense of the living relation between ornamental line and ceramic volume. This sensi-

tivity in the adjustment of ornament to vessel is the unwritten signature of the world's greatest potters.

The variety of ceramic shapes produced by the early Koryo masters serves as testimony to their versatility as well as their sensitivity to shape and function. A *ewer*, or large pitcher, with lotus lid, strongly curved handle, and gently curved spout (FIG. 15-47) is made of unornamented stoneware with celadon glaze. It contrasts in shape with another ewer (FIG. 15-48), which is both incised and inlaid with ornament, and which has a high slender neck and

15-48 Ritual Ewer (*Kundika*), Koryo dynasty, twelfth century. Stoneware with celadon glaze over incised and inlaid decoration, 13¹/₂″ × 5¹/₂″. Asian Art Museum of San Francisco, The Avery Brundage Collection.

15-49 *Panel of the Sun* and *Panel of the Moon,* parts of a continuous screen. Paper, each panel 22″ × 64″.

elongated spout designed for careful pouring at some *lustral,* or purification, ritual.

The Japanese invasion of the Yi kingdom (1592–1598) transferred many Korean potters to Kyushu, the southernmost island of Japan, where they were instrumental in inaugurating the Japanese porcelain industry. Porcelain bowls ("Ido bowls") of Korean make became valued accessories in the Japanese tea ceremony (see pages 541-542) and were naturalized as cultural treasures of Japan.

The long reign of Buddhism as the Korean religion came to an end with the Yi (Choson) dynasty (1392–1910). It was replaced by a strict, formalistic neo-Confucianism that turned attention to public and worldly concerns and the problems of daily life. At the same time, the ancient nature-worship of the shamans, mingled with Daoism, came to the surface, and the themes of art were taken from the flora, fauna, and landscape of the human environment. A popular art flourished in the form of painting on multipaneled screens that could be folded, moved, and variously arranged for residential interiors. The loftiest theme, representing the sun and moon (FIG. **15-49**), was intended for royal settings, the king's throne room, for example. The design was formal, invariant, and repeatable. A red sun and a white moon, the heavenly deities worshiped in shamanistic animism, are symmetrically balanced above mountains, trees, waterfalls, and rapid streams, which were also objects of worship. The shapes are radically abstracted into vivid patterns of expressive, almost calligraphic motifs, as are the colors; the trunks and branches of the ancient pines are painted in flaming red. These figurations of deified natural forces, which exclude all reference to human beings, were intended to magnify the dignity and authority of monarchs who ruled as absolutely as the sun rules the day and the moon the night. Though related distantly to the nature subjects of Chinese and Japanese painting, these works, in their bold, even harsh, shapes and colors, speak a uniquely Korean language, traceable to its ethnic roots.

Conversion Table, Wade-Giles to Pinyin

Wade-Giles	Pinyin	Wade-Giles	Pinyin
Ch'ang-an	Chang'an	Manchu	Manzhou
Ch'i Pai-shin	Qi Baishi	mei-p'ing	meiping
ch'i	qi	Mu-ch'i	Mu Qi
Ch'ien Lung	Qianlong	Nanking	Nanjing
Ch'in	Qin	Ni Tsan	Ni Zan
Ch'ing	Qing	Peking	Beijing
Chao Meng-fu	Zhao Mengfu	Pien ching	Bianjing
Chin	Jin	Shantung	Shandong
Ching Hao	Jing Hao	Shen Chou	Shen Zhou
Chingtechen	Jingdezhen	Shensi	Shaanxi
Chou Chi-ch'ang	Zhou Jichang	Shih Huang Ti	Shi Huangdi
Chou	Zhou	Sima Quian	Sima Qian
Chu jan	Ju Ran	Su Shih	Su Shi
Chu Ta	Zhu Da	Su Tung-p'o	Su Dongpo
Fan K'uan	Fan Kuan	Sung	Song
Foguong	Foguang	Szechuan	Sichuan
Fukien	Fujian	T'ai Tsung	Tai Zong
Hangchou	Hangzhou	T'ai-ho Tien	Taihe Dian
Honan	Henan	T'ang	Tang
Hsia Kuei	Xia Gui	Tai Chin	Dai Jin
Hsia	Xia	Tao, Taoism	Dao, Daoism
Hsieh Ho	Xie He	Tao-chi	Dao Ji
Hsu Pei hung	Xu Beihong	Tatung	Datong
Hsuan p'in	Xuanpin	Ti'en-lung	Tianlong
Huang Kung-wang	Huang Gongwang	ting	ding
Huang Ho	Huang He	Tsung Ping	Zong Bing
Hui Neng	Huineng	Tung Ch'i ch'ang	Dong Qichang
Hui Tsung	Huizong	Tung Yuan	Dong Yuan
K'ang-hsi	Kangxi	Tunhuang	Dunhuang
Kansu	Gansu	Tz'u chou	Cizhou
Ku K'ai chih	Gu Kaizhi	Wen Cheng-ming	Wen Zhengming
Kuan-yin	Guanyin	Wu Chen	Wu Zhen
kuang	guang	Wu Tao tzu	Wu Daozi
Kuo Hsi	Guo Xi	Yen Li-pen	Yan Liben
Lao Tzu	Laozi	ying ch'ing	yingging
Li Ch'eng	Li Cheng	Yüan	Yuan
Liang K'ai	Liang Kai	Yung Cheng	Yong Zheng
Loyang	Luoyang	Yung t'ai	Yongtai
Lungmen	Longmen	Yunkang	Yungang
Ma-Hsia	Ma-Xia		

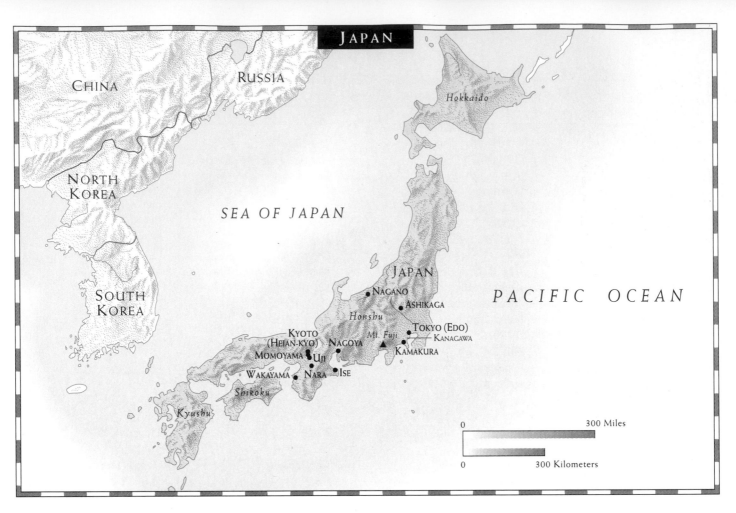

JAPAN

CHINA

RUSSIA

NORTH
KOREA

SOUTH
KOREA

SEA OF JAPAN

Hokkaido

JAPAN

PACIFIC OCEAN

• NAGANO
• ASHIKAGA

Honshu

KYOTO
(HEIAN-KYO) NAGOYA
MOMOYAMA UJI
WAKAYAMA NARA ISE

Mt. Fuji TOKYO (EDO)
← KANAGAWA
KAMAKURA

Shikoku

Kyushu

0 300 Miles

0 300 Kilometers

3000 B.C.	2000 B.C.	B.C. A.D.	552	710	794	1185
JOMON CULTURE		ARCHAIC	ASUKA AND HAKUHO	NARA	EARLY AND LATE HEIAN (FUJIWARA)	KAMAKURA

Haniwa figure
5th-6th century

Jomon vase
3000-2000 B.C.

Ise Shrine, 3rd-century type

Kondo, 7th century

The Sage Kuya
Invoking the Amida Buddha
13th century

Kimmei, Emperor
of Japan, 552

Zen Buddhism begins rise

Civil wars lead to end
of Fujiwara rulers

Introduction of
Buddhism to Japan

New capital established
at Kamakura, 1185

CHAPTER 16

THE ART
OF JAPAN

c.1392	1573	1868
ASHIKAGA	MOMOYAMA AND EDO (TOKUGAWA)	MODERN JAPAN

Kiyotada,
Dancing Kabuki Actor
c. 1725

Hokusai, The Great Wave
c. 1823-1829

Kamakura rule
ceases, 1333

Origin of the tea ceremony

Civil wars, 1333-1392

Tokugawa Ieyasu consolidates his power
as Shogun of Edo (modern Tokyo), 1615

Japan opened to Western trade
and influence, 1854

The arts of Japan have neither the progressive, stylistic continuity of the arts of India nor the wide variety of those of China. A series of foreign influences sporadically affected the course of Japan's artistic evolution; we have noted the importance of the Korean contribution. Yet, no matter how overwhelming the impact of new forms and styles, the indigenous tradition invariably reasserted itself. Hence, the artistic pattern evolved in a rhythmic sequence of marked periods of borrowing, absorption, and return to native patterns.

Because Japan and its nearby islands are of volcanic origin, little stone suitable for carving or building is available. In architecture, this scarcity led to the development of wooden construction carefully devised to withstand the frequent earthquakes and tempests. In sculpture, figures were modeled in clay, which was often left unfired, cast in bronze by the cire perdue (lost wax) process familiar to many other cultures, or constructed of lacquer. Although the lacquer technique originated in China, Japanese artists excelled in creating large, hollow lacquer figures by placing hemp cloth soaked in the juice of the lacquer tree over wooden armatures. The surfaces gradually were added to and finished, but the technique remained one of modeling rather than of carving. Such figures were not only light but very durable, being hard and resistant to destructive forces. Hollow lacquer figures eventually were superseded by sculptures carved in wood, with unusual sensitivity for grain and texture.

ARCHAIC PERIOD

The first artifacts known in Japan are pottery vessels and figurines from a culture designated Jomon, which apparently flourished as early as the fourth millennium B.C. These objects are associated with Neolithic tools, although they persisted in northern Japan as late as the fourth or fifth century A.D., even while a metal culture was being developed fully in the south. An interesting specimen of one variety of Jomon ware is an intricately textured vase (FIG. **16-1**) that indicates a highly developed feeling for ceramic ornament. The surface is modeled rather than painted. Colored a uniform rust red—Jomon pottery was never polychromed—the material is worked into a prominent, rope-like relief (the word *jomon* means "rope decoration"). The asymmetrically arranged coils seem to enwrap another vessel, the texture of which resembles matwork. The potter may have been trying for an illusionistic effect, simulating a textile-insulated pot hanging in a rope sling. Or, the free play of the coils may be simply an exercise in calligraphy, setting off the projecting characters against the flat, incised striations. In any event, the piece suggests that, unlike contemporary Neolithic earthenwares in China (FIGS. 15-1 and 15-2), the Japanese product was considered more as a sculptural object than as a purely ceramic one.

Much later, Japanese objects dating from about the beginning of the Christian era are of three kinds: those imported from the Asian mainland, those copied from imported articles, and those of Japanese invention. Examples, for instance, would include bronze mirrors from Han China, as well as replicas of these mirrors made in Japan. Some of the replicas are adorned with a Japanese innovation—spherical rattles attached to the perimeter. A gray pottery known as *sue* came from Korea, another source of continental influence. Sue soon was copied, and small, comma-shaped stones (*magatama*) were used in necklaces. A third area, Indochina, was the source of motifs used on bell-shaped bronzes, known as *dotaku*. The houses and boats depicted on these bronzes are similar to those on contemporaneous drums from Annam (modern Vietnam).

Within this heterogeneous culture, a specifically Japanese creativity asserted itself in the production of *haniwa* (tubular sculpture made of fired clay) that was placed fencelike around burial mounds, possibly to control erosion or to protect the dead. The upper parts of the haniwa are usually modeled in human form, but these sculptures also

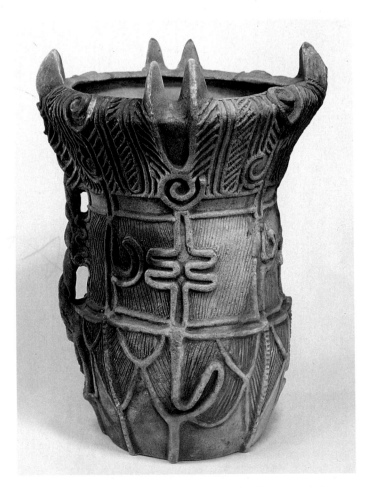

16-1 Vase, from Miyanomae, Nagano District, Jomon period, 3000–2000 B.C. Earthenware, 23²/₃" × 13¹/₄". National Museum, Tokyo.

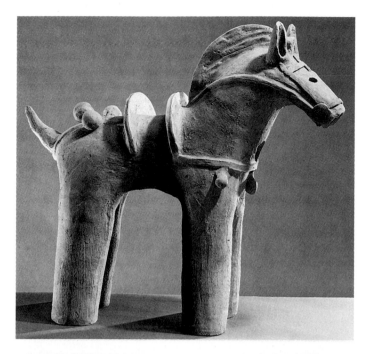

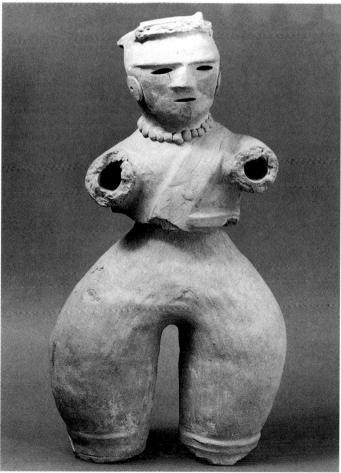

16-2 *Haniwa* figures, horse and peasant, fifth to sixth centuries. Clay. Horse, Cleveland Museum of Art (gift of The Norweb Collection); peasant, Cleveland Museum of Art (James Parmelee Fund purchase).

sometimes take the shape of a horse (FIG. **16-2**), a bird, or even a house. Simple pottery cylinders were used similarly in Indochina, but the sculptural modeling of haniwa is uniquely Japanese. The arms and legs, as well as the mass of the torso, in most instances, recapitulate the cylindrical base of the haniwa. The tubelike character of some later monumental sculpture—and even of a particular wooden doll common in Japan today—may derive from these remote ancestors.

Aside from colossal tomb mounds reminiscent of those found in China, the earliest Japanese architecture was limited to pit dwellings and simple constructions of thatched roofs on bamboo or wooden stilts. From these primitive origins evolved what may be called the native Japanese style of architecture, as distinguished from the imported Chinese style. This native building style has survived into our time in some of the shrines of Shinto, the indigenous faith of the Japanese people.* The custom at the Ise Shrine in Mie Prefecture (FIG. **16-3**) has been to disassemble the buildings every twenty years and to replace them with exact copies. This process has been repeated since the third century, and we may assume that the structures there today reproduce the original ones with considerable accuracy.

The typical Shinto shrine, like the Buddhist temple, consists of several buildings within a rectangular, fenced enclosure. The buildings are disposed symmetrically along a central axis that leads from the outside, through one or more ceremonial gates (*torii*), into and through the compound. This axis is interrupted only by the off-center outermost gate and by the transversely placed main building. The main sanctuary was regarded as the dwelling place of the deity and was not accessible to worshipers, who said their prayers outside the innermost gate. The sanctuary was to be seen only from the outside (much like a Greek temple), and all of the builders' efforts were directed toward the refinement of the building's proportions and details.

The Ise Shrine (FIG. 16-3), the greatest of all Shinto shrines, was rebuilt for the sixtieth time in 1973. It covers an area 55 yards by 127 yards and is enclosed by four concentric fences. Aside from their thatched roofs, the buildings are constructed entirely of wood fitted together in a *mortise-and-tenon system,* the wall boards being slipped into slots in the pillars. Two massive, freestanding posts (once great trunks of cypress trees), one at each end of the building, support most of the weight of the ridgepole. Golden-hued columns and planks of the same wood are burnished to mellow surfaces, their color and texture contrasting with the white gravel that covers the ground of the sacred precinct. In the characteristic manner of the Japanese artist,

*Shinto, or "the Way of the Gods," was based on love of nature, of the family, and, above all, of the ruling family, as direct descendants of the gods. Nationalistic in character, Shinto was embodied in symbolic forms and shunned pictorial representation.

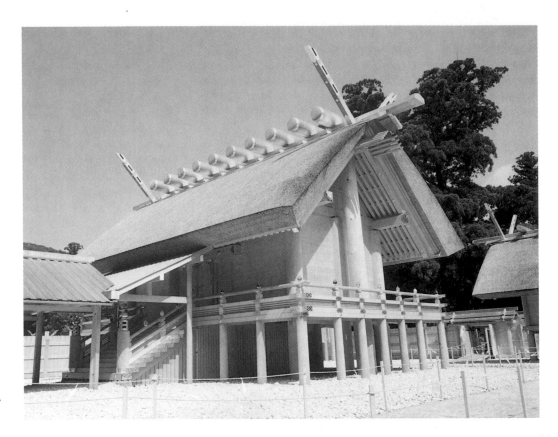

16-3 Ise Shrine, Japan. Rebuilt in 1973, reproducing third-century type.

the thatched roof was transformed from a simple function-al element into one that established the esthetic of the entire structure. Browned by a smoking process, the thatch was sewn into bundles and then carefully laid in layers that gradually decreased in number from the eaves to the ridge-pole. The entire surface was then sheared smooth, and a gently changing contour resulted. The roofline was enhanced further by decorative elements that once had been structural—the *chigi*, or crosspiece, at the gables, and cylindrical wooden weights placed at right angles across the ridgepole. The repeats and echoes of the various parts of the main building and the related structures are a quiet study in rhythmic form. The shrine, in its setting, is an expression of purity and dignity, effectively emphasized by the extreme simplicity of the precisely planned proportions, textures, and architectural forms employed.

ASUKA PERIOD

The development of native traditions was interrupted in 552 by an event of paramount importance to Japan. In that year, the ruler of Kudara (Korean: Paekche), a kingdom in Korea, sent a gilded bronze figure of the Buddha to Emperor Kimmei of Japan. With the image came the gospels. For half a century, the new religion met with oppo-sition, but at the end of that time, Buddhism and its atten-dant arts were established firmly in Japan.

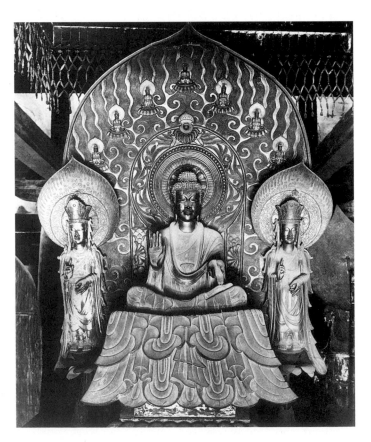

16-4 TORI BUSSHI, *The Shaka Triad*, Asuka period, 623. Bronze, 69¹/₂" high. Hōyū-ji, Nara, Japan.

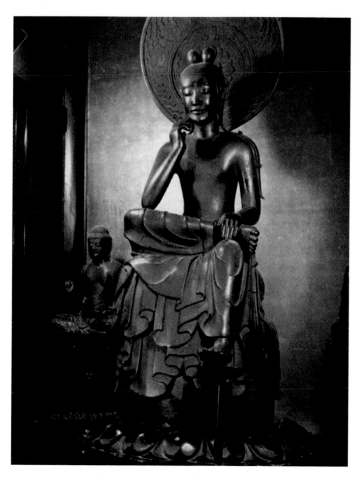

16-5 *Miroku*, Asuka period, mid-seventh century. Wood, 62" high. Chugu-ji nunnery, Hōryū-ji, Nara.

Among the earliest examples of Japanese art serving the cause of Buddhism is *The Shaka Triad* (FIG. **16-4**), a bronze sculpture of Shaka (Sanskrit: Sakyamuni) and attendant Bodhisattvas, made in 623 by TORI BUSSHI, a third-generation Korean living in Japan. Tori's style is that of the mid-sixth century in China. His work proved how tenaciously the formula for a "correct" representation of the icon had been maintained since the introduction of Buddhism almost a century earlier. Yet, at the same time, a new influence was coming from Sui China, which may be seen in the cylindrical form and flowing draperies of the wood sculpture known as the *Kudara Kannon* (Chinese: *Guanyin*). The two styles were blended, and, in the middle of the seventh century, they coalesced in one of Japan's finest sculptures, the *Miroku* (Sanskrit: *Maitreya*) of the Chugu-ji (the suffix -*ji* means "temple") nunnery near Nara (FIG. **16-5**). In this figure, the Japanese artist combines a gentle sweetness with formal restraint in a manner unknown in Chinese sculpture.

Within a little more than half a century, however, all the archaisms of the fused style (loosely called *Suiko*, after the empress who reigned from 593 to 628, or *Asuka*, after

the site of the capital) were swept aside by a new influence from Tang China. The Tang style, which found its way to Japan at the end of the Hakuho period (645–710), dominated Japanese art during the following periods of Late Nara (710–794) and Early Heian (794–897). Chinese models were followed not only in sculpture and painting but also in architecture, literature, and even etiquette.

The mature Tang style appeared suddenly in Japan in the bronze Shrine of Lady Tachibana (FIG. **16-6**). The shrine consists of three full-round figures: the Buddha Amida (Sanskrit: Amitabha) seated on a lotus between the smaller figures of Kannon and Dai Seishi (Bodhisattva attendants), each standing on a lotus. All three are rising from a platform that represents the stylized waters of the Sukhavati lake in the paradise of the Buddha. Behind them is a threefold screen on which are modeled, in relief, the graceful forms of *apsaras* (heavenly nymphs) seated on lotuses and the tiny figures of souls newly borne into Heaven. The scarves of the apsaras and the petals, tendrils, and pads of the lotuses create an exquisite background for the three divinities, while a detached, openwork halo of delicate design frames the head of the Buddha. The ensemble gives us some idea of the glorious Tang bronzes that were melted down in China during the Buddhist persecutions of 845.

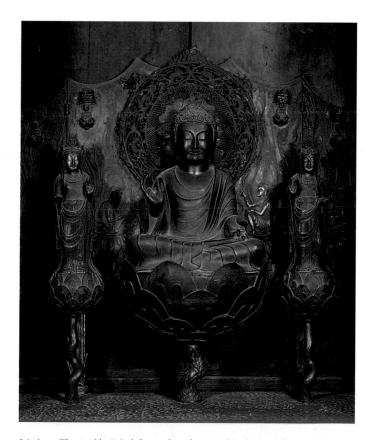

16-6 *The Amida Triad*, from the Shrine of Lady Tachibana, Nara period, early eighth century. Gilded bronze; Amida, 11" high, attendants, 10" high. Hōryū-ji, Nara.

It also clearly demonstrates the remarkable adaptability of the Japanese artist in seizing a new art form and making it his own.

The development of painting in Japan paralleled that of Buddhist sculpture. Some of the earliest surviving examples are found on the *Tamamushi* (beetle-wing) Shrine (FIG. **16-7**), which dates from the first half of the seventh century. The shrine is in the form of a miniature temple on a high wooden base, which was decorated with the iridescent wings of beetles. The four side panels of the base are painted with scenes from the *Jataka* in the style of the Chinese Dunhuang caves of a century earlier, as may be seen in the cell-like composition, the crystalline rock formations, the attenuated figures, and the free linear movement. The shrine paintings also manifest the same delight in surface pattern to the point of disregard of naturalism in scale and spatial relationships.

The Japanese dependence on China during the seventh and eighth centuries is not confined to sculpture and painting. Buddhist architecture adhered so closely to Chinese

models that the lost Tang style can be reconstructed from such temple complexes as the Hōryū-ji or the Todai-ji, which still stand in Japan. The Kondo (Golden Hall) of the Hōryū-ji (FIG. **16-8**), which dates from shortly after 670, is one of the oldest wooden buildings in the world. Although periodically repaired and somewhat altered (the covered porch was added in the eighth century; the upper railing, in the seventeenth), the structure retains the light and buoyant quality characteristic of the style of the Northern and Southern Song dynasties in China. A rather unusual feature of this building is the entasis of its wooden columns. The appearance of this feature here is said to be due to Greek influence, as third-hand knowledge of it may have reached Japan, along with Buddhism, from India by way of China. Although seemingly more appropriate to elastic wood than to brittle stone, entasis was a short-lived feature that soon disappeared again from Japanese architecture.

EARLY HEIAN AND LATE HEIAN (FUJIWARA) PERIODS

A new style of representation arrived in Japan at the beginning of the ninth century. Under the influence of Esoteric Buddhism (page 478), a heavier image with multiple arms and heads was introduced—a type that, in China, was then replacing the earlier, classic grace of the Tang style. The bloated forms of the new style, though they may be repellent, have the merit of somber dignity. In paintings, these bulky figures, often cut off at the sides, give the effect of a mighty force expanding beyond the pictorial format.

From the middle of the ninth century, relations between Japan and China deteriorated so rapidly that, by the end of that century, almost all intercourse had ceased. No longer able to reflect the fashions of China, the artists of Japan began to create their own forms during the Late Heian, or Fujiwara, period (897–1185). At this time, court practices at Heian-kyo (modern Kyoto) were refined to the point of preciosity. A vivid and detailed picture of the period appears in Lady Murasaki's eleventh-century novel *The Tale of Genji*, a work of superb subtlety. The picture that emerges is one of a court in which etiquette overwhelmed morality, a society in which poor taste—in such matters as the color of a robe, the paper used in the endless writing of love letters, or the script itself—was considered a cardinal sin.

The essence of this court is reflected in a set of scrolls (illustrating *The Tale of Genji*), formerly attributed to the twelfth-century court artist TAKAYOSHI but now considered to be an anonymous group effort. Painted in the horizontal-scroll (*makimono*) format, small pictures like the one shown here (FIG. **16-9**) alternate with sections of text. The artists, using a distinctly Japanese technique for representing space, view the scenes from an elevation, remove the ceilings to expose the interiors, and tilt the ground plane sharply toward a high horizon, or one that often is

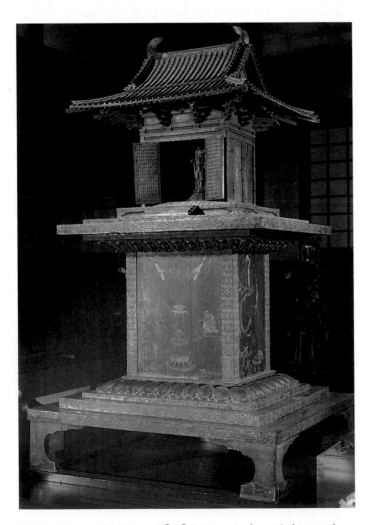

16-7 Tamamushi Shrine, Hōryū-ji, Nara, Asuka period, seventh century. Lacquer on the wood, 7'8" high. Hōryū-ji Museum.

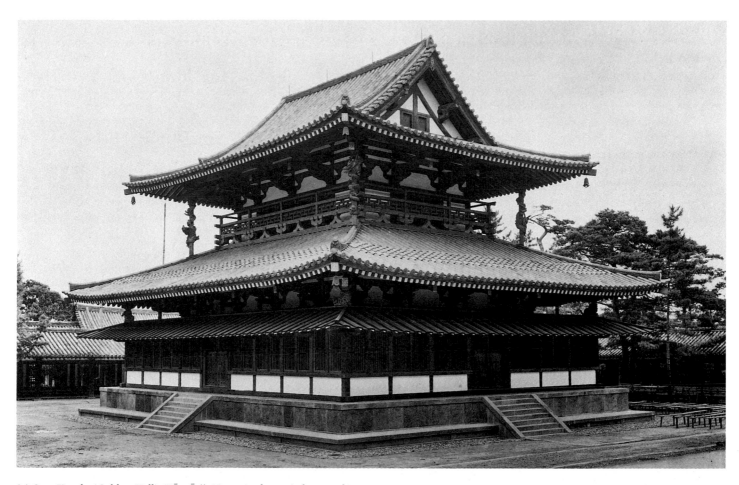

16-8 Kondo (Golden Hall), Hōryū-ji, Nara. Asuka period, seventh century.

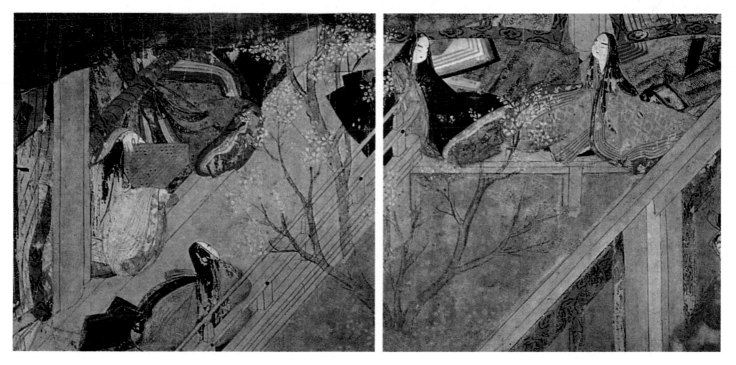

16-9 TAKAYOSHI (?), detail illustrating *The Tale of Genji*, Late Heian (Fujiwara) period, twelfth century. Scroll, color on paper, $8^{1}/_{2}'' \times 15^{3}/_{4}''$.
Tokugawa Museum, Nagoya, Japan.

excluded altogether. Thus, the area of representation is expanded in terms of content and abruptly contracted by the resulting diminution of a sense of depth. Flat fields of unshaded color emphasize the painting's two-dimensional character, as do strong diagonal lines, which direct the eye more along the surface than into the picture space. Human figures have the appearance of being constructed of stiff layers of contrasting fabrics, and although they represent specific characters, their features are scarcely differentiated. A formula for such aristocratic faces, which produced a depersonalizing effect, called for a brush stroke for each eye and eyebrow, one for the nose, and a final stroke (sometimes omitted) for the mouth. Paintings in this purely Japanese style, known as *Yamato-e*,* reflect the sophisticated taste of the Fujiwara nobility for whom these works were created.

A different facet of Yamato-e is represented by *The Shigisan Engi* (Legends of Mount Shigi), painted at the end of the Fujiwara period. One of the first Japanese scrolls designed as a continuous composition, *The Shigisan Engi* illustrates the story of a Buddhist monk and his miraculous

*Yamato is the area around Kyoto and Nara regarded as the cradle of Japanese culture. The suffix *-e* means "picture."

golden bowl. Our episode, called The Flying Storehouse (FIG. **16-10**), depicts the bowl lifting the rice-filled storehouse of a greedy landowner and carrying it off to the monk's hut in the mountains of Wakayama. The gaping landowner, his attendants, and several onlookers are shown in various poses—some grimacing, others gesticulating wildly and scurrying about in frantic astonishment. The Fujiwara aristocracy felt that only the crude and ill-bred would display such feelings and that they were therefore appropriate subjects for humorous caricature. The faces—so unlike the generalized masks in the *Genji* scrolls—are drawn with each feature exaggerated, conforming to a convention of the period to distinguish the lower classes from the nobility. Cartooning of this kind became an important element in Japanese pictorial art.

From the same general period (but of disputed date) are four makimonos of animal caricatures, which are more typical of Chinese Zen painting than of the refined style of Yamato-e. Painted in ink monochrome with a free calligraphic brush, one of these scrolls, previously attributed to the Buddhist Abbot Toba (Toba Sōjō), depicts a medley of frogs, monkeys, and hares in a hilarious burlesque of Buddhist practices. In one section (FIG. **16-11**), a monkey dressed as a priest pays homage to a Buddha in the shape

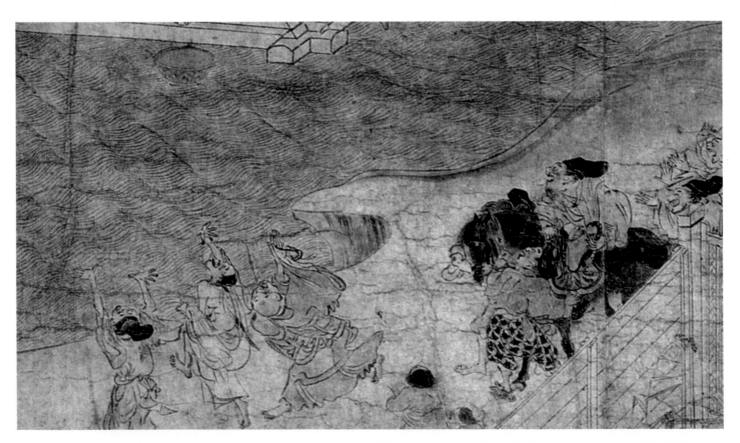

16-10 Detail of *The Shigisan Engi,* Late Heian (Fujiwara) period, late twelfth century. Horizontal scroll, ink and color on paper, 12$^{1}/_{2}$" high. Chogosonshi-ji, Nara.

16-11 Formerly attributed to TOBA SOJO, animal caricatures, Late Heian (Fujiwara) period, *c.* late twelfth century. Detail of a horizontal scroll, ink on paper, approx. 12″ high. Kozan-ji, near Kyoto, Japan.

of a frog seated pompously on a lotus throne with a nimbus of luxuriant banana leaves. In another, more animated passage, the animals tumble and frolic while washing each other in a river. Throughout this whimsical satire, the Japanese predilection for decoration asserts itself in charming clumps of foliage that play a delicate counterpoint to the vigorous movement of the animals.

A more conservative style of Buddhist art continued through the Late Heian period, but a new subject was added. This subject, known as *raigo*, portrayed the Buddha Amida descending through clouds amid a host of Bodhisattvas, welcoming deceased believers to his paradise. Such paintings, products of the Paradise Sects (page 510), eased the rigors of religion for the luxurious courtiers in Kyoto. A remarkable sculptural rendering of the raigo theme is housed at the Hoodo (Phoenix Hall) of the Byōdō-in Temple at Uji, near Kyoto (FIG. **16-12**). The gilded wooden figure of Amida (from the interior of the Hoodo) by the sculptor JOCHO (d. 1057) embodies a serene grace through the expanding curves of face and torso, stabilized into a triangular composition by the elongated legs below. The smaller figures of angels and celestial musicians, floating on clouds as they accompany Amida Buddha on his descent, complete the impression of courtly elegance.

The building that shelters the Amida originally was a country villa inherited by Fujiwara Yorimichi (992–1074). In ancient Japan, villas could serve as temporary retreats from the pressures and turbulence of city life, but they

often also were converted to temples by their owners and became their places of permanent interment. As explained by J. E. Kidder, Jr., "The transition from the city to the country, from a villa to a temple, from a recreation spot to a grave, from this world to the next, was seen hardly as a break in the pattern of human existence and only one more rite of passage." Yorimichi converted his villa into a monastery in 1053 and settled there in 1068, when he retired from politics.

The Phoenix Hall was inspired by aristocratic Chinese palace pavilions but was Japanized through greater integration with its natural surroundings. It is named after the two bronze phoenixes that decorate the ridgepole ends. The phoenix, rising to new life from its own ashes, is a symbol of immortality and thus appropriate for a tomb. Here, this symbolism is not confined to the two rooftop sculptures but seems to permeate the design of the entire building. The plan resembles a great bird in flight, and the swinging, multiple rooflines, with their widely overhanging eaves, suggest its beating wings. Carried by the slenderest of supports, the roofs convey a feeling of floating weightlessness that belies their mass and weight. This impression is enhanced when the building is viewed across the rippling surface of the reflection pond, where its image is put into perpetual motion. We cannot be sure whether this symbolism was intended or not; with or without it, the Phoenix Hall is the most delightful and elegant creation of Chinese-inspired architecture to be found in Japan.

16-12 *At right:* Hoodo (Phoenix Hall), Byōdō-in Temple at Uji, Japan, Heian period, eleventh century. *Below:* JOCHO, Amida (from the interior of the Hoodo), 1053; gilded wood, 9'4" high.

KAMAKURA PERIOD

A series of civil wars led to the downfall of the decadent Fujiwara rulers, and their successful rivals established a new capital at Kamakura, the city that gave its name to the period from 1185 to about 1392. The new rulers, reacting against what they considered to be the effeteness of the Fujiwaras, supported art that emphasized strength and realism. The style of the Nara period (710–794) was revived by UNKEI (*c.* 1148–1223), perhaps the greatest sculptor of Japan. Unkei and his followers went even further than the earlier realists, carefully reproducing their observations of every accidental variation in the folds of drapery and using crystal for the eyes of their sculptures. That they were able, nonetheless, to keep a sensitive balance between the spiritual and the realistic is evident in the superb representation of Kuya (FIG. **16-13**), a priest who is shown as he walked about invoking the name of Amida Buddha. Not only is every detail meticulously rendered, but six small Buddha images issue from the sage's mouth, representing the syllables of a prayer in which Amida's name is evoked. Realism here is carried to the point at which the sculptor is attempting to invest his figures with speech.

Painting during the Kamakura period is most interesting for the advances made in the Yamato-e style, although all types of Fujiwara art also were continued. Perhaps the greatest Yamato-e of this time is *The Burning of the Sanjo Palace* (FIG. **16-14**), one of a series of horizontal scrolls illustrating tales of the *Heiji Monogatari* (Heiji Insurrection). Here, the artist, perfecting the symphonic composition of the Chinese landscape scroll, has added drama with swift

and violent staccato brushwork and vivid flashes of color. At the beginning of the scroll (read from right to left), the eye is caught by a mass of figures rushing toward a blazing building—the crescendo of the painting—and is then led at a decelerated pace through swarms of soldiers, horses, and bullock carts. Finally, the viewer's gaze is arrested by a warrior on a rearing horse, but the horse and rider are positioned to serve as a *deceptive cadence* (false ending). They are merely a prelude to the single figure of an archer, who picks up and completes the mass movement of the soldiers and so draws the turbulent narrative to a quiet close.

Side by side with the vigorous realism of the Kamakura Yamato-e was the enduring formalism of religious art, as shown in the *mandara* (mandala) of Bishamonten (FIG. **16-15**), who, in the Buddhist pantheon, is Guardian King of the North. Here, the unrolling of a scroll reveals not a dashing narrative, but a framed, fearsome icon of a heavenly power, appearing in a swirling cloud of his retainers and relatives, some angelic, some diabolic, all symbolic of the forces of nature subordinate to him.

Bishamonten, the Japanese equivalent of the Indian Vajrapani (Sanskrit: Vaisravana), is one of the five Buddhas who rule the four points and center of the cosmos— Amida, as avatar of Vairocana, is at the center. Wreathed with red lightning and clad in elaborate warrior's armor, Bishamonten towers above his retinue, as cosmic protector and hurler of the thunderbolt. As guardian against evil and destroyer of wicked spirits, he wears the fierce, wild-eyed mask typical of oriental guardian deities (see FIG. 15-11). The composition is symmetrically balanced, the figures carefully placed according to the iconographical program, yet the whole surface is a turbulence of fiery energy expressed in writhing, calligraphic line and smoldering color. The controlled violence of the Bishamonten mandara, contained by

16-13 *The Sage Kuya Invoking the Amida Buddha,* Kamakura period, thirteenth century. Painted wood, approx. 46". Rokuharamitsu-ji, Kyoto.

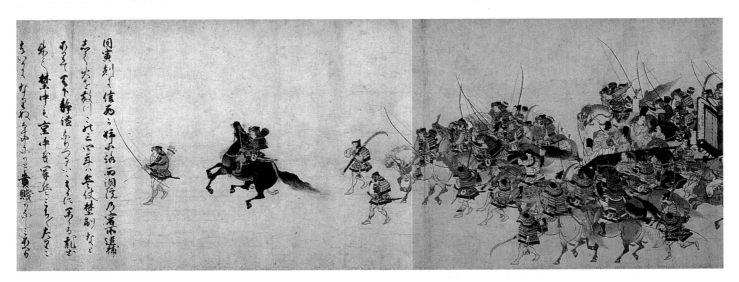

16-14 *The Burning of the Sanjo Palace,* Kamakura period, thirteenth century. Detail of a horizontal scroll, ink and color on paper. 1'4¼" × 22'10". Fenollosa-Weld Collection, Courtesy Museum of Fine Arts, Boston.

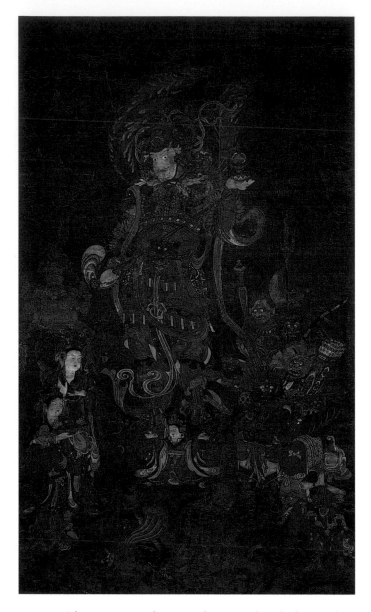

16-15 Bishamonten Mandara, Kamakura period, early thirteenth century. Ink, colors, and gold on silk, 47" × 26³/₄". Courtesy Museum of Fine Arts, Boston.

its frame, is vented outward in the scroll of *The Burning of the Sanjo Palace*. Both works, despite their very different purpose and composition, are products of the Kamakura taste for strong action and precise description of detail.

ASHIKAGA PERIOD

The power of the Kamakura rulers ceased in 1333, after which internal warfare persisted until 1392, when the Ashikaga shoguns (military dictators) imposed a brief peace. Civil war soon broke out again, although the shoguns managed to maintain control amid almost continuous insurrections, and lasted until 1573. A central gov-

ernment was formed, and, after centuries of suspension of diplomatic contact, official relations with China were once again established. The arts, under increased Chinese influence, flourished. New painting styles imported from China coexisted with conventional Buddhist pictures and with paintings in the Yamato-e style carried on by artists of the Tosa family. The monochrome landscape style of the thirteenth-century Song masters Ma Yuan and Xia Gui was adopted by the painter-monk Shubun at the beginning of the fifteenth century. Shubun created evocative, idealized landscapes, sometimes with subjects and associated poems based on Chinese themes, which reflect the deep involvement of Japanese monasteries with Chinese culture during this period. Minchō (1352–1431), also known as Cho Densu, and other painters went directly to Yuan dynasty models. But the most powerful current to come from China was the one that accompanied Zen Buddhism and accounts largely for the flowering of art despite the troubled times of the Ashikaga period. The new philosophy appealed to the samurai, a caste of professional warriors composed of men who held a relatively high position in society and who were supporters of the feudal nobility. They lived by rigid standards that placed high values on such virtues as loyalty, courage, and self-control. The self-reliance required of its adherents made Zen the ideal religion for the samurai.

Because the samurai found Zen attractive, the arts that had been associated with it in China swept Japan. Sculpture, as in China under the influence of Chan Buddhism, declined in importance, and painting imitated the bold brush of the Song masters of the Chan school. Early in the Ashikaga period, the artist Kao (d. 1345) worked in the style of the thirteenth-century Chinese artist Liang Kai, while his contemporary, Mokuan Reien (active *c.* 1323–1345), painted almost indistinguishably from a Chinese predecessor, Mu Qi. Of all the Zen artists in Japan at this time, SESSHU (1420–1506) is the most celebrated. He had several different styles but is best known for paintings in the Ma-Xia manner (page 510). Sesshu greatly admired Song painting, and, although he studied in China, he decried the work of contemporary Ming painters. Nevertheless, he was affected by the Ming style; one of his masterpieces, an ink-splash landscape (FIG. **16-16**), contains elements basic to the Ming as well as to the Song style. Although the landscape recalls the wet style characteristic of Chan painters of the Song, the brushwork is more abstract and the tonal contrasts are more startling, after the Ming manner.

The Tea Ceremony

The influence of Zen went considerably beyond painting. It gave rise, during the Ashikaga period, to the tea ceremony, a unique custom that, among other things, provided a new outlet for the products of the Japanese artist-craftsman. This ceremony soon became a major social institution of the aris-

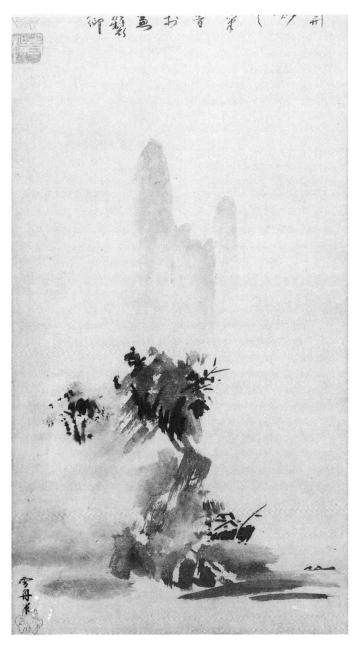

16-16 SESSHU, landscape, Ashikaga period, 1495. Detail of a hanging scroll, ink on paper, approx. 55" high. Tokyo National Museum.

The setting for the tea ceremony was appropriately unpretentious. Special small teahouses, designed to give the appearance of refined simplicity, were placed into carefully planned and subtly arranged garden settings. The Shokintei (Pavilion of the Pine Lute, FIGS. **16-17** to **16-19,** named after the sound of the wind in the surrounding trees) in the gardens of the Katsura Palace, dating from the early Tokugawa period, is a charming example. Its exterior was planned carefully to blend with the calculated casualness of the gardens (FIG. 16-17). A flagstone path leads past moss-covered stone lanterns to an entrance where the guests washed their hands at a "natural" spring. In a rectangular room, scaled to create a feeling of intimacy and adorned only with a shallow alcove (*tokonoma*) in which a single painting and, perhaps, a stylized flower arrangement might be displayed, the host would entertain his guests. The ritual of tea drinking in this setting imposed

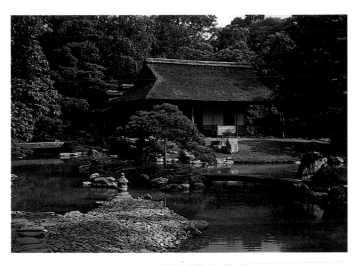

16-17 The Shokintei, Katsura Palace gardens, near Kyoto, early 1660s.

tocracy in Japan. Its function and purpose are described by Father Joao Rodrigues (1562–1633), a Portuguese Jesuit and keen observer of Japanese customs and culture who spent more than thirty years in Japan. Everything used in the tea ceremony, he reports, "is as rustic, rough, completely unrefined, and simple as nature made it, after the style of a solitary and rustic hermitage." The purpose of the ceremony was "to produce courtesy, politeness, modesty, moderation, calmness, peace of body and soul, without pride or arrogance, fleeing from all ostentation, pomp, external grandeur, and magnificence."

16-18 The first room of the Shokintei, Katsura Palace.

16-19 Pond and garden as seen from the second room of the Shokintei, Katsura Palace.

a set of mannered gestures and even certain topics of conversation on all participants. Every effort was made to prevent any jarring note that might disturb the perfectly planned occasion.

Although often emulated in modern times, originally no two teahouses were alike. According to an old tea master, "beauty is lost through imitation," and originality was as important an aspect of the design as the perfection of its execution. Visual surprises were appreciated highly; for instance, the bold pattern of blue and white rectangles with which the *tokonoma* in our example (FIG. 16-18) is papered is an unusual and rather daring departure from the usually neutral and, at best, lightly textured treatment of these alcoves. Important also were the subtlety and finesse with which the building components were treated. Supporting posts were fashioned to keep their natural appearance, and they often remained rounded and knotty like tree trunks. All surfaces were painstakingly rubbed and burnished to bring out the natural beauty of their grains and textures. Common to all teahouses, and expressive of the Japanese love of nature, was the close integration of the building with its natural setting; when their translucent, paper-covered, sliding screens (*shoji*) are opened, the rooms become no more than roofed-over extensions of the garden (FIG. 16-19).

Although inspired and developed by Zen monks and subsequently adopted by the high and low aristocracy, the ritual of the tea ceremony, with its refined standards of taste, had a lasting influence on the style of living of the people at large. The studied simplicity, austerity, and understatement of the fifteenth-century teahouse were monumentalized in the Katsura Palace and, from there, filtered down into domestic architecture to become what is now regarded as the traditional Japanese dwelling.

The esthetics of the tea ceremony were found in the beauty of the commonplace, and each object employed in the ceremony was selected with the utmost discrimination. The connoisseur preferred a tea bowl, a flower container, or other ritual utensil that appeared to have been made without artifice. Pottery used in the ceremony (FIG. **16-20**) was covered with heavy glazes, seemingly applied in a casual manner, belying the skill that had controlled the colors and textures. The irregular, sometimes battered or flawed shapes of many Japanese tea wares provide an extreme contrast to the technical perfection common in Chinese ceramics (FIG. 15-30). Many Japanese wares of this type were given individual names based on literary or historical associations of their decor or on the visual and tactile qualities of the entire piece. Conferring such attention on an individual object and attaching such importance to it at this stage foreshadows the advent of major ceramic artists, who would sign, paint, and even inscribe poems on their wares as part of the development of this craft into a self-conscious and sophisticated art.

The Tosa and Kanō Schools

The artistic understatement of the tea ceremony was counterbalanced by the continuing Yamato-e style of decorative painting. Tosa Mitsunobu (1434–1525), the foremost exponent of Yamato-e during the Ashikaga period, retained the coloristic patterns of his native style but also emphasized ink outline after the fashion of Chinese painting. The new manner of painting that resulted from this combination is most apparent in pictures of the Kanō school. Kanō Motonobu (1476–1559), who was most likely the grandson of the founder of the Kanō school, worked so closely in the Song tradition that some of his paintings have been

mistaken for those of Xia Gui (page 510). Motonobu had, however, a more personal style, in which we find a new emphasis on brushed outlines and strong tonal contrasts—features that became distinctive of the Kanō school. In addition, Motonobu often used Tosa coloring and, at times, even painted in a purely Tosa manner. As a result, the Tosa and Kanō schools became less distinguishable after the sixteenth century.

MOMOYAMA AND EDO (TOKUGAWA) PERIODS

In the Momoyama period (1573–1615), which followed the stormy Ashikaga, a succession of three dictators finally imposed peace on the Japanese people. Huge palaces were erected—partly as symbols of power, partly as fortresses. The grand scale of the period is typified by the Nagoya Castle, built about 1610. This castle also exemplifies how well the new style of decorative painting suited the tastes of the Momoyama nobility. The sliding doors and large screens within the mammoth structure were covered with gold leaf, on which was painted a wide range of romantic and historical subjects, even exotic portrayals of Dutch and Portuguese traders. Traditional Chinese themes were frequent, as were commonplace subjects of everyday experience. But all were transformed by an emphasis on two-dimensional design and striking color patterns (FIG. **16-21**). The anecdotal or philosophical content almost was lost in a grandiose decorative display.

Not every Momoyama artist worked exclusively in the colorful style exemplified by the Nagoya paintings. HASEGAWA TŌHAKU (1539–1610), for instance, carried on the Zen manner of Mu Qi with brilliant success. His versatility,

16-20 Tea-ceremony water jar, named *kogan* (ancient stream bank), Momoyama period, late sixteenth century. *Shino* ware with underglaze design, 7″ high. Hatakeyama Memorial Museum, Tokyo.

16-21 *Uji Bridge*, Momoyama period, sixteenth to seventeenth centuries. Six-fold screen, color on paper, 62″ high. Tokyo National Museum.

which was shared by most artists of the time, is evident in a brilliant, monochromatic screen painting, *Pine Trees* (FIG. **16-22**), whose strong verticals and diagonals are distinctively Japanese. In Japan, the decoration of screens was very highly developed and often exemplifies the highest quality of painting.

Katsura Palace

In 1615, Tokugawa Ieyasu, the last of the Momoyama rulers, consolidated his power as shogun of Edo (modern Tokyo) and established the Tokugawa, or Edo, shogunate, which lasted until 1868. By this time, the emperors had lost their political power and independence and, under a succession of military dictators, had become little more than ceremonial figureheads. Still, in the hope of legitimizing their authority, the shoguns supported the traditional imperial institutions, and Ieyasu, in a magnanimous gesture, donated some land at Katsura (which was at that time a suburb of Kyoto) to members of the imperial family. There, over a period of some fifty years, successive generations of the Hachijo family developed a modest country retreat (*besso*) into a country palace that became the admired, but rarely equaled, standard for domestic Japanese architecture down to modern times.

The Katsura Palace (*c.* 1615–1663; FIGS. **16-23** to **16-25**) was built at a time when the tea ceremony was enjoying its greatest popularity, and many of the palace's design features and tasteful subtleties can be traced back to the earlier teahouses (see FIGS. 16-17 to 16-19). The straight

ro, rooflines of traditional Japanese architecture go back all the way to the Ise Shrine (FIG. 16-3) and stand in striking contrast to the swinging, curving ridgepoles and eaves of the Buddhist architecture imported from China, which originally served structural functions but by this time were overloaded and had become ostentatious decoration (compare FIGS. 16-8 and 16-12, top). At Katsura, the architectural forms express their function simply and without disguise, and the subtle adjustment of their pleasing proportions to each other and to the whole has produced a building of astonishing beauty. The main entrance to the palace, the so-called Palanquin Entry (FIG. 16-24), is a marvelously rich and subtle composition of juxtaposed solids and voids, of rectangular shapes of varying sizes and proportions, arranged along vertical, horizontal, and sloping planes. Lines, planes, and volumes are enriched by a variety of textures (stone, wood, tile, plaster) and by subdued colors and tonal values that build up toward and enframe the composition's focal point—the sliding panels of the doorway.

In the interior (FIG. 16-25), lacquered posts and wooden trim surround painted panels and screens to create settings more sumptuous than those of the teahouse, but just as refined and delicate. Everything is done with the utmost restraint. The rooms are not large by Western standards, but the screens between them can be slid apart, or removed completely, to create sweeping areas of rectangular spaces that also can be opened to the outside to achieve that harmonious integration of building and garden that we have seen, on a smaller scale, in the teahouse (FIG. 16-19).

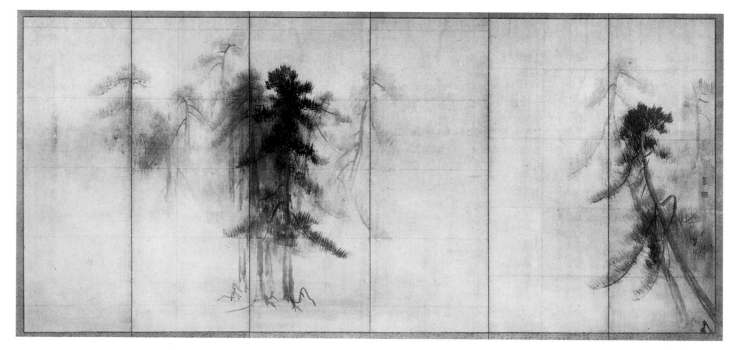

16-22 HASEGAWA TOHAKU, *Pine Trees,* Momoyama period, sixteenth to seventeenth centuries. Six-fold screen, ink on paper, 61" high. Tokyo National Museum.

Gardens

In Japanese garden design, as in architecture, manmade and natural elements are combined to create a sense of balance, proportion, and harmony. Japanese gardens are intended to be retreats in which one can enjoy peaceful seclusion and meditation; this was the intention, as we have seen, of Chinese garden design. They create "landscape pictures" in which waterfalls, streams, lakes, bridges, and teahouses are artfully combined with stones, trees, and shrubs to simulate,

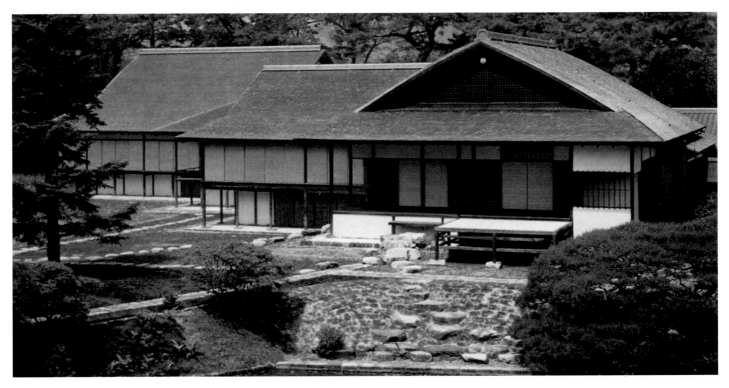

16-23 Eastern facade of the Katsura Palace, c. 1615–1663.

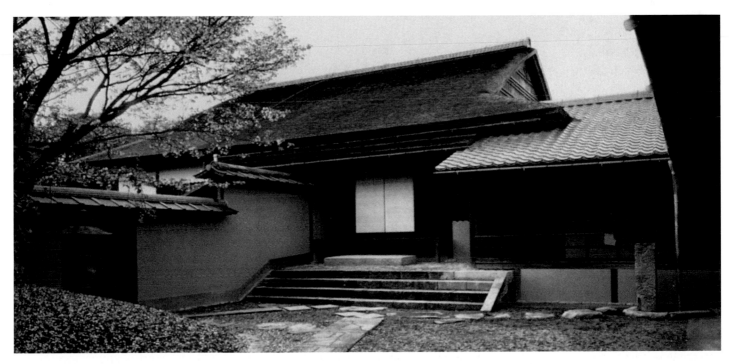

16-24 Palanquin Entry, Katsura Palace.

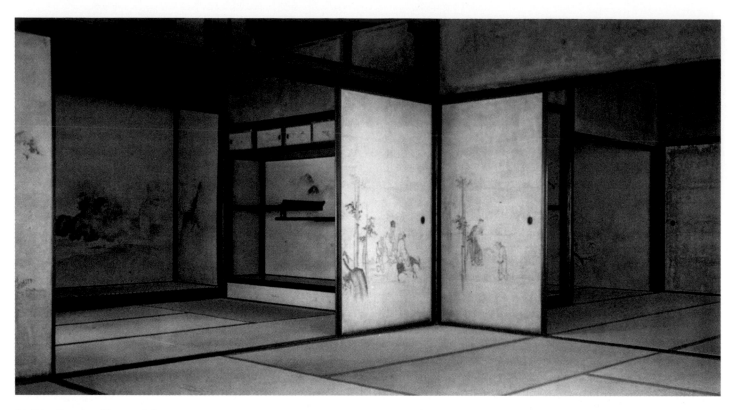

16-25 Interior, Katsura Palace.

in a restricted area, vistas of much larger landscapes. The Katsura gardens skillfully exploit the element of surprise. Long walkways suddenly are blocked by a wall of shrubbery that forces the visitor to turn in the direction of a designed view, such as a single shaped tree dramatically silhouetted against the glittering surface of a pond. Guests are led along carefully designed paths that present charming views of garden and landscape elements at planned intervals. The steppingstones along these paths are small and irregularly spaced, so that visitors must keep their eyes down in order not to stumble. Here and there, larger stones invite a rest and allow guests to lift their heads safely to view their surroundings and appreciate the designed prospect offered to their eyes.

The Katsura gardens cover several acres and are meant to be walked through. The Zen rock gardens, which originated in the thirteenth century, are much smaller and were intended to be viewed from a fixed position. The rock gardens consist of stone groupings in dry landscapes that are symbolic and suggestive of large landscape features. Level ground covered with raked sand or pebbles represents rivers, lakes, or oceans. Scattered over this surface and framing it are rocks, carefully placed singly or in groups: the vertical ones represent islands, cliffs, and mountain ranges; the horizontal ones denote embankments, bridges, and ships. Peninsulas and islands, carved out by the ocean, or a coastline with mountain ranges may be symbolized. The ensemble is intended to induce and facilitate intense meditation, to encourage the spirit to take off in free flight and transform the limited sphere of a tiny plot of soil into a cosmic universe without manmade boundaries.

Decorative Painting

Screen painting during the Tokugawa period was continued in all of its Momoyama magnificence by such artists as Kanō Sanraku (1561–1635), HONAMI KŌETSU (1558–1637), and TAWARAYA SŌTATSU (1576–1643), whose lives spanned both periods. Kōetsu and Sōtatsu also composed numerous scrolls on which pictorial forms of flowers or animals were interlaced with strokes of a free-flowing calligraphy. One such collaborative effort is a deer scroll (FIG. **16-26**), in which the shapes of the animals, painted in decorative gold and silver, are repeated with subtle variations in pose and interval to create an almost musical effect.

OGATA KŌRIN (1658–1716) and his brother Ogata Kenzan (1663–1743) carried the decorative tradition that characterized the Momoyama on into the eighteenth century. Kōrin was primarily a decorative painter, who also worked as a lacquer designer; Kenzan was a master potter, whose line of "natural" wares is still produced today by the ninth artist to take his name. Kōrin is famous largely for his dramatic renderings of rocks, tree branches, and waves, which he combined in elegant and flowing compositions; one is illustrated in FIG. **16-27**. Both artists harmonized the decorative styles of Momoyama and Early Edo with the studied simplicity required of art in the service of the tea ceremony.

16-26 TAWARAYA SOTATSU and HONAMI KOETSU. Deer and calligraphy, Tokugawa period, early seventeenth century. Section of a horizontal scroll, ink and gold and silver on paper, 12¹/₂″ high. Seattle Art Museum (gift of Mrs. Donald E. Frederick).

16-27 OGATA KORIN, *White Plum Blossoms in the Spring,* Tokugawa period, late seventeenth to early eighteenth centuries. Screen, color on gold paper, 62″ high. Tokyo National Museum.

Nanga and Realism

Although the decorative style of the Sōtatsu-Kōrin schools continued to flourish until the nineteenth century, it had to share its popularity with several other trends in later Japanese painting. One, Nanga, "southern school painting," was inspired by the Chinese "literary" school painting of Su Shi and Mi Fu (page 510). The Nanga painters transformed the techniques of their Chinese models into a style that combined virtuoso brushwork with decorative pattern and a strong sense of humor. Two outstanding early representatives of this style are Ikeno Taiga (1723–1776) and YOSA BUSON (1716–1783), who jointly illustrated an album entitled *The Ten Conveniences and the Ten Enjoyments of Country Life*. On one of the pages illustrated by Buson (FIG. **16-28**), a bulbous-nosed figure peering from a hut at richly textured summer foliage is shown with wistful humor by this master of the brush.

Another major style of later Japanese painting, which has been called realistic or naturalistic, is represented by MARUYAMA ŌKYO (1733–1795). His studies of animals, insects, and plants (FIG. **16-29**) combine an almost Western objectivity with an unusual handling of the brush to produce a style that follows the observed forms rather than established conventions. This kind of realism may well be

due, in part, to Western influence. From the mid-sixteenth century on, Portuguese and Spanish missionaries and Dutch traders visited Japan, bringing with them paintings and illustrated books that, despite the efforts of the Tokugawa shoguns to bar foreign influences, had some effect on Japanese art.

Ukiyo-e and Printmaking

The Tokugawa shoguns maintained a static and stratified society, and, as a result, each class developed its own distinctive culture. The center of the plebeian culture was the Yoshiwara entertainment area of Edo, where the popular idols were the talented courtesans of the teahouses and the actors of the Kabuki theater. Kabuki itself was a popular and lusty form of drama that developed in response to a demand for a more intelligible and more easily enjoyed theater than that of the highly stylized No plays, which were patronized exclusively by the nobility and a small number of the *nouveau riche*. Kabuki eventually provided endless subjects for a new art form—a style of genre painting instituted about 1600—that was to have considerable influence on Western art in the nineteenth century. This new art, known as *ukiyo-e* or "pictures of the floating (or passing) world," was centered largely in Kyoto. Toward the end of

16-28 YOSA BUSON, *Enjoyment of Summer Scenery,* from *The Ten Conveniences and the Ten Enjoyments of Country Life,* Tokugawa period, 1771. Album leaves, ink and color on paper, 7" high. Yasunari Kawabata Collection, Kanagawa, Japan.

16-29 MARUYAMA ŌKYO, detail of *Nature Studies*, Tokugawa period, eighteenth century. Horizontal scroll, ink and color on paper, 12¹/₂" high. Nishimura Collection, Kyoto.

the seventeenth century, the center of production shifted to Edo and the predominant medium soon became the woodblock print, which reflected the tastes and pleasures of a bourgeoisie emerging in a feudal society.

The woodblock as a device for printing had been invented in China during the Tang dynasty. The technique was introduced in Japan during the eighth century, when it was employed chiefly to reproduce inexpensive religious souvenirs or charms. In the seventeenth century, Chinese woodblock book illustrations inspired the production of low-cost illustrated guidebooks of the Yoshiwara district.

The art of block printing, as it ultimately developed in the eighteenth century, was a triumph of collaboration. The artist, having been selected and commissioned by a publisher, prepared his design in ink, merely adding color notations. A specialist in woodcutting then transferred the lines to the blocks, and a third man did the printing. The quality of the finished picture depended as much on the often anonymous cutter and printer as on the painter of the original design.

Hishikawa Moronobu (*c.* 1625–1694) was probably the first Japanese artist to employ the woodblock print to illustrate everyday subjects in books and to make and produce individual prints, which he started to do in about 1673. The woodblock quickly evolved as a medium for cheap reproduction and wide distribution. Moronobu's woodblock prints were executed simply in black outline against a plain white paper, as were the prints produced for the next fifty years, but often they were hand-colored by their purchasers. Moronobu's designs of large and simple forms had the exuberance of a young art. The same vitality was expressed in prints of the Torii school by such artists as Torii Kiyonobu (1664–1729), Torii Kiyomasu (active 1694–1716), and TORII KIYOTADA (active in the early eighteenth century; FIG. **16-30**). These artists specialized in portraying Kabuki

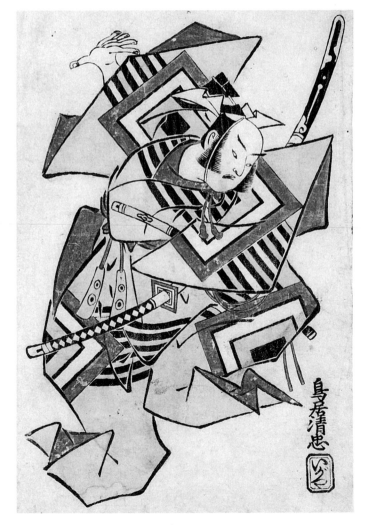

16-30 TORII KIYOTADA, an actor of the Ichikawa clan, *c.* 1710–1740. Hand-colored woodcut, 11¹/₄" × 6". Metropolitan Museum of Art, New York (Harris Brisbane Dick Fund, 1949).

actors. (Kiyonobu was an actor's son.) They worked with a broad rhythmic outline, and, for emphatic pattern, used the bold textile designs of the actors' robes.

At about the same time, members of the Kaigetsudo family were painting pictures and making designs for woodblock prints of elegant courtesans. The Kaigetsudo figures had more grace but somewhat less power than those of the Torii painters. In general, the print style gradually acquired more delicacy during the eighteenth century. The invention of a process of printing in color directly from blocks brought the "primitive" period of ukiyo-e printmaking to an end by about 1741.

Okumura Masanobu (1686–1764) experimented with *lacquer technique* in an effort to increase the luster of the ink in his black-and-white prints. Later, he used a new, two-color method for printing in pink and green, called *benizuri-e*, in which the dominant pink contrasts with patches of pale green and still smaller areas of black to produce a strong color vibration despite the very limited palette. Coincident with the use of color printing, the artists began to work in smaller, more delicate scale. In 1765, a device was introduced that permitted more accurate register and the successful use of even smaller color areas. This led to the development of the *nishiki-e* or "brocade picture," which was a true polychrome print. The new technique encouraged greater refinement and delicacy, evident in prints by the two leading print masters of the time—the incomparable Suzuki Harunobi (1725–1770) and Isoda Koryusai (active 1764–1788). In their work, a new loveli-

ness replaces the monumentality of earlier compositions. The figures are of slighter proportions, the colors are more muted, and the line is lyric rather than dramatic.

After Harunobi died, prints changed rapidly in style, shape, subject, and color. Torii Kiyonaga (1752–1815) and Kitagawa Utamaro (1753–1806) revived the taste for tall, willowy figures. Utamaro, who later concentrated on half-length figures, was fortunate to have the services of craftsmen who were skilled enough in woodcutting to allow him to create extraordinary nuances in color, texture, and line. Buncho (active 1766–1790), working in another vein, made many striking portraits of well-known figures. Even more dramatic are the prints of Tōshūsai Sharaku, who, active for a brief ten months during 1794 and 1795, was a unique and enigmatic figure among print artists. About 160 of his prints survive—all of them piercing, rather acid, psychological studies of actors, wrestlers, or managers. Utagawa Toyokuni I (1769–1825) followed in a similar, less biting manner, but the strength of this style was dissipated in the hands of later artists.

Dozens of other artists contributed to the popular art of printmaking, but during the nineteenth century, Katsushika Hokusai (1760–1849) and Ando Hiroshige (1797–1858) were outstanding. Increasing political and moral censorship, which was to contribute to the decline of this art, led Hokusai to select landscapes as his ukiyo-e subjects. His brilliant and ingenious compositions, such as his *Thirty-Six Views of Mount Fuji* (FIG. **16-31**), make use of striking juxtapositions and bold, linear designs. Nature was his

16-31 Katsushika Hokusai, *The Great Wave*, from *Thirty-Six Views of Mount Fuji*, Tokugawa period, *c.* 1823–1829. Woodblock print, 14³/₄" wide. Museum of Fine Arts (Spaulding Collection), Boston.

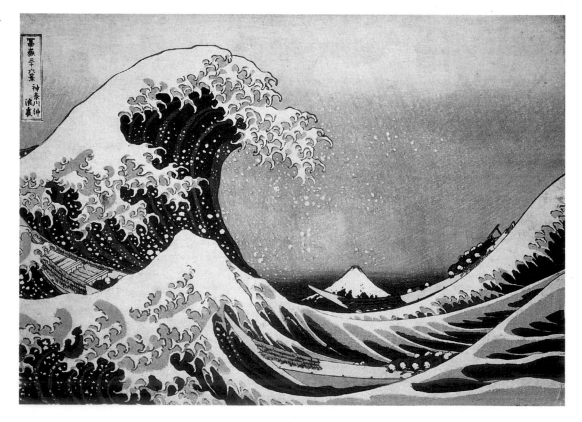

primary subject, but, in its setting, he also included genre and anecdote as minor themes. Hiroshige, too, specialized in landscape and, like Hokusai, painted birds, flowers, and legendary scenes. In general, however, Hiroshige's prints did not evoke the sense of grandeur implicit in Hokusai's work.

These prints, although sometimes influenced by European art, show the Japanese attitude toward nature—the regard for natural forms in their utmost simplicity as a point of departure for an interpretation of reality—which, in turn, will lead to abstract pictorial design.

DOMESTIC ARCHITECTURE

Until recently, the Japanese home—modest or pretentious—has been designed according to basically the same structural and esthetic principles that apply to the teahouse or the Katsura Palace. The traditional Japanese dwelling almost invariably is related intimately to the land around it, and, wherever possible, it is set in a garden closed off by a bamboo fence (a thing of beauty in itself), providing a sense of privacy and intimacy in even the most crowded environment.

The structure is essentially a series of posts supporting a roof. The walls, which are screens rather than supports, slide open from one room into the next or onto the outside. Space is treated as continuous yet harmoniously divisible—a concept that revolutionized architectural theory in the West. Uniformity and harmony of proportions are achieved by the use of the conventional straw mat (*tatami*) as a module. Its dimensions (3 feet by 6 feet) determine most measurements of both the plan and the elevation of the house, so that many of its structural elements can be prefabricated—another feature highly appreciated by Western architects.

In the traditional Japanese house, no furniture is used, except for some low tables and cushions (bedding is rolled up and kept in closets during the day). The various rooms of the house have no specific functions and can be used for any and all purposes. The main room, in which guests are received (FIG. **16-32**), is identified by the tokonoma, where works of art from the owner's collection are displayed one at a time. Quite unlike Western collectors, who tend to convert their homes into museums by displaying all of their objets d'art together, their Japanese counterparts rotate the works in their collections, showing a single work in the tokonoma to suit season or mood—an attitude that conforms with the simplicity and architectural understatement of the traditional Japanese dwelling.

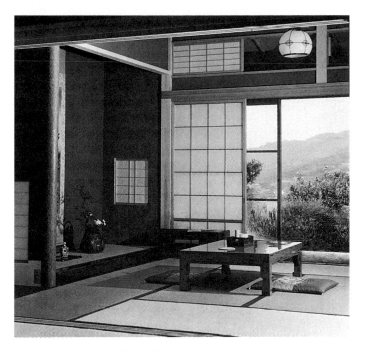

16-32 Main room of a traditional Japanese house.

Despite its sophistication and refinement, the traditional Japanese house suffers from the inconvenience that it cannot be heated adequately. Unlike their Korean neighbors, the Japanese never developed an efficient heating system for their homes. The Japanese love of nature has been cited as a partial explanation for this, to us, evident deficiency. Rather than shutting themselves off from nature's manifestations by retreating into hermetically sealed enclosures, the Japanese preferred to experience climatic changes and simply protected themselves against the winter cold with additional layers of clothing. No wonder, perhaps, that the modern Japanese, newly aware of and acquainted with Western standards of living, long to live in a Western-style house.

With the advent of the Meiji period in 1868, Japan has become increasingly exposed to Western influences. The process of adjusting not only its economy, but also its lifestyle, to Western standards accelerated after the turn of the century, to reach a crescendo after the end of World War II. The pace of Japan's recent development is awesome, not only in its industrial production, which is well known to us, but also in the arts. The Japanese began to excel particularly in the fields of architecture and design in recent years and such men as Kenzo Tange and Arata Isozaki and Kazuo Shinohara now must be ranked among the foremost contemporary architects (FIG. 28-80).

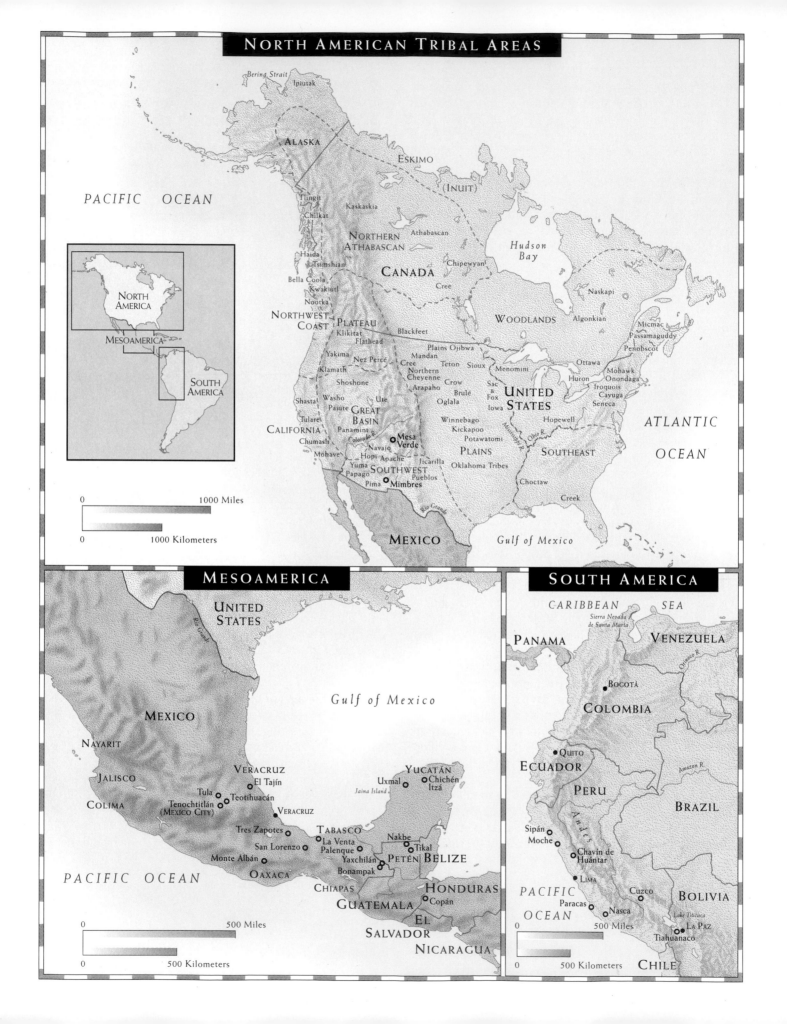

NORTH AMERICAN TRIBAL AREAS

Bering Strait
Ipiutak
ALASKA
ESKIMO
(INUIT)

PACIFIC OCEAN

Tlingit
Kaskaskia
Chilkat
NORTHERN ATHABASCAN
Athabascan
Hudson Bay
Haida
Tsimshian
Chipewyan
CANADA
Bella Coola
Cree
Naskapi
Kwakiutl
Nootka
NORTHWEST COAST
WOODLANDS
Algonkian
Micmac
Passamaguddy
Penobscot
PLATEAU
Klikitat
Blackfeet
Flathead
Plains Ojibwa
Yakima
Mandan
Teton
Ottawa
Huron
Mohawk
Onondaga
Nez Percé
Cree
Northern Cheyenne
Sioux
Menomini
Iroquois
Klamath
Crow
Cayuga
Shoshone
Arapaho
Brulé
Sac
Fox
UNITED STATES
Seneca
Shasta
Washo
Ute
Oglala
Iowa
Pajute
Winnebago
Hopewell
California
GREAT BASIN
Kickapoo
ATLANTIC OCEAN
Tulare
Panamint
Mesa Verde
Potawatomi
Chumash
Colorado
Navajo
PLAINS
Mohave
Hopi
Apache
SOUTHEAST
Yuma
Jicarilla
Oklahoma Tribes
Papago
SOUTHWEST
Pueblos
Choctaw
Pima
Mimbres
Rio Grande
Creek
MEXICO
Gulf of Mexico

NORTH AMERICA
MESOAMERICA
SOUTH AMERICA

0 ————— 1000 Miles
0 ————— 1000 Kilometers

MESOAMERICA

UNITED STATES
Rio Grand

MEXICO

NAYARIT
JALISCO
COLIMA

Gulf of Mexico

VERACRUZ
El Tajín
Tula
Teotihuacán
Tenochtitlán (MEXICO CITY)
Veracruz
Tres Zapotes
TABASCO
La Venta
San Lorenzo
Palenque
Monte Albán
Yaxchilán
OAXACA
Bonampak
CHIAPAS
GUATEMALA
EL SALVADOR
NICARAGUA

YUCATÁN
Uxmal
Chichén Itzá
Jaina Island
Nakbe
Tikal
PETÉN
BELIZE
HONDURAS
Copán

PACIFIC OCEAN

0 ————— 500 Miles
0 ————— 500 Kilometers

SOUTH AMERICA

CARIBBEAN SEA
Sierra Nevada de Santa Marta
PANAMA
VENEZUELA
Orinoco R.
Bogotá
COLOMBIA
Quito
ECUADOR
Amazon R.
PERU
BRAZIL
Sipán
Moche
Andes
Chavín de Huántar
Lima
Cuzco
Paracas
BOLIVIA
Nasca
Lake Titicaca
La Paz
PACIFIC OCEAN
Tiahuanaco
CHILE

0 ————— 500 Miles
0 ————— 500 Kilometers

CHAPTER 17

THE NATIVE ARTS
OF THE AMERICAS
AND OF OCEANIA

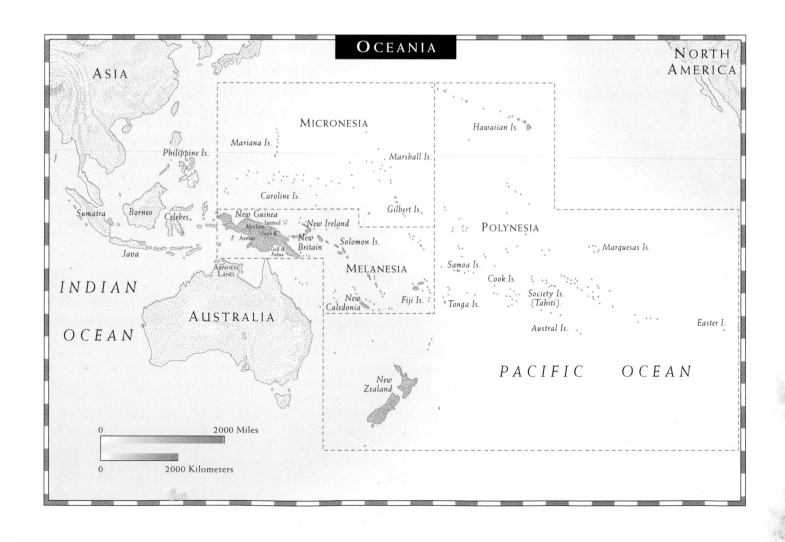

OCEANIA

ASIA

NORTH AMERICA

MICRONESIA

Hawaiian Is.

Mariana Is.

Philippine Is.

Marshall Is.

Caroline Is.

Sumatra Borneo Celebes

New Guinea Iatmul
Abelam Sepik R. New Ireland
Asmat New
Gulf of Britain
Papua

Gilbert Is.

POLYNESIA

Marquesas Is.

Java

ARNHEM
LAND

Solomon Is.

Samoa Is.

Cook Is.

Society Is.
(Tahiti).

INDIAN

MELANESIA

AUSTRALIA

OCEAN

New
Caledonia

Fiji Is.

Tonga Is.

Austral Is.

Easter I.

New
Zealand

PACIFIC OCEAN

0 2000 Miles

0 2000 Kilometers

By "native arts," we understand those products of skilled craft that originate within an indigenous community, that are intended for its own use, and that are expressive of its own mentality and values. Opposed to native aboriginal arts are those that are foreign, alien; they originate outside the community and are incomprehensible to it. In this chapter, we describe the arts of native peoples who were conquered and colonized by Europeans between the sixteenth and the twentieth centuries. It will be obvious to readers of this book how different—in principle, antagonistic—the art forms produced by the foreign conquerors and the conquered natives are in function, style, and meaning.

With the exception of the pre-Columbian peoples of North and South America, native cultures only occasionally produced monumental architecture, sculpture, or painting. The native genius for design often appeared in relatively small sculptures in stone, wood, metal, bone, and perishable materials of many kinds. Painting was often done on a variety of framed and unframed surfaces and in a variety of media, and its ornamental systems were applied in ceramics, weaving, embroidery, basketry, jewelry, costume, and utensils. In this chapter, we are also concerned with many works of these sorts.

THE PRE-COLUMBIAN ART OF THE AMERICAS

Among the native cultures of the world, those that flourished in the Americas before contact with European explorers are exceptional in several important respects. We have remarked in passing that these New World cultures are distinguished by monumental architecture, sculpture, and painting, as well as the craft arts. In addition, some of these groups, like the Maya, had a highly developed writing system and knowledge of mathematical calculation that made possible the keeping of precise records and the creation of a sophisticated calendar and a highly accurate astronomy. Although they used Stone Age technology, did not use the wheel (except for toys), and had no pack animals but the llama, pre-Columbian peoples excelled in the engineering arts associated with the planning and construction of cities, civic and domestic buildings, roads and bridges, and irrigation and drainage systems. They mastered complex agricultural techniques using only rudimentary tools of cultivation. Their works, left in ruins by the Spanish invasions or abandoned to the forces of nature, are being reclaimed from erosion and the encroachment of tropical forests. Today, ever more important discoveries are being made, and now the ruined cities can be visited and marveled at as among the most prodigious creations of human hands.

The origins of these peoples are still a matter of some dispute, centering primarily about the chronology of their arrival in America from Asia. They crossed the now submerged land bridge "Beringia," which connected the shores of the Bering Strait, sometime between 30,000 B.C. and 10,000 B.C. These Stone Age Asian nomads were hunters; their only tools were made of bone, pressure-flaked stone, and wood. They had no knowledge of agriculture but possibly some of basketry. They could control fire and probably built rude shelters. Over many centuries, they spread out until they occupied the two American continents. They were few in number: the total population of the hemisphere in 1492 may not have exceeded fifteen million. By about 3000 B.C., a number of the migrants had learned to cultivate wild grasses, setting the stage for the maize (corn) culture that was basic to the early peoples of the Americas. As agriculturists, the nomads became a settled people and learned to make pottery utensils and lively figurines of clay. Metals were used for ornament, not for tools; these peoples never developed a metal technology. With these skills as a base, many cultures arose over long periods of time. Several reached a high level of accomplishment by the early centuries of the Christian era.

MESOAMERICA

The term *Mesoamerica* (Middle America) names the region that comprises Mexico, Guatemala, Belize, Honduras, and the Pacific coast of El Salvador, triply referring to its geography, ethnology, and archeology. The Mexican highlands are a volcanic and seismic region. In highland Mexico, great reaches of arid plateau land, fertile for maize and wheat wherever water is available, lie between heavily forested mountain slopes, which at some places rise to perpetual snow. The moist tropical jungles of the coastal plains yield rich crops, when the land can be cleared. In Yucatán, a subsoil of limestone furnishes abundant material both for building and carving. The limestone tableland, covered with jungle, continues into the Petén region of Guatemala, which separates Mexico from Honduras. Some of the most spectacular of Maya ruins are located in the region of Yucatán and the Petén, where dense jungle is interspersed with broad stretches of savanna. The great mountain chains of Mexico and Guatemala extend into Honduras (which is seventy-five percent mountainous) and slope sharply down to tropical coasts. Highlands and mountain valleys, jungle and coastlines, with their chill, temperate, and humid climates, alternate dramatically.

The variegated landscape of Mesoamerica may have much to do with the diversity of languages spoken by its native populations; a very large number of different languages are distributed among no less than fourteen linguistic families. Many of the languages spoken in the preconquest periods survive to this day: the Maya tongue still can be heard in Guatemala; the Náhuatl of the Aztecs is spoken in the Mexican highlands; the Zapotec and Mixtec languages linger in Oaxaca and its environs. Diverse as the

languages of these peoples were, their cultures otherwise had much in common: maize cultivation, religious rites, myths, traditions and folklore, social structures, customs, and arts. Yet, some (like the Maya) were distinguished as rich in total achievement; the Toltecs were renowned as great builders and organizers; the Aztecs were reputedly implacable warriors; and the Mixtecs were known as master craftsmen in gold and turquoise. As their history becomes better known, the cultures of Mesoamerica, taken in sum, are revealed as rivaling more familiar great cultures of the world.

Archeological investigation, with ever increasing refinement of technique, has been uncovering, describing, and classifying Mesoamerican monuments for more than a century. Since 1960, when important steps were taken in deciphering the hieroglyphic script of the Maya and in the systematic interpretation of their pictorial imagery, evidence for a detailed account of Mesoamerican history and art has fallen into place. Like the pharaohs of ancient Egypt, many Maya rulers now can be listed by name and the dates of their reigns fixed with precision. This accomplishment reinforced the general Mesoamerican chronology, which is now well established and widely accepted. The standard chronology is divided into three epochs, with some overlapping of subperiods: the Preclassic (Formative) extends from 2000 B.C. to about A.D. 300; the Classic period runs from about A.D. 200 to 900; and the Postclassic begins in about 900 and ends during the first several decades of the sixteenth century. The principal regions of pre-Columbian Mesoamerica are the Gulf Coast region (Olmec culture); Chiapas, Yucatán, and the Petén (Maya culture); southwestern Mexico and the region of Oaxaca (Zapotec and Mixtec cultures); and the Valley of Mexico (Teotihuacán, Toltec, and Aztec cultures). The expansion and wide influence of the principal cultures, however, has made for a fairly even distribution of important archeological sites throughout Mesoamerica.

Preclassic: 2000 B.C. - A.D. 300

VERACRUZ AND TABASCO: OLMEC Olmec culture is known as the "mother culture" of Mesoamerica; the religious, social, and artistic traditions largely reach back to it. Though we know little of its origins and history, its influence is traced readily through the wide diffusion of its institutional forms, its monuments, arts, and artifacts. Excavations in the neighborhoods not only of Tres Zapotes, San Lorenzo, and La Venta, the principal Gulf Coast sites of Olmec culture, but in central Mexico and along the Pacific coast to El Salvador, indicate that Olmec influence was far more widespread than was once supposed, and that it was decisive for all subsequent Mesoamerican cultures as the origin of the distinctive features they all shared.

Settling in the tropical lowlands of the Gulf of Mexico (the present-day states of Veracruz and Tabasco), the Olmec peoples cultivated a terrain of rain forest and alluvial lowland washed by numerous rivers that flowed into the Gulf. It was here that social organization assumed the form adapted and developed by later Mesoamerican cultures. The mass of the population—food-producing farmers scattered in hinterland villages—provided the sustenance and labor that maintained a hereditary caste of rulers, hierarchies of priests, functionaries, retainers, and artisans. These were located by rank within enclosed precincts that served ceremonial, administrative, and residential functions, and perhaps the economic purpose of marketplace as well. At regular intervals, the whole community convened for ritual observances at religious-civic centers such as San Lorenzo and La Venta, which now can be regarded as the formative architectural expressions of the structure and ideals of Olmec society.

At La Venta, earthen platforms and stone enclosures mark out two great courtyards; at one end of the larger was a volcano-shaped clay "pyramid" or mound almost 100 feet high. The La Venta layout is an early form of the

MESOAMERICAN CHRONOLOGY

2000 B.C.	1000	B.C. A.D.	1000	1519
PRECLASSIC (FORMATIVE)			CLASSIC*	POSTCLASSIC

Preclassic	Classic	Postclassic
Olmec (Gulf Coast region) *La Venta, San Lorenzo, Tres Zapotes* Colima Maya (El Petén) *Nakbe*	Teotihuacán Maya (Yucatán, El Petén) *Tikal, Copán, Yaxchilán, Jaina, Bonampak* Zapotec (Oaxaca) *Monte Albán* Huastec *El Tajín*	Huastec *El Tajín* Mixtec *Monte Albán* Maya/Toltec (northern Yucatán) *Chichén Itzá* Toltec (central Mexico) *Tula* Aztec (Valley of Mexico) *Tenochtitlán*

*Many of the cultures listed in the Classic period actually originated during the later Preclassic. The Classic period was the period in which they achieved their unprecedented magnificence.

temple-pyramid, plaza-courtyard complex that will be characteristic of Mesoamerican "urban" design.

Facing out from the plaza are four colossal heads of basalt that weigh about 10 tons each and stand between 6 and 8 feet high (FIG. **17-1**). Almost as much of an achievement as the carving of these huge stones was their transportation across the 60 miles of swampland from the nearest known source of basalt. The heads are hallmarks of Olmec art; a number of others like them have been found at Tres Zapotes and the earlier site of San Lorenzo. Archeologists have now been able to determine that they are images not of gods but of rulers. Both San Lorenzo and La Venta were violently overthrown, and the great heads were deliberately defaced, perhaps for ritual reasons or as the result of the vandalism of particularly hostile invaders.

Though the Olmec worked primarily in basalt, they also created beautifully wrought statuettes in jade representing humanoid creatures with jaguarlike muzzles, doubtless reflecting the cult of a jaguar-god (FIG. **17-2**). The Mesoamerican motif of the animal-man deity here makes an early appearance.

WEST MEXICO: COLIMA In the area of Mexico far to the west of the tropical heartland of the Olmec, Preclassic sites along the country's Pacific coast have yielded small art of a distinctive kind. The pre-Columbian peoples of West

17-2 Ceremonial ax, Olmec, from La Venta, Mexico, 1500–300 B.C. Jadeite, 11½" high. British Museum, London.

17-1 Colossal head, Olmec, La Venta, Mexico, 1500–300 B.C. Basalt, 8' high. 21' in circumference.

Mexico appear to have produced neither massive architecture nor (although they did produce models of perhaps perishable architectural forms) large-scale stone sculpture and, in general, did not share in the cultural achievements of the central and southern zones of Mesoamerica. In fact, the West Mexico states of Jalisco, Nayarit, and Colima frequently have been referred to as cultural "backwaters" relative to the "high" cultures for which Mesoamerica is most famous.

Yet West Mexico had a long and rich artistic tradition dating from the Early Formative period, principally in the medium of clay sculpture. Effigy figures of humans, animals, and mythological creatures have been encountered in distinctive tombs consisting of shafts (as deep as 50 feet) with chambers at their bottom end. Unfortunately, this area was long neglected by archeologists, and our limited knowledge of tomb contents derives primarily from the operations of grave robbers.

The large hollow, ceramic figures found in these tombs exhibit a distinct sense of volume, particularly in the swollen torsos and limbs. The Colima figures are consis-

17-3 Seated figure with raised arms, Colima, Mexico, about 200 B.C.-A.D. 500. Clay with orange and red slip, 13" high. Los Angeles County Museum of Art. The Proctor Stafford Collection.

tently a highly burnished red-orange, in contrast with the distinctive variegated surfaces of the majority of other West Coast ceramics. The area also is noted for small-scale clay scenes that include modeled houses or temples and numerous solid figurines, the latter shown in a variety of lively activities, some of which have been interpreted as festivals and battles.

The ceramic sculpture from this area frequently is described as exhibiting a secular quality seldom encountered in the arts elsewhere in Mesoamerica. To some degree this viewpoint may have been a result of our inability to discriminate religious from nonreligious objects. Many figures have been identified, for example, as "nobles," "warriors," or "shamans." The latter seems to be the correct identification for the seated figure shown here (FIG. **17-3**), especially since it is becoming increasingly clear that the arts of this area, with few exceptions, were often connected with religion and mortuary ritual.

Classic: A.D. 200 - 900

VALLEY OF MEXICO: TEOTIHUACÁN The time period designated as the Classic period in Mesoamerica witnesses the rise and flourishing of great civilizations that are on a par with those of the ancient Near East, which in many respects

they resemble. Though these advanced civilizations originate in the later Preclassic, it is in the Classic period that they achieve their unprecedented magnificence. We have seen at Olmec La Venta an embryonic form of the temple-pyramid-plaza layout. At the awe-inspiring site of Teotihuacán, northeast of modern Mexico City, we can observe the monumental expansion of the Preclassic scheme into a genuine city. The carefully planned area covers 9 square miles and is laid out in a grid pattern, the axes of which were oriented consistently by sophisticated surveying (FIG. **17-4**). At its peak, around 600, Teotihuacán may have had as many as two hundred thousand residents; it would have been at that time the sixth largest city in the world. Divided into numerous wardlike sectors, this metropolis must have had a uniquely cosmopolitan character, with Zapotec peoples located in the western wards of the city and Maya in the eastern. The city's urbanization did nothing to subtract from it as a religious center; its importance as such was vastly augmented. Teotihuacán was later known throughout Mesoamerica as "the place of the gods"; it was visited regularly and reverently by later Aztec kings long after it had been abandoned.

The grid plan is quartered by a north–south and an east–west axis, each 4 miles in length (we are reminded of Hellenistic and Roman urban planning [FIGS. 5-86, 7-11, 7-46]). The main north–south axis, the Avenue of the Dead, is a thoroughfare 130 feet wide. It connects the Pyramid of the Moon complex with the Citadel, which houses the well-preserved Temple of Quetzalcóatl. The Pyramid of the Sun, the centerpiece of the city and its largest structure, is oriented to the west and rises on the east side of the Avenue of the Dead to a height of over 200 feet. The imposing mass and scale of the monuments at Teotihuacán are early indicators of the great feats of the Classic period.

Although the pyramids here do not yet have the regularity of shape characteristic of other Classic period pyramids, they do exhibit the basic elements of form: solid stone construction; superposed, squared platforms, diminishing in perimeter; and ramped stairways ascending to a crowning temple (the probably perishable temple is missing at Teotihuacán). The pyramids at this site at once recall the ziggurat of Mesopotamia and the stepped pyramid of Egypt (FIGS. 2-4 and 3-4). Since these New World structures were built more than two millennia later than their Near Eastern counterparts, we have no good reason to suppose that they were influenced by the earlier works erected halfway around the world. Yet, it is interesting that intensely religious civilizations in two different hemispheres seem to agree in their selection of the pyramid form for the worship of their gods.

At the south end of the Avenue of the Dead is the great quadrangle of the Citadel. It encloses a smaller shrine, the Temple of Quetzalcóatl (the "feathered serpent," a major god in the Mesoamerican pantheon). Its sculptured panels

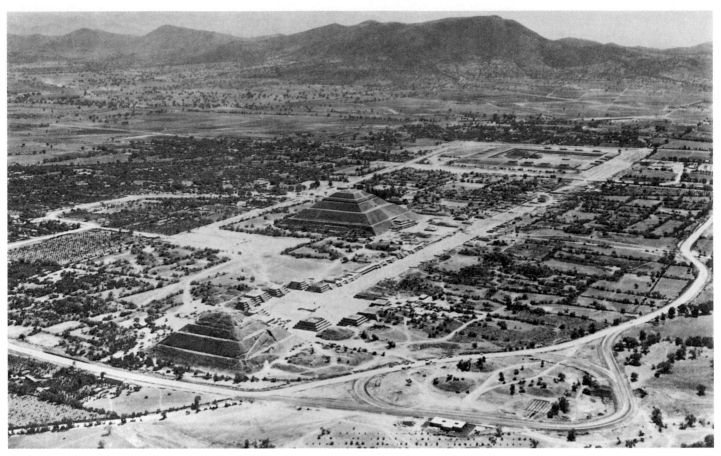

17-4 Teotihuacán, Valley of Mexico. Pyramid of the Moon (*foreground*), Pyramid of the Sun (*center*), the Citadel (*right background*); all connected by the Avenue of the Dead; main structures *c.* A.D. 50–200, site *c.* 100 B.C.–A.D. 600. (Aerial view from the northwest.)

(FIG. **17-5**), long protected by subsequent building, are well preserved. The six terraces of the temple are each decorated with massive, projecting stone heads of the feathered serpent, the symbol of Quetzalcóatl, which alternate with heads of another goggle-eyed figure. Linking these alternating heads are low-relief carvings of feathered-serpent bodies and seashells, the latter reflecting Teotihuacán contact with the peoples of the Mexican coasts. The stone temple and its carved decor manifest that mutually reinforcing union of monumental sculpture and architecture that reminds us of the powerful ensembles distinguishing the art of the ancient Near East, Hellenic civilization, and the Gothic world.

The influence of Teotihuacán was all-pervasive in Mesoamerica. Colonies like Cholula, on the Mexican plateau, were established widely. Others adjoined the southern borders of Maya civilization, in the highlands of Guatemala, some 800 miles from Teotihuacán. Political and economic interaction between Teotihuacán and the Maya in southern Mexico and Guatemala linked the two outstanding cultures of the Early Classic.

GUATEMALA, HONDURAS, YUCATÁN: MAYA A considerable number of strong cultural influences stemming from

the Olmec tradition and from Teotihuacán were active in the development of Classic Maya culture, which has been called "the most advanced, sophisticated, and subtle civilization of the New World"; certainly, Maya culture is exemplary of the whole of Mesoamerican achievement. As with Teotihuacán, Maya civilization's foundations were laid in the Preclassic period, perhaps as early as 400 to 50 B.C.* At that time, the Maya, who occupied the moist lowland areas of Guatemala and Honduras, seem to have abruptly abandoned their early, more or less egalitarian pattern of village life and adopted a hierarchical, autocratic society. This system evolved into the typical Maya theocratic city-state, governed by hereditary rulers and ranked nobility. How and why this happened is still in doubt. The change was signalized by stupendous building projects. Stone structures rivaling those of Teotihuacán in scale rose dramatically, covering square miles of territory with vast, enclosed complexes of terraced temple-pyramids,

*Archeologists working in the jungles of Guatemala at the site of Nakbe currently are excavating the ruins of an early Maya urban center dated about 800 to 600 B.C. This discovery pushes back dramatically the time at which Maya civilization is supposed to have begun and will alter significantly our historical picture of that society.

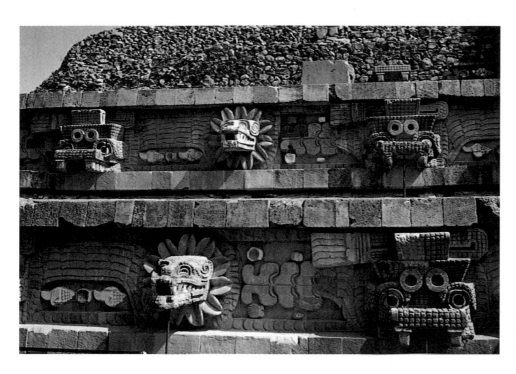

17-5 Detail of Temple of Quetzalcóatl, the Citadel, Teotihuacán, Mexico, third century (?).

tombs, palaces, plazas, ball courts, and residences of the governing elite. The new architecture, and the art that embellished it, advertised the power and interrelationship of rulers and gods and their absolute control of human as well as cosmic life. The unified institutions of religion and kingship were established so firmly, their hold on life and custom was so tenacious, and their meaning was so fixed in the symbolism and imagery of art, that the rigidly conservative system of the Classic Maya lasted almost a thousand years. Maya civilization in the southern region collapsed in about 900, vanishing more abruptly and unaccountably than it had appeared.

Though the causes of the beginning and end of Classic Maya civilization are obscure, the events of its history, beliefs, ceremonies, conventions, and patterns of daily life presently are being revealed in minute detail. The Maya now enter upon the stage of world history as believably as the peoples of other great civilizations. The distorting lenses of myth and legend, which made this group almost akin to the fantastic characters of science fiction, have been removed. This more accurate picture is the consequence of the documentary bequest of the Maya on the one hand and the work of modern archeology on the other.

As we have seen, the Maya possessed an elaborate writing system and highly developed knowledge of arithmetical calculation. These accomplishments enabled them to keep exact records of important events, times, places, and people. They were able to establish the all-important genealogical lines of rulers, which certified their claim to rule, and could construct astronomical charts and tables. They contrived an intricate but astonishingly accurate calendar. Their calendric structuring of time, though radically different in form from ours, was just as sophisticated and effi-

cient. The sixteenth-century Franciscan chronicler of the Maya of Yucatán, Bishop Diego de Landa, declared that time reckoning was "the science in which they believed most and which they valued most highly" of all their achievements. In addition, the Maya mirrored themselves in carved and painted imagery. Though strictly conventional in style, their images, with their hieroglyphic "captions," have great descriptive value.

With these ample documentary materials, modern archeologists have deciphered numerous additional elements of Maya writing in the last three decades. They have made a precise historical record from the calendar and have clarified the iconography of symbol and image. All of these advances have enabled them to bring into ever sharper focus a true picture of the civilization of the Maya.

Time reckoning, like all the arts and institutions of this civilization, was religious in purpose. It aimed to bring human life into the closest possible correspondence with the rhythmic pulse of the living cosmos—the movements of the stars, the diurnal career of the sun, the changes of the seasons, the fluctuations of the climate, and the growth of crops. Within the vital universe of the Maya, all things—animate and inanimate—were interlinked by occult affinities; arts like astrology and divination were practiced to recognize these affinities and determine their influence on human action, while rituals were performed to control them.

Whole populations of greater and lesser gods filled the Maya pantheon and were represented in their art: gods of the Overworld, the Middleworld, the Underworld; gods of the points of the compass; gods of wind and stone, of water lilies, trees, maize, jaguars, jade, serpents, hummingbirds; even a god of the number zero. The business of religion was

to gain access to the gods, to propitiate them with sacrifice and manipulate them with magic. By rituals of sacrifice a god could be summoned up. The celebrants of the rituals, through a vision induced by hallucinogenic drugs or by massive letting of their own blood (usually both), could then unite their essence with that of the god, though only for the duration of the rite. In this mingling of human and divine, the distinction between natural and supernatural disappeared.

This commingling of human and divine also applied to Maya statecraft, for statecraft and religion were one. The ruler was not merely godlike; he (or, at times, she) *was* a god. Kingship and deity shared the rule of the cosmos as well as the rule of the state. In art, the Maya ruler was shown holding the sky in his arms, controlling the motions of the sun and Venus (the morning and evening star), those most ancient and august twin gods of the Maya pantheon. Rulers and gods reciprocally existed, the rulers requiring the gods for the preservation of the state, the gods depending on the ruler for their honor and sustenance. One could not exist without the other. It was in the ritual ceremonies of bloodletting and human sacrifice that the natures of god and king, of divinity and humanity, were commingled.

On all occasions of state, public bloodletting was an integral part of Maya ritual. The ruler, his consort, and certain members of the nobility drew blood from their own bodies and sought union with deity in ecstatic vision (the vision quest). This ceremony was regularly accompanied by the wholesale slaughter of captives taken in war. Wars between the Maya city-states and foreigners were fought principally to provide victims for sacrifice. After prolonged participation in bloodletting rites, these individuals were stretched out on specially designed altars or bound to scaffolds placed on high temple platforms. Their hearts eventually were cut out, and their bodies hurled down the steep stairways. Many captives were forced to play the fatal ballgame in courts laid out adjacent to the temples. The losers of the game were decapitated or otherwise killed. The torture, mutilation, and execution of the victims of the blood ceremonies presented the public with spectacles of profoundly religious import. It has been said that blood was the very mortar of the structure of the Maya system.

ARCHITECTURE The relationship of the Maya politico-religious system to Maya architecture is obvious. The enclosed, centrally located precincts, where the most sacred and majestic buildings of the Maya city were raised, were intended as settings for those religious-civic transactions that guaranteed the order of state and cosmos. The drama of the blood ritual took place within a sculptured and painted environment, where huge symbols and images proclaimed the nature and necessity of that order. The spacious plazas were designed for vast audiences, who, stimulated by drugs, drums, and dancing, were exposed to an overwhelming propaganda. The programmers of that propaganda, the ruling families and troops of priests, nobles, and retainers, carried its symbolism through in their cos-

tumes. They were clad in extravagant profusions of vividly colorful textiles and feathers, each ornamental article having meanings that linked it to supernatural persons and powers. On the different levels of the painted and polished temple platforms, before sanctuaries glittering in the sun, the ruling classes performed the offices of their rites in clouds of incense to the music of maracas, flutes, and drums. The architectural complex at the center of the city was transformed into a theater of religion and statecraft.

In the stagelike layout of a characteristic Maya city center, its principal group, or "site core," was the religious and administrative nucleus of a population settled throughout a suburban area of many square miles. Because it has more hieroglyphic inscriptions and carved monuments than any other site in the New World, Copán, on the western border of Honduras, was one of the first Maya sites to be excavated and one of the richest of them in the trove of architectural, sculptural, and artifactual remains that is still being recovered and studied.

In its principal group (FIG. **17-6**), plazas conspicuously occupy the operational spaces, the Great Plaza to the left and the smaller Middle Plaza at the center. The Middle Plaza is enclosed on three sides by the ball court, the towering, tiered pyramid (Structure 10L-26) with its steep "Hieroglyphic Stairway," and the so-called Acropolis, with its cluster of pyramids. Beyond the Acropolis to the far right are lower, residential buildings, the so-called Cemetery. The Great Plaza is occupied by tall slabs of sculptured stone (to the left in FIG. 17-6), which are meant to be its permanent fixtures. These stelae are images of rulers, whose names, dates of reign, and notable achievements are often carved in glyphs on the front, sides, or back of the stone slabs. Stele H (FIG. **17-7**) represents one of the greatest of the rulers of Copán, 18-Rabbit, in whose long reign from 695 to 738 the city may have reached its greatest physical extent and range of political influence. 18-Rabbit, the thirteenth in a dynastic succession of sixteen rulers, elaborately crowned and wearing ornamented kilt and buskins, makes a solemn ceremonial gesture. His features may be a portrait likeness, which breaks through the archaic mask and stiff frontality into an expression of haughty domination. The dense, deeply carved ornamental details and glyphs that frame the face and figure in florid profusion stand almost clear of the block. The high relief gives the impression of a statue in the full round, though this stele is carved on only one side. A masterpiece of the sculptor's art, this awe-inspiring materialization of the Maya concept of the god-ruler is one of the most memorable works of Mesoamerican art. Remnants of the original red paint are visible on this and many of the other stelae at Copán.

Another great Maya site of the Classic period is Tikal in Guatemala, some 150 miles north of Copán. Tikal, one of the oldest and largest of the Maya cities, rises above the thick tropical forest that once had invaded it completely. The city and its suburbs originally covered some 75 square miles and served as the ceremonial center of a population

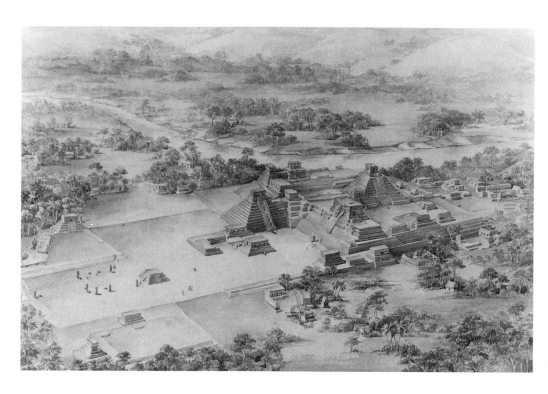

17-6 Principal group of ruins at Copán, Maya, Copán Valley, Honduras, as of late eighth century. Peabody Museum, Harvard University. (Reconstruction drawing by Tatiana Proskouriakoff).

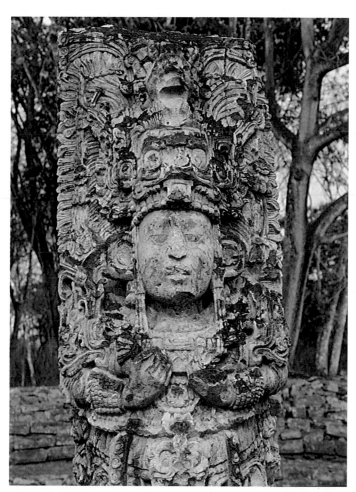

17-7 Stele of the ruler 18-Rabbit, Maya, Great Plaza at Copán, Honduras, late eighth century.

of perhaps seventy-five thousand. Central Tikal was not laid out on a grid plan like its contemporary, Teotihuacán; instead, irregular groupings were connected by causeways. Modern surveys have uncovered the remains of as many as three thousand separate constructions in an area of about 6 square miles. The site's nucleus, the Great Plaza, which is studded with sculptured stelae, contains numerous structures, the most prominent of which are two soaring pyramids facing each other across an open square. The large construction (FIG. **17-8**), Temple I (also called the Temple of the Giant Jaguar after a motif on one of its lintels) reaches a height of 144 feet. It is the temple-mausoleum of a ruler of Tikal, whose tomb is encased in a vaulted chamber excavated at the level of the plaza. The structure is made up of nine sharply inclining platforms, culminating at the summit in a superstructure composed of a supplementary platform and stairway. These elements serve as a base for a three-chambered temple surmounted by an elaborately carved roof comb. The swift upward drive of the great staircase, forbiddingly steep (and perilous in descent!), forces these elements into the towerlike verticality of the pyramid, elevating the temple unit far above the public concourse. This structure exhibits most concisely the Mesoamerican formula for the stepped temple-pyramid and, freed from its dense jungle cover, the compelling esthetic and psychological power of Maya architecture.

SCULPTURE AND PAINTING Architecture, the dominant Maya art, also provided the matrix of Maya sculpture and painting. Rarely do we have sculpture independent of architecture, whether in high relief, in the round, or freestanding. The sculptured stele resembles the detached panel of a wall, and freestanding sculpture, such as it is, is found

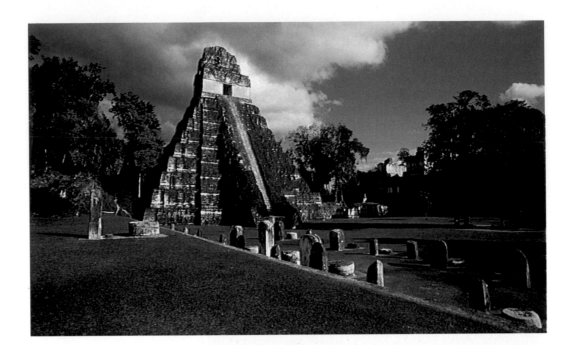

17-8 Temple I (Temple of the Giant Jaguar), Maya, Tikal, El Petén, Guatemala, Classic, *c.* 700.

on the scale of the ceramic figurine. Painting is bound to architecture; murals are the most common form. But considerable painting also has survived on the surfaces of ceramic receptacles (see FIG. 17-13), cups, bowls, and pots, which provide detailed information concerning Maya life and culture.

A striking sculptured head representing the maize god (FIG. **17-9**) was found in the ruins of a palace at Copán, where we have already examined the great stele of 18-Rabbit (FIG. 17-7). With others like it, the head originally was tenoned into the architectural fabric, jutting out from the flat frieze of a cornice. We have noted the significance of maize as the basic foodstuff of Mesoamerica. The personification of natural elements and forces in Maya religion found embodiment in the figurative arts. Here, in the features of head and headdress, the sculptor alludes metaphorically to ripening corn: the face is the cob, the necklace the kernels, the hair the cornsilk, and the headdress the clustering foliage. The graceful motion of the hands suggests the waving of the stalks in the wind. The closed, heavy-lidded eyes turn inward to the young plant's interior life. In the youthful beauty and sensitivity of the face, we find expression of the very idea of spiritual composure. The work is executed with that deft simplification of appearances into plane and volume that are characteristic of native arts. But here the simplifying process stops well short of total abstraction of form. The peculiar traits of Maya physiognomy are smoothed into a symmetry and regularity that subordinate the real to the ideal.

Farther along toward abstraction, but replete with descriptive detail, are the figures of a carved lintel from Yaxchilán (FIG. **17-10**), just across the Mexican state border of Chiapas in Guatemala. The calendrical glyphs surround-

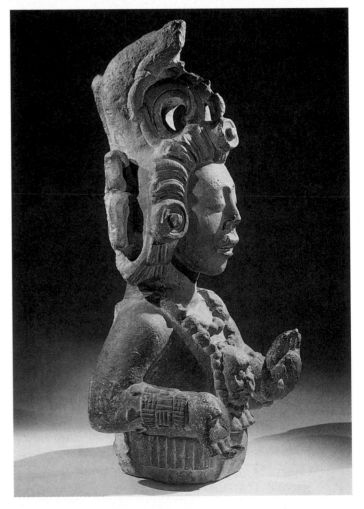

17-9 Maize God, from Temple 22, Maya, Copán, Honduras, *c.* 775. Limestone, 35^1/$_3$″ × 21^1/$_3$″. British Museum, London.

everyday life of the Maya. Small-scale, freestanding figures in the round, they are remarkably lifelike, carefully descriptive, shrewdly psychological, and often comic. A pair that might be called an "amorous couple" (FIG. **17-11**) shows a lecherous old man fondling a courtesan, who replies in kind; he lifts her skirt, she advances her knee. Though apparently no more than an amusing piece of sexual genre, the pair may have religious overtones. The female figure could be the inconstant goddess of the moon, the old man, the god N, a supporter of the arc of heaven. Figurines representing a great variety of subjects regularly are found in tombs among the funeral accessories. This pair comes from Jaina, the Maya necropolis, an island of the dead off the coast of Yucatán. Their mortuary function must be kept in mind as we appreciate their piquant liveliness.

The vivacity of the figurines and their variety of pose are not destructive of the formality of Maya art. Simplification of plane, volume, and contour still is to be

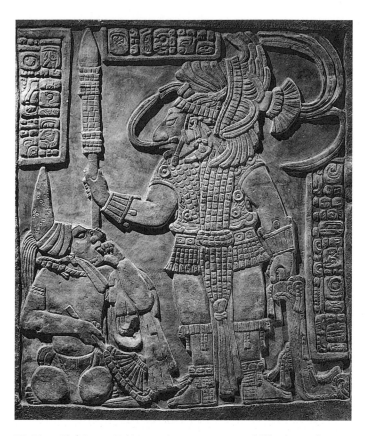

17-10　*Bird-Jaguar Taking a Prisoner,* Maya, Yaxchilán, from Chiapas, Mexico, Late Classic, 755–770. Limestone, 31″ × 30″ × 2³/₄″. British Museum, London.

ing the figures date the commemorated event precisely at February 1, 752 (around the beginning of the Carolingian Empire in Europe). On that day, the Yaxchilán ruler Bird-Jaguar (named for the form of his name glyph) took captive a rebellious enemy lord, who is seen crouching apprehensively at his feet. The capture of a nobleman, later to be sacrificed, was probably a feat prerequisite to the rite of Bird-Jaguar's accession to the throne. The humbled captive, his face bloody, makes a gesture of submission or fear. The king, dressed in battle regalia with spear and feathered headdress, looms threateningly above him.

The hard-edged, slablike carving recalls to a degree the low relief of ancient Assyria (FIG. 2-21), the slight projection being flat rather than round in cross section. This feature is characteristic of much Mesoamerican sculpture. Though Bird-Jaguar's image is confined within the formal rigidity of pose befitting the representation of a ruler, considerable visual information is given in the figure of the captive. The sculptor has sharply observed the foreshortening of the legs, for example, and has been able to pose the figure in a convincing posture of shrinking abjection.

The almost unlimited variety of figural attitude and gesture permitted in the modeling of clay explains the profusion of informal ceramic figurines that illustrate the

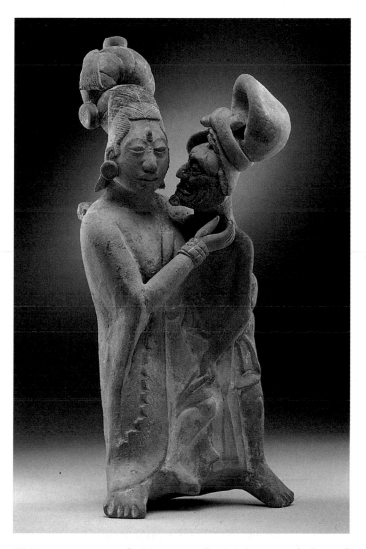

17-11　Amorous couple, Maya, Late Classic, 700–900. Polychromed ceramic, 9³/₄″. Detroit Institute of the Arts, Detroit.

seen in the overall form as well as in its details. This same unity of action with formality of design appears at Bonampak (Mayan for "painted walls"). Three chambers in one structure at this site contain mural paintings that are vivid vignettes of Maya court life (FIG. **17-12**). As in most Egyptian painting (FIGS. 3-34 and 3-44), the figures are rendered in line and flat tone without shading or perspective. They are arranged friezelike in superposed horizontal registers without background settings. Maya painting, like Maya sculpture, is mural; architecture is often its matrix. But, again, the architectural limits do not in any way restrict the scope and circumstantial detail of the narrative; presented with great economy of means, the information given is comprehensive, explicit, and presented with the fidelity of an eyewitness report. At Bonampak, not only can we identify the royal personages who pass in review, but inscriptions give us the precise dates for the events recorded, the days and the months in the years 790 and 791. Like the inscribed dates on the Bird-Jaguar lintel, these impress us with the almost obsessive Maya concern for accurate time reckoning.

The scenes recorded at Bonampak relate the ceremonies that welcome a new heir to the throne; they include pre-sentations, preparations for a royal fete, dancing, battle, and the taking and sacrificing of prisoners. In the scene representing the arraignment of the prisoners (FIG. 17-12), the uppermost register depicts a file of gorgeously appareled nobility wearing animal headgear. Conspicuous among them on the right are retainers clad in jaguar pelts and jaguar heads. The ruler himself, in jaguar jerkin and buskins, is posed at the center and closely resembles Bird-Jaguar in the Yaxchilán lintel (FIG. 17-10). Like the latter figure, he is accompanied by a crouching victim who appears to beg his mercy. The middle level is crowded with naked captives anticipating death. One of them, already dead, sprawls at the feet of the ruler; others dumbly contemplate the blood dripping from their mutilated hands. The lower zone, divided by a doorway into the structure housing the murals, shows clusters of attendants who are doubtless of inferior rank to the lords of the upper zone. The stiff formality of the grandees and the attendants contrasts graphically with the supple, imploring attitudes and gestures of the hapless victims. In this single composition, we have a narrative of those rituals of blood so central in the life of the Maya and throughout pre-Columbian civilizations in Mesoamerica.

17-12 Temple mural of warriors surrounding captives on a terraced platform, Maya, from Bonampak, Mexico, *c.* sixth century. Peabody Museum, Harvard University, Cambridge, Massachusetts. (Watercolor copy by Antonio Tejeda.)

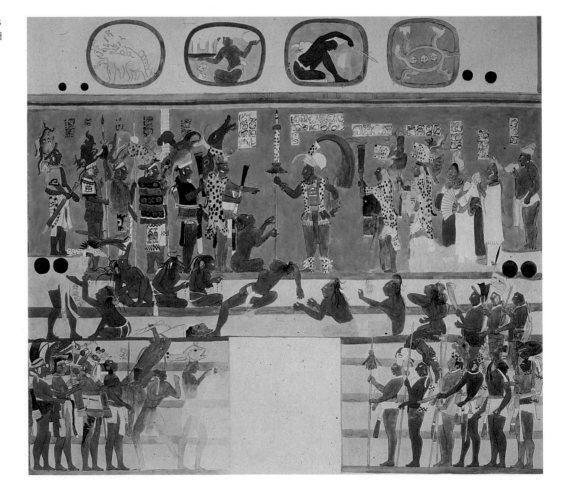

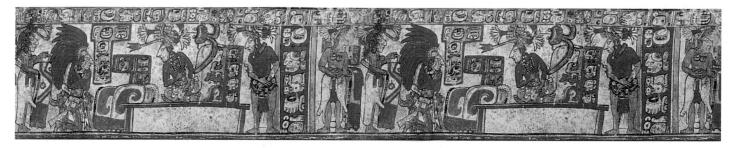

17-13 Polychrome vase from Nebaj in the Guatemalan highlands, rollout view. Approx.6 1/2" high. Anonymous collector.

The same symmetrical formality of large-scale mural painting like that at Bonampak is maintained on the much smaller surfaces of painted vases. Our rollout view of a typical vase design shows a palace scene wherein an enthroned lord receives a tribute of capes from a kneeling, elaborately feathered vassal from whose belt hang human heads. The victorious lord wears a sequined turban laced with water lily stalks; behind him is a cushion of textiles of some sort, and in a column of glyphs that divides the repeated scene, there grins the mask of the god of jest. The composition includes panels of glyphs which, like the narrative scene, are repeated. Doubtless they name the persons who are part of the action and describe the event as actually having taken place. There are two other vases closely related in style to this one, and also historically related, in that all three share in their reading the same event and identify the same central character. The vases memorialize the event and were intended for celebration of the name of its chief actor. These, and vases like them, had a funerary purpose designed to accompany the deceased in his sojourn in the Underworld. They were likely commissioned by the deceased before his death or by his survivors.

Postclassic: 900 - 1521

Throughout Mesoamerica, the Classic period culminated in the disintegration of the great civilizations. Teotihuacán's political and cultural empire was disrupted around 600, and its influence waned. In 700 the great city was destroyed by fire, presumably at the hands of invaders from the north. Around 900, many of the great Maya sites were abandoned to the jungle. Though a later Maya culture continued in northern Yucatán during the Postclassic period, it was strongly subordinated by Toltec influences from central Mexico. The Classic culture of the Zapotecs, centered at Monte Albán in the state of Oaxaca, came to an end around 700, and the neighboring Mixtec peoples assumed supremacy in this area during the Postclassic. Classic El Tajín (Totonac culture), later heir to the Olmec in the Veracruz plain, survived the general crisis that afflicted the others but was burned out sometime in the twelfth century, again by northern invaders.

The war and confusion that followed the collapse of the Classic civilizations broke the great states up into small, local political entities isolated in fortified sites. The collapse encouraged warlike regimes, chronic aggression, and expansion of the bloodletting rite. In Mexico, the Toltec and the Aztec peoples, ruthless migrants from the north, forged empires by force of arms and glorified militarism.

The Mixtecs, who succeeded to Zapotec Monte Albán, were exceptional in that they extended their political sway in Oaxaca by dynastic intermarriage rather than by war. The magnificent treasures found in the tombs at Monte Albán bear witness to Mixtec wealth, and the quality of these works demonstrates the high level of Mixtec artistic achievement. These people were accomplished in sculpture and ceramics. Metallurgy was introduced into Mexico in Late Classic times, and the Mixtec became the skilled goldsmiths of Mesoamerica, renowned for their turquoise mosaic.

The Classic Maya were preeminent in the art of writing and had libraries of painted books. The painted and inscribed book, somewhat inaccurately called a *codex* (plural *codices*), was the precious vehicle that recorded religious occurrences, historical events, genealogical charts, astronomical tables, calendric calculations, maps, and trade and tribute accounts. Codices were painted on long sheets of fig-bark paper or deerskin, which were coated with fine white lime plaster and folded into accordion-like pleats. These manuscripts were protected by wooden covers. Their hieroglyphs were designed to be read in zigzag fashion from left to right and top to bottom. Only four pre-Columbian Maya hieroglyphic codices survive (some scholars accept only three of them as authentic). Bishop Diego de Landa, whom we have met as the Spanish chronicler of the Maya of Yucatán, explains why: "We found a great number of these books in Indian characters and because they contained nothing but superstition and the Devil's falsehoods we burned them all; and this they felt most bitterly and it caused them great grief." Seven historical Mixtec codices survive. A "page" from the beautifully illuminated *Borgia Codex* (FIG. **17-14**), one of a group of codices in a clearly related style, shows the god of life, Quetzalcóatl (black) seated back-to-back with the lord of death, Mictlantecuhtli

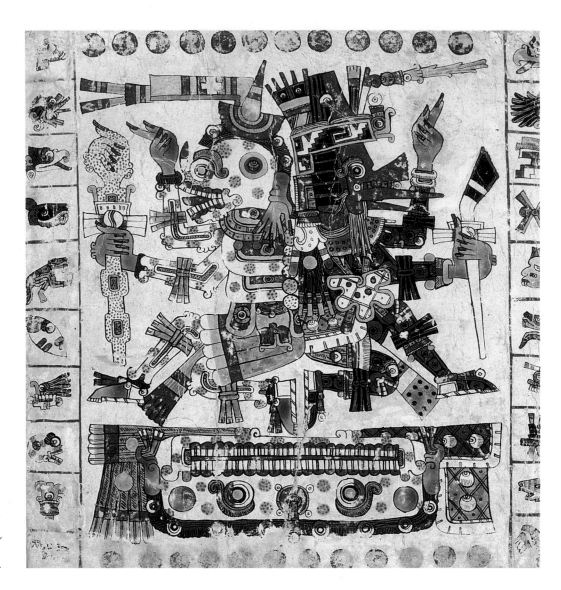

17-14 Death God (Mictlantecuhtli) and Life God (Quetzalcóatl), from the *Borgia Codex*, Puebla/Tlaxcala (?), Mexico, Late Postclassic, *c.* 1400. Deerskin, $10^{2}/_{3}'' \times 4''$. Vatican Library, Rome.

(white). Below them is an inverted skull with a double keyboard of teeth. Both figures hold scepters in one hand and gesticulate with the other. The margins are paneled with symbols of the 20 days of the 260-day Mesoamerican ritual calendar. The fantastic image is an explosion of shapes. The design approaches complete abstraction of visual materials. Were the shapes in less confusion, they would resemble in their taut line and flat, sharp color the face cards of a playing deck.

CHICHÉN ITZÁ: LATER MAYA The flat, scrub-vegetation covered, low limestone peninsula of Yucatán lies north of the rolling and densely forested region of central Yucatán and the Petén. During the Classic period, this northern region was inhabited sparsely by Mayan-speaking peoples who settled around such centers as Uxmal. For still debated reasons, when the Classic sites were abandoned after 900, many new temples still were built in this area. A new

art style, which can be seen in the late temples at Chichén Itzá, is contemporaneous with the political ascendancy in Yucatán of the Toltecs from Tula (a site northwest of Mexico City). The Toltecs ruled at Chichén Itzá during the twelfth and thirteenth centuries.

The northern Maya (under heavy influence from the Toltecs) experimented with building construction and materials to a much greater extent than the Maya farther south; piers and columns were placed in doorways, encrusted decoration of stone mosaic enlivened outer facades. The northern groups invented a new type of concrete construction: a solid core of coarse rubble faced inside and out with a veneer of square limestone plates. The region provided plenty of solid material to work with; Bishop Landa wrote of Yucatán: "The whole land is made of limestone!"

The design of the structure known as the Caracol ("snail shell") at Chichén Itzá (FIG. **17-15**) suggests that the north-

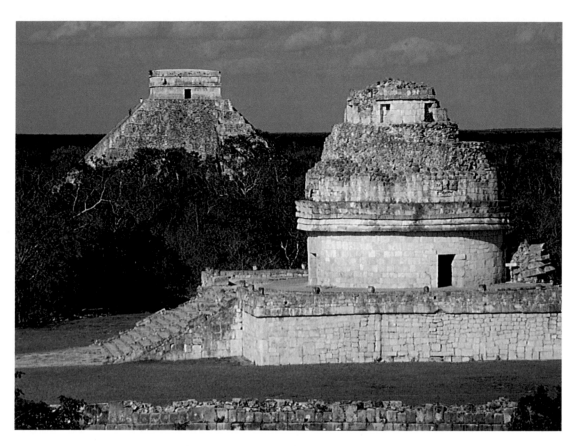

17-15 The Caracol (observatory) and the Castillo (in the background), Chichén Itzá, Toltec-Maya, Yucatán, Mexico, Postclassic, *c.* 1050.

ern Maya were as inventive of architectural form as they were experimental with construction and materials. A cylindrical tower rests on a broad terrace, which is supported, in turn, by a larger platform measuring 169 feet by 232 feet. The tower is composed of two concentric walls enclosing a circular staircase that leads to a small chamber near the top of the structure. Windows along the staircase and an opening at the summit were doubtless used for astronomical observation, which has given the building another name—the "Observatory." Observation of the stars and of their movements made possible the essential astrological calculations that charted their influence.

The Caracol is one among other notable structures at Chichén Itzá—the Temple of the Jaguars, the Temple of the Warriors, and, perhaps most conspicuous, the Temple of Kukulkan (also known as Quetzalcóatl, FIG. 17-5), which is placed upon the summit platform of a great, regular pyramid (and is visible in the background on FIG. 17-15). The "Castillo," as the monument has long been named, is of imposing size, 98 feet high, and each side 182 feet at the base, a majestic symbol of the sacred mountain revered throughout Mesoamerica. Its nine platforms are ascended by stepped ramps on four sides, converging to the temple level. Throughout the structure are inscriptions and reliefs indicative of the Toltec cult of Quetzalcóatl, signatures of Toltec domination of the northern Maya of Yucatán. The Castillo is a kind of paradigm of Mesoamerican architectural form—the great stepped pyramid, with its temple crown, towering above the central plazas of the city.

TULA: TOLTEC The colonnaded Temple of the Warriors at Chichén Itzá resembles buildings excavated at Tula, the Toltec capital north of Mexico City. Detailed resemblances between the sculptures of the two sites support the inference that the builders of Tula worked for the same Toltec masters as those who ruled the Maya at Chichén Itzá.

The name *Toltec,* which signifies "makers of things," generally is applied to a powerful tribe of invaders from the north, whose arrival in south-central Mexico coincided with the great disturbances that, as we have seen, must have contributed to the fall of the Classic civilizations. The Toltec capital at Tula flourished from about 900 to 1200. The Toltecs were great political organizers and military strategists and came to dominate large parts of north and central Mexico, Yucatán, and the highlands of Guatemala. They were respected as the masters of all that came to hand, and later peoples looked back on them admiringly, proud to claim descent from them.

Legend and history recount that in the city of Tula civil strife between the forces of peace and those of war and bloodletting resulted in the victory of the militarists. The grim, warlike regime that followed is personified in four

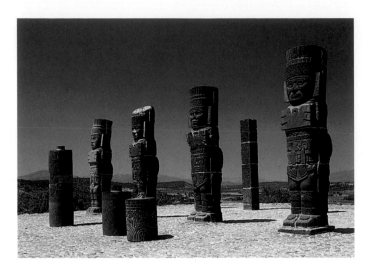

17-16 Colossal atlantids, Pyramid B, Toltec, Tula, Hidalgo, Mexico, Early Postclassic, c. 1050. Stone, 16′ high.

colossal atlantids that portray armed warriors (FIG. **17-16**). Built up of four stone drums each, these sculptures loom above Pyramid B at Tula. They wear stylized feathered headdresses and, as breastplates, stylized butterflies, heraldic symbols of the Toltecs. In one hand they clutch a bundle of darts, in the other, an *atlatl* (throw-stick). The architectural function of these support figures (they originally were designed to support a now missing temple roof) requires rigidity of pose, compactness, and strict simplicity of contour; where possible, all projecting details are suppressed. The unity and regularity of architectural mass and silhouette here combine perfectly with abstraction of form. The effect is that of overwhelming presence. These images of brutal and implacable authority, with "gaze blank and pitiless as the sun," stand eternally at attention, warding off all hostile threats to sovereign power, good or evil.

By 1180, the last Toltec ruler abandoned Tula and was followed by most of his people. Some years later, the city was catastrophically destroyed, its ceremonial buildings burnt to their foundations, its walls thrown down, and the straggling remainder of its population scattered throughout Mexico.

TENOCHTITLÁN: AZTEC The destruction of Tula and the disintegration of the Toltec Empire in central Mexico made for a century of anarchy in the Valley of Mexico. Barbaric Northern invaders, who again must have wrought the destruction, gradually organized into small, warring city-states. Nevertheless, they civilized themselves on the cultural remains and traditions of the Toltecs. When the last wave of northern invaders appeared, they were regarded as detestable savages.

These "savages" were the Aztecs, the "people whose face nobody knows." With astonishing rapidity, they were transformed within a few generations from migratory outcasts and serfs to mercenaries of the Tepanec imperialists, and then masters in their own right of the petty kingdoms of the Valley of Mexico. In the process, they acquired, like their neighbors, the culture of the Toltecs. They had begun to call themselves *Mexica,* and, following a legendary prophecy that they would build a city where they saw an eagle perched on a cactus with a serpent in its mouth, they settled on an island in the great Lake Texcoco (Lake of the Moon). Their settlement grew into the magnificent city of Tenochtitlán, which in 1519 so astonished the Spanish conqueror Cortés and his men.

The Aztecs were known by those they subdued as fierce in war and cruel in peace. Indeed, they gloried in warfare and in military prowess. They radically changed the social and political situation in Mexico. The cults of bloodletting and human sacrifice, though still practiced, had been waning in central Mexico since Toltec times. The Aztecs revived the rituals with a vengeance—and a difference. In the older civilizations, like the Classic Maya, the purposes of religion and statecraft were in balance. With the Aztec, the purpose of religion was to serve the policy of the state. The Aztecs believed that they had a divine mission to propagate the cult of their tribal god, Huitzilopochtli,* the hummingbird god of war. This goal meant forcing conformity on all peoples conquered by them. Subservient groups had not only to submit to Aztec military power but also were forced to accept the cult of Huitzilopochtli and to provide victims for sacrifices to him. Thus, Aztec statecraft used the god to achieve and maintain its ruthless political dominion. Human sacrifice was vastly increased in a reign of terror designed to keep the Aztec Empire under control. To this end, tribute of sacrificial victims was regularly levied on unwilling subjects. It is no wonder that Cortés, in his conquest of the Aztec state, found ready allies among the peoples the Aztecs had subjugated.

The ruins of the Aztec capital, Tenochtitlán, lie directly beneath the center of Mexico City. The exact location of many of the most important structures within the Aztec "sacred precinct" was discovered in the late 1970s, and extensive excavations near the cathedral in Mexico City are ongoing. The principal building is the Great Temple (Templo Mayor), a double temple-pyramid honoring the gods Huitzilopochtli and Tlaloc, the rain god. Two great staircases sweep upward from the plaza level to the double sanctuaries at the summit. The Great Temple is a remarkable example of superimposition, a common trait in Mesoamerica. The excavated structure is composed of five shells, the earlier walls nested within the later. The sacred precinct also contained palaces, the temples of other deities (the Aztec pantheon was as crowded as that of the Maya),

*Pronounced weet-zeel-O-POCH-tlee

a ball court, and a skull rack for the exhibition of thousands of the heads of victims killed in sacrificial rites.

Tenochtitlán was a city laid out on a grid plan in quarters and wards. Its location on an island in Lake Texcoco caused communication and transport to be conducted by canals and waterways; many of the Spaniards thought of Venice when they saw the city rising from the waters like a radiant vision. It was crowded with buildings, plazas, and courtyards, and was equipped with a vast and ever-busy marketplace. The city proper had a population of more than one hundred thousand people; the total population of the area of Mexico dominated by the Aztecs at the time of the conquest has been estimated at eleven million.

The Temple of Huitzilopochtli commemorates his victory over his brothers and sister; since he is a sun god, the nature myth reflects the sun's conquest of the stars and the moon. Revenging the death of his mother, Coatlicue,* at the hands of his siblings, he kills them and dismembers the body of his evil sister, Coyolxauhqui.† The macabre event is depicted in a work of sculpture, whose discovery in 1978 set off the ongoing archeological investigations near the main plaza in Mexico City. The huge stone disk (FIG. **17-17**), about 11 feet in diameter, was placed at the foot of the staircase leading up to the shrine of Huitzilopochtli. Carved on it is an image of the segmented body of Coyolxauhqui. The horror of the theme should not

*Pronounced kwah-TLEE-kway

†Pronounced ko-yol-SHOW-kee

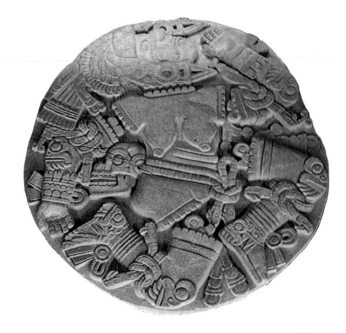

17-17 Coyolxauhqui, from the Great Temple of Tenochtitlán, Aztec, Mexico City, Late Postclassic, *c.* 1400–1500. Stone, diameter approx. 11'.

distract us from its artistic merit; the disk has a kind of dreadful, yet formal, beauty. At the same time, it is an unforgettable expression of Aztec temperament and taste, and the cruelty inculcated by ceremonies of blood. The image proclaimed the power of the god over his enemies and the inevitable fate that must befall them. As such, it was an awful reminder to sacrificial victims, as they were ritually halted beside it preparatory to mounting the stairs that led to the temples above and to death.

The sculpture is marvelously composed. Within the circular space, the carefully enumerated, richly detailed components of the design are so adroitly placed that they seem to have a slow, turning rhythm, like some revolving constellation. (This presentation would be appropriate for a goddess of the sky, no matter her decrepitude!) The carving is confined to a single level, a smoothly even, flat surface raised from a flat ground. We have seen this kind of relief in the Bird-Jaguar lintel from Yaxchilán (FIG. 17-10). It is the sculptural equivalent of the line and flat tone, figure and neutral ground, characteristic of Mesoamerican painting.

In addition to relief carving, the Aztecs, unlike the Maya, produced sculpture unbound to architecture, freestanding and in the round. The colossal monster statue of Coatlicue (Lady of the Skirt of Serpents), ancient earth mother of the gods Huitzilopochtli and Coyolxauhqui, is a massive apparition of dread congealed into stone (FIG. **17-18**). Sufficiently expressive of the Aztec taste for the terrible, the beheaded goddess is composed of an inventory of macabre and repulsive objects. Up from her headless neck writhe two serpents whose heads meet to form a tusked mask. The goddess wears a necklace of severed human hands and excised human hearts. The pendant of the necklace is a skull. Her skirt is formed of entwined snakes. Her hands and feet have great claws, with which she tears the human flesh she consumes. All of her loathsome attributes symbolize sacrificial death. Yet, in Aztec thought, this mother of the gods combines savagery and tenderness, for out of destruction arises new life.

The main forms are carved in high relief, the details are executed either in low relief or by incising. The overall aspect is of an enormous, blocky mass, the ponderous weight of which is in itself a threat to the awed viewer. In its original setting, where it may have functioned in the visual drama of sacrificial rites, it must have had a terrifying effect on victims.

It was impossible for the Spanish conquerors to reconcile the beauty of the great city of Tenochtitlán with its hideous cults. They wonderingly admired its splendid buildings, ablaze with color; its luxuriant and spacious gardens, sparkling waterways, teeming markets, and vivacious populace; its grandees resplendent in the feathers of exotic birds. But when Moctezuma, king of the Aztecs, brought Cortés and his entourage into the shrine of Huitzilopochtli's

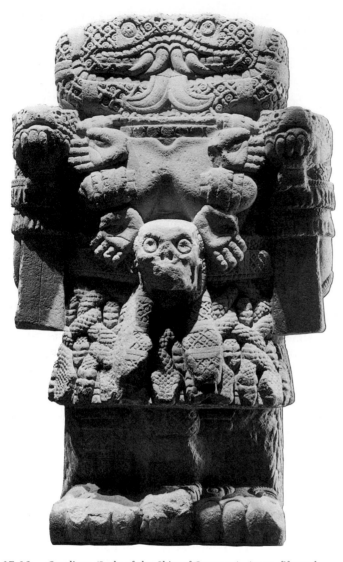

17-18 Coatlicue (Lady of the Skirt of Serpents), Aztec, fifteenth century. Andesite, approx. 8′6″ high. National Archeological Museum, Mexico City.

temple, the newcomers started back in horror and disgust from the huge statues clotted with dried blood. One of Cortés's party, Bernal Diaz del Castillo recorded: "There was on the walls such a crust of blood, and the whole floor bathed in it, that even in the slaughter houses of Castile there is not such a stench." Cortés was furious. Denouncing Huitzilopochtli as a devil, he proposed to put a high cross above the pyramid and a statue of the Virgin in the sanctuary to exorcise its evil.

This proposal would come to symbolize the avowed purpose and the historic result of the Spanish conquest of Mesoamerica. The cross and the Virgin, triumphant, would be venerated in new shrines raised upon the ruins of the plundered temples of the Indian gods, and the banner of the Most Catholic Kings of Spain would wave over new atrocities of a European kind.

SOUTH AMERICA
Central Andes

The story of the great cultures of Andean South America is much the same as that of the pre-Columbian peoples of Mesoamerica: native civilizations jarring against and stimulating one another; production of distinctive architecture and art; extermination in violent confrontations with the Spanish *conquistadores*—Cortés in Mesoamerica and Pizarro in the Andes.

The central Andean region of South America lies between Ecuador and northern Chile. It consists of three well-defined geographic zones, running north and south, roughly parallel to one another: a narrow western coastal plain, where a hot desert is crossed by rivers, creating habitable, fertile valleys; the great Cordillera of the Andes, whose high peaks hem in plateaus of a temperate climate; and the eastern slopes of the Andes, a hot, humid jungle. Highly developed civilizations flourished both on the coast and in the highlands, but their origins are still obscure. These civilizations and their arts succeeded one another with rough correspondence to the Mesoamerican chronology.

CHAVÍN Evidence indicates that, in the first millennium B.C., a cult began to grow that, at its height, prevailed over great portions of the coast and highland areas.* The cult is called Chavín, after the ceremonial center of Chavín de Huántar, which is located in the northern highlands and consists of a number of stonefaced, pyramidal platforms penetrated by narrow passageways and small chambers, surrounding a sunken court.

Chavín de Huántar is famed, too, for its stone carvings. Associated with the architecture and consisting of much sunken relief on panels, lintels, and columns and some rarer instances of sculpture in the round, Chavín sculpture is essentially linear, hardly more than incision. Freestanding sculpture is represented by an immense cult image in the center of the oldest structure, as well as by heads of mythological creatures tenoned into the exterior walls. Although, at first glance, the subject matter of Chavín stone carving appears to exhibit considerable variety, the emphasis is most consistently on composite

*On the basis of recent discoveries, archeologists are now concluding that the pan-regional Chavín culture was the culmination of developments that began some two thousand years earlier in other Andean regions. Complex ancient communities documented by radiocarbon dating as having been built from one thousand to twenty-five hundred years before Chavín are changing researchers' assessments of early New World cultures. Work at such sites as El Aspero, Sechín Alto, and Pampa de las Llamas-Moxeke indicates that planned communities boasting monumental architecture, organized labor systems, and bright, multicolored adobe friezes dotted the narrow river valleys that drop from the Andes to the Pacific Ocean centuries earlier than previously thought.

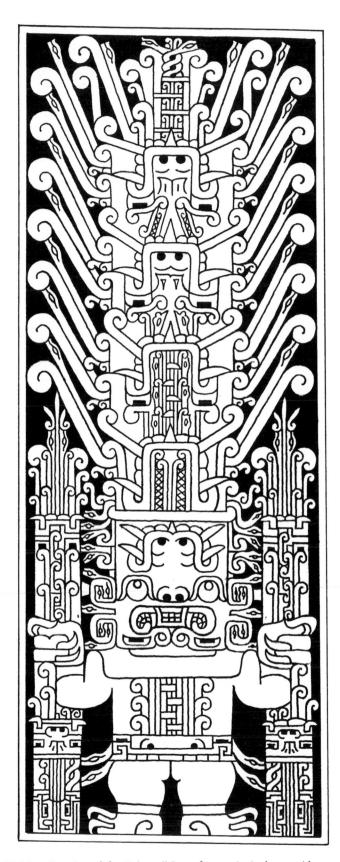

17-19 Drawing of the *Raimondi Stone,* from principal pyramid, Chavín de Huántar, Peru, first millennium B.C. Incised green diorite, 6′ high. Instituto Nacional de Cultura, Lima, Peru.

creatures that combine feline, avian, reptilian, and human features. The *Raimondi Stone* (FIG. **17-19**), which was named after its discoverer, is representative of the late variant of Chavín stone carving. On the lower third of the stone is a figure called the "staff god," versions of whom have been encountered from Colombia to northern Bolivia, but seldom with the degree of elaboration found at Chavín. In this instance, the squat, scowling deity, who is always depicted holding staffs, is shown with his gaze directed upward. An elaborate headdress dominates the upper two-thirds of the slab. Inverting the image reveals that the headdress is composed of a series of fanged, jawless faces, each emerging from the mouth of the one above it. Snakes abound; they extend from the deity's belt, forming part of the staffs; serve as whiskers and hair for the deity and the headdress creatures; and, finally, form a *guilloche* (an architectural ornament that imitates braided ribbon) at the apex of the composition.

The ceramic vessels of the northern Chavín area are identified easily by their massiveness of chamber, spout, and surface relief. The motifs are much like those found on Chavín stone carvings. The stirrup spout became popular at this time and continued to be a commonly used North Coast form until the advent of the Spaniards.

MOCHE The great variations within Peruvian art styles are exemplified by several coastal traditions that developed during the period between about 500 B.C. and A.D. 600 in the cultures of the Moche in the north and Nasca and Paracas in the south.

The Moche concern with ritual is reflected clearly in their ceremonial architecture and ceramic vessels. The former consisted of immense, pyramidal, supporting structures for temples that, due to the scarcity of stone, were constructed of sun-dried mud brick (or adobe). Their scale may be surmised from the remains of the Temple of the Sun in the lower Trujillo Valley, which utilized millions of adobe bricks. The temple atop it already had disappeared by the advent of the Spaniards. As a result of persistent treasure hunting by early colonial residents, only a remnant of the original pyramid remains.

Probably the most famous art objects produced by the ancient Peruvians are the ceramic vessels of the Moche, which were predominantly flat-bottomed, stirrup-spout jars, molded without the aid of a potter's wheel and generally decorated with a bichrome slip. (Their abundance can be credited to the ancient Peruvian practice of seeing that the dead were accompanied in the grave by many offerings.) Moche potters continued to employ the stirrup spout, making it an elegant tube much more slender than the Chavín prototype. This refinement may be seen in one of the famous Moche portrait bottles (FIG. **17-20**), believed to be either a warrior or a priest. In early bottles of this type, the sculptured form was dominant; in time, however, linear surface decoration came to be employed equally.

Warrior-lord, priest, and sacrificial victims appear to be the incumbents of rich tombs recently (1988) excavated near the little village of Sipán on the arid northwest coast of Peru. Looted and unlooted tombs and a pottery cache nearby have yielded a treasure of golden artifacts and more than a thousand ceramic vessels. The tombs' discovery has made a great stir in the world of archeology, contributing immensely to our knowledge of Moche culture, and elevating the Moche above the Inca in importance. Located beneath a large adobe platform adjacent to two high but greatly eroded pyramids, the tombs had escaped the attention of village grave robbers for many years. The splendor of the funeral trappings that adorned the body of the "Lord of Sipán" (as he has been called), the quantity and quality of the sumptuous accessories, and the bodies of the retainers buried with him in his tomb indicate that he was a personage of the highest rank. Indeed, he may have been one of the warrior-priests so often pictured on Moche ceramic wares (and in this tomb, on a golden, pyramid-shaped rattle), assaulting his enemies and participating in sacrificial ceremonies, wherein victims' throats were slit and their blood drunk from ornamental cups.

An ear ornament of turquoise and gold found in the tomb shows a warrior-priest clad much like the dead man (FIG. **17-21**). Represented frontally, he carries a war club and shield and wears a necklace of owls' heads. The figure's bladelike, crescent-shaped helmet is a replica of the large golden one buried with the warrior-priest. The ear ornament of the image is a simplified version of the piece on which it is portrayed. The nose-guard, which is removable, and the golden chin guard also are like those worn by the deceased. Two retainers, with similar helmets and ear ornaments, are shown in profile.

Though the Andean cultures did not develop a system of writing, they had an advanced knowledge of metallurgy long before the Mesoamericans, who must have received it from them as late as the tenth century. Treasure of silver and gold, of course, lured the Spanish invaders to the Americas, and the wildcat plundering of pre-Columbian tombs by grave robbers, both foreign and domestic, continues to scatter precious artifacts worldwide. Needless to say, this hampers the work of archeology. The value of the Sipán find is incalculable for what it reveals about the Moche culture. Moche craftsmanship in gold and other metals and their sophisticated ceramic production place them among the most ingenious cultures of North and South America.

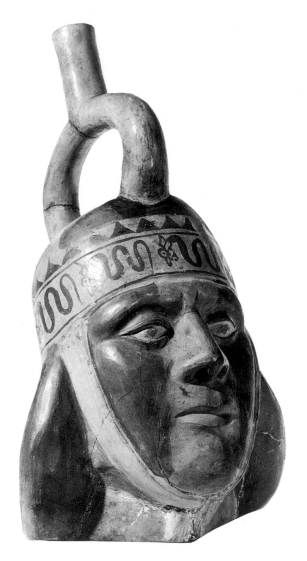

17-20 Portrait bottle, Moche, Peru, fifth to sixth century. Ceramic, 11½" high. American Museum of Natural History, New York.

SOUTH AMERICAN CHRONOLOGY: CENTRAL ANDES AND CIRCUM-CARIBBEAN AREA

	2000 B.C.	1000	B.C. A.D.		1000	1534
PRECERAMIC	INITIAL	EARLY HORIZON	EARLY INTERMEDIATE	MIDDLE HORIZON	LATE INTERMEDIATE	LATE HORIZON
		Chavín *Chavín de Huántar*	Moche *Sipán* *Moche* Nasca Paracas	Tiahuanaco	Inca *Machu Picchu* Tairona (Colombia)	

NASCA Although the Nasca rarely produced ceremonial architecture on a large scale, they did create a comparable art form in their ceramic vessels, which, unlike their counterparts on the north coast, had round bottoms, double spouts connected with bridges, and smoothly burnished, polychrome surfaces. The subject matter is of great variety, with particular emphasis on plants, animals, and mythological creatures. The initially elegant simplicity of their depiction evolved into a style exhibiting a marked complexity and bold stylization (FIG. **17-22**).

Nasca is known not only for its polychrome pottery. Some 800 miles of lines, drawn in complex networks on the dry surface of the Nasca Valley in southwestern Peru, have long attracted world attention as the most mysterious and gigantic works of human art. The earliest of these works trace out biomorphic figures: birds, fish, plants, and, in our example, a hummingbird (FIG. **17-23**)—a motif that, incidentally, is almost identical to hummingbirds on contemporaneous Nasca pottery. The wingspan of the hummingbird is over 200 feet. To produce figures of this scale and accuracy of proportion required some rudimentary geometry and an elementary method of measurement. Geometric forms with miles-long straight lines were drawn later, perhaps as late as Inca times. Uniformly, the Nasca Lines appear light on a dark ground, an effect produced by scraping aside the sun-darkened desert pebbles to reveal the lighter layer of whitish clay and calcite beneath.

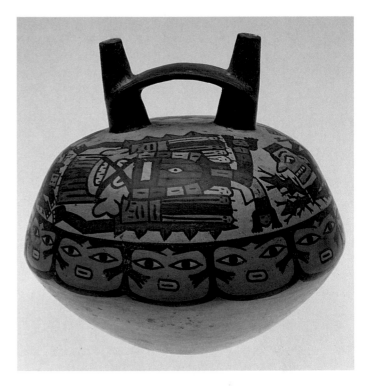

17-22 Bridge-spout vessel, Nasca, Peru, c. fifth and sixth centuries. Ceramic with slip, 5¹/₂″ high. Museum of Cultural History, University of California, Los Angeles.

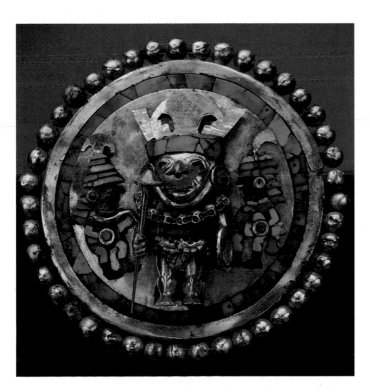

17-21 Ear ornament, from a tomb chamber, Moche, from Sipán, northwestern Peru, c. 300–700. Gold and turquoise, approx. 4⁴/₅″. Bruning Archeological Museum, Lambayeque, Peru.

Speculation continues as to the source, construction, and meaning of the Nasca Lines. Some of the explanations are fantastic: the lines were the work of superhuman beings from outer space who arrived by spaceship or of designers of a colossal athletic field. The construction of such ingenious shapes and of such regular geometry seems nearly beyond mere human agency, especially since, given their immense length and bewildering intricacy, the lines were supposed visible only from the air. But, in fact, the lines are visible from the Andean foothills and the great coastal dunes. Moreover, they are constructed quite easily from available materials; simple stone-and-string methods can be used to lay out paths. Lines left uncompleted have guided the modern reproduction of them.

Indeed, the lines seem to be some sort of paths. They lead in traceable directions across the deserts of the Nasca drainage; they are punctuated by many shrinelike nodes, like the knots on a cord; and they converge at central places usually situated close to sources of water. They seem to be associated with water supply and irrigation, and may have become pilgrimage routes for those who journeyed to shrines by foot. They probably had astronomical and calendric functions, forecasting the onset of the planting seasons. Altogether, the vast arrangement of the Nasca Lines is a system—not a meaningless maze, but a traversable map that plotted out the whole terrain of the material and spiritual concerns of the Nasca.

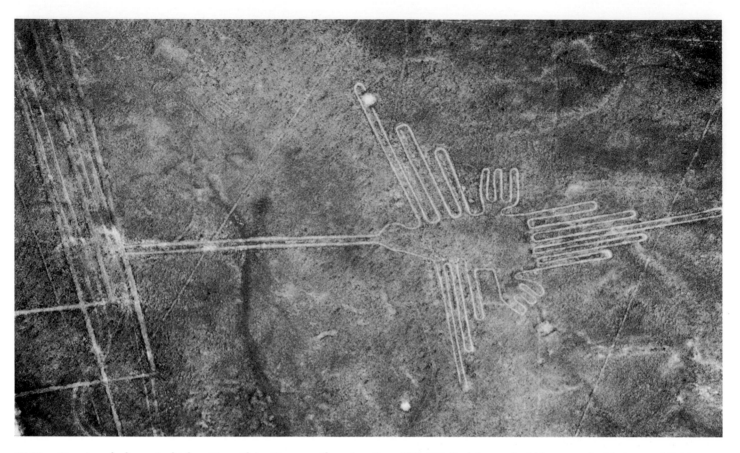

17-23 Drawing of a hummingbird on Nasca Plain, Nasca, southwestern Peru, 200–600. Dark layer of pebbles scraped aside to reveal lighter clay and calcite beneath, 27" wide, 200' wingspan, and 450' total length. (Aerial view.)

PARACAS The Paracas culture, which flourished as early as some five centuries B.C., occupied the extreme southwest coast of Peru, including the Nasca plain; in fact, it preceded the Nasca culture in time, and left its strong influence on Nasca art. Outstanding among the surviving Parascan arts are the funerary textiles, which once wrapped, in enormous layers, the bodies of the dead. The textiles of Paracas (FIG. **17-24**) are world-famous and among the most interesting and enduring masterpieces of Andean art. They are usually embroidered with alpaca or vicuna wool on a cotton weave, in a range of over 150 vivid colors. The design motifs of the grave mantles have a symbolism not yet deciphered. Most singular is a figure called the "Oculate Being," a flying phantom facing outward with huge eyes. Multiplied, these flying or floating beings variously carry batons, fans, and sometimes the skulls or severed heads of enemies (?). Their airy hovering is suggested by the lines that trail out from them and by the slow, kicking motion of the legs. Despite subtle varieties of detail, the motif of the Oculate Being is prominent, along with various feline, serpent, and other animal motifs, and is endlessly repeated in these gorgeous designs. The oculate, or great-eye, motif appears on Nasca pottery (FIG. 17-22), and we shall meet it again at Tiahuanaco (FIG. 17-25).

TIAHUANACO The bleak highland country surrounding Lake Titicaca in southeastern Peru contrasts markedly with the warm valleys of the coast. Isolated in these mountains, at a height of 12,500 feet, another culture developed semi-independently of the coastal cultures until 1000. The art style of this culture, named for Tiahuanaco, the principal archeological site on the southern shores of the lake, then spread to the adjacent coastal area as well as to other highland areas, extending from southern Peru to northern Chile.

Tiahuanaco was an important ceremonial center. The buildings of its Calasasaya sector were constructed of the fine stone of the region: sandstone, andesite, and diorite. Among these impressive structures is the imposing Gateway of the Sun—a huge, monolithic block of andesite, pierced by a single doorway and crowned with a sculptured lintel (FIG. **17-25**). Shrunken beneath an enormous head, the central figure, rigidly frontal, stands on a terraced step holding a staff in each hand. From the blocklike head project rays that terminate in circles and puma heads. The form recalls that of the *Raimondi Stone* (FIG. 17-19) in its frontality and in the symmetrical staffs, as well as in the geometrical conventions used for human and animal representation. The "staff-god" appears in art throughout the

Tiahuanaco period, associated, as here, with smaller-scale attendant figures. On this lintel the god is carved in high relief and stands out prominently against the low-relief border of rows of condors and winged men with weapons who run toward the center. Each of the running figures fills a square panel, giving an effect of movement, which quickens slightly the otherwise static formality of the composition. A border of *frets* (ornamental pattern of contiguous straight lines joined usually at right angles) interspersed with masklike heads forms a kind of supporting lower step.

The carving method should be compared with those of the Maya (FIG. 17-10) and the Aztecs (FIG. 17-17). Here, again, flat relief is carved on a flat ground, although as mentioned, the central panel on the Gateway of the Sun projects an extra level beyond, casting a sharp shadow. But the Tiahuanaco figures are radically abstract, the sculptured equivalent of the linear painting in the *Borgia Codex* (FIG. 17-14). By abstractive distortion of bodily proportion and suppression of descriptive detail, the figures are reduced almost to pictographs; they are more symbols than images.

INCA The Inca were a small highland tribe who established their rule in the valley of Cuzco, with the city of Cuzco as their capital. Between the thirteenth and fifteenth centuries, they gradually extended their power until their empire stretched from Quito in Ecuador to central Chile, a distance of more than 3,000 miles.

The dimensions of this vast empire required skillful organizational and administrative control, and the Inca had rare talent for both; in this respect, they resemble the impe-

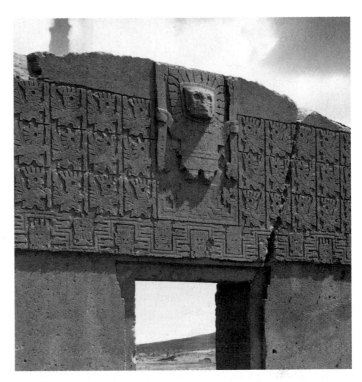

17-25 Monolithic gateway, detail, Tiahuanaco, Bolivia, ninth century (?).

rial Romans. Without writing, but with ingenious maps and models, they divided the empire into sections and subsections, provinces and communities, the boundaries of which all converged on, or radiated from Cuzco. Their organizational talent was matched by their constructional prowess; they were skillful engineers who knitted together the fabric of empire with networks of roads and bridges. They established a highly efficient, swift communication system of runners who used their excellent road system to carry messages in relays the length of the empire. The Inca mastered the difficult problems of Andean agriculture with expert terracing and irrigation. They were metallurgists and mined extensively, accumulating the fabled troves of gold and silver that motivated Pizarro to conquer them.

Although the Inca aimed at imposition of their art style throughout their realm, objects of pure Inca style were confined to areas that came under the power of Cuzco. The Inca were concerned not so much with annihilating local traditions as with subjugating them to those of the empire. Local styles, although they sometimes came to employ a few Inca features, continued to be produced in areas marginal to the centers of Inca power.

Like the Romans, the imperial Inca were great architects. They valued the building art highly and drew their professionals from the nobility. Unlike the Romans, who built in concrete, the Inca were supreme masters of shaping and fitting stone. In addition, they had an almost instinctive grasp of the proper relation of architecture to site. As a

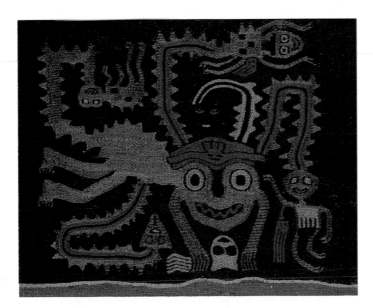

17-24 Detail of a burial blanket, Paracas Necropolis culture, from southern coast of Peru, *c.* 200 B.C.–A.D. 200. Cotton embroidered with alpaca wool, detail dimensions 7¹⁄₈″ × 6¹⁄₄″. Textile Museum, Washington, D.C.

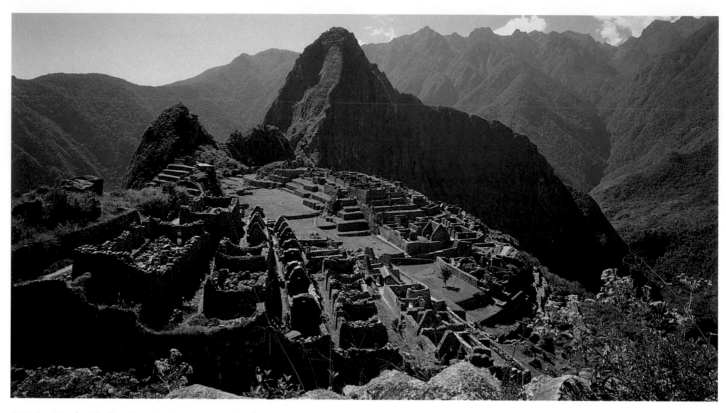

17-26 Machu Picchu, Inca, Peru, *c.* 1500. (Aerial view.)

militant, conquering people they selected sites fortified by nature and further strengthened them by building various defensive structures.

One of the world's most awe-inspiring sights, the Inca city of Machu Picchu (FIG. **17-26**) perches on a ridge between two jagged peaks, 9,000 feet above sea level. Hiram Bingham, the American discoverer of Machu Picchu (1911), described one aspect of its wildly dramatic situation: "On both sides tremendous precipices fall away to the white rapids of the Urubamba River," some 1,600 feet below. In the very heart of the Andes, the site is about 50 miles north of Cuzco, and like other cities of the region, may have been part of a defensive pale around the capital. Though relatively small and insignificant among its neighbors (with a resident population of little more than a thousand), Machu Picchu is of great archeological importance as a site left undisturbed since Inca times. The accommodation of its architecture to the landscape is so complete that it seems a natural part of a geologically terraced mountain range.

We have noted the Inca as masters of stone masonry. Their technique of dry-joining *ashlar* (large square-cut stone) construction is famous; blocks of stone were fitted together entirely without mortar. The joints of the ashlar could be beveled to show their tightness, or laid in courses with perfectly joined faces so that the lines of separation

were hardly visible. The close joints of Inca masonry were produced by abrasion alone; each stone was swung in slings against its neighbor until the surfaces were ground to a perfect fit. Stones in the walls of more important buildings, like temples or administrative palaces, were usually laid in regular, horizontal courses; for lesser structures, they were laid in polygonal (mostly trapezoidal) patterns. (The trapezoid was a favorite architectural figure, commonly appearing as the shape of niches, doorways, and windows.) With Inca stonecraft, walls could be fashioned with curved surfaces, their planes as level and continuous as if they were a single form poured in concrete. It is interesting that building techniques similar to the Inca method of walling in stone were known across the Pacific (in Cambodian temples like Angkor Thom [FIG. 14-36], monumental stone sculpture is actually built up like shaped wall).

A prime example of the single-form effect is a surviving wall from the great Temple of the Sun in Cuzco (FIG. **17-27**). The most magnificent of all Inca shrines, this structure originally was known as Coricancha (Court of Gold) and was dedicated to the worship of the supreme being of the Inca, Viracocha. Viracocha ruled over all the gods of nature, the sun, moon, stars, and the elements. Sixteenth-century Spanish chroniclers wrote in awe of the gold and silver splendor of Coricancha: the interior was veneered with sheets of gold, silver, and "emeralds" (turquoise). "It

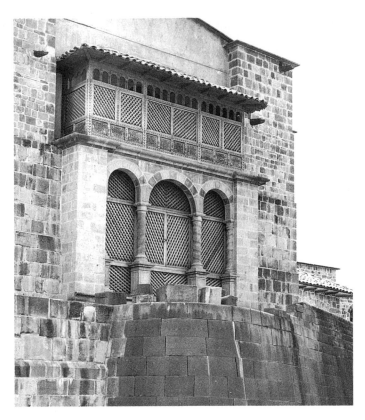

17-27 Wall of the Temple of the Sun (foreground), surmounted by the church of Santo Domingo, Inca, Cuzco, Peru, fifteenth century.

was," wrote one, "one of the richest temples there was in the world." During the Inca revolt against the Spaniards in the 1530s, the temple was destroyed. Later, the church of Santo Domingo, in the Spanish colonial style, was erected on what remained of it, the curved section of wall serving as the foundation of the apse.

The hewn stones, precisely fitted and polished, form a curving, semiparabola (sickle-shape) and are set in such a way as to be flexible in earthquakes, allowing for a temporary dislocation of the courses, which return to their original position. A violent earthquake in 1950 seriously damaged the church; the wall was left standing, and much of the original substructure of the temple came into view, with its chambers, courtyards, and trapezoidal niches and doorways. Santo Domingo has been rebuilt, and now the two contrasting architectural styles stand one atop the other (FIG. 17-27). The Coricancha is of more than architectural and archeological interest. It is a symbol of the Spanish conquest of the Americas and serves as a composite monument to it—one civilization built on the ruins of another.

Circum-Caribbean

TAIRONA In Colombia, the country that occupies the northwestern corner of the South American continent, the

Andes form four parallel ranges separated by deep valleys. Another individual mountain group, the lofty Sierra Nevada de Santa Marta, rises above the Caribbean to the northeast. In this area of the Sierra Nevada, the topography of high mountains and river valleys allowed for considerable isolation and the independent development of various groups. Late inhabitants of this region (from about 1000 to contact with the Spanish conquerors, in the unsettled chronology of the area) included a group known as the Tairona, whose metalwork is among the finest of all of the pre-Columbian goldworking styles.

Technologically advanced and esthetically sophisticated work in gold had been produced in the Peruvian cultures of the Chavín and Moche, mostly by the cutting and hammering of thin gold sheets. The Tairona smiths used the lost-wax process to cast works of the highest quality in fabrication and design. Gold was mined and worked in vast quantities throughout the various Andean regions; it was the dream of the golden world of El Dorado that motivated the ruthless plunder of it by the Spanish invaders.

Peruvian and Colombian gold and silver were most often fashioned into pendants, not meant to be worn simply as rich accessories to costume, but as amulets or talismans representing spiritual beings who give the wearer protection and status. The glow of the burnished material itself was symbolic of the light of heaven; we are told that the Inca, and likely their neighbors, regarded gold as "the sweat of the sun" and silver as the "tears of the moon."

Our pendant (FIG. **17-28**), a bilaterally symmetrical design, shows a bat-faced man, arms akimbo, wearing an immense headdress made up of two birds in the round, two

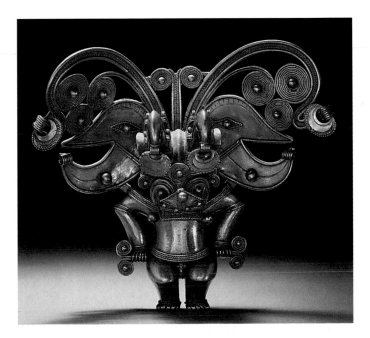

17-28 Tairona pendant. Northeast Colombia, *c.* 1000. Gold, 5¼" high. The Metropolitan Museum of Art, New York, Jan Mitchell Collection.

great beaked heads, and a flowering out of spirals crowned by two overarching stalks. The harmony of repeated curvilinear motifs, the rhythmic play of their contours, and the precise delineation of minute detail, bespeak the technical control and esthetic sensitivity of the anonymous artist. The mastery of the jeweler's craft here manifest is not unique. It is common to the numerous specimens of pre-Columbian metal art that survived Spanish despoliation.

NORTH AMERICA

The styles and objects of the cultures native to North America are well known, beginning with the period of prolonged contact with Europeans. We also have considerable knowledge of many earlier forms and styles, although our information is not nearly as extensive as our knowledge of earlier periods in South America and Mesoamerica. In many parts of the United States and Canada, "prehistoric" cultures have been discovered that reach back as far as twelve thousand years; most of the finer art objects, however, come from the last two thousand years. "Historic" cultures, beginning with the earliest date of prolonged contact with Europeans, which varies from the sixteenth to the nineteenth century, have been widely and systematically recorded by anthropologists. The material objects from these cultures usually reflect profound changes wrought by the impact of alien tools, materials, and values on the native peoples.

Scholars divide the vast and varied territory involved into a number of areas on the basis of relative homogeneity of language and culture patterns. We will briefly discuss both prehistoric and historic art forms from most of these culture areas in this section.

Prehistoric Era

Inuit sculpture, often severely economical in the handling of form, is at the same time refined—even elegant—in the placement and precision of both geometric and representational incised designs. A carved ivory burial mask (FIG. **17-29**) from the Ipiutak culture (c. 300) is composed of nine carefully shaped parts that are interrelated to produce several faces, both human and animal, in the manner of a visual pun. The mask is a confident, subtle composition in shallow relief, a tribute to the artist's imaginative control over the materials. Over the centuries, Inuits also have carved hundreds of small human and animal figures (usually in ivory) and highly imaginative "mobile" (with moving parts) masks used by shamans (FIG. **17-30**) that, due to their fanciful forms and odd juxtapositions of images and materials, were much appreciated by Surrealists in the 1920s.

Early Native American artists also excelled in working stone into a variety of utilitarian and ceremonial objects.

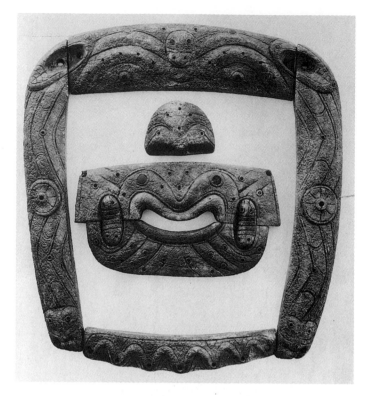

17-29 Set of burial carvings, Ipiutak, *c.* 300. Ivory, greatest width 9¹/₂″. Courtesy Department Library Services, American Museum of Natural History, New York.

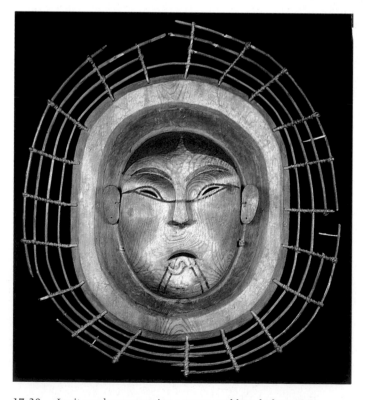

17-30 Inuit mask representing a moon goddess, before 1900. Wood, approx. 25″ high. The Phoebe Hearst Museum of Anthropology, Berkeley, California.

The quite realistic handling of the so-called Adena pipe (FIG. **17-31**), a figural pipe bowl dated between 1000 and 300 B.C., provides an interesting contrast to the two-dimensional, more animated composition on a shell *gorget*, or throat armor (FIG. **17-32**), found at a Mississippian culture site in Tennessee and dating from the Temple Mound II period (*c.* A.D. 1200–1500). The standing pipe figure, although simplified, has naturalistic joint articulations and musculature, a lively, flexed-leg pose, and an alert facial expression—all of which combine to suggest movement. The incised shell

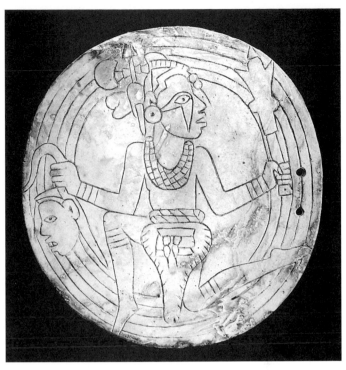

17-32 Incised shell gorget, Mississippian culture, from Sumner County, Tennessee, *c.* 1200–1500. 4″ wide. Museum of the American Indian, Smithsonian Institution, New York.

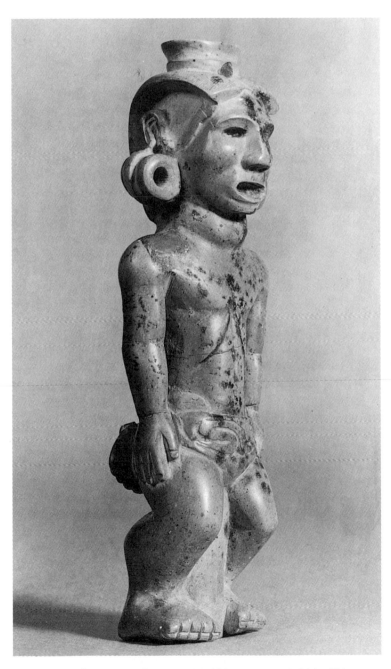

17-31 Adena pipe, Adena, *c.* 1000–300 B.C. Stone, 8″ high. Ohio Historical Society, Columbus.

gorget depicts a kneeling personage with an elaborate headdress, who carries a mace in his left hand and a severed human head in his right. Most Adena and Mississippian objects come from burial and temple mounds and are thought to have been gifts to the dead to ensure their safe, prosperous arrival in the land of the spirits. Other art objects found in such contexts include fine mica and embossed copper cut-outs of hands, bodies, snakes, birds, and other presumably symbolic forms.

Effigy mounds and complex platformed temple mounds have been discovered at several sites in the United States. Effigy mounds, undoubtedly made for spiritual purposes, exemplify the universal practice of creating visually impressive settings for ceremonial activities. Temple mounds, along with small, incised, shell reliefs, such as the Mississippian shell gorget discussed earlier (FIG. 17-32), show strong influence from pre-Columbian Mesoamerica.

Engravings and paintings on rock (called *petroglyphs* and *pictographs*, respectively) are distributed widely across North America. Many of these are sacred sites and probably were used for communal rituals or the recording of personal spiritual experiences, which were very important in traditional Native American religions. Rock arts vary from lively naturalistic or schematic renderings of humans and animals to complex, convoluted compositions of as yet undeciphered symbols. The processions of linear, geometric, human (or spirit) figures carved into rock surfaces near Dinwoody,

Wyoming (FIG. **17-33**), have overlays suggesting successive visits, probably for ritual purposes. Precise dating of rock art often is impossible, and, although the example shown probably was made prior to European contact, others depict horses and guns and have more naturalistic renderings, indicating a later date of execution.

Most Native American art forms (rock painting, pottery, architecture) span great periods of time. Detailed chronological sequences of pottery styles are, in fact, the historian's major tool in dating and reconstructing the cultures of the distant past, especially in the Southwest, where written records were unknown. Many fine specimens of ceramics

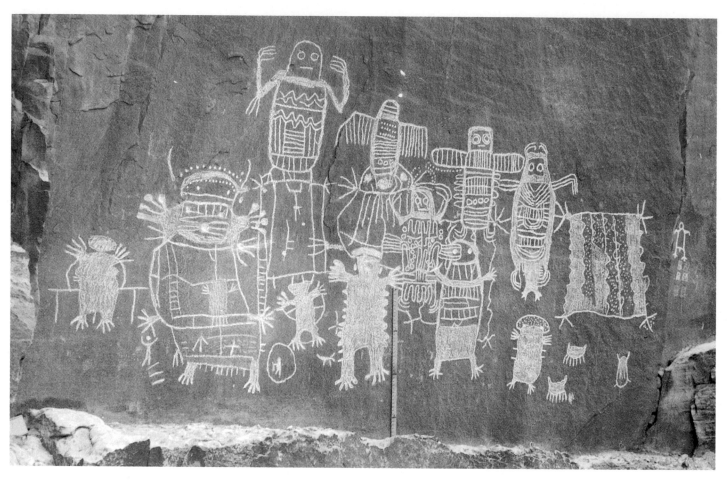

17-33 Human figures engraved on a sandstone cliff, prehistoric Shoshone (?), Dinwoody, Wyoming. Panel, 8'2" × 18'.

NORTH AMERICAN CHRONOLOGY

1000 B.C.	B.C. A.D.		1000	1500	1990
PREHISTORIC ERA*					HISTORIC ERA
Adena-Hopewell	Ipiutak			Kuaua Pueblo	Navajo
					Hopi
				Mississippian	Chilkat, Haida, Kwakiutl, Tlingit
					Iroquois
			Mesa Verde		Crow
					Mandan
				Mimbres	Sac and Fox

*Culture placements in the Prehistoric era reflect not just a period designation but actual chronological positioning.

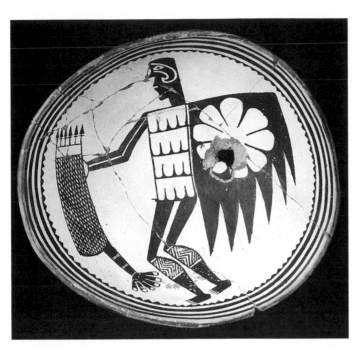

17-34 Bowl, Mimbres, thirteenth century. Ceramic, diameter 9″. Peabody Museum, Harvard University, Cambridge, Massachusetts.

called *kivas*, were the spiritual and ceremonial centers of Pueblo life. Pueblo Bonito contains similar rooms but contrasts with Mesa Verde in its open site and, especially, in its superbly unified plan. The whole complex is enclosed by a wall in the shape of a giant D. The careful planning suggests that it was designed by a single architect or master builder and constructed by hundreds of workers under a firm, directing hand. Modern terraced pueblos, like Taos in New Mexico, although impressive, reflect neither such unified design nor such a massive, well-organized building effort.

Between 1200 and 1400, long before Europeans arrived in the New World, ancestors of the present-day Hopi and Zuñi decorated their kivas with elaborate mural paintings representing deities associated with agricultural fertility. The detail of the Kuaua Pueblo mural shown (FIG. **17-36**) depicts a "lightning man" on the left side. Fish and eagle images (associated with rain) appear on the right side. Seeds, a lightning bolt, and a rainbow stream from the eagle's mouth. All of these figures are associated with the fertility of the earth and the life-giving properties of the seasonal rains.

from the Southwest date from before the Christian era until the present day, but pottery became especially fine, and its decoration most impressive, after about 1000.

A thirteenth-century bowl (FIG. **17-34**) from the Mimbres culture has an animated, graphic rendering of a warrior with a shield in a composition that creates a dynamic tension between the black figuring and the white ground. Thousands of different compositions are known from Mimbres in the Southwest. They range from lively and often complex geometric patterns to fanciful, often whimsical pictures of humans and animals; almost all are imaginative creations of artists who seem to have been bent on not repeating themselves. Designs are created by linear rhythms balanced and controlled within a clearly defined border. Because the potter's wheel was unknown in the Southwest, countless sophisticated shapes of varied size were built by the coiling method. These ceramics are always characterized by technical excellence.

In the later centuries of the prehistoric era, Native Americans of the Southwest constructed many architectural complexes that reflect masterful building skills and impressive talents of spatial organization. Of the many ruins of such complexes, Cliff Palace at Mesa Verde, Colorado, and Pueblo Bonito at Chaco Canyon, New Mexico, are among the best known. Cliff Palace (FIG. **17-35**) occupies a sheltered ledge above a valley floor and has about two hundred rectangular rooms (mostly communal dwellings) in several stories of carefully laid stone or adobe and timber; twenty larger, circular underground structures,

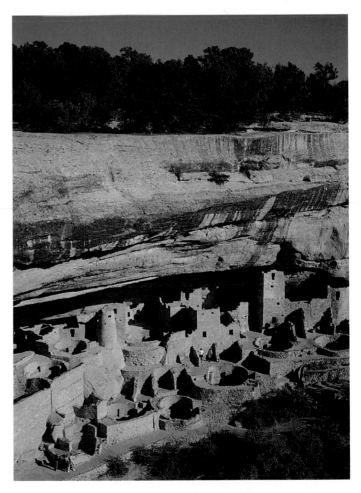

17-35 Cliff Palace, Mesa Verde National Park, Colorado, *c.* 1100.

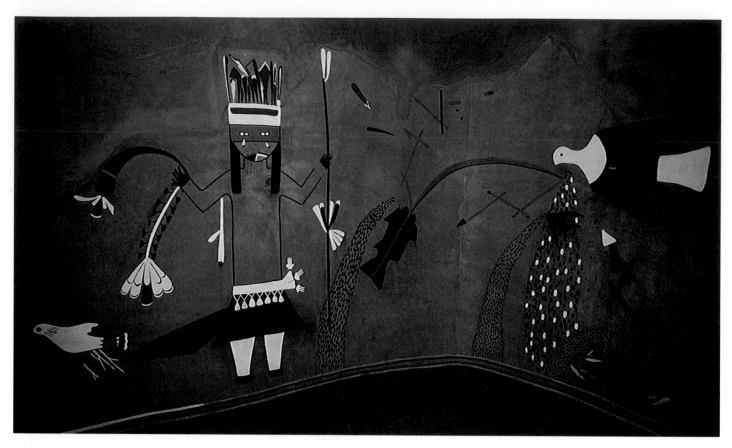

17-36 Detail of a kiva painting from Kuaua Pueblo (Coronado State Monument), New Mexico, c. 1300–1500. Museum of New Mexico, Santa Fe.

Historic Era

SOUTHWEST Obviously, the motivations, functions, and means of art forms from the historic period are better known than those of the art forms from earlier eras; while the complex prehistoric religious murals from the Southwest are hard to interpret, Navajo sand painting, an art that still survives, is susceptible of detailed elucidation. The highly transient sand paintings, constructed by artist-priests to the accompaniment of prayers and chants, are an essential part of ceremonies for curing disease. (In the healing ceremony, the patient sits in the center of the painting to absorb the healing, life-giving powers of the gods and their representations.) Similar rites are performed to assure success in hunting and to promote fertility in human beings and nature alike. The natural materials used (corn pollen, charcoal, and varicolored, powdered stones) play a symbolic role that reflects the Native Americans' preoccupation with the spirits and the forces of nature. The paintings, which depict the gods and mythological heroes whose help is sought, are destroyed in the process of the ritual, so that no models exist; still, the traditional prototypes, passed on from artist to artist, must be adhered to as closely as possible. Mistakes can render the ceremony ineffective. Navajo dry-painting style is rigid—composed of simple curves, straight lines, and serial repetition—despite the potential freedom of freehand drawing. A fine example is *Nightway: Whirling Logs* (FIG. **17-37**). The iconography is complex but explicit as a text. The central figures are the logs whirling in the meeting of rivers from which grow the four holy plants (black tobacco, blue beans, yellow squash, and white corn). On each log stand two Yei. At the east is Talking God, the god who talks to men, carrying his blue squirrelskin medicine bag. At the north and the south are two Humpbacks, the gods who brought seeds to men in their packs. They have mountain sheep horns and woodpecker feathers on their heads. Near them are their "gishes" or medicine canes. At the west is the Calling God with his cane in front of him. Navajo weaving and silver jewelry making are later developments that, until very recently, have met high technical and artistic standards.

Another art form from the Southwest, the Kachina spirit mask, contrasts markedly with the Northwest Coast and Eastern Woodlands masks. The Hopi spirit mask of a rain-bringing deity (FIG. **17-38**) is painted in geometric patterns based on rainbow, cloud, and flower forms. The more expressionistic handling of human physiognomy is quite obvious in the Northwest Coast and Eastern Woodlands masks (FIGS. 17-41 and 17-48).

NORTHWEST COAST Working in a highly formalized, subtle style, the Native Americans of the Northwest Coast

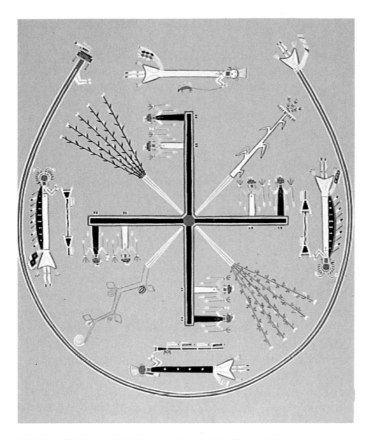

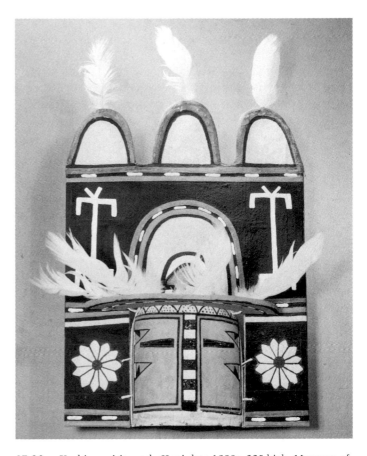

17-37 *Nightway: Whirling Logs.* Painted by Franc J. Newcomb prior to 1933. 22⁵/₈″ × 28³/₄″, Wheelwright Museum of the American Indian, Santa Fe, New Mexico.

17-38 Kachina spirit mask, Hopi, late 1890s. 22″ high. Museum of the American Indian, New York.

have produced a wide variety of art objects: totem poles, masks, rattles, chests, bowls, clothing, charms, and decorated houses and canoes. Masks were carved for use by shamans in their healing rites and by others in public reenactments of "spirit quests." The animals and mythological creatures encountered on such quests were, in turn, represented in masks and a host of other carvings. The Kwakiutl mask (FIG. **17-39**) owes its dramatic character to the exaggeration of facial parts and to the deeply undercut curvilinear depressions, which result in strong shadows. It is a refined, yet forceful carving typical of the more expressionistic styles of the area. Others are more subdued, and some, like a wooden Tlingit helmet (FIG. **17-40**), are exceedingly naturalistic, probably actual portraits, almost as if the artist were proving that no restrictions could be set on artistic representation. Inherited motifs and styles usually were preferred, however, above radical new departures. Although Northwest Coast arts have a spiritual dimension, they are more important as expressions of social status, in that the art form one uses and, indeed, the things one may depict, are functions of that status. Haida mortuary poles and house frontal poles (FIG. **17-41**), used where totemic crest emblems of clan groups are displayed before the clan chief's house, are striking expressions of this interest in social status.

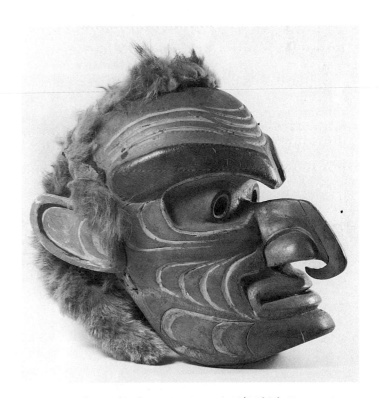

17-39 Mask, Kwakiutl, *c.* 1890. Approx. 13¹/₄″ high. Denver Art Museum.

Another characteristic Northwest Coast art form is the Chilkat blanket (FIG. **17-42**). Male designers provided the templates for these blankets in the form of pattern boards from which female weavers worked. The blankets, which became widespread prestige items of ceremonial dress during the nineteenth century, display several recurrent characteristics of the Northwest Coast style: symmetry and rhythmic repetition, schematic abstraction of animal motifs (in the blanket illustrated, a bear), eye designs, a regularly swelling and thinning line, and a tendency to round off corners.

Elegant, precise, and highly accomplished technically, the art of the Northwest Coast is held by many to be one of the sophisticated high points of Native American artistic accomplishment.

GREAT PLAINS Artists of the Great Plains worked in materials and styles quite different from those of the Northwest Coast. Much artistic energy went into the decoration of leather garments, first with compactly sewn quill designs and later with beadwork patterns. Tepees, tepee linings, and buffalo-skin robes were painted with geometric and stiff figural designs prior to about 1830; after that, naturalistic scenes, often of war exploits, in styles adapted from those of visiting European artists, were gradually introduced. After the Europeans introduced the horse to North America and the establishment of colonial governments disrupted settled indigenous communities on the east coast, a new mobile Native American culture flourished for a short period of time on the Great Plains. The tepee lining illustrated (FIG. **17-43**) is of that later style, when realistic action and proportions, careful detailing, and a variety of colors were employed.

Because, at least in later periods, most Plains peoples were nomadic, their esthetic attention was focused largely on their clothing and bodies and on other portable objects, such as shields, clubs, pipes, tomahawks, and various containers. Transient but important Plains art forms sometimes can be found in the paintings and drawings of visiting

17-40 Helmet. Tlingit. Wood, 12" high. Courtesy Department Library Services, American Museum of Natural History, New York.

17-41 A reconstruction of a Haida Indian longhouse, previously on Queen Charlotte Island. Museum of Anthropology, University of British Columbia, Vancouver, British Columbia, Canada.

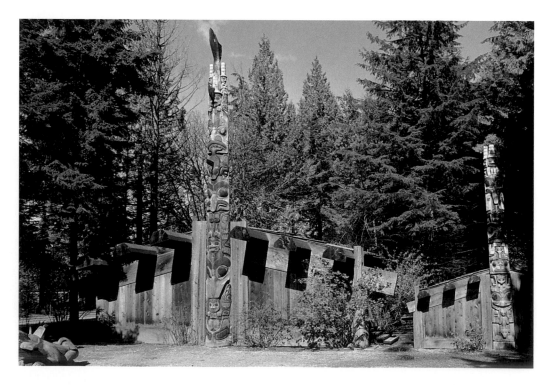

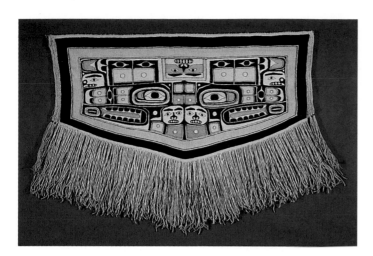

17-42 Chilkat blanket with stylized animal motifs, Tlingit, early twentieth century. Wild goat's wool and cedar bark, 72″ × 35″. Southwest Museum, Los Angeles, California.

white artists. The Swiss KARL BODMER, for example, accurately portrayed the personal decoration of Chief Four Bears (Mato-Tope, FIG. **17-44**), a Mandan warrior and chief. The Chief's body paintings and feather decorations, all symbolic of his affiliations and military accomplishments, may be said to be his biography—a composite artistic statement in several media—which could be "read" easily by other Native Americans. Plains peoples also made shields and shield covers that were both artworks and "power images." Shield paintings often derive from religious visions; their symbolism, the pigments themselves, and added materials, such as feathers, provided their owners with magical protection and supernatural power.

17-44 KARL BODMER, *Mandan Chief Mato-Tope*, 1840. Lithograph, 14″ × 10″. The Thomas Gilcrease Institute of American History and Art, Tulsa, Oklahoma.

17-43 Tepee lining with pictograph of war scenes, Crow, late nineteenth century. Painted muslin, 2′11″ × 7′1″. Smithsonian Institution, Washington, D.C.

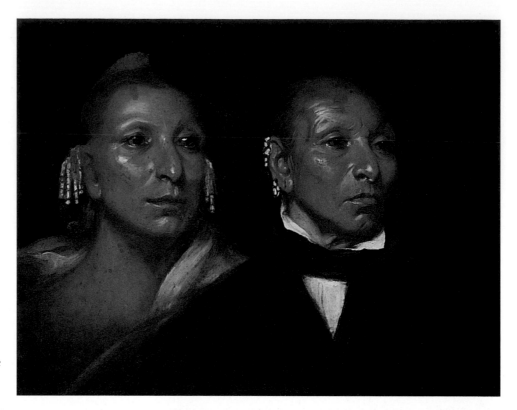

17-45 JOHN W. JARVIS, *Chief Black Hawk and His Son, Whirling Thunder*, 1833. Oil on canvas, 23¹/₂″ × 30″. The Thomas Gilcrease Institute of American History and Art, Tulsa, Oklahoma.

A picture contemporary with Bodmer's, but of widely different style and significance (FIG. **17-45**), was painted by a popular New York artist of the time. It is a double portrait of Black Hawk, chief of the Sac and Fox nations, and his son Whirling Thunder; Black Hawk is dressed in white man's garb, his son appears as a Native American. A short and brutal "war," named after Black Hawk, was waged in Illinois early in the 1830s between Black Hawk's people and settlers and militia aided, ironically, by the Sioux, traditional enemies of the Sac and Fox. The war ended with the defeat and dispersal of the latter. This was only one incident in the tragic uprooting of the native tribes of the eastern United States and their resettlement in the western territories; it was only a short chapter in a grim history of bad faith and broken treaties in which the United States played an unworthy part. Few portraits in the history of world art have depicted so poignantly the emotions of a proud people betrayed, overwhelmed, and dispossessed. The pensive sadness of the son, the noble stoicism of the father, their eyes brimming with tears, were rendered by an artist obviously moved by the significance of his subject.

Curiously, Black Hawk became a hero to the many settlers who sympathized with the native cause. In later years, a colossal statue, the Black Hawk Monument, was erected in Illinois as a memorial to the gallant chieftain and his people.

EASTERN WOODLANDS Artists of the Eastern Woodlands made quilled and beaded objects and items of clothing, often decorated with curvilinear, floral motifs. The Iroquois

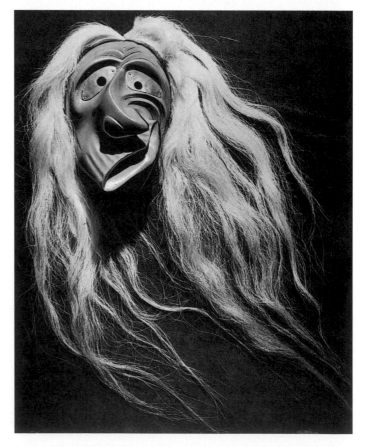

17-46 ELON WEBSTER, False Face mask, Iroquois, 1937. Wood. (The artist was an Onondaga of the Tonawanda Reservation.) Courtesy of Cranbrook Institute of Science, Bloomfield Hills, Michigan.

also carved compelling, expressionistic masks (FIG. **17-46**) for use in the False Face Society ceremonies, which healed physical and psychological sickness and cleansed whole communities of destructive impurities. The spirit "faces" portray legendary supernatural beings whose exploits are recounted in mythology. Bold in conception, these masks rely on a dramatizing distortion and exaggeration of facial features for their strong effects. Like others used in Africa and Oceania, these masks must be hidden when not in use, lest their power inadvertently cause injury.

Whether secular and merely decorative or spiritual and highly symbolic, the diverse styles and forms of Native American art testify to the ancient and continuing artistic sensibility of the peoples of North America. Their creative use of local materials and pigments constitutes an artistic reshaping of nature that, in many cases, reflects the Native Americans' reliance on and reverence toward the environment that they considered it their privilege to inhabit.

OCEANIA

Relative to the abundant records associated with Western art, only a vague chronology can be established for the early arts of Oceania in the absence of documentary evidence, even though archeologists, linguists, and others have gone far in sorting out migration routes, language and racial distributions, and certain aspects of Stone Age technology and social organization. The ongoing efforts of archeologists and other investigators continue to shed light on the development of the arts of Oceania.

The thousands of islands that make up Oceania conventionally are divided into three cultural areas: Polynesia, Melanesia, and Micronesia. Polynesia was the last area in the world to be settled. Its inhabitants brought complex sociopolitical and religious institutions with them. Though each area had and continues to have distinctive qualities that mark its art, a general homogeneity of style (lacking in Melanesia) characterizes much Polynesian art, despite the relative isolation of various island groups during the several centuries prior to European exploration. Polynesian societies typically are aristocratic, with ritual specialists and elaborate political organizations headed by chiefs. Polynesian art forms often serve as a means of upholding spiritual power (*mana*), which is vested in the nobility and channeled by ancestral and state cults.

Melanesia certainly was settled early, and its art forms seem to suggest a variety of overlays of style and symbolism brought with a series of migrations. Art styles are numerous and extremely varied. Typical Melanesian societies are more democratic than Polynesian societies and relatively unstratified. Their cults and art forms address a host of legendary ancestral and nature spirits. Masks, absent in Polynesia, are central in many Melanesian spirit cults, and elaborate festivals, in which masks and other art forms are displayed, occur with some frequency.

The architectural remains, weaving, tattoo, and carved images of Micronesia will only be mentioned here in passing, but the visual arts of the other two areas will be examined in greater detail. The rich arts of Australia and New Zealand, though quite distinct from those of other areas, often are included in discussions of Oceanic art and will be mentioned briefly in this chapter also.

Polynesia

Polynesian artists excelled in carving figural sculptures in wood, stone, and ivory in sizes that range from the gigantic, fabled stone images of Easter Island to tiny ivory Marquesan ear plugs an inch long. These sculptures were generally full-volumed, monochromatic human figures, often dynamic in pose. Polynesians also were adept at making decorative bark cloth, called *tapa*, which played a crucial role in Polynesian society as clothing, bedding, and gift articles, and the art of tattooing was highly developed (the word *tattoo* is of Polynesian origin).

Polynesian carving at its most dramatic is represented by the Hawaiian figure of the war god, Kukailimoku (FIG. **17-47**). Huge wooden images of this deity were erected on

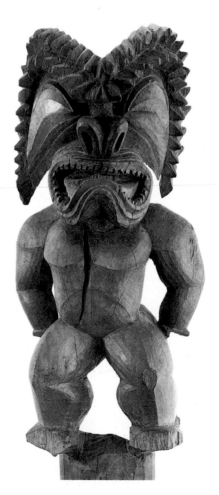

17-47 Kukailimoku, from Hawaii, Wood, 30" high. British Museum, London.

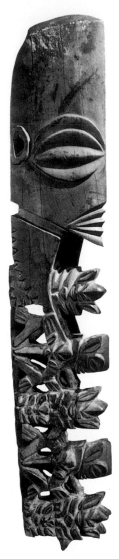

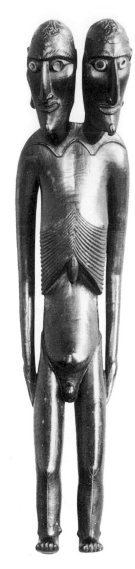

another by the vast distances to be covered in open outriggers to allow distinct regional styles to develop within a recognizable, general Polynesian style. Thus, the arts of central Polynesia, represented here by the contrasting art forms of a wooden District God (FIG. **17-48**) and a skeletalized, double-headed male figure from Easter Island (FIG. **17-49**), are quite different from the Hawaiian figures. The highly polished District God from the Cook Islands has a blade-shaped head and schematized features. Instead of a body, numerous tiny, abstracted figures—the god's progeny—are carved in the same geometric, angular style as the head above. Such carvings probably represented clan ancestors, revered for their protective and procreative powers. Analogous images from Mangaia in the Cook Islands and Rurutu in the Austral Islands also have multiple figures attached to their bodies. All such images refer ultimately to creator deities, who are revered for their central role in human fertility. The double-headed male figure, although rather

17-48 District God, from the Cook Islands, nineteenth century. Wood, approx. 25″ high. Peabody Museum, Harvard University, Cambridge, Massachusetts.

17-49 Double-headed male figure (*moai kava-kava*), from Easter Island, before 1860. Wood, approx. 16″ high. Museum of Natural History, La Rochelle, France.

stone temple platforms that, in varied forms, were part of the apparatus of all Polynesian religions. Although relatively small, the figure illustrated here is majestic in scale and forcefully carved to convey vigorous tensions; in short, the form possesses much of the ferocity attributed to the deity. Flexed limbs and faceted, conventionalized muscles combine with the aggressive, flaring mouth and serrated headdress to achieve a tense dynamism seldom rivaled in any art. This carving is the work of a master sculptor supremely confident with respect to materials and technique—a work that speaks forcefully across cultural barriers.

Even though Polynesians were skillful navigators, various island groups remained sufficiently isolated from one

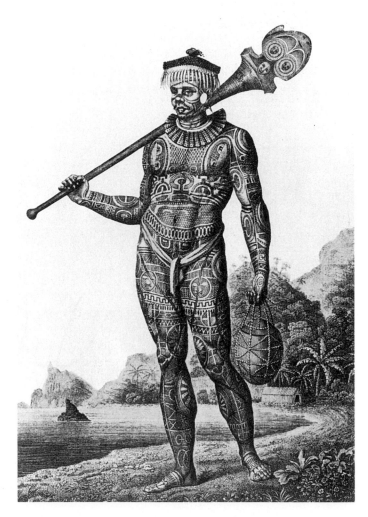

17-50 Tattooed Marquesan warrior, nineteenth century. Engraving.

atypical of much Polynesian work, may represent a mytho-logical ancestor or deity of the early inhabitants of Easter Island. Its bent posture and the emphasis on skeletal struc-ture reflect an esthetic quite different from that of the massively aggressive sculpture of the Hawaiian war god (FIG. 17-47).

Polynesians developed the painful but prestigious art of tattoo more fully than other Oceanic peoples. Nobles and warriors, especially, were concerned with increasing their status, mana, and personal beauty by accumulating various tattoo patterns over the years. An early nineteenth-century engraving (FIG. **17-50**) shows Marquesan tattoo patterns, with divided and subdivided geometric motifs covering most of the body. Such a multiplication of small, repetitive, abstract forms (a feature also seen in the "children" on the District God) is one major tendency in much Polynesian art. The other main tendency—that toward bold, full-volume, large-scale figural sculptures—is manifest in the Hawaiian war god (FIG. 17-47).

The highly distinctive arts of the Maori peoples of New Zealand merge these two stylistic currents in images that are at once dynamic and intricate; major forms are bold but surfaces are covered and interconnected by minute curvilinear detailing. The door lintel shown (FIG. **17-51**) comes from a meeting house generously decorated, inside and out, with technically refined, complex imagery. The subjects are real and mythological ancestors, whose advice and protection were sought for the political, war-making, and ritual deliberations that took place within the meeting house. Countless prestige items and weapons used by the Maori nobility displayed this unique style, as did the tattooing on their faces and bodies (Introduction, FIG. 13). Similar meeting houses are among the most recent examples of a Maori cultural revival in New Zealand. These contemporary structures serve not just the meeting place purpose of years ago, but function also as community cen-ters and an obvious symbol of Maori cultural identity.

Melanesia

Despite the aggressive poses of the figural art of Hawaii and the lively surface convolutions found in the art of New Zealand, Polynesian art generally is characterized by com-pactness, solidity, and restraint, as exemplified in the Cook Islands District God (FIG. 17-48). Melanesian art, on the other hand, has a colorful, flamboyant aspect, epitomized in wood carvings from New Ireland (FIG. **17-52**). The bewil-dering intricacy of the New Ireland wood carvings, called *malanggan*, which are used in display ceremonies of the same name, stems from generous use of openwork and sliverlike projections and from over-painting in minute geometric patterns that further subdivide the image. The result is a "splintered" or fragmented and airy effect. This style is even more remarkable in view of the fact that most of these forms are carved from a single block of wood (a characteristic of all of the woodcarving considered in this chapter). In the dramatic scene shown, several malanggan showpieces are set up in a special house that was opened to

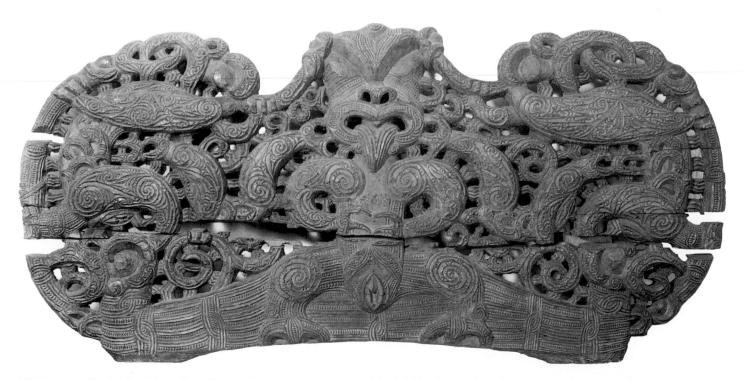

17-51 Door lintel, Maori, from New Zealand, late nineteenth century. Wood, 19" × 45". Peabody Museum of Salem, Massachusetts.

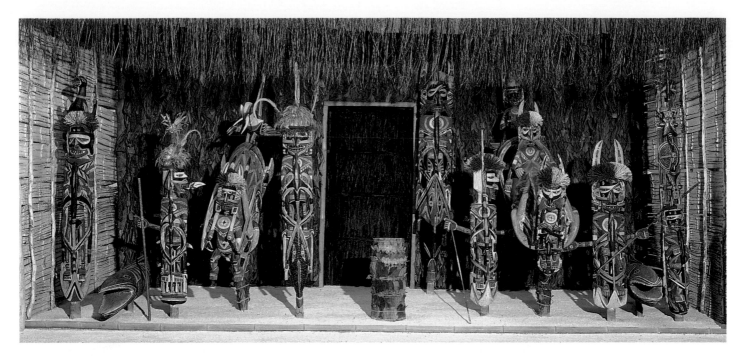

17-52 Malanggan tableau, from New Ireland, nineteenth to twentieth century. Bamboo, palm and croton leaves, painted wood, approx. 8′ high, 16′6″ wide, 10′ deep. Museum für Völkerkunde, Basel, Switzerland.

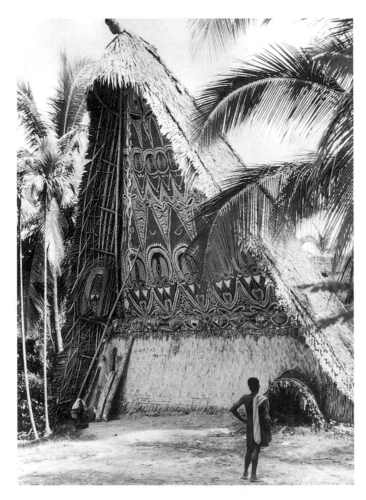

17-53 Ceremonial Men's House, Abelam, New Guinea.

the public; the associated rituals served both to commemorate ancestors and to initiate youths into adulthood. Dancers wearing a variety of intricate masks also performed during these rites.

The Melanesian penchant for color and drama in art is reflected too in the Abelam cult sculptures and paintings found on (and inside) the monumental Men's Houses in New Guinea (FIG. **17-53**). Rows of mythological creatures, intricately painted in contrasting bright colors, are portrayed in the gable paintings on these buildings. The heads of the figures are emphasized for their importance and in recognition of their power.

In other Melanesian art forms from the Papuan Gulf and Asmat areas of New Guinea's south coast, the artists distort human forms according to local preferences, which here, as elsewhere, are not at all attuned to realistic proportions or modeling. The fact that remote spirits and ancestors are portrayed partially accounts for the lack of naturalism, as do the long traditions of repeating and renewing such spiritual images. The Papuan Gulf figure (FIG. **17-54**) is a Melanesian version of the power image, whose in-dwelling spirit is invoked to protect and otherwise benefit the figure's owner. The Asmat pole (FIG. **17-55**) is erected in ceremonies that prepare the participants to avenge the death of a community member in war. The openwork "flags" are penises, exaggerated in a reflection of the Asmat male's aggressive roles in matters involving fertility and power, such as sexual interactions and perhaps head-hunting.

The Asmat and many other Oceanic peoples were headhunters until early in the twentieth century, and many of their art forms were created for rituals concerned with

head-hunting and attendant beliefs about the loss and gain of the life-force. In several cultures, including the Iatmul of the Sepik River, artists cleaned the human skulls of ancestors and reworked them into art objects (FIG. **17-56**) by modeling over the skull with a claylike paste and painting

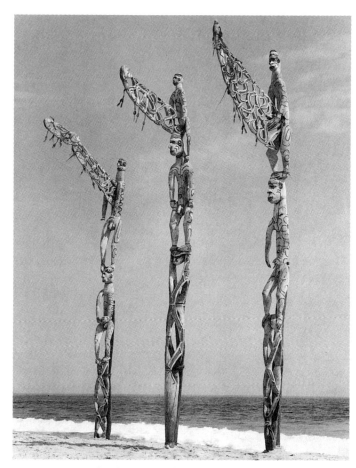

17-55 Ancestral poles, Asmat, from New Guinea, 1960. Wood, paint, sago palm leaves, approx. 18' high. Metropolitan Museum of Art, New York.

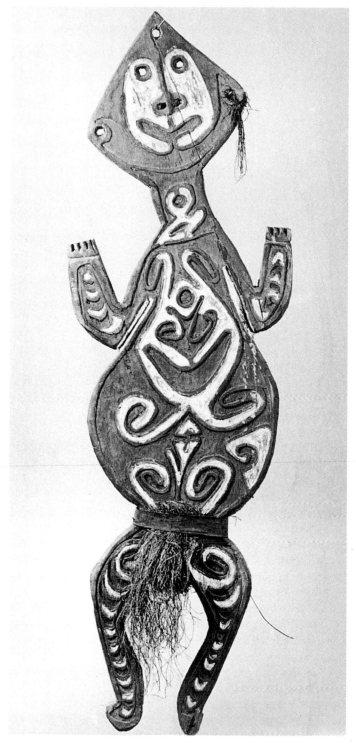

17-54 Spirit figure, from the Papuan Gulf, New Guinea. Wood, fibers, bark, red and white paint, 51" long. Tropenmuseum, Amsterdam, Netherlands.

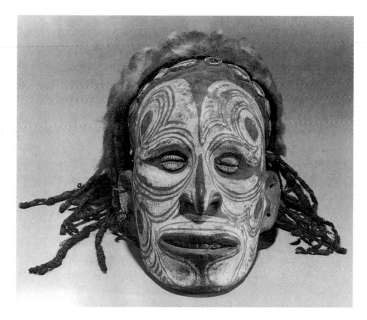

17-56 Skull, Iatmul, from New Guinea, nineteenth to twentieth century. Human skull, clay, paint, human hair, cuscus fur, 10" high. Metropolitan Museum of Art, New York (gift of Mr. and Mrs. John J. Klijman).

the resultant form with the kinds of flowing facial decoration worn in life, particularly on ritual occasions. These graphic images (a fascinating parallel to the "reconstructed" prehistoric skulls found at Jericho, FIG. 1-15) were believed to contain the life-force or power that men sought to increase by head-hunting; the heads were displayed in ceremonies preparing for war or celebrating its success, as well as at funerals.

Face and body decoration are still important art forms in several parts of New Guinea. Although of course extremely transient, such embellishments can be highly complex, colorful, multimedia assemblages of pigments, feathers, fur, leaves, shells, and other materials, which gain both symbolic significance and artistic impact from their combination. Men and women decorate themselves in this fashion to display their idealized beauty and to compete with rivals similarly embellished.

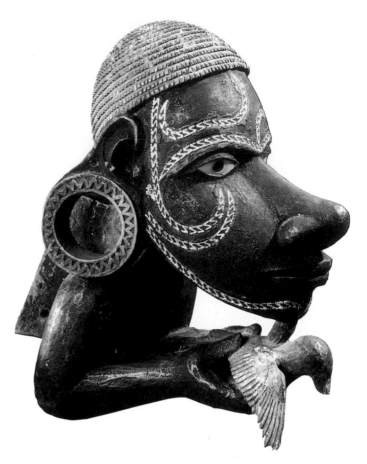

17-58 Canoe-prow figure, from the Solomon Islands, Melanesia, nineteenth to twentieth century. Wood with mother-of-pearl, 6¹/₂" high. Museum für Völkerkunde und Schweizerisches Museum für Völkskunde, Basel, Switzerland.

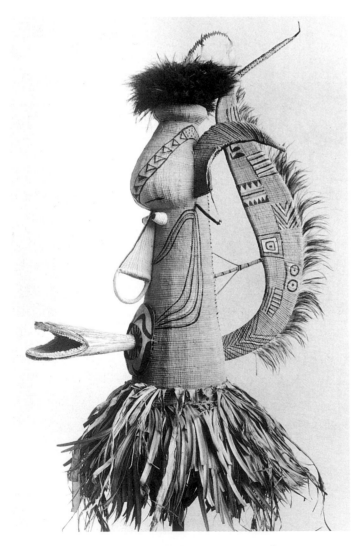

17-57 Mask, Sulka, from Melanesia, 1900–1910. Fiber structure covered with pith, feathers, and pieces of wood, 27" high (without leaf skirt). Übersee-Museum, Bremen, Germany.

Varied types and styles of masks were worn in Iatmul ceremonies, as well as in ceremonies conducted by the peoples of New Britain, New Ireland, Abelam, the Papuan Gulf, Asmat, and other areas. These masks were used in ceremonies to materialize spirits whom the people felt the need to entertain and propitiate (uses similar to those for which masks were employed in Africa and the Americas). Elaborate festivals sometimes included over a hundred such "spirit impersonators," who danced to amuse the human community and, at the same time, to remind it of its obligations to supernatural ancestors and culture-bringers. Many of the same masked spirits played an important role in initiating and educating youths to be fully socialized, productive members of the group. Melanesian artists' creativity and imagination are especially evident in the design of the heads and bodies of spirits. A flamboyant Sulka mask (FIG. **17-57**) is but one example of a type of mask made by stretching and sewing vegetable fibers over a light framework. These and other Melanesian masks were quite perishable; indeed, in some areas, the masks were destroyed ritually at the end of a ceremony, an act that ban-

ished the spirits until their next "invitation" to intervene in human affairs.

Some Melanesian styles, like that of the Solomon Islands, are more restrained than those just discussed. In the canoe-prow carving shown here (FIG. **17-58**), which served both practical and spiritual purposes of protection, the emphasis is on strong modeling, the enlargement of facial features, and very precise inlay patterns of seashell fragments that contrast with the solid dark color of the head itself. In several Melanesian areas, as in areas of Polynesia (recall the Maori lintel, FIG. 17-51), styles combine high-contrast, intricate surface patterns with bold sculpture. In some other areas, masks are not used, suggesting that these may be transitional cultures between those in which the less restrained Melanesian style prevails and those in which the more restrained Polynesian style, with its more solid, full-volumed sculpture is dominant.

Australia

In Australia, most objects are ceremonial aids used to link the native Australian people with the legendary past, or "Dream Time," when their world, its creatures, and its institutions were created. For the native Australian, the fertility of nature and humanity and the continuity of life itself depends on reenactments of the primordial events of the Dream Time. Cosmogonic myths are recited in concert with songs and dances, and many art forms (body painting, carved figures, decorated stones, rock and bark paintings) are essential props in these dramatic re-creations. A bark painting by MUNGARAWAI, entitled *The Djanggawul Sisters* (FIG. **17-59**), describes, in schematic form, the birth of the human race, along with other mythical episodes from the Dream Time. The Djanggawul sisters and brothers are the mythological progenitors of the Yirrkala people of Arnhem Land, a region on the north coast of Australia in the Northern Territory. Symbolic motifs include trees and pole emblems, the rising and setting sun, a Djanggawul brother, and (top right) the artist himself. The intricate style is representative of the main features of Yirrkala art: rhythmic repetition, subdivision into crowded panels, fine detailing, and lack of a ground line, perspective, or modeling.

Australian art is well known, too, for its "X-ray" style (FIG. **17-60**), which simultaneously depicts both the insides (backbone, heart, and other organs) as well as the outsides of human beings and animals. This style of painting is common to the area of Arnhem Land called Oenpelli. Our example shows a hunter and his quarry, a black kangaroo, at the moment a spear is about to strike the startled animal. In contrast to the rather static order of the Yirrkala composition, the Oenpelli painting has a fluid and dynamic quality. The figures are large in relation to the surface on which they have been placed and, unlike the distant, "bird's-eye" view of the Yirrkala painting, the immediacy of the depicted action tends to draw the viewer into its orbit.

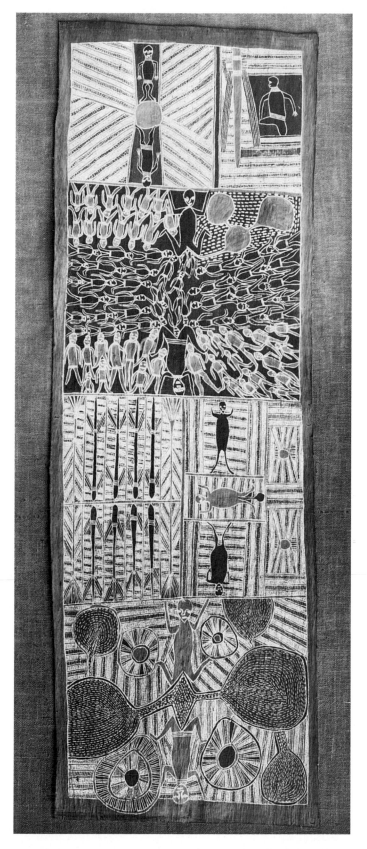

17-59 MUNGARAWAI, *The Djanggawul Sisters*, Yirrkala, from Arnhem Land, Australia. Bark and paint. Art Gallery of New South Wales, Australia.

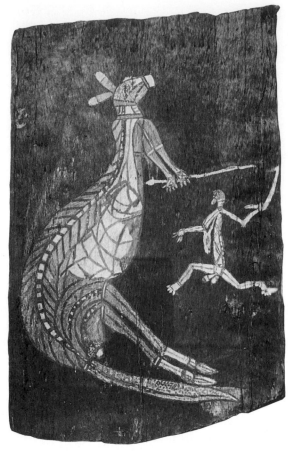

17-60 *Hunter and Kangaroo,* Oenpelli, from Arnhem Land, Australia, *c.* 1913. Paint on bark, 51″ × 32″. National Museum of Victoria, Melbourne, Australia.

AFTERWORD: THE PRESENT

Many of the traditional native arts of the Americas and Oceania are not now being practiced, for they no longer have critical roles in cultural continuity and survival. Yet in a number of places, with the stimulus of cosmopolitan contacts in a shrinking world, they have been revitalized and flourish energetically. New, confident cultural awareness has led native artists to assert their inherited values with pride and express them in a resurgence of traditional arts such as weaving, painting, and carving.

One example that can stand for the many cases of cultural renewal in native art is the vigorously productive school of New Zealand artists who draw upon their Maori heritage for formal and iconographic inspiration. The historic Maori craft of woodcarving (FIG. 17-53) brilliantly re-emerges in what the artist calls a "carved mural" (FIG. **17-61**). *Tawhiri-Matea* (God of the Winds) by CLIFF WHITING is a piece of bravura wood crafting, designed for the very modern environment of an exhibition gallery, or for the embellishment of a corporation wall. The turbulence of wind is given by the restless curvature of the main motif, and in its myriad of serrated edges. The mural depicts events in the Maori creation myth. The central figure, *Tawhiri-Matea,* god of the winds, wrestles to control *te whanau puhi,* the children of the four winds, seen as blue spiral forms. *Ra,* the sun, energizes the scene from top left, complemented by *Marama,* the moon, in the opposite corner. At top right is the reference to the primal separation of *Ranginui,* the sky father, and *Papatuanuku,* the earth mother. The spiral *koru* motifs symbolizing growth and energy

17-61 CLIFF WHITING (TE WHANAU-A-APANUI), *Tawhiri-Matea (God of the Winds),* 1984. Oil on wood and fiberboard, approx. 6′ 4³/₈″ × 11′ 10³/₄″. Meteorological Service of New Zealand Ltd. Collection, Wellington.

flow through the composition. Blue waves and green fronds about *Tawhiri* suggest his brothers *Tangaroa* and *Tane*, gods of the sea and forest.* The artist is securely at home with the native tradition of form and technique, as well as with the worldwide esthetic of modernist design. Out of the seamless fabric made of the union of both, he feels that something new can develop that loses nothing of

*This iconographical explanation courtesy of Meteorological Service of New Zealand Limited, Kelburn, Wellington.

the power of the old. "Our people," he declares, "must develop new forms with which they can identify . . . we need to train the young to have, to find responsibility, within our culture, so that we can be assured of the transmission of the culture." This is a call not only for the renewal of cultural life in terms of its continuity in art, but for the education of the young in the values that made that culture great, values they are called upon to perpetuate. The salvation of their native identity will depend upon their success in making that culture once again their own.

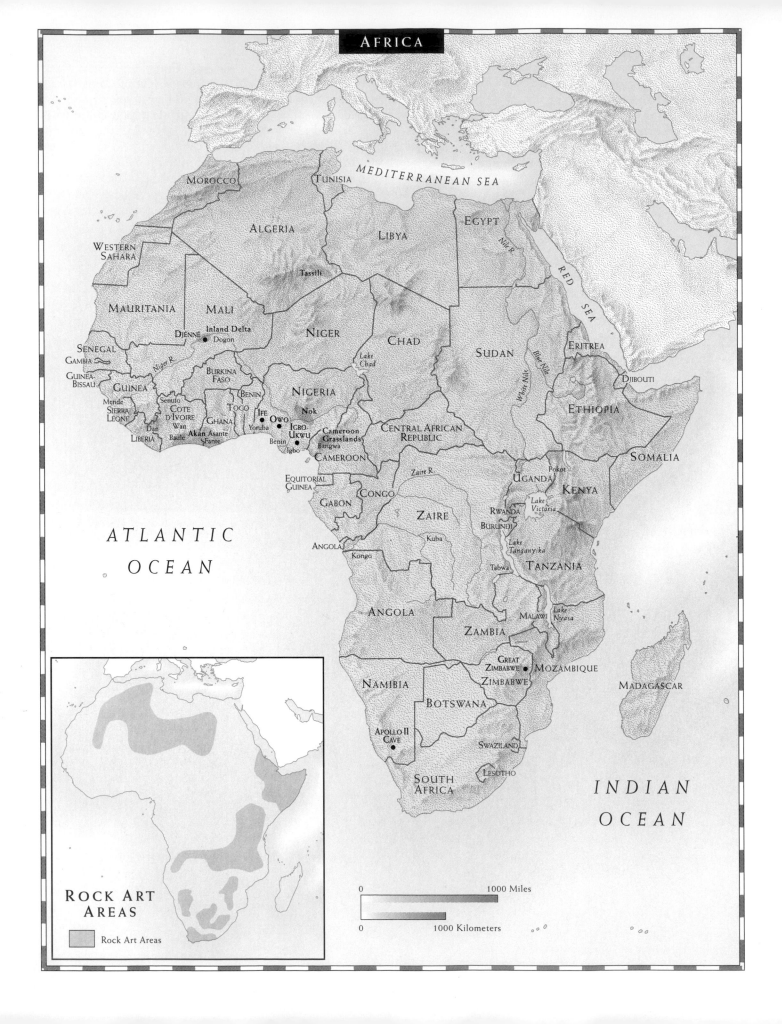

AFRICA

MEDITERRANEAN SEA

MOROCCO
TUNISIA
WESTERN SAHARA
ALGERIA
LIBYA
EGYPT
Nile R.
RED SEA

MAURITANIA
MALI
Tassili
NIGER
CHAD
SUDAN
ERITREA
DJIBOUTI

SENEGAL
GAMBIA
Niger R.
DJÉNNÉ ● Inland Delta
● Dogon
Lake Chad
Blue Nile
White Nile

GUINEA-BISSAU
GUINEA
BURKINA FASO
BENIN
NIGERIA
Nok
ETHIOPIA

Mende
SIERRA LEONE
Senufo
CÔTE D'IVOIRE
Wan
TOGO
GHANA
IFE ● Owo
Yoruba ● IGBO-
Dan
LIBERIA
Baule
Akan Asante
Sfante
Benin ● UKWU ●
Igbo
Cameroon
Grasslands
Bangwa
CENTRAL AFRICAN
REPUBLIC
SOMALIA

CAMEROON
EQUITORIAL GUINEA
GABON
CONGO
Zaire R.
ZAIRE
UGANDA
Pokot
KENYA
Lake Victoria
RWANDA
BURUNDI
Kuba
Lake Tanganyika

ATLANTIC OCEAN

ANGOLA
Konga
Kongo
Tabwa
TANZANIA

ANGOLA
ZAMBIA
MALAWI
Lake Nyasa

NAMIBIA
GREAT ZIMBABWE ●
MOZAMBIQUE
ZIMBABWE
MADAGASCAR

BOTSWANA

APOLLO II CAVE
●
SWAZILAND
SOUTH AFRICA
LESOTHO

INDIAN OCEAN

ROCK ART AREAS

☐ Rock Art Areas

0 1000 Miles

0 1000 Kilometers

Chapter 18

The Arts
of Africa

300 A.D.	800	1600	1900 - Present

Rock art stretches from 25,000 b.c. to 19th century

Jemaa Head, Nok
5th cent. B.C.-4th cent. A.D.

Ife king
Yoruba, 10th-12th cent.

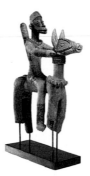

Equestrian figure
Inland Niger Delta
1000-1500

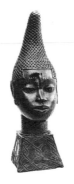

Queen Mother head
Benin, 16th cent.

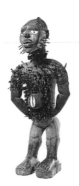

Kongo figure
c. 1875-1900

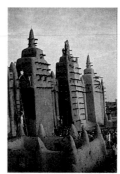

Djénné Mosque
1906-1907

First Sub-Saharan ceramics, 500 B.C.-200 A.D.

First copper alloy castings, 880-100

The enormous African continent—comprising fifty-two nations—is inhabited by hundreds of distinct ethnic, cultural, or linguistic groups that are often, but inaccurately, called "tribes." These groups range in size from a few thousand, governed by groups of elders, to several million, sometimes divided into quite autonomous kingdoms, as among the Yoruba. Many sub-Saharan Africans have been non-literate until the last few generations, whereas Islamic peoples in West Africa have been reading and writing Arabic since at least the twelfth century.

Vastly different topographical and ecological zones also characterize Africa. Parched deserts occupy northern and southern regions, high mountains rise in the east, and countless lush river valleys are common. Three great river systems—those of the Niger, the Zaire (formerly called the Congo), and the Nile—with their tributaries, support varied agricultural economies and large sedentary populations. Huge tracts of grassland are either agricultural or provide pasturage for the animals of nomadic and semi-sedentary herding peoples, who prefer their wandering life-style to that of more settled neighbors and reckon wealth by the size of their herds. Fishermen harvest the oceans and rivers, and some relatively small groups still prefer to hunt and gather their foods even though they (and the herders) know about raising crops in gardens.

Over the millennia the people of Africa have created a vast array of visually expressive forms that have come to be known as African arts. These arts include a broad range of types, materials, and technologies ranging from prehistoric rock images and ceramic sculptures, made well before the time of Christ, to the cement sculptures and urban murals of today. Textiles, jewelry, scarification, and painting normally adorn individuals. Families commission architecture, often finely embellished, as well as pottery, furniture, and shrine objects. The larger men's or women's groups and even whole communities sponsor shrines and their architectural settings. The arts of masquerade and festival incorporate large numbers of objects essential to the creation and expression of meaning in these public performances.

The visual arts encode ideas central to the ideologies and worldviews of African peoples. In some cases the art refers to or displays information—revealing or concealing it—while in others the object itself is an ideological instrument, a value that has no real equivalent. Art then helps define and create culture; it is integral to African life and thought rather than serving only as adornment.

All the hundreds of ethnic groups, speaking as many mutually unintelligible languages, have visual arts that differ according to economy and life-style. Herders emphasize the arts of personal adornment, exemplified by the striking hairstyles and beaded jewelry of young warriors among the Pokot of Kenya (FIG. **18-1**). Early hunters and gatherers made many of the pictographs and petroglyphs found scattered across the continent. Farming peoples have always been the major wood and clay sculptors and metal-

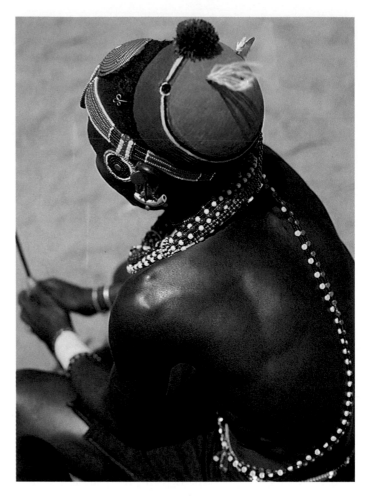

18-1 Male warrior with mudpack hairstyle and beaded jewelry, Pokot, Kenya. Photographed in 1973.

smiths, and it is the art of these agriculturists that will be stressed here.

It is clear that most African peoples make no distinction between "fine" and "applied" art or crafts, and none will be made here. Until recently, too, most African peoples have not isolated visual arts into a distinct conceptual category, as suggested by the absence of a word in most African languages that translates accurately into the English word *art*. This realization connects with other issues regarding these arts: the importance of contexts to their understanding, the variable points of view of commentators, and distinctions between local African interpretations and those of outsiders.

THE VARIED CONTEXTS OF AFRICAN ART

The human and physical contexts in which arts function vary greatly in Africa, which in turn signals the significance of the experience and vantage point of the participant or viewer. A masked performance will be understood in one

way by a performing dancer, but in an entirely different way by an uninitiated child or by a woman being chased by the masquerader. Further, a single masked dancer is usually only one unit in a larger ceremonial whole: the performances, for instance, of several or even dozens of different masqueraders who may reenact stories of origin or invoke multiple ancestors and spirits of nature, as among the Dogon of Mali (FIG. **18-2**). A mask may become more powerful as it grows older; it may then be housed in a shrine, as a power object—both its context and its meaning having changed. A mask will also change radically into a commodity when it is offered for sale to an art dealer. The same mask is transformed again substantially when spotlighted under plexiglass in a museum or when it adorns a collector's living room. Each context offers new points of view, a different audience, fresh opportunities for interpretation, different meanings. It is also essential for us to realize the extent to which we, as outsiders, have affected the arts of Africa and how we help to change their significance when we remove them from their original contexts.

This brief survey of selected types and styles of African art explores varied contexts, combining local information on use, function, and meaning derived from research in Africa with interpretive strategies devised for the most part by outsiders. For it is we who reclassify socially, spiritually, and politically useful objects into "works of art." We will look next at style, artists and their materials, and the historical nature of art. The bulk of this chapter will then be devoted to three major categories into which African art usefully can be divided: leadership arts, spiritual arts, and masquerades. These are only devices for classification; some art forms operate in two or even all three categories. A Benin royal altar (FIG. 18-16), for example, is the site of sacrifices that strengthen the king as a ruler. The altar is also an assemblage of historical and ritual "documents" or "texts" that aid in the reconstruction of Benin art history and ceremonial process. The altar exemplifies other vital dimensions of art, such as its active centrality in the lives of the people who commission and use it, its capacity for encoding values and levels of knowledge, and its varied kinds of symbolism.

STYLISTIC DISTINCTIONS

As is made clear throughout this book, art styles vary according to time and place of manufacture, and by individual hands of artists. Period, geographic, and personal style distinctions are also true for Africa, even if earlier publications stressed what were seen as fairly homogeneous styles developed by entire ethnic groups such as the Yoruba, Dogon, Dan, or Baule, whose styles were also seen as fixed over long periods. Recent scholarship, however, documents a far greater diversity and fluidity of style across regions, time periods, and materials. Not only do the Yoruba or Igbo, for example, have many regional styles; it is now clear that these, as well as individual styles, change over time.

African sculpture and painting are generally characterized by greater or lesser degrees of conventionalization. Most artists work from a conceptual model rather than by perceptual translations from observing living human or animal models. Thus each sculptural or painting genre tends to have its own formal conventions that are held in the artist's mind and are normally shared by others from the region working in the same genre. Akan peoples of Ghana, for instance, have a long-standing convention of figures with flat, disc-shaped heads. Women who model commemorative ceramic sculpture (FIG. **18-3**) for display in royal funerary rites and graveyards work in this style, as do men who carve small wood figures often found on shrines (FIG. 18-21). Each artist works from and incrementally alters these conceptual models with each new work, as the variations seen in the shrine indicate. In the last few decades and in response to influences from Europe and America, however, earlier conventions have been significantly altered. We will look at some of these changes at the end of the chapter.

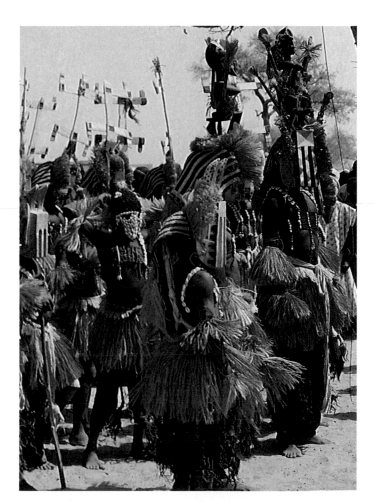

18-2 Dama ceremony masqueraders, Dogon, Mali. Photographed in 1989.

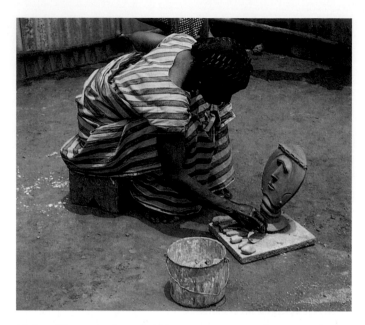

18-3 Woman sculptor finishing ceramic ancestral portrait, Akan, Ghana. Photographed in 1965.

ARTISTS AND MATERIALS

Until the last decade or two, the production of art in Africa was quite rigidly gender-specific. Men were (and largely still are) wood, ivory, and stone carvers, leather workers, ironsmiths, gold and copper-alloy casters, as well as architects and builders. Women are wall and body painters, calabash decorators, potters, and often ceramic sculptors, although men do this in some areas. Both men and women work with beads and weave, men executing narrow strips (later sewn together) on horizontal looms, whereas women work vertical looms, producing cloth with wider weft dimensions. Much art in process, however, is collaborative. Men may build a clay wall, for example, but it will be decorated by women. Festivals, which invoke virtually all the arts, are truly collaborative. In most regions, too, until recently there has been no great emphasis on artists' individuality, even when personal styles are clearly recognizable. This is not to say that art is anonymous or that artists are not honored locally. Rather, Africans have tended not to exalt the individual, innovative artist as much as Euro-Americans do.

CHRONOLOGY AND AFRICAN ART

Like all art, that of Africa is profoundly historical. It can be dated on the basis of style and often by scientific techniques as well. These include contextual analyses of archeological excavations in some cases, along with radiocarbon dating of organic materials (wood, fiber, ivory) and thermoluminescence (for ceramic sculpture and pottery). We try to determine when an object was made and what sorts of

changes occurred over time to forms of similar type. The thin copper-alloy casting of a Benin Queen Mother's head (FIG. **18-4**), for instance, is early in a series of known heads and probably dates from the early sixteenth century. Later cast heads are larger, heavier, and more highly stylized. Thus, while an overall, comprehensive history of African art remains to be written, important historical information is available for many genres and regions.

Furthermore, many works of art are themselves useful documents for historical reconstruction. Questions asked about a figure or mask in an African community elicit answers—accounts of origin or changes over time—that are essential to understanding the history of a people or region or specific art form. From reports in Yorubaland, for example, we know that a finely carved two-panel wooden door from the king's palace in Ikere (FIG. **18-5**) records, in a rather complex composition, the visit of one Captain Ambrose, a colonial officer, to the Ikere king in 1897. Each panel was carved from a single log by a man famous among his own people for his virtuoso doors and houseposts. This master artist, OLOWE OF ISE, was sought after by many kings

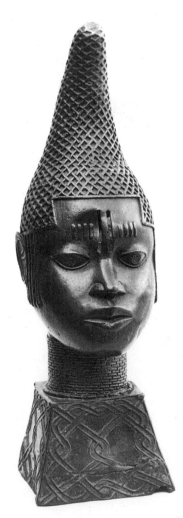

18-4 Queen Mother head, from Benin, Nigeria, early sixteenth century. Bronze, 20" high. National Museum, Lagos, Nigeria.

thousand years. While both precise dating and full understanding of meanings are problematic for much rock art, a considerable literature exists that describes, analyzes, and interprets the varied human and animal activities shown, as well as more abstract patterns that are evidently symbolic. Overall meanings probably coincide with those of the later arts (mostly sculpture) of agricultural areas: references to ideas and rituals pertaining to the origin, survival, and continuity of human populations.

The earliest African sculpture in the round has been found at several Nigerian archeological sites collectively

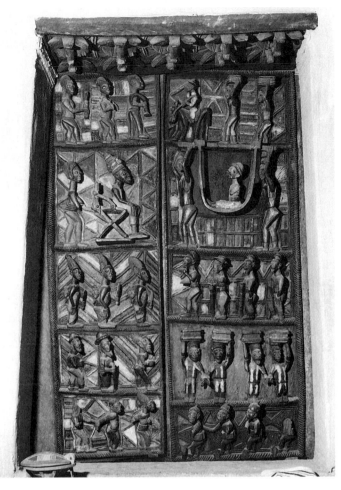

18-5 OLOWE OF ISE, door from the king's palace at Ikerre, Yoruba, Nigeria, *c.* 1910. Wood, approx. 6' high. Trustees of the British Museum, London.

18-6 Running woman, Tassili-n-Ajjer, Algeria, *c.* 2000 B.C. Pigments on rock.

because of his distinctive style and the superior quality of his work.

The earliest known African art occurs among the thousands of petroglyphs and pictographs found in hundreds of sites across the continent. Some animal engravings from Apollo II Cave in Namibia were made perhaps as long as 27,500 years ago, earlier than the great Paleolithic art of Eastern Spain, but perhaps later than the *Venus of Willendorf* (FIG. 1-8). Since humankind apparently originated in Africa, the world's earliest art may yet be discovered there as well. The greatest concentrations of rock art are in now dry desert regions, the Sahara to the north, the Horn in the east, and the Kalahari to the south, as well as in caves and on rock outcroppings in Namibia and South Africa. These are precisely *not* the areas where most African sculpture is found, probably because rock artists were more often herders or hunter-gatherers than farmers. Accurately naturalistic renderings on rock surfaces (FIGS. **18-6** and **18-7**) show animals and humans in many different positions and activities, singly or in groups, stationary and in motion. Most of these were done within the last four to five

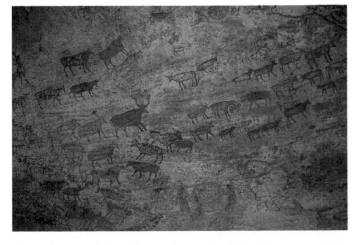

18-7 Cattle herd, Boudeau style, varying dates. Pigments on rock.

called the Nok culture, dating between 500 B.C. and A.D. 200. Because they are so confidently handled, Nok ceramic heads (FIG. **18-8**) and figures suggest that other clay or wooden prototypes, now lost, must have existed in a "formative" style. We are uncertain how these objects were used, but a ritual context is more likely than a simply decorative one. Volumes are full and surfaces are modeled smoothly in these ceramic sculptures, which relate to several extant traditions in the general Nok area. Women are the ceramic artists in several of these, men in others.

By the tenth century A.D., sophisticated cire perdue copper-alloy castings were made in an intricate, rather conventionalized style; dozens of such refined objects were excavated at Igbo-Ukwu in southeastern Nigeria. These are the earliest metal castings known from regions south of the Sahara. By the eleventh and twelfth centuries, however, a very naturalistic style had appeared at Ife in western Nigeria, which has long been considered the cradle of Yoruba culture and civilization, the place where their gods first created the universe. Ife origin stories also account for a line of divine rulers. Undoubtedly a king is represented in the early copper-alloy figure seen here (FIG. **18-9**). This figure, unlike most later African wood sculpture, shows fleshlike modeling, a kind of idealized naturalism in the torso and head that approaches descriptive portraiture. Its proportions are less lifelike, however, than they are ideological. For modern Yoruba, heads are the locus of wisdom, destiny, and the essence of being, ideas that probably obtained eight hundred years ago as well. The casting is fine, if somewhat corroded; it accurately records precise details of the heavily beaded costume, crown, and jewelry worn by both ancient and contemporary kings in Ife and other Yoruba city-states. Dozens of accomplished, detailed, and sometimes realistic sculptures of heads, full figures, and animals, principally in ceramics and copper alloys, are known from Ife. These and related works from Owo undoubtedly were employed in rituals supporting divine kingship.

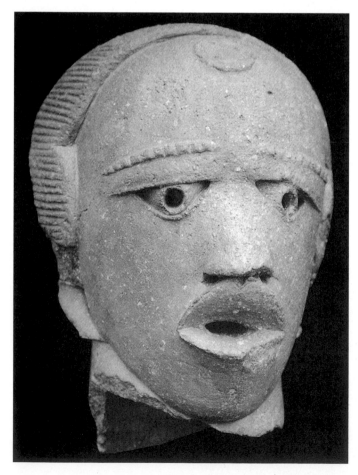

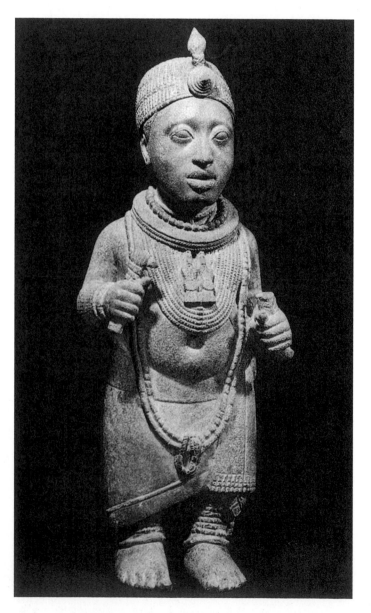

18-8 Jemaa head, from Nok, fifth century B.C. Terracotta, 9¹³/₁₆" high. National Museum, Lagos, Nigeria.

18-9 Ife king figure, Yoruba, tenth to twelfth century. Bronze, 18¹/₂" high. Ife Museum, Nigeria.

A large corpus of ceramic (and some copper-alloy) imagery also has been excavated from tombs in the Inland Delta of the Niger River, northwest of Nigeria in the modern nation of Mali. The dates of many such sculptures fall between A.D. 1000 and 1600, similar to dates from Ife and Owo. This period also brackets two of West Africa's most important medieval empires, ancient Ghana and Mali, from which the modern nation-states took their names. A terracotta horseman from the Inland Delta (FIG. **18-10**) may well represent an official in the court of ancient Mali, or perhaps a visitor to that court. Grave offerings and probably shrine figures, these fired clay images include humans and animals, many in naturalistic poses, others in stiffer, more formal postures. Falling in the latter category, this figure exemplifies a recurrent and widespread iconographic type: the equestrian. While there are no firm data on the specific context or meaning of this horseman, others in the genre (from Dogon, Senufo, Yoruba, Benin, and other peoples) refer to the superior speed, power, wealth, and status of leaders as well as of warriors and invading strangers. Such figures sometimes recall actual people, but more often they depict deities or legendary, heroic ancestors.

Over the last millennium, at least, African peoples have developed countless impressive architectural styles and building types. These range from the twelfth-century stone-cut churches of Ethiopia and the adobe-brick mosques of Mali from the same period and later, to many sculptural and finely painted domestic and spiritual adobe structures still being built across the West African savanna, and the impressive palace structures of Cameroon kingdoms with tall carved posts and lofty thatched roofs. Few early buildings survive south of the Sahara, however, because unfired adobe was so often the building material of choice; unless well maintained, such structures deteriorate rapidly from heavy rains. One exception is a complex of stone ruins called Great Zimbabwe (FIG. **18-11**). At a site first occupied

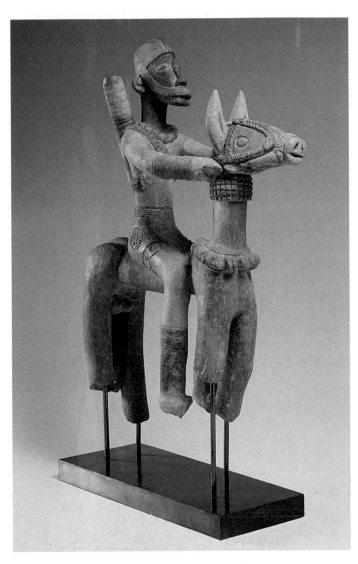

18-10 Equestrian figure, Inland Delta of Niger River, Mali, A.D. 1000–1500. Ceramic, 18" high. Private collection.

18-11 Great Zimbabwe ruins, Zimbabwe, standing enclosures from fourteenth and fifteenth centuries. Stone and mortar.

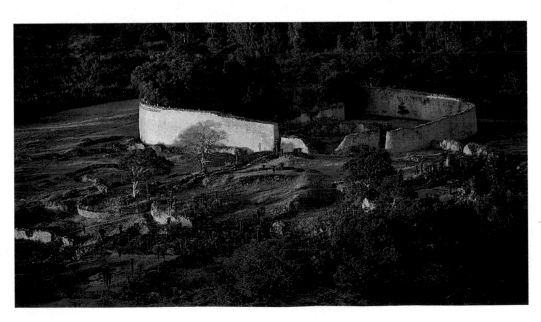

in the eleventh century, the still-standing walled enclosures were made in the fourteenth and fifteenth centuries, when this was the center of an empire with a wide trade network. While actual habitations are gone, the enclosures that remain are unusual for their size and the excellence of their stonework, some perimeter walls reaching a height of 30 feet; one of these encloses a conical stone tower. Trade beads and pottery from Persia, the Near East, and China, along with copper and gold objects, show this to have been a prosperous trade center well before Europeans began their coastal voyaging in the late fifteenth century.

Another exceptional monumental structure is the Friday Mosque at Djénné in Mali, still in active use (FIG. **18-12**). Two earlier mosques were built on this site; this one was completed in 1906 to 1907 in a strongly vertical style. Three symmetrically balanced adobe towers and tall, slender engaged columns combine to create majestic rhythms across the eastern front. This facade also features protruding beams that are partly structural and practical, and partly decorative; as the photograph clearly shows, these sticks

are used as perches for workers in the essential replastering of the exterior that takes place during an annual festival. While this mosque is larger and grander in scale than the area's civic and domestic architecture, many of its stately features are repeated in these urban environments, which in bygone centuries were embraced by the great Sudanic empires now known best in oral traditions and from archeological excavations.

The kingdom of Benin, on the other hand, still exists, and though its history stretches back at least to the thirteenth century, much about Benin art can be learned from observing current rituals and talking with elders. Numerous historical and ritual ties are known to have existed between the divine kings of Ife and those of Benin, and mutually beneficial contacts with Portuguese traders were established in the 1470s. Many complex, finely cast copper-alloy, as well as ivory, wood, ceramic, and wrought-iron sculptures have been produced in Benin (FIG. **18-13**), where castings and ivory carving were (and many still are) royal prerogatives commissioned from guilds of highly trained professionals. Their products are used by the divine king and his court, and they are also dispensed as royal

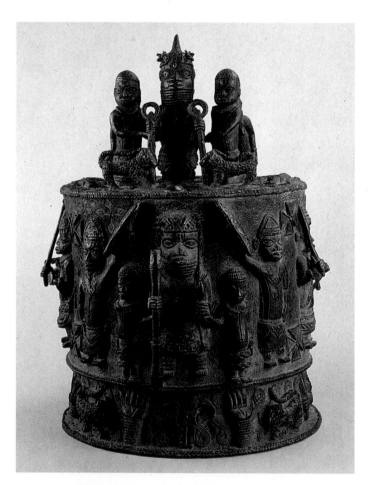

18-12 Friday Mosque, Djénné, Mali, 1906–1907. Adobe and wood, eastern facade.

18-13 Altar of the hand, 1550–1680, Benin, Nigeria. Bronze, 17¹/₂″ high. British Museum, London.

favors to title holders and other chiefs. This altar of the arm or hand, called *ikegobo*, features symmetrical, hierarchical compositions centered on the dominant divine king, seen on both the top and side of the cylinder. At such personal altars, high-ranking officials including the king made sacrifices to their own powers of accomplishment—symbolized by the arm and hand. The altar is concerned with power, both in the anticipated outcome of the ritual and in the iconography of the shrine. The inclusion of leopards on the top and around the base, along with elephant heads and crocodiles (not visible in the photograph) is symbolic of this power; these animals, common in Benin arts, are considered kings in their respective realms. The tame leopards flanking the king on top refer to his suzerainty over even this king of the wilds, and thus indicate his superhuman capacities.

LEADERSHIP AND ART

The relationships between art and leaders in Africa are pervasive, complex, and multileveled. Art forms invoked by leaders range from the obvious—regalia and royal altars—to the more veiled and subtle, such as masquerades conducted for social control, and community shrines served by religious specialists who themselves have considerable authority. Leadership arts often overlap, of course, with those manifesting aspects of the supernatural.

Numerous formal and functional traits characterize the arts of leadership, but the overriding one is their *contrast* with objects owned or invoked by ordinary people. Elite arts are more durable, more iconographically complex, and more expensive than those of commoners. Wealthy and powerful chiefs, kings, and religious leaders commission art and display and otherwise use it, instrumentally, to get things done. Artistically elaborated swords in both Benin and Akan states are good examples; they derive their power in part from being placed on the shrines of dynastic ancestors or nature spirits (FIGS. 18-16 and 18-21). Such swords or other weapons, in the hands of leaders or court members, extend their reach, thereby symbolically representing both military might and protection by the chief or state. For example, state swords are employed by lesser chiefs in swearing their fealty to kings in both Benin and Akan kingdoms, while kings themselves gesture with these swords on varied ritual occasions.

Other art forms, especially stools and chairs that are often finely decorated, elevate leaders, contributing to their actual and figurative superiority and grandeur. Weapons, umbrellas, and other regalia—clothing, hats, staffs, flywhisks—amplify leaders, and contribute to their monumentality, their commanding presence. Fante chiefs in procession (FIG. **18-14**), preceded by a state sword bearer and a counselor, called a linguist, with a gold-leafed wooden staff of office, exemplify well such leadership arts.

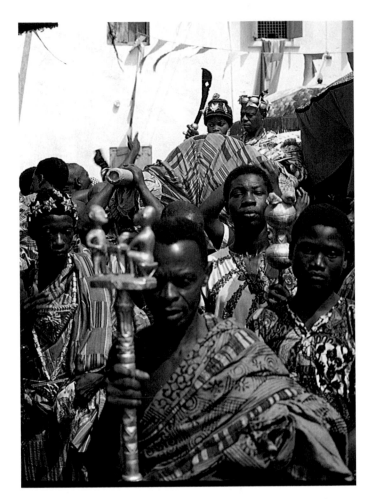

18-14 Fante royal procession with gold and gold leaf regalia, Ghana. Photographed in 1972.

Seated in state, walking or riding in a festival, and supported by a costumed entourage, chiefs and kings with rich attire and symbolic implements evoke both majesty and mystery.

Rich, complex images of leaders are calculated to project political and spiritual powers. These messages derive frequently from what have been called "intentional design redundancy" and "esthetic overload." These phrases refer to conscious layering of sumptuous garments, jewelry, and weapons, proliferation of detailing and symbolic iconography, complexity, cost, the sheer size of compositions, and a general sense of excess. The king of the Kuba peoples of Zaire (FIG. **18-15**) epitomizes such an assemblage, which constructs him as "larger than life," radiating messages about wealth and power from the overload of beads, shells, cloth, animal skins and teeth, and feathers used in his costume. Positioned centrally on a raised platform, the Kuba king is a living collage, an embodiment of power and authority.

The accumulations or complexes of varied symbolic materials that characterize regalia are also traits of shrines

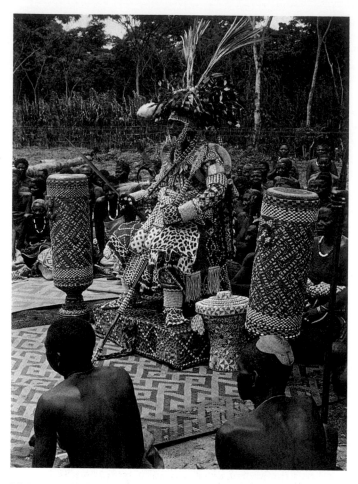

18-15 Nyim (King) Kot a-Mbweeky III in state regalia, Kuba, Zaire. Photographed in 1971.

and altars. A Benin shrine to the heads of divine royal ancestors (FIG. **18-16**), with its base constructed of sacred riverain adobe, features cast copper-alloy heads, each fitted with an ivory tusk carved in relief. The heads, formerly polished, are said to repel evil forces while representing the enduring qualities of kingship itself through the durability of their material. Elephant tusk reliefs commemorate important events and personages in the history of the kingdom; at the same time their bleached white color signifies purity and the vast physical power of elephants, which, like leopards, are metaphors for the king. Further ritual arts include carved wood rattle-staffs that reference generations of dynastic ancestors in their segmented shafts and are also used musically, as are the several pyramidal bells, to call ancestral spirits. The central sculpture in the overall hierarchical composition depicts a divine king flanked by members of his entourage. It is the living king who, with animal sacrifices at such altars, purifies his own "head" by calling upon the collective strength of his ancestors, themselves represented by heads. Thus the varied objects and materials comprising this altar contribute both artistically and ritually to the imaging of royal power, as well as to its renewal and perpetuation.

Many freestanding images of leaders also are found in the courts of kings and in shrines allied to chiefly authority. Two royal figures, from the Bangwa king's court in Cameroon (FIG. **18-17**), stood among many carvings depicting ancestors, chiefs, and priests—those, whether living or dead, who were responsible for the continuity of life itself. Such carved images, intended to display the wealth, power, and taste of the presiding ruler, were gathered as if they

18-16 Royal ancestral altar, Benin, Nigeria, adobe, copper alloy, wood, ivory. Photographed in 1970.

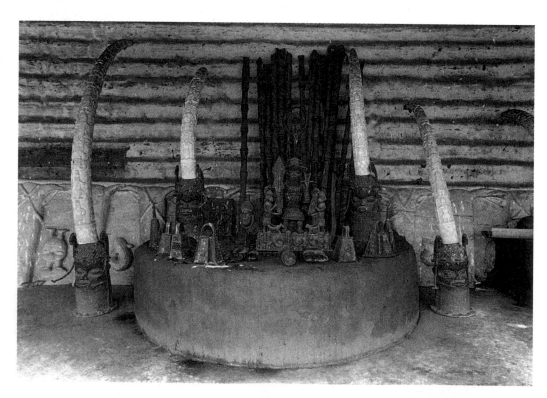

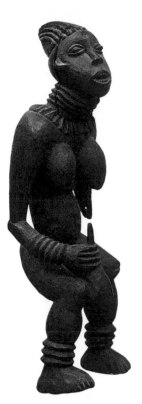

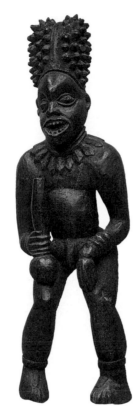

18-17 Dancing royal couple, Bangwa, Cameroon, nineteenth century. Wood, female 33¹/₂″ high, male 35¹/₂″ high. Private collection.

were a supporting entourage for rituals and given food and drink. The female figure in this case is said to portray a royal priestess, a clairvoyant with protective powers. Both carvings express the vitality of dance, probably Africa's premier art form, in several complementary ways: by vigorous asymmetrical posing (including the woman's thrown-back head and her open mouth), constrictions at the joints, which rhythmically energize the figures, and the use of intentionally rough textures (from the adze marks left on their surfaces).

Sculpture and regalia, shrines and altars, as well as many masquerades (see below) are commissioned or served by temporal and spiritual leaders across the continent. These objects can be active instruments of rule or more passive emblems or commemorations. Whatever their form, the arts are clearly understood by African leaders as valuable to both exercising and materializing power and authority.

SPIRITUALITY AND ART

A high percentage of African art has a spiritual dimension. Most figures and masks are symbolic visualizations of unseen supernatural forces. Countless images and shrines have been created as aids to contacting various deities: gods of nature, legendary founding ancestors, and the spirits of

people who have actually lived. Given the pervasiveness of religious arts, it is useful to begin a discussion of spirituality and African art by discussing personal cults, then moving to family-based ancestral representations, and finally taking up the discussion of spiritual arts that serve larger groups, communities, and even states.

Most Baule figural sculptures, like the image seen here (FIG. **18-18**), are personal shrines hidden away in the interiors of their owners' houses. Probably a bush spirit, this

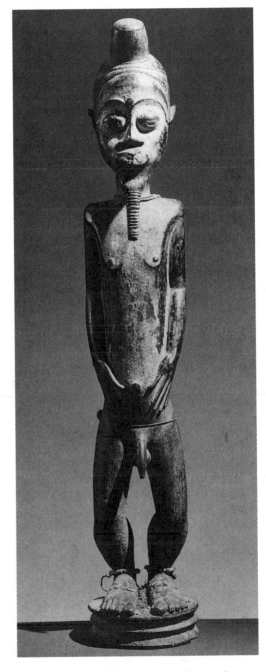

18-18 Bush spirit, Baule, Côte d'Ivoire, nineteenth to twentieth century. Wood, male figure approx. 22″ high. Metropolitan Museum of Art, New York (Michael C. Rockefeller Memorial Collection of Primitive Art, gift of Nelson A. Rockefeller).

figure was ordered from a carver by a person adversely affected, through sickness or another misfortune, by that bush spirit, identified by divination. Offerings were made on or near such figures to feed and honor the spirits, who were thus appeased and thereby induced to care for, cure, or otherwise bless the human petitioner. Sometimes a bush spirit induced its owner to become a diviner, giving that person special powers to help others solve their problems. Diviners may have several such carved shrine figures, fashioned so as to represent handsome people in the prime of life. Even though bush spirits themselves are believed to be unattractive or even ugly, according to local standards, their carvings are refined and made deliberately beautiful, with delicate hairstyles and carefully rendered scarification.

African peoples revere their ancestors, although relatively few materialize ancestral spirits in figurative imagery. Among those who do are the Tabwa of Zaire, represented here by a male and female couple (FIG. **18-19**). Family elders make offerings to such figures to enlist ancestral help with affairs of the living: the productivity of the farms, human health and fertility, land disputes, and so forth. This pair also point to important ideas about complementarity, opposition, and unity that are common in Africa and especially pronounced among the Tabwa. The unified human couple comprises complementary male and female, an opposition articulated in many African belief systems as an explanatory model—called dualism by scholars—that extends to many aspects of life and culture. The unified world is thus seen as composed of dual oppositions: male/female, bush/village, hot/cold, night/day, right/left, up/down, good/bad, among many others. These dualistic ideas compress Tabwa practical and philosophical ideas about gender, morality, time, space, cosmology, and transformation. Likewise, the line of scarification marks dividing the human torso stands for a twofold division of the universe that is actually present in Tabwa country as a north/south watershed. The same bisecting line is seen as a mythical snake connecting earth to sky, wet season to dry, wild or "raw" animals to the cooked food of civilization. Tabwa dualistic thought is actually far more complex than space allows here for explanation; suffice it to say that the power of art forms to incorporate diverse meanings is equivalent to their ability to help define culture and effect change within it.

Complex information is also embodied in a second couple, from Dogon country in Mali, a large carving in which the male and female are integrated through position and other aspects of form on a common base (FIG. **18-20**). Although we are lacking proof as well as information about the original context of this carving, it depicts a married couple and almost certainly represents the primordial, founding ancestors of a subgroup or important family among the Dogon people. The male has a quiver on his back, the female, a baby. Primary social roles—the male as

hunter/warrior and the female as childbearer/nurturer—are thus established here. The male is also shown as dominant by his size, as well as the protector, by his gesture. The carver rejected naturalism in this case (although he was undoubtedly capable of it) in favor of a rectilinear conceptualization that characterizes several Dogon styles. All body parts are present, but they are simplified and rendered tubular, then defined geometrically to reveal complex vertical and horizontal rhythms. Heads and torsos are exaggerated, probably for ideological emphasis, as is documented for several other African peoples. It is likely that this carv-

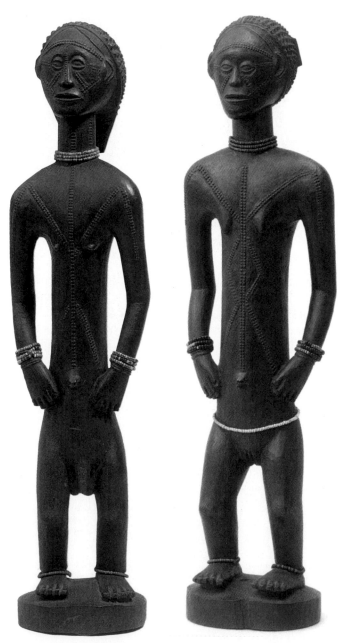

18-19 Ancestral couple, Tabwa, Zaire, nineteenth or early twentieth century. Wood. Metropolitan Museum of Art, New York.

ing served a symbolic and spiritual function, probably in a shrine for an entire community.

Asante and other Akan-speaking communities of Ghana address nature spirits, the most important being Tano, a god associated with a major river of the same name. Numerous shrines dedicated to Tano are consulted by individuals, families, and communities that seek health, prosperity, agricultural productivity, and human fertility. The small, disc-headed figures in the illustration (FIG. **18-21**) were

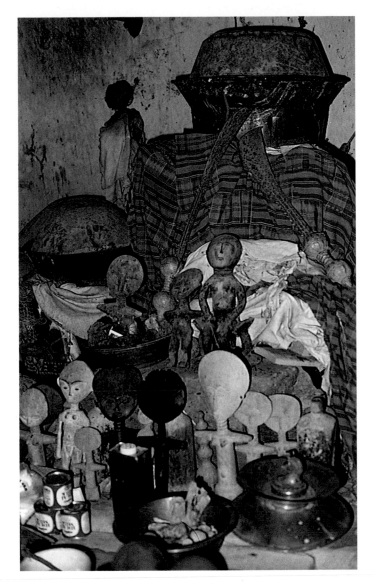

18-21 Tano shrine, Asante, Ghana. Photographed in 1976.

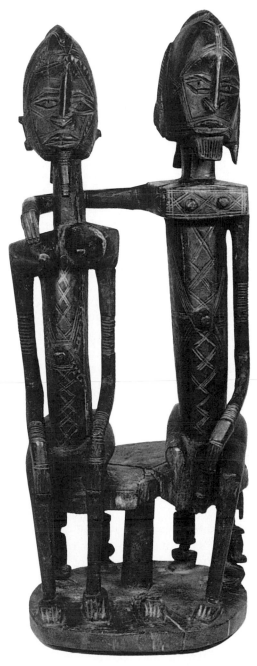

18-20 Couple, Dogon, Mali, *c.* nineteenth century. Wood, 30" high. Photographed in 1975.

brought to the shrine by mothers whom Tano had helped in ending their infertility or in ensuring the safe delivery of a healthy child. To absorb energy from the deity, two state swords lean against the brass basin containing Tano's sacred (and secret) symbols. So empowered, the swords will be effective when used in political rites requiring supernatural sanction, such as installations and swearing oaths of allegiance. The town chief, custodian of these swords, also makes periodic sacrifices here both for his own well-being and that of his constituency.

Most other African peoples worship nature deities as well, although the associated arts vary from one region to another. Among the Igbo of southeastern Nigeria, for example, powerful nature gods sometimes demand that their human constituents build an *Mbari* house. These elaborate,

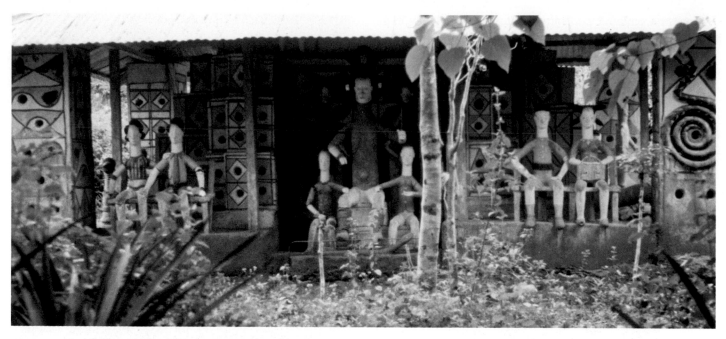

18-22 Mbari house, Igbo, Ndiama Obube, Nigeria, built *c.* 1960. Photographed in 1966.

unified complexes consist of numerous unfired clay sculptures and paintings, occasionally more than a hundred in one Mbari, in a specially designed architectural setting. The adobe houses are built as sacrifices to major community deities, often Ala, goddess of the earth. In the Mbari shown (FIG. **18-22**), this goddess is seated in the center of the front side, her children beside her. The professional artist has enlarged and extended Ala's torso, neck, and head to express her aloofness, dignity, and power. She is the apex of a formalized, hierarchical composition balanced by her children and the seated couples.

More informally posed figures and groups are found on the other sides of the house—beautiful, amusing, or frightening figures of animals, humans, and spirits taken from mythology, history, dreams, and everyday life. The Mbari construction process, veiled in secrecy behind a fence, is itself a stylized world-renewal ritual, while the completed monument shows off that world after the Mbari is ritually opened. Ceremonies for opening the house to public view indicate that the god has accepted the sacrificial offering (of the house) and, for a time at least, will be benevolent. An Mbari is never repaired; instead it is allowed to disintegrate and return to the earth from which it is made and to which it is often dedicated. It is notable that few Mbari are still being made for ritual purposes, and that two recent ones, sponsored by the Nigerian government essentially as "museums," were constructed of cement.

Ancestral and power images from Zaire are conventionalized sculptural forms serving a variety of purposes: commemoration, healing, divination, and social regulation. The Kongo woman and child carving (FIG. **18-23**) repre-

sents a royal; it may commemorate an ancestor or more probably a legendary founding clan mother, a genetrix. Some such figures were called "white chalk," a primary fertility charm in this area, and were owned by diviners. The large standing male carving, bristling with nails and blades (FIG. **18-24**), is a Kongo power figure consecrated by a trained priest with precise ritual formulae. When still in use in Africa, such images embody spirits believed to be healing and life giving, or sometimes capable of inflicting harm, disease, or even death. Each power figure has its own specific role, just as it had its particular medicines attached, in this case, protruding from the abdomen and featuring a cowry shell. Every image is also activated differently; the forces lodged in the Kongo figure were appealed to each time a nail or blade was inserted. Other spirits are invoked by a certain chant or by being rubbed, or by the application of special powders. Their roles varied enormously, from curing minor ailments to stimulating crop growth, from punishing thieves to weakening an enemy in warfare. Especially large figures, like the Kongo male, had exceptional ascribed powers. While benevolent for their owners—who might have been whole communities—they stood at the boundary between life and death and were held in awe by most villagers. Today, however, power images of this sort are more likely to be found in museums than in villages.

The religious arts of Africa are pervasive and greatly varied, from small, simple disc-headed figures that aid women in childbirth to cathartic, community-sponsored Mbari rituals involving the construction of a new symbolic world. Ancestors and different spirit powers, especially those of nature, are still invoked to help people maintain productiv-

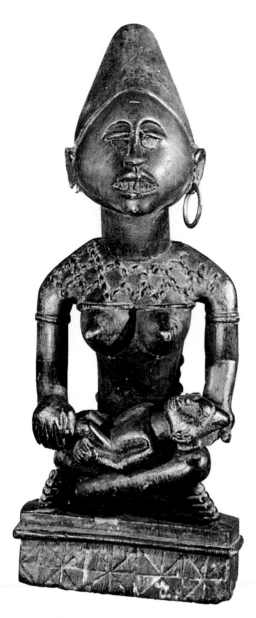

18-23 Ancestral figure, Kongo, from Zaire, nineteenth to twentieth century. Wood and brass, 16" high. Musée Royal de l'Afrique Centrale, Tervuren, Belgium.

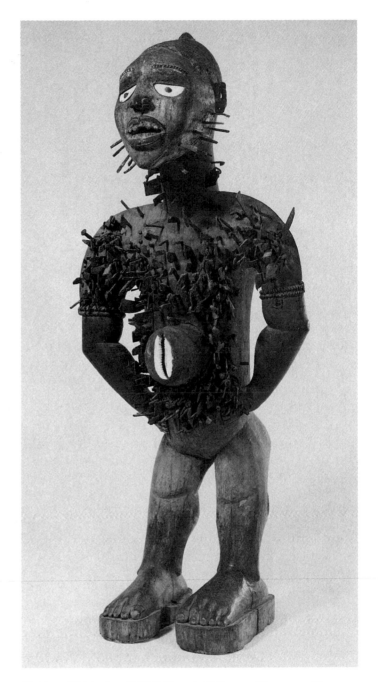

18-24 Nkisi n'kondi (Nail Figure), Shiloango River area, Kongo, Zaire, c. 1875–1900. Wood, nails, blades, medicinal materials with cowrie shell, 46³/₄" high. Detroit Museum of Art, Eleanor Clay Ford Fund for African Art.

ity, good health, and a balanced social order. While traditional religious institutions have been weakened in recent decades, they are still viable in many areas.

MASKS AND MASQUERADES

The arts of masquerade hold an importance, even today in Africa, that is difficult for Americans or Europeans to comprehend because of the essentially recreational and sometimes trivial roles of masks in the modern West. Especially before the advent of colonial rule (around 1900 in most

cases), however, African masking societies had extensive regulatory and judicial powers. Such governmental functions were particularly forceful in stateless societies such as the Dan or Igbo, where masks sometimes became so powerful that they had their own priests and were consulted as oracles. Maskers were empowered to apprehend witches (usually defined as socially destructive people), and some

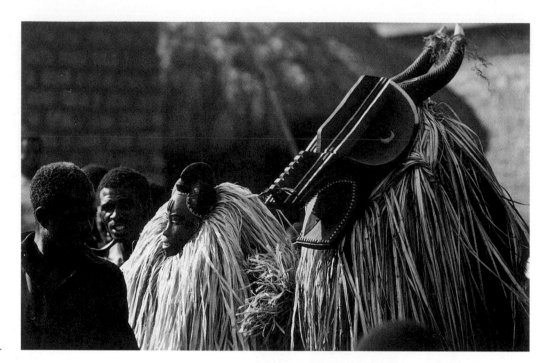

18-25 Senior female (left) and male Goli masqueraders, Wan, Côte d'Ivoire. Photographed in 1978.

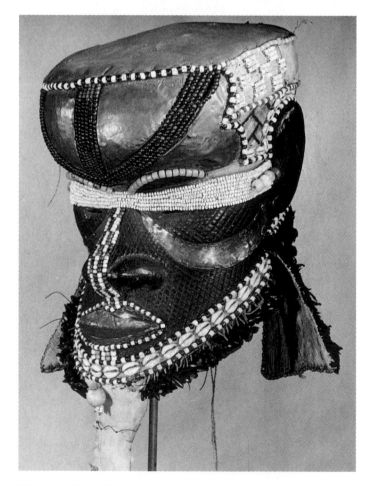

had the power to take human life. Normally, however, and especially today, masks are less threatening, more educational and entertaining. Masked dancers embody either ancestors, seen as briefly returning to the human realm, or various nature spirits called upon for their special powers.

A mask is the focal point of a costume ensemble which, together with held objects, music, and dance gestures, invokes a specific named spirit character. Several maskers together constitute a masquerade, more or less strongly ritualized. Some masked dramas reenact creation stories, while in other cases they may parody behavior considered aberrant or excessive. Their range of dramatic behaviors is very broad. In the Wan Goli masquerade of Côte d'Ivoire (FIG. **18-25**), three characters act out complex ideas about gender and age and social relationships while helping to "create" an ancestor by appearing at his or her funerary rite. One of these masks, representing a synthesis of several bush animals in form or allusion—antelope, crocodile, eagle, vulture—is a metaphor for senior males. Sometimes masks enact animal traits, but more often their behavior symbolizes various human characteristics. African masks in fact range along a continuum from weak spirit power and strong entertainment value to those rarely, if ever, seen but with vast executive powers backed by powerful shrines. Most function between these extremes, crystallizing varieties of human behavior—caricatured, ordinary, amusing, bizarre, serious—that inform and affect audience members because they are staged and framed within the masquerade performance, which is normally only an occasional event.

Masks and masquerades are mediators: between men and women, youths and elders, initiated and uninitiated, the powers of nature and those of human agency, even

18-26 Mboom helmet mask, Kuba, from Zaire, nineteenth to twentieth century. Wood, brass, cowrie shells, beads, seeds, 13" high. Musée Royal de l'Afrique Centrale, Tervuren, Belgium.

between life and death. For many in west and central Africa, masking has an active role in the socialization process, especially for men, who control most masking on the continent. Maskers carry boys away from their mothers to bush initiation camps, put them through ordeals and schooling, and welcome them back to society months or even years later, as men. The Kuba mask shown here (FIG. **18-26**) was danced in such initiations as a commoner who opposes royal authority, and was the first mask seen by novices. At the same time—paradox and contradiction being inherent in masking—this is a royal character who competes with a more important regal mask for the affections of the lone female. The three characters, as legendary ancestors, reenact creation stories, in the process of which they rehearse various forms of archetypal behavior that is instructive to initiates. By the end of the schooling period the novices have been introduced to the secrets of masks and have learned to dance them.

Many Kuba masks, like the one illustrated here, are heavily beaded to signal their royal associations, a symbolism that probably developed in the nineteenth century or before when beads, for the most part imported from Europe, were a form of currency. Beaded Cameroon Grassland masks representing elephants (FIG. **18-27**) main-

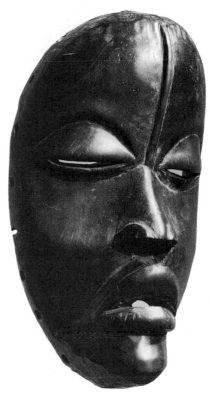

18-28 Mask, Dan, Liberia, nineteenth to twentieth century. Wood, 8¹/₂″ high. Metropolitan Museum of Art, New York.

tain both symbolic associations, to royalty and to wealth, and also to a third idea: the elephant as hugely strong. Elephant society members, in former times, acted as kings' messengers and enforcers; they were men wealthy enough to provide their king with a slave. Today elephant societies are essentially social clubs, but high fees remain, and sumptuous masking costumes are still called "things of money." Society members dance their masks at annual festivals, as well as at installation and funeral rites of revered leaders.

Among the noncentralized Dan people of Liberia, the ownership of spirits—some of which manifest themselves as masks—provides major access to sociopolitical and spiritual power. Mask types are numerous, all controlled and danced by men: police, chasers, pretty singers, firemen, warriors, strangers, and animals. The same Dan artist could fairly naturalistic, polished female masks (FIG. **18-28**) and rougher, abstracted male masks composed of thrusting and receding positive and negative shapes (FIG. **18-29**). Without field information the exact spirit character or use of these masks cannot be known, because functions change over time. A mask could begin its "life" as a benign female entertainer yet gain spiritual energy over a few generations to become a powerful judge or oracle.

While most masks are owned and performed by men, women control and dance certain masks in several contiguous cultures of Sierra Leone and Liberia, such as the Mende,

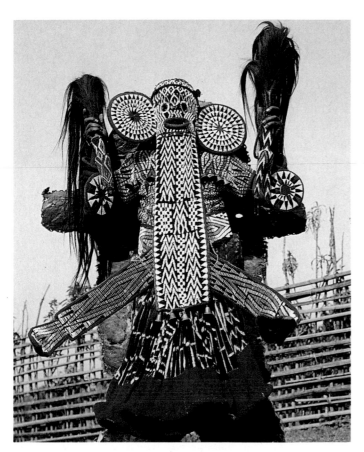

18-27 Elephant masqueraders, Bamileke, Cameroon. Photographed *c.* 1970.

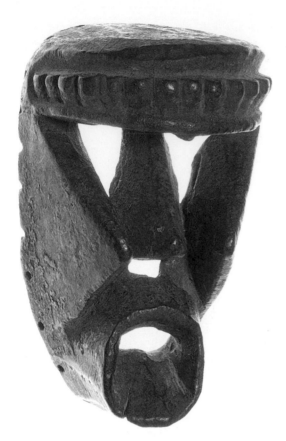

18-29 Kagle (mask), Dan, from Sierra Leone, *c.* 1775–1825. Wood, 9″ high. Yale University Art Gallery, New Haven, Connecticut (gift of Mr. and Mrs. James M. Osborn for the Linton Collection of African Art).

and the masks themselves physically and metaphorically represent the values and powers of women in these societies. With a glistening black surface that evokes ancestral spirits newly emergent from their underwater homes, these masks (FIG. **18-30**) and their parts refer to ideals of female beauty, morality, and behavior. A high, broad forehead signifies wisdom and success. Intricately woven or plaited hair is the essence of harmony and order found in ideal households, also symbolized by mats and textiles. A small, closed mouth and downcast eyes indicate the silent, serious demeanor expected of recent initiates. Women leaders who dance these masks serve as priestesses and adjudicators during the three years that the women's society controls the ritual calendar (alternating with the men's society in this role), thus serving the community as a whole. Women maskers are also initiators, teachers, and mentors, helping girl novices with their transformations into educated and marriageable women. Masked spirits and their symbolic attributes play a major role in girls' initiations among the Mende and several neighboring peoples.

Creation stories are dramatized in elaborate cyclical Dogon masquerades in Mali. According to these legends,

women were the first ancestors to imitate spirit maskers, and thus the first human masqueraders. Men later took masks over, forever barring women from direct involvement with masking processes. This legend is commemorated by a mask, Satimbe (FIG. **18-31**), who appears to represent all women. In Dama ceremonies, held every three to six years to honor the lives of people who have died since the last Dama, Satimbe is among the dozens of different masked spirit characters who escort dead souls away from the village, sending them off to the land of the dead (FIG. 18-2). Once they are ancestors, the deceased are enjoined to benefit their living descendants and stimulate agricultural productivity. Thus ancestors are invited back

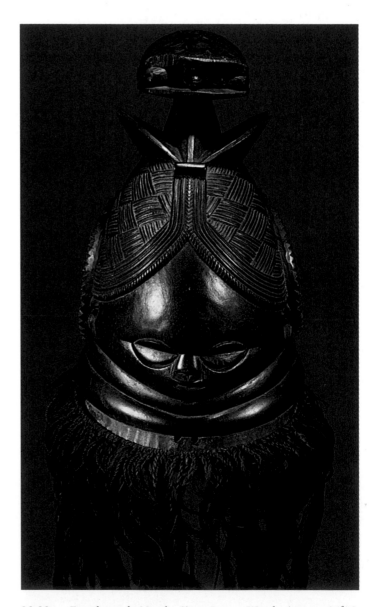

18-30 Female mask, Mende, Sierra Leone. Wood, pigment, 14³/₄″. Fowler Museum of Cultural History, University of California, Los Angeles, gift of the Wellcome Trust.

into the human community periodically to be fed, praised, and shown respect by the living.

Still other masking societies, such as Gelede (FIG. **18-32**) among the Yoruba, celebrate and placate the "mothers"—women generally and especially elders—for their great and mysterious powers. Men's Gelede groups stage masking spectacles involving many different human and animal characters. Two early performers are Ancient Mother, who personifies women's powers, and Oro Efe, a male masked singer who comments on a host of local political, social, and moral problems in songs repeated by a chorus. These displays of power through sung poetry and performed drama are at once didactic, satirical, and entertaining; they hold a mirror up to community life. Specific types of people present as maskers—market women, whites, cattle traders, African strangers, prostitutes, gossips—are lampooned or appreciated, but the overall event, which is highly entertaining, honors older women, imploring them to use their powers productively and protectively rather than destructively.

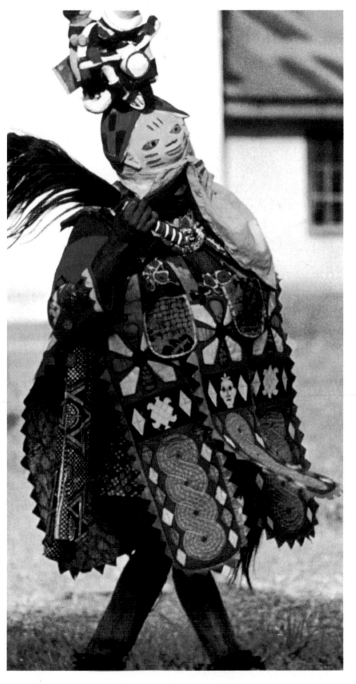

18-31 Satimbe mask, Dogon, Mali, early twentieth century. Wood. Private collection.

18-32 Dancer of the Gelede Society of Meko. Yoruba, Nigeria, 1969.

These few examples of masks and masquerades, from among the thousands performed on the continent, exemplify the exceptionally diverse and important values and meanings that characterize this art form. Since African nations have gained independence, and often earlier, under colonial domination, masks that once had powerful roles in social control have become, at least partially, secularized, yet masking generally remains viable and socially relevant in many parts of the continent.

AFTERWORD: THE PRESENT

The last fifty to a hundred years have witnessed many changes in the forms and functions of the arts of Africa. Colonial governments, followed by those of modern independent nations, have contributed to the erosion of instrumentality in leadership arts even though regalia and court panoply can still be seen in festivals that continue to be value-laden events. The encroachments of Christianity, Islam, Western education, and market economies have led to increasing secularization in all arts. Many figures and masks earlier commissioned for shrines and serious dances are now being made only for purchase by outsiders, essentially as tourist arts. Murals and cement sculptures frequently can be seen in cities, and often make at least implicit comments about modern life. In spite of the growing importance of urbanism (which is pre-European in some areas), however, most African people still live in rural communities. Traditional values, while under pressure, hold considerable force in villages especially, and many peo-

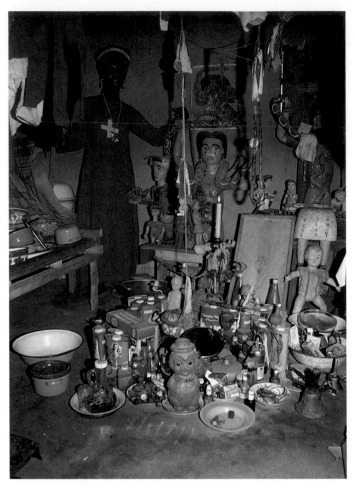

18-33 Mamy Wata shrine, Igbo, Nigeria. Photographed in 1978.

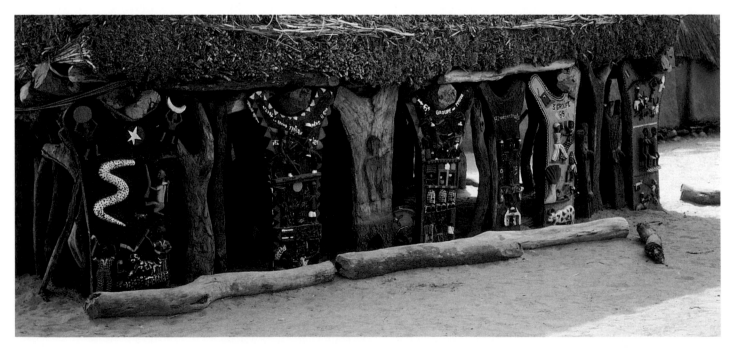

18-34 Togu na (Men's house), Dogon, Mali. Wood and pigment. Photographed in 1989.

ple adhere to spiritual beliefs that uphold the kinds of art forms discussed above. Yet art-supporting institutions are also changing.

Among the new and growing institutions on the continent is the cult of Mamy Wata, a charismatic water spirit of acknowledged foreign origin. Introduced into Nigeria around 1900 by means of a colored lithograph of a tan-skinned, long-haired, beautiful female "snake charmer," this cult has spread to hundreds of communities in many countries, from Senegal to Tanzania. Its priests and priestesses treat age-old problems such as sickness and infertility, but their special focus is modern life: landing a better job, passing an exam, finding cash for buying a car, and so forth. Mamy Wata shrines (FIG. **18-33**) contain gifts and sacrifices preferred by this vain, demanding spirit: altar tables with mirrors, candles, incense, perfume, talcum powder, as well as books, calendars, and Christian items. She likes glittery, showy presents: plastic dolls, brightly painted figures, shiny costume jewelry, and enamelware. This cult, a blend of earlier beliefs about water spirits and messenger snakes with newer ideas relating to progress and the cash economy, shows how African beliefs and arts adapt to changing realities.

As the arts continue to evolve in the late twentieth century, several tendencies are clear: more emphasis on realism than on conventionalization, a broader range of subjects, urban rather than rural settings, more painting than sculpture, brighter colors, new materials, and a greater emphasis on personal style. Most of these trends can be seen in recently installed colorful posts in Dogon men's houses, called *togu na* (FIG. **18-34**). The togu na (known as a "house of words" because men's deliberations vital to community welfare take place under its sheltering roof) is considered the "head" and the most important part of the anthropomorphised village. Earlier posts show schematic renderings of legendary female ancestors, similar to Satimbe mask figures (FIG. 18-31) or stylized ancestral couples. Recent replacement posts feature narrative and topical scenes of varied subjects, more descriptive detail, writing, polychrome painting in enamels, and a desire by their artists to be recognized.

Many contemporary art forms are vibrant in form, as well as relevant to emerging social and political issues. Art in South Africa, for example, first protested the existence of apartheid, then celebrated its demise and the consequent democratically elected government. Change will continue to affect the types, forms, styles, symbolism, uses, and subject matter of African arts, as it always has, and artists from this continent will increasingly receive the recognition they have long deserved.

PRONUNCIATION GUIDE TO ARTISTS' NAMES

Artist's Name	Phonetic Pronunciation
Abakanowicz, Magdalena	ab-a-'kan-o-wits, mag-dŭ-'lā-nŭ
Achilles Painter	ŭ-'kil-ēz
Alberti, Leon Battista	al-'ber-tē, lā-'ōn bat-'tēs-ta
Alexandros of Antioch-on-the-Meander	ă-lig-'zăn-dros *of* 'ăn-tē-ak *on the* mē-'ăn-dŭr
Altdorfer, Albrecht	'alt-dor-fŭr, 'al-breḵt
Ando Hiroshige	an-dō hē-rō-shē-ge
Andokides Painter	an-'dō-ḵē-dēs '
Andrea del Castagno	an-'drā-ŭ del ka-'stan-yō
Andrea del Sarto	an-'drā-ŭ del 'sar-tō
Angelico, Fra	an-'jā-lē-kō, fra
Anguissola, Sofonisba	ang-gwēs-'sō-lŭ, sō-fō-'nēz-ba
Anthemius of Tralles	ăn-'thē-mē-ŭs *of* trăl-ēz
Apollodorus of Damascus	ŭ-pal-ŭ-'dōr-ŭs *of* dŭ-'măs-kŭs
Apollonios of Athens	ăp-ŭ-'lō-nē-ŭs *of* 'ăth-ŭnz
Āqā Mirak	a-ka 'mē-rak
Arata Isozaki	a-ra-ta ē-sō-za-kē
Archipenko, Alexandr	ŭrḵ-'yēp-yŭn-kŭ (*or* ar-ki-'pyeng-kō), ŭl-yik-'san-dŭr
Arnolfo di Cambio	ar-'nol-fō dē 'kam-byō
Arp, Jean	arp, zhan
Arup, Ove	'ă-rŭp, 'ō-vŭ
Asam, Cosmas Damian	'az-am, 'cos-mas dam-'yan
Asam, Egid Quirin	'az-am, ā-'gēt kvē-'rēn
Atget, Jean-Eugène-Auguste	at-'zhe, zhan ö-'zhăn o-'gŭst
Athanadorus	ŭ-thā-nŭ-'dōr-ŭs
Balla, Giacomo	'bal-la, 'ja-kō-mō
Barlach, Ernst	'bar-laḵ, 'ernst
Barye, Antoine-Louis	ba-'rē, an-'twan lwē
Bastien-Lepage, Jules	bas-tyan-lŭ-'pazh, zhūl
Beardsley, Aubrey	'bi(r)dz-lē, 'o-brē
Beckmann, Max	'bek-man, maks
Behnisch, Gunter	'ben-ish, 'gun-tŭ(r)
Bellini, Giovanni	bel-'lē-nē, jō-'van-nē
Berlinghieri, Bonaventura	ber-ling-'gye-rē, bo-na-vān-'tū-ra
Bernini, Gianlorenzo	ber-'nē-nē, jan-lō-'ren-zō
Bertoldo di Giovanni	ber-'tol-dō dē jō-'van-nē
Beuys, Joseph	'bois, 'yō-zef
Bihzad	bi-'zad
Boccioni, Umberto	bat-'chō-nē, ŭm-'ber-tō
Bodmer, Karl	'bōd-mŭr, karl
Boffrand, Germain	bo-'fran, zher-'măn
Bonheur, Rosa	bōn-'ŭr, 'rō-zŭ
Borromini, Francesco	bōr-rō-'mē-nē, fran-'ches-kō
Bosch, Hieronymus	'bos (*or* 'bash, 'bosh), hē-ŭ-'rō-nē-mus
Botticelli, Sandro	bot-ti-'chel-lē, 'san-drō
Boucher, François	bū-'shā, fran-'swa
Bouguereau, Adolphe-William	bū-g(ŭ)-'rō, a-'dolf wēl-'yam
Bourgeois, Louise	būr-'zhwa, lwēz
Bouts, Dirk	'bauts, dirk
Bramante, Donato D'Angelo	bra-'man-tā, dō-'na-tō 'dan-jā-lō
Brancusi, Constantin	'bran-kŭsh (*or* brăn-kū-zē), kon-stan-'tēn
Braque, Georges	brak, zhorzh
Broederlam, Melchior	'brū-dŭr-lăm, 'mel-ḵē-or
Bronzino	bron-'zē-nō
Bruegel, Pieter, the Elder	'broi-gŭl, 'pē-tŭr

Artist's Name	Phonetic Pronunciation
Brunelleschi, Filippo	brŭn-ŭl-'es-kē, fē-'lēp-pō
Buffalmacco, Buonamico	buf-fal-'mak-kō, bwon-ŭ-'mē-kō
Buffet, Bernard	bü-'fā, ber-'nar
Bunchō	bun-chō
Burgee, John	'bŭr-jē, jan
Caillebotte, Gustave	ka-y(ŭ)-'bot, gŭ-'stav
Callot, Jacques	kă-'lō, zhak
Campin, Robert	kan-'pen, rō-'ber
Canaletto, Giovanni Antonio	ka-na-'lāt-tō, jō-'van-nē an-'tōn-yō
Canova, Antonio	ka-'nō-va, an-'tōn-yō
Caradosso, Christoforo Foppa	kar-ŭ-'dos-sō, krē-'sto-fō-rō 'fap-pa
Caravaggio	kar-ŭ-'vad-jō
Caro, Anthony	'ka-rō, 'ăn-thŭ-nē
Carpeaux, Jean-Baptiste	kar-'pō, zhan bap-'tēst
Carracci, Agostino	ka(r)-'rat-chē, a-gŭ-'stē-nō
Carracci, Annibale	ka(r)-'rat-chē, an-'nē-bŭ-lā
Carracci, Lodovico	ka(r)-'rat-chē, lō-dō-'vē-kō
Carriera, Rosalba	kar-'ye-ra, rō-'zal-ba
Cassatt, Mary	kŭ-'săt
Cavallini, Pietro	ka-val-'lē-nē, 'pye-trō
Celer	kē-lŭr
Cellini, Benvenuto	chel-'lē-nē, ben-vŭ-'nū-tō
Cézanne, Paul	sā-'zan, pōl
Chagall, Marc	shŭ-'gal, mark
Chardin, Jean-Baptiste-Siméon	shar-'dăn, zhan bap-'tēst si-mā-'ōn
Chelles, Jean de	shel (*or* shey), zhan dŭ
Chirico, Giorgio de	'kir-i-kō, 'jōr-jō dā
Chō Densu	chō dŭn-su
Christo	'kris-tō *or* 'krēs-tō
Christus, Petrus	'kris-tŭs, 'pā-trŭs
Cimabue, Giovanni	chē-mŭ-'bū-ā, jō-'van-nē
Clodion	klō-dē-'ōn
Clouet, Jean	klū-'e, zhan
Corot, Jean-Baptiste-Camille	kŭ-'rō, zhan bap-'tēst kŭ-'mēl
Correggio	kŭr-'red-jō
Courbet, Jean-Désiré-Gustave	kur-'bā, zhan de-zi-'rā gŭ-'stav
Coypel, Antoine	kwa-'pel, an-'twan
Cranach, Lucas, the Elder	'kran-aḵ, 'lū-kŭs
Cuvilliés, François de	kyū-vē-'yā, fran-'swa dŭ
Daddi, Bernardo	'da-dē, ber-'nar-dō
Daguerre, Louis-Jacques-Mandé	da-'ger, lwē zhak man-'dā
Dai Jin	dī jin
Dali, Salvador	'da-lē, sal-vŭ-'dōr [*also* da-'lē]
Dao Ji	dau jē
Daphnis of Miletos	'dăf-nis *of* mī -'lēt-ŭs
Daumier, Honoré	dō-'myā, o-nor-'ā
David, Jacques-Louis	da-'vēd, zhak lū-'ē
De Kooning, Willem	dŭ-'kū-ning, 'wil-ŭm
Degas, Edgar	dŭ-'ga, ed-'gar
Delacroix, Eugène	del-ŭ-'k(r)wa, ö-'zhen
Delaroche, Paul	dŭ-la-'rosh, pōl
Delaunay, Robert	dŭ-lō-'nā, rō-'ber
Della Robbia, Andrea	dăl-la 'rob-bya, an-'drā-ŭ
Della Robbia, Giovanni	dăl-la 'rob-bya, jō-'van-nē
Della Robbia, Girolamo	dăl-la 'rob-bya, jē-'ro-lam-ō
Della Robbia, Luca	dăl-la 'rob-bya, 'lū-ka
Derain, André	dŭ-'răn, an-'drā
Desiderio da Settignano	de-si-'der-yō da set-tē-'nYa-nō
Doesburg, Theo van	'dŭs-bürgh, 'tā-ō van
Domenichino	dō-mā-nē-'kē-nō
Domenico Veneziano	dō-'mā-ni-kō ve-net-'sya-nō
Donatello	do-nŭ-'tel-lō
Dong Qichang	dong chō-chang
Dong Yuan	dong yan
Dubuffet, Jean	dyū-bŭ-'fā, zhan
Duccio di Buoninsegna	'dŭt-chō dē bwo-nēn-'sā-nya

Artist's Name	Phonetic Pronunciation
Duchamp, Marcel	dyū-'shaṇ, mar-'sel
Dürer, Albrecht	'dü-rŭ(r), 'al-breḵt
Durieu, Eugène	dūr-'yü, ö-'zhen
Eadwine the Scribe	'ă-ŭd-'win-ŭ
Eakins, Thomas	'ā-kŭnz
Eiffel, Alexandre-Gustave	e-'fel, 'al-ek-san-drŭ gū-'stav
El Greco	āl 'grā-kō (also el 'gre-kō)
Epigonos	e-'pig-o-nos
Ergotimos	er-'gō-ti-mos
Ernst, Max	ernst, maks
Euphronios	yu-'frō-nē-os
Euthymides	yu-'thim-ŭ-dēz
Exekias	ek-'sek-yŭs
Eyck, Hubert van	'īk, 'hū-bŭrt văn
Eyck, Jan van	'īk, yan văn
Fan Kuan	fan kwan
Feuerbach, Anselm	'foi-ŭr-baḵ, 'an-selm
Fouquet, Jean	fö-'ke, zhaṇ
Fragonard, Jean-Honoré	frăg-ŭ-'nar, zhaṇ o-no-'rā
Frankenthaler, Helen	'frăng-kŭn-tha-lŭr, 'hel-ŭn
Friedrich, Caspar David	'frēd-rik, kas-'par 'dav-ĕt
Fuseli, Henry	'füs-lē (or 'fū-z(ŭ)-lē), 'hen-rē
Gabo, Naum	'gab-ō, 'na-ūm
Gaddi, Taddeo	'gad-dē, tad-'de-ō
Gainsborough, Thomas	'gānz-bŭr-ŭ
Garnier, J. L. Charles	gar-'nyā, sharl
Gaudí, Antoni	gau-'dē, an-'tōn-ē
Gauguin, Paul	gō-'găn, pōl
Gehry, Frank	'ge-rē
Gelduinus, Bernardus	gel-'dwē-nŭs, bŭr-'nar-dŭs
Gentile da Fabriano	jen-'tē-lā da fab-rē-'an-ō
Gentileschi, Artemisia	jen-tē-'les-kē, art-ŭ-'miz-ē-ŭ
Gentileschi, Orazio	jen-tē-'les-kē, ō-'rat-syō
Géricault, Théodore	zhe-ri-'kō, tā-ō-'dōr
Gérôme, Jean-Léon	zhā-'rōm, zhaṇ lā-'on
Ghiberti, Lorenzo	gē-'bert-ē, lō-'ren-zō
Ghirlandaio, Domenico	gir-lŭn-'da-yō, dō-'men-i-kō
Giacometti, Alberto	jak-ŭ-'met-tē, al-'bert-ō
Giorgione da Castelfranco	jōr-'jō-nā da kas-tel-'frang-kō
Giotto di Bondone	'jot-tō dē bōn-'dō-nā
Giovanni da Bologna	jo-'van-nē da bo-'lōn-yŭ
Girardon, François	zhē-rar-'dōn, fran-'swa
Girodet-Trioson, Anne-Louis	zhē-rō-'de trē-ō-'sōn, an-'lwē
Gislebertus	gēz-lā-'bert-ŭs
Glykon of Athens	'glī-kon of 'ăth-ŭnz
Gnosis	'nō-sŭs
Goes, Hugo van der	'gŭs, 'hyū-go văn dŭr
Gogh, Vincent van	'gō, vin-'sent văn
Golub, Leon	'gol-ŭb, 'lē-an
González, Julio	gōn-'sal-ās, 'hūl-yō
Gossaert, Jan	'gos-art, yan
Goujon, Jean	gū-'zhōn, zhaṇ
Goya, Francisco José de	'goi-(y)ŭ, fran-'sis-kō hō-sā dā
Gozzoli, Benozzo	got-'tsō-lē, bā-'not-tsō
Greenough, Horatio	'grē-nō, hŭ-'rā-sh(ē)-ō
Greuze, Jean-Baptiste	grŭ(r)z (or gröz), zhaṇ bap-'tēst
Gropius, Walter	'grō-pē-us (-ŭs), 'wol-tŭr
Gros, Antoine-Jean	grō, an-'twan zhaṇ
Grünewald, Matthias	'grü-nŭ-valt, ma-'tē-as
Gu Kaizih	gū kī-tsi
Guarini, Guarino	'gwar-ē-nē, 'gwar-ē-nō
Guo Xi	gwo shē
Hagesandros	hăg-ŭ-'săn-dros
Hals, Frans	hals, frants
Hardouin-Mansart, Jules	ar-'dwăn-man-sar, zhŭl
Hasegawa Tōhaku	has-e-ga-wa tō-ha-ku
Hawes, Josiah Johnson	'hoz, jō-'zī-ŭ 'jan-sŭn
Heda, Willem Claez	'hā-da, 'vil-ŭm 'klas
Herrera, Juan de	er-'rer-a, hwan dā
Hesse, Eva	'hes, 'ē-vŭ
Hippodamos	hip-'ad-ŭ-mŭs
Hishikawa Moronobu	hē-shē-ka-wa mō-rō-nō-bu

Artist's Name	Phonetic Pronunciation
Holbein, Hans, the Younger	'hōl-bīn, hants
Honami Kōetsu	hō-na-mē kō-et-s(u)
Honnecourt, Villard de	on-ŭ-'kŭr, vē-'lar (or vē-'yar) dŭ
Honthorst, Gerrit van	'hont-horst, 'gher-ŭt van
Horta, Victor	'hor-tŭ, 'vēk-tor
Houdon, Jean-Antoine	ū-'dōn, zhaṇ an-'twan
Huang Gongwang	hwang gong-wang
Ikeno Taiga	i-kā-nō tī-gŭ
Iktinos	ēk-'tē-nos
Il Guercino	ēl gwer-'chē-nō
Imhotep	im-'hō-tep
Ingres, Jean-Auguste-Dominique	'ăn(ng)grŭ, zhaṇ o-'gŭst do-mi-'nēk
Isidorus of Miletus	iz-ŭ-'dōr-ŭs of mī-'lē-tŭs
Isoda Koryusai	i-sō-dŭ kōr-yū-sī
Jing Hao	jing hau
Jōchō	jō-chō
Jones, Inigo	jōnz, 'in-ŭ-gō
Jouvin, Hippolyte	zhu-'văn, ē(p)-po-'lēt
Ju Ran	jū ran
Juvara, Filippo	yū-'var-a, fē-'lēp-pō
Kahlo, Frida	'ka-lō, 'frē-da
Kahn, Louis	'kan, 'lū-ē
Kaigetsudō	kī-get-sud-ō
Kallikrates	kal-'ē-krŭ-tez
Kandinsky, Wassily	kăn-'din(t)-skē, vŭs-'yēl-yĭi
Kanō Motonobu	ka-nō mō-tō-nō-bu
Kanō Sanraku	ka-nō san-ra-ku
Kaō	kau
Kaprow, Allan	'kăp-rō, ăl-ŭn
Käsebier, Gertrude	'kas-ŭ-bēr, 'ger-trūd(-ŭ)
Katsushika Hokusai	ka-ts(ū)-sh(ē)-kŭ hō-k(ū)-sī
Kauffmann, Angelica	'kauf-man, ang-'gā-lē-ka
Kazuo Shinohara	ka-zū-ō shē-nō-har-a
Kenzo Tange	ken-zō tang-ge
Kiefer, Anselm	'kē-fŭr, 'an-selm
Kirchner, Ernst	'kirḵ-nŭ(r), ernst
Kitagawa Utamaro	kē-ta-ga-wa ut-a-ma-rō
Klee, Paul	'klā, pōl
Kleitias	'klē-tē-ŭs
Klimt, Gustav	'klĭmt, 'gus-taf
Kline, Franz	'klīn, frănz
Kokoschka, Oscar	'ko-kosh-ka, 'os-kar
Kollwitz, Käthe	'kol-vits, 'ket-ŭ
Kresilas	'kres-ŭ-las
L'Enfant, Pierre	lan-'fan, pyer
La Tour, Georges de	la-'tŭr, zhorzh dŭ
La Tour, Quentin de	la-'tŭr, kan-'tăn dŭ
Labrouste, Henri	la-'brŭst, an-'rē
Lange, Dorothea	lăng, dor-ŭ-'thē-ŭ
Latrobe, Benjamin	lŭ-'trōb, 'ben-j(ŭ)-mŭn
Le Brun, Charles	lŭ-'brŭn, sharl
Le Corbusier	lŭ kor-byū-sē-'ā
Le Nain, Louis	lŭ-'năn, lwē
Le Nôtre, André	lŭ-'nōtrŭ, an-'drā
Le Vau, Louis	lŭ-'vō, lwē
Léger, Fernand	lā-'zhā, fer-'nan
Lehmbruck, Wilhelm	'lām-bruk, 'vil-helm
Leibl, Wilhelm	'lī-bŭl, 'vil-helm
Leochares	lē-'ak-ŭ-rēz
Leonardo da Vinci	lā-ō-'nar-dō da 'vēn-chē (or lē-ŭ-'nar-dō dŭ 'vin-chē)
Lescot, Pierre	les-'kō, pyer
Li Cheng	lē chŭng
Li Gonglin	lē gung-lin
Liang Kai	lē-'ang 'kī
Libon of Elis	'lī-bŭn of 'ē-lŭs
Lichtenstein, Roy	'lik-tŭn-stīn, 'roi
Limbourg, Hennequin	'lim-burk, hen-(ŭ)-kăn
Limbourg, Herman	'lim-burk, 'her-maṇ
Limbourg, Pol	'lim-burk, pol
Lin, Maya Ying	lin, 'mī-ŭ yēng
Lipchitz, Jacques	lēp-'shēts (or 'lip-shits), zhak

Artist's Name	Phonetic Pronunciation	Artist's Name	Phonetic Pronunciation
Lippi, Filippino	'lēp-pē, fē-lēp-'pē-nō	Pei, Ieoh Ming	'pā, yŭŭ ming
Lippi, Fra Filippo	'lēp-pē, fra fē-'lēp-pō	Perrault, Claude	pŭ-'rō, klōd
Lochner, Stephan	'lok-nŭ(r), 'stā-fan	Perugino	per-ŭ-'jē-nō
Longhena, Baldassare	lan-'gā-nŭ, bal-dŭ-'sar-ā	Pfaff, Judy	'faf, 'jŭ-di
Lorenzetti, Ambrogio	lō-rent-'sāt-tē, am-'brō-jō	Phiale Painter	fē-'a-lā
Lorenzetti, Pietro	lō-rent-'sāt-tē, 'pye-trō	Phidias	'fid-ē-ŭs
Lorrain, Claude	lŭ-'răn, klōd	Philoxenos of Eretria	fŭ-'lak-sŭ-nŭs of er-ŭ-'trē-ŭ
Luzarches, Robert de	lu-'zarsh, rō-'ber dŭ	Piano, Renzo	pē-'a-nō, 'ren-zō
Lysippos of Sikyon	lī-'sip-os of 'sik-ē-an	Picasso, Pablo	pi-'kas-ō, 'pab-lō
Ma Yuan	ma yŭ-an	Piero della Francesca	'pyer-ō dāl-ŭ fran-'ches-ka
Mabuse, Jan	ma-'bü-zŭ, yan	Piranesi, Giovanni Battista	pē-ra-'nā-sē, jō-'van-nē bat-'tēs-ta
Machuca, Pedro	ma-'chŭ-ka, 'pā-drō	Pisano, Andrea	pē-'san-ō, an-'drā-ŭ
Maderno, Carlo	ma-'der-nō, 'kar-lō	Pisano, Giovanni	pē-'san-ō, jō-'van-nē
Magritte, René	ma-'grēt, rŭ-'nā	Pisano, Nicola	pē-'san-ō, nē-'kō-la
Maiano, Giuliano da	ma-'ya-no, jŭl-'yan-ō da	Pissarro, Camille	pŭ-'sar-ō, ka-'mēl [or ka-mēy]
Maillol, Aristide	mì-'yōl, ar-ŭ-'stēd	Plotinus	plō-'tì-nŭs
Malevich, Kasimir	mŭl-'yāv-yich, 'kaz-ē-mēr	Pollaiuolo, Antonio	pōl-'lī-wō-lō, an-'tōn-yō
Manet, Édouard	ma-'nā, ā-'dwar	Pollock, Jackson	'pal-ŭk, 'jăk-sŭn
Mansart, François	man-'sar, fran-'swa	Polydoros of Rhodes	pal-i-'dor-os of 'rōdz
Mantegna, Andrea	man-'tān-yŭ, an-'drā-ŭ	Polyeuktos	pal-ē-'yuk-tos
Marc, Franz	mark, frants	Polygnotos of Thasos	pal-ig-'nōt-os of 'tha-sos
Martini, Simone	mar-'tē-nē, sē-'mōn-ā	Polykleitos	pal-i-'klīt-os
Maruyama Okyo	ma-rŭ-ya-ma ō-kyō	Pontormo, Jacopo da	pōn-'tor-mō, 'ya-kō-pō da
Masaccio	mŭ-'sat-chō	Porta, Giacomo della	'port-a, 'ja-kō-mō dāl-la
Masolino da Panicale	ma-sō-'lē-nō da pa-nē-'ka-lā	Poussin, Nicolas	pŭ-'săn, ni-kō-'la
Matisse, Henri	ma-'tēs, an-'rē	Pozzo, Fra Andrea	'pōt-tsō, fra an-'drā-ŭ
Melozzo da Forli	mā-'lōt-tsō da for-'lē	Praxiteles	prak-'sit-(ŭ)l-ēz
Memling, Hans	mem-'ling, hants	Préault, Antoine-Auguste	prā-'ō, an-'twan o-'gŭst
Memmi, Lippo	'mem-mē, 'lip-pō	Primaticcio, Francesco	prē-ma-'tēt-chō, fran-'ches-kō
Metsys, Quentin	'met-sìs, 'kvin-tŭn	Pucelle, Jean	pyŭ-'sel, zhan
Mi Fu	mē fū	Puget, Pierre	pyŭ-'zhā, pyer
Michelangelo Buonarroti	mē-kā-'lan-jā-lō bwo-nar-'rō-tē	Pugin, A. W. N.	'pyŭ-jin
Michelozzo di Bartolommeo	mē-kā-'lōt-tso dē bar-tō-lōm-'me-ō	Puvis de Chavannes, Pierre	pŭ-vē-d(ŭ)-sha-'van, pyer
Mies van der Rohe, Ludwig	mēs-van-dŭ-'rō(-ŭ), 'lud-vik	Qi Baishi	chē bì-shi
Millais, John Everett	mil-'ā, jan 'ev-(ŭ-)rŭt	Quarton, Enguerrand	kar-'tōn, an-ge-'ran
Millet, Jean-François	mē-'yā (or mi-'lā), zhan fran-'swa	Raphael	'răf-ē-ŭl (or 'rā-fē-ŭl)
Minchō	min-chō	Rauschenberg, Robert	'rau-shŭn-bŭrg, 'rab-ŭrt
Miró, Joan	mē-'rō, zhu-'an	Redon, Odilon	rŭ-'dōn, ō-di-'lōn
Mnesikles	(m-)'nes-i-klēz	Regnaudin, Thomas	reg-no-'dăn (or re-nyo-'dăn), to-'ma
Modigliani, Amedeo	mō-dēl-'ya-nē, am-ā-'de-ō	Rembrandt van Rijn	'rem-brănt van 'rīn
Moholy-Nagy, László	mō-'hō-lē-'na-zhē	Reni, Guido	'ren-ē, 'gwē-dō
	(or 'mo-hoi-nady), 'laz-lō	Renoir, Auguste	ren-'war, o-'gŭst
Mokuan Reien	mō-ku-an rā-en	Repin, Ilya	'ryā-pyin, il-'ya
Mondrian, Piet	'mon-drē-an, pāt (or pēt)	Ribera, José (de)	rē-'bā-ra, hō-sā (dā)
Monet, Claude	mō-'nā, 'klōd	Richter, Hans	'rik-tŭr, hănz
Moreau, Gustave	mo-'rō, gŭ-'stav	Riemenschneider, Tilman	'rē-mŭn-shnī-dŭr, 'til-man
Morisot, Berthe	mo-rē-'zō, bert	Rietveld, Gerrit	'rēt-velt, 'gher-ŭt
Munch, Edvard	'mungk, 'ed-vard	Rigaud, Hyacinthe	rē-'gō, ē-ŭ-'sent (or ya-'sant)
Mungarawai	mŭng-gŭ-'ra-wa	Rodin, Auguste	rō-'dăn(n), o-'gŭst
Muybridge, Eadweard	'mì-brij, 'ed-wŭrd	Romano, Giulio	rō-'man-ō, 'jŭl-yō
Nadar	na-dar	Rosa, Salvator	'ro-za, sal-va-'tōr
Nanni di Banco	'nan-nē dē 'bang-kō	Rossellino, Antonio	rōs-sāl-'lē-nō, an-'tōn-yō
Neumann, Balthasar	'noi-man, bal-tŭ-'zar	Rossellino, Bernardo	rōs-sāl-'lē-nō, ber-'nar-dō
Ni Zan	nē tsan	Rosso Fiorentino	'rō-sō fyōr-ŭn-'tē-nō
Nièpce, Joseph Nicéphore	nyeps, zhō-'zef nē-sā-'fōr	Rouault, Georges	rŭ-'ō, zhorzh
Niobid Painter	nì-'ō-bid	Rousseau, Henri	rŭ-'sō, an-'rē
Nolde, Emil	'nol-dŭ, 'ā-mēl	Rublëv, Andrei	rŭb-'lyof, an-'drā-(ē)
Novios Plautios	'nō-vē-ōs 'plau-tē-ōs	Rude, François	rüd, fran-'swa
Ogata Kenzan	ō-ga-ta ken-zan	Ruisdael, Jacob van	'rìz-dal, 'ya-kob van
Ogata Kōrin	ō-ga-ta kō-rēn	Runge, Philipp Otto	'rung-ŭ, 'fē-lip 'o-tō
Okumura Masanobu	ō-ku-mur-a ma-sa-nō-bu	Ruscha, Edward	'rū-shā, 'ed-wŭrd
Oldenburg, Claes	'ol-dŭn-bur̲k, klas	Saint-Gaudens, Augustus	sānt-'god-(ŭ)nz, ŭ-'gŭs-tŭs
Olowe of Ise	ō-lŭ-'wā of 'e-sē	Sangallo, Antonio da, the Younger	sang-'gal-lō, an-'tōn-yō da
Onesimos	ō-'nes-ŭ-mōs	Sangallo, Giuliano da	sang-'gal-lō, jŭl-'yan-ō da
Orcagna, Andrea	ōr-'kan-ya, an-'drā-ŭ	Sansovino, Andrea	san-sō-'vē-nō, an-'drā-ŭ
Orozco, José Clemente	o-'rōs-kō, hō-'sā kle-'men-tā	Sansovino, Jacopo	san-sō-'vē-nō, 'ya-kō-pō
Paik, Nam June	pìk, nam jŭn	Schnabel, Julian	'shnab-ŭl, 'jŭ-lē-ŭn
Paionios of Ephesos	pì-'ō-nē-ŭs of 'ef-ŭ-sŭs	Schongauer, Martin	'shōn-gau-ŭr, 'mar-tēn
Palladio, Andrea	pŭl-'la-dē-ō, an-'drā-ŭ	Schwitters, Kurt	'shvit-ŭrs, 'kurt
Pannini, Giovanni	pan-'nē-nē, jō-'van-nē	Senmut	sen-'mūt
Parmigianino	par-mi-ja-'nē-nō	Sesshū	ses-shu

Artist's Name	Phonetic Pronunciation	Artist's Name	Phonetic Pronunciation
Seurat, Georges	sŭ-'ra, zhorzh	Tournachon, Gaspard-Félix	tŭr-na-'shōn, ga-'spar 'fā-lĕks
Severini, Gino	sā-vā-'rē-nē, 'jē-nō	Traini, Francesco	tra-'ē-nē, fran-'ches-kō
Severus	sŭ-'vir-ŭs	Uccello, Paolo	ūt-'chel-lō, 'pau-lō
Shen Zhou	shŭn jō	Unkei	un-kā
Shūbun	shub-un	Utagawa Toyokuni	ut-a-ga-wa tō-yō-kun-ē
Signorelli, Luca	sē-nyō-'rel-lē, 'lū-ka	Utzon, Joern	'ut-zōn, 'yŏr-(ŭ)n
Siloé, Gil de	sē-lō-'ā, hēl dā	Van Dyck, Anthony	văn-dīk, an-'tō-nē
Sinan the Great	sŭ-'nan	Vanbrugh, John	'văn-brŭ (or văn-'brŭ), jan
Skopas of Paros	'skō-pŭs of 'păr-os	Vasarely, Victor	va-'sa-rŭ-lē, vĕk-'tor
Sluter, Claus	'slŭ-tŭr, klaus	Vecelli, Tiziano	vŭ-'chel-lē, tēts-'ya-nō
Song Huizong	song hwā-tsong	Velázquez, Diego	vā-'las-kās, 'dyā-gō
Soufflot, Jacques-Germain	sŭ-'flō, zhak zher-'men	Venturi, Robert	ven-'tū-rē, 'rab-ŭrt
Southworth, Albert Sands	'sauth-wŭrth [also 'sŭth-ŭrth], 'ăl-bŭrt sănz	Vermeer, Jan	vŭr-'me(ŭ)r, yan
		Veronese, Paolo	ver-ŭ-'nā-sē, 'pau-lō
Spranger, Bartholomeus	'sprang-ŭr, bar-tō-lō-'mā-us	Verrocchio, Andrea del	vŭr-'rok-kyō, an-'drā-ŭ del
Stael, Nicolas de	stal, ni-kō-'la dŭ	Vigée-Lebrun, Élisabeth Louise	ve-zhā-lŭ-'brön, ā-lē-za-'bet lwēz
Stieglitz, Alfred	'stēg-lŭts (or -lits), ăl-frŭd	Vignola, Giacomo da	vēn-'yō-lŭ, 'ja-kō-mō da
Stoss, Viet	'shtōs, 'vēt	Vignon, Pierre	vin-'yon, pyer
Su Dongpo	sŭ dong-po	Vitruvius	vŭ-'trŭ-vē-ŭs
Suzuki Harunobu	suz-uk-ē har-un-ō-bu	Wang Meng	wang mŭng
Takayoshi	ta-ka-yō-shē	Wang Wei	wang wā
Tatlin, Vladimir	'tat-lyin, vlŭ-'dyēm-yir	Warhol, Andy	'wor-hal, 'ăn-dē
Tawaraya Sōtatsu	ta-wa-ra-ya sō-(ō-)tat-s(u)	Watteau, Antoine	wa-'tō, an-'twan
Teerlinc, Lavinia	'tēr-lingk, lŭ-'vin-ē-ŭ	Wen Zhengming	wŭn jŭng-ming
Theodoros of Phokaia	thē-ō-'dor-os of fō-kā-ŭ	Weyden, Rogier van der	'vīd-ŭn, rō-'ghēr văn dŭr
Theotokópoulos, Doménikos	tā-o-to-'ko-pū-los, dō-'mān-ē-kŭs	Wiligelmus	vē-lē-'ghel-mŭs
Tiepolo, Giambattista	tē-'ā-pŭ-lō, jam-bat-'tēs-ta	Witz, Conrad	'vits, 'kon-rat
Tinguely, Jean	'tăn-glŭ, zhan	Wolgemut, Michel	'vōl-gŭ-mūt, 'mik-ŭl
Tintoretto	tin-tŭ-'ret-ō	Wolvinius	wŭl-'vēn-yŭs
Titian	'tish-ŭn (or 'te-shŭn)	Wu Daozi	ū dau-tsŭ
Toba Sōjō	tō-ba sō-jō	Wu Zhen	ū jŭn
Toledo, Juan Bautista de	tō-'lā-dō, hwan bau-'tēs-ta dā	Xia Gui	shya gwā
Tori Busshi	tō-rē bŭ-shē	Xu Beihong	shū bā-hong
Torii Kiyomasu	tō-rē-ē kē-yō-mas-u	Yan Liben	yan lē-bŭn
Torii Kiyonaga	tō-rē-ē kē-yō-nag-a	Yosa Buson	yō-sa bus-ōn
Torii Kiyonobu	tō-rē-ē kē-yō-nō-bu	Zhao Mengfu	jau mŭng-fū
Torii Kiyotada	tō-rē-ē kē-yō-ta-da	Zhou Jichang	jō jē-chang
Tosa Mitsunobu	tō-sa mēt-sun-ō-bu	Zhu Da	jū da
Tōshūsai Sharaku	tō-shus-ī sha-ra-ku	Zong Bing	tsong bing
Toulouse-Lautrec, Henri de	tū-lŭz-lō-'trek, an rē dŭ	Zurbarán, Francisco de	sur-ba-'ran, fran-'sis-kō dā

GLOSSARY

Italicized terms in definitions are defined elsewhere in the glossary.

abacus—The uppermost portion of the *capital* of a *column*, usually a thin slab.

Abakans—Abstract woven hangings suggesting organic spaces as well as giant pieces of clothing made by Madgalena Abakanowicz.

Abstract Formalism—See *Suprematism*.

abstract—In painting and sculpture, emphasizing a derived, essential character that has only a stylized or symbolic visual reference to objects in nature.

acropolis—Literally, the "high city." In Greek architecture, the importance of the city temple was emphasized by building it on a hill above the city.

Action Painting—A type of *Gestural Abstractionism* (Abstract Expressionism or New York School) practiced by Jackson Pollock, in which the emphasis was on the heroic aspects of the artist's gesture in making art. Pollock stood on his canvases, pouring liquid paint in linear webs, and, in effect, incorporated his own physical nature into the components of the picture.

adobe—The clay used to make a kind of sun-dried mud brick of the same name; a building made of such brick.

additive—A kind of sculpture technique in which materials, e. g., clay, are built up or "added" to create form.

addorsed—Set back-to-back, especially as in heraldic design.

aerial perspective—See *perspective*.

agora—An open square or space used for public meetings or business in ancient Greek cities.

aisle—The portion of a church flanking the *nave* and separated from it by a row of *columns* or *piers*.

alabaster—A variety of gypsum or calcite of dense, fine texture, usually white, but also red, yellow, gray, and sometimes banded.

alla prima—A painting technique in which pigments are laid on in one application, with little or no drawing or underpainting.

altarpiece—A panel, painted or sculpted, situated above and behind an altar. See also *retable*.

Amazonomachy—In Greek mythology, the legendary battle between the Greeks and Amazons.

ambulatory—A covered walkway, outdoors (as in a *cloister*) or indoors; especially the passageway around the *apse* and the *choir* of a church.

amphiprostyle—The style of Greek building in which the *colonnade* was placed across both the front and back, but not along the sides.

amphitheater—Literally, a double theater. A Roman conception resembling two Greek theaters put together. The Roman *amphitheater* featured a continuous elliptical *cavea* around a central *arena*.

amphora—A two-handled, jar used for general storage purposes, usuallly to hold wine or oil.

Analytic Cubism—An art movement developed jointly by Pablo Picasso and Georges Braque in which the artists analyzed form from every possible vantage point to combine the various views into one pictorial whole.

anamorphic image—An image that must be viewed by some special means (such as a mirror) to be recognized.

anastasis—The Byzantine representation of the resurrection or the Harrowing of Hell.

andron—Dining room in a Greek house.

aniconic—Non-image representation.

animal style—A generic term for the characteristic ornamentation of artifacts worn and carried by nomadic peoples who, for almost two millennia (B.C. into A.D.) migrated between China and western Europe. The style is characterized by use of phantasms, like the dragon.

antae—The molded projecting ends of the walls forming the *pronaos* or *opisthodomos* of a Greek temple.

apadana—The great audience hall in ancient Persian palaces.

apotheosis—Elevated to the rank of gods or the ascent to heaven.

apotropaic—Capable of warding off evil.

apsara—In India, a nymph of the sky or air; in Chinese Buddhism, a heavenly maiden.

apse—A recess, usually singular and semi-circular, in the wall of a Roman *basilica* or at the east end of a Christian church.

arabesque—Literally, "Arabian-like." A flowing, intricate pattern derived from stylized organic motifs, usually floral, often arranged in symmetrical *palmette* designs; generally, an Islamic decorative motif.

arcade—A series of *arches* supported by *piers* or *columns*.

arch—A curved structural member that spans an opening and is generally composed of wedge-shaped blocks (*voussoirs*) that transmit the downward pressure laterally. A diaphragm arch is a transverse , wall-bearing arch that divides a *vault* or a ceiling into compartments, providing a kind of firebreak. See also *thrust*.

architrave—The *lintel* or lowest division of the *entablature*; sometimes called the epistyle.

archivolt—One of a series of concentric *moldings* on a Romanesque or a Gothic arch.

arcuated—Of *arch-column* construction.

arena—In a Roman *amphitheater*, the place where bloody gladiatorial combats and other boisterous events took place.

Arhats—Also *Bodhisattvas*. Buddhist holy persons who have achieved enlightenment and *nirvana* by suppression of all desire for earthly things.

arras—A kind of tapestry originating in Arras, a town in northeastern France.

ars—The technical knowledge and practical skill that made possible the building of Gothic churches. See also *scientia*.

ars geometria—The technical knowledge and practical skills of geometry that enabled architects, sculptors, and especially stained-glass artists to execute their designs, layouts, and assemblies. A sketchbook compiled by Villard de Honnecourt in the early 13th century demonstrates how artists of the time conceived of their work in terms of geometric form.

Art Brut—A term coined by Jean Dubuffet to characterize art that is genuine, untaught, coarse, even brutish.

Art Deco—Descended from *Art Nouveau*, this movement of the 1920s and 1930s sought to upgrade industrial design in competition with "fine art" and to work new materials into decorative patterns that could be either machined or hand-crafted. Characterized by "streamlined" design, elongated and symmetrical.

Art Nouveau—An early 20th-century art movement whose proponents tried to synthesize all the arts in an effort to create art based on natural forms that could be mass-produced by technologies of the industrial age.

ashlar masonry—Carefully cut and regularly shaped blocks of stone used in construction, fitted together without mortar.

assemblage—A three-dimensional composition made of various materials such as *found objects*, paper, wood, and cloth. See also *collage*.

atlantid—A male figure that functions as a supporting *column*. See also *caryatid*.

atlatl—Toltec "throw sticks."

Atmospheric or **aerial perspective**—See *perspective*.

atrium (pl. atria)—The court of a Roman house that is near the entrance and partly open to the sky. Also the open, colonnaded court in front of and attached to a Christian *basilica*.

attic—In architectural terminology, the uppermost story.

attribution—Assignment of a work to a maker or makers. Based on *documentary evidence*(i.e., signatures and dates on works and/or artist's own writings) and *internal evidence* (stylistic and iconographical analysis).

automatism—In painting, the process of yielding oneself to instinctive motions of the hands after establishing a set of conditions (such as size of paper or medium) within which a work is to be carried out.

avant-garde—Literally, the advance guard in a platoon. Artists who work in the most advanced stylistic expression. Also used as an adjective.

avatar—A manifestation of a deity incarnated in some visible form in which the deity performs a sacred function on earth. In Hinduism, an incarnation of a god.

avlu—A courtyard forming a summer extension of the *mosque* and surrounded by porticoes formed by domed squares.

axial plan—See *plan*.

baldacchino—A canopy on columns, frequently built over an altar. See also *ciborium*.

baptistery—The building next to a church, used for baptism.

barays—The large reservoirs laid out around Cambodian wats that served as means of transportation as well as irrigation. The reservoirs were connected by a network of canals.

baron—A feudal lord. See also *fief*.

Baroque—A blanket designation for the art of the period 1600 to 1750.

baroque—Ancient sculpture and architecture that appear to modern art historians to have strong stylistic affinities with 17th- and 18th-century monuments.

barrel or **tunnel vault**—See *vault*.

barroco—Portuguese for an irregularly shaped pearl, from which the word baroque probably comes.

bas-relief—See *relief.*

base—In Greek architecture, the lowest part of the Ionic column.

basilica—In Roman architecture, a public building for assemblies (especially tribunals), rectangular in plan with an entrance usually on a long side. In Christian architecture, an early church somewhat resembling the Roman basilica, usually entered from one end and with an *apse* at the other, creating an *axial plan.*

Bauhaus—A school of architecture in Germany in the 1920s under the aegis of Walter Gropius, whose mission was to give form to space by means of mastery of physical laws of statics, dynamics, optics, and acoustics. It stressed solutions to contemporary problems in housing, urban planning, and high-quality, utilitarian mass production.

beehive tomb—In Mycenaean architecture, beehive-shaped type of tomb covered by an earthen mound and constructed as a *corbeled vault.* See *tholos.*

ben-ben—A pyramidal stone; a *fetish* of the Egyptian god Re.

benizuri-e—A style of Japanese two-color print-making in which the dominant pink contrasts with patches of pale green and still smaller areas of black to produce a strong color vibration despite the very limited palette.

besso—A modest Japanese country retreat.

bevel—See *chamfer.*

bhakti—In Buddhist thought, the adoration of a personalized deity (*Bodhisattva*) as a means of achieving unity with it. In Hinduism, the devout, selfless direction of all tasks and activities of life to the service of one god.

bilingual vases—Experimental Greek vases produced for a short time in the late sixth century B.C.; one side featured decoration in *red-figure technique,* the other *black-figure technique.*

black-figure technique—In early Greek pottery, the silhouetting of dark figures against a light background of natural, reddish clay.

blanc-de-chine—White china ware.

blind arcade (wall arcade)—An *arcade* having no actual openings, applied as decoration to a wall surface.

Bodhisattva—In Buddhist thought, one of the host of divinities provided to the *Buddha* to help him save humanity. A potential *Buddha.* See also *bhakti.*

bombé—Outwardly bowed.

bottega—A shop; the studio-shop of an Italian artist.

Buddha—The supreme enlightened being of Buddhism; an embodiment of divine wisdom and virtue. **Buddhist** (*adj.*)

burin—A pointed steel tool used for *engraving* or *incising.*

buttress—An exterior masonry structure that opposes the lateral thrust of an *arch* or a *vault.* A pier buttress is a solid mass of masonry; a flying buttress consists typically of an inclined member carried on an arch or a series of arches and a solid buttress to which it transmits lateral *thrust.*

caldarium—The hot-bath section of a Roman bathing establishment.

calligraphy—Handwriting or penmanship, especially elegant or "beautiful" writing as a decorative art.

calotype—Photographic process in which a positive image is made by shining light through a negative image onto a sheet of sensitized paper.

camera lucida—A device in which a small lens projects the image of an object downward onto a sheet of paper. Literally, "lighted room."

camera obscura—An ancestor of the modern camera in which a tiny pinhole, acting as a lens, projects an image on a screen, the wall of a room, or the ground-glass wall of a box; used by artists in the 17th, 18th, and early 19th centuries as an aid in drawing from nature. Literally, "dark room."

campaniform—Bell-shaped.

campanile—A bell tower of a church, usually, but not always, freestanding.

canon—Rule, i.e., of proportion. The ancient Greeks considered beauty to be a matter of "correct" proportion and sought a *canon* of proportion, in music and for the human figure.

canon law—The law system of the Church as opposed to civil or secular law.

capital—The uppermost member of a *column,* serving as a transition from the *shaft* to the *lintel.* The *capital* has two elements—the *echinus* and *abacus*—the forms of which vary with the order.

Capitolium—A shrine honoring Jupiter, Juno, and Minerva.

caravansary—An inn where caravans could rest.

cardo—The north-south road in a Roman town, intersecting the *decumanus* at right angles.

cartoon—In painting, a full-size preliminary drawing from which a painting is made. Before the modern era, cartoons were customarily worked out in complete detail; the design was then transferred to the working surface by coating the back with chalk and going over the lines with a stylus, or by pricking the lines and "pouncing" charcoal dust through the resulting holes.

caryatid—A female figure that functions as a supporting *column.* See also *atlantid.*

castrum—A Roman military encampment, famed for the precision with which it was planned and laid out.

catacombs—Subterranean networks of galleries and chambers designed as cemeteries for the burial of the dead.

catafalque—The framework that supports and surrounds a deceased person's body on a bier.

cathedra—Literally, the seat of the bishop, from which the word cathedral is derived.

cavea—The seating area in Greek and Roman theaters and amphitheaters. Literally, a hollow place or cavity.

celadon—A Chinese-Korean pottery glaze characterized by its mat gray-green color.

cella—An enclosed chamber (Greek—*naos*); the essential feature of a Classical temple, in which the cult statue usually stood.

cement—See *concrete.*

centaur—In Greek mythology, a fantastical creature, with the front or top half of a human and the back or bottom half of a horse.

centauromachy—In Greek mythology, the battle between the Greeks and *centaurs.*

central plan—See *plan.*

Ch'an—See *Zen.*

chaitya—An Indian rock-cut temple hall having a votive *stupa* at one end.

chakravartin—In India, the ideal king, the Universal Lord who ruled through goodness.

chamfer—The surface formed by cutting off a corner of a board or post; a bevel.

chancel—The elevated area at the altar end of a church reserved for the priest and choir.

chandi—A Javanese Buddhist temple.

chansons de geste—Epic songs, especially French.

Charuns—Etruscan death demons.

chateau fort—A Romanesque stone castle, surrounded by thick walls and moats, the seat and symbol of the authority of the medieval *baron.*

chatra—See *parasol* or *yasti.*

chevet—The east, or apsidal, end of a Gothic church, including *choir, ambulatory,* and radiating chapels.

chi/rho—The initial letters of Christ's name in Greek, and coming to stand as a monogram for Christ.

chiaroscuro—In drawing or panting, the treatment and use of light and dark, especially the gradations of light that produce the effect of *modeling.*

chigi—The crosspiece at the gables of Japanese shrine architecture.

chimera—A monster of Greek invention with the head and body of a lion and the tail of a serpent. A second head, that of a goat, grows out of one side of the body.

chiton—A Greek tunic, the essential (and often only) garment of both men and women, the other being the *himation* or *mantle;* a kind of cape.

choir—The space reserved for the clergy in the church, usually east of the *transept* but, in some instances, extending into the *nave.*

chroma—Of the two variables in color, the apparent amount of light reflected and the apparent purity, value and tonality represent lightness; chroma, saturation, and intensity represent purity.

chryselephantine—Fashioned of gold and ivory.

ciborium—A canopy, often freestanding and supported by four columns, erected over an altar; also, a covered cup used in the sacraments of the Christian Church. See *baldacchino.*

cinétisme—See Kinetic Art.

circles of confusion—A phenomenon appearing on out-of-focus negatives, observed by modern photographers.

cire perdue—The lost-wax process. A bronze-casting method in which a figure is modeled in wax and covered with clay; the whole is fired, melting away the wax and hardening the clay, which then becomes a mold for molten metal.

cista—A cylindrical container made of sheet bronze with cast handles and feet, often with elaborately engraved bodies, used for women's toilet articles.

Cizhou—A type of northern Chinese pottery characterized by subtle techniques of underglaze painting and incision of a design through a colored slip

clair de lune—A pale, silvery blue Chinese pottery glaze.

clerestory—The *fenestrated* part of a building that rises above the roofs of the other parts.

cloison—Literally, a partition. A cell made of metal wire or a narrow metal strip soldered edge-up to a metal base to hold enamel or other decorative materials.

cloisonné—A process of enameling employing *cloisons.*

cloister—A monastery courtyard, usually with covered walks or *ambulatories* along its sides.

cluster pier—See *compound pier.*

codex (pl. **codices**)—Separate pages of *vellum* or *parchment* bound together at one side and having

a cover; the predecessor of the modern book. The *codex* superseded the *rotulus*. In Mesoamerica, a painted and inscribed book on long sheets of fig-bark paper or deerskin coated with plaster and folded into accordion-like pleats.

coffer—A sunken panel, often ornamental, in a *soffit*, a *vault*, or a ceiling.

collage—A composition made by combining on a flat surface various materials such as newspaper, wallpaper, printed text and illustrations, photographs, and cloth. See also *photomontage*.

colonnades—A series or row of *columns*, usually spanned by *lintels*.

colonnette—A small *column*.

color-field painters— A term used to describe the work Mark Rothko and other painters of the Abstract Expressionist or New York School who explored the optical and mystical effects of fields of color. Also known as Post-Painterly Abstractionists.

column—A vertical, weight-carrying architectural member, circular in cross-section and consisting of a base (sometimes omitted), a *shaft*, and a *capital*.

complementary colors—Those pairs of colors, such as red and green, that together embrace the entire spectrum. The complement of one of the three primary colors is a mixture of the other two. In pigments, they produce a neutral gray when mixed in the right proportions.

composite capital—An ornate combination of Ionic volutes and Corinthian acanthus leaves that became popular in Roman times.

composite view—See *twisted perspective*.

compound or **cluster pier**—A *pier* composed of a group or cluster of members, especially characteristic of Gothic architecture.

computer imaging—A medium developed during the 1960s and 1970s that uses computer programs and electronic light to make designs and images on the surface of a computer or television screen.

Conceptual art—Communicates message and meaning through more permanent media, two-dimensional or three-dimensional or both, often in combination with printed text. The primary purpose is to convey an idea or a concept with whatever visual means are available.

conches—Semi-circular half-domes.

concrete—A building material invented by the Romans and consisting of various proportions of lime mortar, volcanic sand, water, and small stones. From the Latin caementa, from which the English word cement is derived.

condottiere—A professional soldier employed by the Italian city-states in the early Renaissance.

connoisseur—An expert on works of art and the individual styles of artists.

Constructivism—A movement in art formulated by Naum Gabo in which he built up his sculptures piece by piece in space, instead of carving or modeling them in the traditional way. In this way the sculptor worked with volume of mass and volume of space as different materials.

consul—The elected representatives in Roman constitutional government, originally drawn only from among the *patricians*, or wealthy landowners.

contextuality—The causal relationships among artists, art work, and the society or culture that conditions them.

continuous narration—In painting or sculpture, the convention of the same figure appearing more than once in the same space at different stages in a story.

contrapposto—The disposition of the human figure in which one part is turned in opposition to another part (usually hips and legs one way, shoulders and chest another), creating a counter-positioning of the body about its central axis. Sometimes called weight shift because the weight of the body tends to be thrown to one foot, creating tension on one side and relaxation on the other.

corbel—A projecting wall member used as a support for some element in the superstructure. Also, courses of stone or brick in which each course projects beyond the one beneath it. Two such structures, meeting at the topmost course, create a corbeled arch.

corbel tables—Horizontal projections resting on *corbels*.

corbeled arch—See *corbel*.

corbeled vault—A *vault* formed by the piling of rocks in horizontal courses, cantilevered inward until the two walls meet in a pointed arch. No mortar is used, and the vault is held in place only by the weight of the blocks themselves, with smaller stones used as wedges.

Corinthian capital—A more ornate form than Doric or Ionic; it consists of a double row of acanthus leaves from which tendrils and flowers grow, wrapped around a bell-shaped *echinus*. Although this *capital* form is often cited as the distinguishing feature of the Corinthian order, there is, strictly speaking, no Corinthian order, but only this style of capital used in the Ionic order.

cornice—The projecting, crowning member of the *entablature* framing the *pediment;* also, any crowning projection.

Corpus Juris Civilis—Code of Civil Law; the codification of Roman law, supervised by Justinian, which became the foundation of the law systems of most European nations today.

cortile—In Renaissance architecture, an internal court surrounded by an arcade.

Cosmati—A group of 12th to 14th century craftsmen who worked in marble and mosaic, creating work (known as **Cosmato work**) characterized by inlays of gold and precious or semi-precious stones and finely cut marble in geometric patterns.

crenelated—Notched or indented, usually with respect to tops of walls, as in battlements.

cromlech—A circle of *monoliths*.

cross vault—See *vault*.

crossing—The space in a cruciform church formed by the intersection of the *nave* and the *transept*.

crossing square—The area in a church formed by the intersection (*crossing*) of a *nave* and a *transept* of equal width, often used as a standard measurement of interior proportion.

cruciform—Cross-shaped.

crypt—A vaulted space under part of a building, wholly or partly underground; in medieval churches, normally the portion under an *apse* or a *chevet*.

cubiculum (pl. **cubicula**)—A small cubicle or bedroom that opened onto the *atrium* of a Roman house. Also, a small room constructed in the wall of an Early Christian catacomb to serve as a mortuary chapel.

Cubism—See *Analytic* or *Synthetic Cubism*.

cultural constructs—In the reconstruction of the context of a work of art, experts consult the evidence of religion, science, technology, language, philosophy, and the arts to discover the thought patterns common to artists and their audiences.

culture—The collective characteristics by which a community identifies itself and by which it expects to be recognized and respected.

cuneiform—Literally, "wedge-shaped." A system of writing used in ancient Mesopotamia, the characters of which were wedge-shaped.

cupola—An exterior architectural feature composed of *drums* with shallow caps; a dome.

Cycladic art—The pre-Greek art of the Cycladic Islands.

Cyclopean—Gigantic, vast and rough, massive. Cyclopean masonry is a method of stone construction using large, irregular blocks without mortar. The huge unhewn and roughly cut blocks of stone were used to construct Bronze Age fortifications such as Tiryns and other Mycenaean sites.

cylinder seal—A cylindrical piece of stone usually about an inch or so in height, decorated with a design in *intaglio* (incised), so that a raised pattern was left when the seal was rolled over soft clay. In the ancient Near East documents, storage jars, and other important possessions were signed, sealed, and identified in this way.

Dada—An art movement that grew out of the absurdity and horror of World War I. *Dada* protested all art, modern or traditional, as well as the civilization that had produced it, to create an art of the absurd. Foremost among the Dadaists was Marcel Duchamp.

Daedalic—Refers to a Greek *orientalizing* style of the 7th century B.C. Characteristic of the style is the triangular flat-topped head framed by long strands of hair that form complementary triangles to that of the face.

daguerreotype—A photograph made by an early method on a plate of chemically treated metal; developed by Louis J. M. Daguerre.

damnatio memoriae—The Roman decree condemning those who ran afoul of the Senate to having their memorials demolished and their names erased from public inscriptions; the memory of them would be damned.

De Stijl—Dutch for "the style," a movement (and magazine) founded by Piet Mondrian and Theo van Doesburg.

deceptive cadence—In a horizontal scroll, the "false ending," which arrests the viewer's gaze by appearing to be the end of a narrative sequence, but which actually sets the stage for a culminating figure or scene.

deconstruction—A method of analysis proceeding by re-reading the received art-historical picture and showing where and how it is false to the realities of the cultures it attempts to explain and to the meanings of particular works of art.

découpage—A technique of decoration in which letters or images are cut out of paper or some such material and then pasted onto a surface.

decumanus—The east–west road in a Roman town, intersecting the *cardo* at right angles.

decursio—The ritual circling of a Roman funerary pyre.

demos—The Greek word meaning "the people," from which democracy is derived.

demotic—Late Egyptian writing

denarius—The standard Roman silver coin from which the word penny ultimately derives.

descriptive approach to representation—In artistic representation, that which is 'known'

about an object is represented. To represent a human profile "descriptively" would require the artist to depict both eyes rather than just one.

devaraja—In Cambodia, the ideal king who was the Universal Lord and god-king in life and after death.

dhyani Buddha—A representation of *Buddha* in meditation, seated in yoga pose, expressing the tranquility of pure and perfect transcendence of the world.

di sotto in sù—A technique of representing perspective in ceiling painting. Literally, "from below upwards."

diaphragm arch—See *arch*.

dictator perpetuus—Dictator for life, the title awarded to Julius Caesar shortly before his death.

ding—A fine, white proto-porcelain used in Chinese pottery.

diorite—An extremely hard stone used in Mesopotamian and Egyptian art.

dipteral—The term used to describe the architectural feature of double *colonnades* around Greek temples. See also *peripteral*.

diptych—A two-paneled painting or *altarpiece*; also, an ancient Roman and Early Christian two-hinged carved writing tablet, or two ivory memorial panels.

disegno interno—"Inner design," a reference to the Platonic Idea which underlay the visible world.

documentary evidence—In *attributions* of works of art, this consists of contracts, signatures, and dates on works as well as the artist's own writings.

dolmen—Several large stones (*megaliths*) capped with a covering slab, erected in prehistoric times.

dome—A hemispheric *vault*; theoretically, an *arch* rotated on its vertical axis.

Donaustil—A 15th- to16th-century Northern Renaissance painting style that flourished along the Danube River from Regensburg eastward into Austria. The style formed around the depiction of landscape and stresses mood, sometimes heightened to passion.

Doric—One of the two systems (or *orders*) evolved for articulating the three units of the elevation of a Greek temple—the platform, the *colonnade*, and the superstructure (*entablature*). The Doric order is characterized by, i.e., capitals with funnel-shaped *echinuses*, columns without bases, and a frieze of *triglyphs* and *metopes*. See also *Ionic*.

douanier—In French, "customs collector," a term that came to be applied to Henri Rousseau, the French "primitive" painter.

dromos—The passage leading to a *beehive tomb*.

drum—The circular wall that supports a *dome*; also, one of the cylindrical stones of which a non-monolithic *shaft* of a *column* is made.

dry fresco—See *fresco*.

dry point—An engraving in which the design, instead of being cut into the plate with a *burin*, is scratched into the surface with a hard steel "pencil." The process is quicker and more spontaneous than standard engraving and lends itself to the creation of painterly effects. Its disadvantage is the fact that the plate wears out very quickly. See also *engraving, etching, intaglio*.

duomo—Italian for cathedral, from the dome that usually surmounts the cathedral.

Earth, Environmental, or Site Art—A kind of modernist art that constructs with natural or artificial materials monuments of great scale and minimal form. Permanent or impermanent, these works are intended to transform some section of the environment so as to assert its presence and importance as reworked by the hand of the artist.

echinus—In architecture, the convex element of a *capital* directly below the *abacus*.

écorché—A figure painted or sculptured to show the muscles of the body without skin.

elevation—In drawing and architecture, a geometric projection of a building on a plane perpendicular to the horizon; a vertical projection. A head-on view of an external or internal wall, showing its features and often other elements that would be visible beyond or before the wall.

emblema—The central section or motif of a *mosaic*.

embrasure—A *splayed* opening in a wall that enframes a doorway or a window.

encaustic—A painting technique in which pigment is mixed with wax and applied to the surface while hot.

engaged column—A column-like, nonfunctional form projecting from a wall and articulating it visually. See also *pilaster*.

engobe—A slip of finely sifted clay that originally is of the same color as the clay of the pot.

engraving—The process of incising a design in hard material, often a metal plate (usually copper); also, the print or impression made from such a plate. See also *dry point, etching, intaglio*.

entablature—The part of a building above the *columns* and below the roof or the upper story. The entablature has three parts: *architrave* or *epistyle*, *frieze*, and *pediment*.

entasis—A convex tapering (an apparent swelling) in the *shaft* of a *column*.

epistyle—See *architrave*.

escutcheon—An emblem bearing a coat of arms.

esthetic properties of works of art—The visual and tactile features of an object: form, shape, line, color, mass, and volume.

esthetics—The branch of philosophy devoted to theories about the nature of art and artistic expression. Also referring to such theories.

etching—A kind of *engraving* in which the design is incised in a layer of wax or varnish on a metal plate. The parts of the plate left exposed are then **etched** (slightly eaten away) by the acid in which the plate is immersed after incising. See also *dry point, engraving, intaglio*.

ethnocentrism—The tendency to explain and to judge artifacts from the perspective of one's own culture and to the detriment of other cultures.

ewer—A large pitcher.

exarch—A Byzantine governor of a foreign province.

exedra—Recessed area, usually semi-circular.

exemplum virtutis—Example or model of virtue.

Expressionism—A modernist art movement that was a manifestation of subjective feeling toward objective reality and the world of imagination. Characterized by bold, vigorous brushwork, emphatic line, and bright color. Two sub-movements within *Expressionism* were Die Brücke, in Dresden, and Der Blaue Reiter, in Munich.

extrados—The upper or outer surface of an *arch*. See *intrados*.

facade—Usually, the front of a building; also, the other sides when they are emphasized architecturally.

faïence—Earthenware or pottery, especially with highly colored design (from Faenza, Italy, a site of manufacture for such ware). Glazed earthenware.

fan vault—See *vault*

fauces—Literally, the throat of the house. In a Roman house, the narrow foyer leading to the *atrium*.

fauves—Literally, "wild beasts." An early 20th-century art movement led by Henri Matisse and characterized by wild, bright colors.

femmage—A kind of feminist sewn collage made by Miriam Schapiro in which she assembles fabrics, quilts, buttons, sequins, lace trim, and rick-rack to explore hidden metaphors for womanhood, using techniques historically associated with women's crafts (techniques and media not elevated to the status of fine art).

fenestration—The arrangement of the windows of a building.

fengshui—A Chinese notion of "wind and water", the breath of life, which is scattered by wind and must be stopped by water; thus the forces of wind and water must be adjusted in the orientation of Chinese architecture.

fetish—An object believed to possess magical powers, especially one capable of bringing to fruition its owner's plans; sometimes regarded as the abode of a supernatural power or spirit.

feudalism—The medieval political, social and economic system held together by the relationship of a liege-lord and vassal.

fibula—A decorative pin, usually used to fasten garments.

fictor—Latin for "sculptor."

fido—Latin for "to trust."

fief—The land owned by a medieval *baron*.

fin de siècle—Literally, the end of the century, a period at the end of the 19th century and just before World War I in which art and literature languished in a kind of malaise compounded of despondency, boredom, morbidity, and hypersensitivity to the esthetic.

First Style—The earliest style of Pompeiian mural painting. Also called the masonry style, because the aim of the artist was to imitate, using painted stucco relief, the appearance of costly marble panels.

flamboyant style—A Late Gothic style of architecture superseding the *rayonnant* style and named for the flamelike appearance of its pointed tracery.

flute or fluting—Vertical channeling, roughly semicircular in cross-section and used principally on *columns* and *pilasters*.

flying buttress—See *buttress*.

foreshortening—The use of *perspective* to represent in art the apparent visual contraction of an object that extends back in space at an angle to the perpendicular plane of sight.

formalism—Strict adherence to, or dependence on, stylized shapes and methods of composition.

forum—The public square or marketplace of an ancient Roman city.

found objects—Images, materials, or objects as found in the everyday environment that are appropriated into works of art.

Fourth Style—In Pompeiian mural painting, the Fourth Style marks a return to architectural illusionism, but the architectural vistas of the *Fourth Style* are irrational fantasies.

freedmen—In ancient and medieval society, the class which had been freed from servitude as opposed to having been born free.

freestanding sculpture—See *sculpture in the round.*

fresco—Painting on plaster, either dry (dry fresco or fresco secco) or wet (wet or true fresco). In the latter method, the pigments are mixed with water and become chemically bound to the plaster. Also, a painting executed in either method.

fresco secco—See *fresco.*

fret or **meander**—An ornament, usually in bands but also covering broad surfaces, consisting of interlocking geometric motifs. An ornamental pattern of contiguous straight lines joined usually at right angles.

frieze—The part of the *entablature* between the *architrave* and the *cornice*; also, any sculptured or ornamented band in a building, on furniture, etc.

frigidarium—The cold-bath section of a Roman bathing establishment.

frottage—A process of rubbing a crayon or other medium across paper placed over surfaces with strong and evocative texture pattern to combine patterns.

Futurism—A militant group of Italian poets, painters, and sculptors who regularly signed and issued manifestoes declaring revolution in art against all traditional tastes, values, and styles and embracing the modern age of steel and speed and the virtues of violence and war.

gable—See *pediment.*

garbha griha—Literally, "womb chamber." In Hindu temples, this is the *cella,* the inner sanctum, for the cult image or symbol, the holiest of places in the temple.

garth—The garden of a *cloister.*

genre—A style or category of art; also, a kind of painting realistically depicting scenes from everyday life.

gesso—Plaster mixed with a binding material and used for *reliefs* and as a *ground* for painting.

Gestural Abstractionism—Also known as Abstract Expressionism and *Action Painting.* A kind of abstract painting in which the gesture, or act of painting, is seen as heroic and the subject of art. Its most renowned proponent was Jackson Pollock.

gigantomachy—In Greek mythology, the battle between gods and giants.

glaze—A vitreous coating applied to pottery to seal and decorate the surface; it may be colored, transparent, or opaque, and glossy or *matte.* In oil painting, a thin, transparent, or semitransparent layer put over a color to alter it slightly.

glory—See *nimbus.*

glyph—A pictographic component of a pre-alphabetic system of writing, prominent in Mesoamerican inscriptions.

Golden Mean—Also known as the Golden Rule or Golden Section, a system of measuring in which units used to construct designs are subdivided into two parts in such a way that the longer subdivision is related to the length of the whole unit in the same proportion as the shorter subdivision is related to the longer subdivision. The *esthetic* appeal of these proportions has led artists of varying periods and cultures to employ them in determining basic dimensions.

gopuram—The massive, ornamented entrance structure of South Indian temple compounds.

gorget—Throat armor.

graver—A cutting tool used by engravers and sculptors.

Greek Cross—A cross in which all the arms are the same length.

grisaille—A monochrome painting done mainly in neutral grays to simulate sculpture.

groin—The edge formed by the intersection of two *vaults.*

groin or **cross vault**—Formed by the intersection at right angles of two barrel vaults of equal size. Lighter in appearance than the barrel vault, the groin vault requires *buttressing.* See *vault.*

grotteschi—Grotesque images used for ornament in architecture, especially in grottoes.

ground—A coating applied to a canvas or some other surface to prepare that surface for painting; also, background.

guang—A Chinese covered libation vessel.

guilloche—An architectural ornament that imitates braided ribbon, or that consists of interlaced, curving bands.

hallenkirche—A hall church. A type of Gothic design much favored in Germany in which the *aisles* rise to the same height as the *nave* section.

haniwa—Sculptured fired pottery tubes, modeled in human, animal, or other forms and placed around early (archaic) Japanese burial mounds.

Happenings—Loosely structured performances initiated in the 1960s, whose creators were trying to suggest the dynamic and confusing qualities of everyday life; most shared qualities of unexpectedness, variety, and wonder.

Hard-Edge Abstractionists—A movement within Abstract Expressionism or the New York School that rigidly excluded all reference to gesture, and incorporated smooth knife-edge geometric forms to express the notion that the meaning of painting should be its form and nothing else. Ellsworth Kelly is an example.

harmika—In Buddhist architecture, a square enclosure surmounting the dome of a *stupa,* from which arises the *yasti.*

hatching—A technique used in drawing, engraving, etc., in which fine lines are cut or drawn close together to achieve an effect of shading.

Hejira—The flight of Muhammad from Mecca to Medinet-en-Nabi ("City of the Prophet") in the year 622, the year Islam dates its beginnings.

Helladic art—The pre-Greek art of the Greek mainland (Hellas).

herm—A bust on a quadrangular pillar.

hieratic—A method of representation fixed by religious principles and ideas; also, the priestly supernaturalism disparaging matter and material values that prevailed throughout the Christian Middle Ages, especially in Orthodox Byzantium.

hieroglyphic—A system of writing using symbols or pictures; also one of the symbols.

high relief—See *relief.*

himation—A Greek *mantle* worn by men and women over the tunic and draped in various ways.

Hinayana—In Buddhist thought, the Lesser Vehicle to achieve *nirvana.*

Hippodamian plan—A city plan devised by Hippodamos of Miletos *c.* 466 B.C., in which a strict grid was imposed upon a site, regardless of the terrain, so that all streets would meet at right angles. A *Hippodamian plan* also called for separate quarters for public, private, and religious functions, so that such a city was logically as well as regularly planned.

historiated—Ornamented with representations, such as plants, animals, or human figures, that have a narrative—as distinct from a purely decorative—function. Historiated initial letters were a popular form of manuscript decoration in the Middle Ages.

horror vacui—Literally, fear of "empty space," a technique of design in which an entire surface is covered with pattern.

hôtel—A town house.

hubris—Human arrogance towards the gods.

hue—The name of a color. Pigment colors combine differently than colors of light. The primary colors (in pigment: blue, red and yellow; in light: blue, red, and green) together with the secondary colors (in pigment: green, orange, and violet; in light: cyan, magenta, and yellow) form the chief colors of the spectrum. See also *complementary colors.*

humanism—The philosophy that superseded scholasticism, characterized by its chief concern for human values and interests as distinct from, but not opposed to, the otherworldly values of religion.

hydria—An ancient Greek three-handled water pitcher.

hypaethral—A building having no pediment or roof, open to the sky.

hypostyle hall—In Egyptian architecture, a hall with a roof supported by columns.

icon—A portrait or image; especially in the Greek church, a panel with a painting of sacred personages that are objects of veneration. In the visual arts, a painting, a piece of sculpture, or even a building regarded as an object of veneration.

Iconoclasm—A period in 7th century Byzantium in which a series of calamities erupted, indirectly bringing about an imperial ban on images— the destruction of which we call *iconoclasm.* The destroyers of images were known as iconoclasts, while those who opposed such a ban were known as iconophiles or iconodules.

iconography—Literally, the "writing" of images, both the significance and study of them; the analytic study of the symbolic, often religious, meaning of objects, persons, or events depicted in works of art.

iconostasis—The large icon-bearing chancel screen that shuts off the sanctuary of a Byzantine church from the rest of the church. In eastern Christian churches, a screen or a partition, with doors and many *tiers* of *icons,* separating the sanctuary from the main body of the church.

idealization—The representation of things according to a preconception of ideal form or type; a kind of *esthetic* distortion to produce idealized forms. See also *realism.*

ideogram—A simple, picturelike sign filled with implicit meaning.

ikegobo—The Benin altar of the hand or arm, symbolizing the Benin king's powers of accomplishment.

illumination—Decoration with drawings (usually in gold, silver, and bright colors), especially of the initial letters of a manuscript.

imagines (sing. **imago**)—In ancient Rome, wax portraits of ancestors.

imam—The leader of collective worship in Muslim religious practices.

impasto—A style of painting in which the pigment is applied thickly or in heavy lumps, as in many of Rembrandt's paintings.

imperator—A Latin term meaning "commander in chief" from which we derive our word "emperor."

impluvium—In a Roman house, the basin located in the *atrium* that collected rainwater.

impost block—A stone with the shape of a truncated, inverted pyramid, placed between a *capital* and the *arch* that springs from it.

in antis—In Greek architecture, between the *antae*.

in situ—In place; in original position.

incising—Cutting into a surface with a sharp instrument; also, a method of decoration, especially on metal and pottery.

insula—In Roman architecture, a multistory apartment house, usually made of brick-faced *concrete*; also refers to an entire city block.

intaglio—A category of graphic technique in which the design is *incised*, so that the impression made is in *relief*. Used especially on gems, seals, and dies for coins, but also in the kinds of printing or printmaking in which the ink-bearing surface is depressed; also, an object so decorated. See also *dry point, engraving, etching*.

intarsia—Inlay work, primarily in wood and sometimes in mother-of-pearl, marble, etc..

interaxial—The distance between the center of one column drum and the center of the next.

intercolumniation—The space or the system of spacing between *columns* in a *colonnade*.

internal evidence—In *attributions* of works of art, what can be learned by stylistic and iconographical analysis, in comparison with other works, and by analysis of the physical properties of the medium itself.

International Style—A style of 13th–14th-century painting begun by Simone Martini, who adapted the French Gothic manner to Sienese art fused with influences from the north. This style appealed to the aristocracy because of its brilliant color, lavish costume, intricate ornament, and themes involving splendid processions of knights and ladies. Also a style of 20th-century architecture associated with Le Corbusier whose elegance of design came to influence the look of modern office buildings and skyscrapers.

intrados—The underside of an *arch* or a *vault*. See *extrados*.

Ionic—One of the two systems (or *orders*) evolved for articulating the three units of the elevation of a Greek temple, the platform, the *colonnade*, and the superstructure (*entablature*). The Ionic order is characterized by, i.e., volute capitals, columns with bases, and an uninterrupted frieze.

jamb—In architecture, the side posts of a doorway.

jataka—Tales of the lives of, or a scriptural account of the *Buddha*. See also *sutra*.

jihad—Holy war, participation and resultant death in which assures a faithful Muslim the reward of Paradise.

jomon—A type of Japanese decorative technique characterized by rope-like relief. *Jomon* means "rope decoration."

ka—In ancient Egypt, immortal human substance; the concept approximates the Western idea of the soul.

karma—In Vedic religions, the ethical consequence of a person's life, which determine his or her fate.

kermess—A festival celebrating a saint's day.

ketos—Greek for sea dragon.

key or **meander**—See *fret*.

keystone—The central, uppermost *voussoir* in an *arch*.

khutba—The sermon and act of allegiance by the Muslim community to its *imam* that takes place near the *qibla* wall.

Kinetic Art—A kind of moving art. Closely related to *Op Art* in its concern with the perception of motion by visual stimulus, it was a logical step to present objects that actually moved. Characteristic of the work of Alexander Calder and the *Constructivists*.

kivas—Large circular underground structures that are the spiritual and ceremonial centers of Pueblo Indian life.

kore (pl. **korai**)—Greek for "young woman."

koru—Maori decorative spiral motifs.

kouros (pl. **kouroi**)—Greek for "young man."

krater—An ancient Greek wide-mouthed bowl for mixing wine and water.

kufic—An early form of the Arabic alphabet.

kylix/cylix—An ancient Greek shallow drinking cup with two handles and a stem.

lakshanas—Distinguishing marks of the *Buddha*.

lamassu—In Assyrian art, genii guardians in the form of man-headed bulls.

lapis lazuli—A rich, ultramarine, semiprecious stone used for carving and as a source for pigment.

lekythoi—Flasks containing perfumed oil that were placed in Greek graves as offerings to the deceased.

lierne—A short *rib* that runs from one main rib of a *vault* to another.

linear perspective—See *perspective*.

lintel—A beam used to span an opening.

loculi—Openings in the walls of catacombs to receive the dead.

loggia—A gallery with an open *arcade* or a *colonnade* on one or both sides.

longitudinal plan—The *basilican* plan.

lost-wax process—See *cire perdue*.

lotiform capital—A capital in the form of a lotus petal.

low relief—See *bas-relief*.

lunette—A semi-circular opening (with the flat side down) in a wall over a door, a niche, or a window.

luster painting—An Islamic painting technique that gives a metallic sheen to a surface. Designs are based on motifs found in Islamic architectural decoration.

luster ware—A type of colored tile with a metallic sheen developed by the Abbasids in the 9th century at Samarra in Iraq.

lustral—Pertaining to rituals of purification.

luxuria—A 12th-century term for sensual pleasure.

machiocolation—An opening in the floor of an overhanging gallery through which the defenders of a castle dropped stones and boiling liquids on attackers.

madrasa—A higher theological college adjoining and often containing a *mosque*.

maestà—A depiction of the Virgin Mary as the Queen of Heaven enthroned in majesty amid choruses of angels and saints.

Mahayana—In Buddhist thought, the Great Vehicle to achieve *nirvana*.

makimono—A Japanese horizontal scroll.

malanggan—A type of New Ireland wood carving noted for bewildering intricacy, and characterized by generous use of openwork, sliverlike projections, and over-painting in minute geometric patterns that further subdivide the image, resulting in a splintered or fragmented and airy effect.

mana—Spiritual power.

mandala—A magic diagram of the cosmos, the wheel of life, and the cycle of being/becoming. Represents the three spheres of Buddhist cosmology: The Human Sphere of desire; the Bodhisattva Sphere of form; and the *Buddha* Sphere of Formlessness.

mandápa—A Hindu assembly hall, part of a temple.

mandara—*Mandala*.

mandorla—An almond-shaped *nimbus*, or *glory*, surrounding the figure of Christ or other sacred figure.

mantle—A sleeveless, protective outer garment or cloak. See *himation*.

mappa—The handkerchief thrown down as the ritual opening gesture for the beginning of *arena* games.

Marama—The Maori moon god.

masjid—See *mosque*.

Masonry Style—See *First Style*.

mastaba—Arabic for "bench." An ancient Egyptian rectangular brick or stone structure with sloping sides erected over a subterranean tomb chamber connected with the outside by a shaft, which provided the *ka* with access to the tomb.

matte (also **mat**)—In painting, pottery, and photography, a dull finish.

mausoleum—A central-plan, domed structure, built as a memorial.

Mbari house—Ceremonial houses filled with clay sculptures and paintings, honoring community deities of the Igbo tribe in Africa.

meander or **key**—See *fret*.

medium—The substance or agency in which an artist works; also, in painting, the vehicle (usually liquid) that carries the pigment.

megaliths—Literally, "great stone"; a large, roughly hewn stone used in the construction of monumental prehistoric structures. megalithic (adj.) See also *cromlech, dolmen, menhir*.

megaron—A rectangular hall, fronted by an open, two-columned porch, traditional in Greece since *Mycenaean* times. The large reception hall of the king in the palace of Tiryns.

memento mori—A reminder of human mortality, usually represented by a skull.

menhir—A prehistoric *monolith*, uncut or roughly cut, standing singly or with others in rows or circles.

menorah—The seven-branched candelabrum used in Jewish religious practices.

mens sana in corpore sano—Latin phrase meaning "a sound mind in a sound body."

Mesoamerica—The region that comprises Mexico, Guatemala, Belize, Honduras, and the Pacific coast of El Salvador.

Mesolithic—The "middle" prehistoric period, between the *Paleolithic* and the *Neolithic* ages.

metope—The panel between the *triglyphs* in a Doric frieze, often sculptured in *relief*.

mihrab—A semi-circular niche usually set into the *qibla* wall of a Muslim *mosque*, often surmounted by a dome over the bay in front to mark its location.

minaret—A distinctive feature of Muslim mosque architecture from which the *muezzin* calls the faithful to worship.

minbar—The pulpit on which an *imam* stands. It represents secular authority as well as a religious function.

Minimalism—A style of painting or sculpture that consists of a severe reduction of form to single, homogeneous units called "primary structures."

Minoan art—The pre-Greek art of Crete, named after the legendary King Minos of Knossos

mobiles—Sculptures with moving parts.

modeling—The shaping or fashioning of three-dimensional forms in a soft material, such as clay; also, the gradations of light and shade reflected from the surfaces of matter in space, or the illusion of such gradations produced by alterations of value in a drawing, painting, or print.

modern—In art, styles that are cut off from the past.

Modernism—A style or movement that understands the manifestation of progress to be in science and its achievements; it rejects the past, holding the idea that to live by past ideas and values is to regress.

module -A basic unit of which the dimensions of the major parts of a work are multiples. The principle is used in sculpture and other art forms, but it is most often employed in architecture, where the module may be the dimensions of an important part of a building, such as a *column*, or simply some commonly accepted unit of measurement (the centimeter or the inch, or, as with Le Corbusier, the average dimensions of the human figure).

modus francigenum—Latin for Frankish work; a term used by people in the 13th and 14th centuries to describe Gothic cathedrals.

molding—In architecture, a continuous, narrow surface (projecting or recessed, plain or ornamented) designed to break up a surface, to accent, or to decorate.

monolith—A column that is all in one piece (not composed of *drums*); a large, single block or piece of stone used in *megalithic* structures.

monumental—In art criticism, any work of art of grandeur and simplicity, regardless of its size.

mortise-and-tenon system—See *tenon*.

mosaic—Patterns or pictures made by embedding small pieces of stone or glass (*tesserae*) in cement on surfaces such as walls and floors; also, the technique of making such works.

moschophoros—Greek for calf-bearer.

mosque—A Muslim religious building. From *masjid*, meaning a place for bowing down.

mudra—A stylized and symbolic hand gesture of mystical significance, usually in representations of Hindu deities.

muezzin—The crier in the Muslim religion who calls the faithful to worship.

muhaqqaq—A style of Islamic calligraphy that fills the outer rectilinear frame of the *mihrab*.

mullah—An Islamic teacher.

mullion—A vertical member that divides a window or that separates one window from another.

mummification—A technique used by ancient Egyptians to preserve human bodies so that they may serve as the eternal home of the immortal *ka*.

muqarnas—Stucco decorations of Islamic buildings in which "stalactite"-like decorations break up the structural appearance of arches, transforming them into near-organic forms.

mural—A wall painting; a *fresco* is a type of mural medium and technique.

Muslim—One who is a believer in Islam.

Mycenaean—The late phase of *Helladic* art, named after the site of Mycenae.

Nabis—The Hebrew word for prophet. A group of *Symbolist* painters influenced by Paul Gauguin.

naos—See *cella*.

narrative composition—Elements in a work of art arranged in such a manner as to tell a story.

narthex—A porch or vestibule of a church, generally *colonnaded* or *arcaded* and preceding the *nave*.

natatio—In Roman baths, the swimming pool.

Naturalism—The doctrine that art should adhere as closely as possible to the appearance of the natural world. *Naturalism*, with varying degrees of fidelity to appearance, recurs in the history of Western art.

nave—The part of a church between the chief entrance and the *choir*, demarcated from *aisles* by *piers* or *columns*.

necking—A groove at the bottom of the Greek Doric *capital* between the *echinus* and the *flutes* that masks the junction of *capital* and *shaft*.

necropolis—A large burial area or cemetery; literally, a city of the dead.

nenfro—See *tufa*.

Neolithic—The "new" Stone Age, approximately 7000—3000 B.C.

Neoplasticism—A theory of art developed by Piet Mondrian to create a pure plastic art comprised of the simplest, least subjective, elements, primary colors, primary values, and primary directions (horizontal and vertical).

nimbus—A halo, aureole, or *glory* appearing around the head of a holy figure to signify divinity.

nirvana—In Buddhism and Hinduism, a blissful state brought about by absorption of the individual soul or consciousness into the supreme spirit.

nishiki-e—A style of Japanese printmaking called "brocade picture," a true polychrome print.

octafoliate—Eight-leafed design.

oculus—The round central opening or "eye" of a dome.

ogive—The diagonal *rib* of a Gothic *vault*; a pointed, or Gothic, *arch*. **ogival** (adj.)

omnivoyant—All-seeing.

one-point perspective—See *perspective*.

opere francigeno—Latin for in the Frankish manner, used to describe Gothic style buildings created outside of France.

opisthodomos—In Classical Greek architecture, a porch at the rear, set against the blank back wall of the cella.

Optical or Op Art—A kind of painting style in which precisely drafted patterns directly, even uncomfortably, affect visual perception.

optical approach to representation—In artistic representation, only that which is actually "seen" is represented, rather than what is "known" (i.e., a human profile depicted optically would reveal only one eye, whereas a profile depicted "descriptively" would feature two eyes). See *descriptive approach to representation* .

opus modernum—Latin for modern work; a term used by people in the 13th and 14th centuries to describe Gothic cathedrals.

opus reticulatum—A method of facing concrete walls with lozenge-shaped bricks on stones to achieve a netlike ornamental surface pattern.

orans figures—In Early Christian art, figures represented with their hands raised in prayer.

orbiculum—A disc-like opening in a *pediment*.

orchestra—In Greek theaters, the circular piece of earth with a hard and level surface on which the ancient rites took place. Literally, it means dancing place.

order—In Classical architecture a style represented by a characteristic design of the *column* and its *entablature*. See also *superimposed order*.

Orientalizing—The early phase of Archaic Greek art, so named because of the adoption of forms and motifs from the ancient Near East and Egypt.

orrery—A special technological model to demonstrate the theory that the universe operates like a gigantic clockwork mechanism.

orthogonal—A line imagined to be behind and perpendicular to the picture plane; the *orthogonals* in a painting appear to recede toward a vanishing point on the horizon.

orthogonal plan—The imposition of a strict grid plan upon a site, regardless of the terrain, so that all streets meet at right angles. See also *Hippodamian plan*.

pagoda—A Chinese tower, usually associated with a temple, having a multiplicity of winged eaves; it is thought to be derived from the Indian *stupa*.

Paleolithic—The "old" Stone Age, before *c.* 7000 B.C.

palestra—A Roman exercise area, usually framed by a *colonnade*, often found in bathing establishments.

palette—In ancient Egypt, a slate slab used for ceremonial purposes, as in the *Palette of King Narmer*. A thin board with a thumb hole at one end on which an artist lays and mixes colors; any surface so used. Also, the colors or kinds of colors characteristically used by an artist.

palmette—A conventional, decorative ornament of ancient origin composed of radiating petals springing from a cuplike base.

pantomime—A method of representation used in Early Christian and medieval times which simplifies all meaning into body attitude and gesture.

Papatuanuku—The Maori earth mother.

papyrus—A plant native to Egypt and adjacent lands used to make paperlike writing material; also, the material or any writing on it.

parapet—A low, protective wall along the edge of a balcony or roof.

parasol—An umbrella atop a Chinese *pagoda*; a vestige of the chatra on an Indian *stupa*.

parchment—Lambskin prepared as a surface for painting or writing, one of the materials which comprised the leaves of a *codex*.

parekklesion—The side chapel in a Byzantine church.

passage grave—A burial chamber entered through a long, tunnel-like passage.

pastels—Chalk-like crayons made of ground color pigments mixed with water and a binding medium. They lend themselves to quick execution and sketching and offer a wide range of colors and subtle variations of tone, suitable for rendering nuances of value.

patricians—Wealthy landowners of the Roman Republic. Originally the *consuls* were elected from among these landowners.

Pax Augusta—See *Pax Romana*.

Pax Romana—The peace that Augustus established and that lasted for over two centuries under a succession of emperors.

Pax vobis—Latin for "Peace be unto you."

peachbloom—A pink dappled with green Chinese pottery glaze.

pediment—In Classical architecture, the triangular space (gable) at the end of a building, formed by the ends of the sloping roof above the *colonnade;* also, an ornamental feature having this shape.

pendant—Balancing.

pendentive—A concave, triangular piece of masonry (a triangular section of a hemisphere), four of which provide the transition from a square area to the circular base of a covering *dome.* Although they appear to be hanging (pendent) from the dome, they in fact support it.

peplos—A simple long woolen belted garment worn by Greek women that gives the female figure a columnar appearance.

peripteral colonnade—A *colonnade* or *peristyle.* See also *dipteral.*

peristyle—In Greek architecture, a *colonnade* all around the *cella* and its porch(es).

perpendicular style—The last English Gothic style, also known as Tudor, characterized by a strong vertical emphasis and dense thickets of ornamental vault ribs that serve entirely decorative functions.

persistence of vision—Retention in the brain for a fraction of a second of whatever the eye has seen; causes a rapid succession of images to merge one into the next, producing the illusion of continuous change and motion in media such as cinema.

perspective—A formula for projecting an illusion of the three-dimensional world onto a two-dimensional surface. In linear perspective, the most common type, all parallel lines or lines of projection seem to converge on one, two, or three points located with reference to the eye level of the viewer (the horizon line of the picture), known as vanishing points, and associated objects are rendered smaller the farther from the viewer they are intended to seem. Atmospheric or aerial perspective creates the illusion of distance by the greater diminution of color intensity, the shift in color toward an almost neutral blue, and the blurring of contours as the intended distance between eye and object increases.

petroglyphs—Engravings or incisings in rock.

photomontage—A composition made by fitting together pictures or parts of pictures, especially photographs. See also *collage.*

photoscreen—Technique employing photo processes to create stencil screens from graphic images, which then become part of complex printing or painting processes, as in the work of Robert Rauschenberg in his combine paintings.

physical music—A kind of video narrative made by Nam June Paik which comprises in quick succession fragmented sequences of a variety of media: dance, advertising, poetry, street scenes, etc.

piano nobile—The principal story (usually the second) in Renaissance buildings.

pictographs—A picture, usually stylized, that represents an idea; also, writing using such means; also painting on rock. See also *hieroglyphic.*

pictor—Latin for "painter."

Pictorial style—An early style of photography in which photographers desired to achieve effects of painting, using centered figures, framing devices, and soft focus. Gertrude Käsebier was a noted proponent of this style of photography.

Pictorialism—A *Postmodern* approach which sets aside *Modernist* formalism, *Expressionism,* and *Realism* in favor of picture-making, where idea and subject matter determine what the picture will look like. As in *Conceptual Art,* the artist begins with an idea and the picture follows.

pier—A vertical, freestanding masonry support.

pier buttress—See *buttress.*

pietà—A painted or sculpted representation of the Virgin Mary mourning over the body of Christ.

pietra serena—Literally, "serene stone," a type of gray stone used for its harmonious appearance when contrasted with stucco or other smooth finish in architecture.

pilaster—A flat, rectangular, vertical member projecting from a wall of which it forms a part. It usually has a *base* and a *capital* and is often *fluted.*

pillar—Usually a weight-carrying member, such as a *pier* or a *column;* sometimes an isolated, free-standing structure used for commemorative purposes.

pilotis—Thin steel or reinforced concrete posts used by architects in the early 20th century to support concrete roof and floor slabs, avoiding the need for load-bearing walls.

pinakotheke—The Greek word for picture gallery.

pitture metafisica—Literally, metaphysical painting. Exemplified by the work of Giorgio de Chirico, a precursor of *Surrealism.*

plan—The horizontal arrangement of the parts of a building or a drawing or a diagram showing such an arrangement as a horizontal *section.* In axial plan, the parts of a building are organized longitudinally, or along a given axis; in a central plan, the parts radiate from a central point.

Plateresque—A style of Late Gothic Spanish architecture derived from silversmithing, and characterized by its delicate execution of ornament.

plebeian—In the Roman Republic, the social class that included small farmers, merchants, and freed slaves.

plein-air—An approach to painting much favored by the Impressionists, in which artists sketch outdoors to achieve a quick impression of light, air and color. The sketches were then taken to the studio for reworking into more finished works of art.

plinth—The lowest member of a *base;* also a square slab at the base of a *column.*

pointed arch—See *ogive.*

polis (pl. **poleis**)—Independent city-states in ancient Greece.

polychrome—Done in several colors.

polyptych—An *altarpiece* made up of more than three sections.

pontifex maximus—A Latin term meaning "chief priest" of the state religion.

Pop Art—A term coined by British art critic Lawrence Alloway to refer to art that incorporated elements from popular culture, such as images from motion pictures, television, advertising, billboards, commodities, etc.

portico—A porch with a roof supported by *columns;* an entrance porch.

post-and-lintel system—A *trabeated* system of construction in which two posts support a *lintel.*

Post-Minimalist—A movement succeeding *Minimalism* in which the artists wanted to reintroduce a sense of visible process in the work. Using nontraditional sculptural materials like fiberglass, cord, and latex, artists such as Eva Hesse collapsed the pure forms of Minimal art.

Post-Painterly Abstraction—See *color-field painters.*

Postmodernism—A reaction against *Modernist* formalism, which is seen as elitist.

pottery—Objects (usually vessels) made of clay and hardened by firing.

Precisionists—A group of American painters whose work concentrated on portraying man-made environments in a clear and concise manner to express the beauty of the new world of perfect and precise machine forms. Charles Sheeler is an example.

predella—The narrow ledge on which an *altarpiece* rests on an altar.

princeps—A Latin term meaning "first citizen."

pronaos—The space in front of the *cella* or *naos* of a Greek temple.

propylaion (pl. **propylai**)—A gateway building leading to an open court preceding a Greek or Roman temple. The monumental entrance to the Acropolis in Athens.

proscenium—The part of the stage in front of the curtain. The stage of an ancient Greek or Roman theater.

prostyle—A style of Greek temple in which the *columns* stand in front of the *naos* and extend its full width.

provenance—Origin or source.

psalter—A book containing the Psalms of the Bible.

pseudoperipteral—In Roman architecture, a *pseudoperipteral* edifice has a series of engaged columns all around the sides and back of the *cella* to give the appearance of a *peripteral colonnade.*

purlins—Horizontal beams in a roof structure, parallel to the ridgepoles, resting on the main rafters and giving support to the secondary rafters.

purusha—Hindu for the primordial human being.

putto (pl. **putti**)—A young child, a favorite subject in Italian painting and sculpture.

pylon—The simple and massive gateway, with sloping walls, of an Egyptian temple.

qi—In Chinese artistic philosophy, the divine spirit of the Universe, apperception of which allows true artists to paint the truth beneath surface appearances.

qibla—In the Muslim religion, the direction (towards Mecca) the faithful turn when praying.

quadrant vault—Half-barrel vaults. See *vault.*

quadro riportato—A ceiling design in which painted scenes are arranged in panels resembling framed pictures transferred to the surface of a shallow, curved *vault.*

quatrefoil—A type of mosque architecture in which the forms assume the shape of a cloverleaf.

quoin—A large, sometimes *rusticated*, usually slightly projecting stone (or stones) that often form the corners of the exterior walls of masonry buildings.

Ra—The Maori sun god.

ragamalas—Hindu musical modes.

raigo—A Japanese depiction of the Buddha Amida descending through clouds amid a host of *Bodhisattvas*, welcoming deceased believers to his paradise.

raking cornice—The *cornice* on the sloping sides of a *pediment*.

rathas—Small, free-standing Hindu temples carved from huge boulders, found in Mahabalipuram, India.

rayonnant—Or "radiant" style of Gothic architecture, dominated the second half of the 13th century and was associated with the royal Paris court of Louis IX. Fundamental features of rayonnant style include bar tracery and stained glass.

realism—The representation of things according to their appearance in visible nature (without *idealization*). In the 19th century, an approach that supported the representation of the subject matter of everyday life in a realistic mode. Iconographically, 19th-century Realism is the subject matter of everyday life as seen by the artist.

red-figure technique—In later Greek pottery, the silhouetting of red figures against a black background; the reverse of the *black-figure technique*.

register—One of a series of superimposed bands in a pictorial narrative, or the particular levels on which motifs are placed.

Regula Sancti Benedicti—The rule established by Saint Benedict that became the standard by the 9th century for all Western monastic establishments. Monks who live by the rule or "regula" are known as regular clergy, while priests, living without a specific rule and subordinate to their bishops, are known as secular clergy.

relief—In sculpture, figures projecting from a background of which they are part. The degree of relief is designated high, low (bas), sunken (hollow), or *intaglio*. In the last, the backgrounds are not cut back, and the points in the highest relief are level with the original surface of the material being carved. See also *repoussé*.

relieving triangle—In a *corbeled arch*, the opening above the lintel that serves to lighten the weight to be carried by the *lintel* itself. The triangle that is formed is often filled with slabs decorated with sculptural programs.

relievo—*Relief*.

repoussé—Formed in *relief* by beating a metal plate from the back, leaving the impression on the face. The metal is hammered into a hollow mold of wood or some other pliable material and finished with a *graver*. See also *relief*.

reserve column—In Egyptian rock-cut and Etruscan subterranean tombs, a *column* that is hewn from the living rock and serves no supporting function.

respond—An engaged *column, pilaster*, or similar structure that either projects from a *compound pier* or some other supporting device or is bonded to a wall and carries one end of an *arch*, often at the end of an *arcade*. A nave arcade, for example, may have nine *pillars* and two *responds*. Vertical wall elements in *perpendicular style* architecture.

ressaut—The projection above each *capital* formed when engaged *columns* frame recessed *arches* and carry a flat *entablature*.

retable—An architectural screen or wall above and behind an altar, usually containing painting, sculpture, carving, or other decorations. See also *altarpiece*.

rhyton—An ancient Greek ceremonial drinking vessel with a base usually in the form of the head of an animal, a woman, or a mythological creature.

rib—A relatively slender, molded masonry *arch* that projects from a surface. In Gothic architecture, the *ribs* form the framework of the *vaulting*.

rib vault—Vaults in which the diagonal and transverse ribs compose a structural skeleton that partially supports the still fairly massive paneling between them.

Romanist—A 16th-century Northern Renaissance style characterized by a joining of Italian Mannerism with fanciful native interpretations of the Classical style to form a highly artificial, sometimes decorative, and often bizarre and chaotic style.

Rosetta Stone—An Egyptian artifact that gave scholars a key to deciphering *hieroglyphic* writing.

rotulus—The long manuscript scroll used by Egyptians, Greeks, Etruscans, and Romans; predecessor of the *codex*.

roundel—See *tondo*.

rusticate—To give a rustic appearance by roughening the surfaces and beveling the edges of stone blocks to emphasize the joints between them. A technique popular during the Renaissance, especially for stone courses at the ground-floor level.

sacra conversazione—Literally, "holy conversation," a style of *altarpiece* painting popular from the middle of the 15th century forward in which saints from different epochs are joined in a unified space and seem to be conversing either with each other or with the audience.

samsara—In Hindu belief, the rebirth of the soul into a succession of lives.

sarcophagus (pl. **sarcophagi**)—A coffin, usually of stone. From the Greek, "consumer of flesh."

sarsen—A form of sandstone used for the *megaliths* at Stonehenge.

satyr—A follower of Dionysos, represented as part human, part goat.

scarification—Decorative markings made with scars on the human body.

Schmerzensmann—Man of Sorrows, a favorite theme of Late Gothic German sculpture.

school—A chronological and stylistic classification of works of art with a stipulation of place.

scientia—The theory that underlay the building of Gothic churches. See also *ars*.

sculpture in the round—Freestanding figures, carved or modeled in three dimensions.

Second Style—In Pompeiian mural painting, from *c.* 80 B.C. the aim was to dissolve the confining walls of a room and replace them with the illusion of a three-dimensional world constructed in the artist's imagination.

section—In architecture, a diagram or representation of a part of a structure or building along an imaginary plane that passes through it vertically.

semiotics—A linguistic theory that has been applied to literary and artistic endeavors. *Semiotics* is concerned with the nature of signs, the fundamental elements in communication. All constructs are reducible to signs that communicate significance or meaning. The sign (the signifier) can be anything that signifies, and what it signifies (the signified) is its meaning.

senate—Literally, a council of elders. The legislative body in Roman constitutional government.

serdab—A small concealed chamber in an Egyptian tomb (*mastaba*) for the statue of the deceased.

serpentine (line)—The "S" curve, which was regarded by Hogarth as the line of beauty.

severe style—The earliest phase of Classical, sculpture, formal but not rigid in pose, emphasizing the principle of weight distribution.

severies—Thinly vaulted webs or panels between arches, a distinguishing feature of Gothic vaults.

sexpartite vaults—Vaults whose ribs spring from compound *piers*. The branching ribs divide the large square-vault compartment into six sections. See *vault*.

sfumato—A smokelike haziness that subtly softens outlines in painting; particularly applied to the painting of Leonardo and Correggio.

shaft—The part of a *column* between the *capital* and the *base*.

shoji—A translucent rice-paper-covered sliding screen that serves as a room divider in traditional Japanese houses.

sikhara—In Hindu temples, the tower above the shrine.

skene—In Greek theaters, the scene building that housed dressing rooms for the actors and also formed a backdrop for the plays.

skenographia—The Greek term for *perspective*, literally, "scene painting," which during the 5th century B.C. employed linear or single vanishing point perspective to create the illusion of depth.

skiagraphia—The Greek term for shading, literally "shadow painting," said to have been invented by Apollodoros, an Athenian painter of the 5th century B.C.

soak stain—A technique of painting pioneered by Helen Frankenthaler in which the artist drenches the fabric of raw canvas with fluid paint to achieve flowing, lyrical, painterly effects.

socle—A molded projection at the bottom of a wall or a *pier*, or beneath a pedestal or a *column* base.

soffit—The underside of an architectural member such as an *arch, lintel, cornice*, or stairway. See also *intrados*.

space—The bounded or boundless container of collections of objects.

spandrel—The roughly triangular space enclosed by the curves of adjacent *arches* and a horizontal member connecting their vertexes; also, the space enclosed by the curve of an *arch* and an enclosing right angle. The area between the arch proper and the framing *columns* and *entablature*.

Speculum Majus—Latin for The Great Mirror. Authored by Vincent of Beauvais, a scholar at the court of Louis IX, this was a comprehensive summary of medieval knowledge in which accounts of natural phenomena, scriptural themes, and moral philosophy serve a didactic religious purpose.

sphinx—A mythical Egyptian beast with the body of a lion and the head of a human.

splay—A large *bevel* or *chamfer*.

splayed—An opening (as in a wall) that is cut away diagonally so that the outer edges are farther apart than the inner edges. See also *embrasure*.

springing—The lowest stone of an *arch*, resting on the *impost block*.

square schematism—A church plan in which the crossing square is used as the module for all parts of the design. For example, in some Romanesque architecture each nave bay measures exactly one-half and each square in the aisles measures exactly one-quarter of a crossing square, and so on throughout the building.

squinch—An architectural device used as a transition from a square to a polygonal or circular base for a *dome*. It may be composed of *lintels*, *corbels*, or *arches*.

stanze—The Italian word for rooms.

statue column—See *atlantid* or *caryatid*.

stave—A wedge-shaped timber; vertically placed *staves* embellish the architectural features of the building.

stele—A carved stone slab used to mark graves and to commemorate historical events.

stiacciata or sciacciata—A kind of very low *relief*, originated by Donatello, that incorporates much of the illusionism of painting into carving, which in places is hardly more than a scratching of the surface.

stoa—In ancient Greek architecture, an open building with a roof supported by a row of *columns* parallel to the back wall. A covered *colonnade*.

strategos—A Greek general.

strigil—A scraper, used by Greek athletes to scrape oil from their bodies after exercising.

stringcourse—A horizontal *molding*, or band in masonry, ornamental but usually reflecting interior structure.

stucco—Fine plaster or cement used as a coating for walls or for decoration.

stupa—A large, mound-shaped Buddhist shrine.

stylobate—The uppermost course of the platform of a Greek temple, which supports the *columns*.

stylus—A needlelike tool used in *engraving* and *incising*.

subtractive—A kind of sculpture technique in which materials are taken away from the original mass, i.e., carving.

sue—A type of gray pottery emigrating from Korea to Japan in the archaic period.

superimposed orders—*Orders* of architecture that are placed one above another in an *arcaded* or *colonnaded* building, usually in the following sequence: Doric (the first story), Ionic, and Corinthian. Superimposed orders are found in later Greek architecture and were used widely by Roman and Renaissance builders.

Superrealist—A school of painting which emphasized making images of persons and things with scrupulous, photographic fidelity to optical fact.

Suprematism—A type of art formulated by Kazimir Malevich to convey his belief that the supreme reality in the world is pure feeling, which attaches to no object and thus calls for new, nonobjective forms in art—shapes not related to objects in the visible world. Also known as Abstract Formalism.

sura—Verses of the *Qur'an* (Koran).

Surrealism—A successor to *Dada*, *Surrealism* incorporated the improvisational nature of its predecessor into its exploration of the ways to express in art the world of dreams and the unconscious.

sutra—In Buddhism, an account of a sermon by or a dialogue involving the *Buddha*. A scriptural account of the *Buddha*. See also *jataka*.

Symbolists—In the late 19th century, a group of artists and poets who shared a view that the artist was not an imitator of nature but a creator who transformed the facts of nature into a symbol of the inner experience of that fact.

symmetria—Commensurability of parts. Polykleitos's treatise on his canon of proportions summarized the principle of symmetria.

Synthetic Cubism—In 1912 *Cubism* entered a new phase during which the style no longer relied on a decipherable relation to the visible world. In this new phase, called *Synthetic Cubism*, painting and drawings were constructed from objects and shapes cut from paper or other materials to represent parts of a subject in order to play visual games with variations on illusion and reality.

taberna—In Roman architecture, the single-room shop covered by a barrel vault.

Tane—Maori god of the forest.

Tangaroa—Maori god of the sea.

Tanginui—The Maori sky father.

tapa—Polynesian decorative bark cloth.

tatami—The traditional woven straw mat used for floor covering in Japanese architecture.

tattoo—A Polynesian word for the permanent decoration of human bodies.

Tawhiri-matea—The Maori god of the winds

te whanau puhi—The Maori children of the four winds.

technique—The technical process that artists employ to create form, as well as the distinctive, personal ways in which they handle their materials and tools.

tell—In Near Eastern archeology, a hill or a mound, usually an ancient site of habitation.

tempera—A technique of painting using pigment mixed with egg yolk, glue or casein; also the *medium* itself.

tenebrism—Painting in the "dark manner," using violent contrasts of light and dark, as in the work of Caravaggio.

tenon—A projection on the end of a piece of wood that is inserted into a corresponding hole (mortise) in another piece of wood to form a joint.

tepidarium—The warm bath section of a Roman bathing establishment.

terracotta—Hard-baked clay, used for sculpture and as a building material, may be *glazed* or painted.

terribilità—The notion of the sublime shadowed by the awesome and the fearful, often associated with Michelangelo and his works.

tesserae—Tiny stones or pieces of glass cut to desired shape and size to use in *mosaics* to create design and composition.

tetrarchy—Rule by four. A type of Roman government established in the late 3rd century A.D. by Diocletian in an attempt to share power with potential rivals.

texture—The quality of a surface (rough, smooth, hard, soft, shiny, dull) as revealed by light.

theatron—In Greek theaters, the slope overlooking the *orchestra* on which the spectators sat. Literally, the place for seeing.

Third Style—In Pompeiian mural painting, the style in which delicate linear fantasies were sketched on predominantly monochrome backgrounds.

tholos (pl. **tholoi**)—A circular structure, generally in Classical Greek style; also, in Aegean sculpture, a circular beehive-shaped tomb.

thrust—The outward force exerted by an *arch* or a *vault* that must be counterbalanced by *buttresses*.

tie-rods—Beams, bars or rods that tie parts of a building together.

tier—A series of architectural rows, layers, or ranks arranged above or behind one another.

togu na—The "head" and most important part of the Dogon anthropomorphized village. The name means "house of words," because the *togu na* is the place in which occur the deliberations vital to community welfare.

tokonoma—A shallow alcove in a Japanese teahouse which is used for a single adornment, i.e., a painting, or stylized flower arrangement.

Toltec—The Mayan word for "makers of things." The Toltecs invaded the Mayas from the north and contributed to the fall of the Classic Mayan civilizations. The Toltec capital flourished at Tula from about 900 to 1200.

tondo—A circular painting or *relief* sculpture.

torana—Gateway in the stone fence around a *stupa*, located at the cardinal points of the compass.

torii—Ceremonial gates leading to the inside of a Shinto shrine.

trabeated—Of *post-and-lintel* construction. Literally, "beamed" construction.

transept—The part of a *cruciform* church with an axis that crosses the main axis at right angles.

treasuries—In ancient Greece, small buildings set up for the safe storage of votive offerings.

tribune—In Romanesque church architecture, upper galleries built over the inner *aisles*.

triclinium—The dining room of a Roman house.

triforium—The bank of *arcades* below the *clerestory* that occupies the space corresponding to the exterior strip of wall covered by the sloping timber roof above the galleries. In a Gothic cathedral, the blind, *arcaded* gallery below the *clerestory*.

triglyph—A projecting, grooved member of a Doric *frieze* that alternates with *metopes*.

trilithons—A pair of *monoliths* topped with a *lintel*; found in *megalithic* structures.

triptych—A three-paneled painting or *altarpiece*.

trompe l'œil—A form of illusionistic painting that attempts to represent an object as existing in three dimensions at the surface of the painting; literally, "fools the eye."

trouvères—Minstrels of the chivalric age who sang secular music complimenting the sacred love of Our Lady (the Virgin Mary) by praising the worldly love of women and the pursuit of that love as the worthy occupation of the chivalrous knight.

true fresco—See *fresco*.

trumeau—In architecture, the *pillar* or center post supporting the lintel in the middle of the doorway.

Tudor—See *perpendicular style*.

tufa (nenfro)—A porous rock formed from deposits of springs.

tumulus (pl. **tumuli**)—Burial mounds; in Etruscan architecture, tumuli cover one or more subterranean multichambered tombs cut out of the local *tufa*.

tunnel vaults—Continuous, cut-stone barrel vaults.

Tuscan column—Also known as Etruscan column. Resemble Greek Doric columns, but made of wood, unfluted, and with bases. They were spaced more widely than were Greek columns.

Tusci—The ancient people who inhabited Etruria, or modern-day Tuscany.

twisted perspective—A convention of representation in which part of a figure is seen in profile and another part of the same figure frontally. Not strictly *optical* (organized from the perspective of a fixed viewpoint), but *descriptive*.

tympanum—The space enclosed by a *lintel* and an *arch* over a doorway; also, the recessed face of a *pediment*.

ukiyo-e—A style of Japanese *genre* painting ("pictures of the floating world") that influenced 19th-century Western art.

uomo universale—The "Universal" or Renaissance man, who is accomplished in many fields of endeavor. (Although women also attain this state, the word "uomo" is Italian for "man.")

urna—A whorl of hair, represented as a dot, between the brows of the *Buddha*. One of the *lakshanas* of the *Buddha*.

ushnisha—The knot of hair on the top of *Buddha*'s head. One of the *lakshana* of the *Buddha*.

ut pictura poesis— Latin for "As painting (goes), so poetry (goes)."

vault—A masonry roof or ceiling constructed on the *arch* principle. A barrel or tunnel vault, semicylindrical in cross-section is, in effect, a deep arch or an uninterrupted series of arches, one behind the other, over an oblong space. A quadrant vault is a half-barrel (tunnel) vault. A groin or cross vault is formed at the point at which two *barrel* (tunnel) vaults intersect at right angles. In a ribbed vault, there is a framework of ribs or arches under the intersections of the vaulting sections. A sexpartite vault is a rib vault with six panels. A fan vault is a development of *lierne* vaulting characteristic of English Perpendicular Gothic, in which radiating *ribs* form a fan-like pattern.

veduta—Type of naturalistic landscape and cityscape painting popular in 18th-century Venice. Literally, "view" painting.

velarium—In a Roman amphitheater, the cloth awning that could be rolled down from the top of the *cavea* to shield spectators from sun or rain.

vellum—Calfskin prepared as a surface for writing or painting, one of the materials which comprised the leaves of a *codex*.

veristic—True to natural appearance.

vestibule—See *portico*.

vignette—An image with a strong center that becomes less defined at its edges.

vihara—A Buddhist monastery, often cut into a hill.

vimana—In Hindu and Buddhist temples, the pyramidal tower above the shrine (composed of the *garbha griha* and the *sikhara*).

vita activa—In the Middle Ages, the two kinds of life that were open to monks, the *vita activa*, or active life, and the **vita contemplativa,** the religious life of contemplation.

volute—A spiral, scroll-like form characteristic of the Greek Ionic and the Roman Composite *capital*.

voussoir—A wedge-shaped block used in the construction of a true *arch*. The central voussoir, which sets the arch, is the *keystone*.

wall rib—The rib at the junction of the vault and the wall.

wat—A Buddhist monastery in Cambodia.

weight shift—See *contrapposto*.

wergild—A type of medieval recompense for criminal damages inflicted. Literally, "man-money" or "man-gold". The offender must compensate the victim or the victim's kinfolk with a payment in money or in kind.

westwork—A multistoried mass, including the *facade* and usually surmounted by towers, at the western end of a medieval church, principally in Germany.

wet fresco—See *fresco*.

white-ground technique—A Greek vase painting technique in which the pot was first covered with a slip of very fine white clay, over which black glaze was used to outline figures, and diluted brown, purple, red, and white were used to color them.

woodcut—A wooden block on the surface of which those parts not intended to print are cut away to a slight depth, leaving the design raised; also, the printed impression made with such a block Also known as woodblock.

yaksha/yakshi—Male and female Buddhist and Hindu divinities.

Yamato-e—A purely Japanese style of sophisticated and depersonalized painting created for the Fujiwara nobility.

yasti—In Buddhist architecture, the mast which arises from the dome of the *stupa*, *harmika*, and which is adorned with a series of chatras (umbrellas).

yingging—A type of Chinese pottery glaze characterized by a subtle pale blue color.

Zen—A *Buddhist* sect and its doctrine, emphasizing enlightenment through intuition and introspection rather than the study of scripture. In Chinese, Ch'an.

ziggurat—A roughly pyramidal platform for a template, built in ancient Mesopotamia, consisting of stages; each succeeding stage is stepped back from the one beneath.

zoopraxiscope—Device invented by Eadweard Muybridge, which he developed to project sequences of images (mounted on special glass plates) onto a screen in rapid succession, creating the illusion of motion pictures. See *persistence of vision*.

zullah—Shaded area along the central court of Muslim religious buildings.

BIBLIOGRAPHY

This supplementary list of books is intended to be comprehensive enough to satisfy the reading interests of the unspecialized student and general reader, as well as those of more advanced readers who wish to become acquainted with fields other than their own. The books listed range from works that are valuable primarily for their reproductions to those that are scholarly surveys of schools and periods. No entries for periodical articles appear, but a few of the periodicals that publish art-historical scholarship in English are noted.

SELECTED PERIODICALS

American Journal of Archaeology
Archaeology
The Art Bulletin
Art History
The Art Journal
The Burlington Magazine
Journal of the Society of Architectural Historians
Journal of the Warburg and Courtauld Institutes

REFERENCE BOOKS
AND GENERAL STUDIES

Arntzen, Etta, and Robert Rainwater. *Guide to the Literature of Art History.* Chicago: American Library Association/Art Book Company, 1981.

Bator, Paul M. *The International Trade in Art.* Chicago: University of Chicago Press, 1988.

Bindman, David, ed. *The Thames & Hudson Encyclopedia of British Art.* London: Thames & Hudson, 1988.

Broude, Norma, and Mary D. Garrard, eds. *The Expanding Discourse: Feminism and Art History.* New York: HarperCollins, 1992.

———. *Feminism and Art History: Questioning the Litany.* New York: Harper & Row, 1982.

Bryson, N. *Vision and Painting: The Logic of the Gaze.* New Haven: Yale University Press, 1983.

Chilvers, Ian, and Harold Osborne, eds. *The Oxford Dictionary of Art.* New York: Oxford University Press, 1988.

Christe, Yves, et al. *Art of the Christian World, 200–1500: A Handbook of Styles and Forms.* New York: Rizzoli, 1982.

Cummings, P., *Dictionary of Contemporary American Artists.* 6th ed. New York: St. Martin's Press, 1994.

Derrida, Jacques. *The Truth in Painting.* Chicago/London: University of Chicago Press, 1987.

Deepwell, K., ed. *New Feminist Art.* Manchester: Manchester University Press, 1994.

Encyclopedia of World Art. 15 vols. New York: Publisher's Guild, 1959–1968. Supplementary vols. 16, 1983; 17, 1987.

Fielding, Mantle. *Dictionary of American Painters, Sculptors, and Engravers.* 2nd rev. and enl. ed. Poughkeepsie, NY: Apollo, 1986.

Fleming, John, Hugh Honour, and Nikolaus Pevsner. *Penguin Dictionary of Architecture.* Baltimore: Penguin, 1980.

Fletcher, Sir Banister. *A History of Architecture.* 18th rev. ed. New York: Scribner, 1975.

Giedion, Siegfried. *The Beginnings of Architecture: The Eternal Present, a Contribution on Constancy and Change.* Princeton: Princeton University Press, 1981.

———. *Space, Time and Architecture: The Growth of a New Tradition.* 5th ed., rev. and enl. Cambridge: Harvard University Press, 1982.

Gombrich, Ernst Hans Josef. *Art and Illusion.* 5th ed. London: Phaidon, 1977.

Haggar, Reginald G. *A Dictionary of Art Terms: Architecture, Sculpture, Painting, and the Graphic Arts.* Poole, England: New Orchard Editions, 1984.

Hall, James. *Dictionary of Subjects and Symbols in Art.* 2nd rev. ed. London: J. Murray, 1979.

Harris, A. S. *Women Artists: 1550–1950.* Los Angeles: County Museum of Art; New York: Knopf, 1977.

Hauser, Arnold. *The Sociology of Art.* Chicago: University of Chicago Press, 1982.

Hind, Arthur M. *A History of Engraving and Etching from the Fifteenth Century to the Year 1914.* 3rd rev. ed. New York: Dover, 1963.

Holt, Elizabeth G., ed. *A Documentary History of Art.* 2nd ed. 2 vols. Princeton: Princeton University Press, 1981.

———. *Literary Sources of Art History.* Princeton: Princeton University Press, 1947.

Huyghe, René, ed. *Larousse Encyclopedia of Byzantine and Medieval Art.* New York: Prometheus Press, 1963; Excalibur Books, 1981.

———. *Larousse Encyclopedia of Renaissance and Baroque Art.* New York: Prometheus Press, 1964; Hamlyn/American (paperbound), 1976.

James, John, et al. *The Traveler's Key to Medieval France: A Guide to the Sacred Architecture of Medieval France.* New York: Knopf, 1986.

Janson, H. W., ed. *Sources and Documents in the History of Art Series.* Englewood Cliffs, NJ: Prentice-Hall, 1966.

Kostof, Spiro. *A History of Architecture: Settings and Rituals.* Oxford: Oxford University Press, 1985.

Kronenberger, Louis. *Atlantic Brief Lives: A Biographical Companion to the Arts.* Boston: Little, Brown, 1971.

Lucie-Smith, Edward. *The Thames & Hudson Dictionary of Art Terms.* London: Thames & Hudson, 1984.

Lutyk, Carol B. *The Adventure of Archaeology.* Washington DC: National Geographic, 1985, 1989.

Malraux, André; Salles, Georges; and Parrot, André, eds. *The Arts of Mankind.* 13 vols. New York: Golden Press, Odyssey Press, Braziller, 1961.

Murray, Peter, and Murray, Linda. *A Dictionary of Art and Artists.* New York: Penguin, 1976; (paperbound) 1984.

Myers, Bernard Samuel, ed. *Encyclopedia of Painting: Painters and Painting of the World from Prehistoric Times to the Present Day.* 4th rev. ed. New York: Crown, 1979.

———. *Encyclopedia of World Art,* Suppl. vol. 16. Palatine, IL: McGraw-Hill/The Publishers Guild, 1983. (Later edition available.)

Myers, Bernard S., and Myers, Shirley D., eds. *Dictionary of 20th-Century Art.* New York: McGraw-Hill, 1974.

Osborne, Harold, ed. *The Oxford Companion to 20th Century Art.* New York: Oxford University Press, 1981.

Pevsner, Nikolaus. *A History of Building Types.* 1979. Reprint. London: Thames & Hudson (paperbound), 1987.

———. *An Outline of European Architecture.* Baltimore: Penguin, 1960.

———. *An Outline of European Architecture.* 8th rev. ed. Baltimore: Penguin, 1974.

Pickover, C., ed. *Visions of the Future: Art, Technology and Computing in the Twenty-First Century.* New York: St. Martin's Press, 1994.

Pierson, William H., Jr., and Martha Davidson. eds. *Arts of the United States, A Pictorial Survey.* 1960. Reprint. Athens: University of Georgia Press, 1975.

Placzek, A. K., ed. *Macmillan Encyclopedia of Architects* 4 vols. New York: Macmillan/Free Press, 1982.

Podro, Michael. *The Critical Historians of Art.* New Haven: Yale University Press, 1982.

Quick, John. *Artists' and Illustrators' Encyclopedia.* 2nd ed. New York: McGraw-Hill, 1977.

Ragghianti, C. L., ed. *Great Museums of the World.* 12 vols. New York: Newsweek/Mondadori, 1967.

Read, Herbert, and Nikos Stangos. eds. *The Thames & Hudson Dictionary of Art and Artists.* Rev. ed. London: Thames & Hudson, 1988.

Redig de Campos, D., ed. *Art Treasures of the Vatican.* New York: Park Lane, 1974.

Reid, Jane D. *The Oxford Guide to Classical Mythology in the Arts 1300–1990s.* 2 vols. New York: Oxford University Press, 1993.

Renfrew, Colin. *Archaeology: Theories, Methods, and Practices.* London: Thames & Hudson, 1991.

Rosenblum, Naomi. *A World History of Photography.* New York: Abbeville, 1984.

Rubenstein, Charlotte Streifer. *American Women Artists from Early Indian Times to the Present.* Boston: G. K. Hall/Avon Books, 1982.

Schiller, Gertrud. *Iconography of Christian Art.* 2 vols. Greenwich, CT: New York Graphic Society, 1971.

Smith, Alistair, ed. *The Larousse Dictionary of Painters.* New York: Larousse, 1981.

Smith, G. E. Kidder. *The Architecture of the United States: An Illustrated Guide to Buildings Open to the Public.* 3 vols. Garden City, NY: Doubleday/Anchor, 1981.

Snyder, James. *Medieval Art: Painting, Sculpture, and Architecture, 4th–14th Century.* New York: Abrams, 1989.

Steer, John, and Anthony White. *Atlas of Western Art History.* New York: Facts on File, 1994.

Stierlin, Henri. *Encyclopedia of World Architecture 1978.* 1978. Reprint. New York: Van Nostrand, Reinhold, 1983.

Stillwell, Richard, et al., eds., *The Princeton Encyclopedia of Classical Sites.* Princeton: Princeton University Press, 1976.

Stratton, Arthur. *The Orders of Architecture: Greek, Roman and Renaissance.* London: Studio, 1986.

Trachtenberg, Marvin, and Isabelle Hyman. *Architecture, from Prehistory to Post-Modernism.* New York: Abrams, 1986.

Tufts, Eleanor. *American Women Artists, Past and Present, A Selected Bibliographic Guide.* New York: Garland Publishers, 1984.

———. *Our Hidden Heritage, Five Centuries of Women Artists.* London: Paddington Press, 1974.

Turner, Jane, ed. *The Dictionary of Art.* 34 vols. New York: Grove Dictionaries, 1996.

Van Pelt, R., and C. Westfall. *Architectural Principles in the Age of Historicism.* New Haven: Yale University Press, 1991.

Waterhouse, Ellis. *The Dictionary of British 18th Century Painters in Oils and Crayons.* Woodbridge, England: Antique Collectors' Club, 1981.

Wilkins, David G. *Art Past, Art Present.* New York: Harry N. Abrams, 1994.

Wittkower, Rudolf. *Sculpture Processes and Principles.* New York: Harper & Row, 1977.

Wölfflin, Heinrich. *The Sense of Form in Art.* New York: Chelsea, 1958.

Young, William, ed. *A Dictionary of American Artists, Sculptors, and Engravers.* Cambridge, MA: W. Young, 1968.

CHAPTER 1 THE BIRTH OF ART

Bandi, Hans-Georg, Henri Breuil, et al. *The Art of the Stone Age: Forty Thousand Years of Rock Art.* 2nd ed. London: Methuen, 1970.

Bataille, Georges. *Lascaux: Prehistoric Painting or the Birth of Art.* Lausanne: Skira, 1980.

Breuil, Henri. *Four Hundred Centuries of Cave Art.* New York: Hacker, 1979. Reprint.

Graziosi, Paolo. *Paleolithic Art.* New York: McGraw-Hill, 1960.

Hawkes, Jacquetta. *The Atlas of Early Man.* New York: St. Martin's Press, 1976.

Kenyon, Kathleen M. *Digging Up Jericho.* New York: Praeger, 1974.

Kubba, Shamil A. A. *Mesopotamian Architecture and Town-planning: From the Mesolithic to the End of the Proto-historic Period.* Oxford: British Archaeological Reports 1987.

Leroi-Gourhan, André. *The Dawn of European Art: An Introduction to Paleolithic Cave Painting.* Cambridge: Cambridge University Press, 1982.

———. *Treasures of Prehistoric Art.* New York: Abrams, 1967.

Lewin, Roger. *In the Age of Mankind: A Smithsonian Book of Human Evolution.* Washington DC: Smithsonian Institution Books, 1988.

Marshack, Alexander. *The Roots of Civilization: The Cognitive Beginnings of Man's First Art, Symbol and Notation.* New York: McGraw-Hill, 1971.

Mellaart, James. *Çatal Hüyük: A Neolithic Town in Anatolia.* New York: McGraw-Hill, 1967.

———. *The Earliest Civilizations of the Near East.* New York: McGraw-Hill, 1965.

———. *The Neolithic of the Near East.* New York: Scribner, 1975.

Piggot, Stuart. *Ancient Europe.* Chicago: Aldine, 1966.

Pfeiffer, John E. *The Creative Explosion: An Inquiry into the Origins of Art and Religion.* New York: Harper & Row, 1982.

Powell, T. G. E. *Prehistoric Art.* New York: Praeger, 1966.

Renfrew, Colin, ed. *British Prehistory: A New Outline.* London: Noyes Press, 1975.

Sandars, Nancy K. *Prehistoric Art in Europe.* 2nd ed. New Haven: Yale University Press, 1985.

Sieveking, Ann. *The Cave Artists.* London: Thames & Hudson, 1979.

Trump, David H. *The Prehistory of the Mediterranean.* New Haven: Yale University Press, 1980. (Later edition available.)

Ucko, Peter J., and Andrée Rosenfeld. *Palaeolithic Cave Art.* New York: McGraw-Hill, 1967.

Wainwright, Geoffrey. *The Henge Monuments: Ceremony and Society in Prehistoric Britain.* London: Thames & Hudson, 1990.

Windels, Fernand. *The Lascaux Cave Paintings.* New York: Viking, 1950.

Cʜᴀᴘᴛᴇʀ 2 Aɴᴄɪᴇɴᴛ Nᴇᴀʀ Eᴀsᴛᴇʀɴ Aʀᴛ

Akurgal, Ekrem. *Art of the Hittites.* New York: Abrams, 1962.

Amiet, Pierre. *Art of the Ancient Near East.* New York: Abrams, 1980.

Amiet, Pierre, et al. *Art in the Ancient World: A Handbook of Styles and Forms.* New York: Rizzoli, 1981.

Culican, William. *The Medes and Persians.* London: Thames & Hudson, 1965; New York: Praeger, 1965.

Frankfort, Henri. *The Art and Architecture of the Ancient Orient.* Baltimore: Penguin, 1985.

Crawford, Harriet. *Sumer and the Sumerians.* Cambridge: Cambridge University Press, 1991.

Ghirshman, Roman. *Iran from Earliest Times to the Islamic Conquest.* New York: Penguin, 1978.

Groenewegen-Frankfort, H. A. *Arrest and Movement: An Essay on Space and Time in Representational Art of the Ancient Near East.* Cambridge, MA: Belknap Press, 1987.

Hinz, Walther. *The Lost World of Elam.* New York: New York University Press, 1973.

Kramer, Samuel N. *The Sumerians: Their History, Culture, and Character.* Chicago: University of Chicago Press, 1971.

Leick, Gwendolyn. *A Dictionary of Ancient Near Eastern Architecture.* New York: Routledge, 1988.

Lloyd, Seton. *The Archaeology of Mesopotamia: From the Old Stone Age to the Persian Conquest.* London: Thames & Hudson, 1984.

———. *The Art of the Ancient Near East.* New York: Praeger, 1969.

Lloyd, Seton, and Hans Wolfgang Muller. *Ancient Architecture: Mesopotamia, Egypt, Crete.* New York: Electa/Rizzoli, 1986.

Moortgat, Anton. *The Art of Ancient Mesopotamia.* New York: Phaidon, 1969.

Oates, Joan. *Babylon.* Rev. ed. London: Thames & Hudson, 1986.

Oppenheim, A. Leo. *Ancient Mesopotamia.* Rev. ed. Chicago: University of Chicago Press, 1977.

Paris, Pierre. *Manual of Ancient Sculpture.* Rev. and enl. ed. New Rochelle, NY: Caratzas, 1984.

Parrot, André. *The Arts of Assyria.* New York: Golden Press, 1961.

———. *Sumer: The Dawn of Art.* New York: Golden Press, 1961.

Pope, Arthur, and Phyllis Ackerman. *A Survey of Persian Art from Prehistoric Times to the Present.* London: Oxford University Press, 1977.

Porada, Edith, and R. H. Dyson. *The Art of Ancient Iran: Pre-Islamic Cultures.* Rev. ed. New York: Greystone Press, 1969.

Strommenger, Eva, and Hirmer, Max. *5000 Years of the Art of Mesopotamia.* New York: Abrams, 1964.

Wolf, Walther. *The Origins of Western Art: Egypt, Mesopotamia, the Aegean.* New York: Universe Books, 1989.

Woolley, C. Leonard. *The Art of the Middle East, Including Persia, Mesopotamia and Palestine.* New York: Crown, 1961.

———. *The Development of Sumerian Art.* Westport, CT: Greenwood Press, 1981.

———. *The Sumerians.* New York: Norton, 1965.

Cʜᴀᴘᴛᴇʀ 3 Eɢʏᴘᴛɪᴀɴ Aʀᴛ

Aldred, Cyril. *The Development of Ancient Egyptian Art from 3200 to 1315 B.C.* 3 vols. London: Academy Edition, 1973.

———. *Egyptian Art in the Days of the Pharaohs, 3100–320 B.C.* London: Thames & Hudson, 1980.

———. *The Egyptians.* London: Thames & Hudson, 1987.

Arnold, Dieter. *Building in Egypt, Pharaonic Stone Masonry.* Oxford: Oxford University Press, 1991.

Badawy, Alexander. *A History of Egyptian Architecture.* 3 vols. Berkeley: University of California Press, 1973.

Baines, John, and Jaromir Malek. *Atlas of Ancient Egypt.* New York: Facts on File, 1980.

Davis, Whitney. *The Canonical Tradition in Ancient Egyptian Art.* Cambridge: Cambridge University Press, 1991.

Emery, Walter B. *Archaic Egypt.* Baltimore: Penguin, 1974.

Gardiner, Sir Alan Henderson. *Egypt of the Pharaohs.* London: Oxford University Press, 1978.

Lange, Kurt, with Max Hirmer. *Egypt: Architecture, Sculpture and Painting in Three Thousand Years.* 4th ed. London: Phaidon, 1968.

Lurker, Manfred. *The Gods and Symbols of Ancient Egypt: An Illustrated Dictionary.* New York: Thames & Hudson, 1984.

Mahdy, Christine, ed. *The World of the Pharaohs: A Complete Guide to Ancient Egypt.* London: Thames & Hudson, 1990.

Mekhitarian, Arpag. *Egyptian Painting.* New York: Skira, 1978.

Mendelsohn, Kurt. *The Riddle of the Pyramids.* New York: Thames & Hudson, 1986.

Robins, Gay. *Egyptian Painting and Relief.* Aylesbury, England: Shire Publications, 1986.

Romer, John. *Valley of the Kings.* New York: William Morrow, 1981.

Schäfer, Heinrich. *Principles of Egyptian Art.* Rev. reprint. Oxford: Aris and Phillips, 1986.

Smith, E. Baldwin. *Egyptian Architecture as Cultural Expression.* Watkins Glen, NY: American Life Foundation, 1968.

Smith, William Stevenson, and W. Simpson. *The Art and Architecture of Ancient Egypt.* Rev. ed. New Haven: Yale University Press, 1981.

Woldering, Irmgard. *Gods, Men and Pharaohs: The Glory of Egyptian Art.* New York: Abrams, 1967.

Cʜᴀᴘᴛᴇʀ 4 Aᴇɢᴇᴀɴ Aʀᴛ

Betancourt, Philip, P. *A History of Minoan Pottery.* Princeton: Princeton University Press, 1965.

Cadogan, Gerald. *Palaces of Minoan Crete.* London: Methuen, 1980.

Chadwick, John. *The Mycenaean World.* New York: Cambridge University Press, 1976.

Cottrell, Arthur. *The Minoan World.* New York: Scribner, 1980.

Demargne, Pierre. *The Birth of Greek Art.* New York: Golden Press, 1964.

Doumas, Christos. *Thera, Pompeii of the Ancient Aegean: Excavations at Akrotiri, 1967–1979.* New York: Thames & Hudson, 1983.

Evans, Sir Arthur John. *The Palace of Minos.* 4 vols. 1921–1935. Reprint. New York: Biblo & Tannen, 1964.

Fitton, J. Lesley. *Cycladic Art.* Cambridge, MA: Harvard University Press.

Graham, James W. *The Palaces of Crete.* Princeton: Princeton University Press, 1987.

Hampe, Roland, and Erika Simon. *The Birth of Greek Art. From the Mycenaean to the Archaic Period.* Oxford: Oxford University Press, 1981.

Higgins, Reynold Alleyne. *Minoan and Mycenaean Art.* Rev. ed. New York: Oxford University Press, 1985.

Hood, Sinclair. *The Arts in Prehistoric Greece.* New Haven: Yale University Press.

Immerwahr, Sarah A. *Aegean Painting in the Bronze Age.* University Park, PA: Pennsylvania State University Press, 1990.

Marinatos, Spyridon, with Max Hirmer. *Crete and Mycenae.* London: Thames & Hudson, 1960.

Palmer, Leonard R. *Mycenaeans and Minoans.* 2nd rev. ed. 1963. Reprint. Westport, CT: Greenwood Press, 1980.

Pendlebury, John. *The Archeology of Crete.* London: Methuen, 1967.

Taylour, Lord William. *The Mycenaens.* London: Thames & Hudson, 1990.

Vermeule, Emily. *Greece in the Bronze Age.* Chicago: University of Chicago Press, 1972.

Wace, Alan. *Mycenae, an Archeological History and Guide.* New York: Biblo & Tannen, 1964.

Warren, Peter. *The Aegean Civilizations.* London: Elsevier-Phaidon, 1975.

Cʜᴀᴘᴛᴇʀ 5 Gʀᴇᴇᴋ Aʀᴛ

Arias, Paolo. *A History of One Thousand Years of Greek Vase Painting.* New York: Abrams, 1962. (Later edition available.)

Ashmole, Bernard. *Architect and Sculptor in Classical Greece.* New York: New York University Press, 1972.

Beazley, John D. *The Development of the Attic Black-Figure.* Rev. ed. Berkeley: University of California Press, 1986.

Berve, Helmut, Gottfried Gruben, and Max Hirmir. *Greek Temples, Theatres, and Shrines.* New York: Abrams, 1963.

Bieber, Margarete. *Sculpture of the Hellenistic Age.* 1961. Reprint. New York: Hacker, 1980.

Biers, William. *The Archaeology of Greece.* Ithaca, NY: Cornell University Press, 1987.

Blumel, Carl. *Greek Sculptors at Work.* London: Phaidon, 1969.

Boardman, John. *Athenian Black Figure Vases.* New York: Thames & Hudson, 1974.

———. *Athenian Red Figure Vases: The Archaic Period.* New York: Thames & Hudson, 1988.

———. *Athenian Red Figure Vases: The Classical Period.* New York: Thames & Hudson, 1989.

———. *Greek Art.* Rev. ed. New York: Thames & Hudson, 1987.

———. *Greek Sculpture: The Archaic Period.* New York: Thames & Hudson, 1978.

———. *Greek Sculpture: The Classical Period: A Handbook.* London: Thames & Hudson, 1987.

Carpenter, Thomas H. *Art and Myth in Ancient Greece.* New York: Thames & Hudson, 1991.

Charbonneaux, Jean; Roland Martin; and François Villard. *Archaic Greek Art.* New York: Braziller, 1971.

———. *Classical Greek Art.* New York: Braziller, 1972.

———. *Hellenistic Art.* New York: Braziller, 1973.

Coldstream, J. Nicholas. *Geometric Greece.* New York: St. Martin's Press, 1977.

Cook, Robert M. *Greek Art: Its Development, Character and Influence.* Harmondsworth, England: Penguin, 1976.

Coulton, J. J. *Ancient Greek Architects at Work.* Ithaca, NY: Cornell University Press, 1982.

Dinsmoor, W. B. *The Architecture of Ancient Greece.* 3rd ed. New York: Norton, 1975.

Houser, Caroline. *Greek Monumental Bronze Sculpture.* London: 1983.

Hurwit, Jeffrey M. *The Art and Culture of Early Greece, 1100–480 B.C.* Ithaca, NY: Cornell University Press, 1985

Langlotz, Ernst, and Max Hirmer. *The Art of Magna Graecia. Greek Art in Southern Italy and Sicily.* New York: Abrams, 1965.

Lawrence, Arnold W., and R. A. Tomlinson. *Greek Architecture.* New Haven: Yale University Press, 1984.

Lullies, Reinhard, and Max Hirmer. *Greek Sculpture.* Rev. ed. New York: Abrams, 1960.

Martin, Roland. *Greek Architecture: Architecture of Crete, Greece, and the Greek World.* New York: Electa/Rizzoli, 1988.

Mattusch, Carol C. *Greek Bronze Statuary from the Beginnings through the Fifth Century B.C.* Ithaca, NY: Cornell University Press, 1988.

Onians, John. *Art and Thought in the Hellenistic Age: The Greek World View, 350–50 B.C.* London: Thames & Hudson, 1979.

Pedley, John Griffiths. *Greek Art and Archaeology.* Englewood Cliffs, NJ: Prentice Hall, 1993.

Pollitt, Jerome J. *The Ancient View of Greek Art.* New Haven: Yale University Press, 1974.

———. *Art and Experience in Classical Greece.* Cambridge: Cambridge University Press, 1972.

———. *Art in the Hellenistic Age.* Cambridge: Cambridge University Press, 1986.

———. *The Art of Ancient Greece: Sources and Documents.* New York: Cambridge University Press, 1990.

Richter, Gisela M. *A Handbook of Greek Art.* 9th ed. Oxford: Phaidon, 1987.

———. *The Portraits of the Greeks.* Rev. ed. Ithaca, NY: Cornell University Press, 1984.

———. *The Sculpture and Sculptors of the Greeks.* 4th ed. New Haven: Yale University Press, 1970.

Ridgway, Brunilde S. *The Archaic Style in Greek Sculpture.* Princeton: Princeton University Press, 1981.

———. *Fifth Century Styles in Greek Sculpture.* Princeton: Princeton University Press, 1981.

———. *Hellenistic Sculpture I: The Styles of ca. 331–200 B.C.* Madison: University of Wisconsin Press, 1990.

———. *The Severe Style in Greek Sculpture.* Princeton: Princeton University Press, 1970.

Robertson, Donald S. *Greek and Roman Architecture.* 2nd ed. Cambridge: Cambridge University Press, 1969.

Robertson, Martin. *The Art of Vase-Painting in Classical Athens.* Cambridge: Cambridge University Press, 1992.

———. *Greek Painting.* New York: Rizzoli, 1979.

———. *A History of Greek Art.* 2 vols. Cambridge: Cambridge University Press, 1976.

———. *A Shorter History of Greek Art.* Cambridge: Cambridge University Press, 1981.

Smith, R. R. R. *Hellenistic Sculpture.* New York: Thames & Hudson, 1991.

Stewart, Andrew. *Greek Sculpture.* 2 vols. New Haven: Yale University Press, 1990.

Travlos, John. *Pictorial Dictionary of Ancient Athens.* 1971. Reprint. New York: Hacker, 1980.

Wycherley, Richard E. *How the Greeks Built Cities.* New York: Norton, 1976.

CHAPTER 6 ETRUSCAN ART

Banti, Luisa. *The Etruscan Cities and Their Culture.* Berkeley: University of California Press, 1973.

Boethius, Axel. *Etruscan and Early Roman Architecture.* New Haven: Yale University Press, 1978.

Bonfante, Larissa, ed. *Etruscan Life and Afterlife. A Handbook of Etruscan Studies.* Detroit: Wayne State University Press, 1986.

Brendel, Otto J. *Etruscan Art.* New Haven: Yale University Press, 1978.

Mansuelli, Guido. *The Art of Etruria and Early Rome.* New York: Crown, 1965.

Pallottino, Massimo. *Etruscan Painting.* Geneva: Skira, 1953.

———. *The Etruscans.* Harmondsworth: Penguin, 1978.

Richardson, Emeline. *The Etruscans: Their Art and Civilization.* Chicago: University of Chicago Press, 1976.

Ridgway, David, and Francesca Ridgway, eds. *Italy before the Romans.* New York: Academic Press, 1979.

Sprenger, Maja, Gilda Bartoloni, and Max Hirmer. *The Etruscans: Their History, Art, and Architecture.* New York: Abrams, 1983.

CHAPTER 7 ROMAN ART

Andreae, Bernard. *The Art of Rome.* New York: Abrams, 1977.

Bianchi Bandinelli, Ranuccio. *Rome, the Center of Power.* New York: Braziller, 1970.

———. *Rome, the Late Empire.* New York: Braziller, 1971.

Brendel, Otto J. *Prolegomena to the Study of Roman Art.* New Haven: Yale University Press, 1979.

Clarke, John R. *The Houses of Roman Italy, 100 B.C.–A.D. 250.* Berkeley: University of California Press, 1991.

Hanfmann, George. *Roman Art.* Greenwich, CT: New York Graphic Society, 1964.

Hannestad, Niels. *Roman Art and Imperial Policy.* Aarhus, Denmark: Aarhus University Press, 1986.

Henig, Martin, ed. *A Handbook of Roman Art.* Ithaca, NY: Cornell University Press, 1983.

Kent, John P. C., and Max Hirmer. *Roman Coins.* New York: Abrams, 1978.

Kleiner, Diana E. E. *Roman Sculpture.* New Haven: Yale University Press, 1992.

Kraus, Theodor. *Pompeii and Herculaneum: The Living Cities of the Dead.* New York: Abrams, 1975.

Ling, Roger. *Roman Painting.* Cambridge: Cambridge University Press, 1991.

L'Orange, Hans Peter. *The Roman Empire: Art Forms and Civic Life.* New York: Rizzoli, 1985.

MacDonald, William L. *The Architecture of the Roman Empire I: An Introductory Study.* Rev. ed. New Haven: Yale University Press, 1982.

———. *The Architecture of the Roman Empire II: An Urban Appraisal.* New Haven: Yale University Press, 1986.

McKay, Alexander G. *Houses, Villas, and Palaces in the Roman World.* Ithaca, NY: Cornell University Press, 1975.

Maiuri, Amedeo. *Roman Painting.* Geneva: Skira, 1953.

Nash, Ernest. *Pictorial Dictionary of Ancient Rome.* 2 vols. New York: Hacker, 1981.

Pollitt, Jerome J. *The Art of Rome, 753 B.C.–A.D. 337.* Rev. ed. Cambridge: Cambridge University Press, 1983.

Ramage, Nancy H. and Andrew Ramage. *Roman Art: Romulus to Constantine.* Englewood Cliffs, NJ: Prentice Hall, 1991.

Richardson, Lawrence, Jr. *A New Topographical Dictionary of Ancient Rome.* Baltimore: Johns Hopkins University Press, 1992.

———. *Pompeii. An Architectural History.* Baltimore: Johns Hopkins University Press, 1988.

Robertson, Donald S. *Greek and Roman Architecture.* 2nd ed. Cambridge: Cambridge University Press, 1969.

Sear, Frank. *Roman Architecture.* Rev. ed. Ithaca, NY: Cornell University Press, 1989.

Smith, Earl Baldwin. *Architectural Symbolism of Imperial Rome and the Middle Ages.* Princeton: Princeton University Press, 1956.

———. *The Dome, a Study in the History of Ideas.* Princeton: Princeton University Press, 1971.

Strong, Donald, and Roger Ling. *Roman Art.* 2nd rev. ed. New Haven: Yale University Press, 1988.

Toynbee, Jocelyn M. C. *Death and Burial in the Roman World.* London: Thames & Hudson, 1971.

Ward-Perkins, John B. *Roman Architecture.* New York: Electa/Rizzoli, 1988.

———. *Roman Imperial Architecture.* 2nd integrated ed. New Haven: Yale University Press, 1981.

Zanker, Paul. *The Power of Images in the Age of Augustus.* Ann Arbor: University of Michigan Press, 1988.

CHAPTER 8 EARLY CHRISTIAN ART

Beckwith, John. *Early Christian and Byzantine Art.* New Haven: Yale University Press, 1980.

Brown, Peter. *The World of Late Antiquity.* London: Thames & Hudson, 1971.

Du Bourguet, Pierre. *Early Christian Art.* New York: William Morrow, 1971.

Gough, Michael. *The Origins of Christian Art.* New York: Praeger, 1973.

Grabar, André. *The Beginnings of Christian Art, 200–395.* London: Thames & Hudson, 1967.

———. *Christian Iconography.* Princeton: Princeton University Press, 1980.

Hutter, Irmgard. *Early Christian and Byzantine Art.* London: Herbert Press, 1988.

Krautheimer, Richard. *Rome, Profile of a City: 312–1308.* Princeton: Princeton University Press, 1980.

Krautheimer, Richard, and Slobodan Curcic. *Early Christian and Byzantine Architecture.* 4th rev. ed. New Haven: Yale University Press, 1986.

Lowrie, Walter S. *Art in the Early Church.* New York: Norton, 1969.

MacDonald, William L. *Early Christian and Byzantine Architecture.* New York: Braziller, 1963.

Mathews, Thomas, P. *The Clash of Gods: A Reinterpretation of Early Christian Art.* Princeton: Princeton University Press, 1993.

Milburn, Robert L. P. *Early Christian Art and Architecture.* Berkeley: University of California Press, 1988.

Perkins, Ann Louise. *The Art of Dura-Europos.* Oxford: Clarendon, 1973.

Schiller, Gertrud. *Iconography of Christian Art.* See Reference Books.

Volbach, Wolfgang. *Early Christian Mosaics, from the Fourth to the Seventh Centuries.* New York: Oxford University Press, 1946.

Volbach, Wolfgang, and Max Hirmer. *Early Christian Art.* New York: Abrams, 1962.

Weitzmann, Kurt. *Ancient Book Illumination.* Cambridge: Harvard University Press, 1959.

———. *Late Antique and Early Christian Book Illumination.* New York: Braziller, 1977.

Weitzmann, Kurt, ed. *Age of Spirituality. Late Antique and Early Christian Art, Third to Seventh Century.* New York: Metropolitan Museum of Art, 1979.

CHAPTER 9 BYZANTINE ART

Beckwith, John. *The Art of Constantinople: An Introduction to Byzantine Art (330–1453).* New York: Phaidon, 1968.

Chatzidakis, Manolis. *Byzantine and Early Medieval Painting.* New York: Viking, 1965.

Dalton, Ormonde M. *Byzantine Art and Archaeology.* New York: Dover, 1961.

Demus, Otto. *Byzantine Art and the West.* New York: New York University Press, 1970.

———. *The Mosaic Decoration of San Marco, Venice.* Chicago: University of Chicago Press, 1988.

Grabar, André. *Byzantine Painting.* New York: Rizzoli, 1979.

———. *The Golden Age of Justinian: From the Death of Theodosius to the Rise of Islam.* New York: Odyssey Press, 1967.

Grabar, André, and Manolis Chatzidakis. *Greek Mosaics of the Byzantine Period.* New York: New American Library, 1964.

Hamilton, George H. *The Art and Architecture of Russia.* 2nd ed. New York: Viking, 1983.

Hamilton, John A. *Byzantine Architecture and Decoration.* 1933. Freeport, NY: Books for Libraries/Arno Press, 1972.

Huyghe, René, ed. *Larousse Encyclopedia of Byzantine and Medieval Art.* See Reference Books.

Kitzinger, Ernst. *Byzantine Art in the Making.* Cambridge: Harvard University Press, 1977.

Maguire, Henry. *Art and Eloquence in Byzantium.* Princeton: Princeton University Press, 1981.

Mango, Cyril. *Byzantine Architecture.* New York: Electa/Rizzoli, 1985.

———. *Byzantium: The Empire of New Rome.* New York: Scribner's, 1980.

———. *Byzantium and Its Image: History and Culture of the Byzantine Empire and Its Heritage.* London: Variorum Reprints, 1984.

Meyer, Peter. *Byzantine Mosaics: Torcello, Venice, Monreale, Palermo.* London: Batsford, 1952.

Pelikan, J. *Imago Dei: The Byzantine Apologia for Icons.* Princeton: Princeton University Press, 1990.

Rice, David T. *The Appreciation of Byzantine Art.* London: Oxford University Press, 1972.

———. *The Art of Byzantium.* New York: Abrams, 1959.

———. *Byzantine Art.* London: Variorum Reprints, 1973.

———. *Byzantine Painting: The Last Phase.* New York: Dial Press, 1968.

Swift, Emerson H. *Hagia Sophia.* New York: Columbia University Press, 1980.

Von Simson, Otto G. *Sacred Fortress: Byzantine Art and Statecraft in Ravenna.* Princeton: Princeton University Press, 1986.

Walter, Christopher. *Art and Ritual of the Byzantine Church.* London: Variorum, 1982.

Weitzmann, Kurt. *Ancient Book Illumination.* Cambridge: Harvard University Press, 1959.

———. *Art in the Medieval West and Its Contacts with Byzantium.* London: Variorum, 1982.

———. *The Icon.* New York: Dorset Press (Mondadori), 1987.

———. *Illustrations in Roll and Codex.* Princeton: Princeton University Press, 1970.

Weitzmann, Kurt, et al. *The Icon.* New York: Knopf, 1982.

Weitzman, K., and G. Galavaris. *The Monastery of St. Catherine at Mt. Sinai.* Princeton: Princeton University Press, 1990.

CHAPTER 10 ISLAMIC ART

Arnold, Thomas W. *Painting in Islam.* New York: Dover, 1965.

Aslanapa, Oktay. *Turkish Art and Architecture.* London: Faber & Faber, 1971.

Atil, Esin. *Renaissance of Islam: Art of the Mamluks.* Washington, DC: Smithsonian Institution Press, 1981.

Badeau, John S., et. al., *The Genius of Arab Civilization: Source of Renaissance.* John Hays, ed. New York: New York University Press, 1975.

Beach, Milo Cleveland. *Early Mughal Painting.* Cambridge: Harvard University Press, 1987.

Blair, Sheila S. and Jonathan Bloom. *The Art and Architecture of Islam 1250–1800.* New Haven: Yale University Press, 1994.

Brend, Barbara. *Islamic Art.* Cambridge, MA: Harvard University Press, 1991.

Crespi, Gabriele. *The Arabs in Europe.* New York: Rizzoli, 1986.

Creswell, K. A. C. *A Short Account of Early Muslim Architecture.* Rev. and enl. ed. Aldershot, England: Scolar, 1989.

Ettinghausen, Richard. *Arab Painting.* Geneva: Skira, 1977.

———. *From Byzantium to Sasanian Iran and the Islamic World.* Leiden: Brill, 1972.

Ettinghausen, Richard, and Oleg Grabar. *The Art and Architecture of Islam, 650–1250.* New Haven: Yale University Press, 1992.

Golombek, Lisa, and Donald Wilber. *The Timurid Architecture of Iran and Turan.* 2 vols. Princeton: Princeton University Press, 1988.

Goodwin, Godfrey. *A History of Ottoman Architecture.* New York: Thames & Hudson, 1987.

Grabar, Oleg. *The Formation of Islamic Art.* Rev. and enl. ed. New Haven: Yale University Press, 1987.

Grover, Satish. *The Architecture of India: Islamic (727–1707).* New Delhi: Vikas, 1981.

Grunebaum, Gustave von. *Classical Islam: A History, 600–1258.* Chicago: Aldine, 1970.

Hoag, John D. *Islamic Architecture.* New York: Abrams, 1977; Rizzoli (paperbound), 1987.

Kühnel, Ernst. *Islamic Art and Architecture.* London: Bell, 1966.

Lane, Arthur. *Early Islamic Pottery, Mesopotamia, Egypt and Persia.* New York: Faber & Faber, 1965.

Levey, Michael. *The World of Ottoman Art.* New York: Scribner, 1975.

Lewis, Bernard, ed. *Islam and the Arab World.* New York: Knopf, 1976.

Rice, David T. *Islamic Art.* London: Thames & Hudson, 1975.

Robinson, Frank. *Atlas of the Islamic World.* Oxford: Equinox Ltd., 1982.

Schimmel, Annemarie. *Islam in India and Pakistan.* Leiden: Brill, 1982.

Schimmel, Annemarie, and Barbara Rivolta. *Islamic Calligraphy.* New York: Metropolitan Museum of Art Bulletin, Summer 1992, vol. 1, no. 1.

Chapter 11 Early Medieval Art in the West

Arnold, Bruce. *Irish Art: A Concise History*. Rev. ed. London: Thames & Hudson, 1989.

Beckwith, John. *Early Medieval Art: Carolingian, Ottonian, Romanesque*. New York: Oxford University Press, 1974.

Calkins, Robert G. *Illuminated Books of the Middle Ages*. Ithaca, NY: Cornell University Press, 1983.

Conant, Kenneth. *Carolingian and Romanesque Architecture 800–1200*. 4th ed. New Haven: Yale University Press, 1992.

Dodwell, C. R. *Anglo-Saxon Art: A New Perspective*. Ithaca, NY: Cornell University Press, 1992.

———. *The Pictorial Arts of the West 800–1200*. New Haven: Yale University Press, 1993.

Finlay, Ian. *Celtic Art: An Introduction*. London: Faber & Faber, 1973.

Goldschmidt, Adolf. *German Illumination*. New York: Hacker, 1970.

Grabar, André, and Carl Nordenfalk. *Early Medieval Painting from the Fourth to the Eleventh Century*. New York: Skira, 1967.

Harbison, Peter, et al. *Irish Art and Architecture from Prehistory to the Present*. London: Thames & Hudson, 1978.

Henderson, George. *Early Medieval Art*. Pelican Style and Civilization Series. New York: Penguin, 1972.

Henry, Françoise. *Irish Art During the Viking Invasions, 900–1020*. Ithaca, NY: Cornell University Press, 1970.

———. *Irish Art in the Early Christian Period, to 800*. Rev. ed. London: Methuen, 1965.

Hinks, Roger P. *Carolingian Art*. Ann Arbor: University of Michigan Press, 1974.

Klindt-Jensen, Ole, and David M. Wilson. *Viking Art*. 2nd ed. Minneapolis: University of Minnesota Press, 1980.

Laszlo, Gyula. *The Art of the Migration Period*. London: Allen Lane, 1974.

Leeds, Edward T. *Early Anglo-Saxon Art and Archaeology*. Westport, CT: Greenwood Press, 1971.

Lucas, A. T. *Treasures of Ireland: Irish Pagan and Early Christian Art*. New York: Viking, 1973.

Megaw, Ruth, and John V. Megaw. *Celtic Art: From Its Beginning to the Book of Kells*. London: Thames & Hudson, 1989.

Mütherich, Florentine, and J. E. Gaehde. *Carolingian Painting*. New York: Braziller, 1977.

Nordenfalk, Carl. *Celtic and Anglo-Saxon Painting: Book Illumination in the British Isles 600–800*. New York: Braziller, 1977.

Porter, Arthur K. *The Crosses and Culture of Ireland*. New York: Benjamin Blom, 1971.

Stokstad, Marilyn. *Medieval Art*. New York: Harper & Row, 1986.

Taylor, Harold M., and Joan Taylor. *Anglo-Saxon Architecture*. 2 vols. Cambridge: Cambridge University Press, 1981.

Wilson, David M., ed. *The Northern World: The History and Heritage of Northern Europe* A.D. *400–1100*. New York: Abrams, 1980.

Zarnecki, George. *Art of the Medieval World*. New York: Abrams, 1976.

Chapter 12 Romanesque Art

Clapham, Alfred W. *English Romanesque Architecture After the Conquest*. Oxford: Clarendon Press, 1964.

———. *Romanesque Architecture in Western Europe*. Oxford: Clarendon Press, 1959.

Conant, Kenneth John. *Carolingian and Romanesque Architecture, 800–1200*. 2nd integrated rev. ed. New York: Penguin, 1979.

Crichton, George H. *Romanesque Sculpture in Italy*. London: Routledge & Paul, 1954.

Decker, Heinrich. *Romanesque Art in Italy*. New York: Abrams, 1959.

Demus, Otto. *Romanesque Mural Painting*. New York: Abrams, 1970.

Deschamps, Paul. *French Sculpture of the Romanesque Period—Eleventh and Twelfth Centuries*. 1930. Reprint. New York: Hacker, 1972.

Dodwell, C. R. *Painting in Europe 800–1200*. Harmondsworth, England: Penguin, 1971.

Duby, Georges. *History of Medieval Art, 980–1440*. New York: Skira/Rizzoli, 1986.

Evans, Joan. *Art in Medieval France 987–1498*. Oxford: Clarendon Press, 1969.

Focillon, Henri. *The Art of the West in the Middle Ages*. Vol. 1. 2nd ed. London: Phaidon, 1969; Ithaca, NY: Cornell University Press (paperbound), 1980. (Later volume available.)

Gantner, Joseph, Marcel Pobé, and Jean Roubier. *Romanesque Art in France*. London: Thames & Hudson, 1956.

Gibbs-Smith, Charles H. *The Bayeux Tapestry*. London: Phaidon, 1973.

Grabar, André, and Carl Nordenfalk. *Romanesque Painting*. New York: Skira, 1958.

Hearn, Millard F. *Romanesque Sculpture in the Eleventh and Twelfth Centuries*. Ithaca, NY: Cornell University Press/Phaidon, 1981.

Holt, Elizabeth Gilmore, ed. *A Documentary History of Art, I: The Middle Ages*. Princeton: Princeton University Press, 1981.

Kubach, Hans E. *Romanesque Architecture*. New York: Rizzoli, 1988.

Kuenstler, Gustav, ed. *Romanesque Art in Europe*. New York: Norton, 1973.

Leisinger, Hermann. *Romanesque Bronzes: Church Portals in Mediaeval Europe*. New York: Praeger, 1957.

Male, Émile. *Art and Artists of the Middle Ages*. Redding Ridge, CT: Black Swan Books, 1986.

Michel, Paul H. *Romanesque Wall Paintings in France*. Paris: Éditions Chêne, 1949.

Morey, Charles R. *Medieval Art*. New York: Norton, 1970.

Nordenfalk, Carl. *Early Medieval Book Illumination*. New York: Rizzoli, 1988.

Porter, Arthur K. *Medieval Architecture*. 2 vols. 1909. Reprint. New York: Hacker, 1969.

———. *Romanesque Sculpture of the Pilgrimage Roads*. 1923. Reprint. New York: Hacker, 1969.

Rickert, Margaret. *Painting in Britain: The Middle Ages*. 2nd ed. Harmondsworth, England: Penguin, 1965.

Rivoira, Giovanni. *Lombardic Architecture: Its Origin, Development, and Derivatives*. 1933. Reprint. New York: Hacker, 1975.

Saalman, Howard. *Medieval Architecture: European Architecture 600–1200*. New York: Braziller, 1962.

Schapiro, Meyer. *Romanesque Art: Selected Papers*. London: Chatto & Windus, 1977; New York: Braziller, 1976.

Stoddard, Whitney. *Art and Architecture in Medieval France*. New York: Harper & Row, 1972.

Stone, Lawrence. *Sculpture in Britain: The Middle Ages*. New Haven: Yale University Press, 1972.

Swarzenski, Hanns. *Monuments of Romanesque Art*. Chicago: University of Chicago Press, 1974.

Webb, Geoffrey F. *Architecture in Britain: The Middle Ages*. Harmondsworth, England: Penguin, 1965.

Zarnecki, George. *Romanesque Art*. New York: Universe Books, 1971.

———. *Studies in Romanesque Sculpture*. London: Dorian Press, 1979.

Chapter 13 Gothic Art

Adams, Henry B. *Mont-Saint-Michel and Chartres*. New York: Cherokee, 1982.

Alexander, Jonathan J. G. *Medieval Illuminators and their Methods of Work*. New Haven/London: Yale University Press, 1992.

Arnold, Hugh. *Stained Glass of the Middle Ages in England and France*. London: A. & C. Black, 1956.

Arslan, Edoardo. *Gothic Architecture in Venice*. London: Phaidon, 1971.

Aubert, Marcel. *The Art of the High Gothic Era*. New York: Crown, 1965.

———. *Gothic Cathedrals of France and Their Treasures*. London: N. Kay, 1959.

Bony, Jean. *The English Decorated Style*. Ithaca, NY: Cornell University Press, 1979.

———. *French Gothic Architecture of the XII and XIII Centuries*. Berkeley: University of California Press, 1983.

Brandenburg, Alain Erlande. *Gothic Art*. New York: Harry N. Abrams, 1989.

Branner, Robert. *Chartres Cathedral*. New York: Norton, 1969.

———. *Gothic Architecture*. New York: Braziller, 1961.

Duby, George. *The Age of the Cathedrals*. Chicago: University of Chicago Press, 1981.

Dupont, Jacques, and Cesare Gnudi. *Gothic Painting*. New York: Rizzoli, 1979.

Evans, Joan. *Art in Medieval France 987–1498*. Oxford: Clarendon Press, 1969.

———. *The Flowering of the Middle Ages*. London: Thames & Hudson, 1985.

Favier, Jean. *The World of Chartres*. New York: Harry N. Abrams, 1990.

Fitchen, John. *The Construction of Gothic Cathedrals: A Study of Medieval Vault Erection*. Chicago: University of Chicago Press, 1977; Phoenix Books, 1981.

Focillon, Henri. *The Art of the West in the Middle Ages*. Vol. 2. Ithaca, NY: Cornell University Press, 1980.

Frankl, Paul. *Gothic Architecture*. Baltimore: Penguin, 1963.

———. *The Gothic Literary Sources and Interpretations*. Princeton: Princeton University Press, 1960.

Frisch, T. G. *Gothic Art 1140–c. 1450*. Sources and documents in the History of Art Series (H. W. Janson, ed.). Englewood Cliffs, NJ: Prentice Hall, 1971.

Grodecki, Louis. *Gothic Architecture*. New York: Electa/Rizzoli, 1985.

Huizinga, Johan. *The Waning of the Middle Ages*. 1924. Reprint. New York: St. Martin's Press, 1988.

Jantzen, Hans. *High Gothic: The Classic Cathedrals of Chartres, Reims, and Amiens*. Princeton: Princeton University Press, 1984.

Johnson, James. *The Radiance of Chartres*. New York: Random House, 1965.

Johnson, Paul. *British Cathedrals*. New York: William Morrow, 1980.

Katzenellenbogen, Adolf. *The Sculptural Programs of Chartres Cathedral*. Baltimore: Johns Hopkins Press, 1959.

Male, Émile. *The Gothic Image: Religious Art in the Twelfth Century*. Rev. ed. Princeton: Princeton University Press, 1978.

———. *Religious Art in France: The 13th Century—A Study of Medieval Iconography and Its Sources*. Princeton: Princeton University Press, 1984.

———. *Religious Art in France: The Late Middle Ages—A Study of Medieval Iconography and Its Sources*. Princeton: Princeton University Press, 1987.

Mark, Robert. *Experiments in Gothic Structure*. Cambridge: MIT Press, 1982.

Martindale, Andrew. *Gothic Art*. London: Thames & Hudson, 1985.

———. *The Rise of the Artist in the Middle Ages and Early Renaissance*. New York: McGraw-Hill, 1972.

Murray, S. B. *Beauvais Cathedral: Architecture of Transcendence*. Princeton: Princeton University Press, 1989.

Panofsky, Erwin. *Abbot Suger on the Abbey Church of St. Denis and Its Art Treasures*. 2nd ed. Princeton: Princeton University Press, 1979.

———. *Gothic Architecture and Scholasticism*. New York: Meridian Books, 1963.

Pevsner, Nikolaus. *The Buildings of England*. 46 vols. Harmondsworth, England: Penguin, 1951–1974.

Radding, Charles M., and William W. Clark. *Medieval Architecture, Medieval Learning*. New Haven: Yale University Press, 1992.

Sauerlander, Willibald, and Max Hirmer. *Gothic Sculpture in France 1140–1270*. New York: Abrams, 1973.

Sheridan, Ronald, and Anne Ross. *Gargoyles and Grotesques: Paganism in the Medieval Church*. Boston: New York Graphic Society, 1975.

Stoddard, Whitney. *Art and Architecture in Medieval France*. New York: HarperCollins, 1972.

Swaan, Wim. *The Late Middle Ages: Art and Architecture from 1350 to the Advent of the Renaissance*. Ithaca, NY: Cornell University Press, 1977.

Thompson, Daniel. *The Materials and Techniques of Medieval Painting*. New York: Dover, 1956.

Von Simson, Otto Georg. *The Gothic Cathedral: Origins of Gothic Architecture and the Medieval Concept of Order*. 3rd enl. ed. Princeton: Princeton University Press, 1988.

Wilson, Christopher. *The Gothic Cathedral*. London: Thames & Hudson, 1990.

Zarnecki, George. *Art of the Medieval World*. New York: Abrams, 1976.

Chapter 14 The Art of Indian Asia

Acharya, Prasanna Kumar. *An Encyclopedia of Hindu Architecture*. 2nd ed. New Delhi: Oriental Books Reprint Corporation, 1979.

Archer, William G. *Indian Miniatures*. Greenwich, CT: New York Graphic Society, 1960.

———. *Indian Paintings from the Punjab Hills*. 2 vols. London: Sotheby Parke Bernet, 1973.

Asher, Frederick M. *The Art of Eastern India, 300–800*. Minneapolis: University of Minnesota Press, 1980.

Bachhofer, Ludwig. *Early Indian Sculpture*. 1929. Reprint. New York: Hacker, 1974.

Barrett, Douglas E. *Early Chola Bronzes*. Bombay: Bhulabhai Memorial Institute, 1965.

Barrett, Douglas E., and Basil Gray. *Painting of India*. Geneva: Skira, 1963.

Coomaraswamy, Ananda K. *History of Indian and Indonesian Art*. New York: Dover, 1985.

———. *Yaksas*. New Delhi: Munshiram Manaharlal, 1971.

Craven, Roy C. *Indian Art: A Concise History*. London: Thames & Hudson, 1985.

Dehejia, Vidya. *Early Buddhist Rock Temples*. Ithaca, NY: Cornell University Press, 1972.

Ghosh, Amalananda. *Ajanta Murals*. New Delhi: Archaeological Survey of India, 1967.

Ghosh, Sankar Prosad. *Hindu Religious Art and Architecture*. Delhi: D. K. Publications, 1982.

Gopinatha Rao, T. A. *Elements of Hindu Iconography*. 2nd ed. 4 vols. New York: Paragon, 1968.

Gray, Basil, ed. *The Arts of India*. Ithaca, NY: Cornell University Press/Phaidon, 1981.

Groslier, Bernard P., and Jacques Arthaud. *The Arts and Civilization of Angkor*. New York: Praeger, 1957.

Grover, Satish. *The Architecture of India: Buddhist and Hindu*. Sahibabad, Distt. Ghaziabad: Vikas, 1980.

Harle, James C. *The Art and Architecture of the Indian Subcontinent*. New Haven: Yale University Press, 1992.

Head, Raymond. *The Indian Style*. Boston: Allen and Unwin, 1986.

Huntington, Susan L, and John C. Huntington. *The Art of Ancient India: Buddhist, Hindu, Jain*. New York: Weatherhill, 1985.

Kramrisch, Stella. *The Art of India through the Ages*. Delhi: Motilal Banarsidass, 1987.

———. *The Hindu Temple*. 2 vols. Delhi: Motilal Banarsidass, 1991. (Original edition 1946.)

———. *Indian Sculpture*. The Heritage of India Series. London: Oxford University Press, 1933.

Krishna, Deva. *Temples of North India*. New Delhi: National Book Trust, 1969.

Lee, Sherman E. *Ancient Cambodian Sculpture*. New York: Intercultural Arts Press, 1970.

Manwani, S. N. *Evolution of Art and Architecture in Central India: With Special Reference to the Kalachuris of Ratanpur*. Delhi: Agam Kala Prakashan, 1988.

Meister, Michael W. *Encyclopedia of Indian Temple Architecture*. Philadelphia: University of Pennsylvania Press, 1983. Princeton: Princeton University Press, 1991 (4 vols.)

Munsterberg, Hugo. *Art of India and Southeast Asia*. New York: Abrams, 1970.

Rawson, Philip. *The Art of Southeast Asia*. New York: Praeger, 1967.

Rowland, Benjamin. *The Art and Architecture of India: Buddhist, Hindu, Jain*. Harmondsworth, England: Penguin, 1977.

Srinivasan, K. R. *Temples of South India*. New Delhi: National Book Trust, 1972.

Stutley, Margaret. *An Illustrated Dictionary of Hindu Iconography*. Boston: Routledge and Keegan Paul, 1985.

Welch, Stuart Cary. *India: Art and Culture, 1300–1900*. New York: Metropolitan Museum of Art/Holt, Rinehart & Winston, 1985.

Williams, Joanna Gottfried. *The Art of Gupta India: Empire and Province*. Princeton: Princeton University Press, 1982.

Zimmer, Heinrich, and Joseph Campbell, eds. *The Art of Indian Asia; Its Mythology and Transformations*. Bollingen Series 39. 2 vols. Princeton: Princeton University Press, 1983.

CHAPTER 15 THE ART OF CHINA AND KOREA

Bush, Susan, and Christian Murck, eds. *Theories of the Arts in China*. Princeton: Princeton University Press, 1983.

Blunden, Caroline, and Mark Elvin. *Cultural Atlas of China*. New York: Facts on File, 1983.

Cahill, James. *Chinese Painting*. New ed. Geneva: Skira, 1977; New York: Rizzoli, 1977.

Davidson, J. Leroy. *The Lotus Sutra in Chinese Art: A Study in Buddhist Art to the Year 1880*. New Haven: Yale University Press, 1954.

Han Zhongmin, and Hubert Delahaye. *A Journey through Ancient China*. New York: Gallery Books, 1985.

Hutt, Julia. *Understanding Far Eastern Art: A Complete Guide to the Arts of China, Japan, and Korea*. New York: Dutton, 1987.

Lee, Sherman E. *Chinese Landscape Painting*. Rev. ed. New York: HarperCollins, 1971.

———. *Past, Present, East and West*. New York: Braziller, 1983.

Liu, Lawrence. *Chinese Architecture*. New York: Rizzoli International, 1989.

Loehr, Max. *The Great Painters of China*. New York: Harper & Row, 1980.

———. *Ritual Vessels of Bronze Age China*. New York: Asia Society, 1968.

Mizuno, Seiichi. *Bronzes and Jades of Ancient China*. Tokyo: Nihon Keizai, 1959.

Munsterberg, Hugo. *Dictionary of Chinese and Japanese Art*. New York: Hacker, 1981.

———. *Symbolism in Ancient Chinese Art*. New York: Hacker, 1986.

Sickman, Lawrence C., and Alexander Soper. *The Art and Architecture of China*. 3rd ed. New Haven: Yale University Press, 1992.

Siren, Oswald. *Chinese Painting: Leading Masters and Principles*. New York: Hacker, 1973.

———. *Chinese Sculpture from the Fifth to the Fourteenth Centuries*. 4 vols. 1925. Reprint. New York: Hacker, 1970.

———. *A History of Later Chinese Painting*. 1938. Reprint. London: Medici Society, 1978.

Sullivan, Michael. *The Arts of China*. 3rd ed. Berkeley: University of California Press, 1984.

———. *The Birth of Landscape Painting in China*. Berkeley: University of California Press, 1962.

———. *A Short History of Chinese Art*. Berkeley: University of California Press, 1970.

Thorp, Robert L. *Son of Heaven: Imperial Arts of China*. Seattle: Son of Heaven Press, 1988.

Van Oort, H. A. *The Iconography of Chinese Buddhism in Traditional China*. Leiden: Brill, 1986.

Watson, William. *The Art of Dynastic China*. New York: Abrams, 1983.

———. *The Art of Dynastic China*. New York: Abrams, 1981.

Zo, Za-yong, and U Fan Lee. (John Bester, trans.) *Traditional Korean Painting: A Lost Art Rediscovered*. New York/Tokyo: Kodansha International, 1990.

CHAPTER 16 THE ART OF JAPAN

Akiyama, Terukazu. *Japanese Painting*. Geneva: Skira; New York: Rizzoli, 1977.

Cahill, James F. *Scholar Painters of Japan: The Nanga School*. New York: Ayer, 1979.

Drexler, Arthur. *The Architecture of Japan*. New York: Arno Press, 1966.

Eliseef, Danielle, and Vadime Eliseef. *The Art of Japan*. New York: Abrams, 1985.

Fontein, Jan, and M. C. Hickman, eds. *Zen Painting and Calligraphy*. Greenwich, CT: New York Graphic Society, 1970.

Kidder, J. Edward. *Art of Japan*. Milan: Mondadori Editore, 1985.

———. *Early Japanese Art*. London: Thames & Hudson, 1969.

———. *Japanese Temples: Sculpture, Painting, and Architecture*. Tokyo: Bijutsu Shuppansha, 1964.

Lee, Sherman E. *A History of Far Eastern Art*. New York: Abrams, 1982.

———. *Japanese Decorative Style*. New York: Harper & Row, 1972.

Neuer, Roni, and Herbert Ubertson. *Ukiyo-E; 250 Years of Japanese Art*. New York: Gallery Books, 1979.

Paine, Robert Treat, and Alexander Soper. *The Art and Architecture of Japan*. 3rd rev. ed. New Haven: Yale University Press, 1981.

Ragghiant, C. L. (Alberto Guiganino, ed.) *National Museum Tokyo*. New York: Newsweek Great Museums of the World, 1968.

Rosenfield, John M. *Japanese Art of the Heian Period, 749–1185*. New York: Asia Society, 1967.

Rosenfield, John M., and Shujiro Shimada. *Traditions of Japanese Art*. Cambridge: Fogg Art Museum, Harvard University, 1970.

Saunders, E. D. *Mudra: A Study of Symbolic Gestures in Japanese Buddhist Art*. Princeton: Princeton University Press, 1960.

Soper, Alexander. *The Evolution of Buddhist Architecture in Japan*. 1942. Reprint. New York: Hacker, 1978.

Stanley-Smith, Joan. *Japanese Art*. New York: Thames & Hudson, 1984.

Stern, Harold P. *Master Prints of Japan: Ukiyo-e Hanga*. New York: Abrams, 1969.

Sugiyama, Jiro. *Classic Buddhist Sculpture: The Tempyo Period*. New York: Kodansha/Harper & Row, 1982.

CHAPTER 17 THE NATIVE ARTS OF THE AMERICAS AND OCEANIA

Pre-Columbian Art of the Americas

Anderson, Richard L. *Art in Small-Scale Societies*. 2nd ed. Englewood Cliffs, NJ: Prentice-Hall, 1989.

Bennett, Wendell C. *Ancient Arts of the Andes*. New York: Museum of Modern Art/Arno Press, 1966.

Bernal, Ignacio. *The Olmec World*. Berkeley: University of California Press, 1977.

Burger, Richard, ed. *Early Ceremonial Architecture of the Andes*. Washington DC: Dumbarton Oaks, 1986.

Coe, Michael D. *The Maya*. 5th rev. ed. London: Thames & Hudson, 1994.

———. *Lords of the Underworld*. Princeton: Princeton University Press, 1978.

———. *Mexico*. 3rd ed. New York: Thames & Hudson, 1994.

Coe, Michael D., and R. A. Diehl. *In the Land of the Olmec*. 2 vols. Austin: University of Texas Press, 1980.

Coe, Michael, Dean Snow, and Elizabeth Benson. *Atlas of Ancient America*. New York: Facts on File, 1986.

Coe, William R. *Tikal: A Handbook of the Ancient Maya Ruins*. 3rd ed. Philadelphia: University Museum, University of Pennsylvania, 1970. (Later edition available.)

Emmerich, André. *Sweat of the Sun and Tears of the Moon: Gold and Silver in Pre-Columbian Art*. New York: Hacker, 1977.

Fash, William L. *Scribes, Warriors, and Kings*. London: Thames & Hudson, 1991.

Franch, José Alcina. *Pre-Columbian Art*. New York: Abrams, 1983.

Gasperini, Graziano, and Luisa Margolies. *Inca Architecture*. Bloomington: Indiana University Press, 1981.

Grieder, Terence. *Origins of Pre-Columbian Art*. Austin: University of Texas Press, 1982.

Heyden, Doris, and Paul Gendrop. *Pre-Columbian Architecture of Mesoamerica*. New York: Abrams, 1975.

Jones, Julie, ed. *Art of Precolumbian Gold. The Jan Mitchell Collection*. London: Weidenfeld & Nicolson, 1985.

Kubler, George. *The Art and Architecture of Ancient America: The Mexican, Maya, and Andean Peoples*. 3rd ed. New Haven: Yale University Press, 1992.

Lapiner, Alan C. *Pre-Columbian Art of South America*. New York: Abrams, 1976.

Lumbreras, Luis. *Peoples and Cultures of Ancient Peru*. Washington, DC: Smithsonian Institution Press, 1974.

Mason, John Alden. *The Ancient Civilizations of Peru*. Rev. ed. New York: Viking Penguin, 1988.

Miller, Mary Ellen. *The Art of Mesoamerica: From Olmec to Aztec*. New York: Thames & Hudson, 1986.

Paddock, John, ed. *Ancient Oaxaca: Discoveries in Mexican Archeology and History*. Stanford: Stanford University Press, 1970.

Pasztory, Esther. *Aztec Art*. New York: Abrams, 1983.

Proskouriakoff, Tatiana Avenirovna. *A Study of Classic Maya Sculpture*. Washington, DC: Carnegie Institute of Washington, 1950.

Robertson, Donald. *Pre-Columbian Architecture*. New York: Braziller, 1963.

Rowe, John H. *Chavín Art: An Inquiry into Its Form and Meaning*. New York: Museum of Primitive Art, 1962.

Sabloff, Jeremy A. *The Cities of Ancient Mexico*. New York: Thames & Hudson, 1989.

Schele, Linda, and David Freidel. *A Forest of Kings*. New York: Morrow, 1991.

Schele, Linda, and Mary Ellen Miller. *The Blood of Kings: Dynasty and Ritual in Maya Art*. New York: Braziller, 1986.

Sharer, Robert J. *The Ancient Maya*. 5th rev. ed. Stanford: Stanford University Press, 1994.

Steward, Julian H. *Handbook of the South American Indians*. 7 vols. New York: Cooper Square Publishers, 1963.

Stierlin, Henri. *Art of the Aztecs and Its Origins*. New York: Rizzoli, 1982.

———. *Art of the Incas and Its Origins*. New York: Rizzoli, 1984.

Stuart, Gene, and George Stuart. *Lost Kingdoms of the Maya*, Washington, DC: National Geographic Society, 1993.

Thompson, J. E. S. *Maya History and Religion*. Norman: University of Oklahoma Press, 1990.

Viole, Herman J. *After Columbus: The Smithsonian Chronicle of North American Indians*. Washington, DC: Orion Books, 1990.

Wauchope, Robert, ed. *Handbook of Middle American Indians*. 16 vols. Austin: University of Texas Press, 1964–1976.

Weaver, Muriel Porter. *The Aztecs, Maya, and their Predecessors: The Archaeology of Mesoamerica*. 2nd ed. New York: Academic Press, 1981.

North America

Boas, Franz. *Primitive Art*. 1927. Reprint. Magnolia, MA: Peter Smith, 1962.

Broder, Patricia Janis. *American Indian Painting and Sculpture*. New York: Abbeville Press, 1981.

Brose, David. *Ancient Art of the American Woodland Indians*. New York: Abrams, 1985.

Collins, Henry, et al. *The Far North: Two Thousand Years of American Eskimo and Indian Art.* Bloomington: Indiana University Press in association with the National Gallery of Art, Washington, DC, 1977.

Conn, Richard. *Circles of the World: Traditional Art of the Plains Indians.* Denver: Denver Art Museum, 1982.

Corbin, George A. *Native Arts of North America, Africa, and the South Pacific: An Introduction.* New York: Harper & Row, 1988.

Curtis, Edward S. *The North American Indian.* 30 vols. Cambridge: Cambridge University Press, 1907–1930. (Later reprint available.)

Ewers, John C. *Plains Indian Painting.* Stanford: Stanford University Press, 1939. (Later reprint available.)

Feder, Norman. *Two Hundred Years of North American Art.* New York: Praeger, 1972.

Feest, Christian F. *Native Arts of North America.* London: Thames & Hudson, 1992.

Grant, Campbell. *Rock Art of the American Indian.* 1967. Reprint. New York: Vistabooks, 1981.

Gunther, Erna. *Art in the Life of the Northwest Coast Indians.* Portland, OR: Portland Art Museum, 1966.

Holm, William. *Northwest Coast Indian Art.* Seattle: University of Washington Press, 1965.

Jonaitis, Aldona. *From the Land of the Totem Poles.* Seattle: University of Washington Press, 1988.

Kopper, Philip. *The Smithsonian Book of North American Indians.* Washington, DC: Smithsonian Books, 1986.

Murdock, George P., and Timothy O'Leary. *Ethnographic Bibliography of North America.* 4th ed. New Haven: Human Relations Area Files Press, 1972.

Ray, Dorothy J. *Artists of the Tundra and the Sea.* Seattle: University of Washington Press, 1980.

Ritchie, Carson I. A. *The Eskimo and His Art.* New York: St. Martin's Press, 1976.

Snow, Dean. *The Archaeology of North America/American Indians.* New York: Chelsea House, 1992.

Wardwell, Allen. *Ancient Eskimo Ivories of the Bering Strait.* New York: Rizzoli, 1986.

Whiteford, Andrew H. *North American Indian Arts.* New York: Golden Press, 1973.

Oceania

Barrow, Terence. *An Illustrated Guide to Maori Art.* Honolulu: University of Hawaii Press, 1984.

Barrow, Tui T. *Art and Life in Polynesia.* Rutland, VT: Charles E. Tuttle, 1973.

———. *Maori Wood Sculpture of New Zealand.* Rutland, VT: Charles E. Tuttle, 1970.

Bernot, Ronald M. *Australian Aboriginal Art.* New York: Macmillan, 1964.

Buck, Peter H. *Arts and Crafts of Hawaii.* Honolulu: Bishop Museum Press, 1964.

Dodd, Edward H. *Polynesian Art.* New York: Dodd, Mead, 1967.

Firth, Raymond. *Art and Life in New Guinea.* 1936. Reprint. New York: AMS Press, 1977.

Guiart, Jean. *Arts of the South Pacific.* New York: Golden Press, 1963.

Linton, Ralph, and Paul Wingert. *Arts of the South Seas.* 1946. Reprint. New York: Arno Press, 1972.

Newton, Douglas. *Art Styles of the Papuan Gulf.* New York: Museum of Primitive Art, 1961.

Rockefeller, Michael C. *The Asmat of New Guinea: The Journal of Michael Clark Rockefeller.* Greenwich, CT: New York Graphic Society, 1967.

Schmitz, Carl A. *Oceanic Art; Myth, Man and Image in the South Seas.* New York: Abrams, 1971.

Stubbs, Dacre. *Prehistoric Art of Australia.* New York: Scribner, 1975.

Taylor, Clyde R. H. *A Pacific Bibliography: Printed Matter Relating to the Native People of Polynesia, Melanesia, and Micronesia.* 2nd ed. Oxford: Clarendon Press, 1965.

CHAPTER 18 THE ARTS OF AFRICA

Ben-Amos, Paula. *The Art of Benin.* London: Thames & Hudson, 1980.

Bourgeois, Jean-Louis, and Carollee Pelos. *Spectacular Vernacular; The Adobe Tradition.* Chapter 11: "Stealing and Restoring Glory: Histories of the Great Mosques of Djenné." New York: Aperture, 1989.

Cole, H. M. *Icons: Ideals and Power in the Art of Africa.* Washington, DC: Smithsonian Institution Press for the National Museum of African Art, 1989.

Cole, H. M., and C. C. Aniakor. *Igbo Art: Community and Cosmos.* Los Angeles, Fowler Museum of Cultural History, 1984.

Cole, H. M., and Doran H. Ross. *The Arts of Ghana.* Los Angeles: Museum of Cultural History, UCLA, 1977.

Cornet, Joseph. *Art Royal Kuba.* Milan: Edizioni Sipiel, 1982.

Drewal, H. J., and J. Pemberton. *Yoruba: Nine Centuries of African Art and Thought.* New York: Center for African Art in association with Harry N. Abrams, 1989.

Ezra, Kate. *The Art of the Dogon: Selections from the Lester Wunderman Collection.* New York: Metropolitan Museum of Art/Harry N. Abrams, 1988.

———. *A Human Ideal in African Art: Bamana Figurative Sculpture.* New York: Metropolitan Museum of Art, 1986.

———. *Royal Art of Benin: The Perls Collection in the Metropolitan Museum of Art.* New York: Metropolitan Museum of Art, 1992.

Fraser, Douglas F., and H. M. Cole. eds. *African Art and Leadership.* Madison: University of Wisconsin Press, 1972.

Glaze, A. J. *Art and Death in a Senufo Village.* Bloomington: Indiana University Press, 1981.

Kasfir, Sidney L. *West African Masks and Cultural Systems.* Tervuren: Musee Royal de l'Afrique Centrale, 1988.

Kennedy, Jean. *New Currents, Ancient Rivers: Contemporary African Artists in a Generation of Change.* Washington, DC: Smithsonian Institution Press, 1992.

McGaffey, Wyatt, and Michael Harris. *Astonishment and Power (Kongo Art).* Washington, DC: Smithsonian Institution Press, 1993.

McNaughton, Patrick R. *The Mande Blacksmiths: Knowledge, Power, and Art in West Africa.* Bloomington: Indiana University Press, 1988.

Nooter, Mary H. *Secrecy: African Art that Conceals and Reveals.* New York: Museum for African Art, 1993.

Roy, Christopher D. *Art and Life in Africa: Selections from the Stanley Collection.* Iowa City: University of Iowa Museum of Art, 1992.

Rubin, Arnold. *African Accumulative Sculpture.* New York: Pace Gallery, 1965.

Shaw, Thurstan. *Nigeria: Its Archaeology and Early History.* London: Thames & Hudson, 1978.

Sieber, Roy, and Roslyn A. Walker. *African Art in the Cycle of Life.* Washington, DC: Smithsonian Institution Press, 1987.

Vogel, Susan M. *For Spirits and Kings: African Art from the Tishman Collection.* New York: Metropolitan Museum of Art, 1981.

Vogel, Susan M. ed. *Art/Artifact: African Art in Anthropology Collections.* New York: TeNeues, 1988.

Vogel, Susan M. et al. *Africa Explores: Twentieth-Century African Art.* New York: TeNeues, 1990.

Willet, Frank F. *Ife in the History of West African Sculpture.* London: Thames & Hudson, 1969.

CHAPTER 19 LATE GOTHIC ART IN ITALY

Andrés, Glenn, et al. *The Art of Florence.* 2 vols. New York: Abbeville Press, 1988.

Antal, Frederick. *Florentine Painting and Its Social Background.* London: Keegan Paul, 1948.

Cole, Bruce. *Sienese Painting: From Its Origins to the Fifteenth Century.* New York: HarperCollins, 1987.

Cole, Bruce. *Italian Art, 1250–1550: The Relation of Renaissance Art to Life and Society.* New York: Harper & Row, 1987.

Fremantle, Richard. *Florentine Gothic Painters from Giotto to Masaccio: A Guide to Painting in and near Florence.* London: Secker & Warburg, 1975.

Hills, Paul. *The Light of Early Italian Painting.* New Haven: Yale University Press, 1987.

Meiss, Millard. *Painting in Florence and Siena after the Black Death.* Princeton: Princeton University Press, 1976.

Panofsky, Erwin. *Renaissance and Renascences in Western Art.* New York: HarperCollins, 1972.

Pope-Hennessy, John. *Introduction to Italian Sculpture.* 3rd. ed. 3 vols. New York: Phaidon, 1986.

———. *Italian Gothic Sculpture.* 3rd ed. Oxford: Phaidon, 1986.

Schevill, Ferdinand. *The Medici.* New York: Harper & Row, 1960.

Smart, Alastair. *The Dawn of Italian Painting.* Ithaca, NY: Cornell University Press, 1978.

Stubblebine, James, ed. *Giotto: The Arena Chapel Frescoes.* New York: Norton, 1969.

———. *Assisi and the Rise of Vernacular Art.* New York: Harper & Row, 1985.

Van Marle, Raimond. *The Development of the Italian Schools of Painting.* 19 vols. 1923–1938. Reprint. New York: Hacker, 1970.

Venturi, Lionello, and Rosabianca Skira-Venturi. *Italian Painting: The Creators of the Renaissance.* 3 vols. Geneva: Skira, 1950–1952.

White, John. *Art and Architecture in Italy 1250–1400.* 3rd ed. New Haven: Yale University Press, 1993.

CHAPTER 20 FIFTEENTH-CENTURY ART IN NORTHERN EUROPE AND SPAIN

Chatelet, Albert. *Early Dutch Painting.* New York: W. S. Konecky, 1988.

Cuttler, Charles P. *Northern Painting from Pucelle to Bruegel.* New York: Holt, Rinehart & Winston, 1968.

Dhanens, E. *Hubert and Jan van Eyck.* New York: Tabaro Press (W. S. Konecky, Assoc.), 1980.

Friedlander, Max J. *Early Netherlandish Painting.* 14 vols. New York: Praeger/Phaidon, 1967–1976.

———. *From Van Eyck to Bruegel.* 3rd ed. Ithaca, NY: Cornell University Press, 1981.

Fuchs, Rudolph H. *Dutch Painting.* London: Thames & Hudson, 1978.

Hind, Arthur M. *History of Engraving and Etching from the Fifteenth Century to the Year 1914.* 3rd rev. ed. New York: Dover, 1963.

———. *An Introduction to a History of Woodcut.* New York: Dover, 1963.

Huizinga, Johan. *The Waning of the Middle Ages.* 1924. Reprint. New York: St. Martin's Press, 1988.

Meiss, Millard. *French Painting in the Time of Jean de Berry.* New York: Braziller, 1974.

———. *The "Très Riches Heures" of Jean, Duke of Berry.* Preface. New York: Braziller, 1969.

Müller, Theodor. *Sculpture in the Netherlands, Germany, France and Spain, 1400–1500.* New Haven: Yale University Press, 1986.

Panofsky, Erwin. *Early Netherlandish Painting.* Cambridge: Harvard University Press, 1953.

Prevenier, Walter, and Wim Blockmans. *The Burgundian Netherlands.* Cambridge: Cambridge University Press, 1986.

Seidel. L. *Jan van Eyck's Arnolfini Portrait.* New York/Cambridge: Cambridge University Press, 1993.

Snyder, James. *Northern Renaissance Art.* New York: Abrams, 1985.

Van Puyvelde, L. *Flemish Painting from the van Eycks to Metsys.* New York: McGraw-Hill, 1970.

Wolfthal, Diane. *The Beginnings of Netherlandish Canvas Painting, 1400–1530.* New York: Cambridge University Press, 1989.

CHAPTER 21 FIFTEENTH-CENTURY ITALIAN ART: THE EARLY RENAISSANCE

Baxandall, Michael. *Painting and Experience in Fifteenth Century Italy. A Primer in the Social History of Pictorial Style.* 2nd ed. New York: Oxford University Press, 1988.

Bennet, Bonnie A., and David G. Wilkins. *Donatello.* Oxford: Phaidon, 1984.

Berenson, Bernard. *The Italian Painters of the Renaissance.* Ithaca, NY: Phaidon/Cornell University Press, 1980.

———. *Italian Pictures of the Renaissance.* Ithaca, NY: Phaidon/Cornell University Press, 1980.

Blunt, Anthony. *Artistic Theory in Italy, 1450–1600.* Oxford: Clarendon Press, 1966.

Bober, Phyllis Pray, and Ruth Rubinstein. *Renaissance Artists and Antique Sculpture: A Handbook of Sources.* Oxford: Oxford University Press, 1986.

Borsook, Eve. *The Mural Painters of Tuscany.* New York: Oxford University Press, 1981.

Burckhardt, Jacob. *The Architecture of the Italian Renaissance.* Chicago: University of Chicago Press, 1987.

———. *The Civilization of the Renaissance in Italy.* 4th ed. 1867. Reprint. London: Phaidon, 1960.

Chastel, André. *The Age of Humanism.* New York: McGraw-Hill, 1964.

———. *A Chronicle of Italian Renaissance Painting.* Ithaca, NY: Cornell University Press, 1984.

———. *Studios and Styles of the Italian Renaissance.* New York: Braziller, 1971.

Cole, Bruce. *Masaccio and the Art of Early Renaissance Florence.* Bloomington: Indiana University Press, 1980.

———. *Piero della Francesca: Tradition and Innovation in Renaissance Art.* New York: Icon Editions, 1991.

Decker, Heinrich. *The Renaissance in Italy: Architecture, Sculpture, Frescoes.* New York: Viking, 1969.

De Wald, Ernest T. *Italian Painting, 1200–1600.* New York: Holt, Rinehart & Winston, 1961.

Earls, Irene. *Renaissance Art: A Topical Dictionary.* New York: Greenwood Press, 1987.

Edgerton, Samuel Y., Jr. *The Heritage of Giotto's Geometry: Art and Science on the Eve of the Scientific*

Revolution. Ithaca, NY: Cornell University Press, 1991.

————. *The Renaissance Rediscovery of Linear Perspective*. New York: Harper & Row, 1976.

Ferguson, Wallace K., et al. *The Renaissance*. New York: Henry Holt, 1940.

Gadol, Joan. *Leon Battista Alberti: Universal Man of the Early Renaissance*. Chicago: University of Chicago Press, 1969.

Gilbert, Creighton. *History of Renaissance Art throughout Europe*. New York: Abrams, 1973.

————. *Italian Art 1400–1500: Sources and Documents*. Englewood Cliffs, NJ: Prentice-Hall, 1970.

Godfrey, F. M. *Early Venetian Painters, 1415–1495*. London: Tiranti, 1954.

Goldthwaite, Richard A. *The Building of Renaissance Florence: An Economic and Social History*. Baltimore: Johns Hopkins University Press, 1980.

Gombrich, E. H. *Norm and Form: Studies in the Art of the Renaissance*. 4th ed. Oxford: Phaidon, 1985.

Hale, John R. *Italian Renaissance Painting from Masaccio to Titian*. New York: Dutton, 1977.

Hall, Marcia B. *Color and Meaning: Practice and Theory in Renaissance Painting*. Cambridge: Cambridge University Press, 1992.

Hartt, Frederick. *History of Italian Renaissance Art: Painting, Sculpture, Architecture*. 4th ed. rev. by David G. Wilkins. Englewood Cliffs, NJ: Prentice-Hall, 1994.

Helton, Tinsley, ed. *The Renaissance: A Reconsideration of the Theories and Interpretations of the Age*. Madison: University of Wisconsin Press, 1964.

Heydenreich, Ludwig H., and Wolfgang Lotz. *Architecture in Italy 1400–1600*. Harmondsworth, England: Penguin, 1974.

Holt, Elizabeth B. *A Documentary History of Art*. 2nd ed. Vol. 1. Garden City, NY: Doubleday, 1957.

Huyghe, René. *Larousse Encyclopedia of Renaissance and Baroque Art*. See Reference Books.

Janson, Horst W. *The Sculpture of Donatello*. 2 vols. Princeton: Princeton University Press, 1979.

Kempers, Bram. *Painting, Power, and Patronage: The Rise of the Professional Artist in the Italian Renaissance*. London: Penguin, 1992.

Krautheimer, Richard, and Trude Krautheimer-Hess. *Lorenzo Ghiberti*. Princeton: Princeton University Press, 1982.

Lieberman, Ralph. *Renaissance Architecture in Venice*. New York: Abbeville Press, 1982.

Lightbown, Ronald. *Mantegna*. Berkeley: University of California Press, 1986.

————. *Sandro Botticelli: Life and Work*. New York: Abbeville Press, 1989.

Lowry, Bates. *Renaissance Architecture*. New York: Braziller, 1962.

McAndrew, John. *Venetian Architecture of the Early Renaissance*. Cambridge: MIT Press, 1980.

Meiss, Millard. *The Painter's Choice, Problems in the Interpretation of Renaissance Art*. New York: HarperCollins, 1977.

Murray, Peter. *The Architecture of the Italian Renaissance*. Rev. ed. New York: Schocken, 1986.

————. *Renaissance Architecture*. New York: Electa/Rizzoli (paperbound), 1985.

Murray, Peter, and Linda Murray. *The Art of the Renaissance*. London: Thames & Hudson, 1985.

Olson, Roberta J. M. *Italian Renaissance Sculpture*. London: Thames & Hudson, 1992.

Panofsky, Erwin. *Renaissance and Renascences in Western Art*. New York: HarperCollins, 1972.

Pater, Walter. *The Renaissance: Studies in Art and Poetry*. Edited by D. L. Hill. Berkeley: University of California Press, 1980.

Pope-Hennessy, John. *An Introduction to Italian Sculpture*. 3rd ed. 3 vols. New York: Phaidon, 1986.

————. *Sienese Quattrocento Painting*. New York: Oxford University Press, 1947.

Schevill, Ferdinand. *The Medici*. New York: Harper & Row, 1960.

Seymour, Charles. *Sculpture in Italy, 1400–1500*. New Haven: Yale University Press, 1966.

Symonds, John Addington. *The Renaissance in Italy*. 7 vols. 1875–1886. Reprint. New York: Coronet Books, 1972.

Van Marle, Raimond. *The Development of the Italian Schools of Painting*. 19 vols. 1923–1938. Reprint. New York: Hacker, 1970.

Vasari, Giorgio. *The Lives of the Most Eminent Painters, Sculptors, and Architects, 1550–1568*. 3 vols. New York: Abrams, 1979.

Werkmeister, William H., ed.; Wallace Ferguson, et al. *Facets of the Renaissance*. New York: Harper & Row, 1963.

White, John. *The Birth and Rebirth of Pictorial Space*. 3rd ed. Boston: Faber & Faber, 1987.

Wilde, Johannes. *Venetian Art from Bellini to Titian*. Oxford: Clarendon Press, 1981.

Wittkower, Rudolf. *Architectural Principles in the Age of Humanism*. 4th ed. London: Academy, 1988.

CHAPTER 22 SIXTEENTH-CENTURY ITALIAN ART: THE HIGH RENAISSANCE AND MANNERISM

Ackerman, James S. *The Architecture of Michelangelo*. Rev. ed. Chicago: University of Chicago Press, 1986.

————. *Palladio*. New York: Penguin, 1978.

Bialostocki, Jan. *The Art of the Renaissance in Eastern Europe*. Ithaca, NY: Cornell University Press, 1976.

Blunt, Anthony. *Artistic Theory in Italy, 1450–1600*. London: Oxford University Press, 1975.

Briganti, Giuliano. *Italian Mannerism*. London: Thames & Hudson, 1962.

Castiglione, Baldassare. *Book of the Courtier*. 1528. Reprint. New York: Viking Penguin, 1976.

Cellini, Benvenuto. *Autobiography*. Reprint. New York: Random House, 1985.

Clark, Kenneth. *Leonardo da Vinci*. Rev. ed. London: Penguin, 1988.

DeTolnay, Charles, *Michelangelo*, Princeton, Princeton University Press, 1943–60. (5 vols.)

Freedberg, Sydney J. *Painting in Italy, 1500–1600*. New Haven: Yale University Press, 1990.

————. *Painting of the High Renaissance in Rome and Florence*. Rev. ed. New York: Hacker, 1985.

Friedlaender, Walter. *Mannerism and Anti-Mannerism in Italian Painting*. New York: Schocken, 1965.

Goffen, Rona. *Piety and Patronage in Renaissance Venice: Bellini, Titian, and the Franciscans*. New Haven: Yale University Press, 1986.

Hibbard, Howard. *Michelangelo*. 2nd ed. New York: Harper & Row 1985.

Holt, Elizabeth Gilmore, ed. *A Documentary History of Art*. Vol. 2, *Michelangelo and the Mannerists*. Rev. ed. Princeton: Princeton University Press, 1982.

Humfry, Peter. *Painting in Renaissance Venice*. New Haven: Yale University Press, 1995.

Huse, Norbert, and Wolfgang Wolters. *The Art of Renaissance Venice: Architecture, Sculpture, and Painting*. Chicago: University of Chicago Press, 1990.

Jones, Roger, and Nicholas Penney. *Raphael*. New Haven: Yale University Press, 1983.

Levey, Michael. *High Renaissance*. New York: Viking Penguin, 1978.

Murray, Linda. *The High Renaissance and Mannerism*. New York: Oxford University Press, 1977.

Partner, Peter. *Renaissance Rome, 1500–1559: A Portrait of a Society*. Berkeley: University of California Press, 1977.

Pedretti, Carlo. *Raphael: His Life and Work in the Splendors of the Italian Renaissance*. Florence: Giunti, 1989.

Pietrangeli, Carlo, et al. *The Sistine Chapel: The Art, the History, and the Restoration*. New York: Harmony Books, 1986.

Pope-Hennessy, John. *Cellini*. London: MacMillan, 1985.

————. *Italian High Renaissance and Baroque Sculpture*. 3rd ed. 3 vols. Oxford: Phaidon, 1986.

Rosand, David. *Painting in Cinquecento Venice: Titian, Veronese, Tintoretto*. New Haven: Yale University Press, 1982.

Shearman, John K. G. *Mannerism*. Baltimore: Penguin, 1978.

————. *Only Connect . . . Art and the Spectator in the Italian Renaissance*. Princeton: Princeton University Press, 1990.

Summers, David. *Michelangelo and the Language of Art*. Princeton: Princeton University Press, 1981.

Venturi, Lionello. *The Sixteenth Century: From Leonardo to El Greco*. New York: Skira, 1956.

Von Einem, Herbert. *Michelangelo*. London: Methuen, 1976.

Wölfflin, Heinrich. *The Art of the Italian Renaissance*. New York: Schocken, 1963.

————. *Classic Art: An Introduction to the Italian Renaissance*. 4th ed. Oxford: Phaidon, 1980.

Würtenberger, Franzsepp. *Mannerism: The European Style of the Sixteenth Century*. New York: Holt, Rinehart & Winston, 1963.

CHAPTER 23 SIXTEENTH-CENTURY ART IN NORTHERN EUROPE AND SPAIN

Baxendall, M. *The Limewood Sculptors of Renaissance Germany*. New Haven/London: Yale University Press, 1980.

Benesch, Otto. *Art of the Renaissance in Northern Europe*. Rev. ed. London: Phaidon, 1965.

————. *German Painting from Dürer to Holbein*. Geneva: Skira, 1966.

Blunt, Anthony. *Art and Architecture in France 1500–1700*. 4th ed. New Haven: Yale University Press, 1982.

Coulton, G. G. *The Fate of Medieval Art in the Renaissance and Reformation*. New York: Harper Torch Books, 1958.

Evans, Joan. *Monastic Architecture in France from the Renaissance to the Revolution*. New York: Hacker, 1980.

Gibson, W. S. *"Mirror of the Earth": The World Landscape in Sixteenth Century Flemish Painting*. Princeton: Princeton University Press, 1989.

Hitchcock, Henry-Russell. *German Renaissance Architecture*. Princeton: Princeton University Press, 1981.

Kaufmann, Thomas DaCosta. *The School of Prague*. Chicago: University of Chicago Press, 1988.

Kubler, G. *Building the Escorial*. Princeton: Princeton University Press, 1981.

Panofsky, Erwin. *The Life and Art of Albrecht Dürer*. 4th ed. Princeton: Princeton University Press, 1971.

Smith, Jeffrey C. *German Sculpture of the Later Renaissance c. 1520–1580*. Princeton: Princeton University Press, 1993.

Sullivan, M. A. *Bruegel's Peasants: Art and Audience in the Northern Renaissance*. New York/Cambridge: Cambridge University Press, 1994.

Waterhouse, Ellis. *The Dictionary of 16th and 17th Century British Painters*. Woodbridge, England: Antique Collectors' Club, 1988.

CHAPTER 24 BAROQUE ART

Alpers, Svetlana. *The Art of Describing: Dutch Art in the Seventeenth Century*. Chicago: University of Chicago Press, 1984.

Bazin, Germain. *Baroque and Rococo Art*. New York: Praeger, 1974.

Blunt, Anthony. *Art and Architecture in France: 1500 to 1700*. 4th ed. New Haven: Yale University Press, 1988.

Blunt, Anthony, ed. *Baroque and Rococo: Architecture and Decoration*. Cambridge: Harper & Row, 1982.

Brown, Jonathan. *The Golden Age of Painting in Spain*. New Haven: Yale University Press, 1991.

————. *Velázquez: Painter and Courtier*. New Haven: Yale University Press, 1986.

Engass, Robert, and Jonathan Brown. *Italy and Spain, 1600–1750: Sources and Documents*. Englewood Cliffs, NJ: Prentice Hall, 1970.

Fokker, Timon H. *Roman Baroque Art: The History of a Style*. London: Oxford University Press, 1938.

Freedberg, Sydney J. *Circa 1600: A Revolution of Style in Italian Painting*. Cambridge: Harvard University Press, 1983.

Gerson, Horst, and E. H. ter Kuile. *Art and Architecture in Belgium 1600–1800*. New York: Viking Penguin, 1978.

Haak, Bob. *The Golden Age: Dutch Painters of the Seventeenth Century*. London: Thames & Hudson, 1984.

Haskell, Francis. *Patrons and Painters: A Study in the Relations between Italian Art and Society in the Age of the Baroque*. New Haven: Yale University Press, 1980.

Held, Julius. *Rembrandt Studies*. Rev. ed. Princeton: Princeton University Press, 1991.

Held, Julius, and Donald Posner. *17th and 18th Century Art*. New York: Abrams, 1974.

Hempel, Eberhard. *Baroque Art and Architecture in Central Europe*. New York: Viking Penguin, 1977.

Hibbard, Howard. *Bernini*. Harmondsworth, England: Penguin, 1976.

————. *Caravaggio*. New York: Thames & Hudson, 1983.

————. *Carlo Maderno and Roman Architecture, 1580–1630*. London: Zwemmer, 1971.

Hinks, Roger P. *Michelangelo Merisi da Caravaggio*. London: Faber & Faber, 1953.

Howard, Deborah. *The Architectural History of Venice*. London: B. T. Batsford, 1981.

Huyghe, René, ed. *Larousse Encyclopedia of Renaissance and Baroque Art*. See Reference Books.

Kahr, Madlyn Millner. *Dutch Painting in the Seventeenth Century*. New York: Harper & Row, 1978.

————. *Velázquez: The Art of Painting*. New York: Harper & Row, 1976.

Kitson, Michael. *The Age of Baroque*. London: Hamlyn, 1976.

Krautheimer, Richard. *The Rome of Alexander VII, 1655–1677*. Princeton: Princeton University Press, 1985.

Lagerlöf, Margaretha R. *Ideal Landscape: Annibale Carracci, Nicolas Poussin and Claude Lorrain.* New Haven: Yale University Press, 1990.

Lees-Milne, James. *Baroque in Italy.* New York: Macmillan, 1960.

Martin, John R. *Baroque.* New York: Harper & Row, 1977.

Millon, Henry A. *Baroque and Rococo Architecture.* New York: Braziller, 1965.

Nicolson, Benedict. *The International Caravaggesque Movement.* Oxford: Phaidon, 1979.

Norberg-Schulz, Christian. *Baroque Architecture.* New York: Rizzoli, 1986.

———. *Late Baroque and Rococo Architecture.* New York: Electa/Rizzoli, 1985.

Pope-Hennessy, Sir John. *The Study and Criticism of Italian Sculpture.* New York: Metropolitan Museum, 1981.

Portoghesi, Paolo. *The Rome of Borromini.* London: Phaidon, 1972.

Powell, Nicolas. *From Baroque to Rococo: An Introduction to Austrian and German Architecture from 1580 to 1790.* London: Faber & Faber, 1959.

Rosenberg, Jakob. *Rembrandt.* 3rd ed. London: Phaidon, 1968.

Rosenberg, Jakob, Seymour Slive, and E. H. ter Kuile. *Dutch Art and Architecture, 1600–1800.* New Haven: Yale University Press, 1979.

Spear, Richard E. *Caravaggio and His Followers.* New York: Harper & Row, 1975.

Stechow, Wolfgang. *Dutch Landscape Painting of the 17th Century.* Oxford: Phaidon, 1981.

Summerson, Sir John. *Architecture in Britain: 1530–1830.* 7th rev. and enl. ed. New Haven: Yale University Press, 1983.

Tapie, Victor-Lucien. *The Age of Grandeur: Baroque Art and Architecture.* New York: Praeger, 1966.

Varriano, John. *Italian Baroque and Rococo Architecture.* New York: Oxford University Press, 1986.

Waterhouse, Ellis Kirkham. *Baroque Painting in Rome.* London: Phaidon, 1976.

———. *Italian Baroque Painting.* 2nd ed. London: Phaidon, 1969.

———. *Painting in Britain, 1530–1790.* 4th ed. New Haven: Yale University Press, 1979.

White, Christopher. *Peter Paul Rubens: Man and Artist.* New Haven: Yale University Press, 1987.

Wittkower, Rudolf. *Art and Architecture in Italy 1600–1750.* New Haven: Yale University Press, 1982.

———. *Gian Lorenzo Bernini: The Sculptor of the Roman Baroque.* 3rd rev. ed. Oxford: Phaidon, 1981.

Wölfflin, Heinrich. *Principles of Art History: The Problem of the Development of Style in Later Art.* 7th ed. New York: Dover, 1950.

———. *Renaissance and Baroque.* London: Collins, 1984.

Wright, Christopher. *The French Painters of the 17th Century.* New York: New York Graphic Society, 1986.

CHAPTER 25 THE EIGHTEENTH CENTURY: LATE BAROQUE AND ROCOCO, AND THE RISE OF ROMANTICISM

Arnason, H. H. *The Sculptures of Houdon.* New York: Oxford University Press, 1975.

Bacou, Roseline. *Piranesi: Etchings and Drawings.* Boston: New York Graphic Society, 1975.

Boime, A. *Art in the Age of Revolution, 1750–1800.* Chicago/London: University of Chicago Press, 1987.

Blunt, Anthony. *Art and Architecture in France, 1500–1700.* 2nd ed. Harmondsworth, England: Penguin, 1970.

Braham, Allan. *The Architecture of the French Enlightenment.* Berkeley: University of California Press, 1980.

Burchard, John, and Albert Bush-Brown. *The Architecture of America: A Social and Cultural History.* Boston: Little, Brown/The American Institute of Architects, 1965.

Chatelet, Albert, and Jacques Thuillier. *French Painting from Le Nain to Fragonard.* Geneva: Skira, 1964.

Cobban, Alfred, ed. *The Eighteenth Century: Europe in the Age of the Enlightenment.* New York: McGraw-Hill, 1969.

Conisbee, Philip. *Painting in Eighteenth-Century France.* Ithaca, NY: Phaidon/Cornell University Press, 1981.

Crow, Thomas E. *Painters and Public Life in Eighteenth-Century Paris.* New Haven: Yale University Press, 1985.

Cuzin, J-P. *Fragonard: Life and Work.* New York: Abrams, 1988.

Davis, Terence. *The Gothick Taste.* Cranbury, NJ: Fairleigh Dickinson University Press, 1975.

Gaunt, W. *The Great Century of British Painting: Hogarth to Turner.* New York: Phaidon, 1971.

Hayes, John T. *Gainsborough: Paintings and Drawings.* London: Phaidon, 1975.

Herrmann, Luke. *British Landscape Painting of the Eighteenth Century.* New York: Oxford University Press, 1974.

Hitchcock, Henry Russell. *Rococo Architecture in Southern Germany.* London: Phaidon, 1968.

Holt, Elizabeth Gilmore, ed. *From the Classicists to the Impressionists: A Documentary History of Art and Architecture in the Nineteenth Century.* Garden City, NY: Anchor Books/Doubleday, 1966.

Irwin, David. *English Neoclassical Art.* London: Faber & Faber, 1966.

Kalnein, Wend Graf, and Michael Levey. *Art and Architecture of the Eighteenth Century in France.* New York: Viking/Pelican, 1973.

Kimball, Sidney F. *The Creation of the Rococo.* New York: W. W. Norton, 1964.

Levey, Michael. *Painting in Eighteenth-Century Venice.* Ithaca, NY: Phaidon/Cornell University Press, 1980.

———. *Rococo to Revolution: Major Trends in Eighteenth-Century Painting.* London: Thames & Hudson, 1966.

Millon, Henry A. *Baroque and Rococo Architecture.* New York: Braziller, 1961, 1965.

Norberg-Schulz, Christian. *Late Baroque and Rococo Architecture.* New York: Harry N. Abrams, 1974.

Pierson, William. *American Buildings and Their Architects: Vol. 1, The Colonial and Neo-Classical Style.* Garden City, NY: Doubleday, 1970.

Pignatti, Terisio. *The Age of Rococo.* New York: Hamlyn, 1969.

Powell, Nicolas. *From Baroque to Rococo: An Introduction to Austrian and German Architecture from 1580 to 1790.* London: Faber & Faber, 1959.

Raine, Kathleen. *William Blake.* New York: Oxford University Press, 1970.

Rosenblum, Robert. *Transformations in Late Eighteenth Century Art.* Princeton, NJ: Princeton University Press, 1970.

Roston, M. *Changing Perspectives in Literature and the Visual Arts, 1650–1820.* Princeton: Princeton University Press, 1990.

Rykwert, Joseph. *The First Moderns: Architects of the Eighteenth Century.* Cambridge, MA: MIT Press, 1983.

Schnapper, A. *David.* New York: Alpine Fine Arts, 1982.

Schwarz, Michael. *The Age of Rococo.* New York: Praeger, 1969.

Strachey. Lionel (trans.). *Memoirs of Madame Vigée Lebrun.* New York: Braziller, 1989.

Waterhouse, Ellis K. *Painting in Britain, 1530–1790.* 4th ed. New York: Penguin, 1978.

Whinney, Margaret Dickens. *English Art, 1625–1714.* Oxford, England: Clarendon Press, 1957.

———. *Sculpture in Britain, 1530–1830.* New Haven: Yale University Press, 1964.

Whinney, Margaret D., and Oliver Millar. *English Sculpture, 1720–1830.* London: H. M. Stationery Office, 1971.

Wittkower, Rudolf. *Art and Architecture in Italy, 1600–1750.* New York: Penguin, 1980.

Yolton, John W. *The Blackwell Companion to the Enlightenment.* Cambridge, MA: Oxford/Blackwell, 1992.

CHAPTER 26 THE NINETEENTH CENTURY: PLURALISM OF STYLE

Aslin, Elizabeth. *The Aesthetic Movement: Prelude to Art Nouveau.* New York: Frederick A. Praeger, 1969.

Baudelaire, Charles. *The Mirror of Art, Critical Studies.* Translated by Jonathan Mayne. Garden City, NY: Doubleday & Co., 1956.

Bisanz, R. M. *German Romanticism and Philipp Otto Runge.* De Kalb: Northern Illinois University Press, 1970.

Bischof, Ulrich. *Edvard Munch.* Köln (Cologne), Germany: Benedikt Taschen, 1988.

Boime, Albert. *The Academy and French Painting in the 19th Century.* London: Phaidon, 1971.

Bonnat, Jean. *Degas: His Life and Work.* New York: Tudor Publishing Company, 1965.

Borsch-Supan, H. *Caspar David Friedrich.* New York: Braziller, 1974.

Broun, Elizabeth. *Albert Pinkham Ryder.* Washington, DC: National Museum of American Art/Smithsonian Institutions, 1989.

Clark, Kenneth. *The Gothic Revival: An Essay in the History of Taste.* New York: Humanities Press, 1970.

Clay, Jean. *Romanticism.* New York: Phaidon, 1981.

Delacroix, Eugène. *The Journal of Eugène Delacroix.* Translated by Walter Pach. New York: Grove Press, 1937, 1948.

Dixon, Roger, and Stefen Muthesius. *Victorian Architecture.* London: Thames & Hudson, 1978.

Eitner, Lorenz. *Neo-Classicism and Romanticism 1750–1850: Sources and Documents on the History of Art.* 2 vols. Englewood Cliffs, NJ: Prentice-Hall, 1970.

Elsen, Albert. *Rodin.* New York: Museum of Modern Art, 1963.

Fliedl, Gottfried. *Gustav Klimt.* Köln (Cologne), Germany: Benedikt Taschen, 1989.

Friedlaender, Walter. *From David to Delacroix.* New York: Schocken Books, 1968.

Fusco, Peter, and H. W. Janson. *The Romantics to Rodin: French 19th-Century Sculpture from American Collections.* Los Angeles: Los Angeles County Art Museum/New York: Braziller, 1980.

Gerdts, William H. *American Impressionism.* New York: Abbeville Press, 1984.

Hamilton, George Heard. *Manet and His Critics.* New Haven, CT: Yale University Press, 1954.

Hanson, Anne Coffin. *Manet and the Modern Tradition.* New Haven, CT: Yale University Press, 1977.

Herbert, Robert L. *Impressionism: Art, Leisure, and Parisian Society.* New Haven: Yale University Press, 1988.

Hilton, Timothy. *The Pre-Raphaelites.* New York: Oxford University Press, 1970.

Holt, Elizabeth B. *From the Classicists to the Impressionists: Art and Architecture in the Nineteenth Century.* Garden City, NY: Doubleday/Anchor, 1966.

Honour, Hugh. *Neo-Classicism.* New York: Harper & Row, 1979.

———. *Romanticism.* New York: Harper & Row, 1979.

Janson, Horst W. *19th-Century Sculpture.* New York: Harry N. Abrams, 1985.

Jensen, Robert. *Marketing Modernism in Fin-de-Siècle Europe.* Princeton: Princeton University Press, 1994.

Leymarie, Jean. *French Painting in the Nineteenth Century.* Geneva: Skira, 1962.

Macaulay, James. *The Gothic Revival, 1745–1845.* Glasgow, Scotland: Blackie, 1975.

Middleton, Robin, ed. *The Beaux-Arts and Nineteenth-Century French Architecture.* Cambridge, MA: MIT Press, 1982.

Nochlin, Linda. *Gustave Courbet: A Study of Style and Society.* New York: Garland, 1976.

———. *Impressionism and Post-Impressionism, 1874–1904: Sources and Documents.* Englewood Cliffs, NJ: Prentice-Hall, 1966.

———. *Realism and Tradition in Art: Sources and Documents.* Englewood Cliffs, NJ: Prentice-Hall, 1966.

Novak, Barbara. *American Painting of the Nineteenth Century.* New York: Frederick A. Praeger, 1969.

Novotny, Fritz. *Painting and Sculpture in Europe: 1780–1880.* 2nd ed. New Haven: Yale University Press, 1978.

Pelles, Geraldine. *Art, Artists and Society: Origins of a Modern Dilemma: Painting in England and France, 1750–1850.* Englewood Cliffs, NJ: Prentice-Hall, 1963.

Pevsner, Nikolaus. *Pioneers of Modern Design.* Harmondsworth, England: Penguin, 1964.

Rewald, John. *The History of Impressionism.* New York: Museum of Modern Art, 1973.

———. *Post-Impressionism: From Van Gogh to Gauguin.* New York: Museum of Modern Art, 1956.

Rewald, John, Dore Ashton, and Harold Joachim. *Odilon Redon, Gustave Moreau, Rodolphe Bresdin.* New York: Museum of Modern Art, 1962.

Roberts, Keith. *The Impressionists and Post-Impressionists.* New York: E. P. Dutton, 1977.

Rosen, Charles, and Henri Zerner. *Romanticism and Realism: The Mythology of Nineteenth-Century Art.* London: Faber and Faber, 1984.

Rosenblum, Robert, and Horst W. Janson. *19th Century Art.* New York: Harry N. Abrams, 1984.

Russell, John. *Seurat.* New York: Frederick A. Praeger, 1965.

Sambrook, James, ed. *Pre-Raphaelitism: A Collection of Critical Essays.* Chicago: University of Chicago Press, 1974.

Schrade, Hubert. *German Romantic Painting.* New York: Harry N. Abrams, 1977.

Schapiro, Meyer. *Modern Art: 19th & 20th Centuries.* New York: Braziller, 1978.

Sloane, Joseph C. *French Painting Between the Past and the Present: Artists, Critics, and Traditions from 1848 to 1870.* Princeton, NJ: Princeton University Press, 1973.

Sullivan, Louis. *The Autobiography of an Idea.* New York: Dover, 1956.

Valsecchi, Marco. *Landscape Painting of the 19th Century.* Greenwich, CT: New York Graphic Society, 1971.

Van Gogh: A Self Portrait: Letters Revealing His Life as a Painter. Selected by W. H. Auden. New York: E. P. Dutton, 1963.

Vaughan, William. *German Romantic Painting.* New Haven, CT: Yale University Press, 1980.

Weisberg, Gabriel P. *The Realist Tradition: French Painting and Drawing, 1830–1900.* Cleveland: Cleveland Museum/Indiana University Press, 1980.

Wood, Christopher. *The Pre-Raphaelites.* New York: Viking Press, 1981.

CHAPTER 27 THE EARLY TWENTIETH CENTURY: THE ESTABLISHMENT OF MODERNIST ART

Ades, Dawn. *Dali and Surrealism.* New York: Harper & Row, 1982.

Anderson, Troels. *Malevich.* Amsterdam, Holland: Stedelijk Museum, 1970.

Antliff, Mark. *Cultural Politics and the Parisian Avant-Garde.* Princeton: Princeton University Press, 1993.

Apollinaire, Guillaume. *The Cubist Painters: Aesthetic Meditations, 1913.* New York: Wittenborn, 1970.

Barr, Alfred H., Jr. *Picasso: Fifty Years of His Art.* New York: Museum of Modern Art, 1946.

Bayer, Herbert, Walter Gropius, and Ise Gropius, eds. *Bauhaus 1919–1928.* Boston: Charles T. Branford, 1959.

Benevolo, Leonardo. *History of Modern Architecture.* 2 vols. Cambridge, MA. MIT Press, 1977.

Blake, Peter. *Frank Lloyd Wright.* Harmondsworth, Middlesex: Penguin Books, 1960.

———. *The Master Builder.* New York: W. W. Norton, 1976.

Boesinger, Willy, ed. *Le Corbusier.* New York: Frederick A. Praeger, 1972.

Breton, André. *Surrealism and Painting.* New York: Harper & Row, 1972.

Campbell, Mary Schmidt, David C. Driskell, David Lewis Levering, and Deborah Willis Ryan. *Harlem Renaissance: Art of Black America.* New York: The Studio Museum, Harlem/Harry N. Abrams, 1987.

Carls, Carl Dietrich. *Ernst Barlach.* London: Pall Mall Press, 1969.

Carrá, Massimo, Ewald Rathke, Caroline Tisdall, and Patrick Waldberg. *Metaphysical Art.* New York: Frederick A. Praeger, 1971.

Carter, Peter. *Mies van der Rohe at Work.* London: Pall Mall Press, 1974.

Cassou, Jean. *Chagall.* New York: Frederick A. Praeger, 1965.

Dupin, Jacques. *Alberto Giacometti.* Paris: Maeght Éditeur, 1963.

Duthuit, Georges. *The Fauvist Painters.* New York: Wittenborn, Schultz, 1950.

Edwards, Ehrlig. *Painted Walls of Mexico.* Austin: University of Texas Press, 1966.

Elderfield, John. *Kurt Schwitters.* New York: Museum of Modern Art/Thames & Hudson, 1985.

———. *The "Wild Beasts": Fauvism and Its Affinities.* New York: The Museum of Modern Art/Oxford University Press, 1976.

Elsen, Albert. *Origins of Modern Sculpture.* New York: Braziller, 1974.

Frampton, Kenneth. *A Critical History of Modern Architecture.* London: Thames & Hudson, 1985.

Friedman, Mildred, ed. *De Stijl: 1917–1931, Visions of Utopia.* Minneapolis: Walker Art Center/New York: Abbeville Press, 1982.

Fry, Edward, ed. *Cubism.* London: Thames & Hudson, 1966.

Geist, Sidney. *Constantin Brancusi, 1876–1957: A Retrospective Exhibition.* New York: Solomon R. Guggenheim Museum/Philadelphia: Philadelphia Museum of Art/Chicago: Chicago Art Institute, 1969.

George, Waldemar, and Dina Vierny. *Maillol.* London: Cory, Adams, and Mackay, 1965.

Gilot, François, and Carlton Lake. *Life with Picasso.* New York: McGraw-Hill, 1964.

Golding, John. *Cubism: A History and an Analysis, 1907–1914.* rev. ed. Boston: Boston Book & Art Shop, 1968.

Gowing, Lawrence. *Matisse.* New York: Oxford University Press, 1979.

Gray, Camilla. *The Russian Experiment in Art: 1863–1922.* New York: Harry N. Abrams, 1970.

Gray, Christopher. *Cubist Aesthetic Theories.* Baltimore: Johns Hopkins University Press 1953.

Grohmann, Will. *Kandinsky: Life and Work.* New York: Harry N. Abrams, 1958.

Gropius, Walter. *Scope of Total Architecture.* New York: Collier Books, 1962.

Haiko, Peter. *Architecture of the Early XX Century.* New York: Rizzoli, 1989.

Herrera, Hayden. *Frida: A Biography of Frida Kahlo.* New York: Harper & Row, 1983.

Hepworth, Barbara. *A Pictorial Autobiography.* London: The Tate Gallery, 1978.

Hof, August. *Wilhelm Lehmbruck.* London: Pall Mall Press, 1969.

Hunter, Sam. *American Art of the 20th Century.* New York: Harry N. Abrams, 1972.

Jaffé, Hans L. *De Stijl.* New York: Harry N. Abrams, 1971.

James, Philip. *Henry Moore on Sculpture.* New York: Viking Press, 1971.

Jean, Marcel. *The History of Surrealist Painting.* Translated by Simon Watson Taylor. New York: Grove Press, 1960.

Kahnweiler, Daniel H. *The Rise of Cubism.* New York: Wittenborn, Schultz, 1949.

Kandinsky, Wassily. *Concerning the Spiritual in Art.* Translated by M. T. H. Sadler. New York: Dover, 1977.

Kuspit, Donald. *The Cult of the Avant-Garde Artist.* Cambridge: Cambridge University Press, 1993.

Langaard, Johan H., and Reidar Revold. *Edvard Munch: Masterpieces from the Artist's Collection in the Munch Museum in Oslo.* New York: McGraw-Hill, 1964.

Le Corbusier. *The City of Tomorrow.* Cambridge, MA: MIT Press, 1971.

Levin, Gail. *Edward Hopper: The Art and the Artist.* New York: Whitney Museum of American Art/Norton, 1980.

Lodder, Christina. *Russian Constructivism.* New Haven: Yale University Press, 1983.

Martin, Marianne W. *Futurist Art and Theory.* Oxford: Clarendon Press, 1968.

Martinell, César. *Gaudí: His Life, His Theories, His Work.* Cambridge, MA. MIT Press, 1975.

Mashek, Joseph, ed. *Marcel Duchamp in Perspective.* Englewood Cliffs, NJ: Prentice-Hall, 1975.

Meltzer, Milton. *Dorothea Lange: A Photographer's Life.* New York: Farrar, Strauss, Giroux, 1978.

Moholy-Nagy, László. *Vision in Motion.* Chicago: Paul Theobald, 1969, first published in 1946.

Mondrian, Pieter Cornelius. *Plastic Art and Pure Plastic Art.* 3rd ed. New York: Wittenborn, Schultz, 1947.

Morse, John D., ed. *Ben Shahn.* London: Secker & Warburg, 1972.

Motherwell, Robert, ed. *The Dada Painters and Poets.* 2nd ed. Cambridge, MA: Harvard University Press.

Myers, Bernard S. *The German Expressionists: A Generation in Revolt.* New York: Frederick A. Praeger, 1956.

O'Keeffe, Georgia. *Georgia O'Keeffe.* New York: Penguin, 1977.

Osborne, Harold. *The Oxford Companion to Twentieth Century Art.* New York: Oxford University Press, 1981.

Overy, Paul. *De Stijl.* London: Studio Vista, 1969.

Passuth, Krisztina. *Moholy-Nagy.* New York: Thames & Hudson, 1985.

Peter, John. *Masters of Modern Architecture.* New York: Braziller, 1958.

Read, Herbert. *The Art of Jean Arp.* New York: Harry N. Abrams, 1968.

Read, Herbert, ed. *Surrealism.* New York: Frederick A. Praeger, 1971.

Richter, Hans. *Dada: Art and Anti-Art.* London: Thames & Hudson, 1961.

Rosenblum, Robert. *Cubism and Twentieth-Century Art.* New York: Harry N. Abrams, 1976.

Rubin, William S. *Dada and Surrealist Art.* New York: Harry N. Abrams, 1968.

———. *Dada, Surrealism and Their Heritage.* New York: Museum of Modern Art, 1968.

———. *Miró in the Collection of The Museum of Modern Art.* New York: Museum of Modern Art, 1973.

Rubin, William S., ed. *Pablo Picasso: A Retrospective.* New York: Museum of Modern Art/Boston: New York Graphic Society, 1980.

———. *"Primitivism" in 20th-Century Art: Affinity of the Tribal and the Modern.* 2 vols. New York: Museum of Modern Art, 1984.

Russell, John. *Max Ernst: Life and Work.* New York: Harry N. Abrams, 1967.

Schiff, Gert, ed. *Picasso in Perspective.* Englewood Cliffs, NJ: Prentice-Hall, 1976.

Schneede, Uwe M. *Surrealism.* New York: Harry N. Abrams, 1974.

Schwarz, Arturo. *The Complete Works of Marcel Duchamp.* London: Thames & Hudson, 1965.

———. *Man Ray: The Rigors of Imagination.* New York: Rizzoli, 1977.

Selz, Peter. *German Expressionist Painting.* 1957. reprint. Berkeley: University of California Press, 1974.

Selz, Peter, and Jean Dubuffet. *The Work of Jean Dubuffet.* New York: Museum of Modern Art, 1962.

Seuphor, Michel. *Piet Mondrian: Life and Work.* New York: Harry N. Abrams, 1956.

Shattuck, Roger, Henri Béhar, Mitchell Hoog, Carolyn Lauchner, and William Rubin. *Henri Rousseau.* New York: Museum of Modern Art, 1985.

Sharp, Dennis. *Twentieth Century Architecture: A Visual History.* New York: Facts on File, 1991.

Soby, James Thrall. *Georges Rouault: Paintings and Prints.* New York: Museum of Modern Art/Simon and Schuster, 1947.

Sotriffer, Kristian. *Expressionism and Fauvism.* New York: McGraw-Hill, 1972.

Speyer, James A. with Frederick Koeper. *Mies van der Rohe.* Chicago: Art Institute of Chicago, 1968.

Stephenson, Robert C., tr. *Orozco: An Autobiography.* Austin: University of Texas Press, 1962.

Stott, William. *Documentary Expression and Thirties America.* New York: Oxford University Press, 1973.

Taylor, Joshua C. *Futurism.* New York: Museum of Modern Art, 1961.

Troyen, Carol, and Erica E. Hirshler. *Charles Sheeler: Paintings and Drawings.* Boston: Museum of Fine Arts, 1987.

Tucker, William. *Early Modern Sculpture.* New York: Oxford University Press, 1974.

Vogt, Paul. *Expressionism: German Painting, 1905–1920.* New York: Harry N. Abrams, 1980.

Von Hartz, John. *August Sander.* Millerton, NY: Aperture, 1977.

Waldman, Diane. *Joseph Cornell.* New York: Braziller, 1977.

Wright, Frank Lloyd; Edgar Kaufmann, ed. *American Architecture.* New York: Horizon, 1955.

Wheat, Ellen Harkins. *Jacob Lawrence: American Painter.* Seattle: University of Washington Press, 1986.

CHAPTER 28 THE LATER TWENTIETH CENTURY

Albright, Thomas. *Art in the San Francisco Bay Area: 1945–1980.* Berkeley: University of California Press, 1985.

Alloway, Lawrence. *American Pop Art.* New York: Whitney Museum of American Art/Macmillan, 1974.

———. *Robert Rauschenberg.* Washington, DC: National Collection of Fine Arts/ Smithsonian Institutions, 1976.

———. *Topics in American Art Since 1945.* New York: W. W. Norton, 1975.

Amaya, Mario. *Pop Art and After.* New York: Viking Press, 1972.

Armes, Roy. *Patterns of Realism: A Study of Italian Neo-Realist Cinema.* New York: A. S. Barnes, 1971.

Battcock, Gregory, ed. *Minimal Art: A Critical Anthology.* New York: Studio Vista, 1969.

———. *The New Art: A Critical Anthology.* New York: E. P. Dutton, 1973.

———. *New Artists Video: A Critical Anthology.* New York: E. P. Dutton, 1978.

———. *Super Realism: A Critical Anthology.* New York: E. P. Dutton, 1975.

Battcock, Gregory, and Robert Nickas, eds. *The Art of Performance: A Critical Anthology.* New York: E. P. Dutton, 1984.

Beardsley, Richard. *Earthworks and Beyond: Contemporary Art in the Landscape.* New York: Abbeville Press, 1984.

Beardsley, John, and Jane Livingston. *Hispanic Art in the United States: Thirty Contemporary Painters and Sculptors.* Houston: Museum of Fine Arts/New York: Abbeville Press, 1987.

Benezra, Neal. *Martin Puryear.* Chicago: Chicago Art Institute, 1991.

Benthall, Jeremy. *Science and Technology in Art Today.* New York: Frederick A. Praeger, 1972.

Bourdon, David. *Christo.* New York: Harry N. Abrams, 1972.

Brion, Marcel, Sam Hunter, et al. *Art Since 1945.* New York: Harry N. Abrams, 1958.

Carmean, E. A., Jr., Elizabeth Rathbone, and Thomas B. Hess. *American Art at Mid-Century: The Subjects of the Artists.* Washington, DC: The National Gallery of Art, 1978.

Cassou, Jean, K. G. Hultèn-Pontus, and Sam Hunter, with statement by Nicolas Schöffer. *Two Kinetic Sculptors: Nicolas Schöffer and Jean Tinguely.* New York: Jewish Museum/October House, 1965.

Chicago, Judy. *The Dinner Party: A Symbol of Our Heritage.* Garden City, NY: Anchor Press/Doubleday, 1979.

Cockcroft, Eva, John Weber, and James Cockcroft. *Toward a People's Art.* New York: E. P. Dutton, 1977.

Cook, Peter. *New Spirit in Architecture.* New York: Rizzoli, 1990.

Crichton, Michael. *Jasper Johns.* New York: Whitney Museum of American Art/Harry N. Abrams, 1977.

Cummings, Paul. *Dictionary of Contemporary American Artists.* 3rd ed. New York: St. Martin's Press, 1977.

Danto, Arthur C. *Mark Tansey: Visions and Revisions.* New York: Abrams, 1992.

Davies, Hugh, and Sally Yard. *Francis Bacon.* New York: Abbeville Press, 1986.

Deken, Joseph. *Computer Images: State of the Art.* New York: Stewart, Tabori, and Chang Publishers, 1983.

Diamondstein, Barbaralee. *American Architecture Now.* New York: Rizzoli, 1980.

Diehl, Gaston, and Eileen B. Hennessey. *Vasarely.* New York: Crown Publishers, 1972.

Gilbert and George, and Carter Ratcliff. *Gilbert and George: The Complete Pictures, 1971–1985.* London: Thames & Hudson, 1986.

Goodman, Cynthia. *Digital Visions: Computers and Art.* New York: Harry N. Abrams, 1987.

Goodyear, Frank H., Jr. *Contemporary American Realism Since 1960.* Boston: New York Graphic Society, 1981.

Gordon, John. *Louise Nevelson.* New York: Whitney Museum of American Art, 1967.

Gough, Harry F. *The Vital Gesture: Franz Kline.* Cincinnati: Cincinnati Art Museum/New York: Abbeville Press, 1985.

Graham, Peter. *The New Wave.* Garden City, NY: Doubleday, 1968.

Gray, Cleve, ed. *David Smith on David Smith: Sculpture and Writings.* London: Thames & Hudson, 1968.

Hamilton, Richard. *Collected Words 1953–1982.* London: Thames & Hudson, 1982.

Hertz, Richard, ed. *Theories of Contemporary Art.* Englewood Cliffs, NJ: Prentice-Hall, 1985.

Hess, Thomas B. *Barnett Newman.* New York: Walker and Company, 1969.

———. *Willem de Kooning.* New York: Museum of Modern Art, 1968.

Jacob, Mary Jane. *Magdalena Abakanowicz.* New York: Abbeville Press, 1982.

Jacobus, John. *Twentieth-Century Architecture: The Middle Years, 1940–1964.* New York: Frederick A. Praeger, 1966.

Jencks, Charles. *Architecture 2000: Prediction and Methods.* New York: Frederick A. Praeger, 1971.

———. *The Language of Postmodern Architecture.* New York: Rizzoli, 1977 (1981).

Kaprow, Allan. *Assemblage, Environments, and Happenings.* New York: Harry N. Abrams, 1966.

Kepes, Georgy. *Arts of the Environment.* New York: Braziller, 1970.

Kirby, Michael. *Happenings.* New York: E. P. Dutton, 1966.

Lippard, Lucy R. *Eva Hesse.* New York: New York University Press, 1976.

Lippard, Lucy R., ed. *Pop Art.* New York: Frederick A. Praeger, 1966.

———, ed. *Six Years: The Dematerialization of the Art Object from 1966 to 1972.* New York: Frederick A. Praeger, 1973.

Livingstone, Marco. *David Hockney.* London: Thames & Hudson, 1981.

Lovejoy, Margot. *Postmodern Currents: Art and Artists in the Age of the Electronic Media.* Ann Arbor, MI: UMI Research Press, 1989.

Lucie-Smith, Edward. *Art Now.* Edison, NJ: Wellfleet Press, 1989.

———. *Movements Since 1945.* new rev. ed. New York: Thames & Hudson, 1984.

Marder, Tod A. *The Critical Edge: Controversy in Recent American Architecture.* New Brunswick, NJ: Rutgers University Press, 1980.

McShine, Kynaston. *Andy Warhol: A Retrospective.* New York: Museum of Modern Art, 1989.

———. *An International Survey of Recent Painting and Sculpture.* New York: Museum of Modern Art, 1984.

Meyer, Ursula. *Conceptual Art.* New York: E. P. Dutton, 1972.

Mitchell, William J. *The Reconfigured Eye: Visual Truth in the Post-Photographic Era.* Cambridge, MA: MIT Press, 1992.

Nervi, Pier Luigi. *Aesthetics and Technology in Building.* Cambridge, MA: Harvard University Press, 1965.

Norris, Christopher, and Benjamin, Andres. *What Is Deconstruction?* New York: St. Martin's, 1988.

O'Connor, Francis V. *Jackson Pollock.* New York: Museum of Modern Art, 1967.

O'Hara, Frank. *Robert Motherwell.* New York: Museum of Modern Art, 1965.

Papadakis, Andreas. *Deconstruction: Omnibus Volume.* New York: Rizzoli, 1989.

Price, Jonathan. *Video Visions: A Medium Discovers Itself.* New York: New American Library, 1977.

Reichardt, Jasia, ed. *Cybernetics, Art & Ideas.* Greenwich, CT: New York Graphics Society, 1971.

Risatti, Howard, ed. *Postmodern Perspectives.* Englewood Cliffs, NJ: Prentice-Hall, 1990.

Robbins, Corinne. *The Pluralist Era: American Art, 1968–1981.* New York: Harper & Row, 1984.

Rose, Barbara. *Claes Oldenburg.* New York: Museum of Modern Art, 1970.

———. *Frankenthaler.* New York: Harry N. Abrams, 1975.

Rosenberg, Harold. *The Tradition of the New.* New York: Horizon Press, 1959.

Russell, John. *Francis Bacon.* London: Thames & Hudson, 1971.

Russell, John, and Suzi Gablik. *Pop Art Redefined.* New York: Frederick A. Praeger, 1969.

Sandler, Irving. *The Triumph of American Painting: A History of Abstract Expressionism.* New York: Frederick A. Praeger, 1970.

Schneider, Ira, and Beryl Korot. *Video Art: An Anthology.* New York: Harcourt Brace Jovanovich, 1976.

Seitz, William C. *Abstract Expressionist Painting in America.* Cambridge, MA: Harvard University Press, 1983.

Sitney, P. Adams. *Visionary Film: The American Avant-Garde.* New York: Oxford University Press, 1974.

Smagula, Howard. *Currents: Contemporary Directions in the Visual Arts.* 2nd ed. Englewood Cliffs, NJ: Prentice-Hall, 1989.

Smith, Patrick S. *Andy Warhol's Art and Films.* Ann Arbor, MI: UMI Research Press, 1986.

Smithson, Robert. *The Writings of Robert Smithson.* Edited by Nancy Holt. New York: New York University Press, 1975.

Solomon, Alan. *Jasper Johns.* New York: The Jewish Museum, 1964.

Sonfist, Alan, ed. *Art in the Landscape: A Critical Anthology of Environmental Art.* New York: E. P. Dutton, 1983.

Stangos, Nikos. *Concepts of Modern Art.* 2nd ed. New York: Harper & Row, 1985.

Stern, Robert A. M. *Modern Classicism.* New York: Rizzoli, 1988.

Tisdall, Carolyn. *Joseph Beuys.* New York: Solomon R. Guggenheim Museum, 1979.

Tomkins, Calvin. *The Scene Reports on Post-Modern Art.* New York: Viking Press, 1976.

Tuchman, Maurice. *American Sculpture of the Sixties.* Los Angeles: Los Angeles County Museum of Art, 1967.

Venturi, Robert, Denise Scott-Brown, and Steven Isehour. *Learning from Las Vegas.* Cambridge, MA: MIT Press, 1972.

Waldman, Diane. *Mark Rothko, 1903–1970: A Retrospective.* New York: Solomon R. Guggenheim Museum, 1978.

Wallis, Brian, ed. *Art After Modernism: Rethinking Representation.* New York: New Museum of Contemporary Art in association with David R. Godine, 1984.

Watson-Jones, Virginia. *Contemporary American Women Sculptors.* Phoenix: Oryx Press, 1986.

Wye, Deborah. *Louise Bourgeois.* New York: Museum of Modern Art, 1982.

BOOKS SPANNING THE EIGHTEENTH, NINETEENTH, AND TWENTIETH CENTURIES

Ades, Dawn. *Art in Latin America: The Modern Era, 1820–1980.* London: The Hayward Gallery, 1989.

Antreasian, Garo, and Clinton Adams. *The Tamarind Book of Lithography: Art and Techniques.* Los Angeles: Tamarind Workshop and New York: Harry N. Abrams, 1971.

Armstrong, John, Wayne Craven, and Norma Feder, et al. *200 Years of American Sculpture.* New York: Whitney Museum of American Art/Boston: David R. Godine, 1976.

Brown, Milton, Sam Hunter, and John Jacobus. *American Art: Painting, Sculpture, Architecture, Decorative Arts, Photography.* New York: Harry N. Abrams, 1979.

Chipp, Herschel. *Theories of Modern Art.* Berkeley: University of California Press, 1968.

Coke, Van Deren. *The Painter and the Photograph From Delacroix to Warhol.* rev. and enl. ed. Albuquerque: University of New Mexico Press, 1972.

Collins, Peter. *Changing Ideals in Modern Architecture, 1750–1950.* London: Faber & Faber, 1971.

Condit, Carl W. *The Rise of the Skyscraper: Portrait of the Times and Career of Influential Architects.* Chicago: University of Chicago Press, 1952.

Driskell, David C. *Two Centuries of Black American Art.* Los Angeles: Los Angeles County Museum of Art/New York: Alfred A. Knopf, 1976.

Elsen, Albert. *Origins of Modern Sculpture.* New York: Braziller, 1974.

Fine, Sylvia Honig. *Women and Art: A History of Women Painters and Sculptors from the Renaissance to the 20th Century.* Montclair, NJ: Alanheld and Schram, 1978.

Flexner, James Thomas. *America's Old Masters.* New York: McGraw-Hill, 1982.

Giedion, Siegfried. *Mechanization Takes Command: A Contribution to Anonymous History.* New York: Norton, 1948.

———. *Space, Time and Architecture: The Growth of a New Tradition.* 4th ed. Cambridge, MA: Harvard University Press, 1965.

Goldwater, Robert, and Marco Treves, eds. *Artists on Art.* 3rd ed. New York: Pantheon, 1958.

Greenough, Sarah, Joel Snyder, David Travis, and Colin Westerbeck. *On the Art of Fixing a Shadow: One Hundred and Fifty Years of Photography.* Washington, DC: The National Gallery of Art/Chicago: The Art Institute of Chicago, 1989.

Hamilton, George Heard. *Nineteenth- and Twentieth-Century Art.* Englewood Cliffs, NJ: Prentice-Hall, 1972.

Hammacher, A. M. *The Evolution of Modern Sculpture: Tradition and Innovation.* New York: Harry N. Abrams, 1969.

Hitchcock, Henry-Russell. *Architecture: Nineteenth and Twentieth Centuries.* 4th ed. New Haven: Yale University Press, 1977.

Hopkins, H. J. *A Span of Bridges.* Newton Abbot, Devon, England: David & Charles, 1970.

Hunter, Sam. *Modern French Painting, 1855–1956.* New York: Dell, 1966.

Irving, Donald J. *Sculpture: Material and Process.* New York: Van Nostrand Reinhold, 1970.

Kaufmann, Edgar, Jr., ed. *The Rise of an American Architecture.* New York: Metropolitan Museum of Art/Frederick A. Praeger, 1970.

Klingender, Francis Donald and Elton, Arthur ed. and rev. *Art and the Industrial Revolution.* London: Evelyn, Adams and MacKay, 1968.

Licht, Fred. *Sculpture, Nineteenth and Twentieth Centuries.* Greenwich, CT: New York Graphic Society, 1967.

Loyer, Francois. *Architecture of the Industrial Age.* New York: Rizzoli, 1983.

McCoubrey, John W. *American Art, 1700–1960: Sources and Documents.* Englewood Cliffs, NJ: Prentice-Hall, 1965.

Mason, Jerry, ed. *International Center of Photography Encyclopedia of Photography.* New York: Crown Publishers, 1984.

Newhall, Beaumont. *The History of Photography.* New York: The Museum of Modern Art, 1982.

Pehnt, Wolfgang. *Encyclopedia of Modern Architecture.* New York: Harry N. Abrams, 1964.

Peterdi, Gabor. *Printmaking: Methods Old and New.* New York: Macmillan, 1961.

Phillipe, Robert. *Political Graphics: Art as a Weapon.* New York: Abbeville Press, 1980.

Pierson, William. *American Buildings and Their Architects: Technology and the Picturesque.* Vol. 2. Garden City, NY: Doubleday, 1978.

Risebero, Bill. *Modern Architecture and Design: An Alternative History.* Cambridge: MIT Press, 1983.

Rosenblum, Robert. *Modern Painting and the Northern Romantic Tradition: Friedrich to Rothko.* New York: Harper & Row, 1975.

Ross, John, and Clare Romano. *The Complete Printmaker.* New York: The Free Press, 1972.

Ross, Stephen David, ed. *Art and Its Significance: An Anthology of Aesthetic Theory.* Albany, NY: SUNY Press, 1987.

Sachs, Paul, Jr. *Modern Prints and Drawings: A Guide to a Better Understanding of Modern Draughtsmanship.* New York: Alfred A. Knopf, 1954.

Scharf, Aaron. *Art and Photography.* Baltimore, MD: Penguin Books, 1974.

Scully, Vincent. *American Architecture and Urbanism.* New York: Frederick A. Praeger, 1969.

Selz, Peter; Michelson, Annette, tr. *Modern Sculpture: Origins and Evolution.* London: Heinemann, 1963.

Seuphor, Michel. *The Sculpture of this Century.* New York: Braziller, 1960.

Shikes, Ralph E. *The Indignant Eye: The Artist as Social Critic, from the Renaissance to Picasso.* Boston: Banion Press, 1969.

Slatkin, Wendy. *Women Artists in History: From Antiquity to the 20th Century.* 2nd ed. Englewood Cliffs, NJ: Prentice-Hall, 1985.

Spencer, Harold. *American Art: Readings from the Colonial Era to the Present.* New York: Charles Scribner's Sons, 1980.

Summerson, Sir John. *Architecture in Britain: 1530–1830.* 7th rev. and enl. ed. Baltimore: Penguin, 1983.

Sypher, Wylie. *Rococo to Cubism in Art and Literature.* New York: Random House, 1960.

Szarkowski, John. *Photography Until Now.* New York: Museum of Modern Art, 1989.

Thorndike, Joseph, Jr. *Three Centuries of Notable American Architects.* New York: American Heritage, 1981.

Weaver, Mike. *The Art of Photography: 1839–1989.* New Haven, CT: Yale University Press, 1989.

Whiffen, Marcus, and Frederick Koeper. *American Architecture, 1607–1976.* Cambridge: MIT Press, 1983.

Wilmerding, John. *American Art.* Harmondsworth, England: Penguin, 1976.

———. *The Genius of American Painting.* London: Weidenfeld & Nicolson, 1973.

Wilson, Simon. *Holbein to Hockney: A History of British Art.* London: The Tate Gallery & The Bodley Head, 1979.

BOOKS SPANNING THE WHOLE OF THE TWENTIETH CENTURY

Ades, Dawn. *Photomontage.* Rev. and enl. ed. London: Thames & Hudson, 1976.

Andersen, Wayne. *American Sculpture in Process: 1930–1970.* Boston: New York Graphic Society, 1975.

Arnason, H. H. *History of Modern Art: Painting, Sculpture, Architecture.* 3rd rev. and enl. ed. Englewood Cliffs, NJ: Prentice-Hall 1988.

Ashton, Dore. *Twentieth-Century Artists on Art.* New York: Pantheon Books, 1985.

Banham, Reyner. *Guide to Modern Architecture.* Princeton, NJ: D. Van Nostrand, 1962.

Burnham, Jack. *Beyond Modern Sculpture. The Effects of Science and Technology on the Sculpture of This Century.* New York: Braziller, 1968.

Castelman, Riva. *Prints of the 20th Century: A History.* New York: Oxford University Press, 1985.

Compton, Susan, ed. *British Art in the 20th Century.* London: Royal Academy of Arts/Berlin: Prestel Verlag, 1986.

Curtis, David. *Experimental Cinema: A Fifty-Year Evolution.* New York: Dell, 1971.

Davis, Douglas. *Art and the Future: A History/Prophecy of the Collaboration Between Scientists, Technology and the Arts.* New York: Frederick A. Praeger, 1973.

Frascina, Francis, and Charles Harrison, eds. *Modern Art and Modernism: A Critical Anthology.* New York: Harper & Row, 1982.

Haftmann, Werner. *Painting in the Twentieth Century.* New York: Frederick A. Praeger, 1960.

Hamlin, Talbot F., ed. *Forms and Functions of Twentieth-Century Architecture.* 4 vols. New York: Columbia University Press, 1952.

Hatje, Gerd, ed. *Encyclopedia of Modern Architecture.* London: Thames & Hudson, 1963.

Herbert, Robert L., ed. *Modern Artists on Art.* Englewood Cliffs, NJ: Prentice-Hall, 1964.

Hertz, Richard, and Norman M. Klein, eds. *Twentieth-Century Art Theory: Urbanism, Politics, and Mass Culture.* Englewood Cliffs, NJ: Prentice-Hall, 1990.

Hunter, Sam, and John Jacobus. *Modern Art: Painting, Sculpture, and Architecture.* New York: Harry N. Abrams, 1985.

Hunter, Sam. *Modern American Painting and Sculpture.* New York: Dell, 1959.

Jencks, Charles. *Modern Movements in Architecture.* Garden City, NY: Anchor Press/ Doubleday, 1973.

Joachimides, Christos. M., Norma Rosenthal, and Wieland Schmied, eds. *German Art in the 20th Century. Painting and Sculpture, 1905–1985.* Munich: Prestel-Verlag, 1985.

Kraus, Rosalind E. *Passages in Modern Sculpture.* Cambridge, MA: MIT Press, 1981.

Lynton, Norbert. *The Story of Modern Art.* 2nd ed. Englewood Cliffs, NJ: Prentice-Hall, 1989.

Phaidon Dictionary of Twentieth-Century Art. Oxford: Phaidon Press, 1973.

Phillips, Gene D. *The Movie Makers: Artists in an Industry.* Chicago: Nelson-Hall, 1973.

Pontus-Hultén, K. G. *The Machine as Seen at the End of the Mechanical Age.* New York: Museum of Modern Art, 1968.

Popper, Frank, et. al. *Electra: Electricity and Electronics in the Art of the 20th Century.* Paris: Musée d'art moderne de Paris, 1983.

———. *Origins and Development of Kinetic Art.* Translated by Stephne Benn. Greenwich, CT: New York Graphic Society, 1968.

Raynal, Maurice. *History of Modern Painting.* 3 vols. Geneva: Skira, 1949–1950.

Read, Herbert. *Concise History of Modern Painting.* 3rd ed. New York: Frederick A. Praeger, 1975.

———. *A Concise History of Modern Sculpture.* rev. and enl. ed. New York: Frederick A. Praeger, 1964.

Rickey, George. *Constructivism: Origins and Evolution.* New York: Braziller, 1967.

Ritchie, Andrew Carnduff, ed. *German Art of the Twentieth Century.* New York: Museum of Modern Art, 1957.

———. *Sculpture of the Twentieth Century.* New York: The Museum of Modern Art, n.d.

Rose, Barbara. *American Art Since 1900.* rev. ed. New York: Frederick A. Praeger, 1975.

Russell, John. *The Meanings of Modern Art.* New York: Museum of Modern Art/Thames & Hudson, 1981.

Scully, Vincent. *American Architecture and Urbanism.* New York: Frederick A. Praeger, 1969.

———. *Modern Architecture.* rev. ed. New York: Braziller, 1974.

Sharp, Dennis. *Twentieth Century Architecture: A Visual Survey.* New York: Facts on File. 1991.

Spalding, Francis. *British Art Since 1900.* London: Thames & Hudson, 1986.

Tomkins, Calvin. *The Bride and the Bachelors, Five Masters of the Avant-Garde.* New York: Viking Press, 1968.

Tuchman, Maurice, and Judi Freeman, eds. *The Spiritual in Art: Abstract Painting, 1890–1985.* Los Angeles: Los Angeles County Art Museum/New York: Abbeville Press, 1986.

Wescher, Herta. *Collage.* Translated by Robert E. Wolf. New York: Harry N. Abrams, 1968.

Whittick, Arnold. *European Architecture in the Twentieth Century.* Aylesbury, England: Leonard Hill , 1974.

ACKNOWLEDGMENTS

The authors and publisher are grateful to the proprietors and custodians of various works of art for photographs of these works and permission to reproduce them in this book. Sources not included in the captions are listed here.

KEY TO ABBREVIATIONS

AA&A The Ancient Art & Architecture Collection
AL Fratelli Alinari
AR Art Resource
BPK Bildarchiv Preussischer Kulturbesitz
Bulloz J. E. Bulloz, Paris
Canali Canali Photobank, Italy
Fototeca Fototeca Unione at the American Academy, Rome
Gir Giraudon
Harding Robert Harding Picture Library, London
Hinz Colorphoto Hans Hinz
Hir Hirmer Fotoarchiv, Munich
Mar Bildarchiv Foto Marburg
MAS Appliaciones y Reproducciones MAS, Barcelona
NYPL New York Public Library
PRI Photo Researchers, Inc., New York
R.M.N. Photo, Réunion des Musées Nationaux
Scala Scala Fine Art Publishers
Summerfield Summerfield Press, Ltd

Note: All references in the following credits are to figure numbers unless otherwise indicated.

Cover, Vol. I paperbound—Erich Lessing/AR. Frontispiece, Vol. I paperbound—R.M.N.
Introduction—AL/AR: 4, 9, 10; © 1955, 1983, The New Yorker Magazine: 11; Hir: 12.
Part I—Opening photograph Studio Pizzi/Summerfield; black-and-white photograph Griffith Institute, Ashmolean Museum, Oxford.
Chapter 1—Jean Vertut: 1, 5, 11; Robert Laborie: 2, 6; Hinz: 4; CNMHS/SPADEM: 7, 12; J.M. Arnaud/Musée d'Aquitaine: 9; Jean Dieuzaide: 10; MAS: 13; British School of Archaeology in Jerusalem: 14, 15; James Mellaart: 18; Arlette Mellaart: 19, 20; Aerofilms Limited: 21.
Chapter 2—Staatliche Museen zu Berlin: 1; Erwin Böhm: 4; Hir: 5, 16, 17, 19, 22; Courtesy of The Oriental Institute of The University of Chicago: 6, 25; © photo Jean Mazenod, L'art antique du Proche-Orient, editions Citadelles & Mazenod, Paris: 7; Scala/AR: 12; R.M.N.: 13, 15, 27; The Mansell Collection: 20; Klaus Göken, 1992/BPK: 24; Gir/AR: 30; Sassoon/Harding: 31; Stolze: 33.
Chapter 3—Hir: 2, 3, 6, 7, 8, 12, 13, 17, 18, 19, 20, 31, 36; Carolyn Brown/PRI: 4; Harding: 11, 29, 41, 42; R.M.N.: 15, 43; John G. Ross: 16; Mar/AR: 21, 27, 45; Wim Swaan: 25; John P. Stevens/AA&A: 26; Ron Sheridan/AA&A: 32; Jürgen Liepe/BPK: 33; Margarete Büsing/BPK: 37, 38, 39; Lee Boltin: 40.
Chapter 4—Scala/AR: 1; Studio Kontos: 2, 26; Photo by Raymond V. Schoder, © 1987 by Bolchazy-Carducci Publishers, Inc.: 3, 17; Wim Swaan: 4; Hir: 6, 8, 10, 12, 14, 15, 18, 20, 23, 24, 25, 28; Nimatallah/AR: 9, 13; Hinz: 11; Leonard von Matt: 16; TAP: 27.
Chapter 5—TAP: 1, 11, 72: Photograph by Schecter Lee: 2; Alison Frantz: 7, 35, 36, 57; R.M.N.: 8, 65, 93; Studio Kontos: 12, 13, 34, 40, 47, 73, 77, 88, 95; Summerfield: 16, 92; Vanni/AR: 19; Hir: 21, 39, 53, 56, 61, 62, 63, 70, 85, 94; AL/AR: 22(a), 42, 74; Scala/AR: 22(b), 38, 41, 58, 64, 98(a); Photo Vatican Museums: 23, 44, 68; Photo R.M.N./Duplicata: 25; Hinz: 26; Copyright A.C.L., Brussels: 27; Erich Lessing/AR: 28; Canali: 33, 79, 102; Mar/AR: 37, 83; German Archaeological Institute, Rome: 43, 75, 98(b); Photo by Raymond V. Schoder, © 1987 by Bolchazy-Carducci Publishers, Inc.: 45, 80; DAI, Athens. photo: G. Hellner: 55; Ronald Sheridan/AA&A: 60, 81; © 1981 M. Sarri/Photo Vatican Museums: 66, 71; Archivio I.G.D.A., Milano: 67; SANDAK/AR: 76; R. Hoddinott/AA&A: 78; Gian Berto Vanni/AR: 82; BPK: 86, 89, 90; Soprintendenza Archeologica, Rome: 91; Photo Chr. Koppermann: 97; © 1988 T. Okamura/Photo Vatican Museums: 101.
Chapter 6—Hir: 1, 2, 4, 9, 10, 12, 17; David Lees: 3; German Archaeological Institute, Rome: 5, 11, 18; Fototeca: 6; Archivio I.G.D.A., Milano: 8; Photo Vatican Museums: 13; Scala/AR: 14;

Soprintendenza Archeologica per l'Etruria Meridionale: 15; AL/AR: 16.
Chapter 7—Fototeca: 1, 13, 49, 51, 75; AL/AR: 2, 9, 14, 31, 32, 37, 41, 44, 45, 60, 62; German Archaeological Institute, Rome: 5, 6, 16, 33, 48, 52, 53, 55, 67, 73, 76, 79, 82, 86, 88; The American Numismatic Society, New York: 7, 93(a); The Whittlesey Foundation/ Aristide D. Caratzas, Publisher: 10; Ronald Sheridan/AA&A: 12; Photo Archives Skira, Geneva, Switzerland: 17; Canali: 18, 23, 24, 27, 34, 47; 63(b), 81, 90; Foto Biblioteca Apostolica Vaticana: 20; Scala/AR: 21, 26, 58, 65, 85; Madeline Grimoldi: 25; © M. Sarri/Photo Vatican Museums: 28; Photo Vatican Museums: 29, 64; Mar/AR: 35, 83; Oliver Benn/Tony Stone Images: 36; Leonard von Matt: 39, 40; © photo Jean Mazenod, L'art de l'ancienne Rome, Éditions Citadelles et Mazenod, Paris: 42; Summerfield: 43, 78; CNRS: 46; Israel Museum, Jerusalem/ D. Harris: 54; Cotton Coulson/Woodfin Camp: 57; Wim Swaan: 59; Ernani Orcorte/UTET: 61; Erich Lessing/AR: 63(a); De Masi/Canali: 66; Canali/On license of the Ministero per i Beni Culturali ed Ambientali: 69; Peter Muscato: 70; BPK: 71; Istituto Centrale per il Catalogo e la Documentazione, (ICCD): 87; Rheinisches Landesmuseum: 91, 92; Hir: 93(b).
Chapter 8—Yale University Art Gallery, Dura-Europos Archive: 1; Fototeca & Benedettine di Priscilla, Rome: 3; Madeline Grimoldi: 4; Hir: 5, 6, 7, 10, 21, 23, 24, 27; AL/AR: 9, 14; Canali: 12; Andre Held: 13; Scala/AR: 15, 18, 19, 20; Anderson/AR: 17; Foto Biblioteca Apostolica Vaticana: 25.
Part II opening photograph—© photo Jean Mazenod, L'art gothique editions Citadelles & Mazenod, Paris.
Chapter 9—Jean Dieuzaide: 1; Marvin Trachtenberg: 2; Hir: 4, 6, 12, 36; Scala/AR: 7, 13; AL/Gir: 8; Canali: 9, 10, 11, 16; Ronald Sheridan/AA&A: 14, 15; R.M.N.: 19; Alison Frantz: 20; Erich Lessing/AR: 23; Sostegni/Fotocielo: 24; Canali/Cameraphoto: 26, 30; HB Collection: 27; Studio Kontos: 28; Josephine Powell: 29; Enrico Ferorelli: 31; Sovfoto/Eastfoto: 32, 37; Courtesy of Dumbarton Oaks, Center for Byzantine Studies, Washington, D.C.: 33; Philip Craven/Harding: 34; Andre Held: 35; Reenie Schmerl Barrow: 38.
Chapter 10—Yoram Lehmann, Jerusalem: 1; Ronald Sheridan/AA&A: 2, 5; Photo Archives Skira, Geneva, Switzerland: 3; Roger Wood/Continuum: 4, 18; Wim Swaan: 7, 11, 20, 22; MAS: 9; Douglas Dickins, FRPS: 10; HB Collection: 12; BPK: 14; Staatliche Museen zu Berlin: 15; By courtesy of the Israel Antiquities Authority: 16; Josephine Powell: 17; Linares/Yale University Photo Collection: 19; Russell A. Thompson: 23; Gir: 24; Anthony Kersting: 26; Photographer: Daniel McGrath: 27; Courtesy of Dr. Todd Disotell: 37.
Chapter 11—Lee Boltin: 1; R.M.N.: 2(a); Bridgeman/AR: 2(b); Scala/AR: 5; Erich Lessing/AR: 6; Donato Pineider: 8; Mick Sharp: 10; University Museum of National Antiquities, Oslo, Norway: 11; University Museum of National Antiquities, Oslo, Norway. Eirik Irgens Johnsen: 12; Photo Zodiaque: 13; NYPL: 16; Summerfield: 19; Dr. Harold Busch: 22; Hir: 23; Mar/AR: 26, 29; HB Collection: 28; BPK: 30.
Chapter 12—Ronald Sheridan/AA&A: 1; Jean Dieuzaide: 3, 23; Mar/AR: 5, 34; Hir: 8; HB Collection: 9; AL/AR: 10; Canali: 12, 19, 26; Bulloz: 13, 25, 27, 31, 33; W. S. Stoddard: 14; Anthony Kersting: 16; Fotocielo: 18; Scala/AR: 20; Ralph Lieberman: 21; Takashi Okamura/Abbeville Press, New York: 22; Emeric Feher © CNMHS/SPADEM: 28; Arch. Phot. Paris/SPADEM: 29; Gir: 30, 38; Lauros/Gir: 32, 35; Gir/AR: 36; Wim Swaan: 39.
Chapter 13—HB Collection: 1, 3, 35; Harry Bliss, © National Geographic Society: 36; Mar/AR: 8, 18, 51, 53, 54, 55; Hir: 9, 11, 13, 23, 25; Bulloz: 10; Roger-Viollet: 14, 28; © photo Jean Mazenod, L'art gothique, éditions Citadelles & Mazenod, Paris: 15, 34; Aerofilms Limited: 16, 30, 31; Ralph Lieberman: 20, 22; Clarence Ward, Photographic Archives, National Gallery of Art, Washington, D.C.: 26, 49; Gir: 27, 36; Gir/AR: 29, 32, 33, 39; Rapho/PRI: 41;

Wim Swaan: 42; National Monuments Record: 44; RCHME Crown Copyright: 45, 46; Edwin Smith: 47; E.T. Archive: 48; Dr. Harold Busch/AR: 52; German Information Center: 57; Scala/AR: 58; Canali: 60, 61; AL/Canali: 62; Canali/Lensini, Italy: 63; George Holton/PRI: 64.
Part III opening photograph—Justin Kerr; black-and-white photograph Eliot Elisofon.
Chapter 14—Archeological Survey of India, Janpatch, New Delhi: 1, 2, 3, 4, 6, 8, 10, 12, 13, 15, 16, 17; Harding: 5, 7, 30; Joseph Szaszfai: 11; Photo by Edgar Oscar Parker, courtesy of the Visual Collections, Fine Arts Library, Harvard University: 14; David Tokeley/Harding: 18; Barnaby's Picture Library: 19; Gir/AR: 20; Douglas Dickins, FRPS: 21, 23, 33; HB Collection: 22; John Stevens/AA&A: 25; AR: 26; Werner Forman Archive/AR: 27; Eliot Elisofon/Life Magazine © Time Warner, Inc.: 28; R.M.N.: 31; Marie J. Mattson: 32.
Chapter 15—Cultural Relics Publishing House, Beijing: 1, 2, 6; Chavannes: 7; Harding: 8, 27; Laurence G. Liu: 10, 11, 37, 39, 40, 41, 42; R.M.N.: 12, 30; HB Collection: 15; NYPL: 17; AR: 18; Tokyo National Museum: 23; Audrey R. Topping: 32; Edition d'Art, Paris: 35; Werner Forman Archive/AR: 43.
Chapter 16—Kyoryokukai: 1, 16, 21; Courtesy of Jingu Shicho: 3; National Commission for Protection of Cultural Properties, Tokyo: 4, 11, 13; Sakamoto Photo Research Lab: 5, 9; Ogawa Kozo, Asukaen: 6, 7; From A History of Far Eastern Art by Sherman E. Lee, Harry N. Abrams, Inc.: 8, 10, 28, 29; Harding: 12(a); AR: 12(b); Wim Swaan: 17, 18; Shashinka Photo: 19, 23, 24, 25; Tokyo National Museum: 22; Photograph courtesy of the International Society for Educational Information, Inc.: 27; Japanese National Tourist Organization: 32.
Chapter 17—Justin Kerr: 1, 7, 8, 9, 10, 13, 17, 28; Erich Lessing/AR: 2; Rene Millon, 1973: 4; Lee Boltin: 5; Photograph by Hillel Burger: 6, 34, 48; © 1988 Hillel Burger: 12; Foto Biblioteca Apostolica Vaticana: 14; Christopher Rennie/Harding: 15; Damm/ZEFA: 16; Wim Swaan: 18, 25, 35; American Museum of Natural History, New York: 20; Bill Ballenberg, © National Geographic Society: 21; Photo by Denis J. Nervig: 22; E. Hadingham: 23; ZEFA: 26; Douglas Dickins, FRPS: 27; Architectural Drawing Collection, University Art Museum, University of California, Santa Barbara: 33; John Running: 36; Werner Forman Archive/AR: 31; From Karl von Steiner, Die Marquesaner und ihre Kunst I: 50; Photographer: Peter Horner: 52; Dr. George Kennedy, University of California, Los Angeles: 53; Helmut Jäger: 57; Hinz: 58; Meteorological Service of New Zealand Limited: 61.
Chapter 18—H. M. Cole: 1, 22; © 1988 Rachel Hoffman: 2; Photograph by Roy Sieber, 1964: 3; National Commission for Museums and Monuments, Lagos: 4, 8, 9; Jean Dominique Lajoux: 6; T. K. Seligman: 7; James L. Stanfield, © National Geographic Society: 11; © Carollee Pelos, from Spectacular Vernacular: The Adobe Tradition: 12; © 1972, H. M. Cole: 14; Photograph by Eliot Elisofon, 1970: 15, 16; Photograph © by The Barnes Foundation: 20; © 1976, H. M. Cole: 21; Photograph by Philip Ravenhill, 1978: 25; Michel Huet/HOA-QUI, Paris: 27; Photo by Denis J. Nervig: 30; Frank Willett: 32; photograph by Henry John Drewal, 1978: 33; photograph by Philip Ravenhill, 1989: 34.
Part IV opening photograph—Summerfield.
Chapter 19—Canali: 1, 4, 5, 7, 18; Ralph Lieberman: 2, 12; AL/AR: 3, 14, 16; Scala/AR: 6, 8, 10, 19, 20, 21; Summerfield: 9, 15; Gir: 11; Takashi Okamura/Abbeville Press, New York: 13, 17; Anderson/AR: 22.
Chapter 20—Gir/AR: 1; Inventaire général/SPA-DEM Jean-Luc DUTHU: 2; Gir: 3; Artothek: 5; Joseph S. Martin/Artothek: 6, 16; Photo by Richard Carafelli: 11; Paul Laes, Belgium: 13; Canali: 14; Summerfield: 15; © photo Jean Mazenod, L'art gothique, éditions Citadelles & Mazenod, Paris: 19; Jörg P. Anders/BPK: 20; R.M.N.: 21; Yves-Siza: 22; Christopher Rennie/Harding: 23; Photo Verlag Gundermann, Würzburg: 24; Jean Dieuzaide: 25; Luraine C. Tansey: 26.

Chapter 21—HB Collection: 1, 2; Ralph Lieberman: 3, 10, 13, 14, 17, 35, 36, 40, 42; Canali: 4, 8, 12, 19, 23, 24, 25, 28, 30, 32, 33, 34, 49, 52; Erich Lessing/AR: 22; Summerfield: 5, 27, 57; AL/AR: 6, 11, 43, 45, 46, 47, 50, 60, 62; Canali/Lensini, Italy: 7; Mar/AR: 9; Anderson/AR: 15, 21, 38, 51; Brogi/AR: 20; Scala/AR: 29, 58; © 1987 M. Sarri: 31; German Archaeological Institute, Rome: 39; Photo by Philip A. Charles: 48; Takashi Okamura/Abbeville Press, New York: 54; Bridgeman Art Library/AR: 55; Photo by Richard Carafelli: 56; © 1984 M. Sarri/Photo Vatican Museums: 59; Giovetti: 61.

Chapter 22—Scala/AR: 1, 13, 48, 59, 60, 65, 66; AL/AR: 3, 9, 34, 45; R.M.N./Duplicata: 4, 58; Canali: 6, 14, 16, 19, 35, 38, 61, 64; The British Architectural Library, RIBA, London: 10; Ralph Lieberman: 11, 27; Guidotti/Grimoldi: 12; © 1983 M. Sarri/PhotoVatican Museums: 15; R.M.N.: 17, 21, 22, 62; Canali/On license of Fabbrica di S. Pietro, Vatican: 18; Summerfield: 20, 39, 40; Nippon Television Network Corporation, Tokyo, 1994: 23, 26, 28; Photo Vatican Museums: 24; Bracchetti-Zigrossi/Photo Vatican Museums: 25; Rotkin, PFI: 29; Anderson/AR: 30, 36; Fototeca: 32; Gir/AR: 44; Edwin Smith: 46; AR: 47; Harry N. Abrams, Inc.: 50; Phyllis Dearborn Massar: 51, 53, 54; Canali/Cameraphoto: 55, 56, 67; Photo by Jose A. Naranjo: 57; Blauel-Gnamm/Artothek: 63.

Chapter 23—Artothek: 1; Photograph by Schecter Lee: 2; Gir/AR: 3, 4; Jörg P. Anders/BPK: 8, 14; Scala/AR: 11, 20; Studio Milar: 17; R.M.N.: 18; Lauros/Gir: 19; Gir: 21; Bulloz: 22; MAS: 23, 24, 25, 26; Lauros-Gir/AR: 27.

Chapter 24—Anderson/AR: 1, 13; Anthony Kersting: 2, 63, 72; Rotkin/P.F.I.: 3; Canali: 5, 7, 10, 16, 18, 21, 22, 23, 24; AL/AR: 8, 48; Summerfield: 11, 31, 44; G. E. Kidder Smith: 15, 17; Scala/AR: 19, 25, 29, 60; R.M.N./R.G. Ojeda: 26; © 1987 M. Sarri/PhotoVatican Museums: 27; Provinciebestuur van Antwerpen: 38; Blauel-Gnamm/Artothek: 39; Joachim Blauel/Artothek: 40; Artephot/Photo R.M.N.: 41; R.M.N./Duplicata: 43, 56, 69; Arch. Phot. Paris/SPADEM: 47; Novosti/Sovfoto: 49; Photo by Richard Carafelli: 50; Photograph © Mauritshuis, The Hague: 55; R.M.N.: 57, 70; Bulloz: 62; Aerofilms Limited: 64; NYPL: 65; Gir/AR: 66; HB Collection: 67; Roger-Viollet: 68; National Monuments Record: 71.

Chapter 25—Rapho/PRI: 1; British Stationery Office: 2; National Monuments Record: 3, 22; Anthony Kersting: 4, 5, 32; Hir: 7; AL/AR: 8; Scala/AR: 9; Ralph Lieberman: 10; Scala/AR: 11; R.M.N.: 12, 13, 27, 29, 49, 50; R.M.N./Duplicata: 14, 46; Bulloz: 18, 40; The British Library: 20; Summerfield: 25; Country Life Picture Library: 33, 38; Tate Gallery, London/AR: 35; The Collections of the Virginia State LIbrary & Archives: 42; Courtesy of the Library of Congress: 43; NYPL: 44; Photo: Ann Hutchison: 45.

Part V opening photograph—Lauros/Gir.

Chapter 26 map—R. R. Palmer, ed., *Atlas of World History*, Rand McNally, 1975. Permission granted by Reed Consumer Books, London.

Chapter 26—Arch. Phot. Paris/SPADEM: 1; AL/AR: 2, 26; AR: 3; R.M.N.: 4, 5, 6, 8, 12, 40, 55, 69; R.M.N./Duplicata: 13, 16, 17, 18, 37, 65; Gir/AR: 14, 35, 89; Elke Walford: 19, 44; Staatlich Museen zu Berlin: 20; Bulloz: 25; Brownlie/PRI: 27; Anthony Kersting: 28; Moreau/Arch. Phot. Paris/SPADEM: 29; Collection Société Française de Photographie, Paris: 31; Massachusetts Commandery Military Order of the Loyal Legion and the US Army Military History Institute: 34; Thomas Jefferson University Art Committee: 41; Novosti/Sovfoto: 45; © 1981 Sotheby's, Inc.: 46; Tate Gallery, London/AR: 49, 50, 70; Joachim Blauel/Artothek: 51; HB Collection: 59; Courtesy George Eastman House: 68; Michael Agee: 75; R.M.N./R.G. Ojeda: 81; Scala/AR: 86; Courtesy of the Library of Congress: 90; Lee Stalsworth: 91, 92; Mar/AR: 93; Photo: French Government Tourist Office: 95; Chicago Architectural Photography, Co.: 96; Ralph Lieberman: 97; Hedrich-Blessing photograph courtesy Chicago Historical Society: 98; The Preservation Society of Newport County/Newport Mansions: 99.

Chapter 27—Ralph Lieberman: 2; Chicago Architectural Photography, Co.: 3; Ezra Stoller © Esto: 5; © 1996 Estate of Gerrit Rietveld/Licensed by VAGA, New York, NY: 6; Cervin Robinson: 7; © 1995 ARS, NY/VG Bild-Kunst, Bonn: 9, 22, 23; Lucien Herve: 11; © 1995 ARS, NY/ADAGP, Paris: 13, 15, 28, 52, 53, 58, 59, 61, 70; Scala/AR © 1995 Succession H. Matisse, Paris, NY: 14; Erich Lessing/AR: 16; © 1995 ARS, NY/Pro Litteris, Zurich: 17; Elke Walford: 18; Photo: David Heald ©

1995 ARS, NY/ADAGP, Paris: 21, 31, 33, 35, 39; © 1995 ARS, NY/VG Bild-Kunst, Bonn: 22, 23, 54, 60, 68; © 1995 ARS, NY/SPADEM, Paris: 24, 29, 34, 67, 71; HB Collection: 26; Martin Bühler, Basel © 1995 ARS, NY/ADAGP, Paris: 30; R.M.N.: 32 © 1995 ARS, NY/SPADEM, Paris; Photography by Sheldan C. Collins, NJ. © 1996 Estate of Stuart Davis/Licensed by VAGA, New York, NY: 36; © 1995 ARS, NY/ADAGP/SPADEM, Paris: 38, 40, 63; Biff Henrich: 41; © 1996 Estate of Jacques Lipchitz/Licensed by VAGA, New York, NY Courtesy, Marlborough Gallery: 43; Musee de L'Homme: 46; Tate Gallery, London/AR: 47, 55; Martin Bühler, Basel: 50; © 1996 Estate of Vladimir Tatlin/Licensed by VAGA, New York, NY: 51; Photo by Richard Carafelli © 1995 The Georgia O'Keeffe Foundation/ARS, NY: 57; © 1996 Foundation Giorgio de Chirico/Licensed by VAGA, New York, NY: 62; © 1995 Demart Pro Arte, Geneva/ARS, NY: 64; Photo Hickey-Robertson © 1995 C. Herscovici, Brussels/ARS, NY: 65; Schalkwijk/AR: 66; Photo: 1992 Peter Lauri, Bern © 1995 ARS, NY/VG Bild-Kunst, Bonn: 69; photography by Geoffrey Clements, NY. © 1996 Ben Shahn/Licensed by VAGA, New York, NY: 77; Photo: MAS © 1995 ARS, NY/SPADEM, Paris: 80.

Chapter 28—© 1995 ARS, NY/ADAGP, Paris: 1; Tate Gallery, London/AR © 1995 ARS, NY/ADAGP, Paris: 3; Lee Fatherree © 1995 The Pollock-Krasner Foundation/ARS, NY: 4; HB Collection: 5; © 1995 Willem de Kooning/ARS, NY: 6; photo by Edward Owen © 1995 ARS, NY/ADAGP, Paris: 7; 1985, Steve Sloman, NY © 1995 Kate Rothko-Prize & Christopher Rothko/ARS, NY: 9; © 1963 Ellsworth Kelly. Photo by Philipp Scholz Rittermann: 10; © 1995 Frank Stella/ARS, NY: 11; Photo courtesy André Emmerich Gallery, New York: 12; Photograph by Schecter Lee: 13; Photo: Lee Stalsworth 1995 © ARS, NY/ADAGP, Paris: 14; Photo by David Gahr © 1995 ARS, NY/ADAGP, Paris: 16; © 1995 John Chamberlain/ARS, NY: 18; © 1996 Louise Bourgeois/Licensed by VAGA, New York, NY: 19; © 1996 Estate of David Smith/Licensed by VAGA, New York, NY: 20; Photograph by Rudolph Burckhardt. © 1996 Estate of Donald Judd/Licensed by VAGA, New York, NY: 22; Photo by Gianfranco Gorgoni: 24; © 1983 Christo, photo: Wolfgang Volz: 25; © 1996 Richard Hamilton/Licensed by VAGA, New York, NY: 26; David Hockney: 27; © 1996 Jasper Johns/Licensed by VAGA, New York, NY: 28; Rheinisches Bildarchiv © 1996 Jasper Johns/Licensed by VAGA, New York, NY: 29; Photo by: Graydon Wood, 1989. © 1996 Robert Rauschenberg/Licensed by VAGA, New York, NY: 30; Claes Oldenburg: 31; Roy Lichtenstein: 32; Tate Gallery, London/AR © 1995 The Andy Warhol Foundation for the Visual Arts/ARS, NY: 33; photo: Ron Jennings: 34; Photo by Anne Gold: 35; PaceWildenstein: 37; Photo courtesy Allan Stone Gallery. © 1996 Richard Estes/Licensed by VAGA, New York, NY Courtesy, Marlborough Gallery: 38; © 1995 ARS, NY/VG Bild-Kunst, Bonn: 39; Courtesy: Brooke Alexander, New York. Photo: D. James Dee: 40; © 1985 Gilbert & George; Courtesy Robert Miller Gallery, New York: 41; Judy Chicago, 1979; photo: Copyright Donald Woodman: 42; Courtesy Barbara Kruger: 44; Metro Pictures: 45; photo: Artur Starewicz, Warsaw: © 1996 Magdalena Abakanowicz/ Licensed by VAGA, New York, NY Courtesy, Marlborough Gallery: 46; Courtesy Ronald Feldman Fine Arts, New York: 47; Phillips/Schwab: 49; Photo by Robet McElroy. Courtesy André Emmerich Gallery, New York: 50; Photo: Office of Cultural Affairs, city of San Jose © 1995 Dorothea Rockburne/ARS, NY: 51; Paul Macapia: 52; © 1979 David Em: 55; Electronic Arts Intermix: 57; Peter Aaron/Esto: 58, 67; AP/Wide World Photos: 59; The Solomon R. Guggenheim Museum, New York, photo by Robert E. Mates: 60; The Solomon R. Guggenheim Museum: 61; Ralph Lieberman: 62; from *The New Churches of Europe* by G. E. Kidder Smith: 63; David Austen/Tony Stone Images: 64; Ezra Stoller © Esto: 65, 70; Richard Payne, Houston: 66; H. Armstrong Roberts: 68; Michael Bodycomb: 72; Deutches Architektur-Museum Archiv: 73; Michael Melford/The Image Bank: 74; Matt Wargo: 75; Peter Mauss/Esto: 76, 77; Photo: Christian Kandzia/Behnisch & Partner: 78; Photo courtesy of The Japan Architect © Shinkenchiku-sha: 80; Julian Calder/Tony Stone Images: 81.

ILLUSTRATION CREDITS

FIG. 1-3 From "The Archeology of Lascaux Cave," by Arlette Leroi-Gourhan. © 1982 Scientific American, Inc., all rights reserved.

FIGS. 1-16, 1-17 Arlette Mellaart.

FIG. 2-2 From E.S. Piggott, Ed., *The Dawn of Civilization*, London Thames and Hudson, 1961, pg. 70.

FIG. 2-3 From H. Frankfort, *The Art and Architecture of the Ancient Orient*, Harmondsworth and Baltimore: Penguin, 1970, p.69.

FIG. 2-18 © 1975 The Royal Institute of British Architects and the University of London, by permission of Athlone Press.

FIGS. 3-5(a), 4-4, 4-22, 8-11, 9-5 © Hir.

FIG. 3-5(b) From K. Lange and M. Hirmer, *Agypteu Architectur, Plastik, and Malerei in drei Jahrtausenden*, Munich, 1957. Used by permission of Phaidon Press and Hirmer Fotoarchiv.

FIGS. 3-22, 3-28, 7-74, 9-25, 13-59 From Sir Banister Fletcher, *A History of Architecture on the Comparative Method*, 17th ed., rev. by R. A. Cordingly, 1961. Used by permission of Athlone Press of the University of London and the British Architectural Library, Royal Institute of British Architects.

FIG. 4-21 From Alan J.B. Wace, *Mycenae*, Princeton University Press, 1949, Fig. 22.

FIG. 5-6 From J.G. Pedley, *Greek Art and Archaeology*, Prentice-Hall, 1993, Fig. 5.15.

FIG. 5-17 From Marvin Trachtenberg and Isabelle Hyman, *Architecture from Prehistoric to Post-Modernism/The Western Tradition*, Englewood Cliffs, NJ: Prentice Hall, 1986, p. 86, p. 293. Used by permission.

FIG. 5-18 From J. Charbonneaux, *Archaic Greek Art*, George Brazziller, Inc. 1971, Fig. 17.

FIG. 5-29 From H. Berve and G. Gruben, *Greek Temples, Theaters, and Shrines*, Harry N. Abrams, Inc., Fig. 41.

FIG. 5-46 Courtesy of the Agora Excavations, American School of Classical Studies, Athens.

FIG. 5-59 From H. Berve and G. Gruben, *Greek Temples, Theaters, and Shrines*, Harry N. Abrams, Inc., Fig. 66.

FIG. 5-84(a) From H. Berve and G. Gruben, *Greek Temples, Theaters, and Shrines*, Harry N. Abrams, Inc., Fig. 130.

FIGS. 7-3, 15-33 Editions Citadelles et Mazenod, Paris.

FIG. 7-4 From *A Concise History of Western Architecture* by Robert Furneaux Jordan, © 1969, by Harcourt Brace Jovanovich. Reproduced by permission of publisher.

FIG. 7-15 Verlag M. DuMont Schauberg.

FIG. 7-38 From J.B. Ward-Perkins, *Roman Architecture*, Adapted by permission of Electra Editrice, Milan.

FIG. 7-50 From Boethius, "Etruscan and Early Roman Architecture". © Yale University Press.

FIG. 7-84 After George M.A. Hanfamann, *Roman Art: A Survey of the Art of Imperial Rome*, A New York Graphic Society Book, by permission of Little Brown and Co.

FIG. 10-8 From G. Marcais *L'Architecture Musul mane d' Occident*. By permission of Arts et Metiers Grapohiques, Paris.

FIG. 10-13 From K.A.C. Creswell, *Early Muslim Architecture*. Adapted by permission of Clarendon Press/Oxford University Press.

FIG. 10-25 Plan drawn by Christopher Woodward.

FIG. 12-2 From H. Stierlin, *Die Architektur der Welt*, Vol. 1, p. 147, p 188, © 1977 Hirmer Verlag, Munich.

FIGS. 12-4, 12-17 From Kenneth J. Conant, *Early Medieval Church Architecture*. Used by permission of Johns Hopkins Press.

FIG. 12-11 © AL/AR.

FIGS. 13-4, 13-6, 13-7 From Ernest Gall, *Gotische Kathedralen*, 1925. Used by permission of Klinkhardt and Biermann, publishers.

FIG. 13-19 Used by permission of Umschau Buchverlag, Frankfurt.

FIG. 14-9 From Benjamin Rowland, *The Art and Architecture of India*, 1953 Penguin Books.

FIG. 14-29 Madeleine Giteau, "The Civilization of Angkor". Adapted by permission of Rizzoli International Publications.

FIGS. 15-34, 15-36, 15-38 © Laurence G. Liu.

FIG. 21-37 From Marvin Trachtenberg and Isabelle Hyman, *Architecture from Prehistoric to Post-Modernism/The Western Tradition*, Englewood Cliffs, NJ: Prentice Hall, 1986, p. 86, p. 293. Used by permission.

FIG. 21-41 From Nikolaus Pevsner, *An Outline of European Architecture*, 6th ed., 1960 Penguin Books Ltd., © Nikolaus Pevsner, 1943, 1960, 1963.

FIG. 24-20 By courtesy of Electa, Milano.

FIG. 27-10 Photo: Lucien Herve © 1995 ARS, NY/SPADEM, Paris.

FIG. 28-69 James A. Sugar © National Geographic Society.

INDEX

Page numbers in italics indicate illustrations.